The
Illustrated
History of Art

The Illustrated History of Art

David Piper

Bounty
Books

THE ILLUSTRATED HISTORY OF ART

DAVID PIPER

WITH A SECTION ON EASTERN ART BY PHILIP RAWSON

First published in Great Britain in 1981 by Mitchell Beazley,
an imprint of Octopus Publishing Group Limited

Reprinted 1986, 1991,

Published by Chancellor Press (Bounty Books) in 2000

This paperback edition published in 2004 by Bounty Books,
a division of Octopus Publishing Group Limited
2-4 Heron Quays, London E14 4JP
Reprinted 2005, 2006
Copyright © Octopus Publishing Group 1981, 1986, 1991, 2000, 2004

ISBN-13: 978 0 753709 08 5
ISBN-10: 0 753709 08 2

Printed and bound in China

Editor	Paul Holberton
Art Editor	Michael McGuinness
Publishing Director	Jack Tressidder

INTRODUCTION
by David Piper

There is more than meets the eye in any painting or sculpture of high quality. It is the function – and privilege – of books such as this to bring out some of the resonances that might otherwise pass unnoticed. The history that follows is conceived as a commentary, a companion, which I hope will inform, stimulate but above all open the reader's eyes to further pleasures, heightening awareness and enhancing life.

What great paintings and sculptures have in common with any form of great art is their ability to create a fresh order from the flux of life. The pleasure we are given from looking at them is primarily that of having our view clarified, distilled, detached from the distractions that condition our everyday way of seeing. We are able to share a perception of the world different from our own, and more penetrating.

Words about art lose much of their impact when they cannot be related directly to the works they describe, and it has been one aim of this history to bring together words and pictures more closely than ever before. In general, if a work of art is mentioned in the text it is also illustrated – and described in further detail – on the same page.

The book covers the entire span of painting and sculpture from Palaeolithic images to modern art as it looked in the 1980s. In general, the organization is geographic and chronological. But the art of a particular school or movement is usually followed through to its final development, not treated piecemeal. Though enough context is given to orientate the reader, the aim is to keep the focus on the paintings and sculptures themselves; the issues and preoccupations of the day, the conditions under which the works were produced, are discussed not for their own sake but in order to throw light on the form and content of the art.

Particular subjects, or aspects of them, are usually encapsulated within a single two-page "spread". This allows the reader either to begin at the beginning in the conventional way or to enter the book at any point, finding each article more or less self-contained, though it connects with the others to build up a coherent whole.

The broad development of art is unfolded in narrative spreads which begin usually with background information and then cover a particular period, movement or region. In the course of the story some artists arrive of such stature that they have one of these spreads to themselves, either to trace the development of their work or to pause and contemplate a single great achievement.

Where matters of selection were involved I have tried to bear in mind the interests and needs of the gallery-goer, which do not always correspond with those of art historians. This means not only that the overall balance of the history to some extent reflects my own tastes, but also that the quality, preservation and accessibility of what has survived is taken into account.

EDITORIAL AND INDEXING METHOD

The locations, dimensions and mediums of works of art can be found in the list of illustrations that precedes the index. These lists are headed, as are the captions themselves, by the name of the artist or, if this is unknown, by the place of origin or original location of the work.

Titles of all works of art are given in italics, but if translation is inappropriate or the title is a popular one it is also placed in quotation marks and capitalized.

The names of monuments or buildings, notably churches, are usually the local names – thus Ste Madeleine, the Residenz. The abbreviation "S." is used for all the Italian variants, San, Santa, Sant', Santo. For Chinese words the pinyin system is used (though the Wades-Giles spelling is cross-referenced to the pinyin in the index). The Latin forms of ancient Greek names have been used except in the historical section on ancient Greek art; thus Hercules in Renaissance art, Herakles in Greek art.

Contents

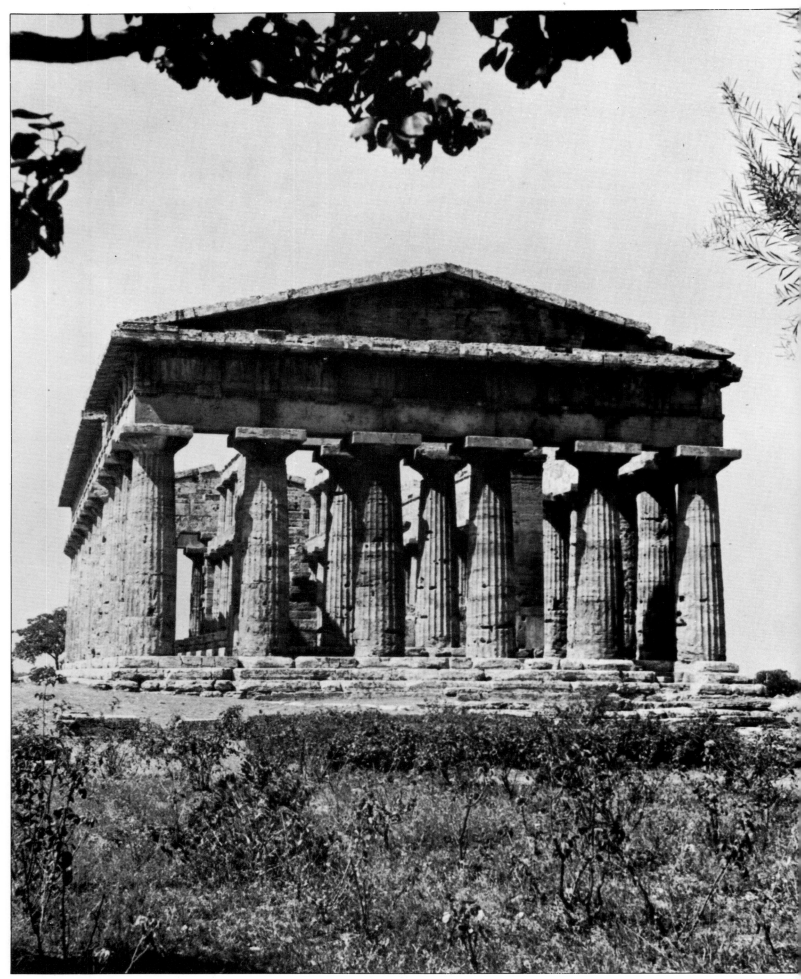

8

ANCIENT WORLDS

In this book the history of art has been organized in the usual way region by region and, for the most part, also in chronological sequence, which may wrongly imply a distancing not only in time and space but in sympathy. In a way it is true of course that the several and disparate worlds considered in this opening section are fundamentally remote. They are mostly "dead" cultures, their languages sometimes entirely unrecorded, sometimes impossible for us to read. Most people in the twentieth-century West can look at a statue by Michelangelo and think they know what it means – and will not be too far wrong; among ancient cultures, the context, function and meaning of a work of art are often less clear, even to scholars.

Yet ancient artefacts have an interest not only as the objects they were but as the objects they are. If the history of art shows anything it is that art does not always move forward in linear progression. It frequently turns back for inspiration, as the Renaissance turned back to the classical world, and as modern art has again turned back to the force of "primitive" sculpture. We may well feel closer in spirit to a Palaeolithic image than to one produced in a sophisticated court of the eighteenth century.

There are two major departures from chronology in the course of this history. One is that the art of Asia is placed at the midpoint of the book, though the civilizations of China and India emerged hardly later than those of Mesopotamia and Egypt. Apart from acknowledging the fact that the arts of East and West have not much cross-fertilized except in the modern era, this shift allows ancient and modern Eastern art to be treated coherently.

Secondly, the tribal arts of Africa, Oceania and North America are considered immediately after Palaeolithic art. In the naturalism and powerful immediacy of cave-paintings millennia old there are parallels with Aboriginal and some African art of quite recent origin; and parallels again between Oceanic, North American Indian and some African tribal art and the cultures that preceded the rise of states and civilizations. As Pre-Columbian art (for convenience treated here also) shows, images produced in the context of the earliest organized states tended to become more formal and stylized, not because naturalism was unattainable but because it was almost irrelevant. The art of many early civilizations was intended to convey, in forms that were approved and perpetual, images of gods and rulers or of the duties of the community towards them.

It was against a background of almost imperceptible change in the art of the Middle East that Greek art of the sixth and fifth centuries BC developed with the swiftness of a revolution. The human body became the focus for sculpture and soon for painting, too, a basic subject of Western art ever since. Though its primacy might be challenged – in the medieval era, or again in our own century – the human figure, together with the making visible of light and space that is its stage, has proved an inexhaustible Western theme.

PAESTUM, ITALY (left)
The Temple of Neptune,
*c.*470-460 BC

PALENQUE, MEXICO (right)
The Pyramid of the
Inscriptions, *c.* AD 700

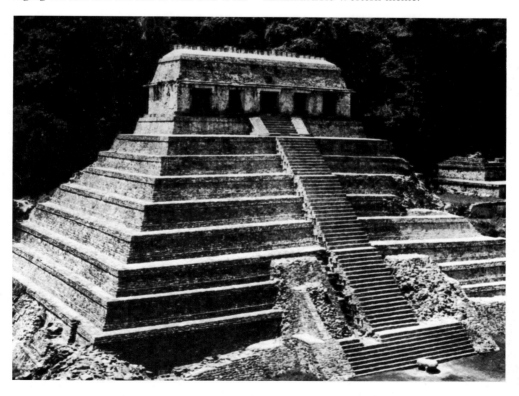

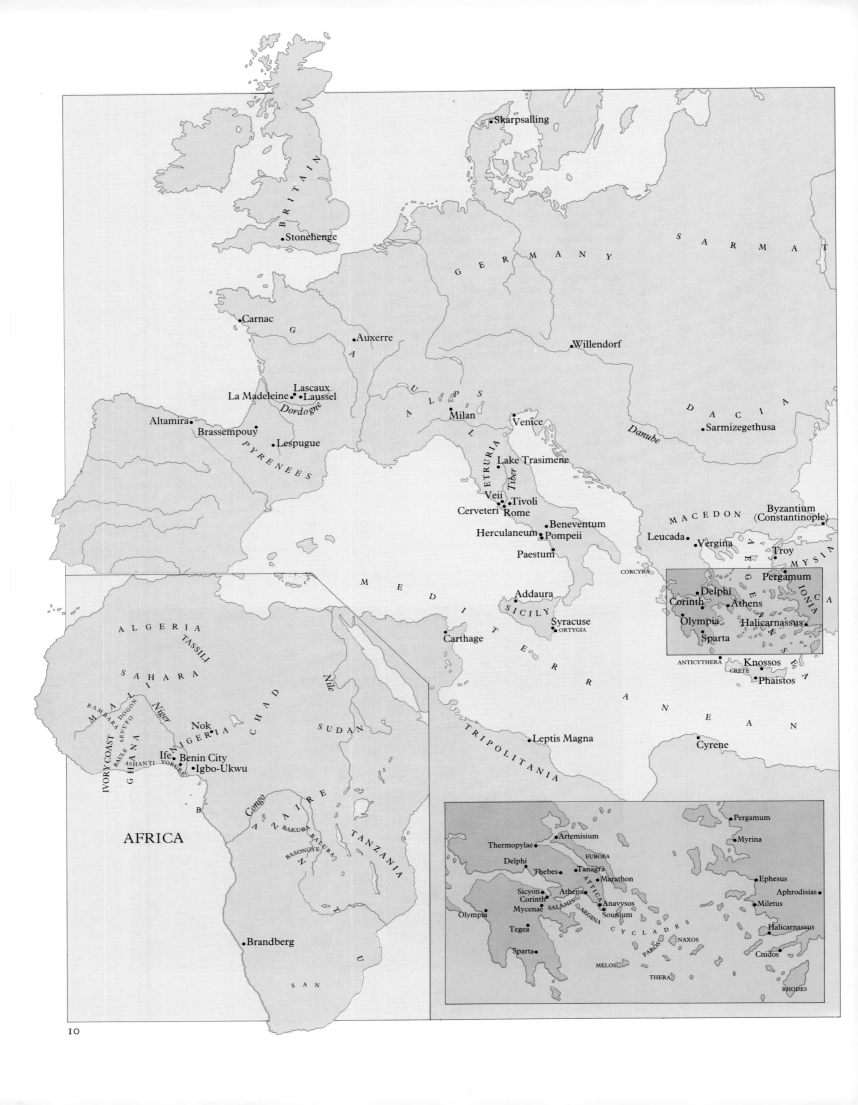

Skarpsalling

SARMAT

GERMANY

BRITAIN

Stonehenge

Carnac

Auxerre

Willendorf

DACIA

Sarmizegethusa

Danube

Lascaux
La Madeleine • Laussel
Dordogne

Milan

Venice

Altamira
Brassempouy

Lespugue

PYRENEES

ETRURIA

Lake Trasimene
Tiber

Veii • Tivoli
Cerveteri • Rome

MACEDON

Byzantium
(Constantinople)

Beneventum

Leucada • Vergina

Herculaneum • Pompeii

Troy

MYSIA

Paestum

CORCYRA

Pergamum

IONIA

Delphi
Corinth • Athens
Olympia • Halicarnassus
Sparta

Addaura

SICILY

Syracuse
ORTYGIA

MEDITERRANEAN

Carthage

ANTICYTHERA

Knossos

CRETE

Phaistos

ALGERIA
TASSILI

SAHARA

MALI
BAMBARA DOGON
BAULE SENUFO
Niger

Nok

NIGERIA CHAD

SUDAN

Nile

IVORY COAST
GHANA
ASHANTI
Ife • Benin City
YORUBA • Igbo-Ukwu

B

Congo

ZAIRE
BAKUBA
BALUBA
BASONGYE

TANZANIA

Leptis Magna

Cyrene

TRIPOLITANIA

AFRICA

Brandberg

SAN

Pergamum

Artemisium

Myrina

Thermopylae

EUBOEA

Delphi
Thebes • Tanagra
Marathon

Ephesus

Sicyon
Corinth
Mycenae

Athens
SALAMIS
AEGINA

ATTICA

Anavysos
Sounium

Aphrodisias

Miletus

Olympia

Tegea

CYCLADES

Halicarnassus

Sparta

PAROS
MELOS

NAXOS

Cnidos

THERA

RHODES

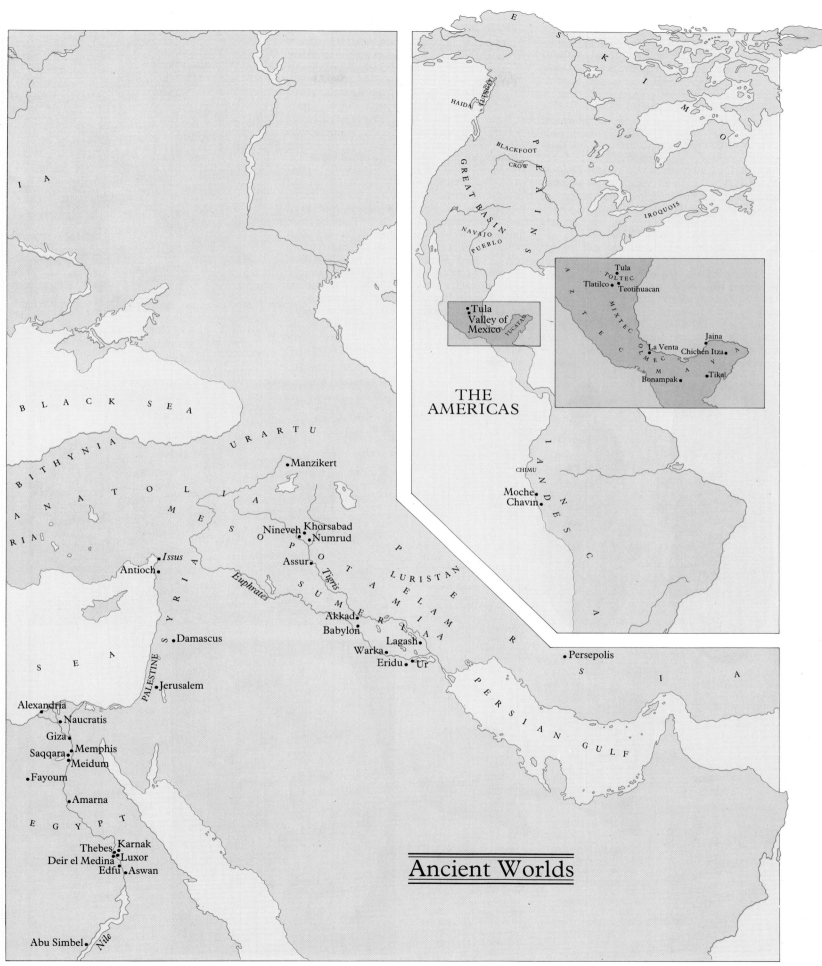

THE
AMERICAS

E S K I M O

HAIDA TLINGIT

BLACKFOOT
CROW

GREAT BASIN

P L A I N S

IROQUOIS

NAVAJO

PUEBLO

Tula
Valley of
Mexico

YUCATÁN

Tula
TOLTEC
Tlatilco Teotihuacan

A
Z
T
E
C

MIXTEC

O
L
M
E
C

La Venta

Jaina
Chichén Itza

M A Y A

Bonampak Tikal

CHIMU

A N D E S

Moche
Chavin

I A

B L A C K S E A

BITHYNIA

A N A T O L I A

URARTU

S Y R I A

Manzikert

M E S O P O T A M I A

Nineveh Khorsabad
Numrud

Issus
Antioch Assur

Euphrates

Tigris

S U M E R

L U R I S T A N

E L A M

P E R S I A

Damascus

PALESTINE

Akkad
Babylon

Lagash

Warka
Eridu Ur

Persepolis

S E A

Jerusalem

Alexandria
Naucratis

Giza

Saqqara Memphis
Meidum

Fayoum

P E R S I A N G U L F

Amarna

E G Y P T

Thebes Karnak
Deir el Medina Luxor
Edfu Aswan

Abu Simbel Nile

Ancient Worlds

11

Palaeolithic Art

The creative impulse to make images – objects without any apparent mechanical use – emerged very early indeed: it was almost simultaneous perhaps with the arrival of man as we know him now, *homo sapiens sapiens*, superseding Neanderthal man.

The earliest surviving man-made works that qualify as art come mainly from Europe, and date from within the huge range of time known as the Upper Palaeolithic period, from about 30000 to about 10000 BC. The Upper Palaeolithic comprises in sequence the Aurignacian, Gravettian and Magdalenian periods, measuring approximately from 30000 to 20000 BC, from 20000 to 14000 BC, from 14000 to 10000 BC. Then, as the climate thawed, mankind entered the Mesolithic era, and a food-producing neolithic culture appeared in Europe about 8000 BC.

The context in which Palaeolithic art was produced was one of developed hunting and food-gathering cultures, which possessed tools and weapons made of stone, wood or bone. Small-scale sculptures, engravings or reliefs have been found on former dwelling-sites – this kind of art antedates the cave-paintings by several thousands of years. Early work tends to concentrate on the human figure; later, more attention is given to animals. The most famous of the early sculptures are the so-called "*Venus*" figures, and the best-known amongst them, the limestone "*Venus of Willendorf*", may also be the earliest, from between 30000 and 25000 BC. Small though she is, she is charged with significance: in the swell of her breasts, belly and buttocks she is a personification of fecundity. The carving is accomplished with a satisfying control, and the interrelationship of the spherical volumes has provoked admiration and emulation in the twentieth century, for instance from the sculptor Brancusi. Comparable figures have been found in France, in Italy, in the Danube basin and as far east as Asiatic Russia. They are often more stylized, ranging from the outstanding ivory "*Venus*" of Lespugue (in the Dordogne) to mere symbols; all are generalized, faceless. Quite as early, however, the first faces in art appear, at the same sites: from Brassempouy in the Dordogne comes a clearly defined head in ivory, conveying the impression of a real woman lurking through the abrasions of millennia – with a sophisticated, almost Egyptian-looking hairstyle.

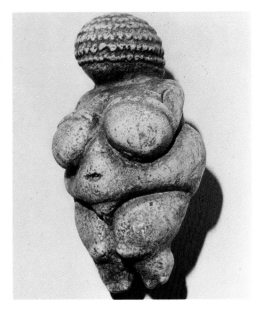

WILLENDORF, AUSTRIA
"*The Venus of Willendorf*",
*c.*30000-25000 BC
Carved from a pebble and once painted in red ochre, the "*Venus*" is of a size to be clutched in the palm of the hand – like an amulet.

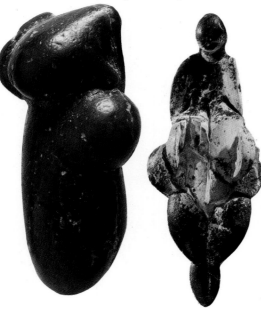

LAKE TRASIMENE, ITALY
(above) "*Venus*" figure,
Aurignacian period?
Sometimes the feminine form was reduced to its essentials, to an evocative symbol. But there is not enough evidence to assume a consistent development, whether towards greater abstraction or away from it.

LESPUGUE, FRANCE (left)
"*The Venus of Lespugue*",
*c.*20000-18000 BC
The figure is damaged, but it is still apparent that the stylization is complex, that this is a relatively sophisticated work of art. On her back, not shown, is incised a hanging cloth. On many of these figurines details may once have been indicated by colour (eaten away by acids in the soil).

LA MADELEINE, FRANCE
(below) *Bison*, *c.*12000 BC
The form of the animal is ingeniously adapted to the shape of the weapon, a club that could be thrown, of reindeer antler. Decorated objects begin to survive in abundance from the late Magdalenian period (named after the cave where this object was found); animal designs predominate, plant forms, geometric and spiral patterns appear very rarely.

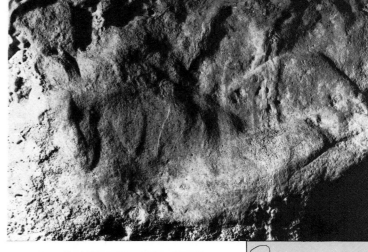

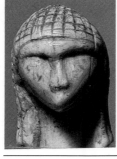

BRASSEMPOUY, FRANCE
(left) *Female head*,
*c.*22000-20000 BC
The ivory fragment is one of a group of statuettes of the late Aurignacian; but its clearly delineated features are almost unique amid the hundreds of finds made in prehistoric sites in the Dordogne caves.

LAUSSEL, FRANCE (right)
"*The Venus of Laussel*",
*c.*20000-18000 BC
Prominent in the woman's hand, the horn suggests later, Bronze-Age, bull-cults. From a rock shelter in the Dordogne, the slab is 45cm (almost 18in) high, and similar in conception to "*Venuses*" in the round.

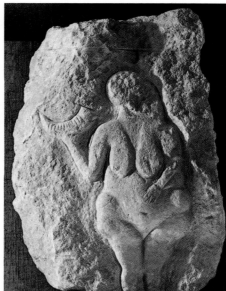

THE DORDOGNE, FRANCE
(above) *Reclining woman*,
*c.*12000 BC
The relative naturalism, unexaggerated proportions and relaxed disposition are highly unusual in the later Magdalenian period. The contour is expressive, the body is understood to have volume, in an era when figures were usually caricatured; naturalism was reserved for animals, which were represented more frequently. A flint was probably used to cut away the rock, and bumps and hollows in the natural surface were incorporated in the sculptor's design.

Techniques of engraving – scratchings or incisions on surfaces of bone, stone or horn – are probably as old as those of carving or modelling, but the best works of this kind are mostly later, of Magdalenian times. True sculpture in relief is much rarer, but was carved sometimes in the openings of caves, where there was enough light to see by, sometimes into rock in the open air. One Gravettian relief, from the Dordogne again, shows, for the first time in Palaeolithic art, a human figure in relationship to an object: with one hand on her belly, she holds with the other a bison-horn up to her face, seen in profile. Later, a more accomplished mastery could produce images of sensuous ease, such as the reclining nude from a cave in the Dordogne.

The earliest paintings were perhaps simply outlines of hands traced in red or black, but pictures of animals came very soon, and the two are found together at the earliest sites so far known, in the Dordogne. Caves with paintings are all in limestone areas, and virtually confined to south-western France and northern Spain; the most famous, the caves at Lascaux and Altamira, were not dwelling-sites but sanctuaries, in use perhaps for hundreds or

thousands of years from early Magdalenian times or just before. Lascaux, discovered in 1940, caused a sensation when it was published after World War II: in the "Hall of the Bulls" the bison and horses seemed to come thundering out of the darkness of prehistory in the vitality of their line and colour – and their size. The "Hall" is some 21 metres (70ft) long, and the beasts are mostly well over life-size. The paintings deep within the cliffs at Altamira, which has a gallery almost as long but much less high, were the first to be discovered, in 1879: they were then hardly to be believed, and the genuine and huge antiquity of these and other sites has been demonstrated only recently by the radiocarbon method and by stratigraphical analysis.

Both caves were devoid of light, and the painting must have been done by crude lamplight, with the broad black or brown contours of the drawing applied with rough felt-tips (as it were) made of moss or hair; at Lascaux the colour was blown on through a tube – red, yellow, brown, violet, but not green or blue – while at Altamira something like a brush was used. The animals are shown in a limited repertoire of positions, and always in profile: at

Altamira the animals do not relate to a ground or base but seem to float across the surface of the rock all ways up – this in spite of a much stronger feeling for mass and volume than at Lascaux. Only at Lascaux do human figures appear – schematic "matchstick" figures that anticipate the greater stylization emerging at the close of the Magdalenian period.

The magical purposes behind the depiction of these animals can only be guessed, but connections with some form of propitiatory hunting cult seem logical, since we find comparable images produced in tribal cultures that have survived almost to the present day – such as those of the Bushmen in South Africa (see over) or the Aborigines in Australia (see p. 23).

Neolithic culture, characterized by the development of ceramics, weaving and agriculture, emerged with the changed climate in Europe from about 8000 BC. Its most prominent relics fall into the category of architecture – stupendous megalithic complexes such as Stonehenge or Carnac – but there also survive painted clay figurines, and many pots incised, modelled or painted with an abstract, often geometric decoration, to be developed further in the metalwork of the Bronze Age.

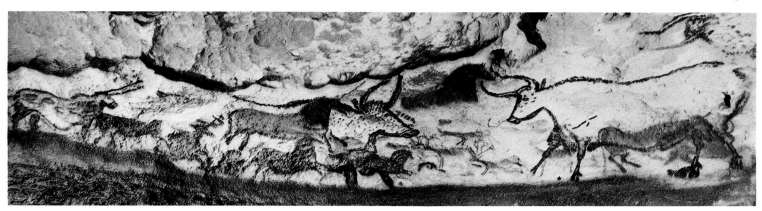

LASCAUX, FRANCE
"The Hall of Bulls",
in use c.15000 BC?
Superimposed bison, horses and deer seem to stampede across walls and ceiling. The pictures were renewed, or new images painted over old ones, countless times,
possibly for centuries; the site fell into disuse perhaps only in Mesolithic times. Lascaux was a miracle of survival, and a few years after its discovery had to be closed to the public, since the paintings were deteriorating alarmingly.

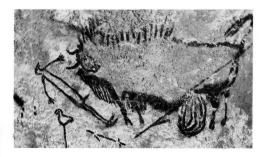

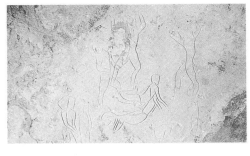

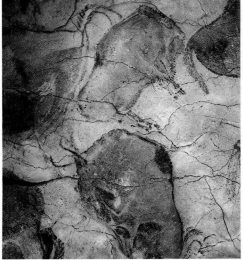

LASCAUX, FRANCE (above)
Detail: *Man and bison*
The man seems drawn less naturalistically than the animal he attacks (?) with a weapon. One theory is that painting the beasts was thought to bring them under the hunter's control.

ALTAMIRA, SPAIN (left)
Detail: *Two bison*,
c.13000 BC?
The beasts represented at Altamira include horses and deer, but are mostly bison. Several of these may have been copied from a dead model, trussed when it had been killed – for instance the lower of the two here.

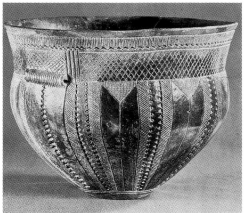

ADDAURA, SICILY (above)
Human figures, c.10000 BC?
Some figures are clearly male, but none is definitely female. They are engaged in a ritual that perhaps involved dancing or acrobatics, and possibly some performers wear masks.

SKARPSALLING, DENMARK
(left) Decorated bowl,
3rd millennium BC
A long series of neolithic cultures in northern Europe and Russia contributed to a tradition of ornamental decoration that culminated in Celtic art (see p. 66). Such ornament was applied also to tombs and megaliths.

African Art 1: Prehistoric and Historic

The traditional art of the continent of Africa can be divided roughly into two kinds – first, the "prehistoric", which has much in common with that of European neolithic culture, but in parts of Africa persisted even into the twentieth century; secondly, much better known, the art that was once called "primitive" or "negro" but is better described as "tribal".

The dating of the prehistoric art is still speculative, but its origins probably go back to at least 7000 BC. The earliest art has been found in the region that is now the Sahara, and consists of images at first scratched or engraved rather than painted on rock surfaces. The most ancient imagery, up to about 4000 BC, is of the chase, of wild animals – elephant, rhinoceros, hippopotamus, giraffe, antelope, ostrich – depicted fairly naturalistically, sometimes on a very large scale: a rhinoceros at Tassili is more than eight metres (26ft) high, and the human hunters can be more than three metres (11ft) tall. There follows (perhaps 4000-1200 BC) the "Cattle" or "Pastoralist" period, and the subject matter expands to include domestic cattle as well as wild animals. The style is at once less vital, smaller in scale, and less naturalistic, yet it shows an awareness of the needs of perspective. Then horses, dogs and a kind of wheeled chariot are included, but increasingly stylized. Horse-driving later gives way to horse-riding; and the drawing of humans can become almost geometrically schematic (a double triangle indicating the body). The scale shrinks, so that images are 30 centimetres (12in) or less high. Finally, the "Camel" period, which lingered on in remote areas until quite recently, shows domestic animals, and even fire-arms and cars, but, taking its name from the Saharan beast of burden, signals the desiccation into desert of a region once populated and life-supporting.

The images of the San (Bushmen) of South Africa were at first engraved on rock surfaces, but later quite vivid colour was employed. The beginnings of their tradition have been put as early as 4000 BC or as late as the fourteenth or fifteenth century AD (the more usually accepted estimate), but their art is an expression of a hunting and food-gathering existence that has been continuous from the remote past. In the earlier work animals seem to be represented in symbolic roles – the elephant is thought to represent rain clouds; also flora appear as well as fauna. In later work a somewhat cruder, more emphatic manner develops, often showing tribal battles, tribes or races (latterly white Europeans are included) being identified by colours. The style is traceable in some variety in the south and far up into the eastern areas of Africa, but is found very rarely in the different terrain of Central or West Africa. In most areas, however, two-dimensional representation is common in other media – notably on cotton, clay or wood – though the motifs and styles do not seem to be related to those of the prehistoric rock-paintings.

It is particularly in these areas, in Central or West Africa, in forest and grassland regions, that the best sculpture, especially in wood, has been created (see over). Surviving examples are mostly not earlier than the nineteenth and twentieth century, but they bear witness to far more ancient traditions. The disappearance of earlier evidence is largely due to the perishable nature of most of the media used; nevertheless, while archaeological exploration in much of Africa is still in its infancy, some startling discoveries have been made. The Nok culture of central Nigeria seems to go back nearly 2,500 years: terracotta figures and heads have been found in the ancient tin fields there which

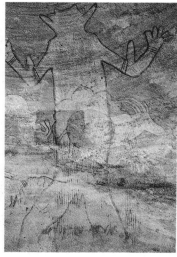

TASSILI, ALGERIA (right)
Rock-painting
In the Sahara desert and its surrounding area there has recently come to light the best and most varied collection of prehistoric rock art in the world; in 1956-57 the shallow caves of Tassili revealed what are probably the earliest known African paintings.

TANZANIA (below)
Rock-painting
Tanzania in East Africa is comparatively rich in rock-paintings, but they are usually less interesting and more recent than those of the Sahara or of South Africa. In technique and pigments they are no more than generically similar: no link need be presumed.

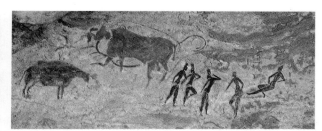

TASSILI, ALGERIA (left)
Rock-painting, of the "Pastoralist" type
Many of the paintings of Tassili show cattle being herded or tended; though bulls and cows are usually distinguishable the same is not true of men and women. The relaxed, hand-on-hip pose of some figures was first used in this phase.

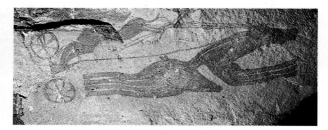

TASSILI, ALGERIA (left)
Rock-painting, of the "Wheeled Chariot" type
Knowledge of the wheel is one sign of progress; and, though the stylization of the figures has increased, the artist has shown them consciously in profile. It is thought that the images depict myths rather than the traffic of everyday life.

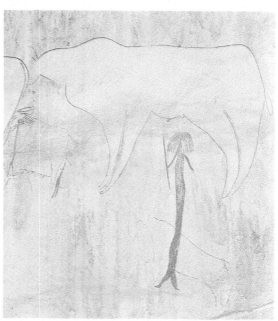

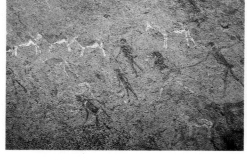

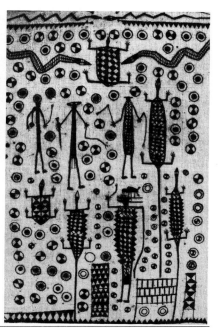

BRANDBERG, SOUTH AFRICA (above) *The White Lady*
Despite its nickname, the striding figure of this famous southern painting is believed to represent neither a lady nor white skin, but a male native in white paint. In this way it can be related to present Bantu practice – that of painting the body white in initiation ceremonies.

IVORY COAST (right)
Embroidered cotton
An agricultural fertility dance is illustrated on the hand-woven cotton, worked by the Senufo tribe. Near the middle of the lower row of figures, surrounded by hunters and reptiles, is a magician, wearing a "fire-spitter" mask. Its marked patterning distinguishes this from rock-painting.

probably date from the fourth or fifth century BC. Excavations in the 1930s at the religious centre of Ife, somewhat to the west of the Nok region, revealed some remarkable heads and figures, stylistically perhaps the distant descendants of the Nok culture, but more than 1,000 years later. Some of the terracotta heads found were extremely stylized, others, particularly those in bronze, were vividly naturalistic, and cast with a sophisticated control of the *cire-perdue* technique. More recently bronzes of perhaps the eighth century AD have been unearthed at Igbo-Ukwu in eastern Nigeria. Surely developed from these traditions are the better-known and far more numerous artefacts of the court of Benin, which was the royal and administrative centre of a great empire.

Early Benin bronzes, of perhaps about AD 1500, show a greater technical sophistication of casting and finish than those of anywhere else, though from the beginning more stylized, more hieratic than the more naturalistic ones of Ife. Later, the stylization became still more pronounced, and the handling progressively less sensitive, though the technique continued into the early twentieth century. The Benin repertoire included the famous *Queen Mother*

heads, with their formal coherence and elegance which to Western eyes evoke immediate recognition of a "classical" quality; these bronze heads, both female and male (the male ones, often with enormous finials of ivory, are in fact more frequent), were essentially commemorative but had also some religious role. Vivid bronzes of birds and animals were also produced, and animated bronze plaques in high relief in which representations of European (Portuguese) figures appeared from very early on. While some discern Western stylistic influences in Benin art, there seems little doubt that both techniques and style were originally indigenous. Bronze was not its only medium; ivory, too, was a favoured material, and was carved at Benin and elsewhere, often for export to Portugal, with great sensitivity.

Further west, the Ashanti cast in bronze and brass small weights that have become justly famous. Recent archaeology has also unearthed evidence (mostly in the form of terracotta sculpture) of long-established, hitherto unknown traditions in nearby Ghana, Chad and Mali – providing some prehistoric context for the greatest achievement of African art, which is surely its woodcarving.

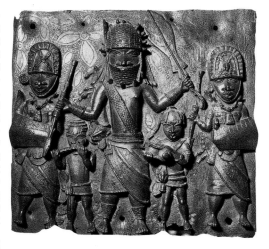

NIGERIA
A Benin king and his retinue
A Dutch visitor to the Benin court in 1667 noted the great splendour of the king's palace and also "the bronze plates decorating the rectangular pillars". The reliefs showed scenes from Benin life; here the king, distinguished by his high beaded collar (and his size and central position) is flanked by soldiers and music-making boys. The narrative quality suggests European influence; and Portuguese engravings were possible inspiration.

NIGERIA (right)
Human head
The subtractive – cut into rather than modelled up – style of Nok terracottas is the basis of suggestions that they reflect a lost tradition of woodcarving. This head is life-size.

NIGERIA (below)
Human head
The fine parallel lines of many Ife bronze *Heads* represent the effects of ritual scarification. Hair was possibly once set in the holes. Again the style calls to mind woodcarving.

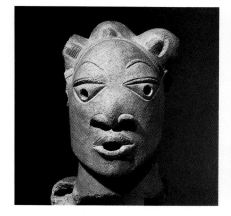

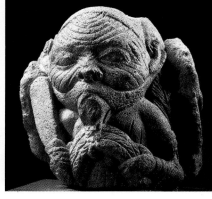

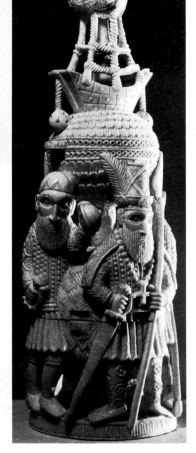

NIGERIA (right)
Queen Mother head
According to tradition, the men of Ife were asked to send a master bronze-worker to the Benin court, to initiate its artists. In later *Heads* – similar, but male – the emphasis on the regalia – the head-dress, the neck-rings – increases, moving distinctly away from natural proportions.

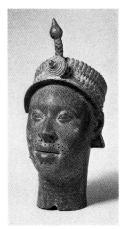

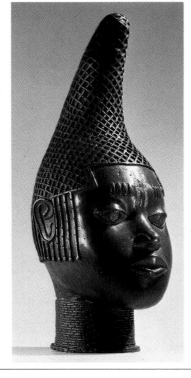

GHANA (below)
A weight
This type of brass weight, used by the Ashanti for weighing gold-dust, their currency, is unique to the region. The weights are inventively varied; they often illustrate proverbs.

NIGERIA (above)
Human head
The Ife culture shared with its Nok predecessor a curiosity about disease and deformity, reflected perhaps in this terracotta, an old man's head backed by the image of an owl.

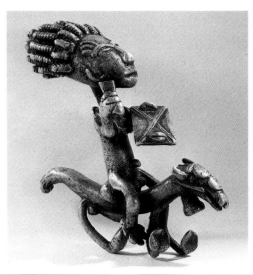

NIGERIA (above)
Salt-cellar
The Portuguese, who first set foot in Africa in 1494, soon appreciated the skill of the local ivory workers and established a trade in objects (such as this, made for export) and craftsmen.

African Art 2: Tribal

European artists and collectors began to take an interest in what was called "primitive" art – mainly the art of black Africa – from about the beginning of this century. They were primarily concerned, however (see p. 374), with the handling of certain formal problems, and very little with the function for which the images were made. To Western artists, from the Cubists onwards, African art suggested ways of escape from the dominant, but seemingly exhausted, academic tradition of naturalism. For Africans, however, art had a quite different function in a quite different way of life, and was essentially an integral part of an all-pervading religion. Individual images were agents, even embodiments at times (though not "idols" to be worshipped, as many Europeans used crudely to think) of the vital forces divined in all living matter. Often they spoke for the spirits of the dead, so perpetuating the vital essence of the ancestry of the tribe, and becoming identified with the ancestral spirits.

Though there are secular aspects to most of the forms used, and some objects are clearly purely decorative and ornamental, generally African tribal artefacts were created for a particular ritual or ceremonial use. This is true not only of masks and figurines but also of carved pieces ranging from musical instruments, sceptres and ceremonial axes to stools, doorposts and doors. Although the individual artist or craftsman might be recognized and highly regarded – sometimes as an exceptional member of the community – the conception of the thing made as a "work of art" in museum terms was very rare. In no instance is this more clear than in that of one of the most widespread of African forms, the mask.

In Europe, African masks are generally shown emotionally and physically stilled in a glass case, taken out of time, but their true context was in motion, in dance. Masks have been made in many different forms – some to be worn not on the head but on the arm or at the hip; many designed as the apex of a whole attendant regalia, of a cloaking garment of straw, twine, bark-cloth, furs – enriched perhaps by a medley of shells or ivory or metal objects. Transfigured, virtually transubstantiated in all this, the masked wearer lost his own personality, and became the vehicle of superhuman spiritual power. When this spirit spoke through the masked, cloaked dancer, he became its sounding-board and mouthpiece.

MALI
Walu mask: *An antelope*
Based on a rocky plateau near the Niger river, the Dogon tribe, creators of this mask form, are both farmers and hunters, many of their masks and figures representing the animals they keep and hunt. The antelope mask is worn at funeral festivals; its high stylization may reflect the penetration of Islam, but its rectangular recessed shape recurs in Dogon building.

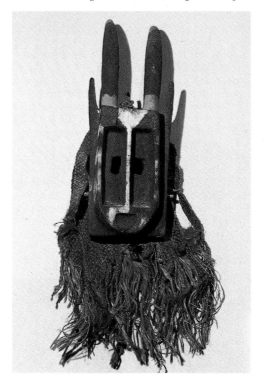

MALI (right)
Dogon dancers
The *kanaga* and the *sirigé*, two masks associated with funerary rites, are being "danced". The story told to the uninitiated is that the *kanaga*, surmounted by a cross, symbolizes a bird; to the initiated, mankind's relationship to the earth and the sky. The *sirigé* dancer bends to touch the earth with the "blade" of his mask and with whirling movements represents the genesis of the universe.

IVORY COAST (below)
Weaving pulley
The function of the pulley was to raise and lower the heddles holding the warp threads. It is Baule work: it is by exception among African artefacts simply decorative, without ritual purpose. This is perhaps reflected in the coolness of the image; the shape of the face beneath a topknot is a formal variation on the shape the pulley needed to be. Its assurance is easy for Westerners to admire.

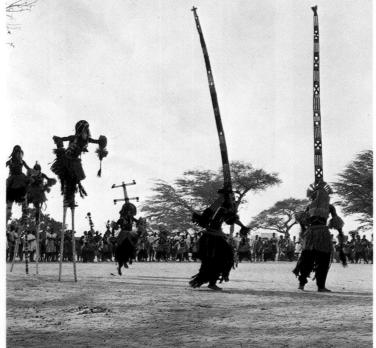

ZAIRE (below)
Kifwebe mask
Heavily hooded eyes, a box-like mouth, incised linear decoration and white and red colouring typify this striking Basongye form. This tribe, who live near the Bakuba in the wet Congo forests, used masks like this in ceremonies intended to ward off sickness.

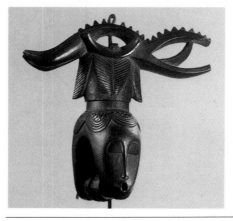

ZAIRE (left)
A mask: *Woot*
The mask is elaborately embellished with beads and cowrie shells; it was made by the Bakuba tribe for use in the initiation rites of a young man's society, and it represents *Woot*, the Bakuba equivalent of Adam. It may be worn only by persons of royal blood.

MALI (above)
Chi wara head-dress: *An antelope*
The Bambara, neighbours of the Dogon, also produce antelope masks, and yet the *walu* is very different from the graceful *chi wara*. There is a Bambara legend that the antelope spirit taught men agriculture; so the mask is worn at fertility rites.

The total image obviously often had to be awe-inspiring, both to satisfy the spirit as a worthy medium for its temporary habitation and to convince those who beheld it of its authority. Yet the forms which masks have taken throughout West and Central Africa, though they can be categorized, as forms, into various stylistic divisions and subdivisions, are not at all consistently related to their meaning or function. Very similar spiritual or emotional concepts could find very different physical expression in different tribal cultures, even if the use of white pigment on a mask, for example, usually indicated a direct connection with the dead (colour other than black, white and the hue of the wood is not usual, many Yoruba masks providing a notable exception). A lofty forehead seems generally (as in the West) to be associated with wisdom, but relatively naturalistic, though superbly simplified masks, which to Western eyes suggest a serene classicism, are found amongst a large range of different tribes with very different associations and functions, including aggressive ones. Once the connection of a carving with its original function is lost, it is difficult to establish with any certainty the purpose for which it was made. Most masks are no doubt anthropomorphic, though portraiture in any sense is very rare; the faces of the masks may show scarifications, recalling the fact that one important medium of art for many tribes is the ritual painting or scarring of the living body to traditional patterns. Bird masks and animal masks also occur (often antelopes or bush-cows); in some areas permeated by Islam, masks nevertheless persist but often in forms stylized almost beyond recognition.

Much tribal ritual is centred on initiation into age-groups – into the young men's or old men's "societies" – each of which has its separate emblems and cult; many carved figures, as well as masks, are associated with such "societies", and often represent patron deities – the god of thunder, the god of fire. Carved figures are as widespread and numerous as masks, and likewise relate to ritual, though some tribes – the relatively prosperous and settled Baule on the Ivory Coast, for example – made carvings almost as luxury goods. The Yoruba in Nigeria were adept carvers of figures in the round, and often crowned their sometimes massive masks with groups of several manikins, highly animated, as if a party were in progress. Among the Yoruba, too, and in some other tribes sculptors could achieve a status and prestige somewhat similar to that of a successful artist in the West.

Study of African tribal art is still at an exploratory stage, and the geographical area involved is enormous – the whole of West and Central Africa, with significant traditions, too, in East Africa. Wood, the dominant medium, is vulnerable to use, to the climate and to the ubiquitous termites or white ants, and the other materials used are also mostly perishable – raffia, for instance, or cotton. After the incursion of Europeans new materials and new motifs – such as the Portuguese musket-bearer, recurrent in West Africa – inevitably followed: both the subject matter and the context of the traditional African arts have been altered by the impact of other cultures not only recently but over a long period of time – Islam and Christianity have been present in Africa for hundreds of years. As the new states of black Africa gradually stabilize into a modern identity, the reconciliation of native traditions with the penetration of Western artefacts and culture should stimulate fresh and original forms of art.

CONGO (right)
A chief's stool
Within their established tradition, workshops or individuals could develop a "manner": this Baluba piece is carved in the "long-faced style of Buli", which is a local region.

NIGERIA (left)
Shango cult figure
Shango is the Yoruba god of lightning and bringer of fertility to women; this is one of his followers.

NIGERIA (below)
Egungun cult mask
This type of mask, which varies in its features, has the dual purpose, in dance, of amusing the crowd and of commemorating an ancestor – jovial acrobats cavort on this Yoruba piece, polychrome, busy with figures.

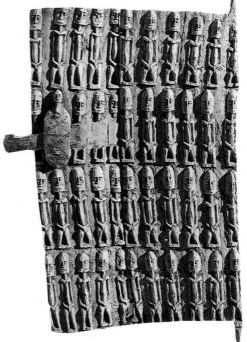

MALI (below)
A granary door
Millet is the staple diet of the Dogon, and the need to grow, harvest and store it safely is imperative. Granaries, built on stone bases to keep it free from damp, adjoin the dwelling-places and are sealed with wooden doors carved with ranks of ancestor figures. It is believed that these will protect the precious harvest from harm; they are sometimes carved with upstretched arms, a plea for rain. The geometrical verticality of Dogon masks recurs in these carvings.

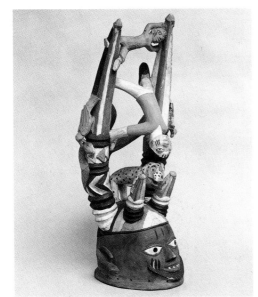

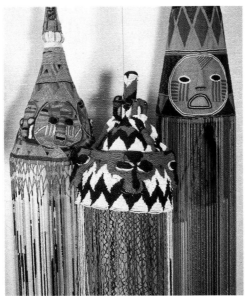

NIGERIA (left)
Bead-embroidered crowns
The identity of a Yoruba king is secret and on his rare public appearances he always wears a beaded crown with hanging fringe to hide his face. These crowns are usually conical, and patterned with faces, often painted faces. Some beads are native, of coral or glass, but most were manufactured in Europe; there are some crowns, too, which mimic Arab turbans or European regalia. The Yoruba were always happy to incorporate extraneous motifs in their versatile art.

Pre-Columbian Art

Civilization in America before the coming of Columbus flourished chiefly in Central America or "Mesoamerica", especially southern Mexico, and on the coastal borders of the Andes mountains of northern South America. In time it spanned approximately between 1800 BC and AD 1500, when it was destroyed by European invasion, and it developed in complete isolation certainly from Europe and probably from the East – an isolation that had lasted from late in the Upper Palaeolithic period, when the original Americans-to-be crossed from their native Asia by the link, now vanished, between Siberia and Alaska. In those 3,000 years civilizations of great complexity came and went and came, some of them practising a highly original and technically accomplished architecture, as well as ceramic, stone and wood sculpture, and painting. Pre-Columbian art developed in considerable diversity over a wide time scale and a vast area, inhabited by many shifting and inadequately recorded peoples; nevertheless certain characteristics, recurrent throughout the region, are forcibly striking – above all a strong and vivid sense for a rather angular linear pattern, but also a feeling for ceramic in three dimensions.

The Mesoamerican cultures are divided into three approximate periods – Pre-Classic, up to AD 200; Classic, 200-900; and Post-Classic, 900 up to the Spanish conquest. From the Pre-Classic period comes mainly simple pottery, including figurines, but also the sophisticated products of the highly developed Olmec culture, which flourished between about 1200 and 600 BC. Most famous are their jade figurines (not shown) and their colossal heads in stone, formidable in the mystery of their purpose, sometimes two metres (8ft) or more in height. The heads are startlingly naturalistic, with a disquieting intensity in their heavy-lipped mouths and frowning expressions. The Olmecs seem to have initiated the Mesoamerican tradition of large ceremonial centres built in stone, and of date-keeping.

The Classic period saw the consolidation of agricultural communities ruled by theocracies centred on cities or religious complexes. They varied in different areas but had common factors – hieroglyphic writing, an advanced astronomy and massive pyramid temples, with the accompanying ritual of a mysterious ball-game and comparable iconographies of sometimes inhumane deities. One distinctive culture was centred on Teotihuacan, a city of about 85,000 people in central Mexico. Better known is the widespread Mayan civilization. The imagery of Mayan art is much concerned with rain and agricultural fertility; formally, the sculpture tends rather to relief, to surface decoration, than to fully three-dimensional expression. Nevertheless, both in stone and in wood, Mayan sculptors show remarkable control of free, cursive, but also densely intricate design: often glyphs (many of which have now been deciphered) proliferate across the surface, filling out the space round the highly stylized but vivid figures. Such carving occurs notably in the temples, on door jambs and lintels, but also on free-standing stelae (not shown) sometimes up to ten metres (30ft) high. One most striking and abundant kind of Mayan art is in fired clay, whether in the form of pots – often painted – or figurines. A few copies of Mayan manuscripts have survived, and rare survivals of mural painting, from the late Classic period, show a developed style and imagery, with profile figures outlined in thick black, filled in with flat colour.

The Post-Classic period was dominated by the emergence of new warrior aristocracies –

TLATILCO, MEXICO (right)
Female figure,
Pre-Classic period
Several early agricultural communities in the Valley of Mexico produced round figurines of this type. The woman is hollow, made of unglazed terracotta, with white slip used to define the eyes, mouth and ears.

TIKAL, GUATEMALA (below)
Door lintel, c. AD 747?
The Maya decorated their ball-courts and temples with stucco, murals and stone- and woodcarving, showing refinement both in handling architectural masses and in decorating surfaces. The lintel came from the interior doorway of a Mayan pyramid temple.

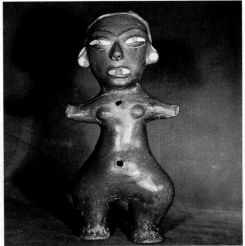

MEXICO (right)
Head, 1200/600 BC
These massive basalt heads were possibly linked to a cult of the jaguar; they are uniquely Olmec. In some jade carvings on a smaller scale feline features are imposed on human faces.

MEXICO (below)
The cosmos, AD 1250/1500
The opening page of this Mixtec manuscript shows the world's five regions – centre and four directions. Various symbols represent the complex constituents of the Mixtec (and also the Aztec) calendar cycles; the fire god holds the centre.

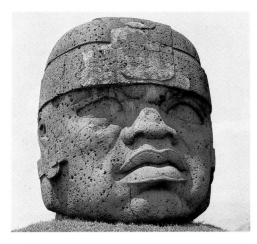

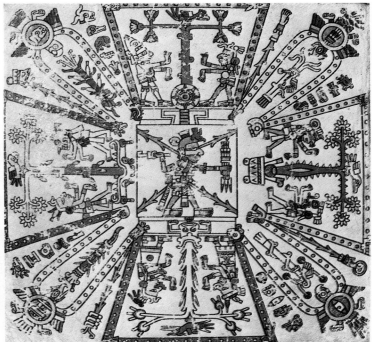

the Mixtecs, the Toltecs and, best known, the Aztecs. They seem to have shared an ever-increasing dependence on gods that required nourishment by human sacrifice. Their sculpture was correspondingly brutal, and often brilliantly and disturbingly expressive. The Toltecs produced colossal free-standing stone sculpture – for example the celebrated male column-figures at Tula – which has a harsh, angular, abstract and massive quality that has much impressed modern sculptors. The Mixtecs produced murals, and especially manuscripts, with flatly coloured figures in complex geometric designs, and were superb craftsmen, in precious stones, in featherwork, in pottery and in cast gold. Aztec art found its most characteristic expression in sculpture – horrifically dramatic, massive (on whatever scale), and handled, often in the hardest of stones, with extraordinary finesse. One of its most famous images is a female deity in childbirth, ruthlessly expressing agony.

In South America, a considerable civilization had flourished from at least 1000 BC, known as the Chavin culture after a temple complex some 3,000 metres (10,000ft) above sea-level in northern central Peru. A chiefly

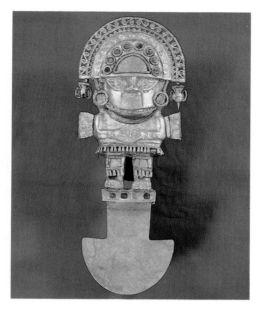

PERU
Ceremonial knife,
AD 1200/1470
Pre-Columbian goldwork of northern South America is of outstanding quality. The Chimu personage is of gold inlaid with turquoise.

small-scale sculpture – birds and complex zoomorphic figures – is associated with it; also pottery and goldwork. Some of the finest goldworkers were the Chimu on the north coast of Peru (c. AD 1200-1470), but also in Colombia and Ecuador metalwork of great sophistication was made – jewellery, vessels and figures in many techniques, including gold cast by the *cire-perdue* method. There still exist superbly worked textiles from Peru, and a rich harvest of vessels has come to light there, either painted or, most notably, modelled into astonishingly naturalistic heads, sometimes so vivid that it seems they must be portraits.

The best-known culture in South America is that of the Inca, though their dominion was in fact brief (AD 1476-1580). They were superb masons, and their most impressive remains are architectural; of their statuary only miniature stone and metal figures have survived in any quantity. These show a marked tendency towards stereotype, an abstract handling of geometric volumes. The Mesoamerican culture fell first to the Spanish, with the conquest of the Aztec Empire by Cortés; the power of the Inca was finally broken by about 1580, and the vital root of the indigenous culture cut.

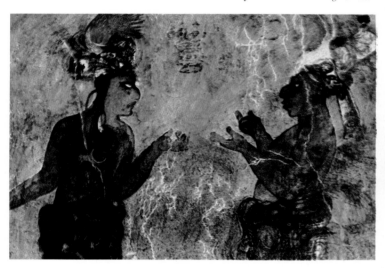

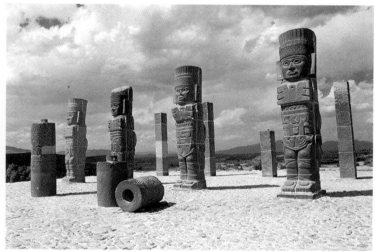

BONAMPAK, MEXICO (above)
Two warriors, c. AD 750
When the Mayan city of Bonampak was discovered in 1946 unique murals came to light, depicting battles and raiding parties which had been launched perhaps in order to obtain enemy prisoners for sacrifice; a religious procession is also shown. These gesticulating, possibly arguing, Indians are lively and expressive; as often in Mayan reliefs, the figures are in profile, in animated silhouette.

JAINA, MEXICO (right)
Priest or *official*?
AD 600/900
The heavy chain, bracelets and tall head-dress suggest a ceremonial functionary; even the markings beside his mouth are scrupulously noted, and this little Mayan, too, seems barrel-chested like a sergeant-major.

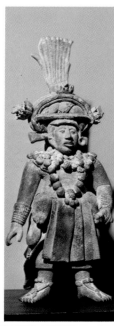

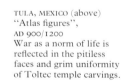

MEXICO (above)
Tlazolteotl, AD 1300/1500
An iron necessity seems to drive forth the child and excruciate his mother, the Aztec birth-goddess.

PERU (right)
Ex voto, c. AD 1500
Spanish interest in Inca gold and silver did not extend to its workmanship. Only small items survive.

TULA, MEXICO (above)
"Atlas figures",
AD 900/1200
War as a norm of life is reflected in the pitiless faces and grim uniformity of Toltec temple carvings.

PERU (right)
Head, c. AD 500
The small ceramics, often in the shape of heads, of the early, Moche culture are among the finest in Peru.

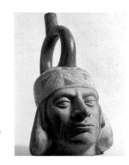

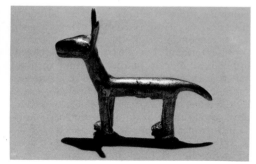

19

A Tlingit House-Post

The Indians of North America developed no such states and civilization as the natives of South and Central America, but consisted up to the time of the European conquest and after of mostly small tribal groups, culturally distinct and speaking different languages. They developed a variety of life-styles in different parts of the continent, and their art was correspondily diverse. Artistry was everywhere applied to the embellishment of everyday objects – tools and weapons, household utensils or clothing – and in some regions rich traditions of painting and sculpture developed, in association with an elaborate religious ceremonial. Some of these traditions have continued to the present, though the societies in which they developed were destroyed or drastically altered with the progressive westward expansion of European settlement. Surviving works of North American Indian art in museums around the world date mostly from the nineteenth or early twentieth centuries, when European control was already firm.

While the northern and western parts of the continent were inhabited by peoples living by various modes of hunting, fishing and gathering, the Indians of the eastern and southern areas were predominantly farmers leading more settled lives. Sixteenth-century European narrators described large-scale architectural sculpture and murals in the prosperous villages of the south-east, and archaeology has revealed numerous smaller artefacts – including pottery, stone sculpture and engraved shell. Sculpture was less developed in the north-west woodlands, though the tradition among the Iroquois of carving "false-face" masks is noteworthy; both painting and embroidery, however, were common techniques, applied to clothing and equipment often in complex geometric designs. The painting was on hide; for embroidery dyed porcupine quills and moose-hair were used until trade with Europeans introduced coloured cloth, glass beads and extraneous floral designs.

In a similar way European trade enriched and transformed the arts of the Plains tribes. These peoples depended for their livelihood on the hunting mainly of buffalo: hide was their basic material, and their art was applied mainly to costumes and essentially portable possessions. A strong tradition of painting developed, executed in two contrasting styles. Traditionally the women painted such objects as rawhide travelling bags and hide robes in a bold geometric style; men created naturalistic paintings of warlike exploits on robes and tepees, and also symbolic designs for objects associated with rituals. Among the farming Pueblo Indians, dwelling in adobe villages in the south-west, the women plaited baskets and painted pottery in sophisticated, usually abstract designs, also applied in weaving; the men were responsible for the symbolic forms, representational but often highly stylized, applied in murals painted in underground sanctuaries and in elaborate masked costumes representing spirits in public festivals staged by the clans of the village. Some rituals, notably among the Navajo, involved the famous "sand-paintings" (one is reproduced on page 458) in which powder was sprinkled on sand in symbolic, stylized motifs from a rich

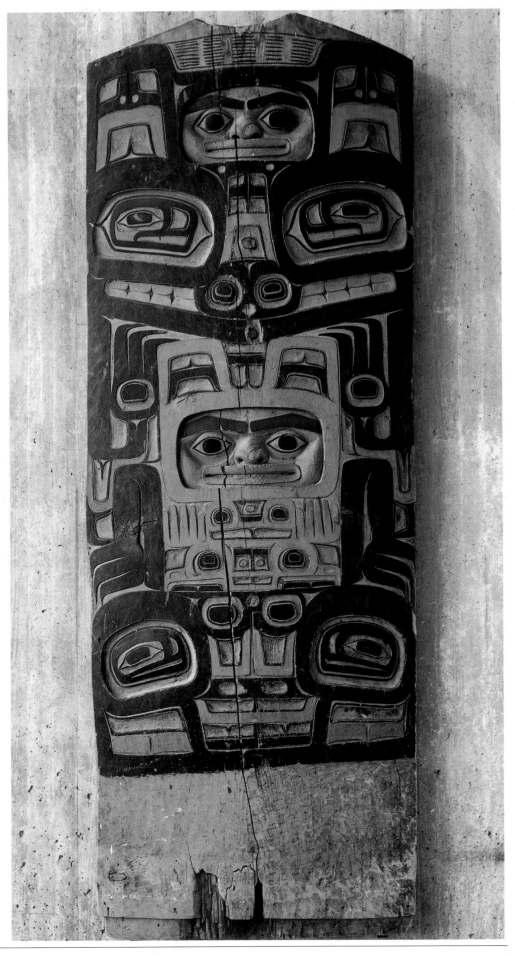

mythological repertoire. Here, in the south-west, archaeology has revealed that the artistic tradition extends back several hundred years before the arrival of Europeans.

Further west, in the Great Basin and California, where the Indians lived in smaller, scattered groups and supported themselves by gathering and hunting, some extraordinarily fine basketry was produced but painting and sculpture were less developed. These arts had their greatest flowering on the north Pacific coast, which was exceptionally rich in natural resources – especially timber – and supported a relatively large and settled population, who lived mainly by fishing. During the winter months much time and energy were devoted to elaborate festivals; for both ceremonial and utilitarian objects the Indians employed a sophisticated woodcarving in a distinctive style. Perhaps most spectacular were the massive house-posts and the free-standing poles carved with figures proclaiming the ancestry and status of wealthy leaders. This sculpture was usually conceived in relief, and often painted, and a similar vocabulary of stylized motifs was applied to two dimensions – painted on wood, hide or cloth, or woven.

In contrast, the living of the scattered, nomadic Eskimos in the Arctic region was hard-won, but the mastery of bone and ivory carving which these people displayed is hardly less remarkable. On tools or weapons, in toggles or amulets on clothing, in decorative studs for things of wood, the Eskimos depicted with fine feeling the birds and mammals of land and sea on which they depended for their livelihood. They were both carved in the round and engraved, in lively hunting scenes. Eskimo woodcarving was less sophisticated, though expressive masks were made.

Contact with Europeans at first stimulated many local traditions, notably on the Plains and on the north Pacific coast, but the subsequent conquest generally had disastrous effects. Nonetheless Indian culture has proved resilient in some areas. Indian artists have worked to supply collectors since the nineteenth century, and sometimes traditional arts have been revived, though not usually for their old purposes. The Haida Indians, for instance, of the north Pacific coast, perfected the art of carving a local stone, argillite, using traditional themes (not shown) as well as novel ones based on European models.

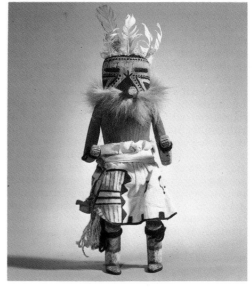

THE SOUTH-WEST (above)
Kachina doll
These small wooden figures represent *Kachina* spirits as they appear impersonated in the sacred dances of the Pueblo – in masks and patterned cloths. Those made for collectors tend to show European influence in pose.

THE SOUTH-WEST (below)
Weaving a blanket
The arts of the hunting and herding Navajo were greatly influenced by the Pueblo, their neighbours. With the simplest of finger-weaving techniques, the woman runs a geometric pattern; men had a different repertoire.

THE MID-WEST (above)
Stone pipe-bowl
Pipe-bowls shaped into quite naturalistic birds or animals are frequent among the numerous small stone carvings, dating to the early centuries AD, of the south-east. This one is from prehistoric Ohio: the bowl is in the bird's back, the legs are a tube.

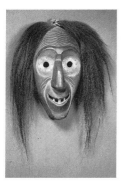

EASTERN WOODLANDS (above)
"False-face" mask
The deliberately grotesque "false-face" masks played a part in Iroquois rituals intended to cure disease.

NORTH PACIFIC COAST (left)
Carved house-post
A work of the Tlingit tribe, the post is a characteristic example of the architectural carving of the north Pacific coast. Its principal motif is a bear in a squatting pose. Though local variations occur, north Pacific coast art was governed by strict conventions, by a language of abstracted curvilinear motifs almost impossible at first sight to relate to the objects they represent.

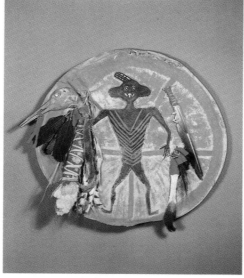

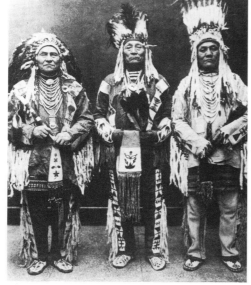

THE PLAINS (above)
Hide shield
Made of buffalo hide, the shield protected not only physically but magically; the stylized figure is the moon-god. It is Crow work.

THE PLAINS (left)
Blackfoot dignitaries
The costumes were adorned with ornamental tassels, with embroidery in floral and geometric patterns and with other accessories, all, like the eagle-feather headdresses, indicative of ritual powers and of social status.

ARCTIC REGIONS (right)
Arrowshaft straighteners
The Eskimo tools are both carved – with polar bear or seal heads – and engraved – with caribou and energetic "matchstick" human figures. (The tool was used on a shaft held over a fire.)

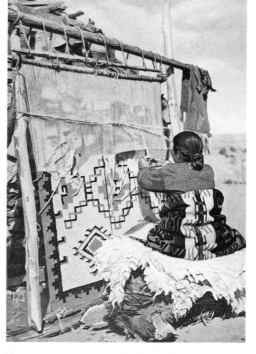

Oceanic Art

The term "Oceanic" is used to describe an enormous geographical zone – nearly 10,000 kilometres (6,000 miles) from north to south and some 14,500 kilometres (9,000 miles) from east to west. The area embraces a continent (Australia), the second largest island in the world (New Guinea), various other large islands such as those of New Zealand – and a multitude of smaller islands spangling the huge swell of the Pacific between New Guinea and South America. Inevitably, the art produced in so vast an area is very diverse in form, and for ethnic as well as geographical reasons. Its makers are the descendants of successive settlings by migrants from the west of mixed origins, some Mongoloid, some Melanotic or dark-skinned. There are often affinities with the art and culture of the tribal peoples of South-East Asia (see p. 276), though these less isolated peoples have mostly come into contact with Buddhism, Hinduism or Islam.

Like the indigenous art of Africa, Oceanic artefacts were not made with any idea of their being "art" as the word is used in the West. Oceanic paintings and sculptures were conceived as an integral part of the religious and social ceremony of everyday island life, and

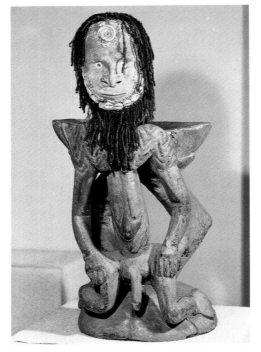

were aspects of the various prevalent forms of ancestor- and spirit-worship. The emphasis on fertility is recurrent, and there are also more sinister echoes of occasional headhunting and ritual cannibalism. Masks and decorated skulls (though not in Polynesia) and ancestor statues abound; traditional motifs are carved or painted on canoes, paddles, shields, pottery, stools and vessels. Naturalistic representation is not normally prized; individual features are subordinated to a strong formal rhythm of drawing or modelling, tending towards distortion or abstraction. The objects or patterns created were often conceived to contain or impart some *mana*, or supernatural power, and usually reflect the imagery of local ceremonial.

There are signs of human settlement in Oceania even as early as the Upper Palaeolithic period, but little art of any great antiquity survives since with few exceptions, such as the colossal lava-stone statues on Easter Island, the materials used are relatively ephemeral – painted and carved wood, bark-cloth, vegetable fibres, feathers and bone. Once created, few artefacts were conserved as treasures or enduring memorials; most were abandoned or sometimes destroyed once their immediate

SEPIK, NEW GUINEA (above)
Ancestor figure
Squatting ancestor figures recur not only in Oceania but in tribal South-East Asia (see p. 276). Such figures could be channels for ghostly power; their pose perhaps had connotations of fertility and rebirth.

NEW IRELAND (left)
Uli (Ancestor figure)
These bisexual images were created for the climax of a series of ceremonies in a three-year cycle. Then huge painted figures were erected, in front of which ritual dances were enacted; this is one of the smaller statues that surrounded the central structure.

NEW IRELAND (below)
"Soul-boat"
Local custom ordained that the body of a dead chief should be laid in a canoe and sent out to sea. His companions are thought to be relatives or supporters, and enemies he had slain. The figures resemble *uli*; every surface is enriched.

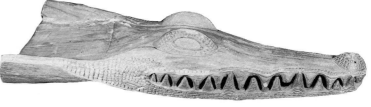

SEPIK, NEW GUINEA (above)
Crocodile head
The crocodile was one of the most favoured animal motifs of the Sepik area, and often, as here, adorned the prows of Sepik canoes. Since it can glide swiftly through the water, it was both appropriate and helpful magically as a figurehead.

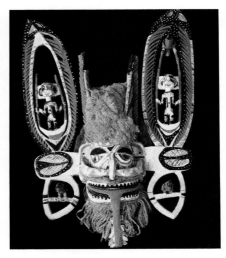

NEW IRELAND (left)
Malanggan
New Ireland *malanggans* ("carvings") show a wider variation of design than is common in Oceanic art. Brightly painted, they were used in funeral rites or in initiation ceremonies; the wearer of a mask like this would represent a spirit.

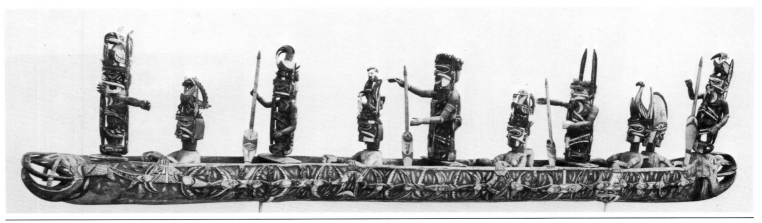

purpose had been fulfilled. However, since foreign intrusion into many parts of the region is fairly recent, the traditions in which they were conceived have often remained unadulterated and stable well into this century.

Ethnologists usually distinguish three main areas in Oceania – Melanesia, Polynesia and Micronesia. The most aesthetically rewarding art comes from Melanesia, which includes New Guinea and the fringes of smaller islands to the north and east: here there is great variety, even within small, but fairly populous, areas such as the Sepik River in New Guinea. Melanesia is also the region closest to Indonesia, where there is a strong feeling for decorative brilliance and fanciful ornament. Carving in wood, often coloured, predominates, and the ancestor figure and the human head are recurrent themes, both in woven or carved and brightly painted masks and in pattern form as decoration on all kinds of surfaces. To a Western observer, unfamiliar with their symbolism, the visual intensity of these images – sometimes horrific, but by no means always so – can be haunting. In parts of New Guinea, craftsmen's work was prized, even collected, and specialist artists emerged.

Besides New Guinea, the sculpture of New Ireland, one of the major islands in the Bismarck Archipelago, has attracted particular attention in the twentieth-century West – especially the ancestor figures known as *uli*, and the closely related decorative sculpture, *malanggan*, displayed at festivals. One product of New Ireland, preserved in a Western museum, the so-called "soul-boat", is famous, not least for its impressive size. The figures in the canoe are human in scale but awesomely demonic and inhuman in appearance; as in the *uli*, significant parts of the body are ferociously emphasized – eyes, teeth and genitalia.

The artefacts of Polynesia, the wide scattering of islands over the Pacific from New Zealand to Easter Island, may seem in comparison less vital, more decorative. Ancestor figures and masks are rare; unfortunately early missionaries were responsible for a thorough and widespread destruction or mutilation of sculpted ancestral deities. But the Polynesian delight in complex rhythms of surface patterning finds many variations in many media, from the spectacular featherwork of Hawaii to the intricately carved wood and greenstone of the New Zealand Maoris – and including the

"living art" of tattoo. The Maori fascination with curvilinear surface ornament was almost obsessive; highly complex linear patterning is found in the carved decoration of canoes and of the doorposts and lintels of meeting-houses, and still persists, even if the original vitality appears only rarely in modern work. Remote in the east, Easter Island produced colossal human figures in stone, sometimes 18 metres (60ft) high, presiding enigmatically over a windswept, treeless landscape.

Australian art was somewhat different in kind: after a first migratory wave Australia remained isolated. The Aborigines' images are mostly drawn or painted rather than carved in the round; scratched on rock surfaces and painted in caves or on the ground, they range from simple figurative images, human or animal, to formal and abstract patterns. Among the most famous are the Wandjina paintings in the north-west – tall white-faced and red-haloed figures (not shown) – and the so-called "X-ray" paintings of Arnhem Land.

Micronesia, the group of islands to the north-west of the Pacific, shows in contrast a handling of form often spare, smooth and austere, at times almost streamlined.

HAWAII (right)
Kukailimoku
The ferocious Hawaiian god of war is made out of vivid feathers on netting over a wicker framework. Natives presented Captain Cook, when he landed, with a similar object: this god demanded human sacrifice.

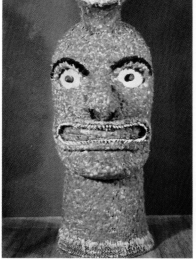

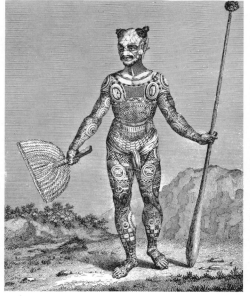

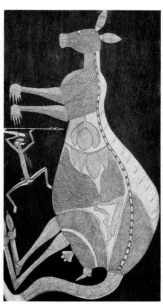

NEW ZEALAND (above)
Carved house-post
A high degree of finish is characteristic of most Maori art. Craftsmen – and the tools they used – were accorded honour, since they did their work under the authority and guidance of a divinity.

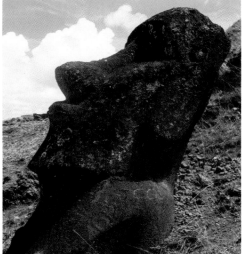

(above) *Tattooed warrior*
This early 19th-century engraving may represent a native of the Marquesas Islands: there the entire skin surface was covered in elaborate designs. In New Zealand the Maoris used to confine tattoos to certain parts of the body; and the more elaborate the tattoo, the greater its wearer's social status or wealth.

EASTER ISLAND (left)
Ancestor figure?
Insufficient wood grew on the island for the making of boats, and the settlers became isolated. Yet many not dissimilar megaliths are found on Sumatra or Nias (see p. 276). Sheer size and their bleak setting make them the most awe-inspiring creations of Oceanic art.

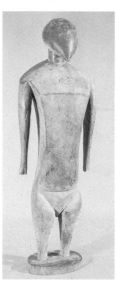

AUSTRALIA (above)
A kangaroo
The portrayal of an animal in the "X-ray" style is a feature limited to the art of Australian Aborigines: it is the depiction, inside the outer shape, of inner organs and the skeleton of their quarry. The image is painted on a strip of bark; its purpose was symbolic, co-ordinating man and Nature.

NUKURO (left)
Tino
Tinos, in Nukuro, one of the Caroline Islands, were the creators of the world. Such Micronesian images in smoothly carved wood were sometimes yet further refined, with hands and feet altogether eliminated, and the smooth, beaked head made still more prominent.

Egyptian Art 1: The Old Kingdom

Prehistoric and tribal art is essentially instinctual, and lacks an architectural context. It is spatially disorganized, without frame or distinction between the figure and the ground on which it stands. The emergence of a highly organized, schematic and structured art about 3000 BC is almost abrupt, and coincides with the rise of civilization itself, suddenly articulate with a written language. The focus of this flowering was those central lands on which Asia, Africa and Europe pivot, and in them especially the basins of the great rivers of Egypt and Mesopotamia; it came perhaps a little earlier in the latter than in Egypt, but Mesopotamia (see p. 28) was to prove much more vulnerable to disruption.

The traditional structure of Egypt's history rests on the account given by one Manetho in the early third century BC. Its chronology is divided into Kingdoms, Old, Middle and New (with two intermediate periods), and these into dynasties calibrating some three millennia. About 3000 BC, a monarch named Menes is said to have united the regions of the northern and southern Nile below Aswan, and to have founded the first of the Old Kingdom dynasties. Menes is often thought to be identical

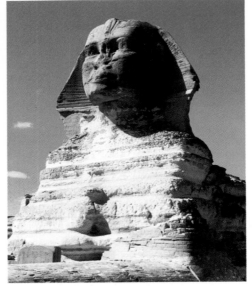

GIZA (above)
The Sphinx, c. 2530 BC
The Egyptian Sphinx was a regal symbol rather than a monster; the Giza Sphinx's head is the head of the 4th-Dynasty ruler Chephren. It was cut from the living rock which provided the stone for nearby pyramids.

with Pharaoh Narmer, and a large cosmetic palette featuring Narmer – one of the earliest specimens of Egyptian art – exemplifies, almost unheralded, its basic and enduring conventions. The low relief is set in a frame of regular shape; within its perimeter, the ground is divided precisely into bands, or registers, on which the images are placed. These are seen in profile, clear cut, and generally directed from left to right. There is no real sense of perspective, but instead an ordering in terms of scale, more important figures being bigger than minor ones. Extreme stylization is already established, and some conventions of drawing: the profile in which the human figure is almost always shown is not strictly true, having usually two left (or two right) hands and feet, with part of the torso and the eye rendered frontally.

Specialists now view with scorn the platitude that Egyptian art continued unchanged for 3,000 years, but for the ordinary spectator the extraordinary consistency of style is striking. Egyptian art had a religious, or magical, purpose, and the stamina of its conventions was due to the stability of religious dogma and the fact that the state was an expression of

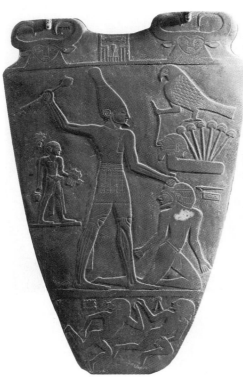

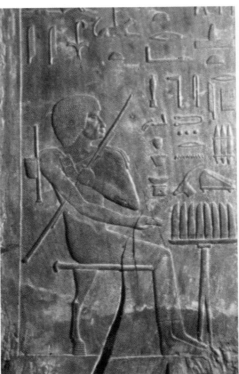

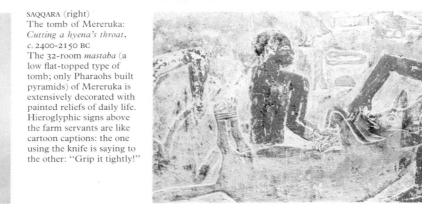

SAQQARA (left)
Hesy-ra before an offering table, c. 2650 BC
In one of the five carved wooden reliefs in Hesy-ra's 3rd-Dynasty tomb, he sits beneath hieroglyphs which list not only his titles but also the libations and the offerings that he hopes to obtain in the after-life. He carries writing materials.

SAQQARA (above)
The tomb of Mereruka, detail, c. 2400-2150 BC
The kilted figure of the *ka* or spirit of the deceased dignitary stands ready in a doorway, so that the *ka* may emerge to partake of the offerings that are spread before him. Both statue and the painted relief beside it follow identical conventions.

MEMPHIS (above)
The palette of Pharaoh Narmer, c. 3100 BC
The slate relief, a rare 1st-Dynasty survival, shows Narmer victorious, overcoming those who opposed his unification of Egypt. The god Horus assists.

SAQQARA? (right)
Servant straining beer, c. 2400 BC
The style of this brightly painted wooden statuette (she guarantees ale for her master's after-life) contrasts with the stiff gravity of royal statuary.

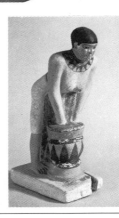

SAQQARA (right)
The tomb of Mereruka: *Cutting a hyena's throat*, c. 2400-2150 BC
The 32-room *mastaba* (a low flat-topped type of tomb; only Pharaohs built pyramids) of Mereruka is extensively decorated with painted reliefs of daily life. Hieroglyphic signs above the farm servants are like cartoon captions: the one using the knife is saying to the other: "Grip it tightly!"

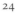

that dogma, indeed was largely a religious institution. The king, or Pharaoh, was a god, and the hierarchy of society beneath him was exactly and divinely fixed and ordered.

In the Third Dynasty, in the late twenty-seventh century BC, the Old Kingdom entered its prime. The capital was established at Memphis above the delta of the Nile; the royal pyramids were located nearby at Giza and Saqqara. Most Egyptian art now extant, even the temple art and colossal outdoor sculpture, was designed not for the use of living patrons but to accompany or adorn the dead. Unlike later European arts, which commemorate the past or the present, this art was prospective, looking to the future, though indissolubly linked with death; and it had an essentially practical purpose. Prayers were meant to be recited by the living which would bring to life the objects surrounding the dead, and all the trappings – clothes, ornaments, weapons, jewellery and so on, and the painted or relief decorations on the walls of tombs showing hunting, feasting and the pleasures of earthly life – were intended for the future delectation and maintenance of the dead man's or woman's *ka*, or spirit, in the after-life.

Painting and relief in Egypt were closely related, reliefs being usually coloured, and conceived in one plane rather than in the round. The walls of tombs and temples were often completely covered with decorations, but always in a disciplined format, within a precisely controlled framework, as in the early palette of Pharaoh Narmer. The subject matter ranged widely, from formal hieratic imagery, closely related to the accompanying hieroglyphics, to representations of earthly life, sometimes enchanting in their naturalism, especially towards the end of the Old Kingdom, notably in the tombs of nobles of the Fifth and Sixth Dynasties. The tomb of Vizier Mereruka has particularly fine reliefs, proving the vivacity possible within set formulae. The famous "*Geese of Meidum*" are as brilliant now as when they were painted, about 2550 BC.

The quality of the monumental sculpture of the Old Kingdom was never to be surpassed. The earliest royal portrait known anywhere, the seated life-size statue of Pharaoh Djoser, of about 2680-2660 BC, is unfortunately much damaged (not shown); it was originally painted, with eyes of inlaid quartz. The statue of Pharaoh Chephren 100 years later demon-

strates the same set form. Both seem still to dwell in concentrated gravity within the cubic block from which they were cut, and on which they were first drawn, in profile on the side, frontal on the front. But though still bound by these limitations of pose, viewpoint and handling such statues are sometimes strikingly naturalistic, like *Prince Rahotep and his wife Nofret*, seated forever as if they had just been groomed by the make-up artist. Especially when the person represented was of comparatively low rank, remarkably realistic images could appear, though in the best of them inessentials continued to be discarded to retain the essential form of the whole. The *Seated scribe* now in the Louvre is indeed the eternal essential bureaucrat. He is less than life-size, but Egyptian sculptors could manage any scale, from small wooden models to the desolate giant rock Sphinx rising 20 metres (65ft) above the desert at Giza.

Middle Kingdom statuary became increasingly static, but could also be softer and more human in feeling, and was also set up not only in tombs but also in public places. But it was in truth an interim period, awaiting the richer and more ambitious art of the New Kingdom.

GIZA (left)
Pharaoh Chephren,
c. 2585-2560 BC
Chephren is carved in a hard stone taking a high polish, and shaped to an established regal formula.

MEIDUM (below)
Prince Rahotep and his wife Nofret, c. 2550 BC
The statues are so vivid that the diggers who first discovered them in 1871 fled in terror. Although

the postures follow rigid formulae, the paint on the faces is as bright and real as life, and the eyes gleam with rock-crystal irises; the details are rendered with minute truthfulness.

SAQQARA (below)
Seated scribe, c. 2450 BC
This small painted statue of the early 5th Dynasty is one of the finest of a large group of very similar *Scribes*. Other dignitaries

were also represented about their characteristic tasks, in typical postures. In this cross-legged pose the kilt was stretched taut, and so could be used virtually as a desk on which to write.

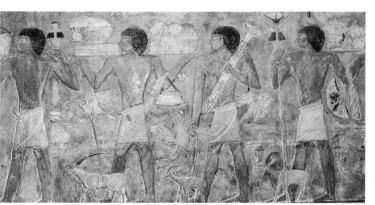

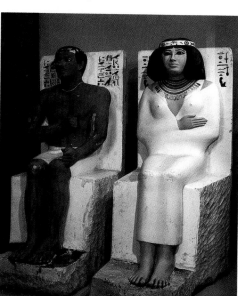

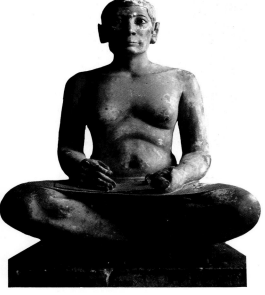

SAQQARA (left)
The tomb of Ptah-hotep, detail: *Funerary procession, c.* 2400 BC
Figures in Egyptian art were not only drawn but also coloured according to

convention: men were red, for instance, women were yellow. The artist first drafted an outline, then chiselled the relief, before applying flat colours to set forth figures and objects.

MEIDUM (below)
"*The Geese of Meidum*",
c. 2550 BC
The procession of various species of geese belongs to a rural scene, stylized but full of vivid incident.

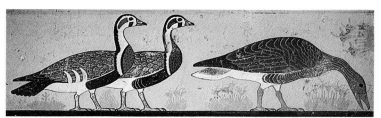

Egyptian Art 2: The New Kingdom

Between the close of the Old Kingdom in 2155 BC and the beginning of the New Kingdom in about 1554 BC the political stability of Egypt was somewhat disrupted; in 1785 BC the Middle Kingdom had collapsed, and Egypt was ruled by alien invaders. But the monarchs of the Eighteenth Dynasty (1554-1305 BC) not only expelled the intruders and re-established internal order, but transformed Egypt into a major world power, with an empire embracing at its peak Palestine and Syria. The Eighteenth Dynasty is usually considered the Golden Age of Egyptian art.

Thebes was now the capital, the centre of enormous architectural projects – the temples of Karnak and Luxor and, above all, across the Nile, the tombs of the Theban rulers tunnelled into the cliffs, the famous "Valley of the Kings". The colossal pyramids and *mastabas* of the earlier periods had proved indefensible against generations of tomb-robbers, but even the hidden rock-cut tombs were not inviolable. Most of the mortuary sculpture has been lost, but surviving examples from the early Eighteenth Dynasty show a development towards a softer, more graceful style, though the poses are much the same. In many tombs the murals

remain, often in gouache on a mud-and-plaster ground rather than in coloured low relief (which the poor quality of the stone precluded); perhaps partly as a result, these paintings, though still carried out within the old conventions, depict the pleasures of earthly life, from fowling to dancing girls, often with greater brilliance and freedom. There is even often more than a hint of movement.

In the midst of the New Kingdom's prosperity there occurred an interlude of a mere couple of decades, about 1379-1361 BC, which has fascinated posterity. Under Amenhotep IV a new art was stimulated by a new religion, a form of sun-worship. This was the cult of Aten, the sun-disk, and Amenhotep, his representative on earth, changed his name to Akhenaten and established a new capital at Amarna.

The individual personality of Akhenaten stands out in surviving statuary uniquely among the severely formal representations of centuries of Pharaohs. Amidst some changes in subject matter arising out of the new cult, the dominant image in Amarna art is that of Akhenaten himself, whose idiosyncratic features, long-faced, large- and loose-lipped, almost dreamily visionary, contrast with the

classic clarity of the busts of his wife Nefertiti. The earliest portraits of the new art are often unflattering to the point of caricature, which has sometimes been attributed to the Pharaoh's insistence on truth and sincerity, but later ones are softened. Generally, Amarna art is more vivid than before, more sensual, and seeks response on a personal rather than on an ideal level; it is much more sympathetic to modern sensibility than the orthodox stream of Egyptian art. Fortunately a significant quantity of Amarna art has survived the ruthless destruction of the subsequent reaction.

The reversion to orthodoxy is, however, far more richly represented, largely owing to the chance of history that preserved the tomb of one of Akhenaten's successors, Tutankhamun, intact from the ravages of tomb-robbers. Assembled about 1361-1352 BC, its store of literally thousands of objects deposited to accompany the dead man into his after-life remained unsuspected until 1922. The overriding impression of this hoard is of sheer ostentation in wealth, with its silver, precious stones, intricate inlay and carving – and gold. The innermost of the layers of Tutankhamun's coffin is made of 110 kilograms (243lb Troy)

AMARNA (left)
Akhenaten with his baby daughter, c. 1379-1361 BC
Incised in limestone, the heretic Pharaoh sits under the sun-disk he worshipped. The sweeping, quite harsh freedom of line is in quite startling contrast beside the rigidity of earlier art.

THEBES (right)
A banquet, c. 1413-1367 BC
Wine, women and song are a recurring theme in the tombs near Thebes. What is remarkable here is the shimmering movement in the hair and robes of the musicians, the feeling for the twining gestures of the dance in the girls beside.

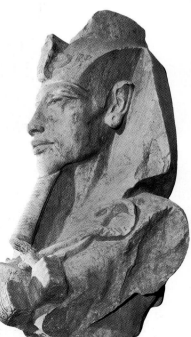

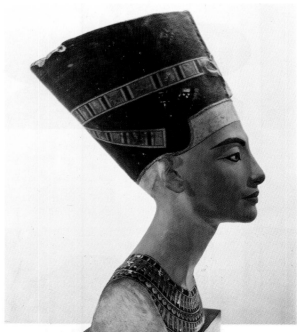

KARNAK (right)
Akhenaten, c. 1379-1361 BC
An inscription says that Akhenaten took a personal interest in the art he had commissioned, and himself briefed the master mason. His crown, his beard set in a cylinder, his flail and crook, are the intimidating symbols of authority; his face is equally stern, but not impersonal. This head is a fragment of a column figure, one of 30 found in a courtyard at Karnak.

AMARNA (left)
Nefertiti, c. 1379-1366 BC
The bust of Akhenaten's Queen was discovered in the studio of the sculptor Tuthmosis in Amarna, and probably it was the model for a series of replicas. The calculated proportions and exquisite profile suggest considerable idealization; the shape of the face has many features in common with that of Akhenaten.

THEBES (above)
One of four cases for Tutankhamun's viscera, *c.* 1361-1352 BC
The four miniature coffins, of beaten gold inlaid with cornelian and coloured glass, covered inside with magical texts, are craftsmen's work of extraordinary quality. The design repeats that of the mummy-case proper.

THEBES (below)
Tutankhamun hunting ostriches, c. 1361-1352 BC
The ostrich feathers which completed Tutankhamun's long-handled golden fan (a treasure of his tomb) are lost, but the embossed hunting scene is perfectly preserved. A walking *ankh* hieroglyph behind the car holds out an identical fan.

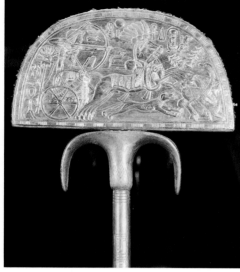

of gold. The proliferation of riches and the virtuosity of the workmanship tend to dazzle our eyes to some unevenness in quality: the return to the old formulae results in rather blatant, though splendid, forms, empty in emotion beside the subtlety of Akhenaten's art – even though here and there the more naturalistic approach stemming from Amarna is maintained, indeed many of the objects in Tutankhamun's tomb must have been made during Akhenaten's reign. Where this freedom persists, notably in reliefs, for instance on the back of Tutankhamun's throne, the art has a touching quality; the sheer profusion staggers the imagination, and its documentary importance for the social, political and religious history of the period is immense.

During the next thousand years Egypt slowly declined in power, becoming subject eventually to a series of invasions. The later New Kingdom Pharaohs were at first intent on the consolidation of the imperial image: the proliferation of colossal statues of Ramesses II suggests an attack of megalomania. These are conceived entirely in traditional terms, being severely simple and hieratic, though often extremely impressive, if mainly in their scale

and in the enigma of their impersonality. Wall-painting and relief carving continue but are conventional in quality – time-worn motifs repeated without variation – and the same is true of most of the manuscript illumination. This, however, was a remarkable Egyptian invention: from these beaten strips of papyrus reed the line leads to vellum, paper and to mass-production printing.

In the last millennium BC patrons and artists continued to imitate and sometimes to refine earlier styles, and the brief Saite Dynasty (664-525 BC) made the past almost into a cult. In the seventh century, Greek traders had been permitted to establish a city at Naucratis on the Nile delta, but though Egyptian influence on Archaic Greek art is quite distinct (see p. 34), Greek culture had no apparent effect on the Egyptians. The conservatism of Egyptian art survived even the final extinction of the indigenous dynasties, and the establishment of the Ptolemaic Kingdom in the wake of the conquest of Alexander the Great. Some of the Egyptian images most popular today date from this time – the animal sculpture, with its distinctive smooth clarity, and the hauntingly cold, implacably sinister animal-headed gods.

THEBES (left)
A panel of Tutankhamun's throne, before 1361 BC
His Queen offers scented oil to her husband in an ornate pavilion; the style and relative intimacy recall Akhenaten's reliefs, and the throne must have been made during the Amarna period.

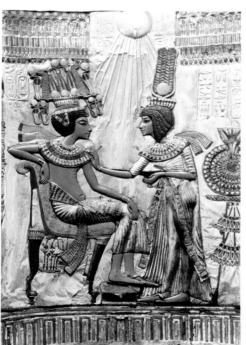

ABU SIMBEL (right)
The Temple of Ramesses II, c. 1304-1237 BC
Four statues of Ramesses, more than 20m (65ft) high, form the imposing façade, cut from the living rock. The features are bland, the forms squared and weighty. (The entire monument was moved up the cliff in 1967.)

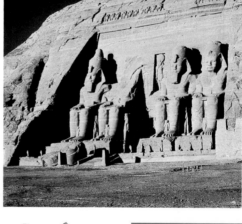

EDFU (below)
The Falcon of Horus, 3rd century BC
A long procession of carved gods and priests lines the steps of Horus' temple, and the capitals of the columns are richly sculpted in low relief. This seems more an idol than a representation: naturalism is subservient to the sacred symbolism.

DEIR EL MEDINA (below)
Cha' and Mere pay homage to Osiris, c. 1405-1367 BC
The brightly illustrated papyrus manuscript is *The Book of the Dead*, a series of prayers to the gods to assure resurrection.

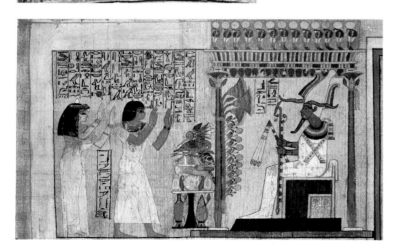

SAQQARA? (above)
Cat, after 30 BC
The hollow-cast figurine inscribed with protective symbols served as a votive offering probably to the goddess Bastet. Many elegant, highly detailed images of animals survive from the later periods.

Western Asian Art

A second major artistic culture of early antiquity was more or less contemporaneous with that of Egypt, developing in the regions stretching from the Persian Gulf to the Black Sea and from the eastern littoral of the Mediterranean as far as the frontiers of modern Afghanistan, but tending always to centre on the basins of the two great rivers Tigris and Euphrates (Mesopotamia). The art of the whole area is embraced by the term "Western Asiatic", but is often labelled according to whichever temporarily dominant strain is under discussion – as Mesopotamian but also as Sumerian, Akkadian, Babylonian, Assyrian, Persian. Geographically less firmly defined than was Egypt on the strong life-line of the Nile, the political development of Western Asia proved as unstable as its frontiers, its continuity ever broken by invasion and alien occupations. Art nevertheless developed fundamentally along consistent lines, reflecting persistently the concepts of divinity and kingship, closely interlocked.

By the fourth millennium BC – somewhat earlier than in Egypt – what had been a scattered agrarian society in the fertile region of the lower Euphrates was tending to coalesce in urban settlements under a deified ruler. The characteristic focus of this culture, the Sumerian, was the man-made staged hill, the *ziggurat*, topped by a temple. From about 3500 BC religious observances were enhanced by remarkable developments in the arts, followed by the invention of a cuneiform writing. Closely allied to the early pictographic symbols was the imagery used in one of the most persistent of all Western Asian media – the cylinder seal, carved with stylized figures or glyphs. Though miniature in scale, these seals tend to survive far better than larger work, which was often in ephemeral materials: stone was very scarce in lower Mesopotamia. In them abstract geometric designs are enlivened by formal images of elemental gods, of animals, of religious ceremonial. The feeling for frieze-like design in low relief, characteristic and persistent in all Western Asian art, is clear, but sculpture in the round was also obviously highly developed, though well-preserved survivors are very rare. The best examples show a sophisticated ability to reconcile the human body with abstract form, but there are also some that look by comparison crude or grotesque. The Sumerians, like the ancient Egyptians, prepared

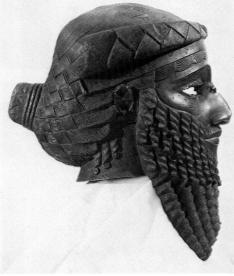

MESOPOTAMIA (right)
Cylinder seal and its impression: *Gilgamesh grapples with a bull and with a lion*, c. 2300 BC
Such seals of stone or fired earth were rolled on damp clay to produce a relief impression, which served as a signature. Myths such as the deeds of Gilgamesh, a great Mesopotamian hero, were often represented.

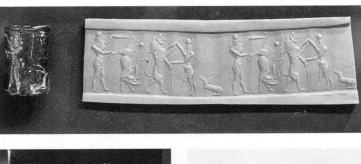

WARKA (above)
"*The Lady of Warka*", c. 3500 BC
The marble head, once part of a body perhaps of wood, is witness to the "Proto-literate" period. Eyes and eyebrows were inlaid with coloured stone: the hair, which is summarily cut compared to the superbly modelled face, was covered by beaten gold or copper.

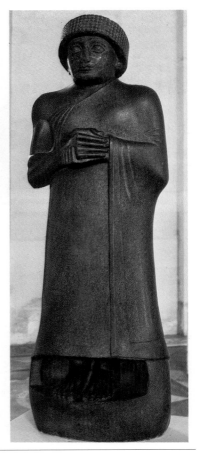

LAGASH (below)
The ruler Gudea, c. 2100 BC
More than 30 statues or parts of statues of Gudea have been identified. Most are carved from the hard stone called diorite, which can be worked to a smooth, subtle finish, with the body largely undifferentiated. But the hands, clasped in worship in a gesture found very early, are well formed.

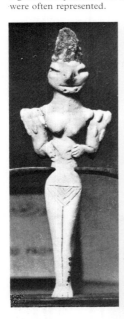

ERIDU (above)
Male figure, c. 4500 BC
This clay idol is one of the earliest sculptures in the round yet unearthed in Mesopotamia. Similar female terracottas survive, their shoulders also being dotted with lumps, which are presumed by some to represent tattooing. They are a mysterious prelude to the rise of civilization.

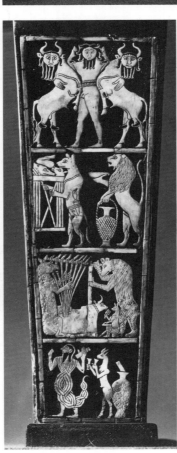

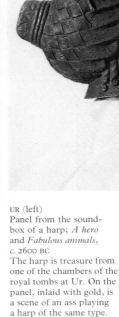

UR (left)
Panel from the sound-box of a harp; *A hero* and *Fabulous animals*, c. 2600 BC
The harp is treasure from one of the chambers of the royal tombs at Ur. On the panel, inlaid with gold, is a scene of an ass playing a harp of the same type. There is a new naturalism in this most famous piece.

NINEVEH (above)
Sargon? c. 2340 BC
This powerful image of an Akkadian ruler shows an accomplished handling of bronze – with distinct textures for the face, hair and beard. The Akkadians adopted Sumerian culture but gave it their own form. The head is hieratic and magnificent, fully assured in its stern simplification.

for an after-life with well-furnished tombs, and excavations, for instance at the famous royal graves of about 2600 BC at Ur, have revealed fragments of a luxurious civilization, rich in gold and silver and precious stones; copper was used extensively for horse-trappings and on furniture.

The Sumerian dynasties were supplanted about 2340 BC by Sargon of Akkad, who for a time unified the Mesopotamian city states on a centre further to the north (near modern Baghdad). The Akkadians, taking over most of the Sumerian artistic conventions, produced some almost fiercely vigorous and more naturalistic images. The Akkadian era was destroyed in its turn by the insurgent Guti from the north, and from about 2125 BC to 1594 BC there ensued a long period of flux all over Western Asia. The shifting, often violent patterns of restless movement affected the forms of art, as new ideas and styles flooded in from all quarters, from Egypt and Syria or from the Aegean; Mesopotamian styles likewise were widely exported. During the domination of the Guti there was, however, briefly a stable regime, apparently inspired by one remarkable ruler, Gudea, about 2100 BC. During his rule a

very impressive, monumental, life-size statuary was developed, highly formalized but with great feeling for the balance of naturalistic representation with abstract sculptural mass. These qualities seem to recur in the sophisticated, hieratic style, remarkably consistent in various media, developing in an empire centred on Babylon by the time of the great lawmaker Hammurabi (about 1792 BC).

A major turning-point in the art of Western Asia came with the consolidation and then spectacular territorial expansion of the Assyrian dynasties from their centres in the northern Tigris valley. The most remarkable and highly distinctive achievement of Assyrian art came in the form of the continuous low relief frieze (see over).

Briefly, even before the collapse of Assyria to the Medes in 612 BC, Babylon had re-emerged as a political and cultural centre, but it, too, succumbed to these new northern invaders. Persian, or Iranian, art, while tending to be influenced predominantly by Mesopotamian example, had already produced its individual styles – very early in the area of Elam and most notably perhaps in the numerous surviving bronze fittings of between

about 1200 and 800 BC from Luristan. The art of the Persian Empire, however, was predominantly architectural in character, with decoration drawing on traditional Mesopotamian themes; the Persians, too, deployed long ceremonial relief friezes, but also developed skilled metalworking techniques. Persian rule was extended from the magnificent capital at Persepolis both east and west.

Other peoples on the periphery produced over the centuries their own variations on Mesopotamian and Egyptian styles – the Hittites in Asia Minor, for example, and the peoples of Syria – and the regions bordering on the Mediterranean looked both ways. Early Greek art shows strong traces of Mesopotamian influence, but in the fourth century BC the Asian thrust westward was finally reversed by Alexander the Great. A Greek influence persisted long after the fragmentation of Alexander's Empire by the Parthian dynasties, although Persian tradition gradually reasserted itself and, under the Sassanian dynasty (AD 224-642), the Hellenistic traditions were reorientalized. In the seventh century AD art in the whole area was fundamentally altered by Islam (see pp. 270ff).

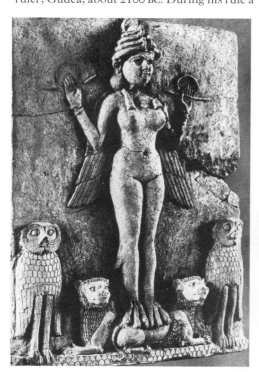

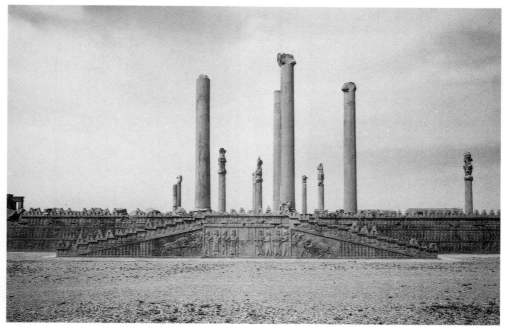

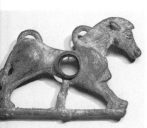

LURISTAN (above)
Horse bit, 9th century BC
Small bronzes showing a wide diversity of elegantly stylized motifs (sometimes Mesopotamian in origin) accompanied prehistoric Iranians to their graves.

MESOPOTAMIA (above)
The goddess Lilith, c. 2000-1800 BC
It is not known where the relief was made but it is thought to date from the Isin-Larsa period – after the collapse of the last dynasty of Ur, before the ascendancy of Hammurabi. The goddess Lilith was a goddess of death: in each hand she holds a length of rope, which signifies the span of man's life; at her feet are her attributes, the lion and the owl, in whose guise she sometimes appeared. The awesomely magnetic terracotta was coloured red and black.

PERSEPOLIS (above)
Processional stair, c. 500 BC
The magnificent ruins of Darius I's Palace attest his power – and the skill of his craftsmen (some of whom were surely Greek).

MESOPOTAMIA (left)
Enamelled vase, c. 700 BC
The vase perhaps reveals, when set beside an early Greek vase, how much the rising Aegean civilization owed to its Asian links – a whole formal vocabulary.

IRAN (right)
Ewer, 6th/7th century AD
The superb metalwork of the Sassanians often has early Persian motifs – deliberately revived.

The Lion Hunt Reliefs from Nineveh

KHORSABAD (below)
Lamassu, c. 710 BC
Colossal winged figures
stood in pairs flanking
the entrance to Assyrian
palaces, benevolent spirits
opposing evil. There are
parallels in Hittite art.

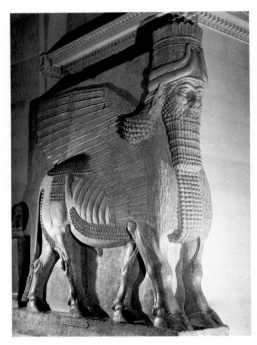

NIMRUD (below)
Bird-headed god,
c. 865–860 BC
Nimrud, the old capital,
has yielded some of the
earliest Assyrian reliefs
– imposing, but modelled
schematically compared to
the later Nineveh reliefs.
The stylized tree reads as
virtually a grammar of
architectural ornament.

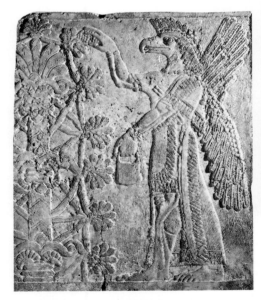

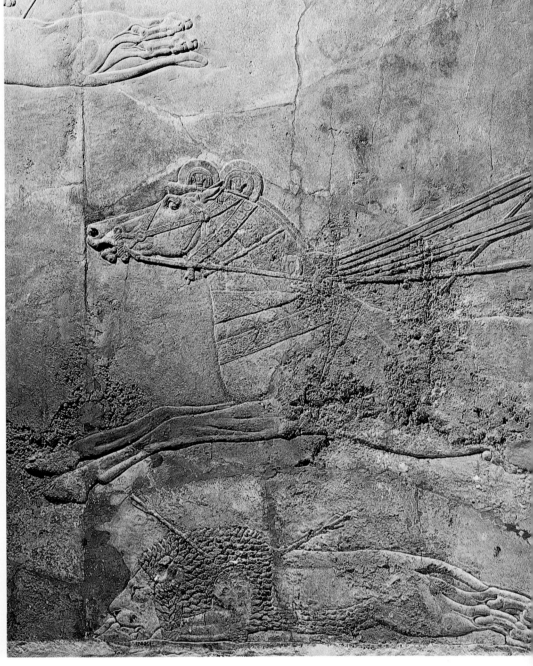

NINEVEH (above)
A herd of gazelles,
c. 645–640 BC
Mostly the highly finished
but repetitive forms tread
the ground undeviatingly;
these gazelles range the
slab with unusual freedom.

The ascendancy of the Assyrians, first over the Mesopotamian area and eventually extending even into Syria, Urartu (Armenia) and Egypt, where they sacked Thebes, began about 1500 BC and ended suddenly with the destruction of their capital at Nineveh in northern Mesopotamia in 612 BC. Their art, like that of their predecessors, was chiefly devoted to the exaltation of an absolute monarch, but the Assyrians, unlike the southern Mesopotamian peoples, had access to plentiful stone, and their most characteristic, and durable, medium was stone carved in low relief. Assyrian relief sculpture reached its greatest accomplishment in the decoration of the palace at Nineveh of King Assurbanipal (ruled 668–627 BC), not very many years before the whole Empire was overwhelmed by the assault of the Medes.

The reliefs at Nineveh are thought to have lined the approaches to the focus of the palace, the throne room, and to have amounted altogether to a length of more than 100 metres (350ft). Men and animals are represented in a continuous processional frieze. This serial arrangement of profile figures along a ground-line goes back very much earlier, not least to the finely modelled cylinder seals that are virtually all that survives of early Assyrian art; it seems almost an instinctive vision, and its principles were applied even to sculpture in the round, for instance to the colossal winged bulls with human heads that guarded the portals of Assyrian palaces, notably at Khorsabad. (Each was provided with five legs rather than four; they were conceived as being seen either from the front or from the side.)

Both the subject matter and the artistic conventions of the carvings at Nineveh had

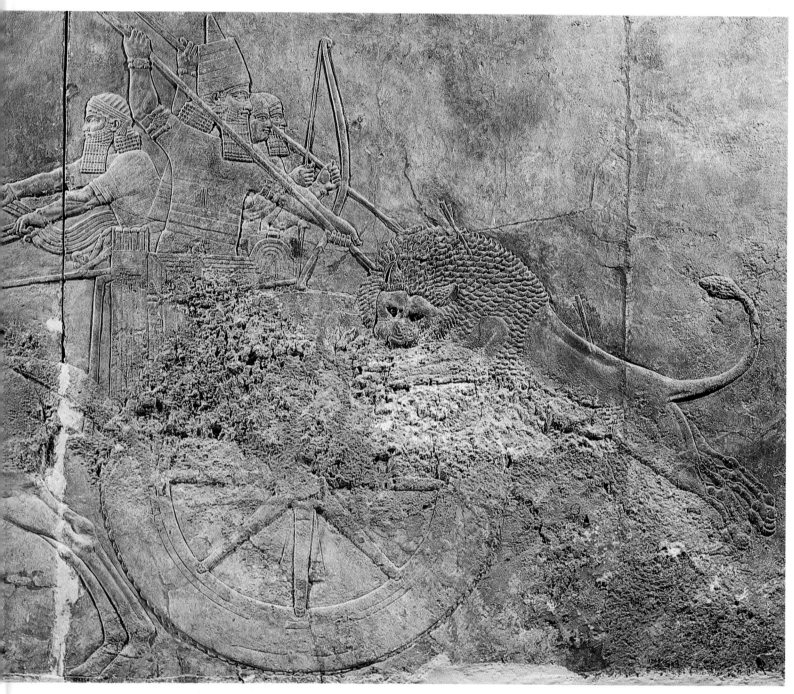

been established earlier, notably at the magnificent palace built by Assurnasirpal II (ruled 883-859 BC) at Nimrud. Here stood bird-headed gods, and kings and attendants larger than life, awe-inspiring in their hieratic rigidity of pose, gesture and costume, and the inhumanity of their expression. Commentaries in cuneiform script were often inscribed across the middle of the friezes; narrative scenes, on themes of royal conquest and triumph, whether over enemies or beasts of prey, supplemented the long rows of figures. Earlier reliefs are quite highly stylized, men and animals alike stiffly articulated. In the Nineveh reliefs the human figures, though richly detailed, are still conventionally handled, but the treatment of the animals has become vividly, sometimes movingly naturalistic. It is as though the artists were moved with some

compassion for the stricken beasts, which they never show for the human victims in the panoramic views, swarming with detail, of armies routed and massacred, cities besieged and stormed. The slaying of lions, however, was virtually a ritual, reserved for the king only, and a symbolic demonstration of his power, brought to ceremonial climax by the pouring of libations over the dead animal.

Figures are seen from the side, though occasionally their shoulders are swivelled; there is no hint of foreshortening. Battles, sieges and hunts, however, are often shown in vistas, mostly with the subject matter mounted up line above line, but sometimes in diagrammatic plan, or bird's-eye view. And landscape effects, remarkable illusions of space or depth, are sometimes created by a sensitive disposition of animals on an empty background.

NINEVEH (above)
*A lion springing at King Assurbanipal, c.*645-640 BC
Such is the finesse, that electric potency emerges within stylized convention.

NIMRUD (below)
*Cooks in a fortified camp, c.*858-824 BC
The Assyrians put figures in a landscape, but never attempted naturalistic space.

Cycladic, Minoan and Mycenaean Art

Somewhere about 2700 BC – about the time when the great pyramids were being built in the Old Kingdom of Egypt – an independent Bronze-Age culture flourished in the group of small islands in the eastern Aegean named the Cyclades. Little is known about it; it was preliterate, and the only witness of its existence is a quantity of objects made on the islands. Most famous are the little marble figures like quintessential dolls, smooth, formal, elegant abstractions of the human figure, delightful to a twentieth-century taste accustomed to the work of a Brancusi. Their original effect, however, was not so pure, as traces of colour indicate that they were once polychrome. ·

Near the end of the third millennium BC, a remarkably sophisticated, apparently unwarlike civilization began to evolve on the island of Crete, just south of the Cyclades. Called Minoan (from a legendary king, Minos), its culture depended on a highly organized economic and administrative structure at the centre of a prosperous trading network across the whole eastern Mediterranean. It developed, too, its own system of writing ("Linear A", still undeciphered, and not Greek), but almost all we know about its history rests on the

evidence that archaeologists have laid bare in the twentieth century. It was centred on several royal palaces; the most famous, Knossos, was excavated by Sir Arthur Evans at the beginning of this century, and has been reconstructed on its ruins, perhaps too much so. By about 1800 BC pottery with painted abstract decoration of great vitality, yet with a precise control in the balance of the pattern, was being produced. By 1600 BC the feeling for curvilinear design was yielding to representational forms, and by then human and animal imagery was taking varied and extremely accomplished shape in other media.

The Minoans seem to have had no interest in large-scale sculpture, but smaller-scale examples survive in abundance. The fullest evidence of the range and development of the Cretan figurative style is found in a profusion of seals for containers and in numerous stone vases, such as the "Harvesters' Vase" (not shown). The seals are in various materials, the best usually engraved in a hard, semi-precious stone such as agate. Highly stylized, but very various in their activity, these figures or animals retain an individual vitality unlike anything Greek or Egyptian.

Many small figurines in the round also exist, connected presumably with religious rites. They are in terracotta, in a material loosely known as "faience", occasionally in ivory, and from perhaps about 1600 BC in bronze. Generally, the modelling of the terracotta figurines is relatively crude and rough; the bronzes are often more vital, of a higher quality, even though they must have been worked, in the wax from which they were cast, with much the same freedom as the terracottas. Important in Minoan imagery is a form of bull sport, presumably of religious significance, but involving daring feats of acrobatics rather than the blood and swords of modern bullfighting.

Minoan history was interrupted, apparently by an earthquake, about 1700 BC. In the subsequent rebuilding of the palaces on a grander scale the art of wall-painting was developed, in a true fresco technique, the colour worked directly on to the wet plaster. The surviving examples (fragmentary, though in many cases now linked up by restoration) date from between 1600 and 1400 BC, and show the same delight in movement and relative naturalism as other Minoan art. The famous head of a girl, christened "*La Parisienne*", has

THE CYCLADES (right)
"Fiddle" figurine,
c. 2800-2500 BC
Such long-necked females, nicknamed "fiddle" after their violin shape, were an early form of Cycladic idol. Emery from Naxos was used to round and polish the small rectangular block.

THE CYCLADES (left)
Female figure, c. 2300 BC
The commonest Cycladic type represents a woman with her arms clutching her body under the breasts. Ranging from 30cm (1ft) high to life-size (rarely), these can justly be called idols, in contrast to such talismans as the "*Venus of Willendorf*" (see p. 12).

MINOAN CRETE (left)
Jug, *c.* 1850-1700 BC
The terracotta jug itself is a rather sophisticated object, and the bold, free spirals and the clam-like figure unite satisfactorily with its bulbous shape. It was found in the palace at Phaistos, and dates from before the first of the earthquakes by which Minoan history is charted.

MINOAN CRETE (below)
Two goats, c. 1450 BC
The finest Minoan seals, seldom much larger than a thumbnail, reveal superb impressions, as clear and crisp today as they were 3,500 years ago, showing a highly evolved finesse.

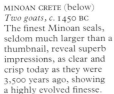

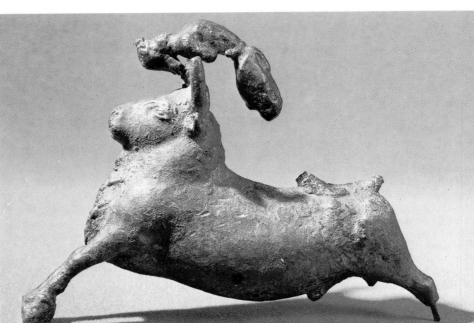

KNOSSOS, CRETE (above)
"*Snake Goddess*",
c. 1600 BC
In Greek cult snakes were attributes of underworld deities, and this figurine must be an earth goddess. And yet there is nothing sinister about her, though a bird of prey perches on her head. She displays her breasts – symbols of her fertility – as if she were a Rococo courtesan.

KNOSSOS, CRETE (left)
An acrobat leaping over a bull, c. 1600 BC
Parts of the acrobat's tautly springing body are unfortunately missing; his feet rest on the bull's back, and his arms are locked round its horns as he does a somersault. This is one of the finest surviving Minoan bronzes, cast solid by the lost-wax method.

KNOSSOS, CRETE
Bull's head *rhyton*, or shaped sacrificial vessel, *c.* 1500 BC
The engraved and painted head is stone, with gilt wooden horns, rock crystal eyes and, encircling the nostrils, inlaid shells. Its naturalism is vivid. The Minoan cult of the bull suggests that the Greek myth of the Minotaur retains a grain of history.

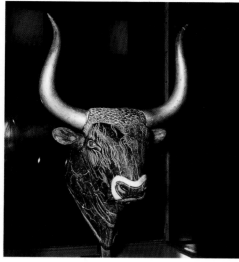

a startlingly modern, impressionistic chic. Recent excavations on the neighbouring island of Thera (modern Santorini) have revealed, marvellously preserved under the volcanic ash, extensive fragments, including what has been claimed as the earliest true landscape of the European tradition.

About 1500 BC, there began a cross-fertilization between the Minoan culture and that of the Greek mainland, especially, to judge by what has survived, with the city of Mycenae, after which the whole civilization is named. Mycenae was excavated in 1876 by the German archaeologist Schliemann, and his finds there and at Troy gave historical substance (though a limited one) to heroic Homeric myth, which scholars had been coming to believe was pure fiction.

Greece had earlier been inhabited by warriors who left little trace of any settled civilization; by about 1550-1450 BC, however, a certain luxury of life is attested by finds in the so-called "shaft-graves" at Mycenae. In these were found objects that must be of Cretan workmanship alongside work in gold, such as the famous gold face masks, of local origin. Then, about 1450 BC, a natural catastrophe

reduced much of Crete to rubble, and the Mycenaeans seem to have taken over the island – tablets from this period, in "Linear B", are in a language of Greek character. Knossos seems finally to have been destroyed not long after 1400 BC, when the leadership of the Aegean passed definitely to mainland Greece.

The Mycenaean version, or adaptation, of Minoan culture flourished most successfully between about 1500 and 1400 BC. In non-Minoan fashion, it expressed itself in terms of violence and of gold. The beautifully modelled bulls on some gold cups are aggressive, while much of the finest ornament was applied to weapons. In fresco and in pottery decoration, the Mycenaean style was much more formal, hieratic and unemotional than the Minoan. But the peak of Mycenaean power came later, between about 1400 and 1200 BC, when its influence was felt throughout the eastern littoral of the Mediterranean, and its art found its most characteristic expression in formidable, rather brutal architecture. Mycenae itself was then destroyed, possibly by Dorian invaders coming south, and the ensuing obscurity lasted until about 800 BC; only then does the tradition of European art begin to take shape.

KNOSSOS, CRETE (right)
"*La Parisienne*", fragment of a fresco, *c.* 1600 BC
The lady was once part of a group of men and women who seem to be toasting one another, presumably in a religious ceremony.

THERA (below)
An interior: *Rocks and lilies*, *c.* 1500 BC
There is much still to be excavated in Thera, but it has already revealed an archaeological wealth in its buried rooms. Thera was a province of the Minoan civilization, without the huge palace complexes of Crete itself, but its relics are often better preserved.

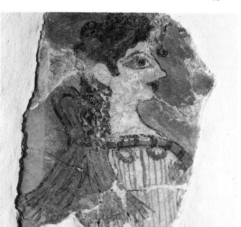

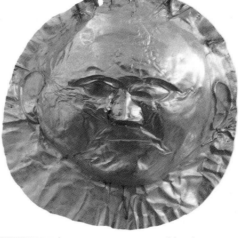

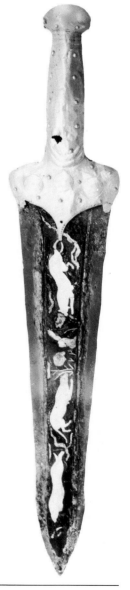

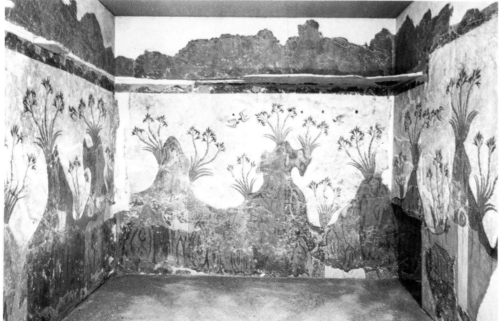

MYCENAE (above)
Gold face mask, *c.* 1500 BC
Gold seems never to have been used by the Minoans; the Mycenaeans imported it, probably from Egypt. Numerous stern, hieratic masks such as this have been found in graves, and suggest a society ruled by despotic warrior chieftains, models for Homer's Agamemnon, "king of men".

MYCENAE (right)
Decorated bronze dagger: *Leaping lions*, *c.* 1500 BC
The rapacious lions are clearly hunting amid the scraps of landscape. They are again of gold, inlaid on a bronze blade about 20cm (8in) long. Even in the jewellery found along with daggers, masks, cups in Mycenaean graves, there is little that is feminine.

Archaic Greek and Etruscan Art

When the Mycenaean culture disintegrated about 1100 BC, conditions in Greece were too unsettled to allow art to develop. It took some three centuries for a shifting, warring society of small kingdoms to stabilize itself in a system of city states. Iron was being worked for tools and weapons; an alphabet evolved; gradually there grew up a rich and complex religious outlook and a sense of national and cultural identity – Hellas.

With the development of commerce and crafts, exploratory traders ranged throughout the Mediterranean and into the Black Sea, and slowly Greek outposts, virtually colonies, were established throughout the region. Not only the Aegean islands but southern Italy and the whole coastal area of modern Turkey became Hellene. Meanwhile, during the seventh and sixth centuries BC, kingships yielded to oligarchies; the first philosophers propounded rational explanations of the world; the first written codes of law were drafted. But it was probably no later than the eighth century BC that the epic poems associated with the name of Homer – still one of the supreme achievements of the human imagination – were organized in their lasting form.

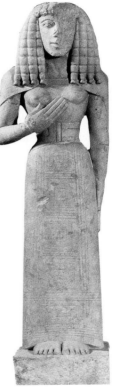

The visual arts were not so precocious. By the tenth century BC, however, some accomplished pottery was being produced, especially in Athens: its style of simple, often very precise, linear decoration is now known as "Protogeometric", and gradually evolved into the full, highly elaborate patternings of the mature "Geometric" of the ninth and eighth centuries BC. These vases are often very large, as tall as a man, and were used as grave markers; the whole surface might be girt with symmetrically balanced and ordered bands of linear decoration – meanders, zigzags, triangles – but in the early eighth century BC figurative elements began to intrude amongst them. First animals, then humans appeared – highly schematized, but foreshadowing that enduring fascination with "man, the measure of all things", that was to characterize Classical and Hellenistic Greek art, persist through the Roman period, and again become dominant in Renaissance Europe. By the end of the eighth century an influence from the east was reflected in vases from Corinth, and the subject matter was increasingly enriched.

In sculpture, during the Geometric period, small schematic figurines in bronze and ter-

ATHENS (right)
Protogeometric vase, 10th century BC
Earlier decoration had been freehand; a compass was used for these circles.

ATHENS (below)
Geometric vase, c. 750 BC
Amid the typically Greek friezes of meander (or fret pattern) and of animals, a corpse rests on a bier and mourners tear their hair.

CORINTH (below)
Stoppered *oinochoe*, or wine cruet, 7th century BC
There is a simple, sturdy delicacy about this little object; and Corinthian pots were widely exported. The cruet, found in Syracuse, is in the early, so-called "Proto-", Corinthian style; the animals were inspired by Asian ornament (see p. 29), but are incorporated with an assured restraint.

EXEKIAS (above)
Aias and Achilles play draughts, c. 550-540 BC
No other black-figure vase-painter took such care to decorate the armour or to spangle the cloaks of his heroes; they are markedly stylized, but there seems a hint of affection for them, as they take time off from Homeric battle. Stools and spears, shields and helmets, form a clear, bold pattern.

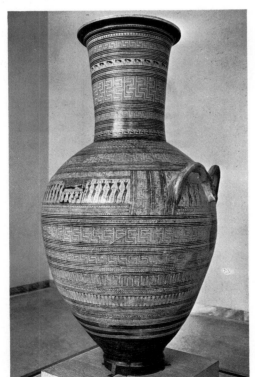

EUPHRONIOS (right)
Herakles strangling Antaios, c. 510-500 BC
The red-figure technique allowed finer detail, a freer, more naturalistic line, but artists remained conscious of pattern and symmetry.

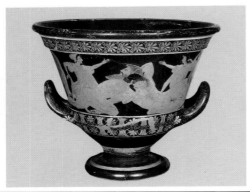

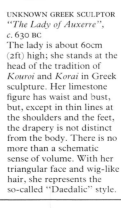

UNKNOWN GREEK SCULPTOR
"The Lady of Auxerre", c. 630 BC
The lady is about 60cm (2ft) high; she stands at the head of the tradition of *Kouroi* and *Korai* in Greek sculpture. Her limestone figure has waist and bust, but, except in thin lines at the shoulders and the feet, the drapery is not distinct from the body. There is no more than a schematic sense of volume. With her triangular face and wig-like hair, she represents the so-called "Daedalic" style.

ATHENS, ACROPOLIS
"The Peplos Kore", c. 540-530 BC
The *peplos* from which the statue takes its name is the Greek female robe – still smooth, without the carved folds that will soon appear. A little colour is preserved; exactly the same pattern recurs on women's drapery on numerous vases. She is more rounded than *"The Lady of Auxerre"*, and her missing arm once protruded. It was a piece attached – itself a sign of freedom from the block.

racotta were produced. It was about the mid-seventh century BC that contact with Egypt inspired a decisive step towards the great Greek tradition of monumental marble statuary. There is still a pronounced oriental, perhaps Mesopotamian, feeling in the four-square statuette known as "*The Lady of Auxerre*" of about 630 BC. The great series of *Kouroi* (boys) and *Korai* (girls) – statues of naked youths and draped women – start slightly later. They are life-size, and carved in that lucent marble in which Greece and her islands are so rich. Initially the *Kouroi* have a standard pose following Egyptian example very closely, but essentially Greek is the complete nakedness, and the emphasis on the body led to an astonishingly swift development towards a brilliant virtuosity in naturalistic representation. The early *Kouroi* are still tightly conditioned by the squared block of stone from which they are cut, and invite only two views, frontal or profile; facial expressions are fixed in the famous, enigmatic "Archaic smile". The latest, those dating from the beginning of the fifth century, show the same basic pose anatomically fully coherent, and the movement of the body implicitly indicated. Their

female counterparts, though draped, show a comparable development.

In the Archaic period the Greek stone temple developed its essential form, providing scope for both painted and sculptural decoration, though the painting has now all disappeared. The sculpture on the pediments, and the reliefs on the rectangular panels (metopes) or friezes that banded the buildings above the columns, sometimes included narrative action. Carved with sharp but exquisite precision, in shallow or deep relief, or almost fully in the round, the figures would have responded dramatically in the bright Aegean sun; their original effect, further enriched by colour, was far removed from their usual bland, monochrome appearance in museums.

During the late seventh and sixth centuries BC Athens regained from Corinth its pre-eminence in vase-painting. Individual artists emerged, and potters and painters sometimes signed their work. Athenian painters at first used the same black-figure technique as the Corinthians – painting the figures in black silhouette over the red Attic clay with details incised – but about 530 BC they invented the red-figure technique, in which the figures are

left unpainted ("reserved") on the clay, defined sharply against the painted ground. The red-figure technique permitted a great advance in subtlety and vitality: internal definition and expression could be achieved by drawing instead of scratching. The subjects were still mainly from heroic mythology, but representations of athletes, of drinking and feasting, courtship, weddings, funerals and everyday scenes – almost genre – increased.

The artefacts of the mysterious Etruscan civilization, dominant in central Italy from about the eighth to the second century BC, were predominantly Greek-inspired, although politically Etruria seems to have been fiercely hostile to Greece, and the Etruscans interpreted Greek themes with independence. The free-standing sculpture that adorned temple roofs has a slightly sinister vigour and expression alien to Greek art, while the carousing reclining couples on their tombs seem to welcome eternity with a toast, as if it were the culminating course in life's banquet. Life's pleasures are often celebrated in the painted decorations, in a comparable style (see further p. 44), of numerous surviving tombs, and the Etruscans were also skilled metalworkers.

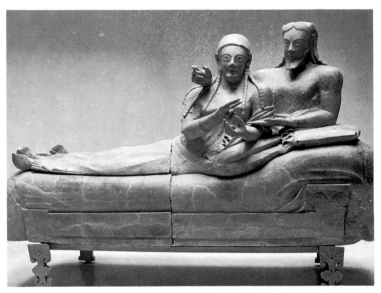
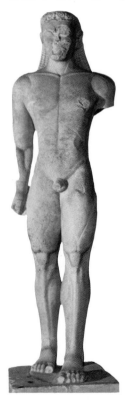
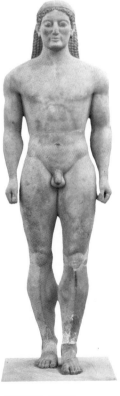
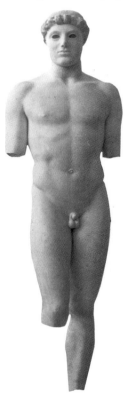

CERVETERI, ETRURIA (above) A sarcophagus, *c.* 550-520 BC
The life-size terracottas gesticulate animatedly, even if their bodies and faces are types, directly comparable to Archaic Greek funerary sculpture.

VEII, ETRURIA (right) "*The Apollo of Veii*", *c.* 500 BC
Once adorning the roof of a temple, and in terracotta, the god moves more freely than Greek *Kouroi*. There is also less concern for anatomical proportions.

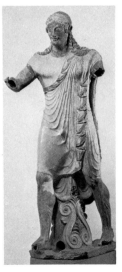

SOUNIUM, ATTICA
Kouros, c. 600-580 BC
Left foot advanced, arms close to the body, hands clenched – the pose could be Egyptian; so could the broad shoulders and thin waist, and the scale – the figure is well over life-size. The treatment of the anatomy, however, is distinctly Greek, though the sculptor has done little more than modify the surface. The tool he mainly used was a point or punch, rather than a chisel, and it was a long, laborious process.

ANAVYSOS, ATTICA
Kouros, c. 540-515 BC
There is no change in pose, but relaxation has set in: rounded contours begin to replace the sharp planes and linear anatomy of the earlier *Kouroi* – though the bones of the calves are cut to a fine edge. On the base an inscription once read: "Stop and grieve at the tomb of Kroisos, slain by wild Ares (god of war) in the front rank of battle". *Kouroi* were often used as grave markers, though they were not of course portraits.

ATHENS, ACROPOLIS
"*The Kritios Boy*", *c.* 490-480 BC
When they came to rebuild the Acropolis after it had been burnt by the Persians in 480 BC, the Athenians shovelled its defiled and broken statuary into the new foundations. Exposed by modern archaeology, far more Archaic sculpture has survived than Classical. The *Kouros* is hardly still Archaic: the limbs are fully modelled and articulated, with the left hip raised as the right leg goes forward.

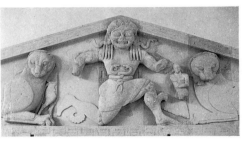

CORCYRA, TEMPLE OF ARTEMIS
West pediment, detail:
A gorgon and two lions, *c.* 600-580 BC

The enormous gorgon is a splendid figure of fright; but there is no unity of scale, or even of subject.

The Artemisium Zeus/Poseidon

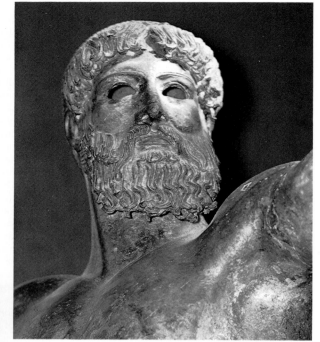

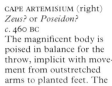

AFTER KRITIOS AND
NESIOTES (below)
Harmodios and Aristogeiton,
original 477-476 BC
The violent action of the
limbs is followed through
into the trunk muscles of
the martyrs for democracy.

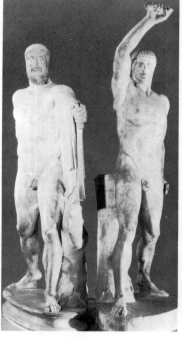

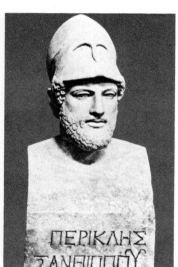

AFTER KRESILAS (left)
Perikles,
original *c.* 429 BC?
Phidias was prosecuted, it
is said, for incorporating a
portrait of Perikles in a
relief for the Parthenon.
Though the story is not
now usually believed, it
is some indication perhaps
that the concept, at least,
of portraiture was born.
Kresilas' statue is often
dated *c.* 440 BC, but then
Perikles was still alive.

AFTER AN ATHENIAN
SCULPTOR (below)
Anakreon,
original *c.* 450 BC
The posture suggested to
a Roman visitor to Athens
"a man singing when he is
drunk" – admittedly wine
and love were this sixth-
century poet's main themes.

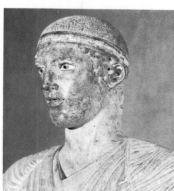

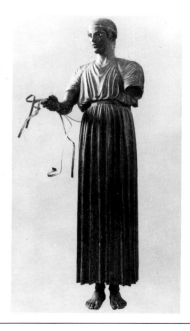

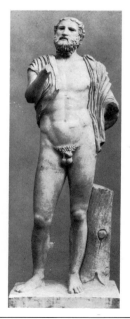

DELPHI (right)
A charioteer, fragment
of a group, *c.* 475-470 BC
The detail still tends to
be linear; the feeling for
volume is not quite ripe.
But the head (detail, above)
has the "eternal springtime"
that Winckelmann found to
dwell in Greek sculpture.

CAPE ARTEMISIUM (right)
Zeus? or *Poseidon?*
c. 460 BC
The magnificent body is
poised in balance for the
throw, implicit with move-
ment from outstretched
arms to planted feet. The

head (detail, left) is a
naturalistic, if superhuman,
mask of imposing energy.
The view intended seems
to be the profile (unlike
Myron's *"Diskobolos"*, see
over), yet the musculature
is harmonious all round.

In 1928 a slightly more than life-size bronze
statue was yielded up by the sea off Cape
Artemisium on the island of Euboea, close to
the scene of a second Greek victory over the
Persian fleet in the year after Salamis, 479 BC.
Since the style of the statue indicates a date of
about 470-450 BC, and since after their victory
the Greeks honoured Poseidon, god of the sea,
as Saviour, Poseidon seems to some an apt
identification. However, others disagree, and
it is just as likely that the bronze was on its way
as booty some centuries later from a quite
different location to Rome, or to Egypt, when
the ship carrying it was sunk by one of the
vicious Aegean storms. In that case the statue
might well represent Zeus, poised to launch a
thunderbolt; Poseidon is perhaps less likely to
be letting go in quite this way with his trident.

Whichever god it shows, this is unques-
tionably one of the most magnificent of all
surviving Greek heroic statues, and almost
incredibly well preserved (the eyes, once in-
laid, are lost). Well over two metres (6½ft) high,
with an arm-span rather wider than that, it
correlates the most closely observed and ac-
curately rendered movement of muscle and
limb in a majestic unity.

Its sculptor is unknown. Various names
have been suggested, including that of Onatas,
recorded in Aegina as a sculptor in metal, but
since there is no known work by him for
comparison, this is pure surmise. Yet in its
muscular power, the suggested movement, the
expressive head, the *Zeus/Poseidon* clearly dif-
fers from contemporary Athenian work. It is in
the so-called "Severe" style that precedes the
mature Classical age, and, technically, it is a
feat of astonishing refinement and virtuosity,
in a medium then only newly exploited. To
cast sculpture on such a scale sophisticated
smelting ovens with shaft furnaces must have
been developed; the *Zeus/Poseidon* is already
more advanced in technique than the equally
famous Delphi *Charioteer*, made perhaps a
decade or so earlier. The *Zeus/Poseidon* was
probably modelled in clay and wax and cast by
the lost-wax process. The *Charioteer* has much
thicker metal walls, and originated perhaps in
a carved wooden model, while projecting ele-
ments were worked independently and then
soldered on. The *Zeus/Poseidon* is in one piece.

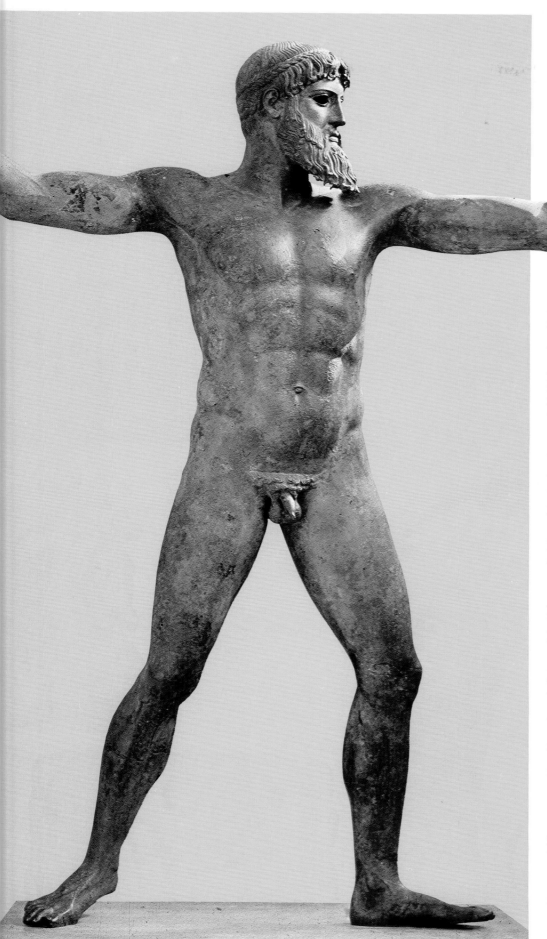

For monumental, free-standing statuary, as distinct from architectural sculpture, bronze rapidly became the prime medium in the Classical age. Bronze, however, is much more vulnerable than stone, being valuable and simple to melt down and recycle for other purposes; the loss has been enormous. As a result it is difficult to appreciate the original nature of the Greek achievement, and to estimate how the Artemisium *Zeus/Poseidon* ranked for quality amongst its lost peers.

The *Charioteer*, unlike the *Zeus/Poseidon*, has preserved its inlaid enamel and onyx eyes. So still in poise, yet intense in concentration, the Delphi *Charioteer* was originally part of an extraordinarily ambitious bronze chariot group with four horses, offered to the sanctuary by a victor in the Pythian Games. It was intended to be seen from below, and the elongation of the lower part of the driver's body would have been hidden by the chariot. The sites of the gods' temples became rich with such offerings, but civic statuary also proliferated, and the striding pose of the *Zeus/Poseidon* is anticipated notably in the famous group by Kritios and Nesiotes of *Harmodios and Aristogeiton*, lovers who slew the tyrant Hipparchos in 514 BC. These were not literal portraits; but the trend towards naturalism crystallized in the second half of the fifth century BC in an interest in the individual; the sculptor Kresilas made a bronze *Perikles*, now known in various Roman marble copies of the head alone, in which the features are still idealized, but the strange shape of the helmeted head corresponds to reports of the "onion-shaped" deformity of Perikles' cranium. Not only statesmen, soldiers and political heroes were honoured with public statues, perhaps always posthumously, but poets, too, and the characterization, though still generalized, was clearly vivid and lively – and not always flattering, as a statue of the poet Anakreon recorded in a Roman copy shows. The props and struts of the copy demonstrate the drawbacks imposed by the transposition – from the bronze original to the less versatile medium of marble – quite apart from the normal tendency, endemic in the act of copying, to blur detail, dilute the concentration, and lose altogether the quality of the surface.

Classical Greek Art

When at the beginning of the fifth century BC the Greek cities of Ionia, under Persian domination, revolted, some of the mainland cities, notably Athens, sent help to their kinsmen. The subsequent punitive expedition by the Persians in 490 BC was routed by the famous Athenian victory at Marathon, but the renewed, much more powerful invasion by Xerxes in 480 BC defeated the Spartans at Thermopylae, took Athens and sacked the city's sacred shrines on the Acropolis, before the Greeks drove the Persians off, first by a brilliant naval victory and then by one on land.

During the following years Greek culture, above all that of Athens, found with astonishing speed and certainty its maturity; this is the classic century of Greek art, the century of the great tragedians Aischylos, Sophokles and Euripides; of Aristophanes' comic masterpieces; of the founding fathers of modern history, Herodotos and Thoukydides, and of moral philosophy, Sokrates and Plato. Amid the violent internecine strife of the leading states, in mid-century, under the leadership of the aristocrat Perikles (c. 490-429 BC) there was established in Athens the classic ideal of democracy, its ceremonial and spiritual centre

the Acropolis, on which Perikles initiated a vast building programme. Here the Parthenon was built from about 447 to 432 BC under the overall direction of Phidias (died c. 432 BC), Perikles' appointed master of the works and the first impresario of the arts in history. The Parthenon sculpture has long been accepted as the masterpiece of Classical Greek art.

The earlier emergence of the Classical style from the Archaic can be seen in the superb fragments that survive from the Temple of Zeus at Olympia, and which once decorated the pediments and the panels known as metopes. They feature mythological stories: on the metopes, the Labours of Hercules; on one pediment a magnificent Apollo towering in a brawl between Lapiths and Centaurs. The mastery of anatomy is matched by the ability to present both expressive movement in the battling figures and, in the *Apollo*, the serene dignity of divine authority, dispensing order. Within the temple was later placed a colossal gold and ivory (chryselephantine) statue by Phidias of *Zeus*; had this survived it might have seemed barbaric rather than classical to modern eyes; it is a reminder that early Greek sculpture was not pristine white, but poly-

ATHENS, THE ACROPOLIS (above) *"Mourning Athene"* c. 470-450 BC
Such votive reliefs, and the similar grave stelae or markers, were the modest commissions of ordinary people. Their understatement is famous: they speak volumes without comment. The style is pure, simple, direct – inscrutably clear.

OLYMPIA, TEMPLE OF ZEUS (above) A metope: *Herakles' twelfth Labour*, 465-457 BC
While Atlas returns with the golden apples of the Hesperides, Athene helps Herakles fulfil his part of the bargain, to take the world from Atlas' shoulders. The static composition fills out the nearly square field.

(below) The west pediment, detail: *Apollo, Lapiths and centaurs*, 465-457 BC
The impassive "Archaic smile" has faded: emotion – surprise, gloom, delight – is expressed not only by gesture but in the faces. Differentiations of age are clear, and figures may sit or recline, twist or engage.

AFTER MYRON (below) *"Diskobolos"* (The discus thrower), original c. 450 BC
The original was bronze, the copy is marble. If the changing contours do not draw the viewer round the form as multiple-viewpoint Renaissance sculptures do, the complementary torsions of the body unfold with a stupendous elasticity. The statue does not correspond with a photograph taken of a discus thrower: it is a summary of his action.

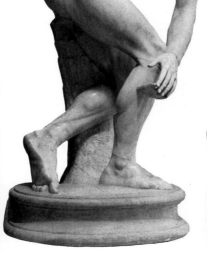

OLYMPIA (right) *Zeus carries off Ganymede*, c. 470 BC
Movement is mastered: the god strides with convincing purpose, but there is trace still of Archaic stylization in the hair. The colours are bright and flat, unmodelled.

UNKNOWN ARTIST (below) "The Ludovisi Throne", detail: *The birth of Aphrodite*, c. 470-460 BC
The altar-like block was unearthed in Rome, and was probably carved by a Greek settled in Italy from imported Parian marble. Folds in Aphrodite's dress reveal the form beneath, as the robes of Archaic *Korai* do not, and their textures are clearly differentiated. Typically for this date, the symmetry is insistent.

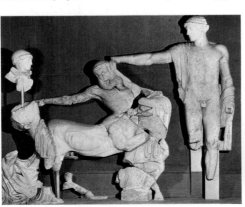

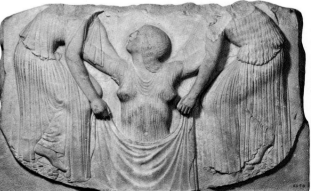

chrome – to which a remarkable terracotta fragment of *Zeus carrying off Ganymede*, also from Olympia, is vivid witness. It is also sometimes forgotten that the ancients themselves believed that the finest Classical work was in bronze (see preceding page).

In the early Classical period the names and personalities of individual artists begin to emerge, although their work is known, if at all, almost entirely through the medium of later Roman copies. Kalamis, Pythagoras (not the philosopher), Myron, were recognized as outstanding in their time, but only Myron can be connected with confidence with surviving copies. The most famous of these is the "*Diskobolos*" (The discus thrower) of about 450 BC, witness not only to the expanding range of poses explored by sculptors, but to their ability to translate the implications of movement into harmonious form. For the first time, there seems no obvious viewpoint; the statue is seen in the round, from any and all angles. The distance between images such as this and the Archaic style of 50 years earlier is startling. The interest in realism slowly increases; on female figures the drapery begins to flow and cling more naturally.

In the second half of the fifth century the style associated with Phidias is dominant. Though nothing now exists that can be confidently ascribed to his own hand, the Parthenon sculptures (superbly coherent in style, though clearly worked on by many different hands) must reflect his vision. Their plenitude was extraordinary: 92 metopes above the colonnade with figures in high relief – mythological combat-scenes on different themes, probably alluding implicitly to Athenian victories over the Persians. Then a continuous frieze, once some 155 metres (500ft) long, set high up inside the colonnade, in very shallow relief – a Panathenaic procession, circling about its focus, the colossal chryselephantine *Athene* by Phidias that once stood within the shrine. Here the sense of forward motion through an implied depth is of great vigour and variety: monotony is skilfully avoided, while in the best-preserved portions the unparalleled precision and delicacy of finish can still be gauged. The third area for sculpture was provided by the pediments: the surviving figures, fully carved in the round, are still monumentally expressive in their majesty, in the fluid movement of their draperies. Plut-

arch, writing some 500 years later, commented with astonishment on the freshness and vitality of the Parthenon sculptures; nearly 2,000 years on again, they seem even more astonishing.

The Phidian style, characterized by serenity and majesty of conception, is discernible elsewhere, in statues – almost all copies – and on grave reliefs. Other names have survived – Kresilas, and Polykleitos, sculptor of athletes and author of a canon of figural proportions. Other temples were built on the Acropolis – the famous caryatids of the Erechtheion are superb amalgams of strength and grace, but a variant, more delicate, light-hearted style appears on the little temple of Athene Nike, making great play with light and airy drapery over the naked body; the *Nike* (Victory) of about 420 BC from Olympia, by Paionios, has a similar sensuousness, an almost weightless effect – the goddess alighting from flight.

In the fifth century BC mural-painting certainly flourished, but we can only infer its quality (see p. 44). Vase-painting continued unabated: scores of individual painters have been identified, developing towards the end of the century a taste for large showy pieces with increased use of colour.

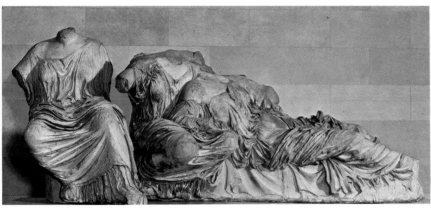

ATHENS, THE PARTHENON
(above) The east pediment, detail: *Aphrodite and two other goddesses*, 438-432 BC
Time has chipped off not only heads and limbs, but also the rich fluting of the drapery – out of the spare formal perfection of the Olympia style has emerged a sensuous, full mastery of medium and expression.

(below) The frieze, detail: *Horsemen in the Panathenaic procession*, c. 440 BC
Illusionistic modelling suggests the fully three-dimensional form within a very shallow relief – a technique quite new. The horsemen are by no means portraits; even if the event is real, not mythological, it is utterly generalized.

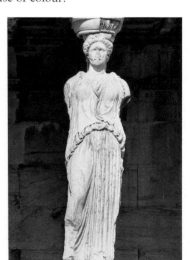

ATHENS, THE ERECHTHEION
(right) A caryatid, c. 409 BC
Caryatids, female figures serving as columns, were an eastern invention, according to Herodotos. Carved only a few years before Athens' humbling defeat by Sparta, the Erechtheion caryatids are a final legacy of the Phidian style – patterns of the classical figure. Each stands tensely, the weight evenly balanced, passing through the figure visibly. Uniquely, Roman copies at Tivoli can be tested against these originals; the carving, the transitions from plane to plane, are less delicate.

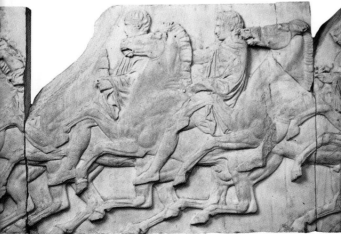

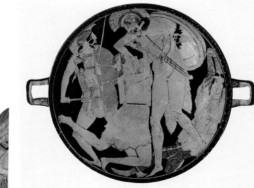

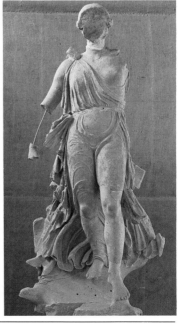

THE PENTHESILEA PAINTER
(above) *Greeks and Amazons, Achilles killing Penthesilea?* c. 455 BC
The foreshortened forms fitted artfully into the field, the precious, decorative effect, perhaps indicate that in both painting and sculpture there was a trend towards surface enrichment.

PAIONIOS (right)
Nike (Victory), c. 420 BC
Nike, originally accoutred in glittering bronze, was placed probably atop a tall column, high in the sun. In the fragments the imposing train of her draperies can still be inferred; and the round of her wind-pressed body is still appreciable.

Fourth-Century Greek Art

In the early fourth century BC the Greek city states continued their struggles for advantage and supremacy – Thebes temporarily obtained hegemony – but in the second half of the century a new power emerged in what had been considered the barbarian north – Macedonia. In 338 BC Philip II of Macedon conquered the mainland to the south, and for the first time Greece was, despite itself, united. Then his son, Alexander the Great, one of the most remarkable characters in history, had by 323 BC, before his death aged only 33, conquered the entire Persian Empire, extending Greek influence from the Danube to the Nile, from the Mediterranean to beyond the Indus.

The fourth century saw important artistic innovations and experiments, still within the framework of the Classical aesthetic. The general trend was to modulate the idealism of the fifth century towards a greater naturalism. Following precedents such as Myron's *"Diskobolos"* (see preceding page), figure compositions were modelled more and more in the round, articulated by contrasting directions of gaze and gesture. Their poses offered the spectator a variety of different viewpoints, none of them complete in itself, not only

suggesting movement in the sculpture, but also impelling the spectator himself to move. Not only is detail – the texture of flesh, the play of muscle, the cling and flow of drapery – more minutely and naturalistically observed, but the interpretation of individual character becomes more emotionally expressive, with an attempt to convey a passing mood in the features. Naturalistic portraiture, though adumbrated in the fifth century (see pp. 36–37), was first fully established in our sense in the statues that ornamented the colossal tomb of Mausolos at Halicarnassus of about 353 BC, where enormous quantities of sculpture were deployed; the Mausoleon was one of the Seven Wonders of the ancient world, and its name has passed into the European languages.

By mid-century, three outstanding artists in sculpture were established – Skopas, Praxiteles and the younger and apparently immensely long-lived Lysippos. Their names have become legendary; though again the attribution of any surviving work remains speculative, a fairly distinctive style is associated with each of them. Skopas was one of the four sculptors recorded working at Halicarnassus, and he also worked on the Temple of

Athene Alea at Tegea and that of Artemis at Ephesus (another of the Seven Wonders). Battered though the surviving fragments from these sites are, they agree with ancient accounts of Skopas as a sculptor of drama and passion, of expressive and moody figures with deep-set eyes.

Praxiteles, with Phidias, was celebrated by ancient writers as supreme. A characteristic of the style associated with him is the "Praxitelean curve" – the rhythm of a nude treated with an overt sensuality based on a very subtle understanding of anatomy. His most famous work, *"The Cnidian Aphrodite"*, survives only in copies; it is the first life-size free-standing female nude in Greek art. Of his other statues, the *Hermes with the infant Dionysos*, excavated in 1877 at Olympia, is in quality by far the finest surviving work associated with him. The beautifully modulated balance of the torso is caught with impeccable accuracy.

Praxiteles worked both in marble and in bronze, and, though the ancients appear to have preferred him in marble, metalworking had become very sophisticated. This is borne out not least by the evidence of Greek coinage, setting a standard which has never been sur-

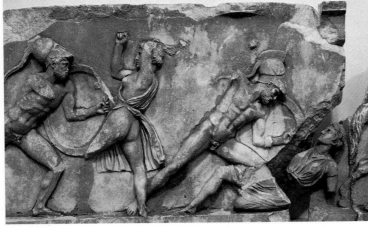

HALICARNASSUS,
THE MAUSOLEON
(right) A frieze, detail:
Greeks and Amazons,
c. 353 BC
Of the three friezes which decorated the monument, this is the best preserved, and is attributed to Skopas. The figures form a pattern of intersecting diagonals which carry the eye along.

(below) *"Mausolos"*
The features are oriental, not of a Greek type, and so perhaps from life. Though probably not a portrait of the Carian satrap himself, but of a member of his family, the swathed figure is alert and individual.

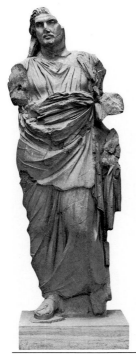

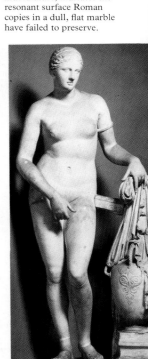

UNKNOWN ARTIST (left)
"The Anticythera Youth",
c. 350-330 BC
The rather traditional pose and proportions suggest a conservative sculptor, not one of the more famous artists active in the century. The superb finish of the bronze, its dense, smooth musculature, indicates the resonant surface Roman copies in a dull, flat marble have failed to preserve.

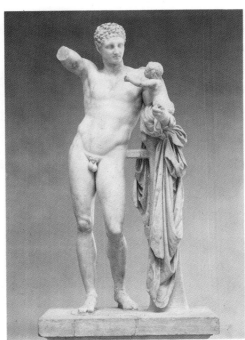

(AFTER?) PRAXITELES (right)
Hermes and the infant Dionysos, c. 350-330 BC
The god is just pausing on the way to deliver the child to the nymphs on Mt Nysa, in India, who will bring him up. Once Hermes dangled a prophetic bunch of grapes before the child (Dionysos was to be the god of wine). The statue is attributed to Praxiteles on the basis of Pausanias' description in his 2nd-century BC *Guide to Greece*, and of its close similarity to *"The Cnidian Aphrodite"*. Although there is a strut (implying that it is a marble copy of a bronze), the quality of the carving convinces many scholars that here is an original. It demonstrates the beauty an ancient critic found to be "melting" – compounded by a lustre in the marble that is almost subcutaneous.

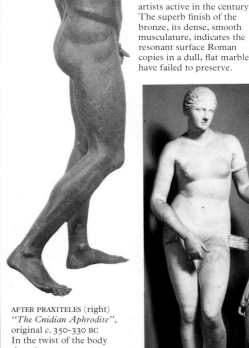

AFTER PRAXITELES (right)
"The Cnidian Aphrodite",
original c. 350-330 BC
In the twist of the body there is more movement than in the 5th century; the goddess is entering her bath. She was placed in a shrine so that she could be seen from four sides – each was equally admired.

AFTER LYSIPPOS? (below)
Alexander the Great
("The Azara Herm"),
original *c.* 325 BC
The bust's simplicity and non-committal calm is in marked contrast to the panegyrics of Alexander's historians, or to the legends Islam later wove about him.

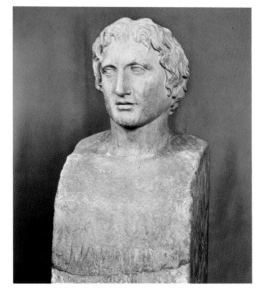

SYRACUSE (below)
Ten-drachma piece,
obverse: *Arethousa*,
c. 479 BC
The nymph Arethousa was a spring on the island of Ortygia, near Syracuse. This coin was the first in a series struck by the city to celebrate its victories.

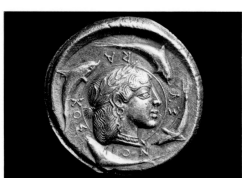

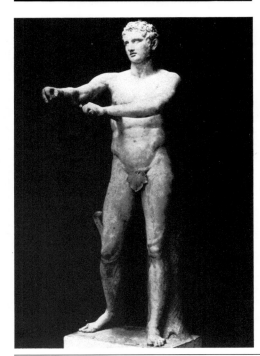

passed: superbly struck examples were being made even in the fifth century, for example the ten-drachma pieces struck in Syracuse (the richest of the western Greek cities) with noble profiles of the city's local goddess, Arethousa. The best of the few large-scale bronzes that have survived cannot easily be linked with a known artist: "*The Anticythera Youth*", recovered from the sea near Anticythera, is of superb quality, its physical perfection suggesting also spiritual serenity.

The third great sculptor, Lysippos, seems to have been active by 370 and still active about 312, suggesting a career comparable with Titian's in length and variety of achievement. At the height of his career he was appointed official portraitist to Alexander the Great, of whom the most sympathetic interpretation recorded in a Roman copy is perhaps that in the Louvre, which can be associated with Lysippos: it has features of a handsome majesty, with a certain brooding melancholy. In Lysippos' celebrated "*Apoxyomenos*" (Youth scraping down) the proportions of the counterpoised body are more elongated, more elegant than earlier, and the head is smaller – exemplifying the so-called Lysippan canon of pro-

portion, which superseded the Polykleitan. There is here, too, a suggestion of melancholy, and again in the massively sensual "*Farnese Hercules*", the archetypal image of heroic, superhuman physical strength, but shown in lassitude. This was an image destined to be repeated in countless copies after the Renaissance, like "*The Apollo Belvedere*", associated with Leochares, a contemporary of Lysippos who also worked for Alexander.

The ideal serenity of such images as these contrasts vividly with the increasing emphasis on naturalistic portraits in the round, with emphatic modelling in the features. A comparable interest, persisting well into Hellenistic times, is evident in many small terracotta figures, some distinctly genre in mood – from comic actors to exquisitely modelled female figurines. Many of these retain a delicate pastel colour, and the really grievous loss from the fourth century is the painting. Though the continuing development of vase-painting is attested by thousands of surviving examples, the visual evidence for mural and panel painting is available only in diluted copies (see p. 44), although recently discoveries have been made at Leucadia and Vergina in Macedonia.

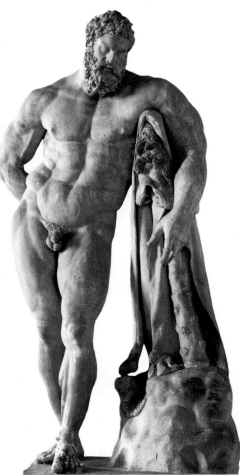

AFTER LYSIPPOS (left)
"*Apoxyomenos*" (Youth scraping down), original *c.* 325-300 BC
Strongly individual, yet quite novel in the way the pose reaches out into space, the figure is quick with life, in a moment of repose after strenuous exercise.

UNKNOWN ARTIST (right)
Comic actors, *c.* 350 BC
Clay figures survive from the 4th century and later in a range of subjects never touched in bronze or stone. They reveal everyday life: the man is shown with the padded jacket and phallus worn in Greek comedy.

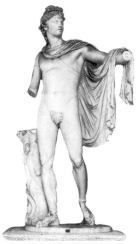

AFTER LYSIPPOS? (left)
"*The Farnese Hercules*",
original *c.* 350-300 BC
The 3rd-century AD copy is inscribed with the name of Glykon, but the figure is closely related to a coin from Sicyon, which is likely to have been based on the famous bronze *Herakles* by Lysippos recorded there.

AFTER LEOCHARES? (right)
"*The Apollo Belvedere*",
original 4th century BC
Apollo had a bow in his left hand and a laurel branch in his right, signifying his role as avenger, purifier, healer. Renaissance copies appear from the 1490s; it became for a long time the classic standard of male beauty.

Hellenistic Art

By the end of the fourth century BC, after the death of Alexander the Great, Greek culture was pervasive throughout the Mediterranean area. Individual centres grew up far from Athens, the original pace-setter: the splendour of the new royal cities of the Macedonian dynasts who had divided Alexander's Empire between them outshone the relatively impoverished (and still generally bickering) city states of mainland Greece. Alexandria in Egypt, Antioch, Pergamum and Miletus in Asia Minor – these became the modern wonders of the ancient world.

A coherent account of the development and interaction of art and artists in the eastern Mediterranean during the long period known as Hellenistic (from about 323 to 31 BC) has yet to be established. The chronological development is often highly speculative, since at many different points in time and space there were contrary currents, and recurrent references to earlier styles – to the fourth, fifth or even the sixth century. Broadly, as the style of the fourth century had been an expansion of that of the fifth, so in the following 300 years artists exploited the new freedoms signalled especially by Lysippos. They readily extended the fourth-century delight in naturalism to themes far removed from the idealized heroics of Classical sculpture: figures of all ages and moods became subjects for sculpture – a drunken satyr, an old woman, a fisherman, a boy removing a thorn from his foot (the type known as a *spinario*), a black, a barbarian, a battered and brutalized pugilist. The treatment was extremely realistic; genre was extended even to caricature, in statues ranging from small terracottas to life-size bronzes. The Hellenistic style was fluent and lively, irregular, often asymmetrical; it gave full play to technical virtuosity, in rendering movement, in showing vivid emotion in pose, gesture and facial expression.

The aspect of Hellenistic style known as "sober" or "simple", or "closed-form" or "centripetal", was developed notably in the relatively conservative workshops of Athens in the third century BC. The famous statue of the orator Demosthenes by Polyeuktos is an admirable example. Copies of the lost bronze original of 280 BC show a balanced, self-contained composition of great dignity, yet the posthumous head (Demosthenes died in 322) is highly individual and movingly expresses a

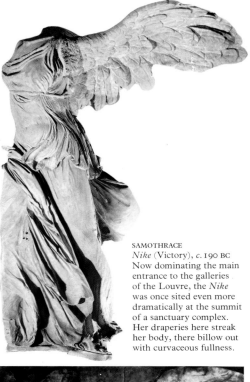

SAMOTHRACE
Nike (Victory), *c.* 190 BC
Now dominating the main entrance to the galleries of the Louvre, the *Nike* was once sited even more dramatically at the summit of a sanctuary complex. Her draperies here streak her body, there billow out with curvaceous fullness.

AFTER POLYEUKTOS (left)
Demosthenes,
original *c.* 280 BC
The true subject seems to be not so much the man, as Demosthenes the idealized champion of Athenian freedom (since lost) against Philip II of Macedon. Comparable interpretative statues were made of past tragedians and philosophers.

PERGAMUM (right)
The Altar of Zeus, outer frieze, east side, detail: *The battle of the gods and giants*, *c.* 180 BC
The head of Alkyoneus (on the left, embroiled with a serpent-limbed giant, but supported by Athene) is cut deeply, almost searingly.

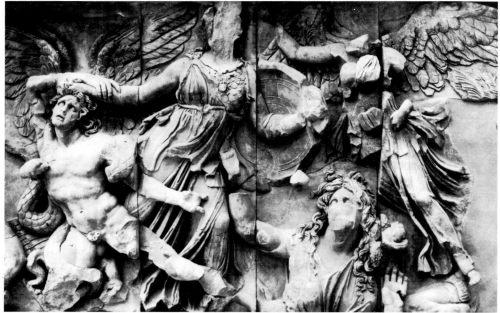

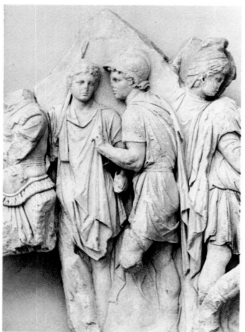

PERGAMUM (left)
The Altar of Zeus, inner frieze, detail: *Telephos and companions*, *c.* 165-150 BC
By choosing the story of Telephos, Herakles' son, who founded a dynasty in Mysia, Eumenes II (197-159 BC) was advertising his claim to divine descent.

AFTER A PERGAMENE SCULPTOR (right)
A dying Gaul,
original *c.* 200 BC
Shaggy hair and the torque around the neck denote a Gaul, shown in his agony with a new sympathy. The original was probably one of several in a sanctuary built to celebrate a victory over the Gauls in 228 BC.

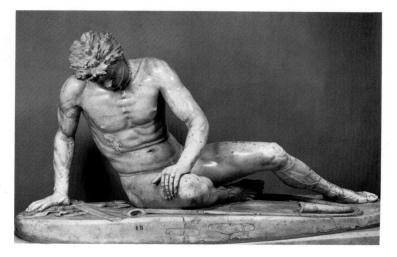

melancholic, almost introspective concentration. It is but one of many vividly particular Hellenistic portraits, reflecting an increasing fascination with individual psychology – the face observed as "the index of the mind".

The most remarkable monument at the opposite pole of the Hellenistic style – the style which has come to be known, by analogy with the work of seventeenth-century masters such as Bernini, as "Hellenistic Baroque" – is the colossal altar of Zeus from Pergamum, under construction from about 180 to 150 BC. The kings of Pergamum were the bulwark of Hellenic civilization against threats from the east, and the altar celebrates Pergamene triumph over barbarians. A whole school of sculptors flourished at Pergamum: their style is vigorous and dramatic, whether expressed in freestanding statuary – the famous studies of vanquished and dying Gauls (known from Roman copies) – or in deep-cut friezes – the originals now in Berlin. After the Parthenon frieze, these are the most ambitious and extensive examples of Greek monumental sculpture that survive. In the external frieze, showing *The battle of the gods and the giants*, running round the base of colonnade rather than above

it, great play is made with the contrast of light and shade, to convey a whirling violence of movement, powerful musculature and emphatic gestures, and at points the figures burst the constraint of the frieze and spill on to the altar steps. The rather later internal frieze seems in contrast to mark the beginning of a classicizing reaction – the relief is shallower, the figures more restrained and linear. This is one of the earliest examples in Greek art of continuous narrative, and foreshadows later, Roman, developments in relief sculpture.

The best-known original single piece in the "Baroque" style is surely the *Nike* (Victory) from Samothrace (an island in the north-east Aegean) of about 190 BC, now in the Louvre. It probably echoes the Classical *Nike* at Olympia (see p. 39), but this winged goddess alighting from the skies in the prow of a ship surpasses her predecessor, seeming almost to quiver against the sea-wind.

The sustained demand throughout the Hellenistic period for female nudes was answered by statuary which, at its best, combines the repose of the Classical tradition with a gentle, rounded sensuality of very subtle charm. "*The Aphrodite of Cyrene*" of the late second or early

first century BC is an exquisite example, a most human goddess arisen from the sea. More famous, and endlessly copied, is "*The Medici Venus*". More contrived, more consciously graceful, and the best known of all is "*The Venus de Milo*", from the island of Melos, now in the Louvre. She was once thought to be fourth-century, and she is indeed in the Praxitelean tradition, but the subtly complex turn of body, the sensuousness of the flesh, the slipping draperies are certainly Hellenistic.

The function of art shifted radically during this period. Monumental sculpture was no longer dedicated primarily to the service of an austere religion, but rather to the glorification of autocratic dynasties, as at Pergamum, and was increasingly employed for the decoration of palaces. The fashion of collecting – connoisseurship in the modern sense – was also established, and the collector's range was not necessarily confined to minor decorative works of art (though statuettes, cameos, engraved gems and seals, small bronzes, goldsmiths' work all proliferated) but extended to full-scale statues and to paintings. King Ptolemy III, for instance, had a vast collection of paintings in Alexandria.

AFTER AN UNKNOWN SCULPTOR (below) "*The Aphrodite of Cyrene*", original *c.* 100 BC? Such statues (or copies of

statues) were widely used by the Romans to adorn their baths and gardens. This is a delicious, very chaste image of nubility.

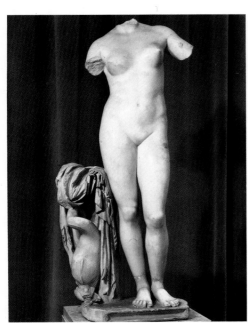

AFTER AN UNKNOWN SCULPTOR (left) "*The Medici Venus*", original *c.* 150-100 BC? The very conscious gesture of modesty adds to Venus' sensuality: she has become a more explicit image of sexual love than "*The Cnidian Aphrodite*" (see preceding page) on which her movement was based. Her posture recurs again and again in Renaissance art: she was a particularly suitable *Eve*. This statue is inscribed as the work of Kleomenes, member of an Athenian studio virtually mass-producing sculptural copies destined for Rome.

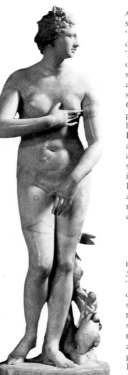

POMPEII (below) *Silenos*, undated This little bronze, a copy of a Hellenistic original, sways under the burden of the candelabrum it once supported. Silenos was a member of Dionysos' train, as his snake, and wreath of grapes and ivy, proclaim. He is wittily conceived, and beautifully finished.

AGASANDROS OR ALEXANDROS (left) "*The Venus de Milo*", late 2nd or 1st century BC The name of the sculptor, otherwise unknown, cannot be read fully on the plinth. The proportions of Venus' breasts and upper torso, and her head, are Classical, but the full, matronly hips, tilted in a gently swaying movement, are Hellenistic.

AFTER AN UNKNOWN SCULPTOR (below) *Antiochos III of Syria*, original *c.* 200-150 BC Antiochos' bid to revive Alexander the Great's Empire brought the new power of Rome into Greek view for the first time. Antiochos extended his control as far as India in the east, then turned to the west. There his opponents sought the help of Rome, which decisively defeated Antiochos, after he had disregarded the advice of the Carthaginian general Hannibal. The door was open for Rome to conquer Greece, and for Greek culture to conquer Rome.

MYRINA (left) *Two women gossiping*, *c.* 100 BC Traces of paint remain: the couch was red, the pleats blue, the women's flesh was pink. An older woman giving advice to a young bride is perhaps shown. Myrina in Asia Minor was a source of numerous terracotta figurines of the type first associated with Tanagra in Greece proper, but it gradually developed its own distinctive forms. In mood and style, this little pottery ornament is a parallel to Rococo pieces.

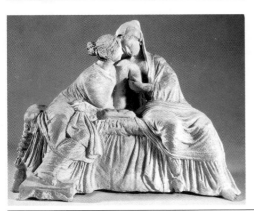

The Lost Riches of Classical Painting

Painting was no less important in ancient Greece than sculpture, but very few originals have survived except in one branch of the art – vase-painting. Not a single mural or panel painting by any of the artists so abundantly praised by classical writers exists in the original, and their nature and quality can be inferred only from literary sources or second-hand versions directly copied from, or distinctly influenced by, early masterpieces.

In the late Archaic period, mural painting seems to have corresponded closely to the style evident in vase-painting: it was essentially two-dimensional, linear, with a limited colour range. The murals in a Greek tomb at Paestum in Italy, of about 480 BC, are no doubt fairly typical, although this is provincial work, and how far it is representative of the best quality cannot be known. In the mid-fifth century, however, chroniclers record a startling progress, both in technique and in the range of effects gained – an increased realism, a sense of movement, a stronger appeal to the emotions. The important advance was the first understanding of foreshortening – but not perspective; at this time the more distant figures were placed above the nearer ones, but still on the same scale and the same plane. The media used were fresco – applying colour to the wet plaster – and an egg-based tempera applied on a dry surface; encaustic, in which the paint was held in warm wax, seems not to have become usual until Roman times.

In the mid-fifth century the most famous artists were Polygnotos, whose murals seem to have reinterpreted the old myths with much the same freedom and pungency as the great contemporary tragedians, and Apollodoros, who invented a primitive chiaroscuro. Apollodoros' pupil, Zeuxis, who is said to have specialized in easel-paintings, rationalized his master's use of shading into a developed system, and became, judging by the famous story that birds alighted to eat the grapes he had painted, the first master of *trompe-l'oeil*. In about 420 BC Agatharchos is reported to have introduced perspective effects in stage scenery. Parrhasios is said to have been the supreme master of that elegant line we can still admire in red-figure vase-painting.

It became increasingly difficult for vase-painters to reconcile the new naturalism with the limitations imposed by the curved shape of their pots, especially since the beauty of their art was dependent on a formal, linear pattern that could marry effortlessly into the surface of the clay. A three-dimensional effect inevitably broke into the harmony. Some delicate late fifth-century white-ground *lekythoi* (oil or perfume containers) show a quite fresh freedom, but there was a marked decline in the quality of vase-painting from about 400 BC.

The fourth century was regarded by later critics as the Golden Age of classical painting. Its most prominent master was the famous Apelles, court painter to Philip II of Macedon and to his son, Alexander the Great; second only to Apelles was Nikias. Apelles apparently excelled all in the brilliance of his colour, in the elegance of his composition and in his handling of light. He is said to have written a treatise, as many Greek architects and sculptors also did (all are now lost), and perhaps in it explained his use of colour. It seems that Classical and some fourth-century painters deliberately avoided the use of green and blue, possibly because it upset their careful modelling in light and dark. Later painters sometimes imitated them to obtain a "Classical" look, and the absence of blue often indicates a later copy of an early original.

PAESTUM (above)
A banquet, c. 480 BC
The view is limited to the profile, except where the torsos twist – and even here there is no foreshortening. Between this and Egyptian or Assyrian art (see p. 30) there is no yawning divide.

PAESTUM (right)
A diver, c. 480 BC
Here there is a sense of space and scale implicit in the landscape, and a hint of movement and freshness quite rare in the cramped symmetry of contemporary red-figure vase-painting.

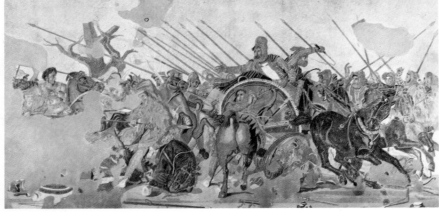

THE ACHILLES PAINTER
(left) *A Muse*, c. 440 BC
The jotted lines behind and beneath the Muse establish space clearly if summarily: the flattish field of such *lekythoi* allowed a naturalism ill suited to other pots.

AFTER PHILOXENOS? (above)
The Alexander mosaic: *Alexander meets Darios in battle*, original c. 300 BC
The composition is densely peopled and animated, and organized both in depth and across the surface, so that the two monarchs confront one another dramatically. The expressions of their faces are equally dramatic. There is a sure mastery of light and shade, within a restricted colour scheme (no blue or green).

AFTER APELLES (right)
Aphrodite wringing her hair, original c. 350 BC
The 100 talents paid by the Emperor Augustus for Apelles' painting would rival the price fetched by a Rembrandt today.

The masterpieces of the fifth and fourth centuries BC were in some cases described in detail by writers (Botticelli, among others, used literary sources to attempt reconstructions in the Renaissance). Closer reflections seem to have been preserved in the volcanic ash that destroyed Herculaneum and Pompeii, and originals are also known by transposition to other media. One was sculpture: a statuette now in Philadelphia seems to derive from Apelles' most famous painting, "*Aphrodite Anadyomene*", showing the goddess standing in water wringing out her hair. Another was mosaic: the famous Alexander mosaic from Pompeii, made in about 90 BC, is associated with an original of about 300 BC by Philoxenos, and probably conveys something of the essence of the style of Apelles' time. Painted copies from Pompeii include one small but majestic *Zeus*, believed to relate to an Apelles painting described by Pliny; and a *Perseus and Andromeda* may be related to one by Nikias. Very recently, original fourth-century murals (not shown) have come to light in Macedonia.

By the end of the fourth century most of the principles and techniques that the Renaissance was to re-establish were known and exploited, with the notable exceptions of mathematical perspective and the potential of oil as a vehicle for colour. Following the establishment of the Hellenistic kingdoms across the eastern littoral of the Mediterranean, Greek art, or art inspired by Greek art, was widely propagated in several separate schools. Hellenistic survivors are far rarer and so that much more difficult to date; as in sculpture (or poetry), painting constantly referred to the art of the past. Its subject matter also expanded from predominantly mythological or historical events to genre – two famous mosaics in Pompeii by Dioskourides, themselves of about 100 BC, but held to reflect late third-century BC paintings, are an example. Still life is also found, and studies of animals, fish and birds. Landscape appears to develop as a distinct branch of art in the second century BC. The luxurious and various decoration of the houses of Herculaneum and Pompeii, dating from the first century BC and the first century AD, probably reflects quite accurately the range available: much of it depends on Greek originals, and even after Rome had become the dominant power in the Mediterranean, the Greek tradition was sustained, often by migrant Greeks.

AFTER APELLES? (above)
Zeus, original *c.* 350 BC
Apelles was famed for his skill in portraiture, and painted, according to Pliny, an image of Alexander the Great as Zeus so lifelike it seemed three-dimensional. Naturalism was Pliny's chief criterion of quality.

AFTER NIKIAS? (below)
Perseus and Andromeda, original *c.* 350 BC
Though the composition is probably based on Nikias, the faces are unheroic, and the general effect is stolid. The Apelles copy (above) has at least some presence; this has none.

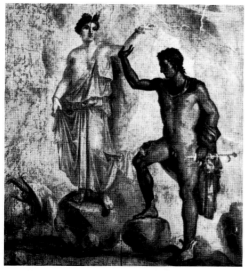

ROME, ESQUILINE
(right) *Odysseus enters Hades*, original *c.* 150 BC
This most lyrical painting is probably a copy of a Hellenistic landscape of about 150 BC. The treatment of light is especially effective; it enters Hades, with Odysseus, from the left, illuminating a broad sweep, in which the artist has placed his figures. The brushwork is swift, even "impressionistic" – which seems to be a later, Roman, technique (the Apelles copy is a better example).

DIOSKOURIDES (above)
Street musicians, *c.* 100 BC
These strolling players, followers of the cult of Cybele, are remarkably vivacious, and the mosaic manages to convey a real impression of sunlight and the open air. It is signed in Greek by its immigrant maker; but it was perhaps not his own composition.

POMPEII (above)
A cat with a bird; ducks and fish, original *c.* 250 BC
As in the Alexander mosaic, the colours are limited to those four (red, yellow, black and white) cited by Pliny as in vogue with some famous painters of the 5th and 4th centuries BC – their use here indicates that the mosaicist imitated an earlier model. The quality is good: the cat almost bristles; the mullet gasp.

ROME (left)
The garden painting in the House of Livia at Prima Porta, detail, *c.* AD 25
A gentle woodland scene is represented in a profusion of foliage and birds seen here and there amongst the trees. These are set back behind the fence in clear perspective; there are subtle changes of tone between close and distant objects, but neither the scale nor the viewpoint is consistent.

Roman Art I: Late Republic and Early Empire

Rome was founded, according to legend, by Romulus and Remus on April 21, 753 BC, and the date at least seems approximately accurate. Roman dominance over Italy came gradually: the regions to the north, including Etruria, succumbed in the fourth century BC, those to the south, including eventually the Greek cities there, in the third. During the second century BC Roman power expanded outside the confines of the Italian peninsula until it encompassed most of the Mediterranean seaboard, progressively extending to reach its furthest limits about AD 100, in the reign of the Emperor Trajan. Then the Roman Empire embraced the whole Mediterranean, and from Britain in the west to Mesopotamia in the east.

Roman art comprises three main strands – the native, so-called "Italic" of the region; the Etruscan, a culture that developed earlier and faster than the Roman although it was soon absorbed into it; and above all the Hellenic. The Greek influence came not only direct, but also filtered through the Etruscans; and especially after the Roman conquest of Greece it was to be decisive. After the Sack of Syracuse, from 212 BC onwards, ship-load upon ship-load of Greek artistic treasure was transported

as booty to Rome; Greek artists likewise migrated. In Rome, in Greece, in Hellenistic outposts (notably at Aphrodisias in Asia Minor), Greek workshops were busily employed, reproducing copies or variants of earlier masterpieces. Thus the dating and place of origin of one of the most celebrated compositions of antiquity, the *Laocoön*, is not untypically obscure. Certainly carved by three sculptors from Rhodes, Hagesandros, Polydoros and Athenodoros, it is equally certainly in the vigorous Hellenistic, specifically Pergamene,

"Baroque" manner, but it has been dated variously from the second century BC to the first century AD. But when it was rediscovered, in 1506, it was in Rome. Rome is the channel through which the Greek tradition was passed to the West.

Yet in Roman use the Greek tradition could entirely alter its character. The status of art and artists in Rome was quite different: art was anonymous, its makers mere instruments of the patrons who commissioned it, and, as artisans, of no social consequence. Art was

ROME (above)
Ampudius, his wife and daughter, 1st century BC
Whatever his origins, the cornmerchant Ampudius was a Roman citizen: the toga he wears is proof. He, like so many Romans, had his very literal likeness planted outside his tomb.

ROME (below)
Augustus, after 27 BC
Augustus was depicted – naked, in armour or, here, in a toga as an officiating priest – in guises and poses derived from Greek prototypes. The head is youthful even in statues made when Augustus was more than 70.

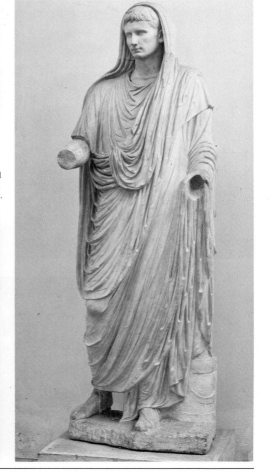

ROME (left)
"The Capitoline Brutus", 3rd century BC
Lucius Junius Brutus was the semi-legendary founder of the Roman Republic; the "portrait" shows a hero.

ROME (above)
Pompey (Pompeius Magnus), *c.* 50 BC?
The head is a subtle blend of native Roman, individual portraiture with the smooth harmony of Greek tradition.

HAGESANDROS, POLYDOROS AND ATHENODOROS (right)
Laocoön, 1st century AD?
Apollo sent the serpents to slay Laocoön and his sons for voicing suspicions of the Trojan Horse. Writhing expressively, their figures became an object lesson for 16th-century artists.

APOLLONIOS (left)
"The Belvedere Torso", c. 100 BC
The famous torso, which, like the *Laocoön,* is clearly Hellenistic in the energy of its tensed musculature, was also made for Rome, or soon found its way there, and was found in the 1490s: it surely influenced Michelangelo's Sistine nudes (see p. 134), and much of his statuary.

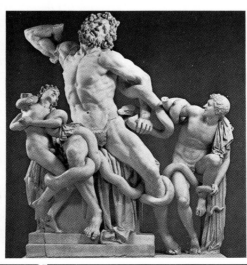

functional: in a highly material and prosperous urban society, it was an adjunct of luxury and a status symbol; or it extolled the glory of the state, the fame of family, the renown of national or civic heroes – propaganda art.

Portraiture became extremely important. There survives from as early as the third century BC an intense and sharply individual bronze bust known as "*The Capitoline Brutus*", which may be Roman or Etruscan. It was the Etruscans who invented the bust form, with its concentration on the head; the Greeks, though their interest in the head as the mirror of the mind is clear from Hellenistic times, did not sever it from the body. The Romans themselves had an ancient, rather macabre tradition recorded by Pliny: "In the halls of our ancestors, wax models of faces were displayed to furnish likenesses in funeral processions – so that at a funeral the entire clan was present". There is an extraordinary statue (not shown) illustrating this practice, a life-size figure of a patrician carrying two such heads of his ancestors, embodying the enduring virtue of the family or clan.

Countless funerary slabs in high relief show an uncompromising realism – with faces pre-sumably taken directly from death masks. They cover a wide range, so that for the first time a comprehensive portrait of the individuals making up a society can be seen, from Emperor to tradesman. Yet a suaver, generalizing Hellenistic strain can also be discerned in the late Republic, for instance in a bust of Pompey (if it is contemporary). This is in fact the earliest certainly identifiable likeness of a major Roman historical figure.

Already in the first century BC such famous generals of the Republic as Pompey were honoured as near-divinities, and their statues erected in public places. When Octavian established himself as the Emperor Augustus, a deliberately idealizing style of portraiture, harking back to a precedent first set by Alexander the Great, was applied to present the supreme ruler, now a god, for adulation and adoration. Statues of Augustus were produced in various modes, and countless repetitions exported all over the Empire: they acted as proxy for Augustus himself, manifesting his authority in substantial form wherever Roman power was established. The official, propaganda aspect of early imperial art is most splendidly illustrated by the Ara Pacis Augustae (the Altar of Augustan Peace), commissioned in 13 BC. When the processions on its side walls are compared to the friezes of the Parthenon (see p. 39), the specificity of the Roman mind is clear: a particular event is recorded, and the figures are thought to be portraits. The dignity and majesty of the Augustan age is reflected also in other media, for instance in the flawless virtuosity of the cameo known as the Gemma Augustea, where the Emperor presides serenely alongside the goddess Roma.

Augustus' successors appear in their portraits in a comparably cool and relatively idealized style, though the image of Nero is distinctly and uncharmingly taurine. But with the Flavian Emperors, starting with the forthright soldier Vespasian (AD 69-79), the Italic tradition seems to revive, and an individual, even unsophisticated character, bourgeois rather than aristocratic, is depicted convincingly in his busts. The propaganda reliefs take on a franker narrative interest, as on the Arch of Titus (Vespasian's successor). In painting, the acclimatization of the Hellenistic style is copiously illustrated in the domestic interiors of Pompeii and Herculaneum, and typically vivid painted portraits survive.

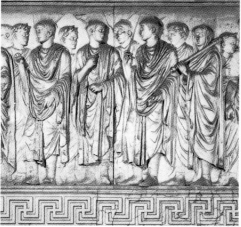

ROME (right)
The Altar of Augustan Peace, detail, 13-09 BC
In the unstated, consciously cool and static majesty of the processional reliefs, the influence of Greek Classical art is strong – Roman "Neoclassicism". Other, allegorical, reliefs are Hellenistic in style.

ROME (above)
Gold coin, obverse: *Nero*, *c.* AD 60-68
The Emperor's portrait was usually idealized, but the artistic Nero preferred a more individual image, of Hellenistic influence. He wears long-curled hair in the Greek fashion; his philhellenism annoyed his senators quite considerably.

ROME (below)
The Gemma Augustea, 1st century AD
Augustus is granted the status and attributes of Jupiter; in size he is the equal of the goddess he accompanies, and he is crowned by Prudence. Below appear defeated barbarians, over whom soldiers erect a trophy.

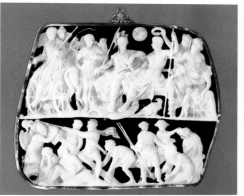

ROME (below)
The Arch of Titus: *Triumph with the spoils of Jerusalem*, *c.* AD 81
The deep relief, the lively and varied poses, the foreshortened candelabrum of the Temple in Jerusalem – an accomplished narrative technique is now applied to real events. The Flavian Emperors propagated its use: the finest achievement of this kind would be Trajan's Column (see over).

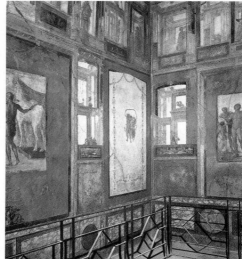

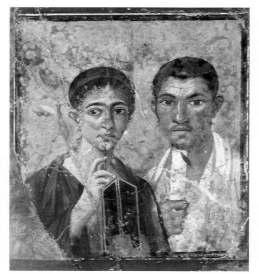

POMPEII
Paquius Proculus and his wife, before AD 79
The dark, distinctively southern features of the couple are vividly rendered. The wax-based medium is found again in the equally individual, later portraits from Fayoum (see p. 62).

POMPEII
A room in "the House of the Vettii", before AD 79
The sophistication of the decorative scheme typifies a late stage of wall-painting; murals featured in Greek domestic interiors but the *trompe-l'oeils* are probably a later, Roman invention.

Trajan's Column, Rome

In the reign of Trajan (AD 98-117) the Roman Empire pushed outwards to its furthest boundaries, an achievement copiously commemorated by monuments, not only in Rome – where Trajan's Forum, the grandest of all the imperial fora, was built, and in it Trajan's Column, an extraordinarily original conception – but elsewhere, for instance at Benevento in southern Italy, where one of the most splendid triumphal arches is preserved.

Temporary honorific arches were customarily erected on the route of generals returning in triumph from successful campaigns: the marble versions translated these into permanent form. One early survivor is the Arch of Titus in Rome, with vivid reliefs inside the arch (see preceding page) deeply cut – exploiting effects of light and shade – and using an appreciable, if unsystematic, perspective. Trajan's Arch at Benevento is the first known to have been decorated with figure sculpture and friezes over both main faces, merging with the architecture in a unified, harmonious composition of rich complexity; but the carving, though again in high relief, is more stately than that of the Arch of Titus, and its content more pacific, depicting the Emperor as a statesman rather than a general.

On Trajan's Column, however, the narrative relief is applied in a new way on a vast scale to spectacular effect. Thirty-eight metres (125ft) high, the Column was dedicated in 113. The marble low relief that winds unbroken up its shaft and retails the course of the Emperor's campaigns against the Dacians (in modern Romania) in 101 and 105-06 is some 200 metres (650ft) long. Its survival for nearly 2,000 years is due partially to its adaptation to Christian purposes: it was originally crowned by a colossal bronze-gilt statue of the Emperor, replaced in the sixteenth century by a *St Peter*.

Characteristically for Roman art, the artist responsible for the Column's conception is unknown; there must have been a team of sculptors working on it, and the quality of the carving is uneven, but the whole, in its magisterial sweep and impetus, clearly reflects the guidance of one remarkable controlling intelligence. This might have been the architect of the Forum itself, the Syrian Greek, Apol-

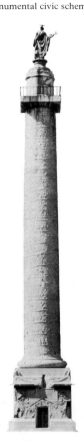

lodoros of Damascus, but that is only conjecture. The Column was sited originally between two new libraries (one Latin, one Greek; now vanished), from the top of which the details of the uppermost parts of the frieze were perhaps more legible (as they were not to be again until binoculars and the photographic zoom lens).

The handling of the subject matter is likewise novel, although reference to battle and victory, to the humiliation of barbarian enemies and to Roman triumph, was not of course new. Processional friezes go back to the Parthenon, and the *Telephos* frieze at Pergamum (see p. 42) shows the beginnings of storytelling in marble relief. A continuous historical narrative had not, however, been attempted before. Trajan's Column is the first visual documentary, a remote harbinger of the medium of film; although Roman scrolls with continuous illustration exist, those that survive are all later than the Column. The relief is shallower than on Trajan's Arch at Benevento, no doubt to help sustain the uninterrupted flow of the story; it was moreover originally heightened with colour. Individual figures are clearly differentiated one from another, and shown on a rather larger scale then either architectural or landscape elements, or their horses; the figure of Trajan himself, emphasized as hero, recurs on a still larger scale. Though consistency of scale had never been a canon of Greek or Roman art, the enlargement for emphasis of the important figures is significant for the future. The story proceeds in two parts, corresponding to the two campaigns, each ending with the submission of the Dacians. The most dramatically effective are the last scenes of all – the march on Sarmizegethusa, the siege, the firing of the city by the defeated Dacians, the pursuit of their ruler, Decebalus, finally his suicide. There are some 2,500 individual figures in all, together with their armour, equipment and all their military paraphernalia, depicted in great detail, making an unparalleled account of the Roman Army in the field. Often, too, the individual participants take on character: they register in facial expression as well as gesture the agony of battle, the pain of their wounds, the misery of their captivity.

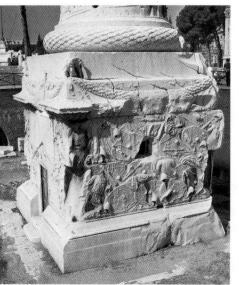

ROME (above)
Trajan's Column, 106-13
The Column stood between two great libraries above an enormous Forum, full of statuary. On the hill behind it rose Trajan's Market, containing vaults of concrete that, even by modern building standards, enclose impressive spaces.

BENEVENTUM (left)
Trajan's Arch, 114-17
More reliefs are arranged in a similar way on the other side – it is supposed that the 12 reliefs facing the town commemorate the Emperor's achievements in the provinces, while those towards Benevento relate his achievements in Italy.

ROME
Trajan's Column, details: (above) *The Roman Army crosses the Danube; Trajan delivers a speech to the legions and they fortify their camp*
As the legions cross the Danube the river looks on in person from his waters. The detail is superb, and more informative than any written history that has come down to us about the progress of the campaign.

(left) The base or plinth of the Column
The laurel wreath girding the foot of the Column is also a symbol of victory. The trophies of armour and weapons in a very precise low relief perhaps inspired similar Baroque ornament. Trajan's ashes were placed in the base when he died.

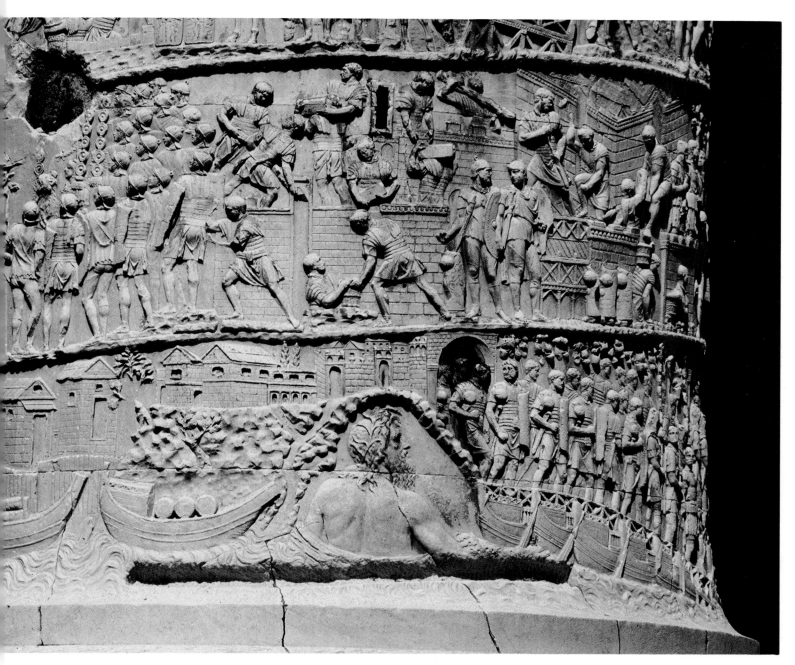

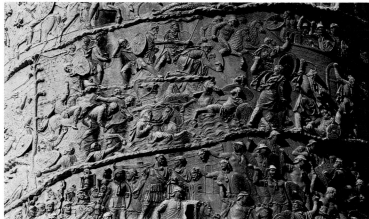

The siege of Sarmizegethusa
The cavalry charge, soldiers swim the river and all make ready to scale the Dacian walls, in a dramatic rush of action reproducing all the gore and confusion of battle. The composition is always vivid, changing its character with the action.

Decebalus' suicide
The agony of defeat, the tragedy of the individual, are recognized no less than the joy of triumph. Gesture and expression reveal the Dacian leader as a hero: he may be the enemy, and doomed to defeat, but he is given an epic role to play.

Roman Art 2: The Hadrianic Period

The reign of Hadrian (AD 117-38) has been called the Golden Age of the Roman Empire, expanded to its furthest extent, consolidated briefly in relative peace and in unheard-of prosperity. Of Spanish origin, Hadrian was a tireless traveller, personally fascinated by the Greek tradition of art (he was nicknamed *graeculus*). He commissioned spectacular architecture, for instance the dome of the Pantheon in Rome and his so-called Villa, his country residence at Tivoli, a huge conglomeration of gardens, baths, temples, pavilions and palaces, liberally adorned with sculpture. Here the generous eclecticism of Hadrian's taste brought together a host of ancient masterpieces – from copies of the famous caryatids from the Erechtheion in Athens to Egyptian gods, from Egypt.

The revival of Grecian taste stimulated a renewed interest in nude sculpture in the round, above all in statues of Hadrian's favourite Antinoüs, drowned in the Nile and subsequently deified by the Emperor. These echo Hellenistic types, but also show innovations in the use of the drill that can be seen again in imperial portraiture, which, though still idealized, took on a new vividness, es-

pecially in the treatment of the eyes and hair. Eyes were given increased definition and expression by drilling out the pupils, hair was more variously and energetically shaped, and the beard reappeared. Highlights were created, "colouristic" effects achieved.

The fashion, begun in Trajan's reign, for burying instead of cremating the dead became widespread in Hadrian's time: the container for the body, the sarcophagus, often carved in elaborate relief, is the medium in which the progress of Roman imagery and style can best be studied and analysed in all its rich variety. Thousands of sarcophagi were produced all over the Empire in the following centuries, most notably outside Rome, in Athens and Anatolia. The carving developed from primarily decorative patterns of swags and garlands to figured reliefs depicting mythological incidents, battles, and extending even to subjects of everyday life. An outstanding, if unusually elaborate, early example is the Velletri sarcophagus: the figures illustrate a number of themes common in Roman funerary symbolism. Hercules' Labours symbolize the triumph of life: his descent into hell and return spells out the hope of rebirth, an extension of

an interest in the individual personality for which the change from cremation to burial is doubtless also evidence.

Signs of disintegrating confidence appear even in Hadrian's time, but the old order was maintained for a time in the reign of that intriguing personality Marcus Aurelius (161-80). Known as "the philosopher Emperor", an intellectual, he was, however, embroiled in recurrent and major military crises. His victories were celebrated, following Trajan's example, by triumphal arches, now lost, and a spectacular Column, less well preserved than Trajan's. The relief is more deeply cut, but the narrative is jerky, repetitious, and less compelling. Of much better quality is his famous equestrian statue of bronze, originally gilded, in the Campidoglio in Rome, the best surviving equestrian monument from antiquity, the ancestor of the Renaissance masterpieces by Donatello and Verrocchio and of countless later images of mounted rulers and generals throughout the world. In fact the output of statuary in the Roman Empire was prodigious, and though a remarkable amount in stone survives (usually in part rather than in whole), staggering numbers have been lost – there are

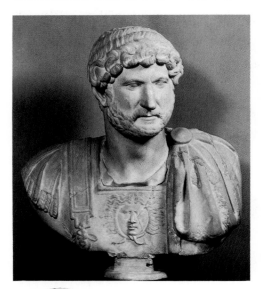

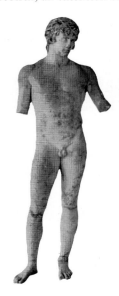

ROME (left)
Hadrian, c. 117-38
Inscribed in Hadrian's vast mausoleum, now the Castel S. Angelo by the Vatican, is the timid little verse: "Gentle little wee tramp soul, the body's guest and friend, where are you off to? Somewhere tiny, dank, bare and wan." The late Roman era seems to begin with Hadrian: outwardly so prosperous, it has been called "an age of anxiety".

DELPHI (right)
Antinoüs, c. 130
Hadrian's appreciation of Greek art is reflected in the marked idealization of his Bithynian love – though the image is still sensual; the head shows the use of a drill. The type was much copied in the Renaissance.

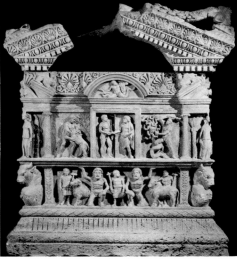

ROME (right)
The Column of Marcus Aurelius, detail, *c.* 181
Incidents from the German and Sarmatian campaigns are depicted in vigorous high relief. More attention is paid to expression in the figures than to narrative coherence; the scale varies widely, but the Emperor is always prominent: here he is receiving a messenger.

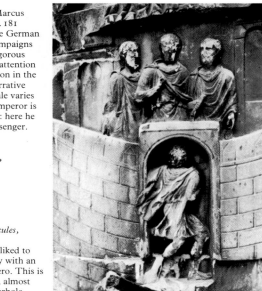

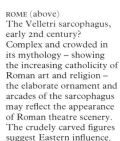

ROME (left)
Commodus as Hercules, c. 180-92
Several emperors liked to identify personally with an admired god or hero. This is near to caricature, almost Rococo in its hyperbole.

ROME (above)
The Velletri sarcophagus, early 2nd century?
Complex and crowded in its mythology – showing the increasing catholicity of Roman art and religion – the elaborate ornament and arcades of the sarcophagus may reflect the appearance of Roman theatre scenery. The crudely carved figures suggest Eastern influence.

ROME (below)
The Ludovisi sarcophagus: *Romans fight Germans,* mid-3rd century
The concern is entirely for movement, not only in the twisting bodies extruding every tiny space but also in their hair and drapery; the deep cutting throws up dramatic shadows. Reliefs such as these were emulated by the young Michelangelo.

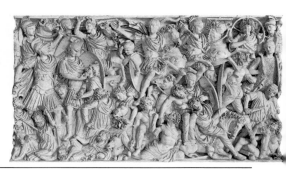

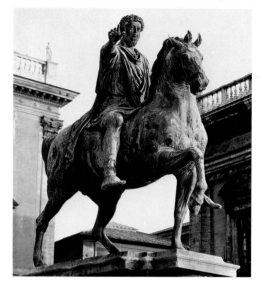

ROME (below)
Marcus Aurelius, c. 161-80
Probably once surmounting
a triumphal arch now lost,
the statue was preserved
thanks to the Christian

misapprehension that it
represented Constantine.
Though the horse (as was
usual) is small in relation
to its rider, the anatomy
is accurate and lively.

said, for example, to have been 80 statues of
Augustus in silver in Rome, let alone countless
more in baser materials.

The craftsmanship of late imperial portrait
busts could reach a high pitch, conveying
character and mood with great virtuosity –
most remarkably in the notorious bust of
Commodus (180-92), decked incongruously
with the attributes of Hercules. The quality of
reliefs on sarcophagi varied enormously, but
they, too, could be superb, as on the Ludovisi
sarcophagus. Here interest in the represen-
tation of space and coherent clarity of com-
position yields to an almost savage relish in a
highly realistic welter of battling bodies,
carved with masterly skill. A feeling close to
compassion can be apparent in that ever re-
curring theme of Roman art, the conquered
barbarian depicted in his human suffering.

During the third and the fourth centuries
AD the formal values of Hellenistic art were
gradually eroded. An early but significant
stage in this process was reached in the gran-
dest of all triumphal arches, that erected in the
province of Tripolitania, in north Africa, at
Leptis Magna in 203 by Septimius Severus.
The reliefs are in varying styles and of varying

quality. The technique known as "negative
relief" was extensively used, that is, under-
cutting with the drill around the figures, rather
than modelling them in rounded form. This
produces a strong but flattening contrast be-
tween light and dark; and the figures, often in
stiff frontal poses, seem rigid and hieratic.
Many of the artists engaged came from the
East, but the old Greek vision, even the ability
to carve in its terms, seems to have been lost.

By the time of Severus, the Emperor cult of
the Roman West was merging with traditions
of idolatry from the East: in reliefs this tells in
the exaggerated scale of the principal figure,
and in an ever-increasing emphasis on fron-
tality. In portraiture there was considerable
variety in style: for example, while Septimius
Severus appeared in the guise of his patron
deity, the god Serapis, Alexander Severus
(222-35) opted for an image almost republican
in its simple directness – though it has also a
certain remote aloofness. Through it all the
Roman genius for realism recurs in images of
often superbly unflattering "verism": the for-
midable bust of Philip the Arab (244-49)
conveys a sense of massive, crude physical
power, undermined by psychological unease.

ROME (left)
*Septimius Severus
as Serapis*, c. 200
This north African-born
Emperor identified himself
with an Egyptian deity; he
sports here four ringlets,
an attribute of Serapis.

LEPTIS MAGNA (right)
The Arch of Septimius
Severus, detail: *Triumphal
procession*, c. 202
Influences from Egypt and
Syria consort in a style far
removed from that of the
Arch of Titus (see p. 47).

EGYPT (below)
*Septimius Severus and
his family*, c. 199-201
Septimius' son Geta was
erased from this stiff, even
sanctimonious image after
his brother and joint heir
Caracalla had slain him.

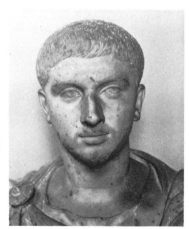

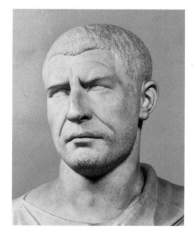

ROME (left)
Alexander Severus,
c. 222-35
The full lips, irregular
nose and sly eyes suggest
a genuine likeness. The
Emperor probably wished
to propagate a virtuous
image in choosing for his
bust a republican style.

ROME (right)
Philip the Arab,
c. 244-49
The millenary of Rome was
celebrated during Philip's
reign; but it is difficult
not to read decadence into
his unprepossessing bust.
He gained the *imperium* by
murder; so, too, he lost it.

Late Antique and Early Christian Art

When, in AD 313, the Edict of Milan established freedom of worship for all religions, and Christianity became legal, the Roman Empire was already showing signs of fragmentation. It was held together, under the Emperors Diocletian (284-305) and Constantine the Great (306-37), by military strength and thoroughly autocratic government. However, in 330 Constantine removed the capital from Rome to Byzantium, and by the end of the century the Empire was finally split into eastern and western portions under separate Emperors.

In art, a withdrawal from naturalism is intermittently evident even in the third century. Its causes are difficult to trace and no doubt various – perhaps the upsurge of popular traditions in the provinces, even within Italy itself; the mood of spiritual crisis that seems to have infected the whole Empire. It was not brought about by the rise of Christianity, as the famous group of *Tetrarchs* embracing, now outside S. Marco in Venice, is proof: the tetrarchy, the quadripartite division of imperial rule, was established by the Christian persecutor Diocletian. Diocletian may be one of the four here, but if so he is indistinguishable from his colleagues. The ex-

pressionless figures carved in the obdurate but prestigious medium of red porphyry have the stiff articulation of puppets, and yet the image has a mysterious potency. In the images of Constantine, the earlier personality cult endures, or revives, but a surer individual characterization is married into a hieratic symbol of majesty – as in one of the most compelling portraits to survive from antiquity, the colossal 2.5 metres (8ft) high head from a statue of Constantine once towering in a basilica in Rome. Dominatingly frontal in pose, it is enlivened by the gaze, over and away from the spectator, of deeply-cut eyes, hugely enlarged in relation to the other features. This emphasis on "the windows of the soul", to express an inner being, is already obvious in many late Roman portraits and will become increasingly marked in Christian figurative art.

In the great triumphal arch set up in Rome by Constantine in about 312-15, the contrast between the old and the new styles is explicit. The arch was the first monument in which earlier reliefs were "cannibalized" – pieces taken from Trajan's forum and elsewhere were incorporated with contemporary work. What seems to be an eclectic appreciation of the

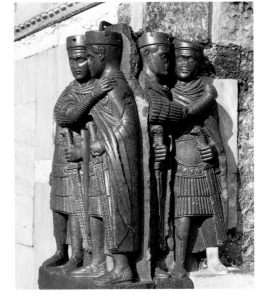

UNKNOWN ARTIST
The Tetrarchs, c. 303
Each Emperor clasps his deputy with his right arm and grasps his sword with his left. Each is identical, a symbol of an idea of unity rather than a real ruler.

ROME (right)
The Emperor Constantine, c. 313
When Nero raised such a colossus, representing himself as the sun-god, he was decried as egomanic. Constantine's even larger statue of himself passed as nothing inappropriate, and its surviving head is indicative of the changed times. The late imperial period was one of renewed, pompous grandeur. (The fleck of stone in the pupil gives added vigour, like a glint of light, to the eye.)

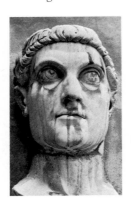

ROME (right)
The Arch of Constantine, c. 312-15
Constantine's triumphal arch, commemorating his victory over Maxentius in 312, stands beside the Colosseum where, shortly before, Christians had been martyred. The thin frieze (detail, below) representing a *largitio*, or distribution of imperial largesse, shows a row of squat figures, much like the *Tetrarchs*. They line up like place-cards – token presences each in a ritual station.

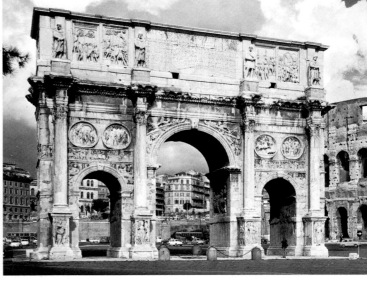

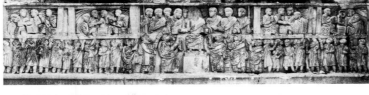

ROME, CATACOMB OF PRISCILLA (left)
The breaking of bread, late 2nd century?
The lively, vivid figures are remarkable survivals from the first beginnings of Christian art. Christ is breaking the bread, the culminating symbolic rite of the Holy Eucharist.

ROME, CATACOMB IN THE VIA LATINA (right)
Hercules and the Hydra, 4th century
The rather crudely daubed hero joins in combat with a vague many-headed snake. Six Labours of Hercules appear among the biblical and mythological scenes in tunnels where both pagan and Christian buried their dead. Hercules probably has allegorical significance, be it pagan or Christian.

earlier art is combined with indifference to its tradition. Roundels of about AD 120, mythological subjects handled with great freedom of movement, are set just above a squad of strictly frontal figures rigidly aligned as if for inspection and drill; the bodies are barely formed, the heads large in proportion; there is no longer any sense of depth. The Hellenic feeling for the unity and physical harmony of the human body and spirit has vanished. For the Greeks, divinity had materialized in the form of the ideally perfect human body; Christian eyes were to be fixed on the hereafter rather than on human proportions.

In the beginning, however, Christians depended on traditional styles and even imagery. They had no other sources on which to draw. In three centuries, Roman art, like the Roman way of life, had spread throughout the Empire; much was exported from Rome, but local workshops also were active. There were inevitably marked regional developments in style: in the west, in Spain, Gaul or Britain, the Roman manner penetrated very thoroughly, even though it was often expressed with a provincial accent – coarser, clumsier, with its principles not always fully understood. In the

east, however, the sophisticated traditions of older civilizations proved more resistant.

For the immediate followers of Christ in the first century AD, the visual arts had little relevance: there were no formal churches, no sites for art. The earliest known church dates from about 230. The earliest Christian art belonged instead to the burial places, the catacombs just outside Rome, cut long and deep into the rock and in use between about 200 and 400, after which they became shrines for veneration. Many painted decorations survive on the walls: space was limited, and techniques and artistic ability are usually of a very impoverished order, but the evolution of a Christian iconography in its formative stages can be followed. The subjects chosen often relate to the salvation of the soul, or to divine intervention on behalf of humans; miracles and episodes in the life of Christ also appear, as in *The breaking of bread* in the Catacomb of Priscilla. Pagan and Christian imagery commingle, not too surprisingly – Rome's ability to acclimatize and incorporate alien beliefs into its own culture was almost inexhaustible. Thus Christ may be equated with Orpheus, descending into hell to save a soul, or purely

pagan symbolism may occur alongside Christian imagery. So Hercules may be Hercules, or he may be the good man who achieved immortality through his labours. The visual character of Christ himself is unsettled, and he is often represented as a beardless youth, interchangeable with Apollo or the sun-god. One of the essential Christian symbols, the Cross, does not appear at first, as in Rome its associations with common criminal executions seem to have been too strong.

Under Constantine, the official status of Christianity made the erection of churches both practicable and necessary, to house a now well-established and elaborate ritual of worship. Early Christian churches did not exploit sculpture, though the craft continued in the decoration of sarcophagi, and developed most notably in miniature form, on ivory reliefs; the wooden relief panels from S. Sabina in Rome (about 432), showing parallel incidents from the Old and New Testaments, are rare survivals. The traditional Roman craft of mosaic, practised all through the Empire as both floor and wall decoration, was soon applied with enthusiasm to Christian themes; fresco was also used, but has virtually all perished.

ROME, CATACOMB OF PRISCILLA (left)
The Good Shepherd,
c. 250-300
Christ had said: "I am the good shepherd", and so he was often shown in early Christian art. Not only in style but in its attributes this figure is derived from pagan sources; it is small, hardly more than a graffito.

ROME, S. SABINA (right)
Panel of a door: *Moses and the burning bush*, c. 432
Since the story is new, it is told simply and directly, without virtuosity. Moses is shown tending his sheep, then removing his shoes at the direction of an angel; there is the burning bush; then in the upper register he communes with God.

UNKNOWN ARTIST (above)
The three Marys at the Tomb; the Ascension, late 4th or early 5th century
Though the simple, blunt forms are much like those of the S. Sabina doors (and similar doors front the finely detailed tomb), there is more indication of what the participants feel; Christ performs a bold, rushing movement; and the carving is of good quality. The compression of space, the varying scales, these are already medieval.

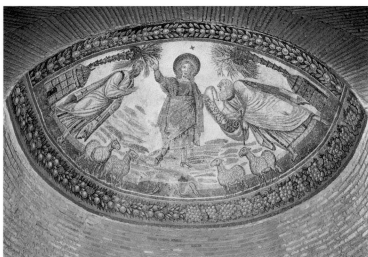

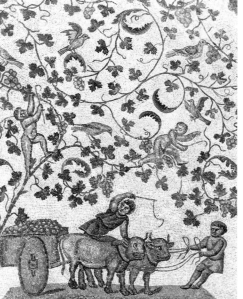

ROME, S. COSTANZA
An apse: *Christ gives the law to SS. Peter and Paul*, 5th century

Christ is youthful, haloed, and radiantly steps from the clouds to deliver his salutation like an Emperor.

Christ will later be shown bearded, but the tradition that St Paul was bald is already established.

ROME, S. COSTANZA
(left) Detail of the vault of the ambulatory: *Putti harvesting grapes*, c. 350
In the rich mosaics of the round church, a mausoleum for Constantine's daughter, purely decorative, secular scenes occur alongside the religious subjects in the apses and (once) the dome.

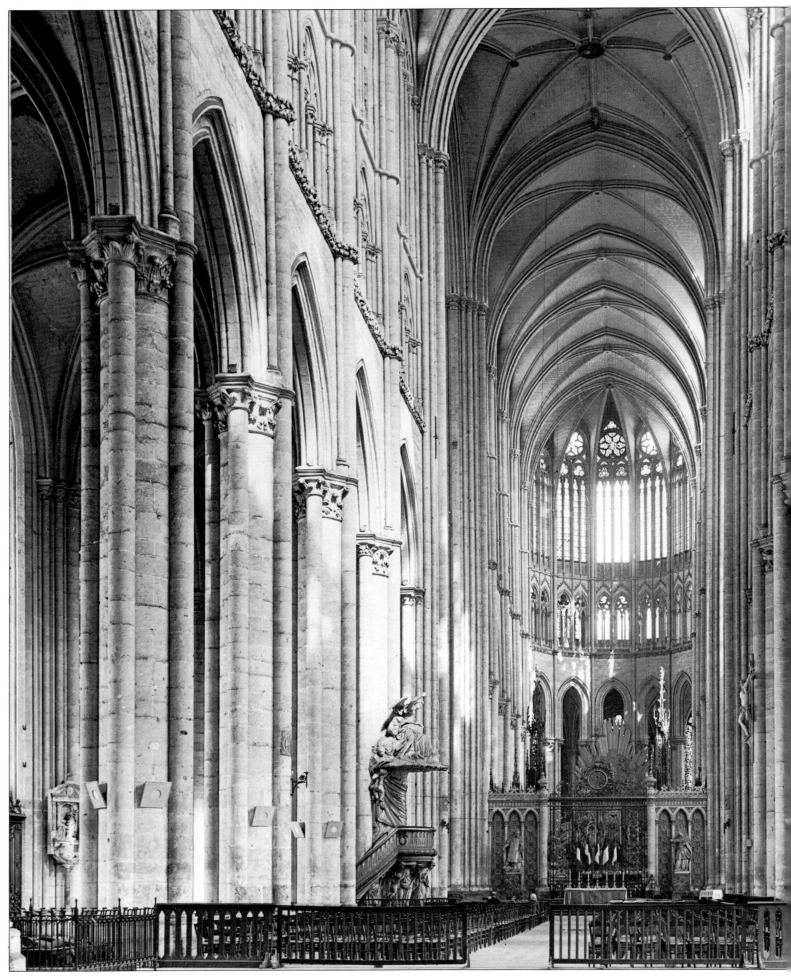

MEDIEVAL AND EARLY RENAISSANCE ART

The Middle Ages were so called because they intervened between the grandeur of Rome and the renewed ability of the Renaissance to emulate the Greek and Roman achievement. The term stretches to include virtually a millennium, from the fifth century AD to the fifteenth, when the men of the Renaissance became the first to invent a period identity for themselves. These were centuries marked by disruption and fragmentation, opening in chaos as the "barbarians" struck wherever Roman civilization was established. Though the newly accredited official religion, Christianity, found a secure haven in the East, in Byzantium, it was not until around 800 that Charlemagne revived aspirations of a European political and religious unity in the Holy Roman Empire.

To those looking back, the Middle Ages for a long time seemed a vast span of cultural debasement, and medieval art the product of ignorance; the name of its most daring and brilliantly innovative style, the Gothic, was originally synonymous with barbaric. As more sympathetic historical research and analysis focused on the period, however, scholars came to see it as transitional – rather than as catastrophic – and in many ways progressive. An interest in the Antique never entirely disappeared, while great positive foundations have survived from the Middle Ages, not least

the universities. The Renaissance itself was transitional, attempting the reconciliation of religious and secular enquiry and beliefs, of pre-Christian and Christian thought.

None the less, most medieval art is very different in form and spirit from classical or Renaissance art, and the difference lies essentially in its other worldliness; for the medieval artist the human body was no longer a subject for celebration in naturalistic form but a means of expressing spiritual realities. This is nowhere more clearly seen than in the mosaics of Byzantium – remote, hieratic and awe-inspiring. Art was for the glorification of God, and though great artistic personalities did exist in this period (Gislebertus is one whose name has survived), the individuality of the artist begins to be stressed only towards the end of the Middle Ages. A great deal of artists' work was carried out in collaboration – most notably in the Romanesque and Gothic cathedrals, in which painters, glass-workers, embroiderers, metalworkers all combined with the architects to create a splendour in which, as voices in a paean of praise, individual contributions are subsumed into a greater whole. With the Renaissance, we see the component parts beginning to separate out as "works of art". In particular, the detached easel-painting, soon to assume a dominant role in European art, comes into fashion.

AMIENS, FRANCE (left)
Interior view, facing east, of the Cathedral, begun 1220

URBINO, ITALY (right)
The courtyard of the Ducal Palace, 1465-69

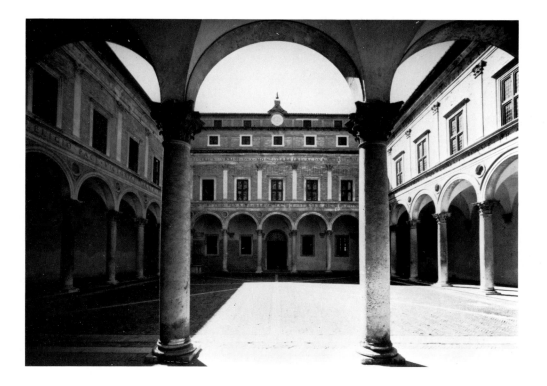

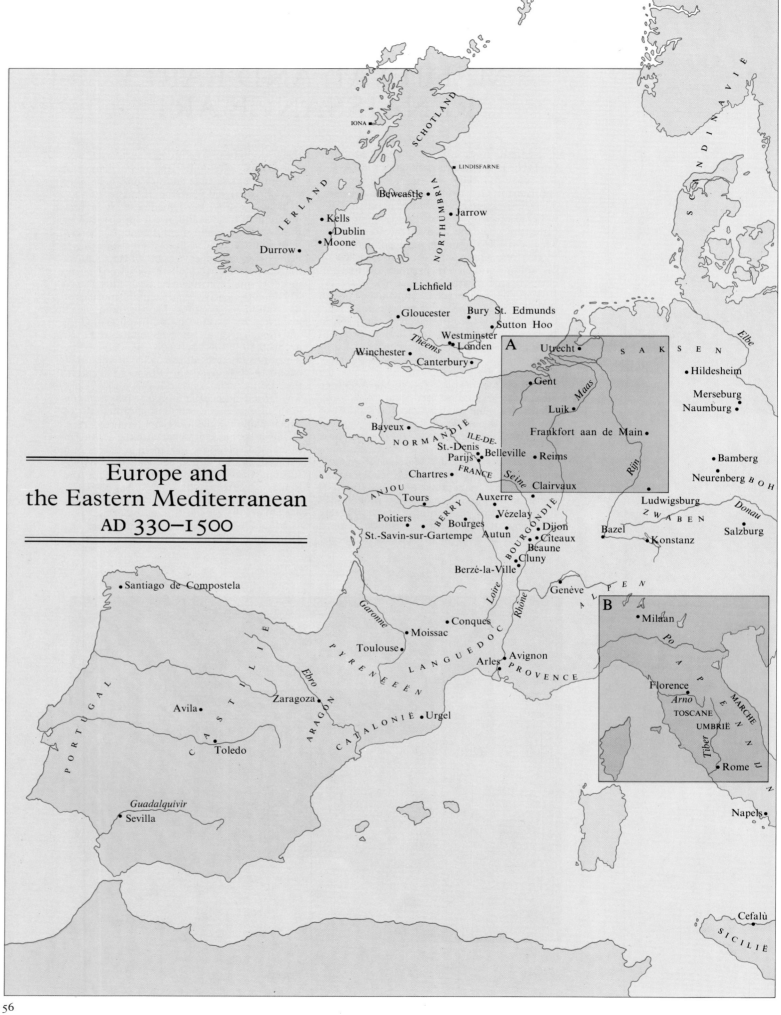

Europe and
the Eastern Mediterranean
AD 330–1500

IONA

LINDISFARNE

SCHOTLAND

NORTHUMBRIA

IERLAND

Bewcastle

Jarrow

Kells
Dublin
Moone
Durrow

Lichfield

Gloucester
Bury St. Edmunds
Sutton Hoo
Westminster
Theems Londen
Winchester Canterbury

S A K S E N

A
Utrecht

Gent

Luik
Maas

Hildesheim

Merseburg
Naumburg

Frankfort aan de Main

Rijn

Bamberg
Neurenberg *B O H*

Bayeux
NORMANDIE
ILE-DE-
St.-Denis Belleville
Parijs
Chartres *FRANCE*

Reims

Seine
Clairvaux

Ludwigsburg
ZWABEN

Donau

Salzburg

ANJOU
Tours
BERRY

Auxerre

Vézelay

Bazel

Konstanz

Poitiers
St.-Savin-sur-Gartempe
Bourges
Autun
BOURGONDIE
Dijon
Citeaux
Beaune
Cluny

Berzé-la-Ville

Santiago de Compostela

Genève

A L P E N

B
Milaan

Po

Conques
Moissac
Toulouse
LANGUEDOC
Arles Avignon
PROVENCE

Loire
Rhône

Garonne
PYRENEEEN

A P E N N I J N E N

Florence
Arno
TOSCANE
UMBRIE
MARCHE

Tiber
Rome

PORTUGAL
Avila
Zaragoza
ARAGON
Urgel
CATALONIE
C A S T I L I E
Toledo
Ebro

Guadalquivir
Sevilla

Napels

Cefalù
S I C I L I E

SCANDINAVIE
Elbe

56

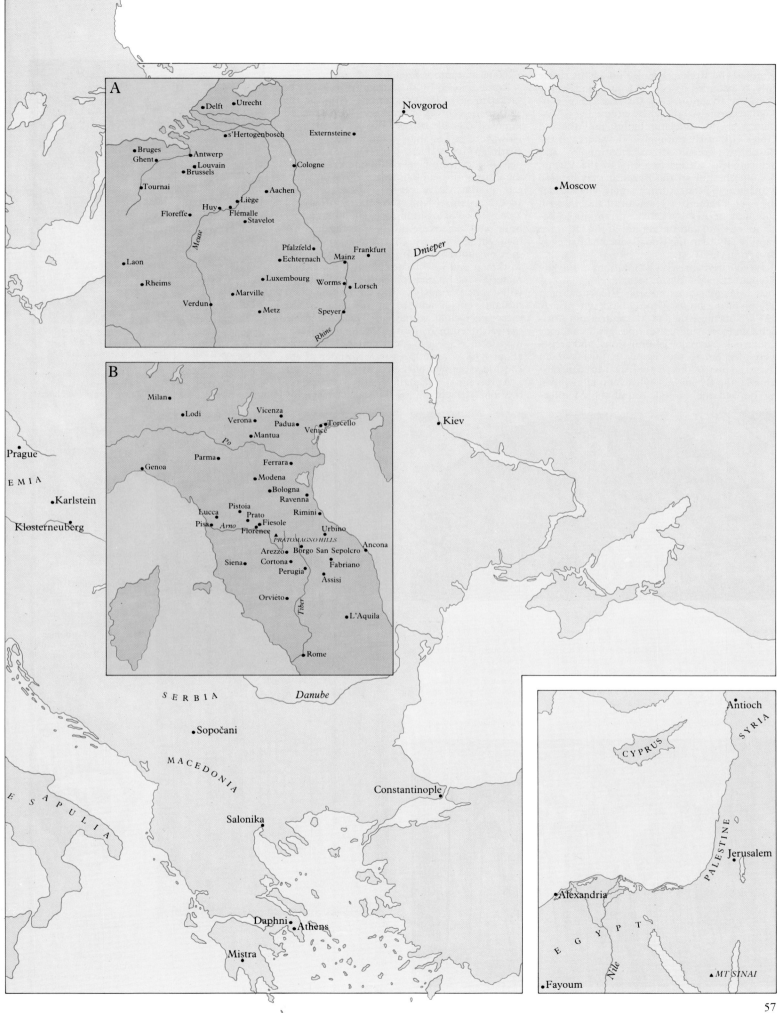

A

Delft
Utrecht
s'Hertogenbosch
Externsteine
Novgorod
Bruges
Ghent
Antwerp
Louvain
Brussels
Cologne
Tournai
Aachen
Moscow
Huy
Liège
Floreffe
Flémalle
Stavelot
Meuse
Pfalzfeld
Frankfurt
Laon
Echternach
Mainz
Dnieper
Rheims
Luxembourg
Worms
Lorsch
Verdun
Marville
Metz
Speyer
Rhine

B

Milan
Lodi
Vicenza
Verona
Padua
Torcello
Po
Mantua
Venice
Prague
Parma
Ferrara
EMIA
Genoa
Modena
Kiev
Karlstein
Bologna
Ravenna
Klosterneuberg
Lucca
Pistoia
Prato
Rimini
Pisa
Arno
Fiesole
Florence
Urbino
PRATOMAGNO HILLS
Ancona
Arezzo
Borgo San Sepolcro
Siena
Cortona
Fabriano
Perugia
Assisi
Orvieto
Tiber
L'Aquila
Rome

SERBIA
Danube

Sopočani

MACEDONIA

Constantinople

E S A P U L I A

Salonika

Daphni
Athens

Mistra

Antioch
SYRIA
CYPRUS
PALESTINE
Jerusalem
Alexandria
E G Y P T
Nile
MT SINAI
Fayoum

Byzantine Art 1: Justinian

In AD 330 the Emperor Constantine, having reunited the Roman Empire under his single rule, transferred its capital from Rome in the West to Byzantium in the East. He consolidated imperial power by embracing Christianity as the official religion, and the old Greek city of Byzantium on the shores of the Bosphorus, renamed Constantinople, and dedicated as a Christian city to the Virgin, became the hub of the Byzantine civilization which was to persist through many vicissitudes for over a thousand years, until the Turkish conquest of 1453, when Constantinople became Istanbul and the capital of the Ottoman Empire. By then the Renaissance had already broken in the West.

From early Christian adaptations of the late Roman styles the Byzantines developed a new visual language, expressing the ritual and dogma of the united Church and state. Early on variants flourished in Alexandria and Antioch, but increasingly the imperial bureaucracy undertook the major commissions, and artists were sent out to the regions requiring them from the metropolis. Established in Constantinople, the Byzantine style eventually spread far beyond the capital, round the Mediterranean to southern Italy, up through the Balkans and into Russia.

Rome, sacked by the Visigoths in 410, was sacked again by the Vandals in 455, and by the end of the century Theodoric the Great had imposed the rule of the Ostrogoths on Italy. However, in the sixth century the Emperor Justinian (reigned 527-65) re-established imperial order from Constantinople, taking over the Ostrogothic capital, Ravenna, as his western administrative centre. Justinian was a superb organizer, and one of the most remarkable patrons of art in history. He built and rebuilt on a huge scale throughout the Empire: his greatest work, the church of Hagia Sophia in Constantinople, employed nearly 10,000 workmen and was decorated with the richest materials the Empire could provide. Though it still stands gloriously, hardly any of the earliest mosaics remain, and it is at Ravenna that the most spectacular witness of Byzantine art in the sixth century survives – though the apse mosaic in SS. Cosma e Damiano in Rome, about 530, is an impressive reminder of the continued activity of the popes.

At Ravenna, within the dry brick exterior of S. Vitale, the worshipper is dazzled by a highly

RAVENNA, S. VITALE
The Empress Theodora, detail, before 547
Mosaic is composed of thousands of minute cubes of coloured glass or stone set in plaster; it is very durable. A rigid design suits it; the sense of life and movement comes from the light, when it catches on the unevenly set facets.

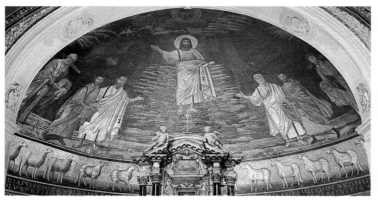

ROME, SS. COSMA E DAMIANO
(above) *Christ with saints*, c. 530
Pope Felix IV appears as the patron on the left. The saints are SS. Peter and Paul, Cosmas and Damian. There is still a factualness about them in contrast to the more otherworldly *Justinian* (below).

RAVENNA, S. VITALE
(below) *The Emperor Justinian*, before 547
On Justinian's left is Archbishop Maximian, on his right perhaps his general Belisarius. The Emperor has a halo, as God's representative – in modified form, the emperor cult persisted.

RAVENNA, S. VITALE
(right) View of the apse, before 547
In contrast to Western practice, the Byzantines conceived church and decoration as a unity. Following late Roman tradition, they built in brick, not stone, and then transformed its surface.

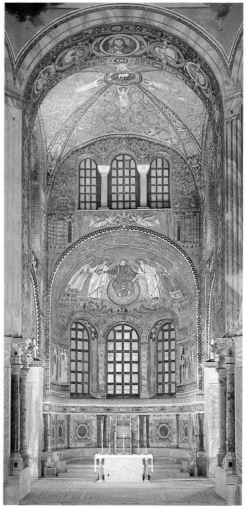

RAVENNA, S. VITALE
(above) Capital in the apse, before 535
There is no trace of the old classical orders – Doric, Ionic, Corinthian. The motif, horses or cattle beside the Tree of Life, is oriental, though the tree has been displaced by a Christian Cross.

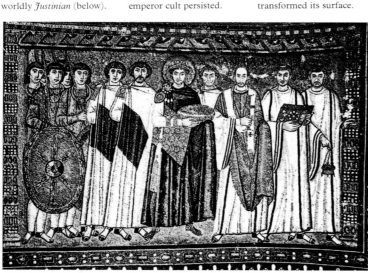

RAVENNA
Theodora? c. 530
Long-standing doubts about the propriety of images are reflected in the rarity of Byzantine sculpture in the round: the Bible explicitly condemned "graven images". The head is so idealized it is hardly still a portrait.

controlled explosion of colour blazoned across glittering gold. Mosaic and beautifully grained marble cover almost all wall surfaces, virtually obliterating the architecture that bears them. The gold, flooding the background, suggests an infinity taken out of mortal time, on which the supernatural images float. In the apse, wrapped in their own remote mystery, Christ and saints preside unimpassioned. Nevertheless, in two flanking panels of mosaic, one showing the Emperor Justinian with his retinue and the other, opposite, his wife Theodora with her ladies, there persists a clear attempt at naturalistic portraiture, especially in the faces of Justinian and Theodora. Even so, their bodies seem to float rather than stand within the tubular folds of their draperies.

In S. Vitale, and in Byzantine art generally, sculpture in the round plays a minimal part. However, the marble capitals (dating from before Justinian's time) are carved with surprising delicacy with purely oriental, highly stylized vine-scrolls and inscrutable animals. A rare example of Byzantine figurative sculpture is an impressive head, perhaps that of Theodora, in which the Roman tradition of naturalistic portraiture lingers.

In the East, Justinian's most important surviving work is in the church, a little later than S. Vitale, at St Catherine's Monastery on Mount Sinai. There, in the great *Transfiguration* in the apse, the figures are again vital, substantial presences, suspended weightlessly in a golden empyrean. The contours, however, are freer, less rigid, than at S. Vitale, and the limbs of the figures are strangely articulated – almost an assemblage of component parts. This was to become a characteristic and persistent trait in the Byzantine style.

Elsewhere (notably at Salonika) there were other local variations of style in mosaic. Relatively little remains in the cheaper form of fresco, and still less in manuscript illumination. A very few sixth-century manuscripts, on a purple-tinted vellum, show a comparable development from classical conventions towards an austere formality, though pen and ink tend to produce greater freedom in structure and gesture. In the famous *Rabula Gospel* of 586 from Syria, the glowing intensity of the dense imagery may even bring to mind the work of Rouault in the twentieth century.

Ivory panels carved in relief have also survived, usually covers for consular diptychs.

These diptychs consisted of two ivory plaques, tied together, with records of the departing consul's office listed on their inner surfaces. The carvings on the outside, representing religious or imperial themes, have the clarity and detachment characteristic of the finest mosaics, and are splendidly assured.

In the eighth and ninth centuries the development of the Byzantine style was catastrophically interrupted in all media. Art was not merely stopped in its tracks: there was a thorough, wide-ranging destruction of existing images throughout the Byzantine regions. Figurative art had long been attacked on the grounds that the Bible condemned the worship of images; in about 725 the iconoclasts (those who would have religious images destroyed) won the day against the iconodules (those who believed they were justified) with the promulgation of the first of a number of imperial edicts against images. Complicated arguments raged over the issue, but iconoclasm was also an assertion of imperial authority over a Church thought to have grown too rich and too powerful. It was surely owing to the Church that some tradition of art did persist, to flower again when the ban was lifted in 843.

SALONIKA, ST DEMETRIOS (left) *St Demetrios and the Virgin*, late 6th or early 7th century
The insubstantial bodies and stylized, patterned robes are delineated almost entirely in straight lines. Though the craftsmanship is of a high standard, the figures lack the powerful presence of Constantinopolitan mosaic panels.

RAVENNA (below)
Archbishop Maximian's Throne, *c.* 550
The expense and craftsmanship of the Throne are remarkable; precious materials figured large in Byzantine art. In the decorative panels oriental motifs are conjoined with the profuse ornament of late classical art. Such non-representational art continued to flourish in the iconoclastic period.

MT SINAI, ST CATHERINE
The Transfiguration, *c.* 548-65
Justinian probably sent a team of mosaicists from the capital to decorate a strategically placed new centre of orthodoxy. Sects with heretical views on Christ's divinity were strong in Egypt, Syria and Palestine, and the Emperor was anxious to counter the threat with orthodox propaganda.

CONSTANTINOPLE (right)
The Barberini diptych: *The Emperor as defender of the faith*, 6th century
The Emperor on a rearing horse may be Justinian, or perhaps Anastasius. Earth personified supports his foot; below, Scythians and Indians pay tribute. The carving and design are precise, clear and certain.

SYRIA (left)
The Rabula Gospel: *The Ascension*, 586
Vigorously shaped in heavy outlines, the figures seem to echo the poses and symmetry of church mosaics, and the border even imitates mosaic. But the design is too crowded for a mosaic, and there is a suggestion of landscape, and much foreshortening.

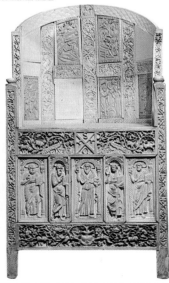

Byzantine Art 2: Revival and Diffusion

The end of iconoclasm – the destructive campaign against images and those who believed in them – came in 843. The revival of religious art that followed was based on clearly formulated principles: images were accepted as valuable not for worship, but as channels through which the faithful could direct their prayer and somehow anchor the presence of divinity within their daily lives. Art rarely had a didactic or narrative function, but was essentially impersonal, ceremonial and symbolic: it was an element in the performance of religious ritual. The disposition of images in churches was codified, rather as the liturgy was, and generally adhered to a set iconography: the great mosaic cycles were deployed about the Pantocrator (Christ in his role as ruler and judge) central in the main dome, and the Virgin and Child in the apse. Below, the main events of the Christian year – from Annunciation to Crucifixion and Resurrection – had their appointed places. Below again, hieratic figures of saints, martyrs and bishops were ranked in order.

The end of iconoclasm opened an era of great activity, the so-called Macedonian Renaissance. It lasted from 867, when Basil I, founder of the Macedonian dynasty, became absolute ruler of what was now a purely Greek monarchy, almost until 1204, when Constantinople was disastrously sacked. Churches were redecorated throughout the Empire, and especially its capital: in Hagia Sophia in Constantinople mosaics enormous in scale took up the old themes and stances, sometimes with great delicacy and refinement.

Despite the steady erosion of its territory, Byzantium was seen by Europe as the light of civilization, an almost legendary city of gold. Literature, scholarship and an elaborate etiquette surrounded the Macedonian court; the tenth-century Emperor Constantine VII Porphyrogenitos sculpted and himself illuminated the manuscripts he wrote. Though his power continued to diminish, the Emperor had enormous prestige, and the Byzantine style proved irresistible to the rest of Europe: even in regimes politically and militarily hostile to Constantinople Byzantine art was adopted and its craftsmen imported.

In Greece, the Church of the Dormition at Daphni, near Athens, of about 1100, preserves some of the finest mosaics of this period: there is a grave, classic sense of great delicacy in its *Crucifixion*, while the dome mosaic of *The*

Pantocrator is one of the most formidable in any Byzantine church. In Venice, the huge expanses of S. Marco (begun 1063) were decorated by artists imported from the East, but their work was largely destroyed by fire in 1106, and later work by Venetian craftsmen is in a less pure style. In the cathedral on the nearby island of Torcello, however, *The Virgin and Child*, tall, lonely, and solitary as a spire against the vast gold space of the apse, is a twelfth-century survival. In Sicily, the first Norman king, Roger II (ruled 1130-54), was actively hostile to the Byzantine Empire yet he imported Greek artists, who created one of the finest mosaic cycles ever, in the apse and presbytery at Cefalù. The permeation of Byzantine art into Russia was initiated in 989 by the marriage of Vladimir of Kiev with the Byzantine princess Anna and his conversion to Eastern Christianity. Byzantine mosaicists were working in the Hagia Sophia at Kiev by the 1040s, and the Byzantine impact on Russian painting remained crucial long after the fall of Constantinople.

The secular paintings and mosaics of the Macedonian revival have rarely survived – their most spectacular manifestation was lost

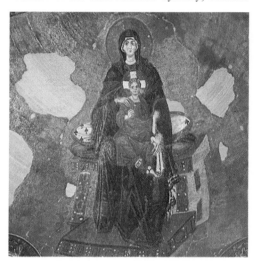

CONSTANTINOPLE, HAGIA SOPHIA (left) *The Virgin and Child enthroned*, 867
The colossal, elongated Virgin dominates the main apse of the vast church. Chroniclers tell how lifelike she seemed, and how the populace was full of delight to see her – especially perhaps women, some of the staunchest opponents of iconoclasm.

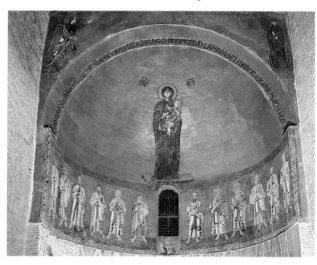

TORCELLO CATHEDRAL (right) *The Virgin and Child*, 12th century
The Madonna's small head and elongated body enhance the striking effect of her isolation, as do the apostles, so much smaller below.

DAPHNI, CHURCH OF THE DORMITION OF THE VIRGIN (above) *The Crucifixion*, c. 1100
Though the rendering is austere and stylized, it has a lyric balance and a restrained tenderness prefiguring Duccio.

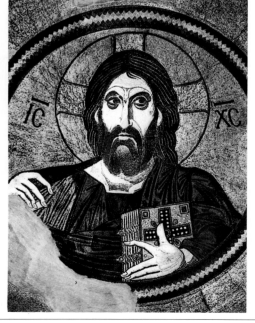

CEFALU CATHEDRAL (right) View of the apse, c. 1148
The *Pantocrator* is here in the eastern apse, not in the central dome, the focus of the Orthodox church. The curvaceous, flowing outlines of the figures, and especially the device of modelling drapery in thin gold ray-like lines, were to persist in Italian painting, notably in Siena (see p. 79).

DAPHNI, CHURCH OF THE DORMITION OF THE VIRGIN (left) *Christ Pantocrator*, c. 1100
This awe-inspiring *Christ* bears little relation to the suffering Saviour shown crucified in the same church (far left). Looking down from the centre of the dome, the great head, with those curiously expressive hands, is indeed Christ the ruler of the world.

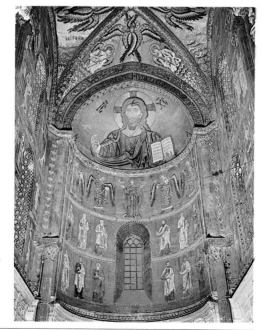

in the burning of the legendary Great Palace in Constantinople during the Sack of 1204. Such works retained much more clearly classical features – the ivory panels of the Veroli casket are an example – but such features are to be found, too, in religious manuscripts and in some ivory reliefs (sculpture in the round was forbidden as a concession to the iconoclasts). The Joshua Roll, though it celebrates the military prowess of an Old Testament hero, reflects the pattern of Roman narrative columns such as Trajan's at Rome; the famous Paris Psalter of about 950 is remarkably Roman both in feeling and iconography: in one illustration the young David as a musical shepherd is virtually indistinguishable from a pagan Orpheus, and is even attended by an allegorical nymph called Melody.

In 1204 Constantinople was sacked by Latin Crusaders, and Latins ruled the city until 1261, when the Byzantine emperors returned. In the interim craftsmen migrated elsewhere. In Macedonia and Serbia (now mainly Yugoslavia), fresco painting was already established, and the tradition continued steadily. Some 15 major fresco cycles survive, mostly by Greek artists. The fresco medium doubtless

encouraged a fluency of expression and an emotional feeling not often apparent in mosaic.

The last two centuries of Byzantium in its decay were troubled and torn with war, but surprisingly produced a third great artistic flowering. The fragmentary but still imposing *Deesis* in Hagia Sophia in Constantinople may have been constructed after the Latin domination, rather than during the twelfth century. It has a new tenderness and humanity which was continued – for instance in the superb early fourteenth-century cycle of the monastic church of Christ in Chora (see p. 64). In Russia, a distinctive style developed, reflected not only in masterpieces such as the icons of Rublev (see over), but also in the remarkably individual interpretations of traditional themes by Theophanes (Feofan) the Greek, a Byzantine emigrant, working in a dashing, almost impressionistic style in the 1370s in Novgorod. Though the central source of the Byzantine style was extinguished with the Turkish conquest of Constantinople in 1453, its influence continued in Russia and the Balkans, while in Italy the Byzantine strain (mingling with Gothic) persisted in the new art founded by Duccio and Giotto.

CONSTANTINOPLE (above)
The Paris Psalter:
David harping, c. 950
Byzantine art in its maturity was always open to the revival of classical or of earlier Byzantine styles. In this instance the reuse of a classical model is unusually obvious.

CONSTANTINOPLE (right)
The Joshua Roll: *The stoning of Achan*, c. 950
The long papyrus scroll was probably written and illustrated at the order of Emperor Porphyrogenitos. The Carolingian Utrecht **Psalter** (see p. 68), though in book form, must derive from a work such as this.

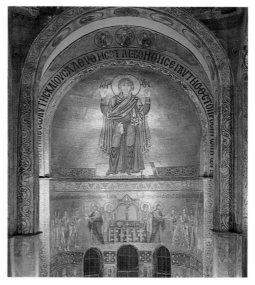

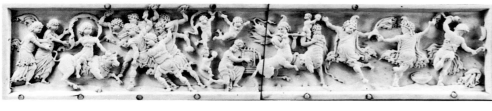

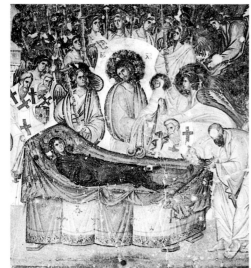

CONSTANTINOPLE (above)
The Veroli casket:
The rape of Europa, 10th or 11th century
The doll-like ivory figures enact an episode from classical mythology in classical groupings and in classical poses. The group of stone-throwers, inappropriate to the myth, is also in the Joshua Roll, and must be taken from the same classical source.

CONSTANTINOPLE,
HAGIA SOPHIA (below)
The Deesis, c. 1261?
The Deesis consists of Christ shown between the Virgin and St John, who intercede with him on behalf of humanity. The mosaic was perhaps made as part of the reception for the Emperor, returning after the Latin rule. The figures are remote, more compassionate than stern.

KIEV, HAGIA SOPHIA (above)
View of the apse, 1042-46
Austere and monumental, these mosaics are the earliest example of Christian art in Russia. They show Byzantine art extremely pure and hieratic; the stylized figures are ordered in firm symmetry.

THEOPHANES (below)
The Holy Trinity, 1378
The three angels who visited Abraham came to symbolize the Trinity. The mannered but lively style of Theophanes took root and flourished for many decades in a native "Novgorod school".

SOPOCANI, YUGOSLAVIA
The dormition of the Virgin, detail, c. 1265
The Dormition is the Byzantine equivalent of the Western Assumption.

Surrounded by elders, Christ, glowing behind the dying Virgin's bed, holds in his arms the babe that is the Virgin's soul reborn into Heaven.

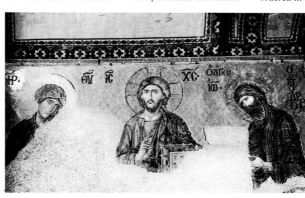

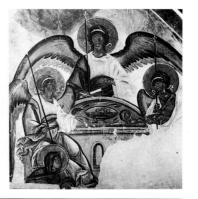

The Virgin of Vladimir

Icons, generally small and so easily transportable, are the best-known form of Byzantine art. A tradition persists that the first icon was painted by St Luke the Evangelist, showing the Virgin pointing to the Child on her left arm. However, no examples that date from before the sixth century are known. Icons became increasingly popular in Byzantium in the sixth and seventh centuries, to some degree precipitating the reaction of iconoclasm. Although the iconoclasts asserted that icons were being worshipped, their proper function was as an aid to meditation; through the visible image the believer could apprehend the invisible spirituality. Condensed into a small compass, they fulfilled and fulfil the same function in the home as the mosaic decorations of the churches – signalling the presence of divinity. The production of icons for the Orthodox Churches has never ceased.

Dating of icons is thus fairly speculative. The discovery at St Catherine's monastery on Mt Sinai of a number of icons that could be ordered chronologically with some certainty is recent. Many different styles are represented. An early *St Peter* has the frontal simplicity, the direct gaze from large wide-open eyes, that is found again and again in single-figure icons. It also has an almost suave elegance and dignity, allied with a painterly vigour that imparts a distinct tension to the figure. There is a similar emotional quality in a well-preserved *Madonna and saints*, despite its unblinking symmetry and rather coarser modelling. Both surely came from Constantinople.

Immediately after the iconoclastic period, devotional images in richer materials, in ivory, mosaic or even precious metals, may have been more popular than painted ones. From the twelfth century painted icons became more frequent, and one great masterpiece can be dated to 1131 or shortly before. Known as "*The Virgin of Vladimir*", it was sent to Russia soon after it had been painted in Constantinople. The Virgin still indicates the Child, as the embodiment of the divine in human form, but the tenderness of the pose, cheek against cheek, is eloquent of the new humanism.

From the twelfth century the subject matter of icons expanded considerably, though the long-established themes and formulae, important for the comfort of the faithful, were maintained. Heads of Christ, Virgins and patron saints continued, but scenes of action appeared – notably Annunciations and Crucifixions; later, for iconostases, or choir-screens, composite panels containing many narrative scenes were painted. Long after it had ceased in Constantinople with the Turkish conquest, production continued and developed in Greece and (with clearly discernible regional styles) in Russia, and in modern Yugoslavia, Romania and Bulgaria. In Russia individual masters emerged even before the fall of Constantinople. The most famous of them was the monk Andrei Rublev (*c.*1370-1430), whose masterpiece, *The Holy Trinity*, is the finest of all Russian icons. He transcended the Byzantine formulae, and the mannerisms of the Novgorod school founded by the Byzantine refugee Theophanes the Greek; Rublev's icons are unique for their cool colours, soft shapes and quiet radiance.

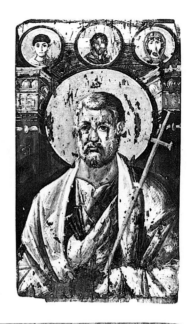

FAYOUM, EGYPT (left)
Artemidorus, portrait on a mummy-case, 2nd century AD
Fayoum has yielded some of the best-preserved painted portraits from classical times. Early icon painters were recognizably schooled in the same tradition: the hypnotic eyes of the icons are already found here, and the *St Peter* (right) was painted in the same technique, using encaustic paint – coloured wax applied while hot.

CONSTANTINOPLE (below)
The Madonna among saints, 6th century
SS. Theodore and George flank the Virgin, who seems withdrawn and preoccupied, and the archangels behind look fearfully up to God.

CONSTANTINOPLE (right)
St Peter, early 7th century
St Peter's pose and format, and the roundels up above, recall consular diptychs, perhaps deliberately. Note how freely the drapery is painted, with bold strokes.

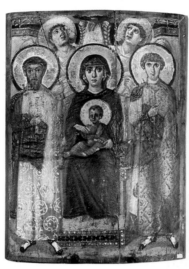

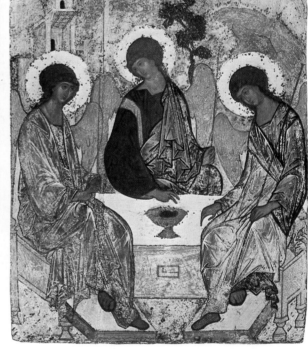

NOVGOROD SCHOOL (below)
The Presentation in the Temple, 16th century?
Typical of the Novgorod school are such tall, rather wooden figures, in cramped poses. The drawing is jerky and the drapery geometric.

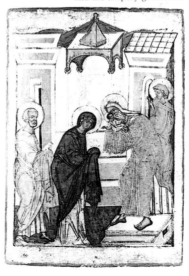

ANDREI RUBLEV (above)
The Holy Trinity, *c.*1411
The three angels who were entertained by Abraham, as Genesis relates, became symbols of the Trinity in art. The firm and unifying symmetry of the meek but aristocratic figures is softened by the subtle play of shape and colour.

CONSTANTINOPLE (right)
St Michael, *c.*950-1000
The Frankish Crusaders who sacked Constantinople in 1204 destroyed the city's treasures barbarously; the Venetians, equally piratical but more discriminating, preferred to loot. This icon in gold and silver, inset with jewels and enamels, was part of their booty.

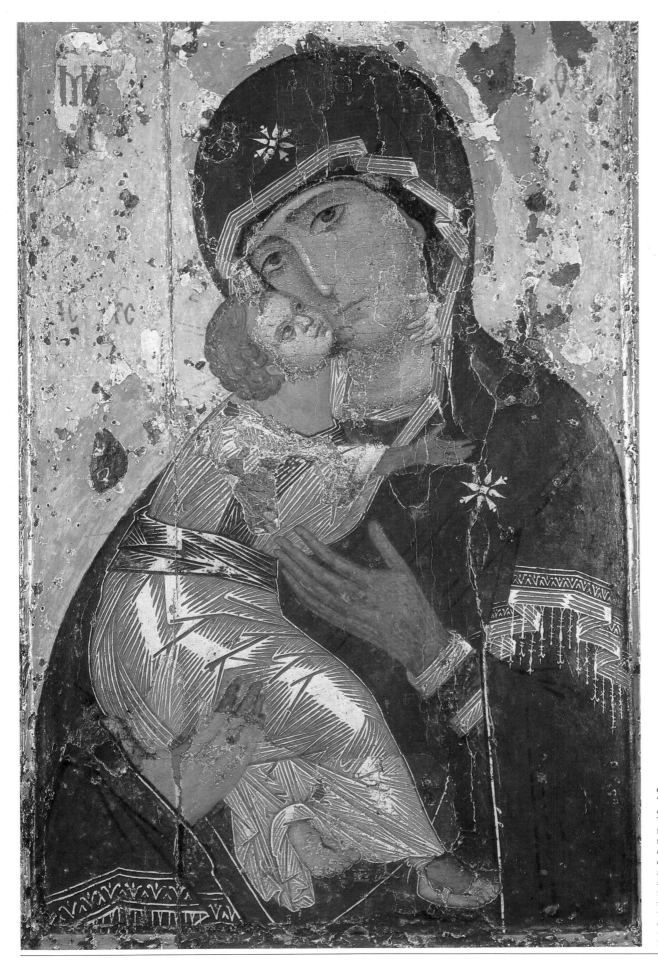

CONSTANTINOPLE
"The Virgin of Vladimir",
c. 1131
The icon has been care-
fully cleaned, but little of
the paint now left is
original – with the great
exception of the Virgin's
and Child's faces. Almost
all early icons have been
repainted not once but
several times. Because it
was abraded by a silver
cover, or *oklad*, the rest of
the icon was damaged too
badly to be restored.

Christ in Chora, Constantinople

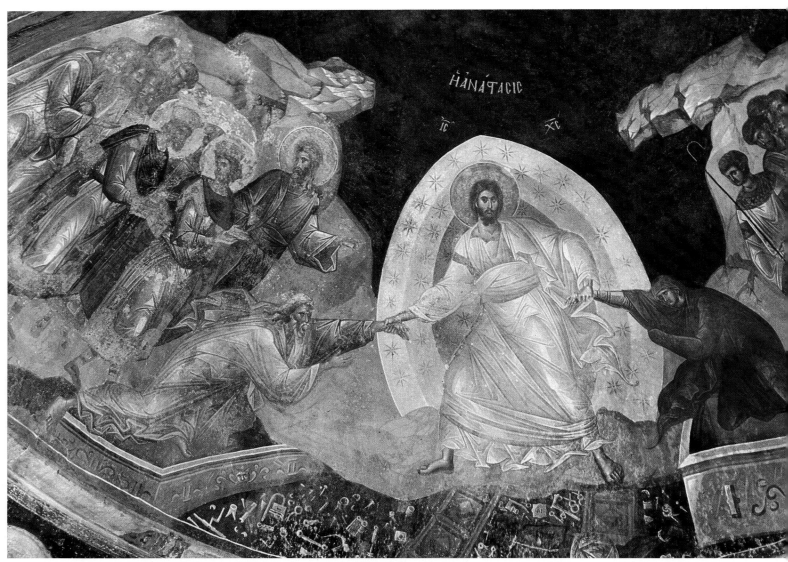

The Chora Monastery, now Kariye Camii, Istanbul (it was converted into a mosque by the Turks and is now a museum) is an outstanding witness to the magical quality of Byzantine art in its late flowering between the Latin occupation of Constantinople of 1204-61 and the Turkish conquest of 1453. Extraordinarily well preserved in many areas, its church was largely remodelled and entirely redecorated by a leading Byzantine statesman, Theodore Metochites, about 1315-21.

The impoverished Emperor was no longer the principal source of patronage; it was more than he could do to maintain and repair the great monuments of the past. New undertakings were on a small scale and were initiated by a few rich feudal families. Yet within the shrunken Byzantine territories, which had been Greek soil for 2,000 years, there was a marked pride in being Hellene, and the Palaeologan artistic revival went hand in hand with the renewed study of the Greek classics. Christ in Chora bears witness to the scholarly refinement of the last Byzantine aristocrats.

One mosaic portrays Metochites, the donor, presenting the church to Christ, but the theme of the decorations is the celebration of Christ and Mary, with incidents from their lives almost in counterpoint. The detail and elaboration of the narrative are rare elsewhere in Western art until considerably later. However, the decoration still serves the ceremonial function of all Byzantine religious art, and has a visionary quality, a dreamlike spirituality, in marked contrast to the monumental, substantial figures being painted (see pp. 82–83) by Giotto at almost exactly the same date. At Kariye Camii the figures and drapery are still subject to conventions nearly a thousand years old, but animated by a novel sprightly vigour.

A colossal *Christ Pantocrator* must have presided over the central dome (lost in its collapse) and the largest surviving mosaic (not shown) is damaged, though still of magisterial yet humane authority. It is a *Deesis*, which would usually show the Virgin and John the Baptist interceding with Christ on behalf of humanity, but John is here omitted because the theme of the church is the Virgin and Christ alone. The subsidiary narrative scenes are of a lively brilliance, at times almost merry, perhaps especially in the apocryphal scenes of the Virgin's childhood, where the artist's imagination might have freer play. Even in more orthodox episodes, or in scenes taken from the Gospels, the treatment is always inventive, full of movement and incident. *The miracle at Cana*, a Gospel story quite commonly represented, is entirely original, the artist having obviously become absorbed by the formal rhythms of the great oil jars, with the strange architectural shapes of the house adding a diminuendo above.

The chapel at the side of the main body of the church, probably a mortuary chapel with wall-tombs, was decorated at much the same time as the rest, but in fresco rather than in mosaic, and probably by a different artist or team of artists. It is of no less splendid quality, though different in theme to answer its special function. The subjects include a spectacular version of *The Last Judgment*, featuring the blessed and the damned, and including weird imagery – of the worm that corrupts all things corruptible and of the scroll of heaven. The lower ranges of the chapel are occupied by hieratic figures, including portraits of the dead, in draperies as stylized and mysterious as incantations. The dome is occupied by a more orthodox image of the Virgin with the Child (not shown), central with angels in the ribs radiating out from her, but the supreme image is the magnificent *Anastasis*, or Resurrection, shown, as often in the East, in terms of Christ's descent into Limbo. With serene but irresistible strength, he lifts Adam and Eve (and so, by extension, all of us) into eternal life.

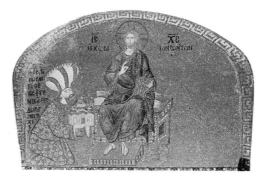

(left) *Theodore Metochites presenting the church to Christ*
Metochites (*c.* 1269-1332), a considerable philosopher and a poet, wears the official head-dress of the Grand Logothete, the controller of the imperial income. Exiled when Andronikos III ousted his master, Andronikos II, he returned in 1330 to become a monk in the monastery he patronized.

The plan of the church of Christ in Chora
The mosaic of Metochites with Christ (A) marks the entrance to the church proper, opening into the space beneath the central dome. Here was once a *Pantocrator*; in the apse ahead there is a *Deesis*.

Smaller domical spaces surround the main dome: the two scenes from the Virgin's life illustrated here are at (B). *The miracle at Cana* is at (C). Flanking the church is the mortuary chapel with an *Anastasis* (D) and a *Last Judgment* (E).

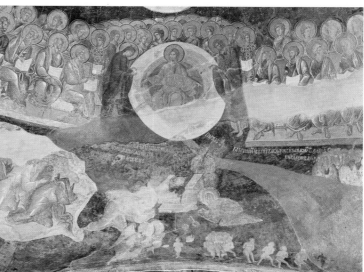

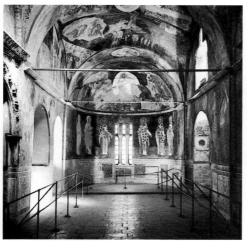

(above) *The Last Judgment*
Christ, enthroned on a rainbow, sits in judgment between the Virgin and St John the Baptist, with angels and apostles on either side. Beneath is the earth, where humanity crouches in prayer or in dread. The whole scene is strongly visionary, with the figures below forming abstract shapes, enclosed in strange, flaring membranes.

(below) *Scenes from the life of the Virgin*
Anna and Joachim embrace their daughter, and she is taken by Joachim to be blessed by the priests. Many such apocryphal but touching and human scenes were included in the huge cycle of the Virgin.

(above) *The Anastasis*
Striding, in luminous robes, Christ the giver of life draws Adam and Eve from the abyss of death. His movement and vigour, unparalleled in earlier Byzantine art, are held in tension by the balance of figures in the curve of the apse.

(above) The side-chapel of Christ in Chora
The Anastasis is in the conch of the apse at the east end. In the vault before it is *The Last Judgment*, and the rich profusion of frescos are all concerned with life after death. Interceding saints stand beneath.

(below) *The miracle at Cana*
The Virgin, St Peter and St John the Baptist are shown with Christ on the right, but the lively servants, and the jars into which they pour the water that will be changed into wine, have become the centre of the action.

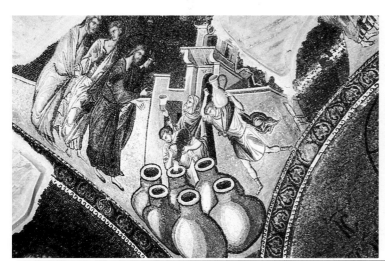

Celtic or Insular Art

The masterpieces of Celtic Christian art – stone crosses raised stark against northern skies, dazzling convoluted illuminations in manuscripts from Ireland and north Britain – have their ancestry in the artefacts of the prehistoric Indo-European tribes. In the centuries before the birth of Christ migratory races moved in successive waves from the north-east, settling the regions to the north of the classical Mediterranean from Mongolia to as far west as Ireland. The Greeks and Romans christened these restless tribes "barbarians": they were illiterate, they had no architecture, painting or sculpture. They nevertheless developed skilled techniques of metallurgy, and worked easily transportable objects – jewellery, helmets, harnesses – with dynamic, abstract or stylized designs. These were their currency; the tombs of their chieftains have revealed not only sophisticated native craftsmanship, but silver and bronze works of Mediterranean origin. Metalwork designs remained the pervasive influence in Celtic art.

The Celts, the tribes called Keltoi by Greeks and Galli by Romans, had established themselves in western Europe long before the rise of Rome. Those in northern Italy, Spain, France, Germany and England were incorporated more or less permanently into the Roman Empire and, when the western Roman Empire fell apart, were embroiled in the disintegration and turmoil of the "Dark Ages", from the fifth to the eighth century. In Ireland, Scotland and northern Britain, however, the tribes had maintained their Celtic traditions intact. Ireland was Christianized in the fifth century, and in the sixth century, while England was still pagan, monasteries in Ireland and north Britain were almost the sole Western strongholds of civilization and the written word.

Engraved, patterned stones are still to be found in astonishing numbers on monastic sites. From simple engraved monoliths they developed into elaborate sculpted crosses, six metres (20ft) high or more. The technique advanced from engraving to relief sculpture, and by the seventh century the regular and symmetrical cross-shape of the top of the stone shaft was standard. Their patterning remained Celtic, incorporating a whole range of geometric designs (deriving from metalwork), and especially interlace patterns. The interlace, that characteristic interweaving of ribbon-like or lace-like tendrils – perhaps a remote echo of

BEWCASTLE, ENGLAND (above) High Cross, late 7th century AD
The sandstone Cross lacks its head, which was probably much like that of Moone. Its sides are carved in low relief with interlace inhabited by animals and birds – the most characteristic and enduring Celtic motif. The Cross gives no clue to its artist or patron.

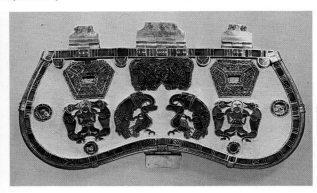

PFALZFELD, GERMANY (left) Carved stone, 4th century BC
The stone was carved in the Rhineland for a heathen purpose that is obscure. On each side is a human head with large, projecting eyes and with converging lobes for hair. Primitive monoliths like this one are the ancestors of the Christian crosses.

SUTTON HOO, ENGLAND Purse lid, c. AD 650
Part of the burial hoard of a heathen chief, the purse shows a *cloisonné* technique comparable to Byzantine metalwork in skill and sophistication.

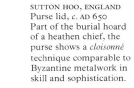

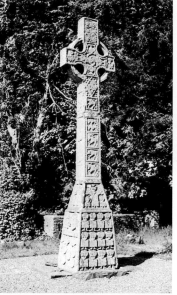

HOCHDORF, GERMANY *Lion*, ornament from a bronze vessel, c. 500 BC
The lion, from a tomb of a Celtic chief found near Ludwigsburg in 1978, may be Etruscan. It is witness to an established trade between the Celts and the Mediterranean – which, however, left few marks on Celtic art.

MOONE, IRELAND (left) High Cross, 9th century AD
The imposing granite Cross shows biblical scenes, with cipher-like figures in a repetitive and symmetrical design. The flat relief recalls the intaglio designs found in Celtic metalwork.

IRELAND
The Book of Durrow: *St Matthew*, c. AD 680
The page is only 16.5 cm (6½in) high. The emphatic, sharp contours of the figure and frame are a sure sign of metalwork derivation. The stocky, block-like figure is like those at Moone.

running water – often involves in its strands stylized animals and in some examples, for instance the ninth-century Cross at Moone in County Kildare, is combined with figurative sculpture. Sometimes the figurative sculpture is even relatively realistic.

This same tradition of interlace ornament and stylized figurative imagery is repeated in the manuscript illuminations produced in Ireland and north Britain, which became celebrated throughout Christian Europe. The crucial texts for the maintenance of the Christian faith were the Gospels – in the beginning was the Word. In the illustration of the Gospel books artists adapted the styles and motifs of their illiterate, heathen predecessors to serve a new belief, and in so doing revitalized them. This is immediately visible in one of the earliest books to be preserved from the great Irish centres, the seventh-century Book of Durrow. In the Durrow manuscript, Celtic interlace, abstract and figurative, is superbly organized in rhythmic line and clear colour.

The usual scheme of decoration included a large decorated initial to mark the opening of each Gospel, sometimes with an elaborately decorated facing page – the so-called "carpet pages". Normally their design is woven symmetrically about the central motif of a cross, but it can be elaborated unrecognizably into a tightly knotted mesh. There may also be a page with the symbol or portrait of the relevant Evangelist: the Durrow *St Matthew*, chequered, flat and frontal as a playing card, but with his feet proceeding eagerly to the right, is an early, undeveloped example, memorable in its simplicity. Later the Evangelist is more usually represented seated full-length, frontal, with the book held up in his hands, or seated at a desk or lectern writing.

England had lapsed into paganism with the Anglo-Saxon invasions of the fifth to sixth centuries, but was converted in the early seventh century. Thereafter, until the Viking invasions in the ninth century, superb manuscripts were produced in the British Isles. The Lindisfarne Gospels of the 690s develop the possibilities of complex ornament still further, introducing new colours and exploiting linear rhythms with great virtuosity. Of the superb manuscripts surviving from the eighth and ninth centuries, the most spectacular is the Book of Kells, made in the remote monastery on the island of Iona, perhaps about 800. In this the decoration is richer, more pervasive, and denser in its interlaces than anywhere else. There are more than 400 decorative initials through the manuscript, no two identical, all elaborated with fantastic exuberance and apparent freedom. The freedom, however, is an illusion, as the compositions are carefully articulated and structured. The most famous of all, the Incarnation initial, XPI, roves with glints of gold through spirals and roundels and interlacings including human heads as well as animal motifs. Left centre, near the bottom, there is a charming study, almost a genre scene, of cat and mouse. This large and luxurious manuscript exemplifies Insular illumination in the splendour of what has been called its "baroque" phase. New decorative elements, more usually found on stone crosses than in manuscripts, are introduced, and also – in the Evangelist portraits – quotations from early Christian and Byzantine manuscripts.

The Book of Kells is contemporary with the first manuscripts of the Carolingian revival, which not only made use of Insular scholarship, but also was alive to the decorative possibilities so brilliantly exploited by the Celts, though its art developed on different lines.

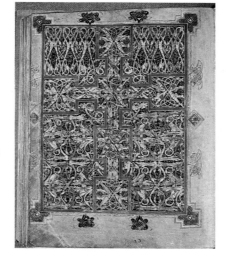

IONA, SCOTLAND
(left) The Book of Kells: *St John*, c. 800
The Kells Gospels are twice the size of those of Durrow, but the size of the figure is much the same, and the greater space is used for enriched ornament. The style of the figure is entirely different, and reflects Mediterranean influence.

(below) The Book of Kells: The Incarnation Initial, c. 800
XPI, the Greek letters CH, R and I, start the first word of St Matthew's Gospel, "Christ". The flamboyant convolutions are a dazzling expression of the value of the Word.

IRELAND (left)
The Lichfield Gospels: Carpet page, early 8th century
The manuscript's origin is unknown, but it must surely be Irish. Though the motif, a cross, is still clear, the ornament tends to the calligraphic, with large, bold loops.

LINDISFARNE, ENGLAND
(below) The Lindisfarne Gospels: Carpet page, c. 690
The artist was Bishop Eadfrith of Lindisfarne: the illumination of the Gospels was no menial task. The design is hard and clear, transferring into the book the values of precious metalwork.

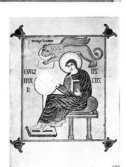

JARROW, ENGLAND
The Codex Amiatinus: *Ezra restoring a damaged Bible*, c. 690
This is not an image of a contemporary scribe in the guise of a prophet: the pose and furniture are a literal copy of a 6th-century manuscript illuminated in Rome.

LINDISFARNE, ENGLAND
The Lindisfarne Gospels: *St Mark*, c. 690
The pose is exactly the same as that of Ezra in the Codex Amiatinus (above left), reversed. Celtic taste transforms the motif by introducing sharp lines, patterning and flattening the figure.

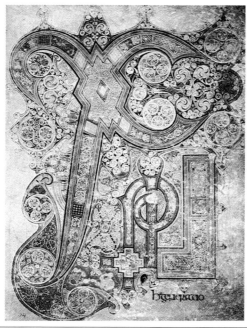

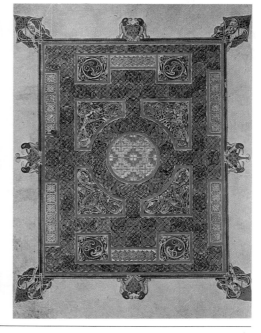

Carolingian and Ottonian Art

Western Europe emerged from the chaos of the "Dark Ages" when the Frankish kings, in collaboration with the papacy, gained sufficient strength to stabilize and consolidate the huge territories they owned. The process was symbolically sealed on Christmas Day 800 with the coronation of Charlemagne as Holy Roman Emperor.

Charlemagne's ambition was to re-create the Roman Empire from his capital at Aachen (Aix-la-Chapelle). With an eye to the Byzantine imperial bureaucracy of educated administrators, he sought a renaissance of learning and art – a *renovatio*, as it was called at the time. Aachen was to reproduce visually the semi-legendary ideal of early Christian Rome: Charlemagne imported massive bronze Roman sculptures from Italy, and wished to be buried in a classical sarcophagus. He took a personal interest in the written word, the primary medium for the propagation of learning, and the script evolved in his time, subsequently refined by humanist scholars of the fifteenth century, is the basis of the lower-case type in which this book is printed. With the help of abbot scholars, such as Alcuin from Northumbria and Theodulf from Spain, he set

up a network of centres of learning in monasteries across present France and Germany, where, under imperial auspices, the masterpieces of Carolingian art were produced.

Charlemagne was not unaffected by the iconoclastic dispute that rent the Byzantine Empire to the east, but, though he pronounced against the worship of images, he accepted the didactic uses of art. The range of subject matter in his time was limited, confined to illustrations to the Bible and the lives of saints, but secular learning was soon also encouraged. Unfortunately almost all the wall-paintings that once helped instruct the people in the Christian faith have vanished – none survive in the important centres – but illuminated manuscripts give some indication of what the large-scale works were like. Aachen and each manuscript centre developed distinctive styles, though all, to a varying extent, borrow from Mediterranean art, and are essentially figurative, though they use the decorative idiom of Celtic traditions in the borders and frames.

The Godescalc Evangelistary of 781-83, written in gold and silver on a purple parchment, sets a luxurious standard. The modelling of the monumental seated *Christ in*

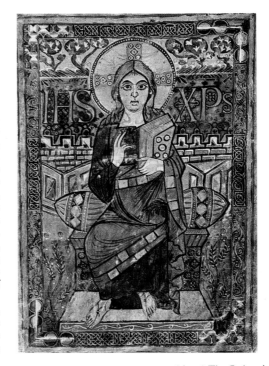

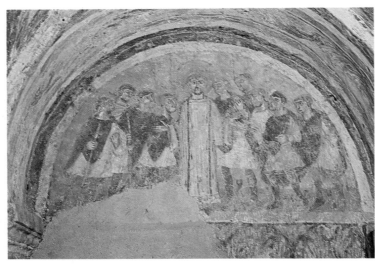

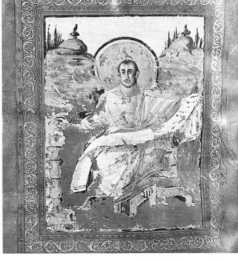

AACHEN (above) The Godescalc Evangelistary: *Christ in benediction*, 781-83
Charlemagne and his wife commissioned this book of selections from the Gospels to commemorate their son's baptism by the Pope in 781. Christ is beardless, as he often was in early Christian art.

(left) The Coronation Gospels: *St John*, c. 795-810
The freely dabbed landscape is an obviously classical feature; so is the suggestion of space within the frame. Later Carolingian artists betray their models less patently, except in secular texts.

(below) The Lorsch Gospels: *Christ between angels*, early 9th century
The style, scheme and iconography are directly related to such works as Maximian's Throne (see p. 59). Christ treads on beasts symbolizing evil.

AUXERRE, ST GERMAIN (above) *St Stephen preaching*, begun 851
The insistent symmetry, and the heavy modelling of basic facial features, suggest a mosaic model, although these are also characteristics of Carolingian manuscripts.

RHEIMS (below) The Utrecht Psalter: Psalm 108, c. 816-35
The fresh and expressive narrative has been seen as an early manifestation of a specifically northern spirit. The manuscript, which by the 10th century was in England, markedly

influenced Anglo-Saxon illumination, and it was copied by Romanesque artists. In the copies, however, the scenes are individually framed, and the classical conception of illusionistic space, still understood here, was lost or abandoned.

RHEIMS (below) The Ebbo Gospels: *St Mark*, c. 816-35
The Evangelist's pose, despite his frenzy, is classical, like those of

the Coronation Gospels. Ebbo, Archbishop of Rheims, who ordered the book, had been librarian to Charlemagne's son and heir, Louis the Pious.

benediction is clearly indebted to Byzantine models, less clearly to classical ones. In the Coronation Gospels (*c.* 795-810), the debt to Roman precedent is beyond doubt (though significantly the Evangelists are shown writing – in Roman times this would have been a menial chore performed by slaves). In the scriptorium at Rheims, about 816 to 835, there developed one of the most remarkable of all medieval styles: the liveliness of the Utrecht Psalter comes as a shock after its austere predecessors, and the scenes are quite freely dispersed through the text, unhampered by any framing. The most striking manuscript in this style is the Ebbo Gospels, in which the figures of the Evangelists are seized with a divine, mystic fury, a quaking or shaking that infects their very garments. This is almost Expressionist art, unparalleled until El Greco.

At Metz, Tours and elsewhere, other magnificent manuscripts were produced, and also carved ivories, generally book-covers, such as the famous covers of the Lorsch Gospels, which are closely related in style to the manuscript paintings. The fine metalwork, in which the regions round the Rhine were to excel for centuries, has now mostly vanished. The ninth-century gold altar in S. Ambrogio in Milan, which may possibly be connected with the Rheims workshops, can give at least an idea of the sumptuous craftsmanship which once decorated the Carolingian centres.

Under Charlemagne's heirs the Empire was dislocated, and by the end of the ninth century had fallen apart under threats from all sides (Vikings from the north, Muslims and Hungarians from the east). However, in 955 Otto the Great was victorious over the Hungarians, heralding a rebirth of the Empire. Ottonian rule aimed to restore the power and splendour of the Carolingian epoch, but its art developed largely independently of the court, in the fiefs of the increasingly powerful bishops and abbots. The styles depended on Carolingian models, and also harked back directly to early Christian examples, but the strongest influence on them was from contemporary Byzantium, as, for instance, in the Speyer Gospels from the Echternach school, showing an increased emphasis on the human figure.

Not only ivories, but also a few larger, spectacular pieces of Ottonian sculpture survive. The most famous are the great eleventh-century bronze doors at Hildesheim, commissioned by Bishop Bernward. Nearly five metres (16ft) high, in two wings, each apparently cast in one piece, they are startling evidence that the knowledge of lost-wax casting had continued since Roman times; in design they are the ancestors of Ghiberti's doors at Florence (see p. 100). On the left wing are eight scenes from Genesis, on the right a corresponding eight from the New Testament. The little figures in the various incidents are full of movement and poignancy. Bernward also commissioned a bronze column, more than three metres (12ft) high, with a continuous spiral relief illustrating the life of Christ; it was clearly inspired by Trajan's Column in Rome.

Perhaps the most impressive surviving Ottonian sculpture is the Crucifix (969-76) of Archbishop Gero. Christ's head is a reliquary, still containing its valuable relic, still venerated in Cologne Cathedral. Carved in wood and painted, it combines painful realism with austere stylization – the heavy sag of the body from the arms of the Cross, the features drawn down in defeat, contrast with the still folds of the loincloth. It looks forward to the masterpieces of Romanesque sculpture.

MILAN, S. AMBROGIO (right) The Golden Altar of St Ambrose, central panel: *Christ in majesty with the Evangelists and the apostles, c.* 824-59 The sketchy but fluent modelling has parallels in Carolingian ivories. In Ottonian works such as Bernward's at Hildesheim (though there the medium is bronze) the modelling is harder, more patterned.

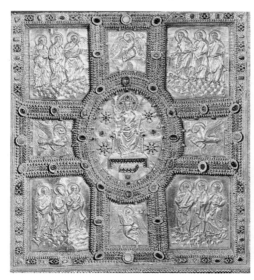

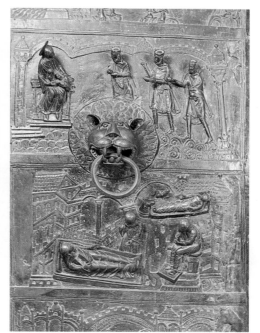

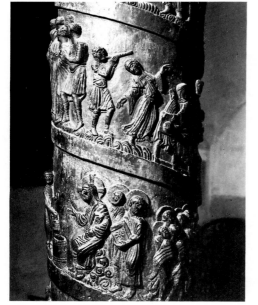

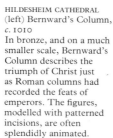

HILDESHEIM CATHEDRAL (left) Bernward's Column, *c.* 1010 In bronze, and on a much smaller scale, Bernward's Column describes the triumph of Christ just as Roman columns had recorded the feats of emperors. The figures, modelled with patterned incisions, are often splendidly animated.

ECHTERNACH (right) The Speyer Gospels: *St Mark,* 1045-46 The conventions of the drapery and setting are Byzantine, but rendered strikingly monumental. This was an influential product of Echternach.

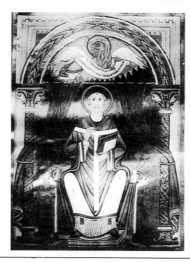

HILDESHEIM CATHEDRAL (left) The bronze doors, detail: *The Nativity* and *The Adoration of the Magi,* 1015 Archbishop Bernward, who had visited Rome, took a personal interest in the Hildesheim workshop. In particular the low-relief backgrounds reveal the stylization that would be typical of Romanesque (see over); the background of *The Nativity* represents no space or structure, but is highly decorative.

COLOGNE CATHEDRAL (below) Gero's Crucifix, 969-76 Many of the devices used here, such as the huge, emotive eye-sockets, could be paralleled in 12th-century Romanesque sculpture in Germany (such as the famous reliefs at Externsteine). A style has emerged that is fully independent of Byzantine or Roman models.

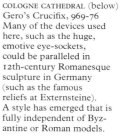

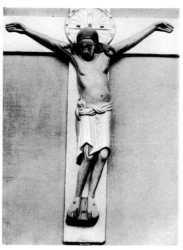

Romanesque Sculpture

The more settled conditions of the eleventh and twelfth centuries permitted the prosperous development of the Church, and particularly of certain monastic orders, notably the Benedictine order of Cluny. In the words of the Cluniac chronicler Radulphus Glaber, "the whole earth . . . was clothing itself everywhere in the white robe of churches". The tremendous expansion of building bore with it a profusion of painting and sculpture, especially stone sculpture, relatively neglected since Roman times. Europe was free from invasion; this was the period of the first Crusades, and of movement not only eastwards, towards Jerusalem, but westwards, on pilgrimage to the magnetic shrine of Santiago de Compostela in northern Spain, and to and fro throughout western and southern Europe. Craftsmen migrated from place to place; they were more frequently than before professional laymen rather than monks, and are sometimes known to us by name. Small wonder that Romanesque art (Romanesque was coined as an architectural term, implying a dependence on Roman building techniques that was ended by Gothic) embraces a considerable variety of styles, reflecting regional differences, cross-

fertilizations and the varying impact of Carolingian and Ottonian, Byzantine, Islamic and also classical Roman influences.

Romanesque sculpture is most commonly carved in relief, and stone sculpture is usually, but not always, an integral part of the architecture of the church to which it belongs. North of Italy, the finest work is found in the portals of churches, and on the capitals of their piers. In France, particularly, the areas round the door – jambs, lintel and semicircular tympanum above – were elaborately carved: in the tympana the great stylized *Last Judgments* inspire awe, but the jambs and capitals often revel in a relative naturalism, or at least in a humane, affectionate mood.

Some elements of Romanesque are apparent in Ottonian art, but its finest flowering was in France, particularly around the abbey of Cluny in Burgundy, and in Languedoc, strategically placed on the pilgrimage routes towards Compostela. In St Sernin in Toulouse, a marble relief of 1094-96, showing *Christ in majesty*, reads like an enlargement of a Carolingian work in ivory or metal: it is uncompromisingly frontal and severe. The colossal tympanum at Conques, another Lan-

CLUNY, ST PIERRE
The third tone of plainsong,
1088-95
The monks at Cluny often spent 10 or 12 hours a day in choir: cosmic "fours" – the 4 Rivers of Paradise, the 4 chief senses – figurated on the apse capitals included musical octaves.

TOULOUSE, ST SERNIN
(right) *Christ in majesty*,
1094-96
Unlike mature Romanesque sculpture, the image does not "grow" out of the architecture. In style and iconography – in the surrounding mandorla and Evangelist symbols – it depends on Carolingian art.

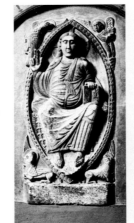

MOISSAC ABBEY (below)
St Peter, c. 1100
In the early work in the cloister the sculptors drew on many models: *St Peter* resembles certain decorated initials in manuscripts from Moissac, but other details are of Roman or Islamic inspiration.

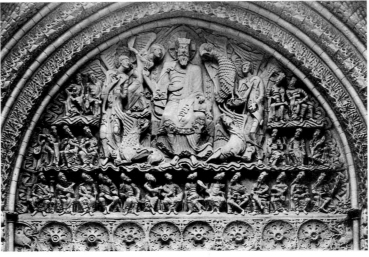

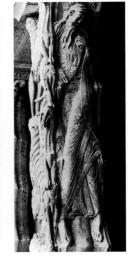

MOISSAC ABBEY
(above) *The Apocalypse*,
c. 1115-20
The tympanum shows Christ, the Evangelist symbols and the 24 Elders described by St John. The Elders perch agitatedly on their seats: only the strangely elongated Christ is still. The richly carved whole, including arch, lintel and its supporting pillar with a prophet, is incomparably imposing.

(above) *Jeremiah?*
The prophet represents a peak, both of restless distortion and of sculptural and architectural unity.

CONQUES, STE FOY (right)
The Last Judgment, c. 1135
The portal at Conques, one of the finest and best-preserved pilgrimage churches in France, has the largest tympanum of all. The figures have the same hard, stylized clarity as those at Moissac, but are serene by comparison. The clear framework and ordered calm on the left-hand side, Paradise, is effectively contrasted with the chaos and confusion of Hell on the other.

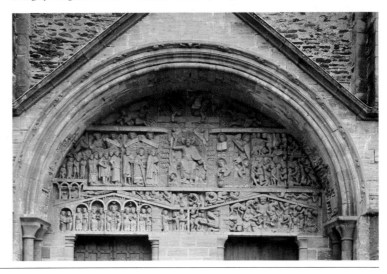

guedoc pilgrimage church, carved only about 40 years later, retains the hieratic element, but is vastly more ambitious and impressive. A similar astonishing development in style can be seen within the confines of the abbey of Moissac, near Toulouse, between about 1100 and 1125. A relief in the cloister shows *St Peter* as rigidly formal as the St Sernin *Christ*. The portal, with *The Apocalypse* in the tympanum, was carved only about 20 years later, and is crowded, busy, almost seething; the prophet, perhaps Jeremiah, carved into the stone strut supporting the lintel, is everything the cloister reliefs are not. His immensely elongated figure is swept sinuously into the undulations of the pillar, hair and beard flowing in unison with the drapery. The undulating rhythm is a feature of Islamic architecture; the emotional intensity seems Spanish. Although the figure is entirely unnaturalistic, and its crossed legs are an anatomical impossibility, the expression of the face is humane and gentle.

Moissac was one of the hundreds of abbeys following the discipline of the great abbey of St Pierre at Cluny in Burgundy. Its vast church was destroyed after the French Revolution, but the fragments that remain include capitals

that accurately reproduced classical Corinthian capitals, though many of them quite happily incorporated little figurative scenes as well: some of these, such as the musicians with instruments illustrating the eight tones of Gregorian plainsong, look almost like genre scenes. The great tympanum of the west façade of Cluny has been lost, but echoes of what must have been a masterpiece survive in the portals of Autun and Vézelay (see over).

Further north, the regional variation of Romanesque known as Mosan, of the river Meuse district, is represented by a fundamentally different masterpiece, the brass font made by Renier de Huy about 1110 for the church of Notre Dame des Fonts. Its technical accomplishment is as remarkable as its sophisticated style, free from the squeezed distortions of Romanesque art elsewhere. It is both sure and free, naturalistic and classical – Romanized rather than Romanesque. Renier must have looked long and hard at antique sculpture; he could certainly have seen sarcophagi, probably triumphal arches with reliefs, and even freestanding classical statues in bronze or stone.

In Britain, there was nothing comparable to the great portals of the French churches,

though sculpture reflects influences from all over the Continent. An impressive survivor is a gilt-bronze candlestick from St Peter's, Gloucester, closely related to German metalwork. German metalwork was widely known and esteemed, and of considerable variety, in silver and gold with enamel insertions, as well as in bronze. The distinguished bronze tomb-cover of Rudolf of Swabia, who died in 1080, is the oldest tomb-figure in Europe.

In Italy, classical influence was always stronger, and more importance was given to the figure in the round. In the north sculptors were clearly also aware of the achievements of Burgundy and Languedoc. Individual artists emerge, such as Wiligelmo, who signed his work in Modena, and Niccolò, who worked in Ferrara, but seems to have journeyed twice to Toulouse. The church of S. Zeno at Verona preserves panelled bronze doors of about 1135-40, in the pattern of the doors at Hildesheim. In the south, in works such as the Archbishop's Throne at Bari, in Apulia, of about 1098, the persistence of the classical tradition is evident, and the supporting "Atlas figures" even suggest the work of Nicola Pisano (see p. 80) in the Gothic period.

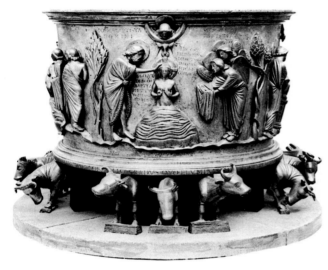

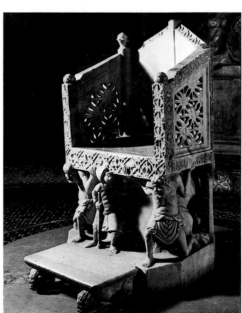

VERONA, S. ZENO (left)
The bronze doors, detail: *The Crucifixion, c. 1140* Compared to Ottonian work, especially the doors of Hildesheim, the figures are crudely modelled, and often grotesque. The technique is less sophisticated. However, the awkward poses make up for their lack of finesse by their liveliness. The borders are of German inspiration; the grotesque heads can be paralleled in the Romanesque art of any country.

RENIER DE HUY (above)
The brass font: *The baptism of Christ, c. 1110* The style is remarkably classical: observe, for instance, the figure with his back turned on the left; generally, how drapery is used to model the form beneath. The font was cast in one piece, except for the oxen, representing apostles.

GLOUCESTER ABBEY (left)
The Gloucester candlestick, c. 1110 The hollow shaft is alive with beasts, foliage and figures, some of them with religious meaning but most ornamental. Though its origins were in metalwork, such interlace is better known in Celtic or Anglo-Saxon manuscripts, even Romanesque ones. In type and shape the candlestick follows Ottonian example.

MERSEBURG CATHEDRAL (left) *Rudolf of Swabia*, after 1080
This is the earliest known example of what became the standard type of tomb for centuries to come. It is not a portrait; the head, in higher relief than the rest, is a mask, and the rest of the body, too, is quite highly stylized.

BARI, S. NICOLA (right)
The Archbishop's Throne, c. 1098
S. Nicola became a major pilgrimage centre after the Normans had taken Sicily and Apulia from the Arabs. While the Throne itself has Islamic ornament, in the vigorous musculature of the supporting figures there is a strong classical feeling; Apulia probably had some influence on the massive style of north Italy.

Gislebertus: The Sculpture at Autun

Central in the great tympanum of the west façade of Autun Cathedral is Christ seated in majesty, presiding with extended hands over the Last Judgment. Central again, just beneath Christ's feet, is the prominent and unabashed claim of individual proprietorship: GISLEBERTUS M(AGISTER) HOC FECIT: Master Gislebertus made this.

This inscription, and the work it signs, is almost all that is known of Gislebertus. It is clear that the source of inspiration for Autun, both the building and its sculptures, was Cluny, and a few fragments from the great abbey church have been attributed to Gislebertus on grounds of style. Autun, dedicated to Lazarus, was closely linked to the church at Vézelay, dedicated to Mary Magdalen, in legend his sister, and certain capitals at Vézelay also bear the marks of Gislebertus' style. Gislebertus was called to Autun soon after 1120, and had made all the carvings in the church by about 1135. His work there is truly unique: though he must have had assistants, his workshop was completely dominated by his personality – style, technique and quality are throughout remarkably consistent; and no other decorative scheme survives from the Middle Ages on such a scale, with such unity of style and conception, and yet so rich in subject matter and formal invention.

Gislebertus started, like the builders, at the east end, and finished with the huge portal at the west. Inside the church he carved capitals of great variety – biblical scenes, moralizing allegories warning of the consequences of sin, and many purely decorative capitals, often with beautifully composed foliage. His iconography clearly stemmed from Cluny, but he usually reorganized the subject to suit his personal, expressive style, and he seems occasionally to have borrowed his imagery from "mystery" plays enacting religious stories. The programme also included a second major portal in the north transept, which has been mostly lost; one remarkable fragment is from the lintel, showing *Eve* naked, lying prone, toying pensively, sensuously with the apple.

The great west tympanum and lintel were carved in the workshop on 29 pieces of limestone, and subsequently assembled above the doorway. The relief is fairly deep, but with

AUTUN, ST LAZARE (left)
Diagram of the tympanum and lintel, explaining their subject matter:
A Souls entering Heaven
B The Virgin enthroned in Heaven
C St Peter, at the gates of Heaven, and apostles
D Christ in majesty, with angels supporting the oval mandorla
E Prophets in Heaven (Enoch and Elijah?)
F The Psychostasis: St Michael and a devil weigh souls
G Devils and the damned at the gates of Hell
H The elect, some rising from their graves
I The damned in torment – being bitten by snakes, being decapitated etc.

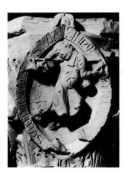

CLUNY, ST PIERRE (above)
The fourth tone of music, 1088-95
The tones of music were part of a complex scheme of "fours" – Gospels, ages etc – in the apse at Cluny. Gislebertus' use of this unusual motif is evidence that he was trained there.

AUTUN, ST LAZARE (below)
The fourth tone of music, c. 1125
Gislebertus' *Tone* appears entirely by itself at Autun and there are more than four bells. It looks as if he used the motif solely because the composition happened to appeal to him.

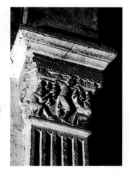

AUTUN, ST LAZARE (right)
Eve, fragment of the north transept lintel, before 1132
After the destruction of the portal *Eve* was used as a building block and so survived. There is no more sensuous nude in medieval art. Stretching forward to whisper seduction to the *Adam* once on the lintel opposite her, she is rather more than 1m (4ft) long, and was originally painted. Perhaps the composition was dictated rather more by the shape of the blocks making it up than was the later west tympanum.

subtle variations in its depth, so that there is a harmonious balance between the colossal Christ and the numerous small-scale figures. The composition is crowded, but divided into ranges simply and legibly. Heaven is above, with the Virgin Mary and others; on the left, the chosen, led to Heaven by St Peter; on the right, the damned, with St Michael and a devil supervising the Psychostasis – the weighing of souls in a pair of scales. On the lintel below, the elect are on the left, the doomed are deployed in a frieze of despair on the right. The surrounding arch has 31 roundels monitoring the seasons of the year and the Zodiac.

The central Christ, some three metres (10ft) high, is both awesome and serene. His anatomy, like that of the major supporting characters, is physically impossible, and disposed according to the needs of the linear rhythms of the design. The drapery falls in a quite distinctive way in shallow scallops, like marks of the tide in sand, which combine an earlier convention, showing drapery in groups of small parallel lines, and the plate-like drapery characteristic of the Cluny workshop. These arbitrary, unnaturalistic features stress Christ's supernatural independence of earthly norms.

Autun and Vézelay are the most impressive survivors of Romanesque art in Burgundy. The tympanum of the central portal at Vézelay is in a more agitated, dynamic style; the linear whorls and waves of the drapery create extraordinary tensions and movement. After the middle of the century, Burgundian sculpture went abruptly into decline, and for the next major sculptural commission in Burgundy, at Dijon, the sculptors turned for their inspiration to the Ile-de-France, to Gothic.

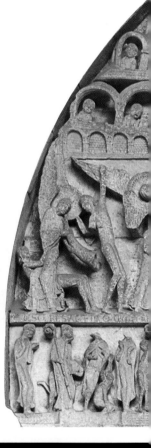

AUTUN, ST LAZARE
The Flight into Egypt, c. 1125-35
Sword on shoulder and panting a little, Joseph leads the donkey, while Mother and Child hold each other tight. Its wheels may represent those on the wooden donkeys used in religious processions; Gislebertus' personal imagery may have its origin in festivals or plays.

AUTUN, ST LAZARE
The dream of the Magi, c. 1125-35
Seldom is naivety quite so affecting. No doubt there was nothing strange in the Middle Ages in three Magi sharing a bed, but the composition is so conceived and handled that the angel interrupting the great decorative sweep of their blanket is both sweet and purposeful.

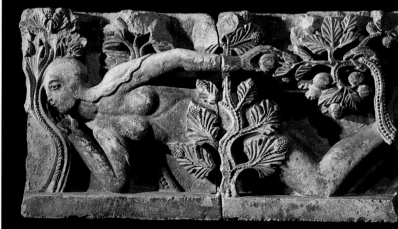

AUTUN, ST LAZARE
The west tympanum and lintel: *The Last Judgment*, *c.* 1135
Gislebertus' tympanum follows the Cluniac formula, but is enlivened by details, especially along the lintel, and refinements that are entirely his own. The smaller figures are more rounded, in higher relief than the larger ones; Christ is in the flattest relief of all. The diagram (right) shows the number and jointing of the stones making up the tympanum; their quantity, and the way the composition continues across the limits of the blocks, are unusual. The sense of an individual artistic personality emerges at Autun as it seldom does elsewhere in medieval art.

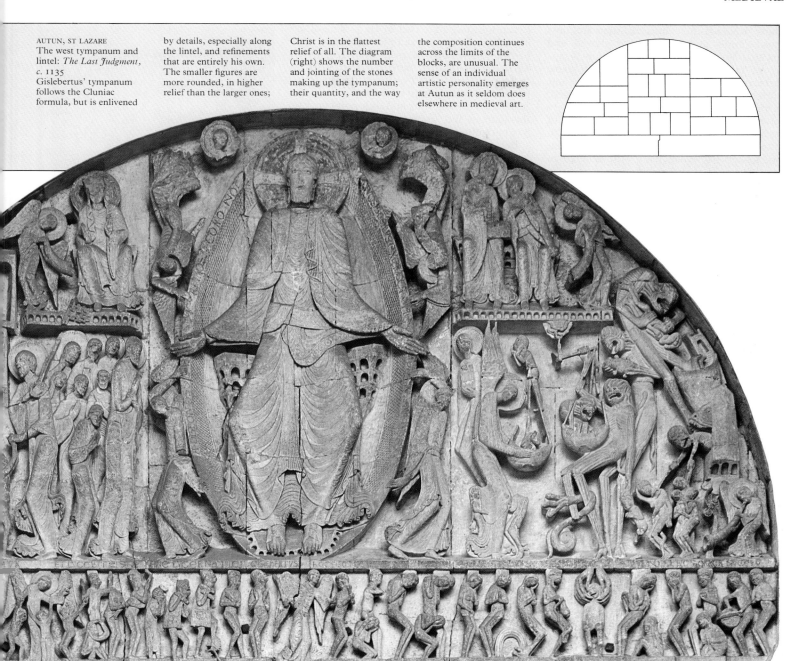

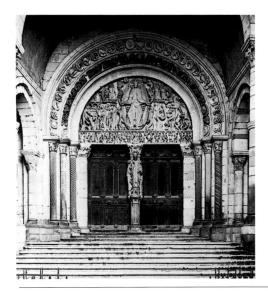

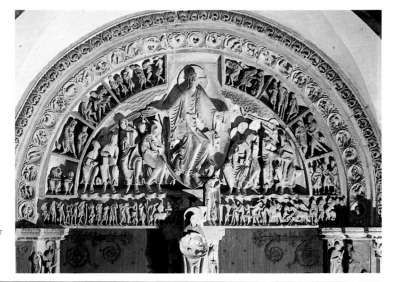

AUTUN, ST LAZARE (left)
The west portal, *c.* 1135
The outer porch is a later addition. All three arches of the portal were once decorated, but the inner one was destroyed in the 18th century when everything was plastered over to hide these works of "the age of superstition".

VEZELAY, STE MADELEINE
(right) The tympanum of the central west narthex portal: *The mission to the apostles, c.* 1130
Christ's blood streams from his hands on to the apostles in an infusion of grace – perhaps reflecting the missionary zeal of Peter the Venerable, Abbot of Cluny. The strange creatures may be inhabitants of the unexplored world.

Romanesque Painting

Many Romanesque churches that are now stark, simple and empty once glowed and vibrated with colour. Damp, Puritan disapproval or unappreciative indifference have destroyed their mural paintings, and their church furniture has been discarded or looted. In France, however, a few murals survive to convey a glimpse of the original appearance of Romanesque interiors, in a style close enough to that of the sculpture to suggest what that, too, looked like when paint still adhered to its surface. Medieval artists were versatile, working with equal skill in different media – sculpture, metalwork, large-scale painting or miniature illumination – and ideas originating in one medium travelled rapidly to another.

The vanished abbey of St Pierre at Cluny once had spectacular murals, which were surely of the first quality and as influential as its sculpture. Its great Abbot Hugh, in his old age, furbished the little priory of Berzé-la-Ville nearby as a quiet retreat, and fortunately parts of its lavish decoration survive to illustrate the Cluny style forcefully. The composition and detailed drapery of its *Christ in majesty* prove that it followed the Carolingian tradition, modified by influences from the Byzantine style practised in Italy. The other important surviving example of Romanesque painting in France is near Poitiers, at St-Savin-sur-Gartempe: here the four distinct cycles include 30 Old Testament illustrations, painted with imaginative freedom on a grand scale; their iconography and style point back to the fantasy and leaping rhythms of Anglo-Saxon manuscripts of the tenth century.

Before the Norman conquest of 1066 an insular style of great originality and splendid vitality had developed in England, to which the illuminators of the Romanesque period often referred. Its figures were characterized by agitated drapery and gestures (stemming ultimately from the Carolingian school of Rheims, which had produced the Utrecht Psalter). Large, very inventive decorated initials continued the complex linear patterns and interlace of the Celtic tradition, usually enlivened by animal grotesques (compare the Gloucester candlestick, p. 71). Under the Normans, notably at Winchester and Canterbury, sumptuous manuscripts were produced to stock the libraries of the proliferating monasteries. Their influence spread as far south as Cîteaux in Burgundy, where the Englishman

CITEAUX (above)
St George, initial of a manuscript, before 1111
As Romanesque sculpture seems often to be shaped by the space it has to fill, so these figures are formed by the shape of the initial R, and decorate the page rather than reproduce the saint's likely mode of battle.

ST-SAVIN-SUR-GARTEMPE (below) *Scene from the life of St Savin*, c. 1100
The lively narrative – every figure is drawn as if in motion, eyes and hands are expressive – is like that of the Bayeux Tapestry. This scene is from the crypt; the entire barrel vault of the nave was also painted.

BERZE-LA-VILLE (right)
The apse: *Christ in majesty with apostles*, before 1109? Though the details of the drapery consist of parallel, V-shaped or zigzag lines, there is a sense of the form beneath – as in Byzantine art. There the patterning is seldom so pronounced. The mural is clearly akin to the Cluniac tympana at Vézelay or Autun.

MASTER HUGO (below)
The Bury Bible: *Moses expounding the law*, c. 1130-40
The striking colours and the new vocabulary of the drapery patterning had a wide influence on mural and manuscript painting. The abstract stylization of the rocks (?) (lower panel) is typically Romanesque.

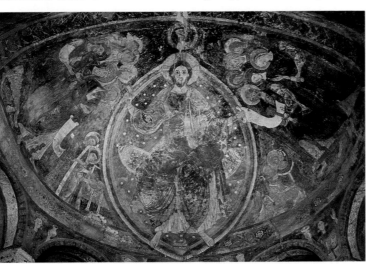

WINCHESTER (left)
The Winchester Psalter: *The mouth of Hell*, c. 1150
The artist must have been struck by an image of St Michael locking the door of Hell in a manuscript (the New Minster Register) produced in his monastery more than 100 years earlier. He made out of it a superb pattern, moral and story.

FLANDERS (right)
The Stavelot Bible: *Christ in majesty*, 1097
This is Mosan work: the strong sense of Christ's bodily structure relates the painting to Renier de Huy's font (see p. 71). Similar Byzantine sources, differently interpreted, lie behind this and the Berzé-la-Ville *Christ*.

Stephen Harding was Abbot from 1108.

The middle of the twelfth century marks the decline of Cluniac power and patronage, and the simultaneous rise of the Cistercians, taking their name from Cîteaux. The Cistercians, in reaction to the musical, literary and artistic devotions of Cluny, retrenched the rule of St Benedict, and called for monks, with the help of lay-brothers, to work on the land. St Bernard of Clairvaux, Harding's successor, fiercely condemned the fantasy and luxuriance of Cluniac church decoration, even though the spreading tide of the Cistercians did not everywhere practise his rigid austerity. Before St Bernard's ban on art of 1134, Cistercian painting had a rare quality of simple humanity.

By the twelfth century, delight in "historiated" or "inhabited" initials, displaying ingenuity and fantastical wit, had become widespread. The interchange of manuscripts was commonplace, and a great variety of styles and manners flourished, absorbing and reinterpreting with confidence older elements or other regional traditions. A feeling for the monumental was always present, as in the superb hieratic *Christ in majesty* in the Stavelot Bible, written at a monastery near Liège.

Mosan (district of the Meuse) painting was hardly less important or accomplished than its sculpture. The maturity of Romanesque painting in England is seen in the Bury Bible of about 1130-40, illuminated by Master Hugo, a "freelance" craftsman who also cast bronze doors and bells, painted murals and carved wood for the appreciative monks of Bury St Edmunds. Characteristically Romanesque in the Bury Bible is the emphasis on hardened contours; the figures are shaped and structured – regardless of anatomy – by the patterns of their draperies; the colours are rich, glowing and enamel-like; there is absolute control of the overall surface design.

In Italy, where Byzantine influences were dominant, there were also strong reminiscences of Roman or early Christian art, from which the new styles of the thirteenth century, notably Giotto's, would develop (see p. 78). In Spain, the style of manuscript illumination and mural painting was markedly individual. The "Beatus" Apocalypse of St-Saver, a commentary on the Revelations of St John by a Spanish monk, Beatus of Liebana, was illuminated for the Gascon abbey of St-Saver in the mid-eleventh century by a Spaniard named

Stephanus Garcia, and was highly influential in France. Its colours are harsh, almost clanging; its fantastic beasts are deployed across the compartmented field of the page with rigidly controlled violence. The Church, while aggressively challenging Islam in Spain, was never impervious to influences from it. Forceful murals and altar frontals painted in Catalonia have a glaring intensity coupled with a strong tendency to geometrical abstraction.

Early in the Romanesque period there was no great emphasis on narrative, although, later, rich narrative sequences illustrated luxurious Psalters and Bibles, or filled the walls of churches (the earliest extant stained glass, so important for the future, is of the mid-twelfth century). However, the most famous surviving narrative is neither religious nor painted, and quite early: the Bayeux Tapestry (it is in fact embroidery) is a vivid secular history of the Norman conquest of England. It was made perhaps in Canterbury about 1080 for Odo, Bishop of Bayeux, and shows the Anglo-Saxon gift for telling a clear, strong story; it has much in common with eleventh-century English illumination. It retains the irrepressible appeal of a strip cartoon.

MEUSE DISTRICT (left)
The Floreffe Bible:
The Crucifixion; the sacrifice of Isaac, c. 1155
The figures are compact and simplified, related to metalwork. They lack the distortion, if also the animation, of Romanesque elsewhere, and anticipate in this Gothic humanization.

CITEAUX (right)
The Tree of Jesse, from a manuscript margin, *c.* 1130
The image of the Tree of Jesse, Christ's lineage as explained in St Luke's Gospel, was a Romanesque invention. The Virgin's pose is Byzantine, but her meekness is Cistercian.

URGEL, SPAIN (above)
Altar frontal: *Christ in majesty with apostles,* early 12th century
The plated quality of the drapery is even closer to metalwork than usual, as the painted panel imitates altar frontals in precious metals and enamel. The figures are grouped into symmetrical shapes, but their faces, eyes and hands are expressive. Great play is made with the haloes.

STEPHANUS GARCIA (left)
The St-Saver Apocalypse:
The torture of souls,
mid-11th century
The firm contours, the areas of arbitrary colour in the field or ground, the elimination even of any suggestion of space, these are Romanesque features.

CANTERBURY? (right)
The Bayeux Tapestry: *King Edward of England, c.* 1080
The embroidery is more than 70m (230ft) long, but only 50cm (20in) high. This is the opening scene: the king sits as kings sat in Ottonian manuscripts, though the animals of the borders are refugees from manuscript initials.

Gothic Art in Northern Europe

The shift from Romanesque to Gothic in the twelfth century is gradual, and first and most clearly apparent in architecture. The styles and technique of Gothic building, announced in Abbot Suger's famous church at St-Denis, outside Paris, in 1137-44, rapidly developed and spread throughout France and then elsewhere: it became established in England after 1174, and imitations of French High Gothic appear in Spain and Germany in the thirteenth century. In Italy Gothic had some impact, but **fundamentally was resisted (see p. 80)**. Gothic was primarily a French style, originating in an area not previously distinguished for art – the Ile-de-France, the personal domain of the French kings and the heart of the slowly emerging French nation. The centre of this area, Paris, became a capital city in this period, and a focal point of European culture.

The best known Gothic art is both complementary and integral to the architecture. The devices of the pointed arch, the ribbed vault and the flying buttress made it possible to erect churches of a kind never seen before, soaring to incredible heights that seemed to deny their physical structure. Solid walls were opened out in huge windows, and stained glass effectually replaced mural painting in church decoration. The glass soon became totally dominant: in the Sainte Chapelle in Paris the walls seem to have disappeared in a flood of coloured light. Such translucent curtains of brilliantly coloured glass, dominating a huge enclosed space, enriching and almost dissolving the architecture in heavenly light, are amongst the most breathtaking effects in all medieval art.

In counterpoint to the heightened spirituality of Gothic art, there was an increasing interest in the natural world and in humanity, which found its expression in the proliferating sculpture on the portals of the great cathedrals. The trend is clear at Chartres. The figures of the early Royal Portal of the west front are still fully part of their columns, almost three-dimensional but closely related to the structure of the doorway. In their cool elegance they are unearthly: the sheer fall of drapery emphasizes their elongation and they float rather than stand on pointed-down toes. The later figures of the much larger and more complex transept portals are far more naturalistic, more relaxed in pose and gesture, and have their feet solidly on *terra firma*. At Rheims, there is a clear

PARIS, SAINTE CHAPELLE
Interior looking east,
1243-48
The chapel was built to house relics bought by
Louis IX, among them the Crown of Thorns. It is walled in stained glass framed in delicate tracery, and gloriously decorated.

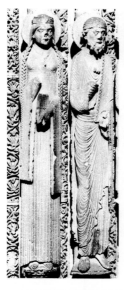 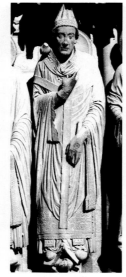

CHARTRES CATHEDRAL
(far left) Detail of west portal figures, *c.* 1150
(left) Detail of south portal figures, *c.* 1215-20
The west portal *Kings* and *Queens* are rigidly pinned to their columns, benign but impassive, and hardly human. The transept *Saints* are much more natural, with more varied gestures, and more expressive faces.

RHEIMS CATHEDRAL (right)
The Annunciation and *The Visitation*, *c.* 1230-40
Gothic drapery is seldom so rich as in the two right-hand figures – there are few parallels for such close imitation of classical sculpture. The left-hand figures are in a smoother, more obviously Gothic style. There is a frieze of very lifelike foliage behind.

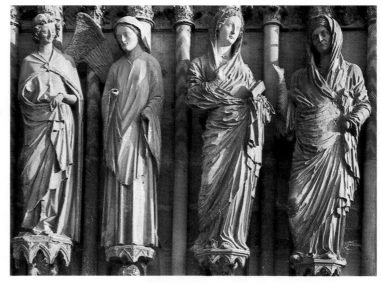

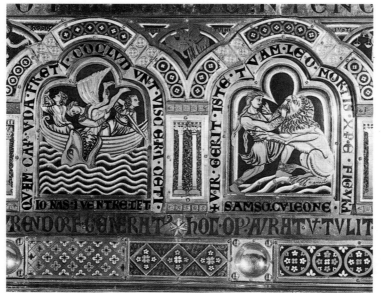

NICHOLAS OF VERDUN
(left) The Klosterneuberg Altar: two of the 45 enamel plaques with biblical scenes, completed 1181
Whether Nicholas' easy, expressive style stemmed from classical or Byzantine sources, it was a distinctly new venture. In its flowing naturalism it moved clearly towards Gothic.

BAMBERG CATHEDRAL
(right) "*The Bamberg Rider*", *c.* 1236?
Secular representations, of historical figures or contemporary potentates, became more frequent in the 13th century, both in France and Germany. The enigmatic *Rider*, in his relaxed and naturalistic pose, recalls the Roman bronze equestrian statue in type but not in style; the style comes from Rheims.

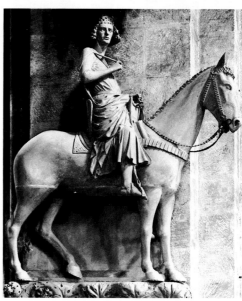

classical influence as well, and the decorated portals are sumptuously developed across the whole west front, extending upwards to a gallery of kings above the rose-window; there are statues of angels on the buttresses, corbels sculpted with heads, gargoyles – the vast body of the cathedral is said to carry about 2,000 pieces of stone sculpture in all.

The iconography of such vast sculptural programmes was carefully worked out, and closely related to theological teaching of the time. There was a gradual movement in the Gothic period towards a gentler, more merciful Christianity, and the changed mood was reflected in the great Gothic portal schemes by the prominent place given to the Virgin, invested with tenderness and grace. In the new universities a humanistic attitude emerged; the search for truth was renewed, which sent scholars back to ancient texts, to Aristotle and Plato. The interest in classical texts runs parallel to a classical current in the arts, and in this the Romanesque font of the Mosan master Renier of Huy had anticipated certain aspects of Gothic. At the end of the twelfth century a great artist from the same region, Nicholas of Verdun (active 1181-1205) introduced a clas-

sicizing style which was widely influential on sculpture, stained glass and manuscript illumination in both France and Germany.

In England, the dominant influence on sculpture was French, but its disposition on church façades and the decorative emphasis of church interiors was quite different. In Germany, the urge to realism produced sculpture of an unprecedented earthly presence: the series of imaginary portraits of the church's founders carved about 1245 by an unknown sculptor in the cathedral of Naumburg in Saxony is a striking example. A similar vivid impact is made by "The Bamberg Rider", an equestrian statue of classical inspiration, introduced via Rheims. Funeral effigies, once rigidly formal and impersonal, became increasingly lifelike, in bronze – the serene figure of Eleanor of Castile in Westminster Abbey (not shown) – or in stone – the tomb-plate of King Philippe IV le Bel of France in St-Denis. These are not yet literal likenesses, but are much more than stereotypes.

Lay patrons and craftsmen were increasingly involved in the arts in the Gothic period. Craftsmen's guilds began to be established in the twelfth century, and the centres of artistic

activity were no longer the monasteries but the cities and towns. Artists travelled, often quite extensively: recurrence of identical designs in places as far apart as Sicily and England can be explained only by good international contacts, and by the circulation of pattern books.

There was no revolution in manuscript painting, as there was in architecture. Gothic illumination remained rooted in the tradition of Carolingian and Ottonian art, but the growing taste for naturalism is often apparent – there is at least one drawing from the life in the work of the English chronicler and illuminator Matthew Paris (took vows 1217; died 1259). Matthew's more formal productions follow long-standing tradition, though there is a softness in his drawing style that derives from France. The most important development was the emergence of elegant and sophisticated court styles under royal patronage in Paris. Personal devotional books became increasingly popular, and those produced in the workshop of Master Honoré (died before 1318) in the reign of Philippe IV le Bel look forward in format and mood to the lavish examples in the "International Gothic" style prevailing at the end of the fourteenth century.

RHEIMS CATHEDRAL (right)
The west façade, begun
c. 1225
Rheims is a culmination of the steady development of portals from the 11th century. The rose-window dominates; the centre gable with *The coronation of the Virgin* shows the later trend to decorativeness.

NAUMBURG CATHEDRAL
(above) *Eckhart* and *Uta*,
c. 1250
Uta draws her cloak up to her cheek, and Eckhart adjusts his sleeve. The two stone figures, life-size and coloured, have a striking stolid naturalism, influenced by Rheims.

MASTER HONORE (right)
The death of the Virgin,
from the Nuremberg Book of Hours, c. 1290?
The heavy frame of the delicately painted scene is characteristically Parisian. Honoré's type of page, its sprays of foliage linking text and picture, became usual in the 14th century.

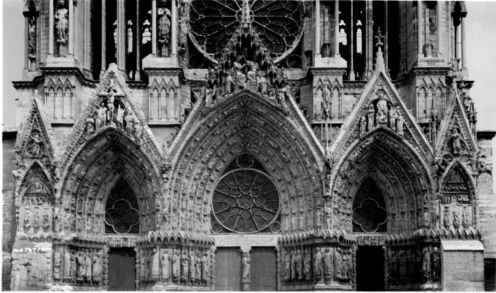

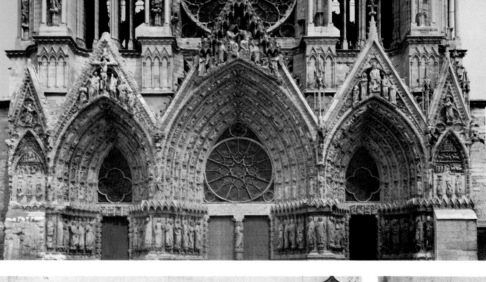

ST-DENIS (above)
Philippe IV, begun 1327
The king's marble face is of an idealized gentleness, with a trace of a smile.

MATTHEW PARIS (below)
The Virgin and Child,
frontispiece to *A History of the English*, c. 1250
The monk Matthew, who dedicates his manuscript to the Virgin, illuminated his own history with lively tinted outline drawings.

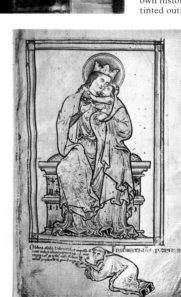

The Genesis of Italian Painting

In the second half of the thirteenth century a revolution of critical importance took place in Italian painting – a new naturalism emerged, in which can be seen the first stirrings of the Renaissance. The change took place in Italy partly because there the tradition of wall decoration in fresco or mosaic had persisted from the time of the Roman Empire, despite a succession of destructive calamities. In the north, by the end of the thirteenth century, this tradition had almost been lost, mainly because Gothic architects had eroded the available wall space in favour of windows.

However, in the same period, altarpieces appear – the earliest examples of what was to prove the dominant format of Western painting, the easel-painting. Their appearance was perhaps prompted by a change in the liturgy, as priests had begun some time before to conduct the service from in front of the altar rather than behind it, but also coincides with a new religious feeling. Now Christ on the Cross was no longer seen with eyes open, in awesome divinity, but with head drooping and eyes closed, in suffering humanity. Emphasis on the Last Judgment was yielding to the theme of the Virgin and Child, images of compassion, in-

tercession and hope. The moving spirit of the new feeling in Italy was St Francis of Assisi, preaching simplicity and humanity, and a more direct approach to God. A fresco in the great church built at Assisi in honour of St Francis commemorates his institution of the custom of making a crib, which serves now as it did then to explain mysteries in human, homely terms. This, to a varying extent, is what both altarpieces and frescos, very often commissioned for the numerous, newly built Franciscan churches, were now to do.

In the thirteenth century the dominant all-pervading style in Italy was Byzantine, its strongest centres Venice and Sicily. In Rome, however, examples of early Christian art, still close to its sources in the painting of antiquity, were plentiful. One of the most important was the fifth-century frescos in S. Paolo fuori le Mura, which were repainted in the late 1270s

by Cavallini (and destroyed by fire in 1823). Meanwhile, in the merchant city-states of Tuscany and north Italy, trade expanded contacts with the north, and the influence of French Gothic art began to be felt. In Tuscan Pisa, well before the end of the thirteenth century, the sculptor Nicola Pisano had achieved a remarkable synthesis of Gothic elegance and fluency with the solidity and realism of antique tradition (see over). By the time he died, before 1284, two painters who in part herald the achievement of their younger contemporary Giotto are already recorded at work in Rome, Pietro Cavallini (active 1273-1308) and Cimabue (active c. 1272-1302).

GIOTTO? (below)
St Francis makes the first crib, c. 1290-1300
The sanctuary where St Francis places the crib is screened off. Above the screen a Crucifix like Cimabue's (right) faces the nave; in Byzantine churches there was a similar arrangement.

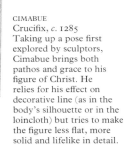

CIMABUE
Crucifix, c. 1285
Taking up a pose first explored by sculptors, Cimabue brings both pathos and grace to his figure of Christ. He relies for his effect on decorative line (as in the body's silhouette or in the loincloth) but tries to make the figure less flat, more solid and lifelike in detail.

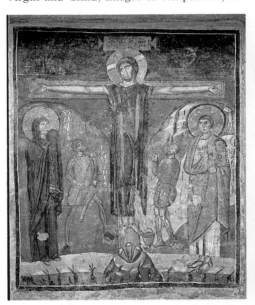

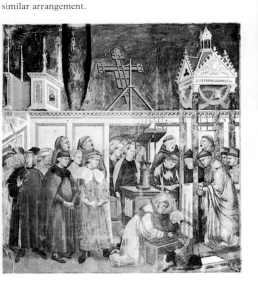

ROME, S. MARIA ANTIQUA (above) *The Crucifixion*, 8th century
In Rome the unbroken succession of popes kept alive the memory of early Christian art; here, even though the iconography is Byzantine (Christ wears a robe, for instance), some of the modelling and drapery recall classical painting.

COPPO DI MARCOVALDO (right) *The Madonna and Child*, 1261
The image is Byzantine, but is signed and dated, and larger than a typical icon. The gilt lines and sharp angles of the life-size Madonna's robes are richly decorative, and beneath them there is a sense of rounded form. (The face is repainted.)

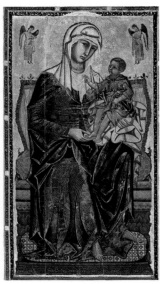

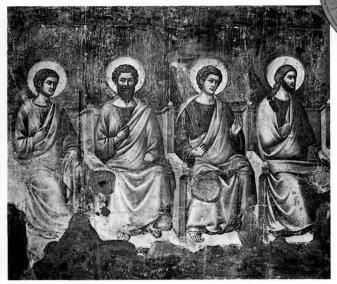

CAVALLINI (left)
Four apostles, detail of *The Last Judgment*, c. 1293
The seated saints have an imposing and convincing solidity. Cavallini is free of the linearity so strong in Cimabue, and his figures anticipate Giotto's in sculptural modelling. But he has not yet mastered the difficulty of presenting a figure in consistent foreshortening – the head (above) of an apostle is a composite view: the right-hand ear is seen in profile. But the head has power.

Cavallini, working in Rome in both fresco and mosaic on a very large scale, was not so much an innovator as a very sophisticated practitioner of the "Greek" or Byzantine style. Most of his work has perished, but the fragments of *The Last Judgment* (*c.* 1293) in S. Cecilia in Trastevere, Rome, show an awareness of the way in which light can be made to model form almost sculpturally, to achieve not only realism but a monumental gravity recalling some classical sculpture. At the same time Cavallini relaxes the rigidity of the Byzantine style; he has a stronger sense of the space figures occupy, he attempts foreshortening and his touch is relatively gentle and free.

Cimabue, too, worked briefly in Rome, but the single work beyond doubt by him is in Pisa, and he is essentially an artist of Florence and its school. He is cited by his contemporary Dante in *The Divine Comedy* as the outstand-

ing artist of his generation, and was diagnosed as the great pioneer by Vasari, who placed his life first in his (the first) history of art. We know now that earlier Italian painters had already begun to humanize the Byzantine vision, notably in Siena Coppo di Marcovaldo (active 1260-76) and Guido da Siena; but Cimabue's name is the one that has survived to attract to itself works of high quality that are due probably to a variety of hands. The colossal Crucifixes associated with him, especially that in S. Croce, Florence (severely damaged in the floods of 1966), show a clear movement towards a more naturalistic treatment of the human figure. The most famous work attributed to him, the four metres (13ft) high "*S. Trinita Madonna*" in the Uffizi Gallery, Florence, has a new sensitivity, an increased tenderness.

"*The S. Trinita Madonna*" hangs in one room in the Uffizi with two other large altarpieces; clearly it has much more in common with one, "*The Rucellai Madonna*", than the other, Giotto's "*Ognissanti Madonna*". Vasari attributed "*The Rucellai Madonna*" to Cimabue. However, it is now usually identified as the altarpiece commissioned in 1285 for S.

Maria Novella, Florence, from the greatest of the Sienese painters, Duccio di Buoninsegna (active 1278-1318). One great masterpiece is certainly Duccio's own work, the colossal *Maestà* (The Virgin in majesty), painted in 1308-11 for the high altar of Siena Cathedral.

In terms of style Duccio's achievement in the *Maestà* was to modulate the Byzantine tradition into "Latin" Gothic. From the Byzantine come elements in the characterization and poses of his people, and the delicate linear gold rays of the draperies. But the Byzantine now kindles into movement, and in the small panels Duccio and his close followers show a consummate mastery in the art of story-telling – his people are vigorous, their action and interaction subtly ordered and compelling. His interiors and landscapes are not literally drawn, his use of light is not consistent, but in narrative terms the panels are marvellously coherent. In his delight in line and colour, as in his almost miniature scale, Duccio's style is very close in feeling to that of the French Gothic illuminators – yet within this small scale, in the scene, for instance, of the Crucifixion, in the centre of the rear face, he can achieve the most solemn monumentality.

CIMABUE (left)
"*The S. Trinita Madonna*",
c. 1280
The Madonna's shrouded, soft, rounded face and gold-striated draperies are Byzantine, but the panel's gabled shape, the throne's elaborate architecture and the layering of the angels framing her are Italian.

DUCCIO (right)
"*The Rucellai Madonna*",
1285
By showing the Madonna from the side, Duccio makes her less hieratic – a real figure, understood to be occupying space, and gentle in contour and colour.

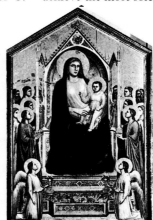

GIOTTO (left)
"*The Ognissanti Madonna*",
c. 1305-10?
The Madonna occupies space like a statue, in fact much like Tino di Camaino's stone *Madonna* (see over). She is charged with monumental solidity, but the delicacy and grace and the human tension between Mother and Child achieved by Duccio (far left) has been foregone.

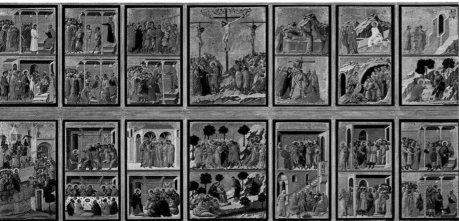

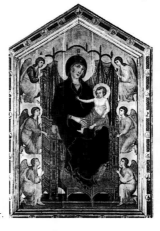

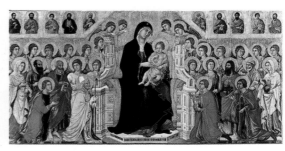

DUCCIO
The *Maestà*, rear face:
Scenes from the life of Christ, 1308-11
The sequence starts at the bottom left (indicated by the larger panel). The figure groupings and the colours are so exquisitely calculated that, despite the small scale, the main

characters and meaning of the story emerge instantly and effectively. In *Christ's arrest* (right), Christ is picked out by the deep colours of his robe and its gold hem, and St Peter, cutting off a soldier's ear, is in green set against the red tints of the crowd. The slight interval and sharp

juxtaposition of feet pointing opposite ways masterfully express the apostles' flight. For its time, the landscape (and that of *The Agony in the Garden*) was ambitious: Duccio attempted to set out an organized space more complex than Giotto's bare stage (see pp. 82–83).

DUCCIO (above)
The *Maestà*, front face:
The Virgin in majesty
Some 4m (13ft) wide, free-standing, painted on both sides (many panels are now dispersed) the finished *Maestà* was borne in solemn procession from Duccio's workshop to Siena Cathedral to the music of trumpets. The Virgin's rich throne sets her back into space; she is notably more solid than "*The Rucellai Madonna*" of some 20 years earlier.

Italian Gothic Sculpture

Between Romanesque and the Renaissance comes Gothic, but "Gothic" is an uneasy term when applied to Italian art of the thirteenth and fourteenth centuries. In Italian architecture the only major building immediately recognizable to northern eyes as characteristically Gothic is the buttressed, soaring, pinnacled mass of Milan Cathedral, begun in 1387. In Italian painting and sculpture we find not only the local adaptation of French and German styles coming south, but the original innovations of Duccio and Giotto in painting, and in sculpture those of Nicola and Giovanni Pisano, father and son, from Pisa.

Pisa is now about 10 kilometres (six miles) from the sea; it once lay at the very mouth of the river Arno, and had developed into a flourishing maritime and merchant republic. It was rich enough in the twelfth century to undertake Pisa Cathedral and the Leaning Tower beside it, and proud enough to compare itself with the ancient Roman republic. In the thirteenth century it had one of the most advanced metalworking industries in Europe; better stone-cutting tools as well as the patronage of an intelligent community may have contributed to the Pisani's new realism.

Although Nicola Pisano (active c. 1258-84) had his origins, as his name indicates, in Pisa, he was brought up in the far south, in Apulia, where the Emperor Frederick II Hohenstaufen had deliberately fostered a classical revival at his court. Nicola's first known (though fully mature) work, the marble pulpit in the Baptistery at Pisa, displays clear borrowings from classical models (specifically from sarcophagi still preserved nearby), though the pulpit is an unmistakably Gothic conception. Signed and dated with proud clarity *Nicola Pisanus 1260*, it continues an Italian tradition of elaborate free-standing carved pulpits: in Italy, the northern fashion of using the portals of great churches to carry sculpture was rarely followed; the Christian mysteries were depicted instead on carved pulpits or on church doors. Here Nicola surpasses his predecessors in the management of crowded figures, merged into broad narrative panels instead of being tightly compartmented in the Romanesque manner. The sense of depth and space, in which the figures seem to move and use their limbs, is quite new. In this emulation of classical form, Nicola Pisano was, like Giotto, an example to the Renaissance.

Nicola's second great pulpit (1265-68) was carved for Siena Cathedral. Here the northern influence is more marked: the movement is both more animated and more fluent, though the figures are still classical in feeling. Already working with him on the pulpit were two assistants who were to become as famous as he, his son Giovanni (active c. 1265-1314) and Arnolfo di Cambio (died 1302?). Giovanni was his father's chief assistant, perhaps even equal collaborator, in Nicola's last major project, an elaborate fountain in Perugia, finished in 1278: characteristically medieval in its encyclopaedic profusion, it has relief panels carved with even greater confidence and freedom than the pulpits. On his pulpit at Pistoia, Giovanni Pisano described himself unabashedly as "born of Nicola, but blessed with greater science", and he was clearly of a tempestuous pride and independence more usually associated with artists of the Renaissance. The pride was matched with genius, energy and versatility. He was also an architect, and from 1284 worked on a design for Siena Cathedral that approximated the French style, involving figure sculpture in the façade; but instead of subordinating the sculpture, he

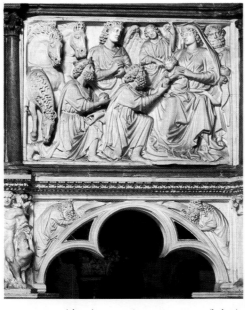

NICOLA PISANO (above)
The Adoration of the Magi, detail of the Pisa Baptistery pulpit, 1260
A Gothic trefoil arch supports a relief panel full of classical echoes; beside the arch *Fortitude* is naked like a Hercules.

PISA, CAMPO SANTO (below)
Phaedra, detail of a sarcophagus, 3rd century
Nicola has borrowed for his Virgin the pose and the matronly dignity of a Roman Phaedra. He lets her drapery, however, fall in Gothic V-shaped folds.

NICOLA PISANO (above)
The Visitation, detail of the Siena Cathedral pulpit, 1265-68
Here Nicola carved more deeply and sharply than at Pisa, developing a more dramatic style that was to be followed by his son and assistant Giovanni (right) – compare the women's faces.

NICOLA PISANO (above)
December, detail from the Great Fountain, Perugia, 1278
The squat figures in the 50 panels set round the fountain are no longer monumental; they have an ease and vigour (though weathered) more akin to French Gothic sculpture.

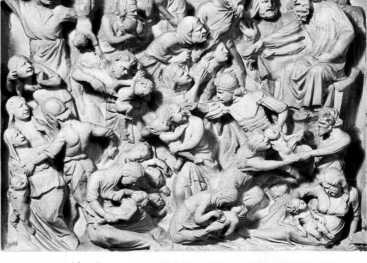

GIOVANNI PISANO (above)
The Massacre of the Innocents, detail of the Pistoia pulpit, 1301
The action seems to swarm over the panel, and yet the deeply undercut figures are grouped by emphatic diagonals swinging the eye across, up and down the composition. The faces are masks denoting grief, fury and terror.

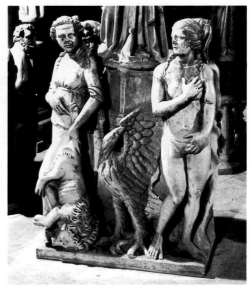

GIOVANNI PISANO (right)
Temperance and *Chastity*, detail from the base of the Pisa Cathedral pulpit, 1302-10
Naked Chastity reproduces a standard pose of Venus. The carving here is tight, more rigid than at Pistoia. Long inscriptions sing Giovanni's achievements.

animated it dramatically so that the architecture became almost a backcloth. The figures, of prophets and wise men of antiquity, are now heavily weathered; the technical virtuosity of Giovanni's chisel has to be seen in his pulpits, at Pistoia (finished 1301), and in the cathedral at Pisa (1302-10). Here, although classical models, especially at Pisa, are used for some individual figures, there seem to be positive echoes of French Gothic sculpture, but Giovanni is not known to have visited the north, and the impact could have come through imported ivories and manuscripts. However, even in the panel at Pistoia of *The Massacre of the Innocents*, a relief composition of turbulent complexity scarcely matched before Michelangelo, Giovanni's style is always subservient to and directed towards narrative ends, even if sometimes his search for vivid expression forces him into audacious distortions.

In his free-standing figures – in wood and ivory as well as marble – Giovanni achieved a remarkable synthesis of Gothic rhythm with classic monumentality. He could convey, in his *Madonnas* (for instance that in Giotto's Arena Chapel, see over), a most tender intimacy between Mother and Child and, in his Christ

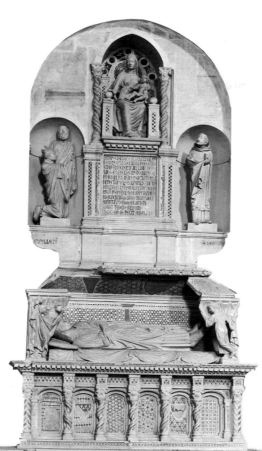

figures, a sense of human anguish within divinity. His feeling for expressive movement took on three dimensions in his now fragmented tomb of Margaret of Luxembourg (1313), in which the dead woman was represented rising from the grave.

Nicola's other famous pupil, Arnolfo di Cambio, stayed closer to his more classicizing manner than did Giovanni, even increasing the monumental simplicity of his figures – as in his crib at S. Maria Maggiore, Rome. The new type of wall-tomb he introduced, for instance Cardinal de Braye's at Orvieto, set a fashion for more than a century, providing a new theme for elaborate sculpture.

The Pisano traditions were continued and adapted in the fourteenth century by sculptors such as Tino di Camaino (*c.* 1285-1337), working in Pisa, Siena, Florence and Naples, and Lorenzo Maitani (active *c.* 1302-30), designer of the façade of the cathedral at Orvieto. At Orvieto also worked another Pisano, Andrea (active from before 1330 to *c.* 1348; no connection with Nicola), but his masterpiece is the bronze doors, 1330-37, for the Baptistery at Florence, in which the figure style, dependent on Giovanni's, is as economic as Giotto's.

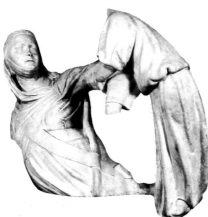

ARNOLFO DI CAMBIO
Tomb of Cardinal de Braye, after 1282
This is an early tomb on two levels: above, the

Cardinal with two patron saints kneels before the Madonna; two angels close curtains in vivid motion on his dead body below.

GIOVANNI PISANO (below)
Fragments of the tomb of Margaret of Luxembourg, 1313
The Empress rises up to her salvation from death between two angels as the Virgin had done in French art – further evidence that Giovanni knew such art.

ARNOLFO DI CAMBIO (above) Detail of a crib: *The three Magi, c.* 1290 Arnolfo's heavy, solid figures (not as originally arranged) have much of the intimate appeal of Nicola's Perugia fountain reliefs: they are elegant as well as dignified.

ANDREA PISANO (above)
The death of St John the Baptist, panel of the Florence Baptistery doors, 1330-37

The disposition and the anguish of the figures show the influence of Giotto's Bardi Chapel frescos of *St Francis* (see over).

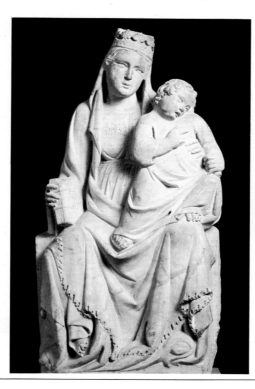

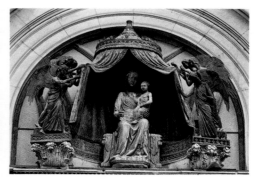

TINO DI CAMAINO (left)
The Madonna and Child, 1321
The Madonna, originally seated above a tomb like Arnolfo's of Cardinal de Braye, has an appropriate classical dignity, but the Child moves from her in sturdily animated contrast.

MAITANI (above)
The centrepiece of the façade of Orvieto Cathedral: *The Madonna enthroned*, 1330
Maitani's Madonna, beset with delicately agitated angels, has a slenderness and sweetness far removed from Tino di Camaino's.

Giotto di Bondone

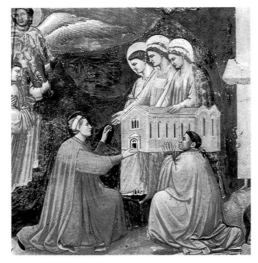

Giotto di Bondone (c. 1267-1337) was described by Dante as the foremost painter of his time, displacing the elder Cimabue in fickle fame and fortune. Posterity, however, has seen Giotto in stronger terms, as the revolutionary who altered the course of painting in Europe, striking out of the Gothic and Byzantine styles towards the Renaissance. Though Giotto's innovations are clearly definable there is, curiously, no documentary proof that he painted the works attributed to him, and this despite the fact that more is known about Giotto the man – his travels, business interests, connections and family life – than is known about any previous Western artist.

Giotto was a citizen of Florence, though he also worked, probably or certainly, in Assisi, Rome, Padua, Milan and Naples. Robert of Anjou, King of Naples, called him his "close and faithful friend". His art and evident business acumen made him sufficiently prosperous to marry twice, support eight children and provide handsome marriage settlements for two daughters. His workshop flourished: three paintings signed by him survive, but they are almost certainly the work of his assistants, signed by Giotto almost as a brand-name.

Comparison with the work of his predecessors, even with Cimabue, makes Giotto's innovations obvious. The great painted Crucifix ascribed to Giotto in S. Maria Novella in Florence shows Christ sagging painfully with the weight of a real human body, seen in depth against the surface of the Cross. Earlier Crucifixes, by Cimabue for instance (see p. 78), are by contrast ceremonial portrayals, in which the physical meaning of Christ's sacrifice is subordinate to ritual decoration. Giotto's "Ognissanti Madonna" – solid, monumental, clearly positioned in space and gravity-bound – makes Duccio's slightly earlier "Rucellai Madonna" (p. 79) seem a floating dream.

Giotto's style is, however, closely anticipated in the fresco cycle of the life of St Francis in the Upper Church of S. Francesco in Assisi. This fact has made the authorship of these paintings one of the most extensively argued controversies of Italian art. Who painted here? Was it an unknown artist who taught Giotto the principles of composition that are more fully developed in the Arena Chapel in Padua? Or was it, as many believe, the young Giotto, here forging his style for the first time?

All are agreed in assigning to Giotto the

GIOTTO (above)
The Last Judgment in the Arena Chapel, Padua, detail: *Scrovegni presents the chapel*, before 1306
The merchant Scrovegni built the chapel to atone for a rich man's sin, usury.

GIOTTO (below)
Crucifix, c. 1290-1300
Giotto's Christ, an early work, is modelled more softly than Cimabue's in S. Croce (see p. 78 and Byzantine prototypes from which its design derives.

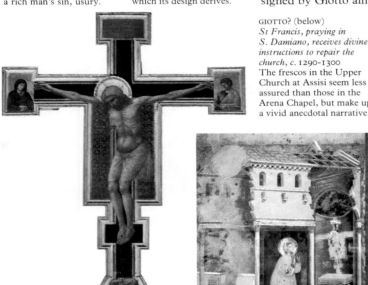

GIOTTO? (below)
St Francis, praying in S. Damiano, receives divine instructions to repair the church, c. 1290-1300
The frescos in the Upper Church at Assisi seem less assured than those in the Arena Chapel, but make up a vivid anecdotal narrative.

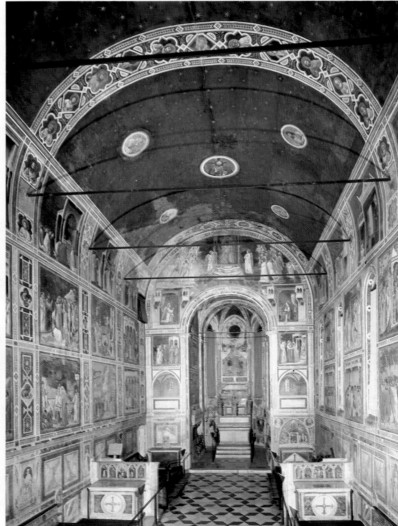

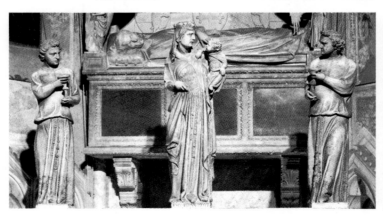

GIOVANNI PISANO
The Madonna and Child and two angels, c 1302-10
Presiding over the altar of the Arena Chapel, the free-standing statues are both sombre and gentle; Mother and Child are in mood intimate rather than majestic. In their gravity Giotto's figures emulate contemporary sculpture; in their expressive force they rival specifically Giovanni Pisano's range.

decoration (and possibly the architectural design) of the Arena Chapel in Padua, commissioned by the wealthy merchant Enrico Scrovegni and completed by 1306. It was a private oratory dedicated to the Virgin, and its sidewalls were decorated with the story of the life of the Virgin (and her parents) and of Christ; Giovanni Pisano sculpted a *Madonna* for the altar. To the east the angel announces her destiny to Mary across the space of the arch, and to the west is the Last Judgment – the beginning and the end of the Christian drama. Each scene of the narrative is complete in itself, yet each is organically related to the others. Giotto's analysis, reducing each episode to its dramatic essentials and presenting it in a form that satisfies both visually and psychologically, has lost none of its force today. At the beginning of the fourteenth century his approach was revolutionary.

In the opening scene, *The expulsion of Joachim from the temple*, the temple is indicated by its essentials – a tabernacle, a pulpit, an enclosing wall indicating the shelter of a sanctuary, a priest blessing a kneeling young man. Joachim, Mary's father, the elderly haloed figure on the right, is almost being pushed

from the temple by the priest into the void outside – the misery of his situation is expressed not only by the priest's action and Joachim's whole appearance, but also by the arrangement of the composition. The difference in scale between the figures and their settings, the representation of a scene not by its optical appearance but by a summary of the objects it contains, are medieval, and the narrative technique can be paralleled in Duccio's *Maestà* (see p. 79). Giotto, however, has introduced a new structural logic and rationally (if not scientifically – that was a fifteenth-century achievement) defined the stage on which his figures enact their play. These figures are often starkly simplified, but there is a credible weight beneath the heavy folds of their draperies – even though Vasari's comment that Giotto deserved "to be called the pupil of Nature and of no other" may now seem a little surprising. Giotto's co-ordination of convincing objects and convincing space into an effective two-dimensional pattern anticipated Renaissance ideals, yet it is perhaps Giotto's feeling for the human figure and the passion it can express that makes his art still so strikingly effective today.

Two other major surviving works generally held to be Giotto's were painted ten or more years later; they are *The life of St Francis* in the Bardi Chapel in S. Croce, Florence, painted perhaps about 1316-20, and *The life of St John the Baptist* in the Peruzzi Chapel in the same church, painted perhaps in the mid-1320s. These scenes, less well preserved than those at Padua, are placed in much larger panels, oblong rather than squarish, and the narrative is generally more fluid and relaxed, with more realistic settings and more habitable architecture, with the narrow stage used in the Arena Chapel opened out. Giotto's followers further elaborated his settings and refined his perspective, but seldom matched his psychological portrayal of the human figure.

In 1329 Giotto was painting in Naples for Robert of Anjou, but hardly a trace remains of his extensive work there. He was appointed architect to Florence Cathedral in 1335 and began its campanile. For the last two years of life he was working in Milan and is believed to have died at the age of 70 in 1337. He soon became a figure not only of history but of legend, and for a time his name served virtually as a synonym for "painter".

GIOTTO
The Arena Chapel, Padua: (left) interior looking east, dedicated in 1306 The frescos narrate the lives of Mary and Christ in three horizontal bands, reading to the right and from top to bottom, then culminating in *The Last Judgment* on the west wall. *The expulsion of Joachim* (right) begins the cycle.

Between the framed scenes are Old Testament scenes or symbols presaging the events of each panel: Moses (above) is placed beside the *Feast at Cana* (right) since in striking a rock to draw water for the Israelites he had prefigured Christ turning water into wine. Much of the undiminished power of Giotto's frescos derives from his economy: observe the firm, bold outlines with which the actions of Christ's humiliators are depicted in *The mocking of Christ* (right). The chapel was clearly built to be decorated and the heavy painted framing provides an architectural division of the box-like, simple structure. The blue of the ceiling seems also part of the original design.

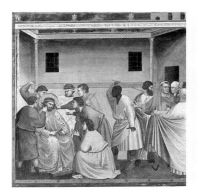

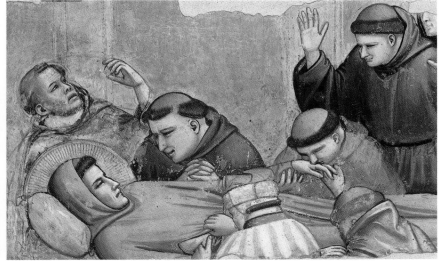

GIOTTO (above)
The death of St Francis, detail from the Bardi Chapel, S. Croce, c. 1320 Giotto's mature style is evident in the Franciscan church in Florence where

he painted four chapels (the frescos in two are lost). Vasari tells us it was Giotto who painted "with great effect the tears of a number of friars lamenting the death of the saint".

GIOTTO (below)
The dance of Salome, detail from the Peruzzi Chapel, S. Croce, c. 1325 In his later work Giotto made use of more elaborate architectural settings.

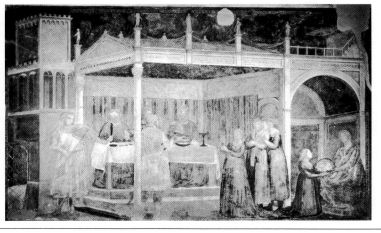

Italian Gothic Painting

The conception of Giotto as the founding figure of Western art emerges in the writings of fourteenth-century humanists such as Boccaccio. However, the idea was firmly and definitively stated only in the sixteenth century by the adopted Florentine painter Vasari. For all Giotto's immense influence, his contemporaries and successors in the fourteenth century did not see his work as breaking away in a new direction they were compelled to follow. The leading school of painting in the first half of the century was not really in Florence, but in Siena. It was Sienese painting, still rooted in the Byzantine tradition – enlivened, in Duccio's work, by the elegance of Gothic – that exerted the greater influence, not only in the courts and city-states of Italy, but further north, in the courts of France.

The most seductive interpreter of Duccio's style was Simone Martini (c. 1285-1344), who was certainly in Duccio's circle, and may have been his pupil. Simone's work has impressive variety, but is characterized by his delight in sinuous line and clear colour, already to be seen in his first known work, a large *Maestà* (Madonna in majesty) of 1315 (reworked 1321). One of a series of important commissions for the Sienese Town Hall (see over), it is very close, in composition and style, to the front face of Duccio's great *Maestà* (see p. 79), but there are hints in the fresco of Simone's innovative talent. In his *St Louis* altarpiece, painted in Naples in 1317, the image of the saint is severely frontal, icon-like, though offset by the movement of the drapery, the sumptuous colour and the detail of the decoration; but the kneeling figure of the donor, Robert of Anjou, is very individual, and the little scenes at the bottom constituting the predella have a coherent unity of perspective never before attempted. Simone's fresco of the military commander Guidoriccio da Fogliano, painted in 1328 (and sited opposite his 1315 *Maestà*) is the first such "history" painting.

Simone's masterpiece – signed by himself and by his brother-in-law Lippo Memmi – is the brilliant and dramatic 1333 *Annunciation*, originally an altarpiece for Siena Cathedral. Set against a field of matt and burnished gold, the angel, swirling in an arabesque of white and gold draperies, fretting his wings, kneels before the Virgin: she shrinks from his awesome message, creating a space between them that almost vibrates. Simone, like nearly every great artist of the time, had worked at Assisi, and something of the massive Giottesque manner of frescos is reflected in his later works; but in the exquisite lyric grace of *The Annunciation* there is no trace of that, but rather an affinity with certain French manuscript illuminations. In 1340/41 he went to France, to the papal court at Avignon; there he met and befriended the great humanist Petrarch, and there he died.

The impact of Giotto on two, perhaps slightly younger, contemporaries of Simone in Siena, the Lorenzetti brothers, Ambrogio and Pietro (both active c.1319-48?), was more marked. Pietro worked in Assisi as well as in Siena; Ambrogio had close connections with Florence. They have clearly distinct artistic personalities, and apparently worked together on only one project, a fresco, now lost, in 1335. Pietro's first documented work, *The Virgin and saints* of 1320 at Arezzo, shows in its little upper *Annunciation* skilful experimentation with the perspective. In Pietro's latest dated work, *The birth of the Virgin* of 1342, this interest in perspective is developed in an interior which has a thorough logic unknown to Giotto. The analysis of three-dimensional

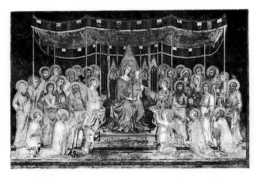

SIMONE MARTINI (above)
Maestà (The Madonna in majesty), 1315-21
The Madonna, as Queen of Heaven, sits under a canopy. Beneath it the reverent figures stand one behind another, in greater depth and variety of pose than in Duccio's *Maestà*.

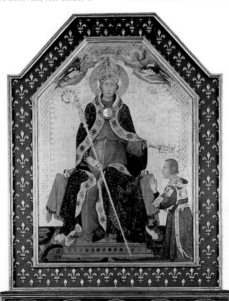

SIMONE MARTINI (left)
St Louis, 1317
To support his claim to the throne of Naples, Robert of Anjou had the artist paint his canonized great uncle, Louis IX, crowning him as he knelt.

SIMONE MARTINI (above)
The Annunciation, 1333
Here Simone has wholeheartedly embraced Gothic rhythms – even the format of the picture echoes the typical portal scheme of a French cathedral façade.

SIMONE MARTINI (below)
Guidoriccio da Fogliano, 1328
The Sienese general rides between two towns he has wrested from the Florentines; the Sienese siege-camp is shown on the right. One of the first equestrian portraits since antiquity, it must echo the Roman idea of triumphal procession. Guidoriccio is both magnificent in his pageantry and hauntingly forlorn against a black sky.

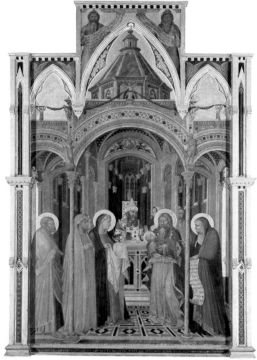

space is equally ambitious in Ambrogio's *Presentation in the Temple*, and the figures, in their simplicity of contour and mass, recall not only Giotto but Nicola Pisano; Ambrogio may even have used Roman or Romanesque sources, as he surely did for his *Good Commune* (see over).

In Florence, none of Giotto's immediate followers was comparable in stature to him or to the great Sienese. The epithet "Giotteschi" (little Giottos) applied to them rather vaguely is, however, scarcely just, and they included some notable artists. The prolific Bernardo Daddi (active *c.* 1290-1348; not shown) offered a sweeter version of the style of Giotto and specialized in small portable altarpieces that became very popular. Taddeo Gaddi (*c.* 1300-*c.* 1366) is said to have been Giotto's godson and to have worked with him for 24 years. His best-known paintings are perhaps the lively frescos in the Baroncelli Chapel in S. Croce, Florence, in which he deployed Giotto's style in a more overtly decorative and animated narrative, packed with incident. Roughly contemporary was Maso di Banco, whose life is entirely obscure, but he was surely the greatest of Giotto's followers; his frescos of *The life of St Sylvester* in S. Croce, probably of the late

1330s, have a striking clarity and solidity, and show a profound grasp of Giotto's principles.

The Black Death, erupting in Tuscany in the middle of the century, inevitably had an effect on art. The population of Siena was halved, and the city never recovered its prominent position. The Franciscans' outgoing humanity was checked, and the bulk of patronage was undertaken under the auspices of the more didactic Dominicans. The Last Judgment or standing saints holding messages or symbols were more typical subjects than intimate scenes from the life of the Virgin set in a perspective interior. In the work of Orcagna (active 1343-68), the versatile dominant figure – painter, sculptor, architect and impresario – in Florentine art in the two decades following 1350, there is a clear tendency to revert to the other-worldly images of the earlier Byzantine tradition. However, the narrative techniques of the Giotto tradition were continued, in more crowded and fanciful designs, by artists such as Taddeo Gaddi's son Agnolo (active 1369-96; not shown). His graceful rhythms and brilliant colours usher in the Florentine version of the "International Gothic" style of the century's close.

AMBROGIO LORENZETTI (above) *The Presentation in the Temple*, 1342
The building is half interior, half exterior, the typical medieval formula, here at its most developed.

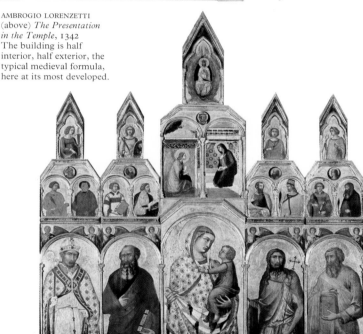

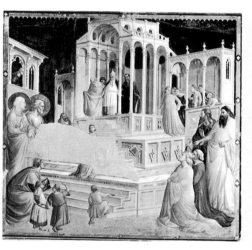

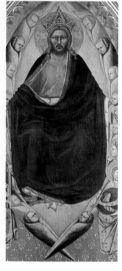

TADDEO GADDI (above) *The Presentation of the Virgin*, *c.*1332-38
Taddeo's repertoire of varied settings, displayed at their best in his *Life of the Virgin* frescos in S. Croce, was copied enthusiastically – this one reappears in French illuminated manuscripts.

MASO DI BANCO (below) *St Sylvester and the dragon*, late 1330s
St Sylvester is seen twice: calming a dragon, and resurrecting two Magi it had killed (seen alive and dead). Maso introduces more detail than Giotto had without prejudicing the narrative impact.

ORCAGNA (above) *The Redeemer*, detail of an altarpiece, 1354-57
Though massive in form, the remote, unsmiling figure of Christ reverts to icon-like immobility and staring-eyed intensity.

PIETRO LORENZETTI (above) *The Virgin and saints*, 1320
Pietro's figures differ from those by Simone; the central Virgin and Child have a solidity of form inspired by Giotto, but also a human tenderness that derives from Duccio.

PIETRO LORENZETTI (left) *The birth of the Virgin*, 1342
The room is like a three-dimensional stage, linked architecturally to the picture's frame. To the right, parallel lines in the coverlet pattern converge as they run into depth, and together with the floor tiles create a coherent space.

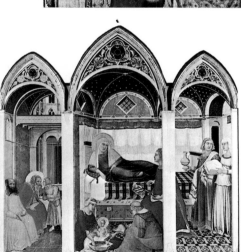

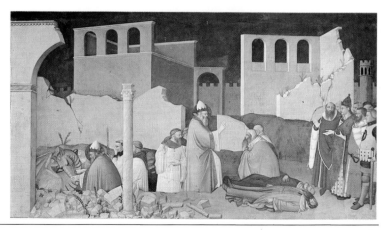

Ambrogio Lorenzetti: The Good Commune

The lively, independent mercantile republics of central Italy were growing both in size and prosperity during the thirteenth century. Among them, Siena is the most brilliant example of a community rebuilding and adorning its communal heart, the city. In Pisa, Florence, Siena and elsewhere the cathedrals were already well advanced; now the streets and squares were levelled and paved, and meeting places, halls and government buildings erected. Siena's new fabric was planned as the visible expression of the city's order and harmony – even as a mirror of the City of God described by the theologians. Its most significant enterprise was the Palazzo Pubblico, or Town Hall, begun in 1284 and largely completed by 1310; from 1315 the nine elected city consuls undertook to fill the huge bare walls of its interior with a remarkable series of frescos, expressing communal aspirations.

In 1315 Simone Martini was commissioned to paint a *Maestà* (see preceding page) in the room where the general council met: there the Madonna presided as patroness and divine ruler of the city, her message spelled out in an inscription. In the adjoining room where the Nine met, Ambrogio Lorenzetti was commissioned in 1338 to paint a series of frescos: on one wall, an allegory of Good Government, of Justice and the Common Good; on the second, an allegory of Tyranny; on the third wall, 12 metres (40ft) long, a vision of the city of Siena and its countryside enjoying the benefits of Good Government. The inclusion of Siena Cathedral, its campanile and the streets and houses around it, brought home the meaning of the allegory to the spectator personally.

The main allegory of Good Government on the north wall is expressed in solemn seated figures representing various virtues, moral, political and administrative. Each figure is named, and its significance spelled out in rhymed inscriptions. The enthroned figure on the left is Justice, linked by a cord to the largest figure on the right, Common Good, or Good Commune. The group of citizens below all face their elected choice, the Common Good; on the right, soldiers securely guard wrong-doers. On the opposite wall is the alternative, a group of vices about the throne of Tyranny – Cruelty, War, Treason and Division. The overall message is clear, an exhortation to the citizens and a call to unity; and it was urgent: the government of the Nine, though unusually durable, was constantly threatened by tension and violence between rival factions.

On the east wall the hieratic range of Virtues adjoins an astonishing city and landscape, unrolling beneath the hovering figure of Security. City and countryside are recorded with an attention to their physical reality in a way never attempted before, although two little panels ascribed to Ambrogio (the first pure landscapes in Western art?) foreshadow his achievement in the frescos. The peasants had carried out their same Monthly Labours on Cathedral portals; but they work now in a real landscape, indicated not by a token rock or tree but by an undulation of hills, winding roads, water and cultivation shaping the earth as it is still shaped about Siena today. The sky, however, is a grey-black blank.

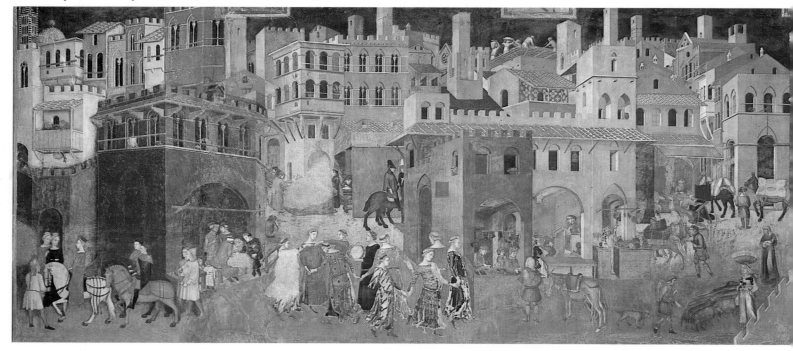

AMBROGIO LORENZETTI (above) *The effects of Good Government on town and countryside*, 1338
Siena Cathedral is on the far left; other buildings, not identified, suggest real structures, with known Sienese features. Ordinary activities such as building a house and washing at a communal fountain are truthfully observed. This realism, so different from the conventions of previous painters, is apparent also in the landscape beside.

(right) *Allegory of Good Government*
The row of citizens pass a symbolic cord running from Justice on the left, with Concord beneath her, to Common Good, throned with sceptre on the right.

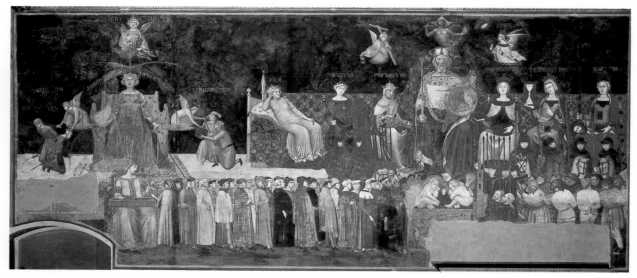

SIENA (below)
Winged Victory, 2nd
century?
Known to have been in
Siena in Ambrogio's day,
the Roman arch relief may
have inspired his figure of
Security, guarding the
landscape in *The effects of
Good Government*. The
original has a suppleness
Ambrogio does not match.

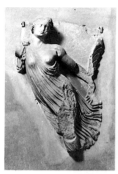

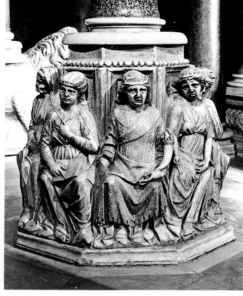

NICOLA PISANO (left)
The Liberal Arts, detail
of the Siena Cathedral
pulpit, 1265-68
Nicola's matrons were
prominent monuments
in the heart of the city.

AMBROGIO LORENZETTI
(below) *Grammar*
The influence of Pisani
sculpture on Ambrogio is
apparent in the drapery
and mass of *Grammar*,
shown teaching a child,
but is less so in figures
that are not allegorical.

The reality rendered has been carefully interpreted. Central in the city dance maidens, the focus and symbol of the harmony of the whole: the light radiates from them to left and right, the buildings recede obliquely from them, and the scale of the figures behind them diminishes. This compositional unity had its counterpart in the deliberate disorganization of *The effects of Bad Government* (much damaged; not shown) where there was no clear focus of attention, and no coherent light.

A whole summary of medieval thought is completed in the medallions that border the frescos; these include symbols of the Liberal Arts and Sciences, the seasons and the planets. In representing these allegorical figures, Ambrogio was clearly stimulated both by contemporary sculpture and by antiquity.

A decade later Siena was to be overwhelmed by a disaster of which the Palazzo Pubblico programme had taken no account – the Black Death, which perhaps killed both Ambrogio and his brother Pietro about 1348, and, in a sense, served to delay the Renaissance.

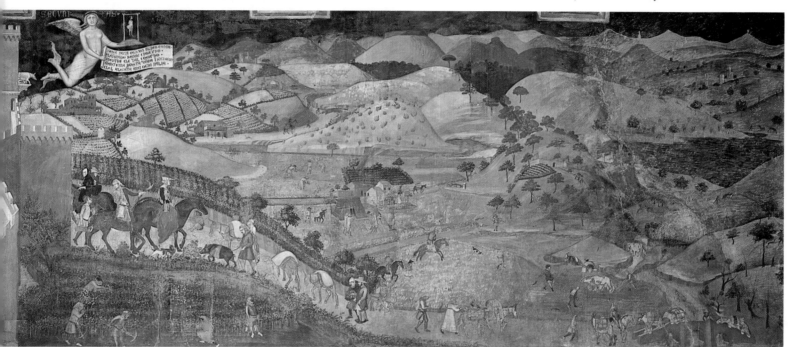

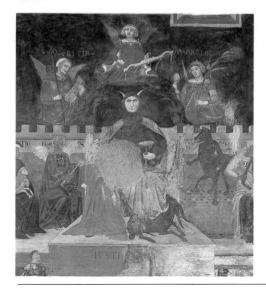

AMBROGIO LORENZETTI
(left) *Allegory of Bad
Government*, detail
This fragment from the
now badly damaged fresco
shows horned Tyranny,
negative counterpart to
the Common Good, with
some of her cohorts.

AMBROGIO LORENZETTI?
(right) *Landscape*, c.1335?
This, and another similar
panel, are probably the two
earliest pure landscapes in
Italian art. In its uniform
bird's-eye view this differs
from the very much larger
Palazzo Pubblico landscape,
which is seen from a view
much closer to eye-level.
Had Ambrogio seen a
Roman landscape fresco
that no longer survives?

International Gothic

The term "International Gothic" is generally used to embrace a style found throughout Europe between about 1375 and 1425, in which the quirks and oddities of natural forms are made subservient to a fluent stylization, answering decorative needs. In it a secular feeling infects even the most devotional works, and religion can seem almost a facet of chivalric romance. Its elegant idiom reflects the sophisticated, cosmopolitan life of the feudal courts of Europe – in Prague, the capital of Bohemia, where the Holy Roman Emperor was based; in the courts of his vassals up and down Germany; in Paris, the French court, outshone in splendour by the courts of the King's relatives in Berry and Burgundy; in the Spanish courts of Aragon and Castile and the English one at Westminster.

In the richer courts kings, princes and aristocrats moved in often outlandish costumes amid costly, flimsy pageantry in an atmosphere of unreality. Art, literature and life were clouded with the visions of troubadour poems, miracles and knights in search of the Holy Grail, which disguised the realities of politics, commerce and war. The precious surface of International Gothic immaculately conceals the travails of profound change – the dissolution of the feudal system it served.

The little portable altarpiece known as the Wilton diptych is an exemplary masterpiece in this style. The diptych is of exquisitely assured quality, the work of a great master, yet his identity and even his nationality are unknown. Its date is the object of continuing learned controversy, estimates ranging between 1377 and 1413; the subject matter is English, but is the painter English, French, Netherlandish, Italian or even Bohemian? The king, in a rich red robe offset by ermine white, attended by his three patron saints, kneels in adoration of the Virgin and Child. They, in their heavenly blues, sway graciously towards him in blessing, from a paradisal meadow of flowers and a thicket of angels' wings. The figures are ranged like a frieze against the stippled gold of the background: kneeling king and Madonna are on the same level, out of time and this world. Though the setting is unreal, the images are minutely and vividly realized, and even in the midst of this almost fairytale religion there is evident the growing fascination of the Gothic mind with the here and now.

UNKNOWN ARTIST (right) The Wilton diptych, c. 1377-1413 The saints, John the Baptist, Edward the Confessor and St Edmund, are vividly individual, while King Richard II, whose emblem, a white hart, is worn by the angels, is demonstrably a physical likeness. After a gap of centuries, realistic portraiture is becoming established.

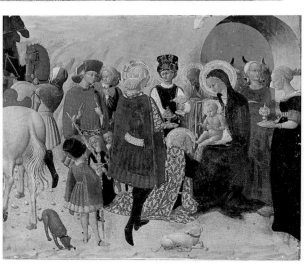

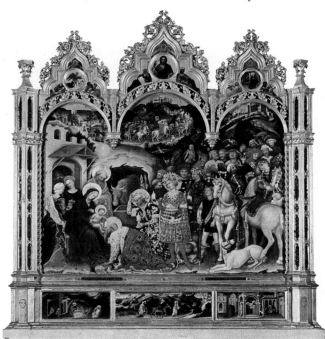

GENTILE DA FABRIANO (left) The Adoration of the Magi, 1423 Courtly, chivalric and jostling with finery, Gentile's pageant shows that he shared Masaccio's interest in rendering the fall of light. But most figures are crowded into the foreground, and not set in a definable space.

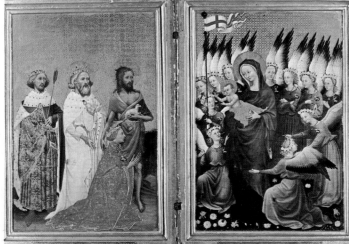

SASSETTA (right) The Adoration of the Magi, c. 1430? Despite Gentile's impact, evident in the figures' gestures and grouping, Sassetta's economical and direct approach is perhaps nearer to the poetic simplicity of Fra Angelico (see p. 108).

PISANELLO (right) Horses, undated Pisanello's countless studies of men, women, animals and costumes were filed in workshop copybooks. Hence some details recur again and again, copied not from life but from drawings. Pisanello had influence in Venice (see p. 122).

PISANELLO (left) St George and the Princess, detail, c. 1435 While sharing Gentile's decorative approach, Pisanello infuses fantasy with solid fact: there exists a sheet of studies of hanged men, the basis for the one on the left.

PISANELLO Filippo Maria Visconti, 1440 With this portrait Pisanello first achieved that perfection of design and refinement of execution for which his bronze, silver and gold medallions were internationally famous.

Though subject to many local variations, the draughtsmanship of the International Gothic style reflects Italian tradition, especially that of Sienese painting. It is not a long step from Simone Martini's *Annunciation* (see p. 84) to the Wilton diptych. There was, too, an Italian version of the style, not only in cities ruled by kings or despots (such as Naples or Milan) but also in the republics: its ablest exponent, Gentile da Fabriano (*c.* 1370-1427), worked in Venice, Florence, Siena, Orvieto and Rome. In its wealth of detail, its delight in mannered pose and richly idiosyncratic costume, Gentile's work is very like that of the northern painters. Though he worked in Florence, the exploration of spatial problems pioneered by Masaccio (see p. 104ff.) at almost the same time interested him scarcely at all. Gentile's influence was as great as Masaccio's; it was decisive on Masaccio's partner, Masolino, on Gozzoli (see p. 110) and on Botticelli (pp. 116ff.); indeed, it persisted almost throughout the early Renaissance period. Gentile also influenced the charming, lyrical, rather archaic art in Siena of Giovanni di Paolo and Sassetta (*c.* 1400-50), but his true heir was Pisanello (*c.* 1395-1455/6), with whom he col-

laborated in Venice. Pisanello began in Verona perhaps as pupil of Stefano da Verona (*c.* 1375-after 1438), whose *Virgin in a rose garden* is a quintessential expression of International Gothic, in style as in iconography. Within an elaborate design and a vision of magical, almost surreal fantasy, Pisanello exercised an accuracy of observation and drawing that could be almost clinical. The same precision recurs in his portrait medals, which revive an antique form but are entirely original in feeling and have never been surpassed in quality.

The Gothic style was sustained into the fifteenth century throughout Europe, from Spain to Germany. In Germany the Master of the Upper Rhine, active about 1420, takes his imagery so far that the Virgin could be reading a poem of courtly love to her attendants, rather than a prayerbook. In Bohemia Master Theodoric (active 1348-70), a rather idiosyncratic artist, echoes the coarse solidity of some French painting. Bohemia was a thriving, influential centre. However, the zenith of International Gothic imagery in painting was reached by the illuminators of Books of Hours for the courts of Paris and Bourges.

Many of the artists most successful in this

field were of Netherlandish origin, who, settling in France, infused the elegance of the French court style with naturalistic detail. Already in the illuminations of Jean Pucelle (*c.* 1300-*c.* 1355) an interest in naturalism (and also in the composition and space of Duccio) was evident. By about 1400 the illustrations were ceasing to be involved with the text, and became, in the Books of Hours, full-page, self-sufficient, differing from easel-paintings only in their medium and scale. Books of Hours were manuals of devotion arranged according to the time of the day and the date; as "aids to gracious praying" they became objects of great luxury. The finest talents illuminated them, including masters such as Jacquemart de Hesdin in Bourges; André Beauneveu, better known as a sculptor; the Boucicaut Master (see over); and above all the three Limbourg brothers, Pol (died 1416), Jean and Herman, who in two famous manuscripts for the Duke of Berry, the *Belles Heures* and the *Très Riches Heures*, produced some of the major masterpieces of the closing of the Middle Ages. Not only courtly occupations such as falconry are shown, but also the genre activities of peasants, with marvellous precision and colour.

STEFANO DA VERONA (left)
The Virgin in a rose garden,
c. 1405-10
The medieval enclosed garden is filled to the brim with detail and colour, and tilted forward in order to display it all. The walled enclosure, bearing fruit or flowers, symbolized the Immaculate Conception.

THE MASTER OF THE UPPER RHINE (below)
The Garden of Paradise,
c. 1420
Naive joy and an almost familiar intimacy give the work its charmingly provincial character. The small round heads are a distinct leitmotif of Rhenish Gothic art.

MASTER THEODORIC (left)
Charles IV receiving fealty, detail of frescos in Karlstein Castle,
c. 1348-70
Theodoric's rather doll-like, homely figures are modelled solidly in light and shade. This detail is part of a huge cycle, filled with portraits.

PUCELLE (below)
The Belleville Breviary: *Strength and Weakness*,
c. 1325
Pucelle's solid naturalism (reflected on a larger scale by Master Theodoric) is attributed to a visit to Italy. But in format and style he develops Master Honoré (see p. 77).

THE LIMBOURG BROTHERS (left) *Les Très Riches Heures du Duc de Berri: February*, 1413-16
The Limbourgs' sophisticated technique places them on the borderline between Gothic and the new 15th-century realism (see over). They set out a coherent perspective with airy delicacy.

Netherlandish Art 1: Sluter and the van Eycks

In the fifteenth century, both north and south of the Alps, artists succeeded in transcribing the facts and details of the natural world convincingly, in wood or stone, in tempera or in oils. An interest in decorative detail develops into a determination to render nature objectively and with consistency. The things shown have an importance of their own: they are no longer secondary to the demands of pattern or to the need to project sacred figures in hieratic form. The flat surfaces of paintings are given a luminous depth. However, particularly in the north, symbolic meanings are hidden in the naturalistic forms. Plants, fruits, furniture and buildings, carefully reproduced in a real world, in real space, are invested with religious significance.

The Netherlands, the vital centre of realism in the north, passed in 1387 under the control of Duke Philip the Bold of Burgundy, but the Netherlandish cities, rich in the trade of cloth, wool and linen, retained their own local government. When in 1420 Duke Philip the Good of Burgundy moved his court north from Dijon to Bruges, Netherlandish artists, enjoying twin sources of patronage – pious, prosperous merchants and what was briefly the most splendid court in Europe – came into their own in their own region.

The pioneers of the new realism had worked in Dijon, at the Chartreuse de Champmol, a Carthusian monastery patronized by Philip the Bold, between about 1394 and 1404. The painter Melchior Broederlam (active 1381-1409) is at first glance essentially of the International Gothic – elegant, dreamy, clearly aware of Italian example, particularly Duccio and the Lorenzetti – but his figures have an earthy solidity that is specifically northern. The revolutionary innovator was a sculptor, Claus Sluter (died c. 1406), Broederlam's exact contemporary at Champmol. In his work uncompromising realism is injected into the Gothic world, with scarcely any concession to rhythmic pattern and ornament. In the characterization of his figures he anticipates the psychological approach of Donatello (see p. 102) working 20 years later in Florence: the more than life-size prophets on his Well of Moses at Champmol have a similar presence and emotional intensity, and, as in Donatello, the bold, freely handled draperies are outward elements of an inner drama. Some of the mourning figures about Sluter's tomb of Philip the Bold, once also at Champmol, are invisible within their hooded draperies, and the heavy robes themselves become images of grief.

The first painter of the new realism clearly emulated the dense solidity of such sculpture as Sluter's. This master, the Master of the Mérode altarpiece, also called the "Master of Flémalle", is generally but still not universally identified as Robert Campin of Tournai (c. 1378-1444). In the work associated with him, the sharply defined bulk and mass of the figures and draperies have lost all trace of the aristocratic delicacy of International Gothic. In the Mérode altarpiece, for the first time the Annunciation, a supernatural happening, is set within a homely contemporary interior. The whole vision is related to the daily experience of the ordinary man. The angel may have wings, but neither he nor the Virgin is haloed.

Campin's *Annunciation* was painted about 1425; by then his slightly younger but far more famous and securely identified contemporary, Jan van Eyck (c. 1385-1441) was fully active, while by 1426 Jan's mysterious brother, Hubert, was already dead. Jan was the appointed court painter to Duke Philip the Good, and seems to have had a close, personal relation-

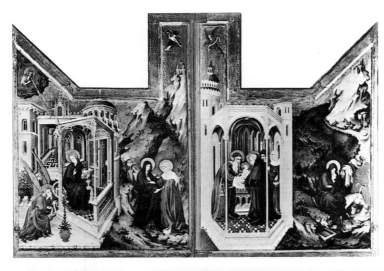

BROEDERLAM (left)
Scenes from the life of Mary, c. 1394-99
The sharply receding architectural boxes are composite interior-exteriors: the formula is still that of Ambrogio Lorenzetti's *Presentation* (see p. 85). What is new is the symbolism residing in apparently ordinary objects: the three windows by God the Father in *The Annunciation* signify the Trinity; the domed tower and walled garden are symbols of chastity; and there is much more.

SLUTER (right)
The Well of Moses, detail: *David* and *Jeremiah*, 1395-1403
The prophets and kings predicting the Passion once stood beneath a Crucifix, now lost; and Jeremiah once had metal spectacles. What remains is still powerfully realistic, rich in human feeling.

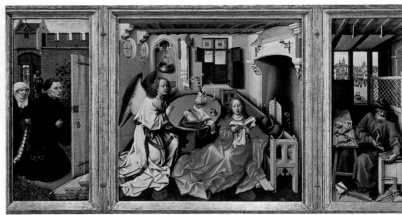

SLUTER
The tomb of Duke Philip the Bold, details: (above) *Mourners*; (above right) *Duke Philip*, 1385-1405
Sluter first worked on the tomb as an assistant to Jean de Marville (died 1389), and took over at his death. The mourners – the Duke's

vassals, officers and relations in funeral robes – are entirely his work, and strongly individualized. The Well of Moses, also in stone, was originally no less richly and vividly painted. Sluter's realism had wide influence; Gerhaerts (see p. 158) took up his mantle.

CAMPIN? (right)
The Mérode altarpiece: *The Annunciation*, c. 1425
The Virgin and angel seem somewhat clumsy, almost plebeian, though the room is comfortably furnished. The presence of objects – the shadows they cast, the stuff they are made of – is crucial to Campin.

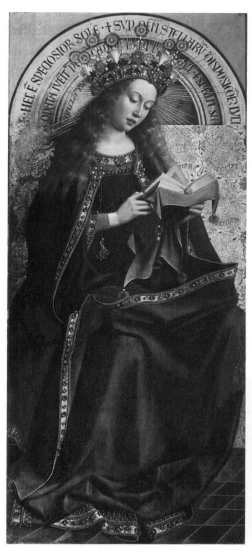

ship with his patron, travelling to Spain and Portugal on diplomatic missions. He clearly enjoyed a status and respect, and probably an income, previously not granted to artists.

Any approach to the van Eycks must centre on their huge altarpiece at Ghent. Its inscription, crediting Hubert with its inception and Jan with its completion (in 1432), is one of the very rare pieces of evidence that Hubert existed and was a painter, though distinguishing Hubert's work from Jan's remains highly speculative. The altarpiece is both large and complex. On the outside of the wings when closed there is an *Annunciation* and below it portraits of the donors, with their patron saints, represented as monochrome statues in niches; when opened, the central theme is revealed as *The adoration of the Lamb*. Though the altarpiece as a whole has many puzzling, even contradictory elements (which the dual authorship may explain), the overall impression of rich and vivid colour, the exactitude with which the appearance of the visible world is tirelessly rendered, the conviction with which the religious theme is translated into physical terms – these qualities make it a landmark in the history of Western art.

Of Jan's own undisputed work, *The Madonna with Canon van der Paele* (1436) represents his style at its most pure. Virgin, saints, and the minutely scrutinized head of the aged donor, solid as a weather-ravaged rock, are presented with a positively ruthless objectivity and completeness: they are held together by the unifying fall of light in a stillness and silence that is almost like a *trompe-l'oeil* waxwork. Though the command of perspective is intuitive and empirical rather than geometrically based as it was to be in Italy (see p. 104), it was quite convincing enough to convey the illusion of distance and depth as never before – whether internal, as here, or external, as in the extraordinary view through the arched window over a great estuary in *The Madonna with Chancellor Rolin*. There, even though the recession of the middle ground is not quite logical, the union of the figures with the setting is complete. Virgin and Child are no less physically present than the great Burgundian official acknowledging their divinity, perhaps not all that humbly – they seem to be visiting him, not he them. Not the least of van Eyck's achievements was the establishment of the modern portrait in its own right.

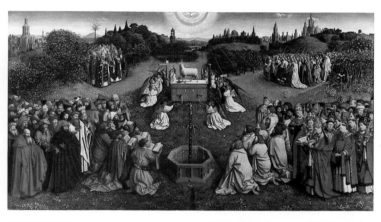

THE BOUCICAUT MASTER (below) *The Visitation*, c. 1405
The Book of Hours from which this page comes, and the man who painted it, take their name from its owner, a commander under the French king. The sky and hills show aerial perspective, the changing light and colour suggesting distance.

JAN AND HUBERT VAN EYCK (above)
The Ghent altarpiece open, detail: *The Virgin*, c. 1426-32
The contrast between the van Eycks and, for instance, Campin or the International Gothic Boucicaut Master is startling; though their aims are similar, the others lack the van Eycks' technique.

JAN AND HUBERT VAN EYCK (above)
The Ghent altarpiece closed, detail: *The Virgin Annunciate*
The round, Romanesque arches symbolize the old order; the trefoil, Gothic windows stand for the new, borne in by Christ's birth.

JAN AND HUBERT VAN EYCK (above)
The Ghent altarpiece open, central panel: *The adoration of the Lamb*
Saints, prophets, virgins foregather to adore. The individual heads, the grass spread with flowers like a tapestry, the glow of light on the horizon are notable.

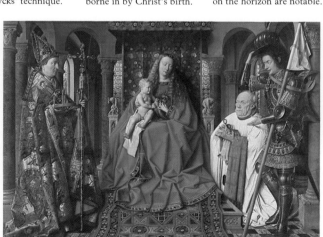

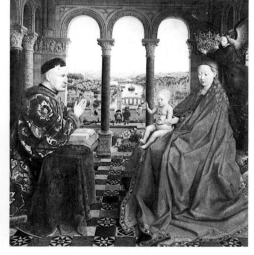

JAN VAN EYCK (left)
The Madonna with Canon van der Paele, 1436
In the wealth of minutely rendered detail – of the architecture, draperies, throne or carpet – there is a carefully calculated, often obscure, symbolism. The light is all-pervasive.

JAN VAN EYCK (above)
The Madonna with Chancellor Rolin, c. 1435
Jan must have refined the use of oils as a vehicle for the pigment, so that he could build the painting up slowly in thin glazes, to achieve subtle modelling and atmospheric luminosity.

Jan van Eyck: The Arnolfini Marriage

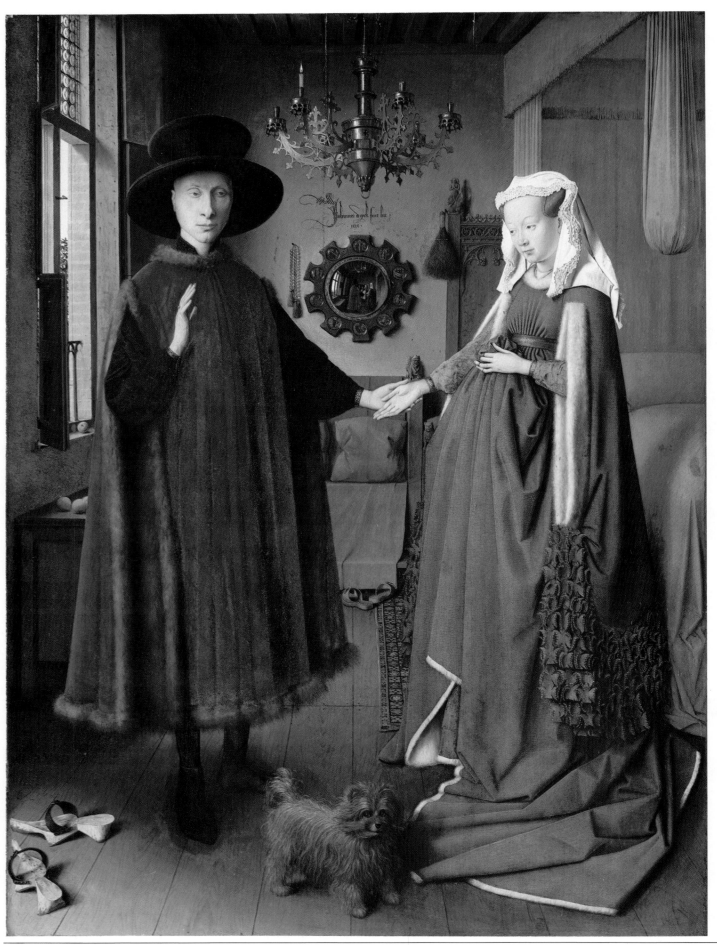

JAN VAN EYCK (right)
Giovanni Arnolfini,
c. 1437
Arnolfini's modest but
warm attire (van Eyck
superbly conveys the
texture of heavy wool)
marks him as a prosperous
bourgeois merchant. He
had court connections,
through which he must
have met and become
friendly with van Eyck.
He became a counsellor
to the Duke of Burgundy,
and advanced him money.
(It is generally accepted
that the sitter here and in
the *Marriage* is Giovanni
Arnolfini, but this is not
absolutely certain.)

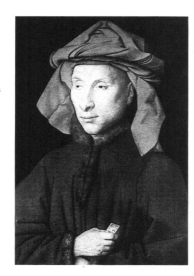

JAN VAN EYCK
(opposite page) "*The
Arnolfini Marriage*", and
details: (above) the mirror;
(left) *St Margaret*, 1434
St Margaret was said
to have escaped from the
belly of a dragon: hence
her role as patron saint
of childbirth. (Giovanna
is quite possibly pregnant.)
The ten roundels of the
mirror show scenes from
Christ's Passion, solem-
nizing the oath-taking.
The mirror indicates
things existing outside
the picture's limits, and
in the 17th century, when
van Eyck's picture was in
Madrid, Velazquez saw
and used the device in his
"*Las Meninas*" (see p. 210)
– complicating further
van Eyck's metaphysics
of illusion and reality.

Within a room of some luxury, Giovanni di
Arrigo Arnolfini and Giovanna Cenami stand
side by side. Her right hand rests on his left,
and his right hand is raised as if to confirm a
vow. They are being betrothed, or perhaps
married. The year is 1434.

It seems that the painter Jan van Eyck, a
friend of Giovanni Arnolfini, a silk merchant
from Lucca in Tuscany who had settled in
Bruges, attended, and recorded the event with
documentary, even legal precision. The signa-
ture, *Johannes de Eyck fuit hic 1434* (Jan van
Eyck was here 1434) is written in a careful
Gothic script, as though he were inscribing his
name as an official witness to the ceremony,
and it is placed above a mirror in which two
figures are reflected, one presumably the pain-
ter, the other a second witness. It is as if the
picture were painted for posterity, as if the
artist knew full well that in 1534 or 1634 he
would not be there, but others would be.

The painting is not, however, a literal record
of a real event, for it is rich in symbolism,
unobtrusive but explicit, though more readily
understood by his contemporaries than by us.
Many details illuminate the significance of the
event, the married state as a continuing human
sacrament. The candle, lit in full daylight, was
not only a necessary prop in the ceremony of
oath-taking, but was a "marriage-candle", a
flame emblematic of the ardour of newly-weds.
The dog was a symbol of marital faith. The
fruit on the window-sill and the crystal beads
beside the mirror are taken over from the
symbolism surrounding the Virgin Mary. The
little figure carved above the back of the chair
is St Margaret, patron saint of childbirth.

This little painting, about 80 × 60 centi-
metres (32 × 23½ in), has become one of the
most famous masterpieces of Western art, a
celebration of a human relationship as vital
today as it was five and a half centuries ago. It
was then astonishingly original – in presenting
full-length portraits confronting the onlooker;
in siting them in a domestic interior without a
religious context; in introducing narrative, and
even genre, elements into a double portrait.
For the picture is also an inventory of objects
lovingly described – the discarded shoes, the
little dog, the fruit; the planked floor, the
grandly intricate brass candelabra; the rich
texture and glowing colours of materials. All
these, ranged in immutable order, comple-
menting the calmly tender central figures and
extending their symmetry, are fused into the
serene composition of the whole by that per-
vasive light, welling from the window.

The picture is the summit, but not the
whole, of van Eyck's revolutionary achieve-
ment in portraiture. His single portraits reveal
a human approach that is quite new; with
modestly posed head and shoulders, the sitters
are seen for themselves and themselves alone.
Their faces (that of the *Man in a turban* may be
van Eyck's own) are intensely scrutinized –
one, at least, preceded by a silverpoint drawing
of vivid delicacy, certainly from the life – but
again the inventory of detail is modelled into
harmony, each item precisely related to the
others. The secret is the accuracy with which
the light is realized, with a subtlety and
flexibility which the refinement of the oil
medium allowed for the first time.

JAN VAN EYCK
A man in a turban
(Self-portrait?), 1433
The day, month and year
are written on the frame,
with van Eyck's motto
"Als Ich Kan" – as I
can (but not as I would).
He seems conscious
that his art will outlive
him – reviving a theme
of classical poets.

JAN VAN EYCK
(above and below)
Cardinal Albergati,
c. 1432
The study for the oil
portrait is a drawing
in silverpoint, that is,
using silver wire on
paper specially prepared
to take its impression.
Notes for the colours are
on the drawing; has the
oil been slightly idealized?

Netherlandish Art 2: Rogier van der Weyden

The dominant figure in Netherlandish painting in the middle years of the fifteenth century was Rogier van der Weyden (1399/1400-64). He was most probably the "Rogelet" (little Roger) documented in Robert Campin's workshop in 1427, for his work certainly reflects Campin's style, though it draws also on Jan van Eyck's. He soon settled in Brussels, and in 1435 was appointed city painter. He visited Ferrara in Italy about 1450, and his works became widely known throughout Europe in his own lifetime. Many exist in several versions – witness both to his popularity and to the assistance of a large workshop.

Rogier van der Weyden's work is characterized by an intense emotionalism, expressed in flowing and dynamic line, which is alien to both Campin and van Eyck. It has been seen as a reversion to Gothic; certainly his calculated appeal to the emotions is paralleled in German art, which persisted into the fifteenth and even the sixteenth century in a recognizably medieval, late Gothic tradition. Rogier, however, whole-heartedly embraced the realism of Campin and van Eyck, and if his grieving figures weep tears, the tears glisten naturalistically. Rogier's vision, like Campin's, ex-

presses the religious sentiment of the ordinary man, but sharpened and deepened by the *devotio moderna*, a spiritual revival initiated in the Netherlands and strong also in Germany. Its textbook was *The Imitation of Christ*, a manual of meditation first appearing in 1418, ascribed to Thomas à Kempis.

Van der Weyden's art is in many ways a critical revision of the work of his two great elder contemporaries. His early *St Luke painting the Virgin* was consciously based on Jan van Eyck's *Madonna with Chancellor Rolin* (see p. 91) – two figures are again placed in a room

overlooking a river, and even van Eyck's two little figures peering over the balustrade reappear. In contrast to van Eyck, Rogier introduces an emotional relationship between his two main characters, creating a gently curving movement echoing from one to the other. Both figures are seen with an involved and tender humanity, far from the objective detachment of Jan's descriptions. The Virgin suckling a child is entirely a mother; the Child crisps fingers and toes with pleasure. Beside the fantastic detail of van Eyck's landscape, van der Weyden's view seems fairly summary,

VAN DER WEYDEN (below)
St Luke painting the Virgin, c. 1434-35?
St Luke's pose looks better suited to an angel in an *Annunciation*, and not very appropriate for drawing. The Madonna is in type like Campin's but the handling is softer more like Jan van Eyck's.

VAN DER WEYDEN (right)
The Deposition, c. 1435
The actors are set out like sculptures on a stage (such life-size tableaux were not unusual), yet overriding a sense of weight or solidity in the figures there is a dominant, dynamic line. The emotion is tragic, yet tenderly resigned.

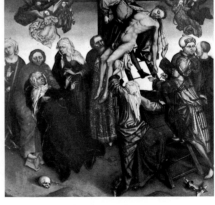

VAN DER WEYDEN (below)
The Last Judgment, c. 1450?
In contrast to the Ghent altarpiece, the single subject continues over the panel divisions. All detail has been pared away. St Michael with the scales advances irresistibly, cleaving Saved from Damned.

AFTER CAMPIN (right)
The Deposition, central panel, c. 1430-35?
Campin's composition no longer exists in its original huge scale, but the impression it made is recorded. Van der Weyden reversed Christ's position, flattened out the figures and characteristically concentrated the effect.

and the two little figures are made more strongly the focus of attention.

Perhaps van der Weyden's best-known masterpiece is his *Deposition* in Madrid. For this the starting point was surely a famous huge *Deposition* by Campin, of which a fragment survives, but which is known in full only in a small copy. From Campin Rogier took over the scale – his figures are almost life-size – the use of a gold background and, above all, the frieze-like disposition and sharp, sculptural definition of the figures. Campin's composition has been superbly simplified – the expressive curving diagonals of the dead Christ and his fainting Mother are held in balance by the central stark vertical of the Cross behind and by the protective sway of the figures at each side. Colour is used to heighten the tragedy: on the left it is in a sombre key, then breaks into agitation in the gold and red of the stricken Nicodemus and the multicoloured garb of Mary Magdalen on the right.

Van der Weyden's enormous *Last Judgment* at Beaune seems a response to the challenge of the van Eycks' Ghent altarpiece. Rogier succeeds in treating a similar compositional problem with much greater unity and monu-

mental effect. This suggests an Italian influence, although it was probably begun before Rogier went to Italy; such an influence is specifically visible in his *Madonna and saints* at Frankfurt, arranged like a *sacra conversazione* (see p. 107) of Italian tradition, uniting saints and Virgin in a tiered semicircle. An *Entombment* (not shown) in Florence is clearly connected with a similar subject by Fra Angelico.

In his portraiture, van der Weyden continued the themes established by van Eyck, but was again more sculptural in feeling: the planes of his faces are more sharply cut by light focused from the side or front, rather than diffused from slightly behind the sitter. There is, too, a greater decorative feeling, as in the transparent linen head-dress of the woman in the portrait in Washington. His people are still, tinged with a pensive melancholy.

The two other important artists active in the mid-fifteenth century were Petrus Christus (died 1472/3) in Bruges and Dirk Bouts (died 1475), working mainly, it seems, in Louvain. Christus was the painter nearest in style and talent to van Eyck, but his drawing is less decisive and he tends to simplify that all-embracing, all-accounting vision. His portrait

of Edward Grimston (1446) is a charming but relatively generalized account of the sitter's likeness; it is novel in setting a head and shoulders against an interior. His *St Eligius with two lovers* (1449), a visual inventory of a goldsmith's shop, is much in the spirit of van Eyck, but, while it has again a novel element – a hint of genre story-telling – it is weaker in drawing and rather cluttered in composition.

Bouts' style seems nearer in feeling to that of Rogier van der Weyden, though lacking his dramatic intensity. His use of colour was highly individual, while his delight in landscape was stronger than Rogier's. His masterpiece, *The Last Supper* (1464-68), illustrating the institution of the Eucharist, is drawn out with solemn precision in true geometrical perspective, with Christ, mild and patient, exactly central. The elongated proportions of the figures are typical of Bouts, and will recur in the work of his followers, such as Justus of Ghent. Bouts' little *Young man* of 1462 has a similar modest, calm and reserved quality, extending the innovation of Christus' *Grimston* to show a landscape glimpsed through a window; but the modelling and lighting of the face is far subtler and more minute.

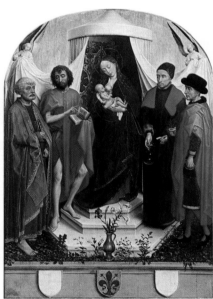

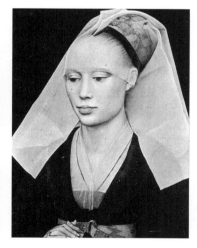

VAN DER WEYDEN (left)
A young woman, c. 1440?
Her head-dress, bare temples and low-cut bodice mark the lady as noble, perhaps of the Burgundian court. The portrait is calm, simple, serene and respectful.

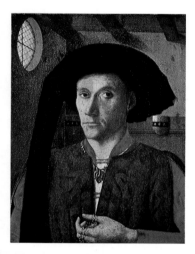

CHRISTUS (right)
Edward Grimston, 1446
In the manner of van Eyck, there is an attempt to trace the fall of light from the window on to the sitter. The device of placing in the hand a symbol of accomplishment or rank is persistent in 15th-century portraits.

VAN DER WEYDEN (left)
The Madonna and saints, c. 1450
Cosmas and Damian, the Medici patron saints, appear on the right, and the arms of Florence beneath: this was surely an Italian commission.

BOUTS (right)
The Last Supper, central panel, 1464-68
Bouts was commissioned by the Confraternity of the Holy Sacrament in Louvain – hence this subject. The emotion is quiet, like the quietness during the Elevation of the Host in the Mass.

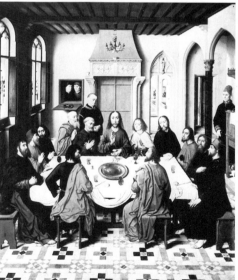

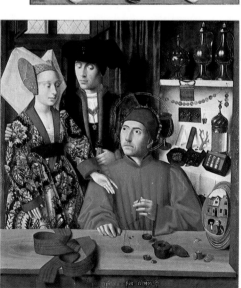

CHRISTUS (left)
St Eligius and two lovers, 1449
Objects are rendered as scrupulously as Jan van Eyck's – even pedantically – and surely have symbolic significance (now obscure); the couple have come to the saint to buy a ring.

BOUTS (above)
A young man, 1462
The pose has an engaging touch of awkwardness or uncertainty. The hands rest as if upon the edge of the frame, a typical illusionistic device.

Netherlandish Art 3, and its Diffusion

The legacies of Robert Campin, Jan van Eyck and Rogier van der Weyden were taken up and amalgamated by Hugo van der Goes, in his brief but fruitful career in Ghent between about 1464 and 1482. In 1482 he died in a monastery, an insane melancholic, and the legend is recorded by a contemporary that he was driven mad by his inability to match the perfection of the van Eycks' Ghent altarpiece, although his own contribution established him securely as one of the greatest masters of early Netherlandish painting.

His Monforte altarpiece, probably of the early 1470s, shows Hugo fully mature. It is perhaps the most relaxed of his major works, painted with superb delicacy in very rich colours. His masterpiece is the Portinari altarpiece (finished before 1476), showing *The Adoration of the shepherds*. Here the colour is more subdued, and the mood is full of awe and even disquiet. The painting is very large, some six metres (19ft) wide including the wings, and full of minutely observed detail – examine the variety of texture of the garments, the still life and the modelling of the figures, faces and – Hugo's speciality – hands. The gentle hills and chill winter trees and sky in the right-hand wing constitute the most beautiful landscape painted in the north in the entire fifteenth century. Despite the naturalism, older traditions are drawn upon – the disparity of scale between the figures; the Gothic angels in elaborate fluttering robes, which contrast with the still birds in the bare trees; above all, the pervasive symbolism. The flowers, the birds, the colours of the draperies, the cornsheaf, Joseph's discarded gloves and shoes – almost every detail hints at an episode in the Old Testament or in Christ's life to come. All these, but especially the figures, have an extraordinarily intense, or charged, presence, and in what is probably Hugo's last major work, *The death of the Virgin*, the undertones of anxiety in the Portinari altarpiece have sharpened to utter psychological disorientation.

The second major centre of art in the latter half of the century was Bruges. There Hans Memlinc (*c.* 1430/40-94) became the most successful and prolific painter, working primarily for a prosperous merchant clientèle. He was born in Germany, and is believed to have

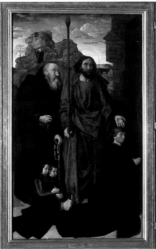
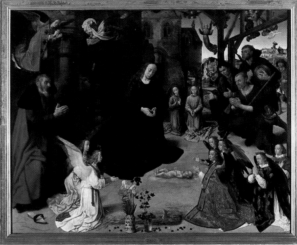
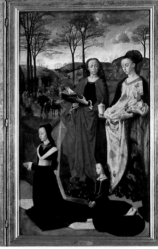

VAN DER GOES (right)
The Portinari altarpiece:
The Adoration of the shepherds, c. 1474-76
The figures seem heavy with the sorrows awaiting Christ and his Mother. The Child is tiny and isolated; the spacing of the figures is oddly unsettling. The earthy naturalism of the shepherds particularly impressed the Florentines when the altarpiece was installed in the city in 1483, and Ghirlandaio copied them in one of his frescos. The violets strewn in the foreground are among many details invested with symbolic meaning: they were associated with Lent, when they flower, and thus with Christ's Passion.

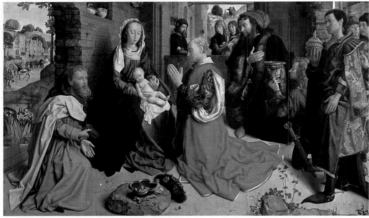

VAN DER GOES (left)
The Monforte altarpiece:
The Adoration of the Magi, early 1470s
The setting is a ruined Romanesque building, rather than the decrepit stable favoured by Campin. This is Eyckian symbolism: Romanesque architecture symbolizes the old order (and ruined, its passing); Gothic symbolizes the new. The superbly painted landscapes are an advance even on the aerial perspective of Jan van Eyck. The top of the picture, where angels once hovered, is missing.

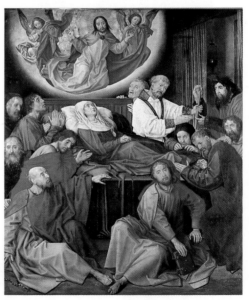

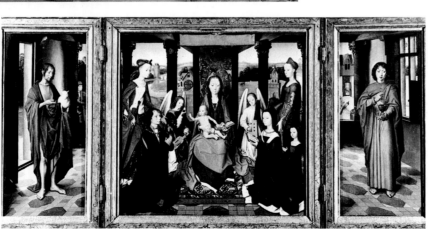

MEMLINC (left)
The Donne triptych:
The Virgin and Child with saints and donors, c. 1480
Memlinc's understatement has been little understood: this used to be thought an early work. In fact it shows his bland, undramatic style in its maturity. Sir John Donne, who ordered the work, travelled from England to Bruges on several occasions.

VAN DER GOES (above)
The death of the Virgin, c. 1480
The apostle in the foreground, staring wildly out of the picture with his head-dress askew, is extraordinarily expressive of a world gone awry. Each apostle is an isolated individual, unable to offer his neighbour comfort. The colours have become strange, and ring harshly.

started in van der Weyden's workshop. In contrast to van der Goes, his style is almost bland, but consistently and flawlessly proficient, maintained by a large and well-run workshop. Memlinc's unobtrusive artistic personality has led to an undue depreciation of his achievement. The Donne triptych (probably of about 1480) is typical: calm and meditative, Madonna, saints and kneeling donors are all upright and symmetrical; there is a hint of music from one attendant angel, and the orderly countryside rolls away beyond. But his portraits are his most characteristic contribution: more than 25 are known. Often forming one half of a diptych, adoring a *Madonna* on the other half, they have always an air of composed contemplation, like lesser saints in their niches. They are unidealized, though the sitters are seen no doubt "at their best".

The diffusion of the Netherlandish vision through Western Europe in the fifteenth century was almost as pervasive as the Italian was to be in the sixteenth. Jan van Eyck, van der Weyden and van der Goes were all patronized by members of the Italian merchant community in the trade centres of Flanders, and their works were known and valued in Italy. A

friend and associate of van der Goes, Justus of Ghent (active *c.* 1460- after 1475) migrated to Italy, to work for Federigo da Montefeltro at Urbino; such immigrants disseminated Netherlandish oil techniques. In the 1470s Federigo seems also to have employed the Spaniard Pedro Berruguete (active 1474-1503: the portrait of Federigo attributed to him is reproduced on p. 112). Netherlandish influence was particularly strong in central Spain, coalescing with the native taste in a distinctive Hispano-Flemish style. In England, by the end of the century, a pale imitation of Netherlandish painting was dominant; but in Germany the vigorous realism of the Netherlands took firmer root and was practised by individual artists of great quality.

In the middle Rhine area, Stephan Lochner (active 1442-51), who is said to have trained with Campin, was the leading painter. Lochner acknowledges Netherlandish perspective and naturalistic characterization, yet is very sweet in colour and softly delicate in his draperies, and still often uses the Gothic convention of the gold background. But very Eyckian indeed was Konrad Witz (*c.* 1400-47), working in the upper Rhine area, Basel and

Geneva. His *Miraculous draught of fish* is set in a closely observed Geneva lakescape with a fascinating and meticulous rendering of reflection and even refraction in water.

In France, the disruption of the Hundred Years War inhibited patronage, but there emerged nevertheless in Charles VII's court one major artist, Jean Fouquet (*c.* 1420-81). He was in Rome between 1443 and 1447, and knew the work of early Renaissance masters such as Fra Angelico as well as he knew the realism of the north. His figures, in settings of classical architecture, are singularly pure and monumental, and drawn with wonderful mastery. He also illuminated manuscripts, in which he made remarkable experiments with perspective. In the south, at René of Anjou's court in Provence, Netherlandish influence was also felt, and the illuminator of *Le Livre du Cuer d'Amour Espris* (The Book of Heart Smitten by Love, completed *c.* 1465) applied Netherlandish techniques to scenes of allegorical romance with highly original results.

However, the most haunting image in French art of the period is on a traditional theme: "*The Avignon Pietà*" of about 1460 is at once harsh, austere and strikingly tender.

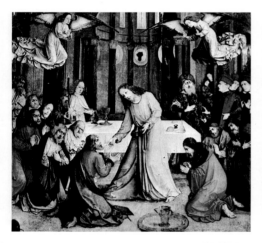

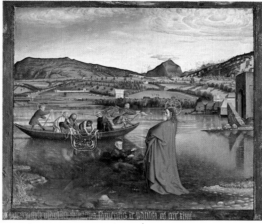

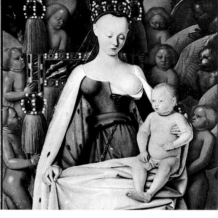

JUSTUS OF GHENT (above)
The Institution of the Eucharist, 1473-75
The elongated figures can be paralleled in van der Goes' and others' work, but may reflect Italian influence. Federigo da Montefeltro (with broken nose) appears on the right, copied from a medal(?).

LOCHNER (right)
The Adoration of the shepherds, 1445
The sweetness in the face of the Virgin, and in the animals and the angels, is typical of Lochner's brand of unworldly mysticism. All God's creatures seem gentle and lovable.

THE MASTER OF THE CUER D'AMOUR ESPRIS (right)
How Hope rescued Heart from the water, *c.* 1465
The *Cuer d'Amour* is a typically Gothic romance, but its illustrations are in the latest realistic style – observe the variety of trees round the Black Knight.

WITZ (above)
The miraculous draught of fish, *c.* 1444
Witz's lake is perhaps the first topographical land-

scape in Western art. His observation of light in water can be compared to Piero della Francesca's *Baptism* (see p. 110).

AVIGNON SCHOOL (right)
"*The Avignon Pietà*", *c.* 1460
That delight in rendering the texture of things, so typical of Netherlandish art, has been put aside; instead the figures are like painted wooden sculptures. They are posed life-size on a shallow stage in strikingly expressive silhouettes.

FOUQUET (above)
"*The Virgin of Melun*", *c.* 1450
The King's mistress is said to have posed for

the Madonna, though she seems built out of spheres; Fouquet must have learnt his obsession with three-dimensional form in Italy.

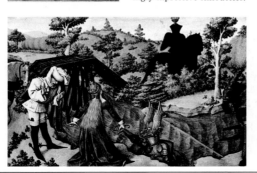

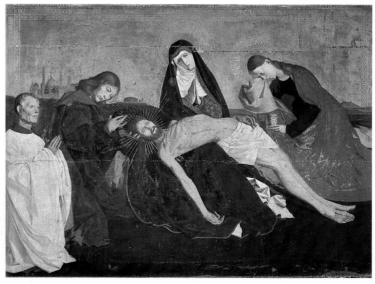

Bosch: The Garden of Earthly Delights

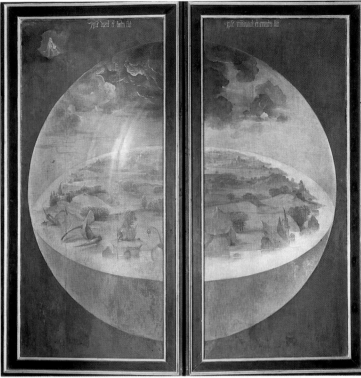

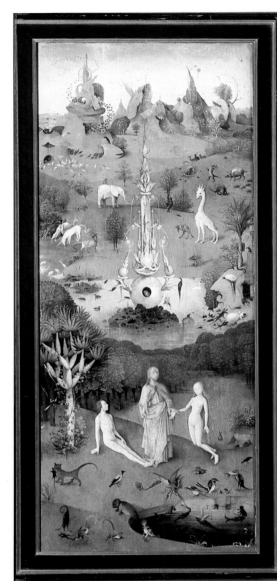

BOSCH (left and right)
The Garden of Earthly Delights, c. 1505-10

(left) with the wings closed:
The creation of the world
The world is housed in a crystal orb, like those often shown held by God the Father. He looks down on the third day from the top left: there are as yet no animals, only strange vegetable and mineral forms presaging those so weirdly and profusely developed in the interior of the triptych.

(right) with the wings open, left panel: *The creation of Eve*; middle panel: *The Garden of Earthly Delights*; right panel: *Hell*
The central panel at first glance appears innocuous enough: a light green landscape, nudes disporting, pinks and blues, touches of scarlet. At a closer view, it resolves into separate groups and zones, into a weird motley of animal, technological, humanoid and architectural apparitions, and the nature of the Delight becomes ambiguous and disquieting.

The Garden of Earthly Delights by Jerome ("Hieronymus") Bosch (active *c.* 1470-1516) is in many ways the last fling of the Gothic Middle Ages. It is a huge triptych, more than two metres (7ft) high, painted, incredibly enough, about 1505-10, when in Italy the High Renaissance had already begun. Bosch, however, seems indifferent to the rationalism and realism of north or of south; instead, the symbolism underlying so much Netherlandish art – Jan van Eyck's work, or Hugo van der Goes' Portinari altarpiece – seems in the *Garden of Delights* to have run riot, and become entirely detached from reality. Its grotesque and fantastic elements are akin to the *drôleries* in the initials or margins of illuminated manuscripts, or to the gargoyles of Gothic cathedrals. But its pessimism, and love-hate obsession with the world of the senses turned sinful and terrifying, are representative of a deep-seated strain in the Christian outlook. In his own day Bosch's work was widely disseminated in engravings.

When closed, the two wings of the triptych show in bird's-eye view *The creation of the world*. They open to show, on the left, Adam waking to see (with pronounced interest) the newly created Eve; in the middle, the Garden of Delights, with a lake at the top with a bulb-based fantasy in the middle, which some have seen as a parody of the Fountain of Life at the centre of the van Eycks' Ghent altarpiece; on the right, Hell with no hint of Heaven. Even in Adam's Garden of Paradise, a cat is disposing of a mouse, and the ritual frolics of the Garden of Delights itself are unremittingly ominous.

The meaning of it all is by no means clear. Some of the symbolism seems fairly intelligible even now – for instance, the recurring giant soft fruits, strawberries, raspberries, as a symbol of carnal appetite – and other details presumably had particular associations for Bosch's contemporaries. But though scholars have succeeded in penetrating the meaning of many objects in earlier Netherlandish painting, in the *Garden of Delights* the profusion of people, animals and things – real, legendary or the product of the artist's own fertile imagination – is baffling. The suggestion that the *Garden of Delights* is the visual manifesto of an heretical creed has been abandoned, not least because one of Bosch's greatest admirers was the ultra-Catholic Philip II of Spain. Psychoanalytical interpretation might seem more appropriate, but has not yielded definite results. Bosch's imagery had an immediate appeal to the Surrealists and their followers, but their hindsight is of little help in determining what meaning it had for Bosch.

However, virtually all we know of the man himself is the unsettling impact of his imagery. He worked in his native town of s'Hertogenbosch (Bois-le-Duc) apparently quite prosperously and comfortably: unlike van der Goes he was not an unusual citizen. Bosch's other compositions are not so unusual, though still unorthodox. In such paintings as *The Crowning with thorns* the evil physiognomies, exaggerating the earthiness of peasants' faces in earlier Netherlandish painting, are even comparable with some of Leonardo da Vinci's caricatures. There are hints of Bosch's strangeness in the usually charming paintings of Geertgen tot Sint Jans (Little Gerald of the Order of St John; active *c.* 1480-90) or in those of the so-called Master of the Virgo inter Virgines (active *c.* 1470-1500). Certain of Bosch's effects – notably the landscape elements in his work – are echoed in the work of Patinir of Metsys (see p. 160) and even the magic of Bruegel, though different, is not unrelated. However, the twentieth century's interest in Bosch is perhaps chiefly a reflection of its own interest in the Unconscious.

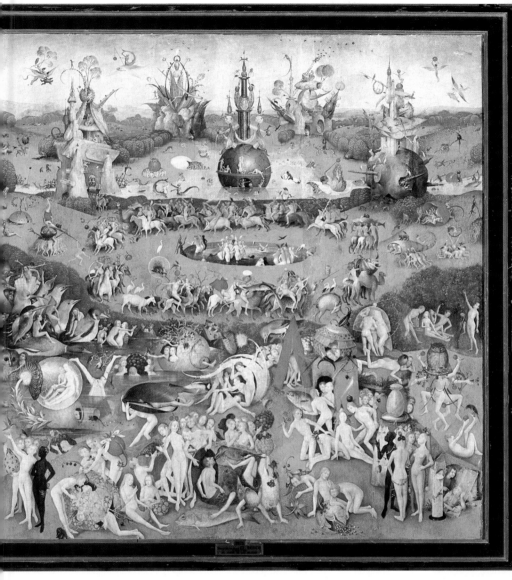

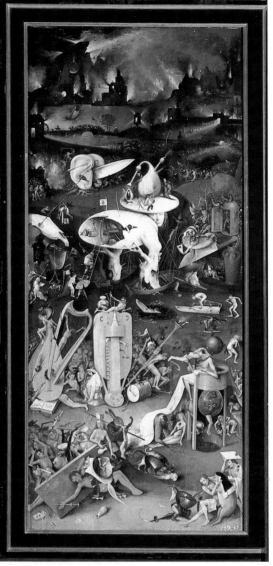

BOSCH (left)
*The Garden of Earthly
Delights*, right panel, detail
In the rest of the painting
the subject matter is extra-
ordinary, but the technique
conventional, even archaic.
Such a sinister night, lit
by terrifying eruptions,
had not been seen before,
and inspired imitations.

GEERTGEN TOT SINT JANS
(below) *Christ as the Man
of Sorrows*, c. 1490
Geertgen is perhaps better
known for painting one
of the earliest night-scenes,
a touching *Nativity*. But
here his theme of man's
inhumanity is a parallel to
the gloomy expectations of
Bosch, and cries penitence.

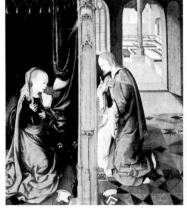

BOSCH (below)
The Crowning with thorns,
undated
The tormentors represent
the four "humours" –
phlegmatic, melancholic,
sanguine and choleric. The
picture seems related to
Geertgen's *Christ*, but the
symbolism and the enigma
are peculiar to Bosch.

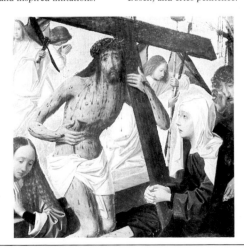

THE MASTER OF THE VIRGO
INTER VIRGINES (above)
The Annunciation, c. 1495
This anonymous master
painted probably in Delft.
His figures are somewhat
wooden and his pictures
joyless, though sometimes
harshly expressive. It is
this pessimism that offers
some parallel to Bosch.

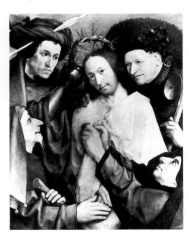

Italian Renaissance Sculpture 1

Unlike the terms Romanesque or Gothic, Renaissance ("rebirth") is not a label imposed by posterity on the past. It was the word used by fifteenth-century Italians to describe the revolution in thought and art of their own time. They were acutely aware of making a break with the past, and fervently believed that they were reviving, after the sleep of ages, classical values and true art.

A specifically Italian phenomenon, the Renaissance flourished – perhaps strangely – in small, newly rich, independent cities torn more or less continuously by internecine struggles. About 1400, some degree of cultural ascendancy among them passed to Florence, where a burst of civic pride stimulated a remarkable series of sculptural commissions for the Cathedral, the Baptistery and to line the outside walls of the church of Orsanmichele. A new breed of patrons emerged – prosperous merchant guilds or wealthy merchant princes, who sought an art that would reflect their city's pre-eminence and their own prestige. In this mood was merged the rapidly expanding humanist rediscovery of the pagan classics, with their emphasis on man, and its ideals were to be expressed in a changed conception of the human figure. In portraiture or landscape the Italian artists never rivalled the naturalism of Jan van Eyck or Hugo van der Goes. The original contributions of Renaissance art were intellectual in character – the study of anatomy, the rational analysis of proportion and the invention of geometrical perspective.

Filippo Brunelleschi (1377-1446) invented single-vanishing-point perspective, although the little paintings in which he first demonstrated it are lost. Its mathematics and theory were revised and propagated by Leon Battista Alberti (1404-72) in his handbook *On Painting*, published in 1435. Alberti was brought up in exile, and his book seems to have been prompted by the revelation of the recent art of his native city when he returned there in 1434. He also wrote on sculpture and architecture, and practised architecture; in his books a humanist method and outlook were applied to the arts for the first time, and the social and intellectual stature both of art and of the artist was inevitably improved.

A starting point for the rapid development of figure sculpture in Florence can be found in the competition set up in 1401 by the textile merchants' guild for designs for a pair of

Leon Battista Alberti
Alberti's architecture emulated the grandeur and scale of Roman imperial building. To painters and sculptors he gave a both practical and theoretical lead, setting forth in his books not only perspective formulae and proportional canons but also principles of style. This is a medal by Matteo de' Pasti, but two others are attributed to Alberti's own hand.

Filippo Brunelleschi
Brunelleschi's bold design for the dome of Florence Cathedral symbolized the enterprise of the city, and he was the initiator of Renaissance architecture. His invention of single-vanishing-point perspective is undated, but probably came in the early 1420s. His influence on sculpture (like Ghiberti, he was trained as a goldsmith) is hard to clarify, but was said to be seminal. Yet he was not a humanist like Alberti.

GIOVANNI PISANO
"The Ballerina", figure from the parapet of Pisa Baptistery, 1297-98
Giovanni's figure is a magnificent example of the Gothic style: a courtly sway, an exquisite grace animate the stone. This grace, rather than classical monumentality, is still the principle of Ghiberti's art.

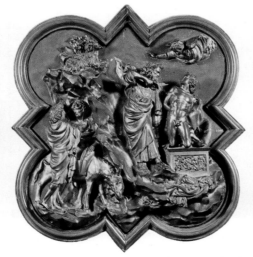

GHIBERTI
The sacrifice of Isaac, 1401
The action is clear, but unity and grace are equally important. The servants and the donkey, which the competitors were ordered to include, fit into the scene more easily than in Brunelleschi's version. In Ghiberti's favour, too, was that he used less bronze.

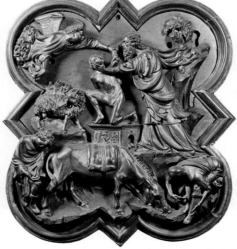

BRUNELLESCHI
The sacrifice of Isaac, 1401
Brunelleschi applies Giotto's principles: he states the action clearly and dramatically. There are also conscious classical touches, such as a Roman altar and a *spinario*, a boy removing a thorn from his foot; Ghiberti's references are more fluently absorbed.

GHIBERTI
Self-portrait, detail of the "Paradise" doors, c. 1450
Placed at eye-level, the portrait presupposes a new public interest in the artist, and Ghiberti was given an unusually free hand – "to execute (these doors) in whatever way I thought would turn out most rich, ornate and perfect", as he reports in his boastful autobiography. Born illegitimate, he was conscious that he had shaped his own career. The form of the portrait, a bust in a roundel, is antique.

ANDREA PISANO
Bronze doors on Florence Baptistery, 1330-37
Andrea's scheme set the pattern for the second set of the doors, of 1401, which had similar four-lobed Gothic frames, and foliage enlivening the surround.

GHIBERTI
The Annunciation, panel of the Baptistery doors, c. 1405-10
The grace and sway of the figures, recalling Simone Martini's *Annunciation* (see p. 84), are Gothic. There is, too, a sense of rushing movement, but controlled and harmonized.

GHIBERTI
The Flagellation, panel of the Baptistery doors, c. 1415-20
In the later panels the architecture becomes recognizably classical, and the figures more solid, better articulated in their movements. The grouping can become more complex.

GHIBERTI (left)
Joseph in Egypt, panel of the "Paradise" doors, c. 1425-47
The larger, square format was Ghiberti's own idea: with it he could make his reliefs work like pictures. Top right, his brothers sell Joseph into slavery; top left, Joseph, now the Pharaoh's Vizier, reveals his identity to them. But the significant details of the narrative are ousted by the crowd of "extras" from the foreground: this is not a passionate drama but a lavish, golden, epic fairy-tale – the architecture looks roofless like a stage-set, the figures posture in antique garments and in gestures borrowed from sarcophagi.

bronze doors to adorn the Baptistery, matching the earlier pair by Andrea Pisano. The young Lorenzo Ghiberti (1378-1455) won, beating Brunelleschi and the Sienese master Jacopo della Quercia. Both Ghiberti's and Brunelleschi's versions of the subject given, *The sacrifice of Isaac*, survive. Brunelleschi's solution is the more naturalistic, and certainly the more violent: Abraham, the terrified Isaac and the angel grapple impetuously. Each of the figures was cast separately and indeed the action as a whole seems applied to the surface, moving across it. In Ghiberti's relief only the naked Isaac was cast separately, and the composition moves with much more grace, not only across the surface but with a suggestion of depth. Ghiberti's is more of a staged tableau – his Abraham is nowhere near so committed to the appalling infanticide as Brunelleschi's – but the rhythms are more sophisticated and more successfully unite the composition. Ghiberti's solution is in fact a supremely skilful interpretation of the old, Gothic traditions, even though the naked Isaac is surely based on a classical torso.

The great bronze doors, incorporating 28 panels with scenes from the life of Christ, occupied Ghiberti and his studio from 1404 to 1424. During that period several great artists, including Donatello and Uccello, worked with him as apprentices or assistants. Following the project's completion, a second pair of doors was commissioned in 1425, though not finally completed till 1452: they became known as the Gates of Paradise. Here Ghiberti adopted a square framework, in which a more illusionistic and pictorial effect was possible. But there is still a strong International Gothic feeling for flow and rhythm, which is to be found, too, in Ghiberti's other works. Perhaps what most marks Ghiberti as a Renaissance man is his awareness of his status as an artist: he included vivid little self-portraits on both sets of doors, and wrote an autobiography.

There is a somewhat similar ambivalence between old and new in the work of Nanni di Banco (died 1421). While harking back to Gothic rhythms, he was nevertheless the most interested of all his contemporaries in the example of antiquity. In his masterpiece, the *Four martyr saints* for Orsanmichele, of about 1414-18, the figures anticipate the majesty of Masaccio's *Tribute money* in the Brancacci Chapel (see p. 106).

Jacopo della Quercia (1374/5-1438), unsuccessful in the 1401 competition for the bronze doors, moved on to nearby Lucca, then northwards to Ferrara; back again in his native Siena, he worked on a fountain (now badly weathered) and together with Ghiberti and Donatello on reliefs for the Baptistery font. A sculptor of great and sensitive talent, he, too, hesitated between the classical and non-classical; but in his latest work, reliefs for the Great Door of S. Petronio in Bologna (c.1425-35), his style found a coherence formidable enough to impress the young Michelangelo profoundly.

The output of sculpture in Florence in the early fifteenth century was prodigious. Many of the commissions went to the della Robbia family, an enduring dynasty founded by Luca della Robbia (1400-82). Their name is mainly associated with polychrome glazed terracottas, especially of *The Madonna and Child*, which continued to be popular till late in the sixteenth century. However, Luca's fluent work in stone, the *Cantoria* (Singers' Gallery; c.1430-38) for Florence Cathedral, still holds its own compared to the later, matching Gallery (not shown) by the greatest sculptor of the age, Donatello (see over).

JACOPO DELLA QUERCIA (right) The Great Door of S. Petronio, Bologna, c. 1425-35; (left) a relief from it, *The sacrifice of Isaac* Jacopo's later treatment of the *Sacrifice* is closer to Brunelleschi's than to Ghiberti's 1401 version. The massive, patriarchal figure of Abraham is made the hero of an epic drama. His drapery is typically full, rife with movement.

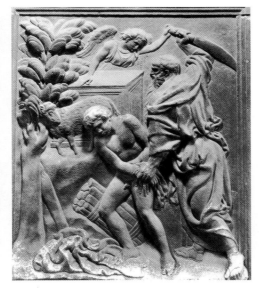

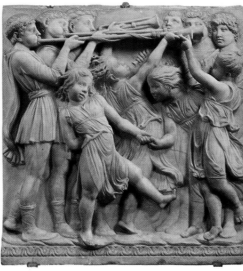

NANNI DI BANCO *Four martyr saints*, c.1414-18
The 14 niches round the square church (because once a granary) of Orsanmichele were allotted to the leading guilds. The desire of each guild to outdo all the others soon made Orsanmichele a showpiece of Renaissance sculpture, with works by Ghiberti, Donatello (see over) and later by Verrocchio. The saints' heads are so closely based on Roman styles that the models used can be guessed. A relief below depicts sculptors at work.

LUCA DELLA ROBBIA (left) *Musicians*, panel from the *Cantoria* (Singers' Gallery), c.1430-38
Though illustrating the text of Psalm 150, spelled out along the frame, the musicians recall pagan Bacchanalia. Luca was perhaps trained by Nanni.

LUCA DELLA ROBBIA (above) *The Madonna and Child*, c.1455-65
Such glazed terracotta roundels lent a touch of imperishable colour to the buildings they adorned. Sculpture in marble now ceased to be painted, but a love of colour persisted.

Donatello

Summing up the life and work of Donatello (1386-1466) a hundred years later, Vasari tells us that in Donatello the spirit of Michelangelo was pre-born. Certainly the similarities between the two Florentine sculptors are striking. Both were generous but formidable, not easily accessible personalities and dedicated artists, who early achieved a brilliant maturity. Both lived long lives, in which their search for emotional expression led them to remould and manipulate even to distortion the classical perfection of form they had recaptured.

Quite soon after he had completed his training under Ghiberti, some time after 1407, Donatello was producing works, rigorous in their nobility, that place him in the vanguard of the Renaissance. Already in his early figures he achieved profound psychological conviction, coupled with an unerring sense of theatre. His *St George* (c. 1415-17) is the second stride of Renaissance art after the 1401 competition for the bronze doors of Florence Baptistery. Originally helmeted and with a drawn sword in his hand, St George is a virile, handsome hero as naturalistic as any classical statue, but also alert; he does not move, but his face is so sharply formed, and his figure so sharply outlined against his large niche, that he seems ready to move. So in the S. Croce *Annunciation*, also life-size, also quite early, a stage is set out for the figures, which are cut so deep and quick they seem to act. The stern prophets Donatello carved (1415-36) to be set high up on the campanile of Florence Cathedral are placed with foot overlapping the niche or looking down in a calculated relationship to the spectator; the heads are broadly and forcefully cut to register from below, but their somewhat severe presence is expressed chiefly by the weight of their deeply cut draperies, which are unprecedentedly monumental.

Even more than *St George* himself, the little relief on the base of the statue draws the attention of art historians, for though blurred by weathering it seems to demonstrate for the first time rationally calculated perspective. With it Donatello also created an entirely new concept in the art of relief carving, producing within an actual depth of millimetres the illusion of a large receding space. The perspective is more complex in his gilt-bronze *Feast of Herod* relief for the font of Siena Cathedral, which anticipates Alberti's 1435 account of single-vanishing-point perspective

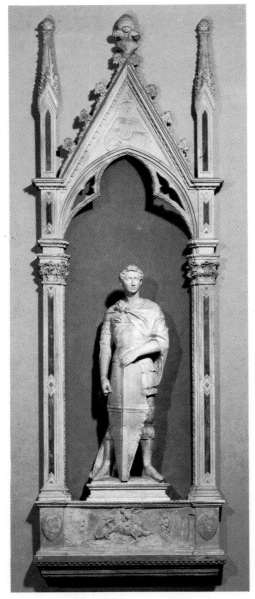

DONATELLO
St George, c. 1415-17
Standing in an unusually shallow niche outside Orsanmichele church, St George's life-size marble figure presents a striking silhouette, poised between defence and attack. On the base, the relief with *St George and the dragon* is the first instance of *stiacciato*, the use of such low relief that the surface of the stone is drawn upon rather than carved – suggesting by pictorial means an atmospheric distance.

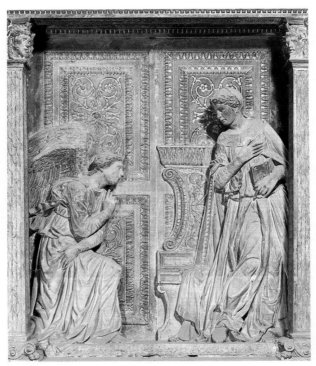

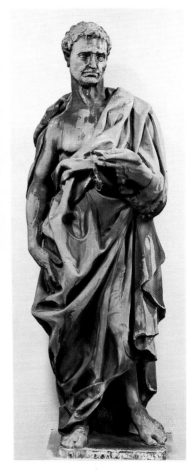

DONATELLO (below)
Jeremiah? 1423
Donatello's prophets for the campanile of Florence Cathedral are unsettling, unprepossessing figures, full of Old Testament fury. The unique drapery is not classical, nor Gothic.

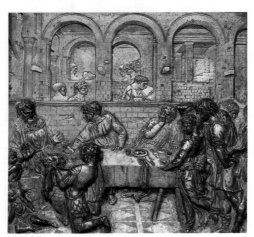

DONATELLO (left)
The feast of Herod, detail of the Siena Baptistery font, 1423-27
The architecture divides the action into three parts: while John the Baptist's head is brought in as if it were a dinner course in the rear, the musicians in the middle section are playing the accompaniment to the dance of Salome, who kicks back her foot on the right; on the left Herod and his fellow-revellers are polarized in shock as it arrives. Donatello makes calculated use of light and shade; the relief is below eye-level.

DONATELLO (above)
The Annunciation, c. 1430?
Carved in gilt *pietra dura* (grey sandstone), Mary and the angel are figures full of emotional insight: the timid, withdrawing Virgin suggests mingled humility and gratitude at God's awesome gift. But perhaps most striking at the time was the realism – Mary's twisting movement as she rises from her chair, the sensation of the angel's arrival. The whole makes a telling comparison with Simone Martini's Gothic, much more lyrical painting of the subject (see p. 84).

by about a decade, but the technique is more traditional: the closer figures are in higher relief, the more distant ones in lower. Here the severe logic of the lines of sight, spelled out by the tiles of the floor, is used to contain in strong tension the explosion of horror of the figures starting back from St John's head proffered on the platter. The mathematician is revealed as a consummate master of narrative.

For the modelling of the *putti* (not shown) round this same font Donatello drew on antiquity, but surpassed it in the vivacity and unconstrained ease of the figures. Smooth and fluid modelling characterizes above all Donatello's *David*, justly one of the most famous sculptures of the Renaissance. It is a controversial work. It has been dated early, since in its sinuous elegance there seem traces of Gothic, and it has been dated late, because its sophisticated concept suggests the sort of humanist outlook that informed Botticelli's mythologies (see p. 118). However, here for the first time is revived the free-standing nude of classical times, and with superb effect – from every angle the body is expressive, the silhouette compact and beguiling, the limbs resting from an implicit movement.

In 1443, perhaps dissatisfied with the opportunities in Florence, Donatello took up a major commission in Padua – a life-size bronze equestrian statue of the army captain Gattamelata. The *Gattamelata* has a simple and austere dignity the equal of the antique *Marcus Aurelius* (see p. 51) in Rome, but it has also a certain introspective melancholy, a strangeness of atmosphere and proportion that grew more marked in Donatello's work as he grew older. In Donatello's second Paduan commission, seven almost life-size bronze statues in the round and 22 reliefs forming the great altar of the "Santo" (S. Antonio), the severe Madonna, rising and advancing to show the Child for worship, has many classical features, and a suavity and naturalism the equal of the best Hellenistic examples, but also an unclassical expressiveness that in Donatello's later work can become uncompromisingly harrowing.

An increasing restlessness characterizes Donatello's last years. He returned to Florence in 1454. From 1457 he was in Siena, preparing bronze doors for the Cathedral, a project which came to nothing. After 1461 he was back in Florence. Either then or before he carved the startlingly harsh *Mary Magdalen* in wood

for the Florence Baptistery. Painted wood was the usual medium of northern Gothic sculptors, and the anguish of the aged Magdalen's parched flesh and toothless grimace seems to reject Renaissance humanism. It must have been carved during one of the brief but violent religious reactions that shook Florence intermittently in the later fifteenth century, but the work is also highly personal; a similar desolation pervades Donatello's last work, the bronze reliefs for two pulpits in the church of S. Lorenzo. The subjects of these are well-known ones, but the design and imagery are quite out of the ordinary, with a forcefulness of expression, a spirituality barely emerging from despair, that rank them among the most sublime achievements of Western sculpture.

The influence of Donatello recurs again and again in the fifteenth century – not only in sculpture but also in painting (see pp. 105, 107) and (probably) in drawing, and not only in Florence but also in Siena and in Padua and northern Italy (see p. 120); only Michelangelo, however, equalled the majesty and anguish of his last visions – though certain Mannerists, such as the painter Rosso Fiorentino, seem to relive some of their torment.

DONATELLO
(below) Reconstruction of the high altar, S. Antonio, Padua, 1446-54; (right) the central statue, *The Madonna and Child*
The altar was dismantled then wrongly reassembled. A sculptural version of the

sacra conversazione theme, the Madonna in silent conversation with saints, Donatello's altar brought the Florentine Renaissance to northern Italy, and had (especially its reliefs, see p.120) immense influence, notably on Mantegna.

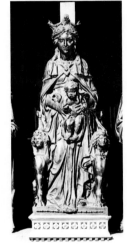

DONATELLO (right)
Gattamelata, 1443-48
In his statue of Erasmo da Narni, the Venetian soldier known by his nickname, "the honeyed cat", Donatello transformed a traditional funerary portrait into an idealized image such as Roman antiquity had used to honour its emperors.

DONATELLO (below)
Lamentation on the dead Christ, detail of one of the pulpits in S. Lorenzo, Florence, *c.* 1465
The effect is disjointed, unruly and intensely emotional – no sculptor had treated the subject with such violent movement and fury before.

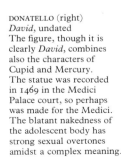

DONATELLO (left)
Mary Magdalen, c. 1456?
This mystic, introverted image reflects the free approach in Donatello's late sculpture, which has much of the extemporized quality of clay models – a forceful, raw and always personal expressiveness.

DONATELLO (right)
David, undated
The figure, though it is clearly *David*, combines also the characters of Cupid and Mercury. The statue was recorded in 1469 in the Medici Palace court, so perhaps was made for the Medici. The blatant nakedness of the adolescent body has strong sexual overtones amidst a complex meaning.

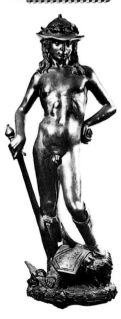

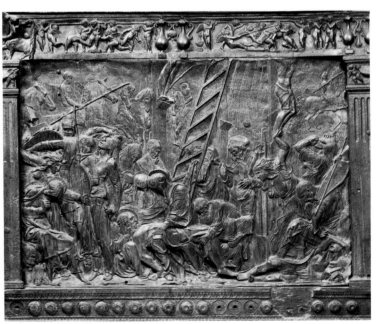

Masaccio: The Holy Trinity

Masaccio (1401-28?) probably completed his fresco *The Holy Trinity* in the north aisle of the church of S. Maria Novella in Florence at the age of 27, in the year when (so far as we know) he died. Who ordered this fresco and why is unclear, though the Lenzi family, corn chandlers, are believed to have been the donors. The fresco has been bruised by time, but five and a half centuries have not blurred its unmatched and magisterial statement of the fundamental principles of the early Renaissance.

The picture has a carefully organized perspective system on the lines first set out by Brunelleschi. The modelling and characterization of the figures have parallels in the sculpture of Donatello. But specifically Masaccio's is the exact control of directed light that unifies the whole, and the indivisible majesty of the conception. The composition is designed to be seen from eye-level as we stand in front of it. Nearest is the skeleton, stripped and stretched in its niche, with an inscription in Italian reading *I was once that which you are; and that which I am you will become.* Slightly above, and set back, kneeling outside the architectural frame, are the two donors in prayer. Above them again, and set back this time within the vault, the Virgin and St John attend the Cross planted on its outcrop of rock. The crucified Christ is supported by the outstretched hands of God the Father, looming majestic behind, who is the only figure seen foursquare in frontal view. Between the heads of Father and Son, in the image of a dove, hovers the Holy Spirit.

The perspective plotting is geometrically exact, the lines converge on a single vanishing point still visible to the searching eye, scored into the plaster beneath the paint. The architecture seems as real as the church in which it is painted – or, as Vasari put it, the painted chapel looks as if it opens through the wall. The classical detail – Corinthian pilasters that frame Ionic columns supporting a coffered vault – is worthy of Donatello or Brunelleschi, and the chamber so well planned in three dimensions that it could be built in stone.

In siting the Christian Passion within classical architecture, not against a Gothic gold background or in an insubstantial landscape, Masaccio suggests that its mystery is not only a matter of faith but is also penetrable by human reason. By his use of perspective, Masaccio anticipates the argument of Nicholas of Cusa, cleric, mystic, geometer and astronomer, that mathematics is the most certain of the sciences, a reflection on earth of heavenly light. The truths of mathematics are not subject to change; neither individual death nor the fall of empires can affect them; natural laws are the reflection or symbols of eternal laws, and it is within their logic that Masaccio's masterpiece is constructed.

Specifically invited into the picture by the Virgin's direct gaze and beckoning hand, the beholder becomes involved in the illusion, calculated to his own human measure, and appearing to his eyes exactly as does any earthly phenomenon. All, divine and human alike, living and dead, share here and now in an immutable eternity, through the mediation of Christ central on the Cross.

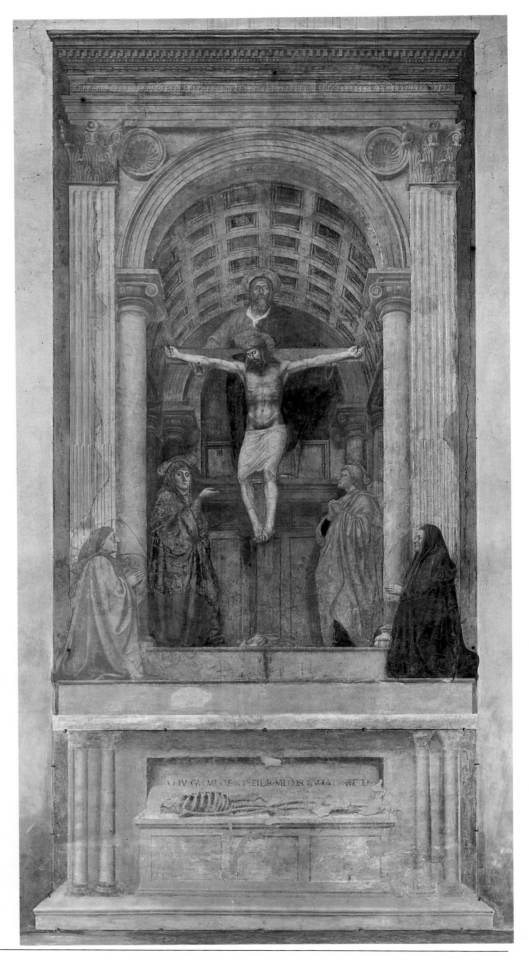

MASACCIO: *The Holy Trinity*, 1428

DONATELLO (left)
St Louis, *c*.1422-25
These classical columns
between pilasters were a
rare precedent for the
Trinity architecture. It
is known that Donatello
and Masaccio were friends,
since Donatello received
on Masaccio's behalf in
1426 money due to him
for his Pisa altarpiece.

BRUNELLESCHI? (below)
Crucifix, *c*.1412
It is rather appropriate
that the *Trinity* Christ
should have been based
on a work in the same
church by that pioneer
of Renaissance art in
Florence, Brunelleschi.

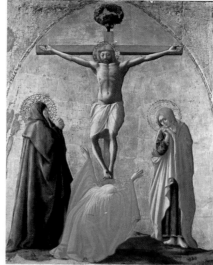

MASACCIO (above)
The Crucifixion, fragment
of the Pisa altarpiece, 1426
Christ's raised chest is
very forcefully modelled,
perhaps so as to stress his
asphyxiating agony. The
figures are strong, simple
shapes, highly expressive;
but note how solidly St
John's feet are planted.

LORENZO DI NICCOLO
GERINI (right)
The Holy Trinity, late
14th century
In other pictures of the
Trinity, God the Father is
shown enthroned; save for
Masaccio's this is the only
known example in which
He stands. Christ's Cross
rests on a rock with a skull,
Adam's skull; his blood
falling on it redeems the
human race. In Masaccio's
fresco the skull has been
replaced by a skeleton.

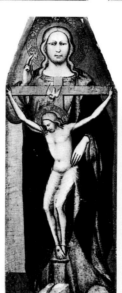

MASOLINO (above)
The Crucifixion, *c*.1428
Masolino's figures show
Masaccio's influence –
they often shared work
(see over) – but are gentle
and graceful by contrast,
not violent in their grief.

MASACCIO (below)
The Holy Trinity, detail
Geometrically calculated
parallelograms, scored in
the plaster, "squared up"
from cartoons, underlie
the Virgin's face, to ensure
correct foreshortening.

MASACCIO'S PERSPECTIVE
The left-hand diagram
reveals the logic of the
perspective Masaccio used:
seen here as it were side-
on, the figures are placed
back in explicitly defined
layers of depth. The line
(AA) marks the picture
plane, the window through
which the viewer sees the
illusion, standing a few
paces back. The floor of
the chapel is tilted down
out of sight, since it is
above the observer's view-
point; the viewpoint is in
fact precisely level with
the top of the altar: the
skeleton under it is seen
from above. None of this,
however, is permitted to
interfere with the impact
of the figures, who are all
of the same size and who
all seem to press against
the picture plane. This
play of flat surface and
illusory space is typical
of early Renaissance art.

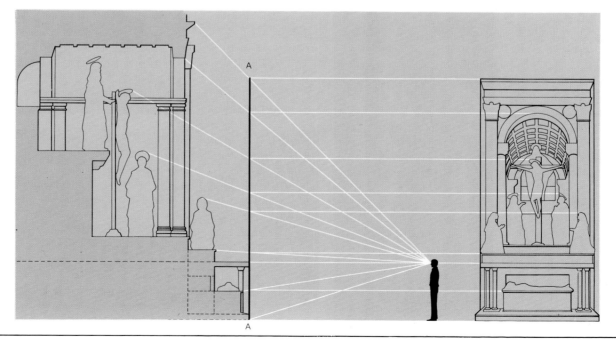

Italian Renaissance Painting 1

In three works, between 1424 and 1428, Masaccio established what we call Renaissance painting. He introduced into public art the experiments Brunelleschi had made a little earlier with geometrical perspective; he revived the sculptural modelling of Giotto, translating Donatello's stringent characterizations into paint; and he fixed and ennobled his grave figures in controlled and directed light. He was, in the words of the art historian Berenson, "Giotto born again, starting where death had cut short his advance".

Masaccio's three great works were *The Holy Trinity* (see preceding page); an altarpiece, now dismembered, painted in 1426 for the Carmelite church in Pisa; and frescos for the Brancacci family's chapel in S. Maria del Carmine, the Carmelite church in Florence. Here *The tribute money*, a rare subject, alludes perhaps to an episode in Florentine politics, the imposition of a property tax, which the rich Brancacci family is said to have opposed; and if so it can be dated 1427. Christ and his apostles stand – simple, substantial figures, tellingly present – in a real landscape, reflecting the profile of the Pratomagno hills east of Florence, and controlled within a Brunelleschian

perspective; in the expressiveness of their bodies and gestures, they reproduce not only Donatello's sculptural form, but also his sense of character in action.

Masaccio shared the commission with the older Masolino (1383/4-1447), and the contrast between their work illuminates vividly the dramatic step Masaccio had taken. In Masaccio's *Expulsion of Adam and Eve* the rejected couple express in every sinew of their massively modelled bodies their shame and anguish; in Masolino's *Fall of Man* there is linear elegance, a Gothic lyricism. Although Masolino was influenced by Masaccio, his Gothic training still tells in the softness and relative sweetness of form and character: the drama is absent.

Masaccio never effected a revolution in taste as Giotto had done, and his example, though instructive, was too vigorous and too demanding for his successors. Florentine patrons, chief among them the Medici, still found irresistible the elegant, decorative tradition to which Masolino belonged. After Cosimo de' Medici had manoeuvred his return from exile in 1434, the Medici family ruled the city like princes in all but name; like princes, they

favoured paintings closer in feeling to the International Gothic which flourished in the courts of northern Italy.

This can appear even in the work of Paolo Uccello (1396/7-1475), an eccentric figure, but one of genius. A dedicated mathematician, Uccello's application of theory in his painting often seems pedantic, and in his fresco *The Flood* (about 1445) perspective complexity conflicts strangely with the tremendous assurance of the great figure in the right foreground. There is again paradox in the large battle decorations he painted to embellish an apartment in the Medici Palace, celebrating a lucky Florentine victory over the Sienese in 1432. These have little sense of real war, rather the ring of medieval pageantry, and Uccello's obsession with perspective merges with a fascination for heraldic patterning. A different poetry is expressed in his very late work *The night hunt:* the perspective is employed more subtly, and the strange scene, its dusk echoing almost audibly with the cries of the hunt, is distinctly romantic in feeling – it owes something perhaps to Netherlandish painting.

Fra Filippo Lippi (1406-69) stands again apart. He was a monk, but was expelled from

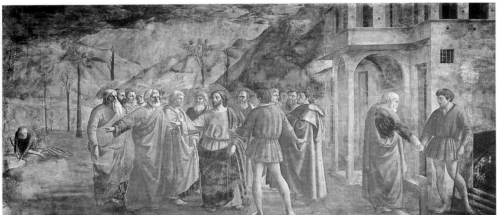

MASACCIO
(left) *The tribute money*, 1425-28; and (below) detail
The taxman (the figure poised with his back to us) demands from Christ his shekel, which is found in the mouth of a fish caught by Peter on the left, and

paid over by him on the right. In each figure, the line from the weight-bearing foot to the head is perpendicular – hence its solid look. The heads are all based on classical heads, while Masaccio built his figures like Donatello's.

MASACCIO (below)
The expulsion of Adam and Eve, 1425-28
Though Masaccio learnt from classical art, there is nothing heroic in these figures; rather they show the influence of Giovanni Pisano's emotionalism.

MASOLINO (left)
Adam and Eve under the Tree of Knowledge, 1425-28
Placed directly opposite Masaccio's *Expulsion* in the Brancacci Chapel, Masolino's work shows in contrast an interest not in the structure but in the surface of forms, though he, too, models by light and shade, much like Masaccio.

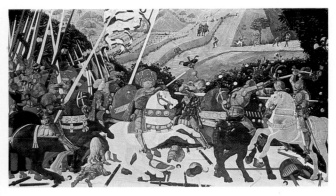

UCCELLO (above)
The Flood, c. 1445
This strange picture is a virtuoso performance in the use of perspective, and has two vanishing points. Wind blows through the draperies, as Alberti had recommended in his *On Painting* not long before.

UCCELLO (left)
The Battle of San Romano, c. 1455
Vasari relates that often Uccello sat up late into the night, and when called to bed by his wife, would cry: "Oh what a lovely thing is this perspective!"

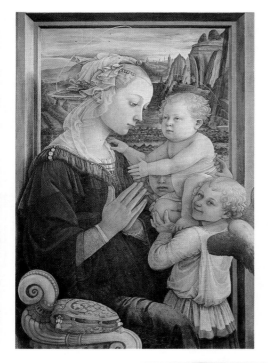

his order for abducting a nun – his patrons the Medici seem to have been indifferent to this peccadillo. The story goes that he was inspired to become a painter while watching Masaccio at work, and in his early paintings, such as his *Annunciation* of about 1440, his dependence on Masaccio is evident in the deep recession and unifying light. But the composition is somewhat illogical, while the drama so crucial in Masaccio gives way to a more static presentation, like a tableau – the kneeling angel is still, the Virgin rather acquiescent. But see the clear, sometimes rather arbitrary, play of colour, and the seductive charm of his flowing line: these are characteristic of Filippo Lippi. There are also elements probably due to Netherlandish example – the incidental domestic detail, the sweetness of expression in the faces and the delightful view through the arches into an enclosed garden. In Filippo's later work, recollections of Masaccio vanish. His delicate line conjures visions of rapt Madonnas, suffused with the radiance of early summer, which anticipate Botticelli. Yet in his frescos at Prato (between 1452 and 1464) the medium seems to have encouraged an epic grandeur not apparent in his altarpieces.

Domenico Veneziano (died 1461) came, if his name is an indication, from Venice, but was working in Florence by the late 1430s. His mastery was in the handling of light: his luminous colour, and the subtle way in which he modulated and reconciled light from different sources, infusing even the shadows, led Vasari to infer that he was already using northern oil techniques, though this is doubtful. Although his works are rare, his influence was far-reaching, most importantly on Piero della Francesca – who worked with him as a young man – but also on Filippo Lippi's son, Filippino Lippi. The signed St Lucy altarpiece, dating from about 1445, is Domenico's major surviving work; the delicate character of his figures acknowledges the Florentine ideals served by Filippo Lippi, but he also was aware of Masaccio and influenced by Donatello. This altarpiece has wonderful little predella panels, now scattered, of which the most delightful is *St John the Baptist in the desert*. St John is, surprisingly, nude (recalling most closely perhaps Ghiberti's sculpture), and seemingly pagan rather than Christian. There is no such ambivalence in the work, equally brilliant in light and colour, of the Blessed Fra Angelico.

FILIPPO LIPPI
The Madonna and Child with two angels, c. 1460
Filippo enshrines the enduring Florentine love of sweetness and charm; he was a prime inspiration for the Pre-Raphaelites.

FILIPPO LIPPI (right)
The Annunciation, c. 1440
Like much of Filippo's work, the altarpiece is exquisitely detailed, and the finesse of his finish was unrivalled. The arbitrary orange of the building placed at the vanishing point is a deliberate emphasis. The Virgin echoes Donatello's in S. Croce (see p. 102).

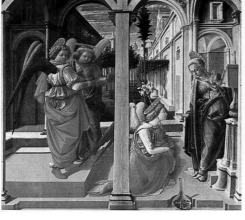

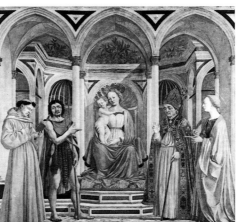

FILIPPO LIPPI (above)
One of the Prato frescos:
The feast of Herod, 1452-64
Many motifs typical of Renaissance painting are here: the perspective tiled floor; the festoons or swags and vases set above a wall; a landscape seen through arches; the illusionistic low wall in the foreground.

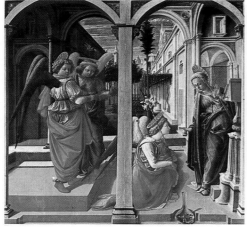

DOMENICO VENEZIANO (left)
St John the Baptist in the desert, c. 1445-48
The nude form almost has the look of bronze about it, so closely is it related to sculpture. Though they are stylized, the rocks behind enclose coherent space.

UCCELLO (below)
The night hunt, c. 1460
As in *The Battle of San Romano,* so here Uccello has taken a subject typical of International Gothic and submitted it to a perspective system.

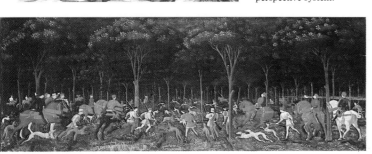

DOMENICO VENEZIANO (above) The St Lucy altarpiece, *c.* 1445-48
The Virgin and saints share one setting (even though the old divisions of Gothic altarpieces are recalled in the arcade) in complex perspective. Two sources of light cast differently slanting shades setting off the heads of both Virgin and Child.

DONATELLO (right)
St Louis, c. 1422-25
The gilt-bronze statue once stood in a niche in the wall of Orsanmichele. Forming half of the semicircle typical of the so-called *sacra conversazione,* St Lucy and St Zenobius, on the right of Domenico's picture, derive from it, the one in pose, the other in the fall of the drapery.

Fra Angelico: The San Marco Annunciation

Fra Angelico (born *c.* 1395 or 1400; died 1455) is quintessentially part of early Florentine Renaissance painting, and yet an individual and untypical personality. The critic Ruskin termed him "not an artist properly so-called but an inspired saint", but he was very much a professional, running a workshop, aware not only of his predecessors but of contemporary trends in art, and taking up commissions in Florence, Cortona, Orvieto and Rome (where he died). In early youth, however, he entered the Dominican monastery at Fiesole, just above Florence, and thereafter led the pious life of a friar.

The Observant Dominicans whom Fra Angelico joined were a reforming movement within the order, emphasizing the need for direct and simple preaching, and rejecting mystic emotionalism. Giovanni Dominici, former Prior of Angelico's convent, had stressed that, steeped in the study of the natural world and inspired by love, the mind of man could grasp the nature of the heavenly world. Fra Angelico's painting is correspondingly clear, direct and optimistic; the certainty of his line-drawing, the radiant light of his pictures and their lucid, shining colours all express this, and also convey irresistibly the painter's own sweetness of nature.

Even when Angelico's subject is high tragedy, the message is not of horror or grief – or even sadness. His *Deposition*, the dead body of Christ being taken down from the Cross, is a *magnificat*, a serene hymn of praise and thanksgiving. The format was not determined by Fra Angelico, but he was able to dispose his imagery very happily within its three divisions: in the centre the body of Christ is displayed with ceremonial gravity; on the left the holy women, with the shroud, are gathered about the kneeling Mary; on the right Florentine worthies in contemporary dress stand in contemplation. On the left, it has been said, the religion of the heart; on the right, that of the mind. To left and right recede landscapes of magical beauty, which have elements still of International Gothic – the flights of angels, the Jerusalem built rather fantastically in Florentine architecture – but they are handled with a sophistication hitherto unseen in Florentine painting. The broad treatment of the draperies, and the figures modelled by light, recall Masaccio (and also Giotto); the tender delicacy of Christ's nude body indicates awareness of Ghiberti's sculpture. The sense of ritual, the singing colours, the flood of heavenly light – these, however, are unmistakably Fra Angelico.

Masaccio had painted chiefly for the Carmelites, who even earlier than the Dominicans had realized the use of naturalism in stating their message with force and immediacy. It is not surprising to see Masaccio's influence already in Fra Angelico's early *Annunciation* for Cortona, although it is tempered by the gentler vision of Masolino. Here also is Brunelleschi's classicizing architecture and his perspective system, characteristically applied towards doctrinal ends: the recession leads from the Virgin, the new Eve, back to the little figures of Adam and the old Eve: Paradise lost is linked to hope of redemption. Fra Angelico's style is always governed by the doctrinal

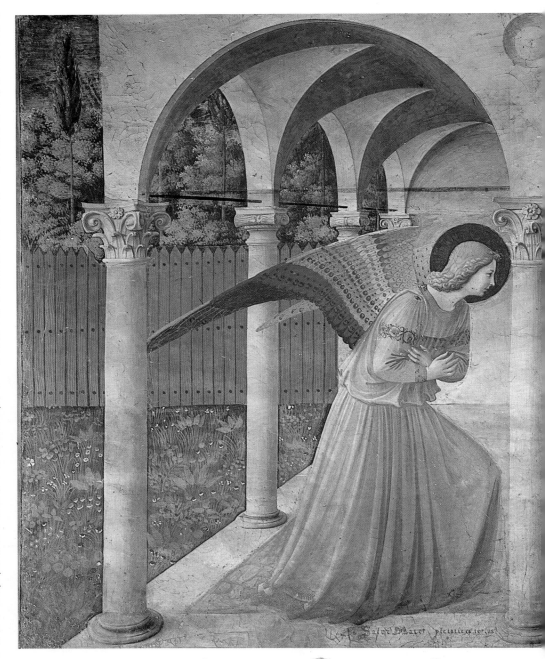

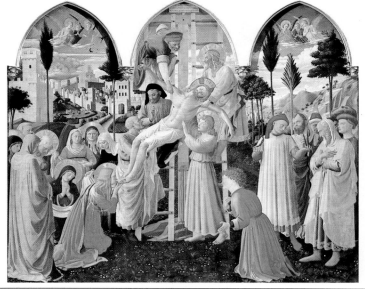

FRA ANGELICO
The Deposition, *c.* 1440?
Fra Angelico took over the commission from the Gothic master Lorenzo Monaco, who died in 1425, having already prepared the panels in their present shape, and partially painted the frame. Fra Angelico divided his composition according to the format, but joined the three panels in a single coherent space. St John, in blue beneath the Cross, closely resembles the St John painted by Masaccio in the *Tribute money*. Nicodemus, in the red cap on the right showing the crown of thorns and the nails, is said to be a portrait of Michelozzo, the architect who designed the new buildings at S. Marco.

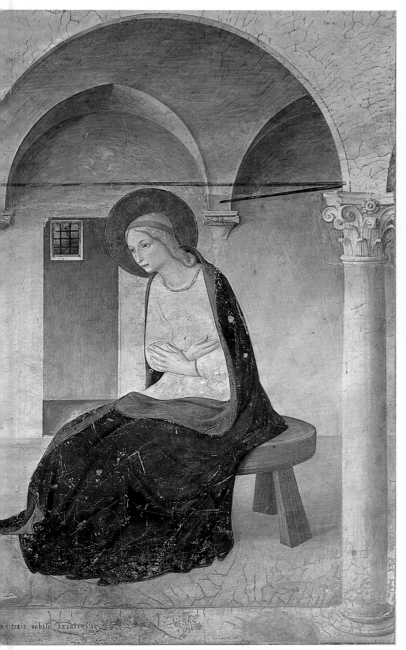

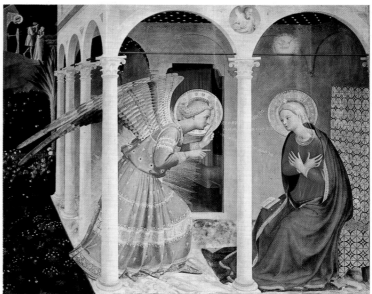

FRA ANGELICO (left)
The Annunciation, at the
top of the dormitory stairs
in S. Marco, *c.* 1450?

FRA ANGELICO
(above) *The Annunciation*,
for S. Domenico, Cortona,
c. 1428-32
The silhouettes of the
figures and the spatial
structure are subtly co-
ordinated, so that the tip
of the angel's wing is on
the picture's centre line.
In the left half, doom; in
the right half, hope of
redemption. This work
formed the basis for many
later *Annunciations*.

(right) *The Annunciation*,
in Cell 3 of the dormitory
of S. Marco, *c.* 1441
St Peter Martyr looks
on, motionless in prayer.
The corridor in which the
figures stand is closed; the
import is concentrated in
the pose and placing of the
Virgin and the angel.

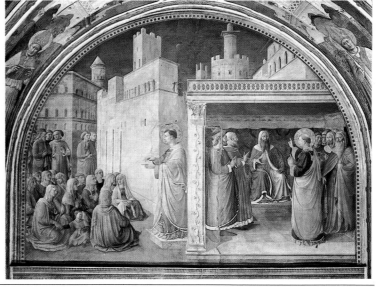

function of his art. Its development can be traced in two other *Annunciations*, both frescos painted in the dormitory of the monastery at S. Marco in Florence where the Fiesole Domin-icans moved in about 1437.

Fra Angelico and his assistants painted the chapels, refectory, cloisters and the cells of the dormitory of the new premises. Each cell had one window, and one fresco as a window on the divine world. In these little chambers of utter simplicity the paintings are entirely austere: the *Annunciation* in cell 3 presents the scene in its most essential terms, pared down from the Cortona version. Fra Angelico's masterpiece, the *Annunciation* at the head of the dormitory stairs, was painted probably after he had been in Rome, at the cultured court of Pope Nicholas V. The Virgin's humility is both plainer and more haunting than before; the articulation of space is exquisite and yet grand. The balance of shapes and structure in the picture is delightful in purely abstract terms.

FRA ANGELICO (right)
*St Stephen preaching and
addressing the Jewish
council, c.* 1447-49
St Stephen's preaching
caused him to be
summoned before the
council, and his profession
of faith there caused him
to be stoned. The two
episodes form part of a
cycle of scenes from the
lives of SS. Stephen and
Lawrence, painted in
fresco in the private chapel
of Pope Nicholas V in the
Vatican. Their wealth of
detail and rich colouring
set them apart from Fra
Angelico's S. Marco
frescos – reflecting the
difference between the life
of humble monks and the
procedural pomp of the
papacy. The spatial clarity
and solid figures directly
recall the work of Masaccio.

Italian Painting 2: Tuscany in Mid-Century

Line-drawing as the basis for design was to become increasingly dominant in Florentine art during the fifteenth century, and the fame of Florence, as the leading school of the arts in Italy, was centred on its *disegno*, its compositional draughtsmanship. We have already seen the emphasis on graceful contour in the later work of Filippo Lippi; his pupil, Botticelli, became the greatest master of sinuous line. Even in the clear light and colour of Fra Angelico, line is the controlling element, and in the work of his chief assistant and follower, Benozzo Gozzoli (*c.* 1421-97), the influence of Masaccio almost peters out, and line, not light, is used to detail his multitudinous figures.

Gozzoli, trained as a goldsmith, was a tireless painter of colourful pageantry. His greatest work was a lavish commission to fresco the walls of the private chapel of the Medici Palace, in 1459. By this time Cosimo de' Medici was aging, and the work was organized by his son Piero the Gouty, whose taste was more courtly than his father's, favouring the glittering and ornate. In Gozzoli's fresco, *The journey of the Magi*, an exotically costumed, animated procession winds its way round the walls of the room; guided by the star in the ceiling above, it travels through fantastic landscapes towards the altarpiece, a *Nativity* by Filippo Lippi. It is full of portraits from the life: included in the crowd are members of the Medici family. The approach and style recall Gentile da Fabriano and International Gothic. Gozzoli's second greatest work was a series of Old Testament frescos (damaged in World War II and now very faded) in the Campo Santo in Pisa – they, too, teem with figures, engaged in contemporary pursuits.

A much stronger artist, who acknowledged Masaccio at least in his method of modelling in light, was Andrea del Castagno (*c.* 1421-57). Such is the extraordinarily harsh vigour of his drawing, that his work seems sometimes a literal translation of Donatello's clear-cut sculpture into paint. The figures he painted between the ribs of the dome of the apse of S. Zaccaria during his sojourn (1441-42) in Venice are forced by an inner emotion into poses of great strain, but their vitality and strength derive from close anatomical study. Castagno's *Last Supper* in the monastery of S. Apollonia in Florence is an early example of illusionism, painted as if it were an extra bay on the end wall of the refectory. Castagno's

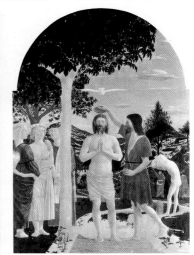

GOZZOLI (below)
Man treading grapes, detail of the Campo Santo frescos, 1468-97
The damaged frescos are now difficult to read, but even in their pristine state the crowded incidental detail must have swamped the biblical narrative.

PIERO DELLA FRANCESCA
The Compassionate Madonna, begun 1445
The frontal Madonna, a massive cylindrical form, imposingly solid against the unearthly gold ground, protectively encircles the human beings who invoke her (among them perhaps

Piero himself, at the back of the left-hand group). The abstract, geometrical quality of Piero's art transforms his compositions into devotional images of remarkable power; the Virgin's head has even been compared to African cultic masks.

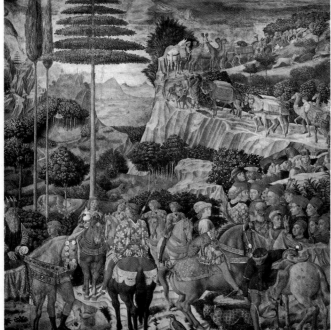

GOZZOLI (above)
The journey of the Magi, detail, 1459-61
The numerous animals leap, hop, sit and fly like those from International Gothic copybooks. But the figures, though decorative, are keenly observed, and the foreshortening is skilful.

CASTAGNO (right)
God the Father, detail of S. Zaccaria apse, 1442
The turbulent grandeur of the drapery recalls the prophets for the campanile of Florence Cathedral by Donatello (see p. 102): this figure, too, is high up.

CASTAGNO (above)
The Last Supper, *c.* 1445-50
Andrea's archaeological

interest is displayed, for instance, in the griffins at each end of the bench: they were a popular motif in

antique furniture. Judas was always placed alone in front of the table until Leonardo (see p. 128).

PIERO DELLA FRANCESCA (above) *The baptism of Christ*, *c.* 1440-50
Here is a famous example of Piero's naturalism: the water of the river in which Christ stands is rendered as transparent in the foreground, then as opaque and reflecting in the background; the change comes just at Christ's feet, where tiny bubbles are visible in the original.

tautness of line and strained poses resemble the work of Antonio del Pollaiuolo a little later, but also anticipate Mantegna, who was to take further Castagno's interest in illusionism and in archaeological detail.

The greatest painter of the mid-fifteenth century was Piero della Francesca (1416?-92). Piero worked in his youth as the assistant of Domenico Veneziano in Florence, and his abiding interest in mathematics was no doubt formed there, but he worked mainly in provincial centres of southern Tuscany – Arezzo, his native Borgo San Sepolcro – in Urbino, in Ferrara and in Rome. In his own time he was famous, but by the seventeenth century he was almost forgotten, and the recognition of his true stature is fairly recent, fostered by a twentieth-century urge to discover abstract essentials even in the most naturalistic art.

An early work of Piero's is the monumental *Madonna della Misericordia* (The Compassionate Madonna) commissioned in 1445 for Borgo San Sepolcro. The almost palpable weight of the Madonna indicates that Piero had looked long and hard at Masaccio. The rigorous geometrical structure underpinning the composition is, however, alien to Masac-

cio, and the different scales of the figures and their setting, a gold background, are archaic: there is already here an other-worldly quality that inhabits all Piero's work. The characters' serene gravity, the relatively light tonality and the clear colour are found in another early work, *The baptism of Christ*. Here in the modelling there is much less contrast between light and shade; instead Piero's characteristic, almost shadowless, all-pervading light (developed in part from Domenico Veneziano) holds the action in a meditative, magic spell. Piero was to handle the modulation of tone and colour with a subtlety that has never been surpassed; his figures, though their shadowing is so slight, are nevertheless as solid as any ever painted. Piero wrote treatises on mathematics and on perspective in painting, but despite his fascination with geometry he was alive to the naturalism of Netherlandish painters, as his landscape backgrounds demonstrate (he may have met Rogier van der Weyden at Ferrara). In Piero's work the claims of line and colour, of naturalism and abstract construction are reconciled uniquely.

Some of Piero's greatest paintings were made for the court of Federigo da Montefeltro

at Urbino (see over). But the major commission of his career was the fresco cycle, *The history of the true Cross*, in the choir of S. Francesco at Arezzo, which occupied him from about 1452 for twelve years – Piero always painted with slow deliberation. The Cross, tangible proof of redemption, was perhaps the most prized of all sacred relics. The story is taken from the *Golden Legend*, a collection of lives of the saints, full of miracles and wonder-working, that remained popular from the Middle Ages to the Reformation. It is divided into ten episodes, starting with *The old age and death of Adam*, for a sprig of the Tree of the Knowledge grew into the wood of which the Cross was made. Subsequent scenes trace the history of the wood in the Old Testament and after the Crucifixion. The calculated perspective and precise use of line and pale colour convey, paradoxically, grandeur and mystery; the narrative and decorative functions of the whole are fulfilled and reconciled in perfect balance. In silence and simplicity Piero finds inexhaustible variety, regardless of scale – later in the majestic, mute triumph of *The Resurrection*, almost life-size, or in the tiny panel of *The Flagellation* at Urbino (see over).

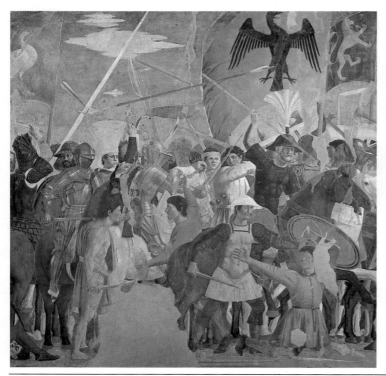

PIERO DELLA FRANCESCA
Details from the Arezzo frescos, c.1452-64
(left) *The old age and death of Adam*
The hard consequence of the expulsion from Eden was eventual death. Adam's last moments are witnessed by the members of his family with restrained grief.

(below) *The victory over Khosroes*
The Persian king had removed the Cross from Jerusalem; the Emperor Heraclius here regains it, in frozen, eerie pageantry.

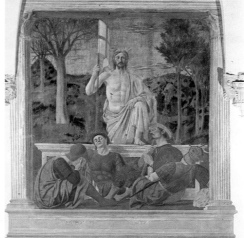

PIERO DELLA FRANCESCA
(left) *The Resurrection*, c. 1463
Christ holding a banner is a Byzantine image, a little archaic; but the sleeping soldiers are a brilliant essay in Renaissance foreshortening. Symbolic dead trees on the left sprout into new life on the right.

PIERO DELLA FRANCESCA
(below) Detail from the Arezzo frescos: *The Annunciation*
The first episode in Christ's life stands for its whole in the *History of the Cross* frescos, which omit the Passion. Architecture both symbolically divides human and divine spheres and plots out the space.

PIERO DELLA FRANCESCA
(above) Detail from the Arezzo frescos: *The dream of Constantine*
According to the legend, Constantine's dream of the Cross (shining from above) won the Roman Empire to Christianity. In this detail it can be observed how the gentle glow of light falling from above into the centre is carefully plotted as it creeps round the edges of the armour of the guard.

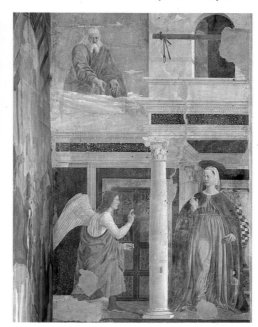

Piero della Francesca: The Flagellation

The dukes or despots ruling the local centres of power in northern and central Italy were always on the lookout for artists to adorn their courts and enhance their prestige. In the mid-fifteenth century they turned most commonly, as one might expect, to the Netherlands or to Florence. The Este in Ferrara briefly obtained Rogier van der Weyden about 1450; Sigismondo Malatesta, tyrant of Rimini, had a classical, humanist monument to himself, the Tempio Malatestiano, designed by Alberti, and his portrait painted by Piero della Francesca in 1451. Alberti moved on to build for the Gonzagas in Mantua; Piero went to Urbino, to the court of Federigo da Montefeltro. In Federigo's magnificent palace, denuded of most of its treasures in the sixteenth century, now resides one of Piero's finest paintings, the small panel of *The flagellation of Christ*.

Piero's picture is not a straightforward representation of an episode in Christ's Passion, since the Flagellation is relegated to a secondary position in the middle ground. Dominant are the three figures in the foreground, on whom the further meaning of the picture must depend, but their identification still poses puzzling questions. Though it no longer exists, in the nineteenth century a phrase from Psalm 2 was written beneath the picture – *Convenerunt in unum* (They met together). Those who met together were princes and kings of the earth, with the purpose of stirring up war against the Lord and his Christ. The Psalm is quoted in the Acts of the Apostles, where the princes are identified with Pontius Pilate, seated here in judgment, and Herod, perhaps the man in luminous grey who directs the flagellators. Grouped together by some com-

BERRUGUETE? (above)
Federigo da Montefeltro, 1477
Soldier, diplomat, scholar and informed patron of the arts, Federigo, Duke of Urbino, was a Renaissance "complete man". He wears the Garter awarded by the King of England and the Ermine bestowed by the King of Naples; the mitre is from the Pope. His son Guidobaldo is beside him.

PIERO DELLA FRANCESCA (below) *Federigo da Montefeltro*, c. 1472-73
On one panel of a diptych Federigo looks towards his wife, profiled on the other. Behind them atmospheric, panoramic views suggest that Piero learned from Netherlandish painters. On the back of the two panels Federigo and his wife are shown seated in allegorical triumphal cars.

PIERO DELLA FRANCESCA (right) *The flagellation of Christ*, undated

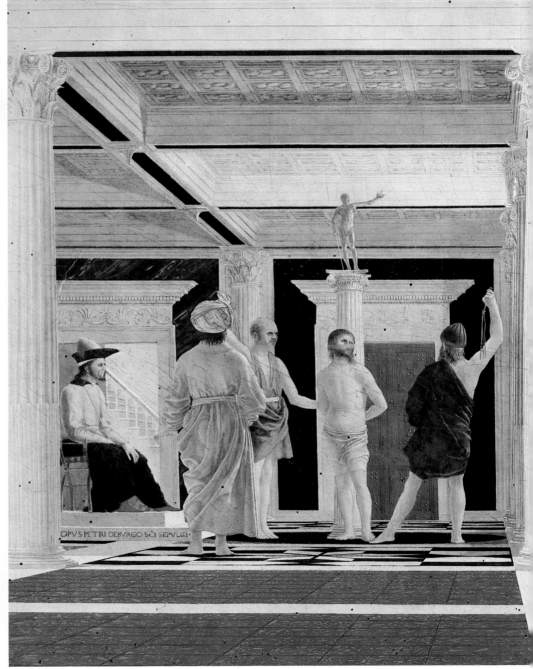

pulsive force stronger than ordinary conversation, the three foreground figures may on one level represent the Old Testament, prefiguring the torment of Christ in the New.

The emphatic placement of the three figures, however, suggests also a topical reference, and the strong individuality of the two flanking figures makes it likely that they are also portraits – the man in profile on the right bears some resemblance to Ludovico Gonzaga of Mantua, who had close connections with the court of Urbino. The austerely beautiful youth, however, whose hair is as blond as a halo, framed by the laurel-tree behind, who stands in a pose so close to that of Christ, left foot forward, his hand at his waist, must be allegorical: it would be bold to represent even the most blameless youth as a larger reflection of Christ.

The picture is divided into two halves, into two theatres of being, by an elaborate perspectival system, mathematically so precise that the plan and elevation of the Hall on the left can be deduced exactly. The loggia, constructed with a perfect command of its classical elements, strongly recalls Alberti's architecture; the design is not perhaps arbitrary, but based on reports brought back from Jerusalem of the surviving buildings there, including Pilate's Judgment Hall. Alberti's Holy Sepulchre in the Rucellai Chapel in Florence, with which Piero's Hall has some details in common, was probably based on the Holy Sepulchre in Jerusalem. The area on the right, however, the real world contrasted to the divine one, is fragmentary in plan. The two areas are lit by different sources of light, but are linked indissolubly by the reiterated elements of the composition, by the harmony of colour, and by Piero della Francesca's extraordinary still and solemn mood. The timeless Christian Passion is reconciled with the topical likenesses of Piero's contemporaries in an immutable formal framework.

The *Flagellation* was painted for the appreciation of learned humanists – not least among them Federigo (who wrote superb Latin). Besides painters – not only Piero but the Netherlandish Justus of Ghent and the Spaniard Pedro Berruguete – visitors to Urbino included the leading intellectuals of the day, among them Alberti. It was in Urbino that Castiglione was to set his famous account of cultured courtly life, *The Book of the Courtier*, and in Urbino that Bramante, the High Renaissance architect of St Peter's, was trained, and the great Raphael born.

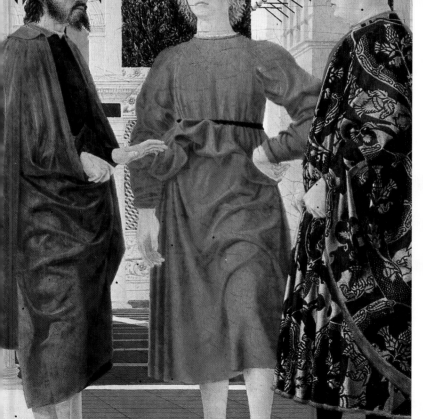

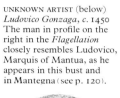
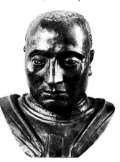

UNKNOWN ARTIST (below)
Ludovico Gonzaga, c. 1450
The man in profile on the right in the *Flagellation* closely resembles Ludovico, Marquis of Mantua, as he appears in this bust and in Mantegna (see p. 120).

URBINO, DUCAL PALACE (right) The *Cappella del Perdono*, 1468-72
The tiny remembrance chapel is comparable to Alberti's structure (below right). Perhaps like Piero's picture it served some private, learned piety with personal references.

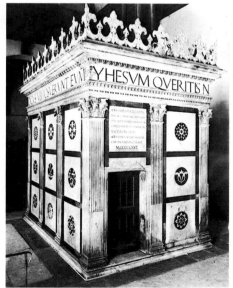

PIERO'S FLOOR PLAN (above)
This is a flagstone of the loggia of *The Flagellation*. The paving, and the whole ground plan of Piero's picture, can be precisely reconstructed – such is the complexity and accuracy of his perspective geometry.

ALBERTI (right)
The Holy Sepulchre in the Rucellai Chapel, Florence, 1467
Alberti's building and Piero's painting share the idiom of their classical ornament and the motif, perhaps symbolic, of a star.

Italian Sculpture 2: New Modes and Types

That persistent Florentine feeling for sweetness and charm so evident in early Renaissance painting is also clear in contemporary sculpture. But if Donatello's harsher style had no immediate followers (save the painter Castagno), this was partly due to a change in the nature of patronage: about the time that Donatello left for Padua, in 1443, expensive public commissions, such as those that had filled the niches of Orsanmichele, died away. Sculptors were engaged mainly on tombs, pulpits and altar furniture, or modest domestic pieces, reliefs and portrait busts.

However, in this period of consolidation, some specifically Renaissance types and forms of sculpture appeared, such as portrait busts and classicizing tombs. Leonardo Bruni, author of a history of Florence and Chancellor of the city, died in 1444. His lavish state funeral commemorated as much his intellectual prowess as his political status, and consciously echoed Roman ceremonies. His tomb is a compound of Christian and classical elements, and looks backward to his earthly accomplishments rather more than it looks forward to his heavenly destiny. The commission went to Bernardino Rossellino (1409-64),

the fourth brother of a family of five masons. He also worked as a master-mason under Alberti, who may have provided the tomb's overall design. The effigy of Bruni itself is beautifully serene and dignified.

The fifth brother of the family, Antonio Rossellino (1427-79), used Bernardino's formula for his tomb (1460-66) in S. Miniato for James, Cardinal of Portugal, who died while visiting Florence. His version was affected by the fashion of the third quarter of the century for graceful movement, so the tomb is brought almost to life by flying angels and delicate drapery. Antonio also produced some remarkable busts. His bust of the physician Giovanni Chellini was probably based on a plaster cast taken from the life, but Antonio has so sensitively handled the texture and mass of the marble that it is more than a mere facsimile. This bust is not of the classical type, though the classical form also became popular; the relatively unsubtle, but powerful head of Piero de' Medici of about 1453 by Mino da Fiesole (1429-84) has conscious classical mannerisms.

The work of Desiderio da Settignano (c. 1430-64) is characteristic of the "soft" Florentine style. The angels on his tabernacle in S.

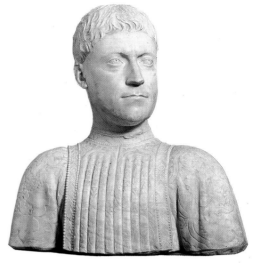

MINO DA FIESOLE
Piero de' Medici, c. 1453
Piero the Gouty, Cosimo de' Medici's son and heir, enjoyed art and the society of humanists. He had "pictures, manuscripts, jewels, cameos, vases and rare books without equal in Europe", as a contemporary reported. In Mino's bust the hair and eyes especially are deliberately classical, reflecting Piero's cultivated taste for the antique. He had perhaps less relish or aptitude for banking or politics.

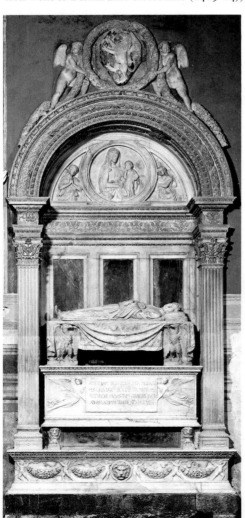

BERNARDINO ROSSELLINO
Leonardo Bruni, c. 1445-50
The Virgin and Child in a roundel above intercede for Bruni's soul. Otherwise

his tomb, like a Roman emperor's triumphal arch, celebrates earthly prestige. The profuse classical ornament lends a rich grandeur.

ANTONIO ROSSELLINO
Giovanni Chellini, 1456
Medieval busts much like this, but set on a pedestal,

had contained sacred relics. This, however, is a secular, unidealized image of a distinguished doctor.

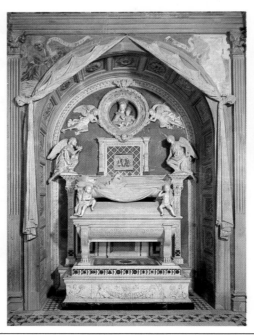

ANTONIO ROSSELLINO (left)
The Cardinal of Portugal, 1460-66
Round the recumbent Cardinal there is a marked flurry of movement: foreshortened angels in relief bear the Madonna forward; free-standing angels spring from bended knee upwards towards her; two mobile *putti* shed tears beside the effigy.

DESIDERIO DA SETTIGNANO
Tabernacle in S. Lorenzo, c. 1460
The deep recession is achieved within a thin layer of marble. In their delicacy and finesse the vases and foliage flanking the tabernacle door (now missing) and *The lamentation over Christ* surpass their antique models, and even precedents by Donatello.

Lorenzo in Florence are the equivalent of the fragile grace of painters such as Filippo Lippi (see p. 107), and an extension of the sentiment of Luca della Robbia's *Madonnas*. The extraordinary subtlety with which Desiderio handled shallow depths of marble had its basis in Donatello's technique.

Movement, specifically the human body in movement, was the major preoccupation of Antonio del Pollaiuolo (1431/2-98). He was said to be the first artist to practise dissection, and the study of the muscular male nude is crucial in his painting and sculpture. In his paintings line defines the forms, in the Florentine manner, with the same vigour we have already seen in Donatello and Castagno. Correspondingly, his sculpture has hard, faceted planes and presents angular silhouettes. There is nevertheless a strange elegance in his work, both in his *Ten nudes fighting*, one of the earliest Italian engravings, and in his little bronze *Hercules and Antaeus*. This represents another Renaissance re-invention, the action group, often on a small scale, which has a dynamic movement inviting the viewer to inspect it from all round. In Pollaiuolo's *St Sebastian* of about 1475, the figures are again

showpieces of the human body in action, as Pollaiuolo makes evident in posing the archers on each side in identical attitudes, like two viewpoints of one statue.

Towards the end of the century an increasing gravity becomes apparent, especially in large-scale commissions carried out by Benedetto da Maiano and Andrea del Verrocchio (1435-88). Verrocchio was even more versatile than Pollaiuolo: he was goldsmith, painter, sculptor and impresario, the master of a large workshop (in which Leonardo da Vinci

was to learn most of his many arts). His earlier work is in the softer tradition of Ghiberti and Desiderio, but there is a more vigorous drama in the life-size *Doubting of Thomas* (1465-83) for Orsanmichele. Even more theatrical was his colossal equestrian bronze of the Venetian general Bartolommeo Colleoni, cast after Verrocchio's death. Its ferocious realism makes a revealing contrast to the sober classicism of Donatello's *Gattamelata* (see p. 103). There is again a lighter, sweeter touch in Verrocchio's work for the Medici. His admirable little *Putto with a fish*, made to adorn a fountain, invites the spectator to move round it, as does Pollaiuolo's bronze.

The sculpture produced elsewhere in Italy was certainly competent, though still Gothic in feeling. One highly individual exception was the work of Agostino di Duccio (1418-81). He was born in Florence but trained perhaps by the Sienese della Quercia: he produced at Rimini and Perugia strange shallow reliefs (not shown) aswirl with drapery. An unknown collaborator with Agostino at Rimini, perhaps Matteo de' Pasti (active 1441-68), carved other reliefs there, remarkable in reproducing the form of Classical Greek sculpture.

VERROCCHIO (below)
Bartolommeo Colleoni, 1481-90
The horse is marching forward, and Colleoni frowns with menacing disdain. He dominates the square in which he stands, presenting a dramatic and peremptory silhouette.

VERROCCHIO (right)
Putto with a fish, c. 1470
The twisting and turning form, inviting the spectator to move round with it, was to be perfected by the great Mannerist Giambologna in the next century.

VERROCCHIO (below)
The doubting of Thomas, 1465
Thomas explores Christ's wound as if he already senses his divinity. The balanced movements of the figures hold the moment in moving, dramatic suspense.

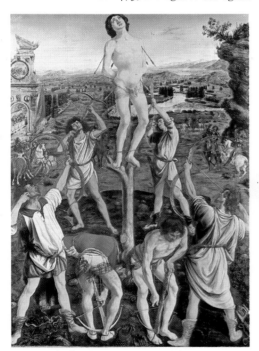

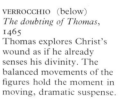

POLLAIUOLO (left)
St Sebastian, 1475
Florence and the river Arno are identifiable in the "portrait" landscape. The picture's pyramidal structure was becoming a common Renaissance compositional theme.

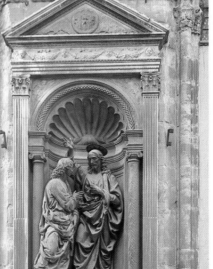

POLLAIUOLO (above)
Hercules and Antaeus, c. 1475-80
Lifted from his mother, the Earth, Antaeus lost his strength and so Hercules conquered him. This is a small version of a life-size painting by Antonio.

MATTEO DE' PASTI? (above)
Botany, c. 1460-68
The sculptor – whoever he was – seems to have been influenced by 5th-century Athenian art. He could have learnt about it through the humanist antiquarian Cyriac of Ancona, who is known to have visited Greece before it was closed to the West by the Turkish conquest of the Byzantine Empire.

POLLAIUOLO
Ten nudes fighting, c. 1460
Uncommissioned and with no real subject, the engraving seems to have been a display piece, demonstrating Pollaiuolo's mastery of movement and anatomy. Engraving, a German invention, enabled an artist to disseminate his work more widely.

Italian Painting 3: Florence and Rome

Florence boomed in the fifteenth century, and, under the control of the Medici banking family, became a national and international centre of finance and commerce. Its prosperity reached its zenith under the leadership of Cosimo de' Medici, from 1434 to his death in 1464. Thereafter symptoms of decline appeared, and at the death of his grandson Lorenzo the Magnificent in 1492 the Medici dominance ended for the time being. There followed a long-threatened French invasion of Italy in 1494, almost welcomed as God's punishment by the fiercely radical Dominican priest Savonarola, whose anti-humanist influence held sway in Florence during the sorely troubled years 1494-98.

However, the artistic prestige of Florence continued supreme throughout the century, acknowledged all over Italy. Commercial contacts with the north promoted artistic interchange; and Florentine artists were gradually assimilating the lessons of Netherlandish naturalism. Works by Jan van Eyck, Rogier van der Weyden (who visited Italy in 1450) and Hugo van der Goes are recorded in Florence, and were much admired, especially Hugo's altarpiece (see p. 96) commissioned by Tommaso Portinari, the agent of the Medici bank in Bruges, and set up as a great spectacle in 1483 in the church of S. Maria Nuova.

Italian approval of the Florentine achievement was sealed when, in the early 1480s, Pope Sixtus IV commissioned Florentine artists to paint the walls of his newly built Sistine Chapel in the Vatican. The controlling artist was Perugino (c. 1445-1523), born in Umbria but trained in Florence, perhaps under Verrocchio; with him worked the Florentines Botticelli, Ghirlandaio and Cosimo Rosselli.

During the course of Perugino's long and prolific career he was a leader of fashion and then, abruptly, old-fashioned. In the grace and harmonious proportions of his figures, in his mastery of perspective and feeling for space and symmetry, some of the key characteristics of the High Renaissance, which overtook him, are nevertheless clear. His achievement is underrated by comparison with Raphael, his pupil, who learned these qualities from him, and his deficiencies are overstressed. At his best he is an entrancing painter, as the most successful of his surviving frescos in the Sistine Chapel, *The giving of the Keys to St Peter*, demonstrates. (Three others were destroyed to make way for Michelangelo's *Last Judgment*.)

SIGNORELLI (right)
The Last Judgment,
detail: *The Saved*, 1499
It is often difficult to see
in Signorelli's much more
dramatic style that he was
Piero della Francesca's
pupil. His interest in the
nude and harsh sculptural
forms recall Pollaiuolo,
but the sweeping drapery,
the variety of gesture,
the serried movement, are
typical of the later second
half of the 15th century.

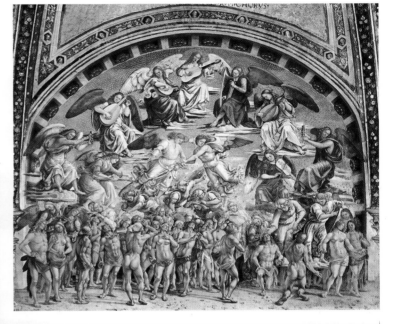

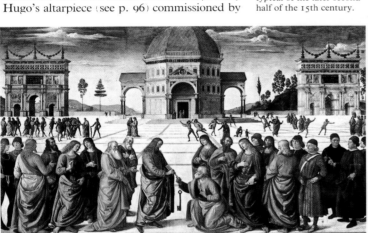

PERUGINO (above)
*The giving of the Keys
to St Peter*, 1481-82
Perugino's skill was to
tell a story clearly and
simply, affectingly and
gracefully, though later in
life his invention failed.
In the line of figures
there is a lovely rhythm.

GHIRLANDAIO (below)
The birth of St John,
1485-90
The birth takes place
in a well-to-do 15th-
century Florentine
private house, visited,
it seems, by interested
15th-century neighbours:
some are known portraits.

GHIRLANDAIO (right)
*The calling of the first
apostles*, 1481-82
The freshness of the
landscape, the vivacity
of the loosely clustered
crowd, these are the
pleasing but perhaps
rather shallow qualities
of Ghirlandaio's work.

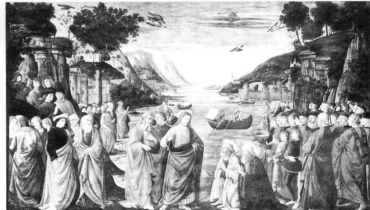

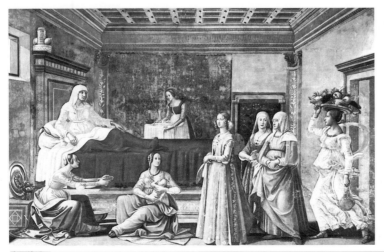

BOTTICELLI (right)
"*The Madonna of the
Magnificat*", c. 1480-90
The circular or *tondo*
frame permits a closed,
harmonious composition,
but it is difficult to fit
upright figures within it.
The rainbow, marking
the Virgin as Queen of
Heaven, is one device
that binds them together.
Graceful line describes
the forms – the hallmark
of the Florentine school
and of Botticelli's work in
particular. This, perhaps,
is the most enchanting of
all Botticelli's *Madonnas*.

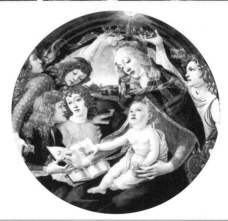

The contribution of Domenico Ghirlandaio (1449-94), *The calling of the first apostles*, is more essentially Florentine in style: in the density of the figures there is something of Masaccio, but rather more of the light, fluent line of Filippo Lippi. Ghirlandaio's shop in Florence was large and prolific, and the most popular with the general public. His major work, frescos (1485-90) in S. Maria Novella, have all the ingredients the public enjoyed – minute detail, inventoried with the delight of a Netherlandish painter; decorative motifs derived from classical antiquity; and gossipy references to contemporary persons.

If Ghirlandaio represents the established, perhaps rather backward-looking, style of the last years of the century, the Umbrian Luca Signorelli (active 1470-1523) anticipates in some respects the style of things to come. As Perugino later did, he acknowledged the influence of Leonardo; unlike Perugino, he could learn from the young Michelangelo, who admired Signorelli's work. He was employed in the Sistine Chapel, and by the Medici in Florence, but his greatest large-scale masterpiece is his work in fresco at Orvieto, with a *Last Judgment* teeming with struggling nudes.

The most remarkable talent working in the Sistine Chapel was Sandro Botticelli (*c.*1445-1510). He trained, probably, with Filippo Lippi in the 1460s, and his female faces retained elements of Filippo's characterization throughout his career. By about 1470 he had established his independence and originality, and was working for the Medici; it was for the Medici that he painted the allegorical scenes that now seem his greatest achievement (see over). His main output, however, was religious, and the many *Madonnas* produced by his workshop and probably also by imitators were especially popular. Botticelli's Sistine fresco, *The punishment of Corah*, shows an instinct for drama and a mastery of expressive gesture: his line could be both delicate and sinewy like Castagno's. His work of the 1490s, however, seems disturbed and strained, affected by the fevered emotionalism associated with the fanatic teaching of Savonarola. His late *Lamentations* are harsh and angular by comparison with earlier work, and make direct and fierce demands on the spectator. In "*The Mystic Nativity*" of 1500 (not shown) the joy of Christ's birth is undermined by little devils scuttling in the foreground.

Filippino Lippi (*c.*1457-1504), the son of Filippo Lippi by the nun he abducted, was trained in Botticelli's studio and through Botticelli learned the sweetness and grace of his father's painting. *The vision of St Bernard* of about 1480 is impressively defined and detailed, seen life-size in hard, clear light and strong colours. However, Filippino also painted monumental frescos in churches in Rome and Florence, which are remarkably well organized and as dramatic as Botticelli's *Punishment of Corah*, with a still greater profusion of antique detail; his figures can be dynamic, very freely painted.

Netherlandish painting had a considerable impact on Florentine portraiture during the late fifteenth century, but naturalistic observation was seldom as unflinching as in Ghirlandaio's *Old man and his grandson*. Not only Ghirlandaio but also, for instance, Botticelli inserted portraits into their frescos, and Botticelli painted a considerable number of panel portraits, usually half-length, set against a plain background or against simple, almost geometric architecture. His sitters look out with the same pensive, haunting gaze as his invented characters.

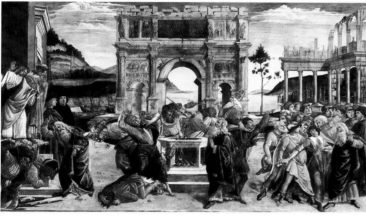

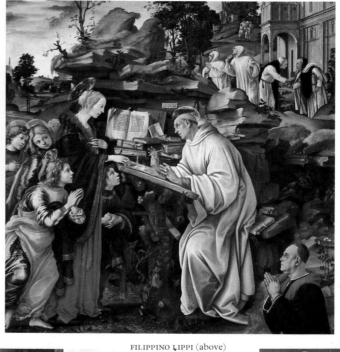

BOTTICELLI (above)
The punishment of Corah, 1481-82
Corah had usurped the priestly authority Moses had delegated to Aaron. In the centre, beneath a replica of the Arch of Constantine, Moses, rod in hand, invokes God's wrath: on the left the

earth opens up to swallow his opponent. Botticelli's fresco repeats again the tripartite division (set perhaps by Perugino) of all the Sistine Chapel works, and it, too, celebrates the divine constitution of the papacy – Moses and Aaron prefigure Christ and St Peter opposite.

BOTTICELLI (below left)
Lamentation over Christ, c.1490-1500
The unremitting grief, the frenzied drapery, the claustrophobia induced by the bleak masonry all create disquiet. The gestures are strangely artificial. Van der Weyden was clearly an influence.

FILIPPINO LIPPI (above)
The vision of St Bernard, c.1480
The elongated figures are drawn with a grace like Botticelli's; the lively angels move eagerly; the rich detail is delightful. St Bernard gazes on the attenuated Virgin with an almost agonized piety, and the donor below echoes him.

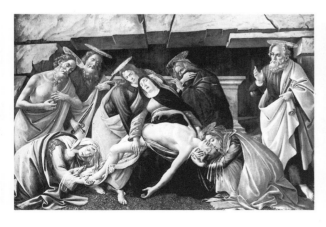

GHIRLANDAIO (left)
Old man and his grandson, undated
The old man is shown "warts and all", but also radiantly and tenderly – in a posthumous memorial?

BOTTICELLI (above)
*A young man, c.*1482?
Botticelli's portraits are conventional, without penetration or variation in pose. However, they have undeniable charm.

Botticelli: Primavera

Botticelli's *Primavera* and *Birth of Venus*, his two most famous mythological paintings, were probably commissioned by or for Lorenzo di Pierfrancesco de' Medici, who was the first cousin of Lorenzo the Magnificent, ruler of Florence. Both hung in the villa at Catello, outside Florence, which Lorenzo di Pierfrancesco had bought in 1477, but they were not necessarily painted as a pair: the *Primavera* is earlier, of about 1478, and *The birth of Venus* later, of perhaps 1482-84. The *Primavera* is the most enchanting visual celebration of spring ever made. Beyond that, its significance is obscure – which is perhaps one reason why it is so endlessly fascinating.

The main theme of the *Primavera* is chosen from Ovid, and is unfolded on the right: the wind-god Zephyr pursues the nymph Chloris, who, at his touch, is transformed into Flora. The central figure, modestly gowned but welcoming with an inclination of the head and hand, is marked out as Venus by the winged Cupid with drawn bow hovering above: she appears not only as Goddess of Love, but as the astrological symbol presiding over April. Her head and shoulders are haloed by a circle of light in the grove of golden-fruited trees: she is "Christianized", a pagan Venus become a source for good. To the left three Graces dance, emanations of Venus (singled out by Alberti in his treatise on painting as admirable subjects for the exercise of artistic skill). On the extreme left stands Mercury, but why he stands just as he does has yet to be convincingly explained.

The mood is festive, a kind of grave rapture, but no story binds the characters together. They are dispersed in solitary or self-sufficient groups, each one in pale introspection. The picture has little depth, instead a two-dimensional patterning which must have resembled most closely Netherlandish tapestries, much prized in Florence at the time. The figures are lucidly drawn and roundly modelled, but come from a dream: they tread weightlessly, leaving the flowers uncrushed beneath their feet. Unreal, elongated, they move to the sinuous rhythms of the picture like slender saplings to an eddying breeze.

In short, the picture is a deliberate reversion to some of the characteristics of International Gothic, disregarding the realism initiated by Masaccio. Although Ovid may have been one starting-point and a classical statue in Florence once identified as Flora another, the mood is more akin to medieval romance than to classical antiquity. Though the faces of his Venuses closely resemble those of his Madonnas, Botticelli's mythologies did not serve the devotional or narrative functions of his religious pictures. The style and subject of the *Primavera* answered the specifications of an intellectual and esoteric circle of humanists, humanists, however, of a quite different stamp from Alberti or Leonardo Bruni (see p. 114). A leading light in the Medici circle was Marsilio Ficino, versed in classical and medieval astrology, poetry, lore and symbolism, and in the abstruse flights of Neoplatonic philosophy. Possibly he conceived the *Primavera* for Lorenzo di Pierfrancesco's education (Lorenzo was only 15 in 1477) – as a homily of which the symbols, acting in some way like astrological

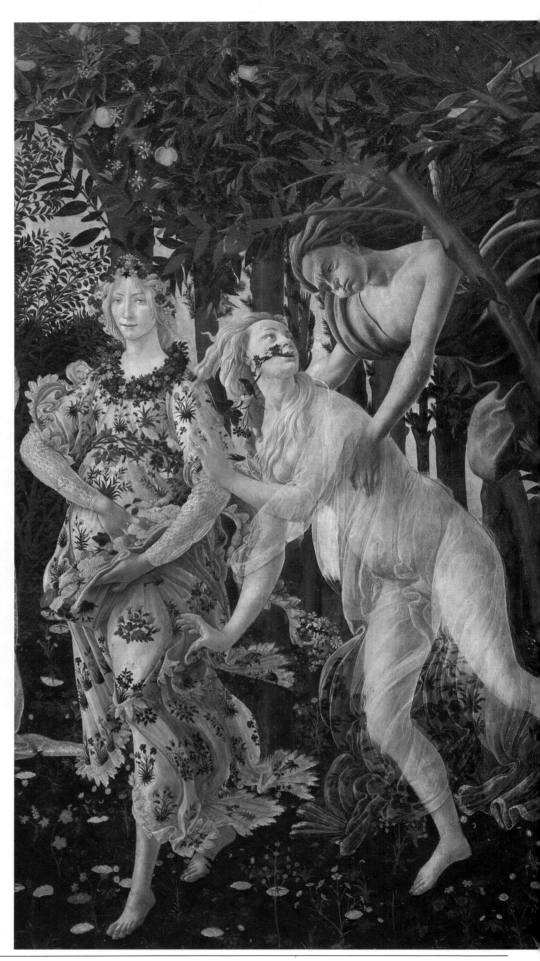

BOTTICELLI: (below) *Primavera*, c. 1478; and (left) detail

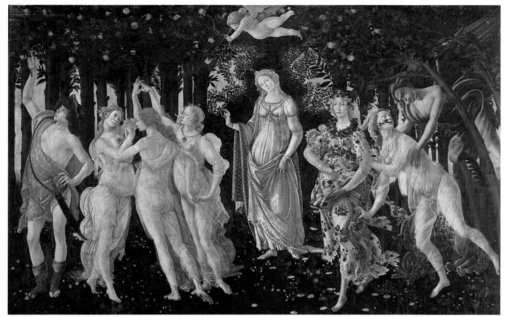

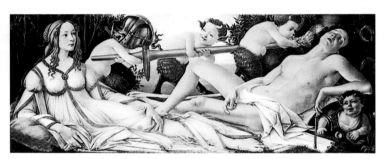

symbols, would exercise a benign influence on the young man. In 1478 Ficino wrote a letter to Lorenzo in which he asked him to meditate on Venus as *Humanitas*, in whom all virtues were compounded, and perhaps the Venus of Botticelli's painting is this same *Humanitas*.

This is one theory, advanced by the art historian Gombrich; another is that the painting was inspired by the poems of Poliziano, also a member of the Medici circle, and that the Venus of the *Primavera* signifies human love while the Venus of *The birth* signifies divine love, in an antithesis of a kind enjoyed by humanists. *The birth of Venus* is a more straightforward enactment of classical myth (or perhaps of the myth retold by Poliziano in a poem of about 1475), although it, too, may contain levels of significance, in a moral and philosophical allegory. Botticelli's *Mars and Venus*, painted for the Vespucci family, perhaps to commemorate a marriage, also has an allegory, of brute strength conquered by benign love. Again, though classical lovers are represented, the figures are not based on classical prototypes.

By 1500 Botticelli was hopelessly out of key with public (or private) taste. He was rediscovered only in the nineteenth century, when artists such as the Nazarenes and the Pre-Raphaelites responded eagerly to the delicacy and vitality, the apparent clarity and deeper mystery of Botticelli's paintings.

A strange, positively neurotic, loner in late fifteenth-century Florence may be mentioned here, Piero di Cosimo (1462-1521). He likewise painted mythological series for private patrons, apparently allegories of the primeval, savage state of man.

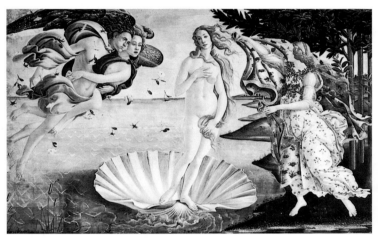

BOTTICELLI (below)
Mars and Venus, late 1480s
No known text describes the traditional lovers Mars and Venus in this way: it is Botticelli's or his patrons' interpretation. Its meaning could be both literary and astrological. There are wasps, *vespi* in Italian, buzzing by Mars' head, which allude to the patrons, the Vespucci.

BOTTICELLI (above)
The birth of Venus,
c. 1482-84
In legend, Venus was born from the sea foam and blown by the west wind on to the shores of Cyprus. Her pose clearly echoes classical statuary of the type called *Venus pudica* – naked Venus covering breasts and vulva with her hands. However, the sloping shoulders and the sinuous lines of her elongated body seem a deliberate reversion to Gothic proportions. It was perhaps still felt to be too pagan to show pagan figures in a pagan style.

BOTTICELLI (left)
Abundance, undated
Botticelli went over a first drawing in black chalk with a pen, introducing highlights with white body-colour. The animated calligraphy is even more pronounced than in his painting.

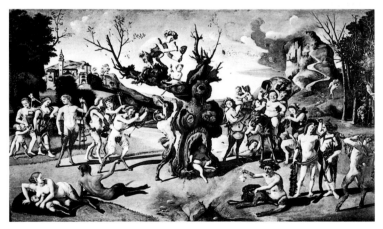

PIERO DI COSIMO
The discovery of honey,
c. 1500
Piero, like Botticelli, also painted mythologies, but

very different in mood. They range from sinister, desolate and yet tender, all but surreal visions to almost comic fantasies.

The main theme or story here is that Bacchus, with the drunken Silenus on a donkey, discovers bees' honey for human use.

Renaissance Painting in North and Central Italy

Andrea Mantegna (c. 1430-1506) was the first Italian born and trained north of the Appennines to make an individual contribution to Renaissance art. His classicism was more extreme than any previous artist's – his settings are archaeological reconstructions – and his experiments in perspective illusionism were bolder than those even of the more mathematically inclined Florentines. He worked in a hard, dry, clear and conscientious style, sometimes unnaturally stony, as if his figures were sculptures; but his art was enlivened by sensitivity and delicacy of touch, and occasionally pierced by fierce emotion.

Mantegna acquired his intellectual love of antiquity in Padua, where the university was an established humanist centre. He was the adopted son and pupil of Francesco Squarcione (1397-1468; not shown), an obscure figure, an indifferent painter, an antiquarian and probable dealer in classical antiquities, an entrepreneur. Squarcione had been deeply impressed by Alberti's theories of painting, and must have passed these on to Mantegna, but Mantegna also gained his knowledge of perspective – and of quality in art – from Florentine artists who had come north – not only Donatello, but also Filippo Lippi, Castagno and Piero della Francesca. He formed his style, which was to change little, astonishingly rapidly: it was already set in his first commission, frescos for the Eremitani church in Padua (ruined in World War II), which he undertook at the tender age of 17. Their powerful perspective effects were clearly inspired by Donatello's reliefs for the high altar of S. Antonio nearby.

In 1454 Mantegna married the daughter of the Venetian painter Jacopo Bellini (see over), and in 1459 he was installed with his family in a house in Mantua as court painter to the Gonzaga dukes. Mantua, small but politically independent since 1328, became under the Gonzagas a centre of humanist learning – Ludovico Gonzaga, as we have seen (p. 320) was in close touch with Urbino. Mantegna subsequently visited Florence and Pisa and painted briefly in Rome (where none of his works survive) but Mantua was to be his base until his death. His most famous work, the frescos of the *Camera degli Sposi*, is in Mantua, in a corner room of the Ducal Palace.

The *Camera degli Sposi* is the most impressive secular decoration of the early Renaissance in all Italy. It was the first to cover walls and ceiling in a single perspective scheme – even co-ordinating the fall of light in the frescos with the light from the windows into the room – and the ancestor of the great illusionist decorations of the High Renaissance and of the Baroque. Central in the room, over the chimney-piece, is a family group – including the court dwarf – on a sort of terrace, revealed by curtains drawn back. The illusionism is sophisticated: one figure stands between the spectator and a pilaster (painted) with his feet on the chimney-piece (marble). On the adjacent wall scenes from Ludovico

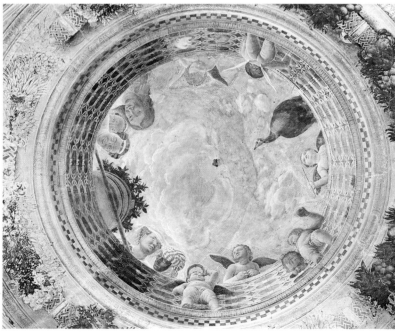

DONATELLO (above)
Relief from the Santo altar: *The miracle of the mule*, c. 1447
A mule led forward by St Anthony of Padua knelt before the Host, convincing a sceptic. The double grills across the arches are an example of the elaborate perspective that influenced Mantegna.

MANTEGNA? (above)
Self-portrait, c. 1490
Mantegna was very aware of his status as an artist. He is wreathed in laurel as the antique poets were; the bust is a prototype for the High Renaissance image of proud genius. (The bronze bust may be by one Gianmarco Cavalli, rather than by Mantegna.)

MANTEGNA
Fresco from the Eremitani: *The martyrdom of St Christopher*, 1448-51
A foreshortened column divides the two episodes. On the left, arrows shot at St Christopher fail miraculously to strike him; on the right the saint's giant body is dragged away, with his head on a platter once visible in the foreground. Mantegna's lifelong preoccupations are already clear – ambitious perspective and bold foreshortening; archaeological detail; firmly modelled, harshly lit, static forms; and colours veering from a clashing intensity to a virtual monochrome.

MANTEGNA (right)
The *Camera degli Sposi*, ceiling, c. 1474
Inspired, perhaps, by the similar *oculus* in the dome of the Pantheon in Rome, Mantegna's skyward peep is a first example of foreshortening from below, which Correggio (see p. 148) was to exploit in his aerial fantasies in nearby Parma some 40 years later.

Gonzaga's life open out over countryside, with the Duke and his small children welcoming home his son Francesco, who had newly been created a cardinal. The countryside, however, featuring Roman ruins and statuary and hilltop towns, is imaginary – Mantua is flat. Above, the room is opened to the elements by an illusionist circular opening inserted in the richly decorated vault. It is like an inverted well, to which *putti* cling, and smiling women looking down into the room seem about to push over into it a precariously balanced flower tub as a practical joke. The illusionism, when it was quite new, must have been even

more startling: the colour and the firmly painted portraits (the first family group in Italian art) would have been even more vivid.

Mantegna's next major work was a pageant sequence of nine huge canvases illustrating *The Triumph of Caesar*. Their original setting and function are unknown, though in 1501 they served as a backdrop to the performance of a Latin play. There was no doubt some suggestion that the Gonzagas were comparable with Caesar, but the sequence was the ideal commission for Mantegna, offering full scope to his antiquarian obsessions.

Mantegna also produced many altarpieces, often enlivening conventional themes by virtuoso effects of foreshortening, as in his *Dead Christ*, stretched out feet first on a table (reproduced on p. 182). There, and in his painting of *St Sebastian*, he introduces "cutoff" figures as an illusionistic device, like the foreshortening, to suggest the picture is larger, but hidden by the frame. The two figures in the *St Sebastian*, with their grotesque features, may show the influence of northern paintings or engravings; Mantegna himself made widely influential engravings, and was the first artist in Italy to produce them regularly.

The Gonzagas had links also with the ruling family in Ferrara, the Estes. Previously the Estes had imported Netherlandish artists or artists from the south, such as Piero della Francesca, but after the middle of the century a local school developed of high quality. Its finest painters, Cosimo Tura (c. 1431-95), Francesco del Cossa and Ercole de' Roberti, all reflect something of Mantegna's angular harshness, and, in varying degree, his interest in antiquity. Isabella d'Este was a passionate, and demanding, art-lover, determined to form a collection of all the best living painters in Italy: she ordered mythological works from Mantegna, Perugino and Giovanni Bellini.

Carlo Crivelli (1435/40-1495/1500) was a Venetian painter who worked mostly in the Marches, and was also strongly influenced by Mantegna in his figure drawing. He specialized in elaborate altarpieces rich with swags of fruit, peacocks and other such decorative detail, sometimes with raised *gesso* relief and studded with semi-precious jewels. Mantegna was as important for northern Italy as Masaccio had been for Florence – his influence, however, was most crucial and fertile in the art of his brother-in-law, Giovanni Bellini.

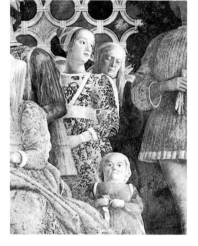

MANTEGNA (left)
The *Camera degli Sposi*, general view, c. 1474
The eye-level views on the left wall make an interesting comparison with Gozzoli's *Journey of the Magi* in the Medici Palace in Florence (see p. 110): the landscape is equally fanciful but evokes now a classical world. The harsh clarity of Mantegna's drawing, clear in the detail (right) of a lady-in-waiting and the court dwarf, is also comparable with that of contemporary Florentines, though it is more static, not concerned to show vigorous movement as was Pollaiuolo, for instance.

COSIMO TURA (right)
The *Virgin Annunciate*, 1469
Cosimo's intense, brittle figures have the same surface hardness as Mantegna's. His love of detail, not so archaeological as Mantegna's, is typical of north Italy.

CRIVELLI (below)
Pietà, 1493
Crivelli's metallic hardness belies his Venetian origins; it is a legacy from Mantegna; so is his

accomplished illusionistic decoration – his delight in marbled surfaces and shining objects. With it he and others could achieve abrasive emotional effects.

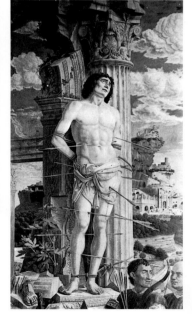

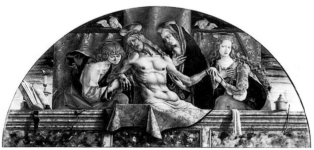

MANTEGNA (above)
The *Triumph of Caesar*, c. 1486-94
Mantegna's fascination for everything antique – buildings, sculpture, furniture, caparisons, utensils, costume, armour – has here full scope.

MANTEGNA (right)
St Sebastian, undated
Vasari was one who complained that Mantegna's figures "sometimes seem to be made of stone rather than flesh and blood". The stone foot beside the saint's seems a wry retort.

Renaissance Painting in Venice

During the Middle Ages, the political and cultural interests of the republic of Venice were more with Byzantium and the East than with the rest of Italy. "Queen of the Adriatic", Venice had already become in the thirteenth century a great naval and mercantile power, but had only gradually expanded her protection over the north-east mainland of Italy, into the Veneto. Apparently unmoved by Giotto's revolutionary work in Padua, virtually next door to Venice, Venetian art had continued largely Byzantine in feeling, and somewhat provincial in quality, until Gentile da Fabriano introduced the International Gothic about 1408. Thereafter a succession of distinguished visiting Florentines (Uccello, Lippi, Castagno) made some impact, but the crucial influence was Donatello, working in Padua in the 1440s. Mantegna, an apprentice in Padua at the time, had been profoundly impressed, and Mantegna's own example was followed for a time by the outstanding Venetian painter of the fifteenth century, Giovanni Bellini, who was his brother-in-law.

The Bellini family was the dominant artistic dynasty in Venice during most of the fifteenth century. The father, Jacopo (c.1400-70/71)

had worked in Florence; he had been a pupil of Gentile da Fabriano, and his style was essentially a somewhat stiff but luminous version of International Gothic. Surviving notebooks show also a sensitive, if free, appreciation of classical art. Gentile (c.1429/30?-1507) is believed to have been the elder of his two sons, and was for long the most famous, ennobled by the Emperor in 1469, and even working for the Sultan Mehmet II in Istanbul in 1479-81. His most remarkable surviving works are ceremonial pageant pictures, large-scale, and painted on canvas: these panoramas feature accurate portraits both of Venetian architecture and townscape (establishing a tradition that was to culminate in Canaletto), and of important citizens. Gentile's grouping, however, is formal and static; it was left to Vittore Carpaccio (c.1450/55-1525/26), who probably started as his pupil, to transpose Gentile's skills – if not quite into movement, into poetic narrative packed with incident and detail from everyday life. Carpaccio's directness and his humanity make him one of the most accessible and loved of all Italian painters, but he was, too, a master of tone and light, clearly reflecting the influence of Giovanni Bellini.

Giovanni Bellini (c.1430?-1516) is presumed the younger son of Jacopo. Uncertain though his birth date is, he must have been well into his eighties when he died. He continued working throughout his very long career, and was always astonishingly inventive and sensitive to the changing moods and discoveries of the passing years, so that right at the end of his life he was responding creatively to the innovations of his own pupils, Giorgione and Titian. He was one of the first artists to sign his work – or the products of his large and busy workshop – fairly consistently, although in his earlier years especially he rarely dated it, and his early development is difficult to reconstruct. A characteristic work, such as the *Pietà* in the Brera, Milan, perhaps of about 1470, clearly acknowledges the sculptural clarity of Mantegna; indeed the design is very close to a relief on Donatello's altar in Padua. But Giovanni's own tenderness is already distinct.

In 1475-76 the sojourn in Venice of an artist from Sicily, Antonello da Messina (c.1430-79), seems to have had a fundamental impact on Venetian painting. The innovation that he demonstrated was (ironically, since he was a Sicilian) the Netherlandish technique of oil-

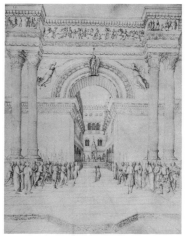

JACOPO BELLINI (left)
Christ before Pilate,
undated
Jacopo's two copybooks show both the influence of Pisanello and an interest in the Antique comparable to Mantegna's – though not classicizing in his sense. They are difficult to place.

GENTILE BELLINI (right)
*Sultan Mehmet II, c.*1480
The temporary export of the city's painter (he was so appointed in 1474) to the Infidel is a sign of Venice's predominantly Eastward interests; her entry into the mainstream of Italian art coincides with a retraction of her power in the Levant.

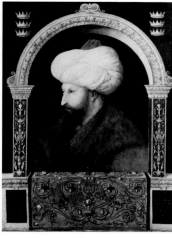

GENTILE BELLINI (below)
The miracle at Ponte di Lorenzo, 1500
The series illustrated the miracles performed by a

fragment of the Cross: here the relic fell into a canal; a friar dived in after it; he could not swim, but the Cross kept him afloat.

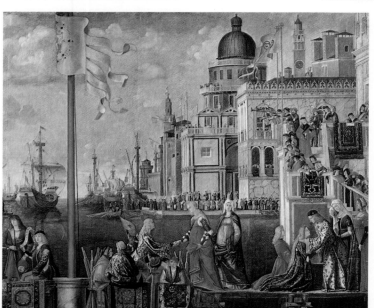

CARPACCIO (left)
St Ursula taking leave of her parents, detail, 1495
The almost orientalizing use of classical ornament, which is evident not only in Gentile's portrait (above) but even in Jacopo's sketch, has vanished (except for the occasional detail in the faithfully recorded architecture). Architecture, naval rig, dress, hangings, the whole splendour of the city is intimately notated, though the view is fictive. The assured perspective is the legacy of successive visiting mainland artists, from Pisanello onwards.

ANTONELLO DA MESSINA (right) *St Jerome in his study, c.* 1460
The detailed interior, with its five sources of light and enamel-smooth finish, was once attributed to Jan van Eyck, and may have been based on part of a triptych by him recorded in Naples.

was elected for life from
among the leading families.
In his palace almost every
important Venetian painter
executed large-scale works;
those of the 15th and early
16th centuries are lost, the
victims of successive fires.

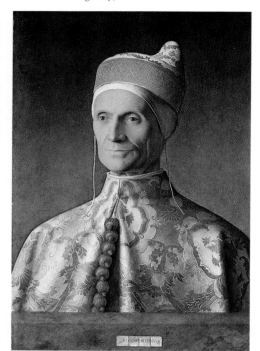

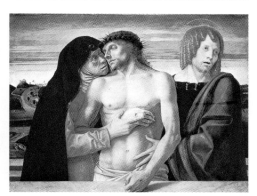

painting, which he had probably learnt from
Netherlanders in Naples, rather than in the
north. Although oil had been used in Italy,
nothing like the range of Netherlandish tech-
niques, especially in the rendering of pervasive
and enveloping light, had been developed
there. Antonello's *St Jerome in his study*,
painted some years before his arrival in
Venice, is very distinctly Eyckian both in the
treatment and in the detail of its domestic
interior. He also approached portraiture in a
Netherlandish fashion: in marked contrast to
the standard Italian formal portrait, the
atmospheric portrait heads of his sitters, with
their alert vitality and vivid eyes, are as indi-
vidual and natural as Memlinc's. He has been
called the first Italian painter to practise
portraiture as an art form in its own right, and
his impact on Giovanni Bellini's portraits is
clear. Bellini's portrait masterpiece is con-
siderably later, about 1502, *Doge Leonardo
Loredan*: it is a superb synthesis of formal,
hieratic clarity with the subtlest modelling –
conveying both the magnificence of the office
and the full humanity of its holder.

It was the flexibility and brilliance of the oil
technique that made Bellini's later master-

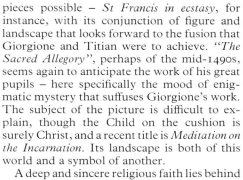

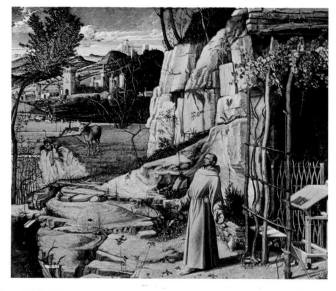

pieces possible – *St Francis in ecstasy*, for
instance, with its conjunction of figure and
landscape that looks forward to the fusion that
Giorgione and Titian were to achieve. *"The
Sacred Allegory"*, perhaps of the mid-1490s,
seems again to anticipate the work of his great
pupils – here specifically the mood of enig-
matic mystery that suffuses Giorgione's work.
The subject of the picture is difficult to ex-
plain, though the Child on the cushion is
surely Christ, and a recent title is *Meditation on
the Incarnation*. Its landscape is both of this
world and a symbol of another.

A deep and sincere religious faith lies behind
Bellini's painting, and undoubtedly informs
the lasting beauty of his religious works, not
least his long series of *Madonnas* (see p. 138).
In old age, however, he ventured on secular
allegories (not shown) often now difficult to
interpret – moved perhaps by the example of
his pupils Giorgione and Titian, but no doubt
also by humanist interests like those which had
moved patrons such as the Medici in Florence
rather earlier. The alertness of his response to
new developments was inexhaustible: reac-
tions to Dürer, as to Leonardo, have been
convincingly traced in his last paintings.

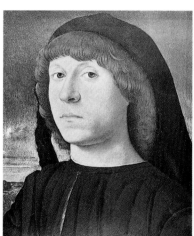

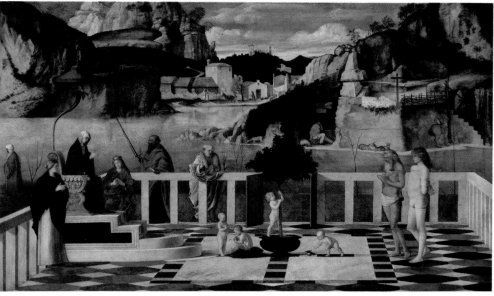

this, in which, further, the
sitter looks straight at the
viewer, recalls van Eyck's
Man in a turban (p. 93),
the first known example.

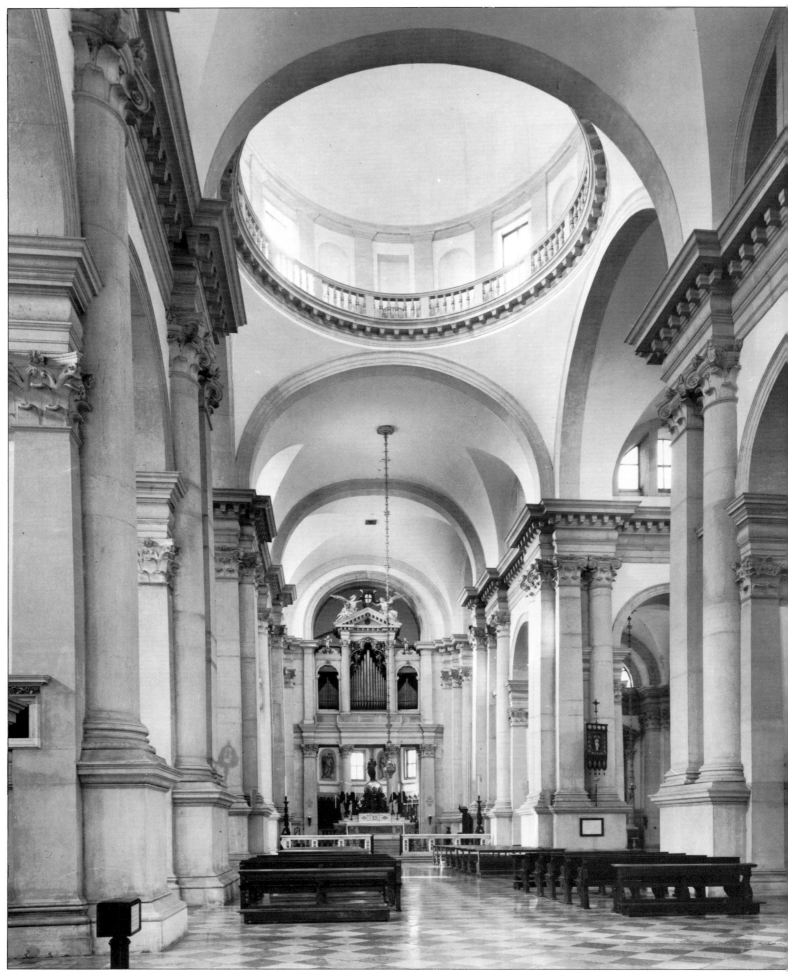

THE SIXTEENTH CENTURY

The concept of the artist as genius originated in sixteenth-century Italy and was applied to three men who were accorded an almost god-like stature – Leonardo, Michelangelo and Raphael. Both in their art, characterized by its mastery of rational design and structural harmony, and in their lives, they created an enduring model of humanist ideals. Yet their masterworks, and those of the other giants of the century, Dürer in Germany, Titian in Venice, Bruegel in the Netherlands, were produced against a background of increasing political and religious turmoil.

In the earliest decades of the century, the spiritual and political unity of the medieval world under the dual authority of the Pope and the Holy Roman Emperor was shown to be fragmented beyond repair. Political conflict between Pope and Emperor came to a head in 1527, when troops led by Emperor Charles V sacked Rome in retribution for Pope Clement VII's alliance with the rising power of France. A greater challenge not only to the Papacy but to the survival of religious art was the Reformation begun by Luther in 1517 under the protection of German principalities, leading as it did to civil war, persecution and, at times, to the pillaging of churches and destruction of images. It was only with the Council of Trent (1545-63) that the Catholic Church began to regain its spiritual confidence – a Counter-Reformation demanding a stricter code for its artists, including the restricted use of what had been a hallmark of Renaissance art, the nude.

Challenges to the authority of antiquity, tradition and the Bible came from other quarters, the astronomy of Copernicus for instance, the physics of Galileo, the altered world view initiated by the discovery of the New World and by the growth of sea trade with the East. Not only the sciences but all the arts were turned to new directions, to ends that were often distinctly secular. Yet the prototypes which were to influence Western art for nearly four centuries were produced under Church patronage. The Roman works of Raphael and Michelangelo for Popes Julius II and Leo X established Italian art as the guiding force for northern artists such as Dürer. The same works provided a point of departure for the development of Mannerism. Though many attempts have been made to show that this style was the outcome of a neurotic sensibility induced by the instability of the established Church and state, it may be understood simply as a "mannered" interpretation – which could be witty, erotic or grotesquely inflated – of the art of the High Renaissance.

Rome's major rival in the sixteenth century was Venice, whose long monopoly of trade with the East had been broken but whose civic wealth still permitted patronage of a most lavish kind. Contemporary writers who praised central Italian artists in terms of *disegno* (draughtsmanship) were sometimes by implication critical of the Venetian emphasis on *colore*, a freer handling of colour and paint and a more spontaneous and less intellectual approach. Yet it is the art of Venice, and the more isolated but great achievements of the north, together with the High Renaissance of Florence and Rome, that established the painting and sculpure of the sixteenth century as the touchstone of Western art.

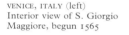

VENICE, ITALY (left)
Interior view of S. Giorgio Maggiore, begun 1565

PRAGUE, BOHEMIA (right)
Vladislav Hall, Prague Castle, begun 1487

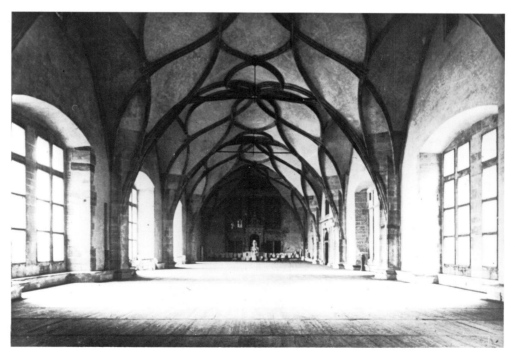

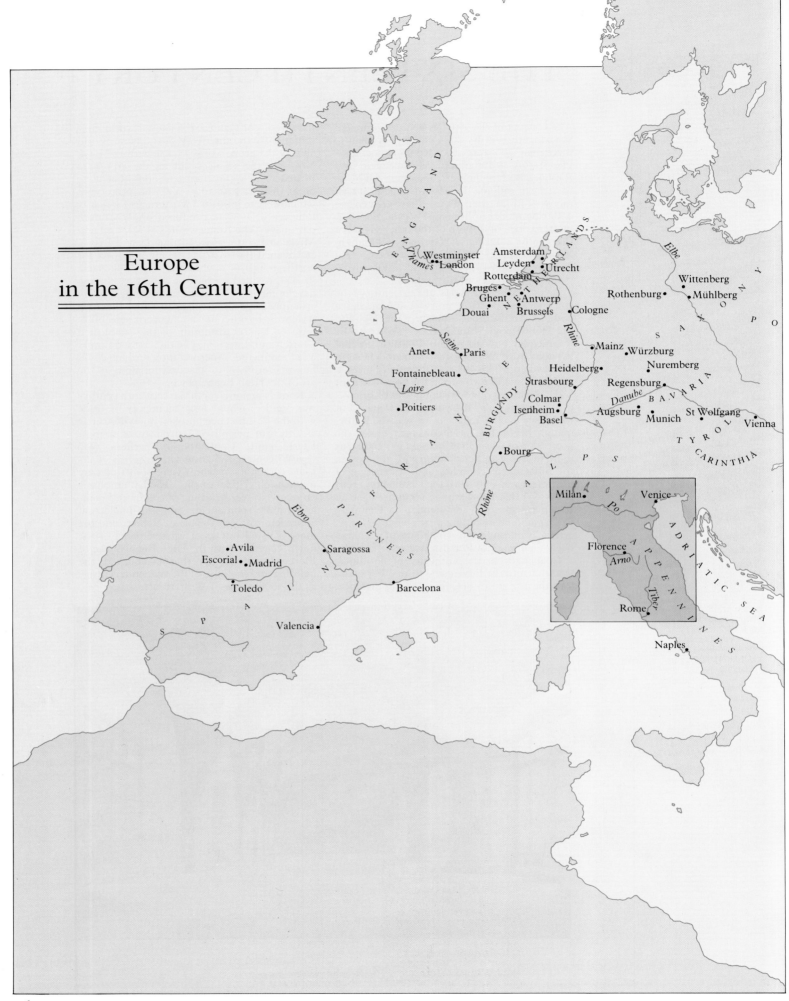

Europe
in the 16th Century

ENGLAND

Westminster
London
Thames

Amsterdam
Leyden
Utrecht
Rotterdam

NETHERLANDS

Bruges
Ghent
Antwerp
Douai
Brussels
Cologne

Wittenberg
Mühlberg

SAXONY

PO

Rothenburg

Rhine

Anet
Seine
Paris

Mainz
Würzburg

FRANCE

Fontainebleau
Loire

Heidelberg
Strasbourg
Colmar
Isenheim
Basel

Nuremberg

Regensburg

Danube

BAVARIA

Poitiers

Augsburg
Munich

St Wolfgang

TYROL

Vienna

CARINTHIA

BURGUNDY

Bourg

ALPS

Milan

Po

Venice

ADRIATIC SEA

Ebro

Saragossa

PYRENEES

Florence
Arno

APPENNINES

Avila
Escorial
Madrid

Toledo

Barcelona

SPAIN

Rome
Tiber

Valencia

Naples

Rhône

Moscow

Dnieper

Kiev

Cracow

L A N D

Istanbul

C R E T E

Alexandria

Trent • Pieve di Cadore

Bassano • Maser

Bergamo • Treviso

Milan • Brescia • Verona • Castelfranco

Cremona • Mantua • Padua • Venice

Po • Parma • Ferrara

Bologna

Forli

Arno • Florence • Urbino

Ancona

Siena

Tiber

Viterbo

Rome

L O M B A R D Y

V E N E T O

F R I U L I

T U S C A N Y

The High Renaissance 1: Florence and Rome

It is still generally accepted that the High Renaissance was both a peak and a watershed in the history of European civilization, and that the Christian era can be divided essentially into pre-Renaissance and post-Renaissance, into medieval and modern. The early Renaissance had been a gradual revolution affecting not only the visual arts but literature, technology and the sciences as well; its consummation and climax, its point of no return, came in the brief moment of the High Renaissance in the early sixteenth century.

Vasari, in his *Lives of the Artists* (1550, revised 1568), formulated the art historical tradition that traces a path from Giotto, who began the break away from Byzantine and Gothic, through the early Renaissance and its prophets Masaccio and Donatello to the summits stormed by Michelangelo. The twentieth century has since discovered a fully realized perfection in Piero della Francesca, but perhaps the quintessential figure of the early Renaissance was Leon Battista Alberti. He was a poet, musician, scholar, mathematician and athlete, a painter, sculptor and architect – the prototype of the "universal man". His treatises conceived the arts as based on reason

the basis for a system of proportions. Leonardo's diagram reconciling circle and square is one image of High Renaissance harmony.

and human reality, and encouraged the scientific study of structure – whether in perspective or in anatomy – so that even religious themes were set forth in realistic terms. However, the attempt of the Dominican priest Savonarola, between 1494 and 1498, to build in Florence a new Jerusalem is a reflection of the continuity of religious belief and its prime claim.

Leonardo, Michelangelo and Raphael, the three great figures whose names often stand for the whole High Renaissance, are discussed in the following pages. They were all grounded in the Florentine tradition, but during the High Renaissance Rome became quite suddenly the main centre of the arts in Italy, barring only Venice. The ambitions of the fifteenth-century popes, such as Nicholas V, had been hampered by lack of political control, and, despite its classical sites and its libraries, Rome had been artistically provincial. Visiting artists, however, such as Fra Angelico, Piero della Francesca, his accomplished follower Melozzo da Forli (1438-94) and then many more, had painted there. By the beginning of the sixteenth century the papacy had established a temporal power, and Pope Julius II, elected in 1503, could dream of reviving the

MELOZZO DA FORLI (left)
Sixtus IV ordering his nephew Palatina to reorganize the Vatican library, 1475-77
The crisp outlines and the relatively flat, unmodulated colour belong to the early Renaissance. The tallest cardinal near the centre is the future Pope Julius II.

PINTORICCHIO (right)
Susannah and the Elders, in the Borgia apartments in the Vatican, c. 1492-94
The gilt gesso relief was inspired by similar work in Nero's Golden House; so also was the elaborate geometric ceiling design. Pintoricchio's work was light, pretty and detailed.

LEONARDO (below)
The Last Supper, c. 1495
It is said that even before Leonardo had finished it the painting had begun to decay. Leonardo departed from the usual fresco techniques to experiment with oil, probably because he wished to work up all the parts together, and so link the individual expressions and gestures of the apostles into one common drama. Vasari's anecdotes suggest that the artist spent rather more time pondering over the work than painting it; beautiful drawings survive to witness Leonardo's perfectionist preparation.

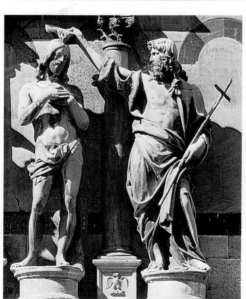

ANDREA SANSOVINO
(left) *The baptism of Christ*, 1502-05
The graceful, almost nude marble Christ stands in a classical *contrapposto* –

the direction of the head balancing that of the legs – and conforms to a canon of classical proportions. Commissioned for Florence Baptistery and set

above Ghiberti's Paradise doors, the group was left unfinished in 1505 when Sansovino was called to Rome. It was completed by Vincenzo Danti (1530-76).

prestige of ancient Rome, and began to rebuild St Peter's, the central church of Christendom, in monumental classical style.

Artists' study of the Antique had become more penetrating, and just at this time excavation yielded important examples of classical sculpture and painting – the *Laocoön*, "*The Torso Belvedere*", "*The Apollo Belvedere*" (see pp. 41, 46) and the paintings and stuccowork of the Golden House of Nero. Though still of the early Renaissance, Pintoricchio (*c*.1454-1513), who had trained under Perugino a little earlier than Raphael, painted "grotesques" inspired by the remains of the Golden House for the apartments of Pope Alexander VI. These were a precedent for Raphael's Stanze (see p. 137) and even for Michelangelo's Sistine Chapel ceiling (see p. 134).

High Renaissance art is far from being all of a piece, and yet its qualities of grace, balance and restraint are quite distinct beside the generally hard and dry manner of the late fifteenth century. Artists not only emulated but surpassed antique models, as the early career of Michelangelo (see p. 132) specifically demonstrates; but even the works of less titanic figures, such as *The baptism of Christ* by

Andrea Sansovino (*c*.1467-1529) for the Baptistery in Florence, display as confidently as Michelangelo's *David* the full assimilation of classical form. The High Renaissance occupied, however, an extremely brief period, coinciding roughly with the working career of Raphael, from his arrival in Florence in 1504 to his death in 1520. It was certainly over by 1527, which brought the shock of northern mercenaries sacking Rome. Yet it had been announced in *The Last Supper* painted in Milan by Leonardo in about 1495, and virtually from the beginning its classic resolutions of early Renaissance preoccupations suggest the fresh departures of the future.

The High Renaissance may be said to open with a flurry of activity just after the turn of the century in Florence, where Leonardo painted *The Battle of Anghiari*, known only through copies, and the *Mona Lisa* (see over), and also set forth crucial compositional problems – the pyramidal group and the *tondo*, or circular, form – explored by both Michelangelo and Raphael. Perhaps its most perfect resolution is Raphael's "*Madonna della Sedia*" (The Virgin enthroned) of 1516-17. Raphael's portrait of Baldassare Castiglione of about the same date,

which still reflects the *Mona Lisa*, also demonstrates the extremely rapid development that occurred within the High Renaissance. Leonardo, Michelangelo and Raphael may each exemplify that classic balance, restraint and harmony claimed as characteristic of the High Renaissance, but none of them can be contained within such a formula.

Briefly together in Florence, these three artists soon left for Rome but Fra Bartolommeo (1472/75-1517) and Andrea del Sarto (see p. 164) continued working there – painters of the first rank by the standards of any other age. At the same time in Venice the great masters Giovanni Bellini, Giorgione and the young Titian were demonstrating the triumph of colour in painting (see pp. 138ff).

The High Renaissance established the fact in Italy that the artist was no longer an artisan but an independent creator, the equal of the poet, the intellectual and the humanist courtier – all of which he might be as well. His fame and distinction depended not only on his craft and skill but on his *invenzione* (invention, imagination), by which he was enabled to undertake and carry off stupendous projects. The concept of the artist as genius was born.

AFTER LEONARDO (below)
The Battle of Anghiari, detail, 1503-06
Leonardo's cartoon for a painting in the Town Hall to celebrate the victories of republican Florence is

now lost, but Rubens' copy of its central part reveals that it intended to convey swift, fierce movement in a complex, close-knit design, with a particular emphasis on the warriors' grimaces.

LEONARDO (left)
The Virgin and Child with a cat, *c*.1478-81
Leonardo's drawings show him "thinking on paper" as artists had never done before – this is not careful study but free experiment, an attempt to solve purely theoretical compositional problems in an early trial of the pyramidal theme.

MICHELANGELO (right)
"*The Pitti Madonna*", 1504-05
Replying to the challenge of Leonardo's *Madonnas*, Michelangelo made three *tondi* between 1501 and 1505, two in marble, one a painting. Like Leonardo's, his poses are contrived and often sharply foreshortened.

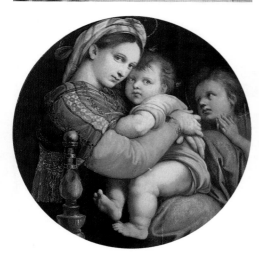

RAPHAEL
"*The Madonna della Sedia*" (The Virgin enthroned), *c*.1516-17
Raphael's composition is a perfect balance of curving forms in a round frame,

stabilized by the discreet upright of the throne arm. It is also an equilibrium of harmonious colours, not rich and glowing like those of the Venetians, but full and subtly satisfying.

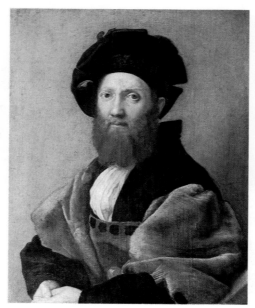

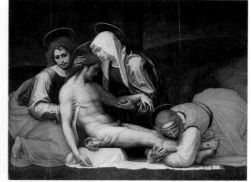

RAPHAEL (left)
Baldassare Castiglione, *c*.1516
The clear gaze and muted colours create warmth and an alert dignity without affectation, setting a new standard in portraiture. In his famous *Book of the Courtier* Castiglione hints at his esteem for Raphael beyond all other artists.

FRA BARTOLOMMEO
The Entombment, 1515
The refinement, softness and pure colours are typical of the Dominican's mature work. He was influenced by Leonardo, but his figures lack Leonardo's mystery, being more sculptural and monumental. There is an emotional strain, recalling Savonarola's preaching.

Leonardo da Vinci

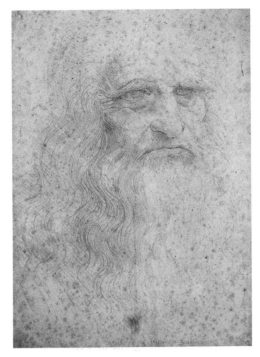

Leonardo da Vinci (1452-1519) was both prophet and arch-exponent of the High Renaissance. The oldest of its three supreme masters, he was nearly 50 when Michelangelo and the precocious Raphael entered their mature careers, but in his paintings of the 1480s and 1490s he had already absorbed and even surpassed the attainments of his contemporaries and, with an extraordinary intellectual grasp matched by an unfaltering skill of hand, he then passed far beyond them – indeed into fields apparently remote from art.

Leonardo's first master was Verrocchio (see p. 115), in whose workshop he learned all the techniques the Florentine fifteenth century could teach him. His first known work, which he painted as an assistant, is the left-hand angel in Verrocchio's *Baptism* of about 1472. Verrocchio, it is said, was so impressed by the intimations of his pupil's genius that he gave up painting.

By 1472 Leonardo was enrolled in the Guild of Painters and was able to accept independent commissions. His concern to convey emotion through subtleties of expression meticulously observed is clearly evident in the early portrait, *Ginevra de' Benci*, perhaps of 1474. There is

again a strong sense of atmosphere in the unfinished *Adoration of the Magi* of 1481, in which many themes that will recur are seen for the first time – in particular his *sfumato* – no clear edge defines the contours – also the structure, created by the disposition and massing of the figures, linked by movement and gesture. The intensive preparation, the multiplication of preliminary sketches, was no less characteristic of Leonardo. Never before had so much of the artist's effort been devoted to the development of the idea, the process of invention. As a result the number of his drawings is immense but his pictures, though highly refined and novel, are relatively few, and often remained uncompleted.

By 1483 Leonardo was working for Lodovico Sforza il Moro in Milan. He seems to have announced himself primarily as a military engineer but also as an architect and sculptor. An equestrian statue got no further than a huge clay model, destroyed, for which, however, numerous drawings survive. *The Virgin of the rocks* was commissioned in 1483 (a second and later version was produced with an assistant's help). The pyramidal group of figures centred on the Madonna, set in a fantastic landscape

LEONARDO (above)
*Self-portrait, c.*1512
Vasari once described the artist, here aged about 60: "In appearance he was striking and handsome; his magnificent presence brought comfort to the most troubled soul". He was a musician of famed skill, a lover of animals – "Nature's own miracle".

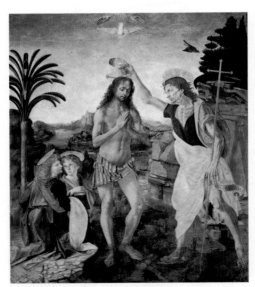

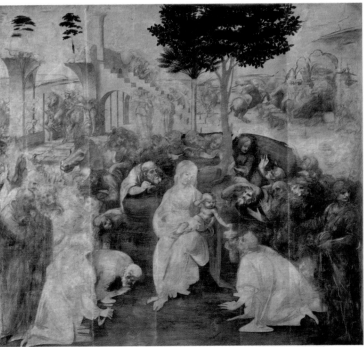

LEONARDO (left)
The Adoration of the Magi, 1481
Leonardo worked from dark to light, building up in oils – a new medium and a new technique in Italy. The almost monochrome underpaint reveals his methods. He created form by tonal blending "without lines or borders in the manner of smoke" – his famous *sfumato* technique. An elaborate perspective preparatory drawing has survived, but even there the mathematical grid is laden with creatures apparently of fantasy, full of inner life.

LEONARDO (below)
Ginevra de' Benci, c. 1474?
The background juniper, in Italian *ginepro*, is the emblem of the poetess. There is a suggestion of her veiled thoughts, of what Leonardo was to call the "motions of the mind"; a sombre, misty riverscape behind echoes the mystery of her heavy-lidded eyes.

VERROCCHIO AND LEONARDO (above) *The baptism of Christ, c.*1472
The graceful angel kneeling in profile, and also his finely modelled robe, the tuft of grass beneath and the landscape above, are attributed to the young Leonardo. He adds to Florentine lucidity a new spiritual element in the pensive head. His master Verrocchio's work by contrast seems brittle, without fluidity or ease.

LEONARDO (left)
Landscape, 1473
The pen-and-ink drawing of the Arno valley above Florence is Leonardo's earliest signed and dated work, with an inscription written from right to left. His interest in geography is apparent as well as his preoccupation with movement: lines suggest swaying trees, and the sweeping strokes foreshadow the pantheism of the later *Deluge* sketches.

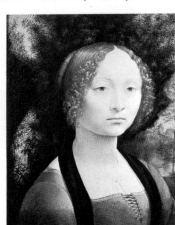

illumined by a mysterious twilight, was to prove a recurrent source of inspiration, especially for Fra Bartolommeo's and Raphael's *Madonnas*. Around 1495 Leonardo embarked on another famous project, *The Last Supper* (illustrated on preceding page): this, though now a ruin, was one of the most influential paintings of the Renaissance. It conveys the psychological drama of a moment of crisis – something never expressed in the more rigid treatment of the subject by earlier painters.

When Milan fell to the French in 1499 Leonardo returned to Florence via Mantua and Venice. Between 1500 and 1508 he produced three major works that have haunted the imagination of posterity – the now vanished fresco of *The Battle of Anghiari* in the Palazzo Vecchio, Florence; the *Mona Lisa*; and *The Virgin and Child with St Anne*. Copies of the central part of Leonardo's cartoon for the *Battle of Anghiari* survive (see preceding page); these, and preparatory studies, witness his concern both for anatomical accuracy and for expressiveness – in the warriors' faces and in the pent-up energy of the horses and men. The *Mona Lisa*, begun in 1503 and taken by Leonardo to France, has been claimed as the

first modern portrait. The consummate technical skill with which tones and colour are merged into volume and the mysterious individuality evoked were unparalleled. The surviving versions of *The Virgin and Child with St Anne* are all unfinished, but they fully demonstrate Leonardo's search for complex and perfect balance in composition, and the unfailing ingenuity he brought to it, which amazed his contemporaries.

Leonardo's last years were restless. He produced fewer paintings but continued to be active in his many fields – in Milan again in 1508. Some sculptural projects are recorded, but no authenticated sculpture by Leonardo survives, and he never built a building, though from an early age he produced theoretical architectural plans and elevations. Then in 1513 he left for Rome, where he seems to have devoted himself chiefly to scientific experiments. His dissections, for instance, gave him an unprecedented grasp of anatomy, and led him to discuss the circulation of blood long before Harvey described its true workings. In 1516 he left for France, where he was the honoured guest of Francis I until his death at the age of 67 in 1519.

Vasari records Leonardo's intellectual curiosity, but his notebooks, virtually unknown to his contemporaries, have revealed to the modern world his astonishing observations and the full scope of his inventive genius. He was quite unlike his contemporaries in his relative indifference to the authority of classical scholarship, to philosophy and to poetry – he started always from what he saw – but he has become the archetype of "*l'uomo universale*", the universal man in whom all human knowledge was embodied. He also, like Michelangelo, provided a model for the concept of genius – not least by his fiercely independent, restless style of life; even by the fact that he was born illegitimate. Claiming the pre-eminence of his preferred art, painting, over the others, he argued that the painter's mind was endowed with a creative capacity which brought him closer to the mind of God. His reputation in his life-time was immense, and it was acknowledged visibly not only in the work of the foremost painters of the time in Florence – Fra Bartolommeo, Andrea del Sarto and, above all, Raphael – but also in Milan and northern Italy – by Correggio in Parma, and by Giorgione in Venice.

LEONARDO (below)
The Virgin and Child with St Anne, c. 1495
The cartoon, in black chalk heightened with white, is one of several variations on a pyramidal composition.

LEONARDO (right)
Mona Lisa, c. 1503-06
The critic Pater expressed a common awe: "All the thoughts and experiences of the world have etched and moulded there".

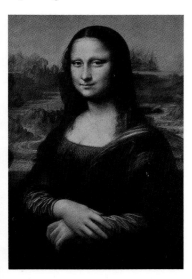

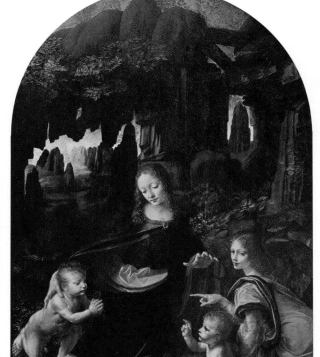

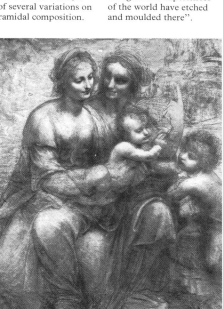

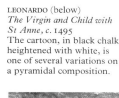

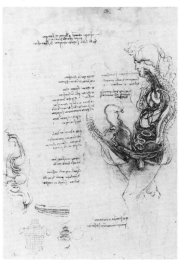

LEONARDO (above)
The Virgin of the rocks, c. 1483-85
Strangeness – a nebulous metaphysical, even divine quality – is conveyed by the mysterious light and the quiet expressions of the Virgin and the angel.

LEONARDO (right)
Flying machine, c. 1486-90
Years spent studying the flight of birds inspired Leonardo's anticipations of a helicopter. The attempt at flight is typical of his ambitiousness and absolute confidence in his powers.

LEONARDO (right)
Anatomical drawing:
Sexual intercourse, c. 1492-94
Dissections made possible a knowledge of anatomy unrivalled in Leonardo's time. Limitless curiosity and sure draughtsmanship yielded scores of studies. The script is in mirror-writing – an unusual but logical consequence of the artist's left-handedness.

Michelangelo Buonarroti

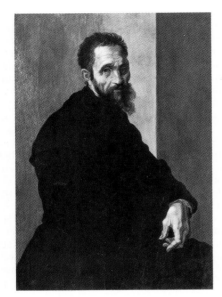

Michelangelo Buonarroti
The artist's troubled, even battered face reflects a life-long struggle with colossal projects, and the sense of failure that recurs in his letters and poetry of often tormented piety. His hand is painted in the shape of the hand of his own *David*.

Michelangelo Buonarroti (1475-1564) was the most sought-after artist in the sixteenth century, and for posterity the outstanding example of an artistic genius. His tumultuous career, with its perpetual struggles and its passionate commitment to art, was to become the master pattern for the Romantic artist.

In 1488, at the age of 13, Michelangelo was apprenticed as a painter to Domenico Ghirlandaio in Florence. He moved after less than a year to the somewhat mysterious "academy" set up in the Casino Mediceo by Lorenzo il Magnifico, where he could study "antique and good statues" and could meet the sophisticated humanists and *literati* of the Medici circle. The Neoplatonic thought current amongst them seems to underlie not only his poetry but much of his painting and sculpture as well.

Following Lorenzo's death, and the brief rule of the priest Savonarola, whose ascetic religion and republican ideals both influenced the young man deeply, Michelangelo left Florence in 1496 for Rome. His reputation, established by the sale of a *Sleeping Cupid* (now lost) as a genuine antique, was sealed by the Vatican *Pietà*, completed in 1499. In its exquisite finish, its flawless classicism, and its evocation

of the human in the divine and the divine in the human, the *Pietà* is indeed a consummation of fifteenth-century art. The perfection of the two figures is informed both by an expert knowledge of anatomy (based on dissections) and by the Neoplatonic theory that the beauty of the body is an expression of its spirit.

Returning, famous, to Florence in 1501, Michelangelo was commissioned by the new republican government to carve a colossal *David*, symbol of resistance and independence. This was the first full statement of Michelangelo's heroic style, and of his inimitable and characteristic *terribilità* (awesomeness). He was also engaged to paint a fresco in the Palazzo Vecchio in rivalry to Leonardo, next to his *Battle of Anghiari - The Battle of Cascina*. The fresco was never painted but the cartoon (now lost), with its convulsive nude soldiers, fascinated artists in Florence.

In 1505 Michelangelo was summoned by the new Pope, Julius II, to Rome and entrusted with an immense sculptural project, the Pope's mausoleum. Although only three of the 40 life-size or larger figures of the early designs were executed – the formidable *Moses* and the unfinished *"Struggling slave"* and *"Dying*

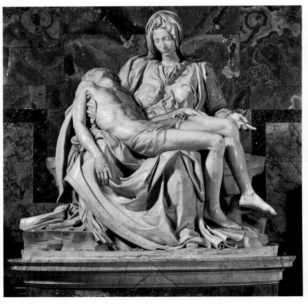

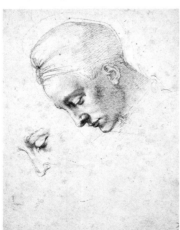

MICHELANGELO (left)
Tityus, 1532
The giant Tityus fed upon by a vulture was a symbol perhaps of the torture of sensual love – as opposed to heavenly love. It was drawn to give to one of his beloved.

MICHELANGELO (below)
"Dying slave", 1513-16
Probably once representing the grief of the world at the passing of Julius II, the suffering figure seems now to feel Michelangelo's and all human torment.

MICHELANGELO (above)
The Vatican *Pietà*, 1499
Christian emotion never has been more perfectly united with classical form. Michelangelo never reached such flawless finish again.

MICHELANGELO (right)
David, 1501-04
The more than life-size *David* is heroically clear-eyed, finely proportioned, and characteristically has both tension and languor.

MICHELANGELO (left)
Study for *Leda*, c. 1530?
The subject, the rape of Leda by Jupiter as a swan, could not be more sensual; and yet the head is so pure.

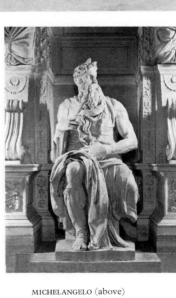

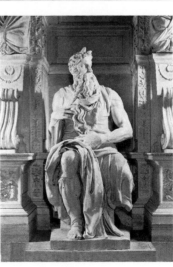

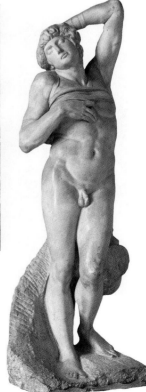

MICHELANGELO (above)
Moses, 1513-16
The severe, massive figure fits uneasily into its final resting place, a mockery of the original, grand scheme. Its strange proportions were determined by its intended position, high up from the ground. In concept, it owes much to Donatello, who had pioneered the Renaissance monumental seated figure.

slave" – the commission dominated most of Michelangelo's life. In 1508 he was transferred by Julius to the Sistine Chapel ceiling, but the constantly aborted history of the tomb, "The Tragedy of the Tomb", ended only in 1547 – some 40 years and five revised contracts later. The final, disproportionately truncated version is in S. Pietro in Vincoli, Rome.

The Sistine Chapel ceiling (see over) was to prove Michelangelo's most celebrated work, but he was always to maintain that he was primarily a sculptor, and, contrary to Leonardo's view, affirmed the superiority of sculpture over painting "as the sun is to the moon". By sculpture, he said, he meant "taking away", that is, carving rather than modelling, as if releasing the image from within the stone. All through his career the unfinished creatures recur, struggling for freedom as if imprisoned in the stone – like man, according to Neoplatonic doctrine, imprisoned in his body.

After the death of Julius II in 1513, Michelangelo could work on the tomb undiverted for a while, but the new Pope, the Medici Leo X, soon engaged him on the façade of S. Lorenzo in Florence. Here was a still better opportunity to harmonize architecture and sculpture in one

design, but it, too, aborted, although Michelangelo was able to fulfil some of his architectural and sculptural ambitions in the Library and the New Sacristy, or Medici Chapel, of S. Lorenzo. The Medici Chapel fell not far short of being completed: two of the Medici tombs intended for the Chapel were installed, and for the third Michelangelo had carved his last great *Madonna* (unfinished; not shown) when he left Florence for ever in 1534.

Arrived in Rome, Michelangelo undertook for the new Pope, Paul III, *The Last Judgment* on the altar wall of the Sistine Chapel. Far from being an extension of the ceiling, this was an entirely novel statement. Between the two projects the stability of Italy had been shown to be pitiably fragile by the Sack of Rome in 1527; the buoyant Neoplatonic Christianity of the early humanists had been overtaken by papal impotence and error and the rise of Protestantism. The mood of *The Last Judgment* is sombre; the vengeful naked Christ is not a figure of consolation, and even the Saved struggle painfully towards Salvation. The colour likewise is sombre; the figures are thick-waisted and heavily muscular, and very forcefully modelled. Michelangelo's last paintings

were frescos in the Cappella Paolina just beside the Sistine Chapel, completed in 1550, when he was 75 years old; but *The conversion of Paul* and *The crucifixion of St Peter* are disturbing visions of undiminished dynamism.

Michelangelo's crowning achievement, however, was architectural – he was appointed architect to St Peter's in 1546. He continued in his last years to write poetry, renouncing in the moving late sonnets the world and even his art; he made remarkable drawings expressing his profound, now often pessimistic, religious feeling; and he carved the two extraordinary, haunting and pathetic late *Pietàs*, one *"The Rondanini Pietà"* in Milan, on which he was working six days before his death.

For his contemporaries the emotionally charged, heroic male nudes of the Sistine Chapel, or the spiralling, exquisitely contorted figures like the marble *Victory* (see p. 164), were more significant, but it is Michelangelo's unfinished, unresolved creations that have especially interested the twentieth century. After Michelangelo, the aesthetic focus becomes not simply the created art object, but the inextricable relationship of the artist's personality and his work.

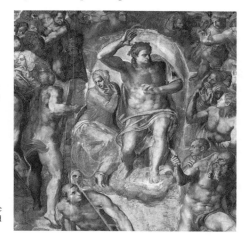

MICHELANGELO (right)
The Last Judgment, detail, on the altar wall of the Sistine Chapel, 1534-41
At the summit of a wall filled with struggling nude figures rising and falling (many have had the nudity overpainted), Christ curses the Damned. With his left hand he much less clearly beckons the Saved, and he seems also to point to his wounds as in the gesture of the Man of Sorrows. It is in strong contrast to the ceiling of 25 years earlier: the nudes have lost their beauty, but doubled their power, their *terribilità*. The great example of the Grand Manner, Vasari called it.

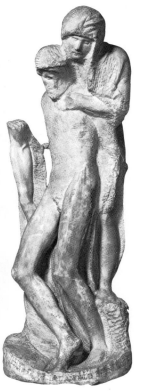

MICHELANGELO (below)
"The Rondanini Pietà", *c.* 1555-64
Mother and Son merge in a rough unfinished sculpture of a rarefied beauty and almost Expressionist power. Reworked and in process of transformation – the artist had destroyed one Christ – the attenuated new beginning has formal parallels in Western art no earlier than this century. Michelangelo was doggedly working on the stone within a few days of his death.

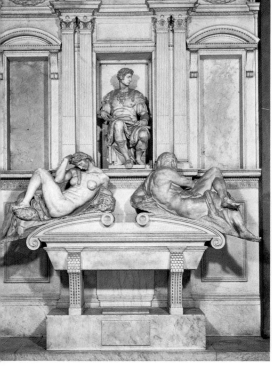

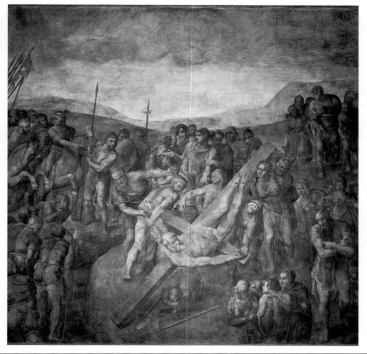

MICHELANGELO (above)
The tomb of Giuliano de' Medici in the Medici Chapel, S. Lorenzo, 1534
Giuliano, with head alert, ready to rise, embodies the Active Principle; on the opposite side (not shown) Lorenzo embodies the Contemplative Principle – a Neoplatonic allegory. The immensely powerful figures of Day and Night, precarious on their sarcophagus, seem to be alien beings of the Unconscious.

MICHELANGELO (right)
The crucifixion of St Peter, 1546-50
Upside down on the cross, St Peter twists round with disturbing contortionism to stare fiercely out at the spectator. He is surrounded by elemental forms that are no longer lit, as before, by potential divinity. The isolated groups cluster round an unsettling vortex, seeming to float without solid edges – as veiled as the unfinished sculptures.

Michelangelo: The Sistine Chapel Ceiling

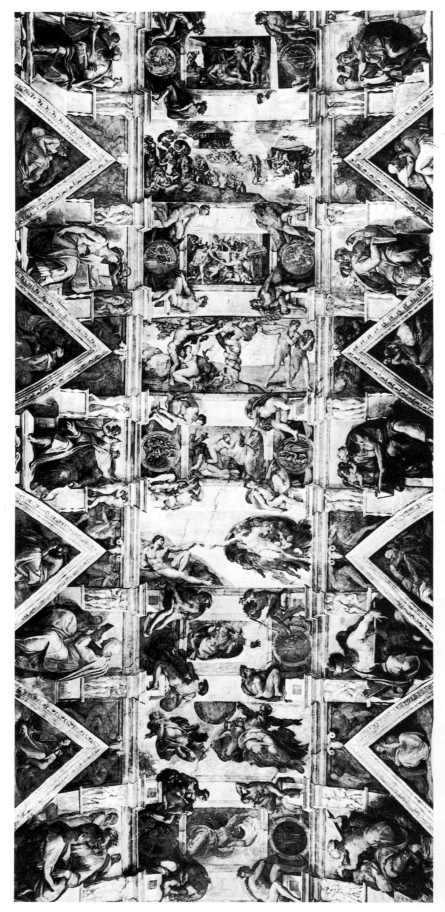

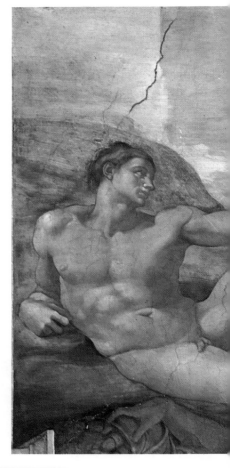

MICHELANGELO
(left) The Sistine Chapel ceiling, 1508-12
The narrative is contained within the long central strip of the barrel vault. It consists of nine scenes from Genesis, three for *The creation of the world*, three for *The creation of Adam* (detail, right), *The creation of Eve* and *The Fall*, and three for *The story of Noah*. The last scene, *The drunkenness of Noah*, above the entrance, shows man in weakness but implies his redemption. Along the sides are figures illustrating the indissoluble concordance of Old and New Testaments, the Old foreshadowing the New: *The ancestors of Christ* listed in St Matthew's Gospel, and pagan *Sybils* and Hebrew *Prophets*, who foretold Christ's coming, in the triangular spandrels of the vault. Separating the nine central scenes are the famous *Ignudi* (male nudes), whose meaning is unclear. Perhaps, though wingless, they are angels, but their vivid force far exceeds the needs of their function, to support fictive medallions and sprays of oak (emblem of Julius II's family); they culminate the Renaissance adaptation of classical modes to Christian use.

(left) The interior of the Sistine Chapel
When Michelangelo painted the ceiling there were two frescos and an altarpiece by Perugino at the end, and windows like those down the sides. These, and two lunettes of Michelangelo's own ceiling, were removed when he came to paint *The Last Judgment*. In 1519 tapestries by Raphael were hung round the lower walls.

(below) *The Libyan Sibyl*
The huge Sibyl, painted after the break of 1510, is in the more monumental, later style. Her figure is an idealization synthesizing the beauty of both sexes.

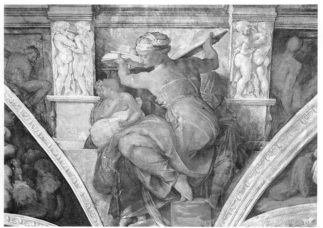

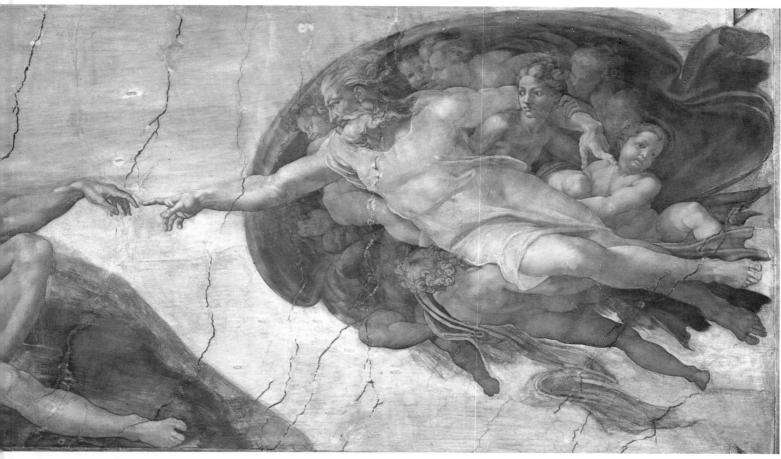

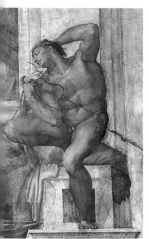

(left) *Ignudo*
The *Ignudi* can be interpreted as a series of formal variations on the classical *"Belvedere Torso"* (see p. 46). They are also an expression of Michelangelo's individual genius – almost art for art's sake; in this and in their strain, thrust and counter-thrust of pose, they were an inspiration for succeeding generations of Mannerist artists.

(below) *The prophet Jonah*
Vasari called it the peak of genius in this supreme work that Michelangelo could paint on a forward-sloping surface a figure that apparently falls backwards.

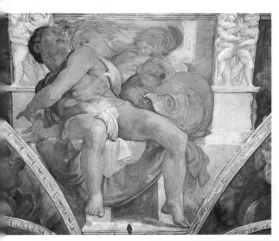

The Sistine Chapel in the Vatican, begun by Pope Sixtus IV in 1473, was and is a place of worship, but it is also the setting for certain extraordinary functions – notably the conclave of cardinals for the election of a new pope. The decorations of the 1480s – frescos by Perugino, Signorelli, Botticelli and others girdling the walls – had illustrated the basis of papal authority in the Old and New Testaments. When he commissioned Michelangelo to paint the ceiling in 1508 Pope Julius II probably wished to assert not only the Christian faith and his role as its leader, but also papal independence from such temporal powers as Louis XII of France, with whom he was embattled. Once entrusted to Michelangelo, however, the scheme became one primarily of Michelangelo's devising.

The commission to paint the ceiling came to Michelangelo at a point when he was obsessed with the design for Julius II's tomb, that is, with sculptural problems, and at first he seems to have fiercely resented the imposition. Julius II was an impatient and demanding patron, while Michelangelo's temperament was often neurotic or moody. In a poem written in 1510 Michelangelo bemoaned his lot – "I am not in a good place, and I'm no painter". But in the event the ceiling was to prove a more satisfactory project than the tomb.

The vast area of the Chapel ceiling, 38.5 × 14 metres (118 × 46 ft), took four years to paint, and was unveiled in part in August 1511 and completely on October 31 1512. It was Michelangelo's first major exercise in fresco, for the *Battle of Cascina* project had never passed the cartoon stage. After un-satisfactory trials with assistants he locked himself away in the Chapel, and virtually single-handed, on dizzy scaffolding of his own design, worked slowly across the expanse of the ceiling, through the days and months, often in acute discomfort. It was an heroic feat never to be surpassed by himself or another.

The extraordinary programme of the ceiling evolved from very simple first ideas – figures of the twelve apostles in an ornamental setting. But once the project had seized hold of his imagination, Michelangelo emended and aggrandized the first conception beyond recognition, though he must have discussed his ideas with learned churchmen – the Vatican was certainly not lacking in theological expertise. Formally, the imagery used clearly reflects the sculptor's frustration: the figures of the *Sibyls* and *Prophets* are variations on the theme of the great statue *Moses* for the tomb of Julius II; the famous *Ignudi* (nudes) likewise take up the mood of the so-called *"Slaves"* intended for the tomb. Michelangelo's style evolved as he progressed from the entrance to the Chapel, with its complex *Story of Noah*, towards the altar wall, and, especially after the break of 1510 when the scaffolding was removed, he simplified the compositions and form, reduced the details, and made the images ever bolder and more dynamic. One of the first images Michelangelo painted when he resumed work in early 1511 was the most famous scene in the Chapel, its climax, *The creation of Adam*, with its electric charge passing from the outstretched hand of God to the hand of the awakening Adam – an unsurpassed image of the most profound human mystery.

Raphael

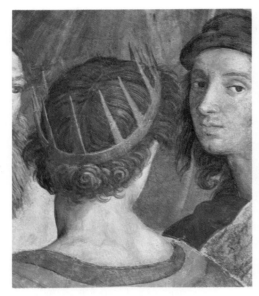

If the name of Raphael is synonymous with the "classical" in High Renaissance art, that is partly because his genius was essentially one of strengthening and refining rather than of revolutionary innovation. In his compliance with his patrons' wishes he resembled an early Renaissance artist more closely than Leonardo or Michelangelo, and in contrast to their moody and formidable personalities he was renowned for his affable and gracious charm.

Raffaello Sanzio (1483-1520) was born in Urbino, the son of a court painter, Giovanni Santi. He was working with Perugino at Perugia by 1500. His early independent work is closely related to Perugino's: elements of that grace that marks his whole career were due to Perugino, and the subtle elegance of his figures and the sweetness of his female faces. But he soon outstripped his master: in his early masterpiece, *The marriage of the Virgin*, so close to Perugino's fresco *Christ handing the Keys to St Peter* (see p. 116), his power of integrating graceful figures into a rhythmic, harmonious unity is already fully developed.

In 1504 Raphael arrived in Florence, where the work of Leonardo and Michelangelo came as a revelation to him. Leonardo's *Mona Lisa* and *Battle of Anghiari* fresco influenced him crucially, yet Raphael proved, as he would time and time again, that his ability to adapt from others what was necessary to his own vision and to reject what was incompatible with it was faultless. Now began the series of *Madonnas*, whose charm, matchlessly evoking the divine within tender humanity, has captured popular imagination ever since. In composition, Raphael's early *Madonnas* relate closely to the pyramidal structures evolved by Leonardo (see p. 129), but the complexity and contrivance of Leonardo is resolved into a perfectly balanced harmony; the enigmatic expression of Leonardo's figures yields to an untroubled radiance; in place of fantastic lunar settings, a serenely placid landscape unfolds.

In his portraits, too, Raphael was influenced by Leonardo, but he retained his own clarity of definition and a strikingly direct apprehension of character. In the portrait of Agnolo Doni the half-length pose, the counterpoint between head and body and the expressive placing of the hands are clearly from Leonardo. There is some trace of Michelangelo in the works Raphael painted before he left Florence, but the full impact of Michelangelo came later.

RAPHAEL
Self-portrait, detail of *"The School of Athens"*
Raphael looks out (from a group of astronomers) with modesty and calm – clear, untroubled. His courtesy was a rival to his artistry: and both, in Vasari's words, "vanquished the world".

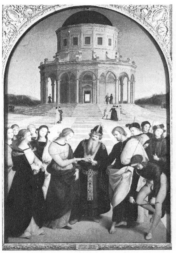

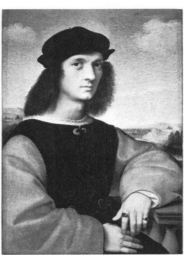

RAPHAEL (left)
Agnolo Doni, 1505
The main elements of the pose derive from the *Mona Lisa*, but the mood is now masculine, and is Raphael's – with almost no *sfumato*.

RAPHAEL (below)
"The Sistine Madonna", 1512
The grandest of Raphael's long series of Madonnas, the human yet visionary Virgin walks on air as if on earth. Originally in the apse of S. Sisto in Rome (hence its name), the altarpiece perhaps deliberately rivalled Byzantine mosaics in the splendour of its colour, its composition, its presence.

RAPHAEL (above)
The marriage of the Virgin, 1504
Firmly signed and dated by Raphael when he was 21, the picture demonstrates a reconciliation of abstract symmetry with the movement and drama of human life – one defining aspect of High Renaissance art. Figures, architecture and atmospheric perspective have poised, solid control.

RAPHAEL (right)
"La Belle Jardinière"
(The Madonna and Child with St John), *c.* 1506
The Virgin's features still recall Perugino's *Virgins*; and the series of *Madonnas* Raphael made in Florence (being mostly small, for private devotion) have a domestic intimacy lost in the later ones in Rome. The physical movement of the figures is wonderfully united with the compositional lines of direction.

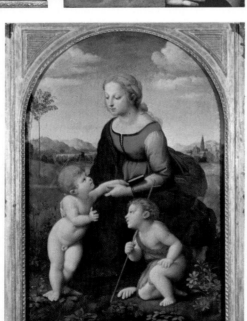
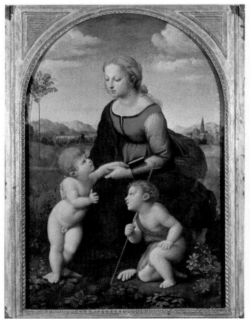

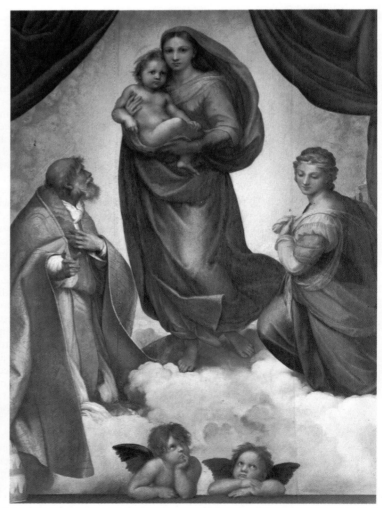

Within four years Raphael had achieved success in Florence and his fame had travelled. By the autumn of 1508 he was in Rome and was entrusted by Pope Julius II with the decoration of the Stanze, the new papal apartments, an enormous commission for the 26-year-old artist. It was nevertheless a triumph. The first room, the *Stanza della Segnatura*, was completed by 1511; its two larger frescos, *"The School of Athens"* and *"Disputa"* (Disputation over the Sacrament; not shown), are a consummation of High Renaissance principles. They stand for the intellectual reconciliation of Christianity and classical antiquity: the Eucharist, one of the central Christian mysteries, is represented on the one hand, on the other an encyclopaedic illustration of classical philosophy, centred on the figures of Plato and Aristotle. Both frescos are miracles of harmony, of movement within strict symmetry, of the marriage of the real and the ideal. In the later Stanze Raphael moved away from the serene perfection of the *Segnatura* and in a sense the climax of the High Renaissance had been reached and passed.

While Raphael was at work on the first Stanza, Michelangelo was locked from sight not far away painting the Sistine Chapel ceiling. It is in the later Stanze that the impact of his work is clearly felt, though Raphael could assimilate even Michelangelo's influence without in the least compromising his own genius. The dominant fresco of the second Stanza, *The expulsion of Heliodorus* (1511-13), is full of tempestuous movement – anticipating aspects of Mannerist, even of Baroque art. There are dramatic contrasts of light and dark, the colours are richer and stronger – perhaps Raphael had learnt something of Venetian colourism from Sebastian del Piombo (see p. 146), who had just arrived in Rome.

Enormous demands were now placed on Raphael, and much of his work, notably in the third Stanza, was carried out by assistants (led by Giulio Romano) following his designs. Many of his designs were engraved in his lifetime, and by this means his influence spread far beyond Rome. Under the new Pope, Leo X, he held an important position in the papal court, besides combining the careers of painter, architect and archaeologist: he initiated the first comprehensive survey of the antiquities of Rome. The High Renaissance obsession with the Antique governed several of Raphael's most important commissions – decorative schemes in the Vatican *Loggie* (not shown), inspired by the antique paintings discovered in the Golden House of Nero, and in the Villa Farnesina. In the Farnesina the fresco of *The triumph of Galatea*, entirely from Raphael's hand, is outstanding – effortlessly perfect, radiantly fresh. Its intricately balanced composition frames in Galatea the supreme example of the figure-of-eight pose.

From this intensely active period date some of Raphael's greatest masterpieces – *"The Sistine Madonna"*, with its exquisite simplicity of design and supremely idealized Mother and Child, painted with the softest *sfumato*; *"The Madonna della Sedia"* (The Madonna enthroned, see p. 129); several portraits, notably that of Castiglione (illustrated on p. 129). In the cartoons for the tapestries (not shown) ordered by Leo X for the Sistine Chapel, he achieved a classic majesty and grandeur yet more vigorous than before. When he died, suddenly, at the age of 37, he left unfinished one of his greatest easel-paintings, *The Transfiguration*. His death was felt as a public calamity; he had become the embodiment of an ideal which seemed to die with him.

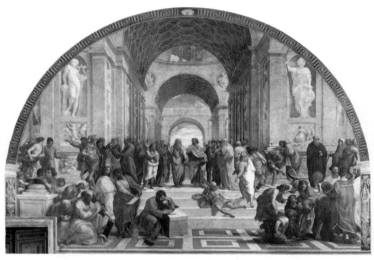

RAPHAEL (above)
"The School of Athens" in the *Stanza della Segnatura*, 1509-11
The perfect structure of reason built by the antique philosophers is symbolized by the architecture – which echoes the plans for the new St Peter's. This has been described as the first "history" painting, a model for countless subsequent "histories". Michelangelo must have influenced the seated foreground thinker.

RAPHAEL (right)
The triumph of Galatea, c. 1513
Surrounding Galatea are riotous pagan creatures, tritons, hippocampi and cupids – classical but also sensual. Even the paddles on Galatea's shell-float are a recondite classical allusion, referring to the paddle-boats recorded in Roman reliefs.

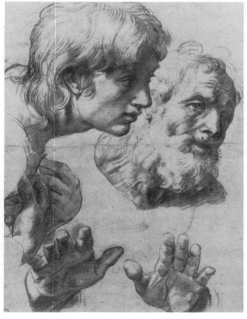

RAPHAEL (above)
The expulsion of Heliodorus, 1511-13
Heliodorus, attempting to steal temple treasures, was thwarted by a miraculous horse and rider (which owe much to Leonardo's *Battle of Anghiari*). For Julius II, borne on a litter to the left, anyone who threatened papal temporal power was a Heliodorus. The effect is most dramatic upon entering the room – the fresco is revealed from left to right.

RAPHAEL (left)
Two apostles, study for *The Transfiguration*, 1520
The study for two figures looking on with amazed expressions reveals Raphael's superb draughtsmanship, and the care and discipline in all he undertook – his art was never "carried away". The proto-Mannerist work itself is shown on p. 164.

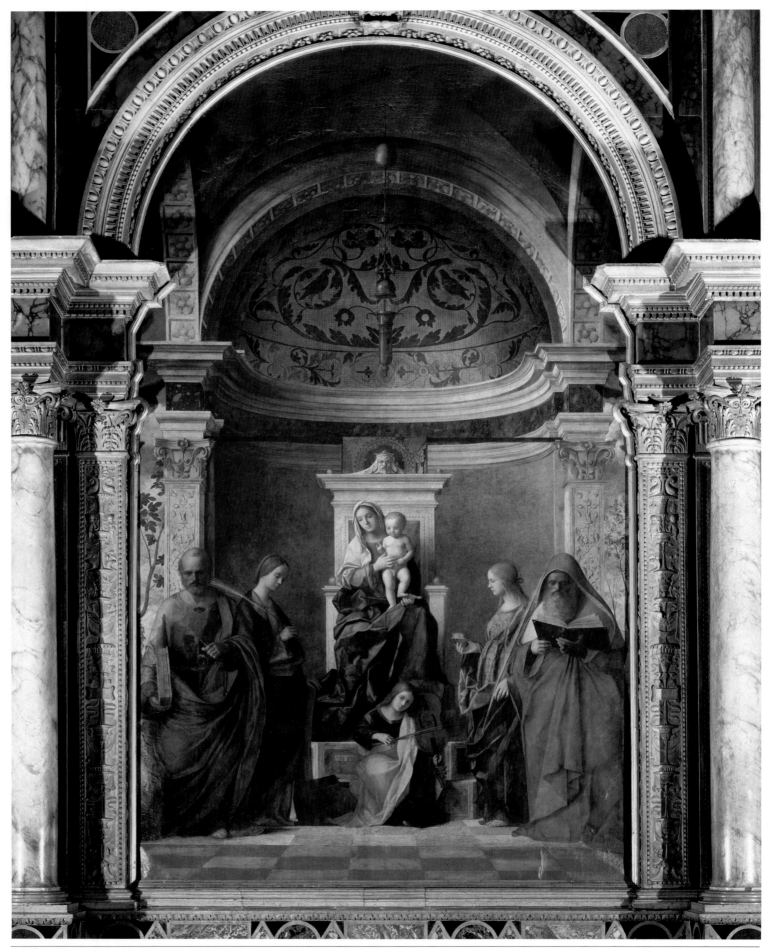

GIOVANNI BELLINI (above)
GIOVANNI BELLINI (above)
The Madonna and Child,
c. 1465-70
Giovanni's early *Virgins*
often have a distinctly waxy
texture; ideal images, they
have a precisely sculptured
form, an almost geometric
neatness. The light is still
hard and dry; the breath of
air which relaxes his later
work has not yet arrived.

Giovanni Bellini's great altarpiece in S. Zac-
caria in Venice was painted for that church
in 1505; it is signed and dated IOANNES
BELLINUS MCCCCCV, and has been there ever
since. It represents *The Virgin and Child with
saints,* and it is perhaps the most perfect
realization of the *sacra conversazione* theme in
all Western painting. In 1506, the year after it
had been finished, the greatest artist of the
Renaissance in northern Europe, Dürer,
visited Bellini in Venice and noted: "He is very
old, and is still the best in painting". Possibly
Dürer was thinking of this painting when he
wrote that; and this work of a man in his
seventies was judged by the critic Ruskin to be
one of the two best paintings in the world (the
other was also by Bellini).

The S. Zaccaria altarpiece is the climax of a
long series of meditations by Bellini on the
theme of *The Virgin and Child.* Especially
early on in Bellini's career his *Madonnas* were
generally smallish panels intended for domes-
tic devotion, continuing the tradition of Gen-
tile da Fabriano and of Giovanni's father
Jacopo. The earliest are still very much in the
early fifteenth-century tradition, hieratic and
quite austere, but very soon human tenderness
between a flesh-and-blood mother and her

child becomes apparent. The slightly melan-
cholic mood could be that of a woman con-
sumed with wonder at the miracle of birth, but
also apprehensive, since the infant in her lap is
a hostage to fortune; yet simultaneously the
image is divine. Divinity is indicated not so
much by the halo (not always present) or by the
hands joined together in prayer, as by that
heavenly radiance and solemnity with which
Bellini imbued his women. Often, when the
Child is recumbent, there is a haunting fore-
shadowing of the *Pietà*, of the dead Christ
supported by his mother. Bellini developed
and enriched the still charm of his *Madonnas*
throughout his career, and in the very late
ones, such as *"The Madonna of the Meadow",*
the image of the Madonna is merged convinc-
ingly into one of the most beautiful of
Giovanni's landscapes, serene in the cool light
of spring, with the little village clear-cut on the
rise beyond. The Mother of God is brought
into direct relationship with day-to-day life.

Bellini's sequence of more monumentally
scaled *sacre conversazioni* began with one, now
lost, painted about 1475, related to a famous
one by Antonello da Messina painted in Venice
about the same time. From the fragments of
this work, and from Bellini's surviving S.
Giobbe altarpiece of about 1490, it can be
deduced that the architectural frame was con-
ceived as integral with the painting, thus tying
the image bodily into the structure and pre-
sence of the church as a whole. In the S.
Giobbe altarpiece, the sense of space, the
relative relaxation of the figures, the glowing,
translucent colour all speak of Antonello's
Netherlandish-oriented vision, and probably
of his technique. The composition, however, is
a little busy, even claustrophobic (it is the only
one of Bellini's compositions entirely enclosed
in an interior). The gain achieved through
simplification in the S. Zaccaria altarpiece is
subtle but substantial.

Here the five figures are almost life-size and
the viewpoint is higher, the spectator closer,
while there is a hint of landscape and open air
at each side. The Virgin is seated, with the
Child blessing, amongst attendant saints – St
Peter with his key, St Catherine with her
martyr's palm, St Lucy, and St Jerome with
his open book. The draperies and the heads are
softly modelled in the fall of a unifying light
(the head of St Jerome, in its pensive medi-
tation, seems already tinged by the mood of the
young Giorgione, whose *"Castelfranco Mad-
onna"* is thought to have been finished in the
previous year). The colours glow in a rich
harmony, and the serene symmetry and bal-
ance of proportions exist in a silence that
somehow is full of music – the music indicated
by the angel with the viol on the step of the
Madonna's throne. The figures, as in most of
Bellini's mature work, have an ample ease
both monumental and peaceful.

Bellini's painting is already of the High
Renaissance. The composition unites in har-
mony the primarily Florentine concern for the
logical, even mathematical, control of space
and proportion with the typically Nether-
dish interest in the rendering of light, while
there is more than a promise of the revolu-
tionary colourism with which Bellini's pupils
and followers were to startle the world.

GIOVANNI BELLINI (right)
The S. Giobbe altarpiece,
c. 1490
The painted architecture
correlated with the real
altar, probably designed by
the architect of S. Giobbe,
one of the first Venetian
Renaissance churches.
The space is an extension
of the spectator's world –
and to be seen from below.

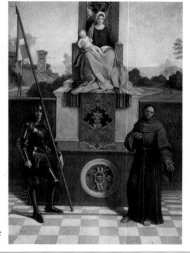

GIORGIONE (right)
*"The Castelfranco
Madonna",* c. 1504
Giorgione's only altarpiece,
painted for his native town
of Castelfranco, is so dated
because it seems similar to
the S. Zaccaria altarpiece,
and it seems to confirm that
Giorgione at first worked
in Bellini's studio. The
strange proportions, how-
ever, with the Madonna so
high, and the moodiness, are
Giorgione's own (see over).

GIOVANNI BELLINI (above)
*"The Madonna of the
Meadow",* c. 1501
The supernatural is hinted
at both in symbolic details –
the stork battling with the
serpent, beneath the eagle
in the dry tree; the monk in
his white robe – and, above
all, in the serene calm.

GIOVANNI BELLINI (left)
The S. Zaccaria altarpiece:
*The Virgin and Child with
saints,* 1505

Giorgione: The Tempest

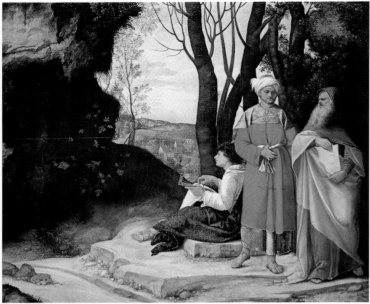

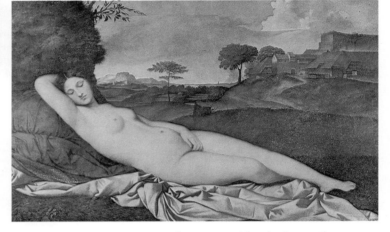

The brevity and obscurity of the career of Giorgione (died 1510) are no index to his importance in the history of art. Although only some 20 paintings are generally associated with him, of which only about six are attributed without dispute, his originality was so potent that these few works have come to stand for an enduring quality of the Western imagination.

Surviving documentation on his life and work is sparse: the main reflection of his personality is that recorded in a brief *Life* by Vasari, who visited Venice about half a century after his death and talked with Giorgione's early collaborator, Titian, and others who may have known the young painter years before. Giorgione was clearly a phenomenon, of a kind new to Venice if not to humanist circles in Florence – a creature endowed with unusual physical beauty as well as grace and wit; gentle and courteous, "always a very amorous man"; a brilliant singer and lute-player. Not least, he had an instinctive gift for the visual arts. He was associated with the humanist circle of the poet Bembo, and with a sophisticated group of private patrons, for whom he painted generally small-scale pictures. Giorgione's only public commissions in Venice were paintings, now lost, in the Doge's Palace, and frescos, now something less than ghostly fragments, on the exterior of the Fondaco dei Tedeschi, the important trading centre (just by the Rialto Bridge) of the German community.

Significantly, Vasari, himself a master of esoteric allegory, was unable to understand the meaning of the figures on the Fondaco dei Tedeschi ("nor, for all my asking, have I found anyone who does"). A certain hermetic mystery is a characteristic of virtually all the paintings ascribed to Giorgione: his characters are engaged in some concern of unworldly significance, in a mood so intense that it verges on the mystical, which no prosaic explanation can ultimately elucidate. Beneath what Vasari called "a harmonized manner, and a certain brilliance of colour" there is an underlying tension, and in this, and in the softness and subtlety of his modelling, Vasari recognized the influence of Leonardo. The emotional

vibrancy of his colour, however, is Giorgione's own, although he could never have achieved it without earlier developments in the flexibility of the oil medium. Vasari observed that he worked directly from nature – and surely swiftly, directly on to the canvas, without the elaborate structural preliminaries that were a necessary part of Florentine *disegno*.

The famous *Tempest* is a key work among Giorgione's few paintings, and a turning-point in the history of art. It is confidently identified with a painting inventoried in 1530 as a "small landscape . . . with the storm, and the gipsy and the soldier". Significantly, hardly 25 years later the compiler of the list did not know what the subject of the painting was, and, significantly also, it is described as a "landscape". For the modern observer the picture must be primarily a meditation, a "mood painting" needing no explanation, exciting chiefly an emotional response. That the story, if any, was never specific seems indicated by the changes Giorgione made as he went along: X-rays have revealed that before the "soldier" existed there was another figure, a naked woman, seated by the river. The mood, however, reflects the recent humanist discovery of a lyrical pastoral world in the Latin and Greek poets. The Renaissance mind also delighted in symbolism and allegory: broken columns may stand for Fortitude, while the naked mother with the child at her breast is an image of Charity, a secularized echo of the Madonna. The male figure may be a soldier, and so personify Fortitude again: his breeches are like those of a German mercenary, but he appears to hold a staff rather than a lance. Pervading all is the

atmosphere created by the impending storm. It is extraordinarily real – the lightning is indicated not as a notional zigzag but as the retina flinches at it; the buildings of the town loom in the weird stillness of the thunder-light; the storm has not yet broken in on the enchanted, mute dialogue of the two figures.

Hints of Giorgione's achievements are to be found in Giovanni Bellini's work – the stillness and, more pertinently, the feeling for landscape (it is probable that Giorgione worked in Bellini's studio). But Giorgione united landscape and figures in one mysterious whole as Bellini never quite did, and he achieved a new harmony between man and Nature, in which one appears to reflect the mood of the other. A similar mystery and harmony of figures with landscape is achieved in the so-called "*Three philosophers*". There is enigma even in Giorgione's portraiture, in the so-called "*Laura*" of 1506, his single firmly dated work, and in the strangely chaste sensuality of Giorgione's *Venus*, the "founding mother" of generations of recumbent nudes.

Giorgione was snatched to his death by plague in his early 30s, and the *Venus* is one of several paintings of his that are known to have been finished by other hands – the *Venus* by Titian. Giorgione's hold over Titian's imagination seems for a period to have been complete, and the famous "*Concert Champêtre*" in the Louvre (see over) is now more generally ascribed to Titian than to Giorgione. In this and in other works Titian realized again Giorgione's magical coherence of figures with landscape, that mysterious sense of music unheard – the essence of his enchanting vision.

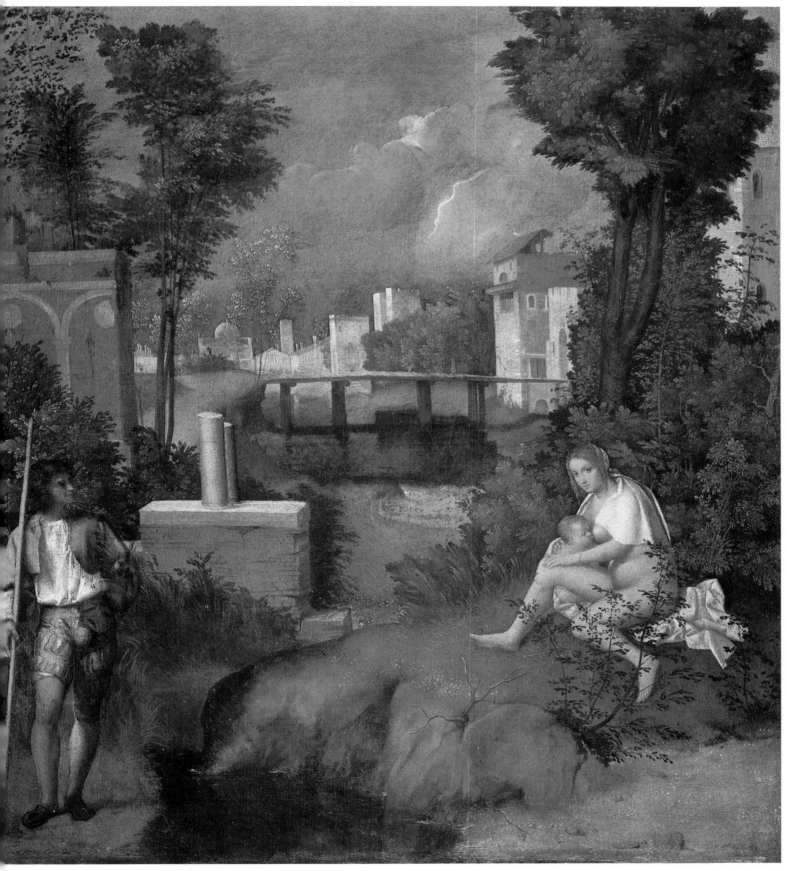

GIORGIONE
The tempest, 1st decade
of the 16th century

Titian

Titian (Tiziano Vecellio, died 1576) came to Venice from his native Pieve di Cadore in about 1500. The city was then at the height of its splendour, although in fact its long political, military and commercial decline had already set in. The Turkish wars, the jealous alliance of other Italian states against her and the pressures of the struggle between foreign powers that raged the length of the peninsula crucially weakened the city. The arts, however, remained resilient. By the mid-sixteenth century supremacy in painting had passed from Florence and Rome to Venice, and the prince of painting was, as a Venetian wrote in 1553, "our Titian, divine and without peer".

Titian's apprenticeship with Giovanni Bellini was followed by association with Giorgione. Even for some years after Giorgione's death in 1510, Titian's identification with Giorgione's style and vision was almost total: he completed several of Giorgione's pictures, and argument as to whether certain early works are in whole or in part by Titian or Giorgione still continues. Both *"Le Concert Champêtre"* (Pastoral music-making) and a *"Noli Me Tangere"* have been ascribed to Giorgione but are now usually accepted as

Titian's; in the latter the landscape is repeated from Giorgione's *Venus* (see preceding page), which had been completed by Titian himself a few years earlier. The idyllic mood and the tenderness are still close to Giorgione.

Soon, however, the titanic but infinitely flexible force of Titian's own genius emerged. With Giorgione's death, the departure of Sebastian del Piombo to Rome, and finally the death of Giovanni Bellini in 1516, Titian was unchallenged. He succeeded Bellini as painter to the city, with a secured income and public commissions. One of these, *The Assumption of the Virgin* for S. Maria dei Frari in Venice, was an astonishing and revolutionary work. It looks forward to Baroque in its dramatic, rushing movement, even in its calculated harmony with its setting, its shape and articulation repeating the forms of the windows, its brilliant colour taking up the rosy tints of the brickwork. *"The Pesaro Madonna"* in the same church is again a daring innovation, placing the Madonna asymmetrically as Bellini would never have dreamed of doing, and creating soaring space above her. The mythological pictures Titian painted between 1518 and 1523 (see over) were no less remarkable. Besides

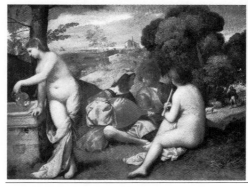

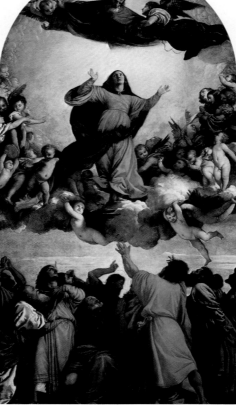

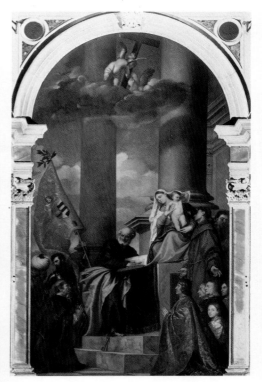

Venice, Titian's works went to Ferrara, Treviso, Brescia and Ancona, and his fame spread to Mantua and Urbino, and further.

In 1530, in Bologna, Titian entered into his long association with the greatest prince in the West, the Holy Roman Emperor Charles V. He became his court painter, portraying him in many guises – as wise ruler, relaxed gentleman or victorious commander – in portraits evoking an ideal of majesty, authority and power. In return he was ennobled, and a story even tells of the Emperor picking up the brush Titian had dropped. Later, Titian painted Charles' son Philip II of Spain, and Charles' great rival Francis I of France. Beside the work of northern European portraitists, Titian's powers of subtle organization and compositional harmony, together with his feeling for a grave and simple dignity, were outstanding. Meanwhile his services as a portraitist continued in demand among the aristocracy, intelligentsia and rich merchants of north and central Italy.

Titian, like Raphael, responded to all the needs of his patrons, although his portrait of the Farnese Pope, *Paul III with his nephews*, perhaps proved too revealing, for, unusually, it was not well received. Titian's versatility, his freshness of approach to each new project, the variety of his treatments, are astonishing. In portraiture he produced a stock of poses so comprehensive that his successors down to the Impressionists used his work as a source-book – most especially Rubens (who, for example, was inspired by *The girl in a fur wrap*), van Dyck, Reynolds and Rembrandt – and Rembrandt alone may be judged to have surpassed him. He introduced into portraiture procedures belonging to other kinds of painting, "history" painting or genre, showing his subjects now in excited motion, now in a dramatic pageant, now intimate and informal.

When Titian visited Rome in 1545-46, at Pope Paul III's invitation, Michelangelo was also in Rome, and the two greatest artists of the period met. Michelangelo admired Titian's work but with reservations: his handling and colour were praised, but his drawing, according to Florentine ideals of *disegno*, had to be condemned. Titian's method, modelling by tone and colour rather than by line or sculptural massing, was clearly opposed to the Florentine tradition, and his response, as if in declaration of independence, was to open up his own colouristic style – as his portrait of the Pope makes evident. His style and technique were already evolving from the more precise contours, modelling and finish of the early portraits to a much bolder, freer style with more highly charged brushwork; he handled the paint increasingly broadly, creating an effect almost like mosaic, with patches of colour. He always, however, built up in stages (unlike his Baroque successors), even though in old age he sometimes used the handles of the brushes or his fingers to move the paint. It was noted of his late work (as it was later of the Impressionists) that while the painting did not cohere if seen close up, when seen from the "proper" distance it became brilliantly clear.

For splendour of colour, the climax was reached in some of Titian's late mythologies painted for Philip II (see over). His last works became sometimes sombre in tone, but they are the most broadly painted, and the most emotional, of all. Such works as the *Pietà* Titian painted for his own tomb are profoundly expressive, highly personal. He died in 1576, aged perhaps 90. Rich in worldly goods and highly honoured in his own time, he had established a claim on immortality that few artists can match.

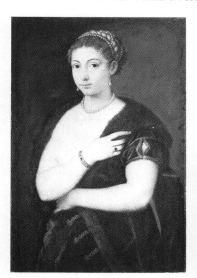

TITIAN (left)
The girl in a fur wrap,
c. 1535
The sensuality of the half-naked girl is heightened by the soft richness of the fur. She was perhaps also the model for *"The Venus of Urbino"* (see over), too. Rubens adapted the pose and the fur for an equally sensuous portrait of his second wife (see p. 202).

TITIAN (right)
Pope Paul III and his nephews, 1546
It is difficult for 20th-century eyes not to read satire into this portrait; and it is supposed that it was unfinished because it annoyed the Pope. Put so baldly, this is wrong, and Titian's major concern is clearly to infuse into the portrait dramatic action.

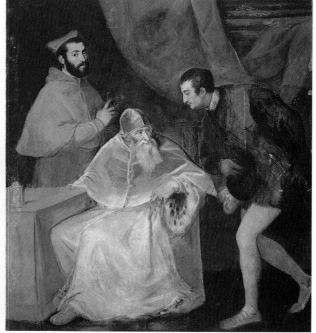

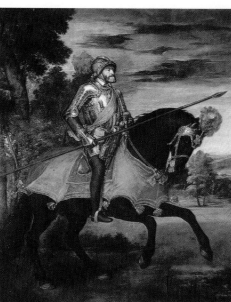

TITIAN (below)
"The Young Englishman",
c. 1540
Implicit in the whole is the aristocratic bearing and gentility of the young man. The blacks glow with splendour, set off by the light of smouldering eyes.

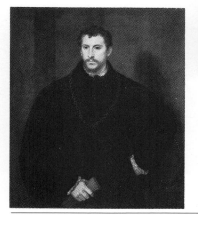

TITIAN (above)
Charles V at Mühlberg,
1548
The Emperor is portrayed as a knight of chivalric virtue, the defender of the Church, the mighty, noble and magnanimous victor. The composition became a basic formula of stately kinship, used by Rubens (see p. 202) and van Dyck.

TITIAN (right)
Pietà, 1576
The design is most unusual, sad, sombre, funereal, but animated by an impulsive movement and by a kind of warmth. At first the picture was based on Michelangelo's Vatican *Pietà* (see p. 132); then Titian extended it at the sides, adding the arm-flinging Mary Magdalen.

Titian: The Rape of Europa

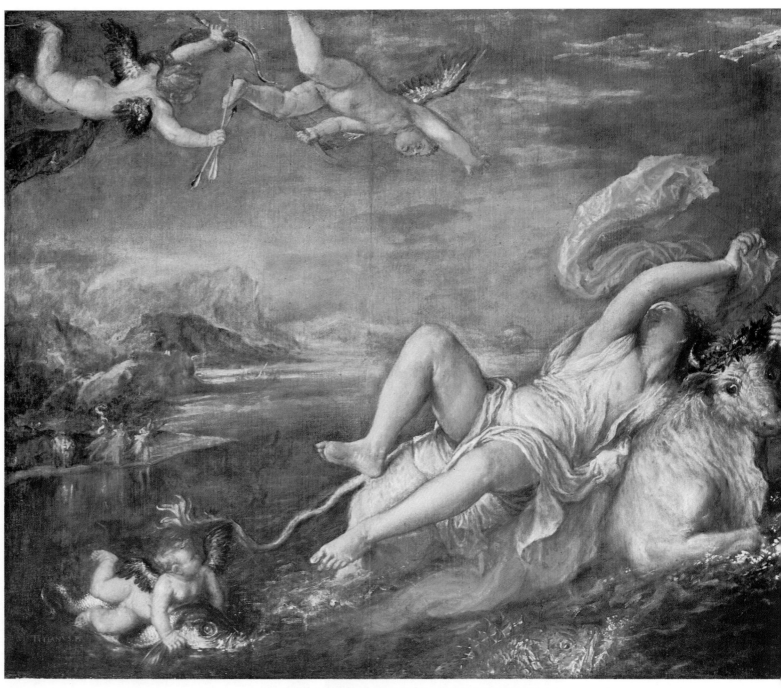

TITIAN (above)
The rape of Europa, 1562
The pagan sensuality of the
poesie Titian painted for
Philip II was surprisingly
contrary to the spirit of
the Counter-Reformation.
It was equally at odds with
the religious austerity and
melancholia that overtook
Philip II at the end of his
life. It is clear that Titian's
mythologies, especially the
poesie, in all their inventive
vigour and uninhibited but
controlled splendour, were
fired by personal passion –
as other works were not; in
contrast his religious works
can often seem superb
ceremonial formalities.

TITIAN (right)
Sacred and Profane Love,
c. 1514
The "meaning" of the two
Venuses has aroused much
learned argument. It is now
generally accepted that the
naked figure is celestial
Love, the divine Venus,
while the clothed woman is
earthly Venus, representing
the generative forces of
Nature. The sculpture on
the sarcophagus, the dis-
tinct landscapes and many
other quiet details, seem
to indicate an elaborate
humanist allegory. What
no one questions or denies
is the supreme beauty, the
elegiac mystery of the work.

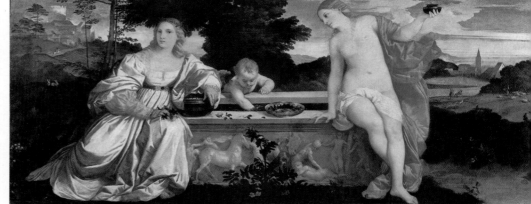

In his great series of mythological paintings, continuing throughout his career, Titian's dominant and ever-recurrent theme is the female nude. Although they often illustrate subjects from classical literature, especially Ovid, and adapt poses and motifs from classical sculpture, these paintings are sometimes so overtly erotic – though rendered with the greatest subtlety and skill – that they disturbed nineteenth-century critics, and their greatness has been fully acknowledged only recently.

One of Titian's most celebrated early essays in the theme is the *Sacred and Profane Love* of about 1514. Its dreaming landscape still echoes Giorgione's, but its celebration of the female figure is much more overtly sensual. Titian's famous *"Venus of Urbino"* of about 1538 has none of the delicate, vernal chastity of Giorgione's sleeping *Venus* (see p. 140) and in later variations he even introduces a male figure contemplating the naked Venus, in some of them a lute player – creating an additional dimension, joining the idea of music to the voluptuous visual harmony. The direct appeal to the senses, as distinct from the more intellectual approach of the Florentines, seems essential not only to Titian but to Venice.

Early in his career, between 1516 and 1523, Titian had painted a magnificent suite of three mythological subjects for Alfonso d'Este of Ferrara. But his greatest mythologies are the seven paintings painted in his old age for Philip II of Spain, called by Titian *poesie* (poetries). The commission probably came when artist met patron at the court of Philip's father, the Emperor Charles V, at Augsburg in 1550-51. Except for the unfinished *Death of Actaeon*, they had all been shipped to Spain by 1562.

The last to be shipped, *The rape of Europa*, is the most joyously sensual of them all. Jupiter, disguised as a white bull, has enticed the unsuspecting maiden Europa to climb on his back; Titian depicts the moment when Europa realizes that the bull has ceased its playful meander in the shallows of the tide, and is taking off for deep waters where she cannot escape. Her perilous, open-bodied pose, with one hand's grasp on a horn so inadequately securing her to her steed, is one of the most breathtaking in all Renaissance art; its inspiration goes back no doubt to the maenads' abandoned Dionysiac dance in reliefs of classical sarcophagi, but it conveys with remarkable naturalism both the ripeness and the frailty of human flesh. Even this picture has been read as tragic, but it is surely not: the lady is no doubt alarmed, reasonably enough, and her companions, gesturing far behind on the shore, are astonished, but ecstasy is promised by the volley of cupids above and the marine cupid riding the great gold fish. The picture has also been called "hilarious", but it is one of the greatest masterpieces of European painting, the dazzling climax of the optimistic side of Titian's late style. The splendour of its colour is matched by the subtlety of its handling – for example, in the play of tones of white in the woman, her draperies and the bull. The iridescence of sea, distant mountains and sky suggests not solid form, but its dissolution in veils of colour: such an illusion of space and atmosphere remained unparalleled until Watteau. Its virtuosity has never been surpassed.

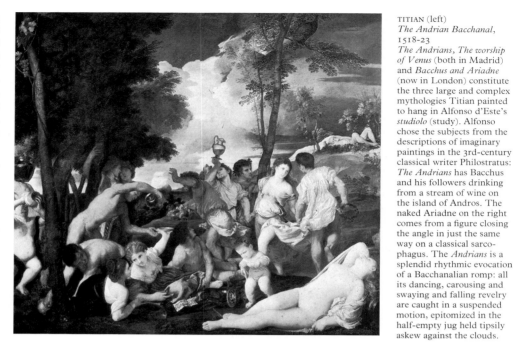

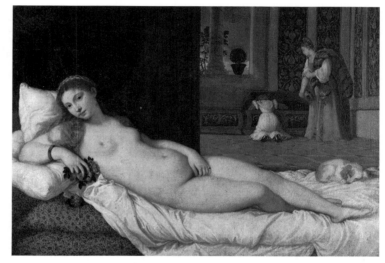

TITIAN (left)
The Andrian Bacchanal, 1518-23
The Andrians, The worship of Venus (both in Madrid) and *Bacchus and Ariadne* (now in London) constitute the three large and complex mythologies Titian painted to hang in Alfonso d'Este's *studiolo* (study). Alfonso chose the subjects from the descriptions of imaginary paintings in the 3rd-century classical writer Philostratus: *The Andrians* has Bacchus and his followers drinking from a stream of wine on the island of Andros. The naked Ariadne on the right comes from a figure closing the angle in just the same way on a classical sarcophagus. *The Andrians* is a splendid rhythmic evocation of a Bacchanalian romp: all its dancing, carousing and swaying and falling revelry are caught in a suspended motion, epitomized in the half-empty jug held tipsily askew against the clouds.

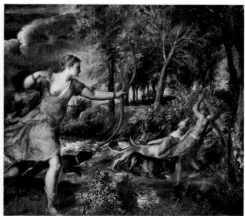

TITIAN (right)
"The Venus of Urbino", c. 1538
Unlike Giorgione's *Venus*, Titian's nude is aware of her own beauty and invites appraisal from admiring eyes. She is, of course, far more than a "pin-up", not only in the harmony and brilliance of the colours but also because there are allusions to marital love and fidelity. The little dog symbolizes faithfulness, and the chest being opened in the background perhaps contains a trousseau. The painting may specifically refer to the marriage of the Duke of Urbino, who bought the painting, and has lent it his name. But its eroticism is unexcused by a mythological setting.

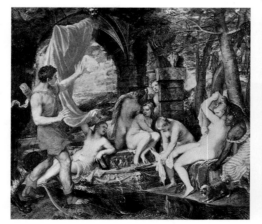

TITIAN
Diana and Actaeon, 1558
The *poesia* is based upon Ovid, who describes the hunter Actaeon surprising Diana and her nymphs bathing: he was punished by being transformed into a stag and killed by his own hounds. Titian's painting is an unabashedly erotic celebration of the female body, though hints of Actaeon's fate are clear – for example the little symbol of fidelity that yaps at his intrusion. Titian's play of white on black flesh, in Diana and her maid, has since held the Western imagination.

TITIAN
The death of Actaeon, after 1562
In most of the *poesie* for Philip II there are tragic overtones, though no other is so sombre as this, the last in the series, which Titian never dispatched. Its vibrant, brusque contours, the almost palpitating forms, offer a striking parallel to the contemporary late work of Michelangelo. The striding Diana avenges her discovery by Actaeon, who, transformed into an animal, in Titian's interpretation sinks into the landscape, and becomes one with it.

The High Renaissance 2: Venice

The dominance of the Bellini family in Venice, the spell cast by Giorgione in the first decade of the sixteenth century, then the long, almost imperial sway of the genius of Titian, tend to obscure the achievements of other artists in Venice and the neighbouring regions, though these are far from negligible.

Long before Titian's first visit to Rome the young Sebastiano del Piombo (*c.*1485-1547) played the part of Venetian ambassador in painting, bringing to Rome a richer use of colour, a sensual splendour, and something of Giorgione's strangeness of mood. Sebastiano worked on some of Giorgione's unfinished paintings, and is sometimes claimed as the sole author of paintings otherwise attributed to Giorgione. He left Venice for Rome in 1511: there his colours influenced Raphael, and Raphael in turn influenced him, but Michelangelo impressed him still more strongly, as Sebastiano's *Pietà* in Viterbo of about 1515 reveals – it is a formidable synthesis of rich Venetian colour with the monumentality of Michelangelo. Partly with Michelangelo's help, Sebastiano was successful in Rome; some of his best works are portraits, displaying individuality within a controlled grandeur.

In Venice itself, the able and sensitive Jacopo Palma il Vecchio (*c.*1480-1528) made an individual contribution. His early work reflects perhaps Carpaccio rather than Bellini, but he later established a kind of middle ground between Giorgione's mood of dream and the riper, hedonistic sumptuousness of Titian. Palma Vecchio may well have influenced Titian in his appreciation of a characteristically lush type of blonde feminine beauty. Towards the end of his career, he was clearly affected by the work of Lotto and by central Italian example (not only Raphael but even the cool distancing treatment of the early Mannerist painters). All this is brought into enchanting synthesis in what is perhaps his masterpiece, his *Venus and Cupid*: matching Giorgione or Titian in colour, it has a distinct lyricism, not least in the precise lines of Venus' nude figure. Palma Vecchio also painted religious works, especially *sacre conversazioni*, and romantic portraits of very high quality.

Although he was painting in the Vatican in Rome in 1509, Lorenzo Lotto (*c.* 1480-1556) was certainly trained in the Venetian tradition, and spent most of his peripatetic career in the north. He was a prolific and inventive artist, but his work was variable in quality. His early style seems sometimes more fifteenth- than sixteenth-century, and his pictures usually have some strangeness, whether of proportion, pose or subject matter. Nevertheless his handling of paint, colour and light was both sensitive and original, especially in his smaller-scale pictures, and he soon took advantage of the discoveries of his contemporaries in north and central Italy; he sometimes, too, seems to echo Netherlandish or German example. His originality tells most strikingly in his portraiture, in which he was concerned with the psychology and personal aura of the sitter as no previous painter had been. His relative lack of success in Venice may have been due more to his temperament than to any want of talent.

Venetian demand for sculpture had been increasing, like that for painting, since the second half of the fifteenth century, but the results were not quite comparable in splendour. Donatello's decade in Padua, 1443-53, seems to have had greater impact on painters than on Venetian sculptors, although the tradition of bronze-casting Donatello established bore splendid fruit in the work of his pupil Bartolommeo Bellano, and Bellano's

SEBASTIANO DEL PIOMBO (left) The Viterbo *Pietà*, *c.*1515
Michelangelo, according to Vasari, provided the design. Certainly the muscular sculptural forms, especially the masculine bulk of the Madonna, clearly show his influence. The colour seems applied to the surface rather than binding the picture into a whole; the effect, the menacing landscape, its lonely moon, is still successfully stupendous.

PALMA VECCHIO (below) *The three sisters*, *c.*1520-25
The title, recorded in 1525, suggests a triple portrait; the half-length format and impersonal features are typical of Palma's many portraits of Venetian beauties, though the sisters may in fact be the Three Graces. Palma Vecchio's ladies are less fleshy, more ornamental, than Titian's.

SEBASTIANO DEL PIOMBO (left) *Pope Clement VII*, 1526
After the death of Raphael, Sebastiano was the most fashionable portraitist in Rome. Here he adopted the pose in which Raphael had painted Pope Julius II (not shown), introducing a sharp haughtiness and a glittering sheen in the colours. On first coming to Rome Sebastiano must have felt acutely his lack of training in *disegno*, hence his frequent, sometimes urgent, pleas to his friend Michelangelo for drawings; but this portrait shows him to have mastered the principles of Florentine form.

PALMA VECCHIO (below) *Venus and Cupid*, *c.* 1520
The blonde flesh of the recumbent nude (a type familiar from Giorgione and Titian) shines radiant against the intense blue of the sky; its sensuality, however, is offset by cool and impassive expression.

naturalism was refined by the greatest master of the bronze statuette, Riccio (Andrea Briosco, 1470-1532), who worked in Padua. His masterpiece is the great bronze Easter Candlestick in the "Santo" (S. Antonio), in which he characteristically handled Christian subjects as if they were episodes from classical mythology. His single figures are often frankly pagan, of an extraordinary technical brilliance and finish: his *Pan* at Oxford has been called the most beautiful bronze in the world. Riccio's numerous such ornaments for a scholar's study have an immensely inventive charm, and even his inkwells in the shape of frogs have an almost monumental dignity.

In Venice, the main field for monumental sculpture was tombs. After a somewhat uneasy irresolution between the claims of the Gothic and Renaissance styles, the Lombardo family, Pietro (*c.*1435-1515) and his sons Tullio (*c.* 1455-1532) and Antonio (died 1516), developed a purer classicizing style owing much to Mantegna, expressed in a series of very grand tombs, especially for the Doges. Tullio Lombardo seems to have been not only a man of considerable learning but a collector of classical statuary. Some of his figures closely reflect

antique prototypes. He had, however, an innate lyrical feeling, most poignant in his late work, for instance the *Bacchus and Ariadne* of the 1520s. The relative stability of Venice in the endless warring that convulsed most of Italy was certainly one reason why major commissions in sculpture continued there into the sixteenth century, while they fell away elsewhere; a telling symptom is the arrival in Venice of Jacopo Tatti, better known as Jacopo Sansovino (*c.*1486-1570), after the Sack of Rome in 1527.

Tatti had taken his name from his master in Rome, Andrea Sansovino (see p. 129), with whom he had worked in the Vatican, gaining first-hand knowledge of antique sculpture. In 1529 he became the official architect in Venice, and his reputation is founded mainly on his Library opposite the Doge's Palace in the Piazzetta. In sculpture, his formal classical style, tempered with an almost romantic eloquence, is splendidly displayed in statues on the façade of his own Loggietta in the Piazza S. Marco, which are rather more delicate than his best-known work, the colossal figures of *Mars* and *Neptune* on the stairs in the courtyard of the Doge's Palace (not shown).

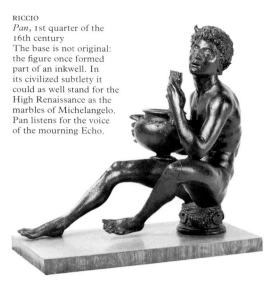

RICCIO
Pan, 1st quarter of the 16th century
The base is not original: the figure once formed part of an inkwell. In its civilized subtlety it could as well stand for the High Renaissance as the marbles of Michelangelo. Pan listens for the voice of the mourning Echo.

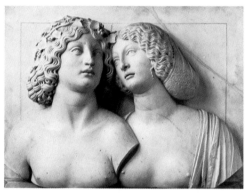

TULLIO LOMBARDO (right)
Bacchus and Ariadne,
c. 1520-30
Bacchus is identified by his vine-leaf fillet and androgynous pectorals. Such is the pastoral mood, the two seem like figures from an idyll by Titian translated into marble. The smooth flesh and patterned hair are much more refined and stylized than in any Roman tomb bust of this format, which also recalls half-lengths by Palma Vecchio. Here the lyrical mood, lacking in Tullio's dry earlier work, may have been induced by the court of the Gonzagas at Mantua, where he worked 1523-27.

LOTTO (above)
The Madonna and Child with St John and St Peter Martyr, 1503
This is Lotto's earliest signed and dated work. The Madonna, in pose and in features, echoes Giovanni Bellini; so do the clear, glowing colours and detailed landscape.

LOTTO (right)
Andrea Odoni, 1527
The sitter, a well-known collector and antiquarian, is presented, unusually, in a horizontal format, with the choice pieces of his collection. Lotto knew Titian's portraiture, and achieved equally imposing results; though they lack perhaps the utter finality of Titian's impressions, his more theatrical productions have often greater power. He was always vivid in his presentation of character, and invented as many compositional solutions as he had sitters – varying setting, gesture, attributes.

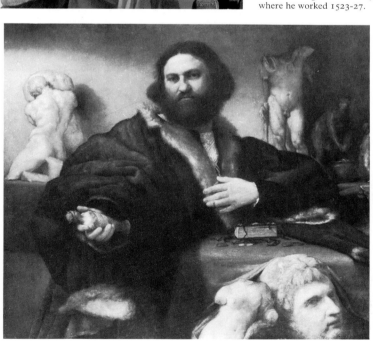

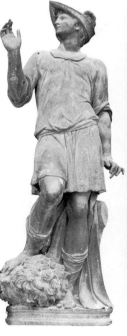

JACOPO SANSOVINO
Mercury, c. 1540-45
The pose of the sturdy but gentle figure is related to Donatello's *David* (see p. 105), not only in its fluent *contrapposto* but in the easy triumph of its stepping leg. The figure is one of four set on the Loggietta amidst a virtuoso display of classicizing ornament.

RICCIO (above)
The Easter Candlestick, 1507-15
The complex Candlestick is like an agglomeration of all Riccio's varied little bronzes in one setting; every detail is exquisitely worked; it is as rich as a wedding-cake. Its figures are *all'antica*, reflecting an interest typical of Padua.

The High Renaissance 3: North Italy

In the sixteenth century the smaller cities in northern Italy retained considerable independence of vision, though they acknowledged the triumphant advances of Venice and Rome. Original artists of high quality practised in Bergamo, Brescia, Ferrara and, most subtly and delightfully of all, in the city of Parma in the Po valley.

Why two very great painters, Correggio (Antonio Allegri, died 1534) and his younger contemporary Parmigianino (whose art is essential to Mannerism: see p. 165), should have emerged in this small provincial town has never been satisfactorily explained. Correggio is said to have trained at Mantua with Mantegna, but though his early illusionistic work clearly reflects Mantegna's example, Correggio's mature style is the very antithesis of Mantegna's austerity; he retained, however, an impeccable accuracy in drawing. Fundamental was the legacy of Leonardo, and his modulation of line by shadow, of shadow by reflected light, so that the spectator's eye almost caresses the form it follows. Correggio was also demonstrably aware of the classical High Renaissance in central Italy, and he was equally aware of Titian.

CORREGGIO
The vision of St. John on Patmos in S. Giovanni Evangelista, Parma, 1521
Christ and the apostles

whom John sees are foreshortened from below – *di sotto in su*, first used by Mantegna in the *Camera degli Sposi* (see p. 120).

Nevertheless, Correggio's part in the High Renaissance may seem an odd accident of time, and almost all his major works anachronisms. His early fresco in the cupola of S. Giovanni Evangelista in Parma juggles illusion and reality, opening up a dizzying sky in a way that anticipates the effects of the Baroque. However, the idea comes from Mantegna, while some of the seated apostles are clearly related to Michelangelo's Sistine Chapel ceiling, and the violently foreshortened figure of Christ hurtling up into the empyrean owes much to Titian's *Assumption* in the Frari in Venice. Correggio's later frescos in the dome of the cathedral at Parma, with their fantastic tumultuous spirals of soaring figures, presage even more closely the development of ceiling painting by Lanfranco and Pietro da Cortona in the seventeenth century.

Correggio's altarpieces are also, in sentiment and structure, far removed from the monumental ideal and classic symmetry of many High Renaissance works. They have a melting tenderness that anticipates not so much the Baroque as the Rococo charm of Boucher or Clodion. In the *sacre conversazioni* the figures round the Christ Child can be as

CORREGGIO (below)
"La Notte" (The Adoration of the shepherds), *c.* 1527-30
The traditionally peaceful subject is transformed by the arrival of angels and by supernatural light emanating from the Child, which anticipates some of the

light and dark effects to be exploited in the later 16th century by Tintoretto and Bassano in Venice. The light is used to create a sense of the miraculous. Dawn streaking the distant sky and the dramatic diagonal recession can both be compared to Titian.

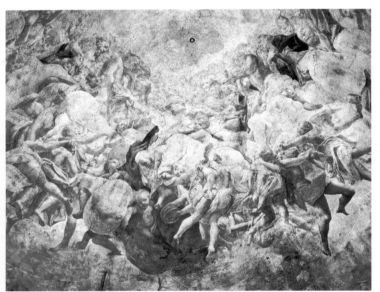

CORREGGIO (left)
The Assumption in the dome of Parma Cathedral, detail, 1526-30
Part of the fresco, a segment of the dome, is shown: the Virgin is borne aloft by a mass of angels in multicoloured clouds that seem almost to rotate. Her robe has now faded (Correggio touched up the fresco with tempera that has fallen off) but she is still visible as intended from the nave.

MORETTO (below)
St Justina, c. 1530
The sturdy donor, who is portrayed with unaffected realism, kneels in prayer like a well-trained dog by the martyred maiden (the unicorn waits patiently). Her brilliantly coloured robes are painted almost with Netherlandish detail.

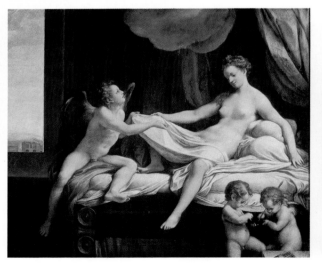

CORREGGIO (right)
Danaë, c. 1531
The climax of Ovid's story, when Jupiter descends in a shower of gold on Danaë, was an uncommon subject, but was later painted also by Titian. Titian's version has greater psychological

drama; Correggio's view is more languid, more hazy, less intense. In contrast to Mannerist painting its lack of artificiality and straightforward simplicity were commended by Annibale Carraci (see p. 185) for revival and emulation.

affectionate and intimate as a family doting over a christened baby. But the handling of the paint, especially the suggestion of the bloom of young life on the flesh, is uniquely Correggio's – in "La Notte" (The Adoration of the shepherds) it is supreme in the voluptuous hovering angels. Correggio applied a similar technique, perhaps more suitably, to a series of *The loves of Jupiter* for Federigo II Gonzaga, Duke of Mantua. Of these the *Danaë* has all the delicacy, lightness and felicity of the finest Rococo, even something of its frivolous eroticism. Although Correggio's impact on his contemporaries was limited, the independence of his vision remained fresh through the years, and subsequent critics more often than not ranked him second only to Raphael.

The towns of Bergamo and Brescia were both within Venetian territory, and as a result the influence of Venetian art was more insistent than for artists in Parma. Though there was no genius, no phenomenon like Correggio, there were considerable painters: Moretto (Alessandro Bonvicino, c. 1498-1554) painted large-scale decorative pageants and numerous altarpieces in Brescia. He responded in varying degree to Titian, but painted with an engaging matter-of-factness – a directness that could be called provincial but which commands respect. His picture of *St Justina* shows a very human donor sharing the space with the unetherial saint. Moretto's interest in individual character served him especially well in his portraiture – he could capture not only the face but the idiosyncracies of his sitter's body. This aspect of his art was brought to an even sharper pitch by his acute and prolific pupil Giovanni Battista Moroni (c. 1525-78) from Bergamo. His work amounts to a gallery of entirely credible, realistic citizens from an unusually large social range portrayed with great informality. Lotto (see preceding page) also worked in Bergamo for a time, and in Brescia again there was Girolamo Savoldo (c. 1480/5-after 1548), perhaps an underestimated talent. He is recorded in Florence in 1508 and matriculated there. He delighted in rich textures shimmering in half light, brilliantly captured in his *Mary Magdalen*.

In Ferrara Dosso Dossi (Giovanni Luteri, c.1490-1542) painted weirdly lit, romantic paintings, some of them recalling Ferrarese painting of the fifteenth century, but touched by the influence of Giorgione. Dosso's extremely opulent colour range may have been stimulated not only by Venetian works at the court of Ferrara but also by the rich collection of Netherlandish painting there. There is a powerful element of fantasy in his mythological and allegorical work, and poetry in the interplay of human figures with landscape. In his later works, however, he moved increasingly towards a rather conventional classicism, having spent some time in the vicinity of Rome, and been affected in the 1530s by the presence of Giuliano Romano in Mantua.

Pordenone (Giovanni Antonio de Sacchis, 1483/4-1539), born in the Friuli to the northeast of Venice, gravitated towards Venice and eventually settled there, but his Venetian frescos have almost entirely disappeared, and it is in Treviso and Cremona that his masterpieces survive. In Cremona he demonstrated an inventive and expressive style which reflects central Italian influence, especially Michelangelo's, with a kind of exaggerated sentiment which bears comparison with some of Sebastiano's religious dramas. In its fervour and energy Pordenone's work anticipates the greatest Venetian painter of the second half of the century, Tintoretto (see p. 170).

MORETTO (left)
A gentleman, 1526
This seems to be the first dated full-length standing portrait painted in Italy. But if Moretto introduced the type, Titian gave it its wide currency – perhaps never having come across Moretto's work, however.

MORONI (below)
"Titian's Schoolmaster", undated
Moroni's portraits are unassumingly realistic, without heroic attributes, and with a clarity typical of Brescian painting. The elegance and ease of the picture, once attributed to Titian (hence its popular title) are rare in Moretto's religious work.

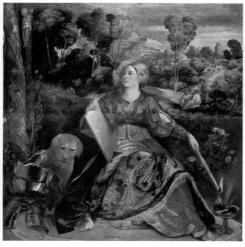

DOSSO DOSSI (below)
Alcina, c.1523
Dense in strange detail, resplendent in colour, the picture may represent the sorceress Alcina from Ariosto's *Orlando Furioso*, who transformed men into trees (visible in the top left corner). Dosso collaborated with Ariosto in devising entertainments at Ferrara.

SAVOLDO (left)
Mary Magdalen, c. 1530?
The dawn sky and silvery highlights on the robes of the Magdalen approaching the tomb are meticulously observed by the Brescian painter. Its realistic force relates the painting to the northern Italian provinces rather than to Venetian styles, though its virtuoso handling of light was surely influenced by Titian – Savoldo settled in Venice about 1520. This "cut-off" picture is known in several versions, but Savoldo's surviving works, typically on a small scale, are few.

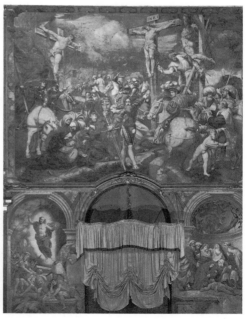

PORDENONE (above)
The Crucifixion, in Cremona Cathedral, 1520-21
Three scenes from Christ's Passion in the nave arcade culminate in the *Crucifixion* fresco at the western end. The illusion of a tableau on a stage seeming to open out towards the onlooker reinforces the impression of violent drama, conveyed by the strenuous movement and bold gestures of almost every figure, and the deep chiaroscuro. Pordenone added *The Resurrection* and the *Pietà* beneath in 1522.

Dürer and Grünewald

In the Germanic territories of the Holy Roman Empire, under the rule of the first two Hapsburg Emperors, Maximilian and Charles V, the first half of the sixteenth century was a period of great economic growth matched by a swift cultural expansion. Great universities were flourishing at Heidelberg, Wittenberg, Vienna; Basel soon rivalled Venice as a centre for printing. The Reformation, gathering its impetus after Martin Luther had nailed his 95 *Theses* on the door of the castle church at Wittenberg in 1517, did not at first stifle the magnificent outburst of creative activity, even though it was to split Europe in two, and to oppose Catholic and Protestant in often bloody violence. Maximilian, Charles V and his son Philip II of Spain were all informed, discriminating and active patrons of the arts, and Renaissance conceptions of princely splendour likewise impelled Francis I of France, Henry VIII of England, and German princelings to active patronage.

In south Germany, Nuremberg was a major trading centre between east and west, rich, beautiful, highly cosmopolitan, permeated by humanist ideas and learning from Italy. There was born Albrecht Dürer (1471-1528), son of a prosperous goldsmith. His early training was in drawing, woodcutting and printing, which were to remain his primary media throughout his career – he was the first truly major artist so to emphasize them. He was the first, and greatest, northern exponent of Renaissance ideals in the visual arts, although he never lost his northern individuality, and his obsession with line. He visited Venice twice, in 1494-95 and 1505-07; he travelled as far as Bologna, but perhaps never reached Florence or Rome. His fame was broadcast through his engravings, and artists in Italy were soon drawing on them for ideas. In Venice he knew and admired above all the aged Giovanni Bellini who, fascinated by Dürer's technique of drawing with the brush, reciprocated Dürer's esteem.

Dürer has been called "the Leonardo of the North", though his scientific investigations were limited compared with Leonardo's. Leonardo was never assailed by the religious anxieties that eventually converted Dürer to Protestantism, but in appetite for life, in fertility of invention and expression, they are comparable. Dürer's visual curiosity extended to the whole of nature – animals, people, costume; in extraordinarily vivid watercolours he noted effects of weather in topographical landscapes or the minute natural details of a piece of turf. Introvert no less than extrovert, he left the earliest sequence of self-portraits that qualify as deliberate autobiography. In the very grand *Self-portrait* of 1498, after his first Italian visit, he used an Italian formula, and, though the rhythms are linear, un-Italian, his pose might seem to derive from the *Mona Lisa* (see p. 131); however, this, one of the earliest portraits to show both hands of the sitter, predates Leonardo's masterpiece. It has been said that Dürer, in his absorption with himself in many guises – as a child of 13; totally naked; even as the Man of Sorrows – was his own *Mona Lisa*. Vanity is not absent. Though patronized by princes such as the Elector of Saxony from 1496 and granted a pension by the Emperor Maximilian himself in 1515, he seems never to have been quite content with his status, compared with the artist in Italy. So he wrote from Venice to a friend: "Here I am a gentleman, at home a parasite". Yet when he journeyed in the Netherlands in 1520 he was received as a great master.

Dürer's commissioned portraits show how skilfully he was able to incorporate Venetian

DURER (left)
The piece of turf, 1503
Dürer reproduces the wild profusion of grasses and flowers with loving care, all the more astonishing for its lack of precedent. Everything is green, and he differentiates the plants with the subtlest variations in tone.

DURER (right)
A young Venetian woman, 1505
Though only lightly painted and probably unfinished, the figure stands brightly out against the dark foil of the background. The sense of lively communication is typical of Dürer's portraits.

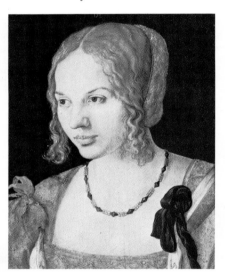

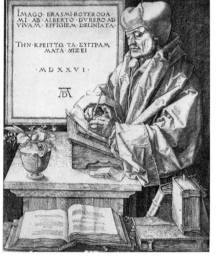

DURER (above)
Erasmus of Rotterdam, 1526
Dürer's largest portrait engraving is not entirely successful, judging by Holbein's portrait of the same sitter (see p. 157). It was probably based on a medal which Erasmus gave for the purpose, though in 1520 Dürer had met the scholar in person. Great care is taken for the light.

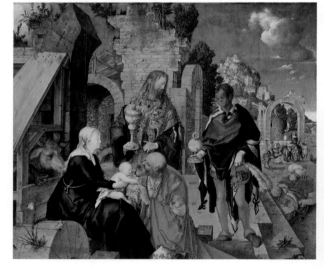

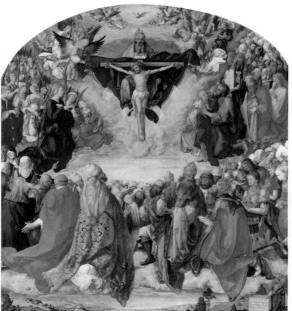

DURER (above)
The Adoration of the Magi, 1504
Dürer's starting point was northern, a scheme in essence like Hugo van der Goes' Monforte altarpiece (see p. 304). On to this he grafted Italianate gesture, grouping, colour, subsuming them into his own style. This is thought to be the central panel of a folding altarpiece, with lost wings.

DURER (left)
The Adoration of the Trinity, 1511
Especially the Virgin in *The Adoration of the Magi* was distinctively northern, in features, in proportions. In this vast, comprehensive statement Dürer achieves a more thoroughgoing blend, a magnificent synthesis of the northern and southern visions, orchestrating with Leonardo's coherence his huge crowd of individuals.

DURER (below)
Self-portrait, 1498
The foppish, elegant effect
is consciously sought. By
portraying himself gowned

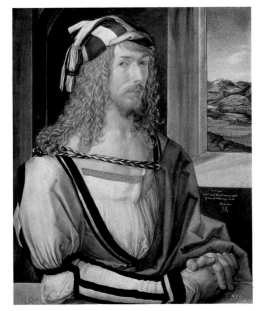

as a gentleman, Dürer states
his claim to an intellectual
and social parity with aristo-
crats – a prince of the arts,
no mere humble craftsman.

breadth of light and colour without sacrificing
the precision of his drawing; he also made
several magnificent portrait engravings. His
paintings did not always match the achieve-
ment of his finest prints (see over), but the
brilliance, the virtuosity of his *Adoration of the
Magi* (1504) more than holds its own in the
challenging context of the Uffizi. In *The Ador-
ation of the Trinity*, 1511, he painted a gran-
diose vision of St Augustine's *City of God*, the
Trinity suspended in the heavens amongst the
airborne host of saints and martyrs, but with a
delightfully detailed, tranquil landscape on
earth beneath. The artist stands in one corner
with a tablet proclaiming his authorship. Un-
questionably, however, Dürer's supreme mas-
terpiece in painting is the two great panels
known as "*The Four Apostles*" (actually John
and Peter, Mark and Paul).

In originality and in expression, Dürer is
surpassed by his compatriot, generally known
as Grünewald. His real name was Mathis
Gothardt-Neithardt (*c*.1475-1528). Though
he was famous in his time, holding high office
as painter, architect and engineer to the
Prince-Bishop of Mainz, his life and his per-
sonality remain obscure. Said to have led "a

melancholy and secluded existence", he de-
picted only religious subjects, while just 30-
odd drawings and a score of paintings survive.
In them, the intensity of emotion, and the
expressionist means of conveying it, shock the
onlooker as does no other painting in Western
art, not even by Goya, until the violent assault
of the Expressionists in the twentieth century.

Grünewald's religious sympathies were ap-
parently with the Reformers; they reflected
anyway a profound and perhaps mystical
spiritual commitment. His subjects mostly
relate to Christ's Passion, and his work is
summed up in one composite masterpiece
(which includes nine of his 20 known paint-
ings), the Isenheim altarpiece, a folding altar-
piece with two sets of wings, completed in 1515
for the church of the hospital of St Anthony at
Isenheim, near Colmar. The outer wings,
when closed, reveal the famous *Crucifixion*,
with a gigantic, lacerated corpse of Christ.
These wings open to reveal an enchanting,
lyrical celebration of *The Virgin and Child*,
counterbalanced on the right by an extra-
ordinary *Resurrection*. The kernel of the altar-
piece is a wooden shrine with St Anthony
enthroned, flanked with two further wings.

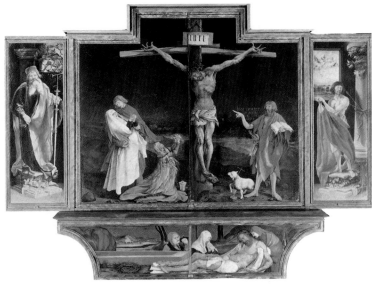

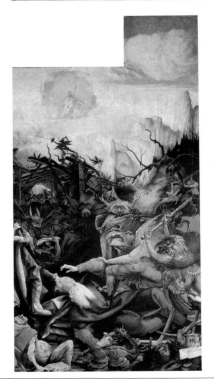

GRUNEWALD (left and right)
The Isenheim altarpiece,
1515
The altarpiece had three
distinct functions: closed,
it served as a plague altar,
reminding the afflicted of
the sufferings of Christ,
which *The Crucifixion* (left)
depicts with a ruthlessness
never seen before. This is
realism, not naturalism:
consistency of neither scale
nor proportion is observed;
the Lamb bleeds into the
chalice; and the Baptist,
though historically dead at
the time of the Crucifixion,
is present, and points with
one hugely elongated finger
at the crucified Christ. The
image is complemented
by two fixed wings, with
SS. Anthony and Sebastian
(patrons of the sick and of
plague victims respectively)
and a predella below with a
Dead Christ, which was a
model for a host of works,
not least Holbein's famous
Christ in Basel (see p. 156).
With the outer wings open,
the altarpiece proclaims the
essential Christian message
of hope and Resurrection;
it was opened for Mass on
Sundays. The two sets of
wings from the altarpiece
are now shown separately;
The Annunciation and *The
Resurrection* (top right)
are on the reverse of *The
Crucifixion*. The amazing
Christ in the *Resurrection*
soars in a crinkling flame,
dissolving into iridescence.
Last, with the inner wings
open, the altarpiece was a
focus of the celebration for
the feast of St Anthony.
One of the wings (right),
*St Anthony assailed by
demons*, is a conception of
tormented violence, with
overtones of Bosch's work.

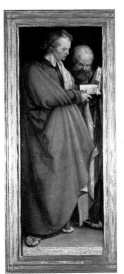

DURER (left and right)
"*The Four Apostles*", 1526
These majestic figures were
intended as the wings of an
altarpiece of the Italian
type, a *sacra conversazione*.
It was never finished, since
Nuremberg Reformed
while it was in progress.
The saints have been inter-
preted as personifications
of the four temperaments –
choleric and melancholic,
sanguine and phlegmatic –
while the inscriptions spell
out Dürer's message to the
faithful of the new religion:
hold fast to the Word and
distrust false prophets. In
the apostles' monumental
yet individualized grandeur
northern particularism is
married to the Italian
tradition of figure drawing,
stemming from Masaccio.

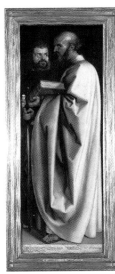

Dürer: The Four Horsemen of the Apocalypse

In the Book of Revelation, when the Lamb opened the first four seals of the prophecy of the Last Judgment, there rode forth four horsemen one after the other. One rider came with a bow, on a white horse, riding out to conquer; one with a great sword on a red horse, to unleash destruction; one with a pair of scales, on a black horse; and finally, Death on a pale horse, and Hell following with him, riding to kill in famine and pestilence.

Such movement, in almost audible thunder, had never been expressed in the woodcut medium before; in terms both of technique and of inspired imagination it has never been surpassed since. Much as Dürer loved experiment in all media, it was through prints, throughout his career, that he established his independence and broadcast his art. Through them, he could reach huge audiences, whether popular or sophisticated, literate or illiterate.

The Apocalypse appeared first in 1498, in a German edition and in a Latin one; a second issue in 1511 had a Latin text. The theme answered the mood of the times – a widespread religious disquiet which was to culminate in the Reformation and split of the Church. A prophecy, that the world would come to an end in the year 1500, was generally believed and, for some, the Pope was not Christ's representative on earth but the Anti-Christ of the Book of Revelation. The message, though, as set out by Dürer, was not entirely one of doom. In *The angels staying the four winds*, the elect are ordinary people with whom the reader could identify.

Dürer's book was the first published by an artist entirely under his own auspices. Earlier illuminated Apocalypses had generally been differently arranged – with full page illustrations distributed through the book, or smaller ones inserted in the text, or with pages consisting of tiers of images explained by captions. Dürer reserved the front of the page for the print, and had the text on the back. The subject matter, with its scope for visionary fantasy, obviously fired his imagination, but the medium, while it encourages expression in linear terms, allows little tonal modulation and is inherently a vehicle for bold, not very subtle, effect. Earlier artists had relied on colour to complete the effect; Dürer achieved a satisfying equivalent of colour in black and white.

Dürer continued to use woodcut, and developed his technique to a remarkable pitch of virtuosity, as in "*The Great Passion*" and *The life of the Virgin*, published also as books, in 1511. In copper engraving, however, he achieved a mastery of modulation in tone which really does make colour superfluous. In the famous print of *Adam and Eve*, 1504, this is applied to Italianate and classical themes. Nevertheless, his northern naturalism is vividly present in the drawing of flora and fauna, for all that these, too, have symbolic meaning. Both his mastery of technique and the richness of his learning, combined with an endlessly fertile invention, reached their peak in the three great single plates of 1513-14, *The knight, Death and the devil* (not shown), *St Jerome* (not shown), and *Melancholia I*. These, with their fantastic wealth of detail brought together in consummately harmonious compositions, can be read almost as humanist tracts. The *Knight* is an allegory of the Christian warrior, *St Jerome* of a Christian scholar, and *Melancholia* a meditation on the process of creation, full of recondite allusion.

Dürer also engraved several portraits (see preceding page) and illustrated three theoretical works, including the important *Four Books on Human Proportion* (1528).

DURER (right)
The Apocalypse: *The angels staying the four winds*, 1498
When the seals had been broken and the horsemen had ridden out, spreading terror, four angels were deputed to hold back the winds while the elect were marked with God's seal – interpreted as the Host.

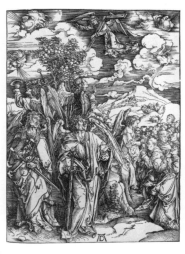

DURER (below)
"*The Great Passion*":
Christ carrying the Cross, 1511
Dürer believed one of the chief functions of art was to represent the Passion. The figure of Christ, the movement of his head, is expressive and pitiable.

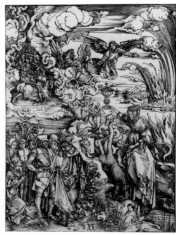

DURER (left)
The Apocalypse: *The Whore of Babylon*, 1498
The Whore is an exact copy of a drawing of a Venetian lady Dürer made in 1495. She sits on a beast with seven heads and ten horns, and conversing with her are the kings of the earth and also merchants – all the rich, powerful and worldly. Their oncoming destruction is apparent behind them, in the exploding sky.

DURER (below)
Adam and Eve, 1504
Both figures are based on antique sculptures – Adam on "*The Apollo Belvedere*" (see p. 41). Eve rather freely on a *Venus* – and are constructed according to canons of proportion. Every detail has meaning: the branch Adam holds may refer to the Tree of Life; the four animals may represent the four humours in their original harmony.

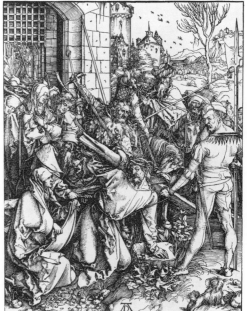

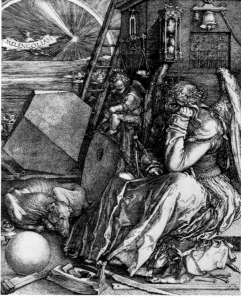

DURER (left)
Melancholia I, 1514
According to the ancients, a melancholic was earnest, a man of intellectual bent; the present meaning of the word came later. The print encompasses this duality: the Comet of Saturn is in the sky: a planet thought to have a depressing effect on the intellect, Saturn was also associated with mathematics, taken as the basis of all learning – hence the mathematical accessories.

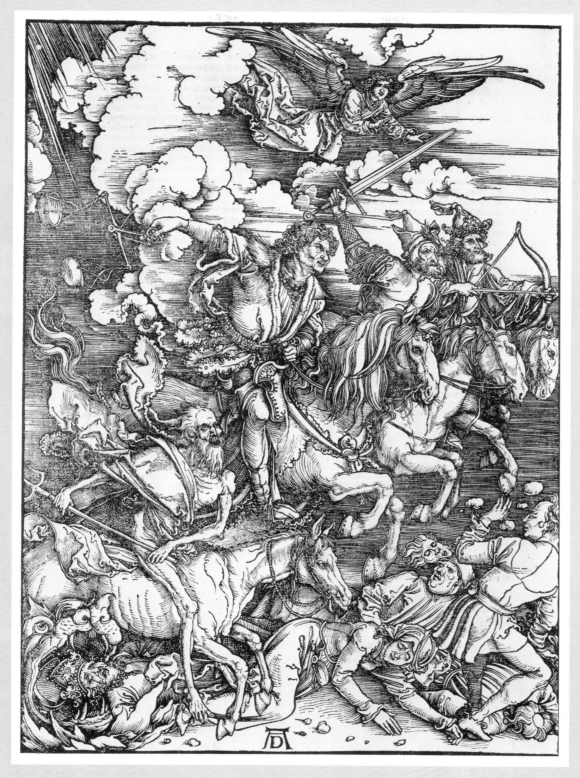

DÜRER
The Apocalypse: *The four horsemen*, 1498
Dürer condenses the text of the Revelation of St John in all the Apocalypse woodcuts, but nowhere with such effect as in *The horsemen*. Disregarding the mass of humanity under their hoofs, all four stare out into the distance, forming a chain across the sheet, which contributes to the sense of movement in the whole. This is reinforced by the contrast of light and dark, and the linear agitation of the fluttering saddle-cloths and other garments. Earlier German art had nothing to compare with Dürer's impression of pandemonium. The seething line is typical of Dürer's early woodcuts; the absence of colour signals its great technical accomplishment.

Painting in Germany before the Reformation

Germany, a congeries of more than 100 autonomous political units under the nominal rule of the Holy Roman Emperor – some 30 principates ruled by Electors; some 50 ecclesiastical territories ruled by Prince-Bishops; some 60 self-governing towns – was flourishing vigorously in the years before the turmoils of the Reformation. Its industries were expanding and prospering; the Fuggers, bankers in Augsburg, had destroyed the monopoly of the Italian finance houses, and the northern humanists had assimilated and were even advancing upon the achievements of Italian letters. The new universities and the printed word consolidated the spread of learning, and, in the sphere of art, the printed image – woodcuts and metal engravings – intensified and accelerated the influence of new styles and novel imagery. Through engravings, the art of the Italian Renaissance became the common heritage of all Europe.

The traffic was by no means all one way. The best known and most prolific of the Italian engravers, Marcantonio Raimondi (c. 1480-1527/34; not shown) had forged Dürer prints in Venice before moving to Rome and becoming the chief disseminator of Raphael and of the works of antiquity. As a boy in Florence Michelangelo had copied an engraving of *The temptation of St Anthony* by Martin Schongauer (died 1491), one of the first artists to raise engraving beyond the level of the popular print. Trained as a goldsmith, Schongauer worked in Colmar, where Dürer arrived too late to study with him in 1492. Schongauer's painting was fairly traditional; his engravings, however, had an original dramatic force and attracted wide attention. Dürer, as we have seen, subsequently developed both the technique and the potential audience of prints.

Dürer's genius, so copious in invention, so brilliant in technique, tends to overshadow all others of his generation in Germany – with the exception of Grünewald. But admirable talents existed besides these two, such as Lucas Cranach the Elder (1472-1553), who spent most of his life in Wittenberg, where he was court painter to the Elector. He was a friend of Luther – he produced the most famous portrait by which posterity knows him – and an early adherent of the Reformed faith, though he continued to work occasionally on Catholic religious commissions. At the outset of his career, in Vienna about 1500, his landscape

CRANACH
Martin Luther, 1521
Cranach painted several portraits of Luther as a new religious hero in the early 1520s. At that time a division of Christendom was not yet irrevocable.

SCHONGAUER (right)
"Noli Me Tangere" (Christ with Mary Magdalen), after 1471
The basis of Schongauer's style was Rogier van der Weyden, reworked in his own softer idiom, recalling Lochner; but this is drawn with the hard outlines of an engraving. There is no chiaroscuro in the mass of meticulous, linear detail.

SCHONGAUER (below)
The temptation of St Anthony, c. 1470
Engravings and woodcuts were at first run off in large quantities and sold at religious festivals and fairs. *St Anthony* is above all didactic, a fearsome warning against the sins of the flesh. While there is sculptural modelling, the saint and demons drawn in such exuberant detail float free in a nebulous space, unnaturalistically.

CRANACH (right)
Adam and Eve, 1526
Cranach's insistence on an unfashionably Gothic style may signify his wish to adhere to northern values, free from Italian decadence.

PACHER (below)
The Four Doctors of the Church, c. 1483
Four doves in virtuoso foreshortening swoop over (from left to right) SS. Jerome, Augustine, Gregory and Ambrose. The harsh modelling of the faces, the perspective and the cut-off figure of Trajan in the foreground repentant before St Gregory (in a dream) recall Mantegna; but the nervous, sinuous poses and contorted hands, not to mention the rich canopies, are Gothic. The modelling of the faces can also be compared with Pacher's painted sculpture; this is anyway a synthesis of outstanding success.

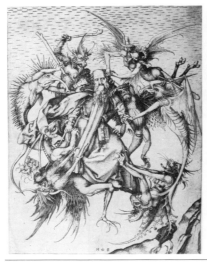

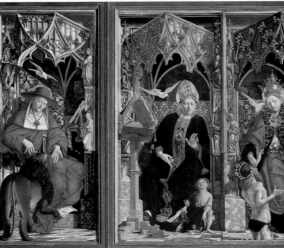

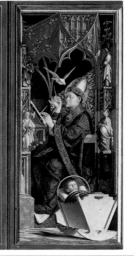

settings had parallels with the "Danube school", and his early portraits have a genial amplitude matching Dürer's. Later, in Wittenberg, aided by a large workshop that included his two sons, he began the prolific production of the kind of painting most generally associated with his name – nudes in landscapes, with biblical or mythological titles (virtually interchangeable) – *Adam and Eve*, *Apollo and Diana*, and so on. Hints of Dürer or of classical antiquity sometimes emerge, but his personal brand of erotic imagery, slightly fey, sinuous and at the same time somehow angular, with his figures looking a little like actors in an amateur charade, is unmistakable. His later portraits became comparatively formal; he was apparently responsible for the first life-size full-length portraits, heralding centuries of state effigies. His printmaking technique is coarse beside Dürer's, but he was the leading image-maker for the Reformation.

Cranach was, perhaps deliberately, a belated Gothic painter, and other artists continued or developed late Gothic traditions more or less unadulterated. The Austrian Michael Pacher (active c.1465-98) remained relatively immune to Italian influence as a

sculptor (see p. 158); as a painter, he transposed Mantegna's perspective effects and rich classical detail into a superb Gothic equivalent. Several artists in Cologne maintained a fifteenth-century idiom well into the sixteenth century: the most accomplished of them, the Master of the St Bartholomew altarpiece (active c.1470-1510), had been trained in the Netherlands and practised a charming version of the style of Rogier van der Weyden. A number of painters, who are known for convenience under the label "the Danube school", though they did not cohere as a group, shared an obsession with the wooded scenery of the Tyrolean region and developed an original vision of landscape, unparalleled in Italy. In power of imagination, the finest of them was Albrecht Altdorfer (c.1480-1538), working in Regensburg in Bavaria. The twentieth century might read his work as "mood landscape"; obviously related to the watercolours Dürer had made on his trips to Italy, it even anticipates some of the effects of Ruisdael and nineteenth-century Romantic landscapists. In his little *St George and the dragon*, the landscape is the focus of interest; saint and dragon are entirely subservient. Altdorfer's masterpiece, how-

ever, is surely his *Battle of Alexander and Darius on the Issus*, with its dizzy illusion of sky and earth as tumultuously involved in the conflict as the multitudinous armies.

Hans Burgkmair (1473-1531), the major artist resident in Augsburg at the beginning of the sixteenth century, shows the impact of his visit to north Italy about 1505 very obviously; he was a prolific portraitist and painter of altarpieces, but also a virtuoso in the technique of the chiaroscuro woodcut, and his image of *Hans Baumgartner*, 1512, is one of the finest woodcut portraits ever made. Hans Baldung Grien (1484/5-1545), who had likewise visited Italy, settled in Strasbourg in 1509; working in many media, he came nearest to Dürer (whom he had known in Nuremberg) in talent and versatility. His most original works, however, were mythological or allegorical paintings, idiosyncratic in their range of colour, which sometimes achieve a macabre intensity. The characterization of his nudes owes something to Cranach, but their structure is more classical. Yet the complete reconciliation of the Italian Renaissance with northern line was not to be achieved until the next generation, by Hans Holbein the Younger.

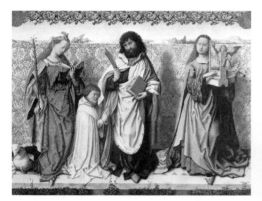

THE MASTER OF THE ST BARTHOLOMEW ALTARPIECE (above) The St Bartholomew altarpiece, central panel, c.1505-10 St Bartholomew is in the centre. The figures are fine examples of the late Gothic style – attenuated, with fragile, twisting fingers, heart-shaped faces and richly embroidered robes.

ALTDORFER (below) *The battle of Alexander and Darius on the Issus*, 1529 The concave roll of the land, bringing the horizon up the picture towards the spectator, is unorthodox, though the bird's-eye view can be paralleled in Bosch or Patenier. The cartouche, and inscriptions within the painting, display a chief interest in the numerical odds against Alexander and the number of dead: painted for a duke of Bavaria, it is a precursor of the scenarios of classical history that lent lustre to Baroque palaces.

ALTDORFER (left) *St George and the dragon*, 1510 There are no arbitrary crags, no orderly lines of hills and trees receding to the horizon – the usual landscape conventions are gone. Instead, glimmers of light seep through the trees that bristle over the panel (the painting is in fact on parchment, pasted on to wood, so like a miniature).

BURGKMAIR (left) *Hans Baumgartner*, 1512 The classical arch framing the background – perhaps, too, his melancholy gaze – serves to indicate that the sitter is a scholar and a humanist. The modelling is bold and free but the detail is of great finesse; the print was made from three blocks, each one inked in a different shade of violet.

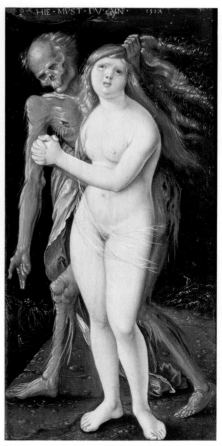

BALDUNG GRIEN (right) *Death and the Maiden*, 1517 Baldung Grien returned to this theme several times, progressively refining and simplifying the image to a horrid immediacy – placing the Maiden's sensuous pale purity against Death's dark, scrawny, protoplasmic decay. The theme of lurking death had been banished in Italy by the Renaissance, but in the north kept its fervour.

Holbein: The Ambassadors

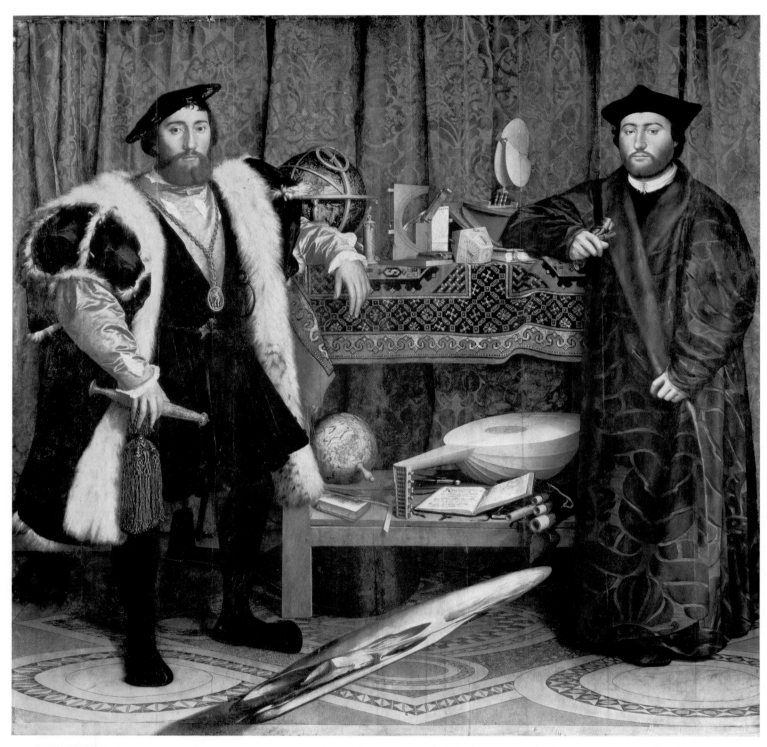

HOLBEIN (above and left)
"*The Ambassadors*", 1533
This is one of the earliest
portraits to show two men
full-length, life-size. They
are as close to real life
as the artist could make
them – illusionistic in every
particular, the picture is a
replica of an instant. It
was perhaps placed (at the
top of a great stair?) where
it could be seen either from
straight on or obliquely –
the angle at which the skull
takes on its true shape
(detail, left). When it is so
seen, the two men blur, and
eternal death overtakes all.

HOLBEIN (above)
The dead Christ, 1521
Though clearly influenced
by Grünewald's *Christ*
in the predella panel of the
Isenheim altarpiece (see p.
151). Holbein depicts the
body of Christ rigid in
death with an exactitude
that deprives the image of
all spiritual comfort: the
tomb imprisons the body
in its *rigor mortis*. Before
this painting, Dostoevsky
cried: "This picture could
rob a man of his faith". It
perhaps belonged to a lost
altar with *The Deposition*.

The men represented are French, Jean de Dinteville and Georges de Selve, Bishop of Lavaur, but Hans Holbein the Younger (1497/8-1543) painted their portrait in 1533 in London, where Dinteville was on a diplomatic mission to Henry VIII of England. Shown life-size, full-length, the two are depicted with exact realism down to the details of their very opulent costumes. The green damask curtain behind and the inlaid marble floor (based on one in Westminster Abbey) are equally scrupulously portrayed, while in the centre, on a two-tiered table, is displayed an elaborate still life – on top, instruments of science and astronomy; below, more earthly interests – a terrestrial globe, an arithmetical textbook, a lute, but also an open hymnal (the text is Luther's revised version). The composition seems to be a Reformed version of the traditional *sacra conversazione*, in which the still life, rather than the Madonna, is the focus of the two figures' intellectual and spiritual commitment. At the same time, in their paired placement, and impassive stillness, the figures are like "supporters" in a massive coat of arms.

Closer inspection, however, reveals an underlying disquiet: the minute badge in Dinteville's cap is a skull; a small crucifix is almost hidden away at the top left; a string of the lute is broken. Most strikingly, but also most enigmatically, the yellowish smear tilted across the foreground reveals itself when seen at an acute angle from the left below (or from the right above) as a skull, distorted by a mathematically exact trick of perspective. And the central still life is also a vanity, a *memento mori*. Dinteville's age is given, on his dagger, as 29; Selve's, on his book, as 25; dials indicate the time to be 10.30 am, the date April 11th; the two men are in the prime of life and health, of material and intellectual accomplishment. But the reality of the stated moment, the instantaneity, is undermined by the omens of mortality, above all by the added dimension of the distorted skull, which the sitters cannot see, and all their science cannot understand. This ambiguous picture, realized with scientific precision and consummate art, combining monumental realism with complex symbolism, is one of the most ambitious and successful achievements of Renaissance art.

Holbein's own name is, literally, a synonym for a skull, and his obsession with human mortality lasted throughout his career, from even earlier than his woodcut designs for a *Dance of Death* (not shown) about 1525. He was born in Augsburg and trained by his father Hans the Elder; he was fully established in Basel by 1520, and there came to know, through the printer Frobenius, a remarkable humanist circle including Erasmus. His early work reflects many influences and was in many media – portraits, designs for engravings, altarpieces, large-scale mural decorations – but common to all was his astonishing technical virtuosity. His *Dead Christ*, in its starkness, may be influenced by Grünewald's expressionism, but its detached, exact observation has a very different effect. A probable visit (or visits) to northern Italy was more fundamental; some paintings seem to acknowledge Leonardo's example very closely, but in his *Madonna and Child with the Meyer family* he

HOLBEIN (above)
The Virgin and Child with the Meyer family, c. 1528
Between 1528 and the death of Meyer in 1531, a portrait of the patron's second wife was added. The Virgin with her lively Child perhaps reflects local sculpture.

HOLBEIN (below)
Sir Thomas More, 1527
Holbein developed to a perfect realism the type of humanist portrait Massys (see p. 160) had taken up. The expressive, sensitively modelled hands are typical of Holbein's minute skill.

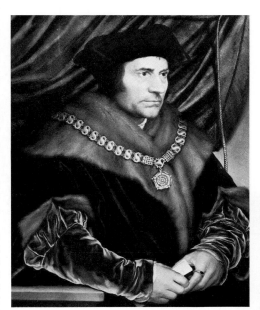

fused the principles of both Leonardo and Raphael with northern literalness into a magisterially monumental image. No one, not even Dürer, had achieved such a synthesis.

After an initial visit to London (1526-28) he finally settled there in 1532, and from about 1536 until his premature death from the plague in 1543 he was court painter to Henry VIII. His personality and his personal convictions remain elusive, but he was clearly sympathetic to the Reformation, even though the shrinking of religious patronage in the Reformed climate of Basel was certainly a strong reason for his move to England. On his first visit, he became attached to the circle of Sir Thomas More, Erasmus' humanist friend: his portrait of More is one of the most gravely humane portraits of the whole Renaissance, and his group of More's family – now lost, but known from a preliminary drawing (not shown) sent to Erasmus – was one of the first "conversation pieces". Like "*The Ambassadors*", it turns a traditional religious format to secular ends.

Soon after his arrival in London for the second time, Holbein painted some superb portraits of members of the German Steelyard, a merchant community. His painted portraits depended on studies from the life made with the aid of some form of perspective aid, such as a *camera obscura*, but the resultant drawings, of which a series has miraculously survived, show no trace of mechanical dependence; they include some of the most delicate but sure reflections of the human face ever made, captured within a contour line quick with life. Holbein established a tradition and standard of quality in miniature to which English practitioners constantly referred, especially the greatest Elizabethan miniaturist, Nicholas Hilliard (see p. 206). From his drawings Holbein could project the images without any loss of quality to any scale – he is most famous for his awesome straddling life-size image of the King. In his state portraiture the static, linear quality became more marked, and he achieved images of cool, aloof splendour that were perhaps matched but not surpassed by Bronzino.

HOLBEIN (left)
Jane Seymour, preliminary drawing, *c.* 1535
Apart from a few details of dress, the finished portrait closely copies the drawing, indicating that, for Holbein, the basis of art lay above all in precision of outline.

HOLBEIN (right)
Henry VIII, 1542
In an image originated by Holbein, and repeated endlessly by copyists, the figure of the King already shows signs of an advanced obesity, skilfully hidden under a bell-shaped surcoat.

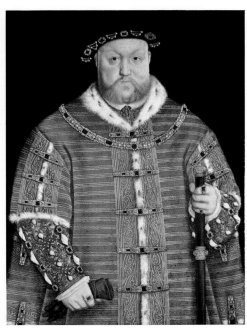

Sculpture in Germany: Late Gothic and Italianate

In the half-century before the Reformation the German-speaking lands produced remarkable sculpture in considerable quantity. Despite sculptors' increasing awareness of the achievements of Italian masters, through prints and also through first-hand reports by visitors to Italy, sculpture north of the Alps always preserved an individual flavour, and the influence of Claus Sluter was enduring. Sculpture was chiefly employed upon altarpieces, and generally conceived within the late Gothic tradition – in intricate, busy, tightly boxed set pieces, with elaborate fretted and pinnacled canopies; free-standing figures were rare, with the exception of the Virgin and Child. There was, however, a tendency towards heightened realism and expressive handling.

One of the first to adopt a more naturalistic style, emulating Sluter, was Nicolaus Gerhaerts (active 1462-73), who may have come from Leyden in the Netherlands, but whose known work is all in Germany – he seems to have ended up in the 1470s at the court of Emperor Frederick III in Vienna. His ability to draw out the character of a figure in stone – witness the atmospheric individuality of his so-called *Self-portrait* (c. 1467) at Strasbourg –

had a wide influence on German sculptors of the next generation. Michael Pacher, active slightly later in the Tyrol, produced one of the earliest surviving and best-preserved late Gothic altarpieces (the losses, dismemberments and discolorations have been enormous) for the isolated pilgrimage church of St Wolfgang. Typical is its towering magnificence, interlocking with the architecture of the choir, though Pacher's lavish use of gold is unusual. Pacher also painted (see p. 154).

Pacher's near-contemporary Veit Stoss (c. 1450-1533) was one of the first to follow Gerhaerts' lead, and to move away from the Gothic spectacular towards a greater emphasis on the individual figure. He left his native town near Nuremberg in 1477, and for 20 years worked in Poland, where his principal commission was the altarpiece at St Mary's, Cracow. This, unlike Pacher's masterpiece, has a relatively simple structure – no spires, no surmounting crucifix, no flanking figures or panel paintings. The central scene is bounded by a great arch that lets air into the whole, though most of the figures are still densely massed along the bottom. On his return to Nuremberg in 1496, Stoss achieved an almost

classical clarity of form – his *St Roch* (not shown) in a church in Florence was admired by Vasari as "a miracle in wood" – then moved about 1507 to an even more emotionally charged expression – though still monumental – which perhaps finds its closest parallel in High Baroque sculpture.

Towards the end of his career Stoss had left his sculpture unpainted, but the first German sculptor known to have delivered his work bare, "true to its materials", is Tilman Riemenschneider (died 1531). Riemenschneider worked very successfully, with a large workshop, at Würzburg, where he was somewhat detached from the mainstream. He delighted still in the elaborate traceries of late Gothic, but experimented with unusual shapes and convolutions, and broke with tradition in designing altarpieces without hinging wings. His sculpture shows the most sensitive and delicate sureness in controlling form and expression.

Stoss was not the only master to practise with great virtuosity in Nuremberg. The stonecarver Adam Kraft (c. 1460-1508) produced vividly naturalistic figures still in a recognizably Gothic context, as in his Tabernacle at St Lorenz in Nuremberg. This is an

GERHAERTS (below)
"Self-portrait", c. 1467
The figure seems to feel some private emotion; face, hands, pose and garments together express an inner drama – just like Sluter's *pleurants* (see p. 90). The figure was probably once placed high up, and leaned illusionistically on a sill.

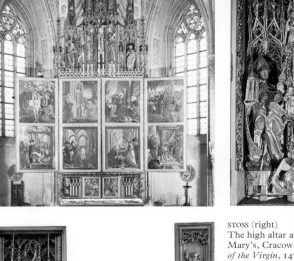

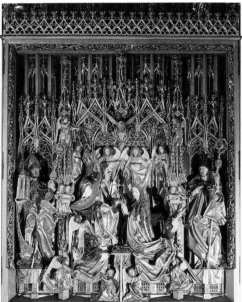

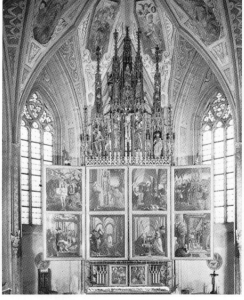

PACHER
The high altar of St Wolfgang:
(far left) with the outer wings open; (left) with the inner wings open, the central tableau: *The coronation of the Virgin*, c. 1471-81
Sculptures and paintings, overlapping and alternating, make up a carefully wrought harmony, linking together the parts of the altar, and the altar to the architecture. There is clear evidence of Italian influence (notably Mantegna's) in the painting (not by Pacher's own hand), but none in the sculpture, unless it is in the skilful grouping of *The coronation*. This, revealed behind the massive wings, seems to be perfumed in rich gold; yet the complex intricacy of the drapery, and above all the canopy, is offset by a simple realism in the faces of the saints, the Virgin, even God.

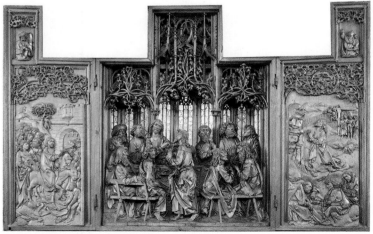

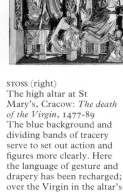

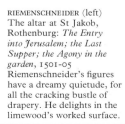

STOSS (right)
The high altar at St Mary's, Cracow: *The death of the Virgin*, 1477-89
The blue background and dividing bands of tracery serve to set out action and figures more clearly. Here the language of gesture and drapery has been recharged; over the Virgin in the altar's centre a towering apostle reaches out wringing hands.

RIEMENSCHNEIDER (left)
The altar at St Jakob, Rothenburg: *The Entry into Jerusalem; the Last Supper; the Agony in the garden*, 1501-05
Riemenschneider's figures have a dreamy quietude, for all the cracking bustle of drapery. He delights in the limewood's worked surface.

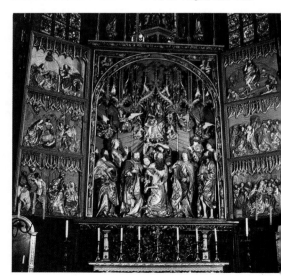

enormous free-standing shrine housing several ranks of life-size figures, arranged in almost conversational groups and seeming to overflow into the church. The Vischer family of bronze-workers, headed by Peter the Elder (c.1460-1529), worked on the Shrine of St Sebaldus from 1488 to 1519, in which time what had begun as a Gothic project much like Adam Kraft's had been combined with sometimes pronouncedly Italianate features. Peter the Elder had a collection of "old Frankish" art – perhaps including Gallo-Roman pieces – and he sent his two sons, Peter and Hermann, who assisted him, to be trained in Italy.

The demand for elaborately carved altar-pieces fell away sharply during the 1520s – due not so much to Italian influence as to the impact of the Reformation. A more secular mode became fashionable. In Augsburg, the great banking dynasty of the Fuggers commissioned Sebastian Loscher (c.1480/5-1548) to decorate their private chapel. Loscher had had first-hand experience of Italian sculpture, and his *putti* once ornamenting the choir-stalls have no religious connotation and are entirely up to date with the High Renaissance. Elsewhere Conrad Meit (died 1550/1), who came

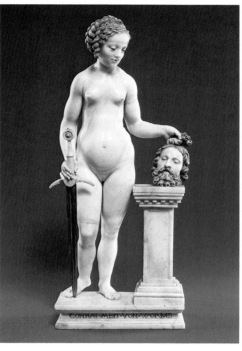

from the Middle Rhine region but worked for 20 years for the Regent of the Netherlands, produced small bronze and alabaster figures, precious, sensual, and closely observed. His little *Judith with the head of Holofernes*, an ornament for the cabinet or *studiolo* of a sophisticated patron, bears comparison with anything of its kind in Italy. Meit also worked in a monumental vein, on the spectacular effigies of the Regent's family at Notre-Dame-de-Brou at Bourg (not shown). These were stone figures smoothly and gently rendered with little detail and no agitation, though richly dressed and adorned with jewellery.

The full adoption of Italian principles can be seen in the work of Peter Flötner (c.1495-1546), working in Nuremberg. His masterpiece, the bronze Apollo Fountain of 1532, is conceived without any trace of Gothic – or of Mannerism. It is very pure and classical, the delicate, superbly balanced and finished form contrasting with the elaborate movement of detail in the pedestal. However, the greatest sculptor of the mid-sixteenth century, though born in the north, in Flanders, did not work there: Giambologna became the supreme Mannerist virtuoso in Italy (see p. 168).

MEIT (above)
Judith with the head of Holofernes, 1510-15
The modelling is firm and economic; colour is used sparingly; the glow of the alabaster is made to suggest the bloom of nubile flesh. The Italianate style has conquered, and is mastered.

KRAFT (left)
The Tabernacle at St Lorenz, detail, 1493-96
The whole structure is a towering Gothic complexity, in which the life-size figures are realistically carved.

LOSCHER (above)
Fragments from the Fugger chapel in Augsburg: *Putti*, 1515
Not only the forms but the sculptural principles are Italianate: these figures are in interacting movement, recalling *The three Graces*. Apparently, however, there is nothing comparable in Italy at this date to this complex of free-standing babes playing in space – though it is suggested in the work of Donatello.

STOSS (above)
The Virgin and Child, c.1520
It seems right to call the work of Stoss' last years "personal"; though he was widely honoured, he was un-settled, quarrelsome, lonely. The Virgin's draperies loop, cascade, twist, crumple and swirl upwards to the energetic, wriggling Child.

THE VISCHER FAMILY
(right) The Shrine of St Sebaldus, 1488-1519
The standard of finish and unity of style are unusually high; and the clarity of the complex whole remarkable. The Italianate figures – sphinxes, mermaids, *putti* – are most in evidence in the lower parts of the Shrine.

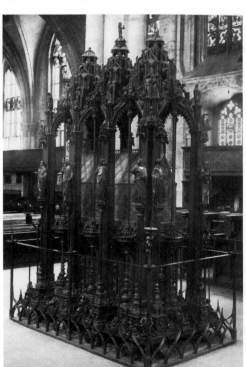

FLOTNER (left)
The Apollo Fountain, 1532
Before this work Flötner had visited Italy twice. He was himself an engraver and woodcutter, and here the design is taken from an engraving, one by Jacopo de' Barbari (died 1516?), one of the first Italian artists to seek and find patronage in the north.

Netherlandish and French Painting

By the end of the fifteenth century in the Netherlands the impetus of original exploration and invention stemming from the work of the van Eycks, van der Weyden and van der Goes faded, and the new generation turned to the all-pervading example of Italian art. Just as the great northern humanists, Erasmus or Thomas More, drew on Renaissance learning, so, too, the artists drew on Italian motifs and the Italian revival of classical antiquity. The "Italian journey" became almost obligatory.

However, among the many artists imitating, borrowing from or creating in the manner of Renaissance art, no genius emerged of the stature of a Dürer or a Holbein, who could integrate a full understanding of its underlying principles with the native northern tradition. Jan Gossaert, known as Mabuse (c. 1478-1533), who worked in Antwerp and for Burgundian patrons, started in a tradition close to Hugo van der Goes, but after an Italian journey in 1508 he began to feature Italianate motifs – classical architecture, classicizing poses – amidst his always teeming detail. He is said to have been the first artist in the Netherlands to paint classical subjects with nude figures. Something of the charm of his earlier style is carried over into later works such as the Malvagna triptych, but here the Italianate music-making *putti* consort rather oddly with the sweetly Netherlandish Virgin, and even more oddly with the elaborate intricacies of the Gothic shrine in which she sits. Mabuse was perhaps most successful in his portraiture, which is direct and charming.

His main rival in Flanders was Bernard van Orley (c. 1488-1541), who worked prolifically in Brussels for the Regents of the Netherlands, producing altarpieces, portraits and designs for tapestries and stained glass. He is supposed to have visited Italy, and he certainly responded to the Italian-oriented, sophisticated taste of his patrons, but again his unpretentious portraits are his best work.

Quentin Massys (1464/5-1530) in Antwerp is the most sympathetic and sensitive artist of this generation in the Netherlands. Italian impact is once again strong (though it is not certain that Massys ever went to Italy) and the influence of Leonardo is apparent, especially in his altarpieces. But he also developed a vivid portraiture that is almost genre – or vice versa. His enchanting study of *A banker and his wife* (1514) is probably genre, with moralizing intent. The still life is described with a loving finesse, down to the convex mirror, which is presumably symbolic. The whole picture has the conviction of a real event, and seems as much a portrait as his *Egidius* of 1517. Here the scholar is shown in his setting (the idea derives doubtless from traditional representations of St Jerome in his study) – a marvellously alert and human likeness. Joos van Cleve (c. 1490-1540; not shown), Massys' contemporary in Antwerp, was in demand for a more formal and official style, in state portraiture.

In his altarpieces, Massys sometimes collaborated with Joachim Patenier (c. 1485-1524), who painted the landscapes. He was a master of the bird's-eye-view panorama, and one of the first to practise landscape for its own sake – the biblical figures are important, but are usually so small as to be almost invisible. Visionary crags and mountains characterize not only Patenier's but most Netherlandish landscape backgrounds until the dawn of the great naturalistic era of the seventeenth century – with the great exception of Bruegel (see over), who stands virtually alone in the Netherlands in the next generation.

The most vigorous painting in the sixteenth

MABUSE (left)
The Malvagna triptych:
The Virgin and Child, and saints, 1510-15
Transalpine Europe had always had closer links with northern Italy than with Tuscany or Rome, and even though Mabuse painted this after he had accompanied a Burgundian embassy to the Pope, Ferrarese painting seems his chief inspiration.

VAN ORLEY (right)
Georges de Zelle, 1519
The Brussels physician was about to marry. The linked hands, of the sitter and on the panel behind, signify union; the N is his wife's initial; the monogram abbreviates "eternity".

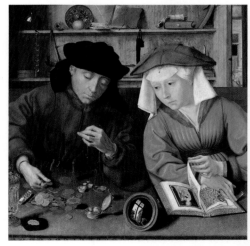

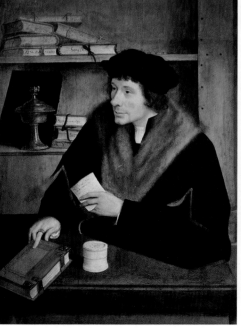

MASSYS (above)
A banker and his wife, 1514
The wife is distracted from her devotional book by the clink and glitter of the coins her husband counts; other details, too (of which the symbolism is now obscure), set spiritual against earthly treasure. Significantly for the future, Massys introduces a new psychological realism (in Christus' comparable *St Eligius* (see p. 303) there is nothing of the kind).

MASSYS (left)
Egidius (Peter Giles), 1517
Egidius was on one half, Erasmus on the other, of a diptych commissioned as a gift for Thomas More, their friend and fellow-humanist.

PATENIER (above)
The Flight into Egypt, undated
The Holy Family escape Herod's ire along a snaky path in (despite its artificial crags) a homely landscape.

century was in Flanders rather than in Holland: activity shifted from Bruges and Ghent to Antwerp, expanding as its deep-water port responded to commerce from the New World, and Brussels. A very puritan version of Protestantism had taken hold in Holland, and the outlook for religious art was bleak (indeed there was iconoclasm). Jan van Scorel (1495-1562) produced sophisticated, cosmopolitan work in Utrecht from 1524, after travels that had taken him to Nuremberg (where he met Dürer), Carinthia, Venice and Jerusalem before an extensive stay in Rome. His first-hand knowledge of Italian art was wider than that of any contemporary. He developed a rapid, fluent technique, with a delicate feeling for light and glowing colour. The delightful *Mary Magdalen* in Amsterdam shows him at his best, entirely himself, having absorbed the experience of his travels into his own vision. In other examples his differing references jostle less happily. Van Scorel's portraits are again his most satisfactory work: he could be both sensitive and very tender. A follower of his, Marten van Heemskerck (1498-1574), spent several years in Rome, and is important not only as a leading exponent of later, northern

Mannerism but also as a topographical recorder of sixteeth-century Rome.

Lucas van Leyden (1494-1533), based in that city, was a remarkably sensitive and delicate colourist, and possibly the first artist in the Netherlands to produce self-portraits. But his greatest achievement was in printmaking: in his engravings he followed very much in Dürer's footsteps, and could rival him in virtuosity. His genre scenes not only provided a starting-point for seventeenth-century Dutch and Flemish genre, but may also have been drawn upon by Caravaggio.

In France, that great patron Francis I attracted to Fontainebleau not only Italian but also Netherlandish artists (including Joos van Cleve), and the next generation of native French painters (the so-called second school of Fontainebleau) mingled the elegance of one tradition with the detailed realism of the other, though the sculptors reflected predominantly Italian example (see p. 167). The best fusion was achieved by François Clouet (c. 1510?-72), the scion of a long dynasty of artists, and an unattributed *Three minions* shows the blend of Netherlandish and Italian elements assimilated into a highly polished Mannerism.

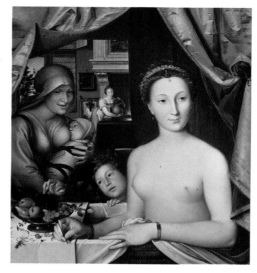

CLOUET
A lady in her bath, c. 1550?
The Italian influence on Netherlandish portraiture was in turn absorbed by the French court painters. According to tradition,

Diane de Poitiers, mistress to two French kings, was the sitter. The scheme – a nude in a definite context, now obscure – is much like that of Titian's "*Venus of Urbino*" (see p. 145).

MASSYS AND PATENIER
(right) *The Crucifixion; saints and donors,* c. 1520-30
Massys and his workshop, deliberately reverting to native tradition, have here "modernized" Campin and van der Weyden, and the figures' archaic gestures stand out vividly against Patenier's richly rolling panorama. Massys' sons continued his production.

VAN SCOREL (below)
Mary Magdalen, c. 1540
More a portrait with the attributes of a saint than a devotional image, van Scorel's picture shows the impact of his travels. Against a Mediterranean sky the Magdalen wears a striped silk mantle and pearls such as a Venetian courtesan might display.

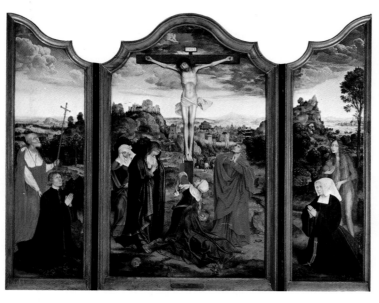

VAN LEYDEN (above)
The engagement, c. 1520-30
Dramatic frontal lighting and strong horizontal axes set up an almost abstract pattern of light and dark areas, indicating a graphic bias. This is very early for pure genre subjects.

FONTAINEBLEAU SCHOOL
(below) *Three minions,* c. 1580-89
The impeccably groomed courtiers of Henri III exemplify the very high finish and rather mannered sophistication of the second school of Fontainebleau.

VAN HEEMSKERCK
Self-portrait beside the Colosseum, 1533
The artist turns proudly to the spectator in a vivid

image of the relationship of northern artists to Rome, then and for years to come. He recorded buildings and statuary, old and also new.

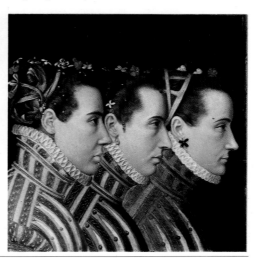

Bruegel: August, or the Corn Harvest

Pieter Bruegel (c. 1525-69) worked in Antwerp and then in Brussels, but early in his career travelled extensively in France and Italy, between about 1551 and 1553. Unlike almost all his northern contemporaries, he took from Italian art virtually none of the surface trimmings, though he surely developed in Italy his sense of space, his organization of majestic compositions in depth and the density of his human figures – though very different in effect, his broadly conceived peasant figures have a physical gravity like those of Giotto. From his journey through the Alps, however, he drew one enduring inspiration – mountains: views from the heights are recurrent in his work.

The most important early influence on Bruegel in Flanders was clearly the work of Bosch. This is apparent not only in the many designs that he made for engravings, but also even in quite late paintings. Many of his pictures illustrate proverbs and parables, most of them depicting humans as creatures of appetite subservient to the whims of nature or to their own folly. Bruegel's religious subjects are usually set in a contemporary context, almost submerged in the ebb and flow of everyday life about them; so in *The procession to Calvary* the spectator has to search amongst the teeming throng across the panoramic landscape, to discern Christ. Nor are his religious characters idealized: indeed, in the London *Adoration of the Magi*, not only Joseph but the three kings are portrayed much like the shepherds and attendant soldiers – in fairly brutish terms. Bruegel's grimmest works, such as *The triumph of Death* (not shown) with its serried legions of skeletons, date from around 1562, during the Spanish persecution of a large Protestant minority in Antwerp. Bruegel removed that same year to Brussels, but his own

BRUEGEL (right)
August (The corn harvest), 1565
This is probably the first picture in the history of art to transcribe the heat of high summer into paint. A group of peasants take a midday break in the shade of a tree, eating, drinking – one is sprawled in sleep. Others are still at work, scything, stacking the corn, carrying sheaves. Through trees on the brow of the slope is glimpsed the village church; in the valley below, close to a farm, other small figures are at work in the fields. Beyond, the landscape melts shimmering away for miles; land and the watery expanse of the estuary merge in haze into the opaque sky. The working figures move with a torpid sluggishness. A man arriving from a path through the dense, shoulder-high corn, bearing liquid refreshment – the sweat that trickles down his chest is not visible but it seems to be there. The extraordinary colours, the dominating hot yellow and green, reverberate through the picture.

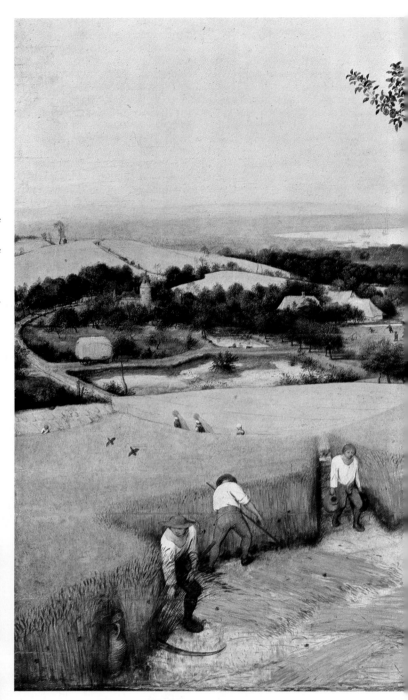

BRUEGEL (below)
January (The hunters in the snow), 1565
If *August* is heat itself, then *January*, in its whites, greys and blacks, is the very rigour of iron winter.

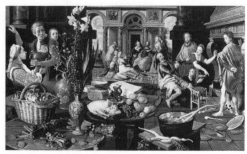

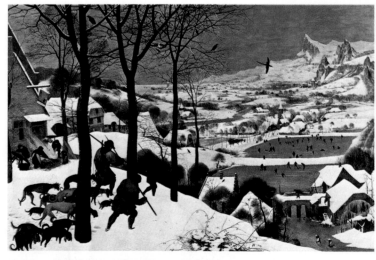

AERTSEN (left)
Christ in the house of Martha and Mary, 1559
Interposing huge piles of food and flowers between the observer and the central scene, Aertsen anticipated pure still life, seen for itself.

BRUEGEL (right)
The peasant wedding, c. 1567
Drawings of peasants from the life underlie the incisive characterization and detail.

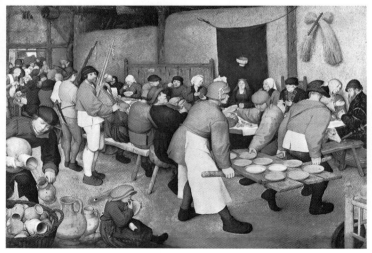

political or religious convictions are not clear; in Brussels the Spanish President of the Council of State, Cardinal Granvella, was an important patron. Despite his nickname, "Peasant Bruegel", Bruegel was a man of culture and discrimination, and a close friend of the great geographer Ortelius.

Quintessential in Bruegel's work is his "close-up" masterpiece of peasant life, *The peasant wedding*. Here composition, wit, and acute observation are superbly fused. Echoes of religious themes may linger – the Feast at Cana, even the Last Supper – but Bruegel's work is entirely of this world. His supreme achievement is *The Months of the Year*, a series painted in 1565 for the villa in Brussels of his patron Niclaes Jonghelinck; there are five survivors, astonishing in their range of mood, of which the most famous are *August* (*The corn harvest*) and *January* (*The hunters in the snow*). Their predecessors are the brilliant miniatures of the changing months by the Limbourgs, in which any religious significance was already peripheral, though the theme of annual rebirth and change always had astrological relevance and allegorical undertones of good and evil, light and dark, life and death. Bruegel's peasants, however, squat, tenacious and unlovely, work the world for survival. Food, its getting and its consuming, is one of Bruegel's preoccupations; no one has surpassed the sensitivity and skill with which he evokes the beauty of the earth that provides. His true subject is Nature herself, with man an integral part of her growth, decay and rebirth.

Bruegel's compositions were repeated by his son Pieter II, but the only painter to deal with similar subjects with originality and more than average competence was Pieter Aertsen (1508-75), working in Antwerp and Amsterdam.

BRUEGEL (below)
The Adoration of the Magi, 1564
There are perhaps traces of Schongauer and of Italian influence in the grouping of figures, but the grimacing onlookers themselves are a clear reference back to those of Bosch (see p. 99). The view of humanity is not kind; nor is it didactically moralistic; Bruegel's realism can be monumental, serene.

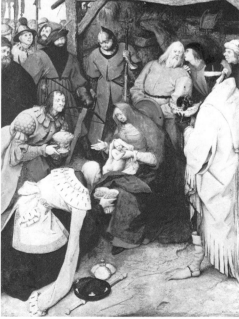

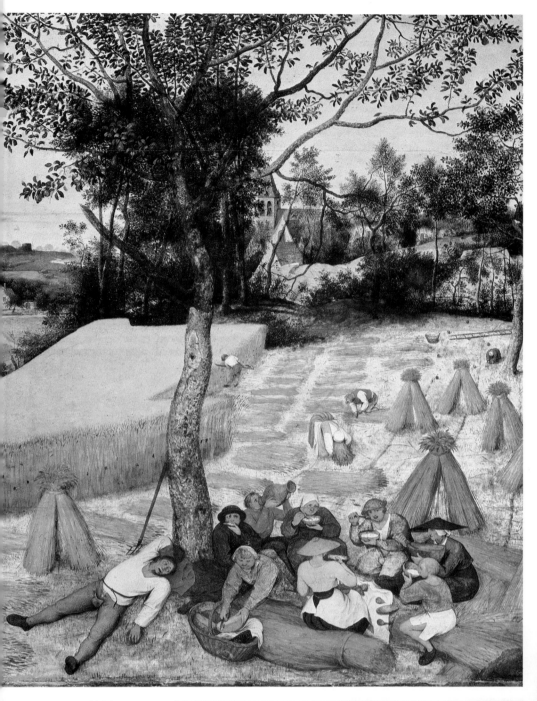

BRUEGEL (right)
The procession to Calvary, 1564
The crowded panorama is full of telling episodes condemning human folly – the moralism of Bruegel's engravings transferred to a religious setting. As an example of hypocrisy, his wife attempts to detain Simon of Cyrene, called to assist the fallen Christ, although a crucifix hangs at her belt. There are also topical references, and the Roman soldiers wear the uniform of the "Habits Rouges" who kept order in Flanders for the Spanish. *The triumph of Death* is in composition quite similar, teeming with corpses hung in attitudes of agony.

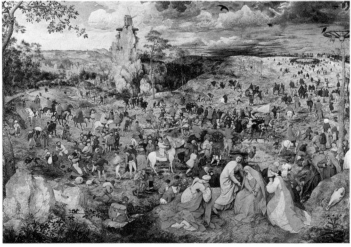

Mannerist Painting in Italy 1

"Mannerism" is a term that has been used in such varying senses through the centuries that it would seem best, in the interest of clarity, to abandon it altogether. However, it has become part of the language of the history of art, and is unavoidable. The first modern systematic historian of art, Giorgio Vasari, was himself a successful painter, and a Mannerist one, so that his application of the word was inevitably approving. For Vasari, the Italian *maniera* meant roughly "style". For later historians, *maniera* and its translation, Mannerism, came to signify rather "stylishness" or "stylization", and Mannerism was denigrated as affected, perverse, decadent – a degeneration from High Renaissance classicism; generally, the term was used to categorize artists who were felt to imitate the manner, especially of Michelangelo, without catching anything of the spirit – artists, that is, who were indeed insincerely mannered. In the last 50 years the term has gradually lost its pejorative force, and is now applied especially to Italian painting and sculpture of the period between about 1520 and 1600, or between the climax of the High Renaissance and the beginning of Baroque. It is seen as a phase of art that is valid and needs no special justification. If argument continues about its terminal dates, about what qualities in a given work of art are Mannerist and what are not, some broad generalizations can be offered with fair confidence.

In Italy, the characteristic tendency of Mannerism was to refine even further the technical virtuosity, the elegance, that had been so consummately balanced with both monumental and human values in the High Renaissance. These gave way to an emphasis on serpentine line (the so-called *figura serpentinata* of Michelangelo); on attenuated forms; on the bizarre contrast of poses and colours; and even to strange, sometimes morbid or pornographic torsions and tensions. Nature seems to yield to artifice. Some seeds of Mannerism are almost evident in the last work of Raphael, as in certain aspects of Michelangelo's style, while the move away from the classic stability of Renaissance art into more shifting realms may reflect the political unsettlement that culminated, in Italy, in the Sack of Rome in 1527, and, in the north, in the Reformation.

However, the forcing-house of Mannerism was not only Rome but Florence, which was still nominally republican, but had in fact been in the hands of the Medici dynasty since 1512. Michelangelo was working in Florence for the Medici from 1516 and there, too, that marvellously gifted painter Andrea del Sarto (1486-1530) was active. His masterpieces, such as "*The Madonna of the Harpies*", 1517, may at first glance compel comparison with Raphael's *Madonnas* – not only for their classicism but also in sheer quality – yet his handling of light, mysterious instead of calm and even, is emotive as Raphael's never was. Del Sarto's pupils included the brilliant Pontormo, Vasari, Salviati and possibly Rosso Fiorentino.

In Rome, Giulio Romano (1499?-1546), Raphael's chief and most gifted assistant, had completed Raphael's *Transfiguration* and other works, and his own style (influenced now by Michelangelo) became increasingly dramatic. Accused of making pornographic prints, he fled from Rome to Mantua in 1524, and there, in the Palazzo del Tè, he produced for Federigo II Gonzaga startlingly violent and illusionistic Mannerist decorations – especially the *Sala dei Giganti* (The Hall of the Giants).

The movement away from classical harmony is to be seen even before Raphael's death. Del Sarto's pupil Jacopo Carucci da

RAPHAEL (below)
The Transfiguration, 1520
The central message is the contrast between heavenly peace and earthly sorrow, as in Titian's *Assumption* (see p. 142), which is also separated into two distinct realms. Hence Raphael chooses to juxtapose the Transfiguration with the healing of an epileptic youth (which follows the Transfiguration in Mark's Gospel, but is not linked with it in a narrative sense). The brittle draperies, the hard colours, the virtuosity of the dramatically lit, gesticulating figures in the lower part, particularly the serpentine movement of the frenzied youth, are distinctly Mannerist in flavour.

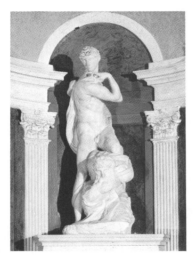

MICHELANGELO (left)
*Victory, c.*1530?
The figure's pose, for all its contortions and spirals, has an effortless quality typical of Mannerism. The victim's features resemble Michelangelo's own – possibly the first of those ironic self-portraits appearing in his later works.

ANDREA DEL SARTO (below)
"*The Madonna of the Harpies*", 1517
The attendant saints glance up at the onlooker, as if no barrier exists between their world and his. Raphael's "*Madonna della Sedia*" (see p. 129) communicates in a similar way; Mannerists sought also directness.

GIULIO ROMANO (above)
The *Sala dei Giganti* (The Giants' Hall), detail, 1534
The room is constructed in the shape of a beehive and the visitor is entirely surrounded by the illusion. There was once also a fireplace of real crushed rocks, fusing illusion with reality.

PONTORMO (below)
*Joseph in Egypt, c.*1515
There is obvious tension between the abundance of elegant forms and the narrative content, and this, combined with the glowing, unreal colour, imparts to the work a febrile quality, typical of early Mannerism.

Pontormo (1494-1557), one of several painters commissioned about 1515 to paint a decorative "programme" for a Florentine bedroom, painted a most unorthodox *Joseph in Egypt*, with freaks of perspective and proportion, flights of stairs going nowhere, statues more lifelike than the human beings. Pontormo's later works are almost hallucinatory. In his *Deposition* in S. Felicità in Florence, the body of Christ follows that of Michelangelo's Vatican *Pietà* (see p. 132), but the figures have little physical weight, and stand on no real ground and in no real space. The colours are high in key and clear, with little light and shade; the draperies seem to have an independent life of their own; the bodies are elongated – in some cases, Pontormo even quotes figures from Dürer. The unease of his art was matched by a neurotic, hypochondriac temperament vividly reflected in his surviving journal, a sensibility he seemed to find reflected in his sitters.

Pontormo's friend and contemporary Giovanni Battista Rosso Fiorentino (1495-1540) also painted a *Deposition*, some years earlier than Pontormo's, in 1521, and no less extraordinary. Cross and ladders form an almost geometric framework, across which the figures, with strange grimaces and emphatic gestures, are arranged in a bizarre conjunction of nakedness and independent draperies. As in Pontormo's version, the scene has no grounding in any earthly reality. Rosso also worked in Rome, but in 1530 he was summoned by Francis I to France (see over).

Mannerism had its effect elsewhere in Italy, most singularly in Siena, on Domenico Beccafumi (c. 1486-1551). His religious paintings have a high-keyed emotional quality, and often flame-bright colours in which something of the earlier Sienese colourist tradition persists. In the north, Parmigianino (Francesco Mazzola, 1503-40), having returned in 1531 to his home town of Parma after some years in Rome, there took the early Mannerist style to its most extreme pitch. Parmigianino, like Pontormo, was an irrational and neurotic personality, but a brilliant draughtsman; he was also an engraver and his work became widely known through engravings. The most famous example of the extreme attenuation of his style is "*The Madonna with the Long Neck*" of about 1535, notable not only for its expressive distortion of perspective and proportions, but also for the strange conceit of a topless pillar.

PONTORMO (above)
The Deposition, c.1526-28
In contrast to his *Joseph in Egypt*, Pontormo resolves the conflict between form and content: the emotion is at a high pitch without detracting from the beauty and grace of the whole.

PONTORMO (right)
The halberdier, c. 1529-30
In 1529-30, 5,000 citizens rose to defend Florence against the expelled Medici. Elegant, poised, removed, this archetypal Mannerist portrait perhaps represents one of these militiamen.

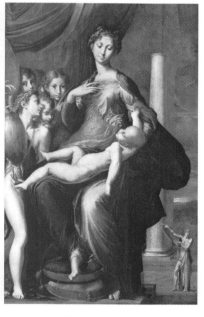

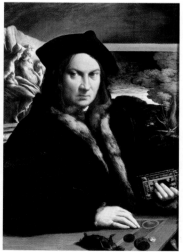

ROSSO (above)
The Deposition, 1521
The scene is lit as if by a flash of lightning, fiercely delineating the hard-edged forms which characterize Rosso's work throughout his career.

BECCAFUMI (right)
The birth of the Virgin, c. 1543
The light is lively, the colours are rich but sombre; the Mannerism of this late work is less strident, and more intimate in mood.

PARMIGIANINO (above)
"*The Madonna of the Long Neck*", c. 1535
No Mannerist work goes further in the distortion of form: the Madonna's seated pose is improbable; the Infant has the proportions of a seven-year-old child. The result is both precious and monumental.

PARMIGIANINO (left)
"*The Priest*", c. 1523
This earliest surviving portrait by Parmigianino earned its title because of the shape of the sitter's hat. His attributes are hardly priestly, however – a relief of Mars and Venus, medals, a figurine, a richly bound book – these indicate, if esoterically, a humanist.

Mannerism 2: The Medici and the French Kings

In 1530 Medici rule was re-established in Florence and Alessandro de' Medici named the first Duke of Tuscany. After his assassination in 1537 Cosimo I consolidated the regime, which provided a degree of stability in Florence for the next two centuries. Cosimo's court painter and the quintessential artist of High Mannerism in Florence was Agnolo Bronzino (1503-72). A pupil of Pontormo, he developed from his master's troubled and troubling style into the coolest and most immaculate technician of the sixteenth century. His flawless polish and emotional detachment were unsuited to religious subjects, and his major exercises in that field, even at their best, as in Eleanora of Toledo's Chapel, remain unstirring, mere exercises. His style suited allegories better: the most famous of them, usually known as *Venus, Cupid, Folly and Time*, is almost certainly identical with a painting of 1545 sent to Francis I of France by Duke Cosimo as a present. The subject is obscure, and in some points open to contradictory interpretations – thus, is the figure of bald, bearded old Time, top right, in collaboration with Truth, top left, opening or closing the curtain between them? An alter-

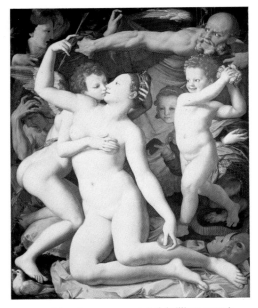

BRONZINO (above)
Venus, Cupid, Folly and Time, c. 1545
The colour is polished to a cool, brilliant enamel; the flesh is pale ivory or marble, the hair metallic, the eroticism disquieting.

native title is *The exposure of Luxury*, but, if intended as censure, in effect it suggests rather a celebration. Certainly pornography has often been proffered under the pretence of condemning itself; and Cupid's embrace of his mother is more than merely filial.

It was in court portraiture that Bronzino's style was most aptly and effectively engaged. In the creation of images of absolute autocracy in human form he has never been surpassed. Even in his portraits of lesser persons, he projects characters of ineffably detached superiority: communication with the onlooker is non-existent; the sitter is there for admiration. In the state portraiture of *Eleanora of Toledo and her son Giovanni*, of about 1546, the sitters' aloof detachment has become absolute; the figures are as still, cold and glazed as waxworks; in the magnificence of their costume, described with an exact refinement, they are effigies of their own status.

The two other leading exponents of the high Mannerist style were Salviati and Vasari, old friends and both former pupils of Andrea del Sarto. Francesco de' Rossi Salviati (1510-63) was a restless, peripatetic character who developed a very elaborate decorative style with a

BRONZINO (right)
Chapel of Eleanora of Toledo, Palazzo Vecchio, detail: *The crossing of the Red Sea*, 1542-44
The impact is chiefly in the posturing figures; the whole reads like an inexhaustible catalogue of Mannerist *contrapposto* and *figura serpentinata*.

SALVIATI (below)
Frescos in the Palazzo Sacchetti, detail: *Bathsheba going to David, c.*1552-54
The muscular proportions of Bathsheba suggest the influence of Michelangelo's *Last Judgment* (see p. 133) combined with a brilliant flare of colour beloved of the high Mannerists.

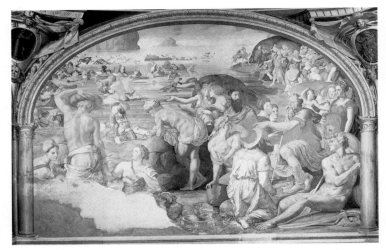

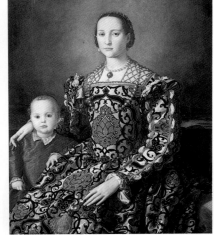

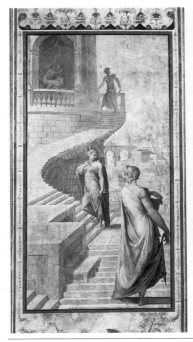

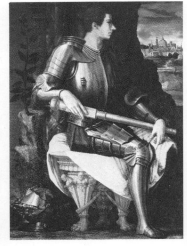

VASARI (above)
Alessandro de' Medici, c. 1533
Michelangelo's *Giuliano de' Medici* (see p. 339) was the model for the arrogant, dissolute Duke's portrait.

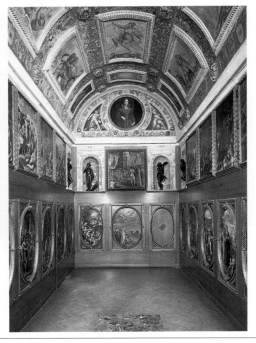

BRONZINO (above)
*Eleanora of Toledo, c.*1546?
Redolent of the consciously aristocratic atmosphere of Cosimo's court, the portrait of the Duchess, daughter of the Spanish viceroy in Naples, has the effect of a still life, compounded by a slight unease – a symptom of the insecurity of Medici rule only 10 years after the infamous assassination of Alessandro by his cousin, the enigmatic Lorenzino.

VASARI (left)
Cosimo I's *studiolo* in the Palazzo Vecchio, 1570-73
The most perfect of high Mannerist "conceits", the decoration has the effect of an encrusted jewel-box, a storehouse of precious objects. Executed under Vasari's eye by a number of assistants, individual elements in the decoration suggest the younger artists, at least, were developing towards a more sober style.

consummate technique. He worked not only in Florence and Rome, but also in Venice and, briefly, at the French court. The clear influence of Parmigianino in his work suggests that he must also have visited Parma. His latest frescos, in Rome, are perhaps the most extravagant of all Mannerist fantasies. Bathsheba winding her way up the improbable aerial stairs towards David's embrace (from the *David* series in the Palazzo Sacchetti, 1552-54) has the febrile elegance of a dream interpreted in ballet; while in Salviati's celebrations of the Farnese dynasty in the Palazzo Farnese (not shown) in Rome the ambivalent play of illusion and reality is worked out with an unsurpassed ingenuity and virtuosity.

The reputation of Giorgio Vasari (1511-74) as a painter was established by a portrait of Alessandro de' Medici; he recorded that in his attempts to paint the armour "bright, shining and natural" he almost went out of his mind. Under Duke Cosimo, Vasari became the leading impresario of art in Florence, with a large studio executing, with varying degrees of quality, complex Mannerist decorations in Florence and Rome. He was a leading spirit in the Florentine Academy of Art, which held its first session in 1562, and the first architect of the grand-ducal Uffizi, now the great picture gallery. But it is above all for his diligent *Lives of the Most Excellent Painters, Sculptors and Architects*, first published in 1550 and expanded in 1568, that he is now honoured; in that work he set the dominant pattern of art-historical writing for centuries.

Italian Mannerism was transplanted into France by Francis I, whose costly attempts to maintain control over Lombardy did not abate his taste for the quality of culture and life he had found in Italy, and who decided that Italian artists were necessary to create in France the setting for the new princely dominance to which he aspired. In 1530, he imported Rosso (see preceding page), and a succession of others, some of whom stayed, others not. If he failed with Michelangelo, Francis did entice the aged Leonardo, but only to die there, and also Primaticcio, Niccolò dell' Abbate, the architect Serlio, Andrea del Sarto and Cellini. The focus of the King's attention was the decoration of the château-palace of Fontainebleau. Here, from 1532, Rosso, followed by Francesco Primaticcio (1504/5-70), attempted a fusion of stucco reliefs and paintings, moving in a coherent rhythm through the long stretch of the Galerie François I. The very elongated, often languid figures are developments of the style of late Raphael via Parmigianino, and in due course the rich elaboration and fantasy of Fontainebleau was to be echoed back in Italy in late Mannerist works such as the Sala Regia (not shown) in the Vatican, executed under the direction of Perino del Vaga (1500/1-45).

Native French painters and sculptors could not be unaffected by the Italian implantation, and, under Francis' successor Henri II, carried on their tradition – the so-called "second school of Fontainebleau" (see also p. 161). The sculptors showed a better grasp of Italianate form; they were indebted especially to Benvenuto Cellini, who made two famous surviving works for Francis I, a gold salt-cellar (see over) and the more than life-size bronze relief *"The Nymph of Fontainebleau"*. She is small-headed and enormously long-limbed, whereas Jean Goujon (died 1568) and Germain Pilon (1527-90) tended to be less extreme: Goujon's reliefs for his Fountain of the Innocents are in comparison highly classicizing. Pilon included in his funerary monuments sculptures of sometimes remarkably intense realism.

ROSSO AND PRIMATICCIO (right) The Gallery of Francis I, 1530-40
Long galleries were alien to Italian architectural tradition, and their chief drawback is, they cannot be viewed as a whole. The problem is solved here by setting up an undulating rhythm between the flat paintings and the posturing sculptures, which leads the eye down the gallery.

PRIMATICCIO (below) Room of the Duchesse d'Etampes, Fontainebleau, detail, *c.* 1541-45
After Rosso's death, Primaticcio assumed his role as chief decorator to the French King. Even Rosso's forms seem sturdy by comparison with these rarefied figures, whose long limbs and small heads recall Cellini's *Nymph*.

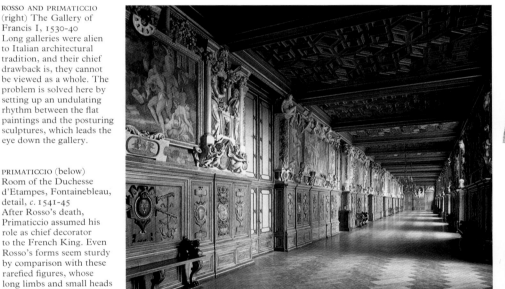

CELLINI (above) *"The Nymph of Fontainebleau"*, 1540-43
Despite the elongation of her limbs, the nymph has a monumental quality, on a foil of intricate, natural detail. She was designed to surmount the entrance of the Château of Anet, a gem amidst the block-like forms of the classical gateway.

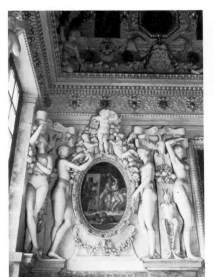

GOUJON (above)
Panel from the Fountain of the Innocents: *Nymphs and tritons*, 1547-49
The figures, though placed against a sweep of draperies closely resembling those in Cellini's *Nymph*, have a more natural appearance. Goujon was at his best in relief, which provided scope for his feeling for surface. The movement is disciplined by French sobriety.

PILON (right)
The tomb of Henri II and Catherine de Médicis, 1563-70
The tomb was designed by Primaticcio, while Pilon executed the sculpture. The traditional realism of the kneeling statues and the effigies below is combined with attention to detail and a new sense of freedom in the poses, deriving from Cellini.

Mannerist Sculpture in Italy

The patronage of the Medici dukes of Tuscany in the last three-quarters of the sixteenth century was even more conspicuous in sculpture than in painting, not least because sculpture, deployed in an almost compulsive fashion for elaborate garden schemes and in public places, contributed spectacularly to the splendour and prestige of their dynasty. The Piazza della Signoria, the focus of civic Florence, was given final form, more or less as it is today, by the Medici. In style, the impetus came from Michelangelo, present in Florence between 1516 and 1534, and especially from the abiding example of his work in the Medici Chapel.

The irascible Baccio Bandinelli (1493-1560; not shown) rather undeservedly enjoyed a virtual monopoly of public commissions in Florence for some 20 years after Michelangelo had finally left the city. His pre-eminence came abruptly to an end in 1555, when Bartolommeo Ammanati (1511-92) returned to Florence from Rome and quickly secured a number of large commissions, among them the Fountain of Neptune (or del Gigante) in the Piazza Signoria. The chief interest of this imposing structure lies in the bronze marine gods and nymphs disposed around the basin;

the large marble block set aside for the giant central figure was defaced by Bandinelli when he heard that what he regarded as his commission was to be awarded instead by competition. Bandinelli also had a very public quarrel with the irrepressible Benvenuto Cellini (1500-71). Cellini's enduring, boastfully rumbustious *Autobiography* – illuminating about artistic life and practice of the time as well as about the variety of his own amorous activities – tends to overshadow his quality as a sculptor. His early work in Rome (where he lived through the Sack of 1527, which he vividly describes) was mainly as a goldsmith, and his sole surviving major work in gold, probably the most important piece of goldsmith's work that has come down to us from the Renaissance, is the famous salt-cellar he made for Francis I of France, where he was working between 1540 and 1545 (see preceding page). In Florence, his most significant commission, his masterpiece on a monumental scale, was the bronze *Perseus* holding aloft the severed head of Medusa, finished in 1554 and set up in the Loggia dei Lanzi. The composition is based on a type of Etruscan statuette, although the inclusion of Medusa's decapitated corpse suggests deliberate rivalry

with Donatello's *Judith* murdering Holofernes nearby. The grace, the macabre elegance, the precious detailing are entirely Mannerist.

A younger contemporary of Cellini, Giambologna or Giovanni da Bologna (1529-1608) was born Jean de Boulogne in Douai on the Flemish border. After two years in Rome, 1554-56, he stopped off, on his way back to Flanders, in Florence, where he remained until his death, as chief sculptor to the Medici and master of a large and flourishing workshop. His output was prodigious, and most variously inventive. He worked with equal virtuosity in stone or bronze, and excelled as much in the creation of fountains for the Medici formal gardens as in the production of small-scale bronzes. His bronze *Mercury* in flight is unsurpassed in its effect of weightlessness in movement. While Michelangelo's ideal beauty had been a nude of predominantly masculine character, Giambologna's *Mercury* is much lighter and more feminine, almost androgynous. Another such masterpiece is the *Apollo* cast for the *studiolo* of Francesco de' Medici (see preceding page). Giambologna's designs, and his own and his many talented pupils' variants on them, were turned out in

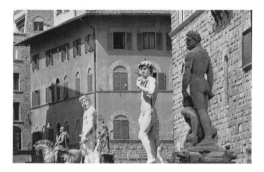

FLORENCE (above)
The Piazza Signoria seen from the Loggia dei Lanzi Here are Bandinelli's harsh *Hercules and Cacus*; a copy of Michelangelo's *David*; Ammanati's Fountain of Neptune; Donatello's rather dwarfed *Judith*; and Giambologna's *Duke Cosimo I*.

AMMANATI (below)
The Fountain of Neptune, detail: *A nereid*, 1571-75 Behind the nymph rises the outsize marble figure of Neptune: she is quite out of scale. The scheme is full of arcane allusions, indeed rather overloaded, but technically is superb.

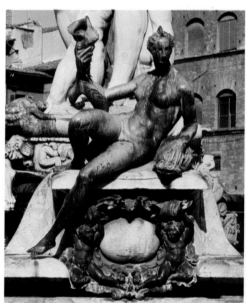

CELLINI (below)
Perseus, finished 1554 The muscular figure pays respect to Michelangelo; the pose, with its powerful, clearly defined profiles, recalls Verrocchio's work,

for instance the vigorous silhouette of the equestrian *Colleoni* (see p. 115). This was Cellini's first foray into life-size sculpture; its encrusted detail recalls his goldsmith's training.

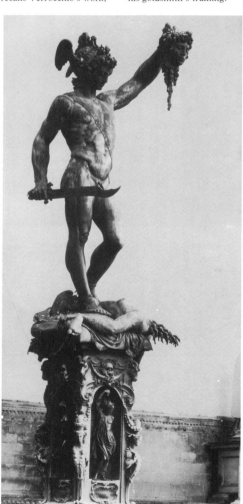

CELLINI (above)
The salt-cellar of Francis I, *c.* 1540 The two figures represent Earth and Neptune, and in style reflect Rosso's and Primaticcio's sculptures in stucco at Fontainebleau (see preceding page). The intense approach to form, with extreme elongation of limbs and a sense of poise, rather than physical movement, is characteristic of Cellini's exquisite work.

GIAMBOLOGNA (right)
Mercury, *c.* 1564 The figure, up on tiptoe, seems scarcely to rest on a puff of air from the mouth of the *putto's* head that is its sole support. In its high finish, suave elegance and rhythmic *contrapposto*, Mannerist principles are displayed at their purest. Yet in its open movement, its involvement in the space surrounding it, *Mercury* also presages the Baroque.

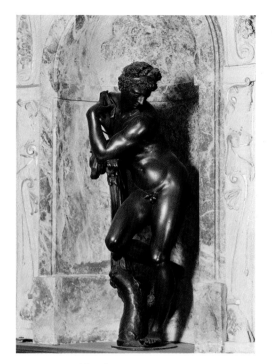

profusion by his studio; bronzes were favourite gifts of the Medici to other princes throughout Europe, and Giambologna's style became very widely disseminated.

On a large scale, Giambologna's range extended to such monumentally virile work as the equestrian statue of Duke Cosimo I, depicted as the founder of the Medici dynasty: gravely idealized, referring back again to the Roman statue of *Marcus Aurelius* (see p. 51), it soon superseded the *tours-de-force* of Donatello or Verrocchio as the pattern from which countless formal equestrian statues all over Europe were to derive. Earlier, in 1583, Francesco de' Medici had had Giambologna's colossal marble group, *The rape of the Sabine*, set up in the Loggia dei Lanzi. Originally the subject was not specific, but identification became necessary when it was set up in a public place, so Giambologna christened it. Beside Cellini's *Perseus*, across the Piazza from Michelangelo's *David*, the statue reads as the ultimate definition of Mannerist principles. A scene of extreme violence is controlled in a virtuoso display of supreme technical skill; the spiralling structure of intertwining bodies, the father defeated between the legs of the tri-

umphant Roman abductor of his daughter, offers no single viewing point to the spectator, but keeps him moving round it, one view dissolving into the next as he traces out the apparently effortless serpentine movement. As an "all-round" statue, it is perhaps the first truly modern sculpture.

Florentine sculpture, or Venetian (where the graceful monumentality of Sansovino's classicism was maintained), seems to have been little affected by the political and religious ferment of the Reformation and Counter-Reformation, or by the consequent artistic policies of the Catholic Church approved by the Council of Trent in 1563. That was more apparent in Rome, where tombs and chapels were encumbered with ponderous, usually prosaic marble, or in Spain. The Mannerist emphasis on grace, elegance, wit and sheer, even perverse, ingenuity was not easily adapted to religious purposes, though Cellini toyed with a religious vocation at the end of his life. But Giambologna's studio produced some exquisite small-scale crucifixes, while in his latest works, such as *Hercules and the centaur* of 1600, the trend towards the vigorous realism of Baroque is clear to see.

GIAMBOLOGNA (above)
Apollo, 1570-73
Both taut, contorted and easy, languid, flowing, the *Apollo* is constructed with a strong vertical on one side – the tree-trunk, lyre and Apollo's forearm – and on the other, swelling curves. It is the finest of the bronze statuettes that grace the tiny *studiolo* of Francesco de' Medici.

GIAMBOLOGNA (right)
Duke Cosimo I, 1587-95
Giambologna took on the task of sculpting the first equestrian monument to be made in Florence with even more than his usual care, and the result certainly surpasses all precedents in the smoothness of its line, its sense of gravity, its high-stepping movement.

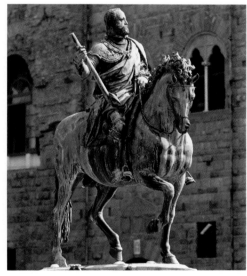

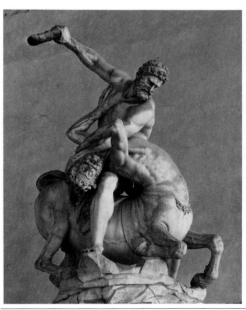

GIAMBOLOGNA (left)
Hercules and the centaur, 1594-1600
The subject had interested Giambologna for more than 20 years; as early as 1576 he had made a silver cast. His studio produced quite a number of statuettes on the theme. These, however, delight in the artificial contortions of consciously virtuoso variations; here the grace and "difficulty" of the form take second place. The demands of the action come first, indeed break the complex harmony up, dislocating its lines. The physical stresses are portrayed with consummate skill: the centaur twists all the way beneath Hercules' left arm, while his bucking legs and wildly spiralling tail intimate the violence of his effort, and his distress.

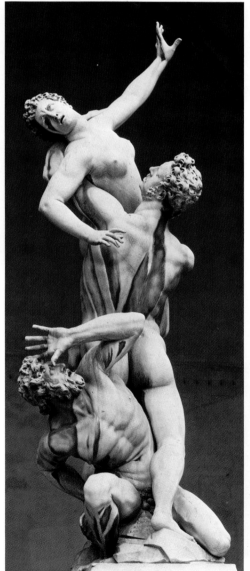

GIAMBOLOGNA
(left and below)
The rape of the Sabine, 1579-83
Giambologna clearly saw this group as a challenge to his virtuosity; no other sculptor had succeeded in integrating three figures into such a coherent spiral. Others had succeeded with two; and the prototype was Michelangelo's *Victory* (see p. 164), the classic demonstration of serpentine form. But the interaction of the figures is not only formal, gesture echoing to gesture, but psychological – glance leads on to glance, culminating expressively in the appeal of the woman to the unanswering heavens.

Painting in Venice: Tintoretto and Veronese

When the plague took Titian in 1576, he was so aged that legend had it he was 99 years old. His figure presided over Venetian painting during most of the sixteenth century, and all his younger colleagues referred to him in their work. But they were also affected by the heady currents of Mannerism emanating from Florence and Rome, which had indeed, briefly in the 1540s, affected Titian himself. And just as Titian's later work reflected the anxiety and spiritual disquiet of the Catholic Church faced with the Reformation, so the profoundly religious Tintoretto responded with an art of great emotional intensity.

Tintoretto (Jacopo Robusti, 1518-94) is reputed to have had written up on his studio wall: "Titian's colour, Michelangelo's line". Venetian colour, Mannerist line might be an accurate description of his sources, but his own synthesis has not much to do with either Titian or Michelangelo. Tintoretto seems to have been virtually self-taught. He evolved his own compositional technique, dependent not only on a large repertoire of study drawings but also on preliminary studies of figures modelled in wax: these he arranged experimentally in special boxes until he found the most dramatic viewpoint and the most effective lighting. The

result was his idiosyncratic presentation of space seen down dizzy diagonals from unorthodox angles. Enormously prolific, employing a large team of assistants, he worked at speed (Ruskin, whose opinion of Tintoretto shifted from profound admiration to an uneasy disapproval, likened his brush to a broom) but with an expressive vigour that achieved a wonderfully pervasive rhythm. He tended to use the sombre ground colours on his canvas for the darks in his painting, working the design over them in lighter colours in broad strokes, "tuning" the whole finally with highlights – a technique that often gives his work an incandescent, unearthly radiance.

Tintoretto is sometimes categorized as a Mannerist painter, but he differs sharply from the Mannerists, especially in the violence of his expression and in his free, "unfinished" handling. He always admired Michelangelo, however, though he seems to have known his work only through copies or casts. *St Mark freeing a Christian slave*, of 1548, an early work in his mature style, is very reminiscent in composition, in its violent foreshortenings, of Michelangelo's almost contemporary *Conversion of St Paul* (see p. 182). Its opulent colour

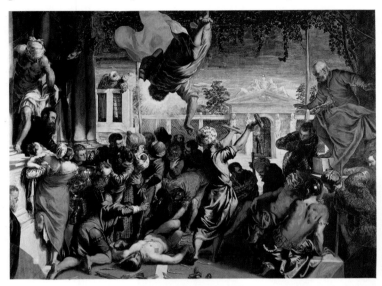

TINTORETTO (above)
St Mark frees a Christian slave, 1548
As the slave's bonds fall away, astonishment at the miracle ripples outwards in shots and glimmers of colour along the rhythmic line of arrested gestures. Chiaroscuro binds in the figures and unifies them all.

TINTORETTO (right)
The finding of the body of St Mark, 1562
Here the colour is muted, the funereal chiaroscuro flickers with livid light, the setting is eccentric. Both these *St Mark* scenes were part of a series for the Scuola di San Marco (St Mark's Confraternity).

TINTORETTO (below)
The Last Supper, 1592-94
A turbulent atmosphere moves like heavy incense through the huge canvas, submerging the gestures of figures in movement or conversation; the heads gleam like spiritual coals. Only the long table, and the incidental genre and still life, provide a solid, earthly foundation for the mystery in the last of Tintoretto's many versions of the theme.

TINTORETTO (left)
Bacchus and Ariadne, 1578
The landscape evaporates into brown and blue mist, and the solid, monumental, nudes float in an arabesque. This was one of a series for the Doge's Palace.

TINTORETTO (right)
Susannah and the Elders, c.1557
The voluptuous *Susannah* glows blonde in the dusky light of the summer garden. The contorted pose and exaggerated prominence of the nearest Elder is not Mannerist indulgence; it points up his voyeurism.

was later toned down, while the emphasis on dramatic contrast of light and shade, and on extraordinary recession into space, increased. In *The finding of the body of St Mark*, 1562, illustrating the Venetian theft of the body of their patron saint from Alexandria, the fantastic burial vault is lit only by the macabre slit of the opening at its far end and by the incandescent apparition of the saint on the left. In the late *Last Supper* of 1592-94, contrasting so strongly with traditional horizontal compositions, Tintoretto's revelation of miracle reaches a climax of drama. Over the diagonal thrust of the long table, the vertiginous tilt of the floor, Christ rises to break bread, which is his Body. Like the Christ here, other figures in Tintoretto's work seem to echo Byzantine motifs, and the glimmering light of his atmospherics may also owe something to the effect of the mosaics in the darkness of S. Marco. These Byzantine effects are paralleled by El Greco, while the movement, emotion and treatment of space foreshadow the imminent Baroque.

Tintoretto's work was not confined to religious subjects. His *Susannah* may be nominally a biblical story, but its impact is sensual and secular. His *Bacchus and Ariadne* is classi-

cal mythology treated with a grave, grandly lyrical pleasure worthy of Titian's great *poesie*, and it is not far in feeling from Tintoretto's great rival, Veronese. Tintoretto was also a prolific portrait painter, though his characterization is often relatively superficial. Yet a few late portraits (see over), mostly of aged men, have a troubling, sombre intensity.

Jacopo Bassano (1517/8?-92), chief among a family of painters taking their name from Bassano, a town in the foothills north-east of Venice, was the closest of the Venetians to Florentine Mannerism, at one stage of his career; later his most characteristic works came nearer again to Titian and to Tintoretto. These were virtually genre scenes with biblical incidents and titles; *The Adoration of the shepherds* (1568), a key-piece in his development, sustains a delicate balance between the religious subject (with that sturdy aerial dance of *putto*-like angels above) and the peasant characterizations of the shepherds below.

Tintoretto's opposite and rival was Paolo Veronese (Paolo Caliari, 1528-88). His pictures seem to come from a different world, and his temperament was certainly very different, but also he was more profoundly impressed by

Titian's early work than was Tintoretto. Veronese is most famous as a painter of vast opulent pageant paintings, celebrating the pleasures of the senses, the nobility of civilized life in Venice, untroubled by any more significant theme. He was also a great portrait painter, conveying the material luxury of aristocratic status, rather than the working of the mind or spirit, within the rich flesh, furs and silks of his sitters. His wealth of contemporary detail often came near to submerging his subject, and the Inquisition accused him of irreverence in his elegantly accoutred spectacular of what appeared to be a *Last Supper*; he made it acceptable by changing the title to *The feast in the house of Levi*. *Mars and Venus united by Love* is a typically sumptuous example of his mythological pictures. His greatest decorative commission was to fresco the Villa Maser for the highly cultivated and sophisticated Barbaro family, in which he collaborated with the great architect Palladio to re-create something of the Augustan atmosphere of Horace's poetic retreat in the Sabine hills. Yet it was Tintoretto, not Veronese, who was to create, in the Scuola di San Rocco, the Venetian counterpart to Michelangelo's Sistine Chapel ceiling.

BASSANO (below)
The Adoration of the shepherds, 1568
The Virgin is gracefully Mannerist (influenced, it seems, by Parmigianino); but the solid, earthy, genre figures such as the kneeling shepherd and his dirty bare feet will reappear almost unchanged in Caravaggio's work. Bassano also painted night scenes, and religious landscapes anticipating Annibale Carracci's.

VERONESE (right)
The feast in the house of Levi, 1573
Since it was commissioned for a convent refectory, it is hardly surprising that the Inquisition objected to Veronese's patrician gala. His great achievement was to organize his teeming detail into an effortless, cool, fully legible grandeur. The figures are nearly life-scale, and Veronese painted even larger feasts.

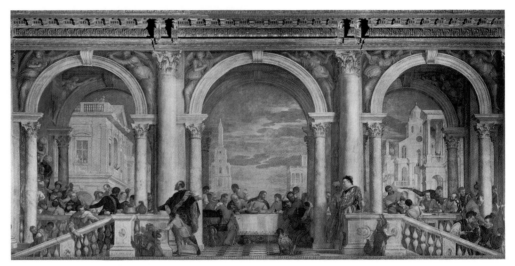

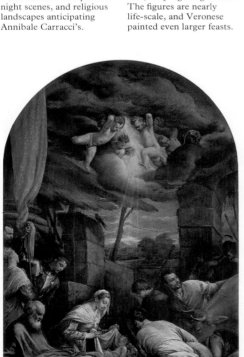

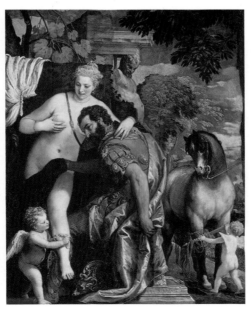

VERONESE (left)
Mars and Venus united by Love, c. 1580
Landscape, architecture, the splendid horse form a dark, cool backdrop, and Mars succumbs in tawny gold and shot purple to Venus' suffused, radiant flesh. The composition is broad and grand, utterly unaffected by a Mannerist interest in effects: it is sublimely decorative.

VERONESE (below)
A fresco from the Villa Maser, detail: *Giustiniana Barbaro and her nurse*, c. 1561
Veronese's illusionistic frescos at the Barbaro villa included not only *trompe-l'oeil* figures – initiating a Venetian tradition culminating in Tiepolo – but also landscapes of an enchantingly atmospheric delicacy.

Tintoretto: The Scuola di San Rocco Crucifixion

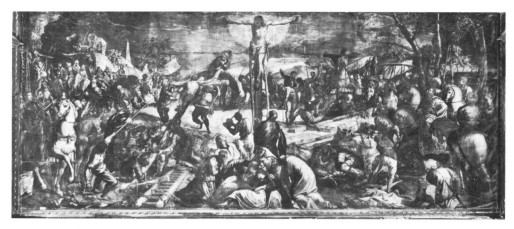

Between 1564 and 1587 Tintoretto virtually took over the building in which the Scuola, or Confraternity, of San Rocco was housed, and decorated its two storeys, both the walls and the ceilings, not with frescos but with canvases, many of them large, some huge – *The Crucifixion*, the largest of them all, is some 12.25 metres (40ft) across.

The Venetian Scuole were charitable organizations, rather like clubs or unions, each linked with a particular saint, and each with a strong *esprit de corps* motivating artistic patronage, often on a large scale. The Scuola di San Rocco, of comparatively recent foundation, in 1564 invited a number of painters, including Veronese and Tintoretto, to submit sketches in competition for the decoration of the smaller hall in its upper storey, the Council Chamber. Tintoretto assured himself of the commission by a trick: instead of a small sketch, he installed a full-scale painting surreptitiously *in situ*, which he then revealed to the astonished committee. He clinched the commission by suggesting that he present the painting to the Confraternity free – an offer which could not be refused, apparently, according to the Scuola's constitution.

The first phase involved the decoration of the Council Chamber only, but included *The Crucifixion*, 1565, and *The road to Calvary*, 1566. The second phase (1575-81) decorated the larger, main hall on the same floor – 13 Old Testament scenes on the ceiling in concordance with New Testament ones on the walls. The final phase, 1583-87, in the Lower Hall, was devoted to scenes from the life of the Virgin. The canvases, virtually encrusting the walls and the heavily coffered ceilings, do not make up a formally coherent whole, though they are disposed symmetrically, but through them all pulses the uniting rhythm of Tintoretto's formidable, rushing style.

The huge panorama of the *Crucifixion* occupies the whole wall facing the door of the Council Chamber. The impact is overwhelming, as it is impossible to get back far enough to take in the whole composition at once. The stark austerity of its central focus – Christ suspended over the huddle of his shattered followers beneath him – contrasts with the radiance ebbing from the Cross itself out to the edges of the composition. There ordinary folk, some interested, some not, set a context of both immediacy and enduring relevance, an effect that the wide screen of the cinema has yet to surpass. In the larger halls, Tintoretto created a wholly new range of imagery to rekindle the traditional stories, but his strange lighting – or lightning – is the essential agent that lifts them into the highest realism of visionary art. It is sometimes complemented by an unreal, hallucinating space and a disdain of mere physical possibility, so far from Renaissance principles as to seem almost medieval in some elements. Yet Tintoretto's vision is not necessarily so stupendous: *The Flight into Egypt*, ghostly in the weird moonlight, is set in a lyrical, rural landscape, and the handling of the Holy Family shows a tenderness quite rare in Tintoretto. In *The temptation of Christ*, in contrast, the luscious image of seduction embodied in Satan has been compared in its imaginative power with Milton's Satan in *Paradise Lost*.

TINTORETTO (above)
Self-portrait, 1573
The humility of this *ex voto*, which hung to the right of the entrance to the Council Chamber in which *The Crucifixion* hangs, does not seem quite to dispel Tintoretto's reputation with his fellow-artists as a ruthless undercutter.

TINTORETTO (right)
The road to Calvary, 1566
The terrible lurching of the crosses and arduous ascent of the figures has the effect of forcing the spectator into the picture space, a characteristic of all Tintoretto's work. The *Calvary* is placed directly opposite *The Crucifixion*.

TINTORETTO (above)
The Flight into Egypt, detail, 1583-87
The Holy Family is placed before a wide landscape, sombre, but romantically echoing the tenderness of Mother and Child.

TINTORETTO (right)
The temptation of Christ, detail, 1579-81
Satan, whose demonic nature is hinted at only by the fire's reflection which reddens his cheeks, extends himself alluringly.

TINTORETTO (above)
The Crucifixion, 1565
The symmetry of the whole design is clear in reproduction, but, seen *in situ*, it is difficult to assimilate. "Surely no single picture in the world", wrote Henry James, "contains more of human life; there is everything in it, including the most exquisite beauty." Perhaps only Rembrandt equalled the cosmic power of this Christ (detail right), swaying forwards towards the onlooker vertiginously, both victim and redeemer: "And I, if I be lifted up, will draw all men unto me."

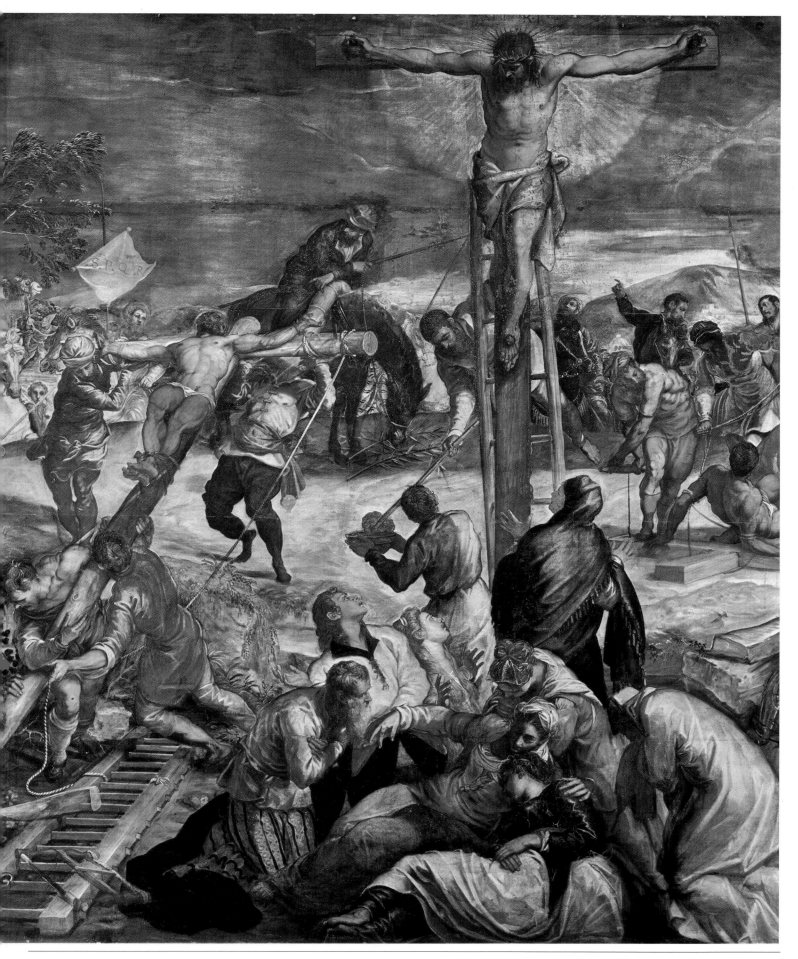

Art in Spain: El Greco

Spain was ruled during most of the sixteenth century by two monarchs, the Emperor Charles V from 1516 until his abdication in 1556, and his son Philip II from 1556 to 1598. Both sought to centralize monarchical power, and both virtually identified the crown with the Church. Charles V's vast inheritance involved Spain in the affairs of Italy (through Naples), the Netherlands and Germany, although influence on the arts in Spain came predominantly from Italy: Spanish artists went there for short or long spells, and Italian artists came to work, or even to settle, in Spain.

Although Philip II was interested in and informed about the arts, patronage in Spain came mainly from the Church. The Counter-Reformation in Spain developed along very pure lines, following the doctrines of the Council of Trent, and emphasizing in art especially those themes which Protestantism was challenging – the Immaculate Conception and the cult of the Virgin; the sacraments; the intercession of the saints. Protestantism never penetrated Spain, but the Counter-Reformation was very active. The Jesuit Order, a Spanish creation, was one expression of the nation's religious fervour, and the visionary poetry of St John of the Cross, the rhapsodies of St Theresa of Avila, were others.

There was considerable variety, almost a dichotomy, in Philip II's own patronage. For all his devout religiousness, he commissioned from Titian those voluptuous, profane *poesie* (see p. 144); he collected the work of Bosch; he aimed at a secular magnificence to reflect the wealth and worldly prestige of Spain, undeterred by continuous war and still unchallenged in her dominion of the New World, whence flowed in virtually unlimited bullion. To paint portraits Philip II employed not only Titian but also the Fleming Antonio Moro (Anthonis Mor, 1519-75), "the Bronzino of the North", who with admirable skill created polished, aloof Mannerist images of human authority. His designs, his tall, narrow poses, were to influence European state portraiture for three quarters of a century. Philip II also patronized the Italian Pompeo Leoni (1533-1608), who sculpted monumental bronzes of the Spanish royal family in the Escorial. But he never made use of El Greco, whose life and work remained centred on Toledo, the "Holy City" of Spain, the citadel of the Jesuits and the Inquisition. Though Toledo was also a cultural and commercial centre, at that time larger than Madrid, El Greco's patrons were primarily ecclesiastics.

El Greco (1541-1614), properly Domenikos Theotokopoulos, as he always signed himself, was born in Crete and trained and worked for some 12 years in Venice, where the paintings of Titian, Tintoretto and Bassano all influenced him; he then passed briefly to Rome, where he is said to have caused offence by suggesting he could improve on Michelangelo ("a good man, but he could not paint"); in about 1577, in obscure circumstances, he migrated to Spain, and lived in Toledo until his death.

El Greco's competence in the Venetian tradition is admirably illustrated by his portrait of Giulio Clovio, painted in Rome about 1570. There is little indication, however, of his mature style, a fusion of many strains – contact with Byzantine art in Crete and Venice; Tintoretto's energy; the elongated figures and acid colours of central Italian Mannerism; and also elements from Correggio and Michelangelo. In one of his many variations of *Christ driving the money-changers from the temple*, El Greco included, bottom right, portraits of his mentors, Titian, Michelangelo, Giulio Clovio

MORO (left)
Mary I of England, 1554
Rich jewels and brocades add lustre to the sombre formality of Philip II's wife, but Moro's precision is a little dour compared to Bronzino's lighter clarity.

LEONI (right)
The tomb of Charles V, detail, 1593-98
The life-size gilt-bronze figures have a ponderous, hieratic majesty, and are impressive technical feats. The tomb was an element in Philip II's project to create in the Escorial a grandiose setting for Hapsburg authority.

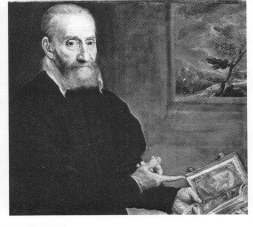

EL GRECO
Giulio Clovio, detail, c. 1570
In design – a half-length figure with a long, looming head in a dark surround – El Greco's portrait of his friend clearly depends on the example of Tintoretto. A renowned miniaturist – he points to his own work in his book – Clovio is our main source for El Greco's career before he left Italy.

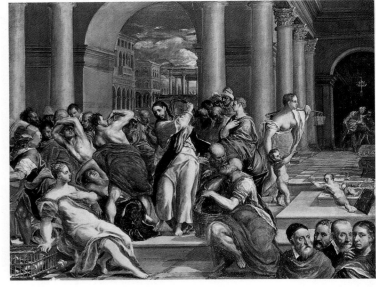

EL GRECO
Christ driving the money-changers from the temple, c. 1572
El Greco returned often to this theme and composition, seeking perhaps his own synthesis and revision of the achievements of his Italian predecessors. The figures are not so far from the Mannerist figures of such artists as Salviati; the architectural setting and the genre recall Veronese.

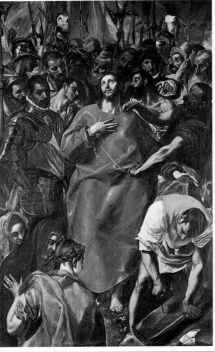

EL GRECO (left)
"*El Espolio*" (The disrobing of Christ), 1577-79
Though trapped among crowded heads, a thicket of pikes, plucking hands, Christ is tall and broad in brilliant scarlet, a chord of triumphant colour amid the foreground yellows. A grandee in contemporary armour stands beside him, and the beholder himself closes the ring of figures. His eye is led inevitably to Christ's uplifted face, and its moist eyes, typical of Spanish religious feeling.

and (probably) Raphael. However, the essential impulse behind the extraordinary spirituality of his later style seems indicated in the story that a visitor to his studio in Rome, one brilliant spring day, found him working in a darkened room, for "daylight blinded the light within him". Increasingly he was to paint the visions of his inner eye.

One of his early commissions in Toledo was "*El Espolio*" (The disrobing of Christ), an unusual subject, though obviously suitable for its setting, the sacristy of the Cathedral. El Greco's seemingly quite original design, with its claustrophobic quality, baffled and shocked the authorities, who at first rejected it. The

handling is Venetian, but, stylistically, its compression is like that of some Byzantine icons, and the huge *Burial of Count Orgaz* (1586) is reminiscent of a Byzantine *Dormition of the Virgin*. This was again an unusual subject, commemorating a miracle of 1323, when SS. Augustine and Stephen materialized to place the dead man, a benefactor, in his grave. Here the real cohabits with the supernatural, though the physical world is driven upwards by a mounting rhythm to be subsumed into the spiritual world. Increasingly, the narrative content disappeared from El Greco's imagery, and even his earthly figures became flickering and elongated, transubstan-

tiated almost into flame; the paintings themselves became more vertical, and the colours incandescent. El Greco's art was highly personal, unique, but not narrow or provincial: a contemporary called him "a great philosopher ... he wrote on painting, sculpture and architecture". His writings are lost, but the inventory of his library reveals an interest in history, literature, theology and philosophy.

In later years his workshop (including his son) produced many repetitions of established themes, but in pictures like *The Immaculate Conception* in Toledo, entirely by his own hand, his later style reached a climax, in dazzling blues, reds and yellows, in the heavenward flare of the tapering figures. In portraits he could be just as emotional and spiritual, or he could retain the sense of the actual, though he imbued it with strange ambiguities. How indeed should the portrait of the enlightened and cultivated *Cardinal Fernando Nino de Guevara* be read? El Greco also produced rare landscapes – weirdly emotional views of Toledo. He had little apparent influence on Spanish Baroque, and was rediscovered only at the end of the nineteenth century (about the same time as Grünewald).

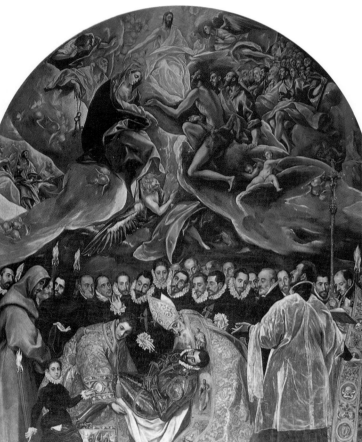

EL GRECO (left)
The burial of Count Orgaz, 1586
The strange mingling of earthly pomp with a supernatural vision is managed with remarkable coherence. The onlooker is beckoned almost imperiously into the painting by the boy; local dignitaries throng around the bending saints; then above the heavens open, to reveal the host on high.

EL GRECO (below)
Cardinal Fernando Nino de Guevara, c. 1600
He looks uncertain, as he grips the chair. But this is the Grand Inquisitor. He recalls Titian's rather odd *Pope Paul III* (see p. 143).

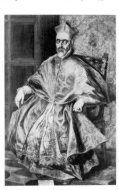

EL GRECO (left)
View of Toledo, c. 1595-1600
The few, small, visionary landscapes of El Greco's late years – Toledo as a Jerusalem or a Sodom – are unique in their time.

EL GRECO
The Immaculate Conception, c. 1607-13
The immensely attenuated figure of the Virgin is borne effortlessly upward by fluttering, immaterial angels, and all that ties it

to the real world are the roses and lilies (symbolic or virginity), painted as if they were real flowers on the altar the picture backs. Hence again the onlooker is given an entry, a transition into the spiritual world.

175

THE BAROQUE ERA

The division between the Renaissance and Baroque periods is a fairly recent convention of historians, and Baroque art represents an expansion and development of Renaissance art, rather than a radical transformation of its principles. Italy continued to be the goal and inspiration of many artists throughout Europe, not only because of the great monuments of the past, but also because artists such as Caravaggio, Annibale Carracci and Bernini had made Rome the most vital artistic centre in Europe. Louis XIV's summons of Bernini to Paris in 1665 and the rejection of the latter's plans for the Louvre are, however, events symbolic of the new order in which France was gradually to assume leadership artistically as well as politically. Baroque art was often used for propaganda purposes, whether for church or state, and Louis's enormous palace at Versailles is one of the most complete examples of the Baroque ideal of the union of all the arts, the *Gesamtkunstwerk*, the orchestration of architecture and landscape, painting and sculpture, furniture and metalwork into one splendid whole.

Though such unity is one characteristic of the Baroque, art also showed remarkable diversity during the seventeenth century and flourished in very different social and political circumstances. For both Spain and Holland this was a Golden Age in the arts, but whereas conditions in Spain represent a continuance of old values, with patronage almost entirely in the hands of the Church and court, in Holland art was no longer the preserve of the rich and powerful, but appealed also to the prosperous middle classes, who collected paintings suit-able to the modest size and pretensions of their houses. Holland's Golden Age coincided with the birth of political independence and the growth of economic prosperity, but Spain at the same time was declining from its pre-eminent position in world affairs, and its great national school of painting and sculpture was perhaps a belated expression of its former glories. In terms of its importance for the future, the democratization of art in Holland is one of the most significant aspects of seventeenth-century culture. Virtually the whole fabric of Dutch life became the subject matter of artists, and genres such as landscape and still life were virtually instituted during this period. A great deal of space has been given to Dutch art, reflecting not merely the presence of some outstanding painters, but the extraordinary proliferation of minor masters of superb quality.

The change from Baroque to Rococo, the arrival of the eighteenth century, brought gradual modulations of mood and tempo. The scope of art remained essentially the same, though its scale was usually less grand, sited as much in the private house as in the palace, with the small porcelain figure perhaps more typical an expression of the taste of the time than the heroic marble statue. Secular art, and the portable easel-painting, continued to increase in importance, and showed unmistakably the impact of ideas of the Age of Enlightenment, and of the first seeds that would blossom, or erupt, in the French Revolution. In the nineteenth century there would be a definite change of direction – something much closer to a break in tradition.

VERSAILLES, FRANCE (left)
The *Galerie des Glâces*, begun 1678

TWICKENHAM, ENGLAND (right) Strawberry Hill, begun 1747

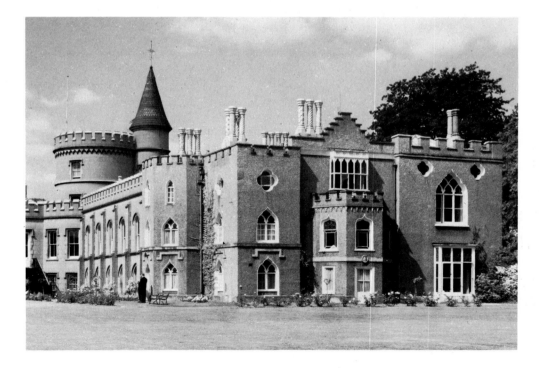

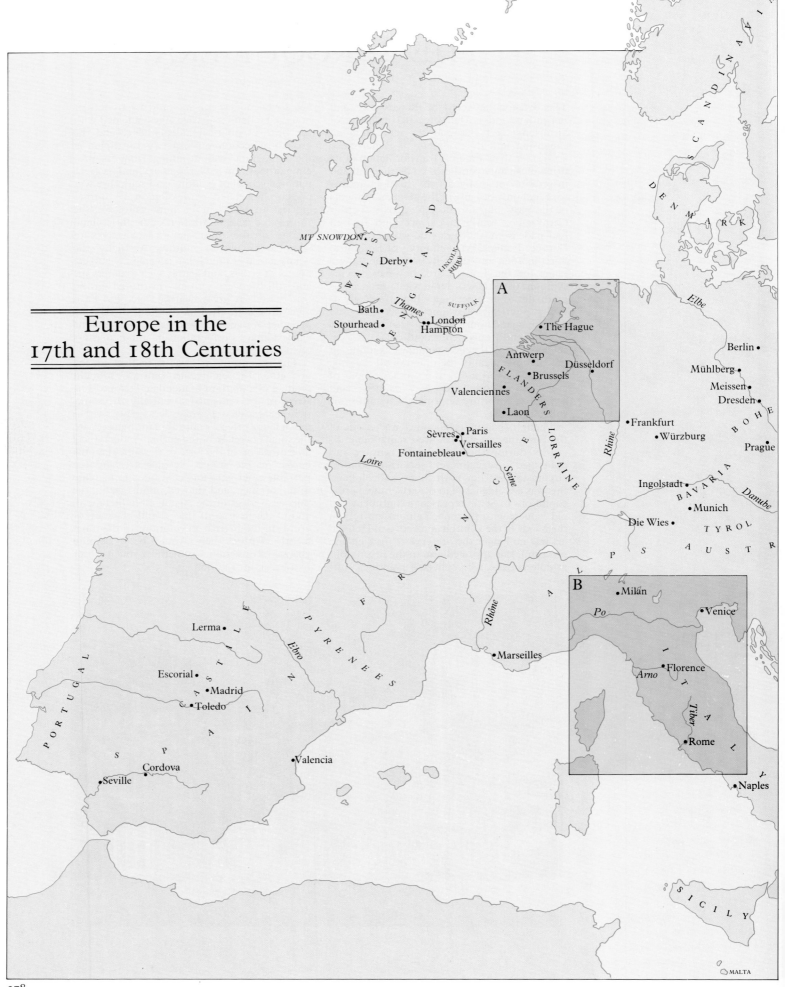

Europe in the 17th and 18th Centuries

SCANDINAVIA

DENMARK

MT SNOWDON

WALES

ENGLAND

Derby

LINCOLNSHIRE

Bath

Thames

SUFFOLK

Stourhead

London
Hampton

A

The Hague

Antwerp

Düsseldorf

FLANDERS

Brussels

Valenciennes

LORRAINE

Laon

Sèvres Paris
Versailles

Fontainebleau

Loire

FRANCE

Seine

Rhine

Elbe

Berlin

Mühlberg

Meissen

Dresden

BOHEMIA

Frankfurt

Würzburg

Prague

Ingolstadt

BAVARIA

Danube

Munich

Die Wies

TYROL

ALPS

AUSTRIA

B

Milan

Venice

Po

Marseilles

Rhône

ALPS

Arno

Florence

ITALY

Tiber

Rome

Naples

PORTUGAL

CASTILE

Lerma

Escorial

Madrid

Toledo

PYRENEES

Ebro

SPAIN

Cordova

Seville

Valencia

MALTA

SICILY

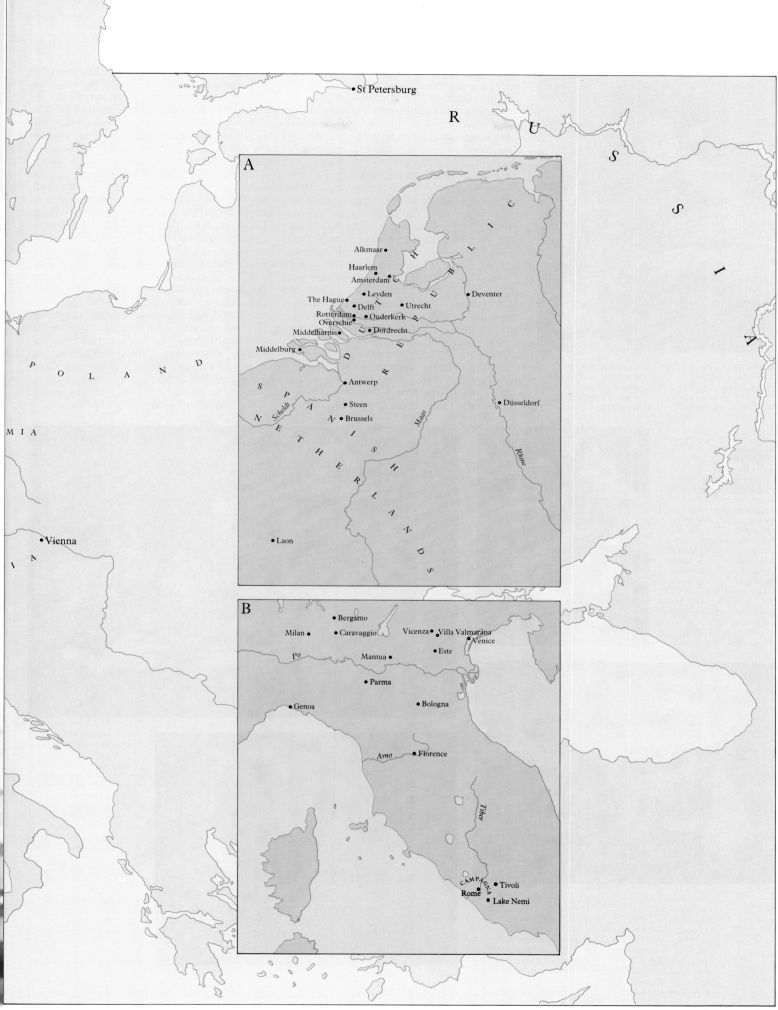

St Petersburg

R U S S I A

A

D U T C H R E P U B L I C

Alkmaar
Haarlem
Amsterdam
Leyden
The Hague
Delft
Utrecht
Rotterdam
Ouderkerk
Overschie
Middelharnis
Dordrecht
Middelburg
Antwerp
Steen
Brussels
Laon

Deventer

Düsseldorf

S P A N I S H N E T H E R L A N D S

Scheldt
Maas
Rhine

POLAND

MIA

Vienna

IA

B

Bergamo
Milan
Caravaggio
Vicenza
Villa Valmarana
Venice
Este
Mantua
Po
Parma
Genoa
Bologna
Arno
Florence
Tiber
CAMPAGNA
Tivoli
Rome
Lake Nemi

Michelangelo da Caravaggio

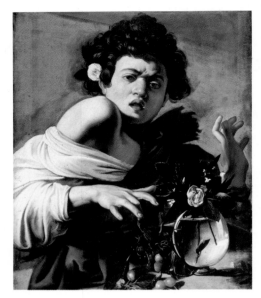

CARAVAGGIO
Boy bitten by a lizard,
c. 1596-1600
This subtly foreshortened
study of the physiognomy

With Caravaggio (1571-1610), a new type of artist appeared on the European scene. It had been foreshadowed in Michelangelo, but the idea that artistic genius is autonomous, and almost necessarily in opposition to authority and convention, is embodied not only in Caravaggio's painting but in the drama of his brief and violent life.

He was born Michelangelo Merisi da Caravaggio – Caravaggio being the name of his native town near Milan. His earliest work was certainly northern Italian in feeling (derived ultimately from Giorgione), and continued so even after his arrival in Rome in about 1593. There he began by painting still lifes for the established late Mannerist painter Il Cavaliere d'Arpino, and still life plays a prominent part in most of his early work, both religious and genre. His genre scenes – not mere grotesques but situations observed with a novelist's eye – he probably sold on the open market, but he soon attracted the attention of wealthy patrons, men such as Cardinal del Monte, an important figure in the papal management of the Counter-Reformation, but a hedonist as well. For such patrons he painted not only religious works but also a series of Bacchic and

of fright was perhaps not ordered, but sold painted. Caravaggio probably used himself as a model, but made the figure younger.

narcissistic youths with unmistakably erotic overtones. In these early works the essentials of his revolutionary style are already clear – the realism of his characters; the sharply defined, rich and vivid colours, especially of stuffs; and the harsh light from a single source by which his compositions, for all their earthiness and detail, are consolidated into monumentality.

In his brief career in Rome – a mere 13 years – this epoch-making style was fully developed. So, too, was his picturesque and obstreperous personality. "He would swagger about . . . with his sword at his side, with a servant following him, from one ball court to another, ever ready to engage in a fight or an argument, with the result that it is most awkward to get on with him" – so noted a visiting painter from the north, van Mander. Before 1600 he received important commissions, but few of them were completed without major rows and rejections. His first public work, three pictures for the Contarelli Chapel in S. Luigi dei Francesi, Rome, was obtained through Cardinal del Monte. Painting here on a new scale, Caravaggio ran into technical difficulties, and there was considerable revision and repainting, while his original altarpiece for the Chapel, *St*

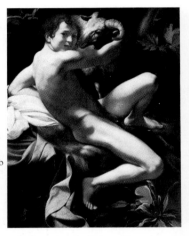

CARAVAGGIO (right)
St John the Baptist,
1597-98
This is primarily erotic,
a picture of a naked youth,
and the ostensible subject
can be identified only from
the ram, with a fleece worn
by John the Baptist in the
desert. Caravaggio often
used famous works as models
in his series of such youths:
here St John's pose recalls
Dawn on Michelangelo's tomb
of Lorenzo de'Medici (see p.
133). As in other early works,
the highly contrived design
and studied lighting effects
give the painting the air
of a virtuoso performance.

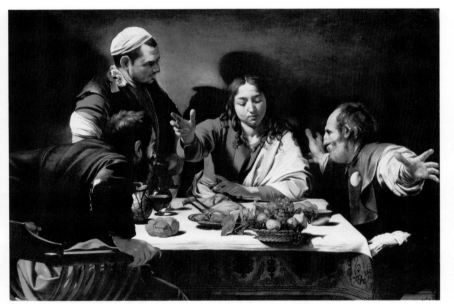

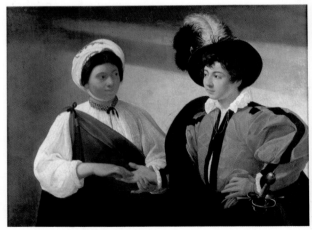

CARAVAGGIO (above)
The fortune teller,
c. 1594-95
Caravaggio's almost life-size
genre subjects are few, but
famous. Their direct and
naturalistic approach was
widely imitated, but their
psychological sensitivity
was seldom matched. Con-

temporaries described these
genre works as being "in the
manner of Giorgione". Cara-
vaggio, from the north, owed
much to northern masters
such as Moretto of Brescia
and Savoldo (see p. 149) and
their followers, who could
provide some precedent for
his genre and his lighting.

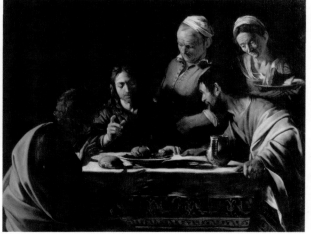

CARAVAGGIO (above)
The Supper at Emmaus,
c. 1596-1600
The moment is the sudden
recognition by two pilgrims
that the stranger who has
joined them is the risen
Christ. Caravaggio's own
is the intensified drama,
which includes even the
basket of fruit that is
about to fall from the table.

CARAVAGGIO (left)
The Supper at Emmaus,
c. 1605-06
The restrained, implosive
tension of Caravaggio's
later treatment contrasts
with the drama of the first
version. The shooting arm of
the right-hand disciple, for
instance, has been replaced
by a clenched grip. The
light picks out a few details
with a greater calculation.

Matthew and the angel, was rejected by the clergy ostensibly because St Matthew looked too proletarian. The Chapel was completed only in 1602, after Caravaggio had undertaken new work in S. Maria del Popolo (see over).

The scale, force and revolutionary treatment of the famous *Calling of St Matthew* in the Contarelli Chapel shows his vision fully mature, even before he was 30. Matthew sits at the customs seat, amidst a group of gaudily plumaged, aggressively limbed layabouts, in a contemporary Roman tavern. Christ appears on the right, only his face and hand visible – the hand, beckoning and claiming Matthew, deliberately echoing the creative hand of God the Father in Michelangelo's Sistine ceiling. Matthew, interrupted, looks sharply up, his hand indicating as clearly as words: "What, me?" A comparable directness – an invitation almost to participate in the action – invigorates the first *Supper at Emmaus*: the disciple's hand, foreshortened violently, is flung almost out of the picture, as if to seize hold of the onlooker.

Several of Caravaggio's large altarpieces painted in Rome were fiercely criticized. In some the clergy objected to the naturalistic dirty linen and feet; everywhere to the lack of idealization; in *The death of the Virgin*, to the swollen Virgin herself, said to have been modelled on a drowned whore pulled out of the Tiber. Nevertheless, individual patrons, cardinals and lay aristocrats alike, recognized Caravaggio's genius and bought his work as eagerly as they bought the Carracci's (see p. 184), whose classicism seems radically opposed to it. But Caravaggio, the spontaneous innovator – he seems to have worked without drawings directly on to the canvas – was in fact on good terms with Annibale Carracci, and much of the power of his work stems from a profound assimilation of High Renaissance tradition, Roman and Venetian.

Caravaggio's career in Rome was punctuated by sharp and sometimes bloody clashes, documented in police files. He was imprisoned twice in 1605, and had also to leave Rome for a month after wounding a lawyer. In 1603 a resonant libel action had been brought against him by a fellow-painter, Giovanni Baglione (who later became Caravaggio's biographer). In May 1606 came the climax, when Caravaggio, enraged by an opponent in a game of tennis, stabbed and killed him. He fled to Naples, and then on to Malta in 1607. In Malta, his initial welcome, with commissions and installation as a Knight of the Order of St John, was followed, the next year, by an assault on a judge, imprisonment, escape and flight to Sicily. Thence back to Naples in 1609, where he was badly wounded, perhaps in a vendetta attack. He died in 1610 of malaria, aged 38.

His later works, religious compositions a little larger than life scale, are very dark and simplified in detail and in colour. Beside the clangour of his earlier works, they seem to be meditations in formidable silence, as if they were the work of a far older painter, brooding on the threshold of death.

Caravaggio's nature was not such as to form around him a faithful school of followers, but his spreading influence on European art is incalculable. In Italy, the Carracci pupils Reni and Guercino reflected him in various ways; on the Dutch Utrecht school his impact was decisive. These, however, adopted chiefly his method of lighting or superficial mannerisms. The essence of his vision was better understood by the more original artists of the age, by Ribera and Velazquez in Spain, by La Tour and the Le Nain brothers in France and – above all – by Rembrandt in Holland.

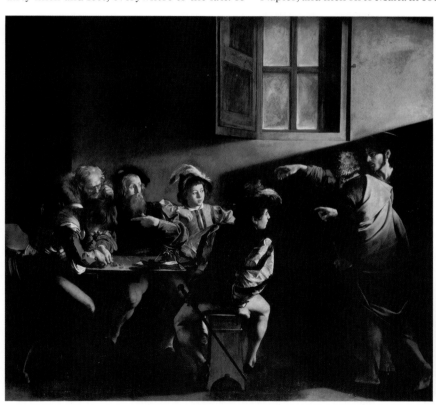

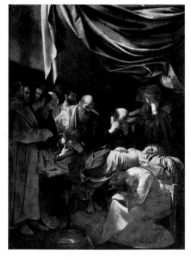

CARAVAGGIO (right)
The death of the Virgin, 1605-06
The softened light lingers, suspending the mourners in a cold, grieving dawn. St John, behind the Virgin's head, Mary Magdalen and the grouping of the heads show a debt to classicism; the diagonal arrangement will be typically Baroque.

CARAVAGGIO (below)
The Resurrection of Lazarus, 1609
The works Caravaggio painted after he had fled from Malta show signs of haste, and are not well preserved. But the pity and terror of their composition still shine through their blackened state.

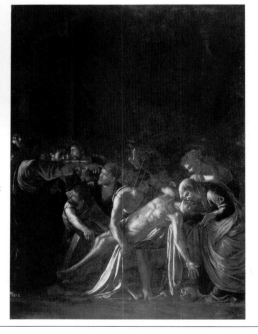

CARAVAGGIO (left)
St Matthew and the angel (1st version), *c.* 1599
Caravaggio's first public work was taken off the wall by the priests, who felt that "the figure ... did not look like a saint, sitting with crossed legs and with his feet crudely exposed to the people". But through this very indecorum the Christian message emerges clearly with new vigour. They may have objected really to the suggestive proximity of the angel.

CARAVAGGIO (above)
The calling of St Matthew, *c.* 1597-99
The principal of the Roman Academy, Zuccaro, could not understand the acclaim this picture instantly earned: in its realism he saw only imitation of Giorgione. In fact Caravaggio's sources for the Bohemian group were northern genre works: and here the psychological penetration of Caravaggio's genre is brilliantly adapted to the narrative purpose of this religious painting.

Caravaggio: The Conversion of St Paul

In July 1600 the papal treasurer Tiberio Cerasi acquired, for his resting place, a chapel in S. Maria del Popolo, Rome, and shortly afterwards commissioned the two outstanding (but very different) painters in Rome to decorate it: Annibale Carracci to paint the altarpiece and Michelangelo da Caravaggio to provide two paintings for the side-walls.

Caravaggio's subjects were the conversion of St Paul and the crucifixion of St Peter. His first versions were not satisfactory – whether to the client or to himself is not known; the second versions were paid for in November 1601. The Carracci altarpiece, *The Assumption of the Virgin*, had probably been finished before then, likewise the ceiling decoration, painted to Annibale's design by an assistant. The St Paul subject was already fairly popular, the St Peter one less so, but they are the two subjects of Michelangelo's last paintings, in the Cappella Paolina in the Vatican, which must have been in Caravaggio's mind, though his solutions are very different.

The large difference reflects not only Caravaggio's profoundly personal view of the world but also the shifting attitude, within the Catholic Church, to the function of religious painting and consequently its style. Faced with the division of Europe between primarily Protestant north and primarily Catholic south, the Catholic Church had reasserted its doctrines and against the Reformation proclaimed the Counter-Reformation: the rigour of the Inquisition was only one aspect of a movement of self-examination, of confirmation of faith and of positive propaganda. This new and active fervour was fuelled by direct and personal appeal to the faithful through the arts; Caravaggio strengthened the meaning of St Peter's martyrdom and St Paul's conversion by telling their stories in contemporary idiom and down-to-earth detail – even if the staider clergy felt he pushed realism too far.

The conversion of St Paul could represent a man tripped over backwards in a stable, but even before the viewer recognizes the subject he is aware of the electric potency of a supernatural event in this mundane image. Like Michelangelo, Caravaggio has chosen the moment when Saul was flung to the ground blinded, as if by lightning, and accused by God: "Saul, Saul, why persecutest thou me?" But there is in the Caravaggio none of the supporting cast of airborne Christ and angels present in the Michelangelo. The bucketing steed has become a rather heavy hack, and the agitated crowd is replaced by one solitary baffled groom, an old peasant with a varicose vein; these two have heard nothing. The source of light is not shown; but the violent, even awkward foreshortening of the figure hurled down expresses an impact of huge energy, and the outflung arms embroil the whole in the vortex of a blinding miracle.

For contemporaries, this must have been a stunning vision. Formally, Caravaggio has exploited already known methods – even more dramatic foreshortening occurs for example in Mantegna and Tintoretto. But the overall assault on the beholder's emotions in such concentration was unparalleled. The courtly elegance of the still prevailing Mannerist style seems both esoteric and effete in contrast.

CARAVAGGIO (below) *The crucifixion of St Peter*, 1600-01 No earlier painter had made the focus of this subject so emphatically the action and effort of raising the cross. St Peter appears the more helpless – an ordinary, perplexed, suffering old man, though still robust and dignified. The composition seems more effective from an oblique viewpoint, from outside the chapel.

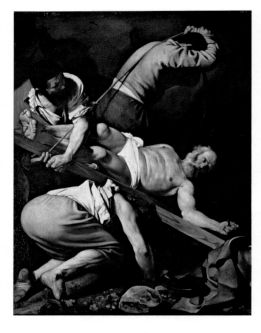

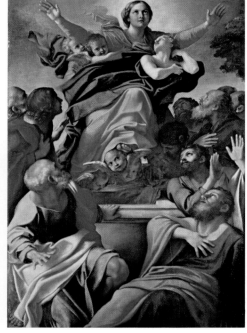

ANNIBALE CARRACCI (above) *The Assumption of the Virgin*, 1600-01 The Carracci altarpiece is flanked by the two Caravaggios; the artists worked in their studios probably without close knowledge of each other's designs. Neither was likely to compromise for the sake of the other, anyway, even though in many respects *in situ* their pictures clash. Annibale's forms are pale-coloured in a serene, diffuse light, against Caravaggio's luminous browns and blacks. Yet in both the figures are life-size, solidly modelled, and crowded against the frame.

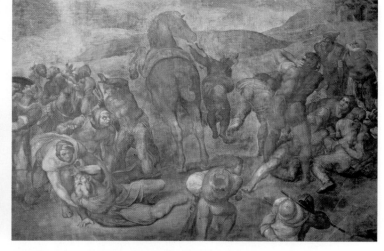

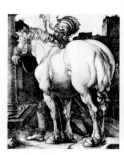

DÜRER (above) "The Large Horse", 1505 Engravings by northern artists were an inspiration for Caravaggio's own vision of common-life realism. Dürer's stolid animal was perhaps the prototype of the nag in the *Conversion*.

MANTEGNA (right) *The dead Christ*, c. 1490 Mantegna's picture is an early precedent for the use in the *Conversion* of extreme foreshortening for emotional effect.

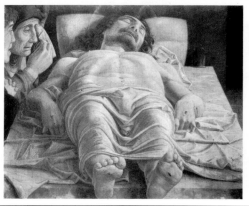

CARAVAGGIO (right) *The conversion of St Paul*, 1600-01 The picture is a masterpiece of simple, forcefully stark, concentrated drama. The unbalanced composition, in which the massive, unmoved figure of the horse fills almost the entire canvas, makes all the more emphatic the prostrate Saul's shock. He falls back thunderstruck almost out of the picture frame, involving the viewer as a witness.

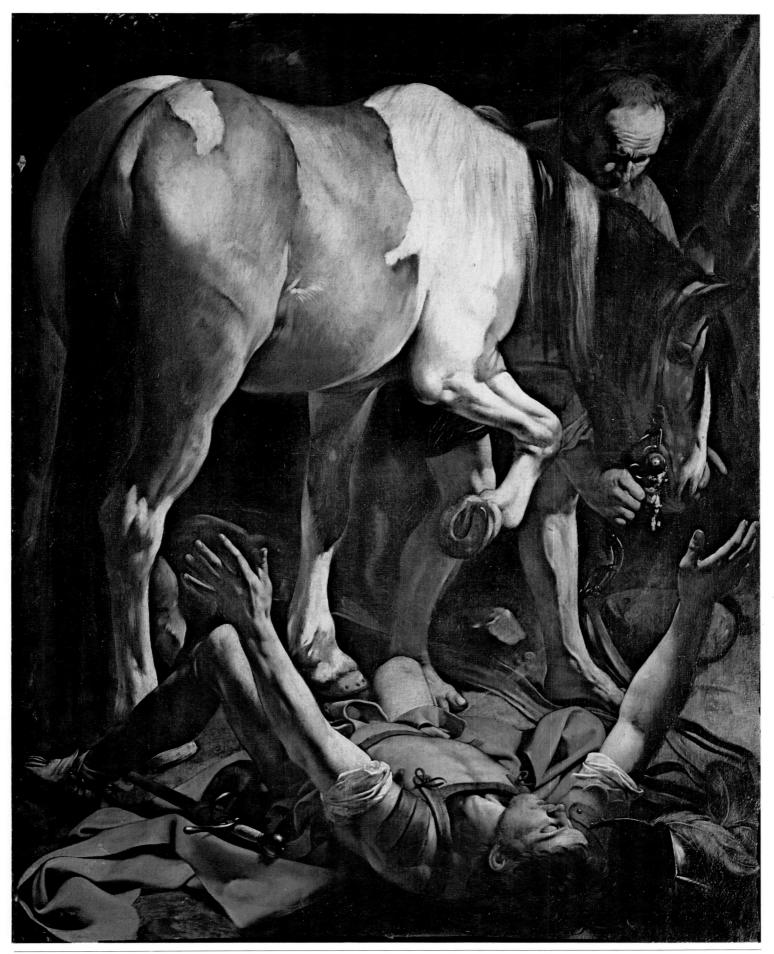

The Carracci and their Pupils

While Caravaggio's dramatic realism was to be one seminal constituent of Baroque painting, the vigorous and equally radical return to High Renaissance principles initiated by the Carracci family in Bologna was to be another – and in Italy the more important. The Carracci drew their inspiration not only from Raphael but also from the Venetians, excluding neither the grandeur of Michelangelo nor the tenderness of Correggio. Like Caravaggio, they were in reaction to the artificialities of the Mannerist style, but they attempted reform and, unlike Caravaggio, they wholeheartedly espoused the traditional practice of *disegno*, the elaborate analysis and resolution of a composition by means of drawings.

The Carracci designated their studio in Bologna a teaching academy about 1585. Their attempt to combine the best elements of previous masters produced a codification of "classicism", in which ideal forms, reprieved from Mannerist distortion, were clearly organized according to the demands of the subject, placed in correct perspective, structured by firm lines of direction and enlivened by resonant colour. Their "academic" programme inevitably repelled many critics of the nine-teenth century, who saw the Carracci and those who followed them as deadhanded imitators, even plagiarists, boring offenders against the cardinal Romantic virtue of originality and the inspiration of genius. The renewed appreciation of their classical revival is comparatively recent.

The three Carracci were Ludovico (1555-1619) and his cousins, Agostino (1557-1602) and his younger brother Annibale (1560-1609). Though they shared much, they are clearly distinguishable artistic personalities. Agostino, the intellectual and the teacher, probably the principal motivator of the academy and a disseminator of Renaissance designs by able engravings after Old Masters, was less of a painter, though his altarpiece at Bologna, *The last communion of St Jerome*, was famous. The eldest, Ludovico, remained based all his life in Bologna. In his early work, full of colour and movement, a Venetian feeling predominates, but his later work is paler, more refined – sometimes sentimental.

Annibale was the major artist among the three. His fame during the seventeenth and eighteenth centuries rested on his decorations for the Farnese Palace in Rome (see over), and

ANNIBALE CARRACCI
Pietà, c. 1599-1600
Annibale Carracci and Caravaggio were both Counter-Reformation artists and sometimes had the same patrons: their works, otherwise distinct, share a clear, monumental expression of immediate impact. Annibale's art intentionally reflects Raphael, Michelangelo and the Antique; this is a more softly idealized version of Sebastiano del Piombo's *Pietà* in Viterbo (see p. 146).

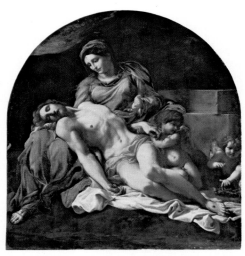

ANNIBALE CARRACCI (below)
The butcher's shop, c. 1582
Probably painted as a studio exercise, this is even more "low-life" than Caravaggio's genre scenes. Quite possibly it satirically represents the Carracci's own academy. For all their high ideals they did not lack humour.

AGOSTINO CARRACCI?
(left) *Annibale Carracci,* late 1580s
In their different ways, the Carracci were as self-consciously artistic as Caravaggio: this portrait miniature has a certain romantic idealization. It seems also to presage Annibale's sad decline.

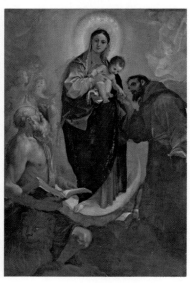

AGOSTINO CARRACCI
(above) *The last communion of St Jerome,* 1593-94
The firm verticals, the undulating, frieze-like horizontal grouping and the lines of direction forming a central triangle declare this work a classicist manifesto. It had wide influence, not least on Poussin.

LUDOVICO CARRACCI
(above) *The Madonna and Child with saints, c.* 1590
The subject matter is clearly and hierarchically organized, composed with academic correctness but sweetened by a light touch and bright, gentle colours.

ANNIBALE CARRACCI (left)
Landscape with the Flight into Egypt, c. 1604
The landscapes painted by Annibale in Bologna show strong northern influence. In the later landscapes painted in Rome, such as this one, he evolved a lasting formula of "classical" landscape – a vista conjured along recessing diagonals of castles, trees, winding rivers and hilltop towns.

ANNIBALE CARRACCI (left)
A prisoner, early 1590s
This, one of the many fine drawings by the Carracci, is probably a copy after a *St Sebastian* by Titian; and it is also probably a preliminary drawing for an unfinished *Samson in prison*. The Carracci often adapted motifs in this way from Renaissance masters; their vigour and feeling were unimpaired by such deliberate eclecticism.

in the ninetenth century was denied on the same evidence. While his formal style shows a consistent development, the sensitivity of his technique was matched by a very flexible attitude to subject matter. Early on there were exercises in realistic genre, unprecedented in Italy, such as the life-size *Butcher's shop*; brisk drawings that are perhaps the earliest true caricatures; and many delightful "straight" portraits. Further, Annibale developed (from early experiments by Veronese or the Bassani) a new art of landscape; this was influenced when he was in Rome by Flemish artists resident there, and also by the fragments of antique frescos newly revealed. In Annibale's landscapes Nature, freshly observed and gravely ordered, reflects the solemnity of the events portrayed in it. Not only his pupil Domenichino but Claude and Poussin were to acknowledge Annibale's example in different ways in their own work.

Annibale had visited Venice and Parma (where he saw Correggio's work) in the mid-1580s. A remark from a letter of his, about Correggio, illustrates sharply a main and enduring concern in his own work. "I like this straightforwardness and this purity that is not reality and yet is lifelike and natural, not artificial or forced." In Bologna, he painted a series of large altarpieces, developing a sure ability in monumental composition, in the interrelating of large forms; he also acquired admirable fresco techniques in the decoration of various Bolognese houses. By 1595, when he was summoned to Rome, he was fully equipped for work in the Farnese Palace. The impact of Rome simplified his compositions and rendered his forms more massive – in this alone resembling Caravaggio's. His late work, overshadowed by attacks of melancholia, is darkly expressive and emotional.

Annibale brought from Bologna to work with him in Rome a sequence of superbly gifted younger artists, notably Domenichino (Domenico Zampieri, 1581-1641); Giovanni Lanfranco (1582-1647); and Guido Reni (1575-1642). Domenichino developed his own version of classicism, rather dry and correct but sometimes of great charm, as in his Raphaelesque *St Cecilia* cycle in S. Luigi dei Francesi, and he also carried on the Carracci interest in landscape. Lanfranco, who came originally from Parma, developed a much freer and more painterly style, which proved more popular and which his rival Domenichino was compelled to emulate. Lanfranco's *Virgin in glory* in the dome of S. Andrea della Valle, Rome, ascending like a paean to the open lantern, both followed up Correggio and indicated the way the High Baroque would explode masonry with simulated heavens.

Guido Reni's work shows both a slightly unexciting restraint and an ability to charm; his later work, such as *Atalanta and Hippomenes* (c. 1620), became subtly but markedly simplified. His studio's large output of cloying *Virgins* led to an unjust devaluation of his ability until recently.

The younger Guercino (Gianfrancesco Barbieri, 1591-1666) never worked with Annibale, but was much influenced by Ludovico: his early paintings in Bologna were attractively vivid, and soon reinforced by a rather Caravaggesque light and shade. In Rome, his *Aurora* of 1623, on the ceiling of the Casino Ludovisi, is a masterpiece of illusionist perspective. His boldness of conception was, however, to be followed up by others. His later work in fresco and oils is much more conventional, though the brilliance of his drawings was undimmed throughout his career.

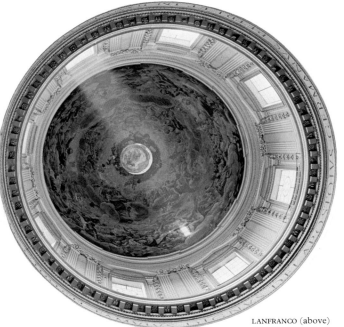

GUERCINO (below)
Profile head of a man,
after 1630
This sketch from the life, typical of the Carracci circle, displays a wry observation containing an element of caricature.

DOMENICHINO (above)
The martyrdom of St Cecilia, 1611-14
Eloquently posed figures clothed in harmonious, light colours act out an elegant classical drama. Such frescos may charm or may seem insipid; they influenced Poussin.

GUIDO RENI (above)
Atalanta and Hippomenes,
c. 1620
Hippomenes won his race against speedy Atalanta by dropping three golden apples, which she stopped to pick up. Their flowing movements are opposed in a softened chiaroscuro.

LANFRANCO (above)
The Virgin in glory,
1625-27
The groups of figures, on ascending layers of clouds, are illusionistically painted *di sotto in su* (foreshortened from below), not yet overflowing the vault as they were to do later, in the decorations of the developed High Baroque.

GUERCINO (right)
Aurora, 1621-23
The chariot and horses resemble a similar *Aurora* by Reni, but the addition of towering illusionistic piers – illusionistically ruined at one end – makes a more impressive ceiling.

Annibale Carracci: The Farnese Gallery

The Gallery of the Palazzo Farnese is the last of the three great classic decorations in Rome, following Raphael's Stanze in the Vatican and Michelangelo's ceiling in the Sistine Chapel. The Palazzo is a building of much grandeur, the creation of a succession of famous architects, including Michelangelo and Giacomo della Porta, who built the Gallery, with its three tall windows overlooking the garden to the Tiber beyond, in 1573. The palace was the Rome headquarters of the great patrician dynasty of the Farnese, used by various members of the family, including the very young Cardinal Odoardo Farnese, who summoned Annibale Carracci from Bologna in 1595.

Annibale's first decorations were in Odoardo's study, the Camerino (1595-96, not shown). Painting began in the Gallery about 1597, and the frescos of the vault were finished in 1600. Annibale's brother Agostino played some part in these, but the overall design and the bulk of the work were Annibale's. The Gallery has noble dimensions – 20 metres (66 ft) long by 6.5 metres (21 ft) wide, its coved and vaulted ceiling ten metres (32 ft) high. Its function, which conditioned Annibale's design, was both for receptions and for the display of classical statuary in the Farnese collection (now in Naples).

The programme – subject matter and story-line – of the decoration was probably provided by Odoardo's learned librarian, Fulvio Orsini, in consultation with the painter. The preliminary workings were exhaustive, involving more than one thousand drawings. The theme – odd for a cardinal, however youthful, but natural enough for lay members of the family – is pagan, profane and erotic: scenes taken from classical mythology to illustrate the power of love, the exalted but very physical love of the gods – even if some discern a deeper Christian message of Divine Love pervading the whole. The scenes are not linked in any continuous narrative progression, but echo and respond to one another in form and composition.

The idea of opening up an enclosed space by means of illusionist painting was already well developed, and Annibale had several examples before him in Bologna. But he chose the system

ANNIBALE CARRACCI (above) The Farnese Gallery: *The loves of the gods*, 1597-1600 Everything above the cornice is painted, even the frames of the pictures. At the end *Polyphemus* hurls a rock at Acis, whom he had caught in the arms of his love Galatea. Other panels illustrate similar stories, culled from Ovid.

(below) *View of the inner wall of the Farnese Gallery* The figures of the ceiling were a foil to the classical sculpture originally set in niches below, as Giovanni Volpato's engraving shows. Over the central door is Domenichino's *Virgin and unicorn*, painted, like the other wall panels, a little after the vault (c. 1604-08).

used by Raphael and Michelangelo, which was to build (or rather paint) a framework containing either paintings or illusory visions of the open sky above. However, the way in which illusionistic features are conjoined with real ones in the Gallery is much more complex than in earlier examples, and seen from a point central in the room, with one's back to the windows, the illusion of a picture gallery continuing above the cornice and carrying right across the vault is vivid – though the effect cannot be captured in photographs.

The colour is strong and lucent; the bodies of the participants are modelled densely, with a sculptural clarity, to answer the real antique marbles that once stood below. Their forms echo and restate precedents from the great masters of the Renaissance – the theme of the naked youths is obviously inspired by Michelangelo's Sistine *Ignudi* – and from classical antiquity. But their vitality springs from the fact that each is also studied from the life, and the central "framed painting", *The triumph of Bacchus and Ariadne*, which owes much to the study of reliefs on Roman sarcophagi, has a richness and fluency not to be found either in antiquity or in the High Renaissance. In the rhythm of this procession, at once measured and exuberant, both the classicism of Poussin and the surge of Rubens are heralded, and, although Annibale's compartmental solution for ceiling painting was not often followed, his mastery and delight in illusionism speak already of the High Baroque.

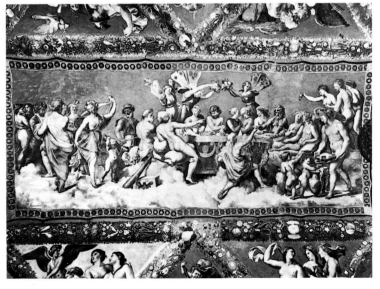

RAPHAEL (below) The ceiling of the Villa Farnesina *loggia*, detail: *The marriage of Cupid and Psyche*, 1518 Raphael's *loggie* in the Vatican and his ceiling in the Farnesina (across the Tiber from the Farnese Palace, and visible from its windows) were important precedents for Annibale, in both their style and their compartmented scheme. Raphael's vision of pagan deity, executed perhaps wholly by his assistants, clearly inspired Annibale.

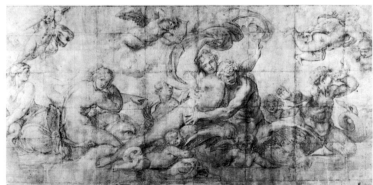

AGOSTINO CARRACCI Cartoon for *Glaucus and Scylla* on the inner wall of the Farnese Gallery, c. 1597-99 Though Annibale no doubt sketched the preliminary design, the scale cartoon is the work of his brother and assistant Agostino. Conception and pose are magnificently robust, and the triton blowing a conch in the (modified) painting probably inspired Bernini, who must have visited the Gallery; he used the motif in his *Neptune* (see over).

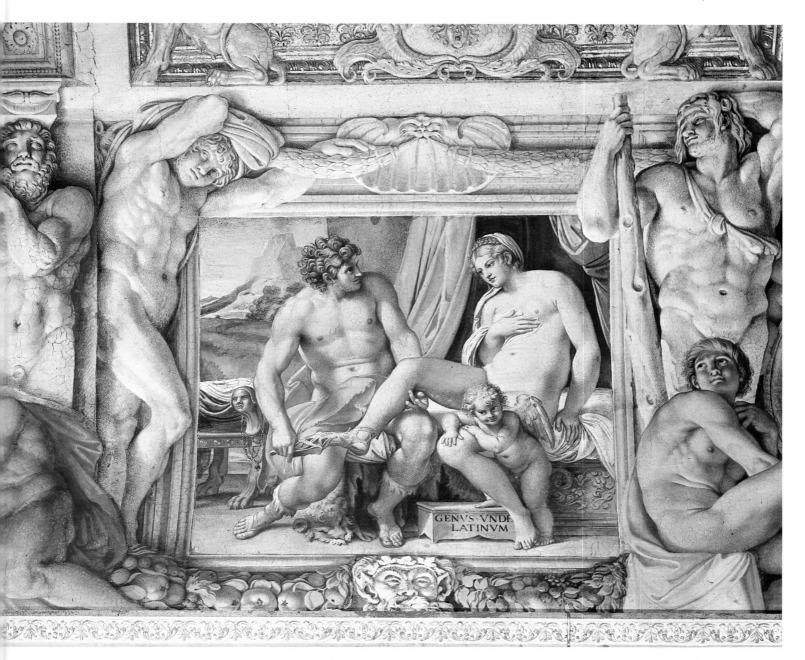

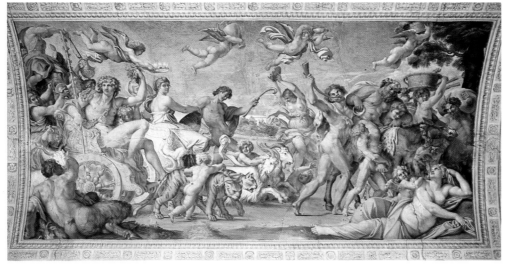

ANNIBALE CARRACCI (above)
The Farnese Gallery,
detail: *Venus and Anchises*,
1597-1600
From the union of Venus
and Anchises was born the
founder of Rome, Aeneas,
as the inscription on the
footstool, a quotation from
Virgil's *Aeneid*, indicates.
Surrounding the pair are
illusionistic stone "Atlas

figures" and busts called
"terms" – both classical
architectural ornaments.
In front of them, in vivid
contrast, are illusionistic
fleshy figures, based on the
Ignudi of Michelangelo's
Sistine ceiling. Further
details reproduce yet other
textures, and the illusion
of planes lapping and over-
lapping is very successful.

ANNIBALE CARRACCI (left)
*The triumph of Bacchus
and Ariadne*, 1597-1600
The *Triumph* is the centre-
piece of the ceiling and
of the whole Gallery. The
idealized forms are derived
from Raphael, though their
heaviness and musculature

echo Michelangelo; the
reclining goddess filling
out the right-hand bottom
corner comes from Titian's
Andrians (see p. 145). This
classicist formula still has
energy, a disciplined rich-
ness and – despite lengthy
preparation – real warmth.

The High Baroque in Rome

"Baroque" is a description applied, often loosely, to most European art in the seventeenth century and on into the early eighteenth; but its variations, from Caravaggio to Poussin, from Rubens to Rembrandt, from its service to Catholicism to its use by the Protestant north, may seem at times to have little in common. If essentially it was a realist reaction against the artificiality of the Mannerist style, at the same time astonishing techniques of illusionism and exuberant movement were developed, especially in Rome.

Its greatest practitioners were all-rounders, to whom narrow specialization in any one art would have been an unacceptable limitation. It found its fullest expression in the persons of Bernini in Italy and Rubens (fundamentally influenced by his Italian stay) in the north: both supreme representatives of an aristocracy of genius, moving as equals amongst aristocrats of blood and rank. The latter, however, were also their patrons, and in Rome the period saw the sharpening of rivalries between the great family dynasties, Farnese, Borghese, Barberini, who were aware of the prestige and glamour that artists could provide for them. That awareness was to be brought to massive

fruition in the absolutism of Louis XIV in France; employing armies of artists to celebrate at Versailles and elsewhere his invincible, all-conquering radiance, the Sun King needed (like Francis I shortly before) the best, wherever they might come from. He therefore brought to Paris in 1665 even Bernini, the maestro whose name is almost synonymous with the purest peak of the whole movement, the so-called High Baroque of Rome.

Son of a sculptor (Pietro) of considerable talent himself, Gianlorenzo Bernini (1598-1680) was a prodigy, enjoying papal patronage by the time he was 17. The reigning pope was Paul V, a Borghese, and before Bernini was 25 he had a series of remarkable sculptures behind him, all Borghese commissions. In them his development progressed rapidly, absorbing earlier influences (Michelangelo, Giambologna, the Antique) into a highly personal style, expressed with spectacular virtuosity. The fluent coherence of his *Neptune and triton* of 1620 is already far from Mannerist tension; in the *Apollo and Daphne* of 1622-24 he has abandoned the multiple viewpoint of Giambologna and the figures are presented in a limited view, as if they were figures in a

painting. In the *Apollo* an appreciation of the Carracci, of Reni, even, in its vivid naturalism, of Caravaggio, is clear. His characters are seen at the most expressive moment – Daphne as she turns from woman to tree, then *David* (1623) at the moment of hurling the stone, compelling the spectator to complete the action with his own imagination, and so implicating him emotionally. So, too, in the portrait busts – often the most formal and pompous of modes – his sitters can be caught not only in movement but in speech to an unseen companion. In his bust of *Costanza Buonarelli* (c. 1635) – an intimate study of a friend, indeed mistress – he created a type of unpretentious, vividly naturalistic sculpted portraiture not to be found again till Houdon in the late eighteenth century.

In 1629 Bernini became architect to St Peter's, and from then on the great spectaculars, exploiting all kinds of techniques and materials, began. Between the Barberini Pope Urban VIII's death in 1644 and the election of Alexander VII in 1655 he was out of favour, though always busy, and his place at the Vatican was taken by Alessandro Algardi (1595-1654; not shown), an extremely pro-

BERNINI (right)
Neptune and Triton, 1620
Bernini's art was founded from his earliest years on superb craftsmanship. He daringly contorts this single piece of marble to the limits of its strength, creating a rich variety of textures – in flying drapery, in straining musculature, or in Neptune's waterlogged, wind-blown hair.

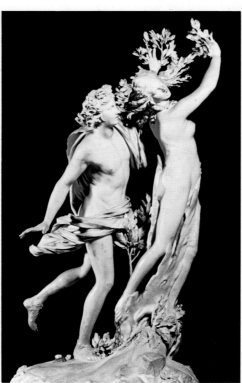

BERNINI (left)
Apollo and Daphne, 1622-24
The statue was originally set in a niche opposite the door to a room, to obtain impact upon entrance. Though his statues were never coloured, Bernini achieved an astonishing illusionism; nobody had previously represented Daphne's metamorphosis as such a convincing organic process. The delicacy (for instance, of the leaves) and the contrast between flesh, bark, hair and drapery are amazing.

BERNINI (above)
David, 1623
The *David* shows the same interest in momentary facial expression, typical of the Baroque, as Caravaggio in his *Boy bitten by a lizard* (see p. 180) or Rembrandt in some early self-portraits (see p. 281). Commanding the viewer's gaze from a predetermined angle, *David* is conceived not simply as a work of art, but as an object dominating its surrounding space.

BERNINI (below)
Cathedra Petri (St Peter's Chair), 1656-66
Set beneath the dove of the Holy Spirit in the midst of gilded rays and a riot of angels, the huge papal throne closes the vista down the vast nave of St Peter's. The Four Doctors of the Church sustain the papal chair; their drapery is animated

by a violent turbulence, as if the Holy Spirit were a wind rushing through the church, transporting the onlooker to another sphere. Using bronze, marble, stucco, stained glass and light itself, the *Cathedra* is architectural sculpture, both mystical and highly theatrical, propagandizing the awesome majesty of the pope's divine mission.

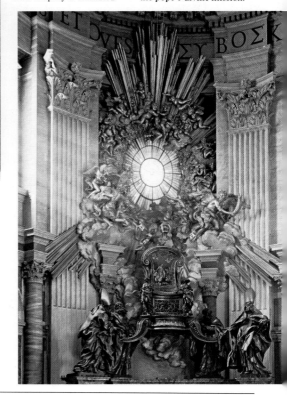

ficient but deliberately less exuberant sculptor. During this period Bernini's most complex display of bravura, the Cornaro Chapel, was completed (see over).

After 1655 he orchestrated his most important creation, the *Cathedra Petri*, his setting for St Peter's Chair in the apse of St Peter's – a sun-burst of imagery. His 1665 visit to France, to design an enlarged Louvre, was not a success – French taste resented the imposition of Italian forms – although from it came one of the most splendid of all royal busts, that of Louis XIV. His last years were busy with the creation of the great colonnade of St Peter's Piazza, but perhaps his most delightful contributions to the Roman scene were his fountains, such as *The four rivers* in the Piazza Navona, where he brought even water into play as an integral element of his sculptural vision. Bernini was always of boundless energy, not only sculptor and architect but dramatist, wit (terrible in his wrath), a brilliant painter and caricaturist (he executed several dashing self-portraits – though painting was for him more a private pleasure).

The leading painter of the High Baroque in Rome was Pietro da Cortona (1596-1669), a protégé of the Barberini. His early work, in the 1620s, develops the Bolognese traditions in easel-paintings and in fresco with a comparable range of religious and mythological subject matter. But these paintings, monumental in composition and gesture (almost matching Poussin), are free in movement and handling. In the 1630s he completed a most astonishing *tour de force* with his great allegorical ceiling in the Barberini Palace: extending the illusionistic examples set by artists such as Lanfranco and Guercino, he opened the space to the heavens with levitating figures apparently soaring not only up but down into the confines of the room itself. In Florence he carried out decorations of equal brilliance and meanwhile, as an architect, he designed churches in Rome of a remarkable individuality.

In Rome, Pietro's painting was not immediately influential, many patrons preferring the comparative sobriety of his classicizing rival, Andrea Sacchi (1599-1661; not shown), but its implications were to be developed further by Pozzo in the 1690s (see p. 234), and by the great Austrian and south German Rococo decorators of the eighteenth century.

The Piazza and Basilica of St Peter's, Rome
Bernini began the great Piazza, his most famous work of architecture, in 1656 and completed it in 1667. It crowns and conjoins into coherence two centuries of building, and extends imposingly like two great arms to embrace the faithful. Its design is complex, but its effect simple and direct. The engraving is by Francesco Piranesi, 1772.

BERNINI (above)
Louis XIV, 1665
In old age Bernini's brilliance in handling textures was undiminished, exuberant, but also finely calculated in its effect – to create in marble an ideal of absolute monarchy.

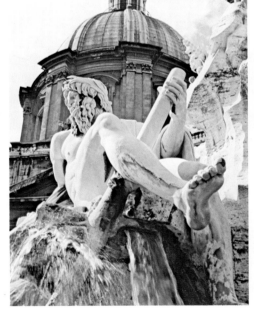

BERNINI (left)
Costanza Buonarelli, c. 1635
In the 1630s Bernini produced a series of portrait busts which for vividness can be compared only with rapid sketches. The surface is in fact painstakingly cut to serve an unusually precise and clearly conceived expression.

BERNINI (above)
The four rivers, detail, 1646-51
Bernini's picturesque allegory of the world's fresh water – the four rivers represent the four continents then known – is one of the landmarks of Rome, continuing the papal reorganization of the city round focal points. It complements the sculptural architecture of S. Agnese, by Francesco Borromini (1599-1667), behind.

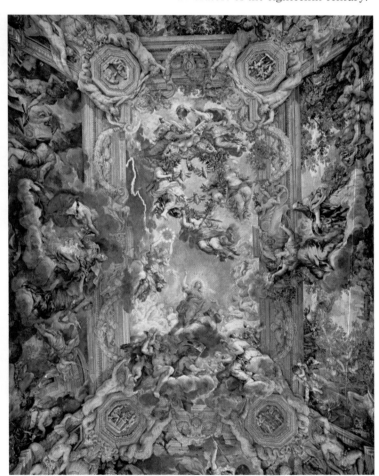

PIETRO DA CORTONA
Allegory of divine Providence and Barberini power, 1633-39
Pietro's ceiling is set in an architectural frame like that used by the Carracci in the Farnese Gallery, but is united in one composition, opens up greater illusionist space and is animated by upward and downward movement. Dominant is the figure of Providence, who gestures towards the wreath containing bees, the Barberini emblem.

Bernini: The Cornaro Chapel

The Cornaro Chapel, in S. Maria della Vittoria in Rome, is the fullest expression of the diverse talents of which Bernini's extraordinary genius was composed. Commissioned by the Venetian Cardinal Federigo Cornaro, it occupied some (but incredibly by no means all) of the energies of Bernini and his collaborators in the seven years between 1645 and 1652.

Its assorted elements – sculpture in various materials, painting and architecture – consort in inseparable concert; though music may seem to be the one form of art lacking, a musical analogy comes to mind. It is akin to a great concerto, in which the soloist is not only the conductor but also the composer and the producer of the whole spectacle. In fact the only part carried out by Bernini's own hand is the central group, St Theresa in her ecstasy (it is perhaps the most celebrated individual achievement in all Baroque sculpture). The rest, with that genius for delegation that also was Bernini's, was carried out by a team of collaborators, stuccoists, marble-cutters and painters, working faithfully to the master's carefully conceived design.

The whole is best seen, and designed to be seen, as a picture or scene on the stage, from a fixed point directly in front of the chapel. It consists of St Theresa's vision, the climax and centre of the action, attended and discussed by members of the Cornaro family in the "boxes" at the sides. The focus of light on St Theresa – real light, from a concealed window above, shafted down simulated light-rays of bronze behind – kindles her being in the moment of supreme ecstasy, expressed physically with such conviction that it seems almost sexual. It is in fact an exact translation into marble of the saint's account of her "transverberation", the vision of a smiling angel piercing her heart with a golden spear. "The sweetness caused by this intense pain is so extreme that one cannot possibly wish it to cease ... this is not a physical, but a spiritual pain, though the body has some share in it – even a considerable share." The effect of the swooning figure, the head fallen back with eyes blinded under half-closed lids, lips half-open – a spiritual orgasm – is strengthened by the brilliant agitation of the drapery, equally infected by the intensity of her agonized rapture. The whole composition is held in breathtaking balance by the dizzy equipoise of the two figures of saint and angel, almost in a rocking movement.

The vivid conviction of the whole springs from Bernini's personal identification with the beliefs of Counter-Reformation Catholicism in its maturity, especially as propagated by the Jesuit orders. The devout – and Bernini himself – practised the daily repetition of the spiritual exercises of the founder of the Jesuits, St Ignatius of Loyola, which were intended to intensify awareness of all-pervading, omnipotent Divine Love. Many of these exercises required their practitioners to imagine, as precisely and as physically, even as painfully as they could, the sufferings and experience of Christ and the saints. Art such as Bernini's, representing the saints in mystical ecstasy as an example to which the faithful could aspire in their own prayer, was similarly concerned to reveal spirituality through external means.

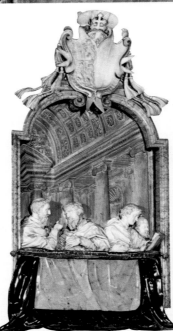

(above) The vault
The painting and stucco represent subject angels adoring the Holy Spirit. Thence the angel who strikes St Theresa has descended, blasting like a thunderbolt the pediment beneath which the saint swoons ecstatic (below).

(above and above far right) The Cornaro family
Federigo, the patron, is shown discreetly at the far (right-hand) end of the west "box". The others, deceased at the time of the commission, talk or read about St Theresa. The illusionistic reliefs behind them open space to the side like a transept, as if their Chapel were a self-contained church.

(left) Skeletons
Inlaid (intarsia) marble skeletons are placed left and right in the floor in front of the altar. A recurring feature, almost a signature, in Bernini's work, such skeletons perhaps symbolize both the ubiquity of death and its impotence (on the floor beneath the viewer's feet) against the power of faith (shown by the Cornaro).

The "supporting cast" for the St Theresa is composed of painting – the vault of the chapel's ceiling dissolved in a glory of cloud-borne heavenly hosts; of architecture, cunningly articulated to give the illusion of a larger space, to create a "stage" projecting, even bulging out, under the impact of the angel's arrival; of sculpture, in the watching figures and in the reliefs flanking the tabernacle; and of what are prosaically described as the "applied arts", here never more richly or ingeniously applied in variety of material and texture, providing chords of colour to sustain the lucent pallor of saint and angel – bronze, richly veined marble and marble intarsia (the skeletons inlaid in the pavements – here, as elsewhere in Bernini's imagery, not content to lie still but dancing almost a jig).

Orchestrated in superb harmony, the diverse elements in the Cornaro Chapel combine to produce the supreme synthesis of Bernini's sculptural career – a work that was to be a wonder of the world for a century and a half. Then for austere Neoclassic dogma it became more than suspect, notorious as the most outrageous example of Baroque excess, only to be reassessed and triumphantly reinstated for twentieth-century eyes.

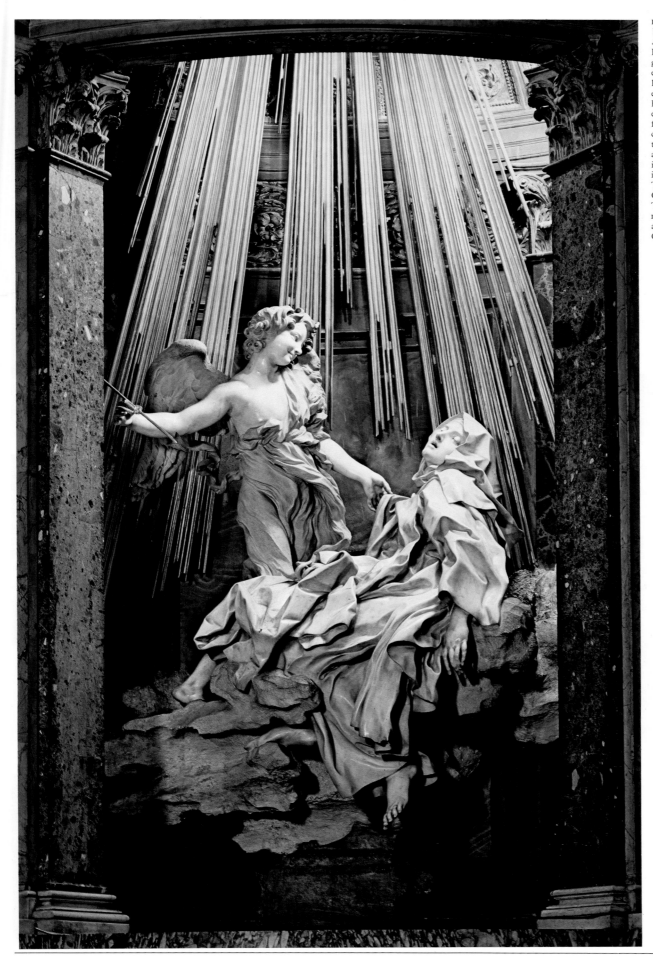

BERNINI
Vision of the ecstasy of St Theresa, 1647-52
Bernini transmogrifies glittering white marble to express a purely psychological, indeed a mystical, experience. St Theresa's hanging foot and hand. her entirely fluid and boneless form, her ebbing drapery, convey her utter surrender to her transport. The little angel's melting smile and iron-tipped spear speak of its bittersweet agony. The climax of the Cornaro Chapel's composition, St Theresa is the kernel of its message: through prayer and faith real experience of God in this life is possible.

French Art 1

Three strands can be distinguished within the texture of French art in the first half of the seventeenth century: the realistic; the classicizing; and, emerging at the beginning of the reign of the Sun King Louis XIV, the court Baroque. All reflect in some degree France's geographical position, between Italy and Flanders, but the influences she derived from the north had themselves been conditioned by exposure to Italy and its creative centre, Rome.

Thus the realistic strain, the art of the Le Nains or the very different art of Georges de La Tour, is typically northern – in the tradition of Bruegel – rather than Mediterranean, yet in style and approach derives in various degrees from Caravaggio. The three Le Nain brothers came from Laon, though they worked in Paris, and their art has a provincial feeling; it seems to have answered to a bourgeois taste rather than to a courtly one. The youngest, Mathieu (1607-77), fostered more social pretensions than the others as a master painter to the city of Paris, but his group portraits are reminiscent of the burgher groups so popular in Holland. Antoine, the eldest (c. 1588-1648), usually worked on a small scale (often on copper), but also produced many family groups, sometimes set in domestic interiors, and some genre pictures. The borderlines, however, between the work of the three are still unclear, and they often collaborated.

The work associated with Louis (c. 1593-1648), the middle brother, is by far the most original. His usual subjects, low-life or peasant scenes often on quite a large scale, are the same as those of many Dutch painters, but akin most closely perhaps to the work of Il Bamboccio (Pieter van Laer, 1592-1642; not shown) who was one of the many Dutch artists working in Rome in the wake of Caravaggio, and who popularized scenes of beggars and brigands between 1627 and 1639. Louis, too, is supposed to have visited Rome, yet his characters are specifically and soberly French, and, peasants though they be, they have a classical quality in their statuesque grouping and in the enigmatic gravity of their demeanour; painted in subdued and often melancholic colours, greys, grey-browns and grey-greens, they compel with a strange, listening silence.

Georges de La Tour (1593-1652) was truly of the provinces, working in Lorraine all his life. The source of his style is Caravaggio transmitted through Dutch artists such as

GEORGES DE LA TOUR (below) *St Jerome*, 1630s The single saint with still-life attributes was a favourite Caravaggesque type. The light and shade and sculptural realism are quite close to Caravaggio.

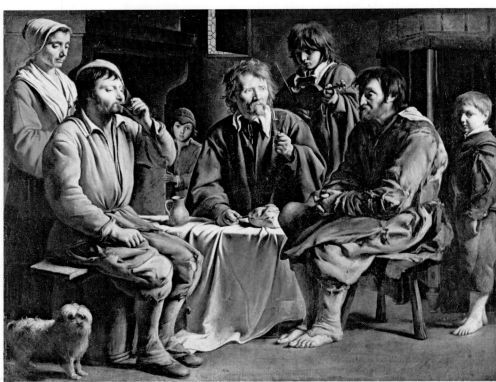

LOUIS LE NAIN (above) *The peasants' meal*, 1642 Louis's groups of patient peasants, whose air of melancholy is reinforced by the silvery colours, have no obvious parallel in contemporary art or literature, and it is not known who bought such works. The subject matter is genre, but the treatment is neither sentimental nor humorous; instead it is sober, factual, sincere.

ANTOINE LE NAIN (left) *A woman and five children*, 1642 Antoine's paintings are distinctly more naive than his brothers'; the composition has not the same studied order, and is without the enigma of Louis's works or the worldliness of Mathieu's. His small, stiff and somewhat awkwardly constructed figures have much charm, like that of certain Dutch artists.

MATHIEU LE NAIN (above) *The guardroom*, 1643 The confident self-display of these Parisian officers recalls Dutch militia groups, and the Caravaggesque lighting the Utrecht school (see p. 213), but in composition this is more sophisticated.

THE LE NAIN BROTHERS (below) *The Adoration of the shepherds*, c. 1640 The Le Nains' religious works show that they were open to the influence of followers of the Carracci, such as Guercino. Here there are strong diagonals, counterpoised movement.

Honthorst or Terbrugghen (see p. 213). The early paintings concentrate on low-life genre, typically Caravaggesque subjects (even saints are shown very much as elderly peasants). In the 1630s he introduced into his paintings a lighted candle, naked or shielded, the single source of light; at the same time he simplified his forms, insisting less on detail, achieving in the single figure a classic monumentality – especially striking if, for instance, that figure is a serving-woman intent on crushing a flea.

La Tour's later paintings are mostly religious (connected possibly with a local Franciscan revival), but his people – even when mesmerized in contemplation and modelled almost without detail – remain of this earth. In his masterpiece, *The new-born child*, there is no explicit religious symbolism – simply a woman and her child and an attendant, observed in static calm in the warm, steady glow of the candle flame with utterly cool detachment – yet it is one of the fullest records of the miracle of birth, human or divine, ever painted. The quietism and intense serenity of La Tour's later work have answered some deep need of the twentieth century; like Vermeer, he remained unappreciated for centuries.

In the work of Philippe de Champaigne (1602-74), born a Fleming and trained in Brussels, French sobriety and control find alternative expression. His early work in Paris is a drier, more restrained version of Rubens or van Dyck, as in his portraits of his patron, Cardinal Richelieu. But after 1643, working for the Jansenists – a movement as near to Puritanism as was possible in the bosom of the Catholic Church – he developed a sober, realistic style of superbly proportioned portraiture. That, too, can be described as classic. with its effect of decorum and of dignity.

Champaigne's most famous painting, the *Ex voto* of 1662, represents his daughter, a nun, in beatific yet sober prayer. Afflicted by an apparently incurable paralysis, she was restored following a novena initiated by her prioress, beside her. A miracle is being celebrated, but the restrained composition is calm in its austere greys, blacks and browns. The two figures are disposed almost geometrically, and the only indication of supernatural intervention is the ray of light (that might be from some earthly window) falling between them.

As Champaigne adapted Flemish Baroque, so Simon Vouet (1590-1649) was the seminal figure who moderated Italian Baroque towards a compromise acceptable to French taste. In Italy for 14 years, from 1613 to 1627, he developed an eclectic style, but leaned more towards the classicizing manner of the Carracci than to the dramatic intensities and contrasts of Caravaggio; he was influenced by Guercino and perhaps especially by Reni. Back in France he had a very successful career, both with easel-paintings and with large decorative projects, threatened only by the arrival of Poussin in 1640. Vouet's work, comparable in colour to Champaigne's, is in structure a more fluid and expansive version of the classicism Poussin was formulating in Rome (see over). Vouet's influence was to be superseded in the later years of the century by that of Poussin, but Vouet had grasped both the rhetoric and the realism of Italian Baroque, and his restrained version of it indicated the direction to be taken towards the Grand Manner of the Sun King. In the same period, the great cardinal princes Richelieu and Mazarin were establishing the tradition of patronage which Colbert, Louis XIV's chief minister and factotum, was to consolidate under the directorship of Vouet's pupil, Lebrun.

VOUET (left)
St Charles Borromeo,
late 1630s
On his return from Rome to France in 1627, Vouet opportunely introduced the new Baroque style of Italy – evident here in the firm modelling, insistent architectural background and strong diagonals.

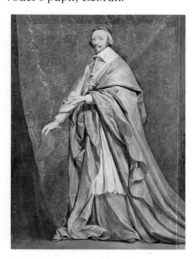

CHAMPAIGNE (right)
Cardinal Richelieu,
c. 1635-40
Though the rich textures and commanding pose recall van Dyck, the whole is simpler, crisper, sterner.

GEORGES DE LA TOUR (left)
A woman crushing a flea,
c. 1645
The light is used not so much to model in three dimensions as to delineate the forms sharply against a dull, darkling background. An almost sordid subject is treated with an abstract, transfiguring stillness.

GEORGES DE LA TOUR
(right) *The new-born child*,
c. 1650
In La Tour's mature work the forms are severely simplified and reduced almost to silhouettes. The meticulously painted details and dry, wrinkled skin of the early *St Jerome* have gone: instead the forms are softly and very shallowly modelled, types not portraits. The result is to transform a homely moment into something permanent and universal.

CHAMPAIGNE
Ex voto, 1662
Despite its bare, simple composition, the picture radiates a joyful piety. The inscription commemorates the sudden recovery of Champaigne's daughter "when the doctors had despaired, and Nature's jaws gaped". Missals and crucifixes, the hands and the daughter's eyes turned up to heaven, testify that it was all due to prayer.

Poussin: The Holy Family on the Steps

The classical strain in French art found its greatest exponent in Nicolas Poussin (1593/4-1665) – though Poussin's working life was spent almost entirely in Italy. For subsequent generations, not only in France, he gave classicism a definitive form – one that was at the same time so vital and rich in possibilities that Cézanne, prophet of the revolution in painting more than two hundred years later, sought "to do Poussin again, from nature", envying his perfect clarity of form and structure. Poussin sought the ideal synthesis of form and subject matter, of landscape with figures, of light with colour and mood, and in the noblest works of his maturity, between 1630 and 1660, achieved

it. In them he refined his early sensuousness, freely inspired by Giovanni Bellini, Giorgione and Titian, with a high seriousness, sobriety and linear perfection in the tradition especially of Raphael, from whom Poussin inherited the formal preoccupations of *The Holy Family on the steps* (1648) in particular.

Poussin's *Self-portrait* is sumptuous but severe, set against an almost abstract composition of rectangular picture frames. It is the portrait of a man who expressed visually a Stoic philosophy of self-control and self-sufficiency, perhaps more deeply than he transmitted the Christian faith or ethic. In seventeenth-century Rome, where he lived

from 1624, he found a learned and sensitive society that nourished the artistic expression of this temperament. A brief spell (1640-42) in Paris was unhappy; he worked habitually alone, painting what he wanted to paint, and he was ill at ease with the large-scale mural decoration and workshop management required of him at the French court.

Even in Rome, Poussin's cool severity, achieved by the rigorous elimination of all inessential detail, was in striking contrast to the emphatic art of his great Baroque contemporary, Bernini. The difference between Poussin and the swirling rhythms of the art being produced all around him seems extra-

ordinary. Yet it was a logical enough development of that ordering of the picture space already achieved in the work of the Carracci and Domenichino. Although the theme of the *Holy Family* is entirely Christian, it has little in common with the propagandist emotionalism of the Counter-Reformation Baroque. Like Poussin's landscapes (see over) the *Holy Family* reads not as a mystical vision but as a superb effort of will, eye and intellect to extract an enduring order from the transitory world of life. Bernini realized Poussin's achievement when he tapped his forehead when looking at one of his paintings and said: "Signor Poussin is a painter who works up here."

POUSSIN (above)
The poet's inspiration,
*c.*1628-29
This early work shows the young Poussin's sensuous delight in Venetian colour and atmosphere. The poet, watched by the Muse of Epic, presents his work to the seated Apollo.

POUSSIN (above)
Self-portrait, 1649-50
Poussin painted only two, very similar, portraits, both of himself, as favours to friends. In recording his likeness he stated his principles, those of an austere and profoundly cultivated man, versed in the classics and in the Stoicism of Horace and Cicero. The female bust signifies Painting, her diadem Perspective.

ROME, ESQUILINE (right)
"*The Aldobrandini Marriage*", detail,
1st century BC
Found in a house on the Esquiline Hill, this is one of the few Roman frescos of the highest quality that survive. It inspired Poussin's general composition, and St Joseph's pose with outstretched foot seems a conscious reference to the reclining youth here. In Rome Poussin drew and studied classical remains avidly, so as to found his art on antique principles.

RAPHAEL (left)
"*The Madonna of the Fish*", detail, *c.*1513
Raphael's altarpiece was almost a proto-Baroque composition, not least in the use of a sweeping diagonal backdrop. It comes late in a series of Madonna compositions by Raphael, Leonardo and Michelangelo, to which Poussin's *Holy Family* is a deliberate coda. The pose of his Mother and Child is based on Raphael's; his Madonna's face has the same abstract purity.

POUSSIN (below)
Preparatory drawing for
The Holy Family, 1648
The figure group has been resolved almost in its final form, but the two middle background buildings that help to centralize the composition round the Virgin, and to suggest great depth, have not been determined. The way in which Poussin blocks out the figures in light and shade shows him thinking in sculptural terms, of solid forms displayed in an almost abstract harmony.

POUSSIN (left)
The Holy Family on the steps, 1648
Though Poussin avoids Venetian colourism, the mask-like solidity of the Virgin's face recalls the *Madonnas* of Giovanni Bellini. Raphael, the Antique and Michelangelo all contribute to a work full of symbolic allusions to the Old and the New dispensations. There are few better examples, even in Poussin's varied range, of Baroque synthesis or of 17th-century classicism.

Landscape Painting in Italy

Ideal landscape is sited in Italy, though its finest exponents, Nicolas Poussin and Claude Lorraine (1600-82) were French. Its origins are to be found in those serene depictions of landscape by the great Venetian painters of the late fifteenth and early sixteenth centuries, Giovanni Bellini, Giorgione and the young Titian. The essential stimulus, however, is surely Giorgione's, in works such as *The tempest* (see p. 140), in which the landscape has an importance equal to that of the enigmatic figures within it. The Venetian paintings in turn reflected an Arcadian mood first appearing in literature: it is already discernible in Boccaccio's fourteenth-century stories, but was widely popularized in the humanist Jacopo Sannazzaro's poem *Arcadia*, fully published in 1504; these sources echo classical precedents, particularly Virgil's *Eclogues*.

The Arcadian vision seems to have been especially fostered by the reaction of northern genius to the enchantment of Italy – an intoxication particularly with that lucid Italian light in which the world seems to take on a preordained clarity. This special quality of perennial, perfected calm already suffuses the topographical views of the Fleming Paul Bril (1554-1626), who arrived in Rome about 1575 and stayed until his death. The Frankfurt-born Adam Elsheimer (1578-1610) was also irresistibly drawn to the magnet of Rome. He is a fascinating figure: his intense interest in light, due surely to some extent to contact with Caravaggio, was inherited in Holland by the pioneering landscapist Seghers and by Rembrandt, while in Italy his etchings and small paintings markedly influenced his fellow northerners. He produced landscapes of a brooding, spiritual quality unknown before. However, his most perfectly concentrated works are his night scenes; the revelation of a suffusing daylight in all its moods was the achievement of the Frenchmen Claude and Poussin.

Both these painters – but Poussin more than Claude – owed something also to the landscape paintings of their predecessors in Italy, such as Annibale Carracci and Domenichino. But neither of these had realized the poetic mood and elegiac feeling that the two French expatriates working in Rome were able to evoke. Landscapes are only a part of Poussin's magnificent achievement (see preceding page), but all his work is constructed on the same principles – an almost crystalline ordering of the visible world. In Poussin's landscapes allusions to specific places are rare; instead, with their distant temples, cities and towers, they present an ideal classical past of pristine perfection, precisely contrived – the dominant horizontal elements in the countryside are almost always balanced by vertical buildings in strongly defined, almost abstract masses. While the landscapes are often majestically large in relation to the small human figures that people them, it is the humans who tell the story and infect nature with their mood. Poussin never painted pure landscapes – even *Summer*, in his late series *The Four Seasons*, which seems to be a straightforward rural scene, tells the biblical story of Boaz and Ruth. In *The burial of Phocion* the wonderful stately recession of space, through winding paths articulated by travellers and trees, past peaceful waters to the central tomb, the splendid temples, the serene hilltop town – this all seems the perfect setting for the Stoic fortitude and principle of the statesman Phocion, first condemned for treason, then posthumously honoured with a public statue by his fellow-citizens. Human virtue is matched by the solemn harmony of nature.

ELSHEIMER (above)
Rest on the Flight into Egypt, 1609
Elsheimer died young, mourned by Rubens and other artist friends. He anticipated Claude in his sensitivity to the moods of nature, and in the accuracy with which he recorded light effects (on a miniature scale).

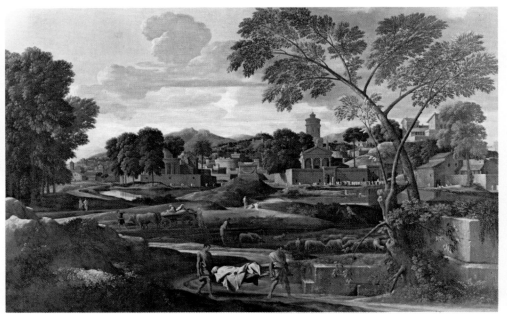

PAUL BRIL (above)
Landscape with hunting scene and the Baths of Titus, c. 1620?
Although he painted the Roman countryside as a rather harsh, Mannerist panorama, Bril conveyed the noble grandeur of ruins in a tranquil atmosphere. His genre figures may now seem no less ideal than nymphs, gods and heroes.

POUSSIN (right)
Summer, or Ruth and Boaz, 1660-64
Summer is given meaning by the story of Ruth and Boaz, symbolizing the marriage of Christ and the Church. The corn is threshed in the antique way with horses, whose grouping echoes a relief on the Arch of Titus in Rome, drawn by Poussin.

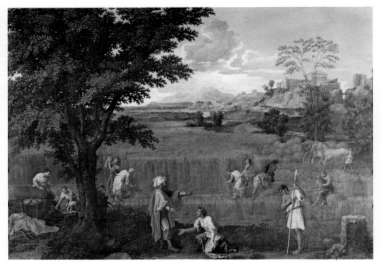

POUSSIN (above)
The burial of Phocion, 1648
This is one of Poussin's great Stoic landscapes. The statesman Phocion, who had earned dislike for his moral severity, was condemned to death on false charges and his corpse carried out by hirelings to ignominious burial. Poussin re-creates not simply a classical golden past, but a calm landscape of moral order, of glorious austerity. The overall setting is inspired by the hills of Rome; the details are based on reconstructions of ancient Roman ruins by the 16th-century architect Palladio.

CLAUDE (above)
Tree, c. 1650
The painter Sandrart relates that Claude often rose well before dawn to make an excursion into the countryside round Rome, where he sketched until nightfall, often in company with his friend Poussin.

CLAUDE (below)
Ulysses returning Chryseis to her father, 1644
The subject, an episode from Homer, has no narrative importance: it is a peg on which Claude hangs an idyllic classical reverie, a memory of the Bay of Naples transmuted.

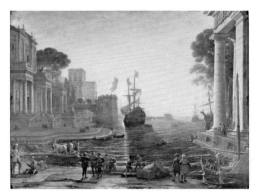

CLAUDE (right)
Egeria mourning over Numa, 1669
According to Ovid, Egeria, while wandering distraught through the countryside in mourning for her husband, Numa, disturbed the rites of the goddess Diana by Lake Nemi, near Rome; she subsequently turned into a spring. Out of this rather sinister tale, and the inspiration of Lake Nemi itself, Claude has created a haunting lyricism, a kind of classical dream-garden. In the landscape there are references to the estates of the Colonna family, for whom the work was made; later, Henry Hoare was to design the landscaping of Stourhead (see p. 255) on Claudeian models – with just such a temple as the round one depicted here.

Poussin's contemporary compatriot but very different colleague, Claude, drew on the same cultural springs of antiquity, in the light of which he interpreted even his biblical subjects. By contrast he seems to have been essentially unliterary – a pure painter. He evoked his visions, flawless in their consistency of mood, from studies from nature – and these include some of the most enchanting drawings ever made – through compositional drawings to the final painting. The basic structure of his paintings varied surprisingly little through his long career – very often a long recession, over plain or ocean, framed between strong verticals (trees or buildings) to right and left – but within this formula the variations he played in his subtle treatment of light are endlessly delightful. His figures are usually in classical garb, but, unlike Poussin's, his costumes and temples belong to a dream and are not archaeological quotations. The atmosphere is elegiac, never stormy, though a lyrical brooding pervades everything: his classical buildings are often ruinous or echoingly void, his people like actors entranced to find the stage on which they move is the real world – the countryside around Rome. Though the pictorial structure

CLAUDE (above)
Self-portrait, after 1644
This drawing is prefixed to Claude's *Liber Veritatis,* a unique private record of sketches of nearly all the paintings that left his studio. It was compiled perhaps in an attempt to establish his authorship, since he had imitators; it is typically modest.

and content are firmly classical, the mood would later be enjoyed as Romantic.

Claude's influence on posterity's image of the lost Golden Age has been enduring: it led even to attempts in eighteenth-century England to re-create and recapture that lost idyll in the earth, water and trees of the real countryside. However, the age of the Picturesque revelled also in the contrary outlook provided above all by Salvator Rosa (1615-73), born in Naples. Although he worked a great deal in Rome, he always retained a Neapolitan bravura, and was famous for depicting a sombre violence in which the wild and desolate landscape often seems positively hostile. Both the "history" and the straightforward unsubtitled landscapes he painted thrill with a precociously Romantic feeling for the sinister.

Between these two extremes – the idyllic and the horrific or "sublime" – others pursued a more eclectic path; the most distinguished of them was Gaspard Dughet, also known as Gaspard Poussin (1615-75). He painted many landscapes close to Poussin's calm and ordered vision, but also others, more naturalistic, in which the rhythms of the countryside seem subjects sufficient in themselves.

SALVATOR ROSA (above)
Landscape with a bridge,
c. 1640
Like many of his time, the wit Horace Walpole, in the Alps in 1739, saw Rosa as a Romantic: "Precipices, mountains, torrents, wolves, rumblings – Salvator Rosa!"

GASPARD DUGHET (below)
View near Albano,
c. 1630-40
Dughet made many more romantic variations on his brother-in-law Poussin's mythological landscapes. Finest are his rustic scenes such as this, a parallel in Italy to Dutch landscape.

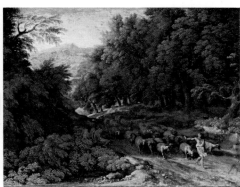

French Art 2: The Sun King

Louis XIV's reign of almost unparalleled stamina – 72 years long, from 1643 to 1715 – brought about the remodelling not only of French but of European court civilization. Palaces and their furniture were laid out and arranged so as to support and glorify the image of an absolute monarch. Well before the end of the century Rome had ceased to be the artistic centre of Europe, and the corridors and decoration of Versailles were to be emulated in England, Germany, Italy and Spain.

The arts were organized, almost industrialized, in the service of the Sun King by Colbert, one of the ablest administrators in history. The headquarters of artistic production were the Academy, founded in 1648; and Colbert's executive manager was Charles Lebrun (1619-90) who became Director of the Academy in 1663. Poussin, the greatest French painter of the century, lived in Rome, and his recall in 1640 had not been a success, but he had important French patrons, and it was Poussin's practice and principles that were to become the essential canons of the Academy's taste. However, Poussin became dogma only after a celebrated theoretical storm, the battle of the "Poussinistes" and the "Rubenistes":

Lebrun eventually gave judgment in 1672 in favour of antiquity and of Raphael, for the vigorous drawing and classical idealism of Poussin against the rhythms and colour and realism of Rubens and the Venetians; academicism was established.

Early on in his career Lebrun had been rivalled by Eustache Le Sueur (1616/17-55), a fellow pupil under Vouet. Although Le Sueur never visited Rome, he carried on the Rome-oriented vision of Vouet, notably in his decorative paintings for the Hôtel Lambert in Paris, and became influenced more and more by Poussin and Raphael. But the death of Le Sueur in 1655, following that of Vouet in 1648, left the field clear for Lebrun, whose organizational ability sometimes obscures the fact that he was a highly gifted painter. Lebrun was in Rome between 1642 and 1646, probably with Poussin but evidently also studying the great decorative schemes of painters such as Pietro da Cortona. In Paris, first the minister Fouquet recognized his abilities, and then Colbert saw in him the ideal instrument for his centralization of art in the service of the State, for "*la gloire de la France*". By 1664 he was first painter to the King and Director of the

LE SUEUR (left)
The Muses, c. 1647-49
Le Sueur's pictures in the *Cabinet d'Amour* in the Hôtel Lambert introduce the type of chaste, blonde woman he derived from engravings after Raphael. In delicacy they compare with Poussin's early work.

LEBRUN (right)
Louis XIV adoring the risen Christ, 1674
Lebrun was often forced to deviate from his strictly classical theories by the task set him – to produce large-scale glorifications in which Baroque drama and gesture were invaluable. Forms and composition derive from Raphael's *Transfiguration* (see p. 164), but not the spirit.

COYSEVOX (above)
Louis XIV, 1687-89
French court Baroque was founded on a vision of a new classical age – with the Sun King as Emperor and his court as a new Rome. Coysevox's statue for the Town Hall of Paris represents Louis dressed as for a Roman Triumph and in classical posture. In his portrait busts of his friends and fellow-artists, Coysevox struck a more informal mood.

SARRAZIN (below)
Caryatids on the Pavillon d'Horloge of the Louvre, 1641
As slaves supporting the roof of their conqueror's building, caryatids, too, had an imperial meaning. Sarrazin's females are as classical as Poussin's, and archaeologically more accurate than those of the artists he had met in Italy. They mark perhaps the first appearance of the classicism dominating the vast quantity of sculpture produced under Louis XIV.

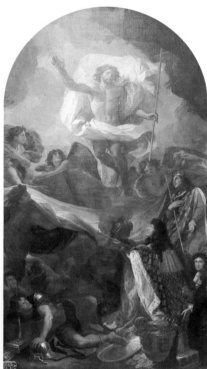

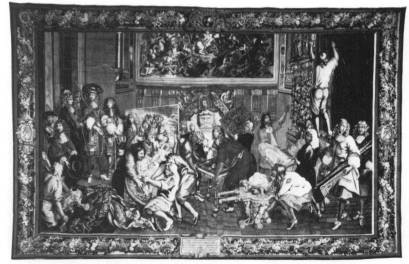

LEBRUN (above)
Louis XIV visiting the Gobelins factory, 1663-75
The tapestry gives an idea of the range of items made at Gobelins under the close direction of Lebrun. Above hangs Lebrun's cartoon for a tapestry of Alexander the Great, whose imperial virtues were understood as a prototype of Louis XIV's.

Gobelins tapestry factory; as Director of the Academy he codified its rules and practices, and wrote a treatise, *The Expression of the Passions*, a typically rational grammar of the irrational, which was an influential text-book for long after his death. His own painting was not entirely restrained by theory – a work such as his vision of *Louis XIV adoring the risen Christ* has both vigorous movement and a nice equation of the relative importance of the two main characters. However, his final importance in French art is certainly as a sort of team manager in the great decorative ensembles, especially Versailles, collaborating with architects and with sculptors to bring magnificently up to date the tradition of Fontainebleau.

Versailles and the palace pattern that it set offered numerous opportunities for the deployment of sculpture, not least in the vast formal gardens – 80 hectares (200 acres) at Versailles. The sculptors, responding to exactly the same taste as the painters, do not include, however, original masters of the order of the expatriate Poussin and Claude. Their outlook was established by Jacques Sarrazin (1588-1660), who indeed taught many of them. Sarrazin, during his long stay in Rome (some

20-odd years) worked with or for artists as diverse as Domenichino and Bernini, and he established himself in France as an extremely able and versatile technician, rather than an artist with a committed personal vision. With a large studio of assistants, he developed inevitably towards an ever more classicizing style. The Anguier brothers (François, 1604-69, and Michel, 1613-86), who had worked with Bernini's rival Algardi in Rome, were somewhat more individual, but the main ally of Lebrun in the extensive sculpture programme of Versailles was Sarrazin's pupil François Girardon (1628-1715). In his figural groups Girardon evolved a style based on Poussin's (and reflecting tacitly Poussin's method of constructing miniature groups of figures in wax as studies for his pictures). Pierre Puget (1620-94) had too individual a temperament to work successfully at Versailles; his works were classical enough, but too intense and perhaps too Italianate for most of the court. The impact of Bernini, even after his 1665 visit to Paris, was always muted in France, although the taste of the aging Louis XIV became increasingly florid, and sculptors such as Antoine Coysevox (1640-1720) pro-

vided a more full-blooded Baroque flourish in the last years of the century; Coysevox's *forte*, however, was perhaps his lively portrait busts.

In his last years, Lebrun yielded in favour to Pierre Mignard (1612-92; not shown), with a vivacious, colourful line in portraiture, kitting out his aristocratic sitters with allegorical attributes as Venus, Thetis and so on. Sébastien Bourdon (1616-71) developed in his portraits a very competent and elegant variation on van Dyck; his religious and mythological paintings were a softer version of Poussin, less rigorously ordered if more seductive in handling. Poussin and Rome, which he visited in 1634-37, were abiding inspirations, although Bourdon's work as a whole is not easily defined or consistent, and he also copied (perhaps fraudulently) both Claude and the Le Nains.

The splendour not only of the court but of the prosperous Parisian merchant class had its peony-like flowering in the parade-dress portraits of Nicolas de Largillière (see p. 242) and Hyacinthe Rigaud (1659-1743). Rigaud's *Louis XIV*, in full royal pomp and acres of ermine, was one of the most splendid (and influential) portrayals of royal absolutism, but loyal to the facts of an aged face amidst it all.

MICHEL ANGUIER (left)
Amphitrite, 1680
Anguier's figure is mildly Baroque: classically posed, but clothed in voluptuous flesh and lively drapery – signs of Algardi's tutelage.

GIRARDON (below)
Apollo tended by nymphs, 1666
The group was moved from its enclosed niche to this "picturesque" grotto in the late 18th century, and the original strict symmetry destroyed – the Sun King's rigorous formality had long ceased to be congenial.

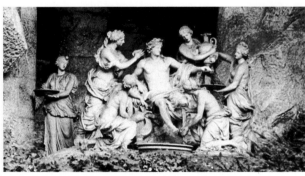

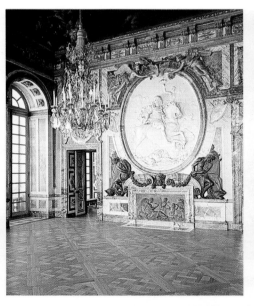

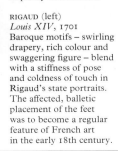

LEBRUN AND COYSEVOX (above) The *Salon de la Guerre* (Hall of War) at Versailles, 1681-83
The overall design is Lebrun's, the sculpture in bronze and stucco is Coysevox's. Within the scope of the roundel, *Louis XIV on horseback* caracolling over fallen enemies, there are fine, typically Baroque effects of movement both into and across the space.

BOURDON (left)
Mythological drawing, undated
Because he could work in almost any style and give it his personal flavour, Bourdon is difficult to classify. Yet he often enriched the classicism of the day with sensuality and poetic fantasy.

PUGET (above)
Milo of Crotona, 1683
In his marble of the legendary wrestler who was trapped in a tree trunk and devoured by wild beasts, Puget created a truly French form of Baroque: violent in movement and in expression of the victim's agony, yet classical in control and in purity of silhouette.

RIGAUD (left)
Louis XIV, 1701
Baroque motifs – swirling drapery, rich colour and swaggering figure – blend with a stiffness of pose and coldness of touch in Rigaud's state portraits. The affected, balletic placement of the feet was to become a regular feature of French art in the early 18th century.

Art in Flanders

Even before the death of Bruegel in 1569, the Netherlands had been rent by vicious fighting which continued for nearly 50 years. By the end of the sixteenth century, however, the territory had been divided into the Dutch Republic (including Holland) in the north and the Spanish Netherlands (including Flanders) in the south, and the art of the now quieted communities reached new heights.

Seventeenth-century painting in Flanders and in Holland is remarkable not only for its quality but also for its quantity, especially considering the smallness of each area; each was essentially different in character. The art of the fiercely independent Protestant Dutch was supported mainly by a prosperous merchant class, and much concerned with secular subjects; the art of Flanders, which remained under the Catholic Hapsburgs, was oriented to the court (both in Flanders and in Spain) and the Church of the Counter-Reformation. Flemish art reached its zenith rather earlier than Dutch art, but was shorter-lived, and did not produce so various and copious a harvest in almost every branch of art. In Flanders a single exuberant genius, Peter Paul Rubens (see over), was the presiding eminence and main

driving force, and on his death the decline of Flemish painting was almost instantaneous.

To some degree the earlier Netherlandish passion for naturalism, and the astute observation found in Bruegel's work, persisted. At the beginning of the seventeenth century, however, its best-known exponents worked abroad, providing specialist skills in still life or landscape for decorative projects in Italy – for instance the Bril brothers in Rome (see p. 196). The production of small genre and still-life paintings continued throughout the period in Flanders, but with few exceptions they do not compare in quality with the great output of religious and courtly painting.

Rubens' studio, the power-house of Flemish painting, was established in Antwerp by about 1612. His huge practice employed not only younger pupils and assistants, but distinguished artists of his own generation working in collaboration. Jan I Brueghel (1568-1625), younger son of Pieter Bruegel and known as "Velvet" Brueghel, specialized in still life and in extensive landscapes peopled with small genre or mythological figures. Jan seems a somewhat improbable ally for Rubens, and his collaboration, mainly in bowering Rubens'

VAN DYCK (above)
Marquesa Caterina, c. 1625
The shimmering, tender Baroque style van Dyck evolved in his Genoese portraits depended on the use of crusts and glazes of pigment, which he learned from the great Venetian painters. Stately, refined, faithfully characterized, his portraiture soon rivalled Rubens' in its influence.

RUBENS AND "VELVET" BRUEGHEL (left)
The Virgin and Child in a garland, c. 1620
Brueghel's garland frames Rubens' Virgin, evoking a symbolic enclosed garden. His highly finished flowers contrast with Rubens' more broadly painted figures.

SNYDERS (above)
The fruit-seller, before 1636
Snyders was one of the first to concentrate on still-life and animal painting. He developed a particular interest in the handling of light reflected on objects, infusing fruit with a tempting succulence. He favoured quite large, complicated arrangements.

CORNELIS DE VOS (right)
The artist and his family, 1621
Meticulous, factual portraiture made Cornelis very popular with burghers of Antwerp. His style depends on that of Rubens, also borrowing from the palette of the young van Dyck, but he lacks the sensitivity of either Rubens or van Dyck; beside them he seems rather linear and dry. He painted altarpieces, too, and some Baroque historical pictures in the manner of Rubens.

PAUL DE VOS
The stag hunt, c. 1630-40
Like Snyders, his teacher and brother-in-law, Paul de Vos was a specialist in both still lifes and hunting scenes. In both artists there was a development towards greater drama and Baroque movement: in this late work the hounds arrow in on the upward-straining stag in a forceful composition made up of colliding diagonals. Rubens admired de Vos: he had four paintings by him.

Madonnas with flowers, stemmed perhaps from close personal friendship rather than shared artistic feeling. Frans Snyders (1579-1657), having trained with Bruegel's elder son, Pieter the Younger, became closely linked with Rubens' studio after returning from Italy in 1609. A specialist in still life and animal and hunting scenes, he supplied these elements where needed in many of Rubens' compositions, and later in Jordaens'. The energy of Rubens' painting opened up Snyders' style and his scale; even his still lifes can be infused with violent movement, and are sometimes invaded by predatory animals which seem to have escaped from his vigorous and frequently ferocious hunting scenes. Closely linked to Snyders was his brother-in-law Paul de Vos (1596-1678), also an animal painter; Paul's brother Cornelis de Vos (1584-1651) was mainly occupied with relatively staid burgher portraits, but also worked for Rubens at times.

Rubens' studio was not so much a teaching academy as a production team, and his two most celebrated associates, Jacob Jordaens (1593-1678) and Anthony van Dyck (1599-1641), though of a younger generation, were not really pupils. Jordaens, who never visited Italy, was an Antwerp man and stayed there all his life, working with Rubens from about 1618 until the master's death, mainly as a figure painter. From his Mannerist beginnings he grew into a robust, Rubensian style and by about 1635 was developing it very much in his own way. Although on Rubens' death he took over the great artist's last commission, the extensive decorations of Philip IV's hunting lodge near Madrid, it was about then that he turned to Calvinism, and the most interesting works of his later career are his genre scenes.

Van Dyck, a precocious genius, was with Rubens little more than two years (about 1618-20), although the older master's style affected his own indelibly. By his twenty-first year he was already ripe for independence; a first foray into England in 1620-21 was followed by an extensive sojourn in Italy, mainly in Genoa but with trips through the rest of the country to study and copy the Venetian masters – Tintoretto, Veronese, above all his abiding inspiration, Titian. His livelihood derived in great part from portraiture, and in his series of court portraits of the Genoese aristocracy he established a style of characterization that was to persist all over Europe for more than two centuries: in his visions of tall and aloof, yet relaxed, elegance, he showed the most subtle ability to marry a precise physical likeness into compositions of fluent and elaborate Baroque splendour. His genius was, so to speak, the feminine aspect of Rubens': although, particularly in his early work, he could be so close to Rubens as to be confused with him, his more delicate sensibility soon became apparent – the moon to Rubens' sun. There was not room for both of them in Flanders, and after a brief second Flemish period (1628-32), he took up Charles I's invitation to come to London (see p. 206), and remained based there until his premature death in 1641. He was certainly then investigating the possibilities of a return to Europe in the place of Rubens, who had died the year before.

Two outstanding painters who were not directly connected with Rubens were Adriaen Brouwer, who worked for much of his brief career in Haarlem (see p. 226), and David Teniers the Younger, whose genre paintings, for which he is best known, were much influenced by Brouwer. Teniers, however, was also court painter to Archduke Leopold Wilhelm, the Spanish Viceroy in Brussels.

TENIERS (left)
The country fair, c. 1650
Teniers' best and most characteristic genre works are outdoor scenes filled with tiny figures carousing in a *kermis,* or festival. He produced at least a dozen variations on this scene, and many more like it.

TENIERS (below)
The picture gallery of the Archduke Leopold, c. 1650
The taste of the Archduke (seen in black) for Venetian painting is evident. Such crowded hanging was the norm until the 20th century.

JORDAENS (above)
The riding academy, c. 1635
Jordaens' oil-sketch of a rider with Mercury and Mars was one design for a series of tapestries. In scale and in allegorical content it was a typical courtly commission, like Rubens' Médicis cycle (see over).

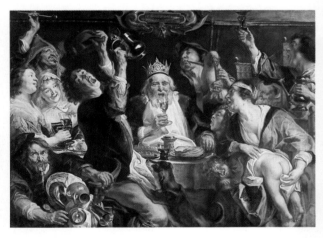

JORDAENS
The king drinks, c. 1645
The "king" was a figure of Flemish folklore, associated with the Epiphany and its feasting. Such an earthy subject was quite foreign to Rubens, although the rich fleshiness and even some of the facial types derive from him. Jordaens' bloated merriment seems a sort of genre pastiche of Rubens' voluptuous Bacchanalia.

Peter Paul Rubens

As Bernini is the supreme representative of Baroque in Italy, so Peter Paul Rubens (1577-1640) is the commanding figure of Baroque in the north – indeed his influence was further-reaching and more enduring than Bernini's. Trained by Flemish Mannerists who are now virtually forgotten, Rubens, more than most artists of the past, developed his style by assiduous copying: he set out for Italy in 1600, and by the time of his return to Flanders in 1608 had absorbed, with remarkable industry, both the heritage of the Antique and of the Renaissance and the art of his contemporaries, Caravaggio and the Carracci. Co-ordinating northern and southern tradition, he emerged in the first decade of the century with a new vision, dazzling to patrons and artists alike.

The fame and prestige Rubens acquired in his own lifetime was the equal of Titian's: he was an artist prince, the peer of monarchs in style, culture and deportment. His collection of art rivalled that of the great patrons of the time. He was both painter and supremely efficient impresario; both polished courtier and ambassador of peace between warring states. The energy and exuberance of his art resounded through the age and beyond it.

Rubens' crucial formative period began in his twenty-third year, when he arrived in Italy. He became painter to the Duke of Mantua, at whose court he put the finishing touches to his artistic education and courtiership (he had already served as a page when an adolescent in Antwerp). He visited Spain for the first time in 1603, and succeeded in fascinating the Duke of Lerma, later to be Philip IV's Chancellor. His equestrian portrait of Lerma, in which much of his mature style is already clear, was inspired by Titian's portrait, still in Spain, of *Charles V at Mühlberg* (see p. 143). With Baroque illusionism, Lerma advances, life-size and magnificent, out of the picture. Returning to Italy, Rubens continued to study – especially Titian, Veronese and Tintoretto – with detailed and critical care, building up a reference library of hundreds of copies.

Back in Antwerp, he was appointed court painter to the Archduke Albert and the Infanta Isabella in 1609, and in the same year married Isabella Brandt. Confidently launched on a tide of enduring prosperity, Rubens built himself a spectacular house and garden (still to be seen in Antwerp) in the Italian style: he pined for Italy and was already preparing *The*

RUBENS (above)
Self-portrait, c. 1639
Rubens was international in scope as no artist had been before him. He wrote: "I regard all the world as my country, and I believe I should be welcome everywhere". A correspondent of scholars and confidant of crowned heads, he used his status to propagate the values of humanism, peace and Italianate civilization. A sensual appetite for life was moderated by sincere religious feeling in the spirit of the Jesuit revival.

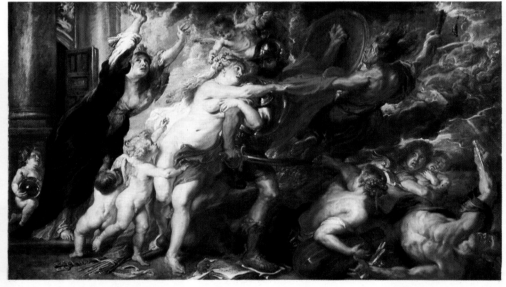

RUBENS (above)
The Duke of Lerma, 1603
Rubens swivelled Titian's profile equestrian portrait of Charles V (see p. 143) through 90° so that Lerma seems to break through the picture surface towards the onlooker. The composition is determined by diagonals receding into depth and by rhythmic curves. The horse is a superb animal: the English and the Dutch depicted horses, but never such splendid creatures as Rubens' or van Dyck's.

RUBENS (right)
Self-portrait with Isabella Brandt, c. 1609
Rubens' marriage portrait is just the sort of picture any gentleman in Antwerp might have commissioned – highly finished, proper and discreet. He and Isabella sit in a honeysuckle bower, a symbol of their conjugal bliss. The tenderness of the portrait is restrained by a poised elegance that is a world away from the young Rembrandt's *Self-portrait with Saskia* (see p. 218).

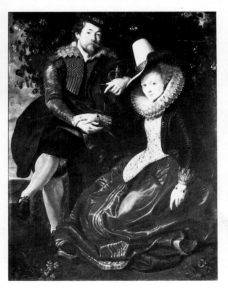

RUBENS (above)
The horrors of war, 1638
Rubens himself explained his allegory, painted for the Duke of Tuscany: "That lugubrious matron clad in black (on the left) ... is unhappy Europe, afflicted for so many years by rapine, outrage and misery". In vain Venus tries to restrain Mars; in his train come Pestilence and Famine. Rubens' dynamic style can carry off so large a theme.

RUBENS (right)
Hélène Fourment in a fur wrap, c. 1638
Of all Rubens' portraits of his youthful second wife, this is the most intimate – playful, sensuous, erotic – that classic gesture of modesty, the arm across the breasts, becomes here a gesture of exposure.

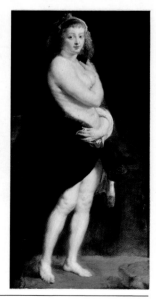

Palaces of Genoa, published in 1622, as propaganda to displace the continuing Gothic style of architecture in the north. Even before the Archduke died in 1621, the Infanta came increasingly to rely on Rubens, as confidant and as adviser in her political difficulties.

After about 1615, Rubens' early vigorous but somewhat dark-toned style gave way to a clearer palette, and he achieved in such works as *The rape of the daughters of Leucippus* that radiance and abundance of colour that is the essence and delight of his painting. Numerous large and important commissions – notably *The descent from the Cross* (see over) and a series of 39 ceiling paintings (destroyed by fire in 1718) for the church of St Charles Borromeo – culminated in his best-known surviving series, *The life of Marie de Médicis*, for the Luxembourg Palace in Paris. On his journey to France he was already representing the Infanta Isabella; after a second visit to Spain in 1628, he visited England primarily as an ambassador charged to negotiate peace, but he also agreed to paint a series of canvases for the ceiling of the King's new Banqueting House.

The scale of his commissions, matching the scale of the Baroque palaces and churches for which they were destined, precluded the possibility that Rubens could carry them out single-handed. He had begun to organize his studio almost as soon as he had returned from Italy. He put together a team of collaborators – many of them already or later to be considerable painters in their own right – and determined his prices by the amount of his own work present in the finished object. Although he usually "pulled together" his assistants' work in the final stages, nowadays his preliminary drawings and oil-sketches sometimes seem more compelling than the finished works, which are highly contrived, though often freely and dashingly painted. In Rubens' day it was the other way round, however: the conventions of the courts and the ceremonial of the Counter-Reformation Church demanded pomp and circumstance, and a "suspension of disbelief" that people will usually only accord now to performances of Grand Opera. The speed and sureness with which he transcribed his first, free thoughts on to paper is amazing, and the small-scale oil-studies on panel, often virtually monochrome, in which he decided the balance of tones and established the dominant rhythms and accents of the final composition, have unprecedented vigour.

Rubens had been temporarily shattered by the death of Isabella Brandt in 1626, and the failure of his negotiations in England disillusioned him with statecraft. On his return to Antwerp he made repeated attempts to retire, so as to paint to please himself and to enjoy life with his second wife, Hélène Fourment. He painted Hélène frequently – in mythological or religious roles, or in frankly sensuous portraits (she was 16 when he married her in 1630, and he was 53). On his country estate, the Château de Steen, he painted boldly colouristic landscapes, glimpses of a wonderfully rich and varied nature, sometimes combined with visions of disporting nudes. Though he was wealthy enough not to need to sell another picture, he could never escape the embroilments of the Spanish court, and when he died in 1640 he was engaged on a series requiring 112 paintings for Philip IV's hunting lodge.

Rubens successfully disseminated his art by means of engravings, doing his best to control both their quality and his copyright. His heritage remained vital for two centuries to come, influencing artists as diverse as Watteau, Gainsborough, Delacroix and Renoir.

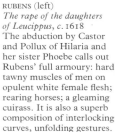

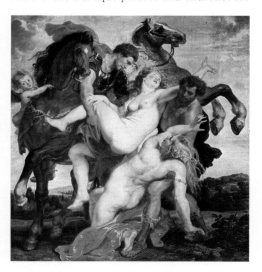

RUBENS (left)
The rape of the daughters of Leucippus, c. 1618
The abduction by Castor and Pollux of Hilaria and her sister Phoebe calls out Rubens' full armoury: hard tawny muscles of men on opulent white female flesh; rearing horses; a gleaming cuirass. It is also a superb composition of interlocking curves, unfolding gestures.

RUBENS (below)
The Château de Steen, c. 1636
Rubens' own mansion, the small castle surrounded by farms and orchards, is on the left, and it has been hazarded that the hunter in the foreground is a self-portrait. Rubens' lyrical landscapes lead the eye to and fro over a nature almost in movement. The lighting, and the sultry impasto of the sky, anticipate Turner.

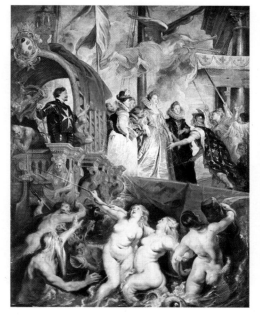

RUBENS (left)
The Luxembourg Palace cycle: *Marie de Médicis lands at Marseilles*, 1622-25
The 24 paintings of the cycle describe the life of Marie, wife of Henri IV of France, in epic terms. By investing the prosaic events of Maria's career with dramatic splendour Rubens made his reputation as Europe's foremost court painter. Though he painted on groundwork provided by his assistants, Rubens' own bravura and spontaneity are unflaggingly displayed – a sign, among other things, of the efficiency with which he organized his studio. Fame sounds a clarion call as the Queen, arriving from Florence, is welcomed by the allegorical figure of France. Below, voluptuous naiads and hearty sea-gods rise up to celebrate it.

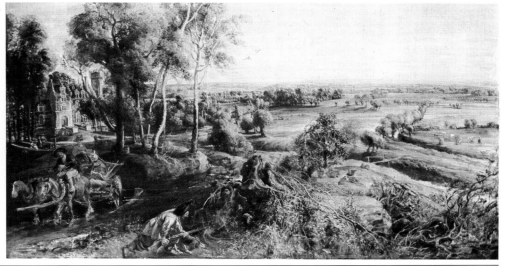

RUBENS (above)
The ceiling of the Banqueting House in London: *The apotheosis of James I*, 1629-34

The nine canvases of the ceiling uphold the divine right of monarchy in a scheme adapted from ceiling frescos in Italian churches.

Rubens: The Descent from the Cross

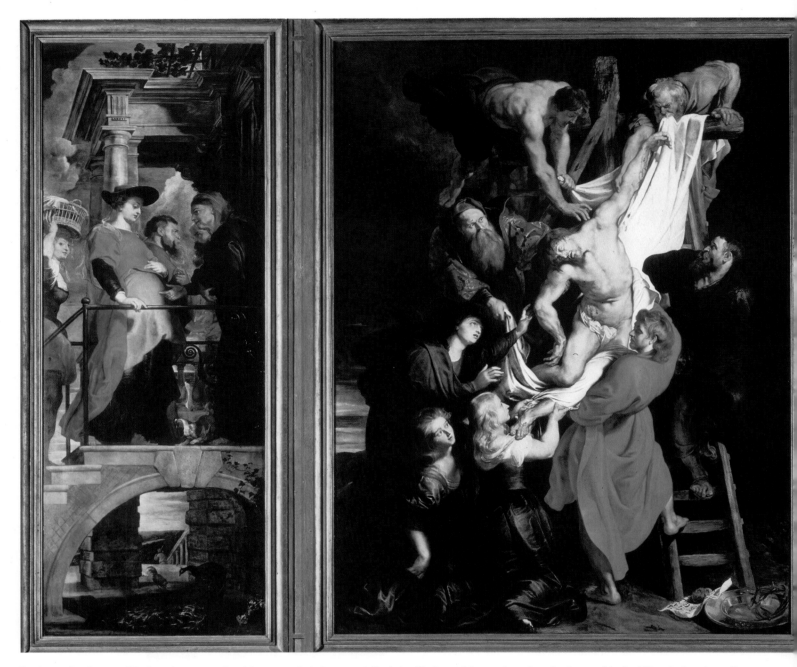

In the early phases of Rubens' career, after his return from Italy in 1608, two masterpieces are supreme. Both are large altarpieces, both now hanging in Antwerp Cathedral, but they were not painted as a pair. The first, *The raising of the Cross*, painted in 1610-11, was commissioned for the church of St Walburga in Antwerp, now demolished; the second, *The Descent from the Cross*, completed in 1614, was always intended for Antwerp Cathedral. Although Rubens had been appointed (in 1609) court painter to the Viceroys of the Netherlands, these commissions came not from that quarter, but from the merchant classes.

The Descent established Rubens then and there as the greatest painter in northern Europe but, though it was less well received, the muscular and emotional turmoil of *The raising* is closer to the subsequent trend of Rubens' work. In its original form, *The raising* had an old-fashioned, complex framework involving not only closing wings but predella

panels below, and God the Father with angels above. The central triptych, to which it was reduced in the eighteenth century, was far from old-fashioned. It was emphatically Baroque, and violent in action, treatment and expression – in the straining muscles of the men heaving up the Cross, in the deep, thrusting diagonals of the composition, in the anguish of the crucified figure. The two wings extend the action and the emotion: on the left, the Virgin and St John look on in a group of horrified women and children; on the right, a mounted Roman officer controls the preparations for the two thieves' execution. On the outer panels were four saints connected with the original church.

In contrast, *The Descent* appears calm and classical. Now the agony is past; the mood is of the most profound sorrow, almost elegiac in the superbly controlled decline of the dead Christ's body down the diagonal white fall of the winding-sheet, caressed by the eloquent

hands that guide it. The design is unforgettable, reused by Rembrandt and many others.

The subjects of the two wings are complementary in theme to the central panel, but do not extend the action as do those of *The raising*. *The Visitation* and *The Presentation in the Temple* on the inner surface of the wings, and a colossal *St Christopher* and a *Hermit* carrying a lantern, the light of the world, on the outer panels, are all linked by the Greek meaning of Christopher, "Christ-bearing", the patron saint of the commissioning guild.

The Descent from the Cross was a not uncommon subject both in northern and Italian painting, though Rubens' interpretation is influenced most clearly by the Italians – works by Caravaggio and the sixteenth-century painters Daniele da Volterra and Il Cigoli all provided ideas for Rubens' composition. Many of the working stages towards *The Descent from the Cross* survive, and illustrate Rubens' methods clearly – first drawings di-

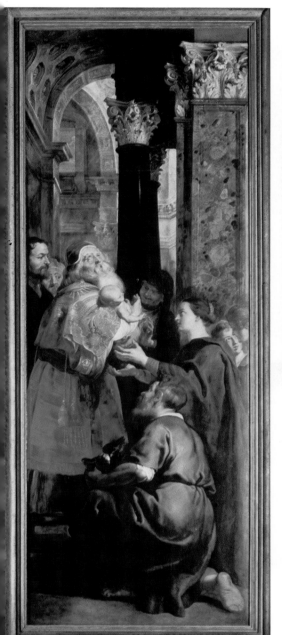

RUBENS: (left) *The Descent from the Cross*, 1611-14

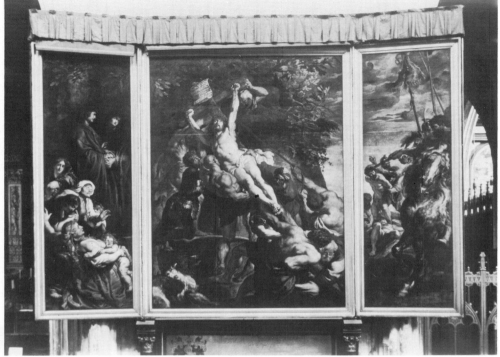

RUBENS (above)
The raising of the Cross,
1610-11
The realism of the action,
the lighting and the solidity
of the bodies show the
influence of Caravaggio,
but Rubens has introduced
passion and bravura, and
exaggerated everything –
the paint itself seems now
to shimmer and vibrate.

DANIELE DA VOLTERRA
(right) *The Descent from
the Cross*, begun 1541
The scale and spectacle
of Daniele's painting had
early showed the trend of
Counter-Reformation
taste. Rubens preserved
the strong diagonals, but
reworked the composition
to achieve greater unity
and dramatic coherence.

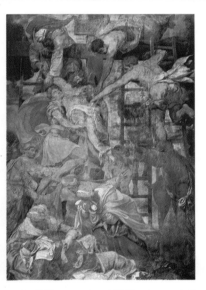

rected towards a resolution of the composition;
then an oil-study, sometimes very fully worked
out, as is that for *The Descent* (this was prob-
ably submitted to the client for preliminary ap-
proval); then a reference back to detailed chalk
studies from the life; and finally the execution
of the full-scale painting itself. The imagery is
rich in references not only to Italian masters
but also to classical motifs – St Christopher
clearly echoes "*The Farnese Hercules*" (see
p. 41) with his club, while the pose of the dead
Christ reflects closely (in reverse) that of the
late Hellenistic statue of *Laocoön*.

When Rubens' pictures were finished, the
studio often produced replicas, and through
engravings the design was broadcast to a far
wider audience. From an engraving of *The
Descent*, Gainsborough – to take an example –
made a free copy in oils, and then, fascinated
by its formal rhythms, transposed it into the
merry bucolic group on the cart in *The harvest
wagon* (not shown), one of his best landscapes.

RUBENS (above)
Drawing of the *Laocoön*,
c. 1606
Rubens' sketches of the
works of art he had seen
in Italy were an abiding
inspiration – he used them
rather as Rembrandt used
his hundreds of drawings
from the life. Rubens was
a superb draughtsman, and
often infused his drawings
with greater vividness than
the original (p. 46) had.

RUBENS (right)
Copy after Caravaggio's
The Entombment, c. 1605,
reworked c. 1613
When he reworked the copy
of Caravaggio he had made
in Italy, Rubens probably
had in mind the design of
his own *Descent*. He has
heightened the luminosity
of Christ's white body, and
introduced more sorrowful
feeling into Caravaggio's
rather aggressive realism.

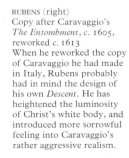

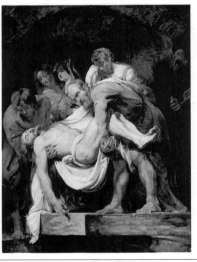

Art in England

English painting had its roots in the residence in London during the 1530s of the Swiss-German painter Hans Holbein the Younger. He founded no school, and after his death in 1543 inspired no successors in quite the same Renaissance tradition. To fill his place came painters such as Hans Eworth (*c.* 1520- after 1573) from the Netherlands, who practised the international Mannerist style of court portraiture – after the example of Anthonis Mor (see p. 174) rather than that of Bronzino.

In the latter half of the sixteenth century, when, in Elizabeth I's reign, Protestantism was re-established, painting was virtually confined to portraiture. Its peculiarly English development was towards the stiff, linear and hieratic, and it reached its zenith in the miniatures of the native-born Nicholas Hilliard (1547-1619) and of his follower, the refugee French Huguenot Isaac Oliver (before 1568-1617; not shown). In miniatures of a jewel-like brilliance, Hilliard achieved a delightful balance between symbolism, allegory and individual characterization. On a larger scale, a pedestrian kind of formal portraiture – faces surmounting stiff, upright costumes, set in airless niches – persisted into the first quarter of the seventeenth century. Even the more naturalistic portraits by further Netherlandish immigrants were still very sober.

Charles I, who succeeded to the throne in 1625, changed all this. He had travelled in Europe, and was a sophisticated patron whose collection of Renaissance art, chosen largely by himself, rivalled anything in Europe. In 1630 he commissioned Rubens to decorate his classical Banqueting House, built eight years before. Failing to persuade Rubens to stay, Charles welcomed van Dyck (see p. 200) in 1632 like a prince – knighting him, bestowing gifts, a house, an income. Anthony van Dyck was crucial to Charles: his portraits were designed to support the King in his claim to be absolute monarch (a claim which he, unlike Louis XIV, failed to establish). Charles was celebrated in varying aspects of his kingly role: sumptuous in coronation robes; as the ideal gentleman engaged in country pursuits; as a knight and warrior, the chivalric defender of his people. Other artists painted Charles, too, but it is van Dyck's image of this melancholic, doomed King that is enshrined in history; no one else could conjure such romance and poetic elegance out of Charles' slightly unpre-

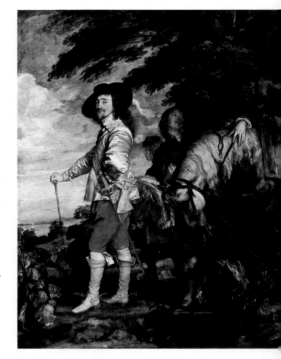

EWORTH (right)
Queen Mary I, 1554
Eworth's unpretentious but perfectly competent likeness typifies the state of English portraiture before van Dyck's arrival.

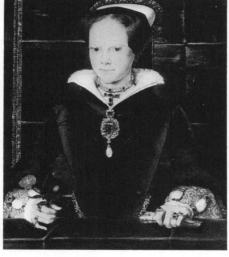

HILLIARD (below)
Young man in a garden, *c.* 1588
The lovelorn youth – his condition is explained in an inscription – exhibits the elegant melancholy of an Elizabethan sonnet. Symbolic thorns and blossoms enclose his slender figure in delicate tracery.

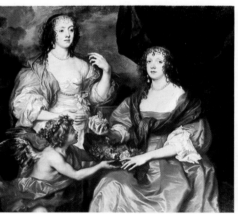

VAN DYCK (above)
Charles I hunting, *c.* 1638
In Protestant England van Dyck was unable to use allegorical personifications to indicate the qualities of his sitter. He managed, however, to suggest kingly ideals by subtler means.

VAN DYCK (left)
Lady Elizabeth Thimbleby and Dorothy, Viscountess Andover, *c.* 1637
Such languid elegance and sleepy *hauteur*, such a play of brilliant light upon the drapery – English artists were still recasting the spells of van Dyck's art in the early 20th century.

VAN DYCK (right)
Charles I on horseback, *c.* 1638
Titian (see p. 143) and Rubens (see p. 410) had restated the theme of the equestrian ruler, and van Dyck portrayed Charles I in conscious emulation. The life-size picture was hung at the end of a long room, and created the impression of an extended vista into an ideal English park, with old English oaks, in which the King awaited the spectator's homage.

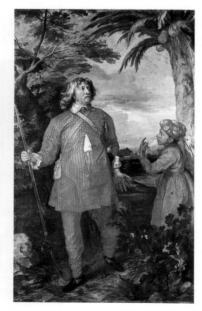

VAN DYCK (left)
William Fielding, Earl of Denbigh, *c.* 1633
Since van Dyck's portrait commemorated the Earl's return from India, he is shown wearing Indian silk pyjamas, attended by an oriental servant; he steps forward with the vigour of an explorer. The splendid costumes of van Dyck's sitters were often no more part of normal wear than the Earl's exotic garments.

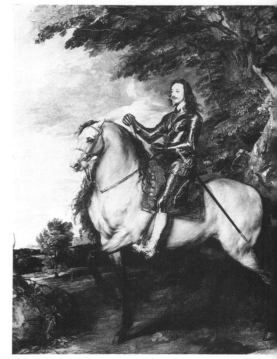

possessing figure. There is a story that van Dyck's portrait of Charles' head, painted to serve Bernini as a model for a bust, moved the devotedly royalist Italian to tears by its aura of tragedy to come – the King was executed by Parliament in 1649.

Meanwhile Charles' courtiers were dazzled by van Dyck's revelation of what the new Baroque vision could do for their prosaic persons. Employing his profound knowledge of his first master, Rubens, and of the great Italians, especially Titian, whose work he could study anew in Charles' collection, van Dyck achieved an easy fluency and rich brilliance hitherto unimagined in England. A breathing air floods the picture space; bodies formerly fixed in a rigid stance relax, caught in balance between one movement and the next; stiff Jacobean costume melts in coloured cascades of broken light, silks, soft leathers, satins. Van Dyck imported and established a tradition of portraiture that was to dominate English painting for more than two centuries. However, he also established Rubens' studio production methods, with assistants working not only on replicas but on first versions, so that the quality of his overall output is uneven.

Van Dyck died just before the outbreak of the Civil War that, in the 1640s, destroyed the royal autocracy and ultimately the King himself. The artistic patronage of the victorious rebels was minimal; Robert Walker (c. 1605-after 1656; not shown), an indifferent artist, portrayed the Parliamentarians, using van Dyck's poses because, he said, being the best, they relieved him of the necessity of inventing new ones. However, in the work of William Dobson (1610-46), who painted the embattled Royalists, there can be seen a brief but remarkable native development of van Dyck's Baroque – a robust, individual vision that drew perhaps even more on Venetian painting. In the very English art of miniature a genius emerged, Samuel Cooper (1609-72), whose fascination with the idiosyncracies of the human face was reconciled to a strong decorative rhythm – "the van Dyck in little".

With the Restoration in 1660, the mantle of van Dyck passed to the Dutch-born Sir Peter Lely (1618-80) who, again with the aid of a highly organized studio, dominated the English scene until his death. His style developed van Dyck's in a more robust but less refined mode, admirably suited to the coarser, more self-indulgent manners and morals of the Restoration court, and to the well-fleshed attractions of Charles II's mistresses.

Lely was followed as court painter by the German immigrant Sir Godfrey Kneller (1646-1723), who painted the portraits of seven British monarchs (also of Louis XIV and of Peter the Great of Russia). His studio was still larger and more mechanized than Lely's, but at its best his own fluent and muscular brush could organize the wigs and draperies of the period into splendid ensembles, equal in quality to the portraits of Maratta in Rome or Largillière in France (see pp. 234 and 242).

In the second half of the century, a foundation for genre and landscape painting was laid. Francis Barlow (1626-1704), a naive but charming painter of wild life, was a native exception among immigrant Dutchmen painting landscapes and battles, most notably the van de Veldes (see p. 223), marine painters of seminal importance. Van Dyck towers over the age – "We shall all go to Heaven", Gainsborough was to say on his deathbed, "and van Dyck is of the company" – but these artists, too, were an important prelude to the Golden Age of English painting.

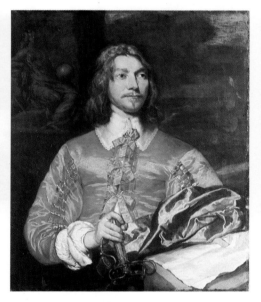

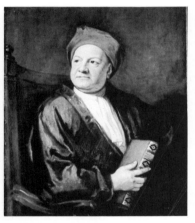

VAN DYCK (above)
Charles I from three angles, c.1636
Van Dyck succeeded in transfiguring Charles' features without altering their literal appearance. Even so, Charles' large nose is not so prominent in other portraits. Bernini's bust, for which van Dyck's picture was a guide, is lost.

KNELLER (above)
Jacob Tonson, c.1717
Kneller's most famous works are his portraits of the members of the Kit-Cat club, the unofficial forum of Whig political and literary dissent. The portrait of Tonson, who commissioned the series, shows Kneller's splendid, sturdy grasp of character.

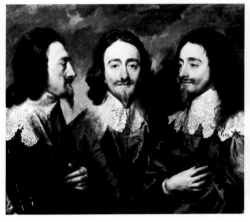

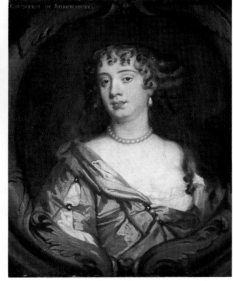

DOBSON (above)
A cavalier, c.1643
Dobson could hardly avoid the influence of van Dyck, but his portraits show an independent alertness, a forceful characterization and vivid colour contrasts new in English art. He was the most distinguished English painter between Hilliard and Hogarth.

LELY (left)
Anna, Countess of Shrewsbury, c.1670
The Countess was one of the more notorious of Charles II's mistresses. Lely's portraits, clearly deriving from van Dyck, are bolder, cruder, more direct. The textures of his draperies have none of the morning freshness of van Dyck's; they flicker with an afternoon light.

COOPER (above)
Oliver Cromwell, 1656
Having recorded Charles' vanquisher "warts and all" as he demanded, Cooper later painted miniatures of Charles II. His prices and international prestige were the equal of Lely's.

BARLOW (above)
Buzzards about to attack some owlets, undated
Barlow, known in his day as "the famous painter of fowls, beasts and birds", was the father of a long line of sporting painters.

Art in Spain

The flaming vision of El Greco has dazzled the imagination of posterity to the exclusion of all other late sixteenth-century painters in Spain, yet El Greco, for all his appeal to a mystic passion in the Spanish soul, was not only a foreigner but untypical. In the native character, the mystic strain was offset by a relish for physical detail, a delight in intense realism. The Church, in combative mood, took pride in the example of her visionaries and martyrs – but also in their sometimes hideously gory sufferings. Spanish dignity, her pride in her faith, her Empire and her nobility, so evident in the portraiture of the period, could easily erupt into sometimes ferocious passion.

By the time El Greco died, in 1614, Toledo had ceased to be the capital of Castile and Spain; the court was settled in Madrid, and other cities, too, had developed and prospered. Early in the century painting flourished especially in two centres, Valencia and Seville. Francisco Ribalta (1565-1628) in Valencia developed an early Spanish Baroque, influenced by Titian in technique but powered also by the enduring involvement of Spanish painters with the drama of light and shade first revealed by Caravaggio. Jusepe de Ribera

(1591-1652), believed to be Ribalta's pupil, settled in 1616 in Naples, then still a Spanish colony, where Caravaggio had been active only a short time before. His early work there is intensely Caravaggesque: sharply focused light lingers on vivid detail against a dark ground (hence the Spanish term, *tenebrismo*), and is used to portray with minute realism low-life and sometimes grotesque subjects (such as *The bearded woman* suckling her child).

The style of Ribera's middle maturity was more balanced, the contrasts of light and dark less fierce, but his painting lost nothing in immediacy. The predominance of martyr-

doms in his work tends to be exaggerated, but his most famous painting is *The martyrdom of St Bartholomew* of the 1630s, typifying the feeling aroused by the Counter-Reformation in Spain; the spectator is compelled into an emotional participation with the subject, by the coarse, heaving executioners, the sharply observed crowd, the tensions of the saint's naked body. All this is centred on the saint's heavenward gaze, appealing to God almost with despair. Later Ribera's colours lighten, and paintings such as *The mystic marriage of St Catherine* are suffused with a spirituality now of lyrical tenderness. Ribera was gifted with a

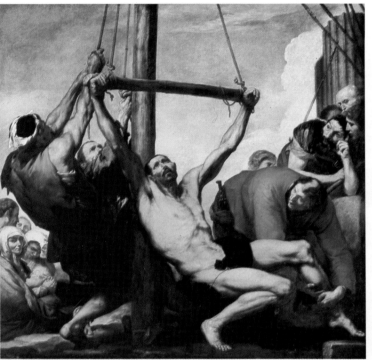

MENA (above)
Mary Magdalen, 1644
Mena excelled in carving grief or mystical passion with controlled intensity. The expressive head of his painted wood *Magdalen* is accentuated by her hand, so tautly spread, so penitent.

RIBALTA (above)
St Bernard embracing Christ, c. 1620-28
Ribalta was more than a mere *Caravaggisto*: he used Caravaggio's lighting to lend a sculptural monumentality to his figures. The composition is simple, the realism – despite the visionary content – strong.

RIBERA (above)
The martyrdom of St Bartholomew, c. 1630
The flaying of the saint has not yet begun, but all its agony is already felt in the unbalanced distortion of his body and the efforts of his tormentors. In sheer violence Ribera passes both Caravaggio and Rubens.

RIBERA (below)
The mystic marriage of St Catherine, 1648
Ribera's late work is all serene and spiritual: his early emphatic chiaroscuro has yielded to light and air. His figures are less tightly drawn, his colour is more luminous, his brushwork is freer and more fluid.

RIBERA (right)
The bearded woman, 1631
The inscription hails a great wonder of Nature, and, though the subject is grotesque, the approach is respectful. Caravaggio had used strong chiaroscuro to dramatize action: the Spanish also employed it to add monumental force to entirely static subjects.

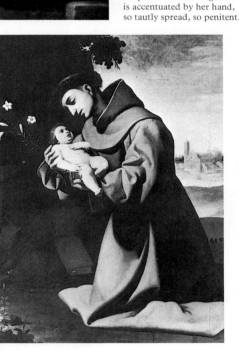

ZURBARAN
St Anthony of Padua with the infant Christ, 1650s
The soft atmospheric light, the delicate modelling, the

predominant browns and greys date the picture to the 1650s. The formidable simplicity of Zurbarán's art has lost its full starkness.

remarkable sureness of touch, and he developed a very swift technique, working directly on to the canvas – *alla prima*.

The most steadfast exponent of Spanish *tenebrismo* was Francisco Zurbarán (1598-1664). He spent most of his active life in Seville, where he early on established a friendship with Velazquez. His commissions came mostly from monks, and were on monastic themes: he responded with simple, imposing images – of monks in prayer or saints in adoration – boldly, powerfully, sculpturally modelled. Most stunning perhaps is the series he painted for the Convent of Guadalupe (1638-39, not shown); in a typically Spanish way his pictures express intense spiritual emotion in very physical terms, and are best compared to the polychrome wood sculptures of Zurbarán's contemporaries Martinez Montañés or Pedro de Mena (1627-88). Their theatrical realism was the sculptural equivalent of processions and festivals in which the sufferings of Christ or of martyrs were enthusiastically enacted, and their influence persisted for centuries in popular religious art.

Zurbarán's secular commissions were few, the most important being for ten great canvases on *The Labours of Hercules* from Philip IV, but a series of still lifes is attributed to him: these pots, dishes and fruit take on an almost sacred aura in the searching light that brings them into being out of the surrounding darkness. They recall similar elements in Velazquez's early work and represent at its best a continuing tradition in Spanish art.

Zurbarán was overshadowed towards the end of his life by Murillo, and his style softened slightly, perhaps under his influence. Bartolomé Esteban Murillo (1617/8-82) also worked almost entirely in Seville, at first in the dominant *tenebrismo*, but moving towards a much lighter, more open and freer style, modified again by Flemish and Venetian influence after study of the royal collections on a visit to Madrid in 1655. He not only painted religious subjects, but also developed a form of genre, carrying on the tradition of low-life pictures founded by northern artists working earlier in Rome. His many pictures of *Urchins*, usually ragged and poor, are characterized with a lively tenderness that captivated eighteenth- and nineteenth-century sensibilities, and made them some of the most highly priced paintings in the world – only to be dismissed (unjustly) by the twentieth century as sentimental. Sentiment indeed they have, but the masterly command of line, colour and composition is not weakened by coyness or mawkishness. Murillo's mature religious work shows great delicacy and fluency, and his many ethereal variations on the theme of *The Immaculate Conception* seem almost Rococo (the Spanish term is *estilo vaporoso*); they have also a sweetness which turned saccharine in the hands of innumerable copyists and imitators.

In 1660 Murillo founded, with others, the Seville Academy of Painting. Among his colleagues, Juan de Valdés Leal (1622-90) was perhaps the last of the great Spanish Baroque painters. He was trained in Cordova but was active most of his life in Seville. His early work is firmly in the *tenebrismo* tradition; in his mature style he deployed vigorous brushwork to achieve an intense emotional impact. His colour was often dramatic but sometimes very sombre, as was only fitting in his series on *Death and Judgment*. He sometimes verged on the grotesque, at the opposite pole to his colleague Murillo, and equally far removed from the magisterial control of the greatest Spanish painter of them all, Velazquez.

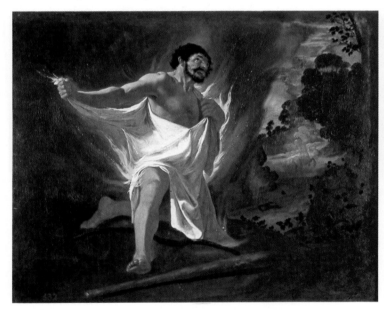

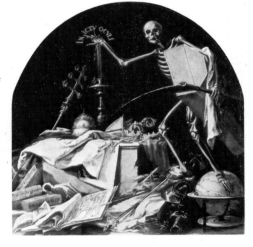

ZURBARAN? (above)
Still life, c. 1664?
Zurbarán seems the artist most likely to have painted such an austere, simple and yet mysterious evocation of quite ordinary objects. At Guadalupe he made still life an intense supplement to the mood of the narrative.

ZURBARAN (above)
Hercules seared by the poisoned robe, 1634
The dying Hercules writhes in torment, poisoned by the blood of the centaur Nessus. *The Labours of Hercules* series was designed to be placed high above windows, but does this explain why the scene should take place at night? It was perhaps rather the artist's delight in the effects of *tenebrismo*.

MURILLO (right)
Boys playing dice, undated
The frequency with which Murillo's engaging ragamuffins have been reproduced has lessened the impact of their exciting colour harmonies and finely modelled forms, painted in a deft *alla prima* technique.

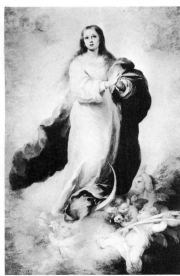

MURILLO (left)
The Immaculate Conception, c. 1655-60
The adolescent Virgin has a beauty at once serene and humble. The subtle drawing of her ascending figure, the rich broad blue of her mantle on its gently balanced diagonal, make this, among Murillo's many versions of the subject, one of the most attractive.

VALDES LEAL (above)
The triumph of Death, 1672
A quite unambiguous moral, gruesome chaos and violent religiosity pervade this whole allegorical series, painted for a hospital. Here Death extinguishes Life's flame. Mounds upon mounds of superbly painted still life describe the range of human activity to which Death puts a horrible end.

Velazquez: Las Meninas

Diego Rodríguez de Silva y Velásquez (1599-1660) was trained and began his independent career in Seville, painting mainly still lifes and scenes of peasants, who sometimes play a part in a religious story. His early works exhibit the Caravaggesque influence dominant in Spain, without the emphatic tonal contrasts of such *tenebrismo* painters as Zurbarán.

Almost abruptly, in 1623, he became court painter in Madrid, and thereafter until his death his prime concern was portraiture. He admired Rubens (who with characteristic generosity seems to have persuaded him to go to Italy in 1629-31), and was the exact contemporary of van Dyck and of Bernini, yet his portraiture in its sobriety is the antithesis of their Baroque rhetoric and elaboration. Velazquez extracted the essence of aristocracy – or, for that matter, of childhood or dwarfdom – in simplicity and dignity. He worked directly on to the canvas, usually, it seems, without preliminary drawings, realizing the physical form of his subject not so much in rhythmic line (as Rubens did) as by an immensely subtle tonal analysis in little touches – observe the smallness of the brushes on his palette in *"Las Meninas"*. His art is one of meditative observation rather than of overt expression or energetic composition – he admired Titian, but apparently actively disliked Raphael.

He himself summarized the complexity of his art in his famous *"Las Meninas"* (The maids of honour, finished in 1656). Here, seemingly, we have the painter at work in his studio, which has been invaded by the little Infanta (momentarily poised for admiration) with her suite – her attendant maids and her dwarf, who echoes the royal child so grotesquely, and a great dog. At the far end of the room, an enigmatic figure turned against a flare of light looks back as he mounts the stairs beyond an open door. Beside this figure are the framed images, shadowy and silvery, of the King and Queen, with two large paintings hung above. Each and every one is solidly there, established unerringly back from the foreground light into the shadowed depths of the great room, set in pyramid groupings interlocking across the surface. *"Las Meninas"* was once known as *The family*, and seems to be an assertion of the artist's pride and right of place in the royal hierarchy. But if you ask what is on the front of the huge canvas he is painting, or where the King and Queen in the mirror are standing, then the picture reveals ever richer ambiguities, in subject matter as in formal construction.

"Las Meninas" owes much to Velazquez's second stay in Italy, 1649-51, which forged his mature style. Freshly inspired by Venetian painting, he reached a new command of singing colour and a brilliant, liquid handling revealed in the portrait he made in Rome of Pope Innocent X (reproduced on p. 482) or in another set piece, probably painted before *"Las Meninas"*, The tapestry weavers, which again has layers of meaning.

Manet and the Impressionists would be fascinated by the way in which Velazquez could catch with unerring accuracy not the mere physical substance, say the hairs of a dog, literally recounted, but the essence of its appearance in light, its gleam in the eye.

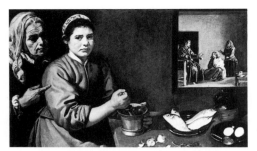

VELAZQUEZ (left)
Christ in the house of Martha and Mary, 1618
The figures and objects are observed with close intensity in strong light, but even in this early genre scene Velazquez was already conjuring with his subject matter, with small but vital ambiguities: is the background scene a picture on the wall or a glimpse through to a second room? The serious and enigmatic expression of the younger woman and the clear gesture of the older – echoing that of Martha in the scene behind – suggest that this is a meditation by two servants on a Gospel story intimately related to their calling. The objects may then take on symbolic meaning, and the work is deepened, enriched.

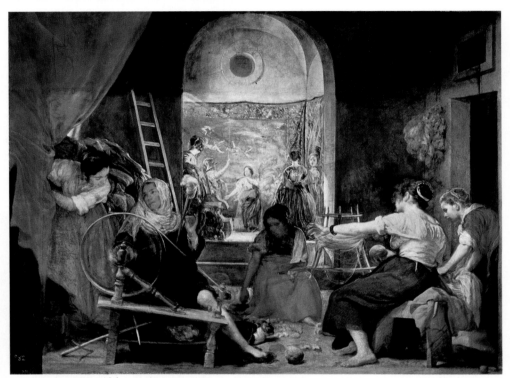

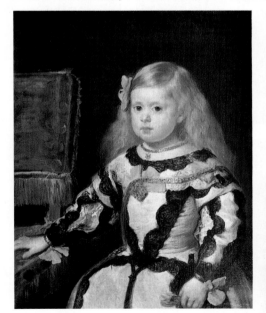

VELAZQUEZ (above)
The Infanta Margarita, c. 1656
The portrait of the little royal princess who is seen again in *"Las Meninas"*, painted at about the same time, shows a similar pose without repetition: the fall of light and the textures are observed entirely afresh. It is easy to see how much Velazquez could offer the Impressionists – the bold pattern, the liquid purity and truthfulness of colour.

VELAZQUEZ (above)
The tapestry weavers, c. 1654
Beneath the realism of the picture (in his rendering of the spinning-wheel's blurred spokes Velazquez anticipates photography) there is a tacit reference to the myth of Arachne, who boasted her spinning was the equal even of the goddess Athena's. Note the interplay of separately lit spaces, and the movement.

VELAZQUEZ (below)
Philip IV, 1634-35
Like Rubens, like van Dyck, Velazquez based his royal portraits on Titian's prototypes – there were many Titians in the Spanish royal collection. Velazquez's less flamboyant portraiture expresses much the same ideal of a Baroque monarch as do his great contemporaries – splendour and decorum achieved with perfectly relaxed ease.

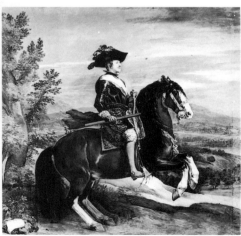

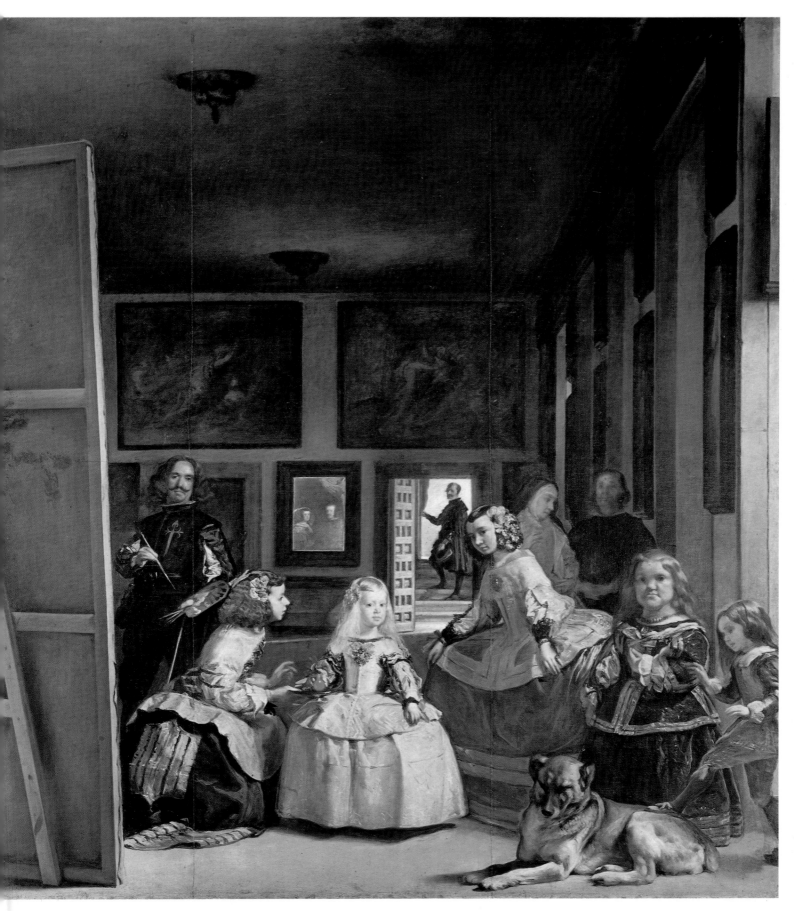

VELAZQUEZ: "*Las Meninas*" (The maids of honour), 1656

Art in the Dutch Republic

In 1555 the 17 provinces comprising the Netherlands had been made over by the Emperor Charles V to his son Philip II, King of Spain. Soon afterwards a bitter struggle for independence from Spanish dominion began, and by the Twelve Years Truce of 1609 the seven provinces that lay north of the great river estuaries (modern Holland) achieved their religious and political – Protestant and democratic – freedom. The other provinces, as Flanders, remained Catholic under the autocratic Spanish rule, and ultimately became modern Belgium. One painter stands for Flemish art in the seventeenth century – Rubens. He had a counterpart of equal if not greater stature in Holland – Rembrandt. Yet Rembrandt, though so universal a painter, cast no such spell over his contemporaries in Holland as Rubens did in Flanders. Although the art of both regions had its roots in early Netherlandish painting, the development of each was very different, and Dutch art was of astonishing variety.

Political and economic factors in Holland do not explain the sudden emergence of so many painters of the highest talent (and some of genius) but obviously they conditioned it in some measure. The great achievements of Dutch art were not for court or Church, but for a primarily bourgeois and secular clientèle. Protestantism, especially the radical Calvinist kind predominant in Holland, permitted no images in churches; there was no hereditary aristocracy with great estates and palatial houses, and the patronage of the House of Orange at The Hague was relatively modest. The new patrons were the people, a phenomenon that astonished visitors to the country. "As for the art of painting", recorded an English traveller in Amsterdam in 1640, "and the affection of the people to Pictures, I think none other go beyond them ... all in general striving to adorn their houses, especially the outer or street room, with costly pieces. Butchers and bakers are not much inferior in their shops, which are fairly set forth: yea, many times, blacksmiths, cobblers etc. will have some picture or other by their forge and in their stall. Such is the general notion, inclination and delight that this country's natives have to painting."

Dutchmen earned the money to do this kind of shopping in a commercial boom supported by the great success of Dutch maritime en-

REMBRANDT
Two women teaching a child to walk, c. 1637
Realism is the keynote of Dutch art. While Rubens in Flanders founded his art on classical principles and ideal forms, Rembrandt in Holland refused to go south, or to compromise his own vision for Italianate idiom. Rembrandt used sketches from the life almost as Rubens used a figure from a Renaissance masterpiece. Here Rembrandt catches in a few strokes the child's apprehension, and the two women's different attitudes, ages and physical strengths.

SAENREDAM (right)
St John's Church, Haarlem, 1645
Saenredam was a leading specialist in architectural painting (see p. 222). The north aisle in the picture shows the plain, bare walls typical of Dutch Protestant churches, in which art no longer had a place or function.

HOOGSTRATEN (below)
The slippers, c. 1660-75
Samuel van Hoogstraten (1627-78) had been a pupil of Rembrandt's, then spent a peripatetic career. This work shows clearly Delft influence – from Vermeer or Fabritius (see p. 228). His comfortable Dutch interior has two "cabinet" pictures, quite large of their kind. But he portrays more than a room: the slippers and keys hint at love and courting. Such symbolism is frequent in Dutch art.

VAN DE CAPPELLE (above)
The large ferry, 1660s
Van de Cappelle's career underlines the bourgeois nature of art in Holland. He was by profession a dyer, and rich: he bought Rubens, van Dyck and Rembrandt. He painted as a hobby, and sketched for his paintings (see p. 223) from his pleasure yacht.

REMBRANDT (left)
The syndics of the Cloth Guild, 1662
The historian van Gelder commented that "five *staalmeesters*, of four different religious beliefs, in brotherly unity round a table, are a typical symbol of the power, commerce and tolerance" of the Dutch Republic. The painting is a masterpiece to rival any in the world.

deavour. As they bought for their own houses, they needed generally small-scale works; they preferred a subject matter that lay in the realm of everyday experience and reflected their own interests – those of a consumer society. They delighted in art as the "mirror of Nature" – that northern naturalism firmly established by the van Eycks and so despised by Michelangelo in Italy. They were answered by a brilliantly faithful portraiture – not only of themselves but of all aspects of life: the countryside; their streets and buildings; their ships and boats; their homes and all their contents; succulent inventories of fruit and meat; flowers, even utensils or articles of clothing; including also the *drôleries* of life, in scenes of taverns and brothels. The side of life not seen, as it had been in Bruegel, was work.

To meet the demand, artists became specialists, concentrating on one branch of art, often repeating their more successful compositions. A marketing system that was the forerunner of the modern art market emerged. Painters could sell at fairs or from their own studios, but the trade of picture-dealing was also established, many painters doubling as dealers. For many, painting was only one

means of livelihood, only one commercial outlet: the prolific landscapist van Goyen, for instance, speculated in the land he painted and (in the great tulip mania) in the tulips that grew on it; perhaps the favourite alternative occupation of artists was tavern-keeping. Many went bankrupt, though others prospered.

The two centres in which the Golden Age of Dutch painting was announced, in the first two decades of the seventeenth century, were Haarlem and Utrecht. At Haarlem local painters discerned with fresh eyes a local landscape as a subject worthy in its own right, and also the pictorial possibilities of the boisterous life of the taverns and brothels. These they exploited with a gusto of movement, a virtuosity of brushwork like that of Frans Hals, who portrayed the new patrons in the town – merchants, teachers and civic dignitaries.

Catholic Utrecht was different. Its artists were mainly oriented to Italy – the landscapists to its sunshine and to its classical associations, others, notably Gerrit van Honthorst (1590-1656) and Hendrick Terbrugghen (1588-1629; not shown), particularly to the discoveries of Caravaggio. They both went to Italy, and brought back a style delighting in the dramatic

effects of forced lighting, together with a fascination for the detail of rich materials and flesh, and for low-life subjects. Their interest in optical effects (Holland was the centre of scientific optical experiment at this time) was to be absorbed by Vermeer and refined from their often vulgar drama into the quiet silences of his unique world. Honthorst was really a cosmopolitan artist; he was a Catholic all his life (which was not in fact unusual in Holland or amongst painters there) and worked for Charles I in England before he became court painter to the House of Orange in The Hague. He specialized in quite sharply observed, rather stiff portraits, very far removed from the easy bravura of Hals or the psychological penetration of Rembrandt.

All Dutch towns of any size – Delft, Dordrecht, Alkmaar, Leyden, The Hague, Amsterdam – had their own painting industry. No one town was the capital of Dutch art. In each, strongly individual traditions and corporate prides persisted. Yet common to them all was fascination with the material substance of life; common to them also was an underlying affinity with the formal discoveries of the Baroque movement, stemming from Italy.

REMBRANDT (left)
Four orientals beneath a tree, c. 1655
The trade with the East that was an important part of Dutch prosperity also brought Mughal miniatures to Europe, and Rembrandt copied more than 20. This one formed the basis of his etching *Abraham entertaining the angels,* 1656.

LASTMAN (right)
Juno discovering Jupiter with Io, 1618
Jupiter had metamorphosed Io into a cow in an attempt to disguise his adultery. Lastman, one of the best exponents of the Italianate "history" painting favoured by court circles in Holland, was Rembrandt's teacher.

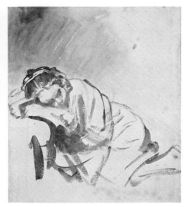

REMBRANDT
A girl sleeping, c. 1656
The intimacy is very much Rembrandt's own, but the naturalism and spontaneity are features of Baroque art throughout Europe. The pose is from the life, and yet behind it is a profound knowledge of artistic tradition, both northern and southern.

HONTHORST (above)
The banquet, 1620
This is one of the last pictures Honthorst painted in Italy, where he made his name painting night scenes. Silhouetting a figure in the foreground became a trick of the young Rembrandt.

HONTHORST (right)
William of Orange, after 1637
The pillar and the parapet are obvious props, and the whole approach is stolidly traditional. The absence of any drama was due as much to the patron as the artist.

Hals: A Banquet of the St George Civic Guard

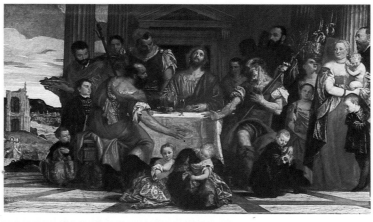

VERONESE (right)
The feast at Cana,
1559-60
Rubens, van Dyck and
Velazquez had all drawn
inspiration from the great
Venetians, and if Hals
had sought a precedent
for his banqueting groups
he could have found no
better than Veronese's.
Engravings of his works
would certainly have been
available, suggesting more
sophisticated means than
could earlier Dutch art
of unifying complex and
crowded compositions.

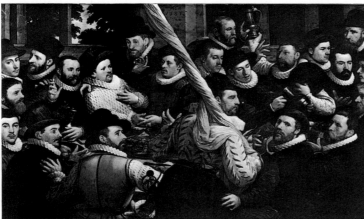

CORNELIS VAN HAARLEM
(left) *The banquet of
Haarlem guardsmen,* 1583
Cornelis has introduced
variety, but the twists
and turns of the figures
add up to no concerted
unity. The traditional
elements which Hals was
to transform are clear.

FRANS HALS (below)
*The banquet of the St
George Civic Guard,* 1616
There are clear lines of
direction articulating the
whole, and the officers are
convincingly grouped in
starts of movement or in
natural conversation.

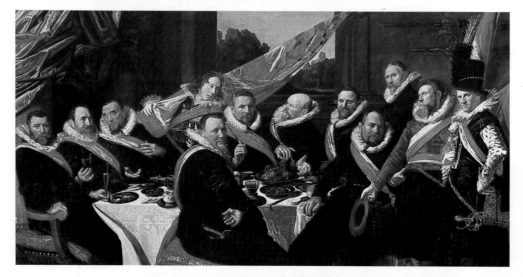

FRANS HALS (right)
*The regents of the St
Elizabeth Hospital, c.* 1641
The restricted colours,
the subdued mood and the
isolation of the figures
are characteristic of the
painter's late style. It
was to culminate, in the
portraits Hals painted
in his 80s, in canvases
constructed virtually
in monochrome, except
for a few colour accents.
Though his exuberance
vanished, Hals never lost
his touch, and he painted
freely and boldly, with
ever increasing directness,
until his penniless death.

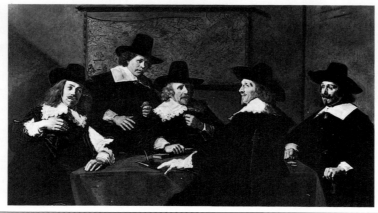

The work of Frans Hals (*c.* 1581/85-1666) is
one of the inexplicable miracles of the great
surge of Dutch painting in the seventeenth
century. Hals was Flemish-born (which per-
haps explains something of his bravura) but
spent virtually his whole life in the small town
of Haarlem, painting the locals. The sparse
records of his career – a series of financial,
domestic and legal disasters – indicate a
failure to cope with life entirely at odds with
the exultant vigour and spontaneity of his art.

Hals worked almost entirely in portraiture;
even his genre subjects read as portraits. Hals –
though it took centuries for this to be fully
realized – turned mere likenesses into great
pictures. His particular genius was not for
"psychological insight" but the ability to cap-
ture the individual presence of his sitters and
almost fling them alive on to the canvas. This
he achieved by a swift, very free technique:
working often with a restricted palette, he
modelled, not by rounding off and smoothing
out, but by a sequence of dabs, dashes and
slashes that close-to can look haphazard, but
then at a distance cohere into images vibrant
with life. No drawings can be firmly attributed
to him – he worked directly on to the canvas.

Hals' instantaneous technique and im-
mediacy of effect make the unerring control
and organization of his compositions all the
more incredible. Everything is subordinate to
the impact of the whole image. Consider the
famous "*Laughing Cavalier*". What lingers in
the memory is that not altogether explicit
smile, yet the costume and all its detail is a
marvel of laundering. Nowhere is Hals' spon-
taneous orchestration of detail better shown
than in the great group portraits – Hals, as
Vincent van Gogh remarked, "painted a
whole glorious republic".

The group portrait of civic bodies was a
Dutch speciality, beginning well back in the
sixteenth century with stiff rows of individual
heads. Cornelis van Haarlem (1562-1638) had
succeeded in enlivening their composition,
but it was Hals alone who could catch alive
the brash, brilliant, vulgar ostentation of the
Civic Guards at their junketing. The Civic
Guards clung dearly to their memories of
heroic resistance against the Spanish, but by
1616, when Hals painted his first group, their
gatherings were more like the outings of a
social club than military parades; although
martial dress, banners and equipment were
splendidly displayed, the main focus of their
meetings was food and drink – consumed in
indefinite banquets (the authorities tried to
reduce them from a week to three days).

Hals painted the Company of St George at
Haarlem three times, in 1616, in about 1627
and finally (not shown) in 1639. The 1627
composition is the most splendid: it is resolved
into two groups, linked by the flash of the
furled flag and by the marvellous invention of
the genial and tipsy captain turning his glass
upside down in the right centre. There is an
explosion of colour against the purplish cur-
tain in the background – a surf of blues, whites,
reds, yellows and greens. Amidst it all each
participant is sharply individual. It is a truly
Baroque composition – the swirl, the emphatic
diagonals; the direct technique, the colour and
excitement; the naturalism and illusionism.

FRANS HALS (left)
"*The Laughing Cavalier*",
1624
Only Velazquez can rival
Hals for brushwork that
seems to live a life of its
own on the canvas. Yet
the figure is solid: the
elbow seems to jut out,
and the torso to pivot
against the background.

FRANS HALS (right)
Willem Croes, c. 1660
In his later paintings
Hals avoided complexity
of pose or brilliance of
colour, and the presence of
the sitter emerges the more
forcefully and frankly.

FRANS HALS (below)
*The banquet of the St
George Civic Guard,
c.* 1627
Each officer has more
character, and the whole
has a greater ease and
more natural variety than
had the earlier *St George*
group portrait. There the
interruption of the spec-
tator is clearly felt; here
there seems to be too much
din, the officers seem too
involved in their feasting
to pay much attention.

Rembrandt van Rijn

Rembrandt Harmensz. van Rijn (1606-69) is almost a separate dimension in Dutch art. His influence was felt in nearly every branch of it, and has recurred inexhaustibly in the history of art ever since. Though the broad outlines of his life are known, there are few informative details: Rembrandt himself, however, charted the moods of his career with extraordinary frankness in an unprecedented series of more than 100 *Self-portraits* (see over).

Rembrandt's early work in Leyden reflects his first master, the Amsterdam painter Pieter Lastman (see p. 213). Through him he learnt the general principles of Italian Baroque painting, especially of Caravaggio, and also of Elsheimer, which had been filtered back to Holland by the Utrecht painters. It was perhaps also Lastman who inspired the young artist to aim for the highest values in painting, attainable, according to the opinion of that time, only in "history" painting (that is, in epic, mythological or religious works). Although Rembrandt in particular was to demonstrate that these values could be revealed in any branch of art, his obsession with moral themes endured throughout his career.

His early work is dramatic, with stressed diagonals, sharp recessions, contrasts of light and shade (these are sometimes very fierce) and also hard, clear contours. His heroic characters, however, dressed in contemporary costume, sometimes as peasants, are even less idealized than Caravaggio's – even today some of his early pictures seem provocatively vulgar. For Rembrandt the Bible was a story of then, now and for ever: he was profoundly religious (in later life he became an adherent of a radical Protestant sect, the Mennonites) and his religion was profoundly rooted in real life. Rembrandt's insistence on truth – in nudes, genre, biblical scenes (often indistinguishable from genre scenes) and portraits – persisted throughout his life; his power to marry naturalism into majestic compositions of subtle design and sometimes transcendental power developed continuously. His naturalism was offset – maybe even deliberately counterpointed – by a delight in clothing groups or single figures in picturesque or romantic costume, or portraying them in dual roles, so that an epic subject, a saint or an historical figure, is also clearly a literal portrait.

By the 1630s, having moved to Amsterdam, the principal city of Holland, in 1631-32, Rem-

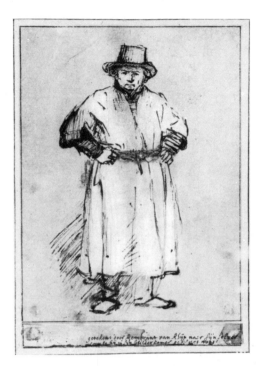

REMBRANDT (above)
Self-portrait in studio attire, c.1650-60
More than 50 pupils once in Rembrandt's studio have been identified by name; and they disseminated his style. His art was highly personal, but Rembrandt apparently needed constantly to teach.

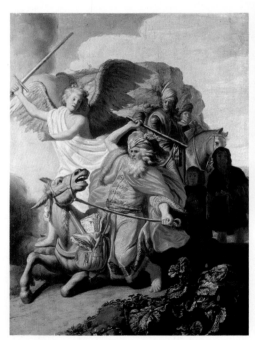

REMBRANDT (left)
Balaam, 1626
Balaam's ass halted at the sight of an angel Balaam could not see. Rembrandt's composition exaggerates an earlier one by Lastman. The richly cloaked Balaam typifies Rembrandt's love of ostentatious paintwork.

REMBRANDT (right)
The blinding of Samson, 1636
This is perhaps the most "Baroque" picture Rembrandt ever painted, probably emulating the searing drama of the Rubensian style favoured at courts. The horror is extreme, and so is the use of all the illusionistic, dramatic and violent devices dear to Baroque art. It may have been painted as a gift for Constantijn Huyghens: he greatly admired Rubens.

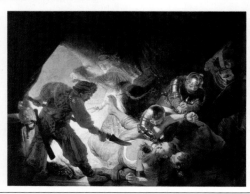

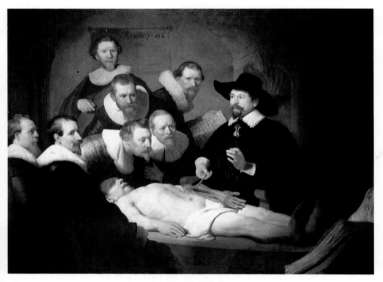

REMBRANDT (left)
The anatomy lesson of Dr Tulp, 1632
Hals' group portraits are clearly Baroque in an international sense, but *The anatomy lesson* is really not: it lacks a smoothly flowing or united composition: each figure is sharply individual and there is latent tension rather than overt violence. In the company's fascinated intentness on the corpse there is a palpable unease, almost an awareness of their own mortality. This is the first painting which Rembrandt signed with his full name, in keeping with its importance. Already the disposition of light and shade is masterly, and is a vital element of the drama. Yet the face of every man is also a precise portrait.

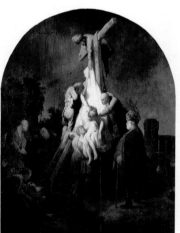

REMBRANDT (above)
The Descent from the Cross, 1633
The large costumed figure stresses the contemplative mood Rembrandt sought. He wrote that he wanted his series to express "the greatest and most natural emotion" – not movement.

REMBRANDT (above)
The return of the Prodigal Son, 1636
The etched line is febrile with the reunion's emotion.

brandt had refined the construction of his compositions, and especially his handling of the half-tones between the extremes of light and dark, and was now fully competent to organize paintings of a monumental scale. The first of his great group portraits, *The anatomy lesson of Dr Tulp*, 1632, no doubt established his reputation in Amsterdam, investing what might have been a formal group with high drama. The drama is higher still in his *Blinding of Samson*. The scope of his patronage was expanding, and, through the leading connoisseur Constantijn Huyghens, Rembrandt obtained a commission from the Stadtholder, the ruler of federal Holland, for five large *Passion* scenes. The *Passion* scenes are more characteristic of the mature Rembrandt: the mood is both dramatic and yet sombrely reflective – his *Descent from the Cross* shows an awareness of Rubens' composition in Antwerp (see p. 204) but is entirely Rembrandt's own in feeling. Christ is no elegant, ideal figure, but a broken wreck of human flesh.

Rembrandt's most famous work, "*The Night Watch*", is also his largest – 3.5 × 4.5 metres (12 × 15 ft): finished in 1642, it marks both a climax and a turning point. Rembrandt

transposed the traditional Dutch Civic Guard group into a "history" composition of stupendous drama, colour, tonal contrast and movement. Characteristically Rembrandt's is the inexplicable element, the incandescent figure of the little girl. The year 1642, however, marked the beginning of the decline of Rembrandt's financial and fashionable fortunes, and perhaps too of his personal confidence and happiness (his wife Saskia died in this year). The mood in his painting becomes ever more sombre, more searching; the paint itself both richer and more troubled; the psychological intensity of his images more impressive and haunting. The 1640s and 1650s were his most productive period for etchings – some, such as the famous Hundred-Guilder Print, as rich and complex as his major paintings – and for drawn, painted and etched landscapes (see p. 220); during the same period he made hundreds of direct and forceful drawings (usually in a thick reed-pen), tautly structured yet almost throbbing with life.

In his last two decades Rembrandt tended to simplify his compositions, rejecting his earlier highly-strung Baroque for a more classical, more stable and enduring structure. His use of

paint and handling of light became ever richer and subtler. This light, charged with an intense spirituality, seems to come from within rather than from an external source. His portraits and self-portraits transcend the individual they so vividly and faithfully depict and become "intimations of the universal destiny of mankind". One of his greatest and most mysterious works, the picture known as "*The Jewish Bride*", is conventional enough in theme – it is perhaps simply a wedding portrait of two ordinary people – but it celebrates marriage as a sacrament, a dedication in mutual love at once human and divine; formally it echoes traditional depictions of the biblical Jacob and Rachel.

Rembrandt taught pupils all through his working life, and many of them, while with him, responded to Rembrandt's vision with work of remarkable quality. Some, such as Ferdinand Bol, remained in some degree loyal to that vision throughout their careers, and Aert de Gelder, almost his last pupil, continued painting works of distinction in his style into the eighteenth century. His most able pupil was Carel Fabritius, the vital link between Rembrandt and Vermeer (see p. 228).

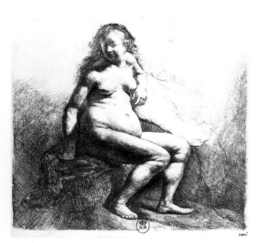

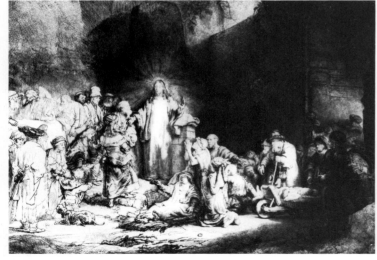

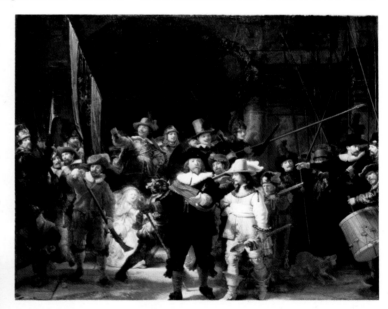

REMBRANDT (left)
Nude on a mound, 1631
In this early etching the contrasts of light and shade are heavy but the mature Rembrandt's transfiguring light is absent. The nude is a true "Venus with garter-marks": his art was always realistic, but later not so rebelliously unidealistic.

REMBRANDT (right)
"*The Night Watch*" (The Company of Frans Banning Cocq and Willem van Ruytenburch), 1642
A pupil wrote in 1678: "It is so painter-like in thought, so dashing in movement, and so powerful" that the pictures hanging beside it seem "like playing cards".

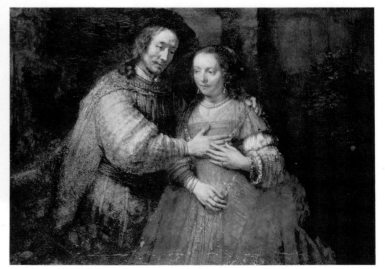

REMBRANDT (above)
The Hundred-Guilder Print: *Christ healing the sick*, c. 1648-50
The etching, known by the very large price it fetched,

is most carefully worked. Rembrandt made use both of drawings from life and of Renaissance sources – notably engravings after Leonardo's *Last Supper*.

REMBRANDT (right)
"*The Jewish Bride*", c. 1665
The silence seems to echo; the light seems spiritual, emanating from the figures.

Rembrandt: The Self-Portrait at Kenwood

The main course of Rembrandt's life is fairly clear – his birth in Leyden in 1606; his early success (with pupils even in his twenty-first year) in his home town; in the 1630s, fashionable prosperity in Amsterdam; then the decline in popularity, the death of his wife Saskia in 1642; financial mismanagement, culminating in bankruptcy and the enforced sale of his superb art collection in 1656/57; the deaths of his common-law wife Hendrickje Stoffels in 1663 and of his only son Titus in 1668; his own death in 1669.

The recorded facts reveal little about one of the greatest artists in history, rivalled in scope of imagination and universal appeal perhaps only by Shakespeare. But the skeleton provided by the documents is endowed with both flesh and spirit by the sequence of *Self-portraits* – more than 100 drawings, etchings or paintings, ranging from his beginnings as an artist to the last year of his life. They constitute the most remarkable autobiography ever painted, and culminate in the searching self-interrogations of Rembrandt's last decade: amongst these the three-quarter-length portrait at Kenwood, London, is one of the most impressive and haunting.

In almost all the late *Self-portraits*, the demand that the spectator identify with the artist is irresistible: he looks at himself, searching; you look at him; he looks at you. In some of these portraits, Rembrandt is very much the Protestant, holding his human identity clear of the dark as if by sheer will-power – alone with himself, uncertain perhaps if man is made in the image of God but determined to find out. The search for identity is there even in the earliest portraits, though these are often clearly studies, exercises in capturing momentary expression. The Dresden double portrait with Saskia, of his brash middle years in Amsterdam, is also a brash image, Rembrandt exultant at his fortune and rather vulgarly unconcerned with the dignity of his station (compare Rubens' similar portrait, p. 202). The element of role-playing, as in the London National Gallery portrait, where he is posed and clad like a Titian portrait then believed to represent the prince of poets, Ariosto, persists almost to the end. But in one of the last of all (also in the London National Gallery) Rembrandt, hands folded, quietly resigned on the threshold of death – but in his paint still vital with life – records simply himself.

REMBRANDT (above)
Self-portrait drawing by a window, 1648
The pose and setting recall the many paintings and etchings Rembrandt made of scholars or of saints seated in a room by a window: in comparison and contrast the artist appears as an earnest, prosaic burgher – his hat completes the image.

REMBRANDT (left)
Self-portrait in Munich, detail, *c.* 1629
Like Caravaggio (see p. 180) Rembrandt wants to catch a momentary start in paint, and exploits sharp contrasts of light and shade to do so – but also introduces mystery.

REMBRANDT (right)
Self-portrait in Berlin, detail, 1634
The somewhat mysterious drama of the portrait (left) is retained; there is now more of a swagger: the boisterous youth yields to a romantic, but hardly less truculent, young man.

REMBRANDT (right)
Self-portrait at Kenwood, London, *c.* 1665
Against the predominant dark brown to red of the whole, the focus is on the lighter key of the face, the grey hair, the cap almost slashed on to the canvas. The face is old, seen without vanity or flattery. No one knows the meaning of the semicircles incised on the background: if they hint at a possible ideal order, the ruggedness of the face contradicts them sharply. There is paradox again in the rich fur of the robe and the workaday context. Tools of the trade are perfectly legible from a distance, but closely inspected become ambiguous. Seen closer still, they are like pure paint energized, and the hand holding them is just a brusque zigzag of paint dragged down, diminishing as the brush unloads. Rembrandt had no truck with the kind of art that conceals the art: he left his workings bare and one of his few remarks on record is a warning to connoisseurs not to expect high finish: "Don't poke your nose into the painting or the smell will kill you."

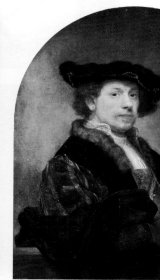

REMBRANDT
Self-portrait with Saskia, *c.* 1635
Of the bold self-conscious bravura there is no doubt; but beyond that the interpretations vary: is there some unease? What does Saskia think of it all? The still life and raised glass recall genre tavern scenes, with a moral undertone.

REMBRANDT
Self-portrait after Titian's "Ariosto", 1640
Both Titian's "*Ariosto*" and Raphael's *Castiglione* (see p. 337) had passed through the Amsterdam sale-rooms in 1639. The more mature Rembrandt's interest in Renaissance art was increasing, and was to be reflected in his painting.

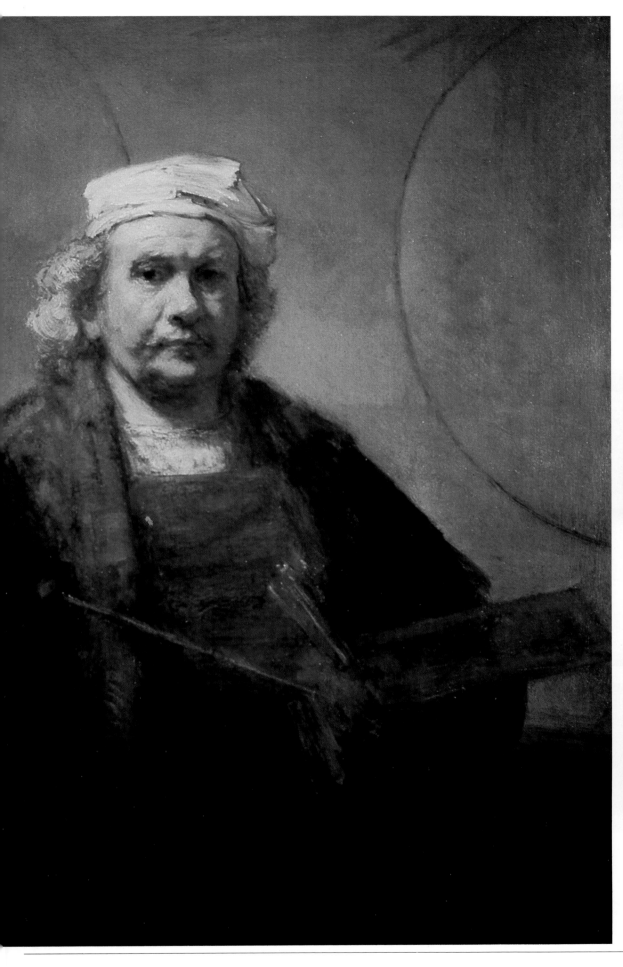

REMBRANDT
Self-portrait in Vienna,
detail, 1652
The later self-portraits
are mostly frontal – the
painter face to face with
himself. Rembrandt by this
time was painting probably
more for himself than for
clients or on commission.

REMBRANDT
Self-portrait in Cologne,
detail, *c*. 1669
The image is undeniably
grotesque – Rembrandt as
a genre old man. However,
he peers from the shadows
with a bruised grin: the
vigour and freedom of
the impasto asserts life.

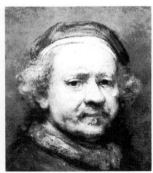

REMBRANDT
Self-portrait in London,
detail, 1669
The lonely suffering of
Rembrandt's last years
(with Hendrickje dead, his
son Titus dead, aged 27)
is never more than hinted
at even in his latest *Self-
portraits*. Their dignity is
powerful, utterly honest.

Dutch Landscape 1

"Landscape" was originally a Dutch word, established in the late sixteenth century. By then, the particular talents of Netherlandish, and especially Flemish, artists in the painting of earth and sky, woods and water were widely recognized, though the northern bent for landscape was much older than that: it had already been apparent in the miniature illuminations of the Limbourg brothers at the beginning of the fifteenth century, and in the sixteenth century in the panoramic settings of Bruegel's works. Until the seventeenth century, however, landscape had generally remained a setting or a stage for religious or mythological events; it was particularly the Dutch who found in the landscape itself a sufficient story-line, even a heroic quality.

The emergence of landscape painting in Holland was part of the general Protestant withdrawal from religious art: a changed clientèle demanded from artists a different subject matter and new aesthetic values. Pictures of the land, the fatherland for which they had fought, naturally appealed to a people that had just achieved its independence, and the countryside was an integral part of the daily life they loved to record in all its aspects,

capturing its reflection indoors, stabilizing its impermanence, in small easel-paintings.

Within the highly talented output of the early Dutch landscape artists, two main moods can be distinguished. One was more naturalistic – in extreme form, topography, mapping exactly the features of a given place at a given time; the other was an ideal vision. Even the most naturalistic landscapes, however, were all painted indoors, though built up on the basis of drawings sketched on the spot. Dutch ideal landscape, generally called Italianate, is suffused with nostalgia for a golden Mediterranean light and a climate in which a gentler way of life might flourish; it is parallel in form to, and partly dependent on, the work of Annibale Carracci, Domenichino and Claude

(see p. 196), though usually less dreamy and artificial, peopled with more homely figures.

The discovery of the local landscape was sparked off by a Flemish influx – refugees from the fighting that ended in the capitulation of Antwerp to the Spanish in 1585. It took shape – like many other forms of Dutch painting – in Haarlem, where in 1585 settled Gillis van Coninxloo (1544-1607). His work in Antwerp (and elsewhere) had been fully Mannerist, showing a relish for landscape but using it as a stage-set for his figures. He followed his predecessors in adopting a high viewpoint, sometimes even approaching a bird's-eye view, with much more land than sky. In his later work, the figures became less important, and were almost lost in the fantastic wooded scenes that he

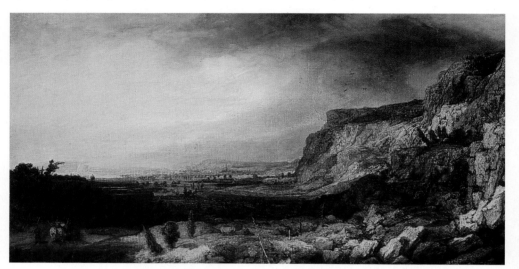

CONINXLOO (below)
The forest, c. 1600
Coninxloo's pictures were popular as "poetic visions of the primeval wilderness". His figures are costumed, as if acting in a play; the landscape, too, is fanciful, but trees and shrubs are observed naturalistically, and there is a deliberate play of light and shade.

SEGHERS (right)
Landscape, c. 1630
Unlike artists such as Coninxloo, Seghers built up his landscapes in tonal masses. These tonal masses are the whole composition: in a sense, the landscape is neither real nor imaginary; it represents only a mood. His etchings have similar effects of light and dark.

AVERCAMP (right)
Winter landscape, c. 1610
The high horizon is a sure mark of the picture's early date. The figures are disposed at careful intervals so as to lead the eye from detail to detail and back into space. Though the picture is thus artificially composed, the whites of ice and sky are convincingly wintry.

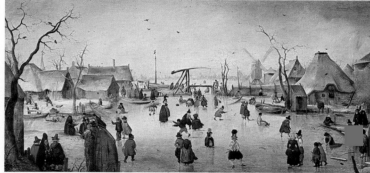

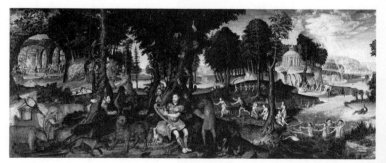

SAVERY (above)
Orpheus charming the animals, c. 1625
Savery's picture is more obviously Mannerist than Coninxloo's, though later. The trees, however, and the exotic animals are observed with even closer naturalism.

ESAIAS VAN DE VELDE (right)
The ferry-boat, 1622
Some of Esaias' landscapes are so full of figures and action that they could as well be called genre. Note that the tones lighten in the distance, as they do not in Avercamp's picture.

loved, though he kept to established conventions. His views were framed between two strong elements in the foreground (*repoussoirs*) and his colours proceeded in a standard formula from warmish browns in the foreground through shades of green into a bluish distance.

Coninxloo's followers included the Flemish-born Roelandt Savery (*c.*1576-1639) and David Vinckboons. The indigenous Dutch tradition, however, can be said to start with Hendrick Avercamp (1585-1634), probably a pupil of Coninxloo. Though still using many of the same conventions, Avercamp painted landscapes without a story, filled instead with the details of everyday life. He is most famous now for his winter landscapes, ice-covered rivers thronged with people, in which the hiss of skates on the ice and the voices sharp on the crisp air are almost audible. A far greater talent, indeed one of the original geniuses of the whole movement, was Hercules Seghers (1589/90-*c.*1635), who certainly trained under Coninxloo. He was born in Haarlem but worked also in Amsterdam and The Hague. His life is obscure – apparently much troubled – and his paintings are few. It was through his etchings, remarkable both in

technique and imagery, that he was mainly known, although Rembrandt owned no fewer than eight of his paintings. Seghers' view of the world was grand yet desolate, with figures and buildings subordinate to a sweeping panorama of plains and arid mountains – brooding, often hostile, and charged with awe. Despite the vast distances they convey, his paintings are small in scale, and in a very restricted palette.

Esaias van de Velde (*c.*1591-1630), from Amsterdam, was perhaps also a pupil of Coninxloo. His vision seems to have been more generally influential and was certainly much less disturbing than Seghers'. He became the leader of the Haarlem landscapists, delighting in the detail of outdoor life as had Coninxloo, but lowering the viewpoint and the horizon, and developing a method of atmospheric, or tonal, recession. In paintings such as *The ferry-boat* he established the main themes to be developed by the next generation. Pieter van Laer, who painted street-scenes and beggars in Rome, where he was known as Bamboccio (see p. 192), was also a product of Haarlem.

The Italianate painters developed from the example of the long-lived, prolific and versatile Abraham Bloemaert (1564-1651; not

shown) of Utrecht. His pupils, unlike him, all visited Italy, and came to see nature in terms of the sunny Roman Campagna, peopled with agreeably picturesque rustics and their animals. The likeness of the work of Jan Both (*c.*1618-52), of Cornelis van Poelenburgh (*c.*1586-1667) or of Breenbergh to Claude's is clear, though theirs lacks the variety and invention, and the superbly serene structure, of the Frenchman's art. The most successful of the Italianate landscapists was the prolific Nicolaes Berchem (1620-83); his work, devoid of the German Elsheimer (see p.404), but his pleasurably and immediately digestible for generations of picture-lovers.

The Dutch landscapists who travelled to Italy had taken varying note of the miniatures of the German Elsheimer (see p. 196), but his work found a stronger echo in the painted landscapes of Rembrandt – almost doom-laden scenes (see p. 224) strongly influenced by Seghers. In his landscape etchings and drawings Rembrandt encompassed and surpassed the range of the specialists, above all in his elegiac meditations on the simplest of country views, transformed into breathing air by a miraculously economic use of line.

BOTH AND POELENBURGH (below) *Landscape with the Judgment of Paris*, undated
The landscape is Both's, the figures Poelenburgh's. The landscape is constructed by means other than those of "native" landscape, though detail is no less naturalistic.

BERCHEM (right)
The crab-fishers, undated
There is no sense of the classical past in Berchem: even his ruins are haunted by cows, and picturesque rather than evocative. He could almost be described as a painter of rustic genre.

REMBRANDT (left)
Landscape with a village, *c.*1650
Rembrandt's ink-and-wash landscapes are like van Goyen's compositions (see over) reduced to a skeleton.

REMBRANDT (above)
"Six's Bridge", 1645
The etching needle shapes one tree, then another; then the firm outline of a bridge rail; two little figures, a far horizon, the mast of a boat.

The assurance and exact power of Rembrandt's line are stupendous. Though the traditional title is wrong, this is a topographical view, and the bridge and village have been identified.

Dutch Landscape 2: "Classic"

In the wake of the pioneers of Dutch naturalistic landscape, Seghers or Esaias van de Velde, the discovery of the Dutch countryside really began – its endless flatness, laced with water; its endless skies for ever changing in wind, sun and cloud. The prolific painter and draughtsman Jan van Goyen (1596-1656) was the most remarkable figure of the first generation, based in The Hague from 1631 till his death, but an insatiable traveller.

Following van de Velde, who taught him for a time, he developed still further the emphasis on landscape. He lowered the horizon, so that the vista is observed generally from eye-level, and the elements in it are very much the commonplace ones that a Dutchman would see as he went about his ordinary business. Though held in tension by a system of shallow diagonals, his compositions seem indefinitely extensible on either side, and their flat horizontals are emphasized by the proportions of the picture, usually much wider than it is tall. His palette is almost monochrome, containing no more than browns, thin greens and muted yellows, and the grey tones of an overcast northern day. The cloud formations in the dominant sky are used to establish a mood. His views are often identifiable, the silhouettes of known towns, churches and windmills fretting the far horizon. This delight in the portraiture of places was soon extended, in the work of other painters, to include meticulous records of streets and towns, the façades of buildings, the interiors of churches.

Salomon van Ruysdael (c. 1600-70), uncle of the more famous Jacob, a contemporary of van Goyen, spent a very successful career entirely in Haarlem. His paintings of the 1630s, especially his views over broad sheets of water, could easily be mistaken for van Goyen's. Gradually, however, his work became less austere, his palette richer, his subject matter somewhat more animated: both life and weather seem more cheerful, and there are sometimes quite colourful effects in the sky. Aert van der Neer (c. 1603-77) used again a restricted palette for his famous moonlight scenes (not shown); also working in Haarlem was the most remarkable of those artists who specialized in townscape or architectural painting, Pieter Saenredam (1597-1665). He painted little else other than the whitewashed interiors of churches, brimming with pale light through clear windows, empty and silent. The diminutive figures exist, it seems, solely to establish the soaring scale of the vaulted roofs.

Between about 1640 and 1670 Dutch landscape reached its full maturity, its so-called "classic" phase as distinct from the "tonal" phase exemplified in van Goyen's and Seghers' paintings. The "classic" phase in its various moods consolidated the naturalistic discoveries of the "native" Dutch observers, such as van de Velde and van Goyen, with a truly Baroque strength and richness. Painters such as Berchem had been captivated by the reflection of Italian sunlight and the picturesque detail of the Mediterranean scene; artists such as Cuyp and Ruisdael were more deeply influenced by the Italianate tradition.

Aelbert Cuyp (1620-91) of Dordrecht painted sky, land and water suffused by a golden light much more Italian than Dutch, but the light grips and harmonizes the whole landscape: it is an integral, essential and extremely beautiful element in his achievement. He seems never to have gone to Italy, only to have studied its reflection lingering in the work of his contemporaries who had been there. Yet there is no greater master of sublime serenity in visionary landscape than Cuyp, besides

VAN GOYEN (below)
View of the village of Overschie, c. 1645
The details are just like those of Esaias van de Velde (see preceding page). But here the sensation of looking out over an artificially constructed stage has disappeared: diagonals (and the vertical spire) give the picture structure and, much more naturally, lend a subtler symmetry.

JACOB VAN RUISDAEL (right) *View of Haarlem*, 1660s
The clouds are a powerful force, and strong contrasts of light and dark move over the face of the land.

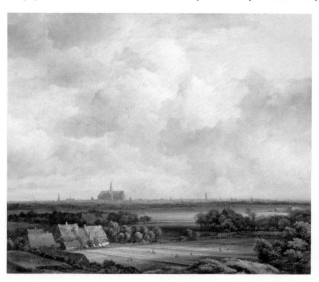

SAENREDAM (right)
St Bavo, Haarlem, 1660
The view shows the choir, wholly austere except for its patterned vaulting. The picture is quite small, and with virtually no colour; but the perspective, and the modelling of convex and concave surfaces, are extremely subtle; the tonal modulations of the airy space are exquisitely controlled. There is a quiet intimacy. Another view by Saenredam is reproduced on p. 212.

SALOMON VAN RUYSDAEL
(left) *View of a river*, 1630s or early 1640s
Salomon tended to paint a little more precisely than van Goyen, but could fix a gentle afternoon as freshly. He has none of the drama of his nephew Jacob (above). Note the subtle symmetry between the two uprights, the tree and the small sail.

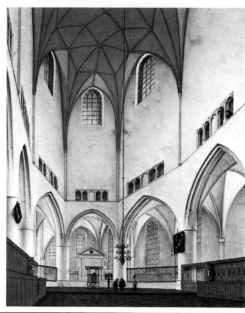

Claude himself. But while Claude peopled his Roman Campagna with figures from classical mythology, the Dutchman achieved a no less mysterious transcendence with a mundane cast of cows, horses and his stolid compatriots. The composition is usually anchored on the figures, human or animal, in silhouette at one side of the foreground; the landscape winds, often across water, back deep into the distance under a paradisal sky of late evening.

Cuyp's cows became, in the paintings of the young Paulus Potter (1625-54), the chief subject of the landscape, though the same cool golden light played about the variegated texture of their hides. Cuyp also loved to paint great sheets of water, with ships becalmed above their own reflections, and in this the Amsterdam painter Jan van de Cappelle (c. 1624-79) specialized. Van de Cappelle indeed could surpass even Cuyp in the magic of his dreams of sailing ships afloat like wraiths between sky and water, yet intricately and firmly structured by their lofty masts and sails and the dark horizontals of their hulls. Cuyp and van de Cappelle confined themselves to rivers or estuaries, but the two Willem van de Veldes went out to the open sea: Willem the

Younger (1633-1707) could achieve a majestic composition to rival in strength any by his contemporaries – as in his *Cannon shot*; later he and his father both migrated to England, and established marine painting there.

The greatest genius of Dutch landscape, unsurpassed in his power to endow it with the heroic significance till then thought commensurable only with religious or epic painting, was Jacob van Ruisdael. His "tragic" work is considered, in relation to his famous *Jewish cemetery*, in the next pages. But his mood could also be gently pastoral, taking pleasure in the movement of the landscape, the changing pattern of sun and shadow. Ruisdael had no standard formulae: his trees are individuals; so, too, are his clouds; the humid air of Holland seems to move amongst them. In this his one-time pupil Meindert Hobbema (1638-1709) could rival him in strength, though Hobbema employed a limited range of compositional devices, and his work in mass can seem monotonous. Yet each one on inspection proves as sharply observed, as freshly painted, as Ruisdael's. His paintings as a whole show a much more cheerful and optimistic temper – Ruisdael with sunshine.

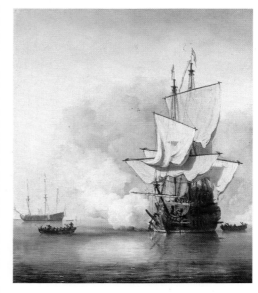

WILLEM VAN DE VELDE THE YOUNGER
The cannon shot, c. 1660
In the "classic" phase of Dutch landscape painting

the objects or elements in the picture were certainly naturalistic; but, more than that, they were dynamically organized to striking effect.

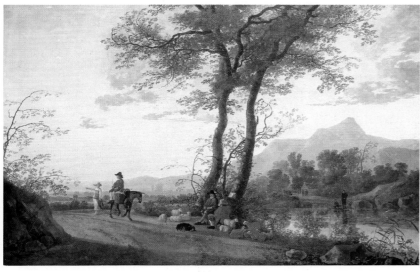

CUYP (above)
View of a road near a river, mid-1650s
The colours are autumnal; it is peaceful early evening. If the light is Italianate, the structure – particularly the mountain on the right – is a development from Seghers' compositions.

POTTER (below)
Cows resting, 1649
Potter's light has not the quiet calm and airy repose of the great masters – his golden light is sometimes cloying. Yet he was both precocious and successful, and his smaller pictures are gloriously textured.

VAN DE CAPPELLE (above)
View of the mouth of the river Scheldt, c. 1650?
In contrast to others, van de Cappelle favoured firm central motifs. The middle-ground boats are solid, but sky and water dissolve all around into a haze, being unbounded by any sharp horizon and unfixed by any foreground mass. Another scene by van de Cappelle is illustrated on p. 212.

HOBBEMA (left)
The avenue at Middelharnis, 1689
In the last three decades of the century, landscape – and other kinds of painting – declined in quality. Few artists kept that "classic" balance between naturalism and contrivance of Hobbema's late landscape.

Ruisdael: The Jewish Cemetery

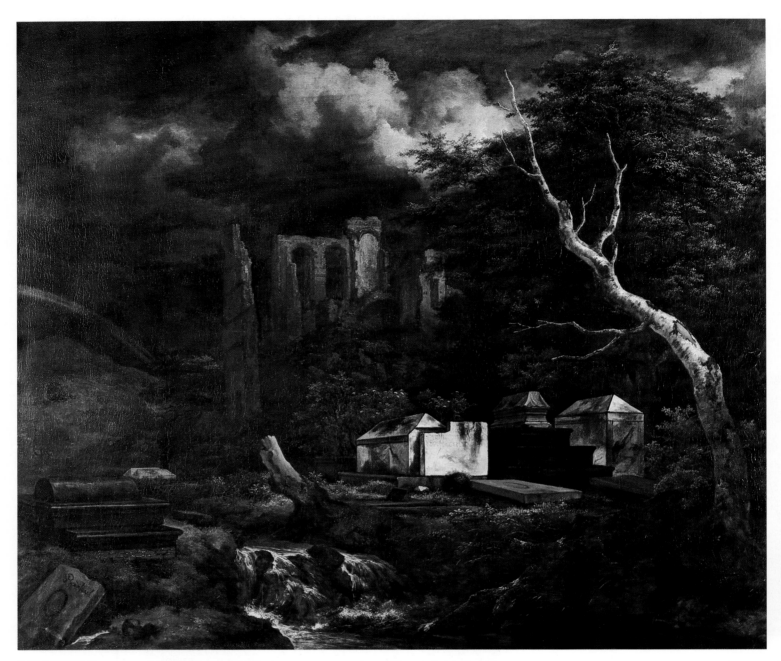

JACOB VAN RUISDAEL
(above) The Dresden
Jewish cemetery, 1660s
There are no figures, no
animals: the tombs are the
central characters; trees,
buildings, sky, a stream
and the changing light are
the supporting cast. Each is
charged with an animating,
transfiguring atmosphere.

JACOB VAN RUISDAEL
(right) The Detroit
Jewish cemetery, 1660s
In this version the mood
seems warmer: the trees,
for instance, are less stark;
the desertion is not quite so
absolute: there is a cottage
amid the ruins, and two
small, black-robed figures.

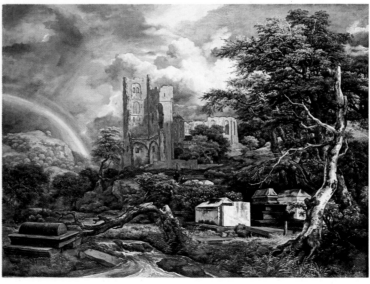

JACOB VAN RUISDAEL
*Tombs in the Jewish ceme-
tery at Ouderkerk, c.* 1660
The positions of the tombs
have been slightly altered
in the paintings, but they
retain their striking shapes.

So, too, the other elements
were no doubt closely based
on observation from life,
though even the drawing
has been organized into a
composition – the birds in
the sky, the placed trees.

The tragic drama of nature is felt in most of the paintings of Jacob van Ruisdael (1628/9-82), but only in the two versions of *The Jewish cemetery* is it so explicit, and the symbolism so overt. The strongest accents in the composition, in each case, are the tombs, painted "from the life", as is proved by two drawings and by the tombs themselves, still to be seen in the Jewish cemetery at Ouderkerk near Amsterdam. They catch the eye not only because of their near-central position, but because the light of the lowering sun picks them out and a tree almost points to them. Simultaneously amid the dark rain clouds kindles a rainbow – the age-old symbol of hope and Resurrection.

In both versions, the cluster of the tombs is identical, but otherwise the paintings vary considerably, in the whole and in the rest of the details. The surrounding landscapes, for all their vivid presence, are fantasies. Both versions are presumably of the 1660s, though which is the earlier is uncertain. The Dresden version is the more sombre, the rainbow more tentative, the ruined church a different building much further gone in decay, sunk deeper in oncoming night. (Note, however, how important in each version is the vertical accent of the ruined flank of the building, holding the light and stabilizing the whole composition.) As Constable was to observe, Ruisdael enveloped the most ordinary scenes with grandeur, and in his work as a whole – with its evocation of melancholy and its drama of light and shade – the Romantic movement would find a prophet of its own feelings towards Nature; Goethe, however, analysed a profounder poetry in this composition: "Even the tombs themselves, in their state of ruin, signify something more than the past: they are tombs of themselves".

Ruisdael developed that combination of realism and romanticism found in a greater or lesser degree in all his mature work from the example of his predecessors and contemporaries. His fascination with trees is reminiscent of the late Mannerist follower of Coninxloo, Savery; his ability to consolidate the facts of earth, foliage, water into classical compositions surely owed something to the Italian example filtered back to Holland chiefly by painters from Utrecht. His delight in mountainous spectacle, in crags and waterfalls alien to his native Dutch landscape, was formed perhaps by the Scandinavian visions of Allart van Everdingen (1621-75); in contrast, his panoramic sweeps of the true Dutch plains doubtless owed something to the great horizontal sweeps of Philips de Koninck (1619-88). Finally, his compulsive effect on the spectator's imagination demands comparison with Rembrandt. But, though in a few instances Ruisdael produced visions very close to some of Rembrandt's rare painted landscapes, no specific influence from Rembrandt can be seen. Ruisdael's technique, which derives much of its impact by marrying a broad, majestic massing of forms with a very detailed characterization of individual elements, could certainly be called Baroque; however, in realizing landscape as an equivalent of the tragic human condition, Ruisdael was profoundly original, and his empathy with the rhythm of transient and inexorable Nature is akin to that of Romantic poets such as Wordsworth.

EVERDINGEN (left)
A waterfall, 1650
Everdingen was probably taught by Savery, who had travelled in the Tyrol. He himself travelled to Scandinavia with a patron in 1640, and in the 1650s he introduced into his pictures the waterfalls and log huts he had sketched there.

KONINCK (below)
View over flat country, 1650s or 1660s
Typical of Koninck is the bisecting horizon: no house or church joins land and sky. The slightly raised viewpoint stresses the endlessness of the plain: and Ruisdael, too, was to exploit such an effect of panorama.

JACOB VAN RUISDAEL
(above) *Winter landscape*, c. 1670
Desolate figures tramp the frozen river in the freezing dusk. The river slants against an ominous counter-diagonal into a void: even in this homely scene there is a sense of the insignificance of man.

REMBRANDT (right)
The stone bridge, c.1637
The lighting is not naturalistic: it erupts into the dark of the painting, and blanches the tree it strikes. It is a theoretical landscape, like those of Seghers, not a sublimation of natural landscape like, for instance, Ruisdael's picture (above).

Dutch Genre and Portraiture 1

In the seventeenth century, genre – broadly, the painting of scenes from everyday life, even of the humblest kind – became separated out, like landscape or still life, as a subject in its own right. Secular, even low-life, subjects had been painted before, but in order to illustrate an allegory, a proverb or a moral. Caravaggio in Italy had painted still life or peasant characters as interesting in themselves or worthy of high art, but the emergence of Dutch genre was probably an independent development, for the favourite themes of the earliest Dutch genre painters can be traced back into previous Netherlandish religious and allegorical painting. In fact, there are probably moralizing undertones in many Dutch genre scenes that today seem to have no other subject than what they so realistically show.

Dutch genre, like Dutch landscape, made its most promising beginning in Haarlem, as an extension of the naturalism of Frans Hals' vivid portraiture. Its first subjects were what the Dutch called *Merry companies*, groups of drunken roisterers. Hals in his early career painted one or two such genre scenes, and Willem Buytewech (*c.*1591-1624), who worked closely with him for a time, popul-

arized the *Merry company* set in an interior. However, though he was a prolific and elegant etcher and draughtsman, Buytewech's rare paintings seem stiff and studious beside Frans Hals' portraiture; so do those even of Frans' brother Dirck Hals (1591-1666). The *Merry company* theme was soon extended to include guardroom scenes or tavern scenes featuring soldiers. The specialists in this form, such as Willem Duyster in Amsterdam or Pieter Codde, also introduced light effects from the Utrecht Caravaggisti, as did Judith Leyster (1609-60). She, however, more closely than anyone else, could occasionally catch the spirit

and the crisp vivacity of Frans Hals' paint in her small genre works. In 1635 she married Jan Molenaer, who also specialized in genre, which by this time encompassed almost every kind of social or domestic activity.

The genius among the early genre painters was Adriaen Brouwer (1605/6-38). Though he worked most of his brief life in Antwerp, he was born Dutch and he was in Haarlem in the 1620s. His pictures – always small-scale – show a knowledge both of Bruegel and of Frans Hals, and he observed his chosen subjects, peasants squalid both in aspect and in setting, with scrupulous objectivity. His

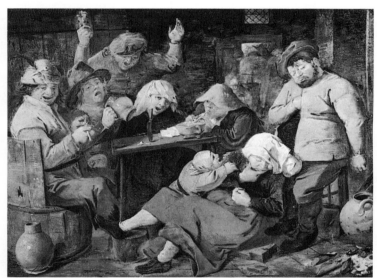

BROUWER (right)
Peasants in an inn, c. 1627-31
The squat figures and their vividly caught expressions (surely showing Frans Hals' influence) are typical of Brouwer. His coarse figures are both reprehensible and laughable – for instance, the mother who nods off while her child howls – but each figure is an individual, and, as such, sympathetic. The detail is particular and rich, indicated with a swift and broad brush, related consummately to the whole. Glowing greys and browns set the atmosphere: tonal modulations are extremely sensitive. It was Brouwer's achievement to transform subject matter quite the reverse of ideal or beautiful into a major work of art.

BUYTEWECH
Merry company, c. 1617-20
The bearded man left of centre is the very one that Frans Hals also painted in his *Shrovetide revellers* of about 1615 (not shown) – confirming links between

Buytewech and Hals and Hals' crucial influence in the emergence of Dutch genre. The picture perhaps represents the Five Senses, but the exaggerated stances of the figures show a clear attempt at vivid realism.

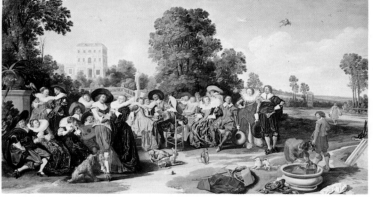

DIRCK HALS (left)
A garden party, c. 1624
Dirck Hals' style is closer to Buytewech's than to his brother Frans'. Although these people are bourgeois, use of a landscape setting recalls the origins of the *Merry company* theme in 16th-century Netherlandish *kermis* pictures – peasants disporting themselves in an outdoor festival. Bruegel had painted such scenes, and the immigrant Flemish follower of Coninxloo (see p. 220), Vinckboons, was painting them in Holland by 1610. Teniers continued the tradition in Flanders.

LEYSTER (left)
The offer, c. 1635?
The man offers her gold, but the seamstress seems determined to preserve her virtue. The man's leer, and the woman's concentration on her task, are caught in a frozen moment with an art anticipating Vermeer's.

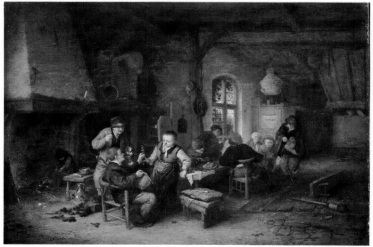

ADRIAEN VAN OSTADE
(right) *Inside an inn,* 1653
The room has shadowy depths into which creep patches of light, in a style learnt from Rembrandt. The figures are dumpy and are painted briskly and in movement, like Brouwer's, but this is a kind of respectable version of his low life.

scenes could be comic, but neither caricatured nor condescending. He painted his people, in their weaknesses and their passions, as one of them, and the known facts of his Bohemian life suggest a strong sympathy with them. Brouwer has always been "a painter's painter": Rubens, for instance, had 17 of his paintings and Rembrandt owned six paintings and many of his very free drawings, which clearly influenced Rembrandt's own drawing style.

Those who followed in Brouwer's wake included some artists of talent approaching genius and a remarkable number of unusual competence. Characteristic was the prolific Adriaen van Ostade (1610-85). Early on he showed not only Brouwer's influence but also Rembrandt's, but later moved towards a more picturesque but less vital version of low life, probably one that was more acceptable to an ever-widening clientèle. His brother Isaack (1621-49; not shown), who started along similar lines, later developed his own vision of landscape and genre combined. Gerrit Dou (1613-75), a pupil of Rembrandt in his early Leyden days, continued all his life to paint small, highly finished and increasingly cosy domesticities, often a single figure set in a window. His example was followed by the prolific painter Gabriel Metsu (1629-97) and by Frans van Mieris the Elder (1635-81).

Nicholaes Maes (1634-93), one of the most talented of Rembrandt's later pupils, worked with distinction very much in his master's Amsterdam manner, but turned about 1660 to painting society portraits and metamorphosed his style into an international Baroque almost indistinguishable from that of English or French counterparts such as Lely or Bourdon. Throughout the seventeenth century, the demand by the Dutch for portraits was constant, and was answered by a whole range of extremely able portraitists. Their work, to be sure, was less disturbing than Rembrandt's shadowy psychological probings, and tended to concentrate on rich superficial textures of flesh and costume. At their best the best among them – Thomas de Keyser, Bartholomeus van der Helst (1613-70) – were of high quality.

The crowning splendour of Dutch genre painting was the Delft school (see over), but the Leyden-born Jan Steen (1626-79) is more generally representative of its final phase. The son of a brewer, his sympathies were somewhat akin to Brouwer's. He was briefly a publican and brewer himself in Delft between 1654 and 1657, where he was doubtless aware of Vermeer, and he was in Haarlem between 1661 and 1670, where Frans Hals' art had a pronounced effect on his own. Steen's popular reputation rests on his vigorous, bustling portrayals of carousing gatherings, in which he himself, relaxed and unbuttoned, is sometimes a participant. His output, however, was much more varied, though not always of high quality – packed with detail and colour yet freely and rhythmically painted, and always psychologically coherent. He painted not only genre but also historical, biblical and allegorical pictures (he was a Catholic), and in his genre paintings the moralizing or allegorical element is more evident than in most of his contemporaries' pictures. He depicted his figures not only in contemporary costume with domestic props, but also in theatrical guise, as if they were enacting a scene from the *Commedia dell'Arte*. Many critics have compared Steen to Molière, and his control of production is indeed worthy of a great dramatist-actor-manager. The elegant lightness and wit of his late pictures have almost an accent of Rococo, suggesting that Watteau is not far off.

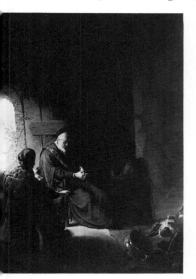

DOU AND REMBRANDT (left)
The blind Tobit and his wife Anna, c. 1630
The finish marks the work as Dou's, but the design, the chiaroscuro and the subject are more typical of Rembrandt. Rembrandt made many studies from the life but seldom painted genre; his biblical subjects, however, are often almost indistinguishable from it.

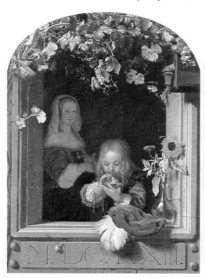

MIERIS THE ELDER (right)
Soap bubbles, 1663
The composition, a figure confronting the spectator from a window, had been popularized by Dou. Mieris has added even more detail, and hints of *vanitas* typical of still life (see p. 232).

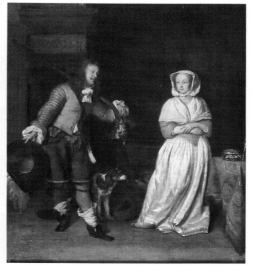

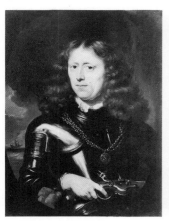

MAES (above)
Admiral Binkes, c. 1670-77
Later Dutch portraitists adopted Baroque devices, even if his attributes fail to energize the Admiral; perhaps the need for a good likeness inhibited fluency.

VAN DER HELST (above)
A young girl, 1645
The general run of Dutch portraiture – Rembrandt and Hals excepted – has a naive quality, though the likeness is probably exact and the stiffness often charming.

METSU (above)
The hunter's gift, c. 1661-67
Metsu was probably taught by Dou, but his varied art reflects other influences often more strongly. The grace of the figures recalls Steen; the subject, though it is more politely and subtly mentioned, is once more the trial of a woman's virtue.

STEEN (left)
The doctor's visit, c. 1665
The bowl of charcoal on the floor contains an apron-string, burnt as a remedy for the girl's illness. The doctor will be of no better use, for she is sick of love; the picture above the bed indicates her passion. In his approach and in some of his devices Steen offered precedents for Hogarth.

Dutch Genre and Portraiture 2: Delft and Deventer

The brief harvest of genius between about 1654 and 1670 in the small town of Delft is an astonishing phenomenon in European painting; it can be compared in Dutch art only with the achievement of Rembrandt. Though it coincides with Rembrandt's last years, it is quite different in vision – in its classic poise, its restraint, its clarity. In Vermeer it produced the one artist in Holland who can equal Rembrandt's intimations of mystery and immortality – within a more restricted range.

There is in fact a link between Rembrandt and Vermeer, in the elusive personality of Carel Fabritius (1622-54). He was working with Rembrandt in the 1640s and was by far the most gifted of his pupils. By 1650 he was in Delft, but there he was tragically killed by an explosion in a gunpowder magazine in 1654. Very close to Rembrandt in his understanding of the possibilities of paint textures and tonal contrasts, in a sense he reversed Rembrandt's vision: he worked in darks against light, rather than in lights against a dark ground, his subjects becoming coolly luminous in a pervasive natural light. He also experimented with perspective effects – as in his topographically exact little *View of Delft*, 1652.

These two interests, in the reflections of cool light and in optics and illusionism, have an important place in the mature work of Jan Vermeer (1632-75), who owned at least three paintings by Fabritius. Further, Antony van Leeuwenhoek, an exploratory genius of the microscope and the science of optics, was Vermeer's fellow-citizen and exact contemporary, and ultimately his executor. Contemporary assessment of Vermeer is almost non-existent, and after his death he remained unrecognized for almost 200 years. His works are rare – doubtless he worked very slowly: only some 40 paintings by him are known, and no drawings that are certainly his at all. His very few early paintings are in the tradition and manner of the Utrecht Caravaggisti – religious or genre subjects relatively large in scale, for example *The procuress* of 1656. Even before 1660, however, his mature style was established – small-scale paintings, featuring one or two figures (most characteristically a single one) in a mildly lit, serene domestic interior. Some moral or allegorical significance, as well as a hint of narrative or latent drama, seems to persist: *A girl asleep at a table* is said to be drunk; *A woman weighing pearls*

possibly embodies a reflection on human vanity, her action paralleled in the picture of the Last Judgment hanging behind her.

Vermeer's greatness lies in his unique ability to invest the simplest pose or transient gesture of ordinary life with a monumental, spellbinding permanence. In his utterly calm, detached observation of domestic intimacy, he achieves a celebration of the simple marvel of human life unmatched before or since. Part of his achievement is the precise structure, the "architecture" of his compositions, and the subtle answering relationships between their component elements – the still life, the rich pattern and texture of materials, the modulation of light from an open window across the wall, of reflected light everywhere. The colour range is cool; a favourite colour chord is blue and yellow. The solidity of the forms is both intensified and offset by a highly original use of scattered highlights, virtually dots of light with a *pointillé* effect that makes the surface vibrant. The perspective is calculated so as to involve the spectator, compelling the eye back from the immediate foreground deep into the picture, but also suggesting that the picture extends forward into the spectator's own

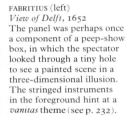

FABRITIUS (left)
View of Delft, 1652
The panel was perhaps once a component of a peep-show box, in which the spectator looked through a tiny hole to see a painted scene in a three-dimensional illusion. The stringed instruments in the foreground hint at a *vanitas* theme (see p. 232).

VERMEER (right)
A girl asleep at a table,
c. 1656
This is thought to be an early work because there is an emphasis on still life, as in *The procuress*; there is an opening into another room, probably derived from de Hoogh, seldom repeated by Vermeer; there seems to be strong moralizing though the import is not certain.

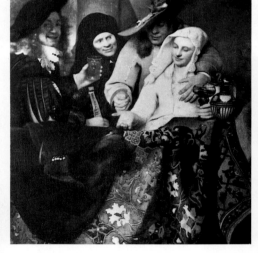

FABRITIUS (below)
A goldfinch, 1654
In Rembrandt's work, light plays suggestively about the forms; here the light strikes the form and is obstructed: there is no interpenetration. Fabritius uses Rembrandt's techniques to paint a more literal, more material truth.

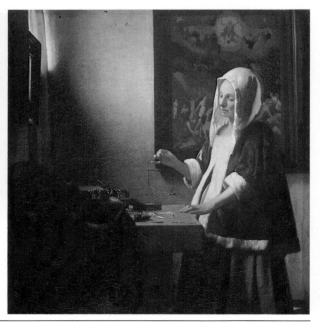

VERMEER (above)
The procuress, 1656
The figures are crowded; there is little of the haunting stillness of Vermeer's maturity. Only one other of his pictures is dated, and this is a rare certainty in his development – it was painted when he was 24.

VERMEER (right)
A woman weighing pearls,
c. 1665
The pearls are specks of light – an obvious instance of Vermeer's "pointillism"; the tiny sprinkled dots are usually apparent only on close inspection. Here is Vermeer's art fully mature.

space. The staging of his pictures owes something perhaps to experimentation with mirrors (though mirrors are seldom shown in his pictures); it is certainly an indication of the artist's special fascination with the techniques of perspective, most evident in *"The Artist's Studio"* (see over). Though the characteristic Vermeer is an interior, he brought the same qualities to two remarkable urban views; one, his *View of Delft*, unparalleled in Dutch landscape, the other a street scene, in which he handled the subject much as de Hoogh did.

Pieter de Hoogh (1629-84) of Rotterdam was in Delft from about 1653 until the early 1660s, and thereafter in Amsterdam. His early work consisted of low-life subjects – peasants, soldiers, tavern scenes; his later works show a falling-off in quality. His masterpieces – demonstrating Delft's catalytic artistic climate – almost all date from his decade there. In Delft he was surely aware of Vermeer, although it may well be that in some respects he anticipated Vermeer; both alike responded to the values and patronage of a secure and prosperous urban bourgeoisie. De Hoogh's compositions are usually rigidly constructed, sometimes almost geometrically organized: his

figures are housed firmly within the horizontals and verticals, within the rectangular definitions of his interiors or courtyards. Yet he is also the master of the "escape route" – of vistas leading from one enclosed space to another, rich with invitations to further exploration, suggesting a whole town of domestic interiors, the whole fabric of an urban society. He uses more figures than Vermeer, and very often children, in enchanting evocations of family contentment. His pictures are warmer in tone than Vermeer's, and lack Vermeer's supreme, magical intensity.

Comparable in quality and mood, though he did not work in Delft, is Gerard Terborch (1617-81). Terborch painted not only domestic interiors but also portraits, and finally settled after wide travel (perhaps in Rome, certainly in Spain and in London) in Deventer, a community even smaller than Delft. His pictures are a bewitching amalgam of highly subtle sophistication and a very direct and fresh grasp of character. His small-scale, almost miniature, portraits are like Velazquez in little; their decorum and gravity – even monumentality – are remarkable, not least in relation to their scale.

TERBORCH (below)
A boy picking fleas from a dog, c. 1655
Psychological delicacy and virtuosity in the painting of stuffs are the virtues of Terborch's painting. Boy and dog are vividly observed, and the open book and hat beside add a context: he has returned from school and should be at his homework.

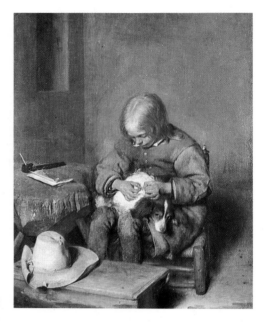

VERMEER (right)
View of Delft, c. 1660
Its bold colours, its quiet composition without any of the forceful diagonals and accentually placed figures usual in landscapes of the "classic" phase (see p. 222), above all the naturalism of its air and light set this painting apart. *"Pointillé"* dots mark glints of light, and all the horizontals and verticals seem to have been softened in the gentle air.

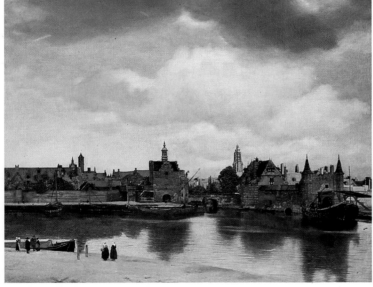

DE HOOGH (below)
The backgammon players, 1653
The subject and treatment are in the tradition of Duyster and Codde (see preceding page); there is no firm articulating framework of the kind typical of de Hoogh's Delft compositions.

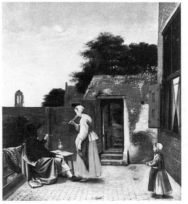

DE HOOGH (above)
A man smoking, a woman drinking and a child in a courtyard, c. 1656
The static figures have a quiet repose typical of de Hoogh's Delft period. The textures of things glitter with phosphorescent light a little like Vermeer's (left).

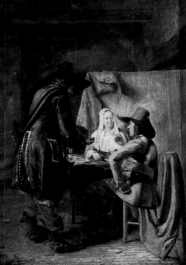

TERBORCH (left)
Self-portrait, c.1668
There is a sort of lively pomposity in the figure, pushing forward his bowed shoe and with arms akimbo beneath his cloak. The light on his lace front and long hair is beautifully handled. The picture is only about 60cm (28in) in height.

DE HOOGH (right)
A musical party, c. 1677
De Hoogh's later work is quite different in feeling: he leaves behind quiet women and their children, to show rather grander settings – here the "escape route" is more elaborate, and perhaps the most successful element.

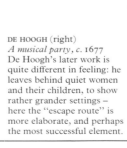

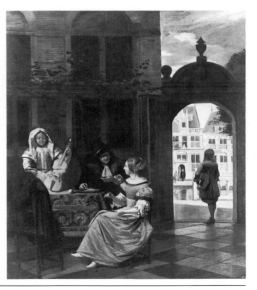

Vermeer: The Artist's Studio

The subject matter is detailed with all Vermeer's firm modelling and luminous, cool serenity: a painter, seen from behind, is in the act of painting on the easel before him the figure of a young girl who stands in the gentle light of a window in the corner of the room. It is a rich and typically Dutch interior – the black and white marble pattern of the floor; the sumptuously textured curtains; the fine brass chandelier; a map of Holland on the wall – inhabited by an inimitable element, Vermeer's pervasive and all-creating light.

On inspection, however, several questions about the picture begin to arise. This is no ordinary working painter's studio, cluttered and untidy; the painter is dressed in a costume that is certainly not studio garb. His model's shoulders are clad in a rather indeterminate drapery; her head is wreathed with what seem to be laurels, and though she has the features of a typical Vermeer girl (a daughter perhaps) she is accoutred with a fine trumpet and a large tome (that will soon surely be uncomfortably heavy). She must represent either a Muse – the Muse of History, Clio – or Fame, both of

whom earlier artists had shown with these accessories. Vermeer painted other allegories, and his widow is known to have referred to this painting under the title *The art of painting*. But this work celebrates the triumph of the painter's art far more movingly and convincingly than any Baroque contrivance of allegorical females could ever do, partly just because Clio, or Fame, is also a simple Dutch girl, dressed up rather touchingly and awkwardly; the artist in the picture, however, has not yet started with her person, he is beginning on his canvas with the laurels of fame.

But then, how did Vermeer himself set about the painting we see? There is no evidence in this or in any other painting that he worked otherwise than *alla prima*, directly on to the canvas, without preliminary studies or drawings – and this in spite of the absolute certainty with which the very elaborate structure and detail of the picture is established. He could, however, have framed his composition on a two-dimensional surface – ready to trace as it were – by the ingenious disposition of two mirrors, one behind the artist, the other in

front, so placed as to include the image of his own back as he painted. If so, this is a self-portrait, characteristically rejecting any self-revelation. There is still some ambiguity about the exact scope of the painting, a query, for example, as to whether the foreground curtain and chair are inside or outside the main subject of the picture. There are also ambiguities in the significance of the subject matter – the map of Holland, for instance, so ostentatious on the wall, looks like an assertion of Dutch national pride, but is beyond doubt of the Dutch provinces under the old Spanish rule.

The painting is signed (though for long it was attributed to de Hoogh), and is thought to be late within Vermeer's mature period, somewhere between 1665 and 1670. Some elements restate established motifs: painters at work (and seen from behind), the transitional device of the foreground curtain drawn back between the picture and the spectator – these occur in Rembrandt or in masters such as Dou or Mieris. What is unique to Vermeer is the monumental whole into which they are bound – entirely credible and yet unfathomable.

VERMEER (below)
The head of a girl, c. 1666
Though the girl may well be Vermeer's daughter, it is an impersonal portrait.

It seems to have been made chiefly to experiment with a favourite colour contrast, or to explore a fascination with the behaviour of light.

VERMEER (left)
An allegory of Faith,
c. 1669
This seems stilted. "The Artist's Studio" is instead really a genre picture of an artist painting an allegory: hence its greater success.

VERMEER (below)
Diana and her nymphs,
c. 1654
The subject, like that of the *Allegory* (left), is essentially Italian; classical myths and theatrical allegories were not main Protestant themes.

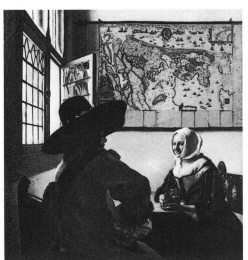

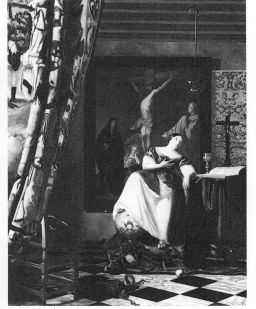

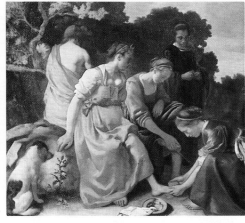

REMBRANDT (right)
The artist in his studio,
c. 1628-29
There is no high-flown allegory about this little genre work – it is hardly even a self-portrait. In Rembrandt's picture there is both a comic element and a debunking realism – the opposite of Vermeer's quiet, high seriousness.

VERMEER (left)
A soldier and a laughing girl, c. 1657
Both the Italianate subject and the composition of "The Artist's Studio" owe much to the Utrecht school – even if the Utrechtian device of silhouetting a foreground figure against the light in the picture is more bluntly used in this early work.

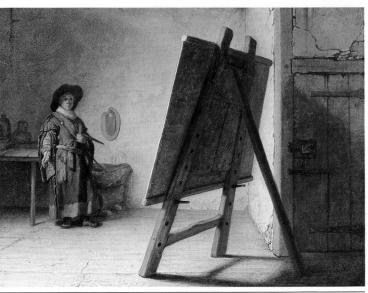

Dutch Still-Life Painting

The expression "still life", used to describe a category of painting, does not appear until about 1650, and then, significantly, in its Dutch form. It eventually became the habitual term for paintings of any kind of inanimate object – flowers, fruit, food of all kinds; tableware (from the grandest of gold or silver goblets to Venetian glass and Delft plates, or cutlery and the infinitely subtle white tones of napery); books, manuscripts, musical instruments. Yet still-life elements have recurred in Western art since classical times, and Netherlandish artists especially had long delighted in dwelling with vivid, doting accuracy on such objects, though not of course as the prime subject of their illuminations or pictures. In the sixteenth century, however, artists such as Aertsen (see p. 162) had painted detailed kitchen interiors in which the still life predominates, while the nominal pretext for the painting – Christ with Mary and Martha, for instance – is merely glimpsed in the rear.

In earlier pictures still-life objects were often, perhaps generally, introduced for their symbolic value. These values underlie much seventeenth-century still-life painting in Holland – the *vanitas* theme, for instance, announced in its most obvious form by a skull, reminding the viewer of the transience of all things; or references to the Five Senses (which occur, too, in genre painting). But while the vanity of all pleasures of this world is acknowledged by the Dutch, the admonition *memento mori* (remember death) always goes hand in hand with the celebration – remember life – implicit in the act of painting itself. The enduring enchantment of still-life painting rests in the paradox that the ephemeral subject – the cut flower, the emptied glass, the frailty of the butterfly – is translated by the illusionistic skill of the painter into immortality.

In seventeenth-century Holland, painters, and whole families of painters, tended to specialize in one aspect of the art – in flower-pieces or in "breakfast" and the more elaborate and complex "banquet" pieces; in studies of game or of fish; or in more overtly symbolic variations on the *vanitas* theme. All these subjects embodied a particularly Dutch pleasure, nourished in a hugely successful commercial society, in sensuous materialism – but these bourgeois took as much delight in a spiral of lemon peel as in the splendour of gold or silver plate. Certainly the price of the

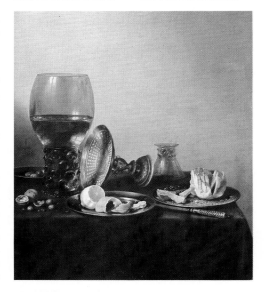

CLAESZ.
Breakfast piece, 1637
The objects are bound in a spell of light that joins them in an intimate unity. It preserves about

them a lingering aura – as if they had just been handled by someone. Their textures are delicately evoked and contrasted – this is no dry inventory!

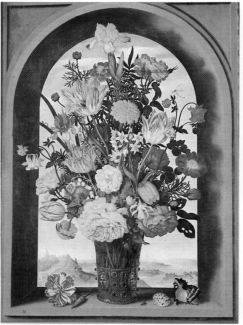

AMBROSIUS BOSSCHAERT
THE ELDER (left)
A vase of flowers, c. 1620
Bosschaert habitually included flowers from all seasons in one picture, and often the very same bloom recurs from picture to picture. He must have worked from a portfolio of drawings rather than from the life.

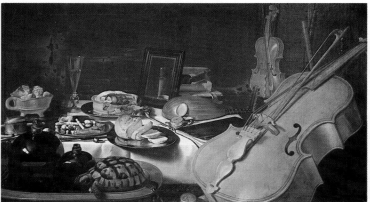

CLAESZ. (left)
Still life, 1623
Numbers of symbolic references can be discovered in the objects shown. All Five Senses are present – touch in every object; sight particularly in the mirror; hearing in the musical instruments; smell in the stoppered and unstoppered jars; taste in the half-eaten food. There are also many *vanitas* references to the passing of Time – the long-lived tortoise, symbol of old age; the lamp wick; the watch; the half-empty glass that once was full and soon will be empty.

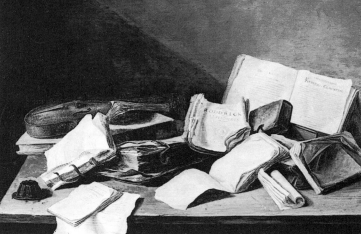

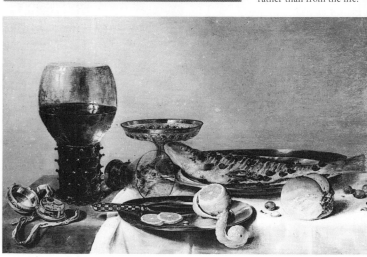

HEDA (left)
Breakfast piece, c. 1634
Claesz. and Heda painted similar delicately balanced compositions, and similar motifs. Heda's touch was slightly more meticulous, and his later works tended to be grander, like Kalf's.

DE HEEM (above)
Still life of books,
c. 1625-29
Still lifes of books were a local speciality of Leyden, a university town; de Heem was there as a young man. Unlike others, he did not specialize in one type of

still life, and, could change his style: the quite emphatic chiaroscuro of this picture was a passing interest. In Antwerp he tried a more Baroque style, comparable to that of Snyders (see p. 200) but rather cooler, as befitted a Dutchman.

objects painted was never forgotten: even flowers might be more than a simple pleasure, for this was the period of the great Dutch tulip boom, when the bulb itself might well cost much more than a painting of it. Still-life painters were as highly esteemed as other painters, and fed a rich export market.

Foremost amongst the early flower-specialists was Ambrosius Bosschaert the Elder (1573-1621), born in Antwerp but working mainly in Middelburg. His characteristic compositions consist of a vase of flowers set centrally in a niche through which a landscape can be seen. Each flower is described, "spelled out", with exact and impartial literalness in an even light. His tradition was carried on by many painters (including his own three sons and his brother-in-law, Balthasar van der Ast), though the subject matter increasingly included insects, shells, lizards or toads. In step with the general development of Dutch painting, their compositions became more naturalistic, modelled in terms of light and shade, with the illusion of depth and air. Modern eyes, glutted with ubiquitous colour photographs, cannot realize the delighted astonishment that such illusionist reproductions of the

elements of everyday life evoked in contemporaries – especially perhaps those faithful portrait likenesses of food on a table, seen from a high viewpoint to get in as much as possible.

The ablest popularizers of the breakfast piece were Pieter Claesz. (1597/8-1661) and Willem Heda (1599-1680/2), both based mainly in Haarlem. Like their contemporary, van Goyen, working in landscape, they were able to distil drama out of unspectacular objects by the calculated interrelationships between the elements of their composition, and the subtlest transitions of tone. Theirs was a tonal rather than a colouristic painting.

Slightly younger, Jan de Heem (1606-83/4) won an international reputation in a variety of kinds of still life; working mainly in Antwerp from 1636, he had an instinctive affinity with Flemish Baroque exuberance, a delight in movement and colour. Later again, the outstanding figure in the so-called "classic" phase of Dutch still life (corresponding to the "classic" phase of landscape painting) was the wonderfully talented Willem Kalf (1619-93). Though he worked briefly (1642-46) in Paris, his career was mainly in Amsterdam. His luxurious paint – influenced surely by Rem-

brandt's chiaroscuro, but also by Vermeer's scintillating treatment of light – is matched by a new richness of subject matter – plate, glass, exotic pearly-gleaming nautilus shells – answering the taste of a wealthy, patrician rather than bourgeois clientèle. Luxury, however, is always controlled by the most delicate feeling for compositional unity.

Kalf's contemporary Abraham van Beyeren (1620/21-90) specialized rather in more sumptuous banquet pieces, crowded with incident and variety, yet subtle in colour harmonies. Van Beyeren also painted fish-pieces, though paintings of dead game are rare in Dutch art till late in the century (there are two by Rembrandt). A "moving" variant on still life was developed later in the century by artists such as Melchior de Hondecoeter (1636-95), who depicted domestic or exotic birds and animals. Flower-painting, however, was perhaps always the most popular, and remained popular until well into the eighteenth century, sustaining its quality in the hands of successive generations rather better than other branches of Dutch art; some of the later flower painters, such as the van Huysum family, fell little short of their predecessors in talent.

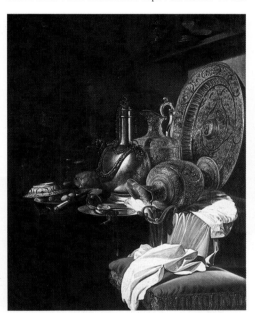

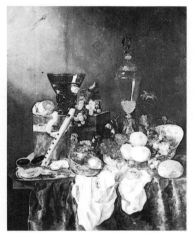

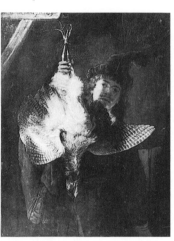

VAN BEYEREN (left)
Still life, undated
Van Beyeren's work seems a more modest, restrained version of the exuberant displays of the Flemish artists, or even de Heem.

REMBRANDT (right)
Self-portrait as a hunter, 1639
Rembrandt often ranged into subject matter other Dutch artists did not touch; it is not easy to ascertain the purpose of this picture. Rembrandt, of course, was a great master of the fall of light on texture.

KALF (left)
Still life, 1643
There is a new grandeur, lavishness and refinement in Kalf's painting. Goethe's comment on Kalf is famous: "One must see this ... in order to understand in what sense art is superior to Nature ... There is no question, at least there is none for me, that if I had to choose between the golden vessels or the picture, I would choose the picture".

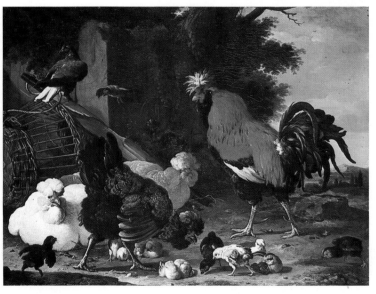

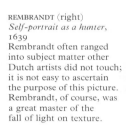

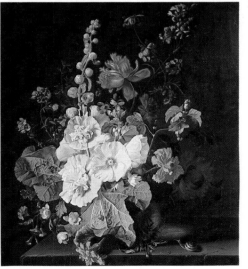

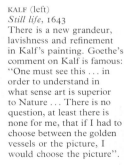

JAN VAN HUYSUM (left)
A vase of flowers,
c. 1710-20
Jan van Huysum (1682-1749) was the most highly paid flower painter of his day. The dewy freshness and harmony of his colours are delicious. His lighter touch and heightening key announce the Rococo era.

HONDECOETER
Cocks, hens and chicks, with other birds, c. 1668
Hondecoeter's interest in

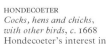

texture, his nicely blended colours and his naturalism are praised; his fowls had an international reputation.

There is often in them an allegory – of the Nations of Europe at War, or here, more simply, Family Life.

Late Baroque in Italy

Baroque painting in the Grand Manner, in particular decorative painting in the churches and, to a lesser extent, in the great aristocratic palaces, had been practised in Italy throughout the second half of the seventeenth century, and it continued into the eighteenth. In central Italy it remained within the tradition established by Pietro da Cortona (see p. 189), and perhaps its main development was towards an ever-increasing virtuosity in illusionism, in dissolving solid domes and vaults into celestial visions spiralling up into endless heavens. In Rome, a spectacular climax was reached in the *Allegory of the missionary work of the Jesuits* with which Fra Andrea Pozzo (1642-1709) exploded the nave vault in S. Ignazio in the early 1690s. In sculpture, the influence of Bernini remained paramount, and his emotive style was continued in the work of his former assistant Antonio Raggi (1624-86) and others. Raggi's carving and stuccowork, for instance in the church of Il Gesù at Rome, is of a brilliance and colour almost comparable to that of his master.

Rome remained the fountain-head of sculpture until well into the eighteenth century, even though in painting its importance as a centre of ambitious decorative projects waned. Nevertheless in central Italy, in Rome, Florence and Bologna, the principles of classicism and *disegno* were sustained: painters such as Carlo Maratta (1625-1713) continued to model their figures firmly and solidly and to evolve their compositions by means of painstaking preliminary drawings. The tradition was to culminate in the relatively sober vision of the German-born Mengs (see p. 304), whose Neoclassical figure painting is often strikingly reminiscent of the Carracci.

The important developments in decorative painting occurred elsewhere – to the south, in Naples, blossoming artistically under foreign domination, and to the north, in Venice, which was clearly in decline as a commercial or political power, but, like Rome, was already drawing tourists irresistibly from all over Europe. In both Naples and Venice painters exulted in the rhetoric of the Grand Manner with a new freedom: for these artists the movement of the brush, conjuring aerial rhythms of line, in strokes of brilliant colour suffused in light, became predominant – more important than literal accuracy of drawing.

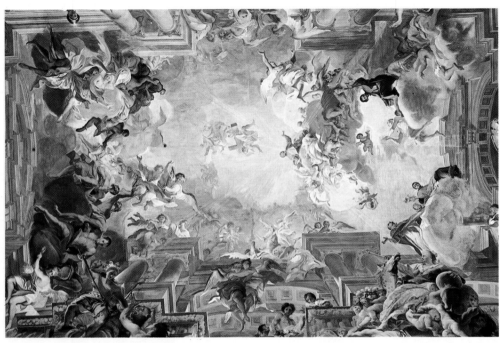

POZZO (left)
Allegory of the missionary work of the Jesuits, 1691-94
Padre Pozzo's ceiling for S. Ignazio, celebrating the developed strength of the Jesuit order, has crowded figures hurtling in a space deeper than any by Pietro da Cortona. Padre Pozzo's perspective, fully effective only from a single spot in the nave, was imitated in Germany and in Austria, where he settled in 1702.

GIORDANO (below)
Venus, Cupid and Mars, undated
One need only compare the Venus with a female nude by Annibale Carracci (see p. 187) to see how Giordano has infused the classicist tradition with the sensuality of Venetian art. Luca was consistent only in the zest with which he painted; he painted with great speed, being known as "Luca fa presto" (Luke quick-hand).

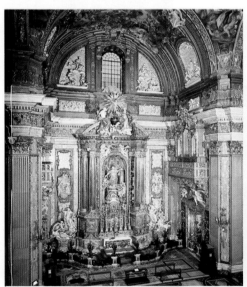

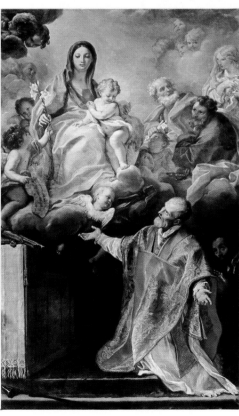

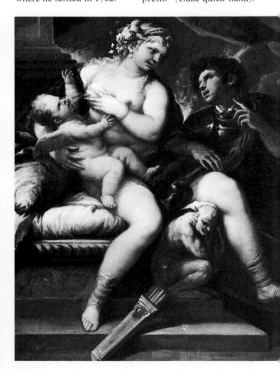

RAGGI
St Ignatius' Chapel, Il Gesù, 1683
Raggi's stucco sculptures, so rapturous in gesture, so turbulent in movement, set in such a rich setting, typify the increasingly decorative development of Bernini's union of all the arts revealed (see p. 190) in the Cornaro Chapel.

MARATTA (right)
The Virgin and Child with St Philip Neri, c. 1690
Maratta was the leading painter in Rome, and his prestige was enormous. He continued the classicizing trend of Andrea Sacchi, who taught him: his version of this subject is much more sober than that of the Neapolitan Solimena.

In Naples the prototype artist of the new fashion was Luca Giordano (1634-1705). Probably a pupil of Ribera, and therefore an heir to the Caravaggesque tradition, he became an endlessly inventive and prolific virtuoso in many styles, approaching each project as a problem to be solved by the application of whatever style might seem most fitting. Luca borrowed ideas impartially from the Venetians or from Pietro da Cortona, from Rembrandt or Dürer. He led a life typical of the leading late Baroque and Rococo artists, answering the calls of patronage wherever they might promise most richly; thus he worked in Naples, Madrid, Rome, Florence and Venice. His longest stay was in Madrid, where he was painter to the Spanish king for ten years from 1692, and where he decorated ceilings in the Escorial (not shown). He was succeeded in Naples by Francesco Solimena (1657-1747), who tended to revise Giordano's spirited manner back to a more sober reliance on academic drawing and composition, though his pictures were still often dashingly painted.

In Venice the major exponent of the late Baroque style was Sebastiano Ricci (1659-1734). Early study in Bologna, Parma and Rome established him in a tradition of relatively solid modelling, which he never entirely abandoned, but to it he brought a fluent bravura and a freedom of movement that he had learnt from older Venetian painters. He pitched his colour and tone ever higher in key, towards that magical luminosity and heady atmosphere for which Venetian eighteenth-century decorative painting soon became internationally renowned, above all in the work of Tiepolo (see over). In his verve, and his intelligent and wide-ranging eclecticism, he is the Venetian parallel to Luca Giordano, and like him was mobile, working in Milan, Vienna, Bergamo and Florence as well as in Venice. Quite late in life, for four years from 1712, he was in London with his nephew Marco Ricci (1676-1730), and then in Paris, where he met Watteau, and copied some of his paintings. He and Marco, often collaborating, answered the taste of Europeans on the "Grand Tour" of Italy for landscapes, and they were early practitioners of the *capriccio*, or "ruinscape".

The more classicistic strain in Venetian painting is better exemplified by Giovanni Battista Piazzetta (1683-1753): he worked, in a more staid and "academic" manner, not on grand decorations but mostly on altarpieces, and was firmly resident in Venice, where his large studio became an influential school. He, too, had been trained in Bologna, where the early work of Guercino made an impression on him, and he continued to rely on solid but dramatic modelling. His initially fairly sombre key (sometimes exploiting a Caravaggesque chiaroscuro) lightened in the 1730s. There was a large demand, especially from abroad, for his pastoral genre works (see p. 244).

In the eighteenth century foreign commissions, not only for genre and landscapes, not only for easel-pictures but also for ceiling paintings, became increasingly important for Italian artists. They provided the main market for Venetian painters in particular, and many of the most gifted were prepared to travel extensively to fulfil them. Like the Ricci, Giovanni Antonio Pellegrini (1675-1741; not shown) was peripatetic, working in Baroque palaces and country houses in England, Austria and Germany; so were Jacopo Amigoni (1682-1752) and others, all exporting a brilliant, hedonistic idiom of decoration, which often has clear affinities with French Rococo.

SEBASTIANO RICCI (right)
Pope Paul III reconciles Francis I with Charles V, 1686-88
Reference to Titian's *Paul III* (see p. 143) explains the oddly Mannerist elongation.

SOLIMENA (below)
The Virgin and Child with St Philip Neri, 1725-30
Solimena created majestic, dramatically lit altarpieces, influential and in demand both in Naples and abroad.

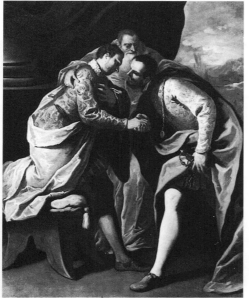

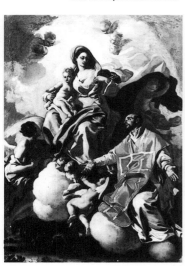

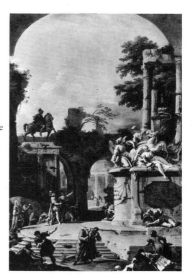

SEBASTIANO AND MARCO RICCI (right)
Allegorical tomb for the Duke of Devonshire, c. 1720
The Riccis' agglomerations of items from the classical past were a precedent for the *capricci* of Canaletto or Panini (see p. 254). This was one of a series, organized by an impresario, Owen McSwiny, of "tombs" for the leading English Whigs – in fact pastiches of well-known antiquities combined with gratifying allusions to the coats of arms and achievements of the living patrons.

AMIGONI (below)
Venus and Adonis, c. 1740-47
Amigoni's figures, clothed in an aura of frailty, are sweet and pure. There is much that recalls Titian, but the mood, and the high key of colour, are Rococo.

PIAZZETTA (right)
The Adoration of the shepherds, c. 1725
In an era that rejoiced in bravura, Piazzetta's art was intense and introspective. His figures are quite firmly modelled – in a style learned not in Venice but in Bologna – yet they are enlivened by highly tactile dragged brush-strokes. The flickering light and shade are Caravaggesque, but make the figures more homely than monumental.

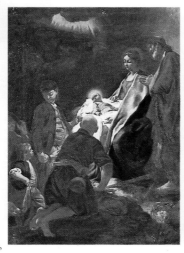

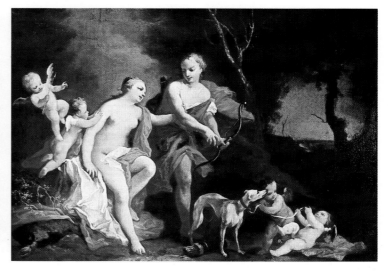

Tiepolo: The Residenz at Würzburg

One of the most spectacular achievements of eighteenth-century art is the decorative ensemble of about 1750 in the Prince-Bishop's Palace, or Residenz, at Würzburg. It is the work of the great German architect Balthasar Neumann and the last of the great Venetian painters, Giambattista Tiepolo (1696-1770), and its two main elements are the staircase, or *Treppenhaus*, and the salon, or *Kaisersaal*.

In the *Kaisersaal* marble, gold, stucco and glass come together with the colour, light and fluency of Tiepolo's paint to achieve a masterpiece of *Gesamtkunstwerk*, that union of the arts that lacks only music to become opera. On the ceiling are painted incidents from the life of Emperor Frederick Barbarossa, who had invested the Bishop of Würzburg in 1168 – almost in the Dark Ages. In Tiepolo's interpretation the action is transported into the sixteenth century, into the Venetian costume of Veronese, and has been rendered incandescent with light. The ceiling shows an exultant Apollo conducting across the heavens a triumphal chariot bearing Beatrice of Burgundy towards Frederick, her husband-to-be, who is enthroned on a steeply towering edifice on the other side, while Glory with a flaming torch hovers above. The *Treppenhaus*, with its complex iconography, *Olympus with the four quarters of the Earth*, is hardly less luminous.

Tiepolo's art in his maturity was the consummation of Baroque fresco, as complex and inventive as that of any of his predecessors, yet controlled and disposed with crystal clarity. The illusion in the *Kaisersaal* is complete – from the real, solid floor the eye travels up into the intricacies of art and so to the apparent dissolution both of the real and of art: the gilt stucco, now real, now a painted imitation indistinguishable from the real, melts into a heaven flooded with light and with an air that is almost breathable. Tiepolo's magic is most telling in the foreshortened horses that surge across the sky; their ancestors are to be found in Reni, Guercino (see p. 185) or Giordano, but only Tiepolo could inspire the spectator with a sense of almost interplanetary "lift-off". The glorious white creatures retain all their physical and massive presence, yet are superbly and triumphantly indifferent to gravity. In the frescos on the walls Tiepolo had less scope for such aerial heights of fantasy, and presented the scenes on stages revealed behind heavy curtains raised by angels; yet the quality of painting is equally high, and illusion interpenetrates reality equally deftly.

Tiepolo's earlier work had been influenced by the sculptural modelling and heavy chiaroscuro of his older contemporary Piazzetta, and was mostly in oil. Fresco, with the opportunity for working over vast areas at great speed, released his genius, and for it he developed his characteristic high tonal key, within which he could make even his shadows glow with light. His frescos, whether religious or secular, are so joyfully radiant that to some nineteenth-century critics they seemed intolerably frivolous. There is no doubt, however, of Tiepolo's religious sincerity. Later in his life a strain of melancholy became stronger and his altarpieces could strike a grave and elegiac mood, for instance in the ashen blues of the *modello* for an altarpiece of *St Thecla* for the Cathedral at Este. Yet the overwhelming impact of his art is its heart-lifting colour and light.

At the end of his career, in the service of Charles III in Madrid, his aerial perspectives became even more free, his figures sporting in their heavens became as light as bubbles in champagne, but this climax was attended by indications that new fashions were on the way. His almost equally brilliant son and collaborator, Domenico, painting in fresco what was in fact genre at the Villa Valmarana (see p. 244), was by 1757 "burying the Grand Manner right under his father's vigilant eye", as the historian Wittkower has put it, and the end of Tiepolo's life in Madrid was clouded by lapse from favour, when the King came to prefer the Neoclassical manner of Mengs.

TIEPOLO (below)
Abraham visited by the angels, c. 1732
Even after Tiepolo had developed his light-filled fresco style, he retained a more sombre and emphatic approach (conditioned in part by the medium) in his large-scale canvases in oils.

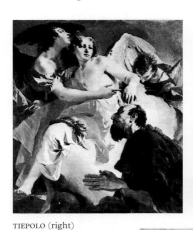

TIEPOLO (left)
St Thecla delivering the city of Este from the plague, 1759
Instead of the typically Baroque drama of the early altarpieces, Tiepolo's late *modelli*, or prior sketches, for religious canvases show airy, shimmering brushwork. (He left the full-scale work to be done by assistants.) They are, however, more solemn than his frescos – in approach recognizably Counter-Reformation art.

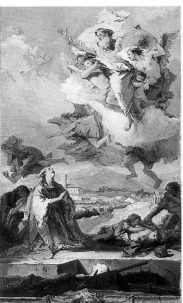

TIEPOLO (right)
The banquet of Cleopatra and Anthony, detail of the Palazzo Labia ballroom, 1745-50
The greatest influence on Tiepolo was Veronese: his complex illusionism at the Villa Maser (see p. 379) and the animated spectacle of his famous vast *Banquet* pictures lie behind the Palazzo Labia frescos.

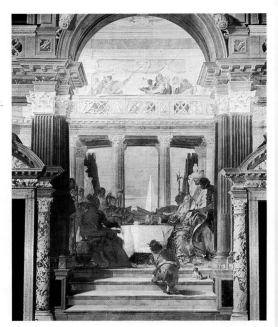

TIEPOLO (right)
Olympus with the four quarters of the Earth, detail of the ceiling of the *Treppenhaus*, Würzburg, 1752-53
Tiepolo exalts the four continents then known – Africa, Europe, America, Asia – in a cosmorama of races, costumes, flora and fauna, in which mythical and allegorical figures commingle with living persons. Apollo, in the middle, pays homage before the portrait of the Prince-Bishop. The group below, symbolizing Europe, includes the artist and his son Domenico.

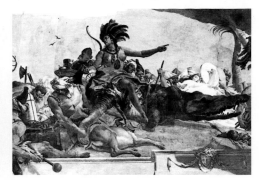

TIEPOLO
America, in the *Treppenhaus*, Würzburg
On each of the four walls is represented a continent: this splendid woman in a feathered head-dress is the personification of America.

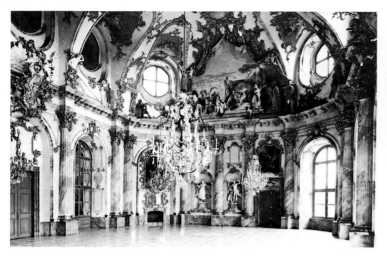

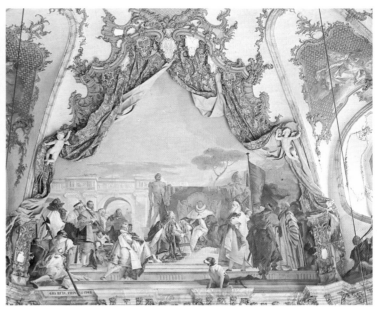

NEUMANN AND TIEPOLO (above) The *Kaisersaal* in the Residenz, Würzburg, 1751-52

TIEPOLO (below) *Apollo leads Beatrice to Barbarossa*, in the *Kaisersaal*, Würzburg

TIEPOLO (right) *The marriage of Beatrice and Barbarossa*, in the *Kaisersaal*, Würzburg

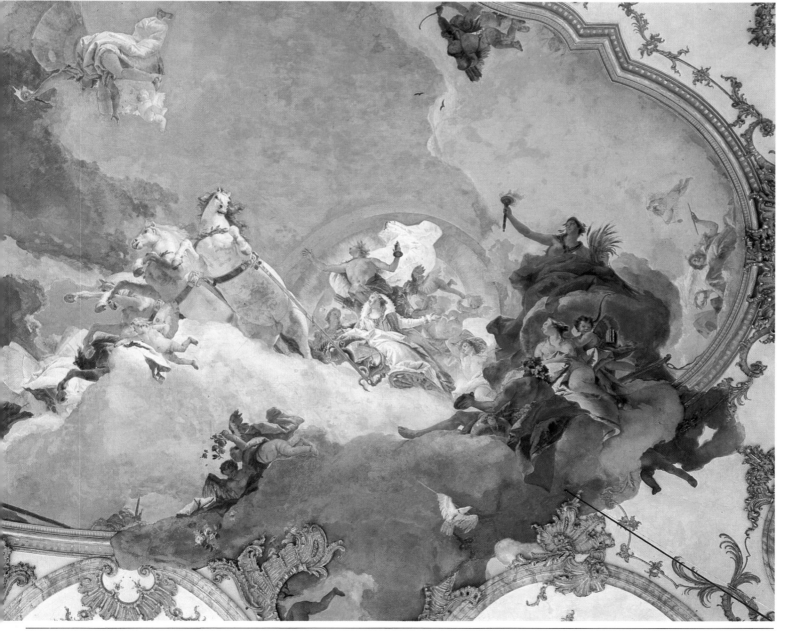

Watteau: The Embarkation for Cythera

Men and women in pairs, almost afloat in their silks against the haze of the sunset sky and the distant misty peaks, ebb down from the right of the painting, where stands a sculptured bust of the goddess Venus wreathed with roses and convolvulus, towards a boat awaiting them at the shore of an inlet of the sea. The picture is all autumnal gold, with a certain lilt of melancholy, a dying fall of farewells, and echoes of unheard music.

Of the two slightly different versions of *"The Embarkation for Cythera"*, one in Berlin and one in the Louvre, the earlier one in the Louvre was the enrolment picture which Jean-Antoine Watteau (1684-1721) deposited with the Académie in 1717 – a little belatedly, as he had become an Academician in 1712. He called it originally *Le pèlerinage à l'Ile de Cythère*, translatable as "the pilgrimage to, or on, or towards the island of Cythera". The title by which it has long been known, *"The Embarkation for Cythera"*, came later, and, though it was universally adopted, it is surely wrong, as has recently been shown. In legend, Cythera is the island where Venus rose from the sea, and here indeed she is, in statue form. But clearly the pilgrims are not setting off for the island but about to leave after a day's enchanting dalliance on it.

Fêtes galantes, showing lovers in a pastoral setting, sometimes banqueting, often with music, had attracted painters since the sixteenth century at least: an obvious prototype for Watteau's version is Rubens' *Garden of Love*,

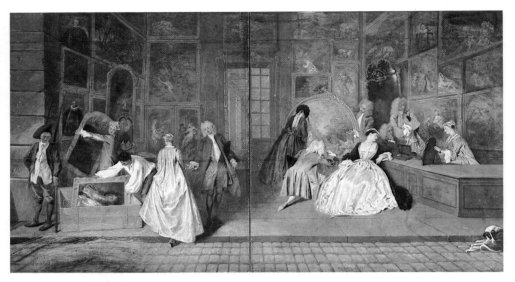

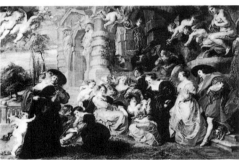

RUBENS (left)
The Garden of Love, c. 1632 Rubens' *fêtes galantes* (but not yet called that) were an inspiration to Watteau and other 18th-century painters – although they transposed his extrovert sensuality into an intimate, more graceful, Rococo key.

WATTEAU (above)
"L'Enseigne de Gersaint" (Gersaint's signboard), 1721 Watteau's "shop sign" has a greater realism, a more specific setting than his earlier pictures. Flemish artists hang recognizably on the walls; the man in the middle may be Watteau.

WATTEAU (below)
The Louvre *"Embarkation*

for Cythera", properly *The pilgrimage to Cythera,* 1717

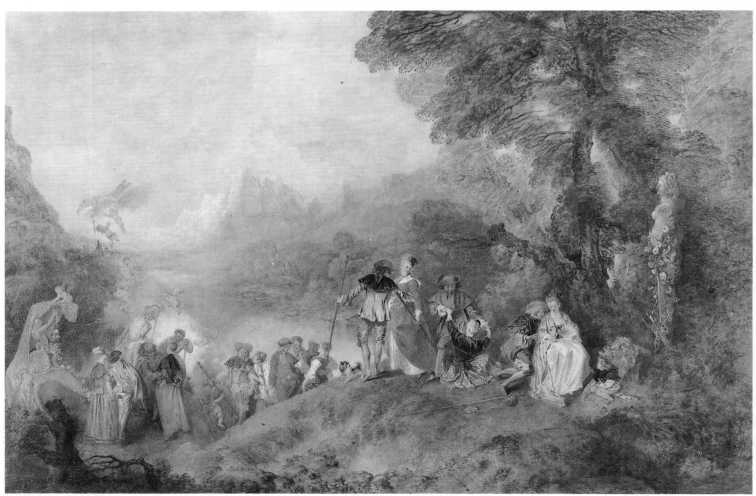

which Watteau certainly knew. His literary source was probably a musical entertainment, *The Three Cousins*, by Florent Dancourt, which appeared in 1700. It had pilgrims journeying to a temple of Love in Cythera, whence, a couplet pointed out, no girl returned without a lover or a husband. In Watteau's picture – which is very like a stage presentation, almost an opera – this consummation has clearly been brought about, as the couples turn lingering to the boat; yet pleasure is shadowed by the approach of evening. Time is not to be denied, and the transience of youth, the bittersweet of love itself, is only just below the surface.

The inspiration of the stage is obvious in most of Watteau's work, and in particular that of the Italian *Commedia dell'Arte*, with its costumed stock characters, of whom the best-known is Pierrot – he typifies its element of pathos and its occasional edge of satire. These qualities are indeed almost always present in Watteau's painting. But the enduring fascination of his artificial never-never world must be due in great part to the brilliance of his technique. From his very early days, he kept sketchbooks with swift notations of figures from the life, and these he used again and again in his paintings. He is one of the world's most bewitching draughtsmen, marrying strength and fragility, power and delicacy into his swallow's-wing line; this quality he transposed into his painting with no loss of grace. Over an underpaint of pearly white, sometimes hazing to blue or palest pink, he drifted on trees in

washes of green and golden brown; then the figures, in a thick impasto modelled with incisive gesture; over this, transparent glazes, in a technique based on that of the sixteenth-century Venetians, so that the overall impression is of shimmering depths. His Flemish origins, however (he was born in Valenciennes, which until a few years before his birth was part of Flanders), are apparent in the rhythm and colour of his compositions, and his debt to Rubens was never forgotten. When Watteau arrived in Paris in 1702 the argument among French painters between "Rubenisme" and "Poussinisme" (see p. 198) was already swaying back towards Rubens.

The tinge of melancholy in Watteau's work is matched by his life. His health was undermined by early hardships, and he had less than ten years left when he became an Academician. In 1719-20 he was in London, partly in hopes that the famous Dr Mead might cure his consumption, partly perhaps from a desire to extend his sphere of action. He was already, however, fatally ill. On his return to France, as his death approached, he destroyed a large number of his more erotic paintings. One of his last paintings, however, *"L'Enseigne de Gersaint"* (Gersaint's signboard), for a picture dealer called Gersaint, who looked after him, was a new departure.

After his death, Watteau's style in *fêtes galantes* was carried on by Jean-Baptiste Pater and Nicolas Lancret, both of whom had competence but not Watteau's unique magic.

WATTEAU (below)
The Berlin *"Embarkation for Cythera"*, 1718
Here the moral lurking in the first version is made explicit: lovers turn to leave with a more obvious regret. The lyric haze of the first version has turned to a brighter clarity. The lady with the fan beneath the statue of Venus (now *"The Medici Venus"*) has a face of clearly Rubensian type.

WATTEAU (above)
"La Toilette", c. 1720
The picture is superbly ambiguous: the lady seems to have been surprised in the privacy of her chamber, but is she undressing or dressing? Her pose reveals as much as it conceals. Why the onlooking maid, if not to reinforce the erotic atmosphere? The moral laxity, the shell couch-head, her body's oval, are Rococo.

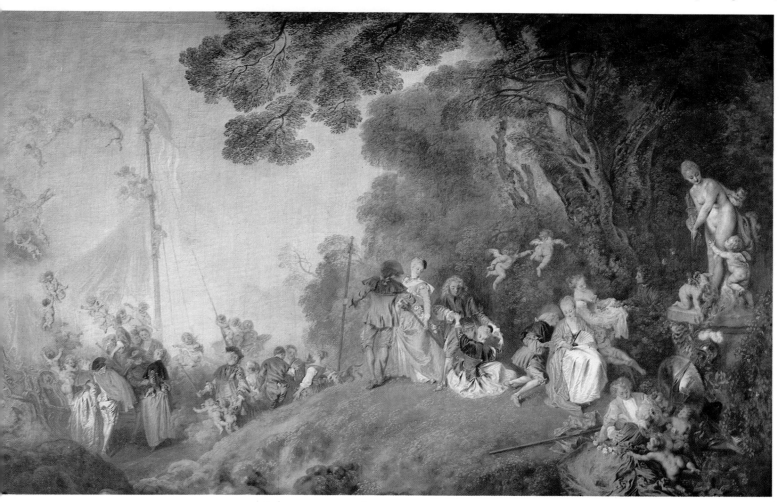

French and German Rococo

The word "Rococo" appears to derive from the French *rocaille*, perhaps in a kind of rhyming analogy with *barocco* (the Portuguese word for an irregular pearl, and arguably the source of the word "Baroque"). *Rocaille* means literally "rock work", but Rococo has come to describe primarily a style of decoration exploiting irregular or at least asymmetrical forms, and shell, rock or plant motifs linked by C- and S-scrolls. This style of interior decoration developed in France in reaction to the grandiose formality of Louis XIV's reign, and its roots were in the "grotesque" ornament of Italy and in the decorative tradition of the school of Fontainebleau, which had never entirely faded during the seventeenth century – it had been sustained by illustrators and especially perhaps by theatrical designers.

The dividing line between Baroque and Rococo is as difficult to establish as the exact moment when the surge of a wave breaks into its own spray. Rococo continues the movement of the Baroque, but tends to fragment it and to express itself on a smaller scale (even, at its most elegant, a miniature one); the surface becomes all-important; monumentality and pomp give way to relative informality, to gaiety and often to frivolity. In painting and sculpture, these stylistic qualities are to be found with a correspondingly less solemn subject matter – characteristically Rococo are mandarins in spindly pagodas, cavorting monkeys and shepherds and shepherdesses in pastoral idylls. It coincides with a new current in French manners and morals, and embodies the sensitive and highly sophisticated feeling for the visual arts of a society that valued elegance and artifice and light-hearted wit. Although Watteau (see preceding page) is always called a Rococo artist and indeed has some essential characteristics of the style, his underlying seriousness of mood transcends it. The archetypal painter of the French Rococo was François Boucher (1703-70).

Boucher began his career making engravings of Watteau's pictures, but during four years spent in Italy (1727-31) learnt much from Veronese and Tiepolo: though he was never to attempt the scale and sweep of the Grand Manner, his characteristic palette of light but rich pastel colours reflects Tiepolo's impact. In France, his most steadfast patron was the highly influential royal mistress Madame de Pompadour, whom he portrayed many times (see over). She induced him to extend his range to the designing of ambitious decorative schemes for the royal châteaux, and of spectacular stage productions; his resulting involvement with tapestry design brought him the directorship of the Gobelins factory, and in due course he became the King's painter. In his pictures, he transformed classical mythology into scenes of erotic gallantry, copiously populated with nubile nudes (some of whom were recognizable to contemporaries as fashionable beauties of the court). His apparently effortless erotic charm is, however, based on a formidably sure draughtsmanship. If in mood and colour he was both repetitive and unfailingly artificial, his execution was always brilliant and his inventiveness inexhaustible. He perfectly answered the needs of the sophisticated society of Louis XV's reign, even though after 1760 changing taste found him unserious and even immoral – the critic Diderot reluctantly admired his art as *"un vice si agréable"* (so delightfully wicked).

Jean-Honoré Fragonard (1732-1806) was briefly and not happily Chardin's pupil, and then more aptly Boucher's. Like Boucher, he saw Tiepolo's work in Italy, and was a protégé

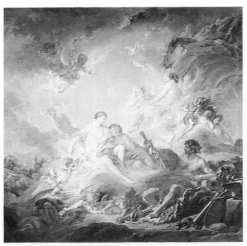

BOUCHER (left)
Vulcan presenting the arms of Aeneas to Venus, 1732
In the years up to about 1750 Boucher painted a large number of unheroic mythological pictures, all vigorous, erotic, poetic and decorative – they were in fact part of decorative schemes. In these qualities he is the intimate, informal equivalent of Tiepolo.

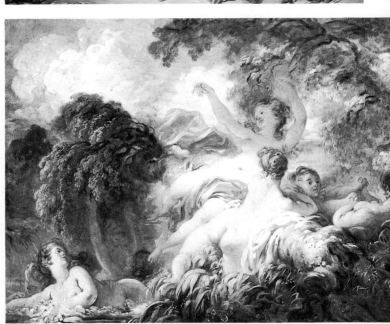

BOUCHER (right)
Diana bathing, 1742
The mythological settings eventually became no more than a pretext for painting gorgeous female nudes, set off, as here, by glowing draperies and a fine still life at bottom right.

FRAGONARD (left)
Music, or M. de la Bretèche, 1769
The inscription states that the picture was painted in one hour. It is a sketch, but the characterization is fully realized, and the light and shade finely gradated; in its bravura handling it recalls Frans Hals, whom Fragonard greatly admired.

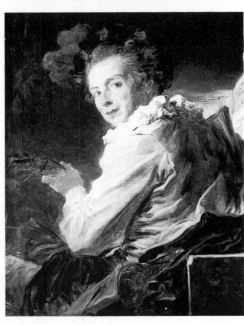

FRAGONARD (right)
Women bathing, 1777
Painted *alla prima* in a blend of translucent thin washes and dense impasto, this picture by Fragonard recalls the brushwork and curvilinear composition of Rubens – see the nymphs in *The disembarkation of Marie de Médicis* (p.411). In the emphatic bare bottom there is conscious prurience.

of Madame de Pompadour. His themes, in their erotic gaiety, often have much in common with Boucher's, and appealed to the same clientèle, but his style developed differently: more like Watteau, he responded to the colour and free handling of Rubens and to the verve of Frans Hals. Though his pictures are often full of creams and pinks, they are never merely pretty effervescences: the dash and fluent freedom of his brushwork find their nearest counterparts in Gainsborough and Goya, and there is usually an edge of prurience or satire. Like Boucher, he sometimes delighted in nostalgic landscapes, with or without ruins, which can seem precociously romantic in mood, like the landscapes and "ruinscapes" of his gifted friend Hubert Robert (1733-1808).

The French Rococo style was exported by itinerant French artists, but also, through engravings, by a new generation of virtuoso printmakers. It influenced all Europe – it was only in England that it was not so pervasive. In Germany, however, particularly Catholic south Germany, Rococo took its own distinct form. It flowered relatively late but continued longer, from about the second quarter of the century to its end, and it was religious rather

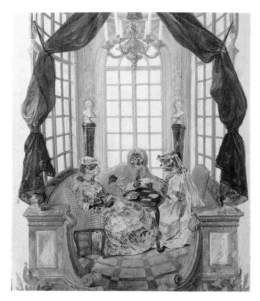

HUET (above)
The monkeys' salon, 1735
Christophe Huet (died 1759) was a master of the informal decorative scheme,

using to good effect the graceful and light-hearted arabesque, chinoiserie and *singerie* ("monkey-game") that typify Rococo décor.

than secular. Often, in its large scale and even massiveness, and particularly in its fascination with spatial complexities, it was very much within the framework of Baroque; many indigenous artists had been trained in Italy, or had visited it, while Italians from Padre Pozzo to Tiepolo had brought Italian Baroque north. There was also, not to be ignored, already a strong tradition of stucco decoration in south Germany, and an established delight in light, bright tonalities and colours.

These chief factors combined to produce an exuberant and heady hybrid, and especially brilliant concerts of the arts in the Catholic churches. Artists such as the Zimmermann brothers, Dominikus (1685-1766) and Johann Baptist (1680-1758), and the Asam brothers, Cosmas Damian (1686-1739) and Egid Quirin (1692-1750), produced interior spectaculars unsurpassed in their kind anywhere. They introduced visual opera (even at times visual musical comedy) into the repertoire of church décor. The exhilarating, airy and spacious effects obtained, often in small churches, are usually combined with a sweet simplicity, and in the artful sophistication of the Asams there was remarkable religious sincerity.

ROBERT (right)
Felling trees at Versailles, 1778?
Robert had visited Italy with Fragonard, and his landscapes, with their ruins, frond-like trees and tiny figures, have an Italianate charm. Also a landscape gardener, he designed some of the parks at Versailles.

THE ASAM BROTHERS
(below) The altar of the church of Maria Victoria, Ingolstadt, 1734
The close derivation from Roman Baroque is clear, but here the brothers have chosen delicate colours in a high key rather than rich marbling or dramatic light. Every inch is decorated.

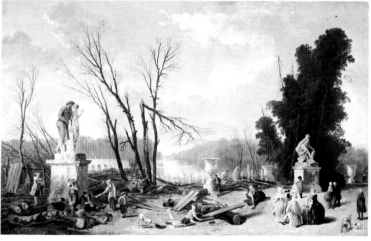

ST NICHOLAS MALA STRARIA, PRAGUE (below)
Detail of the upper nave, frescoed 1760-61
Swirling movement and an interplay of advancing and receding masses surround the delightfully posturing figures in the Jesuit church.

THE ASAM BROTHERS
(right) St John Nepomuk, 1733-46
The skilful relationship of sculpture to architecture creates a sense of spacious grandeur in this church, set on a tiny site next to Egid Quirin Asam's own house.

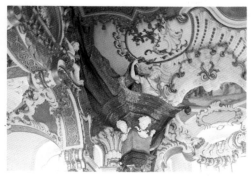

THE ZIMMERMANN BROTHERS
Detail of the ceiling of Die Wies, Bavaria, 1745-54

The church was stuccoed by Dominikus with luxuriant, colourful fronds and scrolls proliferating asymmetrically.

French Rococo 2: Portraiture and Sculpture

By the time that Louis XIV died, in 1715, after more than 70 years on the throne of France, the pomp and splendour of Versailles had become old-fashioned, though it was still the pattern for most European courts. During the Regency (1715-23) of the Duke of Orleans, Versailles virtually closed down and the boy-king Louis XV was housed in the Tuileries in Paris. An aristocratic taste succeeded the royal one: instead of the palace, the private house became the frame of culture. It was here that Rococo belonged, which, as we have seen, was primarily a style of interior decoration – even the frame of a work of art had an importance, often equal to that of the work itself. Mirrors were never long out of sight in this scheme of things; in them the self-conscious denizens of the salons could confirm their elegance, and naturally the portraitists flourished.

Two long-lived and superb professionals had become established in the previous reign, Rigaud, who had painted the aging Louis XIV (see p. 199) and Nicolas de Largillière (1656-1746). Rigaud continued to paint the court, but Largillière's clientèle was as much middle-class as aristocratic, though the flourishing *haute bourgeoisie* aspired to an elegance hardly less lavish; Largillière also painted sumptuous still lifes (see over). Although both artists answered the continuing demand for the formal "parade" portrait, their work shows the start of a clear movement away from the stupendous and magnificent towards the lively and informal. Their portraiture was always conditioned by the need of their clients to be seen at their best, but the gestures become less grandiose and robes, wigs and lace are more negligently agitated. The fashion for presenting sitters in allegorical terms – the females particularly, as the heroines or goddesses of some classical mythology, clothed in becoming (and sometimes rather scanty) fancy dress – continued to flourish. This element of role-playing, stemming especially from the Baroque portraiture of van Dyck, and prevailing also in Holland and England (Largillière had worked in Lely's studio), was well suited to the make-believe society of Louis XV's Paris; its level could vary from the realms of the gods to the Arcadian idyll of milkmaids and shepherdesses later aped by Marie Antoinette.

Following Largillière and Rigaud, the leading portraitist was Jean-Marc Nattier (1685-1766), endlessly in demand both in Parisian

THE MEISSEN FACTORY (above) *The concerto, c.* 1760
Rococo was as much a mood as a style, affecting all the arts; indeed the fragile grace of porcelain attracted sculptors rather more than noble marble. Advances in techniques of firing and enamelling made possible such rich, deep and exquisite colours.

NATTIER (below)
Mlle Manon Balletti, 1757
The lady was the daughter of a successful actress of the Italian company in Paris. Nattier has enclosed her in an enchanting purity, suggesting palpitating flesh within the subdued colours of the rose and her gown.

LARGILLIERE (right)
The painter with his wife and daughter, c. 1700
Despite his daughter's airs, his wife's prim face and his own haughty mien, there is an easy informality about Largillière's family portrait. The artist-gentleman sits with gun, hunter and brace.

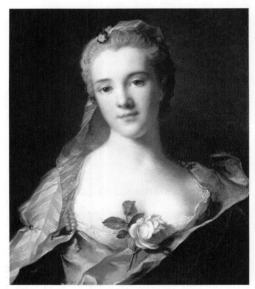

CARRIERA (right)
Self-portrait with an image of the artist's sister, 1709
In a quick, skilled hand, coloured chalks, or pastels, can be both decorative and spontaneous; it is a most direct medium, in which loose squiggles, melting planes and soft colours are characteristic. Rosalba has a pastel chalk in the holder between her fingers.

DROUAIS (below)
Comte and Chevalier de Choiseul, 1756
The Dauphin's two sons are dressed as Savoyards in national costume (of velvet, with gold buttons), beside a hurdy-gurdy. The spirit and mood prefigure Marie Antoinette's, enacting the tasks of a milkmaid in the dairy she had at Versailles.

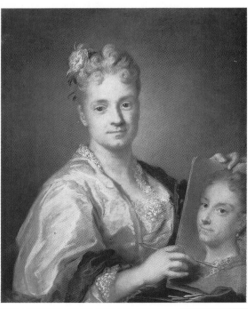

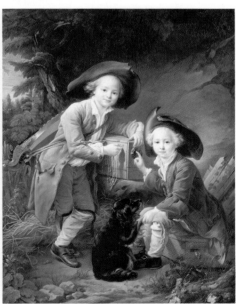

high society and at Louis XV's court. In keeping with the scale of the salon or boudoir, he painted mainly head-and-shoulders or half-length portraits, often in elaborately carved oval frames. In his pastel colouring, and a certain soft (though usually vivacious) sweetness of expression, he reflects the influence of the Venetian painter Rosalba Carriera (1675-1757). Though she spent most of her life in Venice, where she was much in vogue among tourists, a visit to Paris from 1719 to 1721 was extremely successful, and the mood of her both elegant and intimate portraiture was carried on by most of the successful French portraitists of the time. The prolific Louis Tocqué (1696-1772; not shown), Nattier's son-in-law, even exported the style eastwards in extended visits to Russia and Denmark. Both Tocqué and the younger François-Hubert Drouais (1727-75) were patronized by the Dauphin, and the quintessence of their "feminine" style is illustrated in a series of portraits of Madame de Pompadour, who was also painted many times by her protégé Boucher. This kind of portraiture was often most successful less than life-size, and even on an almost miniature scale.

The artist, however, who reflected most

brilliantly the alert wit and sensibility of educated Parisian society, who could match its intellectual as well as its fashionable sparkle, was Maurice-Quentin de La Tour (1704-88). Following Carriera, he worked in pastel, and perhaps has hardly been surpassed in his ability to catch the movement of life in each particular sitter's features and gesture.

In sculpture, there was a parallel movement away from the grandiose and the monumental style of the established Baroque. Even though the production of classic statuary – that white progeny of nymphs, heroes and deities peopling the gardens of Versailles – did not entirely cease, the Rococo taste for the small-scale soon expressed itself. Most characteristic, perhaps, are the animated, rhythmic groups produced by the booming porcelain factories – Sèvres, Meissen and many others. Established sculptors began to produce terracotta models for mass-production. The trend is clearly illustrated in the work of Etienne-Maurice Falconet (1716-91), who began in monumental, classicizing terms, but gradually tempered especially his smaller works with a softer charm, often introducing markedly erotic overtones – almost the three-dimensional

equivalent of Boucher's painting. His style is seen at its most purely Rococo in the figures he made for the Sèvres factory, where he was director of sculpture from 1757 to 1766. He never entirely lost his interest in the monumental, however, and his most famous work, the bronze of *Peter the Great*, in St Petersburg, is heroic in scale and mood.

The culmination of erotic Rococo figure sculpture comes with Claude Michel, known as Clodion (1738-1814). There is a remarkable virtuosity in his flesh-pink terracottas, and a sensuality as rich as Boucher's, but fermented by a dynamism that can be compared to Fragonard's verve in paint. The portraiture of Quentin de La Tour had its counterpart in the busts of Jean-Baptiste Lemoyne the Younger (1704-78; not shown) or of Louis-François Roubiliac (c.1705-62), a Huguenot from Lyons who, from about 1732, worked in England (his bust of Hogarth is illustrated on p. 248). Roubiliac, too, worked for a porcelain factory, in Chelsea, but his most spectacular works are his splendidly animated funerary monuments, which, on a simpler and smaller scale, sustain the rhetoric of the tradition stemming from Bernini.

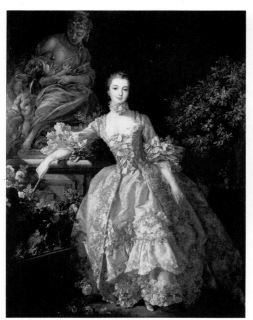

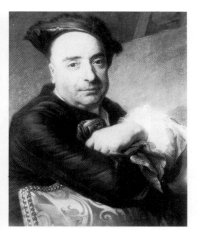

QUENTIN DE LA TOUR
(left) *M. Claude Dupouch*, 1739
La Tour's pastel portrait of his drawing-master, leaning so casually on the back of an armchair, seems as instant as a snapshot, but also conveys a warm and sympathetic presence.

FALCONET (right)
Erigone, 1747
Falconet's nymph, a model for a porcelain figurine, has an animated softness and warmth, which Falconet (as he stated in numerous essays, published in 1781) found to be lacking in the sculpture of antiquity.

CLODION (right)
Bacchante, c.1760
The classicism is clear in the pose and attributes of this small terracotta. But it is transformed by a finesse, a flowing grace, a smooth, elegant titillation.

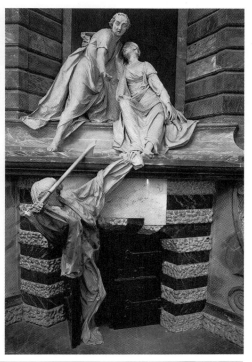

BOUCHER (above)
Mme de Pompadour, 1759
Boucher's brush enhanced the charms of the King's famous mistress in a series of ravishing portraits. He also decorated her rooms in the same sumptuously weightless manner, soon dubbed "*style Pompadour*".

FALCONET (right)
Peter the Great, 1766-68
In depicting the Tsar on a horse rearing dramatically on a rock, Falconet kept alive the Baroque tradition that Bernini had brought to Louis XIV's Paris, and to which the Empire would return. But he obtained no such commission in France. To set the horse rearing – diminishing its support – was a great technical feat.

ROUBILIAC (right)
Monument to Lady Elizabeth Nightingale, 1761
Vainly her husband tries to save Lady Elizabeth from Death, leaping from below like a jack-in-the-box. The idea is taken from Bernini's tomb of Pope Clement VII in St Peter's (not shown).

Genre and Still-life Painting

By the eighteenth century pictures of small to medium size, in handsome but not too large urban houses, had become a normal and integral part of interior decoration. Already in the late seventeenth century Netherlandish immigrants in England are recorded supplying landscapes and other subjects for lintels or mantels at a fixed price per foot. It was above all in Holland, with its prosperous, middle-class society, that painters had explored the subject matter suitable for this sort of picture – the prosaic aspects of everyday life, landscape, still life and genre scenes, often with some anecdotal interest.

Although the ever-growing market for paintings was answered mainly by exercises in the conventions established by the Dutch, in virtually all countries there was already present an indigenous tradition. In Italy, a taste for genre is already apparent in the late fifteenth-century paintings of Carpaccio. Caravaggio had raised genre to high art; later, the Bolognese painter Giuseppe Maria Crespi (1665-1747; not shown) had reduced even the most solemn biblical themes to the terms of peasant life, in humble, indeed sordid settings. Crespi's many pupils included the Venetians

Pietro Longhi (1702-85) and Giambattista Piazzetta (see p. 235), and even in his altar-pieces, in the restraint of their colour and their rustic characterizations, Piazzetta seems nearer to genre than to Baroque exaltation. Throughout his career he also painted and made finished genre drawings, especially half-lengths and heads of peasant characters, which were widely popular, and about 1740 painted some highly evocative and mysterious pictures, hovering between allegory and genre.

Pietro Longhi, on the other hand, was the daily chronicler of incident and gossip in the pleasure-loving and carnival-going Venetian society of his time, and worked in a much more Dutch vein. His little paintings, haunted by black-swathed revellers in white-beaked masks, have a repertoire ranging from such trivia as a visit to the doctor to more exotic, headline-catching events – such as the visit to Venice of a rhinoceros. Then Giandomenico Tiepolo (1727-1804), the son and collaborator of the great Giambattista, raised genre to a grander scale in his frescos for the Villa Valmarana near Vicenza. Here, as in Longhi, there is no more than an occasional spice of satire, and their mood is almost mysterious,

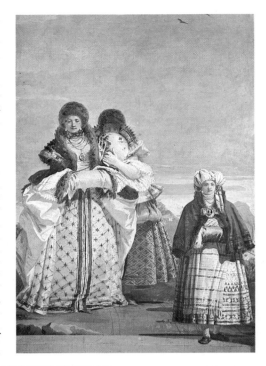

PIAZZETTA (right)
The fortune-teller, 1740
The figures are portrayed with something of the ripe sentimentalism that made Murillo's *Urchins* popular. The clear suggestiveness of the figures' gestures is in accord with the Rococo love of tastefully prurient pictures of peasant girls in states of *déshabillé*.

TROOST (below)
The city garden, c. 1742
Troost is often compared to Hogarth, with whom he was exactly contemporary, but he lacks Hogarth's moral intention. This charming, highly finished painting, which combines a Rococo elegance with elements of traditional Dutch genre, is a tribute to a new concept of civilized, bourgeois living.

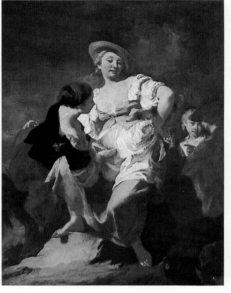

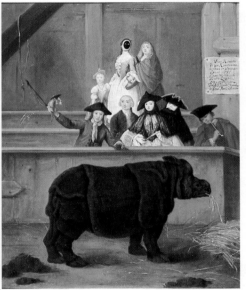

DOMENICO TIEPOLO (above)
The winter promenade, 1757
In the 18th century the boundary between genre and "history" painting was slowly eroded; the process was completed in the 19th. Domenico's subjects – this is one of a pair representing Summer and Winter – were thought suitable only for the guest house of the Villa Valmarana. Delight in trivial details of every-day life is thinly disguised in an allegory of the Seasons.

LONGHI (left)
The rhinoceros, 1751
Longhi's paintings have an airless quality, reflecting the claustrophobia of upper-class life in Venice – the "parade of appearances", as Lorenzo da Ponte, Mozart's librettist, called it. Manners and dress are described with unremitting decorousness.

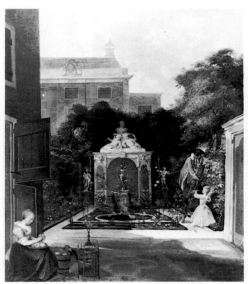

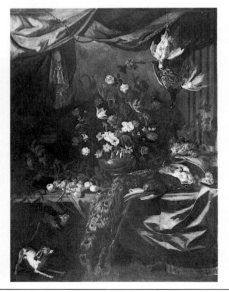

LARGILLIERE (left)
Still life, c. 1690
Largillière was trained in the Flemish tradition under Lely in London, and the heaped-up sumptuousness, the rich textures, even the dog in movement beneath, all recall Flemish still life.

OUDRY (right)
The white duck, 1753
The accuracy of natural detail reflects a growing scientific interest in the world, and in the late 18th century private menageries became popular. Oudry is best known for his still life with virtuoso surface effects, though his book illustrations are notable, and he had a successful career as a designer at the famous Gobelins factory.

strangely poised between the comic and the melancholic; his astonishingly original tumblers, clowns and other figures seem to foreshadow not only Goya but also early Picasso.

A host of painters in Holland pursued the themes set in the seventeenth century. Many were capable, but none was of great originality, with the exception perhaps of Cornelis Troost (1697-1750), who recorded little portrait and genre groups with a charming, somewhat Italianate, elegance. In France, Dutch and Flemish genre and still-life paintings were collected with avidity, and some French artists, such as Largillière, the portraitist (see preceding page), painted brilliant still lifes of dead game in a very Flemish manner. France produced the supreme master of still life, the painter who seems both to sum up and to transcend the achievements of his predecessors in Holland, Chardin (see over). Jean-Baptiste Oudry (1686-1755), a pupil of Largillière, early on developed a distinct style, depending little on the Netherlandish traditions – light and open, with a most subtle command of tone: he specialized in game pieces for the royal hunting lodges, and in the most delicate modulation of white on white.

It was in France, too, that genre themes with a moral sentiment found for a time an appreciative audience. The leading master was Jean-Baptiste Greuze (1725-1805). From 1755 on, he produced a long series of subject pictures, the nature of which is indicated by their titles (such as *The grandfather reading the Bible to his family*, or *The paralytic tended by his children*). In these he attempted to reconcile the values of genre with those of "history" or epic painting, while in mood he answered the "sensibility" of the time – that ready compassion and eager emotional conscience characteristic of the 1760s and 1770s, of a society a generation away from revolution. Greuze's "sensibility", his moralizing and sentimental didacticism, was exactly in key with the theories of the leading writer on art, Denis Diderot (1713-84), who diagnosed in Greuze "the painter of virtue and the saviour from moral degradation". In a sense, Greuze reacted against the frivolities of the followers of Watteau, and his compositions, emphatic with meaningful gesture, paying homage to Poussin, foreshadow the Neoclassicism of David. Yet his single-figure studies of girls and children have a sometimes mawkish sweetness that is another aspect of

the erotic taste of the Rococo. His influence in Europe, propagated by engravings, was enormous, and inspired much of the sentimental genre of the nineteenth century.

Many of Greuze's genre figures are portraits, and some qualities of genre could also be applied to portraiture, notably small-scale group portraiture. The "conversation piece", in which the sitters are seen in their domestic setting, engaged in some leisurely pastime, was essentially a Dutch invention but became an English speciality, associated above all with **William Hogarth** (see p. 248). The conversation piece reflected pride in family and property, the secure status of a prosperous landed gentry and merchant class, and many artists exploited it in the eighteenth century. Arthur Devis (1711-87) is the "primitive" among them, preserving his rather doll-like sitters with awkward charm in a silvery silence; both Francis Hayman (1708-76) and the young **Gainsborough** (see p. 252) produced masterpieces in the genre. Hayman also painted bucolic allegories and scenes from the stage; Hogarth, however, was the restless, endlessly inventive master of genre, extending its capacity to story-telling and biting satire.

GREUZE (left)
The son punished, c. 1777
The over-emphatic effects may be due to Greuze's study of the theatre. The wicked son returns to find his father dying – as at the end of a play: one expects the actors to cease their posturing and take a bow.

DEVIS (below)
The James family, 1752
The figures are presented in quiet isolation before a landscape: this so-called conversation piece is an inventory of family and possessions, more Rococo than robust in the grand old tradition of Kneller.

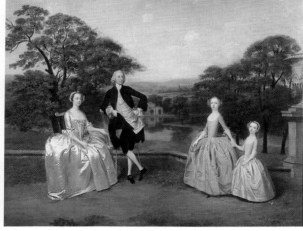

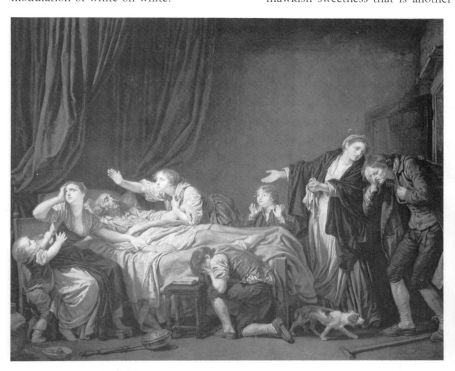

GREUZE (left)
The broken pitcher, c. 1773
The artist's beautiful but heartless wife, Gabrielle Balbuty, posed for this unambiguous allegory of lost innocence. Greuze does not hesitate to titillate while mourning for her virtue.

HAYMAN (right)
The wrestling scene from Shakespeare's As You Like It, c. 1744
Figures and setting reflect the staging conventions of contemporary theatre. This is an early example of the later vogue for paintings and prints of episodes in plays.

Chardin: The House of Cards

Jean-Baptiste-Siméon Chardin (1699-1779) developed only two main themes throughout his long career – still life, and domestic genre subjects. The still life is usually observed in the kitchen, rather than in the opulent dining-room implied by so many Dutch and Flemish still lifes; the genre scenes, too, are often sited "below stairs" – servants about their chores or – a favourite focus – children at play.

The boy building a house of cards is a subject to which Chardin returned several times. The concentration of the child, the delicacy of the operation on which he is engaged, are matched by the painter's concentration and subtlety. The image is essentially of transience, expressing the brevity and innocence of childhood: the cards will collapse and be put away in the half-open drawer; the child will grow up. This is observed with the utmost objectivity, though bourgeois values are implicit – a leisured society in which a house of cards is practicable, a secure family context. But there is no moralizing intent, as in Greuze; no sly overtones, as in Fragonard; and no trace of Boucher's Rococo fantasy.

Chardin's approach to his subjects was direct, relying not on preparatory drawings but on painting from nature straight on to the canvas: the density and richness of his paintings comes from an elaborate building up of the paint itself. For this there were precedents (there was the example, for instance, of Rembrandt's impasto), but it was noted by contemporaries as entirely new. The arbiter of contemporary taste, Diderot, commented: "There is a magic in this art that passes our understanding. Sometimes thick coats of colour are applied one above the other so that their effects seep upward from below. At other times one gets the impression that a vapour has been floated across the canvas, or a light sprayed over it. Draw near, everything becomes confused, flattens out, disappears, but step back and everything takes shape again, comes back to life" – effects achieved by a combination of broad and very fine brushwork, sensitive both to the textural qualities of the objects and to the pictorial qualities of the canvas. But the handling is supported by an ability to select a composition in which modern eyes can diagnose an abstract structure underlying the vivid reality of the images.

Chardin's beginnings were unorthodox: he did not pass through the Academy, and he had difficulty in establishing his artistic status. He was constantly being compared with Dutch and Flemish predecessors. The move from still life to scenes of domestic genre was prompted in part by this need to "elevate his art" and his prestige. For a time he further expanded his range to paintings that have elements of portraiture, but characteristically his subjects perform some undramatic, domestic action. Although these seem not to have met with such general favour, all aspects of his work were very successful, not so much among the middle classes as among his fellow-artists and with aristocratic connoisseurs. He repeated many subjects in replicas, and there was a widespread demand for engravings of his work, surpassing, it was noted at the time, the demand for the hitherto more fashionable allegorical and historical pieces.

CHARDIN (below)
Skate, cat and kitchen utensils, 1728
Exhibition of this early still life led to Chardin's election in 1728 to the Académie Royale. It shows, consummated for the first time, a sensuous pleasure in the substance and texture of paint which soon became characteristic of the French school. Chardin lies behind the still lifes of Courbet, Manet, Monet and Cézanne.

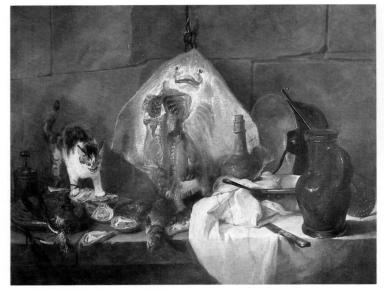

REMBRANDT (above)
The flayed ox, 1655
Rembrandt's picture was surely known to Chardin, and probably a precedent for the aggressive realism of Chardin's lurid *Skate*, disembowelled and bloody on its hook. Rembrandt's glow of light against dark was a more lasting lesson.

CHARDIN (left)
Saying grace, c. 1740
Chardin's modesty seems stark beside Boucher's sparkling gaiety (right). Perhaps he needed such unassuming, uninteresting domestic settings (so they perhaps appeared to those who preferred Boucher) to set off the voluptuousness of his paint. He depended, as Boucher did not, on the perspicacity of connoisseurs.

BOUCHER (right)
Breakfast, 1739
The very close similarity in composition between the two pictures emphasizes the difference in approach.

CHARDIN (above)
Still life with a wild duck, 1764
Chardin's reversion to still lifes in his latter years was due perhaps partly to his second marriage, to a rich wife, who brought him a new financial independence and thus artistic freedom.

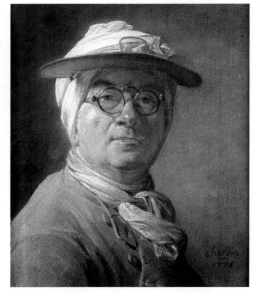

CHARDIN (above)
Self-portrait with an eyeshade, 1775
Neither illness nor failing eyesight stopped the aged Chardin painting, though he was forced to work in pastel. His very late *Self-portraits* are outstanding in their naked directness.

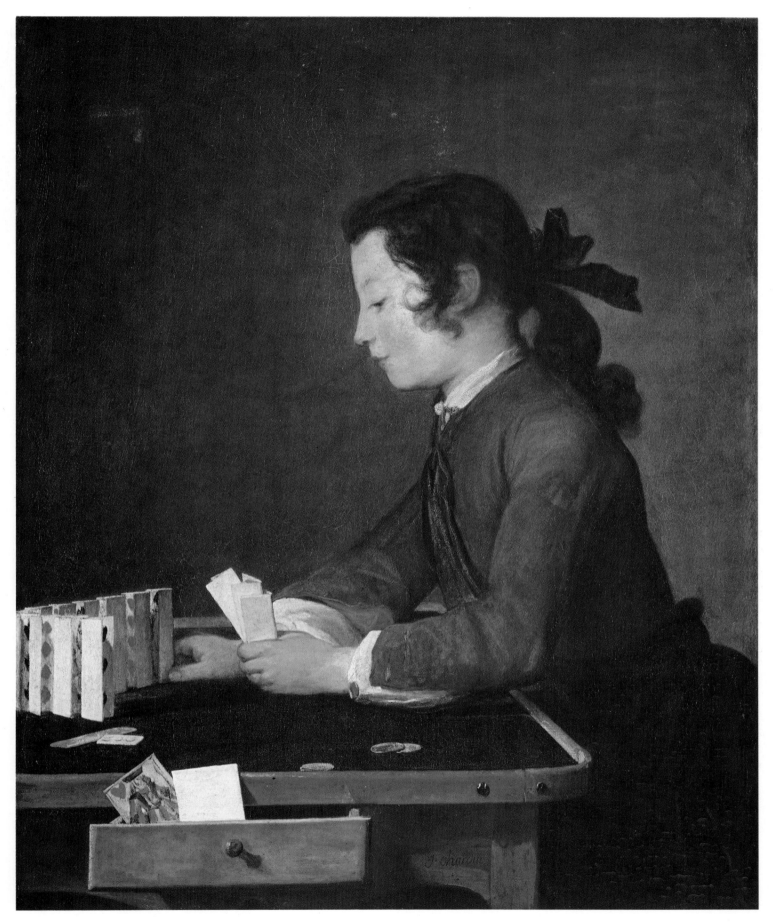

CHARDIN: *The house of cards* (in the National Gallery, Washington), *c.* 1741

William Hogarth

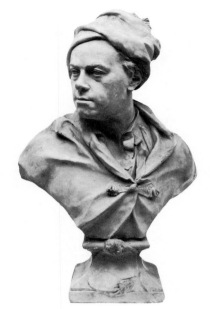

William Hogarth (1697-1764) was the first British-born painter to achieve an international influence and stature: artists such as Holbein, van Dyck, Lely, Kneller had all been immigrants. Highly individual and independent, truculent and frankly chauvinistic in his distrust of Continental art and artists, Hogarth asserted the validity of an English genius in art. Yet his spiritual allegiance was as much to literature, with the novel and the drama, as to painting, and his influence on the direction later painters would take was small. By his example, however, he helped his profession on its way to independence from a narrow aristocratic patronage, especially by his success in protecting the copyright of engravings, which increasingly became a source of income for artists. It was through engraving – the discipline in which he was trained – that Hogarth was primarily known, in Britain and abroad.

His character is reflected faithfully in his forthright *Self-portrait* of 1745. A touch of traditional pomp persists in the drape of the red curtain, but he presents himself otherwise informal, in his cap, with the tools of the trade, palette and brushes; with his English pug-dog Trump, and his spiritual associates, the works

of the heroes of British culture, not Homer or Virgil but Shakespeare, Milton and Swift. The allusion to Swift, the biting satirist, is more obviously significant, since Hogarth's enduring fame derives from his satirical genre and his portraits. But the allusion to Shakespeare and Milton may be a reminder that he also saw himself as the first truly British exponent of epic and dramatic painting. His ventures into more traditional fields are little remembered, but posterity has admitted the claim of his friend, the novelist Henry Fielding, that Hogarth was the first great comic-history painter, just as *Tom Jones* established Fielding as a comic-history writer in prose. For Fielding, comedy was no less "serious" than tragedy, and Hogarth's busy scenes are not mere burlesques, but moral and social satires in key with the philanthropic, reforming mood of Henry Fielding's novels.

On the palette in the portrait is the "line of beauty", reference to Hogarth's treatise *The Analysis of Beauty*, and in its broken curve a patent recognition of Rococo. Although he ridiculed the English connoisseur's obsession with foreign art, and "the ship-loads of dead Christs, Madonnas and Holy Families" arriv-

ROUBILIAC (above)
William Hogarth, c. 1741
In his terracotta Roubiliac captures Hogarth's tenacity,

but Hogarth disapproved of portraitists ("men of very middling parts"), acquiescent in artistic bondage.

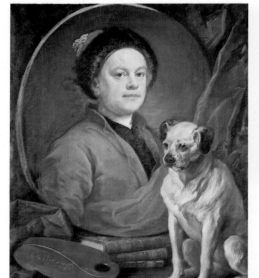

HOGARTH (left)
Self-portrait, 1745
The "line of beauty", the S-line across the palette, refers to Hogarth's book *The Analysis of Beauty*, a naive but novel approach to aesthetics, which was to him concrete proof of his own intellectual status.

HOGARTH (above)
Sigismunda, 1759
The spectacular price paid for a *Sigismunda* wrongly ascribed to Correggio provoked this attempt at the Italian Grand Manner. Hogarth met with ridicule and riposted with an attack on connoisseurs' values.

HOGARTH (below)
Engraving from *The Analysis of Beauty*, 1753
Hogarth's "precise serpentine line" of beauty, one of Rococo "intricacy which leads the eye and mind a wanton kind of chase", is based on Michelangelo's advice: "Always make a

figure pyramidal, serpent-like, and multiplied by one, two and three". The line is demonstrated at the top of the plate, curving round a cone, and in the classical statuary below. Hogarth's iconoclasm tends to conceal his debt to the European tradition.

HOGARTH (left)
Marriage à la Mode: Soon after the marriage, 1743-45
The marriage was one of convenience – for the wife's bourgeois family, a title; for the husband's, money. The couple meet at breakfast; the groom, a lace bonnet in his pocket, has spent the night in a brothel; the wife has been playing cards. The steward grumbles off with the bills. The picture is most exquisitely painted as well as rich satire.

HOGARTH (right)
The Four Times of Day: Night, 1738
A drunken magistrate, loathed for his enforcement of an Act against gin, has the contents of a chamber pot emptied on his head.

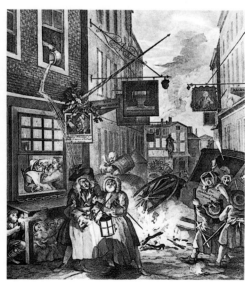

ing on the London market, he visited Paris in 1743, and the influence of Watteau and especially Chardin can be detected in the vigorous delicacy of his handling of paint.

Hogarth found his material not only in the swarming streets of contemporary London, but also on the stage: like a drama, *The Rake's Progress* unfolds the story of the destruction of its hero in eight separate paintings, each a crucial scene in the development of the plot. The moral of the whole, the Rake's destruction, is soon obvious, and the delight of the paintings is their satirical observation, endlessly inventive and intricate in detail, and with many targets, of contemporary taste in pictures and furnishings, as well as morals and manners. However, the quality of the paintings is uneven, since they were primarily intended as designs for engravings. Artistically, the finest set is *Marriage à la Mode*, where both the formal composition and the "stage-craft" – the dramatic impact – are at their best (this series was perhaps aimed at a more middle-class market, though likewise intended for engraving). His last series, *An Election*, is the largest in scale, the most broadly Baroque in composition and Hogarth's

clearest acknowledgment of his Dutch and Flemish ancestors, but it is unsurpassed by any genre painter in its teeming dynamism. This set satirizes corruption in public affairs; there are others in which the satirical comment is milder, such as *The Four Times of Day*, which has no continuous theme other than the element of time and of London topography. However, Hogarth's characters are always firmly rooted in the grossness of contemporary London life, and many of them were immediately identifiable as portraits of contemporary celebrities.

Not only a similar directness, but the same instinct for theatre, is found in Hogarth's portraiture. His conversation pieces are enlivened by the atmospherics of a domestic drama, overt or latent, far surpassing that of his rivals – indeed it is sometimes uncertain whether his little groups are portraits or pure genre. In his life-scale single portraits, working usually within the conventional head-and-shoulders format of the time, he produced honest, vivid, direct characterizations, suggesting the opening of a new, bourgeois chapter in the history of portrait painting. This directness is most remarkable in an unparal-

leled painting of the heads of his servants (not shown), and even more in the famous sketch *The shrimp girl*, a marvel of fresh and immediate notation, in which the girl's cry can almost be heard above the murmuring hubbub of the Covent Garden market.

Hogarth never followed up this exploration of "democratic" portraiture, but in at least one case he produced a quite deliberate, and brilliantly successful, attempt to marry the Grand tradition of formal portraiture with his own frankness of vision. The painting of *Captain Coram*, 1740, repeats very closely a design used by the French Baroque painter Rigaud (otherwise an object of Hogarth's scorn), and derived by Rigaud ultimately from van Dyck; amidst the Baroque swirl, the drapes, the column, the many accessories, the bluff sea-captain presides, benign and homely, sitting in a chair with his feet barely touching the floor.

Popular response to Hogarth was keen, but that of British connoisseurs was not. Posterity, however, has ranked him ever higher, while through the medium of his prints he was recognized and admired, especially as a social commentator and reformer, throughout Western Europe.

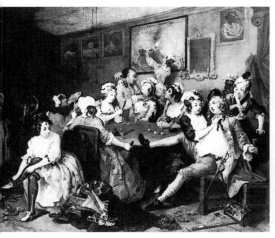

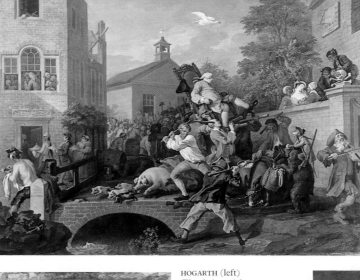

HOGARTH
The Rake's Progress:
(above) *The orgy*; (below)
The madhouse, 1733-35
All Hogarth's gifts as a story-teller attend his spirited *Orgy*, in which the "serpentine line" of his aesthetic theory can be traced in the arrangement of figures. In *The madhouse*, stark lighting accents the tragic drama of the Rake, burned out in syphilitic body and brain, and dying in the company of lunatics – one thinks himself a king, another thinks he is God.

HOGARTH (left)
An Election: Chairing the member, 1754
The four paintings of this series satirize election practices in a town bluntly dubbed Guzzledown. The parties, Whig and Tory – Orange and Blue, or New Interest versus Old – are polarized over many issues, but Hogarth leaves little choice between them. In this, the last scene, the Tory victor, who has waged an anti-Semitic campaign, is chaired by the Blue mob and harangued by the Orange. His procession is, ironically, led by a Jewish fiddler. It is no accident that the Tory resembles the goose overhead and the swine below (Hogarth was interested in the new-born art of caricature, and in the science of reading the soul in the face – physiognomy).

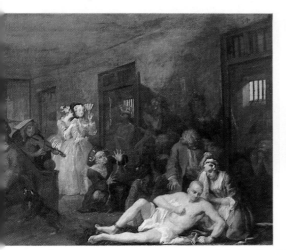

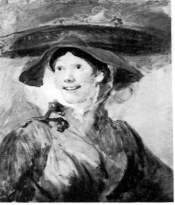

HOGARTH (left)
The shrimp girl, 1745
Hogarth's gifts as a story-teller may easily obscure the spontaneous skill of his painting, vivid in rare oil-sketches anticipating the verve of Manet; but this one is probably unfinished.

HOGARTH (right)
Captain Coram, 1740
A brilliant adaptation of Baroque state portraiture to a middle-class idiom, Hogarth's portrait, painted for the Foundling Hospital which Coram had founded, had a further significance: through it he induced other artists to donate pictures to the Hospital. They were shown publicly, initiating the institution of London exhibitions and ultimately of the Royal Academy.

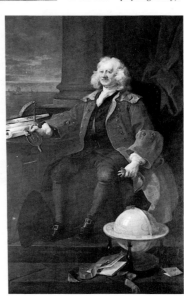

British Portraiture and Genre

The coming of age of British painting is marked by the foundation in London of the Royal Academy of Arts in 1768. Hogarth, the "father" of British painting, had been a solitary figure, and left no school of followers. It was one of the Academy's roles to establish British painting as a significant current within the mainstream of the European tradition.

The intellectual and theoretical creed of the Academy was set out by its founding President, Sir Joshua Reynolds (1723-92), in a series of remarkable *Discourses*, delivered one each year to the students. These still stand as a lucid statement of the case for eclecticism, for formulating a composite style, drawing from the best of antiquity as well as from the masters of the Renaissance and after. Reynolds had studied the Old Masters during an extended and crucial visit to Italy (1750-52), and his knowledge of them informed and influenced his work for the rest of his life. Among British artists of the time, only the landscapist Richard Wilson (see p. 255) and Reynolds' early rival Allan Ramsay (1713-84) had a similarly cosmopolitan artistic education.

In London from 1753, Reynolds rapidly established a successful portrait practice, be-coming involved in the literary circle of Dr Johnson, Boswell, Edmund Burke, the playwright Goldsmith and the actor Garrick. His reliance on the Old Masters in his painting was comparable to a writer's use of the classics, more a matter of giving his work a richer resonance by quotation and cross-reference than of straight copying or plagiarism (though some contemporaries accused him of that). The tenets of his *Discourses* were firmly based on a characteristically eighteenth-century rationalism and morality, and his aims were the Sublime and the Ideal. Thus, for him, the supreme achievement of painting could be found only in epic or "history" painting, the grandest of subjects matched by the grandest of styles. This doctrine was to remain like an albatross about the shoulders of English painting for the next century. Reynolds' own attempts at history painting are not great successes, and his true achievement was to raise humble "face-painting" to the imaginative level of high theatre. He borrowed and integrated classical poses into his portraiture, and created a new kind of portrait, halfway between literal likeness and traditional mythological painting – as in *Lady Sarah Bunbury*

REYNOLDS (below)
The Hon. Augustus Keppel,
1753-54
Striding in classical pose and yet quick with genuine naturalism, the Admiral seems actively involved in the shifting weather of life.

REYNOLDS (right)
Sarah Siddons as the Tragic Muse, 1784
Reynolds' "Grand Style" was nicely suited to Mrs Siddons' fame in London as a tragic heroine, in its astute sense of theatre.

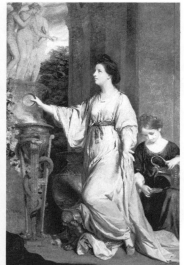

REYNOLDS (above)
Self-portrait, 1773?
The university gown, the bust of Reynolds' ultimate hero, Michelangelo, and the luminous chiaroscuro echoing Rembrandt are deliberate illustrations of Reynolds' eclectic credo, stated with original force.

REYNOLDS (left)
Lady Sarah Bunbury sacrificing to the Graces, 1765
Props from mythology and antiquity embellish a literal likeness of the sitter, who, with classical gesture, worships at the altar of beauty.

RAMSAY (below)
Margaret Lindsay, c. 1775
The artist's wife is painted with a graceful intimacy Reynolds emulated; but he had little sympathy for Ramsay's Rococo delicacy.

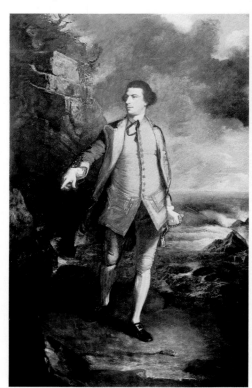

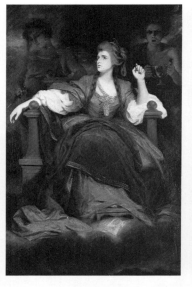

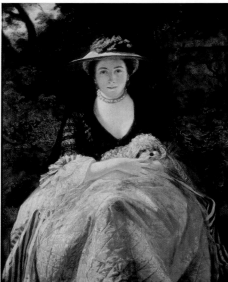

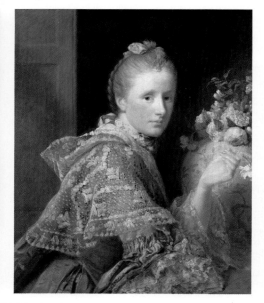

REYNOLDS (right)
Nelly O'Brien, 1760-62
Reynolds' simpler portraits are more to modern taste, especially those of well-known friends such as this famous demi-mondaine. She often sat for him: her haunting beauty is evoked

with an informality that reflects a close relationship. The delicate handling of the different textures, the delight in soft shadows and reflected lights upon the face, recall Rubens' portraits of Hélène Fourment (see p. 202), not by chance.

sacrificing to the Graces – culminating in his tremendous vision of the actress *Sarah Siddons* as a Michelangelo Sybil. Yet he could still extract the sublest nuances of character, and he was inexhaustibly flexible in his approach to each new sitter – in this he was without peer, and his rival Gainsborough (see over) admitted ruefully: "Damn him: how various he is!"

Reynolds' work became widely known through mezzotints, which could reproduce more of the richness of tone of oil-paintings than could line-engravings, and in which a few English engravers were the supreme virtuosi. His reputation has since suffered from various shortcomings – overproduction, with much work done by the studio; his use of perishable techniques (due to his restless search for new effects and for the lost secrets of the Venetian colourists); perhaps, too, a personal failing of charm. His ambition, his reasonableness, a certain cool at the heart of his character, may seem unattractive. Yet this was not apparent to contemporaries. Urbane and strong-willed, he raised the artist's calling to a new dignity by his personal example; his portraiture provided generations of English artists with a grammar and syntax of form; and the Academy he was largely responsible for founding proved an enduring institution.

Within the Academy there grew up, in fact, a solid tradition of draughtsmanship, technique and professional conduct, and this in spite of an uneasy relationship between it and the more original of Reynolds' contemporaries. For Reynolds, the landscape painting which Wilson practised, which was the true but frustrated love of Gainsborough, was a lesser form of art. Lesser still was genre or animal painting. George Stubbs (1724-1806), primarily a horse-painter, could command prices sometimes higher than Reynolds', but has been recognized only in this century as an artist of comparable stature. Indifferent to cultural precept, he visited Italy briefly to confirm his view that Italian art had nothing to teach that could not be learned from Nature. His true "academy" was eighteen months spent drawing equine anatomy from the appalling carcases of decaying horses in a remote farmhouse in Lincolnshire, resulting in a scientific and artistic landmark – the etchings in his remarkable treatise *The Anatomy of the Horse*, 1766. The knowledge he gained was applied to his paintings of horses and animals, but was controlled by a mastery of space, form and colour unmatched in his time.

Stubbs, too, had epic yearnings, as his many studies of horrific animal conflict witness – his images of lions assaulting horses influenced Delacroix. The provincial painter Joseph Wright of Derby (1734-97), who like Stubbs never became a full Academician, only an Associate, succeeded in raising genre to almost heroic proportions, though he, too, has waited till this century for reappraisal. Fascinated with candlelit or moonlit effects, he applied them sometimes to industrial or scientific subjects, but also to landscape, treated sometimes apocalyptically, foreshadowing Romanticism. He was also a forthright portraitist.

It is also as a portraitist that George Romney (1734-1802) is primarily remembered. Holding aloof from the Academy, he specialized in somewhat sweetly generalized portraits, with statuesque poses and broadly handled draperies. The Hogarthian tradition of the conversation piece was carried on by several competent painters, most notably by the German-born Johann Zoffany (1734/5-1810), reflecting eighteenth-century domesticity with a stolid, but still often sprightly charm.

STUBBS (above)
Flayed horse, 1766
The tradition of sporting pictures recording the English gentry's love of horses, hunting and dogs did not satisfy Stubbs, a natural scientist whose study of structure informs his drawings and canvases.

STUBBS (left)
The reapers, 1786
Landscape and human activity are observed with a direct simplicity which had scarcely been seen since Bruegel. The capacity for rendering form in space is classic; the rhythmic movement of the workers across the surface of the picture has a frieze-like quality; yet the composition is transformed by the naturalism of the figures. Like the landscape itself, they are emphatically English – far removed from the artifice of idealized Italianate pastorals. The light evokes the drawing-on of evening, an understated melancholy.

ROMNEY (above)
Emma Lady Hamilton, 1785
Romney's portraits are not usually searching; he projected a glamorous, simple handsomeness, not unlike that of early Hollywood publicity photographs. Emma, the famous mistress of Nelson, had lowly origins but a Hollywood-like career.

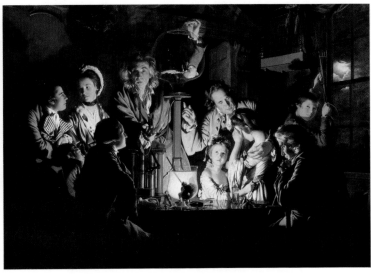

WRIGHT (left)
The experiment on a bird in an air pump, c. 1767-68
A new "historical" genre is created to express the contemporary collision of science and humanity as the child's pet bird is asphyxiated to demonstrate the creation of a vacuum. Wright's chiaroscuro lends an almost religious feeling.

ZOFFANY (above)
Mr and Mrs Garrick by the Shakespearean temple at Hampton, 1762
Garrick employed Zoffany for self-publicity; Zoffany made his name painting Garrick in his stage roles. Garrick's elegant villa by the Thames, with its Adam temple and its Capability Brown park, is the setting.

Gainsborough: Mary, Countess Howe

Thomas Gainsborough (1727-88) painted Lady Howe's portrait about 1763-64. The sitter, the wife of a naval officer later to become one of Britain's heroes, was in her early thirties, the painter a little older, just settling into his assured maturity. The portrait was painted in the fashionable spa of Bath, where Gainsborough had moved from his native Suffolk in 1759. His early portraits in Suffolk had been of the provinces, a little naive and tending to the awkward, but both direct and delicately sensitive. He had already produced masterpieces with these qualities, such as the small-scale *Mr and Mrs Andrews* of about 1748, doubtless a marriage portrait, which unites the vivid young couple with an equally vivid portrait of the fertile sunlit Suffolk corn country. For the fashionable clientèle of Bath a more fully resolved sophisticated elegance was necessary, and for it Gainsborough deliberately evolved an appropriate style, inspired above all by the example of van Dyck.

In a very early portrait of his Bath period, the *Mrs Philip Thicknesse* of 1760, the pose is developed from a precedent by van Dyck into spiralling Rococo movement. Original and essentially informal compared with most society portraiture, it was disconcerting as such to some contemporaries. "A most extraordinary figure, handsome and bold", commented one, "but I should be very sorry to have anyone I loved set forth in such a manner." Four or five years later the image of Lady Howe, no less original and equally paying homage to van Dyck, is stabilized in a more orthodox decorum, but with that bewitching ease of informality within formality, in which none have surpassed Gainsborough. The difficult marriage of a literal likeness ("the principal beauty of a portrait", said Gainsborough once, perhaps in peevish response to his rival Reynolds' insistence on generalizing) with the urgency of his almost fluid handling of colour in paint is here magisterially consummated. Lady Howe is at once of flesh and blood, and a shimmering cascade of pinks and greys. The hat, so lovingly dwelt upon, adds a touch of chinoiserie. The landscape has dissolved away from the factual account of the Andrews painting, and is perhaps the least satisfactory part of the composition: the silver birch, a complementary vertical to the sitter's figure, is an afterthought.

A little later, in his most famous portrait, *"The Blue Boy"*, Gainsborough made his most explicit homage to van Dyck. It was painted not as a commission but for the artist's own pleasure, though he showed it at the Academy in 1770. The subject was a friend, Jonathan Buttall, the dress a van Dyckian studio prop – the fancy dress fashionable with sitters at the time and used by many painters other than Gainsborough, including Reynolds. The result, a sophisticated romantic vision, shows all the fluency with which Gainsborough's style was opening out. Here landscape and figure are fully integrated, echoing each other in their rhythm. Gainsborough had a passion for music, and in contrast to Reynolds' more theoretical and literary bent, his genius demands a musical analogy. "One part of a picture ought to be like the first part of a tune ... you can guess what follows, and that makes the second part of the tune." Reynolds, in his tribute to Gainsborough after his death, indicated much the same, praising "his manner of forming all the parts of his picture together; the whole thing going on at the same time, in the same manner as Nature creates her works".

In the final phase of Gainsborough's career, in London, where he moved in 1774, his style became ever more fluent, free and open. His loyalty to the likeness remained – as in *Mrs Siddons*, seen as an imperious lady of fashion in remarkable contrast to Reynolds' apotheosis of the same sitter (see preceding page). Gainsborough at his most inspired, his most original, as in the flickering, shimmering vision of *"The Morning Walk"*, seems to merge his sitters into the landscape as in a happy dream.

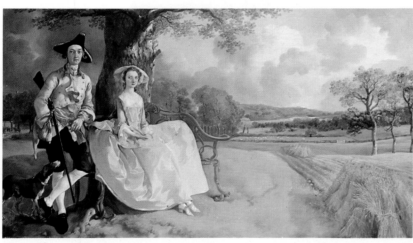

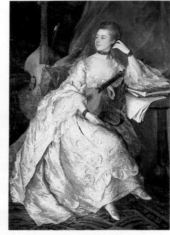

GAINSBOROUGH (left)
Mrs Philip Thicknesse, 1760
Gainsborough's style was nourished by van Dyck and some French Rococo. This portrait could be set beside Boucher's images of *Mme de Pompadour* (see p. 243), but its nervous intensity differentiates it.

GAINSBOROUGH (below)
"The Morning Walk"
(Mr and Mrs Hallett), 1785
Gainsborough's animated brushwork drew comment from Reynolds – "those odd scratches and marks ...this chaos which by a kind of magic at a certain distance assumes form".

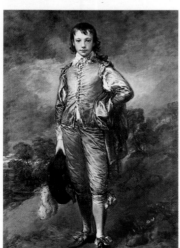

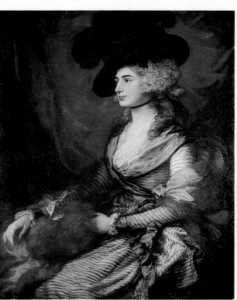

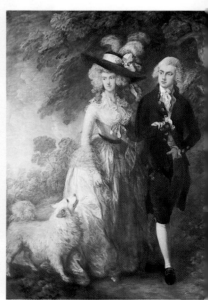

GAINSBOROUGH (above)
Mr and Mrs Andrews, c.1748
At heart a landscapist who earned his living "in the Face way", Gainsborough started his career painting precise conversation pieces closely comparable with the work of Devis (see p. 245).

GAINSBOROUGH (left)
"The Blue Boy", c.1770
Gainsborough worked with very long brushes, in oils thinned to the consistency of watercolour, to achieve his shimmering effects.

GAINSBOROUGH (right)
Mrs Sarah Siddons, 1785
"Damn the nose, there's no end of it", Gainsborough is reported to have remarked. He uses it to enhance the presence of the sitter, shapes it into the nature of her imposing beauty.

GAINSBOROUGH
Mary, Countess Howe,
c. 1763-64

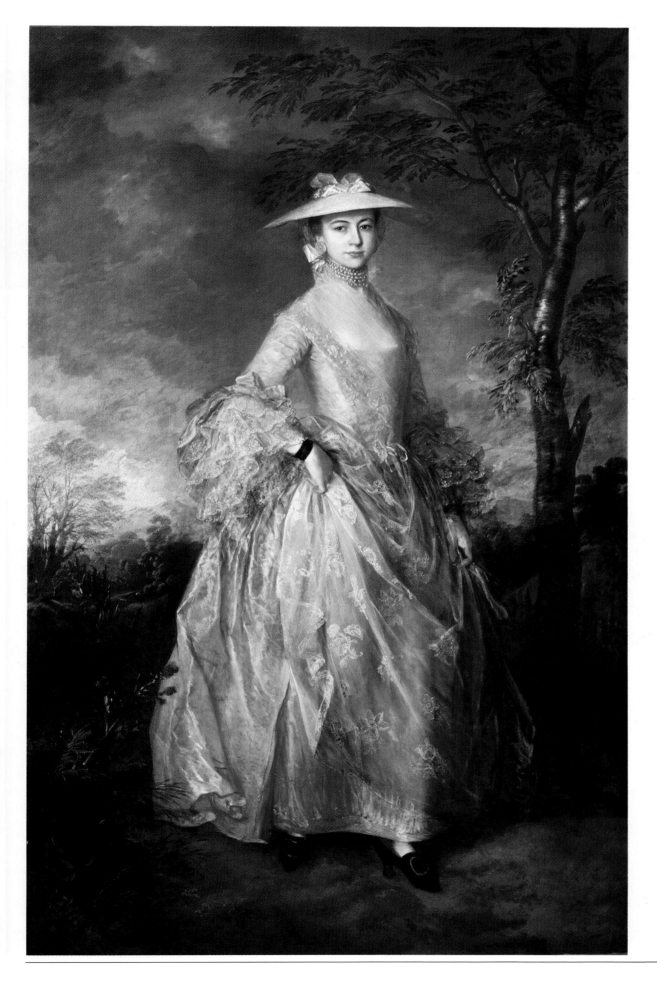

GAINSBOROUGH
Mary, Countess Howe

Landscape: View-Painting and the Grand Tour

Landscape painting in its own right, established in the seventeenth century, persisted and ramified during the eighteenth, although the supreme example of the great Dutch masters was not to be taken much further until the early nineteenth century, by Constable. In topography, the major contribution came from Venice. The subject matter was urban rather than rural, but the stones of Venice, rising like a dream from the waters of the lagoon, are no ordinary urban prose. Canaletto (Giovanni Antonio Canal, 1697-1768) was the finest transcriber of its poetry on to canvas.

Canaletto began by painting views in a broad and dramatic style, very far from picture postcards. The masterpiece of this phase is *The stonemason's yard* of about 1730. The view is of S. Maria della Carità, now the Accademia, Venice's famous gallery. The focus, however, is more on the activity in the foreground; there is a feeling almost of genre. Canaletto's later, more familiar pictures show the Venetian scene more grandly; they are set pieces displaying her architectural splendours, drawn with the greatest accuracy but also, at their best, capturing the atmosphere of the city – her light, air, water and sky – in glorious harmony.

Venice had been for some time a magnet for tourism, and tourism of a grand and moneyed kind: the well-to-do of all northern Europe might spend two or three years of their youth on the Grand Tour, of which the prime goal was Italy, and in Italy Rome and then Venice. This steady stream provided the greater number of Canaletto's patrons, and when his clients could not come to him, because of war, he had to go to them – hence, probably, his sojourns in England, 1746-56, revealing London as radiant as Venice, in Venetian weather. In England, his work produced several competent imitators, while the peripatetic Bernardo Bellotto (1720-80; not shown), his very able nephew and pupil, exported his style to Germany, Austria and Poland.

Canaletto's equivalent in Rome was Giovanni Paolo Panini (*c.* 1692-1765), recording contemporary Rome and its ceremonial but also, for the fashionable, classically-minded tourist, its archaeology. He painted ruins in the same mood of inquisitive awe that set Gibbon to write *The Decline and Fall of the Roman Empire.* He also popularized the *capriccio*, or "ruinscape", grouping several famous monuments of antiquity together in one compo-

TISCHBEIN (below)
Goethe in the Campagna,
1787

Goethe's *Italian Journeys,*
printed in 1816, is the best
account of a Grand Tour.

CANALETTO (left)
The stonemason's yard,
c. 1730
Warm, luminous tones
envelop the concentrated
detail; Canaletto's views
could be much drier later.
The picturesque ramshackle
and domestic disorder of the
foreground are a glimpse of
a working Venice "behind
the scenes", and could even
be compared with Cornelis
Troost's genre (see p. 244).

CANALETTO (right)
The Arch of Constantine,
Rome, 1742
Canaletto re-created the
scene from studies made
on an earlier visit to Rome:
five such views were bought
by the English consul in
Venice, Joseph Smith, his
chief patron. Smith was
the connection by which
Canaletto came to England.

PIRANESI (right)
*View of the Villa of
Maecenas at Tivoli,*
c. 1760-65
Piranesi's highly influential
Vedute di Roma (Views of
Rome) began to appear in
about 1748. Many of the
plates faithfully recorded
archaeological minutiae;
others evoke a Romantic

vision of departed Rome:
primeval ruins rear heroic
against the assaults of Time
and Nature; diminutive
troglodytes, refugees from
Arcadia, caper among them.
Piranesi defended Roman
art against the preference
given by Winckelmann to
the Greeks, stressing the
awe and grandeur of Rome.

PANINI (left)
*The interior of St Peter's,
Rome,* 1731
The tiny figures and the
dramatic viewpoint, ampli-
fying the grandeur of the
architecture, are typical
of Panini's views of ancient
and modern Rome, which
transform the eternal city
into a colossal stage-set.

PIRANESI (right)
Etching from the *Carceri
d'Invenzione* (Imaginary
prisons), *c.* 1745
Exploring a theme set by
earlier stage designers,
notably the Bibiena family,
Piranesi gave a Romantic
scope to his imagination,
using dizzying perspectives
to create haunting scenes.

sition, offering the tourist three or more for the price of one. The tourists were eager buyers and Panini's work was exported all over Europe. Canaletto also made *capricci*, sometimes of juxtaposed ruins, sometimes purely fanciful picturesque concoctions. Probably more influential than either,' however, was Giovanni Battista Piranesi (1720-78), whose etchings were best-sellers well into the next century. His dramatic use of light and shade is strikingly successful in his famous *Views of Rome*, but even more so in his fantastic and vertiginous *Carceri d'Invenzione* (Imaginary prisons), begun about 1745.

These found a ready response with the Romantics, but Piranesi was also a learned (though controversial) archaeologist and a seminal influence on the growth of Neoclassicism. His *Views* were the source from which cultivated Europeans, especially if they had not been to Rome, formed their image of the eternal city. The preoccupations of the visitors are crystallized in the portrait of the greatest of them all, Goethe, by Johann Heinrich Wilhelm Tischbein (1751-1829). The poet is shown, half-reclining in contemplation, in the lowlands outside Rome, the Campagna:

here is antiquity, the fragment of a classical frieze trailing a grape-heavy vine of today.

Not only Grand Tourists but artists came to Rome; in fact artists swarmed to it, to stay for years at a time, sometimes for ever. Their studios formed part of the sightseers' round, and in them the Claudeian tradition, the expatriate vision of an ideal Italy, was also sustained. Claude-Joseph Vernet (1714-89) was for years in Rome, and, when he went back to France, applied a fairly pure version of Claude's style to a royal commission to paint the French ports. The Venetian painter Francesco Zuccarelli (1702-88; not shown) exported a more sentimental, Rococo variant to London, where he was more popular than his friend, the Welsh Richard Wilson (1713-82). After some years in Rome in the 1750s, Wilson applied classical principles, an austere and grave dignity, to British landscape, in classics of a kind not known before, accurate in the particular, but raising the particular to the ideal, the general. British patrons, however, preferred their landscapes to come from abroad, and their real contribution lay in their treatment of the landscape itself: a succession of highly gifted landscape gardeners trans-

posed damp English earth into visions of Arcadian pastoral – an ordering of nature based on classical principle, but inspiring a distinctly Romantic nostalgia.

British patronage failed likewise adequately to support the landscapes of Thomas Gainsborough. Gainsborough, who had early captured a Suffolk harvest countryside that one can almost smell (see preceding page), moved thence to a more Rococo sophistication, acknowledging Dutch example. In this he abandoned descriptive portraiture (referring a prospective patron to the topographical artist, Paul Sandby (1725-1809; not shown), a seminal watercolourist). Gainsborough's mature landscapes are almost the equivalent of musical improvisations; as a starting-point for the composition he might arrange sticks, stones and scraps of foliage on a table.

Gainsborough's rhythm and felicity of colour had in some degree a Venetian counterpart in the work of Francesco Guardi (1712-93). Not so successful as Canaletto's, Guardi's visions of Venice as a figment of dream materializing amidst the irradiant mist and sky of the lagoon would find a more sympathetic response in eyes used to Impressionism.

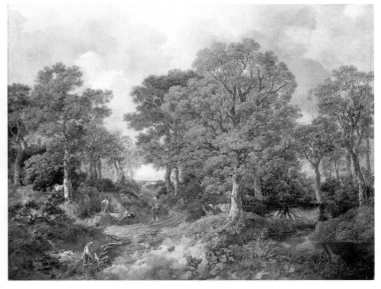

VERNET (above)
View of the Bay of Naples, 1742
Low, flat, panoramic seashores had been painted by Salvator Rosa and others. Vernet's are freer in handling, lighter in tone, rather more atmospheric.

WILSON (right)
Snowdon, c.1770
Wilson has interpreted the Welsh mountain and its crater-like lake in a mood of classical calm. He was active just before Britons discovered the Picturesque in their native landscape.

GAINSBOROUGH (above)
"*Cornard Wood*", c.1748
The wood is probably not a real one; Gainsborough stressed that landscape

painting was a creative act. It can be compared both to Dutch and to French landscapes, but notable is the liveliness of the light.

STOURHEAD, WILTSHIRE
View of the park
The temple is straight out of a Claude painting (see p. 197). The park was created in the mid-18th century by a banker with a good collection of Claudes.

GUARDI (right)
View of a canal, c. 1750
Guardi's sketchily painted, often rather low-life scenes of Venice are as delicate as Chinese landscapes. His choice of views, sometimes seemingly fragments, also anticipates Impressionism.

EASTERN ART

Several art traditions of the East have a continuous history far longer than any in Europe, but it was only recently that their greatness came to be recognized in the West. For many centuries, interest in Eastern works of art tended to be specialized – admiration for Muslim textiles, for instance, or Chinese porcelains. In the first part of the nineteenth century a number of French and English painters were captivated by a romantic image of the Islamic world and its decorative arts, among them the French painter Delacroix. Then painters such as Manet and Whistler were strongly affected by the prints of Japan, the Post-Impressionists van Gogh and Gauguin even more so. At the same time the religion, culture and art of the East began to be studied systematically, though scholarship in this area still cannot compare to the breadth and detail of Western art history. During the twentieth century many European and American artists, from Kandinsky and Klee on, have found direct inspiration in the arts of China, India and Japan.

What was it that Western artists found in Oriental art which they could not find in their own traditions? The answer involves not only the arts but also the cultural attitudes and values of the East. Islamic art has cultivated a both geometric and calligraphic idealism, reaching continually into the realm of the abstract – identified in Islamic thought as the archetypal zone of divine creation. Indian art, however, and the South-East Asian art derived from it, tended to express their intuitions through an imagery of cosmic deities endowed with immense, often very sensual charm. The mythic dramas of India are enacted in the language of the dance, but their imagery is set in a time-scale vast beyond human understanding. China was less concerned with the sheer vastnesses of the world. It did, however, see Nature as a constant flow of change, of unbroken appearance and disappearance, and it expressed this sense of unceasing movement in the calligraphic aspect of its painting, which was carried over also into both sculpture and ceramics. Japanese art adapted Chinese insights to its own more intimate view of Nature.

Behind the very diverse expressions of Indian, South-East Asian, Chinese and Japanese arts lie two principal unifying inspirations. First, the external world we perceive is seen not as a phenomenon produced externally by a mechanical Nature but as fragments from a whole, projected through the life experience of each individual. Reality can never be known by collecting its external fragments but must be apprehended by inward focus upon the whole. The second inspiration is the belief that to aim like this for a vision of the whole represents the highest cultural value, and may lead to the individual's release from suffering and anxiety, and perhaps from reincarnation.

These inspirations corresponded quite closely with a tendency appearing in Western art and culture at the end of the nineteenth century – an increasing refusal to try to depict outer reality as if it was somehow independent of the artist, and a search for principles of form rather than for appearances. By turning inward to explore new worlds of form and by making art works as "objects" which do not originate in the natural order of things, modern artists, like those of the East, have tried to extend the spectator's sense of what it means to be material, and their awareness of man's participation in active creation.

ISFAHAN, IRAN (left)
View of the court of the
Madraseh Chaharbagh,
1706-14

ANGKOR WAT, CAMBODIA
(right) View of the temple
in the centre, early 12th
century

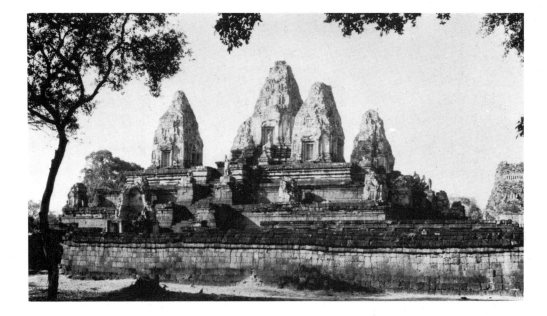

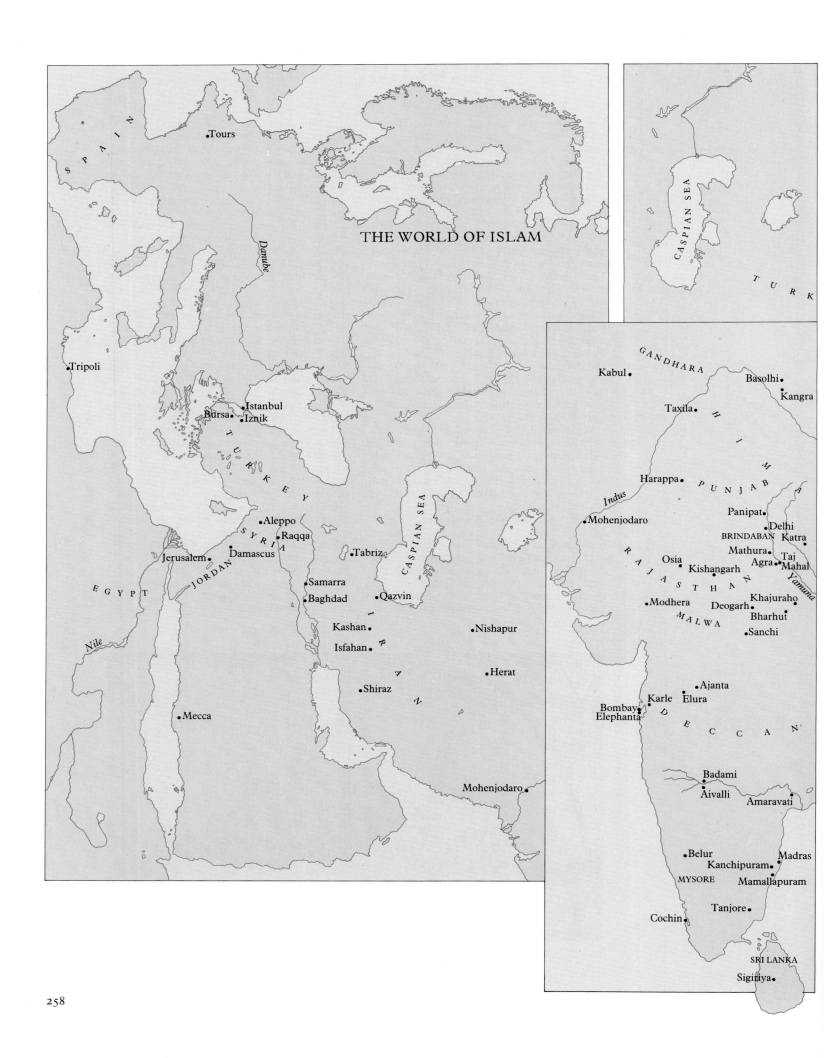

THE WORLD OF ISLAM

Tours

Tripoli

SPAIN

Danube

Istanbul
Bursa • Iznik
TURKEY

Aleppo
SYRIA Raqqa
Damascus
Jerusalem
JORDAN
EGYPT
Nile

Samarra
Baghdad

Tabriz

Qazvin

CASPIAN SEA

Kashan
Isfahan
IRAN

Nishapur

Herat

Shiraz

Mecca

Mohenjodaro

CASPIAN SEA

TURK

GANDHARA
Kabul
Basolhi
Kangra
Taxila
HIMA
Harappa
PUNJAB
Indus
Mohenjodaro
Panipat
Delhi
BRINDABAN
Katra
Mathura
Osia
Kishangarh
Agra
Taj
Mahal
RAJASTHAN
Yamuna
Modhera
Deogarh
Khajuraho
MALWA
Bharhut
Sanchi

Ajanta
Karle
Elura
Bombay
Elephanta
DECCAN

Badami
Aivalli
Amaravati

Belur
Madras
Kanchipuram
MYSORE
Mamallapuram
Tanjore
Cochin

SRI LANKA

Sigiriya

258

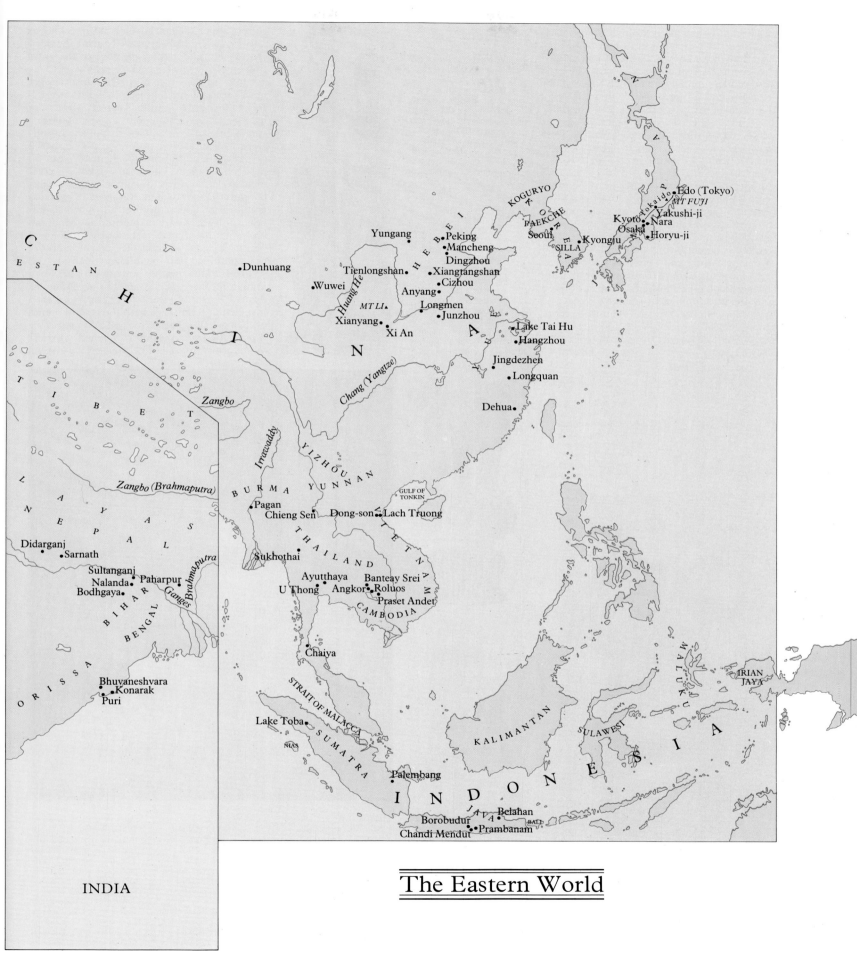

C E S T A N

C H I N A

T I B E T

Zangbo

Zangbo (Brahmaputra)

Dunhuang

Yungang •B. Peking
Mancheng
Dingzhou
Tienlongshan • Xiangrangshan
Wuwei • Cizhou
Anyang •
MT LI ▲ Longmen
Xianyang • Junzhou
Xi An

KOGURYO

PAEKCHE
Seoul
SILLA Kyongju

Edo (Tokyo)
MT FUJI
Kyoto • Yakushi-ji
Osaka • Nara
Horyu-ji

H E B E I

Huang He

Lake Tai Hu
Hangzhou

Jingdezhen

Longquan

Dehua •

Chang (Yangtze)

Irrawaddy

Y I Z H O U

Y U N N A N

BURMA

Pagan •
Chieng Sen

GULF OF
TONKIN

Dong-son • Lach Truong

V I E T N A M

H I M A L A Y A S

N E P A L

Didarganj •
• Sarnath

Sultanganj •
Nalanda • • Paharpur
Bodhgaya •

B I H A R

Ganges Brahmaputra

B E N G A L

O R I S S A

Bhuvaneshvara •
• Konarak
Puri •

T H A I L A N D

Sukhothai •

Ayutthaya • Banteay Srei
U Thong • Angkor • • Roluos
Praset Andet

C A M B O D I A

Chaiya •

Lake Toba •

STRAIT OF MALACCA

SUMATRA

NIAS

Palembang •

KALIMANTAN

SULAWESI

MALUKU

IRIAN
JAYA

I N D O N E S I A

JAVA
Belahan •
Borobudur • BALI
Chandi Mendut • Prambanam

INDIA

The Eastern World

Indian Art 1

India's devastating climate has ensured that we have only the scantiest remains of its early arts; there are huge gaps in Indian art history, even though we know that the Indian peoples have made art in many media since the early third millennium BC: it was then that the first great Indian culture began to flourish in the Indus valley, declining about 1,200 years later. The Indus valley was then well watered and fertile, supporting numerous towns and villages, and at least two great cities, Harappa and Mohenjodaro, with streets on a rectangular plan, granaries and advanced drainage systems. All the works of art surviving, however, are small-scale – hundreds of soapstone seals and clay impressions of seals, pottery, terracotta figures and a handful of tiny bronze or stone sculptures in the round. The seals frequently depict cattle; some represent scenes of bull-wrestling and bull-vaulting before an icon of a head on a pole, both customs that still survive among the aboriginal peoples of India. And one most important religious subject is a male dancer in the company of animals, represented in seal impressions and in one surviving, though damaged, stone sculpture – possibly a remote prototype of the god Shiva.

DIDARGANJ (right)
Yakshi? or *Royal devotee?*
mid-1st century BC?
This paragon of Indian beauty surely continues the technique and scale set by Maurya sculpture now lost: she is well over life-size, the polished surface gleams sensuously, her nude body is plump and luscious, well nourished – in Indian art a sign of wealth and status. The face is individual, and might be a portrait of some royal princess, idealized.

SARNATH (below)
Lion capital, 240 BC
The four lions, once atop a towering Maurya column, were perhaps intended to symbolize the cosmic axis of the world; a frieze below depicts four animals which represent its four corners – indicating the universality of Buddhism. The lions are formalized but lively, and distantly related to lions in Persian art (see p. 29).

After the dispersion of the Indus valley culture about 1800 BC virtually no art is known until stone sculpture appeared during the third century BC, under the patronage of the great Emperor Ashoka of the Maurya dynasty (272–322 BC). An early convert to Buddhism, he set up a series of monolithic pillars at sites associated with the Buddha's career. Most were inscribed with injunctions cut by Ashoka's command, and the pillars, of polished sandstone, have capitals representing imperial animals – lion, bull, horse, elephant – but no base or footing. These are Ashoka's chief memorials, but there was undoubtedly a contemporary and related tradition of wooden architecture and sculpture, all of which has now vanished. It seems indeed that Mauryan sculptors developed techniques of colossal figure carving – the basis of a style of sculpture that continued into the following period.

The Buddha, neither god nor prophet but a human teacher, died about 489 BC. After his death his bodily relics were dispersed, then installed in reliquaries within the solid domes of shrines called *stupas*; the domed shape of the *stupa*, raised on a plinth and crowned with tiers of honorific umbrellas, became itself a symbol

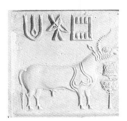

HARAPPA (left)
A buffalo, c.2500–2300BC
The buffalo often appears on Indus valley seals and was probably essential to the economy. It is fluently drawn, but without such agility as many Minoan seals are (see p. 32).
The horns are exaggerated, to suggest its fecund power?

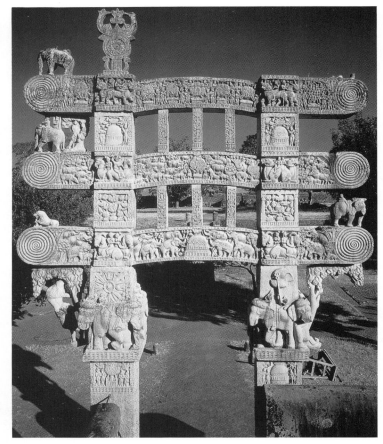

HARAPPA (above)
Ceremonial dancer,
3rd millennium BC
The dancer's body is defined by subtly angled planes, and there is a sense of blithe,

spiralling movement in the figure's twisting torso and cocked leg, without parallel in any other object extant from the early civilization of the fertile Indus valley.

BHARHUT (left)
Yakshi, 2nd century BC
The ancient Indian nature spirits kept their place and meaning within the context of Buddhist art: the *Yakshi* holds a branch of a mango tree (referring to the old belief that the touch of a beautiful woman will make a tree flower), a metaphor of the fruits to be garnered by following the Buddha.

SANCHI (above)
The eastern gate of the Great Stupa, inner side, 1st century BC
The crowded details of the reliefs present fascinating glimpses into Indian life of their time; they depict events from the life of the Buddha (though the teacher himself is not represented) and scenes from his earlier incarnations. A definite

sense of depth is suggested by the overlapping of forms; there are even occasional attempts at foreshortening. The lintels may be based on the painted scrolls used by travelling story-tellers to illustrate their stories – hence the two ends of each appear to be rolled up like a scroll – and the reliefs are to be read in that way, in continuous sequence.

of Nirvana – that Release from reincarnation that is the only end of suffering. The *stupas* became centres of pilgrimage, and were embellished with decorated stone railings, gateways and narrative panels. The earliest sculptural style, in quite shallow relief with rather angular, sharply cut figures, is represented by the remains of the elaborate railings of the *stupa* at Bharhut (second century BC), largely built during the brief Shunga dynasty of northern central India. But the most complete (now restored) early *stupa* is the famous Great Stupa at Sanchi built by the Shatavahana dynasty, rulers of central and southern India from 220 BC to AD 236. The Sanchi *stupa* has four gateways of distinctive shape, carved in more massive relief and with more complex subject matter than at Bharhut. At Bharhut there is no developed sense of space – the relief is more like a translation into stone of an outline drawing – but at Sanchi that characteristically Indian feeling for full, rounded volume is clearly developing. The Shatavahana dynasty, lasting longer in the south than in central India, also built an important series of *stupas* around Amaravati from about 20 BC to AD 300, featuring vividly sensuous

sculptures in white limestone – gracefully carved figures in varied movement. The Shatavahanas sponsored trade with South-East Asia, and the Amaravati style appears in Buddhist settlements on the coasts of South-East Asia and even as far away as Sulawesi.

With the development of Buddhism, monasteries were founded, and in the western Deccan numbers of cave-monasteries were cut in living rock from the second century BC. Their halls, for instance at Karle, were decorated with sculpted images embodying beauty and physical well-being, and with wall-paintings. Unfortunately the earlier (first century BC) paintings on the walls at Ajanta, the most famous of these rock-cut monasteries, have greatly deteriorated, though it is clear that they depicted incidents from the *Jataka* tales (describing the Buddha's previous incarnations) in styles closely related to Shatavahana art.

The first image of the Buddha himself was carved about the end of the first century AD, either in the great cosmopolitan city and religious centre of Mathura, then ruled by a dynasty of central Asian origin, the Kushan, or at Gandhara (see over). Previously it had been improper to represent the Buddha in human

form, but Buddhism was becoming increasingly popular, needing a more personal focus. The humanity of the prince Shakyamuni, who became the Buddha, was acknowledged, though icons suggested his attainment of Nirvana by their transcendent peacefulness.

Buddhism almost from its inception had been split between the stricter form, Hinayana, the so-called "Lesser Vehicle", denying the Buddha divinity but seeking personal Nirvana, and Mahayana, the Greater Vehicle. Mahayana invested the Buddha with divine status, and postulated the existence of divine compassionate Bodhisattvas, beings who would later become Buddhas but had paused on their way in order to assist all mankind to Nirvana. Mahayana Buddhism was to spread eastwards to Tibet, China, Korea and Japan; Hinayana Buddhism had its greatest influence in Sri Lanka and in South-East Asia.

Contemporary with the historic Buddha was another teacher, Mahavira, whose archaic religion is known as Jainism. Jain-inspired sculpture survives alongside Buddhist art, for instance at Mathura, where the remains of what may have been a Jain *stupa* reflect particularly Buddhist sculpture at Karle.

KARLE (below)
The Buddha preaching, flanked by worshippers, 2nd/4th century AD
The magnificent flanking figures are more than life-size and their scanty but elaborate clothing suggests royal status. The figures follow an ideal canon: the males have broad shoulders and chests, firm hips and a virile appearance; their females are in contrast soft and more rounded, with large breasts and hips and tiny waists. Their opulent well-being indicates that the cave is a palace fit and worthy of the Buddha's teaching proclaimed within. Two Bodhisattvas attend the Buddha in the central relief.

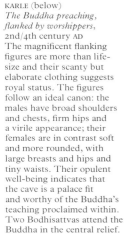

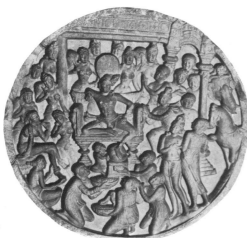

AMARAVATI (left)
The presents of King Bandhuma, from the *Vessantara Jataka,* late 2nd century AD
Like many such scenes of the *Jatakas* at Amaravati, the relief has convincing depth, filled with figures. The king receives gifts of gold and sandalwood in the presence of his daughters.

KATRA (right)
Seated Buddha, mid-2nd century AD
Making the *abhayamudra* (fear-repelling gesture) the Buddha sits beneath a bodhi tree, attended by royal Bodhisattvas. The linear draperies assist the powerful projection of the massive, heroic figure.

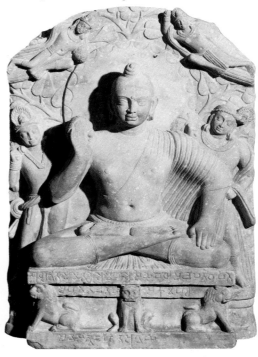

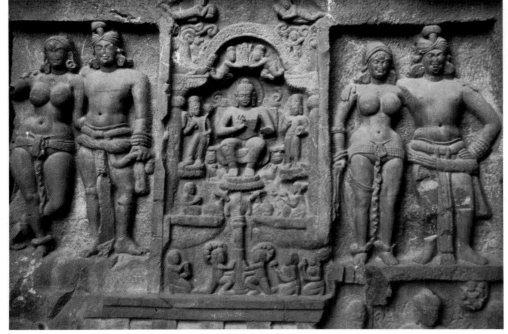

MATHURA (right)
Yakshi, 2nd century AD
The figure conforms to the same voluptuous canon as the donors at Karle (left); even more is made of the soft, undulating shape of the female body. She carries a birdcage and a parrot pecks at her hair, suggesting that *Yakshis* shared the attributes of the courtesans of the day, since one of the accomplishments of these ladies, mentioned in the *Kama-sutra,* was to teach a parrot to talk.

Indian Art 2: From Gupta to Pala

Mahayana Buddhism flourished throughout India and its various kingdoms from the third century BC to the seventh century AD, when the older Hindu religion began to revive and the Buddhist Gupta Empire finally disintegrated. Although a modified Buddhism, Vajrayana Buddhism, continued to be practised under the Pala dynasty in the north-east, the invasion of the Muslims in 1196 destroyed the Pala kingdom and virtually obliterated all traces of Buddhism from India. From about the third century AD, however, it had been carried with their wares by Indian traders and by missionaries all over Asia, and in Tibet and Nepal the styles evolved in Gandhara, Mathura and in the Gupta Empire have developed uninterrupted until the present century.

Gandhara, in the north-western corner of India, was the cross-roads of overland trade routes from both East and West – from China and from the Roman Empire. Numerous Buddhist *stupas* and monasteries, encrusted with stone and stucco sculpture, attest the wealth of its merchants and rulers in the early centuries AD. In contrast to the contemporary art of Mathura (see preceding page), Gandharan sculpture shows the native Indian softness and

rounded form overlaid by a strong influence from Graeco-Roman art, visible especially in the mould of the features and in the pattern and comparatively heavy sweep of the draperies. In its turn, Gandharan art had an influence on the sculpture of Mathura and other Indian centres, and was exported by stages as far as China, Korea and Japan.

However, the heartland of Buddhist India was the middle Ganges plain, where the Buddha himself had lived and taught. There the great sacred sites – such as Sarnath, where the Buddha had preached his first sermon; Bodhgaya, where he had attained enlightenment – attracted pilgrims from all over the orient. In this region the Gupta dynasty gained power about AD 320. Early Gupta art developed the types and images established in Mathura, representing the enlightened Buddha and the compassionate Bodhisattvas in "bodies of glory" – supernaturally suave and gentle forms, on which the clinging drapery was represented almost as a transparent veil. These painted sculptures were intended to convey, partly through the very smooth surface of the stone, a condition of radiant peace with which the devotee could identify.

GANDHARA (below)
Standing Bodhisattva,
2nd century AD
Numerous almost identical
Bodhisattvas survive, all
with this fluted drapery and
zigzag hems. Perhaps the
decorative treatment of the
hair and moustache echoes
rather similar features
of Roman sculpture in the
same era (see p. 50).

AJANTA (right)
Flying nymph, late 5th
century AD
The heavenly nymph soars
in flight, as the swing of
her necklace indicates. A
detail of a large fresco of
celestial beings adoring the
Buddha, she has rich ornaments and a splendid turban,
illustrating the luxury and
liveliness of Gupta art.

SARNATH (above)
The first sermon,
5th century AD
The icon depicts the
Buddha preaching the Law
(*Dharma*) in the Deer Park
at Sarnath. The Buddha
compared the rules of right
conduct to the spokes of a
wheel, and his hands are in
the *dharmachakramudra* (the
turning of the Wheel of the
Law), one of many gestures
used to symbolize aspects
of the Buddha's teaching,
here amplified below in a
relief. The elegant, rather
limp hands, softly rounded
face and narrow torso, and
the smoothness, the reticent
carving of the stone, are
typical of the Gupta style.

NALANDA (below)
Seated Bodhisattva,
8th or 9th century AD
The stucco icon, image of
supreme compassion, makes
the gesture of dispensing
gifts (*varadamudra*). Ornate
jewels signify his status as
a royal Bodhisattva – at
Nalanda the chief means
of distinguishing the many
Bodhisattvas from images
of the Buddha. The marked
emphasis on lips, nose and
eyes seems a Pala feature.
Nalanda was an important
centre of pilgrimage and its
style and iconography was
disseminated, chiefly by
means of votive bronzes,
as far afield as Borobudur
in central Java (see p. 278).

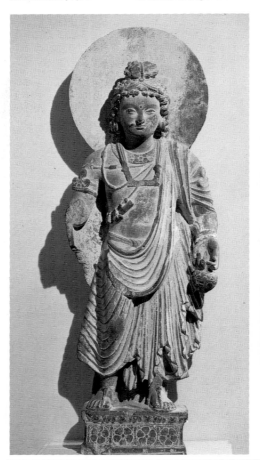

PAHARPUR (above)
Shiva and dancing girls,
8th century AD
Pala shrines in Bihar and
Bengal were built in brick,
into which terracotta reliefs
were set in thousands.

The figures have the broad
shoulders and slender waists
of Gupta fashion, but also a
superhuman opulence which
extends even to the details
of jewellery and clothing –
all once brightly painted.

The caves in the gorge of Ajanta are the richest depository of Indian Buddhist painting, although the murals there, and scattered relics elsewhere, can only hint at the state of the art in early medieval India. In Caves 1 and 17 in particular there are substantial remains of huge programmes of wall-paintings belonging to the fifth or sixth century: the drawing reflects the rounded fullness of Gupta sculpture, with smooth, supple contours; the faces are simply but boldly delineated; and the crowded delights of the princely mansions depicted glow with bright colours. At Ajanta there is also a quantity of sculpture of the same period – massively generalized, frontal images carved out of the solid mother-rock (see over). These icons, too, were once painted, and the cells, halls and corridors of the caves were richly and variously decorated from floor to ceiling with a brilliant repertoire of Buddhist legend and belief.

The Gupta Empire was decaying in the sixth century, though it was briefly revived by the cultured conqueror Harsha in the first half of the seventh century. In the eastern part of the Empire – Bihar and Bengal – the Pala dynasty was consolidated about 760. The Vajrayana Buddhism fostered by the Pala kings embraced elements of mystical Hinduism, and in the West it is known after its basic texts, the Tantras, which proclaim all earthly things to be the product of cosmic sexual activity, and therefore essential to the existence of the Great Whole. Orthodox Buddhism asserts that life is without value; Tantrikas claim that life offers positive experiences to be cultivated according to complicated systems of medicine, psychology, metaphysics, ceremonial and magic. The sweet, erotic style of Gupta art was adapted for schemes or tableaux of painted and sculpted figures, both masculine and feminine, which demonstrated the states of mind and body the Tantrika could achieve. The bright colours – blues, greens and reds – of the skin, the proliferation and disposition of arms and legs, these all had a prescribed significance, intended to trigger radiant inner icons in the mind's eye, and so assist meditation.

One great Pala site is Paharpur in Bengal, where the ruin of the mountainous plinth of a Buddhist shrine built in the eighth century still retains more than 2,000 of its terracotta sculptured panels. On each, summary, doll-like figures represent different episodes, anecdotes, truths and admonitions of the great body of Sanskrit literature, both Buddhist and Hindu. There is a greater attention to detail in the stucco icons produced at Nalanda, a large monastic complex and university in Bihar, though the influence of the soft, unbroken contours of Gupta sculpture is still at work. Illustrated Buddhist texts also survive, in a style closely related to the Pala sculpture.

The later Gupta style had penetrated China and South-East Asia, modifying or supplementing the Indian-inspired traditions already established there, but through the Pala dynasty the Gupta tradition was transmitted to Nepal, Tibet and Indonesia. The Buddhism of Tibet is an amalgam of Tantric Buddhism and native necromantic elements, and its pantheon has many deities. Tibetan monasteries were filled with paintings and sculptures on every scale, from miniature to colossal, representing the gods in all their variety of attributes – often calm and of an idealized beauty, reflecting Pala styles, but sometimes gloriously angry and threatening, depicting the fierce aspect of a compassionate Bodhisattva confronted with evil. Nepalese art was yet further modified by an accretion of Hindu elements.

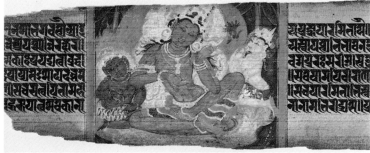

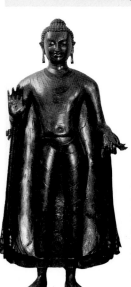

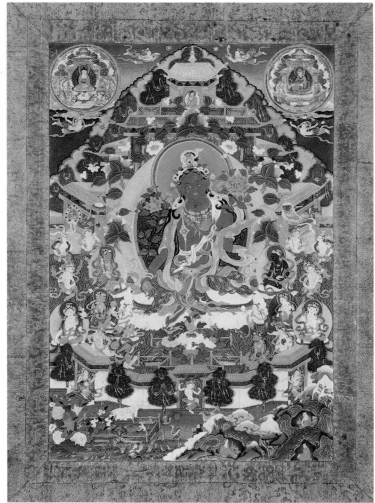

BENGAL (above)
The Ashtasahasrika Prajna-paramita: The Bodhi-sattva Samantabhadra with Tara, the incarnation of Buddhist wisdom, and the dwarf Acharya Vajrapani, c. 1120
The figures preserve the manuscript from harm and attract divine favour.

TIBET (below)
The Heruka in union with his shakti Nairatmya, 17th century?
The attributes held in his 28 hands identify this particular emanation of a Buddha; his union with his female creative energy (*shakti*) symbolizes the unity of the Tantric system.

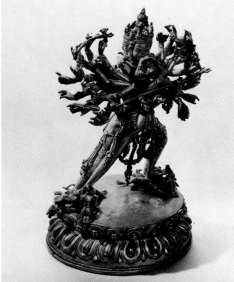

SULTANGANJ (above)
Standing Buddha, early 9th century?
This colossal bronze is a unique survival, an early version of the Gupta style adopted in Nepal. In its frontal view it is close to Nalanda stucco sculpture, but its more delicate, slim, etiolated form is typical of later Nepalese art.

TIBET (above)
Thangka (temple banner): *The goddess Tara, the incarnation of Buddhist wisdom,* late 17th century
Thangkas were intended as aids to meditation, and rigid canons governed the disposition, proportions and colours of the images. They had to be framed by two coloured borders – symbolizing the *thangka's* visionary character. Figures and costume are of Indian type; the subsidiary detail of the background depends on Chinese prototypes.

Indian Art 3: Hindu Art

Hinduism had displaced Buddhism as the dynastic religion of central and southern India by about the beginning of the seventh century AD. Soon afterwards, coinciding with a great effervescence of literary activity, as Brahmin scholars put together the *Puranas*, virtually encyclopaedias of Hindu legend, a distinctive Hindu style of art emerged in the south. In the major shrines, under the patronage of a succession of powerful dynasties, halls and galleries of painting and sculpture illustrating the *Puranas* were created, and the chief deities at the heart of the developing Hindu religion – Shiva, Vishnu and the Goddess, Devi – were hymned in colossal, sometimes almost terrifying icons. Though the style of the sculpture was adapted from that of the rock-carving in Buddhist cave-monasteries of the western Deccan (see preceding page), southern Hindu art is characterized throughout its long development by its own elaborate schemes of mythical imagery.

The Chalukya dynasty, which ruled larger or smaller parts of south-west India from the sixth to the thirteenth century, built at Aivalli (Aihole) the first significant group of Hindu temples, with vigorous but relatively crude sculpture representing the deities of the pantheon in a rather limited formal vocabulary. Towards the end of the sixth century, however, at Badami, the Chalukyas undertook the cutting of a series of caves filled with monumental sculpture of more varied expression and of superb quality: its style was influenced by the Deccan tradition of Buddhist carving seen in the caves at Ajanta. There are also a few surviving fragments of painted decorations at Badami (also Deccan in derivation), which echo the stunningly beautiful *Apsaras* painted perhaps 50 years earlier at the rock fortress of Sigiriya in Sri Lanka; the remains at Badami and Sigiriya are all that is left of the enormous cycles of decoration once widespread in the shrines and palaces of early medieval India.

The first powerful patrons of Hinduism on the eastern side of peninsular India were the Pallavas. Their principal cities were Mamallapuram and Kanchipuram, and around Mamallapuram, in numerous rock-caves along the coast, the Pallavas expressed their devotion to the great Hindu deities in a cool and restrained style – the sculpture derived, it seems, from the style of the sculpture of the Amaravati *stupas,* the painting from the styles

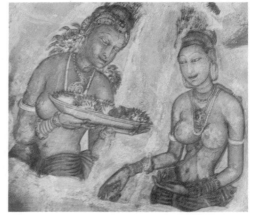

ELEPHANTA (above)
Shiva, 8th century
The god is represented as Shiva Maheshvara, that is, in his three aspects – the wrathful Aghora, on the left; Uma Devi, the blissful one, on the right; in the middle the beneficent Tatpurusha. Shiva's awesome image, 3.5m (11ft) high, is one of the main icons of the shrine, carved from the rock in a bold, broad, hieratic style.

BADAMI (right)
Vishnu sitting on Ananta, 578
Smaller reliefs are almost scattered round the huge, sumptuously ornamented icon. Vishnu is usually represented reclining on the Serpent of Eternity (as at Deogarh, see over) but here he sits within its coils in a posture of royal ease, raising his symbols, the conch and the *chakra.* If not so generous in form, he echoes Ajanta work in type, pose and facial details.

AJANTA (below)
Panchika and Hariti, 6th century
From Cave 2, the double icon displays the Buddhist god of wealth, Panchika, and his consort, the goddess of Plenty; like her Western counterpart, Charity, she carries a child. The heavy, rounded appearance of the deities typifies the Ajanta style – due in part to the porous nature of the stone.

SIGIRIYA (right)
Apsaras, detail, late 5th century
In style and technique, the figures closely resemble the 5th-century frescos at Ajanta (see preceding page), though rather freer in execution: the elaborate details of hairstyle and jewellery are drawn directly in colour and the contours later outlined in black. A maid offers flowers and fruit to a lady, who has a body the colour of "ripe corn" – considered a mark of high birth; the maid, on the other hand, has dark skin, over which she wears a transparent red blouse.

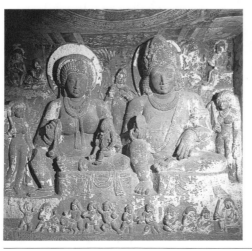

MAMALLAPURAM (right)
The descent of the goddess Ganga, mid-7th century
Carved on a huge granite outcropping, the tableau of massive forms is perhaps the most complex medieval Indian sculpture extant. It represents the reward for his austerity of the sage Bhagiratha, the Ganges water; in the rainy season, water runs down a natural cleft in the rock, to become the focus of the action. Each figure is simply and clearly defined, with little ornament, but a fine sense of life; animals – especially the elephants, making their way to drink at the holy river – are represented with sympathetic naturalism.

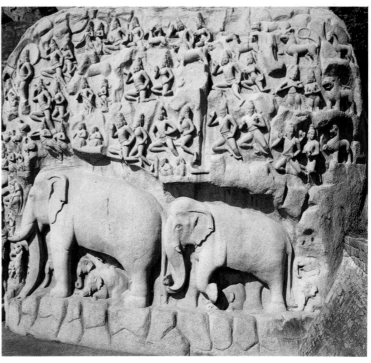

represented in the caves at Ajanta. The legend of *The descent of the goddess Ganga*, cut into the face of a cliff, is the most famous of the Pallava reliefs; the narrative is episodic, uncompart-mented: the different phases of the tale are dispersed over the whole field of the rock and woven together in a single tissue of interacting figures, though these are solid and separate, seldom overlapping. The Pallavas were traders, and their art was exported and took root in Indochina and Indonesia.

North and to the west, inland among the mountains at Elura (Ellora), there is a vast complex of Buddhist, Jain and Hindu caves, all sculpted in related styles between the sixth and ninth centuries – most stupendous among them the Kailashanatha temple, cut by the Rashtrakuta dynasty, successors to the Chalukyas on the west coast. In the icons and narrative reliefs decorating the many shrines at Elura, the sculptors strove to convey a sense of transcendent being, imparting to the figures a tremendous volume and strength; some of them embody such strenuous movement that they seem to be bursting out of their frames.

The sculpted cave at Elephanta, an island off the coast near Bombay, was one of the first of the great Hindu works to arouse the admiration of the West. Elephanta was ruled first by the Chalukyas and then by the Rashtrakutas, and it is unclear which of the two dynasties sponsored its sculpture. The cave is dedicated to Shiva, the awesome god of phallic and destructive power. Only the interior is artistically significant – its great icons, probably once plastered and painted, are flanked by colossal narrative panels (not shown), which, in appropriate scenes, impress the spectator with a sense of erotic sweetness extraordinary on such a massive scale. All the sculpture has a clarity, with smooth and simple volumes, reminiscent of the early Chalukya sculpture at Badami.

After the collapse of the Pallava dynasty, the Cholas, like the Pallavas a seafaring, merchant power maintaining close links with South-East Asia, became dominant in south-east India. The Cholas built plentifully – hundreds of smaller shrines survive, and a few huge pyramidal temples, expressive of imperial ambition. The greatest early Chola temple is the Rajarajeshvaram at Tanjore, in which are preserved not only carvings but also, inside the ambulatory, a unique scheme of painted decoration, including female dancers posing provocatively, performing gymnastically with great fluency. Some of the finest Chola works are bronze icons cast by the *cire-perdue* method, commonly less than half life-size, made to be borne in procession. They are usually of a male or female deity – most often Shiva or Parvati – or sometimes joint images of gods and their consorts; their sensuous elegance and slender proportions are the Hindu paradigms of that ideal canon of beauty first expressed in the sculptures at Amaravati.

In the last phase of purely Hindu sculpture there was a marked tendency towards the decorative. The Hoyshalas, the last dynasty to rule in Mysore (falling to the Muslims in 1386), built temples – with some relation to northern shrines (see over) – displaying simplified figures that are often hardly more than supports for extravagant ornament, deeply cut multiple loops and curlicues. After the decline of the Cholas several dynasties in the south undertook ever vaster schemes of stone and painted stucco sculpture in the decoration of their stupendous shrines; the scale and the need for immense numbers of figures led to a decline in expressive intimacy in favour of superficial magnificence.

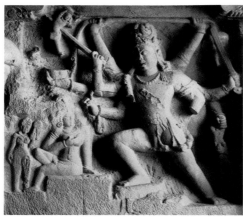

ELURA (right)
Shiva's dance in the elephant skin, c. 580–642
Shiva prepares to slay the demon Andhakasura, who has threatened to carry off Parvati. He wears the skin of the elephant-demon, Nila, flayed by Virabhadra, a ferocious form of Vishnu, and strides forward in a highly energetic attack.

TANJORE (below)
Dancing girl, c. 1000
Exaggeratedly contorted, the whirling figure no doubt reflects both the dancing and religious prostitution customary in major Hindu temples of medieval India.

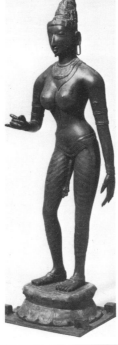

MADRAS (left)
Parvati, 10th century
As the *shakti* (consort) of Shiva, Parvati embodies the strength and potency of the deity. Long-limbed and heavy-breasted, the elegant bronze, 1m (40in) high, recalls the Sigiriya *Apsaras.*

BELUR (right)
Heavenly nymph, 12th/13th century
The age-old image of the Yakshi is reinterpreted in terms of the intricate ornamental detail typical of the Hoyshala period.

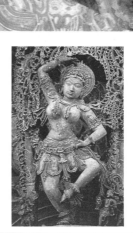

COCHIN (above)
Vishnu, late 17th century
As at Badami, Vishnu sits on the Serpent of Eternity, whose five heads form a canopy behind the supreme god; the coincidence of this unusual iconographic motif suggests Chalukya tradition was still strong in the area. The vigorous fantasy of the palace mural is typical of the flowering of wall-painting in the late Hindu period, redeeming a rather lifeless treatment of the figure in a carnival of dense, colourful pattern.

The Kandarya Mahadeva Temple, Khajuraho

After the death of Harsha and the eclipse of the Gupta Empire in the seventh century AD, India was divided into numerous warring kingdoms, ruled mostly by Hindus. These dynasts also vied with one another in building ever more elaborate temples, displaying some of the finest architectural sculpture the world has seen. Indeed in northern India the temple itself was conceived as a sculpture, as a colossal monolith encrusted with an extraordinary wealth of sculptured forms, both figurative and decorative, carved in stone but originally cloaked in plaster and brightly painted.

The Hindu temple symbolized the axis of the cosmos, the mountain Meru, which rises through the different realms of Earth and Heaven, its spire reaching towards the Beyond. Inside the temple tower, the comparatively small sanctuary contained the source of the temple's sanctity, an icon or emblem of one of the major gods or goddesses. Inside and out, the temples were hung with garlands of sculpture, depicting in broad bands most often gods and godlings in their Heaven, entertained eternally by celestial musicians and dancers. Their heavenly delights were imagined to encompass the highest pinnacles of human longing, uncontaminated by the evils and suffering of earthly life.

Wall-paintings also survive in patches in the temples, reflecting the style of the sculpture and conceived not very differently. All the arts of medieval India were informed by one constant idea, derived from the dance-drama, which had flourished in India since at least the second century BC – first to awaken and then to reconcile traces of the powerful emotions felt during that long series of rebirths which every Indian, Buddhist or Hindu, knew he had experienced. Both sculpture and painting reflect the bodily imagery of gesture and posture of the dance-drama, and share in its ultimate aim, to bring the spectator into that supreme emotional condition, *Rasa*, which is a genuine version of Blissful union with the divine ground of being, Brahman. The experience that brings one most intensely to *Rasa* is sexual love in all its variety. Apart from certain images of terrible gods and spirits, Hindu temple art always presents its *dramatis personae* as supremely beautiful, charming to the eye and seductive to the hand.

The early evolution of the Hindu temple is difficult to reconstruct. Shrines of the second century BC have been excavated, bearing some resemblance to Greek temples, but the earliest known example of the developed Hindu shrine, at Sanchi, dates from the fifth century AD. The basic styles and sculptural formulae of the southern Hindu temple (see preceding page) are found from the sixth, seventh and eighth centuries; then in the north superb temples rise, at Deogarh, Osia, Khajuraho; in Orissa, at Bhuvaneshvara, Puri and Konarak; in the north-west, at Modhera. Deogarh, which is early – even possibly of the sixth century – is modest in scale; Khajuraho, built between 950 and 1050, was a huge complex of some 80 temples round a large lake. Of its 25 temples still intact, the shrine of Kandarya Mahadeva is perhaps outstanding; its famous erotic sculptures – the Heavenly Bands – represent Hindu sculpture at its finest.

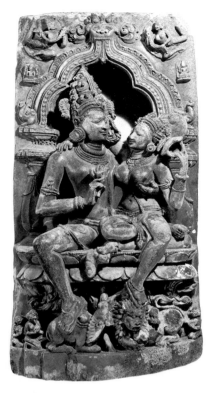

ORISSA (left)
Shiva and Parvati, 12th century
The icon once stood inside a shrine. Its two deities were carved according to strict canons, described in illustrated manuals: hence the great god Shiva and his consort Parvati have rounded faces "like full moons", noses arched "like parrots' bills", and eyes shaped "like willow leaves".

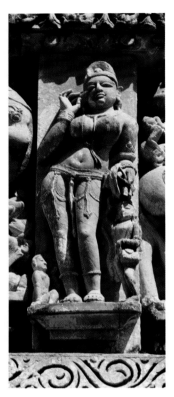

KONARAK (below)
The Surya temple, detail: *A wheel, emblem of the chariot of the sun-god Surya,* 13th century
Surya's temple, known as the Black Pagoda, is famous for its explicitly erotic figure carvings. The wheels support the *mandapa,* the body of the temple, and are carved with the vine and tendril motifs typical of Orissan sculpture. On the temple itself single celestial deities stand at the side of embracing couples.

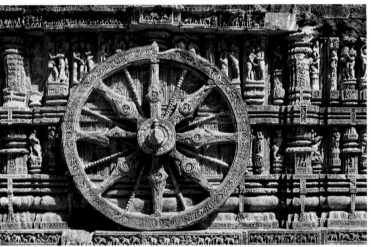

KHAJURAHO (above)
The Kandarya Mahadeva temple, detail of the Heavenly Bands: *An Apsara, c.* 1000
These pneumatic beauties, swelled with unremitting amorous desire, swarm in Heaven, where their role is to arouse and gratify every possible sexual impulse, and so to reward the heroes and saints for the virtue shown in their earthly existence.

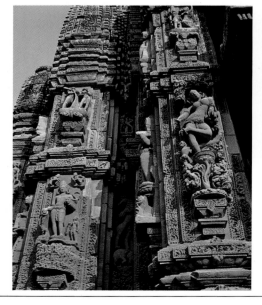

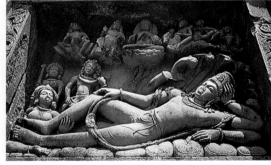

BHUVANESHVARA (left)
The Rajarani temple, detail, c. 1000
The celestial girl under a tree echoes the Nature spirit, or *Yakshi,* of early Indian sculpture. Creepers and foliage abound, rising from the supernatural sap felt to be coursing from within the whole temple.

DEOGARH (above)
Vishnu lying on Ananta, 6th century
The supreme god lies on the serpent of Eternity, symbolizing the endless revolutions of time, as described in the *Vishnu Purana,* the cosmic myth relating the activities of the primordial godhead.

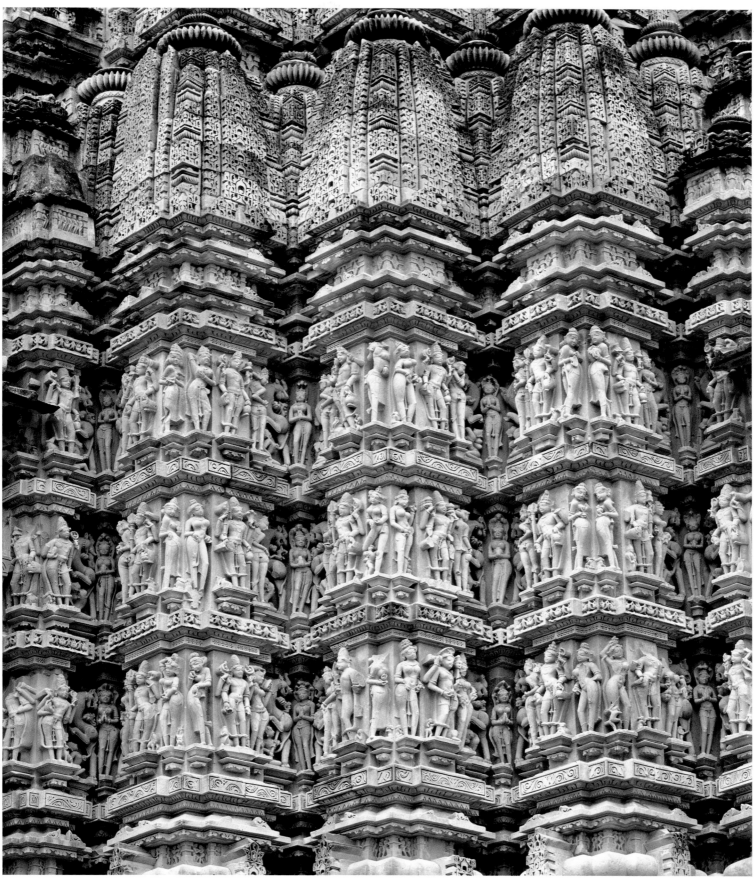

KHAJURAHO (above)
The Kandarya Mahadeva temple, detail of the Heavenly Bands, *c.* 1000
The figures follow standard proportions for fashionable beauty; posture and gesture are always elegant, while the elaborate hairstyles and ornament represent the apex of royal fashion. Clothing is minimal, not interfering at all with our perception of the underlying body, and the sexual attributes are emphasized. Sculptural form is almost totally rounded, evoking memories of erotic sensation and the delights of touch. Above, the rhythmic ornamental forms, the multiplicity of the mouldings, the perpetual pattern of rib rising upon rib, these are intended to excite, in a tempo of visual drumming. The main bulk rises 30m (100ft) high, surrounded by 84 decorated buttresses, and is dedicated to Shiva.

Indian Art 4: Mughal and Rajput

Islam came to India first of all modestly, with Arab traders, to the western seaboard – then as a holocaust. Muslim armies invading from Afghanistan in the late tenth, eleventh, twelfth and thirteenth centuries looted and systematically destroyed every Buddhist or Hindu temple and institution that fell to their arms: not one ancient temple survives in the north-west or the northern Deccan. At first the raids were seasonal – the Turko-Afghan Muslims disliked the pre-monsoon heat – but in 1120 the first of a series of Muslim sultanates was established in Delhi. In the suburbs of the modern city the Q'utb Mosque and Minar still stand, bearing finely cut, purely Islamic sculpture of about 1200.

By this time Persian painters also were employed at the Muslim courts, although nothing survives from before the early six-teenth century. From the same period other manuscripts have come down to us that show an amalgamation of Persian and Hindu styles, so it is reasonable to assume, too, a tradition of purely Hindu narrative illustration. Scattered sixteenth-century manuscripts are sufficient to give an idea of its main characteristics, and Jain manuscripts produced in western India

from the fourteenth to the seventeenth century are in a variant mode of the same essential style. In Hindu narratives the figures are types, conventional and repetitive, defined by strong outlines in rather gaudy colours and placed in simplified, almost two-dimensional settings. In the evolved Indo-Muslim style, these ele-ments are transformed by the brilliant colours, highly finished execution and rhythmic draughtsmanship – stemming ultimately from the discipline of calligraphy (see over) – of the more developed Persian painting.

In 1526 the first Mughal Emperor, Babur, won northern India at the Battle of Panipat. The supreme examples of Indo-Muslim paint-ing were produced at the courts of the third, fourth and fifth Mughal Emperors, Akbar (ruled 1556-1605), Jehangir (ruled 1605-27) and Shah Jahan (ruled 1628-58), the builder of the Taj Mahal. Akbar set up his workshop, run by Safavid painters from the court of Shah Tahmasp in Persia (see p. 274), as an instru-ment of his policy of cultural and religious unification: it produced histories of Akbar's reign to be circulated amongst his Hindu and Muslim feudatories, and each also received the literary classics of the alien culture in trans-

lation. Akbar's atelier evolved a unique style, in which Hindu conceptions and European realism (derived from engravings) were com-bined in a modified Persian matrix; many compositions were the work of several hands, frequently both Muslim and Hindu – one doing the general outline, another the portrait heads, another the landscape, yet another the colouring. The large miniatures of Akbar's atelier revel in worldly complexity, and aim not only to teach but to fascinate: events are stirring, emotions uninhibited; the whole is a blend of consciously beautiful colour, perfect-ionist calligraphy and meticulous realism.

Jehangir, who took over Akbar's atelier on his death, had a special interest in botany and zoology: albums of birds, animals and flowers were produced for him, as well as narrative paintings which became somewhat more de-scriptive and austere, less dynamic. Jehangir's artists recorded the world with dispassionate curiosity – whether it was the largest lion Jehangir had ever shot, or one of his nobles dying of debauch, alcoholism and drugs. Jehangir's son Shah Jahan, however, had a taste for the finely wrought and decorative, to which the fine jades he commissioned also

DELHI (below)
Detail of the sculptured calligraphy on the Q'utb Minar, c. 1200

The relief bands embody phrases from the Koran in Persian script. As usually in calligraphy (see over),

the rhythms of the vertical and curved, long and short, strokes of the lettering reflect those of the chant.

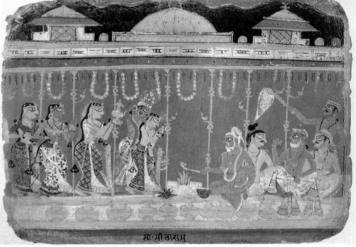

RAJASTHAN (above)
The marriage of Vasudeva and Devaki, 1525
Within a simple enclosure, schematic figures, typical of early Hindu miniatures, act their parts in the nup-tials of Krishna's parents, as told in the *Bhagavata*.

WESTERN INDIA (left)
The Uttaradhyayana-sutra: Mahavira surrounded by dancers and musicians, c. 1460
The simple but harmonious colours and naive, sharply outlined figures are common to all Jain manuscripts.

AKBAR'S ATELIER (right)
The Hamsanama (Deeds of Mohammed's uncle, Hamsa): *Gardeners beating a giant trapped in a pit*, c. 1570
Closely observed animals and plants, actively posed, delicately modelled figures, are united harmoniously in a brilliant overall pattern.

AKBAR'S ATELIER (below)
The Akbarnama (Deeds of
Akbar): *Akbar's officers
reconcile a rebel, c.* 1590
The anecdotal narrative is
disposed in layers mounting
up the picture; every inch
glistens with a different
colour, but all the parts
are fully legible. Persian
influence is clear in the
colours and composition.

SHAH JAHAN'S ATELIER
(right) Jade cup, 1657
The cup resembles a ripe
gourd, tapered to a handle
shaped into the head of a
wild goat. The wax-soft
appearance is an illusion
(jade is so hard it cannot
be scratched by steel: it
is carved with gems) – an
effect of the lobed shape
and subtle modelling. The
fine jades produced at Shah
Jahan's court were mostly
the work of Persian artists.

testify. But when Shah Jehan was deposed and imprisoned by his son Aurangzeb, the atelier was abolished and the artists dispersed, to find their livings in the bazaars of Delhi and Agra, or at the lesser courts of Rajasthan.

In these courts, during the tolerant rule of the great Mughals, artists had been producing album paintings and illustrations in a purely Hindu style, although they had learnt from the example of metropolitan Mughal art to essay portraiture and historical record, and to work their figures into a richer landscape. Specifically Hindu, however, is the clear compartmentalization of these compositions, re-asserted strongly after the demise of the Mughal atelier. Now recognized as one of the world's great artistic achievements, Hindu Rajput miniatures were made from the early seventeenth to the nineteenth century at the greater courts in Rajasthan proper and in the neighbouring Punjab hills. Rajasthan painting naturally reflected Mughal influences from Delhi and Agra more directly, but its subject matter was Hindu and romantic – the legend of Krishna in particular stimulated an extraordinary output of erotically flavoured paintings. The superb large-format miniatures and

small portraits painted at the court of Kishangarh by an artist of genius, Nihal Chand (active 1730-50), for his ruler, Savant Singh (who was also a renowned poet and the passionate lover of the poetess Bani Thani), are one high point of the Rajasthan school. Nihal Chand's idealized women have beautifully rounded and elegant features, and emanate an erotic aura of delicate, dreamlike poetry.

The Krishna legend was also treated in the Punjab hills. In a variety of styles, ranging from the rough and violent in Basohli to the elegiac and softly atmospheric in Kangra, painters retailed the progress of Krishna's allegorical life and love-affairs among the cowherds and cowgirls of Brindaban. Brindaban is a region on the banks of the Yamuna river, reinterpreted mystically as the realm where earth and heaven fuse, just as Krishna fuses the human and divine. Lines from one of Savant Singh's poems parallel the seductive, nostalgic radiance of the Kangra paintings:

"Seeing the idiot world around me, I long for Brindaban, and the Yamuna's sweet waters; but life is slipping by. How deeply I yearn for Brindaban; how afraid I am that life is slipping by."

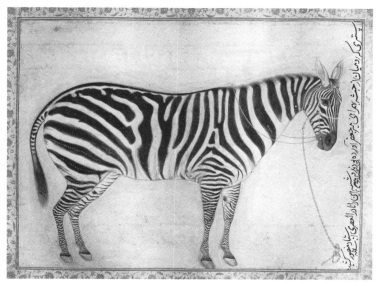

JEHANGIR'S ATELIER
(left) *The zebra*, 1621
Inscribed with the legend,
"A zebra, which the Turks
... brought from Abyssinia,
painted by Mansur in the
16th year of the reign of
Jehangir", the painting
records with delicate detail
the liquid eye, the hair of
the forelock, and the soft,
dark muzzle of the animal.
The court painters followed
the Emperor everywhere,
with instructions to note
anything of interest: they
made exact likenesses, but
these lack vigour – unlike
the teeming records of the
reign of Akbar the Great.

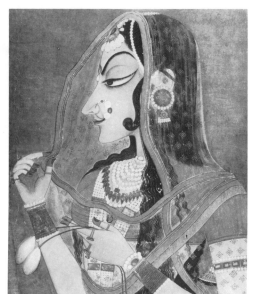

SCHOOL OF NIHAL CHAND
(left) *Radha, c.* 1750
Savant Singh idealized
his beloved Bani Thani
in his poetry as Radha,
Krishna's beloved; this
perhaps is a romanticized
portrait of Bani Thani.
The elegant stylization of
facial features – the long
pointed nose and curving
eye – and the refined use
of line are the supreme
distinction of Nihal Chand.

KANGRA (right)
*Krishna and Radha in a
grove, c.* 1780
Sharp details are set in a
range of colours from dark
to a lovely powdery pastel.
The passionate mutual love
of Krishna – an incarnation
of the supreme Vishnu –
and Radha symbolizes the
union of the soul with god.

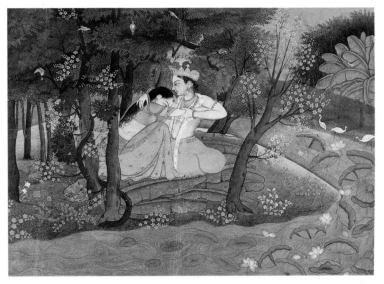

Islamic Art 1: Calligraphy

The Prophet Mohammed was a combative personality, and the religion he founded, Islam, was dynamic, assertive and zealous to spread his teachings by conquest and force. Within three decades of the death of the Prophet in 632, Muslim Arab armies, surging out across the borders of modern Jordan, had overrun the Byzantine provinces of Syria and Egypt, North Africa as far as present-day Tripoli, and Sassanian Persia as far as present-day Kabul. In the eighth century the Muslims were halted inside the borders of France by Charles Martel at the Battle of Tours (732), and slightly later in Asia Minor by the Byzantine Emperors; by then the heirs of Mohammed, the Caliphs, having transferred their capital to Damascus, ruled all North Africa and Spain, all Persia, all Afghanistan, and large tracts of Turkestan in the present USSR.

Having little developed art and architecture of their own, the Arabs adopted and adapted the traditions of the lands they conquered, employing local craftsmen to rebuild or redecorate previous structures, or to decorate their new buildings with fragments of older ones. Mosaicists of Byzantine training adorned the Dome of the Rock in Jerusalem, the

octagonal Islamic shrine established there to challenge the Christian Holy Sepulchre. The Arabs borrowed from Sassanian decorative forms in Persia, from late classical, even Coptic, ornament in Egypt, Syria and North Africa; from this assortment of Graeco-Roman forms they fused selected motifs into a remarkably unified Islamic style, formed and propagated above all in the arts associated with the written word.

The doctrines of Islam, rigidly governing every aspect of religious and secular life, are enshrined chiefly in the Koran, the word of Allah dictated through Mohammed, and also in a large collection of maxims and sermons, the *Traditions*, supposedly spoken by the Prophet. The Arabic text of the Koran was probably established in definitive, edited form by the middle of the ninth century. Its text was always written with a slant-cut reed-pen, in a calligraphy intended not only to convey His message but also, in its beauty, to reflect the glory of God. Calligraphy, the art of writing the sacred book, was regarded as the highest of all the arts, and the calligraphic forms of Arabic letters were soon used as ornament on

TURKEY (right)
Hilyah (Description of the Prophet), 1691-92
The Ottoman sultans in Istanbul attracted many artists from Tabriz; early Turkish illumination is often very close to the Persian style. In Turkey, however, a greater degree of naturalism prevailed – apparent in the garlands which adorn the border.

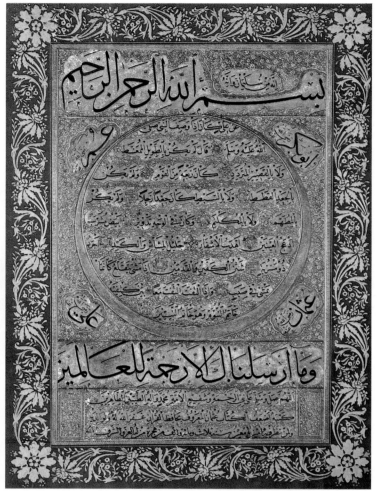

IRAQ OR SYRIA (right)
Chapter heading from a Koran, 9th/10th century
Early Kufic script is artless and emphatic; but the gold frame and the leaf-like medallion demonstrate a growing decorative impulse.

BAGHDAD (below)
Frontispiece and text from a Koran, c. 1000
Text and ornament are separate here, but in other pages unified. The exquisite Naskh lettering makes this a rare example of its kind.

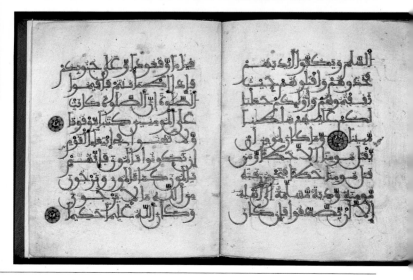

IRAN (left)
Text from a Koran, 11th/12th century
High, exaggerated uprights typical of the Kufic script contrast with a background of graceful, golden scrolls.

NORTH AFRICA OR SPAIN (right) Text from a Koran, 11th century
The Maghribi script, with its bold, rounded but spare serifs, little embellished at first, originated in Spain.

textiles, metalwork, ceramics, furnishings and architecture. As the art of the scribe developed, other forms of decoration, chiefly arabesque and geometric, were introduced to provide elaborate frames for chapter headings and "rubrics" – emphasized phrases.

The earliest scripts used to transcribe the Koran were the Kufic group, developed in the seventh century. They stress the horizontal and vertical strokes, but use loops sparingly. Then the ends of the horizontals and verticals were greatly extended, and even "foliated" with elaborate serifs – a mode probably invented in Egypt in the eighth century. During the tenth century the use of the more curvilinear Naskh script became widespread, and by the fifteenth century six other kinds of script had been developed. To write any of these scripts well demands, according to Islamic tradition, special qualities of personal purity, concentration and even divine inspiration. In its developed form the calligraphy corresponded to the rhythms and cadences of chanted speech, so that the lengths and proportions of the letters were altered, not only to enrich the visual pattern, but also to embody the musical phrasing in which the words were

sung. Though much less individual than Chinese calligraphy, written with the brush, Islamic calligraphy permits the writer some freedom of expression, by allowing him to follow the promptings of his inner ear – within the recognized canons of perfection for each type of script. It was perhaps the scribe's personal urge to express praise and reverence for the sacred book that carried him beyond the forms of the letters themselves into abstract decoration, usually developed out of the calligraphic forms, but also incorporating the geometric and arabesque patterns originating in other arts; once they had been introduced, it was chiefly in manuscripts that these patterns were developed and transmitted.

The arabesque is essentially an S curve, composed of opposing spirals. The relative proportions of the spirals may vary considerably, and the foliage and flowers forming its original basis are usually stylized out of recognition. As in calligraphy, the Islamic aesthetic demands that the hand be schooled to execute the arabesque without any of those tremors or linear faults which indicate a failure of concentration. Beside, or instead of, the arabesque, which was used as a background

linking together the sequences of lines, a repeating geometric pattern – interwoven combinations of circles, squares, pentagons, hexagons, octagons or stars – was used for the frontispieces, especially of Korans of the thirteenth and fourteenth centuries. These are often strikingly reminiscent of masterpieces of Christian Celtic art (see p. 66).

Geometrical shapes have a profoundly important role to play in Islamic art, since they are considered as the archetypes of all form, symbolizing the divinely ordained pattern of the universe. A generalized, "all-over" geometric design was even felt to be superior to the idiosyncratic variations of calligraphy or arabesque, and to represent the closest approach of the human understanding to God's Nature. Though the educated Muslim recognizes that geometrical forms are not in themselves divine, but merely symbols of divinity, nevertheless a kind of geometrical complacency has been the particular disease to which Muslim art has sometimes succumbed. Islam, however, seems to have preserved a continuing consciousness of the sacred function of ornament which other decorative traditions once possessed, but usually have lost.

TURKEY (above)
Basmallah (In the name of God, the compassionate,
the merciful), 1834
A religious invocation is spelled out in bird form.

NISHAPUR, IRAN (left)
Earthenware bowl,
late 10th century
The intrinsic elegance of Kufic lettering, appearing by itself or in combination, was exploited consummately by artist-potters of the Samanid dynasty (874-999).

IRAN (below)
Tailor at work,
early 17th century
Calligraphic line is elegant, rhythmic, economic, fluid; Riza Abbasi, famous artist of the Isfahan court, translated all these qualities into his masterly drawings.

IRAN (left)
Frontispiece from a Koran, early 16th century
Persian calligraphy had its finest flowering under the Safavid Shahs, and Tabriz became a flourishing centre (see further pp. 274-275) for artists and illuminators, and
scribes: there the idea of enclosing, enshrining, the script within elaborately decorated lozenge or star medallions was developed. The lavish use of gold, here exploited in striking contrast with the lapis lazuli, is also typical.

Islamic Art 2: Decorative Arts

The Western distinction between "fine" and decorative art is impossible to sustain when considering Islamic art, and not only because the greater part of Islamic religious art, being non-figurative, would have to be classed as decorative. The basis of all the Islamic arts is painstaking craftsmanship, pursuing an ideal of consummate and laborious flawlessness; in this all the arts are equal. Further, although the highest perfection could be achieved by an Islamic craftsman only with the aid of what a Westerner would call "inspiration", the idea of the artist in the Renaissance sense could never gain ground. The craftsman's achievement was dependent not on inventive genius but on selfless application to his task and on closeness to the source of all skill, God.

The Muslim art that has always been most highly valued in the West is that of textiles. The earliest examples show Islamic adaptation of the traditional motifs of the areas the Arabs had conquered – some fine early silks feature designs based on Byzantine or Sassanian heraldic figures and animals. Soon, however, the weavers, too, were drawing on the developing common repertoire of Islamic art – arabesque and geometric ornament – although

on silks and carpets from Safavid Iran representational images like those in miniature painting (see over) were also included. Weaving, being the product of so many warp and woof threads calculated on the loom almost as on an abacus, could also be a vehicle of mathematical symbolism; so, too, could the sequences of knots forming the patterns of carpets, which were used in the Islamic world not only to cover floors and walls, but also to serve a religious purpose in the mosque. The most laborious and most skilfully woven Islamic textiles are the small rugs on which the worshipper kneels and prostrates himself in prayer. Their design is based usually either on the arched niche, or *mihrab* (with or without its hanging lamp), which in the mosque marks the direction of Mecca, or on the garden of Paradise, complete with symmetrically arranged flowers, shrubs, trees and pools.

The most precious Muslim artefacts are items of metalwork – in gold, silver, steel, bronze or brass – in which the craftsmen of several Islamic dynasties excelled. Vessels, candlesticks, pen-boxes and jewellery all tend to share a common aesthetic, an elegant contour and a lustrous, highly finished surface,

IRAQ (below)
A fragment of silk, 9th/10th century
Islamic appropriation of Sassanian styles (see p. 25) is clear in the figures, in the tree's stylized foliage; Kufic script runs below.

IRAN (left)
Carpet, 16th century
A central medallion, the fairly naturalistic forms of animals, and fine scroll and foliate patterns over a rich background – these typify the Safavid carpet.

SYRIA (below)
Brass inlaid basin, 1240
The craft of metal inlay reached a peak in the 13th and 14th centuries under Ayyubid and Mamluk rule, notably in Damascus (hence the term "damascening").

IRAN (below)
Bronze cauldron, 12th/13th century
Exquisitely incised with animals and interlocking abstract designs, Seljuk

metal artefacts are often further decorated with a unique "animated" script – characters in Kufic and Naskh calligraphy ending in human and animal heads.

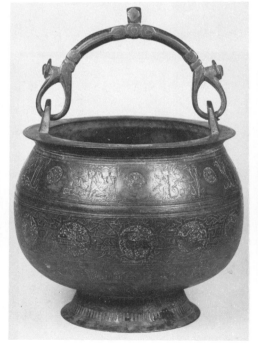

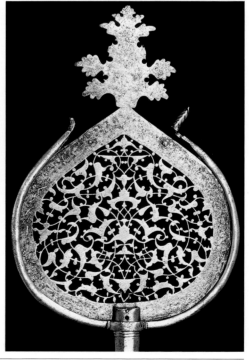

IRAN (right)
Standard, 16th century
Great artistry was applied to the making of weapons under the Safavid rulers. The pattern is a complex

blend of geometric with arabesque; it is symmetrical on the vertical axis, but otherwise not one element recurs. The steel is overlaid with gilt calligraphy.

making it extremely hard to judge by the eye the true thickness or weight of a piece. Weaponry in particular was wrought with a consummate and often minute skill; Islamic craftsmen developed extremely intricate techniques of inlay and overlay (especially of gold and silver on baser metals), in which they have never been surpassed. The decoration was sometimes calligraphic, the calligraphy – a verse from the Koran – being superbly integrated within repeating designs of foliage or rosettes; the approach was essentially linear, reflecting the rhythms of the scribe.

The first major development in Islamic ceramics seems to have taken place in Iraq during the ninth century, at Baghdad and Samarra, capitals of the Abbasid caliphate (750-1258), where a white tin-glaze was produced in imitation of the white Chinese Tang dynasty ware (see p. 286), and soon enhanced with green and blue "Tang" splashes. The refinement in Islamic pottery consists chiefly in the glazes, since the making of porcelain, though it continued to be imported from China, remained an impenetrable secret; the shapes of the vessels display fluent contours comparable to those of metalwork. By degrees

the Muslim potters developed their own coloured and lustre overglazes, in which they executed first calligraphy and, later, heraldic designs; by the twelfth century they had applied to pottery most of the arabesque and calligraphic repertoire, and also splendid stylized human and animal forms. A special development of Islamic ceramics was tiling, used for the cladding of mosques or tombs. During the Safavid period in Iran huge decorative schemes were undertaken, and vast areas of wall were scaled with thousands and thousands of decorated tiles – producing an effect comparable in magnificence to the great stained-glass curtaining of European Gothic cathedrals. The tiles were set in plaster in complex geometric and arabesque designs, often on concave and convex surfaces, necessitating the most abstruse mathematical calculations.

The architectural ornament of a mosque consisted not only of ceramic, but also of wooden, stucco and stone sculpture – and the finest Islamic sculpture is architectural. Still recognizable in the design of the furniture of an Islamic mosque are late antique and Byzantine features – the canopy of an early *mihrab*, for instance, hooded in a scallop-shell, or

acanthus sprays still adorning capitals. Islam however, developed an inhibition against sculpture in the round or in high relief – sculpture which "casts a shadow" – and Islamic sculpture is characteristically flat, in low relief or sometimes deeply incised, but the integrity of the surface-plane is consistently preserved. Stucco figures do exist, but sculpture consists again usually of arabesque or calligraphy, a dominant inspiration in architectural ornament: carved in relief in stone, the flat characters of the various scripts sometimes underwent surprisingly sensuous variations.

The *minbar* or pulpit of carved wood occupied an honoured place in the mosque, and received the finest wooden (and sometimes ivory) inlay, predominantly geometric in design. Domestic interiors and doors, balconies and screens were also decorated with the most delicate inlay or low relief or fret carving, but the intention seems always to have been essentially religious – to create an atmosphere of peace in which the individual could be mindful of God. That was achieved above all by the demonstration of an overall complex geometric unity, subsuming into one whole the variety among the subordinate elements.

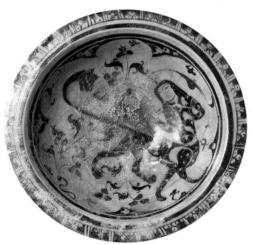

SYRIA (above)
Bowl, 12th/13th century
Before its destruction by the Mongols in 1259, the city of Raqqa was famous for its pottery, close to Iranian designs but with a distinctive greenish glaze.

IRAN (below)
Tiles, late 14th century
The glazed and lustre tiles of Kashan, often featuring, as here, a raised arabesque, adorned the interiors both of private houses and of the finest, richest mosques.

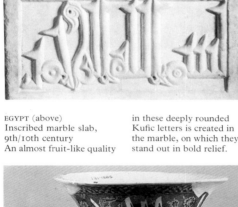

EGYPT (above)
Inscribed marble slab, 9th/10th century
An almost fruit-like quality in these deeply rounded Kufic letters is created in the marble, on which they stand out in bold relief.

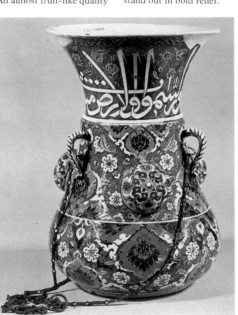
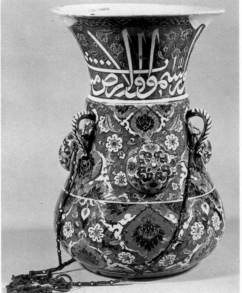

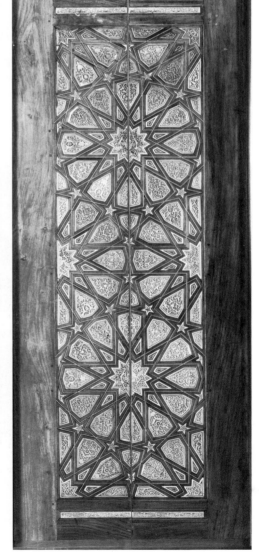

TURKEY (above)
Mosque lamp, c. 1557
In the mid-16th century the blue and white glazes of early Ottoman pottery were supplemented with a vivid tomato red – special to the ware made in Iznik.

EGYPT (right)
Pair of doors inlaid with ivory, 13th/14th century
Highly intricate geometry was the delight of Mamluk architects and designers. These precious doors came probably from a *minbar*.

Islamic Art 3: Representational Arts

Although it is often said that Islam forbids representational art, there is evidence in the *Traditions* that the Prophet deliberately did not order the destruction of paintings of the Christian Holy.Family. It is, however, true that Islam has no religious tradition of representational art, though there are some manuscripts of later centuries which illustrate the Prophet's life, including certain of his encounters with the divine. Islamic figurative art is generally secular.

There was little early established tradition of painting in north-western Africa and the Arabian peninsula, and Islamic art in these regions remained mainly abstract or calligraphic. Elsewhere, especially in present-day Iraq, Iran, Syria and Turkey, vivid representational styles flourished over the centuries, developing traditions already vigorous in these regions before the Arab invasion. The first Caliphs and the Ummayad rulers (661-750) took over from their predecessors all the traditional trappings of royalty, which included representational art. Artists provided public expression of autocratic power – accounts of battles, the submission of enemies, great animal hunts. We hear, for example, of a tenth-

century lord of Aleppo who, after his defeat of a Byzantine army, was installed in a pavilion quickly decorated by his artists with scenes of his triumphs. These princely themes are constantly repeated in the major form of Islamic representational art to have survived, illuminated manuscripts. But it was also the artist's task in early Islamic courts to decorate the private apartments of the nobility, with stucco reliefs and murals representing dancers, wrestlers, buffoons, or, in the baths, images of amorous couples or fighting warriors.

Thousands of illuminated manuscripts were produced under the patronage of Islamic princes and nobles, the majority being works of literature and history. Baghdad was the most important centre in the first flowering of Islamic miniature painting, in the thirteenth century. Though there are a few Byzantine and Sassanian features, the figures, moving with some confidence in three dimensions, are clearly related to a number of ivory carvings surviving from Fatimid Egypt (969-1171), with lively forms active amid scrollwork. The figures also bear a generic resemblance to the highly accomplished, if schematic, figures painted on ceramic dishes (not shown) under

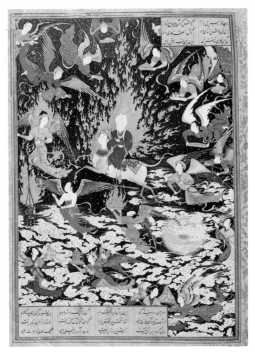

SULTAN MUHAMMAD? (above)
Nizami's *Khamseh: The ascension of Mohammed*, early 16th century
Brilliant, flaring colour is the hallmark of Shah Tahmasp's finest painter.

EGYPT (right)
Panel, 11th/12th century
Vital, charming, Fatimid openwork ivory carving has a style quite distinct from that of Byzantine ivories of this date (see p. 61).

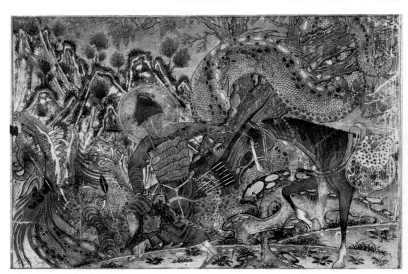

IRAN (above)
Firdausi's *Shahnameh: Bahram Gur slays a dragon*, c. 1340
The mountains and dragon reveal Chinese influence.

HERAT, IRAN (right)
Hafiz's *Divan: Dancing Sufi dervishes*, c. 1490
The fresh, delicate style established by the great Bihzad is quite entrancing.

MIR SAYYID ALI? (left)
Firdausi's *Shahnameh: Bahram Gur slays onagers*, background detail, c. 1525
Disdain for perspectival consistency never excludes the scrupulous observation of flower, stem and leaf.

the Seljuq Turks, ruling in Iran (1037-1194); but the miniatures have greater freedom.

In all Islamic manuscript painting the emphasis is on the outline, which echoes elements of the calligraphic repertoire – a range of straight, slightly bowed, undulant, angled and single- or double-curved strokes. The sculptural solidity of the figures is scarcely felt despite their contoured bulk; unlike even the most stylized figures in Byzantine art, they are described without reference to an underlying bodily structure. They are purely calligraphic entities, enclosing fields of flat colours. These principles remained firm for all Islamic illuminators, even though in Iranian work of the Ilkhanid dynasty (1256-1336) influence from Indian and from central Asian Buddhist painting can be clearly discerned, and later manuscripts also display Chinese elements.

The greatest and most consistent Islamic pictorial art was produced during the late fifteenth and early sixteenth centuries under the Timurid and Safavid dynasties in the cities of Iran, notably Herat, Shiraz, Isfahan, Tabriz and Qazvin. Later, much of high quality was painted in the capitals of the Ottoman Turks, Bursa and Istanbul, but the skill of the Iranian

miniature painters has never been surpassed anywhere. The foundations of the tradition were laid probably at Tabriz and Shiraz, but the first great flowering came at Herat. After the death of Tamerlane his son Shah Rukh (ruled eastern Iran 1405-46) gathered round him in Herat a large atelier of painters. Their pictures set what became the standard pattern for later works, with numbers of small figures laid out across an open format, and a high horizon permitting a large area of ground. The colours are high-keyed, and robes and buildings highly decorated; mountains are rendered in ranks of curves, and the earth sprouts with stylized sprays of flowering plants.

The school of Herat produced one of the most famous geniuses of Islamic art in the painter Bihzad (active *c.* 1470/85-*c.* 1510/20; not shown). Bihzad's own work is unfortunately at best rare, but he had numerous pupils and followers who faithfully reflect his style. It was Bihzad's essential skill to give to individual figures and groups, within the glowing pattern of their setting, an extraordinary sense of movement and variety. He and his school illustrated notably the legends versified by Nizami in his *Khamseh* and the epic *Shah-*

nameh (Book of Kings) of Firdausi, but also the mystic works of Sa'di and Jami and, less frequently, the poetry of the great Hafiz. The Timurid dynasty proved short-lived, but Herat remained an important centre under the Safavid dynasty (1502-1736), though Bihzad himself ended his life in the new capital, Tabriz, in western Iran.

It was in Tabriz in the first half of the sixteenth century that the greatest Safavid painters mostly worked, among them Mir Sayyid Ali, Aqa Mirak, Mirza Ali and Sultan Muhammad, the leading painter in the brilliant court of Shah Tahmasp (ruled 1524-76). The skill of these artists consisted not only in their draughtsmanship but also in their freshly conceived colour sequences, radiating over the surface. (Riza Abbasi in Isfahan was known mainly for his drawing, see p. 271).

Many manuscripts of Ottoman Turkey were illustrated in a style probably derived from the Safavid schools. More direct was the influence on Indian painting: the techniques of the Tabriz school were transplanted to India by the third Mughal emperor, Akbar the Great, who brought Mir Sayyid Ali himself to India to work for him (see p. 268).

AQA MIRAK? (left)
Firdausi's *Shahnameh: King Khosroes I's war prizes are pledged for, c.* 1530
His emphasis on decorative still life (such as the carpets that superbly follow their own perspectival logic) distinguishes the work of Aqa Mirak. He, too, was a Tabriz painter at the court of Shah Tahmasp, to whom this codex was dedicated.

MIRZA ALI? (right)
Jami's *Haft Aurang: A father's discourse on love*, mid-16th century
Despite the use of vivid, glowing colours applied so precisely that the surface seems almost enamelled, there is nothing stilted or conventional about this vision of a Safavid court at leisure. Their refined pleasures – chess, music, poetry and conversation – are shown with lively and sophisticated immediacy.

TURKEY (left)
Murad III's *Surnama: Sweepers performing before the sultan, c.* 1582
Ottoman art tended to be naive, bold, and generally prosaic beside the poetic delicacy of the Iranians. The subject matter was more limited – scenes of everyday life, ceremonials and entertainments. Here one of the artisan guilds displays its special skill before Sultan Murad III.

South-East Asian Art 1: Indonesia

Indonesia, the group of islands situated to the south-east of the Asian continent – including Sumatra, Java, Bali, Kalimantan (central, eastern and southern Borneo), Sulawesi (Celebes), Maluku (Moluccas) and Irian Jaya (Western New Guinea) – is inhabited by diverse ethnic groups sharing a complex cultural and artistic inheritance. Human settlement in the region is extremely ancient, but surviving evidence of the distant past is scant and inconclusive: Chinese influence (both of the proto-historic Shang and of the later Zhou – see p. 282) was early felt, and also the influence of the bronzeworking Dong-son civilization, which flourished in Vietnam in the early centuries BC. It is impossible to state with any precision when Indian culture began to exert a significant influence in Indonesia, but the three religions practised there today – Buddhism, Hinduism and Islam – all arrived there from the west.

Apart from Buddhist and Hindu temples (see over), most of the Indonesian art that survives is in perishable materials – carved wood, or textiles – and so must have been made comparatively recently. There are important exceptions, however – a widely dispersed group of megalithic monuments, some of which may be very ancient (though on Sumatra and on the much smaller nearby island of Nias the practice of erecting large worked stones continued into the nineteenth century); and various examples of bronzework after the Dong-son pattern, such as richly decorated sacred battle-axes and large kettle-drums. These drums were cast by a sophisticated *cire-perdue* process and bear shallow reliefs of heads, of figures engaged in ceremonial or of abstract ornament. Some of them may have been associated with rainmaking ceremonies. "*The Moon of Bali*" (not shown), preserved in the temple of Pejeng, is the most famous and sacred of these drums; other large examples are kept by families, while small ones were used for the purchase of brides.

Many of the peoples of Indonesia still live or lived until very recently in tribal societies. Their tribal art has been categorized in two main modes, designated the "monumental" and the "ornamental-fanciful". The megaliths of Nias and Sumatra, and many of the objects created throughout Indonesia in association with rites and sacrifices made to ancestors, exemplify the former; the "ornamental-fanciful" mode, essentially two-dimensional, is reflected in some degree in the bronzes, and finds characteristic expression in the decoration of the houses of the region, in textiles and in painted carvings. The two modes, which, it is assumed, sprang from different sources, are now often found within the same tribal culture, or intermingled in one artefact.

One salient feature common to all Indonesian tribal art (and further afield – it shares some characteristics with tribal art on the mainland, or with Oceanic art, see p. 22) is reverence for ancestors, expressed in many forms. The people of Nias erected their megaliths in honour of dead chieftains, while the Toraja of Sulawesi populate terraces in the cliffs with permanent galleries of standing wooden effigies of the dead, looking out over the rice fields. Numerous wooden carved standing or squatting figures, presumably embodying ancestor spirits, come from Maluku and the north-western tip of Irian. Protective ancestor figures are included in the carved decoration of houses, or in textiles – for instance the ceremonial *ikats* woven by the Dayak of Kalimantan, which sometimes incorporate a lozenge design derived from a

SUMATRA (below)
Ancestor figure?
Colossal and mysterious, the megalith is one of a circle of such stones on the island of Samosir, in the middle of Lake Toba, which perhaps represent ancestors. The conception of the figure seems rather more advanced than that of the famous Easter Island megaliths (see p. 23), surely similar in purpose.

NORTH VIETNAM (right)
The god of wine,
1st century BC
The bronze candelabrum, found in a tomb at Lach Truong, and a product of the seafaring Dong-son people, based in the Gulf of Tonkin, has affinities with works of Zhou China in its incised patterning. The ridges at the mouth are tongues: the god was known as "loosener of tongues".

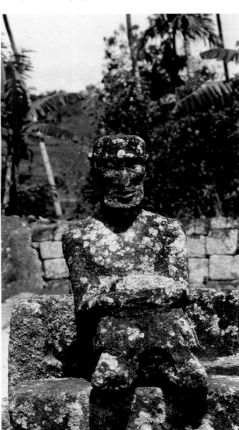

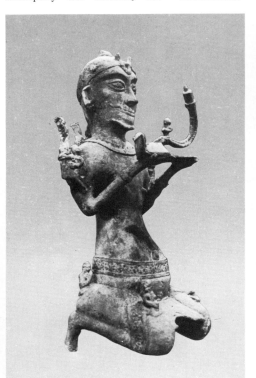

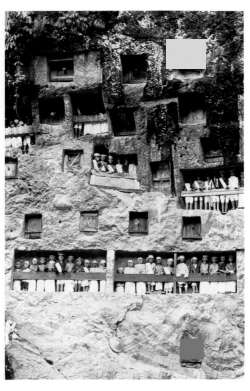

KALIMANTAN (right)
Ikat textile
Among the Dayaks designs based on the squatting ancestor figure were used to decorate blankets (*pua*) worn at feasts. It was given only to the womenfolk of the chiefs to weave such patterns, since they were conceived to have powers to protect and benefit.

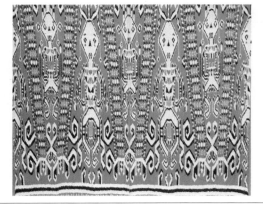

SULAWESI (above)
Ancestor figures
Mortuary festivities are an important aspect of life among the Toraja. Before a host of guests, the dead man or woman, clothed and bejewelled, is placed within a rock-cut chamber; outside, a realistic effigy is put up to signify the continuing existence of the spirit.

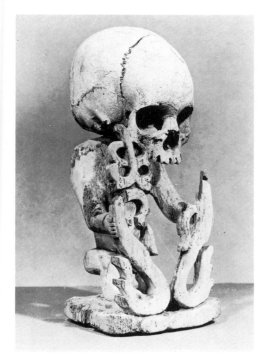

frontal view of the squatting ancestor figure. All power is thought to flow from the ghostly realm, and ancestor figures act as intermediaries for the flow of that power.

In some areas, the wooden ancestor figure has instead of a carved head the skull of the dead person attached, and the cult of the skull – essentially an extension of the reverence for ancestors – is widespread. Everywhere heads are collected and treasured, sometimes (among the Batak of Sumatra) in the roofs of family houses, sometimes (among the Dayak of Kalimantan) in village shrines, and some of the most imposing monuments of Sumatra are huge stone troughs made to hold skulls. Headhunting expeditions, launched in order to collect skulls so as to reinforce the "spiritual property" of the group, have or had a central importance in the ceremonial of certain tribes.

The elaborate decoration of wooden houses in Indonesia is famous. The large dwelling-houses of the Batak are often ornamented with engraved and painted abstract designs, and with carvings representing symbolic human breasts, lizards, monster heads and roughly-hewn squatting figures. The houses of the Toraja of Sulawesi, splendid constructions

raised on piles, with enormous flying roofs, are also embellished with carvings and paintings: the façades are decorated with geometric and figural designs, and the post supporting the projecting roof often bears the carved head of a buffalo, chief among their sacrificial animals.

Tribal societies, preserved more or less unchanging in some islands even to the present day, had given way elsewhere often very early to a system of kingship. The arts associated with these kingdoms, recorded from the early medieval period, are both religious (most stupendous is that of Java, see over) and secular. Some of the secular, originally courtly, arts that continue to be practised are the painting, carving and manipulation of puppets called *wayang*, extremely stylized, highly graceful figures (not shown), and the intricate working of small ceremonial swords called *kris*, revered as cult objects chiefly in Java and in Bali. The *batik* textiles of Java are also famous: *batik* is a technique of dying cotton (or, more recently, silk) in elaborate designs by coating the reserved areas, in each dip, with wax, and was developed in the palaces of the petty rulers of Java after the fragmentation of the medieval kingdoms that built its great temples.

IRIAN JAYA (above)
Ancestor figure
Ancestor carvings are seen as the dwelling-places of the spirits of the dead. A skull may replace the usual carved head; and this figure holds scroll-like objects that may refer to the snake – symbol of the power and regenerative force of nature.

SULAWESI (right)
The façade of a house
The abstract patterning of a curvilinear motif based on the horns of a buffalo and a concentric circle is typical of Toraja houses; the richer the decoration on a façade, the higher the occupants' status in the strict clan structure of the village.

BALI (below)
Kris and scabbard
The solemn forging of a *kris* gives the dagger a "soul" and so links the prospective owner with his ancestors. The blade has characteristically an exaggerated shoulder; the hilt is inset with jewels; in the earliest examples the hilt was wrought in the shape of a human figure, now elaborately stylized but still discernible.

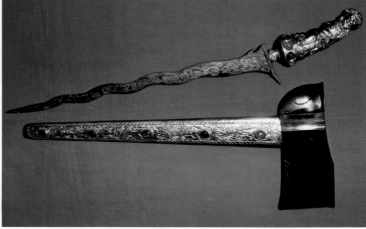

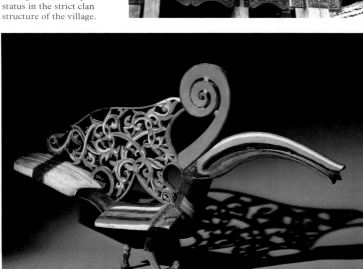

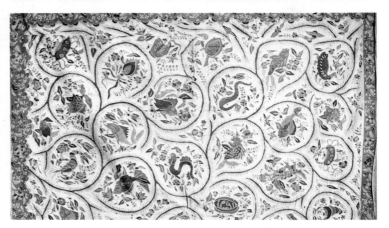

KALIMANTAN (above)
A hornbill
The Dayaks made images of the hornbill as part of the three-day festivities in honour of the war-god, Singalang Burong, held on the return of the tribe from a headhunting sortie. The carving is a rather fanciful representation of the bird, brightly coloured and elaborately modelled, with a characteristic delight in spiral and curl.

JAVA (above)
Batik textile
The cotton is dyed in one of many traditional patterns; in this, made up of intersecting circular tendrils, the elliptical spaces are inhabited by tiny creatures of fancy, exhibiting clear affinities with Chinese art. Indeed it is quite likely that the *batik* technique originated in China, though only in Java did it attain this peak of refinement.

South-East Asian Art 2: Java and Burma

Borobudur in central Java is one of the most extraordinary stone monuments ever made. It is a vast structure, but does not seem to have been a tomb, a palace or even a temple, but instead a profound and intricate expression through architecture and sculpture of Buddhist doctrine – it forms in plan, for instance, a *mandala*. Its construction must have required an army of craftsmen and an architect of genius, but there is no record of who built it or why, although its date is generally assumed to be late eighth or early ninth century AD, and its sponsor a member of the central Javanese Shailendra dynasty (778-864).

Not the least remarkable thing about Borobudur is that it is the culmination of an artistic tradition that seems to have been very short-lived. Western Java had first been settled by Indian traders perhaps in the first century AD, and Buddhist monasteries were certainly established there by the fourth century, but there is no evidence of any significant undertaking in stone – architecture or sculpture – for a further three centuries. The earliest extant Javanese stone sculpture, which is Hindu, dates from the early eighth century, hardly 100 years before Borobudur.

In elevation, Borobudur is a kind of flat, solid pyramid, composed of eight terraces of diminishing size. Around the perimeter of the five lower terraces, which are square in plan, runs a broad, roofless corridor, lined with relief sculpture, and with *Buddhas* sculpted in the round in niches surmounting the walls, facing out over the surrounding country. The three topmost terraces are circular in plan, unwalled, and carry 72 lattice-work *stupas*, bell-shaped, each sheltering a colossal *Buddha*; and the climax of the monument is a single, solid *stupa*, representing Nirvana. Borobudur

symbolizes the ascent of a believer, following the precepts of Buddhism, from the baseness of ordinary human existence to the ultimate condition of psychological and philosophical enlightenment – the *stupa* at the apex. The sensation, when emerging from the enclosed walls of the square terraces on to the open levels of the circular terraces, is extraordinary, an intimation of the Buddhist experience of understanding the nature of the cosmos.

The style of the figure sculpture at Borobudur, unique to Java, though clearly derived from India, is characterized by massive, full

BOROBUDUR (below)
Pippalayana and Bhadra,
8th/9th century
The second terrace of the complex is decorated with reliefs depicting the life of the Buddha and his prior incarnations, the *Jatakas*, which represent, in metaphorical terms, the many virtues of the Buddha. Here his chastity is typified by the legend of Pippalayana and Bhadra, who married but still remained celibate.

BOROBUDUR (right)
One of the 72 *Buddhas*,
8th/9th century
The 72 *Buddhas* in their *stupas* round the topmost terraces denote the phases of enlightenment undergone by a devotee in pursuit of Nirvana. Their huge figures convey great tranquillity – faces smiling peacefully, bodies scarcely inflected, the volumes contained and at rest. No more radiant symbols of Buddhism exist.

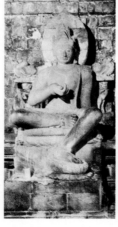

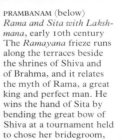

PRAMBANAM (below)
Rama and Sita with Lakshmana, early 10th century
The *Ramayana* frieze runs along the terraces beside the shrines of Shiva and of Brahma, and it relates the myth of Rama, a great king and perfect man. He wins the hand of Sita by bending the great bow of Shiva at a tournament held to chose her bridegroom,

but is banished from court; he retreats to the forest with Sita and his favourite half-brother Lakshmana. Sita is carried off by the demon-king Ravana, while Rama is pursuing a gold deer sent to mislead him, but Rama rescues her: he has obtained assistance from the King of the Monkeys. So, too, the forms are unrealistic, but highly ornate.

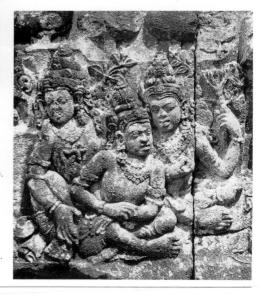

BOROBUDUR (right)
The story of King Sibi,
detail: *Visitors arrive in their ship*, 8th/9th century
The ship, with tripod mast and heavy outrigger, seems an accurate representation of the vessels that sailed the Indonesian seas more than 1,000 years ago. The semi-legendary King Sibi was renowned for generosity, and his flourishing, cultured realm was a resort of many visitors from other lands.

CHANDI MENDUT (above)
The Bodhisattva Vajrapani,
8th century
The smooth, round quality of the icon is reminiscent of the Buddhist carvings in the Ajanta caves (see p. 262). The Bodhisattva Vajrapani sits in a posture of royal ease, as befits the supreme lord of divine and powerful beings who are converted to the Buddhist doctrine, and the special companion of the Buddha Shakyamuni.

and rounded forms, with slow rhythms in their movements and compositions. But although the figures are generalized and ideal, the narrative scenes are rich with precise naturalistic detail from contemporary life, illustrating ships, buildings, weapons, furniture, costume. A similar style prevails in the other monuments built by the Shailendra dynasty, among which the shrine of Chandi Mendut is perhaps outstanding. It is much smaller, consisting of a single cell, encrusted on the exterior with decorative and narrative relief panels positioned with a superb sense of design; the interior contains three gigantic stone icons, the Buddha and two Bodhisattvas. Their smooth surface contours are interrupted only by jewellery worn by the Bodhisattvas.

The last of the great central Javanese shrines, Lara Jonggrang at Prambanam, built in the early tenth century, was clearly undertaken as a Hindu rival to Buddhist Borobudur. Originally the enormous complex contained 232 temples, fully provided with icons and covered with relief sculpture. The terraces still display a remarkable series of relief panels summarizing the Hindu classics; Lara Jonggrang also happens to possess some of the

earliest known representations of Indian dance postures (not shown).

In eastern Java, between 927 and the beginning of the sixteenth century, when Islam came, there was a succession of dynasties, which built in stone or brick or cut in the rock a large number of smaller Hindu and Buddhist shrines containing extremely accomplished stone sculpture, both narrative reliefs and large icons. A colossal *Vishnu riding on Garuda* was commissioned in the eleventh century by one King Airlanga, whose portrait it may also be; there is also an enchanting feminine *Supreme Buddhist Wisdom* from Singasari (not shown), carved perhaps to personify a thirteenth-century queen. In style, eastern Javanese art depended on the central tradition, but tended towards more fantastic imagery and a more linear description of form.

Most of the monumental sculpture surviving in Burma is Buddhist. Probably from about the seventh century AD the country was divided between two peoples, the southern Mon and the northern Pyu, both practising Buddhism. After the fall of the Pyu capital in 832 the northern regions were infiltrated by Burmans, who brought with them the cult of

Nats, a mixed collection of beings, including nature spirits, ancestors and ghosts. In time this cult and the Buddhism of their predecessors were merged into a hybrid religion, still a force in Burma today. A tradition of painting and sculpture was established in the time of the Mon and Pyu, and King Anawratha, who in the eleventh century established the capital of the united Burmese territory at Pagan, employed Mon artists in large numbers. Palaces and shrines occupying several scores of acres sprang up, richly ornamented with painting and painted terracotta sculpture, which is still there in Pagan in some quantity today, since in 1286 the city was sacked by the Mongols and virtually abandoned.

Apart from the ruins at Pagan and elsewhere, the heritage of Burmese art consists of a few small medieval bronzes, of high quality, and quantities of carvings and gilt stuccowork of uncertain age: there has been little variation in style. The figures are simplified and generalized, enacting legends mostly of Buddhist derivation in elegant postures reminiscent of the dance; the supreme qualities of Burmese art are its airy spirituality and inspired decorative finesse.

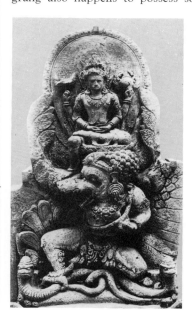

BELAHAN, EASTERN JAVA (left) *Vishnu seated on Garuda, c.* 1042
The sculpture may represent King Airlanga himself in the guise of his patron Vishnu. The sublime peace of the expression of the god contrasts vividly with the wild ferocity of his terrible vehicle, Garuda, who is a kind of bird, and symbolizes cosmic energy.

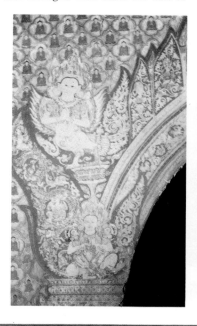

PAGAN, BURMA (right)
Frescos decorating an arch in the temple of Muy-tha-kut, 11th or 12th century
Inside Burmese temples the painted decoration includes usually fiery jets like those sculpted outside (far right). The two figures are prior Buddhas, part of a scheme depicting scenes from the Buddha's previous lives, which serve as a reminder of the Buddha's teaching.

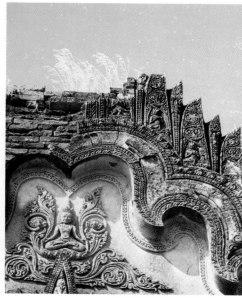

PAGAN (above)
Terracotta ornament, 12th century
The ornament on Burmese temples is calculated to lend apparent lightness to heavily vaulted structures. The decoration on the arch depicting jets of flame and curling smoke symbolizes (not, however, too literally) the energy generated by contemplating the Buddha.

UPPER BURMA (above)
The Buddha in the bhumi-sparsamudra, 17th century
The Buddha's gesture is to touch the ground, in order to call the earth-goddess to witness his complete fitness to enter Nirvana.

BURMA (left)
Sutra chest, 18th century
In *sutra* chests the sacred texts that every monastery needed were kept; they were sumptuously ornamented, sheathed in gilt gesso, and inset with mirror glass.

South-East Asian Art 3: Cambodia and Thailand

From about the late first century AD, Indian trade settlements began to appear around the coasts of South-East Asia, and became sources for the dissemination of Indian religious practices and ideas. Both Buddhism and Hinduism had taken root in the coastal regions of South-East Asia and in some of the islands, notably Java (see preceding page), by about the fourth century AD.

One of the most important early Indian settlements was at Palembang, near the Strait of Malacca, which acted as a centre for the diffusion of a style based on that of Amaravati (see p. 261). A large bronze icon of the Buddha from Sulawesi is the most splendid (and rare) example of the earliest Buddhist style to permeate the region. But it was in Cambodia that the first distinctly South-East Asian style of high quality emerged, influenced by Indian importation but clearly also dependent on an existing native style of some sophistication, probably worked in perishable materials. This sculpture, both Buddhist and Hindu, evolved in the two monarchies of Fu-nan (second to sixth century) and its successor Chen-la (sixth to seventh century). Stone icons of Hindu and Buddhist deities survive from the latter part of

the sixth century onwards, all single figures sculpted with a strong feeling for volume, even if rigidly defined in frontal view – the mould from which was formed the classic Cambodian style of Angkor Wat in the twelfth century. Associated with the Fu-nan icons are stone lintels from the temples (not shown), which were carved with an opulent ornament – rich foliage, jewellery – which reappears on the early buildings of Angkor.

Towards the end of the eighth century, Chen-la disintegrated, to be re-formed under a new dynasty founded by Jayavarman II (died 850), a son of the old royal family, who had been in exile for some years at the court of the Shailendra in Java. His successor Indravarman (ruled 877-89) had his capital at Roluos in the south-east, but he built the first great reservoir at Angkor, which was to be the largest city in the world before modern times.

Perhaps the most beautiful of all the works of the early Angkor period is at Banteay Srei, a private foundation of the tenth century just outside the capital. The lintels decorating the doorways of the three shrines and subsidiary buildings are effervescent with the most opulent decorative carvings, exuberant foliage and

jewel-strings (symbolizing wealth); exterior panels are carved with standing figures and the pediments with Hindu legends, again amidst profuse ornament. In Angkor itself ever vaster schemes of architectural sculpture were undertaken, reflecting the expanding ambitions of the successive rulers of the growing Khmer Empire. Within the greatest of the mountain temple complexes in the city, Angkor Wat, built in the early twelfth century, more than a mile of stone reliefs recount a panorama of legends from Hindu mythology, in which the heroes are identified with the aggressive and ambitious king who built the Wat, Suryavarman II (ruled 1113-45). The relief, however, is hardly three centimetres (1in) deep; nevertheless the artists were able to mount complex compositions suggesting vigorous movements in deep space.

In 1177 Angkor was sacked by the neighbouring Cham people, marking the end of the era of the great Hindu emperors of Cambodia. About 1200 Jayavarman VII, a grandson of Suryavarman and a Buddhist, began to rebuild the city as Angkor Thom; he erected his own mountain temple complex, the Bayon temple, striving to outdo the Wat in the scale and

SULAWESI (right)
The Buddha, detail,
3rd/5th century
Probably the oldest image of
the Buddha in South-East
Asia, the icon was perhaps
imported from India or Sri
Lanka. Undulating loops
of drapery – gathered in the
bend of the left arm as in
the first Amaravati images
(see p. 260) – are drawn in
grooves across a sleek body.

CAMBODIA (below)
Vishnu, late 7th century
The style of the icon is
that of Prasat Andet, one
of the major temples of the
Khmer kingdom of Chen-la.
It combines severity with
a certain sensuous charm;
its blocky, cubic form is
finished smoothly, and the
drapery is mainly incised.

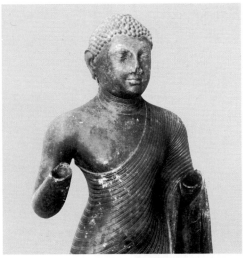

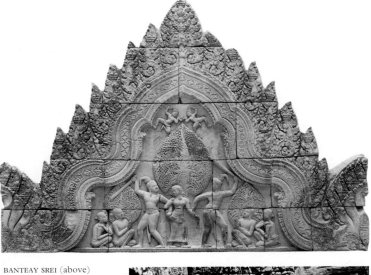

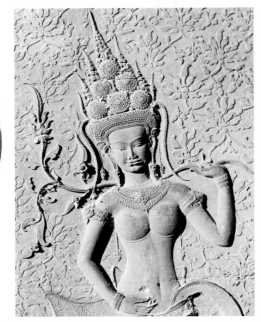

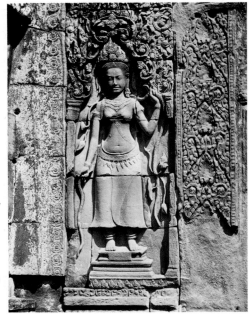

BANTEAY SREI (above)
Pediment, 10th century
The demons Sumbha and
Nisumbha fight over the
most beautiful of the
Apsaras, Tilottama, framed
by the elaborate jewel and
foliage motifs typical of
early Khmer architecture.

ANGKOR WAT (left)
Apsara, detail, 12th century
The heavenly dancing girls
of the Wat are dressed in
the height of fashion, with
elaborate hairstyles and
rich jewellery. They stand
against rich floral back-
grounds, representing the
brocade hangings of Heaven.

ANGKOR THOM (right)
Devata, early 13th century
This charming maiden is a
divine guardian of a door
to the Bayon temple; she is
carved with the same precise
attention to details of dress
as the dancers on the Wat,
if less happily proportioned.

ANGKOR WAT (below)
Detail of the great frieze
showing *The battle of the
Pandavas and the Kauravas*
on an outer gallery, early
12th century

The horse rears in violent
forward movement; men
with rubbery limbs crowd
every available space, in
an exciting scene from the
Hindu epic *Mahabharata.*

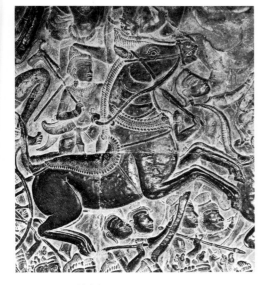

quantity of its reliefs. These are rather clumsily executed, however, and their compositions are stiff and hierarchical, although the beautiful *Devatas* who guard its portals are worthy rivals to the divine maidens carved on the Wat. On Jayavarman VII's death, Angkor declined in the face of attacks by the people of central present-day Thailand, and the ideals of absolute kingship which had inspired so much of the art of Cambodia were extinguished.

Neighbouring present-day Thailand had been ruled in the eleventh and thirteenth centuries by the Khmer; before that it had been the domain of the kingdom of Dvaravati, a confederation of the indigenous Mon peoples inhabiting also southern Burma. From the sixth to the eleventh century Buddhist art had flourished there, influenced by regional Indian styles, though the faces usually show features characteristic of the local Mon population, with distinctly marked, out-turned lips and downward-curving eyelids outlined in double channels. After the eleventh century, the northern regions of Dvaravati were infiltrated by the Thai, and when the Khmer disappeared from the scene the Thai moved further south. Shortly afterwards the Burmans moved in

among the Mon peoples in present-day Burma (see preceding page), and the Mon ceased to be an entity.

Like the Burmans, the Thai were animist, reverencing Nature spirits, and remained so even after their conversion to Buddhism. The Buddha was felt, animistically, to embody the supernatural potency of the whole region and nation. There were several rival traditional types of icon: the dominant type was the "Sukhothai", a gracefully rounded, sinuous figure named after the city in central Thailand, but two others deserve mention – the rather squarely modelled "U Thong" type (not shown), popular notably at Ayutthaya in the south, and the more massive, almost crude "*Lion*" or "Chieng Sen" type (not shown) in favour in the northern regions. Colossal brick-and-plaster *Buddhas* were erected inside many shrines: these, now ruined or heavily restored, were modelled according to one of the Thai prototypes, and so were wall-paintings of the Buddha, also lost or repainted; the oldest surviving paintings are on cloth. Buddhism, however, is still a force in Thailand today, and Buddhist art is still being produced which, in conception, owes much to historic styles.

ANGKOR THOM (right)
Details of reliefs from
the outer terrace of the
Bayon temple: *A military
parade*, early 13th century
Events from Khmer history
are represented, and also
charming genre scenes of
life in Angkor Thom. The
parade possibly celebrates
Jayavarman VII's retaking
of the city from the Cham;
it looks gauche beside the
earlier, Hindu style (above).

CHAIYA, THAILAND
(below) *Bodhisattva*,
mid-8th century
One of the finest extant
masterpieces of Mon art,
the figure sways with a
delicate, sensuous motion
that betrays the influence
of Gupta India (see p. 262).
All the elaborate details of
jewellery – crown, ear-rings,
necklaces and armlets – are
lovingly cast and chased.

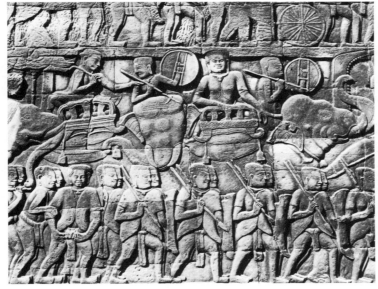

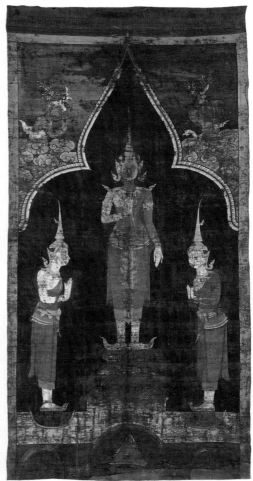

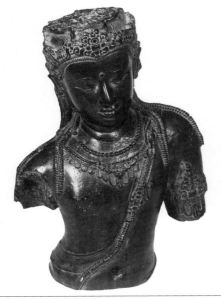

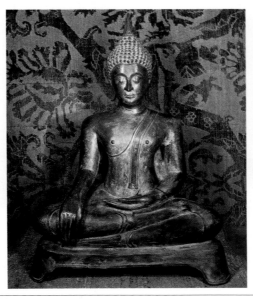

CENTRAL THAILAND (left)
*The Buddha calling
the earth to witness,*
14th century
Of the classic "Sukhothai"
type, the Buddha has long,
elegantly pointed hands, an
oval head with deep, arched
brows and a pointed skull.

THAILAND (above)
*The Buddha with two Bodhi-
sattvas attended by spirits,*
18th century
Little early Thai painting
survives, but even recent
examples show the sinuous,
elegant figure-style of the
early "Sukhothai" icons.

Chinese Art 1: Relics of the Tombs

We should know little of China's Bronze-Age art were it not for the elaborate burial practices of its ruling class. During the early dynasties of the Shang (*c*.1600-*c*.1072 BC) and the Zhou (*c*.1027-475 BC), the important families maintained large subterranean tomb complexes, from which the ancestral dead were conceived to watch over the fortunes of the living. Apart from its already remarkable pottery, some of the first notable Chinese works of art are bronze vessels for use in ceremonies undertaken to appease these spirits: cast by a complex piece-mould process, they bear complicated zoomorphic designs, originally magical and protective glyphs, developed into endless linear proliferations with backgrounds of square scrolling. Many have dedicatory inscriptions inside the bowl, which are among the earliest surviving examples of the archaic Chinese script. The ceremonies grew more extensive and elaborate in the Zhou period: the vessels bear long inscriptions describing the circumstances in which they were cast, but the decoration is often less complex.

Besides the pottery and the bronze vessels, some of the most attractive early works to survive are numerous small bronze or jade

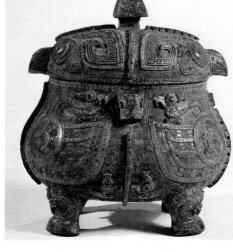

ANYANG (above)
Bronze vessel, *c*. 1200 BC
The vessel represents two owls standing back to back, and displays the Chinese genius for rounded form played against a complex two-dimensional pattern.

plaques, which decorated either horse tackle or the pole-tips and hub-caps of chariots. Animals are frequently represented. They are stylized, however, in stereotypes that are recognizably akin to some of the pictograms of the archaic Chinese script on the ceremonial bronze vessels. At the very beginning of Chinese culture an affinity between writing and art was firmly established, never to disappear.

China's history is chequered with periods of destructive political upset. The power of the Zhou dynasty was disintegrating in the eighth century BC, and the succeeding periods – the so-called Spring and Autumn period and the Warring States period – remained unsettled until the establishment of the harshly centralized Qin dynasty in 221 BC. This interim, however, was paradoxically an era of astonishing cultural and technological advance, and during it lived China's two greatest moral philosophers, Confucius and Laozi – the one elaborating a humanistic outlook in a series of famous adages, the latter developing a philosophy ordering man's mystical union with Nature. Artistic production increased in quality and sophistication: luxurious objects of jade, bronze and fine lacquer were wrought in

NORTHERN CHINA (below)
Incense burner, *c*. 200 BC
The censer reflects the widening spread of Taoist beliefs among the wealthy classes: it represents a craggy mountain rising from the sea, the dwelling-place of the immortals and fabulous beasts of Taoist mythology.

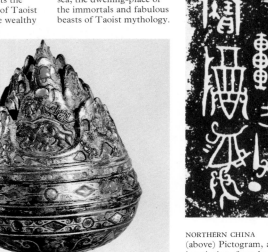

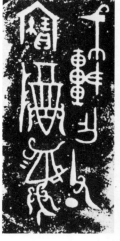

NORTHERN CHINA
(above) Pictogram, and inscription, from bronze vessels; (below) animal-shaped plaques, *c*.1200 BC
The first Chinese writing survives on ritual vessels and the so-called "oracle bones" used in ceremonies to decide when and how a sacrifice should take place. The text informs us: "This vessel is dedicated to my father"; it shows symbols combined to express ideas more complex than those of the first "picture-letters".

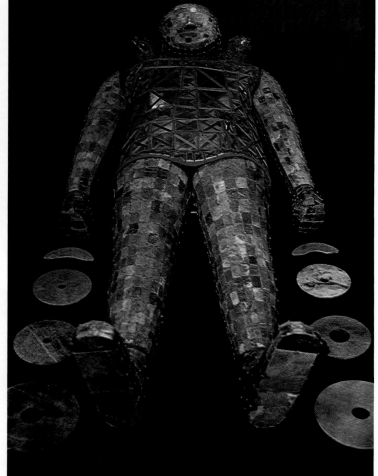

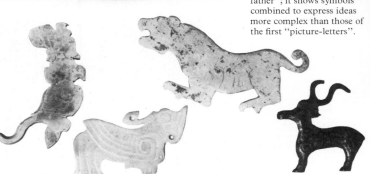

MANCHENG (above)
Burial suit, *c*. 113 BC
Taoist mythology includes a belief that jade has the power to conserve the body after death. In Han times, even in modest tombs, the corpse was furnished with costly jade pieces; Prince Liu took the belief to its logical conclusion and had prepared for himself and his wife whole suits, each made of more than 2,000 jade tablets sewn together with gold thread. Each suit, it is reckoned, would have taken ten years to make; the extravagance of early Chinese burial furniture can seem almost oppressive.

thousands to satisfy the demands of China's growing class of wealthy landowners. Compared to the glyphic look of Shang decoration, their ornament is playful and refined.

China is a land full of ancient sites awaiting investigation. Since coming to power the government of the People's Republic has conducted a series of model excavations of ancient tombs, dramatically increasing our fragmentary knowledge of its huge past. Some of the most remarkable finds come from the imperial tombs of the Western Han dynasty (206 BC-AD 8), revealing a vigorous and varied artistic tradition. Ornament has an undulating, cursive character, found for instance on inlaid bronze incense-burners – their "cloud" motifs are typical of Han decoration. By then the aristocratic burial customs of the previous era had spread to all levels of society; the funereal pottery found in more modest tombs of Han date is covered with a lead-green glaze, in an obvious attempt to ape the aristocratic bronze, in shapes which also imitate metalwork.

Great care was taken in Han burials to preserve the corpse, not physically by mummification but magically by means of jade emblems placed at all of the body's nine orifices (including the eyes); the tomb of Liu Sheng, of the imperial family, has revealed entire suits of jade plaques encasing the corpses of the prince and his wife. The dead were customarily surrounded also by representations of the world they knew – figures of attendants, soldiers, musicians, animals – especially favourite horses – models of stoves, granaries, pig-pens, houses. Formerly their servants and animals were slaughtered to accompany lords into the next world, but this practice was abandoned in the fifth century BC under pressure from the Confucians; the substitutes were usually on a small scale, made of wood or clay, although some especially fine bronze figurines are known – among them a "Flying Horse" made under the Eastern Han dynasty (AD 8-220). Near Mount Li in western China, the extravagant burial mound of China's self-acclaimed first Emperor, Shihuangdi – the first and only effective ruler of the Qin dynasty (221-206 BC) – more than two thousand life-size terracotta warriors and horses have been excavated, probably a grandiose emblem of the army with which this tyrant enforced his rule. Even early in the Tang dynasty (AD 618-907) royal tombs were lined with reliefs or paintings of everyday life, and filled with figurines.

The parallel with ancient Egypt is obvious. Art was used as a means of realizing in the spirit world the objects, people and animals the dead would need to use. The material possessions of the dead went with them to the grave, and elaborate precautions were taken against grave robbers. Major tombs of the Qin and Han dynasties were enclosed by huge artificial hills and approached by avenues called "spirit roads", lined with colossal stone guardian figures. Few survived the troubles at the end of the Han period, but near Xianyang, in western China, is a mound believed to be the grave of General He Qubing, who died in 117 BC after a lifetime of harrying the Hunnish tribes to the north of the country. The colossal figures – several horses and a buffalo – which stood before his tomb are the earliest examples of Chinese monumental sculpture to survive, and mark the beginning of a tradition which continued into Ming times. It was probably in the carving of these large-scale sculptures that the skills necessary to the sculpting of the colossal Buddhist icons of post-Han China were developed (see over).

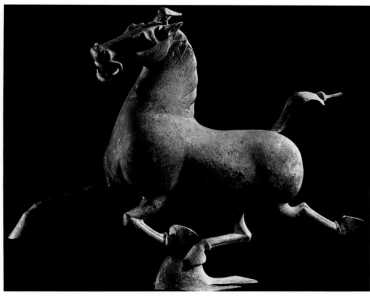

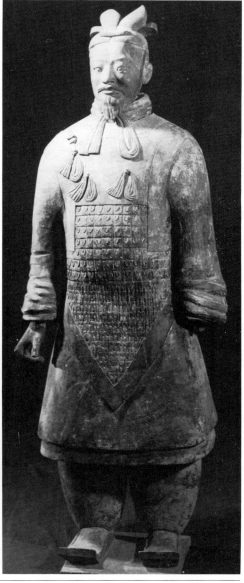

WUWEI, WESTERN CHINA (left) *"Flying Horse"*, 2nd century AD
The horse is depicted with one hoof resting on a bird in flight; in the rhythm of its briskly clip-clopping limbs, its bouncing ears and tail, there is a fine sense of its movement. More than 200 similar bronzes were discovered in the same tomb, though this one is unique.

MT LI (right)
A warrior, c.246-210 BC
The figure is a general in full battle regalia, and he holds the highest rank of all the terracotta figures so far excavated from the army of thousands buried near Mt Li. The general is clearly individualized, like the other soldiers; they may even be portraits of the rank and file of the army that Shihuangdi led.

LONGQUAN (above)
One of the Emperor Tai-zong's chargers, c. AD 649
Reliefs representing the Emperor's six chargers in sandstone once lined the anteroom of his splendid mausoleum. The horse is fully caparisoned, moving at a brisk, high-stepping trot; though rather broadly modelled, it is conceived in a naturalistic spirit typical of Tang sculpture.

XIANYANG (above)
Recumbent horse, c. 117 BC
The animal appears to be struggling from the stone out of which it is carved. Disturbingly monumental, it is one of several from the burial mound probably of General He Qubing, and a fitting memorial, as he owed his victory over nomadic tribesmen raiding from the north in 119 BC to horses he stole from them.

Chinese Art 2: Buddhist Art

Buddhism was the chief inspiration of figurative art in China between the collapse of the Eastern Han dynasty in AD 220 and the rise of the Tang at the beginning of the seventh century – and even well after; during the Tang and Song dynasties, however, though the religion never died out in China as it did in India, Buddhism declined, while Confucianism revived and secular art became increasingly important. Entering the fringes of the country from India as early as the first century AD, Buddhism was brought to China chiefly by missionaries from Gandhara (see p. 262), and when Buddhism was adopted more widely in the fifth century, after the accession of the Wei dynasty (386-535), the influence of Gandharan art held wide sway.

The iconography of the great works of Chinese Buddhist sculpture and painting is based mainly on two principal Buddhist sacred books, the *Lotus Sutra* and the *Amitayus Sutra*, cosmic texts permeated with an atmosphere of stupendous miracle. Chinese artists were inspired by them to undertake compositions often on a colossal scale in a "transcendent" style; the orthodox Buddhist triad, of the 'Buddha and two Bodhisattvas, was re-

peated again and again (sometimes with other attendants and assisting deities), while the Bodhisattva Maitreya, the Buddha of the future age, was a favourite image of royal, monastic and communal patrons.

The Wei dynasty was only one of six ruling China – some of them concurrently – between the demise of the Han and the reunification of China under the short-lived Sui dynasty (581-618). These dynasts and their nobles were responsible for a series of immense rock-cut monasteries, complete with vast decorative schemes of high-relief sculpture (and painting, though little remains). The chief sites are in the north – Yungang (460-535), Longmen (495 to about 700), Tienlongshan (mainly seventh to eighth century) and the Dunhuang oasis (mainly sixth to ninth century) – and these furnish the most extensive evidence left to us of early Chinese Buddhist art; numerous Buddhist monasteries certainly also flourished in the more southerly cities, but their remains are few. Bronzes also survive, on a smaller scale, matching the enormous major works in imagery and style; large-scale bronze icons in the round also existed, and were probably amongst the outstanding works of Buddhist

sculpture, but they were melted down during the later persecutions of the religion.

The stylistic evolution of Chinese Buddhist sculpture begins with the colossal static icons at Yungang, where the smoothly rounded figures are recognizably close to Gandharan work. By the beginning of the sixth century a more linear style predominated, notably among the sculptures of Longmen, where some of the icons are extremely severe figures, with harsh faces. Towards the end of the sixth century, partly due to fresh influence from Gupta India, the sculptures became again more full-bodied, and this trend culminated in the superb *Bodhisattvas*, with well-fleshed torsos in the Indian fashion, of the Tang dynasty (618-907). Many of the great rock-cut icons at the cave sites bear inscriptions testifying to the piety of the individual – maybe a prince – or of the group who commissioned the work. Not only icons were made: numerous reliefs were carved in honour of such a great event as, for instance, the visit of an empress. Numerous devotional stelae were also erected, illustrating in low relief and often in a more dynamic, curvilinear style narrative episodes from the *Sutras*, or sometimes the Pure Land

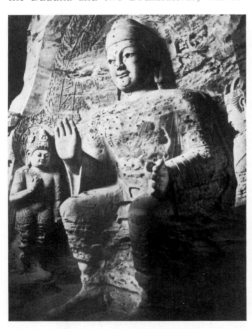

YUNGANG (above)
The Buddha, c.460-70
The tranquil, sensuous aura of Gandharan sculpture has been expanded, inflated, to a colossal scale. The body of the Buddha beneath his robes has become a broad smooth volume, over which sweep undulant draperies, indicated by linear folds.

LONGMEN (right)
An empress visits Longmen, c.522
Despite the flat carving, the relief conveys a fine sense of forward movement, largely due to the taut arcs of the linear draperies, typical of the sculpture in this cave. Such reliefs may reflect the style of lost wall-painting at the court of the northern Wei rulers.

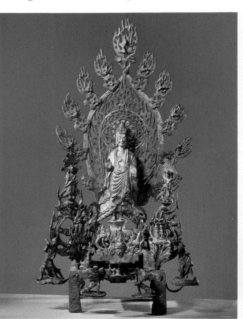

NORTHERN CHINA (left)
Maitreya, 522
The Buddha of the future is surrounded on his altar-piece by eight tiny Bodhisattvas, while below two donors proffer bowls. The central figure's elaborate draperies with fluted edges, his sharply defined facial features and his bewitching smile – all are features of the many bronzes produced under the northern Wei.

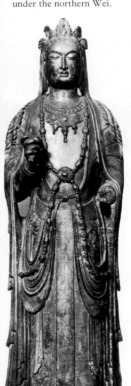

NORTHERN CHINA (above)
Bodhisattva, 8th century
During the Tang dynasty China re-established trade contacts with India, with immediate consequences in Chinese sculpture: figures sway with easy indolence, displaying plumply elegant forms beneath transparent draperies. The full forms of Indian art are fused with Chinese linearity.

XIANGTANGSHAN (left)
Bodhisattva, c.550-77
The column-like figure is gently, smoothly rounded, in contrast to the sharply delineated jewellery, Indian in inspiration. Yet the air of calm and majestic beauty is closer to the great icon of Yungang than to the Tang figure (above), in which the Gupta influence is stronger. Indian influence is present here, but not yet decisive.

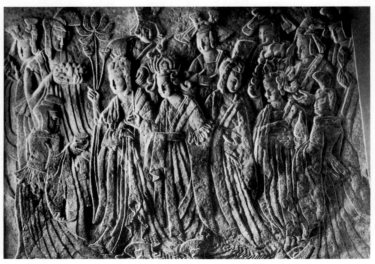

Paradise of Amitabha to which the faithful are transported after death, which is figured in some seventh-century wall-paintings at Dunhuang (not shown).

The aristocratic burial customs of the Han dynasty had subsequently spread to all sections of society, and by the time of the Tang it was usual for every family to furnish their dead in their graves with "spirit figures", ceramic people and animals. Ceramic sculpture had been put to Buddhist use as early as the eighth century, but the earliest surviving examples are tenth-century – figures of Luohans (the original disciples of the Buddha) in which an aspect of Chinese art more familiar to the West emerges – a sharply drawn idiosyncracy of feature and character. The *Luohans* make a strong contrast with the idealization of earlier Buddhist icons, though they, too, are distantly related to Gandharan models – to attendant figures in Gandharan icons of the Buddha. They rapidly became widely reproduced, in sets of 16, in all media; each was individually characterized, some as handsome young monks, others as sages of fantastic character, craggy, bizarre and gnarled figures whose gaunt, bony faces testify to their spiritual

YICHOU (below)
Luohan, late 10th century
It was taught that no one could equal the Buddha; so his disciples, who reached Nirvana almost as he did, were called merely "worthy ones" that is, *luohans*.

efforts. This new idea of individual personality infected even the *Bodhisattvas* made in wood, clay and stone by the sculptors of the Song (Sung) dynasty (960-1279): these are still ideally plump, and wear rich garments and highly wrought ornaments, but they appear much more as individual human beings than as purely symbolic figures.

Buddhism had never displaced the older modes of thought and custom enshrined in Confucianism and Taoism, and its hold was periodically weakened by politically motivated attacks. The main target of imperial policy, the great monasteries, continued, however, to flourish during the Yuan (1271-1368) and Ming (1364-1644) dynasties, and their halls were filled with painted scrolls, murals and large-scale sculpture – dynamically animated works, vividly coloured, and with a strong illusory presence (the sculptures often had inset glass eyes). Once Buddhism had been extirpated from India, there was no further vitalizing influx from the west; China, however, passed to the east, to Korea and Japan, both traditional Buddhism and that most individual form, founded by the late 5th-century Indian immigrant Bodhidharma, Chan (Zen).

WESTERN CHINA (below)
Devotional stela, 554
The Buddha is central, flanked by his disciples, Bodhisattvas and guardians.

Above, twin Buddhas reveal the *Lotus Sutra* miracle, while the lower tier is given over to the inscription and an incense-burner.

CHINA (below)
Camel with grooms,
Tang dynasty
Such "spirit figures" were provided for the needs of

the dead in the beyond; the lively camel, glazed in a characteristic yellow and green, would act as a beast of burden for the deceased.

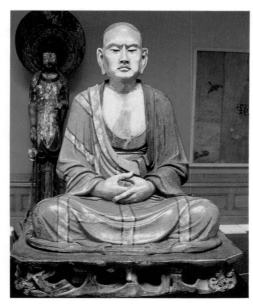

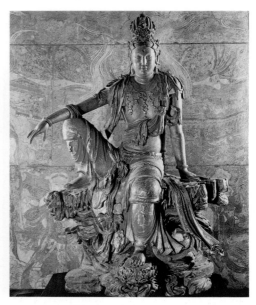

NORTHERN CHINA (above)
Guanyin, Song dynasty
The fulsome, elegant figure poses with graceful languor in the *maharaja-lila*, the position of royal ease – a consummate image of disinterested compassion, as benefits Guanyin, who was the special comforter and the protector of mankind.

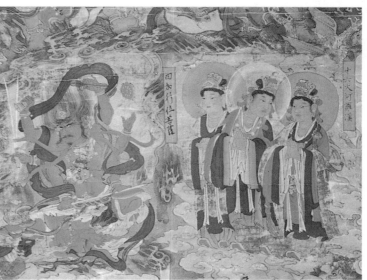

NORTHERN CHINA (left)
Hanging scroll, detail,
14th century
The colourful figures – a Buddhist manifestation of a Tantric deity, and three Bodhisattvas attending, in a fantastic surround – are typical of Ming Buddhist painting; the skilfully elaborated strands of drapery fly out around, creating a strong, dramatic presence.

Song (Sung) Porcelain

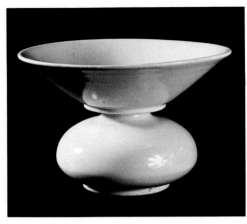

The beautifully inflected swelling curves of the pot are typical of the creamy-white porcelain produced in the northern province of Hebei during the Tang era.

HAIDIAN, PEKING (below)
Vase and cover, late 14th century
The copper-red underglaze patterns are more typical of Ming pots, although this is of the Yuan dynasty, a transitional era in ceramics.

CHINA (below)
Items of Song porcelain:
A Northern celadon bowl, 11th century;
B Jun bowl, probably 12th century;
C Ding bowl, 12th century;
D Cizhou vase, 12th century
Jun ware was valued for its luminous bluish glaze, more opalescent, and softer and subtler, than the heavy olive-green of the celadon bowl, incised with flowers and scrolls. The wares of the Ding factories, in the northern province of Hebei, are some of the most famous of the Song era; the bowl

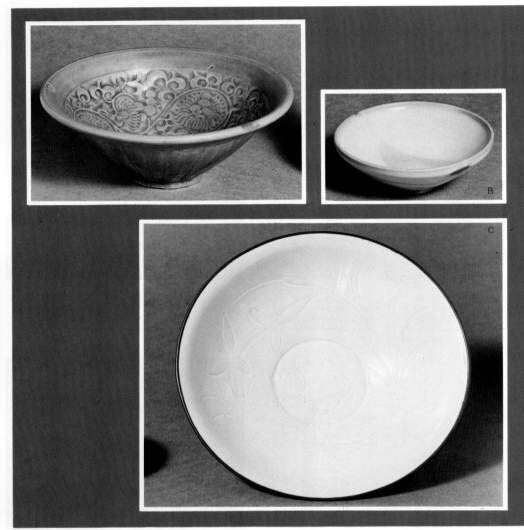

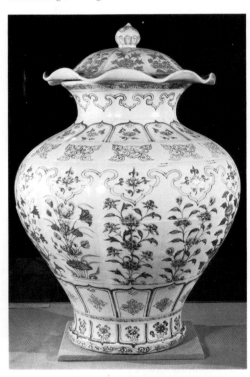

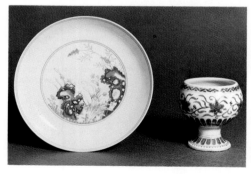

JINGDEZHEN (above)
Stem cup, c. 1426-35;
Plate, c. 1723-35
The cup is rather heavily potted and displays the deep blue decoration and glaze of the classic era of

Ming blue-and-white ware. The Qing plate bears an exquisite design of plants flowering amidst rocks, in a translucent silvery glaze – a perfection later marred by over-fussy decoration.

In Western cultures ceramics have seldom attracted major artists, though the Rococo epoch is a significant exception. In China, where porcelain was invented, and where pottery of a quality the West has long envied was produced for hundreds of years, ceramic as a medium had a far-reaching importance, not only because much Chinese sculpture, even on a large scale, is ceramic, but also because the patron classes, from the Emperor downwards, devoted to porcelain as much interest and appreciation as to metalwork or any other art – in some instances, more.

In fact pottery has been produced at very many sites in China since neolithic times (since about 4000 BC) and has been consistently of high quality. But the high-fired, creamy-white wares produced under the Tang dynasty (AD 618-907) are probably the world's first true porcelain, although the invention had been prefigured by a stoneware with an olive-brown feldspathic glaze appearing in southern China in the third century. True porcelain is made of ground feldspathic stone and white kaolin, fired at a very high temperature, when it vitrifies, and is invariably glazed – the glaze usually also contains some feldspar, and fuses with the body of the pot when it is fired. In the aesthetic of porcelain the form of the pot and the glaze are intimately connected; though the glaze is the chief standard by which the vessel is judged, its effect depends on the way light amplifies the shape that carries it.

Many Tang pots still echo the shapes and decoration of bronze vessels, in a hang-over from the Han dynasty (see preceding page). The crucial development came during the Song (Sung) dynasty (960-1279). The Buddhist Song Emperors paraded a religious poverty, using vessels not of precious metals but of supposedly lowly clay, and therefore took a direct interest in the kilns; the taste for this fine porcelain soon spread throughout the Empire. Typically, Song ware has a subtle, clearly outlined, organic shape, glazed usually in monochrome and often incised with an ornament; but it was produced in many local varieties. Most have blue-green glazes, and are known in the West as celadons; of these some feature a thick, glutinous glaze which produces very refined and suggestive optical effects – including the dull-green Northern celadons,

has a freely incised design, a pair of mandarin ducks (symbols of happy marriage) amid reeds and comb-like waves glazed in translucent ivory. The Cizhou vase, of classic *meiping* shape, is of fine stoneware, not of porcelain: the decoration is here more important – bold, purple-black peonies against a buff ground. Its design, though, is applied beneath the glaze; on later porcelain, the colours are enamel, a part of the glaze itself. Song porcelain has a subtlety and simplicity which, compared to later ware, can be called classic.

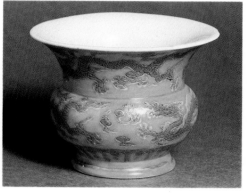

JINGDEZHEN (above)
Jar, *c.*1506-21
The design of free-ranging dragons, moving between the vapours of the air and the waves of the depths, is applied in enamels, overlaid by light incised lines.

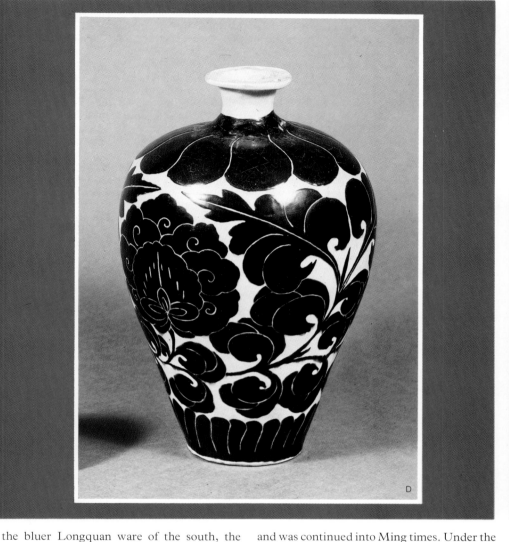

SOUTHERN CHINA (above)
Bodhidharma. 18th century
The creamy-white Dehua porcelain statuette depicts the Indian philosopher who founded in 520 in China the form of Buddhism known as Chan (as Zen in Japan).

JINGDEZHEN (below)
Meiping vase, *c.*1662-1722
Bearing the mark of the Kangxi reign, the summit of Qing enamelled wares, the nobly shaped vase was intended to hold a single branch of a prunus tree.

the bluer Longquan ware of the south, the complex Jun celadons with their mulberry flashes, and the crackled grey-blue *guan* ware; others are more thinly glazed, including the greeny-blue *qingbai* ware and also the white, delicately potted Ding ware, in which the incised ornament is important.

In the earlier periods the form of the ceramic was more important; later the glaze and the surface became the chief considerations. The overlap lies in the Song period, and the group of wares called Cizhou seem most obviously to initiate the development away from monochrome to a more elaborate coloured decoration. Cizhou ware has a white or buff ground, on which a fairly simple design is imposed in black or brown. By the beginning of the thirteenth century, potters had learned how to execute their designs in red, green and even yellow enamels – the forerunners of Ming and Qing polychrome wares.

The tendency towards greater surface decoration was consolidated under the Mongol Yuan dynasty (1279-1368). Ornament was applied both in copper red and in cobalt blue – the latter was far more successful and popular,

and was continued into Ming times. Under the Ming dynasty (1368-1644) porcelain production was concentrated in the city of Jingdezhen; the bases of a high proportion of Ming pots are inscribed with the monograms of the reigning Emperor (often forged on later wares). Earlier types continued to be made, but taste moved increasingly to favour polychrome glazes: different colour combinations predominated at different times – red, green, blue and yellow; yellow and blue; yellow and green. The Manchu Qing dynasty (1644-1911) pursued the refinement of decoration to its extremes, although Dehua ware – in which religious figurines as well as vessels were made – was valued for its pure white colour and delicate modelling. The various overglaze enamel liveries which became popular in the Qing dynasty – the black, green and rose families – feature an extraordinary variety of design; though the shapes of the pots may have been standardized, their painted decoration was inimitable in another medium because it exploited and harmonized with the curvature of the surface. This is the great beauty of the later Chinese porcelain.

Chinese Art 3: Landscape Painting

The history of Chinese painting extends back well beyond the date of any surviving works: painting emerged as the supreme Chinese art probably during the Han dynasty (206 BC-AD 220). The development of Chinese painting was nevertheless continuous, rooted from the beginning in calligraphy – the art of writing characters expressively with brush and ink – and primarily devoted to landscape – the manifestation of the subtle workings of the Tao, or Nature-as-change.

It was during the Han dynasty that the famous Chinese imperial civil service or "bureaucracy" was created – a class of scholars, poets and men of letters fitted by their education for the administration of the Empire. Painting was part of the gentleman's curriculum, one of the means by which he expressed his personal understanding of the world in a manner worthy of his ancestors. Surviving literature provides plentiful evidence of its theory and practice, which can be supplemented by one scroll, just possibly original, that is attributed to Gu Kaizhi (*c*.344-406) and illustrates Confucian maxims.

Literature of the Tang dynasty (618-907) records the existence and merits of a number of painters, but few silks or scrolls survive, and those are mostly copies. The great formative period of classic landscape painting was that of the Five Dynasties (907-60) and the Northern Song (960-1127). Its development was stimulated both by the application of Taoist philosophy and by the needs of imperial court ceremonial, it being the crucial role of the Chinese emperor to maintain the harmony between Nature and man; landscapes representing the desired course of Nature's changes were elements in the rituals. But, although many of the outstanding painters of this time were professional members of the court atelier, some of the greatest, such as Li Cheng and Fan Kuan (active *c*.990-1030), were Taoist recluses. Their landscapes consisted of dense, rocky motifs rising vertiginously through the upright picture. An outstanding professional, active later in the eleventh century, was Guo Xi, whose grandiose spaces are filled with rough terrain and gnarled trees drawn with nervous calligraphic loops.

In the second half of the eleventh century an important group of gentlemen artists – among them the great Mi Fei (1051-1107) – gathered round the statesman, poet and artist Su Shi.

Their outlook was Confucian, and they developed a theory of painting according to which the expressive qualities of the picture were a reflection of the personality of the artist – the work had value as a record of the inspired insight of the artist into the realm of Nature. The demarcation was made which coloured the entire subsequent history of Chinese painting – between the professional, usually the member of an academy, who painted painstakingly and objectively, and the gentleman amateur, who painted when the spirit moved him and in order to cultivate his spirit.

The last Emperor of the Northern Song dynasty, Huizong, an accomplished painter of flowers and birds – an important vein in Chinese painting – lost northern China to the Mongols and died in captivity. One of his sons, the founder of the Southern Song dynasty (1138-1279), set up a new capital in the beautiful city of Hangzhou, and gathered there an almost legendary gallery of major painters. Xia Gui (active *c*.1180-1230; not shown) painted huge landscape panoramas with sparse and abrupt "axe-cut" strokes; Ma Yuan (*c*.1190-*c*.1224; not shown) painted asymmetrical compositions, of which the true subject is the

FAN KUAN (below)
Travelling among the mountains and streams,
early 11th century
A massive towering outcrop dominates the scene, above the figures that set its scale. Fan Kuan's painting was felt to be instinct with the energies of Nature.

AFTER GU KAIZHI (right)
Admonitions of the instructress, detail, original *c*. 375
The silk scroll illustrates Confucian moral precepts: the ladies of the imperial harem are taught conduct – not so much deportment as worldly wisdom. The style has exquisite, wispy grace.

MI FEI (above)
Spring mountains, clouds and pine-trees,
c.1050-1100
The misty hills have no outlines but are formed by large blots of ink laid on very absorbent paper. The aim was not to re-create the object in Nature but to express its spirit. "Anyone who talks about painting in terms of likeness deserves to be in a class with the children", wrote Su Shi.

MUQI (right)
*A mother gibbon and her baby, c.*1250?
Part of a hanging triptych, this image of maternal protectiveness haunts the memory. The mother clasps her child, gazing out at the spectator with a most vivid directness. The two sit on a branch, drawn in rough strokes of fluid ink, with all the careless beauty of Muqi's extraordinarily deft, eloquent and vigorous style.

empty space to one side set off by the strongly brushed rocks to the other. But the artist who created the subtlest suggestions of the infinite void of time and space was the Chan Buddhist monk Muqi (1180–1270?).

During the unhappy years which brought the end of the Song and the establishment of the Mongol Yuan dynasty (1279-1368), several great masters nevertheless emerged. They were highly conscious of the past, and they sought to recapture in their own quite distinct styles the harmony and coherence of early Song painting; then they themselves became paradigms to be imitated by later artists. It was a standard requirement for professional painters of the succeeding Ming dynasty that they could paint in the different style of the six main Yuan painters – Gao Kegong (misty, rain-drenched landscapes), Zhao Mengfu (archaizing, spare calligraphy), Ni Zan (dry but luminous brushwork), Huang Gongwang (superbly fresh landscapes), Wu Zhen (landscapes with a mood of sober melancholy) and Wang Meng (c.1301-85), who became famous for his dynamic rhythms and dense, rich textures, formed by so-called "dragon veins". The great masters of the Ming

dynasty (1368-1644) were yet more numerous, including both amateurs and professionals, deeply imbued with their great heritage, and working largely within the repertoire established by it. They included Dai Jin, Shen Zhou, Wen Zhengming, Jia Ying and Tang Yin (1470-1523); also Dong Qichang, a practising connoisseur who wrote on the history, theory and classification of painting.

The painters of the Qing dynasty (1644-1911) inherited therefore a range of prescribed themes to be treated according to a thoroughly annotated practice. Many good artists continued to work within it, but those who sheered off into individual and sometimes extravagant mannerisms are perhaps more interesting. Two of the greatest of these "Individualists" were Buddhist monks, Zhu Da and Shitao (1630-1717); Shitao invented an original graphic style and also composed the most profound of the many books on the spirit of Chinese painting. The Individualist spirit lived on in the equally bold work of the eighteenth-century painters, but their originality seems originality for originality's sake beside the extraordinarily vibrant effects of Shitao's calligraphy.

GUO XI (above)
Early spring, 1072
For the Chinese, everything shares in a single cosmic principle, the Tao; rocks are living things and man participates in their life. It is this boundless and all-pervasive quality that Guo Xi seeks to capture. The Tao also expresses itself in flux; "the spring mountain wrapped in dreamy haze and mist" contains hints of seasonal change in the flickering lights and shifting compositional lines.

WANG MENG (below)
Forest dwellings at Juqu, c. 1370
Terraces of dense inter-penetrating rock ascend the picture plane, linked by winding lines – "dragon's veins". There is no single compositional focus and the horizon lies beyond the picture space, giving that sense of limitless space which is an expression of the nature of Tao: "Beyond mountains there are more mountains . . . Beyond trees there are yet more trees."

TANG YIN (left)
A poet and two courtesans, c. 1500
Tang Yin stands between the scholar-painters and the professional artists; an amateur by temperament and training, but demoted after being involved in an examination scandal, Tang Yin was forced to paint for money. He executed several such elegant, open, lightly coloured pictures of girls from the pleasure quarter of Suzhou, and he became a source of inspiration for 18th-century *ukiyo-e* print-makers in Japan (see p. 297).

SHITAO (above)
The gleaming peak, c. 1700
In his youth, Shitao had travelled all over China, and he often depicted real places, but universalized the experience so that *The gleaming peak* has become all mountains – Shitao is seeking to express "the hidden forces of heaven and earth". The brush-strokes delineating the contours and crevices of the rocks form a complex, spreading network; and Shitao asserted: "A single brush-stroke is the origin of existence and the root of myriad phenomena."

Korean Art

Korean art has always been treated as something of a poor relation amongst the arts of the East, which is a grave injustice to an artistic tradition which has created some of the world's most beautiful objects in a distinctive style. Moreover, Japanese art owes an enormous debt to Korea, for it was via Korea that the Japanese came into contact with Buddhism and Buddhist art, both Korean and Chinese.

Korea's original population was probably related to the Siberian Tunguz; but by the fourth century BC the country had fallen under the influence of its huge neighbour, China. In AD 372 Buddhism was adopted in Koguryo, the nearest to China of the three kingdoms into which Korea was divided – Koguryo, Paekche and Silla – until the seventh century, when all three were united under the Great Silla dynasty, with its capital at Kyongju. Hundreds of tombs from the early Korean dynasties stand ruined on the mountain-sides and the coastal plains; most of them were long ago looted, but from certain large royal tombs some stupendous feats of craftsmanship have survived, such as the crowns from Kyongju – intricate, complex structures assembled from sections of sheet-gold cut into the stereotyped outlines of

sacred trees, with long, swaying "branches" and trailing "fronds" carrying loose, shimmering fillets of gold and jade.

From reliefs and from a few early tomb paintings of the fifth and sixth centuries it is clear that the Koreans followed the Chinese custom of surrounding the dead with images of the world they knew. In the paintings, scenes perhaps derived from Chinese prototypes rather harsher in tone are infused with a gentle and refined expression characteristic of the Korean genius. What remains of the Buddhist temples of the Three Kingdoms is scanty (though literature tells of many magnificent buildings); the more ancient sites obviously provided the prototypes for early Japanese Buddhist shrines. Surviving from the temples are several early Buddhist images, already showing, despite their clear debt to Chinese example, distinctive features of Korean style: quite un-Chinese is their graceful subtlety and the sweetness of their linear modelling – the outlines undulate, floating off into delicate curves of decorative drapery. One of the most famous Korean images is a large seated figure of Maitreya in gilt bronze, now in the National Museum, Seoul. Its almost exact double in

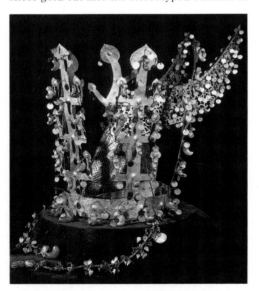

KYONGJU (left)
Royal crown,
4th/6th century
The tombs of the kings of Silla (in south-eastern Korea) have yielded several elaborate gold crowns, hung with comma-shaped pieces of jade with antler-like branches; these mysterious forms may be connected with shamanistic rituals.

SILLA OR PAEKCHE? (right)
Maitreya, early 7th century
The gilt-bronze Buddha of the future is serenely seated, half cross-legged, in meditation. Compared to other early *Maitreyas* from China or Japan, he displays distinctly Korean features of calm, grace and transcendence; his robes ripple mildly, decorously.

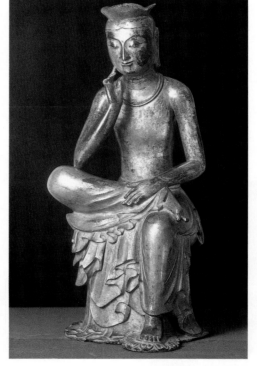

KANG HUI-AN (above)
A sage resting on a rock,
15th century
Against the soft washes of ink in the background, and the calligraphic sweep of the vine, the figure of the sage is sharply drawn; the contrast heightens his cheerful, luminous presence. Zen ideas – the concept of enlightenment won through meditation on the natural world – are surely implicit. Kang Hui-an, an amateur painter in the Chinese sense, was well travelled; his work is related to and holds its own beside both Chinese and Japanese art.

KOREA (below)
Wine pot, late 12th century
During the "Golden Age" of Korean ceramics, in the 11th and 12th centuries, Koreans created some of the finest celadon ware ever known, using a soft, bluish-green glaze on vessels of widely varying shape. Once they had learnt to handle high-fired porcelaneous ware from the factories of Yue, China, they evolved their own unique style.

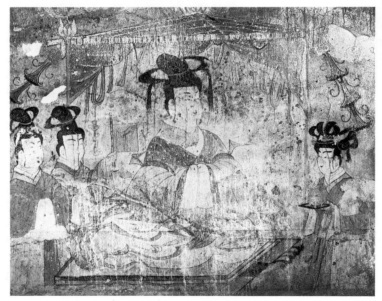

KOGURYO (left)
A nobleman and his wife,
mid-5th/6th century
The ancient tomb-painting still preserves the seated man attended by his wife (who kneels at the right). Strongly outlined and once highly coloured, they bear witness to the refinement of life under the Koguryo in northern Korea. Other tombs have revealed murals of wrestling, hunting and dancing. Chinese artists had infiltrated Korea, and some close parallels have emerged in Chinese tombs.

wood is treasured in the Koryu temple in Kyoto, Japan, and the elongated, graceful "*Kudara Kannon*" in Japan (see over) is traditionally attributed to a Korean artist. Strong Chinese influence, however, is still apparent in eighth-century work, but the colossal, splendid stone Buddha in the Sokkuram in Kyongju (not shown) may be influenced by Indian Mathuran or Gupta sculpture.

The best known achievement of medieval Korean art is in ceramics. After the fall of the Great Silla, under the Koryo dynasty (918-1392), potters evolved a celadon ware related to Chinese celadon both in body and in type of glaze, but inlaid with designs in differently coloured slips in an original Korean technique. The contours of each pot are subtly suggestive of organic shapes, and the painted decorations are brushed freshly and with vitality. From the Koryo period there also survive religious paintings of remarkable courtly beauty (the majority are now preserved in Japan).

Buddhism, the state religion of the Great Silla and the Koryo dynasties, then fell out of favour with the accession of the Yi dynasty (1392-1910). The new rulers fostered a strict Confucianism, which rapidly penetrated the educated and connoisseur classes. Art became predominantly secular. Following the example of the Chinese Song dynasty, official ateliers of artists and craftsmen were established, with carefully defined grades. Professional work was restricted on the whole to formal portraits and to standardized decorative schemes. However, like those in China (see preceding page), Korean amateur or scholar-painters sought to convey their vision of universal change in a highly expressive, calligraphic style – though few works by these early Yi painters have survived. Those of the celebrated Kang Hui-an (1419-65), who had travelled into Ming China, exhibit fairly heavy, dark contours and modelling strokes that are powerful and swift, slightly resembling the style of his contemporary in Japan, Sesshu (see p. 294). An Kyon (1418-94) was greatly honoured for his landscapes. The Yi nobles also appreciated fine ceramics: a white porcelain, sparingly decorated in blue underglaze, was produced for the court, and a coarse pottery (*punch'ong*) was made for daily use. (*Punch'ong* was soon to be particularly admired for its simplicity and directness by the Japanese tea-masters).

In the late sixteenth century Korea became a battlefield, invaded in 1592 by the Japanese under the dictator Hideyoshi, seeking an avenue to attack China. Its treasures were despoiled, and its potters deported to Japan (where they infused new life into the Japanese ceramic tradition). Yet the tradition of amateur painting was maintained by a succession of gifted artists, such as Yi Chong (1578-1607; not shown), the slightly later Yi Jing and the powerful calligrapher Kim Myong-guk. Kang Hui-an's brushwork was revived in the work of Chong Son (1676-1759), but further strengthened and hardened. Although these painters still generally followed Chinese prototypes, their work attained a distinctively Korean character, resembling neither Chinese styles nor the work of Japanese contemporaries. In the eighteenth century the meditative landscape painter Yi In-mun (1745-1821) and the genre painter Kim Hong-do (1745-c. 1818; not shown) achieved an original expression.

The distinctly Korean artistic language emerged above all in the early sculpture, in pottery and in painting, where there is an original sensitivity to the changing course of Nature. The distinctively Korean quality is one of refinement and honeyed delight.

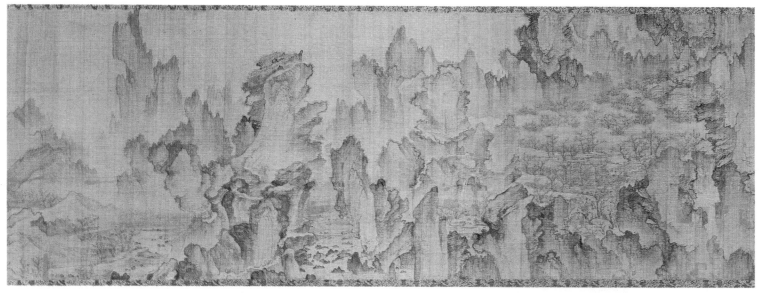

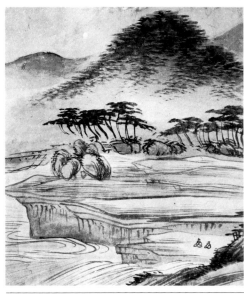

AN KYON (above)
The dream of the peach-blossom garden, 1447
An Kyon's painting of the prince An Pyong's vision is one of Korea's earliest surviving landscapes. The complex, fantastical style reflects Song influence.

CHONG SON (left)
The mountain by the river, 18th century
The first to paint truly Korean landscapes, Chong Son wielded his brush with energy. He freed himself from Chinese restraint.

YI IN-MUN (right)
A young Immortal under a fir tree, 18th/19th century
Yi In-mun, a professional, gave traditional images new, sprightly life. The Taoist Immortal, or sage, is at one with Nature.

Japanese Art 1: Art of the Buddhist Temples

Japan is a treasury of some of the world's greatest sculpture, virtually all of it Buddhist, and at first strongly dependent upon prototypes from Korea and China. Medieval Buddhist art in Japan, however, is often much better preserved than in China or Korea, and, because of the lack of correlative examples, it is often difficult to decide whether a particular piece is imported, or by a native Japanese, or by an immigrant.

Japanese history before Buddhism came is divided into three principal epochs, the Jomon (approximately 7500-200 BC), the Yayoi (200 BC-AD 200) and the Tumulus (AD 200-600). From these periods mostly small-scale ceramic sculpture survives. The neolithic Jomon figurines are of grey and red earthenware, their bodily features defined with ridges and shallow incisions, great round eyes giving the abstracted image life. The Tumulus period takes its name from the great burial-mounds constructed by its rulers, around which quantities of *haniwa* have been found – ceramic cylinders topped by figures of retainers, women, animals and houses. According to an ancient text, *haniwa* were substitutes for the living people and real objects which had in former times accompanied the great into the grave – though archaeology has not corroborated this.

The first wave of Buddhist influence came to Japan from the kingdom of Paekche in Korea; it is reported that the Korean king sent the Emperor of Japan a gilt-bronze image of the Buddha in AD 538. The Emperor declared himself deeply moved by the profound Buddhist doctrine, but because pestilence came in its wake the gift was thrown into a canal. However, more images, and then artists (including one known master, Tachito, from China), followed, and by the end of the sixth century Prince Shotoku, Regent of Japan, was welcoming Buddhism openly. The famous monastery of Horyu in the region of Nara was founded then, among others, and images began to be produced in large numbers. At first Buddhist sculpture was confined to a few subjects only – Shaka (the historical Buddha), Yakushi (the healing Buddha), Miroku (or Maitreya, the Buddha of the future), Kwannon or Kannon (the Bodhisattva of compassion) and the guardian kings of north, east, south and west. Two Buddhist trinities (the Buddha flanked by two Bodhisattvas) in bronze are recorded by the hand of Tori,

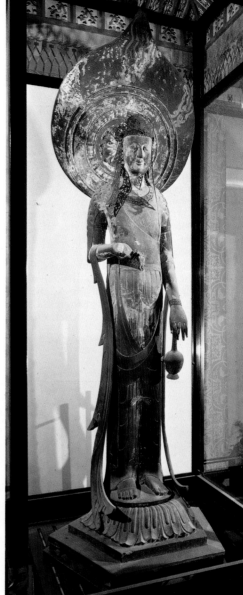

JAPAN (right)
"The Kudara Kannon",
7th century
The ethereal camphorwood deity of compassion has the linear grace of Korean art, but was probably carved in Japan (the wood is rare in Korea) – by an immigrant?

JAPAN (left)
A *haniwa: A warrior*,
3rd/6th century AD
The burial mound of one emperor of the period had 11,200 such *haniwa*, partly supporting its steep sides.

HORYU-JI, JAPAN (below)
The death of the Buddha,
711
The highly emotive dry-clay group in its artificial cavern is staged on a floor in the five-storey pagoda of the ancient monastery.

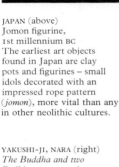

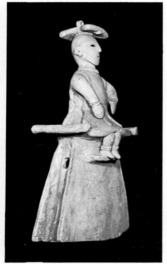

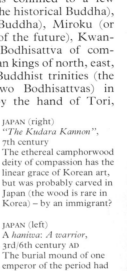

JAPAN (above)
Jomon figurine,
1st millennium BC
The earliest art objects found in Japan are clay pots and figurines – small idols decorated with an impressed rope pattern (*jomon*), more vital than any in other neolithic cultures.

YAKUSHI-JI, NARA (right)
The Buddha and two Bodhisattvas, c. 726
The three colossal deities gleam darkly against their great haloes – once gilded, the bronze has blackened with time. Their smoothly rounded limbs show Tang influence – a solidity in contrast to the remote grace of Korean-influenced figures. Though prototypes exist in China, and colossal bronze *Buddhas* are recorded in literature, none survives so huge, or of such quality.

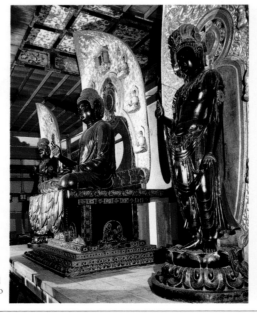

grandson of the immigrant Tachito, who was rewarded for them with a higher social status. The style of this early Japanese sculpture is clearly derived from Chinese examples (compare, for instance, those at Longmen and Yungang, see p. 284), often brought to Japan through the medium of Korea – as with "The Kudara (Paekche) Kannon", traditionally ascribed to a Korean artist. The forms are somewhat stiff and elongated, smoothed into gently gradated surfaces scored with a calligraphy of drooping folds and graceful pleat-ends.

During the seventh and eighth centuries, wood became a favoured medium of Japanese sculptors. It was carved and polished into smoothly undulating volumes, formed by gentle contours, more or less enlivened by linear patterning. One of the finest examples of this period, however, is in bronze, the colossal free-standing Buddhist trinity at the Yakushi temple in Nara, probably of the early eighth century. The drapery lines coil freely about the magnificent and massive *Yakushi*; the Bodhisattvas, too, are plump, epitomizing elegance. Such huge images, probably derived directly from Chinese Tang prototypes now lost, were frequently ordered during the Nara period

(710-84) from each province to celebrate the passing of a plague, an emperor's accession and so on; one which survives at the Todai temple in Nara (not shown) consists of nearly five tons of metal, even though the figures are hollow, cast by the lost-wax method.

Another vein of sculpture, in unfired clay, appears in the freely modelled small figures of mourning disciples in the tableau of *The death of the Buddha* (711) in the Horyu monastery. Each disciple is conceived as a distinct individual. A similar realism charges the magnificent dry-lacquer portrait of the Chinese monk Ganjin, founder of the Toshodai monastery and widely revered as a kind of saint in Japan. From China he seems to have brought with him artists, and a new wave of influence. The huge *Kannon* in the Toshadai temple, 5.5 metres (18ft) high, with its thousand arms (in fact 953) creating around the calm face a fantastic aureole, is also of dry-lacquer. While the *Ganjin* initiates a new and powerful tradition of portrait sculpture, surely related to the trend in China that culminated in the individualistic figures of *Luohans* (see p. 285), the *Kannon* reveals a new ponderous and static style, with drapery of heavy curving folds.

During the Heian period (784-1185) an esoteric sect, the Shingon Buddhists, began to flourish; their prolonged rituals required large numbers of images embodying a ramified pantheon of spiritual powers, each with distinct, often fantastically elaborate attributes. In the eleventh century the sculptors resorted to the technique (*yosegi*) of jointing sections of carved wood in order to produce ever more complex figurations. The elaborate rituals practised during the Kamakura Shogunate (1185-1392) were no longer under state patronage, though much sculpture, both large and of high quality, continued to be made for them, with increasingly dynamic invention and with insistent realism. Two great woodcarvers of the thirteenth century, Unkei and Kaikei, were famous; their statues of guardian deities (not shown) are magnificently menacing.

The Buddhist temples were furnished not only with sculpture but with murals, embroidered banners, figured silks, illustrated manuscripts, drawings and block-printed scrolls. Private individuals owned both miniature versions of the images in the temples and small portable shrines, sometimes carved in precious materials.

TOSHODAI-JI, JAPAN (right)
The priest Ganjin,
before 763
The coloured dry-lacquer statue of the blind Chinese monk (who endured terrible hardship on his journey to Japan) may have been made in his lifetime, perhaps by an artist trained in China.

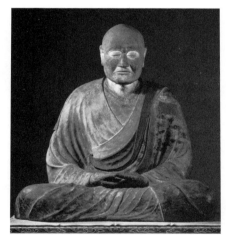

TOSHODAI-JI, JAPAN (below)
"*The Kannon with 1,000 Arms*", after 759
Dry-lacquer, lacquer over cloth, is both surprisingly light and hard, permitting the artist to treat surfaces in highly elaborate detail, even those of sculptures on a monumental scale.

JAPAN (right)
The Bodhisattva Fugen,
12th century
The plump-faced, gentle divinity, painted on silk, is conceived in terms of fine line and flat colour. Indian and Tang models still exerted considerable influence in this period.

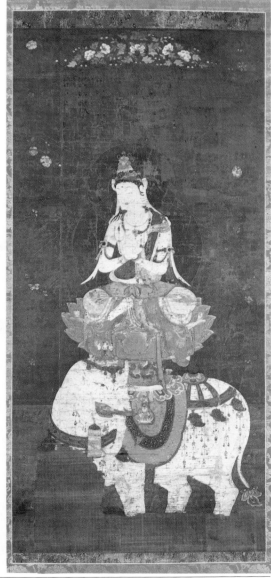

JAPAN (below)
Fudo, 13th century
Fudo's fierce grimace and stalwart stance, conveyed with the forceful realism characteristic of Japanese sculpture of the Kamakura era, clearly evokes his role as the chastiser of evil, immovable and impartial.

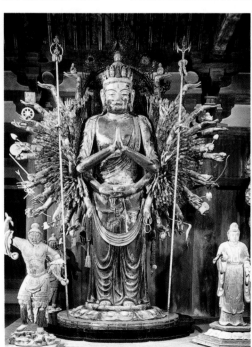

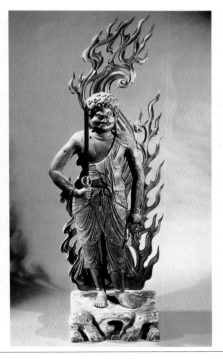

Japanese Art 2: Zen Ink-Painting

"Zen" is the Japanese pronunciation of the Chinese "Chan" – the vigorous, fundamentalist Buddhist sect which first flourished in China under the Tang dynasty. It stood for the rejection of the elaborate rites and duties of the traditional Buddhism practised in the great monasteries, with their immense apparatus of ceremonial, their treasures of paintings and sculptures; Zen monks sought enlightenment through personal dedication, through austerity and concentrated meditation, and expected to reach it in the midst of the ordinary course of everyday activity.

During the Kamakura Shogunate (1185-1332) Zen Buddhism was adopted by much of the warrior class. The Shogunates were military dictatorships ruling Japan in the name of a puppet emperor, regarded, together with his courtiers, by the Shogunate as effete, frivolous, fettered by ceremonial. The Shogunates fostered in contrast Zen Buddhism and the caste and code of the Samurai ("Warriors"), whose ethics and prowess were founded on the precepts of Zen. In their martial arts of sword, bow and spear Zen discipline, the training by which enlightenment might be attained, played a significant part. The strokes of the

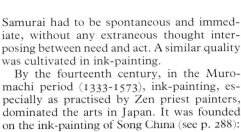

Samurai had to be spontaneous and immediate, without any extraneous thought interposing between need and act. A similar quality was cultivated in ink-painting.

By the fourteenth century, in the Muromachi period (1333-1573), ink-painting, especially as practised by Zen priest painters, dominated the arts in Japan. It was founded on the ink-painting of Song China (see p. 288): pure black Chinese ink (*suiboku*) was the prime medium, and its subjects, too, were drawn from the Chinese repertoire – above all landscapes and the seasons, but also portraits. Its aesthetic demanded directness of vision, the spontaneous reflection of sensitivity to Nature – it was closely based on Chinese canons, but was achieved by the Zen techniques of meditation. A series of painters had gradually established this Chinese style in Japan – among them Shubun (active 14th century; not shown) and Bunsei (active 15th century); the greatest of them was Sesshu (1420-1506), who was perhaps the greatest distinctively Japanese ink-painter, although he, too, was still strongly influenced, like his predecessors, by the great painters of the Southern Song dynasty, including the Zen monk Muqi (see p. 288), but also by

SESSHU (below)
Autumn landscape, late 15th century
Sesshu's achievement was to implant a tradition of landscape painting based on observation. His clear vision superseded earlier ethereal landscape dreams. He varied his use of ink inventively; famous was his *haboku* (broken-ink) style.

BUNSEI (right)
The layman Vimalakirti, 1457
Zen monks sought to avoid ostentation with a simple, personal art. The portrait, beneath a eulogy, captures a direct, sober essence, but in the poverty is richness – the vigour of the sharply angled outlines, set off by quieter, even fuzzy, textures.

EITOKU (right)
Plum-trees by water, 16th century
A series of sliding screens in the Juko-in monastery are given to Eitoku. Straw brushes (*warafude*) gave his line distinctive spikiness.

MOTONOBU (right)
The small waterfall, early 16th century
The clear, almost pen-like lines of Motonobu's brush recall Sesshu's directness, but there is a hint, too, of the decorative *yamato-e* which he also practised. Motonobu often added bright colour to the firm lines of his compositions.

the Ming painter Dai Jin. It is reported of Sesshu that while he was studying in China (1467-68) he was regarded as the greatest living ink-painter there. In fact Sesshu's brush-line was harsher and more angular than that of the Song painters, expressing his experience of Nature with greater freedom and a stronger personality, overriding the academic harmony of form and spirit for which the Chinese masters were then striving. Later generations of Japanese artists were to draw continually on his example – not least the painters of the Kano family school.

According to tradition the founder of the Kano school was Kano Masanobu (1434-1530; not shown), who began painting in the soft style of his master Shubun, and then developed a more decorative expression in remarkably clear and balanced compositions, notably in a huge series, mostly lost, of murals and screen-paintings for Zen monasteries. His son Kano Motonobu (1476-1559) consolidated the Kano style in strong and lyrical outlines reflecting his admiration of Sesshu, but also of the styles of the great masters of Song China. Like his father he worked for Zen monasteries, and he did much to gain the Kano school its

official status with the Shogunate.

The great castles on towering stone plinths built by the nobles during the rule of the Momoyama Shoguns (1568-1615) in response to the import of cannon offered huge acreages of wall to be painted – an opportunity to which the Kano artists responded with energy and imagination. The great genius was Kano Eitoku (1543-90), grandson of Motonobu. He injected into the subdued ink-painting style the rich colour and gold-leaf characteristic of the secular decorative traditions of *yamato-e* (see over), and in his screens set huge trees or rocks, drawn in great sweeping lines, against a golden, hazy, immaterial background. Unfortunately little by his hand has survived the destruction of the palaces and castles in which he worked. There are also decorative screens, atmospheric, asymmetrically designed, by his contemporary Hasegawa Tohaku (1539-1610), who is best known, however, for his monochrome painting, and the subtlety of his apparently casual brushwork. The Kano school continued to flourish into the eighteenth century, gradually losing inspiration.

The strict Zen style of painting was given fresh life in the Edo period (1615-1867), when

simplicity and directness was reasserted by Niten (1584-1645), ink-painter and Samurai swordsman, whose brushwork has a corresponding swift, summary quality. Niten's vivid monochrome brushwork was matched by that of his contemporaries Sotatsu (died 1643) and Koetsu (1558-1637), who were not only ink-painters (though not in the Zen style) but also decorative artists, instrumental in the revival of *yamato-e*. The conception of Zen was by this time no longer so austere; the tea ceremony, originally practised by monks as a contemplative ritual, came to be cultivated as more an aesthetic than as a religious activity, and it is from the Momoyama and early Edo periods that the finest, subtly casual, decorated vessels associated with it survive. The renewal of Zen stimulated also the development of the allusive, epigrammatic 17-syllable verse-form of the *haiku* and its pictorial counterpart the *haiga*, perfected by the poet-painter Yosa Buson (1716-83; not shown). A closely similar aesthetic informed the painting practised by Zen monks to test their intuitive insight – an extreme, "minimal" version of the principle that has always guided Japanese ink-painting – to express the most by means of the least.

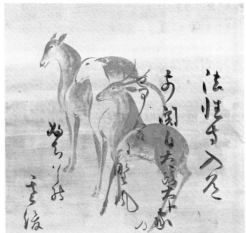

KOETSU AND SOTATSU
(above) *Deer*, detail of
a scroll, 17th century
Sotatsu, who practised in
several styles, invented a
new technique of modelling
by manipulating wet ink.
His deer illustrate the
calligraphy of Koetsu.

NITEN (left)
Bird and branch, late 16th
or early 17th century
Niten is supposed to have
attacked paper with ink as
if fighting an enemy. His
few surviving works, mono-
chrome paintings, typify
that vital spontaneity so
admired by Zen Buddhists.

BUNCHO (right)
*Heron wading among lotus
flowers*, 18th/19th century.
This painting of Buncho
(1763-1840) has the typical
calligraphic economy and
austere composition of the
haiga style. He was an
eclectic artist, studying
various Japanese styles
and Chinese ink-painting.

TOHAKU (above)
Pine-trees, detail of a
screen, late 16th century
With almost evanescent
strokes of soft brown ink
on paper, Tohaku evoked
air and mood – a sense of
peace in a morning mist.

KENZAN (left)
Ceremonial tea-bowl:
Evening glory, late 17th
or early 18th century
Ogata Kenzan (1663-1743)
was himself a tea-master.
His enamelled glazes are
boldly, playfully dabbed.

Japanese Art 3: Yamato-e

The essentially secular mode of painting the Japanese call *yamato-e*, "Japanese painting", grew originally out of Chinese Tang dynasty styles which penetrated Japan and were assimilated in early medieval times. It was initially a court style, and clearly distinct from the painting (see preceding page), directly inspired by later Chinese example, which dominated the arts during the Kamakura and Muromachi Shogunates (1185-1573). Its more formal, more decorative, more colourful aesthetic was entirely opposite to the spontaneity, intuition and personal expression – usually in monochrome – of the Zen ink-painters, although, as we have already noticed, the two modes interacted to some extent.

Features of *yamato-e* are early apparent in the famous portraits of court dignitaries by Fujiwara Takanobu (1141-1204), reflecting the extremely strict conventions governing the intercourse of the medieval Japanese nobility. The faces now seem highly stylized, with an emphasis on simple, graphic design enlivened with decorative detailing. In their day, however, their realism caused some scandal.

The most important examples of *yamato-e* are painted scrolls. During the Heian period (784-1185) probably Tang Buddhist scrolls imported from China inspired the development of long narrative scrolls, *emakimono*, mirroring the sophisticated and cultured pleasures of the imperial court. A group of the earliest and finest of these illustrates the celebrated eleventh-century novel of courtly life by the lady Murasaki, *The Tale of Genji*, with the scenes alternating with passages of text. The figures, outlined in black ink, are drawn according to a formula; it is their fashionable robes which define their identity and status, rather than the faces reduced to empty ovals, with noses rendered by little hooks, eyes by tiny black ticks. Buildings are mostly roofless and in such projection as to allow a view of interior scenes.

Other narrative scrolls of different type but of a related style were devoted to the lives of Japan's Buddhist saints or to Japan's often ferocious history, retailed sometimes satirically, sometimes highly dramatically. The twelfth-century *Ban Dainagon* scrolls are perhaps the most dramatic. They are remarkable in that successive episodes are integrated into a continuous representation, carried for-

TAKANOBU (below)
The courtier Taira-no-Shigemori, ◂
late 12th century
The courtier's impassive, delicately painted face is offset by the angular, decorative formula of his black ceremonial robe, accented by the sword and *shaku*, a kind of sceptre. Taira-no-Shigemori was apparently a mild, sincere man; here is no vainglory.

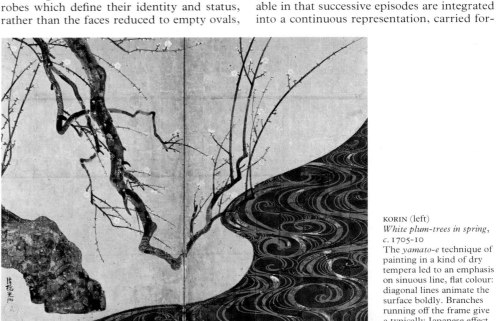

KORIN (left)
White plum-trees in spring, c. 1705-10
The *yamato-e* technique of painting in a kind of dry tempera led to an emphasis on sinuous line, flat colour: diagonal lines animate the surface boldly. Branches running off the frame give a typically Japanese effect of space extending further. (Such patterns inspired Art Nouveau, see p. 369).

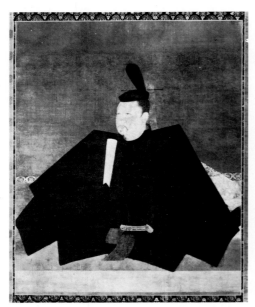

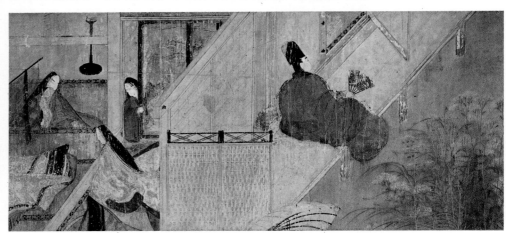

UNKNOWN ARTIST (above)
The Tale of Genji: An interior with figures, 12th century
With soft, subtle colours and delicate interplay of line, the anonymous artist evoked a mute atmosphere almost of suspense. The tale of amorous intrigue also flattered the Heian nobility by showing their refined pleasure in calligraphy and painting. The novel's 54 chapters were originally illustrated with about 80 or 90 images, of which only 19 survive.

MITSUNAGA? (right)
Ban Danaigon: The flight of the court, late 12th century
The three extant scrolls of this story are assigned by tradition to Tosa Mitsunaga, active at the imperial court. Ban Danaigon was a villainous politician, who without any grounds or scruple accused a rival of setting fire to a gate of the imperial palace. Here people stare or run or are confused – all sharply characterized – as the smoke rolls forth.

ward in countless vividly drawn, animated figures, barely millimetres high, as the long scroll was unrolled from right to left. All classes of people, from nobles to peasants, are depicted, in a range of hectic gesticulations expressing violent emotions.

The skill in portraying lively genre with dashing line and decorative colour was to be practised and developed vigorously from these early prototypes in a long series of narrative scrolls reaching virtually to modern times. The tradition was dominated by the Tosa family school, established in the conservative and ceremonious environment of the sacred imperial court of Kyoto. The early Tosa artists cultivated refined techniques of surface decoration, with rich colouring and much gold-leaf; during the early Shogunates the school declined, but its decorative splendour re-entered the mainstream of Japanese painting during the sixteenth and seventeenth centuries, having been reanimated by Tosa Mitsunobu (1434-1525; not shown). From the example of the Tosa school the artists Koetsu and Sotatsu (famous also for their experiments in ink-painting, see preceding page) developed in the early seventeenth century in Kyoto a

colourful style, which was taken up by Ogata Korin (1658-1716), an ardent admirer of Sotatsu. Korin's superbly elegant screens and scrolls combined elements from the traditional imagery of Chinese painting (see p. 288) with Japanese folklore, presented in dramatic designs and with an extraordinary feeling for colour and texture. He also painted, in contrast to the formal splendour of his purely decorative works, lively naturalistic studies.

The final and outstanding period of *yamato-e* dates from the removal of the Shogunate from Kyoto to Edo, modern Tokyo, in 1615. Art for the citizens of Edo, an urban class of a new prosperous type, was a matter neither of social ceremonial nor of religious expression, but was purely for pleasure. For their delectation the revived *yamato-e* style was applied to genre paintings such as that of the Matsuura screens, peopled with ladies in gorgeous contemporary dress. Such would be the subject matter of *ukiyo-e* (see over); and the prime medium of the *ukiyo-e* artists, the woodblock print, was developed in seventeenth-century Edo notably by Moronobu (*c.* 1618-94), who was one of the first to use the process for the mass-production of book illustrations.

Moronobu saw himself as a follower in the *yamato-e* tradition, and signed himself accordingly. Erotic art was practised by all Edo artists; Sigimura Jihei (active late 17th century) made magnificent prints of sexual dalliance, which were very popular.

The range of expression of *yamato-e* extended from its early sophisticated formality to the sentimental, highly opulent and sometimes crude Edo styles; not the least of its many offshoots was the art of lacquer-painting. Several famous painters had experimented with lacquerware, including Koetsu and Korin in the seventeenth century; in China, lacquerware had been made since ancient times and became very popular during the Ming dynasty. During the Edo period the Japanese developed a quite extraordinary skill in painting little lacquer cups and dishes, and in particular the compartmented medicine-boxes known as *inro*. These were attached to the wearer's sash by a cord secured with a *netsuke*, a small carving in wood, ivory or a semi-precious stone. Whether in relief or in the round, within a remarkably small, miniature compass Japanese craftsmen were able to conjure astonishing, fantastic effects.

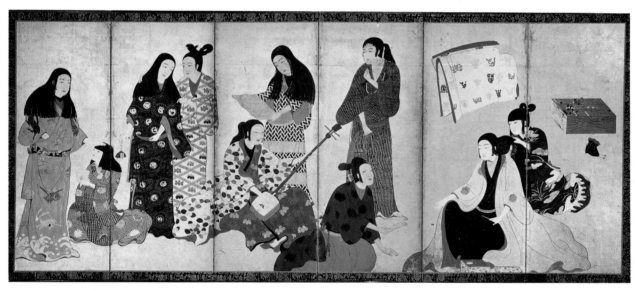

UNKNOWN ARTIST (left)
A Matsuura screen, early 17th century
A conversation piece of ladies at their leisure, this screen is one of a pair which might once have advertised a textile shop. The patterned kimonos are clearly displayed. A rosary worn by the third figure from the right and a clay pipe in the second screen are Western imports.

UNKNOWN ARTIST (below)
Lacquer box, late 18th century
The range of lacquerware extended from dishes made for aristocrats to utensils for the modestly affluent. Shallow relief was often used, with a great variety of colours, gold- and silver-leaf and metallic dust to give a glamorous sparkle.

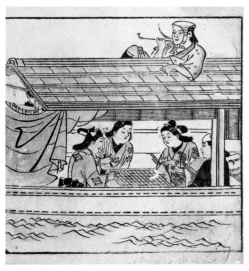

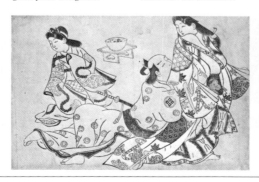

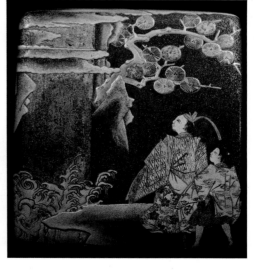

MORONOBU (left)
A river-boat party, c. 1682
Moronobu depicted his lovers with unprecedented frankness, reflecting the interests of the public without further pretensions. His prints were considered vulgar by the cultivated and by some artists, but opened the way for the great print designers.

JIHEI (below)
An insistent lover, c. 1685
Jihei adapted his style to the exigencies of his medium; he disposed black and white in a gorgeously ornamental design, with a sweeping line – suitably sensual, for most of his drawings and prints were erotic. His treatment is florid but not unsubtle.

Japanese Art 4: Ukiyo-e

The subject matter of *ukiyo-e*, "pictures of the floating world", first appeared in screens and hanging scrolls (see preceding page), but in the later seventeenth century was taken up by woodblock printers. *Ukiyo-e* prints, published both as illustrations to novels and as independent pictures, were made in the shops of specialist craftsmen to artists' designs, and their typically calligraphic style was already formed in the hand-coloured prints made by Kaigetsudo Ando (active 1700-14) and his associates. In Kaigetsudo Ando's single-figure pictures of famous beauties of the Yoshiwara, the brothel quarter of Edo (now Tokyo), the emphasis was placed on the gorgeous designs of the kimonos, depicted with wiry curves and strong, broad angles in a boldly two-dimensional composition.

Lacquer prints appeared about 1720, in which certain parts of the design, such as the sash of a kimono, were painted with glossy ink, while other parts were covered with glue and dusted with metallic powder – a technique exploited later in the century by Sharaku. The invention of the multi-block colour print by Suzuki Harunobu (1724-70) came in 1765. Harunobu's imagery revolved around a fragile type of woman, almost childish, tripping along the street, or pictured at home lounging or in conversation, or making love: it was Harunobu who established the prevalent mood of *ukiyo-e* during the second half of the eighteenth century, as a vision of everyday reality invested with an elegant glamour.

Amongst a multitude of considerable artists at work during the first maturity of the Edo print were three giants, Koryusai, Kiyonaga and Utamaro. At first the style of Koryusai (active 1765-84) was very close to his master Harunobu's, but after Harunobu's death he began in the 1770s to design to a new, larger format (which soon became standard for other artists) and commenced a long series of courtesan pictures – beauties of the Yoshiwara, standing or promenading either alone or with attendants – whose images he presented in splendid compositions, using sheaves of lines to define cascades of drapery and sweeping folds. He was also pre-eminent in bird and plant compositions, and, like nearly all the other Edo artists, he produced prints showing sexual love in action. Kiyonaga (1752-1815) specialized in extended compositions of figures in an architectural or landscape setting, the landscapes distinguished by a remarkably subtle aerial perspective. His designs were frequently continuous over a number of sheets – two or three or more – bringing extended narratives within the reach of the print.

Utamaro (1735-1806) is often looked on as the greatest of the *ukiyo-e* printmakers. He evolved a new type of female beauty, large-bodied, soft but strong, evoked in broadly looping lines – and also used this type in his illustrations of Japanese legend and folklore. He was fertile in technical devices, introducing effects conveying the transparency of fabrics, and cutting off the figures by the borders of the composition – a trick which was to be admired and imitated by Impressionists (see pp 342 ff).

These artists were rivalled at the end of the eighteenth century by a younger generation, including the mysterious Sharaku (active 1794-95). He is thought to have been by profession an actor in the traditional Noh theatre; he turned to prints for ten months in 1794-95, producing at least 136 remarkable portraits of Kabuki actors. His forceful and searching draughtsmanship is relished now, but his harsh characterizations do not seem to have appealed to the public at the time.

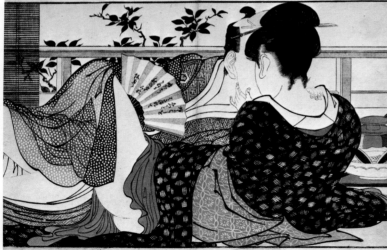

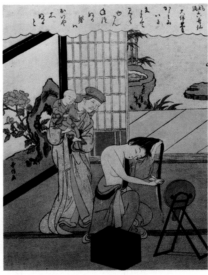

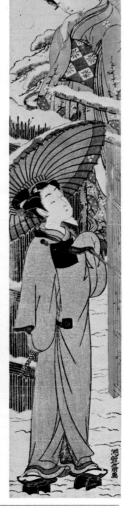

KAIGETSUDO (left)
A courtesan, c. 1714
Kaigetsudo Ando (or Anchi) drew the designs, his staff cut the blocks, printed the prints and coloured them in by hand. The lady's kimono is richly decorated with cursive script from a poem: these early prints retained a "raw" quality reflecting accents of the brush in the formation of sweeping arcs, scribbled flutters of line.

HARUNOBU (right)
A lady dressing her hair, 1768
Suzuki Harunobu was the first artist to over-print the drawn black-and-white design with colours, using one block for each colour. His quiet, domestic ladies were inspired, it is said, by a waitress named O Sen.

KORYUSAI (right)
At the gate, c. 1771
The *hashirakake* or hanging-pillar print was intended to decorate wooden pillars in Japanese country homes. Koryusai cleverly adapted perspective to persuade the fashionably dressed ladies to fill the narrow frame.

KIYONAGA (below)
Cherry blossom, c. 1787-88
Kiyonaga's gently coloured scene, the central part of a triptych, catches the mood of a stroll in a park with extraordinary freshness – especially considering its consciously elegant humour and its stylization of tree and robe. No wind rustles the trees, but it is vivid in the lady's touch to her hat, in her fluttering gown.

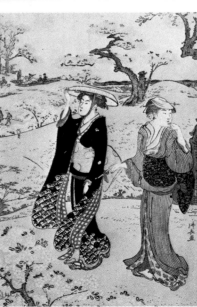

UTAMARO (above)
Folio from *The poem of the pillow,* 1788

In his erotic prints as in his others Utamaro could combine unusual, effective

angles (emphasizing here the erogenous nape of the neck) with superb design.

Hokusai (1760-1849) had in contrast an immensely long career: in his later years he signed himself *The old man mad about drawing*, and he was indeed an experimental artist, full of humour and appreciation for the oddities of both life and art. Until about 1823 he produced comparatively conventional actor and courtesan prints, and in 1798 one tiny series of *Views of Edo*, his first landscapes. Then between 1823 and 1829 he found fame with his *Thirty-six Views of Mount Fuji* (later made up to 46 prints): no previous *ukiyo-e* artist had taken such a direct interest in the drama of landscape, carried in such a witty and bold design. He was extremely prolific, not only in prints but in bird and flower pictures, illustrated greetings cards and in drawings (his *Manga*) collected from 1814 in 13 volumes.

Hokusai was a major artist, but also a transitional figure, linking the eighteenth century to the nineteenth. Under some pressure from censors, the subject matter of the prints changed: Hiroshige (1797-1858) became the greatest artist of landscape. His *Views*, though certainly influenced by Hokusai's style, abandoned his bravura, and were full of poetic atmosphere, with a sympathetic observation of

the common people about their daily business. Kuniyoshi (1797-1861) developed quite another mode, Japan's rich repertoire of legends, the warfare of the Samurai. In sets of large prints, including triptychs, he illustrated heroes battling against hideous odds and monsters. But the work both of Kuniyoshi and of

Hiroshige is variable; Western influence and declining standards of technical accomplishment were eroding the quality of Japanese prints at just about the same time that Western painters began avidly to collect them, and to incorporate their bold designs and superbly decorative colour into their own work.

HOKUSAI (right)
Folio from *Thirty-six Views of Mount Fuji: Southerly wind and fine weather*, c. 1823-29
Hokusai's landscapes fused observation with pattern: for this quality Japanese prints became famous. The particular quality of the *Thirty-six Views* was their range of mood – here placid and serene, but in *The wave*, (not shown), one famous print of the series, wild, dramatic and spectacular.

HOKUSAI (right)
Folio from *Little Flowers: Peonies and a sparrow*, 1828
Although Hokusai did not introduce bird and flower compositions to the print, he extended its range and elevated its status beyond

that of a proletarian art form. The subjects of such albums as *Little Flowers* were sketched from nature, but in one of the approved Chinese styles. Utamaro also had produced prints of birds, animals, insects, fish.

KUNIYOSHI (above)
Folio from *The Heroes of Suikoden: Tameijiro dan Shogo grapples with his enemy under water*, 1828-29
The 108 heroes, engaged in improbable feats, are drawn melodramatically, almost satirically – precursors of the Western comic.

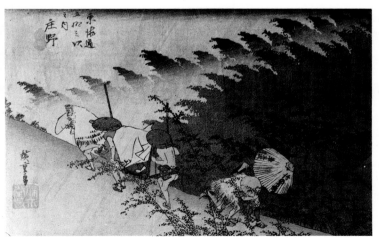

SHARAKU (above)
The actor Otani Oniji as Edohei, 1794
In the fifth month of the season of 1794, the Kabuki theatre at Edo was playing a tale of intrigue between members of great families, in which a valet, Edohei, conspired with another man wickedly to rob his master. Sharaku's portrait of him is

an intense characterization of his villainy; indeed it was faulted for exaggeration. The bold draughtsmanship is offset by a background sprinkled with mica-dust. Sharaku's are the finest examples of actor prints – one of the main subjects of *ukiyo-e*. The actors were of the Kabuki, not the "highbrow" Noh theatre.

HIROSHIGE (left)
Folio from *Fifty-three Stages of the Tokaido Highway: A shower at Shono*, 1833
Hiroshige, like Hokusai, prepared his prints from sketches. He purveyed rural scenes and country life in a romantic mood, sometimes in rather mannered designs.

THE AGE OF REVOLUTIONS

The French Revolution of 1789 heralded an era of often violent change which, in Western art, was to accelerate throughout the nineteenth century and culminate in the overthrow of the notion that an essential constituent of painting and sculpture was its ability to create an illusion of natural appearances. During this period the patronage of Church and nobility was largely replaced by that of the middle classes and the state, and France completed its eclipse of Italy as the artistic centre of Europe. Yet the wealth of Italy's classical heritage provided a major inspiration to the movement known as Neoclassicism. The art of its most influential exponent, Jacques-Louis David, expressed through the imagery of the distant past a belief in a Utopian future.

Classical principles of reason and clarity were, however, challenged by the new Romantic enthusiasm for the primacy of feeling. A strain of pessimism in much Romantic art reflects a deep insecurity, of which other symptoms were the revolutions flaring through the century. Goya's "Black Paintings" achieved an unparalleled morbid intensity. Another notable characteristic of Romantic art is its reverential awe for Nature; during the nineteenth century landscape became the major single subject of painting.

Towards the middle of the century a Realist movement, socially aware in art no less than literature, directed the sharp focus developed by the Romantics on to very mundane subjects, reproduced sometimes with almost photographic fidelity. The artists who responded most successfully to the development of photography were, however, the Impressionists, who wished to capture the everyday world with as much immediacy as the camera but to surpass it in rendering the sensation of the moment in colour and light.

An opposing movement in the last quarter of the century was Symbolism, which, in its rejection of the realities of the present, has often been seen as a second wave of Romanticism. Links can be found also between the Symbolists and the rather amorphous group known as the Post-Impressionists; many of the artists associated with both styles were appalled by the ugliness of the industrial civilization taking shape and wished to retreat from it, by embracing mysticism, as did some Symbolists, or by turning back to more primitive perceptions, as did Gauguin, or by making a virtual religion of art itself. The struggle of artists such as Gauguin and Cézanne to reshape the physical world in paint according to new, subjective, artistic laws led towards the irrevocable breakthrough of Cubism.

In Scandinavia, Germany and Austria it was the urgency of the movement called Expressionism that made the most significant inroads into the new territory of form opened up by Post-Impressionism. Amidst a maelstrom of cross-fertilizing styles and approaches, the dissolution of naturalism culminating in Cubism led with astonishing rapidity to the institution of purely abstract art, in France, in Germany, in Italy and in Russia. Already before World War I the Futurists were exploiting the new language of art in the creation of a new world, and Constructivism became the artistic language of the early Russian Revolution almost as Neoclassicism had been the artistic language of the French Revolution.

PARIS (left)
View of the grand staircase of the Opéra, 1861-74

BARCELONA (right)
The façade of Casa Batlló, begun 1905

CHICAGO (far right)
The Carson Pirie Scott store, 1899-1904

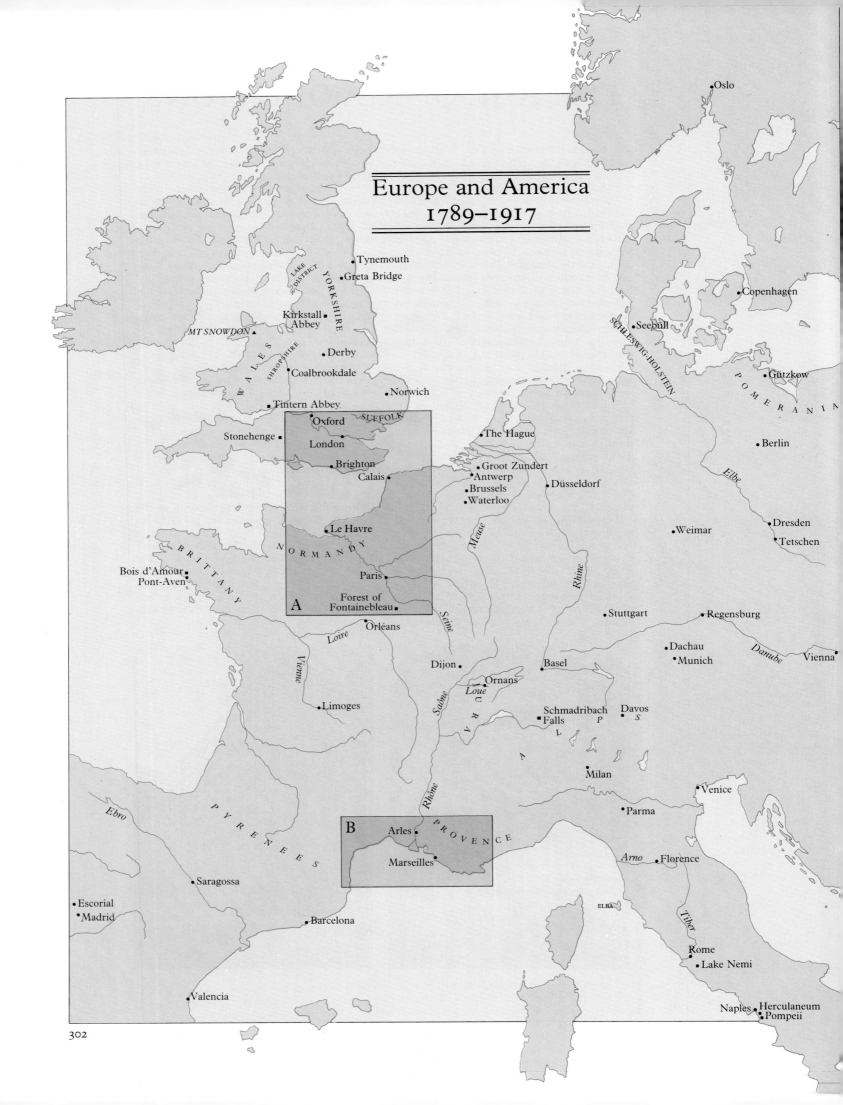

Europe and America
1789–1917

Oslo

Tynemouth

Greta Bridge

LAKE DISTRICT

YORKSHIRE

Copenhagen

Kirkstall Abbey

SCHLESWIG-HOLSTEIN

Seebüll

MT SNOWDON ▲

Derby

WALES

SHROPSHIRE

Coalbrookdale

POMERANIA

Gützkow

Tintern Abbey

Norwich

Oxford

SUFFOLK

Berlin

Stonehenge

London

The Hague

Brighton

Groot Zundert

Antwerp

Elbe

Calais

Brussels

Düsseldorf

Waterloo

Weimar

Dresden

Le Havre

Tetschen

NORMANDY

Meuse

A

Paris

Rhine

BRITTANY

Bois d'Amour
Pont-Aven

Forest of
Fontainebleau

Stuttgart

Regensburg

Seine

Orléans

Dachau

Munich

Danube

Vienna

Loire

Vienne

Dijon

Ornans

Basel

Loue

J U R A

Limoges

Saône

Schmadribach
Falls

Davos

A L P S

Milan

Rhône

Venice

Parma

P Y R E N E E S

Ebro

B

Arles

PROVENCE

Arno

Florence

Marseilles

Saragossa

ELBA

Escorial

Madrid

Barcelona

Tiber

Rome

Lake Nemi

Valencia

Naples

Herculaneum

Pompeii

St Petersburg (Petrograd)

Stockholm

Oxford
Stour
Flatford Mill
Dedham
Hampstead Heath
London • Wapping
Thames
Walton • • Shoreham
Epsom

Moscow

Brighton

Calais

Oise

Argenteuil

Asnières

La Grande Jatte

Port-Marly
Chatou
La Grenouillère
Louveciennes
St-Cloud
P A R I S
Ville d'Avray
Meudon
Marne
Seine

Etretat
Epte

Le Havre
Honfleur
Trouville
Rouen
Oise
Grandchamp
Deauville
Eragny
Giverny
Auvers
Valmondois
Pontoise
Marne
Paris
Seine
Maincy
Barbizon
Fontainebleau
Kiev

A

B

Rhône
St-Rémy
Arles
▲ MONT STE-VICTOIRE
Aix-en-Provence
Stes-Maries
L'Estaque
St-Tropez
Marseilles
La Ciotat

Céret
Collioure

Danube

QUEBEC
St Lawrence
Quebec

WHITE MTS

NEW HAMPSHIRE

MAINE

Hudson

Boston ▲ BUNKER HILL

CATSKILL MTS
MASSACHUSETTS

PENNSYLVANIA
West Point

New York

Pittsburgh

Philadelphia

NORTH-EASTERN USA

David: The Oath of the Horatii

The movement called "Neoclassicism" is discernible from about 1760, and it reached its climax in the paintings of Jacques-Louis David (1748-1825) and the sculptures (see p. 308) of Canova between about 1780 and 1800. Though reference back to the example of classical antiquity was nothing very novel, it had seldom been so wide-ranging and so detailed; Neoclassical artists sought anew the underlying principles of ancient art, and their motivation was often highly moral. Neoclassicism was perhaps the first movement in Western art to put theory before practice.

Knowledge of classical painting and furniture in particular had been greatly extended by the steady growth of excavations in Italy. In 1738 Herculaneum was discovered, Pompeii in 1748; and there was a wave of fashion for things classical, or classical-looking. Although it was later to embody a revulsion against the pretty frivolities of Rococo, early Neoclassicism handled its antique look with distinctly Rococo sentiment – for example in the paintings of David's teacher Joseph Vien (1716-1809). The immensely influential Johann Joachim Winckelmann (1717-68), the first of the great German art historians, was the prophet of the nobler lessons to be learnt from classical art. He found his ideal in Greek art as opposed to Roman, and diagnosed the essence of Greek beauty as "noble simplicity and serene grandeur". His friend and fellow-German in Rome, Anton Raffael Mengs (1728-79), attempted to transpose Winckelmann's theories into practice: his *Parnassus* of 1761, rejecting Baroque illusionism and colour, is laid across the ceiling as if it were a sculptured relief – simple and cold, if not quite noble and grand.

The Scotsman Gavin Hamilton (1723-98), who reached Rome in 1748, though a much lesser artist than Mengs (who was also a superb portraitist), was a seminal figure. He anticipated not only the style but the themes of Neoclassical painting, and in his illustrations of the *Iliad* and in his *Oath of Brutus* hit upon two of the central interests of Neoclassical art, heroic classical epic and moralizing classical history. His *Oath of Brutus* certainly influenced David's *Oath of the Horatii*.

Though it was bred on Italian soil, the impact of Neoclassicism was most concentrated in France, where it came more and more to respond to the moral values expounded by the philosophers of the Enlightenment. Coinciding with the wide-ranging radicalism that culminated in the French Revolution, its mood was stoic, even puritanical; its emphasis was on civic virtue. The Revolution, when it came, endeavoured to base itself politically, ethically and culturally on republican Rome.

In Rome in 1775 David abandoned the influence of Boucher's Rococo for classical art – not only the ancients but also Raphael and Poussin. He painted *The oath of the Horatii*, the archetypal picture of purist Neoclassicism, in Rome in 1784. David said that he owed the subject to the tragedian Corneille, the picture to Poussin, but his classic reduction to essentials was reached only after a long and arduous series of studies (the foot of one Horatius was reworked 20 times). The picture established not only David's reputation but also the relevance of Neoclassicism to current issues.

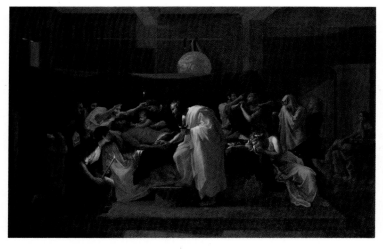

POUSSIN (left)
Extreme Unction, 1644
Neoclassical painting was as much a return to the rigours of Poussin as to the lessons of ancient art, which Poussin had studied with care (see p. 195).
In its language – gestures, composition, use of colour – Neoclassicism differed little, but it was more dramatic, more earnest, less complex.

VIEN (below)
The cupid seller, 1763
The subject is closely related to a wall-painting discovered in Herculaneum, but it was chosen no doubt as an allegory of sexual negotiation – its laxity and prettiness is pure Rococo.

GREUZE (below)
Septimius Severus reproaches Caracalla for seeking his death, 1769
Despite its classical detail, its frieze-like composition, its motifs already unearthed from antique art by Poussin, Greuze's picture failed. Its meaning was unclear.

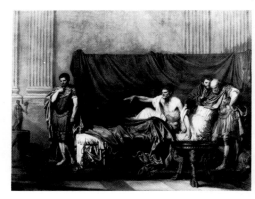

MENGS (below)
Parnassus, 1760-61
Apollo and the Muses can be traced to antique prototypes, but they are seen through Raphael's eyes. With supreme efficiency Mengs reached a carefully balanced composition and a minute finish, eschewing both passion and rhetoric.

HAMILTON (right)
The oath of Brutus, c. 1763
Because the son of King Tarquin had raped Lucretia, Brutus swore to expel despotism from Rome and create a republic. Earlier artists, following Ovid, had shown the rape; Hamilton, following the historian Livy, stresses moral action.

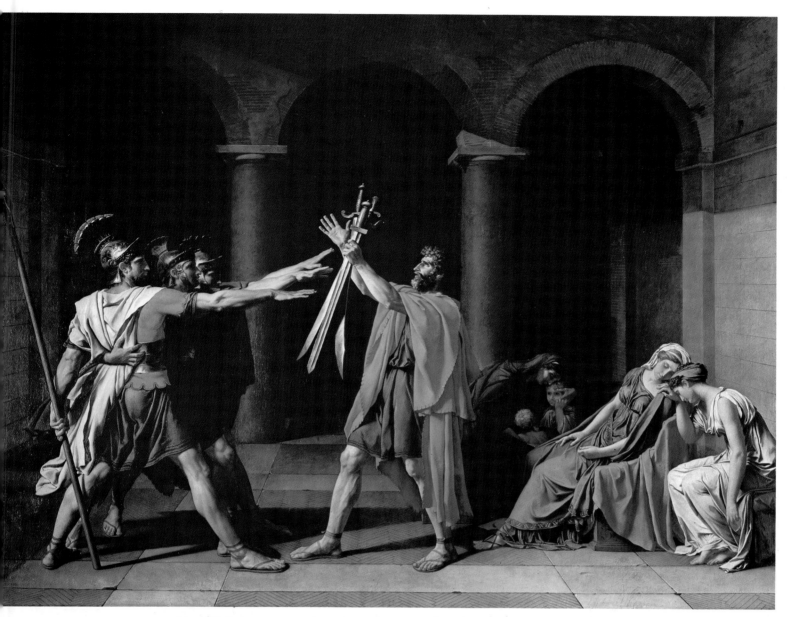

DAVID (above)
The oath of the Horatii, 1784
To settle the war between the two states, the three Horatii brothers of Rome engaged to fight the three Curatii of Alba. All died save one of the Horatii, who, returning to Rome, found his sister mourning one of the Curatii, to whom she had been betrothed. Infuriated, he killed her. David ignores the lurid and more spectacular possibilities of the story, and invents an undocumented moment – the swearing of an oath by the three brothers that they will dedicate their lives to their country. The masculine energy of the brothers and their father is contrasted with the ladies' tender compliance with fate; the brothers' untarnished devotion to duty is echoed in the clear, sharp morning light and in the simplicity, austerity of the composition.

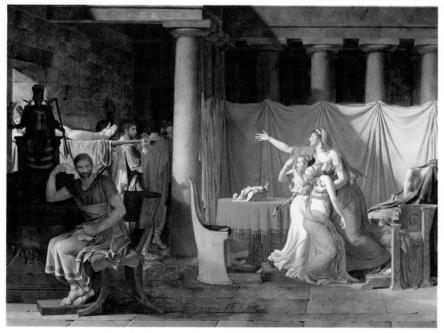

DAVID (left)
The lictors bringing Brutus the bodies of his sons, 1789
Painted in the very year of the Revolution, David's picture was not specifically political propaganda, but it strikingly expresses the moral fervour that fuelled the Revolution and carried it to such lengths. Brutus had ordered the execution of his own sons because they had rebelled against the republic he had founded. His taut figure, seated with tightly crossed legs in the foreground, is a remarkable image of personal emotion screwed down by the sense of moral duty. (The hand pointing to his head is not only a reference to a pose common in classical art, but also indicates Reason ruling from the head). Another such masterpiece, of 1787, was *The death of Socrates*, where, too, action is less the subject than conscience and consequence.

Neoclassical Painting: The Grand Style

The pure intensity of David's painting in the 1780s was the distilled essence of Neoclassicism, but it did not last long. The outbreak of the French Revolution in 1789 at first provided an ideal climate of opinion; David was prominently active in politics and his art entirely in key with events. *The death of Marat*, 1793, is virtually a canonization of the great revolutionary – a Christian *Pietà* transposed into a secular mode. After the fall of Robespierre, in 1794, David was imprisoned twice, and in the second spell, in 1799, he began *The intervention of the Sabine women*, a subject which could be interpreted as a revulsion against the excesses of the Reign of Terror and the guillotine, and a plea for reconciliation. Formally, its composition was a new development, using Greek models and with a suggestion of sensuality new to his work (some of his own pupils condemned it as being Rococo!)

Napoleon was needed to bring the Revolutionary convulsion under control and harness it to constructive purpose, although this purpose proved very different from the original ideals. David's art, as much as others', became an overt celebration of the Napoleonic Empire. He recorded contemporary events,

sometimes on a vast scale – *The coronation of Napoleon* (1805-07; not shown) includes more than a hundred identifiable portraits. His style became increasingly theatrical and pompous – pageant painting, in the tradition of Veronese, but applied to the heroic events of his own time. In this he had been preceded by American painters working in England, Benjamin West (1738-1820) and John Singleton Copley (1738-1815). West's *Death of Wolfe*, 1771, was a documentary recording General Wolfe's heroic death at Quebec in 1759 – relatively small in scale, yet in the grand style, in modern terms and modern costume.

West's style was modelled most nearly on Poussin, Copley's on Rubens. Both were acknowledged as revolutionary, but neither took the American Revolution as a theme (indeed West became the favourite of George III and succeeded Reynolds as President of the British Royal Academy); that was left to West's pupil, John Trumbull (1756-1843), who had himself fought in the War of Independence. He produced the first cycle of Revolutionary paintings, beginning in 1786, and took them back to America with him in 1816. Like Copley's, Trumbull's style was in a Baroque tradition

DAVID
The death of Marat, 1793
Marat was assassinated in his bath by Charlotte Corday: he suffered from a skin disease, soothed by its medicated waters, and she, inflamed to murder by his radical pamphlets, gained access to him by

means of the letter he holds. David has reconstructed the scene with archaeological accuracy, but has reduced it to its barest essentials, investing it with the most delicate, tender tones; it is still tragic, and with all the emotive force of a Revolutionary slogan.

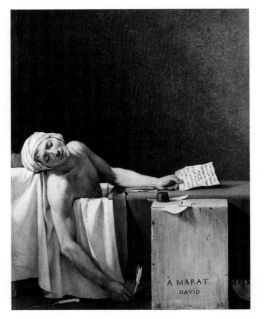

DAVID (left)
The intervention of the Sabine women, 1799
In David's pictures of the 1780s, women had grieved impotent in the shadows; here they burst to the fore. In the packed but frozen action, like a carved relief, there are innumerable references to earlier artists – Raphael, Poussin, Rubens, Lebrun – and Greek vases; it is a little incongruous.

TRUMBULL (right)
The death of General Warren at the Battle of Bunker Hill, 1786
The splash of colour is the prime means by which the ardour of the fighting is conveyed. Bunker Hill was the first major battle of the American Revolution.

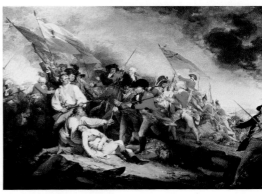

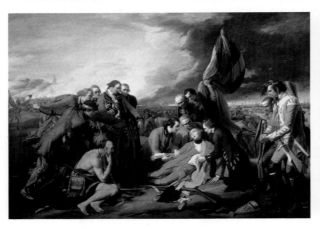

WEST (above)
The death of Wolfe, 1771
Before David's *Death of Marat* West had already used a religious formula, *The Deposition*, to impart an aura of tragedy to an historical event. There are

even 12 colleagues round the dying General, like 12 apostles, but the Cherokee makes 13 (he is in the pose of *Mourners* traditional on grand tombs). Wolfe died in the capture of Quebec, which made Canada British.

STUART (above right)
George Washington, 1795
Stuart complained that as soon as Washington sat for him, "a vacuity spread over his countenance", and it cost him some difficulty to achieve this alertness.

COPLEY (right)
A boy with a squirrel (The artist's half-brother), 1765
Reynolds praised Copley's freshness but faulted his hard lines, cold colours and too particular detail; these the American later avoided.

rather than a Neoclassic one. Copley had staged his *Death of Chatham* (not shown) as a one-man show in London in 1781, outside the Academy – the one-man show was still a novelty, and Copley's example perhaps inspired David's one-man showing of his *Sabine women* in Paris in 1800.

Copley's early work in America, before 1774, had been almost entirely portraiture. He was self-taught, and his knowledge of the European tradition had been acquired largely through engravings, but his extraordinarily vivid portraits show an innate eye for character. In their clarity of contour and often trenchant simplicity, they both anticipate the Neoclassic vision and preserve something of the freshness of the primitive. In England, his style tended to yield to the more atmospheric quality of the English fashion. Another American, Gilbert Stuart (1755-1828), who had started with West in London in 1775, likewise (though openly contemptuous of the Grand Manner) veered more to the fashionable English portrait style, and took it back to America with him in 1793. His subsequent fame rests on his oft-repeated image of *George Washington*.

The greatest of the Neoclassical portrait painters was beyond doubt David. His early portraits are astonishingly realistic, presaging the clear vision of his heroic classical subjects, but more relaxed. Direct portraiture continued all through his career, often of friends or professional men, but the supreme example of his more austere Neoclassic vision is the unfinished *Madame Récamier* of 1800, in which David's sheer painterliness is evident. The best example of his state portraiture is the finely dignified yet equally finely detailed whole-length of *Napoleon in his study*. It is in remarkable contrast to the heady, romantic atmospherics with which Sir Thomas Lawrence (1769-1830; not shown) in England invested the great.

After the fall of Napoleon and the Restoration of the Bourbons in France, David became an exile in Brussels, where he died in 1825. He was a great teacher, and the ramification, modulation and eventual dilution of the Neoclassical style in painting was furthered mainly by his pupils. François-Pascal, Baron Gérard (1770-1837) was one of the most successful, both with portraits and with mythological "history" paintings, but softer, even sentimental in comparison. His portrait of *Madame Récamier* is clear evidence of a more fussy and already almost mannered style. Gérard served both republic and Empire, and then switched without difficulty to propaganda for the restored monarchy. Anne-Louis Girodet (1767-1824) was more interesting, though David disapproved of his "poetic" tendencies; these, however, appealed to Napoleon. Although he was regarded in his lifetime as a leader of the classical school, the successor of David, he is also a precursor of Romanticism (with paintings such as *Ossian receiving the generals of the Republic*, 1802, not shown; or *Atala's entombment*, 1808). Napoleon also recognized Pierre-Paul Prud'hon (1758-1823), who was not a pupil of David's, and his painting shows him an heir to Correggio rather than a Neoclassicist (David called him the Boucher of his day). The painter most successful in capturing the glamour of Napoleon in action was David's pupil and close friend Antoine-Jean, Baron Gros (see p. 326), whose high sentiment and drama established a tradition eagerly exploited by the Romantics. The true heir of David's Neoclassical style was Ingres (see p. 332), but the impact of his immensely long career came later.

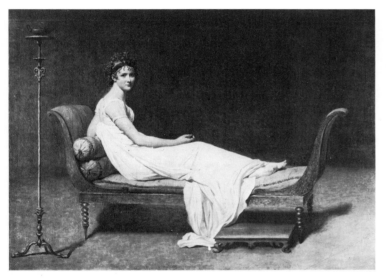

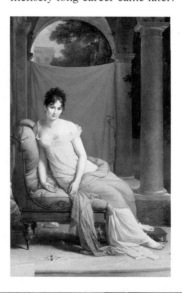

DAVID (left)
Mme Récamier, 1800
The woman, the stand, the divan are arranged in space like abstract sculptures; and David, having organized and produced funerals and pageants in the Revolution, probably designed both the furniture and her gown.

GERARD (right)
Mme Récamier, 1802
Dissatisfied with David's too severe vision, removing her to the elevation of some dispassionate deity, Mme Récamier commissioned Gérard, who obliged with a portrait of ingratiating softness. It is more human, more affable, perhaps truer to the gentle, winning way of the leading hostess of the Directoire, but much less subtly individualized.

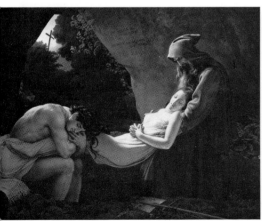

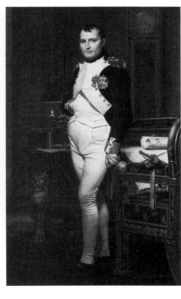

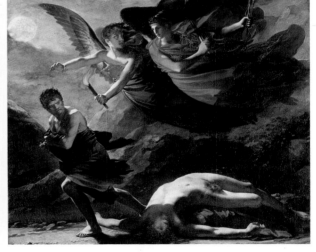

GIRODET (above)
Atala's entombment, 1808
The subject is taken from a novel by Chateaubriand. Atala had taken poison, as she was just about to break her vow of eternal chastity.

DAVID (right)
Napoleon in his study, 1812
The candles are low; the drafts of his legal code are on the table. The time is 4.13 a.m. Napoleon works while his subjects sleep.

PRUD'HON (above)
Justice and Divine Vengeance pursuing Crime, 1808
Prud'hon's allegory uses
Neoclassical models from Flaxman and Canova, but these are transformed by dramatic, emotive lighting.

Neoclassical Sculpture

Sculpture could respond more satisfactorily than painting to the ideals of Neoclassicism, in the quest for the quality defined by Winckelmann as "noble simplicity and serene grandeur". Sculpture and drawing offer opportunity for the clear definition of line and contour; the sculptor could achieve a material monumentality, a most solid physical presence, removed, however, from the accidents of ephemeral mortal life by the inexpressive cool pallor of marble. The purest Neoclassical painting, such as David's in the 1780s, strained towards the condition of sculpture.

Although no sculptor emerged of a stature quite comparable to David's, the dismissal of almost all Neoclassic sculpture as cold, academic and lifeless is gravely unjust. An exception was always made for the work of Jean-Antoine Houdon (1741-1828), especially for his brilliantly vivid portrait busts, and certainly his enormous talent and superb technique were untrammelled by dogma or theory. He created a portrait gallery of those men of wit and reason whose influence was felt throughout Europe – Voltaire and Rousseau, Diderot, d'Alembert and many others. He sculpted Jefferson and Benjamin Franklin; invited to America, he created a stately yet vital statue of George Washington. His flexibility is perhaps best apparent in his variations on the theme of the aged philosopher Voltaire.

Houdon survived the Revolution, and was even privileged to model both Napoleon and Josephine from the life. His enchanting contemporary Clodion (see p. 243) was not so fortunate: his erotic version of the Antique, his delicate, lively little terracottas were too Rococo in feeling for the Puritan austerities of the Revolution, which ruined his career. The sculptor who answered most nearly to Neoclassical taste and theory was the enormously successful Italian, Antonio Canova (1757-1822), born in Venice, but based in Rome from 1780. His early work in Venice had been more or less in key with contemporary French classicizing sculpture, but Rome revolutionized his ideas and his practice. His *Theseus and the Minotaur* of 1781-82 is as uncompromisingly austere as anything he was to carve in his whole career. It shows not the combat but the moment of Theseus' victory, and the idealized figure of Theseus may be an allegory of the sculptor's own triumph over his earlier style – the naturalistically treated, half-bull, half-human Minotaur. Canova, however, always kept his roots in the world of natural appearances, beginning each day by drawing from the life, but in his finished work he sought another kind of Nature, the realization in art of the philosopher Kant's definition of Nature as "the existence of things in so far as it is determined by general laws". Thus, in perhaps his most famous work, the *Cupid and Psyche*, the idea was evolved from a rhythmic, almost abstract study in clay of the interlocking of two embracing figures, which developed into an image that is at once an idyll of young love in innocence and a distillation of ecstasy. The *Cupid and Psyche* is nevertheless more akin to Roman, or to Roman copies of Hellenistic sculpture than to Greek sculpture of the classic era: that Canova had never seen until his visit to London in 1815, when he was greatly impressed by the fifth-century sculptures from the Parthenon that Lord Elgin had bought from the Turks, where he found "the truth of nature united to the finest forms".

Canova's range and clientèle were wide, his work sought after in Bonaparte's France as in England. In the Augustinerkirche in Vienna, for the Archduchess Maria Christina, he cre-

HOUDON (right)
Denis Diderot, 1771
Houdon conveys even the wit of the observation Diderot seems to making, and has apparently caught him not only in a fleeting moment but in an habitual expression. Houdon's busts surpass even Bernini's in their sheer vivacity.

HOUDON (below)
Voltaire, 1778
The robe could be either a toga or a dressing-gown; it is a timeless foil for the *tour de force* of the head. The hands grip the chair, the body strains forward, the head turns to speak. Houdon made this study – it is in terracotta – just before Voltaire's death.

HOUDON (left)
George Washington, 1788-92
To achieve an utter fidelity, Houdon noted his sitter's features scientifically, and took measurements of his body. Washington's right hand rests on Roman *fasces* and a ploughshare, making him a modern Cincinnatus – the modest Roman farmer who saved his country – but Washington refused to be shown in classical garb.

CANOVA (below)
Cupid and Psyche, 1787-93
The statue intends neither a single nor a multiple viewpoint; in a sense, it has no viewpoint at all. It is an entirely closed image, cold and impenetrable; despite their tense vitality, *Cupid and Psyche* permit no share in the ideal union of their flawless forms. (Try as he surely will, the viewer can never see both faces at once.)

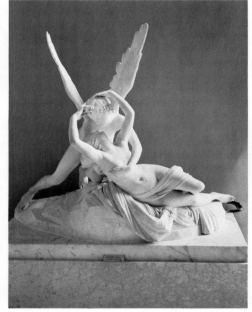

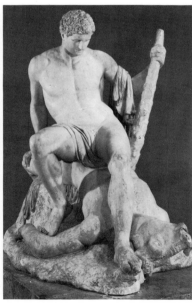

CANOVA (left)
Theseus and the Minotaur, 1781-82
The hard, smooth dullness of the marble reproduces the effect of Roman copies of Greek statuary. The self-imposed absence of expression studiously avoids the "excesses" of Bernini.

It is said that Canova had intended to represent the drama of hero and beast as they grappled – a Baroque subject – but chose instead (advised by his friend the painter Gavin Hamilton) its conclusion, so Theseus could be static, composed, ideally aloof and detached.

ated an impressively original Neoclassic development of the Baroque grandiose funeral monument. Austere in conception, it is none the less dramatic, even theatrical, and rich in a symbolism from which almost all specifically Christian reference has evaporated.

Canova's reclining figure of *Paulina Borghese as Venus Victrix* (1805-07) is the three-dimensional equivalent of David's *Madame Récamier*, but this is far more idealized and, of course, in the smoothest of marble drained of all ephemeral colour. Canova did not achieve, and would not have wished to achieve, the vivid immediacy that Houdon captured from his subjects, and portraiture was not really his *forte*. He developed, however, the convention of the nude heroic portrait – in the female *Paulina Borghese* and in an extraordinary colossal version of Napoleon (not shown). One of the earliest of these nude portraits had been by Jean-Baptiste Pigalle (1714-85) – the seated *Voltaire*, in which the philosopher's aged and shrunken body is shown with astonishing naturalism; the usual heroic portrait statue supplied a more or less realistic head with an entirely ideal torso.

The European market for sculpture was

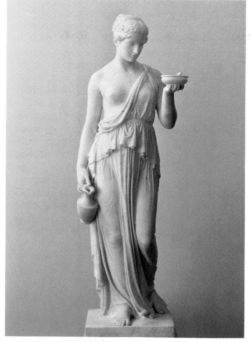

expanding spectacularly, and continued to do so throughout the nineteenth century. The middle classes began to commission portraits, and, while the demand for grandiose funerary monuments dwindled, it was more than offset by the production of heroic statuary for public places, a celebration of heroes that found its focus in public squares and in national shrines such as St Paul's Cathedral in London or the Walhalla near Regensburg.

The demand was answered by a vigorous breed of sculptors: the heroic mode seemed to have a special attraction for artists from the north, though they found their inspiration in classical Rome, and often settled there for life. The most talented and successful of Canova's heirs was Bertel Thorvaldsen (1770-1844), born in Copenhagen but working in Rome from 1796 to 1838, and patronized by a clientèle as international as Canova's. He took Canova's style towards an even more austere classical simplicity, shedding all last traces of Baroque movement. Gottfried Schadow (1764-1850), a sculptor of very great technical virtuosity, worked in his native Berlin after a spell in Rome, and John Flaxman (see over) had an extended stay in Rome, 1787-94.

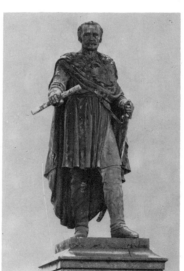

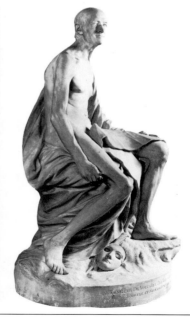

THORVALDSEN (above)
Hebe, 1806
Thorvaldsen's goddess of youth emulates classical Greek sculpture, but rejects the columnar folds and the austerity, for instance, of the Erechtheion caryatids (see p. 39): the marble glistens, the contours are luxuriously full and soft.

CANOVA (left)
Paulina Borghese as Venus Victrix, 1805-07
Napoleon's sister poses as the goddess whom Paris judged the fairest, to whom he awarded the apple. It is an allegorical portrait, so Canova had justification for generalizing her features. The virtuoso realism of the Grecian couch on which she lies rivals Bernini's.

SCHADOW (left)
Field-Marshal Blücher, 1815-19
Schadow knew the work of both Canova and Houdon, and preferred Houdon. His statue of the Prussian commander at Waterloo is individual, and imposing, but none too classicizing. Schadow draped a lion-skin over Blücher's otherwise modern costume only at the insistence of Goethe.

PIGALLE (below)
Voltaire, 1770-76
The vigorous head, with its distant gaze fastened on intellectual problems, contrasts with the frailty and rottenness of the body. When exhibited, the statue was found eccentric, and it seems a deliberate mockery of the heroic male nude.

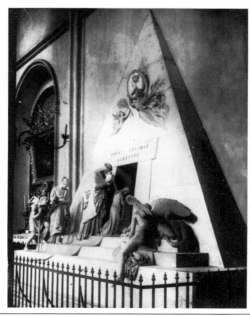

CANOVA (above)
Sketch for *Cupid and Psyche*, 1787
Canova's *bozzetto* reveals him intent from the start on the formal currents that bind his figures together. There is no question of an initial spontaneity the finished work has lost.

CANOVA (right)
Monument to Archduchess Maria Christina, c. 1805
Piety bears the ashes into the open dark door of the tomb, followed by figures moving in the slow flow of an elegiac rhythm. By the lion of Fortitude leans the genius of Mourning.

Neoclassics and Romantics in England

The historians' search for a satisfactory definition of Romanticism in the visual arts still continues unresolved. The confusion arises because, as Baudelaire observed, Romanticism is precisely situated neither in an artist's style nor in his subject matter, but in himself – an inconstant factor. Romanticism continues the high seriousness of Neoclassicism, but tends both to intensify it and to widen its scope, often looking more closely at Nature – whether concentrating on its violent or peaceful aspects – and plunging into politics, feelings and issues of the day; sometimes altogether misfiring under the strain of its ambitions. Style and subject matter are determined by individual taste or principle, for Romanticism was never a coherent movement (coherence is hardly a Romantic concept); nor perhaps was classicism, but the fundamental difference between the Romantic and the classicist is surely that, for the latter, the motive force is rational, while for the Romantic it is emotional.

Goethe, the youthful exponent of Romanticism in Germany, the author of the best-selling early Romantic novel *The Sorrows of Young Werther* (1774), developed into the elder statesman of European culture, for whom classicism was health and Romanticism sickness. In France, Delacroix, in whom Baudelaire discerned the archetypal Romantic painter, himself maintained sturdily (if with Romantic passion) that he was a pure classicist. In England, John Flaxman (1755-1826), the draughtsman and sculptor whose outline drawings were acclaimed throughout Europe as capturing the very essence of classical form, was the friend and the exact contemporary of William Blake (1757-1827), a pivotal figure in any definition of Romantic art.

Flaxman's illustrations to Homer, precise, economic, faultlessly balanced, are in a sense the *ne plus ultra* of Neoclassicism, realizing the ultimate reduction to stark, pure outline. But Flaxman also illustrated Aeschylus and Dante, both poets of vision, and Blake again illustrated Dante, in the same linear terms, though with rather different effect.

The middle ground between classicism and Romanticism was occupied by the Swiss-born Henry Fuseli (or Füssli, 1741-1825). His initial interests were literary, religious and radically political, but he developed an early enthusiasm for the writings of Winckelmann. In 1765, having moved to London, he trans-lated Winckelmann, but next year, in Paris, met the Romantic philosopher Jean-Jacques Rousseau. Having settled for a career as a painter, he learnt his craft in Rome between 1770 and 1778, and there discarded Mengs' cool interpretation of Winckelmann's Neoclassicism for an exaggerated version of Michelangelo's style. His famous wash-drawing of *The artist moved by the grandeur of ancient ruins* (1778-79) is typical of his emphatic manner – stressing the subjective emotion of the artist rather than any objective antique quality in the colossal fragments. It also illustrates the inherent danger of the emotional interpretation – pushing the sublime to the brink of the ridiculous, and drama into melodrama. Fuseli subsequently drew not only on the Antique, but also on Milton, Teutonic legend and Shakespeare. In works such as his sensational *Nightmare* he exploited subject matter that is intrinsically Romantic, and his strangely perverse erotic visions of sinister women have excited psychoanalytical attention. Yet his compositions remained formally within Neoclassical conventions; although his technique and execution were not adequate to fulfil the originality of his imag-

FLAXMAN (above)
Illustration to the *Iliad: Princes all Hail!*, 1795
Agamemnon sent Ulysses to placate Achilles, having taken his prize. Flaxman emulates the purity of an Athenian black-figure vase.

BLAKE (below)
The good and evil angels struggling for the possession of a child, 1795
Orc (Evil), despite his destructive nature, also represents pure energy (indicated by the flames)

BLAKE (below)
Newton, 1795
A silhouette of classical beauty and ideal anatomy (derived from a figure on the Sistine Chapel ceiling), Newton the scientist was for Blake an oppressor who attempted to quantify life with a pair of dividers. This is a Romantic view; beside it Flaxman's vision of mental torment (right) lacks emotional power, for all that the stylistic conventions are so similar.

vital to man's salvation; Los (Good) is in a fallen state, since he has fettered Orc in a fit of jealousy. Blake parades the schizoid crisis of his Romantic philosophy; his idealized forms are strangely Puritan.

FLAXMAN (above)
Illustration to Aeschylus' *The Furies*, 1795
Orestes, having killed his mother, Clytemnestra, in revenge for his father's death at her hand, was then pursued by the Furies.

FLAXMAN (below)
Monument to Sophia Hoare, 1821
Though Flaxman executed several large-scale works, smaller commissions found him at his best. Christian sentiment emerges despite so much classical detailing.

ination, his distortions and linear attenuations had a considerable effect on the more deeply committed and spiritual art of Blake.

In official eyes, Blake was an eccentric, even thought by some to be mad. He was certainly a loner, a supreme example even among the Romantics of the visionary, the individualist, the radical. He was scornful of the official establishment of art, but he had been a fellow-student with Flaxman at the Academy schools and his earliest work was in the Neoclassic mode, while his enduring belief in an art of shadowless contour was strengthened by training as an engraver. From these beginnings, however, he developed his own style and technique with which to express his vision. Blake is unique in English art in being both a major poet and a major artist: much of his work consists of engraved hand-coloured books in which verse was integrated with illustration, rather as in medieval illuminated manuscripts. In his painting, as in his poetry, he developed a new, personal, exaltedly unearthly and convolutedly obscure mythology, entirely opposed to the cool reasonableness of the age of sensibility. Blake never travelled abroad, but championed revolution, whether in America

or France. He preached enthusiasm and excess. His authority was his own inspiration, his inner eye. But although he abandoned perspective and illusionism, his inner eye could formulate its vision only through the experience of his outer eye, and his style reflects engravings of Michelangelo – perhaps also the influence of the Gothic ogee curve.

Though the personal and intuitive basis of Blake's work was prophetic of the course modern art was to pursue, he was too individual to inspire a great movement. Nevertheless, one rather exceptional aspect of his work founded a tradition that has been fruitful ever since. The elegiac pastoral vision of a series of celebrated minute woodcuts for a translation of Virgil's *Eclogues* (the woodcut reproduced here is more or less actual size) became a source notably for Samuel Palmer (1805-81), during a brief period of spiritual inspiration and dedication in the 1820s. Palmer's early evocations of the landscape about the village of Shoreham in Kent are almost hymns of contemplation and adoration, as if he had rediscovered there the Garden of Eden before the Fall – certainly before the Industrial Revolution.

FUSELI (above)
The artist moved by the grandeur of ancient ruins, 1778-79
Fuseli's adulation of the Antique found expression in a dynamic, exaggerated, muscular figure style based on Michelangelo's work in the Sistine Chapel, though tempered by a measure of Mannerist attenuation.

BLAKE (below)
The circle of the lustful, from Dante's *Inferno,* Canto V, *c.* 1824.
Tales involving infraction of the conventional sexual code – like Dante's of Paolo and Francesca – frequently appealed to the Romantics. Blake depicts the circle of the damned adulterers as a whirl of bliss, with the two young lovers united forever in a halo of bright light.

FUSELI (left)
The nightmare, 1781
Fuseli's picture made his name when exhibited at the Royal Academy in 1782. It is a fantasy of rape, representing oppressively

the terror of the young girl. The horse's head thrusting through the heavy curtains is a typically Romantic symbol of savage power. Fuseli habitually resorted to violent chiaroscuro.

BLAKE (above)
Thenot under a fruit tree, 1821
Palmer called these woodcuts "Visions of little dells, and nooks, and corners of Paradise ... the exquisitest pitch of intense poetry".

PALMER (below)
Early morning, 1825
The scene is recorded with minute attention to natural detail – typical of Palmer's Shoreham period: he saw Nature as an expression of the divinity of its creator.

Francisco de Goya

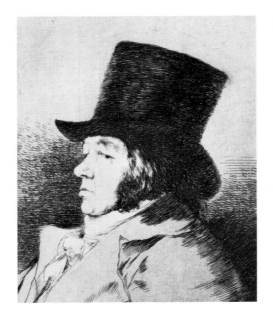

GOYA (above)
Los Caprichos, frontis-
piece: *Self-portrait*, 1798
The top hat cocked at a
jaunty angle suggests the
dandy: the image was etched
the year before Goya was
made First Court Painter.

After the splendours of the seventeenth century – the art of Velazquez, Ribera, Zurbarán and Murillo – the Spanish seemed content to adopt current international styles without injecting much originality. Close connections with Italy were maintained through the Spanish dominion of Naples, and major Italian artists were imported by the Spanish court and the Church, the principal patrons. Luca Giordano, in Spain 1692-1702, deployed Baroque rhetoric across the ceilings of the Escorial; the Venetian Amigoni and the brilliant Neapolitan painter Giaquinto consolidated late Italian Baroque in Spain in decorations for the Palace of the Orient in Madrid after 1734. Both were appointed court painters, and helped in 1751-52 to set up the Academy of San Fernando, which did much to establish artistic standards and status in Spain. Giambattista Tiepolo worked in Spain from 1762 to 1770, and the Neoclassicist Anton Raffael Mengs came with Charles III from Naples in 1761. The French Rococo style had been acclimatized in Spain when the crown had passed in 1700 to the Bourbon grandson of Louis XIV, Philip V.

Francisco de Goya y Lucientes (1746-1828), in his beginnings, practised in most of these varying traditions. Born and trained in Saragossa, then the second city in Spain, he was soon attracted to Madrid, the political and cultural capital under the centralizing policy of Charles III. He did not settle there, however, until 1773: his initial attempts to win a scholarship at the Academy failed, and in 1770-71 he was in Italy (notably in Rome and Parma). His first major commission was for a series of frescos for the church of Nuestra Señora del Pilar in Saragossa, which are fully Baroque, and already show the bold colours and free handling that were to characterize his later work. In Rome he had met Mengs, who in Spain secured him employment designing cartoons for tapestries to hang in the royal palaces. Some of these are as lightly frivolous as diversions by Domenico Tiepolo.

In Madrid from 1773, Goya rapidly became established as a designer of decorations, as a virtuoso of religious frescos and as a portraitist. He was prosperous, friendly with a liberal intellectual set, sympathetic to the ideas of the Enlightenment, but apparently unmoved by the storms of Revolution raging in France. He was a familiar in the highest circles, and became, according to a legend that

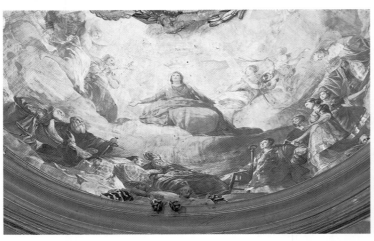

GOYA (above)
The dome of Nuestra
Señora del Pilar, Sara-
gossa: *The Virgin, Queen
of martyrs*, detail, 1781
In speed and energy – he
painted the entire ceiling
in only four months – Goya
might have rivalled Luca
Giordano. He had learnt his
technique in Italy, and the
conception and design echo
Italian example – a double
tier of figures rises in a
vortex against skies no less
luminous than Tiepolo's.

GOYA (below)
The sunshade, 1777
The couple pose with light,
fashionable ease, almost
dazzlingly smart – Rococo
with an added verve. This
was a cartoon for a tapestry
in a royal dining-room.

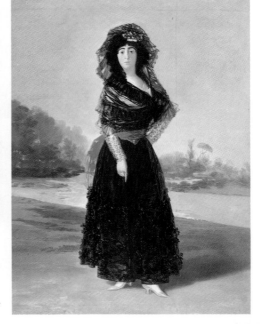

GOYA (left)
The Duchess of Alba,
1797
The Duchess dresses as a
Maja even in mourning:
the gilt slippers, crimson
sash and her coal-black
eyebrows were all part of
the fashion. Despite the
skimpiness of the land-
scape and the anatomical
awkwardness of her arms,
the Duchess is a powerful
figure, pointing allusively
to no ordinary signature.

GOYA (below)
Nude maja, 1802-05
The two versions show the
same girl in the same pose,
clothed and unclothed. The
Inquisition took them both
in 1815 and judged both
obscene. She is hardly less
provocative in full dress,
and clearly offers herself
sexually. Her pose recalls
the abandoned nude at the
right of Titian's *Andrian
Bacchanal* (see p. 145),
then in the royal collection.

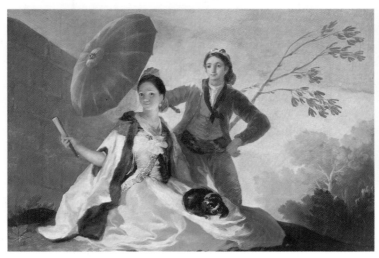

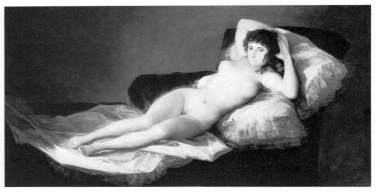

is by no means improbable, the lover of one of the grandest ladies in the land, the Duchess of Alba. The elegance of his several portraits of the Duchess may recall Gainsborough's fluency and lyricism, but their originality is startling even now. The portrait of 1797 shows the Duchess in widow's weeds, wearing rings inscribed *Alba* and *Goya*, pointing with one forefinger to the ground at her feet, where, if you look closely, is written *Goya Solo* (only Goya). The riddle is Goya's own indeed. The lady is imperious, haughty, and commands attention, almost crackling with static electricity. In 1799, after 13 years in the King's service, Goya was created First Court Painter, the highest artistic honour in Spain.

The variety of Goya's art in the years of his prime is inexhaustible. The famous pair of *Majas*, naked and clothed, of about 1802-05, are the most delightful, untroubled celebration of the erotic in all his work. *Maja* is untranslatable: it refers to the dandy cult of Madrid's new proletariat, who dressed with a gypsy flamboyance and an independent pride which it became fashionable on occasions for aristocrats to imitate. Goya drew on this source again for his *Two majas on a balcony*, where the

combination of beauty, coquetry and the sinister is unsurpassed.

Both versions of the *Maja* belonged to, and were possibly painted for, the all-powerful Manuel de Godoy, Prime Minister, Generalissimo of land and sea forces, and lover of the Queen. Goya painted him in 1801 in a design that is both unorthodox and grandly, even pompously, formal. Goya's independence, his disregard of the standard European portrait conventions, is evident again in his extraordinary life-size group, *Charles IV and his family* (1800). The royal family seems curiously gauche in the dazzling plumage of their brilliantly painted costumes – this is the most eccentric state portrait ever painted by an appointed painter to a crown. Although most observers have seen it as mordant satire, the King himself appears to have been pleased.

The problem of Goya's loyalties is a difficult one. During the French occupation, 1808-12, he painted the French dignitaries. When Madrid was liberated in 1812, he had almost finished an equestrian portrait of Joseph Bonaparte, on which he then substituted the head of the liberator, the Duke of Wellington. His superb and appalling vision of the mass-

acre by the French of Madrid citizens on May 3rd, 1808, painted in 1814, seems less a patriotic war memorial than an expression of rage at the horror of man's inhumanity; and towards the close of his long life, in 1824, when Spain was subjected to a repressive regime, he withdrew in self-imposed exile to France, where he died four years later.

The dichotomy in Goya's temperament, the black pessimism that produced the "Black Paintings", had emerged long before, but not in public. The glamorous world of the distinguished and the court seems to have ceased to intrigue him after 1802, when the Duchess of Alba died. Yet the event that is generally thought to have confirmed and released his obsession with the horrific is the severe illness that left him stone deaf in 1793. Devils had appeared in his work even previously, and *Los Caprichos* of 1799, even *The Disasters of War* (though that series was not published in Goya's lifetime) – etchings in which Goya's obsession with the macabre is clearly present – could still be accepted as social satire. The revelation of the "Black Paintings" and allied works such as *The colossus* (see over) of his later years did not come until well after his death.

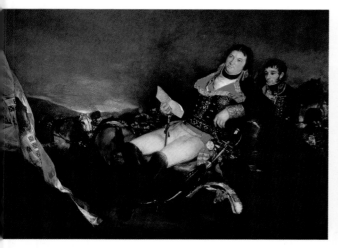

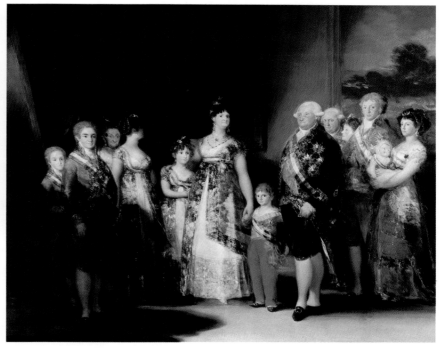

GOYA (above)
Don Manuel de Godoy, 1801
The 35-year-old supremo leans back in a leisurely pose, gloriously attired, surrounded by the panoply of a military commander, against a dark sky that is seemingly about to erupt with the explosion of war. He seems formidably self-satisfied, gazing beyond the furled standard with an almost cruel delight at some private pleasure.

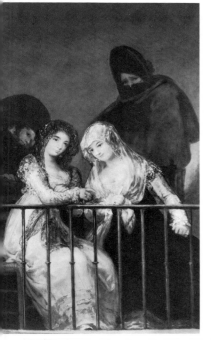

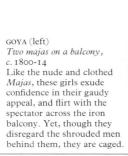

GOYA (left)
Two majas on a balcony,
c. 1800-14
Like the nude and clothed *Majas*, these girls exude confidence in their gaudy appeal, and flirt with the spectator across the iron balcony. Yet, though they disregard the shrouded men behind them, they are caged.

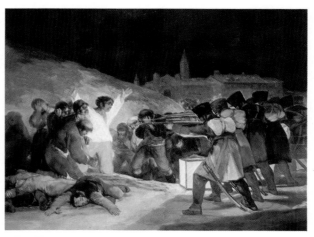

GOYA (left)
May 3rd, 1808, 1814
The Spanish insurgents are driven in a seemingly endless stream towards the pool of light and blood in front of the lethal phalanx of firing French soldiers.

GOYA (above)
Charles IV and his family, 1800
Replying to Velazquez's *"Las Meninas"* see p. (210), Goya has included himself (dark) on the left; the Queen's uplifted jaw recalls the earlier Infanta's. There is a story that Goya refused to paint one of the princesses full-face as he found her impossibly plain.

Goya: The Colossus

The Disasters of War:
(right) *This is how it is;*
(below) *This is worse,*
c. 1810-15
Goya's mixed technique
of etching and aquatint
produced the equivalent of
a pen-and-wash drawing;
by drawing the human body,
dead or mutilated, in the
unimpassioned idiom of
Flaxman's illustrations to
the classics, he intensified
the horror. Certainly the
war brought atrocities, but
these etchings (first pub-
lished after Goya's death)
seem as much a reflection
of a personal sensibility as
anti-war propaganda.

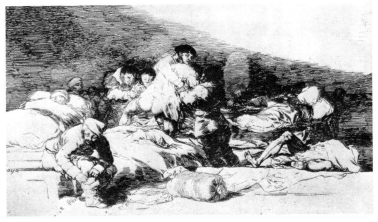

GOYA (below right)
Los Caprichos, plate 43:
The sleep of Reason, 1799
A preliminary drawing has
apparently direct echoes
of Fuseli's *Nightmare* (see
p. 311), but these do not
persist in the etching. The
table on which the figure
rests is inscribed: *The
sleep of Reason produces
monsters*; and the message
is defined in the subtitle:
*Imagination abandoned by
Reason produces impossible
monsters; united with her,
she is the mother of the arts.*

It is a visionary image;
its subject is creativity,
and in theme and import
the image is quintessentially
Romantic: reason is a vital
control but the life-giving
impulse is imagination, here
breeding unchecked, with
no hint that the sleeper will
awake, and the monsters be
dispelled. The sole fact
alleviating the pessimism is
that the artist, Goya, could
realize and control this
vision in such memorable
form within the symmetry
of a rectangle of paper.

GOYA (right)
The straw manikin, 1791-92
Even before his illness, and
in public commissions, hints
of his "black" imagination
appear in Goya's art. *The
straw manikin* was one of
a series of cartoons for
tapestries to be woven in
the royal factory. Scenes
of pastoral country life
were required, and Goya
shows women performing a
ritual in a peasant festival.
Yet the manikin looks like
a human victim, and in the
faces of the women there is
something quirkily inhuman.

GOYA (right)
Saturn, 1820
In the "Black Paintings"
Goya realized in paint the
unelucidated visions of his
private infernal mythology
on the walls of his living-
rooms. He chose to paint
in his dining-room Saturn
devouring his offspring
(a rare classical subject
amid what baffled visitors
described as *caprichos*).

GOYA (left)
*Self-portrait with Dr
Arrieta*, 1820
Compassionate, but blind to
Goya's demons, the doctor
holds up the glass with a
firm, supporting right arm
(emphatically horizontal).
Goya inscribed his gratitude
on the painting and gave it
to his doctor, but also made
copies of it for himself.

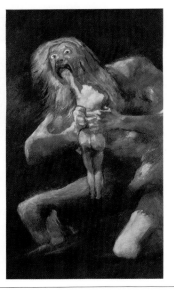

Goya painted *The colossus* (originally called
The giant) in the years 1808-12, that is in the
period when Spain took the full brunt of the
Napoleonic Wars for the first time. Character-
istically enigmatic and mysterious as the image
is, there are grounds for thinking it as much a
reflection on war as his famous etchings, *The
Disasters of War*, the first of which date from
about 1810. Lines from a poem by Juan
Arriaza about the wars have been identified as
a possible stimulus for Goya's image: "On a
height above yonder cavernous amphitheatre a
pale colossus rises, caught by the fiery light of
the setting sun; the Pyrenees are a humble
plinth for his gigantic limbs." *The colossus*
may represent the emergent spirit of a defiant
Spain against French invasion, but, if so, the
people in the picture do not seem confident of
success. A related mezzotint (not shown) of a
giant seated solitary on a low horizon, brood-
ing, dates from about the same period or rather
later. Otherwise *The colossus* must speak for
itself. The painting is not physically colossal
(some 1.5 metres (5ft) high), but its impact
certainly is, achieved by the dramatic clash of
opposing scales and values. Probably, as in so
much of Goya's work, it is more a general, non-
partisan statement on the human condition, an
allegory of human impotence.

In a famous plate in the series of etchings *Los
Caprichos* (or Phantasmagoria, 1796-98), there
is a similar clash of reality and surreality. The
artist is seen slumped in sleep, and surely
nightmare, with a host of bat-winged monsters
battering at him. A grave illness in 1793 had
left Goya virtually stone deaf; turned inwards
by the consequent isolation upon the tumult of
his own mind, he became increasingly ob-
sessed with the spectres that thronged his
imagination. *The Disasters of War*, in which
the most appalling miseries and tortures that
man can inflict on man are vividly and ruth-
lessly rendered, conveys not so much com-
passion or anger or patriotic fervour as an
appalled fascination and a resigned horror:
This is how it is, read several captions. But then
the plate showing a man impaled on a splin-
tered tree-trunk, his arms severed, has the
laconic subscription: *This is worse*.

Goya's addiction to the abnormal and vio-
lent expressed itself elsewhere, in his scenes of
asylums, of religious flagellants, of witchcraft.
The accumulating agony and exhaustion of
Goya's inner world are mirrored vividly in a
late *Self-portrait* showing the artist in the arms
of the doctor who nursed him during a second
crucial illness in 1819, with omnipresent de-
monic figures hovering in the murk of the
background. The last manifestation of his
morbid obsessions was the famous "Black
Paintings" Goya concocted to adorn the in-
teriors of his own house on his retirement. To
be condemned to live surrounded by these
paintings would be a fearsome sentence, but
Goya chose as it were to paper his house with
them. Painted very broadly, often with the
palette knife rather than the brush, in dark and
sombre tones, they closely anticipate in their
mood and hideous violence the savage pes-
simism of twentieth-century Expressionism.
Goya's genius was recognized again in the age
of Manet and Baudelaire, but his "Black
Paintings" appeal specifically to our own.

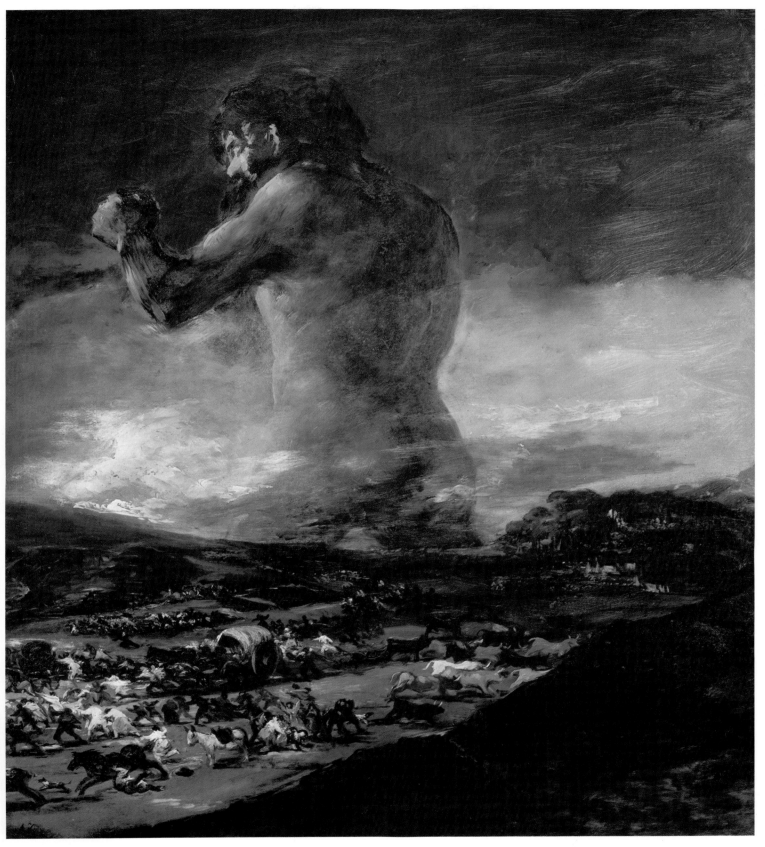

GOYA
The colossus, 1808-12
The naked colossus is from one world, the scattering, running figures in the foreground belong to our puny planet (only a donkey is unmoved by the panic). Yet the giant's threat is directed not overtly against the men and women below, but against a force, presumably on his own scale, out of view on the left. Superhuman forces engaged in their own titanic conflict disrupt and destroy ordinary people's existence almost haphazardly. Painted in a very free technique, the giant looms upward phantom-like through cloud, while the fleeing men and animals are shaped more solidly in a swift impasto.

Romantic Landscape in Britain and America

Sir Joshua Reynolds had asserted firmly that landscape was a secondary form of art, inevitably subordinate to the painting of ideal or heroic subjects. Yet within 20 years of his death both Constable (see over) and Turner (see p. 320) were working irresistibly towards the establishment of landscape as the most characteristic achievement of English art.

The changing climate of thought and sentiment reflected the increasing popularity of "back-to-Nature" movements, and the influence of Jean-Jacques Rousseau and of the English Lake poets. The growing fashion for Picturesque tourism, practising a conscious, often rather self-conscious, appreciation of the real countryside, went hand in hand with an increasing demand for paintings and engravings of it. Favourite sites for expeditions and sketchings were the "wilder" regions of Britain – the Lake District and the Welsh mountains – and ruins romantically situated on deserted moors or uninhabited hills.

Subject matter that is explicitly Romantic had been exploited by Wright of Derby – a delight in mysterious moonlight or in volcanic eruptions, even in incandescent visions of the factories of the Industrial Revolution. A French immigrant, the brilliantly professional Philippe Jacques de Loutherbourg (1740-1812) ranged, like Wright, from the Picturesque to the Sublime; in 1781 he exhibited his Eidophusikon, in which he mounted the drama of Nature on the stage – views of natural scenery subjected, by means of artificial lighting and sound effects, to varying effects of sun, storm and lightning. John Martin (1789-1854) developed a strong taste for spectacular melodrama, turning from sensitive landscapes in a traditional manner to apocalyptic visions of lurid plains, canyons and mountains, and gigantic temples of desolation; beneath, minute figures act out episodes from the Bible or from Milton. These explosions of the imagination became widely known in mezzotint.

Meanwhile, however, a relatively realistic tradition, depending directly on Netherlandish example, had persisted; it bore fruit in England at the close of the eighteenth century in the provincial Norwich school, headed by John Crome (1768-1821). His masterpiece, *The Poringland oak*, of about 1818, catches a local, rural subject with all the freshness of a Hobbema: unostentatious, positively ordinary, it seems in hindsight a staging-post to the meditations of the Barbizon school. Crome's younger colleague John Sell Cotman (1782-1842) was of more obvious originality, a master who extracted simplified but bold patterns from the natural landscape.

Cotman's finest work was in watercolour, developing a tradition by then firmly rooted throughout the country, with a wide market in both the aristocratic and middle classes. By the end of the eighteenth century, some skill in draughtsmanship was part of a gentleman's education, and most of the professional watercolourists were also drawing-masters. Much of their work was topographical, but watercolour was also used by painters with aspirations to the Sublime, above all John Robert Cozens (1752-97). His father, Alexander Cozens (c. 1717-86; not shown), had insisted both on working from Nature and on the need for originality in composition. To teach the latter, he published a system based on the idea of elaborating a landscape design from random abstract blots (more or less as Leonardo da Vinci had once suggested). His son evolved, though still in the studio, dreaming visions of Italy or the Alps – Constable was to call him "the greatest genius that ever touched land-

JOHN ROBERT COZENS (above)
Lake Nemi, c. 1778-79
A muted blue-grey tonality characterizes Cozens' Grand Tour watercolours, and a melancholy, thoroughly romantic atmosphere his image of the famous lake near Rome. He made exact topographical notations at the site and then perfected his painting in the studio.

LOUTHERBOURG (above)
Coalbrookdale by night, 1801
The "dark satanic mills" of industry were for a short time the objects of awe and Romantic wonder. Far from provoking dismay at their intrusion into a once lovely valley, these Shropshire furnaces were found "sublime". Loutherbourg later described Coalbrookdale as "worthy of a visit from the admirer of romantic scenery" – an extension of the standard cliff and crag.

CROME (above)
The Poringland oak, c. 1818
Continuing traditions of landscape established by the Dutch, Crome chose a view without obvious drama. Nature herself is found to be a subject of intrinsic worth, honestly painted, not transformed, as by Wilson, into a Picturesque glory, nor infused with Romanticism.

COTMAN (right)
Greta Bridge, 1805
From relatively simple views Cotman created watercolours of quiet dignity in a unique style, displaying a superb precision of brushwork and facility of design. By his own account, he studied colouring from Nature. He never excelled the masterpieces of his youth, painted on tours in northern Britain between 1803 and 1805.

MARTIN (above)
Joshua commanding the sun to stand still, 1816
Martin's paintings are in the tradition of Salvator Rosa, the heroic landscape overwhelming the figures. They offered nothing new in the interpretation of Nature on canvas – they were primarily literary in inspiration – but fascinated a large public in England, France and America.

scape" – "Cozens is all poetry". The brief-lived Thomas Girtin (1775-1802), the friend and fellow-student of Turner, made important technical innovations in watercolour, abandoning the usual practice of establishing the design initially in monochrome. He used a rough off-white paper, on which he spread brilliantly controlled washes, allied with what was at times stippling in pure colours. The result was a solidity and vibrancy that enabled watercolour to rival oil-painting.

The American vision of landscape took some time to shake European blinkers from its

eyes. Washington Allston (1779-1843) spent long periods in Europe, studying with Benjamin West from 1801 to 1808. A friend of the poet Coleridge, he took an essentially Romantic stance – he likened painting to music and sought to express subjective qualities of mood in landscape, and of personality in portraiture. John Martin's emphasis on the confrontation of the human with the divine influenced much of Allston's later landscape, but from his more subtly colouristic style he is often called "the American Titian".

A more specific attachment to the American

genius of the American place was sought by later painters associated with the "Hudson River school". The greatest of them, Thomas Cole (1801-48), observed that "the painter of American scenery has, indeed, privileges superior to any other; all Nature here is new to art". Although preconceived European formulae affected their approach, and some painters tended to introduce strong moral or didactic themes, the Hudson River school at times produced images of an intensity both new and startling – for instance Cole's *Sunny morning on the Hudson River* of about 1821. The most famous work of the leading theorist of the school, Asher B. Durand (1796-1886), *Kindred spirits*, depicts Cole communing with Nature on a ledge over a rocky torrent.

The Hudson River school approach persisted through the nineteenth century, though moving in general away (and happily so) from more grandiose, moralizing, themes towards pure landscape. Several painters developed a delightful variation, genre subjects in landscape, which often reflected the more idyllic side of the ever-advancing western frontier – for instance, *Fur traders descending the Missouri* by George Caleb Bingham (1811-79).

GIRTIN (right)
Kirkstall Abbey, c. 1800
The ruins of the Cistercian Abbey are not recorded in the interests of antiquarian topography, though Girtin has evoked the delicacy of the Gothic tracery and the crumble of old stonework. The Yorkshire countryside and its weather are the real subject of the watercolour. Girtin's expressive, broad handling fully realizes the Romantic potential of the landscape; his work was important in establishing the place of watercolour in British painting. Turner said: "If Tom Girtin had lived, I should have starved."

ALLSTON (left)
Moonlit landscape, 1819
The mood of a Gothic novel (Allston had once attempted to write one) seems to infect his subject. It is invested with haunting tensions, in a fascination for the effects of supernatural forces.

DURAND (right)
Kindred spirits, 1849
Admiring the scenery in a Catskill glen, the two men (Thomas Cole and the poet William Cullen Bryant) create a typically Romantic image, wanderers or solitary figures dwarfed by Nature. Durand's training as an engraver is evident in the unsoftened detail and hard linear technique of the work.

COLE (right)
Sunny morning on the Hudson River, c. 1827
One of the first artists in America to devote himself wholly to landscape, Cole travelled from New York along the Hudson in search of inspiring scenery. The European tradition shows in the use of sunlight to give life to the wooded hills, and in the *repoussoir*, the foreground focus of rock and tree, leading the eye into the distance towards the plain. The Hudson River painters also ranged into the Catskill Mountains of New York and the White Mountains of New Hampshire.

BINGHAM (above)
Fur traders descending the Missouri, 1845
The enchanted stillness of the river belies the wildness of the country, where the traders bartered with the Indians for furs. There is a Chinese delicacy in the pale tones and the figures of the French trader and his half-breed son in their boat.

Constable: The White Horse

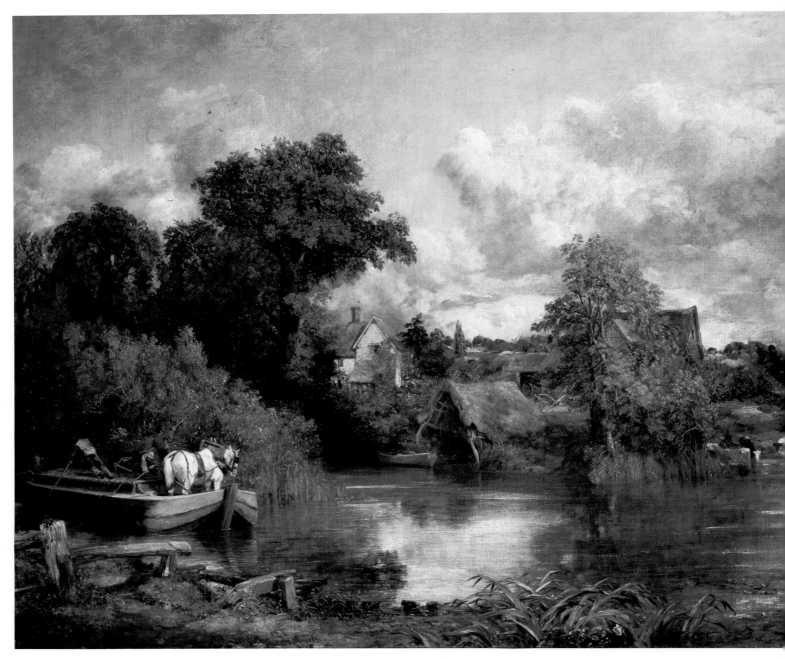

In late 1819 John Constable (1776-1837) was at last elected an Associate of the Royal Academy and was able to sign his latest work, now known as *"The White Horse"*, as A.R.A. The painting remained one of the artist's favourites' throughout his life, and in 1829 he bought it back from its first buyer. When exhibited in 1819, it had been greeted with enthusiasm by the critics – "what a grasp of everything beautiful in rural scenery", wrote one, predicting that "this young artist" would soon be at the top of his profession. The "young artist", however, was already 42, and success was coming late. Full membership of the Academy came only in 1829, after the most fruitful decade of his life had come to a close with the death of his wife in 1828, and he himself died nine years later.

Constable had been a slow starter. Son of a Suffolk mill-owner of some substance, he began full training at the Royal Academy schools in London when already 23. Although he always deplored the imitation by artists of earlier painters, he loved and often copied them, Claude as well as Gainsborough, though his affinity to the Dutch masters, to Ruisdael and Hobbema, is perhaps greater.

Constable insisted that the essential source for any original painter must be Nature itself, and that there was no alternative to drawing directly from Nature. His conviction was the foundation of his art, and of his own highly personal style, which became mature only by about 1810, when he was in his 30s. It did not mean that all his work was done in the open air, but he made endless studies, in pencil, in watercolour or in brilliantly free impressions in oil on paper or small wood panels, directly from his subject. Afterwards he used their material in building up his large compositions (what he called his "six-footers"), and for the famous *Haywain*, begun in 1821, he worked through a whole series of compositional variations, from a miniature scale to sketches equal in size to the finished painting. It was an experimental, pragmatic process, and the interrelationship of all these variations is often unclear, but Constable was adamant (though posterity does not always agree) that the finished painting was the climax of the process.

His longing was always to distil the eternal from the ephemeral, and to reveal what he loved to call the chiaroscuro in Nature, the interlocking harmony of the elements. Constable knew Wordsworth, whose poetry answered his painting, and quoted a phrase of his when describing his wish to make monumental "one brief moment caught from fleeting time". Empathy with Nature in all its moods informed them both, though Constable found his inspiration in the domestic, man-made landscapes of his native Suffolk, of Hampstead Heath or in the beaches of Brighton, rather than in the mountains and lakes Wordsworth loved. If there is ever an awesome quality in Constable's work it is in the skies, and in the

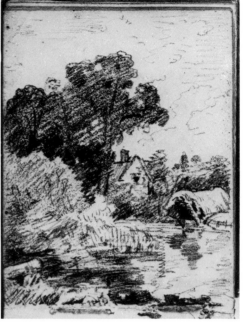

CONSTABLE (above)
Oil-sketch for *"The White Horse"*, c. 1819
Constable made a full-scale study in oil before painting his Academy entry – a procedure he later elaborated. This sketch corresponds less closely to the finished work than the several oil-studies for the later *Haywain*, and less closely also to prior studies made from Nature.

CONSTABLE (left)
"The White Horse", 1819
The first of Constable's "six-footers" – huge works devoted to mundane rustic scenes – the picture compelled immediate attention, if only for its size: such a humble subject had never before been presented on such an heroic scale. It was shown under the title *A scene on the river Stour*, "a placid representation of a serene, grey morning, summer". The barge-horse is being ferried across the river between Flatford and Dedham in Suffolk at a point where a tributary interrupted the towpath.

CONSTABLE (left)
Clouds, Sept. 5th, 1822
Constable's series of cloud studies typifies his almost scientific attempt to capture permanently the momentary in Nature.

CONSTABLE (above)
Pencil sketch, 1814
Constable compiled his oils from swift annotations in pencil or watercolour – this became an ingredient of *"The White Horse"*.

CONSTABLE (left)
The haywain, 1821
Constable's view of the house of a close friend, on the Stour near Flatford Mill, was distilled from long acquaintance, from studies made over many years, proving his heartfelt attachment to the scene. His emotional involvement with landscape was intense: he wrote: "The sound of water escaping from milldams, etc., willows, old rotten planks, slimy posts, and brickwork – I love such things. . . . Painting with me is but another word for feeling." The lavish scattering of highlights, "Constable's snow", which give vibrancy to the work, puzzled contemporaries.

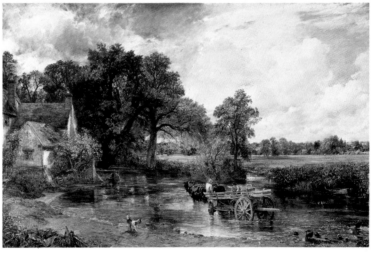

mood created by qualities of light – as in the small watercolour of *Stonehenge* with its double rainbow. Constable's love of Nature was both intense and true and faithful: he wrote: "Painting is a science and should be pursued as an enquiry into the laws of Nature". His "experiments" included studies of types of cloud formations, and his results were attempts to establish, in free, swift, open brushwork, the equivalent on canvas of English sunlight running through moist air, the wind rustling foliage and wimpling the water.

Constable's deepest impact, and his warmest reception, was in fact in France. *The haywain* was singled out by Géricault at the Academy in 1821 and in 1824 French critics acclaimed his work at the Paris Salon. Delacroix, entranced by Constable's light aerial key, reworked the background of his *Massacre at Chios* (see p. 329), and Constable's poetry of the ordinary later had effect on the rural meditations of the Barbizon school.

CONSTABLE (right)
Stonehenge, 1836
Ever more vigorous and masterly effects are evident in Constable's later works, especially in this watercolour view of the inherently dramatic "Druidic" megaliths of Stonehenge. A gleaming sky highlights the grey stones, revealing the artist's aim "to give 'to one brief moment caught from fleeting time' a lasting and sober existence, and to render permanent many of these splendid but evanescent exhibitions, which are ever occurring in the changes of external Nature".

Turner: Dawn after the Wreck

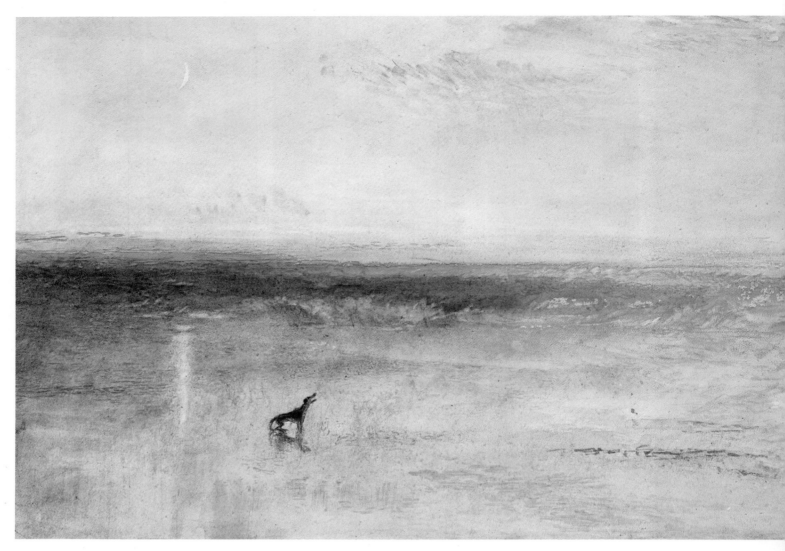

The sea, stretching to the horizon and beyond, illimitable as the skies above, is one of the elemental images of Romanticism. It compelled many artists to paint it, yet remained essentially indefinable – seeming, in an evening calm, to suggest a peace beyond understanding, but in storm one of the most formidable agents of inhuman, destructive power in Nature. The career of Joseph Mallord William Turner (1775-1851) was a long one, but through almost all of it he was obsessed by the sea in all its moods, though most of all by its more violent aspects.

Dawn after the wreck is a watercolour painted with the full freedom of Turner's later years, probably about 1840. It belonged originally to a friend, the Rev. Kingsley, but it may well have started as one of what he called his "beginnings", and not necessarily with the idea of being worked up into a "finished" picture for framing and hanging on a wall. Turner kept sketchbooks all his life (all left to the nation, amongst 19,000 or so watercolours, and now in the British Museum). In the later books, hundreds of colour sketches record atmospheric effects, many of which may read to the modern eye as pure abstracts; already in 1799 he told a colleague he had "no settled process", but "drove the colours about till he had expressed the idea in his mind". *Dawn after the wreck* may well have started with

Turner snatching at an effect of turbulence of light and colour and painting very fast, perhaps with the aid of the sharp end of the brush, even fingers. The stability of the composition hangs on the strong yet disturbed horizontal of the horizon, transfixed by the tremulous reflection suspended from the frail sickle of the new moon, which together with the flecks of cloud defines the sky as sky. Then the addition of the title spelled out the Romantic desolation; the sea, the victorious destroyer, subsides, passion all but spent. And possibly after that came the shivering dog with its almost audible howl of mourning.

Turner was very precocious. He started traditionally, as a travelling topographical draughtsman and watercolourist. He exhibited *Tintern Abbey*, a drawing of literal linear accuracy and great accomplishment, in the Royal Academy in 1795, when he was only 20. Unlike Constable, he was able to make himself acceptable to the art establishment and public very early: he was a full Academician by 1802 – a recognition denied Constable, born one year later, until 1829. Gradually, however, as he developed towards an ever greater freedom, his work began to mystify most people. His later pictures were called "fantastic puzzles", but were nonetheless based on the faithful observation of Nature. The first of his famous vortex compositions, *Snowstorm: Hannibal*

TURNER (above): *Dawn after the wreck, c.*1840

TURNER (above)
Tintern Abbey, c. 1795
Together with Girtin, Turner had copied watercolours by John Robert Cozens – *Tintern Abbey*

reflects the influence of Cozens' wistful tonalities. Such Picturesque views contributed significantly to Turner's income, and first made him known abroad.

TURNER (left)
The slave-ship, 1840
Turner reacted emotionally
to a recent scandal in which
a slave-ship's captain had
thrown overboard those of
his "cargo" dying of fever.

TURNER (below)
*Snowstorm: Hannibal
crossing the Alps*, 1812
Turner attempted to show
the truth of natural fury,
rather than exaggerating
its scale, like John Martin.

TURNER (above)
*The Thames near Walton
Bridge*, c. 1807
Turner seldom sketched
in oil in the open air. This
exception may pre-empt
innovations by Constable.

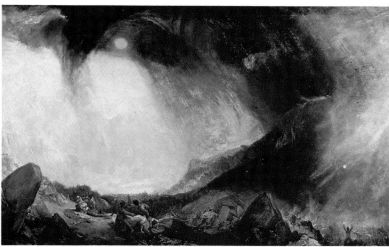

TURNER (below)
*Sun rising through vapour:
fishermen cleaning and
selling fish*, 1807
The seascapes and harbour
scenes of Cuyp and van de
Velde challenged Turner at
the beginning of his career.
Determined not just to rival
but to excel these masters,
he adopted similar subject
matter, but introduced his
own concern with elusive
effects of natural light.

TURNER (above)
*Venice: S. Giorgio
Maggiore*, 1819
Turner's first visit to Italy
in 1819 was a revelation of
light and colour, a decisive
event in his career. The
freedom of these water-
colours indicates a direct
and revolutionary response
to the haunting, luminous
atmospherics of Venice,
held in pure transparent
tints on a white ground.

crossing the Alps, 1812, was based on a violent
storm he had witnessed two years before in
Yorkshire. In an overarching, overwhelming
paroxysm, Nature rears in all its blind force, in
the biting fury and flurry of snow, cloud and
ice. At the other extreme, his *Burning of the
Houses of Parliament* (1835; not shown) shows
light and fire threatening to consume not only
the centre of Government but the earth and
water as well. Gradually his basic theme
became light itself, in an almost Shiva-like
capacity as creator and destroyer – creator, by
revealing the physical world, destroyer, by
dissolving solid form in luminous veils of
colour. Already in 1816 the writer Hazlitt
complained that Turner's paintings were "re-
presentations not properly of the objects of
Nature as of the medium through which they
were seen". It was part of Turner's achieve-
ment successfully to transpose into oils the
technique of watercolour, with all its lightness
and fluency, and ability to capture the most
fleeting, evanescent atmospheric effects.

Though the public found such works eccen-
tric ("pictures of nothing, and very like it"),
Turner painted a whole series of pictures,
spread over many years, in which he self-
consciously and provocatively allied himself to
the European tradition, challenging Claude
and Poussin, Cuyp and van de Velde, Wilson,
even Titian, Veronese and Rembrandt. In
paintings such as *The slave-ship*, 1840, he
evoked marine catastrophe in terms surpassing
Géricault's *Raft of the Medusa* (see p. 327) –
here the tormented seas are laced with human
blood. In contrast, his paintings (not shown) of
Norham Castle, made in the early 1840s, are
rich with a radiant serenity, and make a
fascinating comparison with the very similar
viewpoints he had selected at the same site in
the late 1790s: these early watercolours had
been romantic enough, but in the late full-scale
oils the subject is dissolved into insubstantial
mists of glowing, shimmering colour, in which
castle or cattle are mere accents subsumed into
emanations of light.

In his lifetime Turner was recognized as a
genius who might be criticized but not denied,
and in John Ruskin (1819-1900) he found a
sympathetic critic and panegyrist of genius. In
Modern Painters, 1843, Ruskin placed Turner,
as the artist who could most stirringly and
truthfully measure the moods of Nature, at the
culmination of a tradition stemming from
Dürer and the Venetian colourists. Turner and
Constable dominated the subsequent course of
landscape in England, and both were ac-
claimed in France, though Turner rather later.
The Impressionists took respectful note, if
with reservations; and his work has continued
to have reverberations, not least in the abstract
painting of the later twentieth century.

German and Scandinavian Romanticism

After the magnificent originality of Dürer, Holbein, Grünewald, no outstanding Germanic genius in painting or sculpture had emerged. The great German and Austrian Baroque and Rococo decorators had worked with brilliant virtuosity in an international tradition; the ablest German Neoclassical painter, Mengs, spent most of his working life in Italy and Spain. Nor, to begin with, was there an upsurge in the visual arts comparable to the astonishing Romantic literary activity in Germany. Goethe was established long before his death in 1832 as the presiding genius of European culture, and he was followed by remarkable writers in the Romantic spirit, such as Schiller, von Kleist, the mystic Novalis and Tieck, while the Schlegel brothers' Romantic philosophy was discussed throughout Europe. Napoleon's domination of Europe inspired by reaction a sense of common racial and cultural inheritance amongst German intellectuals, even though the diverse kingdoms and principalities of the German peoples were to remain fragmented for many years yet.

In the 1770s the young Goethe had emerged as the prophet of German Romanticism – in the violence, and colourful appeal to German legend, of *Götz von Berlichingen*, in the introspective melancholy of *The Sorrows of Young Werther*, and in a panegyric of Gothic architecture. At this time Goethe identified art with "Nature", emphasizing the particular rather than the general, and the overriding importance of autonomous "genius", although he came later to feel that the emphasis on feeling over reason was becoming morbidly unbalanced. His involvement with the visual arts continued all his life, and he knew personally the painters Runge and Friedrich.

German Romanticism found its characteristic visual expression in three modes, which often came together in a single work – landscape, overt symbolism, and nationalistic medievalism. In its visionary intensity it was closer to English than to French attitudes, but generally more dour in temper and more concerned with explicitly religious themes. The models from which Romantic landscape developed were provided by the established traditions of pastoral landscape, as is clear in *Northern lights*, about 1790, by Jens Juel (1745-1802), in which a conventional, even tame, formula is opened up on to a limitless ether. Juel taught at the Copenhagen Academy, where both Friedrich and Runge studied. The

FRIEDRICH (right)
Monk by the sea, 1809
Friedrich later removed two boats he had originally included in the landscape, in order to emphasize its starkness and spiritual isolation. On it von Kleist commented: "Because of its monotony and boundlessness, with nothing but the frame as foreground, one feels as if one's eyelids have been cut away" – in terror in the face of infinity.

JUEL (left)
Northern lights, c. 1790
Juel enjoyed a popular reputation for his scenes of the open air, somewhat in the spirit of Gainsborough. Here, however, the picture stimulates curiosity by its very enigma. Who is the man sitting by the gate? Where does the path lead? The gate, notably, is shut on the dissolving distance.

KOCH (left)
Schmadribach waterfall, 1808-11
Earlier such a landscape would have been equated with a desert, but to Koch the elemental forces of Nature conveyed something of the heroic *terribilità* he admired in Michelangelo.

DAHL (above)
Clouds, 1825
The trees and spires rising into the sky are devoid of symbolic meaning. Dahl was interested in Nature only for its intrinsic beauty, and so was close in spirit to Constable; he developed the example notably of Ruisdael.

RUNGE (above)
Morning, 1808-09
Despite the enigmatic and slightly absurd imagery, the painting could stand as an illustration to Wordsworth's poem *Intimations* *of Immortality*, conveying divine unity and rhythm in Nature. In the baby's eyes, every element seems "apparelled in celestial light, the glory and the freshness of a dream".

influential Anton Koch (1768-1839) at first produced classicizing ideal landscapes, echoing Poussin, which, though he retained a firm grasp of structural principles, he later invested with an emotional, Romantic feeling.

The outstanding interpreter of German Romantic landscape was Caspar David Friedrich. Born in Pomerania, he worked from 1798 in Dresden, but his temperament seemed always to retain the cold melancholy of Baltic shores. His landscapes are the purest expression in European Romantic art of the yearning of man for communion with Nature, even if their prevailing tragic sadness speaks of alienation, and ultimate solitude, in the attempt. The essence of Friedrich's message is summed up in his *Monk by the sea* of 1809: the solitary – it must be, doomed – figure is a small dark accent between the voids of land, sea and sky. There was some give and take between Friedrich and his friend, the Norwegian Johan Christian Dahl (1788-1857), but Dahl's interests were more in the naturalistic side of Romantic landscape. He was making detailed studies of cloud formations at the same time as Constable, in the 1820s, quite independently.

Friedrich's work is dense with symbolism

(see over), but the symbolism of Philipp Otto Runge (1777-1810) is even more overt. Runge, like Goethe, published a work on colour theory, but was also much influenced by the linear purity of Flaxman's illustrations. He died aged merely 33, leaving only fragmentary witness of his main ambitions. A mystic who might easily have become a Lutheran pastor, he had a virtually religious, all-embracing, dedication to art, and landscape was the only branch of art that could support its intensity, being for him a medium for the comprehensive representation of all the elements of life. He aimed ultimately at a *Gesamtkunstwerk*, incorporating all the arts – poetry, architecture and music. Of his major project, *The Four Phases of Day*, only one vast canvas (subsequently dismembered) was completed, *Morning*. In this the sharpness and delicacy of his vision are brilliantly clear. His portraits are perhaps his most successful surviving works: that of his parents, whose wooden vigour in the relentless light is contrasted with the dewy but also merciless innocence of the grandchildren, is one of the most extraordinary and monumental portraits of the early nineteenth century. In his engravings of *The Phases of the*

Day, he condensed his symbolic language into a near-diagrammatic form.

The medievalist and nationalist approach is best exemplified by the Nazarene group. These young artists formed a quasi-religious Brotherhood of St Luke in Vienna in 1809, and in 1810 migrated to Rome, to what would now be called a commune, in an abandoned monastery, where they lived, painted, prayed and sang together. The original leader, Franz Pforr (1788-1812), who had illustrated Goethe's *Götz* in a Dürer-like style, left a striking medieval reconstruction, *The entry of Emperor Rudolf of Hapsburg into Basel*, before his early death. He was succeeded by Friedrich Overbeck (1789-1869). Generally, the Nazarenes wished to fuse the best of early Italian styles (especially Raphael's) with the best of German (Dürer); they also revived early techniques, fresco and tempera, and in this the most talented of them was Peter von Cornelius (1783-1867), who early illustrated Goethe's *Faust*, developing a hard, linear style of great vigour and intensity. However, the example of the Nazarenes, as a breakaway group extolling primitive techniques and ways of life, was perhaps more significant than their work.

RUNGE (right)
Morning, from *The Phases of the Day*, 1803
The series of engravings appeared as *Die Zeiten* in 1805, indebted to the style of Flaxman, and to motifs culled from Bellini and early Renaissance art, but the meaning was new.

In sentiment they perhaps seem close to Blake, but Goethe compared these prints with the music of Beethoven, which "tries to embrace everything and in doing so always loses itself in the elemental, yet still with endless beauty in the particulars".

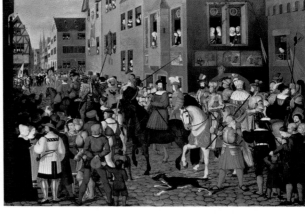

PFORR (above)
The entry of Emperor Rudolf of Hapsburg into Basel in 1273, 1808-10

This is one of the first large medieval history subjects, depicted in a consciously archaic style.

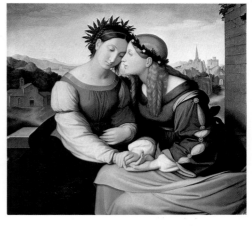

RUNGE (above)
The artist's parents and his children, 1806
The cool light mercilessly exposes the figures – the suspicious gaze of the old couple, stiffened by age, contrasts with the children's pure absorption with the bright flowers.

CORNELIUS (right)
Faust and Mephisto on the Brocken, c.1811
The style owes much to Dürer. Romantic artists sought the imaginative and passionate in literature – Goethe's *Faust*, plays by Shakespeare, ancient epic – Homer, Virgil and Ossian.

OVERBECK (above)
Italia and Germania, 1811-28
The physiognomies, dress and colours are based on Raphael. The landscape, too, is Italianate, save for a

Gothic church spire. The wreaths and idealization of the faces emphasize the eternal significance of the encounter. The artist used the composition of a Visitation for the embrace.

Friedrich: Man and Woman Gazing at the Moon

Caspar David Friedrich (1774-1840) has shown the man and woman from behind, beheld by us as they themselves behold the moon. Our own position is uncertain, since we see them from above; no stabilizing foreground links us. They are alone together, as almost all Friedrich's figures are alone, as if alienated, silent, their faces unseen. Beyond them, the moon rides remote in infinity.

The picture is replete with Friedrich's personal symbolic imagery. Thus, for him, the moon represents Christ. The pine trees (Christian faith on earth) are traversed by a stony path (the path of life) winding uphill (towards Christian redemption). The shattered and dying oak tree and the dolmen represent transience and paganism, while the dark abyss falling away to the right shows the way down to temptation and unbelief. However, the impact of the picture is far from being entirely dependent on the spelling out of its symbolism. The success of Friedrich's finest paintings rests on their vivid visual coherence, their credibility as real topographical sites.

The painting is a variation on a design which obsessed Friedrich throughout his career, and which had been established in the haunting solitudes of *Moonrise over the sea* of 1822, in which Friedrich repeats with only slight variations a version of 1819, *Two men contemplating the moon*; here the two men of the *Moonrise* are replaced by the artist himself and his wife. The theme reached its most complex elaboration in *The stages of life* of 1835.

All Friedrich's work is religious, the most astonishing example coming early in his career, *The Cross in the mountains* of 1808, known as the Tetschen altar. It was in fact used as an altarpiece, though it is a landscape, which caused controversy. The sun sets, the old order passes, its last gleams transmuted in the golden figure of Christ on the crucifix, while the rock symbolizes steadfast faith in Christ. The mood has a serene, even optimistic quality unusual in Friedrich's work. The famous *Abbey graveyard under snow*, with the gaunt Gothic choir rising in a snowy graveyard amongst shattered trees, is more typical. Terrifying in its bleak mystery, it is one of the most haunting images of European Romanticism.

Friedrich's predilection for Gothic forms has no doubt some nationalistic significance, and his work included positive references to the German struggle for freedom against Napoleon. But Friedrich's art was essentially non-topical, visionary. "The artist should not only paint what he sees before him, but also what he sees within him. If, however, he sees nothing within him, then he should also omit to paint what he sees before him".

In the 1812 painting of Friedrich by Georg Friedrich Kersting (1785-1847), the artist is seen in an austerely empty studio, summoning up his picture from within himself rather than from outside. Friedrich was nevertheless a close and precise observer of Nature, as a great many drawings make clear. The detailed precision of his drawing reinforces his startling contrast of the mundane with the unearthly. His people may appear in frock-coat or dress and bonnet – dressed, as it were, for office or shopping – but poised on the brink confronting eternity. Usually his figures are unemphatic, often seen from behind. They are simply and exactly described, yet such is their still intensity that the effect is transcendental.

Friedrich's technique could seem somewhat dry; painterly virtuosity, the sensuous delight in the painter's materials, was always strictly subordinated to the image to be produced, in a style descriptive rather than expressive, so that he was for long condemned as a literary painter. Many of his paintings are of twilight or dusk or moonlight, but in fact he was a most subtle colourist. He lived out his life quietly in Dresden, and the considerable attention that his work had at first attracted dwindled, until at his death he was almost neglected – and so he remained until the 1890s, when the Symbolists rediscovered the formidable potency of his imagery. Indeed, echoes of Friedrich are to be found in the greatest of the northern Expressionists, Edvard Munch. Friedrich's art, in fact, was no less revolutionary than the very differently generated landscapes of Constable and Turner. The analogy of his art with Chinese landscape painting, though it cannot be pressed too far, is striking – the vision of man alone in the immensity of a natural world that is the symbol of an infinity beyond.

FRIEDRICH (above)
The Tetschen altar: *The Cross on the mountains*, 1808 Friedrich himself designed the gold frame. On the base, shafts of light around the eye of God echo the rays of the setting sun, while the wheat-ear and grapes refer to the Last Supper. The star above symbolizes both death and resurrection.

FRIEDRICH (below)
A dolmen near Gützkow, c. 1837 These prehistoric burial stones, stranded like wrecks in the sea of time, fascinated Friedrich: they suggested at once human transience and eternity. A dolmen occurs in the left foreground of *Man and woman gazing at the moon*.

FRIEDRICH (above)
Abbey graveyard under snow, 1810 The way in which the once Picturesque attractions of the Gothic past are raised into mystical symbolism is typically Romantic. The skeletal trees and the Gothic ruin endure against time in transcendental melancholy.

A German Romantic poet, Körner, had described a similar, earlier picture as a *Totenlandschaft* (a landscape of the dead). Indeed the monks appear to be carrying a bier into the "bare ruin'd choir" of the church. A mist completes the sense of sepulchral mystery and lost faith.

FRIEDRICH (left)
Moonrise over the sea, 1822 Though ostensibly closely observed and naturalistic, the canvas takes on a near-abstract appearance, with its vertical and horizontal axes and colour contrasts – the reddish browns of the land and the suffused bluish-purple sky. The sea without any horizon, a recurrent motif, suggests infinity and the unknown, against the familiar, homely silhouettes of the gazing townspeople.

FRIEDRICH (below): *Man and woman gazing at the moon*, c.1830-35

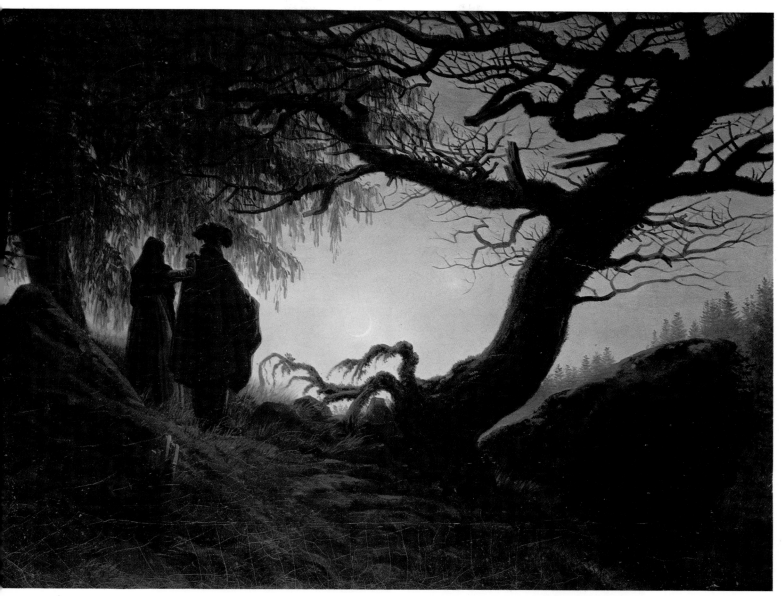

FRIEDRICH (left)
The stages of life, c.1835
This is perhaps the most personal of all Friedrich's images of transience. Sea and sky shine luminously, but soon after he painted them Friedrich had a stroke from which he never fully recovered. The painter is the old man confronting infinite spaces, while his children and grandchildren stand, sit or play close by.

KERSTING (right)
Caspar David Friedrich in his studio, 1812
The painter has shuttered the lower part of his studio window, blocking out the world, the better to visualize his inner world as he broods over his canvas. The bars of the window form a Cross in the sky, like a delicate blessing.

French Romanticism

The figure who links French Neoclassicism with Romanticism is Antoine-Jean, Baron Gros (1771-1835), considered by David a wayward pupil, yet his favourite. David made over his studio and, he hoped, his principles to Gros when he went into exile after the defeat of Napoleon in 1815. It had been Gros rather than David, in paintings such as *Napoleon on the battlefield at Eylau* (1808, not shown) or *The plague at Jaffa* (1804), who translated the heroic glamour, the legendary quality, of the Napoleonic era into paint. Gros's sense of drama infected his brushwork with a bravura much admired by the Romantics; by 1831, his huge *Napoleon at Eylau* could be identified by a Romantic critic as "the birth of the Romantic school". Although these compositions are in the grandiloquent classic tradition of "history" painting, the formidable and gruesome realism of the corpses in their foregrounds made a profound and lasting impression, especially when the Napoleonic triumph had turned to defeat. Gros's emotional instability, culminating in his suicide, is in key with one aspect of the Romantic temperament.

Not only his work, but the temperament and life-style of Théodore Géricault (1791-1824) –

not least his premature death, aged only 33 – make him an archetypal Romantic artist, in the example of Byron or Chatterton, Chénier or Keats. His first important painting, in the spirit of Gros, the dynamic portrait *An officer of the Chasseurs*, 1812, was offset by *The wounded cuirassier leaving the field*, painted in 1814 when Napoleon was in exile in Elba. Subdued in colour compared with the brilliance of the *Chasseur*, it is an image of defeat, but also of the glamour of death: it was found the more shocking because presented on an heroic scale, life-size. Géricault was obsessed throughout his brief life with images of violence. Horses provided him with one elemental example of power and speed, and in 1816-17, when he was in Rome (where the energy of Michelangelo's style had impressed him), he planned a colossal painting of the traditional race of riderless horses along the Corso; later, in England, he was to paint horses again, and his own death followed a riding accident.

His great masterpiece of 1819, *The raft of the Medusa*, has come to be seen as a manifesto of French Romanticism, much as David's *Oath of the Horatii* had been one of Neoclassicism. Here again, he treated an unheroic subject on

an heroic scale. The subject was topical, sensational, and open to political interpretation. The *Medusa* had been wrecked in 1816, a catastrophe ascribed, if on tenuous grounds, to Government incompetence. The survivors on the raft had endured the horrors of mutiny, exposure, starvation, even cannibalism. The moment chosen by Géricault was the terrible spurious dawn of hope, when a ship was sighted from the raft but passed without noticing. The composition, with its strong diagonal stresses, refers back to Baroque rather than to Neoclassical example, but the moulding of the figures is solidly founded on classical techniques and groupings. Though the theme is so intensely dramatic, even melodramatic, the figures in the finished painting have become idealized, perfect physiques, well-shaven and undisfigured by emaciation or sores; yet Géricault had painted studies for it from actual corpses, even severed limbs, with vivid objectivity. When first exhibited at the Salon, it seems initially to have been uncontroversial, and was even awarded a medal, but it had some *succès de scandale* later in London, and by 1847 the historian Michelet could see in it a comprehensive allegory of the troubles of

GROS (above)
The plague at Jaffa, 1804
Gros invests Napoleon with implicitly royal powers of healing and immunity when faced with plague-stricken troops during his Egyptian campaign. Postures from Italian religious painting, the ghastly realism of victims and the serenity of Napoleon are conjoined to effect his "canonization".

GERICAULT (right)
An officer of the Chasseurs, 1812
David had immortalized *Napoleon crossing the Alps* (not shown) in 1800, with his hero on a rearing horse against a scene of battle. Using a very similar pose, Géricault abandons the cult of personality and glorifies the sheer excitement of battle in the momentary stance of horse and rider, the energy of the paint, the vividness of colour.

GERICAULT (left)
A wounded cuirassier leaving the field, 1814
The vigorous movement of the horse is contrasted with the halting progress of the injured soldier, courageous even in defeat. This was a pendant to the *Officer of the Chasseurs*, and its sombre, apprehensive mood evokes the disillusion which followed Napoleon's fall from power in 1814.

DELACROIX (below)
The barque of Dante, 1822
Virgil is leading Dante into Limbo across the river Acheron, in which bodies of the damned are tossed. The corpses, composition and the Michelangelesque quality of the figures recall *The raft of the Medusa*, although Delacroix's rich colours anticipate the trend of his later painting.

France. Géricault's last works were remarkable studies of mad men and women, painted as scientific case-studies for a psychiatrist friend, but intensely emotive.

When Géricault died in 1824, Delacroix, in his *Barque of Dante* of 1822, had already paid his tribute to *The raft of the Medusa*, and was emerging as the presiding genius of the Romantic movement (see over), though he would never have categorized himself as such. The emotive subject matter used by Delacroix – exotic and oriental themes, violent depictions of animals, historical stories from the Middle Ages as well as from antiquity, and also from

the poets of passion, Shakespeare, Tasso and Byron – these were all adopted by many other painters. Landscape, too, was a development especially congenial to the Romantic temperament (see p. 340). Paul Delaroche (1797-1856; not shown) became aligned with Delacroix more because of rows with the Salon and his medievalizing "romantic" subject matter than for his style; his flair for the psychological moment in narrative was weakened by sentimentality, but he was immensely popular.

Géricault produced a few small pieces of sculpture, bronzes of powerful expressive force that anticipate Rodin's quality, but

generally sculpture was not a medium that the Romantics found congenial or particularly suitable. François Rude (1784-1855), a loyal supporter of Napoleon, went into exile with David in 1815, until 1827. His ability to fuse Napoleonic classicism with Romantic fervour and drama is strikingly shown in his *Departure of the volunteers* ("The Marseillaise", 1835-36), for the Arc de Triomphe in Paris. (Napoleonic and Revolutionary themes, forbidden under Charles X, returned to favour after 1830 under Louis-Philippe). Antoine-Louis Barye (1796-1875), who had first trained as a painter under Gros, turned his attention to the popular Romantic theme of wild animals, although his technique, in a prolific output of vivid small bronzes, was naturalistic rather than expressively Romantic. The most remarkable Romantic sculpture of all is Rude's *Awakening of Napoleon*, 1845-47.

By that date, Romanticism in France was established, consolidated by the support of critics and theorists. Middle-of-the-road Salon artists drew copiously if superficially on its achievement. But by then Courbet (see p. 338) was already active in Paris.

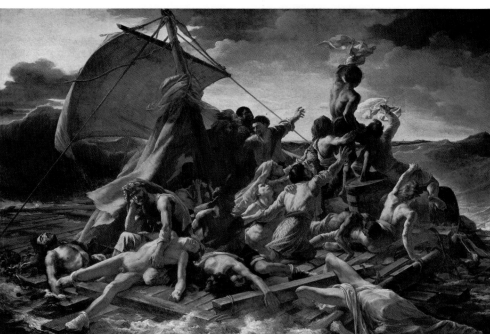

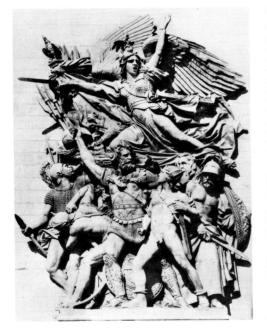

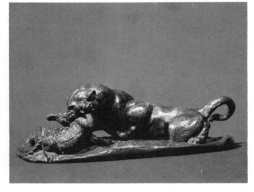

GERICAULT (above)
The raft of the Medusa, 1819
The exceptional intensity of Géricault's researches for the *Medusa* resulted in his eventual nervous collapse. The horrible and unheroic ordeal of the victims is elevated by visual reference to Michelangelo and Caravaggio, but no facile moral emerges: Géricault sought veracity, a conscientiously unsparing view of men at the limits of endurance.

GERICAULT (right)
A kleptomaniac, 1822-23
Dr Georget at the Paris asylum commissioned a series of objective studies of the pathological mind, believing that every mental illness was registered in a specific facial expression. Restraint and compassion infuse Géricault's portrait: it captures the sense of the subject's individuality even while the sitter is alienated within his own obsession.

RUDE
The departure of the volunteers, 1833-36
Rude echoes both spirit and structure of Delacroix's *Liberty leading the People* (see over). Recalling the heroism of the people who in 1792 had rallied to the Revolutionary cause, the vitality of the figures shows him realizing fully the dynamic possibilities of gesture and grouping.

RUDE (left)
The awakening of Napoleon, 1847
Rude liked David's blend of classicism and topical reference, though he here transforms it into a mystic archetype of French glory.

BARYE (above)
Jaguar devouring a crocodile, 1850
Many Romantics saw wild animals as metaphors of untrammelled freedom, their savagery expressing a primal urge in Nature.

Delacroix: The Death of Sardanapalus

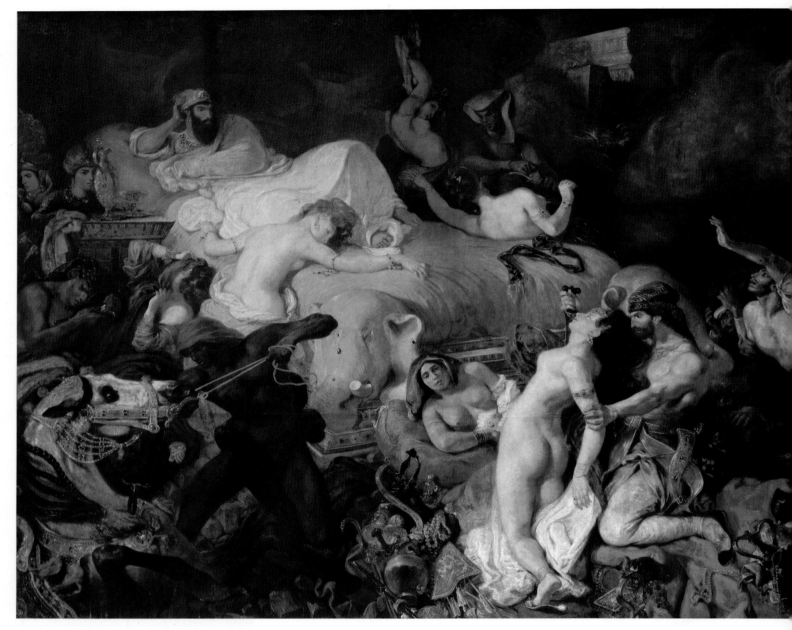

The first painting Eugène Delacroix (1798-1863) exhibited at the Salon in Paris was his *Barque of Dante* (1822; see preceding page), clearly influenced by Géricault and equally clearly in the Grand Tradition. Though it provoked some criticism it was bought for the royal collection. In 1824 he showed *The massacre at Chios*, which owed something to Gros's *Plague at Jaffa* (see preceding page); but while Gros had celebrated Napoleon serene in the midst of pestilence, Delacroix's *Chios* was a lament, or perhaps a celebration, of defeat. Although it was criticized for its "unfinished" quality, and its bold juxtaposition of colours seemed crude to contemporary taste, it was nevertheless bought by the state.

The death of Sardanapalus was a very different matter. It coincided in the Salon of 1827-28 with Ingres's *Apotheosis of Homer* (see p. 333) – confronting the Neoclassical principles of calm, clarity and nobility with dynamic bravura, colour, violence, exotic subject matter, sensual passion and morbid despair – a manifesto of extreme Romanticism. Delacroix

himself called it "an Asiatic feat of arms against David's Spartiate pastiche".

Sardanapalus is from Byron's drama of the same name. Byron's hero, though certainly of a voluptuous temperament, had in fact committed an heroic, self-sacrificial suicide, but Delacroix described him thus: "Besieged in his palace by insurgents . . . Reclining on a superb bed on top of a huge pyre Sardanapalus orders the eunuchs and palace officers to cut the throats of his women and his pages, and even of his favourite horses and dogs; none of the objects that have contributed to his pleasure must survive him." Hence, a self-indulgent, almost bored figure presiding impassively over a sensual abandon of destruction, in a clash of resonant colour and collapsing shapes.

Sardanapalus represents the climax of Delacroix's developing obsession with death and pessimism, and of his pictures of doomed heroic figures in despair and defeat; and his style was now fully evolved to deal with them – the movement of the paint itself, the chords of colour, being integral to the expression of the

artist's emotion. Delacroix clearly identified himself very closely with Sardanapalus; unlike Géricault's *Raft of the Medusa* (see preceding page) this is a work of personal fantasy, and ultimately remote from reality – no drop of blood obtrudes, for all its violence. Yet it is typical of Delacroix that the artist's involvement is balanced by a disciplined detachment, and the whirl of flesh and pleasure and colour spinning out from Sardanapalus is held within a controlled composition. But public reaction was violently hostile, and Delacroix himself had doubts, referring to the painting as his "retreat from Moscow" and keeping it thereafter unseen in his studio until his death.

In 1830 Revolution displaced the last of the Bourbon monarchs and installed the so-called "citizen-king" Louis-Philippe. Delacroix was a conservative in politics, a cool, impeccable dandy in society, and not one to participate on the barricades, but he painted the spirit of revolution, *Liberty leading the people*. The picture found favour: henceforward he was relatively secure in official patronage.

DELACROIX (left)
The death of Sardanapalus,
1827

DELACROIX (below)
The massacre at Chios, 1824
Byron, whom Delacroix
admired, had passionately
identified with the cause
of enslaved Greece; and yet
Delacroix shows an episode
from the War of Liberation
with a curious ambiguity:
the Turks' indifference is
as striking as the inertia of
their victims. Fatalistic
figures mostly recline in
a fresh, brilliant landscape.

DELACROIX (left)
Still life with a lobster,
1827
The conjunction of still
life and landscape is some-
what bizarre: exhibited in
the Salon in the same year
as *Sardanapalus*, it seems
to intend another kind of
antithesis to Neoclassical
theory and practice. The
tartan plaid among the
disparate objects reflects
Delacroix's current anglo-
philia: he had spent some
months in England in 1825.

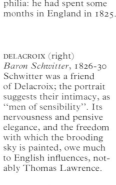

DELACROIX (right)
Baron Schwitter, 1826-30
Schwitter was a friend
of Delacroix; the portrait
suggests their intimacy, as
"men of sensibility". Its
nervousness and pensive
elegance, and the freedom
with which the brooding
sky is painted, owe much
to English influences, not-
ably Thomas Lawrence.

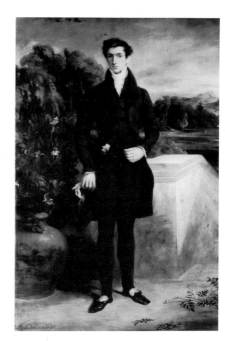

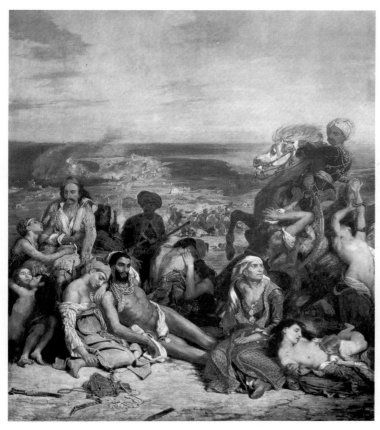

His voyage to North Africa in 1832 has been
likened to other artists' voyages to Italy. It
provided him with a source, recorded in many
sketchbooks, of exotic sensuous imagery and
of glowing colour. Its impact is summarized
in his small, famous and influential painting,
Women of Algiers, a memory of a harem
interior into which he had managed to gain
entry, a vision of languor half-asleep in volup-
tuous, floating colour. Violence however, was
still the theme of much of his later work, and in
an impressive series of small-scale paintings he
depicted horses, lions and tigers, symbols of
power and passion, with a vigour and intensity
rivalling Rubens. However, in his large official
commissions, he moved away from his more
Romantic obsessions. His aloof temperament
had always made him suspicious of the
publicity-conscious postures of militant Rom-
anticism, and it may be that he is equally
significant as the writer of the most elegantly
styled and perspicacious journal in the history
of art, and as the subject of an apologia by
Baudelaire, as for the bulk of his paintings.

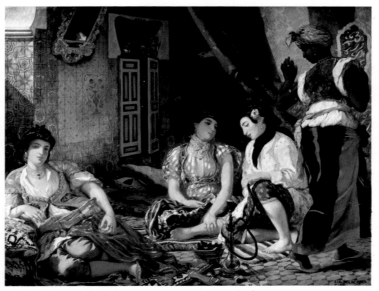

DELACROIX (above)
Liberty leading the people,
1830
Although Liberty is more
than a frigid abstraction,
and the People are workers,
not the bourgeoisie who
were in fact triumphant,
this is more a patriotic
than a specifically socialist
work. If it is restrained in
key and composition beside
Sardanapalus, it epitomizes
Romantic rebellion: per-
sonal protest has replaced
David's corporate idealism.

DELACROIX
Women of Algiers, 1834
The surface is patterned in
a close and intricate harmony
of colour, suggesting a new
attention to current theories
on colour complementaries.
The intensity of the almost
abstract design enhances
rather than dominates the
mood of subdued eroticism.
The Impressionists took
note, and so did Matisse.

Painting in Victorian Britain

The nineteenth century in Britain, after victory at Waterloo in 1815, was a period of peace at home and growing prosperity at the centre of a vast Empire. The Industrial Revolution had brought profit; its attendant miseries, in some ranks of the working classes, provoked no political revolution. Queen Victoria's reign (1837-1901) is synonymous with stability. Political life, so turbulent in France in the same period, was comparatively gentlemanly, and so, too, with few exceptions, was British art.

Art was considered as an educative and edifying element in civilized life, to be based on solid principles of Truth, Sentiment and Health. The expounder of these values, John Ruskin apologist for Turner (see p. 321) and then for the Pre-Raphaelites, assumed the stature of a major moral prophet. The maintenance of moral health required wholesome subjects – rural idylls for tired urban eyes, and religious, historical or modern themes with an edifying message. The trend is clear in the work of Sir David Wilkie (1785-1841), known as "the Scottish Teniers". He turned from his lively scenes of Scottish low life to elevated modern themes, such as the highly patriotic *Chelsea pensioners reading the Gazette of the*

Battle of Waterloo. The taste for genre developed in various ways – in fashionable costume scenes from contemporary literature; in picturesque studies of children; in the full-scale detailed documentaries of Victorian life produced by William Powell Frith (1819-1909) in the 1850s.

Crown, aristocrats and commoners generally concurred in taste. Queen Victoria's favourite painter, Sir Edwin Landseer (1802-73), appealed to the national love of animals; indeed his universally popular *Monarch of the glen* was at first intended for the elevated environs of the House of Lords. In the huge project of decorating Pugin's new Gothic Houses of Parliament at Westminster, important elements of national taste were clearly reflected, not only the renewed appreciation of medievalizing styles, but also, in its frescos (not shown), a growing interest in early Italian painting and the art of the German Nazarenes.

The Pre-Raphaelite Brotherhood was the fruition of such trends. The association of seven very young artists was formed in 1848, when their leader, William Holman Hunt (1827-1910), was only 20. Their programme was simple – to express serious, sincere ideas in

HOLMAN HUNT (below)
The awakened conscience, 1852-54
In accordance with Pre-Raphaelite practice, every detail points to the moral

drama – for example, the music on the piano, *Oft in the stilly night*, and the cat under the table playing with a bird. Hunt's concern for realism was tireless.

LANDSEER (below)
The monarch of the glen, 1850
The sentimental appeal of the noble beast, and the

Scottish element, popularized by royal enthusiasm for the Highlands, made this an image familiar in parlours throughout the land.

FRITH (above)
Derby Day, 1856-58
Frith used photographs, and numerous models, for his panoramic picture of racing day. The copyright for engraving was bought before the painting had been begun – the appeal of his ingredients was assured.

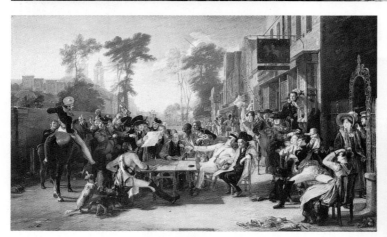

WILKIE (above)
Chelsea pensioners reading the Gazette of the Battle of Waterloo, 1822
At this first attempt to touch upon a "serious" subject, Wilkie scored a remarkable hit – it was railed off from delighted crowds at its exhibition.

MILLAIS (right)
Christ in the house of his parents, 1850
Using heavy symbolism to foreshadow the Crucifixion – the wound of the nail in the palm of the Child, the presence of St John and the sorrowing Virgin – Millais created a picture full of

sentiment and meaning. Its awkward poses, reflecting in part the influence of the Nazarenes (see p. 323), and the realistic features (a professional carpenter was the model for Joseph) outraged the dignified piety of the public. This condemnation roused Ruskin to defence.

a truthful way, relying on direct observation of Nature. They found authority in the example of Italian painters before the time of Raphael, whose work they knew mainly through engravings, but in practice what was so startling was their brilliant, luminous colour, helped by the use of a pure white ground. This seemed to many crude and even scandalous: the French critic Taine concluded that there must be "something peculiar in the condition of the English retina". To modern eyes their sharp vividness seems the most exciting phenomenon in Victorian painting; perhaps less so their typically Victorian high moral content. In *The awakened conscience*, 1852-54, by William Holman Hunt, a "loose" woman starts up from her lover's knees as her conscience is called to higher things. Sir John Everett Millais (1829-96) was the most naturally gifted of the group; to his horror, the painstaking, admirably observed and admirably drawn *Christ in the house of his parents*, 1850, caused scandal, and was lamented in a famous paragraph by Charles Dickens, the chronicler of England's social distress, as unacceptable in its naturalism – "to speak plainly, revolting". To modern eyes, nothing could be more whole-

some, and it is a far cry from the provocative Realism of Courbet. Pre-Raphaelitism, as a movement, lasted less than a decade; Holman Hunt continued faithfully in its principles, but Millais, in art-style as in life-style, was slowly absorbed into the Royal Academy, ending as its President.

Dante Gabriel Rossetti (1828-82), a major figure in the group, and a poet, too, nourished in a rather hot-house imagination the most original visions of any of the Brethren. In one of his earliest works, *The Annunciation* of 1850, the integration of symbolism with form and colour created an entirely new image of the Virgin. Something of Rossetti's visionary quality persists in the art of Sir Edward Burne-Jones (1833-98). With Rossetti, the designer William Morris and others, he painted frescos of scenes from Arthurian legend in the Oxford University Union (1857-62; not shown), which constituted one of the last productions of the movement. Burne-Jones' work was admired all over Europe, not least by the Symbolists (see further p. 371).

Outside the Brotherhood, the painter whose practice corresponded to Pre-Raphaelite ideals most closely was Ford Madox Brown

(1821-93). He was well aware of the art of the German Nazarenes, but the Pre-Raphaelites influenced his high key of colour and his dedicated naturalism. His *Work* (1852-65) is a striking "real allegory", like Courbet's *Studio* (see p. 338), though too crowded with minute detail for visual coherence; it is a better attempt to involve the whole range of society. His landscapes make an interesting comparison with the Barbizon school – similar aims pursued very differently. Hunt, too, sought symbolic and moral effects, and moral earnestness steadily inspired the work of George Frederick Watts (1817-1904), whose portraits are still recognized as outstanding. His allegorical subjects became diffuse, overcome by the attempt to portray eternal truths, but in his *Hope* he produced a compelling image.

Watts' didactic earnestness was out of key with the ideal art of the late Victorian Academicians, such as Lord Leighton or Sir Lawrence Alma-Tadema, working in a virtually international academic tradition (see p. 335). But the English art scene from the 1860s was provoked and disturbed by the presence of the American Whistler (see p. 344), who came from Paris with a quite different approach.

MADOX BROWN (right)
Pretty baa lambs, 1851
Painting in the open air, Brown explored ground also covered by the Barbizon school and Impressionism, but in a quite different way, with brilliantly light colour and in minute detail. He pioneered Pre-Raphaelite landscape with Hunt, and Ruskin urged their followers to produce work of even more painstaking naturalism.

BURNE-JONES (left)
King Cophetua and the beggar maid, 1884
Burne-Jones' sombre colour, the softness and grace of his line, are related to the work of Puvis de Chavannes (see p. 370) and to Art Nouveau. The subject, taken from an Elizabethan ballad, is literary and quasi-medieval, but "I mean by a picture", he said, "a beautiful romantic dream of something that never was, never will be".

ROSSETTI (above)
The Annunciation, 1850
The simple primary colours and compressed, elongated space were revolutionary at the time, and unacceptable. The Virgin conforms to a distinctly Pre-Raphaelite aesthetic, with long face, large eyes and wavy hair.

MADOX BROWN (right)
Work, 1852–65
Belief in the moral function of the arts and the necessity for social reform inspired Brown's didactic painting. To the right stand Carlyle and Frederick Maurice, the Christian Socialist; to the left the idle rich and the tramp pass the workers by.

WATTS
Hope, 1886
Watts' Symbolist image of an emotional state entitled Hope (but equally eloquent of Despair) was reproduced in thousands of delicately

coloured mezzotints. The wan, attenuated figure is strikingly close to those of Puvis de Chavannes (see p. 370). She is blindfold, and holds a harp on which she plucks unheard music.

Ingres: La Grande Odalisque

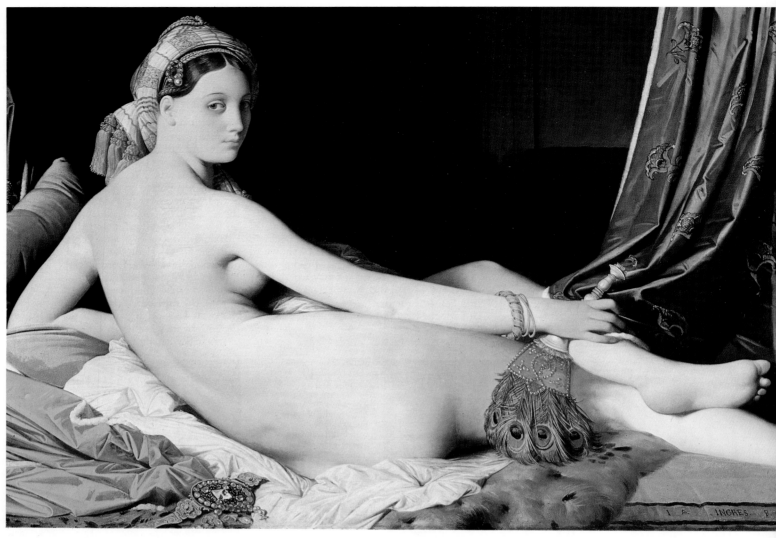

Jean Auguste Dominique Ingres (1780-1867), a pupil of David's, is said to have assisted in the painting of the famous reclining *Madame Récamier* (see p. 307), for which David seems to have made a nude study, and the pose is echoed in Ingres's own *"La Grande Odalisque"* (The concubine), painted in Rome in 1813-14. It is an essay in the long tradition of recumbent female nudes that stems from Titian's *"Venus of Urbino"* (see p. 145), and one of many variations on Ingres's personal and so successfully realized vision of the nude. Of these the most natural and, in the objective precision of its drawing, the most classical, is the earlier *"Valpinçon Bather"* of 1808, a superbly cool study in pale flesh colours and tones of white, yet also in its secretive way intensely erotic. Ingres's famous command of line is already completely assured.

The domination of contour is in accordance with the Neoclassical principles of David, but the total impression of the *Odalisque* is of a nude seen for its own sake rather than as an illustration of any ideal or heroic theme. It departs from strict Neoclassic canons, both in subject matter and in the way it is handled. Though preceded by many assiduous studies from the life, the anatomy is unnaturalistically modified for the sake of the composition – contemporary critics observed disapprovingly

INGRES (below)
"The Valpinçon Bather", 1808
The effect of suspension of time and gravity is achieved by the diffusion of light, the insistent verticals and the refined contour of the sitter's untroubled repose.

INGRES (above)
"La Grande Odalisque" (The concubine), 1814
The *Odalisque* was commissioned by the Queen of Naples, Napoleon's sister, but never delivered, since the Emperor's fall intervened. Ingres remained in

Rome but sent the picture to the Paris Salon of 1819, where one critic wrote: "Sworn enemy of modern schools, and infatuated with Cimabue, he has taken the dryness, crudity, simplicity and all the Gothic traits with a rare talent."

INGRES (below)
The Turkish bath, 1859-62
A description of a women's bath in Istanbul, and illustrated accounts of oriental travels, inspired Ingres's complex composition, which includes several portraits, though not of Easterners.

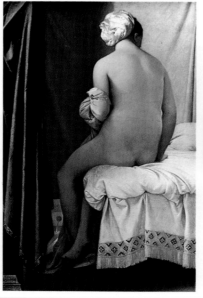

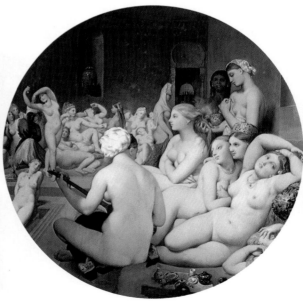

INGRES (below)
Oedipus and the Sphinx,
1808, reworked 1825
Ingres enlarged the picture
in the 1820s, filling in the
figure of the Sphinx and
adding the fugitive man,
thereby investing it with
immediacy, and stressing

the element of terror –
the horrible fate of those
who failed to solve the
riddle. Oedipus is posed
apparently in imitation of
the Antique, but Ingres
was not just a stylist: he
wrote: "I copy only from
Nature and never idealize."

INGRES (below)
*Joseph Woodhead, his wife
Harriet and her brother
Henry Comber*, 1816
Each figure is drawn with
admirable precision, each
face carefully portrayed,
traced without shading in
Ingres's unfaltering line.

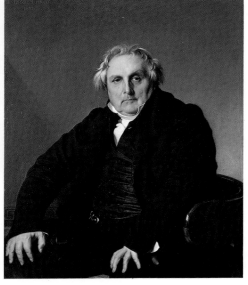

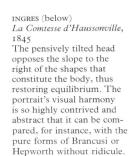

INGRES (left)
Louis-François Bertin,
1832
Bertin's pose presented a
problem until Ingres saw
him in earnest discussion,
and used this stance. As
the founder of the *Journal
des Débats*, Bertin stood
for the liberal bourgeoisie
and the establishment; this
perhaps aided the portrait's
success in the 1833 Salon.

INGRES (below)
La Comtesse d'Haussonville,
1845
The pensively tilted head
opposes the slope to the
right of the shapes that
constitute the body, thus
restoring equilibrium. The
portrait's visual harmony
is so highly contrived and
abstract that it can be com-
pared, for instance, with the
pure forms of Brancusi or
Hepworth without ridicule.

INGRES (below)
The apotheosis of Homer,
1827
Ingres attached considerable
importance to this work
(for a ceiling in the Louvre
but conceding nothing to its
position), and was hurt by
the lack of due appreciation.

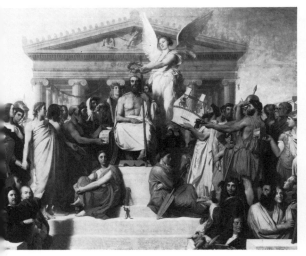

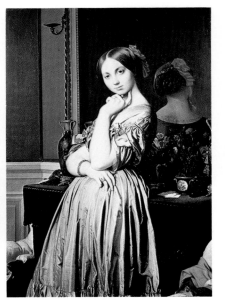

that the back had been elongated by the
equivalent of at least two vertebrae. The effect
is more closely related to the cool, smooth
eroticism of much sixteenth-century Manner-
ist painting than to Ingres's beloved Raphael.
When finally exhibited in Paris, the *Odalisque*
was found eccentric and bizarre. Only with
"*La Source*" of 1856 (see over) did Ingres
produce an image of the nude that responded
entirely to popular taste.

Ingres's obsession came to a remarkable
climax in the famous *Turkish bath*, completed
when he was 83 (as he noted beside his
signature with a natural pride). This extra-
ordinary welter of nudes, the highly refined
result of a series of searching studies, appears
in the abstract view as a remarkable resolution
of swarming curving forms within a tondo
form. Admired by Prince Napoleon, it was
painted only a year before Manet's notorious
Olympia (see p. 342). Ingres's vision was ap-
parently acceptable partly because it was
clearly placed in an exotic fantasy world.

Ingres's early career was far from an un-
mitigated popular success. Even in lucidly
drawn classical subjects, such as the *Oedipus
and the Sphinx* of 1808, there is something
strange, and the painting was criticized for
being flat and shadowless; he was accused of
being Gothic, of being *un Chinois égaré*, a
Chinaman who had lost his way. Alienated by
French censure, he spent many years in Italy
(1806-24), but in mid-career he became estab-
lished and returned to Italy (1835-41) as
Director of the French Academy in Rome.
Although artists of opposing views never quite
reached the point of pitched battle, as factions
of writers did at the famous opening of Victor
Hugo's Romantic drama *Hernani*, their anta-
gonisms were ferocious, and Ingres was a man
of high and stubborn temper. At a Salon show,
after Delacroix had left, it is reported that
Ingres demanded that the windows be opened:
"I smell sulphur."

Ingres's influence was extensive and endur-
ing over successive academic generations (but
also on Degas and even on Matisse). The vast
Apotheosis of Homer, 1827, was to remain the
model for many frigid murals. It is a response
to Raphael's *School of Athens*, laboriously and
efficiently executed as if expressly to illustrate
Winckelmann's description of "noble sim-
plicity and calm grandeur"; but its artificiality
discourages the modern spectator.

Arguably, Ingres's most purely successful
work is that in which he was most closely
committed to his own contemporary reality.
The exquisite delicacy of his early pencil
portraits, mostly done in Italy, has rarely been
surpassed, while in minutely detailed and
highly finished parade portraits he was to
mirror the sumptuous material prosperity of
the Parisian bourgeoisie of the mid-century,
and create images of formidable monumen-
tality. Few portrait painters illustrate better
Dostoevsky's note that the portraitist's job was
to catch his sitter at the moment when he
looked most like himself – most individual, yet
representing a whole human social type.
Baudelaire praised the *Monsieur Bertin* of 1832
and the later *Comtesse d'Haussonville* as "ideal
reconstructions of individuals".

Academic Art in Europe

In the first half of the nineteenth century, most of Europe experienced a boom in the production of paintings; a new market opened up as patronage expanded from the top ranks of society to an increasingly large and prosperous urban bourgeois population. The art trade became widely and firmly established: through official exhibitions, through dealers, and especially through mass-produced prints (made possible by technical improvements in engraving processes), pictures reached an enormous clientèle. In sculpture (see p. 354), there was a corresponding demand for small-scale works for domestic settings, and a growing national and civic pride prompted ubiquitous municipal architectural sculpture and statues.

The training of the artists who produced this kind of art was based, almost throughout Europe, in the official academies. This orthodox professional stream of nineteenth-century art was dismissed almost completely by later critics (dazzled by successive progressive avantgardes), and only recently has its long overdue reassessment begun.

The principles of the academic tradition were rooted in the *disegno* of early Renaissance Florence – stressing the importance of drawing, the defining contour of line; the detailed preliminary study; the subordinate role of colour; and the necessity both of classical balance and of "finish". These principles had been upheld in the French Academy by a long line of painters from Lebrun to David. The highest themes were classical or Christian, and the noblest subject was the human form, to which a certain decorum of "nobly" expressive pose and gesture was appropriate. These principles persisted through the nineteenth century, but interiors, sentimental scenes of peasant life, views of exotic lands and customs, portraits, genre scenes in the Dutch mode – these were all also in great demand, painted again in a closely detailed manner.

The dominant figure of the academic, classical tradition was Ingres (see preceding page), whose name became almost synonymous with it, and the polarization between academic classicism and Romanticism was conveniently but too sweepingly summarized in the fierce antagonism (theoretical, practical and personal) of Ingres and Delacroix. In fact even Ingres's classicism could be far from orthodox, and what we now call academic art was not the only kind to receive major official patronage –

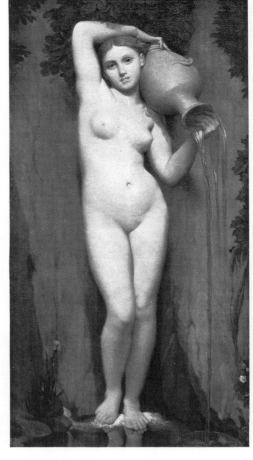

INGRES (right)
"La Source" (The spring), 1856
Ingres's generalized nudes gave rise to the type called the *femme de l'Ecole*, which joined sensuality with dewy innocence. His allegorical figure triumphed in the Salon, fetching a ransom.

COUTURE (left)
The Romans of the Decadence, 1847
The moral of Couture's highly-praised historical allegory on contemporary society was: "Crueller than arms, lust descended upon Rome and avenged the conquered world."

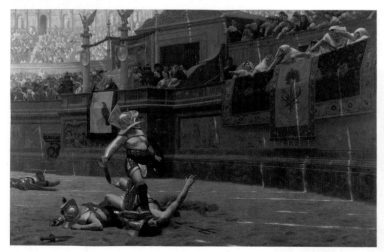

FLANDRIN (right)
Theseus recognized by his father, 1838
The studied monumentality and high finish of the work echo Neoclassical example, but it lacks any deep-felt meaning or spirit.

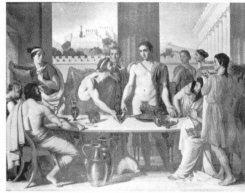

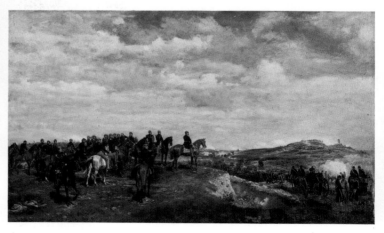

GEROME (above)
The gladiators, c. 1859
With vehement gestures the crowd urge the victor to slay his opponent – a scene presumably calculated to arouse repugnance with a moralistic intention. The artist paid almost pedantic attention to archaeological detail, and his real powers of draughtsmanship earned him the Prix de Rome, the highest accolade the Academy could bestow. His interest in the human figure, evident in these poses recalling the life class, led him eventually to concentrate on sculpture.

MEISSONIER (right)
Napoleon III at the Battle of Solferino, June 24th, 1859, 1863
Scarcely suggesting ultimate victory, the scene of battle is relatively realistic in its spirit. Meissonier used photography to study the movement of the horses.

Delacroix himself was far from unsuccessful – even though the stereotype of the unrecognized genius, the starving Bohemian painter embattled against a philistine public, dates from this period. Considerable fortunes could be made, especially through engravings, and Paris swarmed with artists. Its artistic vitality and the reputation of its training workshops, *ateliers*, run by most of the leading painters, made it the centre of European art, much as Rome had been in the eighteenth century. The highly romanticized reflection of Parisian art student life is to be found in Murger's *Scenes from Bohemian Life* (1849), which was the source of Puccini's famous opera *La Bohème*.

Typical of the middle generation of the academic painters was Thomas Couture (1815-79), though he was more eclectic than some. Couture's vast *Romans of the Decadence* (some 7.5 metres (25ft) wide), exhibited at the Salon in 1847, challenged the great Venetian decorative painters, Veronese or Tiepolo, but it also owes much in construction to Bolognese classicism. The archaeological detail is very accurately researched, and the overall mood, morbid and sensual, was no less in accord with mid-century bourgeois taste, conferring

respectability on a somewhat dubious subject. Not only the nude, but disguised scenes of torture, of female subjugation, were constant themes amongst Salon painters. Couture ran a famous *atelier*, and his students included Puvis de Chavannes, Fantin-Latour and Manet.

Many painters followed more closely in Ingres's path, notably Hippolyte-Jean Flandrin (1809-64), one of his pupils; his *Theseus recognized by his father*, 1838, represents the pure classicizing style, somewhat dry and arid, applied to the pure classical subject. Jean-Léon Gérôme (1824-1904), the most famous of the next generation, likewise exploited classical themes, for instance in his *Gladiators*, but now with realistic violence. Ernest Meissonier (1815-91) was a brilliant master of the small-scale costume or history piece, reducing the Napoleonic campaigns to miniature proportions painted with minute accuracy and great technical virtuosity. The name of Adolphe William Bouguereau (1825-1905; not shown) stands for the extremes of smooth gloss finish; Degas invented the word *bouguereauté* to describe such academic paintings. With Alexandre Cabanel (1823-89), Bouguereau dominated the Salon in the second half of the

century, and was influential in excluding from it all revolutionary work from Manet onwards.

The difficulty of containing artists within the opposing categories of academic or classical and Romantic is exemplified by the work of the extremely talented Théodore Chassériau (1819-56). Cherished pupil of Ingres, he nevertheless developed an expressively Romantic use of colour, stimulated by Algerian trips in 1840 and 1846. The short-lived Henri Regnault (1843-71) was acclaimed in the Salon for his colouristic skill; and elements of Romanticism influenced many of the middle-of-the-road academic artists ("*le juste milieu*"). The conflict between Romantic and classical tends to be overstressed, largely as a result of the violence of contemporary controversy.

In Britain, Frederic, Lord Leighton (1830-96), President of the Royal Academy from 1878, preferred antique themes, but also travelled in the Levant and found inspiration there for his highly polished works, which had much in common with French, as with German, academicism. The ideal conventional art of late Victorian England is exemplified in the reconstructions of domestic Roman life by Sir Lawrence Alma-Tadema (1836-1912).

CHASSERIAU (below)
The toilet of Esther, 1841
The biblical heroine in this exquisitely coloured work is an Ingresque nude, but the moood is exotic, orientalizing. It even seems to anticipate the approach of the Symbolists at the end of the century.

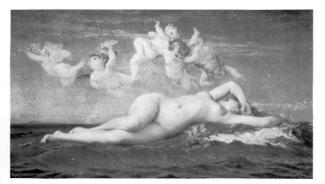

CABANEL (left)
The birth of Venus, 1863
The critic Zola denounced Venus (bought by Napoleon III) as made not of "flesh and blood – that would be indecent – but a kind of pink and white almond paste".

ALMA-TADEMA (below)
The Baths of Caracalla, 1899
Alma-Tadema's precise archaeological environs cloak his languorous ladies in nostalgia. He also evoked daily life in ancient Egypt.

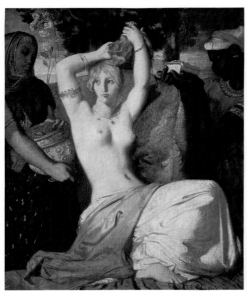

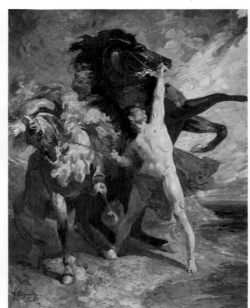

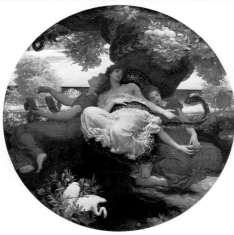

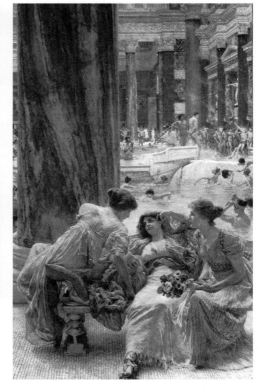

LEIGHTON (left)
The Garden of the Hesperides, 1892
In a sophisticated tondo format, the artist evokes a paradise where daughters of Evening guard golden apples, symbolic of love.

REGNAULT (above)
Automedon with the horses of Achilles, 1868
Painted in Italy, this huge Neoclassic canvas attracted attention for its theatrical effect, bold conception and free, colouristic technique.

French Realism

The movement known as Realism in the arts was formulated with most consistency and authority in France, between about 1840 and 1880. Like the label "Romanticism", the movement from which Realism in part developed and which in part it superseded, "Realism" is applied to concerns far wider than those of an identifiable artistic style. By 1840 some of the consequences of the Industrial Revolution were becoming apparent, among them the concentration of vast populations in the great urban centres, in which proliferating slums new in their scale and density contrasted with the showy display of wealth by the successful classes. Inevitably such violent imbalances within the structure of society began to involve artists, thinkers and writers, who were themselves only part of surges of unrest that found relatively mild outlet in the French revolutions of 1830, but erupted all over Europe and especially in France in 1848 (the year Marx and Engels published their *Communist Manifesto*). Realism relates closely to the philosophical work of writers such as Comte, Fourier and Proudhon; of historians such as Michelet and Taine; of novelists from George Sand to Zola and the Goncourts. As Romantic

painting had seemed summarized in the work of Delacroix, so Courbet is the archetypal painter of Realism.

"Painting", claimed Courbet, "is an essentially *concrete* art, and can only consist of the presentation of *real and existing* things." Scenes from the past – classical, medieval, even Revolutionary or Napoleonic – were inadmissible. The emphasis on the present went hand in hand with the new permanence of the fleeting moment made possible by the techniques of photography, initiated by Daguerre about 1827 – photographs were already proving useful to Courbet for his painting by the 1850s. The most remarkable of the French nineteenth-century photographers was Félix Nadar (1820-1910), whose portraits, such as the famous one of Baudelaire, rival any portrait by a Realist painter not only in mere naturalism, but in monumentality and vividness – although in sheer size photography could not (yet) match the epic canvases on which Courbet and others painted scenes from working-class or peasant life, challenging the heroic dimensions of traditional "history" painting (see over).

The most remarkable statement of the ideo-

DAUMIER
Nadar in a balloon, 1862
Nadar was the first man to photograph from a balloon.

The caption reads *Photography is elevated to the height of art*; the craze sweeps the city below.

NADAR (below)
Charles Baudelaire, c. 1863
Celebrities flocked to Nadar's Paris studio, even Baudelaire, though he had declared photography mere naturalism, the enemy of art.

GUYS (left)
Two ladies with muffs,
c. 1875-80
Guys' art was a superior kind of journalism, with an amoral, sardonic delight in life's passing parade. These fashionable ladies represent the comfortable, gentle aspect of the Second Empire, as opposed to the poverty and villainy shown by Millet and Daumier.

DAUMIER (right)
The dream of the inventor of the needle-gun, 1866
Daumier greatly admired Goya's *Disasters of War* (see p. 314), but his image of a gleeful satanic boffin contemplating the efficacy of a new weapon adds a horribly modern dimension, briskly, humorously noted in a datelessly racy line.

DAUMIER (left)
Ratapoil, c. 1850
It is hard to appreciate now what a strong denunciation of the Bonapartist regime this caricature appeared at the time. Daumier had been imprisoned briefly in 1832 for sedition, and so Mme Daumier kept the terracotta original carefully hidden in a lavatory, wrapped up in a straw bottle-cover.

DAUMIER (right)
Rue Transnonain, April 15th 1834, 1834
Daumier's stark lithograph depicted a recent outrage – innocent residents of a Paris tenement block had been killed in a police raid. Its unvarnished realism – it is just like a newspaper photograph – was such that the lithographic stone was confiscated by the state and most of the prints destroyed.

logy behind the Realist movement in painting came from Baudelaire, in a famous essay, *The Painter of Modern Life*. The "modern" (that is, post-Romantic) painter should be a faceless man in the crowd; a dandy, aloof and uncommitted, yet with the clear unprejudiced vision of a child. His subject matter should be drawn from contemporary life and fashion, and his medium should be swift, reflecting immediate impressions, and suitable for wide circulation.

This applied almost wholly to Daumier, and some of it fitted Courbet. Yet the painter Baudelaire chose to typify his thesis was Constantin Guys (1805-92), who was a minor artist by comparison. Honoré Daumier (1808-79) was one of the most original and profound figure painters in oil in the history of art, and a sculptor who foreshadowed Expressionism. His public reputation, however, rested for most of his life on his satirical caricatures, published in journals from 1824, and exploiting to the full the technical possibilities of lithography. His satire extended almost everywhere, but was most often political, directed against the absolute monarchy of Charles X, and then, after 1830, against Louis-Philippe, whom Daumier held to be a turncoat. After

Louis-Philippe had been toppled in 1848, Daumier's wary scepticism was not appeased by the new Republic or by the new Empire of Napoleon III. His crucial strength was his ability to extract from a topical situation a visual image that summarized an essential quality of human life.

Daumier's artistic stature was gradually acknowledged after 1848. Balzac compared him to Michelangelo, the younger generation saluted him and the aging Delacroix even copied his oils – sombre images often very pessimistic in atmosphere. His *Third-class carriage*, about 1862, shows working-class people in an entirely modern situation, un-idealized yet monumental in their patient passivity. Contrariwise, he took one of the archetypal symbols of Romantic failure in European literature, Don Quixote, and, in a series of paintings (not shown), invested him with a strangely credible, eerie reality that no other illustrator of Cervantes has begun to approach. His dense yet vigorous paint reflects both Rubens and Rembrandt, and owes something to Delacroix, but its effect, of an image stirring within the paint, is unique.

About the time that Daumier started paint-

ing working-class subjects, in the mid-1840s, Jean-François Millet (1814-75) turned his attention to subjects drawn from the life of the peasantry. In his densely-worked oils, featuring a single peasant, or a small group, at work in a dimly defined, apparently infinite landscape, Millet created a rural, peasant version of heroic painting. As social comment this could be called reactionary or nostalgic, for Millet did not paint the new working class of the cities; to later generations his sentiment, for instance in his most famous picture, *The angelus*, has seemed, in fact, sentimental; the great power of his style, its monumental simplicity, its classical significance, are only now being reassessed.

The opposite of Millet's vision of the heroic countryside appeared in the horrific townscapes of the intense, even neurotic, Charles Meryon (1821-68), a rather isolated figure. Owing to colour blindness he worked in black-and-white: Victor Hugo praised his topographic etchings of Paris, as visions of the city as a staging-post to Hell. Gustave Doré (1832-83; not shown), better known for his illustrations to literary classics, also illustrated the slums in *London: A Pilgrimage*, 1872.

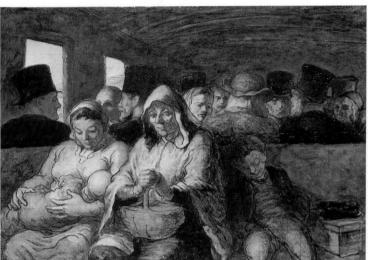

DAUMIER (left)
The third-class carriage,
c. 1862
The brushwork is almost grimy, strengthening the impression of dullness and the grinding poverty of the travellers. Without heroism or sentiment, each is firmly and clearly characterized. Painstakingly, Daumier sought perfection in several versions made of this scene.

MERYON (right)
The morgue, 1854
The harsh contrasts of light and shade combine with the scratchy line to conjure up a hauntingly claustrophobic setting for macabre, ant-like figures about their doomed business. Meryon's highly expressive townscapes are just as Romantic as Realist.

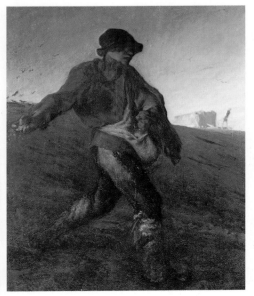

MILLET (left)
The sower, 1850
In 1848 the peasantry had rebelled, protesting exploitation and oppression, and Millet's first version of *The sower*, exhibited in that year, was denounced as socialist. In fact his intent was more to evoke the eternal, almost biblical unity of man and land.

MILLET (right)
The angelus, 1855-57
The religious element is now more explicit. The subject had also a personal meaning for Millet, since his beloved grandmother had always stopped, when the angelus was rung, to pray for "those poor dead". Warm colours of evening strengthen the sentiment, without vitiating Millet's firm draughtsmanship. In the 1860s Millet turned to pure landscape (see p. 341).

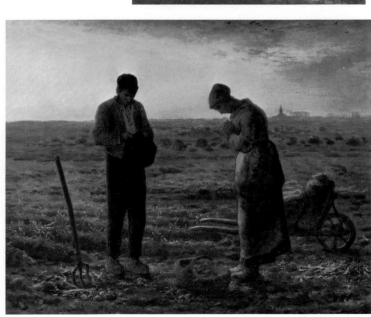

Courbet: The Artist's Studio

Gustave Courbet (1817-77) painted his huge *Artist's studio* (it is nearly six metres (20ft) wide) in 1854-55. He subtitled it *A real allegory, determining a phase of seven years in my artistic life* when it was first exhibited in his independent "Pavilion of Realism" at the Universal Exhibition in Paris in 1855. The critical reception was very mixed, but the 40 or so works displayed established Realism, or Courbet's personal vision of it, as a powerful movement that could not be ignored.

Courbet himself gave a long, detailed account of this painting, starting: "It is the moral and physical history of my studio." On the right are "all the shareholders, that is my friends the workers, the art collectors. On the left, the other world of trivialities – the common people, misery, poverty, wealth, the exploited, the exploiter; those who thrive on death". It is not clear either from the individual characterizations, or from Courbet's own description (intellectual rigour was never his *forte*), which represent good and which bad

in the left-hand group, but an acquaintance of Courbet's said that the seated huntsman with his dog and the farm labourers behind him stood for healthy country life. Others in the group included workers representing poverty and unemployment in the urban working classes; a destitute old republican of 1793 – all that was left of the heroic legend of Revolution and the Napoleonic Empire – a curé, an undertaker, and a pedlar hawking rubbish. The group on the right includes Courbet's loyal patron, Bruyas, the philosopher Proudhon, the writer Champfleury, and the poet and critic Baudelaire with open book. But the focus of the picture is the artist himself at work, attended by a superbly painted nude (Naked Truth), and a child (Innocence), though it is a landscape of his native Ornans region that is depicted on the easel.

The composition can be construed as a secularized *sacra conversazione* in triptych form; the plaster figure with adjacent skull, behind the canvas, appears to be a crucified

COURBET (above)
Self-portrait with a black dog, 1844
In this, Courbet's first accepted Salon picture, the subject – an informal figure in a rural setting – is in the tradition of van Dyck and Gainsborough, but the self-assurance of the face, compounded by the low viewpoint, establishes the young man's individuality. This initiates a series of robust, extrovert *Self-Portraits* of some power.

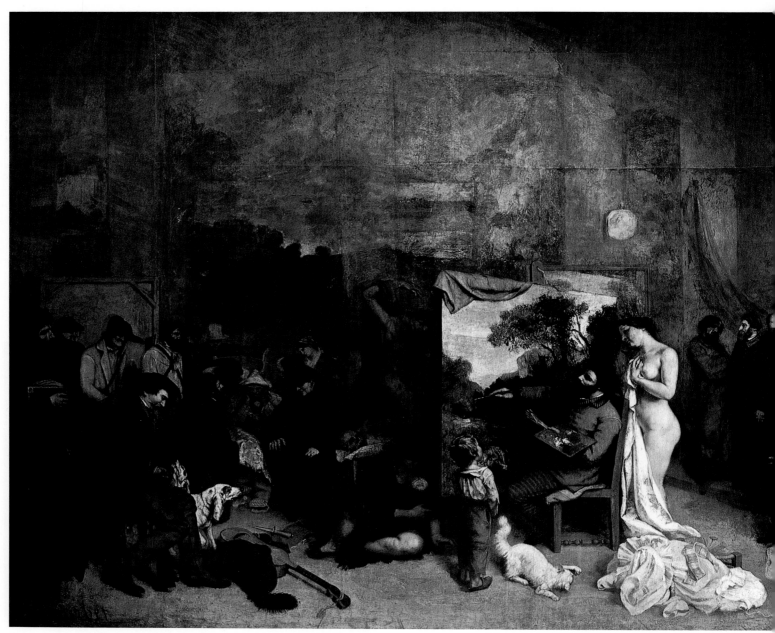

Christ. It also invites comparison with that Neoclassical manifesto, Ingres's *Apotheosis of Homer* (see p. 333), but Courbet's central figure of artistic genius (himself) is set in the context of real people from contemporary life ("society at its best, its worst and its average . . . my way of seeing society in its interests and its passions"). The theme has been interpreted in terms of Fourierist socialism – a personal, concrete expression of an association of Capital, Labour and Talent, an ideal harmony of society. Yet the picture also expresses alienation in a way that Baudelaire himself might have approved: there is scarcely any communication between the three groups, or even between some figures in the groups. The artist in the centre is the hope of communication.

As "real allegory" the picture's internal contradictions baffled contemporaries. The people are all real, faithfully and vividly portrayed, but as an event the gathering is impossible, and even its setting, the walls of the studio, is vague and unidentified. The choice

of characters is also far from an adequate representation of contemporary society. However, it made an impression (Delacroix considered it "one of the most outstanding paintings of the times") and it has since continued to fascinate. Not least, it opens a doorway to modern art: here the artist is shown dominant at the centre of the world. In *The studio* not just the artist, but for the first time the "activity of creating art" becomes the subject. In Courbet's self-portraits and in his portraits of his friends, too, the artist as maker assumes heroic stature, even when surrounded by children, as is *Proudhon*.

Courbet had come to Paris from his native Ornans, in the mountainous Jura of France, in 1840. His early *Self-portrait with black dog* suggests his flamboyant and truculent character, though not his lifelong social and political commitment. Even though *The studio* was the last major work in which he tried to programme his political, social and moral ideals, he continued to participate in politics, taking a

prominent part in the Commune of 1871, until, following a brief imprisonment, he was forced into exile in Switzerland, where he died. His artistic and social sympathies are strikingly expressed in the unemotional but monumental *Stone-breakers* (1849; destroyed) – two men shown simply at their dehumanizing task. In the same year he also depicted a small-town funeral, *A burial at Ornans*, on an heroic scale. He always drew on the real, but with great variety and with a brilliantly broad and free style, often laying on with a palette-knife. Courbet's still lifes have a density, a weight of presence comparable with those of Chardin or, for that matter, of Cézanne. His nudes were of a veracity, sometimes unflattering but often also startlingly erotic, that many found offensive. *The bathers*, again a life-size genre subject, allegedly provoked Napoleon III to assault it with his riding whip at the Salon of 1853. Perhaps, however, his landscapes of the Jura (see over) are the best examples of the beauty, the rich, sombre colour, of his paint.

COURBET (left)
The artist's studio,
1854-55
Courbet's great manifesto rejects both academicism, represented by the dusty plaster figure, and Romanticism, symbolized by the plumed hat and the guitar. Champfleury, Baudelaire and Proudhon, however, who are shown in it, expressed dislike of the work, finding Courbet's vanity and the autobiographical tone of the painting distracting. It is in fact the true subject.

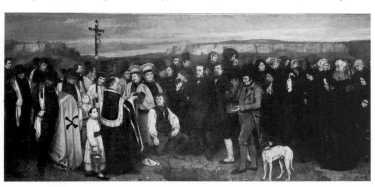

COURBET
A burial at Ornans,
1849-50
All sorts of people from Courbet's native town posed for this vast canvas, a mirror of provincial life and death. The onlookers' grief, fear and indifference are dispassionately noted; the faces struck Parisian critics as shockingly ugly.

COURBET (left)
The stone-breakers, 1849
Courbet wrote to a friend: "I stopped to look at two men breaking stones on the road. It is rare to find an expression of such utter and complete misery; and at once I had an idea for a picture." It was neither expressionist nor sentimental, however.

COURBET (left)
The bathers, 1853
The scandal of the 1853 Salon, *The bathers* attracted universal odium. It is an incongruous picture: even if the women are earthily mundane, their extravagant gestures are reminiscent of the nymphs and goddesses of 17th- and 18th-century art, but almost violent.

COURBET (above)
Pierre-Joseph Proudhon and his family, 1865
Proudhon's "thinker" pose and books indicate a larger reality than the man amidst his family (the portrait is set in 1853). Details such as his worn shoes and his daughters' toys enable the viewer to reconstruct the sitter's situation, though.

French Landscape: The Barbizon School

The art of landscape was relatively slow to become established in France; although in England Constable and Turner, in Germany Friedrich and also more modest German and Austrian naturalist painters had considerably broadened its scope, landscape in France at first remained firmly rooted in the tradition of Poussin – the ideal landscape, conceived as a stage for an heroic story. Landscape was officially accepted as a distinct category of art only in 1817, and its acclimatization dates really from about 1824, when the impact of Constable and of Bonington, shown that year in Paris, was sharply felt, though artists were already preconditioned by a growing Romantic concern with the direct study of Nature.

This interest was matched by an increasing attention to the seventeenth-century Dutch painters, and was most fruitful in the remarkable but still underestimated work of Georges Michel (1763-1843). Rather isolated, and neglected by contemporary critics, his landscapes recall those of Rembrandt or Ruisdael, but he was one of the first to work in the open air, and his contention that a landscapist needed a mere four square miles to provide him with subject matter for a lifetime is close to Constable's discovery of the ordinary and everyday.

The brief-lived Richard Parkes Bonington (1802-28) is an important link between the English and French schools; though he was English-born, from the age of 15 he lived mainly in France, and was a friend of Delacroix. If his brilliantly handled genre scenes of medieval and oriental subjects owe much to French example, his landscapes in oil or in watercolour, especially when painted directly from the subject, have an immediacy of effect and brilliance of colour rivalling the native British tradition. He and Delacroix were in turn friends of Paul Huet (1803-69). Political activist on the barricades in the 1830s and, to begin with, dogmatically opposed to academicism, Huet briefly associated with the Barbizon painters, and ended as the so-to-speak official leader of Romantic landscape when Romanticism had become respectable. His output is of variable quality, but, working consistently in the open, he could usually retain spontaneity in his less formal pictures.

Barbizon is a village on the fringe of the Forest of Fontainebleau, where numerous painters worked and often lived, "led" by Théodore Rousseau (1812-67). Rousseau was certainly impressed by Constable, and based

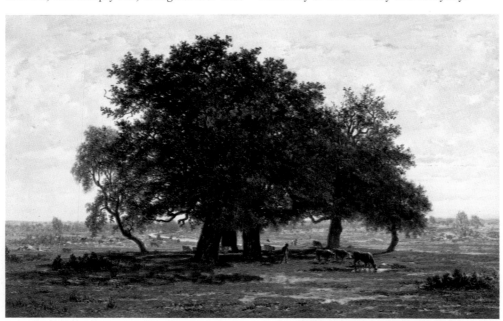

ROUSSEAU (left)
A group of oaks near Barbizon, 1852
A simple rustic view, with the spreading oaks elevated into a splendidly imposing image, a sense of sun and shade, the heavy peace of afternoon – what more could anyone want of landscape? Critics carped at the unconventional composition, the use of broad brushwork and often dense impasto.

BONINGTON (below)
View of Normandy? c. 1824
Bonington made several trips to Normandy between about 1820 and 1828, setting off on the open road, stick in hand and knapsack with painter's gear on his back. The fresh, light spontaneity of this painting is typical of his style; quite probably he painted it north of Paris in the countryside Michel also painted, with different effect.

MICHEL (right)
The storm, c. 1820-30
Michel dramatized the fields and heaths outside Paris with bold strokes of colour within a dark tonality. This is not a finished work but an *ébauche*, an oil-sketch in which the elements of the picture were "blocked out".

HUET (below)
Elms at St-Cloud, 1823
Huet shared the irritation of Academicians faced with "unfinished" works, though he esteemed spontaneity. Like Corot and Rousseau, he kept in the studio his studies, which can now be compared with the exhibited works of the Impressionists.

DAUBIGNY (right)
Snow scene: Valmondois, 1875
Snow scenes were an excuse for the almost abstract play of tones and colours, and were painted by Courbet and the Impressionists. By the 1870s Daubigny was commercially successful and respectable, but also friendly with Monet; as a member of the Salon jury, he gave the Impressionists what support he could.

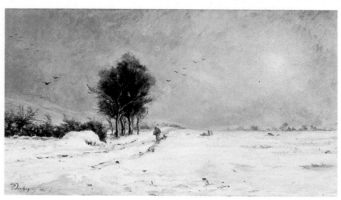

his work on the close scrutiny and analysis of natural forms on site. He was in fact the ancestor of much academic landscape of the later nineteenth century, and accepted as such from about 1850, but in his early days (consistently rejected by the Salon between 1836 and 1848) he was known as "*le grand refusé*". His work shows him a master of stillness, though his imagination seems sometimes constrained by a rather dour naturalism.

The work of Narcisse Virgile Diaz de la Pena (1807-76) was more immediately acceptable: he painted the Fontainebleau woods with a much freer (sometimes rather flashy) style, and established an enduring popularity. Charles-François Daubigny (1817-78) was, in an historical sense, perhaps more important than either Rousseau or Diaz, for he is the link between their naturalism and the development of Impressionism – he was criticized precisely for producing mere "impressions". He always worked directly from his subject, in which water and sky often played a large part (he used a boat as a floating studio). Early insistence on detail gradually yielded to a more free and open style, with which he achieved remarkable effects of light and atmosphere. In 1865 he was

with Courbet, Monet and Boudin at Trouville, and his influence on Monet was considerable; the spirit if not the technique of his later paintings is closely akin to that of the early Impressionists.

Rousseau and Daubigny had no great political involvement, unlike Courbet and Millet, whose work was far from being confined to pure landscape, and who are generally classified as Realists (see pp. 336 ff). The best of Courbet's landscapes (and the more directly and faithfully dependent on nature, the better they are) combine a material drama with a sense of massive formal structure that has not been surpassed; however, when he introduced emotional elements – animals – he could be almost as sentimental as Landseer. Millet was closely associated with Barbizon from 1849, but only in his latest work did pure landscape play the dominant role in his vision.

The greatest landscape painter of the mid-century presents a curious paradox of Romantic and classic values. Jean-Baptiste-Camille Corot (1796-1875), amiable in person, unambitious, detached from politics, avoiding controversy, went his own admirable, independent way (in 1846, when he was awarded

the Légion d'Honneur, aged 50, he was still being subsidized financially by his father). Crucial to his development was his Italian sojourn, 1824-28, where it was not the awesome aura of the Old Masters that impressed him, but the lucid light of the Italian countryside. There Corot worked directly from the subject, painting generally small-scale pictures, tuned as it were by his perfect tonal pitch, and harmonized by a sense of design as delicate as the finest balance. The crystal clarity of these idylls is partly the result of his technique: he used thinned, translucent paint applied almost in washes but with sharp precision. Back in France, he then developed a poetical type of landscape of an entirely different character, almost a Romantic variation on Rococo dreams of rustic but elegant figures in a silvery-greeny-grey haze of foliage; these, once extremely successful, were subsequently condemned out of hand, and are only now becoming seriously appreciated again for their painterly subtleties. In his later years, in certain figure paintings and portraits (not shown), Corot developed a power of sculptural modelling that surpasses even Courbet's, and is not to be found again till Cézanne.

DIAZ DE LA PENA (left)
Gypsies going to a fair,
1844
For years a familiar figure

in and about Fontainebleau, Diaz painted richly dappled woodland scenes, bubbling with light and bright colour.

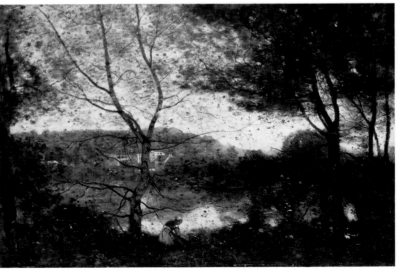

COURBET (below)
The Loue valley in stormy weather, c. 1849
In 1849 Courbet spent the summer near Paris with Corot. He used light effects to define space, rather than the conventional structure of planes receding from a sharply defined foreground.

MILLET (above)
Spring, 1868-73
In Millet's late work the forces of Nature assume the epic quality that his labouring peasants once had. His later technique was looser, lighter, more colourful, perhaps under the influence of early Monet.

COROT (above)
The island of San Barto-lommeo in Rome, 1825
Such fresh Italian studies, bathed in Mediterranean light, were, for Corot, raw material for more stately, if also very fine landscapes destined for the Salon.

COROT (below)
View of Avray, c. 1835-40
Here Corot animated one of his favourite views with little dabs of paint, in a way that looks forward to the fresh visions of Renoir. These pictures became the foundation of his reputation.

Edouard Manet

Political revolutions rarely lead to the instant stability of the new regime, and the upheavals of 1848 and 1870 in France were no exception. The radical republicanism that toppled Louis-Philippe in 1848 led within three years to the *coup d'état* by Louis-Napoleon, who was established (by plebiscite) as Napoleon III of the Second Empire. His downfall in 1870, after catastrophic defeat by the Germans, was followed by the socialist, even anarchic, Commune in Paris before relative stability was achieved by the Third Republic. The Second Empire was nevertheless a period of brilliant opulence and artistic ferment.

The 1850s and 1860s contained a rich profusion of styles, practised by overlapping generations – Delacroix died only in 1863 and Ingres in 1867, while Courbet, born in 1819, was at the peak of his powers. The rising generation, born mostly in the 1830s, became notorious during the 1860s; pioneering the most fundamental revolution in the visual arts since the Renaissance, they were not yet acceptable to public or academic opinion.

Edouard Manet (1832-83) was early on considered the leader of the avantgarde, although he dissociated himself from formal connection with the painters who became known as the Impressionists. Born of a well-to-do family, he was slightly older than they were, and the image he presented to the public all his life was that of the elegantly conventional man-about-town, just as he appears in the polite effigy by Henri Fantin-Latour (1836-1904). His art, on the other hand (when he emerged from Couture's *atelier*), flouted convention in both style and content.

If Courbet, most clearly in his *Studio* (see p. 338), had demonstrated the artist's sovereignty, showing the artist as hero in the act of re-creating the world, in Manet the germs are visible of that development by which the paint itself becomes the subject. From Realism he learned the importance of taking subjects from contemporary life and treating them on a life-size scale. However, he combined this approach with an audacious adaptation of traditional iconographic themes, sometimes even adopting the style of the Old Masters, especially the Spanish and the Venetians. His *Absinth drinker* of 1859 was rejected by the Salon, although *The guitarist* (not shown) of 1861 was a success; real confrontation came in 1863, when (following noisy controversy over

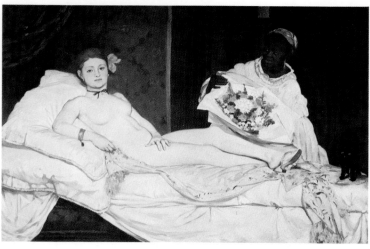

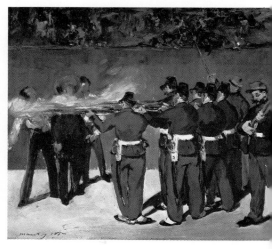

the Salon's policy of acceptance and rejection), Napoleon III arranged a Salon des Refusés, an event sometimes still cited as the starting point of modern art. The *refusés* included Manet, Whistler, Pissarro, even Cézanne.

The major scandal was caused by Manet's *"Déjeuner sur l'Herbe"* (The picnic), in which Manet repeated with some exactness figures from a subject by Raphael engraved by Marc-antonio. In the engraving (not shown) the three main figures were all nude, but Manet clad the two males in the dark jackets and trousers of 1863, leaving the female figure naked; her direct and unabashed gaze invites the spectator into the picture. The spectators of 1863 mostly rejected the invitation with rage and ridicule. But the manner of the painting was scarcely more acceptable than the subject matter, and upset even Courbet. Manet suppressed the traditional rendering of form in chiaroscuro, with modelling by gradation of tone, in favour of a method that seemed, at first, flat – in fact it caught the effect of unfiltered daylight, simplifying detail, sharpening silhouettes and kindling colour.

In the same year Manet painted his most famous picture, *Olympia*, though he did not submit it to the Salon until 1865. Surprisingly it was accepted, but its reception by the public was extremely hostile. The subject matter, echoing – or perverting – the established tradition of recumbent nudes descending from Titian's *"Venus of Urbino"* (see p. 145) to Goya's *Nude maja* (see p. 312), was found obscene. (The fashionably acceptable version is represented by Cabanel's *Birth of Venus*, see p. 335) One critic called her "Manet's rancid Olympia". Here Manet even more markedly simplified and emboldened his handling, using no half-tones, but flat colour which he disposed, contrapuntally, in sharp contrasts. The delicate subtlety of the harmonies of blacks, greys, and whites was recognized only years later; what appeared as vulgar banality is now seen as a brilliant metamorphosis of a somewhat over-exploited subject.

From 1866 Manet had the support not only of Baudelaire, but of Zola, a positively pugnacious apologist. Meanwhile, his control of form developed following a visit to Spain, while both his compositions and his aloof, objective approach to his subject matter were influenced by Japanese prints, then just beginning to become popular, and by photo-graphy. Typical is the portrait of *Zola*, which unites still life and vivid portraiture – the casual informality of the writer's working study transposed into a very intricate pictorial structure. In his *Execution of Maximilian* there may be an explicit political comment, but generally Manet's realism was apolitical; as Zola replied to the socialist requirements of Courbet's friend Proudhon, "The artist is at no-one's service and we refuse to enter yours".

In the 1870s Manet's frequent reliance on blacks and greys, on flattened silhouettes, was happily "aerated" by the influence of the Impressionists, though he refused to exhibit with them as a group. His colour key heightened; his handling of paint became lighter, looser and still more deft, and, though he hardly ever (being essentially an urban creature) painted landscape, much of his work became suffused with light, air and movement. His importance as a graphic artist is also considerable; he translated some of his own most important works into prints for wide publication, but also produced some vivid journalism, notably of the Siege of Paris – a black-and-white equivalent of his power of summary description in painting.

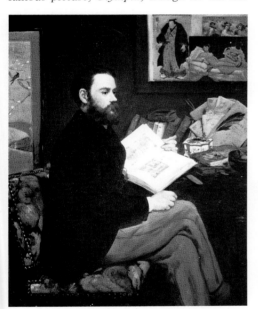

MANET (left)
Emile Zola, 1868
The Japanese *Samurai* print and painted screen, and the reproduction of a Velazquez (hidden by one of his own *Olympia*) are a tribute by Manet to the influences on his work.

MANET (right)
Argenteuil, 1874
At Argenteuil by the Seine with Monet in the summer of 1874, Manet became convinced of the value of *plein-air* painting, even though Impressionist interest in the transitory never affected his concern for structure.

MANET (below)
Chez Père Lathuille, 1879
The restaurant proprietor's son posed as an eager lover of the smart young woman. Manet's technique is freer than ever before – note the quick strokes on the hand.

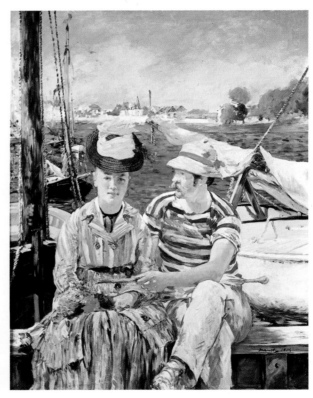

MANET (right)
Civil War, 1871
During the 1870 Commune Manet saw corpses like this on the streets of Paris, and made a rapid drawing, the basis for his lithograph. The body of the soldier in the centre recalls an earlier work by Manet, *The dead toreador* (not shown), but also Daumier's *Rue Trans-nonain* (see p. 336) and a long tradition going back to Mantegna and Grünewald. Here is another example of Manet charging old forms with sharp topical reference.

Whistler: Falling Rocket

James Abbot McNeill Whistler (1834-1903) was a true international – born in Massachusetts, brought up early on in Russia, then at West Point (failed in Chemistry); as a Navy cartographer he learnt the techniques of etching, before his definitive expatriation in 1855, first to Paris, and, in 1859, to London. Wit, dandy and aesthete, he provoked outrage and astonishment in the sedate worlds of High Victorian art and society.

On his arrival in Paris in 1855, as a student, he was struck by Courbet's forceful denunciations of the official art of the Paris Salon after visiting his one-man show, the celebrated "Pavilion of Realism". In 1859, rejected by the Salon, Whistler, with Manet, showed in a later, comparable "counter-exhibition" where Whistler's *At the piano*, modelled by mass and colour rather than line, was approved by Courbet; subsequently, Whistler was profoundly influenced by Courbet, and at times worked alongside him, although his admiration for the tonal subtleties of Velazquez's paintings in the Louvre and for the flattened, schematic patterning of Japanese prints was to prove more enduring inspiration. (Japanese prints began to arrive in numbers in Paris in the 1850s, and in the 1860s Whistler built up a considerable collection of Japanese art.)

From 1859, with his move to London, Whistler fought off the influence of Courbet. His famous *White girl* of 1862, a *succès de scandale* (alongside such landmarks as Manet's "*Déjeuner sur l'Herbe*") at the Salon des Refusés in 1863, reflects something of the wistful characterizations of young women painted by the Pre-Raphaelite Rossetti. It is an exquisite modulation of tones of white, and Whistler later added the definition *Symphony in white no. 1* to the title. This is symptomatic both of his increasing dedication to the subtle gradations of tonal painting and of his belief in the importance of purely formal pictorial values – overriding that of literal representation. His musical titles – *Symphony, Arrangement* and later the famous *Nocturnes* – stress his notion of the harmonics of tone, colour and line – the equivalent of a kind of mood music. Even in portraiture he claimed the supremacy of abstract form over naturalistic representation. His preferred title for *The artist's mother* (1872), one of the most famous of nineteenth-century portraits (and paradoxically, it seems, a most faithful one), was *Arrangement in grey and black no. 1*. In its subdued delicate tonalities it echoes Velazquez, but its flattened space, its exquisitely calculated disposition ("arrangement") across the picture plane – these qualities anticipate the abstract preoccupations of much twentieth-century painting; they also affected younger Impressionists, and indeed Seurat, when the painting was shown in Paris in 1882, and later they were adapted by Intimistes such as Bonnard and Vuillard. As to the subject of the portrait, Whistler provocatively denied the right of the public to be concerned with it; an arrangement in black and white was what it was – "To me", he said, "it is interesting as a picture of my mother, but what can or ought the public to care about the identity of the portrait?" However, in spite of the emphasis here on purely formal values, and elsewhere in his work on instantaneity, Whist-

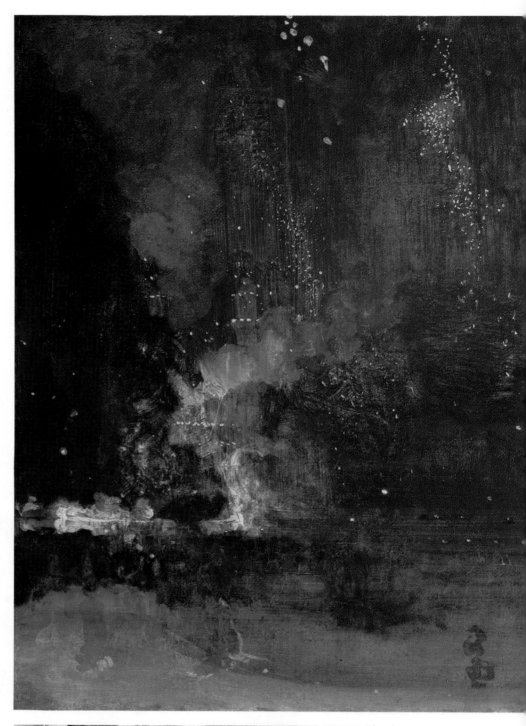

WHISTLER (above)
Falling rocket: Nocturne in black and gold, c. 1874
In Whistler's words, "The masterpiece should appear as the flower to the painter ... with no reason to explain its presence – a joy to the artist – a delusion to the philanthropist – a puzzle to the botanist." Aestheticism had no room for art expressing the goodness of Nature, as Ruskin saw it.

WHISTLER (left)
At the piano, 1858-59
The counterpoint of black and white already suggests an association of tonality with musical harmonics.

ler was never really at one with Impressionist theory or practice: he was essentially subjective rather than objectively descriptive. His work, however, was equally incomprehensible to his contemporaries.

His confrontation with established British art and the public came to a climax in 1876 with the exhibition in London of *Nocturne in black and gold: Falling rocket*. Painted about 1874, it is a lyrical exclamation of delight at the effect of fireworks, raining coloured fire through the night at a display in a London pleasure garden. The English critic John Ruskin was revolted by it, for reasons that are not entirely clear (for Ruskin had been the champion of the late work of Turner). Then at the height of his prestige as national moral, no less than artistic, prophet, Ruskin in a famous article denounced Whistler for flinging "a pot of paint . . . in the public's face". Whistler sued for libel. The resulting trial was (in retrospect) one of the most entertaining in legal history. Whistler's wit coruscated, even more brilliantly than his painted fireworks. Some of the phrases used have passed into the language. Asked how long he had taken to "knock off" the painting", he answered, "About two days"; asked then if it was for two days' work that he asked 200 guineas, he replied: "No. I ask it for the knowledge of a lifetime". It is a response, provoking applause in the courtroom, that still echoes today. Whistler won, but he was awarded only a token farthing damages, and the costs led to his bankruptcy.

Whistler's harmonics were usually more subdued than those of the *Rocket*, above all perhaps in his twilight meditations on the Thames, transmuting its industrial daytime prose into mysterious dreamy poems – drifts of shadow glinting here and there with reflected lights. Such works as his *Cremorne lights: Nocturne in blue and silver*, 1872, pre-date Monet's mist-hazed accounts of Rouen Cathedral by nearly 20 years.

Delighting in controversy, deliberately provoking antagonism, Whistler was not the ideal propagandist to reconcile British taste with the new values of French art, although towards the end of his life his influence, especially on Sickert, was decisive. His prolific and delightfully sensitive etchings found an appreciative public, however, and his influence on interior decoration was also important; he was a pioneer in simplification, sweeping out Victorian clutter, using clear and plain colours.

WHISTLER (left)
Wapping-on-Thames,
1861-64
The limited colour range may owe a debt to Manet, but the silvery tones and the almost abstract design of masts and rigging behind the obliquely-angled foreground figures are wholly original.

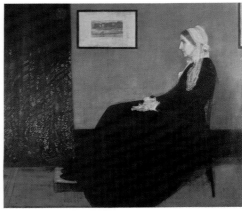

WHISTLER (left)
The white girl: Symphony in white no. 1, 1862
The critic Castagnary thought she was a girl on the morning after her wedding night. Her soulful look, the drooping lily and contrast of pale and vivid colours perhaps suggested his interpretation: the picture seems an elegy for lost innocence.

WHISTLER (above)
The artist's mother: Arrangement in grey and black no. 1, 1862
Whistler's affection for his mother, a devout woman, was deep. Working rapidly, he refined each application of paint to reach a delicate, almost transparent harmony of tones, evoking the gentle resolve of his subject.

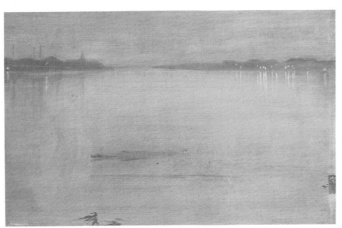

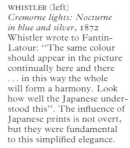

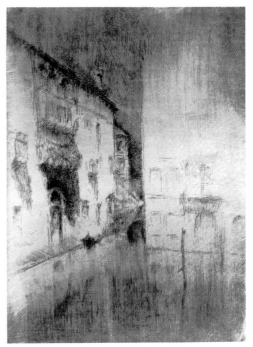

WHISTLER (left)
Cremorne lights: Nocturne in blue and silver, 1872
Whistler wrote to Fantin-Latour: "The same colour should appear in the picture continually here and there . . . in this way the whole will form a harmony. Look how well the Japanese understood this". The influence of Japanese prints is not overt, but they were fundamental to this simplified elegance.

WHISTLER (right)
Venetian palaces: Nocturne, 1879-80
The shimmering etched lines make mystery out of nuances of reflected light.

Impressionism 1: The Early Years

Paintings associated with the movement called Impressionism have become perhaps the most widely known, best loved and most easily assimilated pictures in the whole history of art – and delightful to live with, as the rich collectors of Europe and America discovered in the 1890s. The beginnings of Impressionism, however, were not auspicious. The Impressionists advanced in the first place from certain beach-heads established by the Romantics, by the Realists, especially Courbet and the Barbizon landscapists, and by Manet. They were committed to painting the world as they saw it – the world immediately around them, the modern world – that is, to realism, to naturalism, even to illusionism, though this was hardly recognizable as such at first to the public. Their Realist doctrine encouraged painting directly from the subject – if an open-air one, then out-of-doors. Yet concentration on the purely visible revealed an optical world composed of innumerable touches of colour, not necessarily encompassing or describing discrete, three-dimensional forms.

The Impressionist analysis could be undertaken in various ways. Monet and Sisley were more or less non-intellectual, attempting an intuitive apprehension of the effects of light. Others sought a rational analysis of the sensation of vision, as did Pissarro (at certain stages) and especially Seurat, whose pointillism was supposedly scientifically based. A third approach was concerned more with the objects that comprise the visible world, and the separateness and interrelationship of these objects are a major consideration in Degas's figure studies, in Renoir's later work, and above all in Cézanne's.

The movement started to coalesce amongst a little group of fellow-students in Paris between 1859 and 1864 – Pissarro, Monet, Renoir, Sisley and Bazille. They had common interests – Courbet, the Barbizon painters – and from about 1866 found in Edouard Manet a sympathetic elder. They also had in common the enthusiasm of youth, and an enemy, the orthodoxy of the academic Salon painters. However, they were sharply different personalities and were to develop along very different lines. They may initially have had some political affiliation, inevitably left-wing, but only Pissarro remained a committed and active socialist; their subject matter, however, was most often pleasure or pleasurable – people enjoying themselves, landscapes enjoyable to look at, celebrated in lively high-keyed colour. The movement formally emerged only in 1874, when the Impressionists' work had been rejected wholesale by the Salon, and they formed the Limited Company of Painters, Sculptors and Engravers, which staged its own exhibition in the studio of the photographer Nadar. It was then that they were dubbed "Impressionists". Between 1874 and 1886 there were eight exhibitions by the group, though the only important member to exhibit at all of them was Pissarro, and already in the early 1880s there were doctrinal and technical dissensions.

The main immediate precursors of Impressionism were Eugène Boudin (1824-98) and Johan Barthold Jongkind (1819-91; not shown). Boudin's delightfully airy little paintings, especially his seashore scenes, were, like Jongkind's, in the Barbizon tradition, but had an added vivacity and sparkle of colour, Impressionistic in effect. Claude Monet was (with Sisley) probably the most single-minded of the Impressionists (see over); Camille Pissarro (1830-1903), while loyal throughout to their initial premises, was the most aware of the necessity of development, including reaction

BOUDIN (right)
The jetty at Deauville, 1865
Boudin encouraged the boy Monet at Le Havre, and initiated him (overcoming his first reluctance) into the art of painting in the open air. His fresh seascapes abandoned tradition in their informality and lack of structure. Seen always from a distance, and noted rather than studied, these fashionable strollers of the resort are unposed; they are momentarily arrested on the canvas, just like the clouds.

PISSARRO (right)
Red roofs, 1877
The rich colours and thick strokes of paint impart a striking brilliance, without compromising an essential structure. Pissarro was the most perseveringly analytic of the Impressionists, always experimenting in the use of pure colours to render light.

RENOIR (left)
At the inn of Mother Anthony, 1866
Renoir's first monumental group portrait was a tribute to Courbet and to tradition. His approach is Realistic, and academic in its concern for form and structure, but its informality, the careful tonal harmony and experimental brushwork, are new.

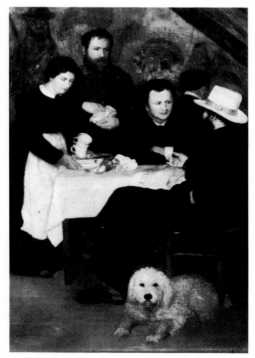

RENOIR (right)
Monet working in his garden, 1873
With his "rainbow palette" Renoir infused his often unremarkable subjects with light and warmth and the feeling of summer. Working together at Argenteuil, both he and Monet used tiny dabs of paint, making the picture shimmer, bringing out its surface in blossoming colour.

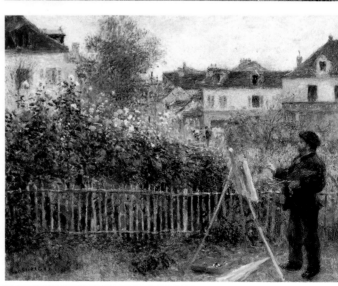

to new styles and influences. Pissarro's early admiration for Corot yielded to one for Courbet; in a period at Pontoise, 1866-69 (where he was the neighbour of the young Cézanne, and encouraged him), his landscapes reflected Courbet's rather sombre-toned naturalism, which proved unpopular, and he lived in great poverty. In the Franco-Prussian war Frédéric Bazille (1841-70) was killed; Pissarro and Monet took refuge in London, and Monet's example, together with the experience of Constable and Turner, led Pissarro to a lighter palette and a looser technique with which to interpret the creative play of light over the physical world. Through the 1870s in France, he was almost the anchorman of the movement, with a stubborn, sometimes slow and even occasionally boring scrutiny of nature – "the most naturalist of them all", observed one critic in 1878.

Pierre Auguste Renoir (1841-1919), from a poor family in Limoges, started life as a porcelain painter, which surely fostered his delight in delicate linear brushwork (not really an Impressionist quality) and in the brilliance of high colour translucent over a pure white ground. He first worked beside Monet in 1864, but even his early *At the inn of Mother Anthony* shows his reliance on the traditional example of the Old Masters – "It is in the museum that one learns to paint", he later said, which is almost heresy to Impressionism. He also, in the mid-1860s, digested Courbet's lessons of monumentality and modelling, especially of the nude. In 1869, with Monet again at La Grenouillère, and in the next few years, he came as close to classic Impressionism as he ever did. Yet he remained obstinately always non-doctrinaire: his paintings are primarily a sensuous response to the pleasure life offers.

Alfred Sisley (1839-99) was in a sense the narrowest of the major figures of Impressionism, from 1870 concentrating solely on landscape in a very light and airy manner, scintillating with pure colour. At times his work is very close to Monet's; he showed great tonal sensitivity, painting floods, snow, mist in subdued colour with delicate subtlety.

Berthe Morisot (1841-95), taught by Corot, married Manet's brother Eugène, and she perhaps influenced Manet towards working in the open air – opening out his style into Impressionistic fragmented colour. She exhibited landscapes and scenes from domestic life at all but one of the Impressionist exhibitions.

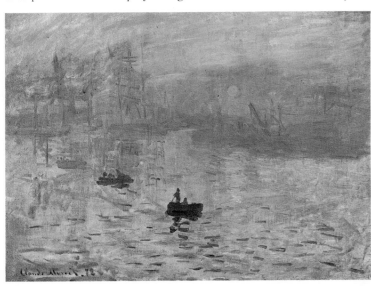

MONET (left)
Impression: Sunrise, 1872
This was the painting that earned the Impressionists their name. "What freedom, what ease of workmanship", wrote one sarcastic critic. The title acknowledges that the work is a sketch; Monet exhibited it since it caught as well as any reworking the effect he sought. The lack of "finish", or labour, to which the critics objected, made possible its instantaneity.

SISLEY (right)
Floods at Port-Marly, 1876
Sisley's series recording the heavy floods at Port-Marly on the Seine near Paris are perhaps his most successful works. His style matured slowly, influenced to the last perhaps by Corot; he gradually came to adopt techniques used by Monet and Renoir, applying colour in small areas – almost in a divisionistic way – working intuitively, without theory. There is nothing English in his art; he was born of English parents in Paris.

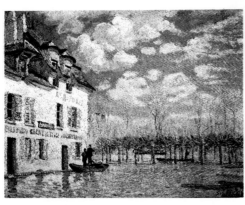

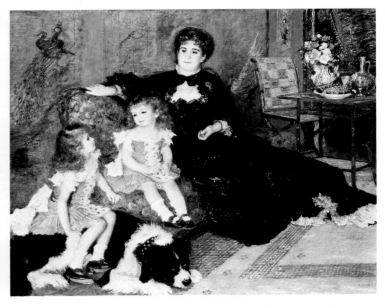

RENOIR (above)
Mme Charpentier and her children, 1878
Renoir's later career was successful, after he found a market in the late 1870s for his seductive portraits of women and children. He achieves movement, vivid life in bright colour; what matters the bland absence of critical characterization?

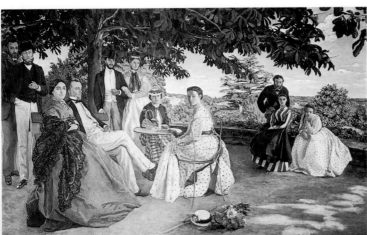

BAZILLE (left)
The artist's family, 1867
Bazille was a member of the nuclear Impressionist group, but his development was cut short by his death in war. Just as he had felt impelled to volunteer, so his portrait is formidably respectable; he was conscientiously Realist, and worked hard at it, made sketches in the open air, and also used photographs.

MORISOT (above)
The butterfly chase, 1874
Morisot seems to combine the dashing, varied strokes of Monet or Renoir with the more smoothly graded tones, and favourite silvery greens, of her teacher Corot. This scene is typical of her informal, intimate glimpses of women and children – though many were interiors. Her subject matter, unlike Manet's, was unoffending.

Claude Monet

Cézanne's famous summary of Claude Monet (1840-1926) contains an essential truth, applicable to Monet's work throughout his long career: "Monet is no more than an eye – but, my God, what an eye." His approach to his art was always pragmatic and intuitive, rather than based on scientific analysis; he was, however, endowed with a formidably stubborn stamina of purpose.

Monet was brought up in Le Havre, and his early awareness of open marine light may well have been a lasting influence, as his exposure to African sunlight during army service in Algiers, 1860-62, certainly was. In Le Havre Boudin (see preceding page) introduced the teenager to the possibilities of open-air painting, to the search for an equivalent in paint to the look and feel of moving light and air; a little later Jongkind, with his sensitivity to changing light and weather, opened his eyes still further.

In Paris, he became a student with the academician Gleyre, and in Gleyre's studio in 1859 his association with the future Impressionists – Renoir, Sisley, Pissarro – began. An early marked influence from Courbet – his use of strong earth colours, his broad, direct technique with the palette knife – yielded to

that of Manet; Monet's own "*Déjeuner sur l'Herbe*" (The picnic; not shown) and his *Ladies in the garden* of 1866 and 1867 are at once a salute and an extension to Manet's *Déjeuner* (see p. 342). They are woodland idylls really, but contemporary, non-mythical, and Realist – a sun-dappled, relaxed bourgeois picnic treated on the heroic scale, life-size, painted from nature – with the interest shifting markedly to the effects of light.

After 1867, and the mass rejection from the Salon of work by himself and his friends, he settled all the more obstinately into his independence, though he often had to live in great poverty. With Renoir at the riverside restaurant and bathing resort of La Grenouillère, painting in the open air, he pursued the interplay of light on restless water, working out for himself by experiment the way that the surface colour of objects and even shadows are modulated into a quite different appearance by reflected light and the neighbouring colours. He tried out techniques of fragmentary brushwork, using pure colours, especially primaries (red, yellow, blue) against their complementaries (green, violet, orange), laid on in short, broad strokes. He became fascinated with

NADAR (above)
Claude Monet, 1899
Monet's patriarchal figure altered little in his last 25 years. At 84, visitors found him still robust – "an impression of rusticity dispelled as soon as he spoke: then one realized how great a spirit he was".

MONET (below)
The cart – snow-covered road at Honfleur, 1865
Jongkind often painted the one scene in different weathers. Jongkind's urge to precise observation and Courbet's vigorous style here combine to influence Monet's early technique.

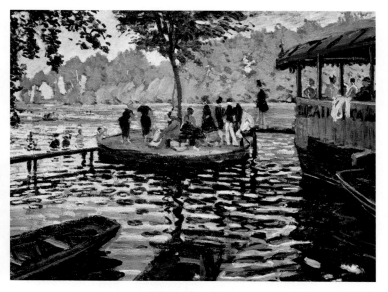

MONET (left)
La Grenouillère, 1869
Of all the Impressionists, Monet and Renoir were the most interested in scenes of contemporary life, especially the unpretentious and lively gatherings of the Parisian working and middle classes. La Grenouillère, a resort on the Seine near Chatou, was a perfect subject and, painting there, the styles of the two artists came as close as they ever did. Both used fragmented brushstrokes and dots to render the river's shifting surface, but Monet's technique was the broader, with a vibrancy in which the movement both of the landscape and of the people in it is mirrored.

MONET (left)
Ladies in the garden, 1867
Monet's obsessive fidelity to appearances is revealed in the story that he dug a trench in his garden to hold his giant canvas, so he could work directly from nature. He painted it in several sessions from one model in various dresses and poses, but worked only in bright sunlight, in order to retain the unified impression of a brilliant summer's day.

MONET (right)
Gare St Lazare, 1877
Monet explores mainly the vaporous effects of steam and smoke within a light-filled but confined space. Touches of vivid colour, especially red, serve to bring forward more distant forms and to determine the relative positions of the objects in the opaque air.

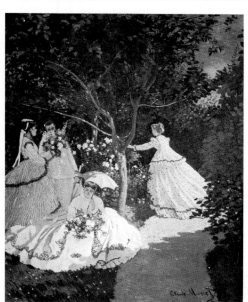

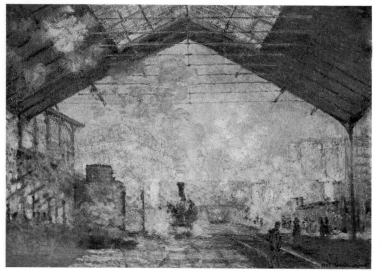

atmospheric conditions, and painted mists and thaws in which mass and form almost dissolved, until light itself seemed to be the subject – the physical objects hardly more than the means by which light could conjure up its own shape. Traditional linear perspective vanished; the depth of the painting was established by the accuracy of the aerial perspective and the recession of the colours.

In 1870-71, Monet took refuge from the Franco-Prussian War in London, and there, though always critical of their work as a whole, took note of Constable's style and especially of Turner's, whose atmospheric concerns had anticipated his, although Turner had worked with different techniques and from different principles of colour. Back in Paris, Monet, with Pissarro, was the main instigator of the first independent Impressionist exhibition, and it was from one of his studies shown there, of a harbour sunrise (see preceding page), that critics coined the word "Impressionism", which has stuck ever since.

In 1877 Monet began his long series of studies, often repeated from the same spot, of a single motif, shown under different conditions and at different times of day. The *Gare St*

Lazare series was the first, continuing the Realist emphasis on themes from contemporary life (the poet and critic Gautier had called railway stations "the new cathedrals of humanity, the centres where all ways converge"). In another sense, however, it was a new departure in naturalism, an attempt at absolute loyalty to the ephemeral effect at a given moment. These series would eventually develop, in his final *Waterlilies*, into the equivalent of musical variations on a theme.

By 1880, Monet's personal relationships with the other Impressionists were beginning to fade, as both they and he increasingly developed their own divergent styles. Monet's work continued very bright in key, but increasingly he abstracted the interplay of colours from the forms on which light kindles them. During the 1880s he travelled extensively, sometimes using a travelling "canvas box": in the box a number of canvases was slotted, and he would move from one canvas to another as the day wore on and the light changed. But he began sometimes (a shift from absolute naturalism) to modify the image before him in the interests of creating a more satisfying colour structure – in this Seurat (see p. 358) may have

influenced him. His formal simplifications sometimes resemble Gauguin's or van Gogh's.

Monet's acceptance by the general public came very slowly – in the mid-1880s he was even attacked by the younger generation, including Seurat, and criticized by otherwise enlightened critics. But by 1890 he was at last developing a popular market, especially in the United States, and in some financial security settled in on that long sequence of thematic series – his *Haystacks*, his *Poplars*, his *Rouen Cathedral*; the magical interpretations of London mist over the Thames; and, for all of 20 years from about 1900 till his eyesight failed before his death in 1926, the continuing variations on the lilies in his own water-garden at Giverny. These marvellous and often enormous canvases increasingly became simply harmonious modulations of colour – an effect that was to be noted with admiration by many painters of the second half of the twentieth century. And yet, although Kandinsky hailed the work of his later years – particularly the *Haystack* series – as the inspiration of modern abstract painting, Monet remained to his death a figurative painter, for whom the objects of Nature were the ruling inspiration.

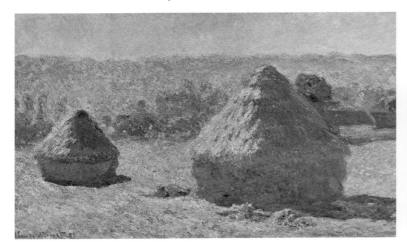

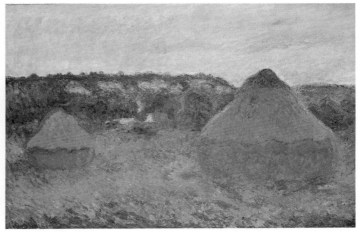

MONET (above)
Two haystacks, 1891
Repeated studies of one motif in varying daylight conditions was the logical result of Monet's life-long concern with instantaneity. He moved from canvas to canvas, registering minute changes in the shimmering "envelope" of coloured light – here that of broad day.

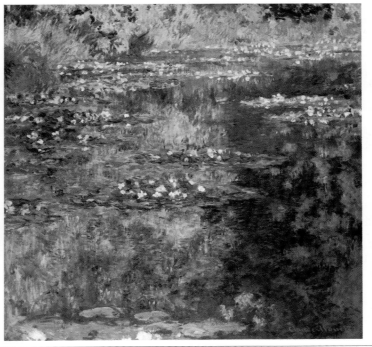

MONET (above)
The cliff at Etretat, 1883
During the 1880s Monet returned to the Normandy and Brittany coast to paint seascapes unprecedented in force and movement. The fury of the waves smacking through the narrow gap of a massive rock formation is captured in brushwork of a new breadth and freedom. But there is no trace of pantheistic Romanticism.

MONET (above)
Two haystacks, 1891
Now approaching sunset dims the palette and blunts the contrasts in an overall red. Kandinsky, on seeing one of the *Haystack* series, suddenly became aware of "the unsuspected power of the palette, which surpassed all my dreams . . . At the same time, unconsciously, the object was discredited as an indispensable element of the picture", he wrote.

MONET (left)
The lilypond, after 1900
Though the growing formlessness of Monet's late works is partly explained by his failing vision, more significantly they represent the ultimate development of Impressionism into subjectivity. The recognizable features of the garden – the trees, banks and little Japanese bridge – dissolve in some of the richest, most poetic colour harmonies to be found in painting.

Impressionism 2: The Later Years

By the time of the last Impressionist exhibition in Paris in 1886, such coherence as the original Impressionists had ever had as a group had already largely disintegrated. The shock of novelty was being supplied by younger artists, such as Seurat, whose *La Grande Jatte* (see p. 358) was in the show. Pissarro exhibited some Seurat-influenced divisionist paintings; Monet and Renoir were absent. Degas, who had exhibited at five earlier shows, showed a sequence of pastels of nudes, or rather naked women (see over); yet, although Degas is associated with Impressionism, and he knew all the Impressionists well, it is difficult to call him one of them. He is more adequately described as a Realist (yet all the Impressionists would have claimed to be that). He was closest to Manet, in his insistence upon drawing and his respect for the Old Masters, and, though committed to contemporary subjects, he never worked in the open air or finished his figure studies in front of the model.

In 1886 van Gogh was in Paris; so was Toulouse-Lautrec; the American Mary Cassatt exhibited at the show. Gauguin was in Pont-Aven; both Pissarro and Cézanne had withdrawn from the fray, Pissarro to Eragny

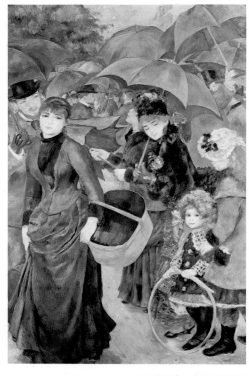

RENOIR (below)
Umbrellas, c. 1881-84
Renoir is surely best loved for his paintings of women – the sugary, sensual beauty of his standard female face. Here both Impressionist and harder brushwork appear.

and Cézanne to his native Aix-en-Provence, pursuing his lonely course (see p. 360) in modest financial independence following his father's death. 1886 saw the end of Cézanne's friendship with Zola, whom he had known from a boy, with the publication of Zola's novel *L'Oeuvre*, which branded him as an interesting failure. It was interpreted by many as a critical obituary of Impressionism. The original group, whom Pissarro now called the "Romantic Impressionists", were beset by individual problems of style, while their personal relationships had degenerated into what van Gogh saw as "disastrous squabbles".

We have followed the career of the supreme painter of Impressionism, Claude Monet, to his death in 1926 (see preceding page). The later career of Camille Pissarro never compromised his persistent integrity, his faithfulness to his original ideals; but the flexibility of his imagination and his curiosity enabled him to take into account the discoveries of much younger colleagues (he had supported Cézanne, Gauguin and Seurat). Pissarro was sustained by an idealistic belief in the moral and social importance of art ("The most corrupt form of art is sentimental art, orange-blossom

PISSARRO (below)
A view from the artist's window, Eragny, 1888
Using Seurat's divisionist technique – but not his flat, summary forms or shallow space – Pissarro sought to capture the reflections of strong daylight in mingled dots of colour. The result is a spare, rather dull and unevocative painting.

PISSARRO (below)
The Boulevard Montmartre at night, 1897
Despairing of a "scientific" analysis of light, Pissarro reverted to an intuitive approach, painting with the skill of his hand rather than the calculation of his brain. He caught surface effects, sensations of moving light, more successfully than ever.

PISSARRO (left)
The potato harvest, 1886
In his correspondence with his son Lucien, which is full of intriguing sidelights on the Impressionist movement, Pissarro wrote: "It is only by drawing often, drawing everything, drawing incessantly that one fine day you find to your surprise you have rendered something in its true character." That reveals the artist, not the socialist or idealist. The need to sell work prompted his genre etchings, in which, perhaps, Pissarro's various talent forms a bridge from Millet's approach to that of Gauguin and the Nabis.

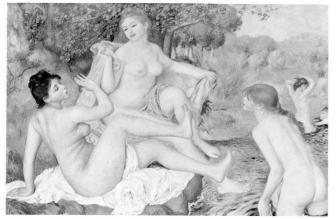

RENOIR (left)
The bathers, c. 1884-87
The design derives from a 17th-century lead relief, *Nymphs bathing,* by Girardon, but since these women are presumably bathing at some notional resort, the subject is rendered contemporary. There is a marked conflict between the firm drawing of the foreground nudes and the more Impressionistic treatment of the background; Renoir was seeking, in his own Post-Impressionism, to reconcile them. His nudes are in the grand tradition of Rubens and Courbet, but already show a concern to simplify form and outline.

art which makes pale women swoon"). Technically and theoretically, he saw the point of Seurat's divisionist analysis of light, and tried it out for himself between 1884 and 1888, only to find that it was irreconcilable with other, older principles – spontaneity, instantaneity, all those "effects, so random and so admirable of Nature". Also, his eyesight began to give trouble, and he reverted to a development of his earlier style; his later urban views are quintessentially Impressionistic in style and choice of subject. He achieved some financial security only in the 1890s, but when he died in 1903 he was acknowledged as a great master both by the public and by artists as diverse as Gauguin and Cézanne.

Auguste Renoir also had shown dissatisfaction with Impressionism, and had already declined to exhibit with the Impressionists in 1884. His increasingly solid modelling owes much to a renewed appreciation of the Old Masters, and his later work emphasized, in varying degrees, a formal and monumental quality. His *Umbrellas*, finished in 1884, is a carefully judged, elaborate design, though distinctly contemporary in subject matter. Shortly afterwards, he turned his attention to the classical and timeless theme of the nude, and his *Bathers* of about 1884-87 was built up in the traditional studio manner, through successive preliminary drawings and studies – the result is quite remote from Impressionist instantaneity. This again was not satisfactory, and, though he continued painting ample and luscious nudes, he reverted to a more colouristic style in the 1890s – perhaps influenced by the brilliance of light he had seen on his trips to North Africa. In his late paintings his colour warmed, becoming even garishly hot.

Towards the end of his life Renoir realized what seems to have been a dream of his youth, and he turned to sculpture. Crippled with arthritis well before his death in 1919, he "dictated" to an assistant some of the most simple, monumental nude sculptures known to art, and they had some influence on the development of twentieth-century sculpture.

After World War I, by the time Renoir and Monet died, Impressionism was almost forgotten amongst working painters, but in the early, exploratory years the Impressionists had notably enlarged the scope of art. They had revealed a world brilliant with light and shot through with colour, and followed through Realist principles, so that virtually anything in the world was a justifiable subject for art. Monet had identified one of his prime aims as "instantaneity", the translation into paint of a particular subject at a particular time, in a particular condition of light or weather. On the way this was done, photography and Japanese prints had a definite effect. As techniques improved, the camera was beginning to be able to freeze, within the rectangle of the film, the motion of passing life. The snapshot effect was eagerly exploited – by Degas in particular, but by Renoir, too, even in his *Umbrellas* – bodies could be cut off within the frame, and mere fragments could make up a picture. Japanese prints showed how asymmetrical elements in a composition could achieve a similar snapshot effect, and for younger painters, above all Gauguin, how effective strong colours and boldly outlined shapes could be, when distributed across the surface with equal emphasis. Even in the most essentially Impressionist works, such as Monet's series *Rouen Cathedral*, objective sight became difficult to distinguish from subjective vision, and the image represented had to be accommodated to the pattern of the picture surface.

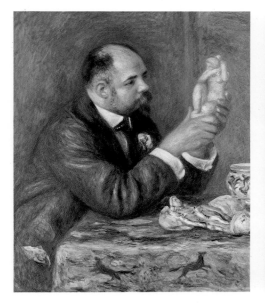

RENOIR (above)
Ambroise Vollard, 1908
Vollard, portrayed holding a statuette by Maillol, was a sharp businessman, and a connoisseur of some flair. He opened his gallery in the Rue Laffitte, Paris, in 1894 and became a major dealer in Impressionist paintings. His portrait by Cézanne or by Picasso (see p. 374) is of a quite different kind.

GAUGUIN (right)
Harvest in Brittany, 1888
This is an Impressionist work, but already the design is based on bold, silhouetted shapes (reflecting probably the influence of Japanese prints); colour is applied as frankly as possible. In Brittany Gauguin found an ideal of "primitive" life, and more to paint than only "the real and existing".

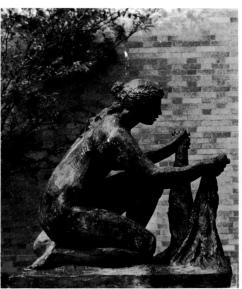

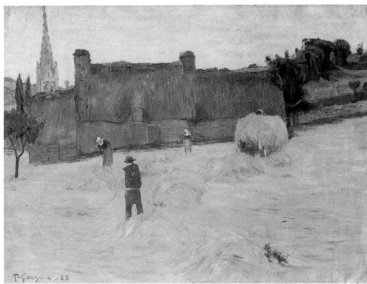

RENOIR (left)
The washerwoman, 1917
The similarity between the heavy form of Renoir's nude and the work of Maillol (see p. 355) is obvious; Maillol had commented (on Renoir's late paintings of equally massive nudes): "That's real sculpture."

MONET (above)
Rouen Cathedral: full sunlight, 1894
After his series of *Haystacks* and *Poplars*, Monet embarked on more than 20 canvases studying the west front of Rouen Cathedral at different times of day from morning to evening.

The intricate forms of the decorative Gothic stonework dissolve in the play of light, and the Cathedral seems to lurk only nebulously behind the clotted brushwork. In this reduction to the purely optical, Realism is fulfilled, and undermined: its limits were made obvious.

Degas: The Little 14-Year-Old Dancer

Hilaire Germain Edgar Degas (1834-1917) was once described by Renoir as the greatest sculptor of the nineteenth century, a claim that may seem exaggerated not only in the light of other sculptors' work – especially Rodin's – but also because *The little 14-year-old dancer* was the only piece of sculpture exhibited publicly in Degas's lifetime. Yet his protégée Mary Cassatt, too, agreed with Renoir.

His reputation as sculptor has in fact only very recently rivalled his long-acknowledged stature as a master craftsman in paint, in pastel and in line. While Monet, Pissarro, Sisley seemed at times to dissolve mass and contour in atmosphere, Degas's artistic ancestry was from the Old Masters, and especially from Ingres. He always retained a profound admiration for Ingres's draughtsmanship. In his Realism, his emphasis on contemporary subject matter, he was entirely in key with Impressionist beliefs, but in his interpretation, in terms of line and silhouette, he was closest to Manet. Like Manet, he was an urban creature: his interest in landscape extended only as far as

the race-course. Even there, he always followed traditional studio practice, not working in the open. Like Manet, too, he would cut off his figures at the frame – apparently arbitrarily, but in fact to achieve a calculated balance in the composition. He sought in so doing to enhance the impression of spontaneity and instantaneity, and he delighted in the immediacy of observations made from unusual angles. Yet he said: "No art was ever less spontaneous than mine. What I do is the result of reflection, and study of the great masters; of inspiration, spontaneity, temperament, I know nothing".

His subject matter ranged from the café life of Paris, even its murkier aspects – *The glass of absinth*, 1876 – to its *café-concerts* and of course to the ballet: it is the perennial charm of his young ballet-dancers that has established the enormous popularity of his work. Yet they are not, seen on close inspection, glamorized; indeed Degas's true subject was the animal body objectively observed, whether human or horse. His famous series of nudes bathing, washing, drying, rubbing down etc., were seen, he said, as if through a keyhole. "My

DEGAS (right and far right)
Two views of *The little 14-year-old dancer*, 1880
The critic Huysmans saluted Degas's work as "the only real modern attempt of which I know in sculpture". Comparable *Ballet-dancers* in wax left by Degas as mere sketches usually show more obviously the movement implicit here.

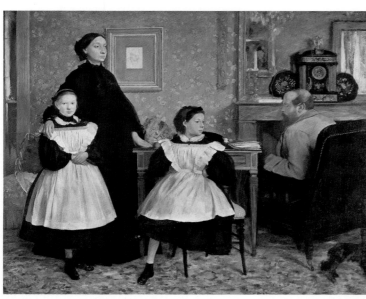

DEGAS (above)
The Bellelli family, 1858-59
The tensions of an unhappy family – Italian relatives of the artist – are shown in the aloof expression of the mother and half-turned back of the father, and also in their spatial relationship. Ingres, Pontormo, Holbein influenced his line, colour and poses and yet Degas's is a wholly contemporary work, already showing his concern for the expressive qualities of the human body.

DEGAS (right)
The glass of absinth, 1876
Degas often used a steep, angled viewpoint to give the effect of a random design, in which human subjects are caught unaware in their characteristic postures. The unbroken zigzag which here leads the eye in and out of the picture confines the dejected figures within a narrow space, reinforcing their mutual alienation.

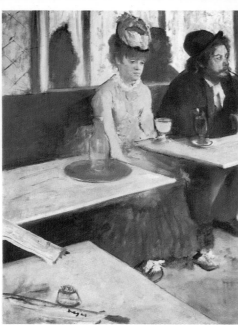

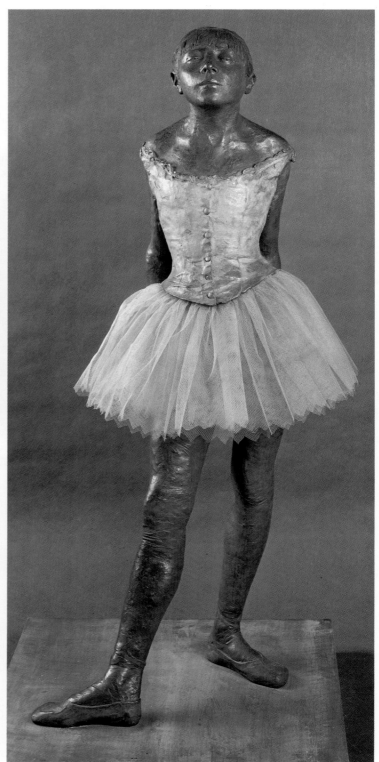

women are simple, honest people, who have no other thought than their physical activity."

His portraits include some of the most remarkable painted in the whole nineteenth century. Even in a composition as monumental and structured as the early *Bellelli Family*, 1860-62, he achieves vividness, and the informal poses in the tightly organized design produce strong overtones of psychological strain.

From about 1872 he returned again and again to ballet themes, seeking in them the perfect balance between instantaneous, transitory effects of movement and the more

general, abstract qualities found in classical artists; he avowed to a patron that he painted ballet scenes "because I find there, Madame, the combined movements of the Greeks". He represented them in all media, especially in drawings, over and over again, moving from oils by about 1880 to pastel applied in many different ways, as his difficulties with failing sight increased. As his control of line became less secure, his interest in colour grew, and so, too, probably his experiments in sculpture.

At his death more than 70 statuettes in wax, amongst many other broken fragments, were

left in his studio, and were first cast in bronze in 1921. They were of horses, of nudes, and above all of dancers, modelled with a rough finish but an incomparable grasp of balance and the vital tension of implicit movement. *The little 14-year-old*, on a larger scale, is the only one worked up to a finish. Shown in the Impressionist Exhibition of 1881, it was, in its context, an almost blatant manifesto of Realism – a wax figure, with real hair, a satin ribbon, a muslin tutu. In the original wax model Degas had also supplied satin shoes and a linen bodice (though covered with wax). In the bronze casts, though, hair, ribbon, and tutu are "real", the remainder is metal, and the rather pert, plain face is not coloured – it is almost time-worn for a 14-year-old. The public seems to have found the extreme naturalism of the statuette disconcerting, and yet, for all its naturalism, *The little dancer* is in formal terms superbly sculptural, entirely in the round, only to be understood and grasped by the spectator's movement around it. Within, it is taut with intimations of movement.

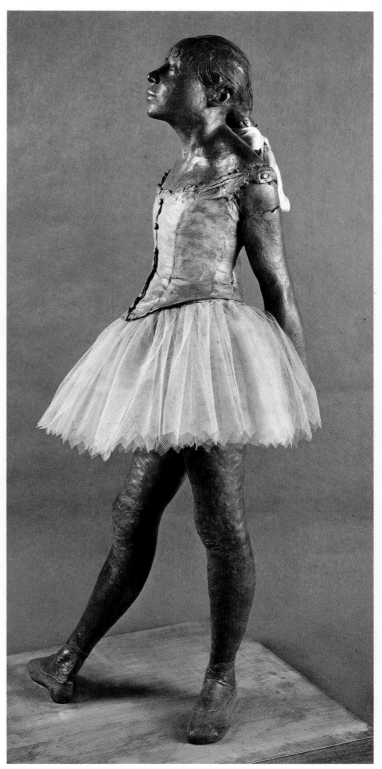

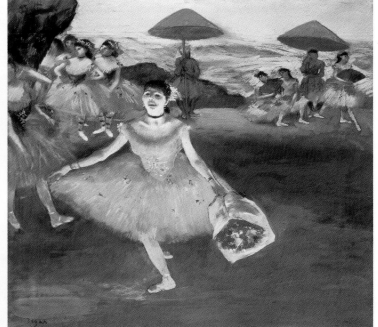

DEGAS (below)
A dancer on stage with a bouquet, 1878
Japanese prints lie behind the bisection of the figures on the far left by the edge of the canvas, and the lack of linear perspective. Even in the dancer's triumph, in the ungainly stance of the chorus, the sheer physical effort of it all is stressed.

DEGAS (left)
Woman drying her feet, c. 1885
The detachment with which Degas studied the female nude (almost always, before, treated with a conscious delight) is due not to his "misogyny" but rather to an utterly unromantic approach to the visual world. His interest lay in the private language of the body, and in the relations of form to space. Yet in the velvety textures he created in his experiments with pastels, in the light held almost under the skin, in the tense contours of his models, the sensuality is undeniable. Degas's transformation of conventional media was of pioneering significance.

Sculpture in the Later 19th Century

In terms of quantity, sculpture reached new heights during the second half of the nineteenth century – the city centres, parks, public buildings, churches and cemeteries of the Western world are still populated by its products. There was also an increasing demand for sculpture on a smaller scale, as an element of bourgeois interior decoration, met by the development of patent pointing machines. Reduced facsimiles of famous works became available to all, in unlimited editions and in all sizes. The statuary of a living sculptor could also be published in this way, and reproductions became an important element in his income – like engravings for painters.

Within the wide variety of eclectic styles flourishing in Europe and America, a persistent Neoclassic strain was perhaps dominant. Classicizing sculpture adorns the neo-Gothic **Albert Memorial** in London (1864-76; not shown). One of the most popular images of the century was the Canova-derived *Greek slave* by the American Hiram Powers (1805-73), shown at the Great Exhibition of 1851. The Englishman John Gibson (1790-1866) produced a *Tinted Venus* – reverting, historically quite correctly, to the Classical Greek practice of colouring marble – which caused a stir when exhibited in London in 1862. In Germany, rather later, the sculptor Adolf von Hildebrand (1847-1921) seems sometimes to have drawn inspiration from Archaic Greek *Kouroi*; he restated Neoclassical principles with resounding influence, though more by his writing – above all *Das Problem der Form*, 1893 – than by his carvings. The gifted Alfred Stevens (1817-75) was a sculptor of a rather different order, reinterpreting with rare sensitivity the Renaissance vision of Raphael and Michelangelo – most ambitiously in his unfinished monument to the Duke of Wellington in St Paul's Cathedral, London.

The major contribution to sculpture came from France. Jean-Baptiste Carpeaux (1827-75) developed from Rude's Romantic sense of drama and movement a "painterly" sculpture of great verve and virtuosity. His masterpiece, the delightful group, *The dance*, 1869, made for the façade of the Paris Opéra, is positively Rococo in its animation and gaiety. But one genius presided over the last quarter of the century, and came to establish his supremacy over all European sculptors – Auguste Rodin (1840-1917). No sculptor had made such an impact since Bernini; Rodin virtually regenerated sculpture as a major art form.

Rejected as a student by the Ecole des Beaux-Arts, Rodin was beset by difficulties in his early years, but by 1875 he had saved enough to finance a visit to Italy, during which the influence of Michelangelo's work became decisive. In 1877, aged 37, he exhibited *The Age of Bronze* at the Paris Salon. This aroused great interest, and criticism; accusations that it was a direct cast of a living model now seem absurd, but indicate how revolutionary its treatment of the nude then seemed. It was certainly far more naturalistic than anything else in the Salon, being endowed with life and movement not only in the configuration but also in the texture and play of light on the body, and not least in the expression of internal emotion through physical form. In this, in bestowing permanence on the transient moment, Rodin's sculpture was comparable to contemporary Impressionist painting, but its symbolic content was alien to Impressionist theory, and the vitality of its modelling depends on an accurate understanding of anatomy and the study of Renaissance and classical example. With *The Age of Bronze* and the

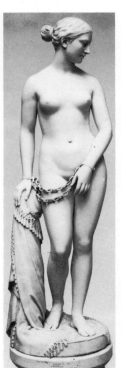

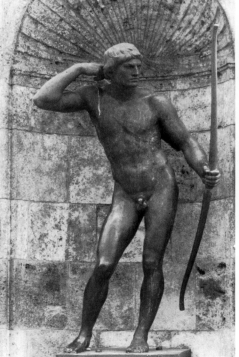

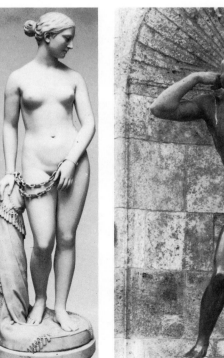

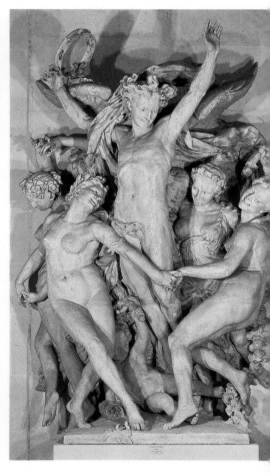

STEVENS (right)
Monument to the Duke of Wellington, detail: *Valour and Cowardice*, 1858-1912
Stevens died long before his greatest work had been completed. His design had won the competition held in 1858; in 1867 the model was ready. Its architectural frame, surmounted by the Duke's equestrian statue, is traditional, but the figures, here Valour and Cowardice, on the other side Truth and Falsehood, have a welcome vigour and simplicity, in contrast to the ornate and fanciful confections created in profusion in his time.

GIBSON (above)
The tinted Venus, 1851-52
Long used to monochrome Neoclassical statues, the public was not won over by Gibson's innovation. Now it seems not so startling: the colours are cosmetic, adding little realism. The Venus is too respectable, in type, pose and polish.

POWERS (right)
The Greek slave, 1843
The ingredients for the stunning success of the slave girl were probably her nubility and shame; her chains excited both compassion and lust. The treatment and theme have many parallels in contemporary academic painting.

HILDEBRAND (left)
The Hubertus fountain, detail: *The archer*, 1907
Hildebrand's hard and pure bronze typifies his severe Neoclassicism. He insisted that the image be conceived in the material of which it was made – unlike Rodin, who transferred images into bronze or stone as it suited.

CARPEAUX (above)
The dance, 1866-69
Carpeaux's work broke all sorts of academic rules: it was exuberantly sensual, anatomically incorrect and vivaciously unmonumental. One offended critic found that its Bacchanalian figures reeked of wine and vice, but they are innocuous really.

figures that followed it, Rodin staked his claim as a sculptor in the heroic mould of Donatello and Michelangelo. From 1880, when the French government commissioned an entrance portal for the new Museum of Decorative Arts – The Gates of Hell (see over) – that claim was acknowledged.

From 1880 to his death in 1917 Rodin was offered a series of public commissions, almost all of which, however, were delayed or rejected, because of financial problems (*The burghers of Calais*) or public opinion (*Balzac*). His colossal *Balzac*, finished in 1898, caused a storm of protest – it was cast and set up in Paris only in 1939 – yet it is certainly the most original and artistically satisfying work of public monumental statuary made during the nineteenth century. Throughout his career Rodin also worked in portraiture, at his best conveying vivid impressions of the head as the index of the mind and spirit, and made thousands of drawings. In his small statuettes, modelled with remarkable freedom, he created images anticipating the Expressionist vision. His impact was overwhelming on subsequent generations, who could not, however, advance from it but only react against it.

In France, the finest reaction to Rodin came from Aristide Maillol (1861-1944). An admirable painter, he turned to sculpture only when he was 40. His noblest work is all on the theme of the female nude, which he saw in terms of classical repose and restraint; the storm of Rodin's emotionalism evaporates in serene calm. In its simplicity of form and volume, Maillol's work is also comparable to the sculptures carried out by Renoir's assistant to his dictation in his old age (see p. 351); arguably, however, Degas (see preceding page) was the greatest sculptor of this generation, though more limited in scope than Rodin.

The highly original Italian Medardo Rosso (1858-1928) became celebrated as an "Impressionist" sculptor, perhaps with more justice than Rodin. His extraordinary group *Conversation in a garden*, 1893, seems full of the verbal echoes and silences of a Chekhov play, solidified for a moment into physical substance. His bust *"Ecce Puer"* seems to come as close as sculpture can to an Impressionist dissolution of form. The future, however, lay with Hildebrand's search for form that was "true to its material" (see p. 394).

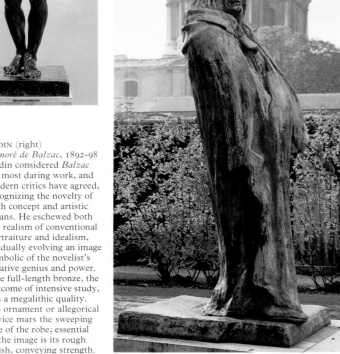

RODIN (left)
The Age of Bronze, 1875-76
The life-size figure was first exhibited under the title *The vanquished*; it was later also called *Man awakening to Nature*. It is a symbolic representation of an emotional state not strictly defined – in this it is "Post-Impressionist". The generalized, smooth form of the academic nude has been broken up into a more realistic unevenness, giving light and movement.

RODIN (right)
Honoré de Balzac, 1892-98
Rodin considered *Balzac* his most daring work, and modern critics have agreed, recognizing the novelty of both concept and artistic means. He eschewed both the realism of conventional portraiture and idealism, gradually evolving an image symbolic of the novelist's creative genius and power. The full-length bronze, the outcome of intensive study, has a megalithic quality. No ornament or allegorical device mars the sweeping line of the robe; essential to the image is its rough finish, conveying strength.

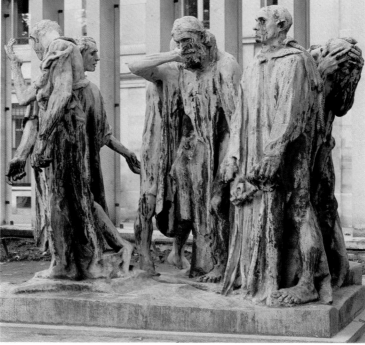

RODIN (left)
The burghers of Calais, 1884-86
Rodin wanted his sculpture to be felt as well as seen, to be set where these men had walked, on the cobblestones of Calais. Each of the hostages (to Edward III of England, who freed them in the end) has a new mood – obstinacy, hope, despair.

MAILLOL (below)
Young girl with drapery, 1910
Maillol's sturdy progeny of static female nudes contrasts with Rodin's fluid, expressive and naturalistic art. He alters nature for the sake of structure and stresses geometric form.

ROSSO (right)
"Ecce Puer", 1910
The features emerge as if through a veil, a mystical premonition of something unformed. Having visited Paris in the 1880s, Rosso knew Rodin's work, and his theme of flux (see over).

ROSSO (below)
Conversation in a garden, 1893
The freedom of composition is unprecedented: the forms, the sculptor and two ladies talking casually, seem to be reshaped and fixed by the forces of light and space.

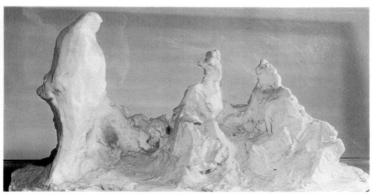

Rodin: The Gates of Hell

The commission for the great portal that came to be known as "The Gates of Hell" was offered to Rodin by Antonin Proust, Minister for Fine Arts, in 1880. But the museum for which the Gates were intended was never built, and the Gates themselves were still unfinished when Rodin died, in 1917.

The prototype was provided by the most famous doors in Western art, those made by Ghiberti for the Baptistery in Florence in the fifteenth century (see p. 100). Rodin's initial drawings show a similar division into panels, but this framework gradually dissolved in the creative flow of Rodin's imagination, until each leaf of the doors, in its upward and downward surge, became more reminiscent of the movement of Michelangelo's *Last Judgment* (see p. 133). Originally, the iconographic stimulus had been religious, provided by Dante's *Inferno*, and *The thinker*, central above the two leaves of the Gates, was at once an imaginary portrait of Dante and a symbol of man's creative mind. *The thinker* was to be Rodin's most famous image, repeated on a monumental scale in marble and bronze, and widely reproduced on a small scale.

The Gates became, amongst other things, the storehouse in which Rodin accumulated a repertory of images (more than 200) on which he was able to draw for the rest of his life. His inability to finish the Gates seems not to have worried him greatly: they responded to the continual flux of his creative imagination; Rodin compared the project with Gothic cathedrals – "Were they ever finished?" That, however, illustrates a clear limitation of his genius: creation was for him a continuous process, and a final resolution of a complex composition, especially of groups of figures, escaped him. *The burghers of Calais* (see preceding page) remains a gathering of single figures, linked by their psychological tensions rather than by any formal compulsion. The Gates of Hell is made one unit by the architectural framework of the gateway, but Rodin's figures spill all over it, thrust forward and dissolve into it. This flux of becoming, of waxing and waning, corresponds to the movement of the pliable clay in the artist's fingers. Rodin was not a theorist, but he believed profoundly that the artist should create form by the working of his imagination through his fingers into the clay – the antithesis of the procedure of his revered Michelangelo, who cut away the block to reveal the figure as he met it in the marble. Rodin was quite happy that his clay be translated into marble as well as bronze, but the carving was done almost invariably by assistants. In those remarkable sculptures in which a highly finished figure, or fragment of a figure, emerges to pristine perfection in the midst of rough-hewn marble, he used the effect of Michelangelo's unfinished statues, but for different ends. Michelangelo's figures are not finished; Rodin's express his fascination with the contrast of formed and inchoate, finite and infinite, with flux and with the mystery of birth.

The iconographic content of the Gates was altered and developed no less than the sculptural form, but the overall mood remains coherent. Dante's *Inferno* is transformed into a Baudelairean symbol of Hell in the mind.

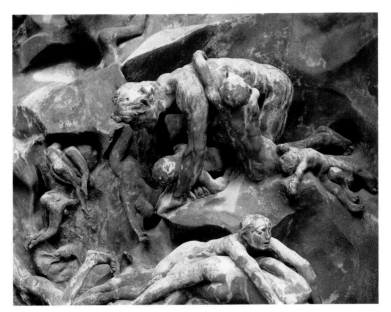

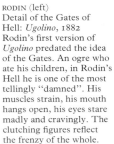

RODIN (left)
Detail of the Gates of Hell: *Ugolino*, 1882
Rodin's first version of *Ugolino* predated the idea of the Gates. An ogre who ate his children, in Rodin's Hell he is one of the most tellingly "damned". His muscles strain, his mouth hangs open, his eyes stare madly and cravingly. The clutching figures reflect the frenzy of the whole.

RODIN (below)
The thinker, 1880
Rodin's starting point was Michelangelo's *Lorenzo* (not shown), who embodies the Contemplative Principle in the Medici Chapel in S. Lorenzo in Florence. Deeply tinged with the intellectual pessimism of the 1880s, the image suggests creativity without resolved outcome. Rodin at his own wish was buried beneath a cast of it.

RODIN (below)
Crouching woman, 1882
Rodin's most concentrated work on the Gates, in the earlier stages, coincided

with a passionate affair: some of the gloomy figures inspired by the *Inferno* are also driven by the most violent, pressing eroticism.

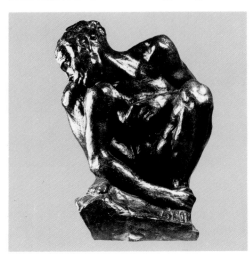

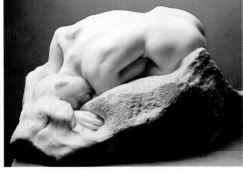

RODIN (above)
The Danaid, 1885
Rodin found the poses that evoked a mood or emotion by letting his nude models move around the studio as he sketched. The finish of his marble work contrasts with the roughness of his bronzes – his aim was a blurred luminous quality rather than a high polish.

RODIN (right)
Nero, c.1900-05
Rodin made thousands of pencil-and-wash drawings, in which he could exploit the same tensions between volume and movement on the surface that vitalize his sculpture. In these free drafts the subject is often ambiguous – this is like a Renoir nude struck mad.

356

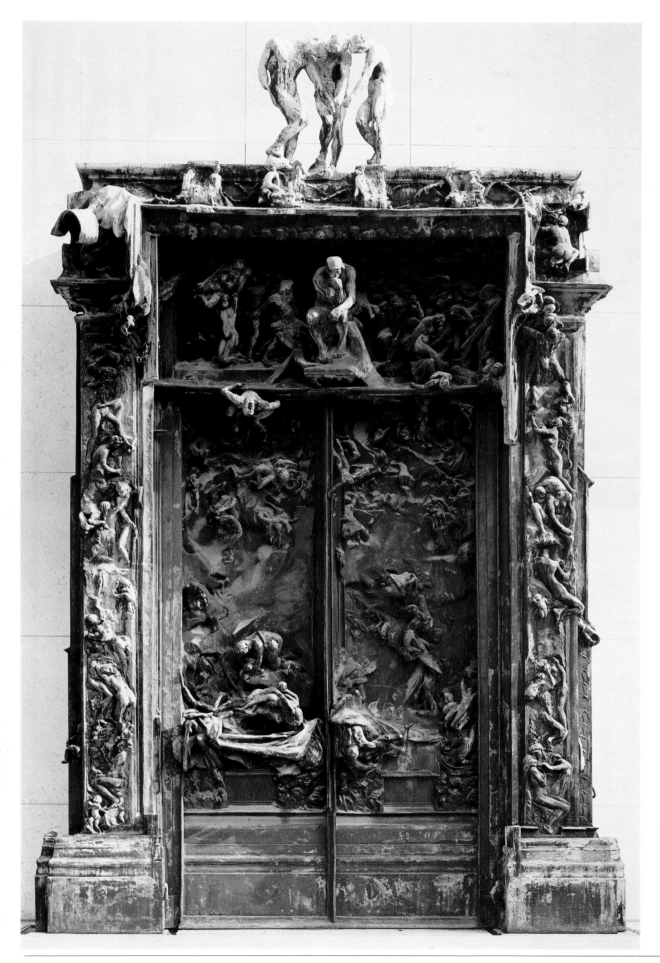

RODIN
The Gates of Hell,
1880-1917
Anatole France commented
thus: "You will not find
monsters in the Hell of
Rodin . . . the evil demons
through whom these men
and women suffer are their
own passions, their loves and
hatreds; they are their own
flesh, their own thought."

357

Seurat: La Grande Jatte

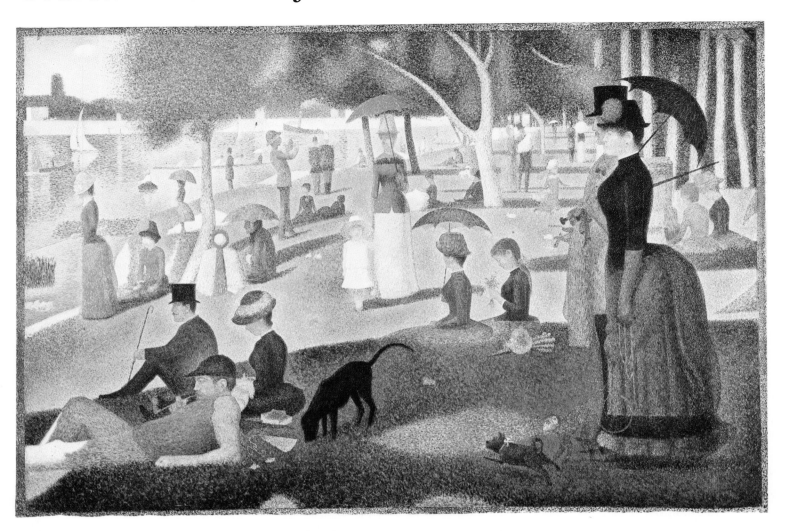

La Grande Jatte, named after a weekend resort on the banks of the Seine popular among Parisians, was begun in 1884 and finished in 1886, and exhibited in that year in the last Impressionist exhibition. Seurat's admission to the show, due largely, it seems, to Pissarro's championship, caused dissension among the original Impressionists. Indeed this picture is obviously at variance in very important points from the practice of Impressionism – so much so that subsequent historians distinguish the style evolved by Seurat with the label "Neo-Impressionism". The interest in light, in colour created by light, and in a very high key of colour, is still dominant, but the technique is both more fragmented and more precisely (even at times mechanically) worked out. In its contemporary subject matter *La Grande Jatte* is still Realist, but the effect in sum and detail is as if the Impressionist vision had frozen: the sense of implicit movement, the feeling for ephemeral effects, are rejected in favour of a timeless, highly formalized, monumental quality. Realist in some aspects the image may be; it is in no sense naturalistic.

Georges Seurat (1859-1891) was a seemingly orthodox, docile student at the Ecole des Beaux-Arts in Paris, 1877-78, working a great deal in the Louvre, studying there intensely the masterpieces of traditional art from Greek classical sculpture to the Italian and northern Renaissance. However, he extracted his own conclusions from them, and was probably already interested in theoretical writings on colour, such as those published by Michel-Eugène Chevreul and others, leading to the demonstration that juxtaposed colours mix in the human eye, and that the colour so mixed is purer than any pigments mixed on the palette. By 1881 Seurat had developed a highly original drawing technique in black crayon, extracting simplified and very solid figures by the subtle and exact control of tone. His early painting in colour always tended towards a similar simplification: even his small oil-studies, painted in the open, direct from the subject, moving gradually towards the lighter palette of the Impressionists, demonstrated his primary interest in an exactly articulated composition, plotted with equal emphasis across the picture plane, using simplified silhouetted shapes, and increasingly shallow space.

By 1883, he was developing the technique known as pointillism, a system of applying paint in isolated dots of pure colour. His first major work in this technique, on the grand scale of ambitious Salon pictures, "*Une Baignade, Asnières*" (A bathing scene at Asnières), was finished in 1884. The subject, urban recreation at the riverside, was an Impressionist one, and the innumerable preliminary studies likewise reflect Impressionist practice; but their integration into the whole was a studio process, and an austere call to order of the chaotic, multitudinous impressions with which nature assails the eye.

The exhibition of *Asnières* in 1884 and of *La Grande Jatte* in 1886 established Seurat as the spearhead of the new avantgarde. The exponents of Neo-Impressionism, Pointillism or Colour Divisionism were supported by critics such as Fénéon and the Belgian poet Verhaeren, but older Impressionists (with the exception of Pissarro) read *La Grande Jatte* as a counter-Impressionist manifesto.

For Seurat, "the purity of the element of the spectrum is the keystone of technique", and he continued to work with tireless industry towards the perfection and simplification of his system until his premature death from an unidentified illness in 1891. He had continued to produce *grandes machines*, major exhibition pictures, extending his subject matter to further aspects of modern urban life, even adapting motifs from the abstracted imagery of posters and fashion plates, but always resolving his pictures into immobile patterns, even when his subject was the sea or his theme motion, as in his last big canvas, *The circus*. "I want", he said, "to make modern people move about as if they were on the Parthenon frieze, in their most essential characteristics."

Apart from his impact on Pissarro's style in the 1880s, Seurat's work inspired only one disciple of significance, the prolific Paul Signac (1863-1935), who remained to the end faithful to the divisionist principle and technique, although his vision was less subtle and more coarsely handled.

SEURAT (left)
La Grande Jatte, 1884–86
Seurat's biographer, the
critic Fénéon, described the
picture: "It is four o'clock
on Sunday afternoon in the
dog-days. On the river the
swift barks dart to and fro
... A Sunday population has
come together at random,
and from a delight in the
fresh air ... Seurat has
treated his figures in a
summary or hieratic style,
like a Puvis de Chavannes
(see p. 368) gone modern."

SEURAT (right)
The yoked cart, 1883
The rich colour and the
seemingly casual design –
cutting off the cart at the
edge of the canvas – re-
call "pure" Impressionism.
Seurat, however, achieves
a still image purged of all
superfluous detail, evoking
a mood of calm expectancy.

SEURAT (below)
*Seated boy with a straw
hat*, 1883-84
Seurat liked to sketch in
black crayon on thick white
paper; its textured surface
enabled him to achieve the
fine tonal gradations which
characterize his atmospheric
drawings. Sometimes, like
this one, they were studies
for larger pictures (this is
the youth on the left in the
Asnières canvas); yet they
possess all the qualities
of finished works of art.

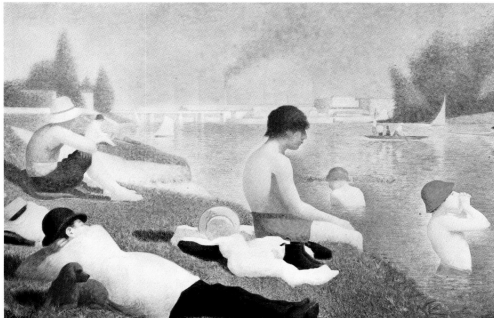

SEURAT (above)
"Une Baignade, Asnières"
(A bathing scene at
Asnières), 1883-84
Seurat's method was based
on contemporary scientific
theory, even if the separate
dots of colour are not small
enough to blend in the eye,
as presumably he intended.
(This was pointed out only
some 40 years later.) But
Seurat's "scientific" basis
helped to justify his artistic
aim, to capture on canvas
the essence of appearances.

SEURAT (right)
*The "Bec du Hoc" at
Grandchamp*, 1885
The dynamic mass of cliff
against calm sea and sky
rears imposingly; Seurat's
dots and strokes vibrate
before the eye, enlivening
the surface – much as the
less regimented brushes of
Monet or Renoir also did.

SIGNAC (above)
*View of the marina at
Marseilles*, 1905
Seurat's divisionism and
deliberated arrangement
of forms is here enlivened
by vibrant "Fauve" colour
(Matisse was a friend).
Signac had earlier painted
working-class or industrial
scenes, perhaps with implicit
social comment; he was a
professed anarchist. Seurat's
politics were less definite.

SEURAT (above)
Study for *The circus*, 1890
Seurat was later influenced
by the philosopher Henry,
who proposed that certain
analysable factors in a com-
position determined what
emotional message it had:
upward curves and leaping
forms here signal gaiety.
He sought "to do Poussin
again", but from science.

Post-Impressionism 1

The term "Post-Impressionism" was coined by the critic Roger Fry for the title of his exhibition in London in 1910-11, *Manet and the Post-Impressionists*. Cézanne, Gauguin, and van Gogh were strongly represented, also Seurat and Signac, but more thinly; in Fry's second "Post-Impressionist" show, 1912, the range extended even to Picasso and Braque. Though the term can be applied so loosely as to be almost meaningless except as a rough chronological indication, it has persisted. In fact, the major artists to whom it is generally applied shared only a stubborn, often belligerent, refusal to be like anyone else; each, in varying degree, was a loner, misfit or outcast, voluntary or involuntary, not only from the artistic orthodoxy of the time – the Paris Salon – but even from ordinary society. Yet all of them passed through Impressionism, and their mature paintings are developments from Impressionist beginnings.

The beginnings of Post-Impressionism date from the years when Impressionism, as a movement of artists with common theories, practice and sympathies, was disintegrating – that is, the mid-1880s. Within a few years, after seeing the 1891 Salon des Indépendants

in Paris, the Belgian poet Verhaeren was writing: "There is no longer any single school, there are scarcely any groups, and these few are constantly splitting. All their tendencies make me think of moving and kaleidoscopic geometric patterns, clashing at one moment only to unite at another, which now fuse and then separate and fly apart a little, but which all nevertheless revolve within the same circle, that of the new art." Within the new art, the sympathy of one master for another was not always obvious: Gauguin always reverenced Cézanne, but Cézanne thought Gauguin was no painter at all, and told van Gogh that he (van Gogh) was mad. Degas was intrigued by Gauguin's works and bought several, but Monet never took Gauguin seriously. Only Pissarro seemed genuinely and selflessly open to objective appreciation of honest explorations in all styles: in 1886 the first and greatest of the "primitives", Henri Rousseau le Douanier (see p. 388) had first exhibited and provoked huge hilarity – only Pissarro recognized the quality that the apparent naivety of drawing and the imagery concealed.

Subsequent historians have tended to distinguish two fundamental trends in Post-

Impressionism. The pursuit of formal values is seen as the basic concern of Seurat (see preceding page) and of Cézanne. They are claimed as the spiritual ancestors of several of the major explorations of the twentieth century, notably Cubism and much modern abstract art. By contrast, the revolutionary ways in which other artists realized form have been interpreted as means rather than ends, the ends being the most vivid expression possible of the artist's emotion: so such artists as Gauguin and van Gogh can be categorized as precursors not only of the Fauves, but of the whole Expressionist movement. One trend has been seen as moving towards the objective and the classical; the other towards the subjective – an intensification of Romanticism. Such interpretations must be viewed with caution – the Romantic qualities evident in Cézanne's early work, for example, are not expunged in his very last paintings: they are still there, though differently expressed, for they were an integral part of his temperament.

The "Post-Impressionists", as the epithet implies, were mostly of a younger generation than the founding fathers of Impressionism, and they revolted against their elders while

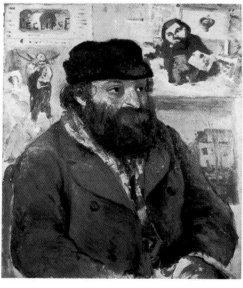

PISSARRO (right)
Paul Cézanne, 1874
Pissarro encouraged the young Cézanne, persuaded him to exhibit at the first Impressionist show (1874) and never lost confidence in him. He followed Manet's *Zola* (see p. 343) in posing his sitter with pictures relating to him, chiefly a caricature, top right, of Cézanne's early mentor, the great Courbet.

GAUGUIN (below)
Vincent van Gogh, 1888
Gauguin distorts colour to reflect Vincent's obsession with sunflowers, unbalancing the painter in relation to his canvas; he simplifies line, abandons modelling, makes an abstract pattern. His new art had evolved in early 1888 in Brittany, a few months before his visit to van Gogh in Provence.

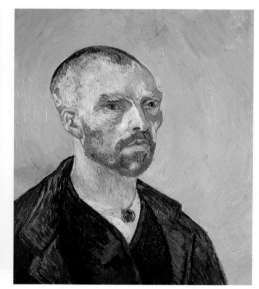

VAN GOGH (left)
Self-portrait, 1888
Van Gogh had such a rage for Japanese art that he gave his strongly modelled self-image slanted eyes. Inspired by a custom of Japanese painters, he began exchanging portraits with colleagues. This picture, finished before he left for Arles, was dedicated "to my friend Paul Gauguin".

CEZANNE (below)
The rape, 1867
Cézanne's concern to use the brushwork itself as an element of the composition is apparent in his earliest paintings. At this time he used to send Zola poems which, like Zola's Realist novels, and like this picture, have melodramatic, violent themes – an urgent quest to penetrate the heart of life.

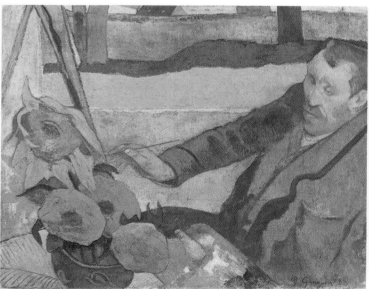

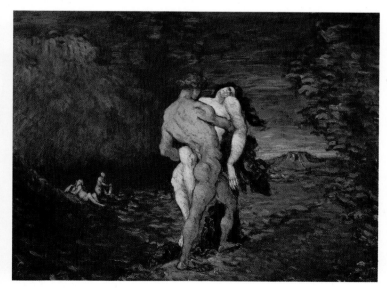

taking many of their discoveries for granted. The great exception was Paul Cézanne (1839-1906). Unlike his contemporaries, notably Monet, Renoir and Pissarro, he always had before him the prospect of financial stability, although his prosperous father kept him on a meagre allowance until his death in 1886, when Cézanne was already well advanced in middle age. His early style, deeply imprinted by both Delacroix and Courbet, was sometimes flagrantly Romantic, with sensational subject matter, for instance that of *The rape* of 1867, painted in a thick, often seemingly clumsy style. Associating in Paris with his old school-friend, Zola (admiring the Realism – almost brutalism – of Zola's novels), he suffered repeated rejection from the Salon in consort with the Impressionists. His portrait of the dwarf *Achille Empéraire* (1868-70), a grotesque subject treated with heroic emphasis, the paint applied thick and coarse, was not simply rejected but excited positive revulsion. This was what Cézanne later referred to as his *couillarde* (approximately, "gutsy") style, broadly painted with trenchant use of the palette-knife; it lightened under the influence of Pissarro especially. Cézanne worked with

him for periods at Pontoise and Auvers, and the impact of Impressionist practice is first visible in works such as *"La Maison du Pendu"* (The suicide's house) of 1872; but already here a very solid, almost diagrammatic sense of underlying structure, foretelling his later development, is perceptible. He returned to his native Provence for short periods in 1876 and 1878, and was there more permanently from 1883; following the death of his father, he was able to devote himself undistractedly to his endless battle with the intractable landscape that confronted him (see p. 366).

The 1880s were a watershed; it was then that

Western art was released from the representational concerns with which it had been preoccupied since the Renaissance. Of the pioneers of this modern art, van Gogh (see over) died in 1890, Seurat in 1891, the same year that Gauguin (see p. 364) left for Tahiti. Cézanne continued unsung until the new century. Each asserted in his own way the absolutism of his own personality. Twenty years later, in the first decade of the twentieth century, the great revolutionaries of modern art were to act on that independence to the point of taking the visible world to bits and reassembling it according to their own vision.

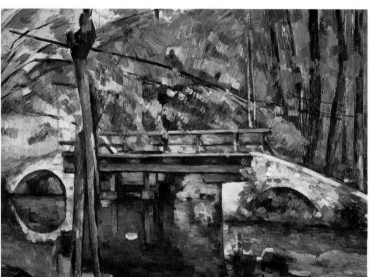

CEZANNE (left)
The little bridge at Maincy, 1882-85
Cézanne's reconstruction – no longer an imitation – of what he saw was always based on a careful analysis of colour, light and shade. Unlike Gauguin, or van Gogh sometimes, he never abandoned the modelling of volume by tonal gradation, though his brushwork had also a purely surface value.

VAN GOGH (below)
Montmartre with windmills, 1887
Van Gogh's interpretation of Impressionism, which he had adopted just the year before, was entirely individual. In Paris he had admired Monet's brilliant brushwork, and Pissarro had led him to heighten his key. But only Vincent could give a placid view such urgency.

CEZANNE (left)
Achille Empéraire, 1868-70
Cézanne elected to present to the jury of the Salon of 1870 this huge portrait of a dwarf, just because it would certainly displease them; it was duly rejected. He was, it seems, in revolt against everything. The portrait has an alarming force in its contrasting colours, thick brushwork, and very subject.

CEZANNE (left)
"La Maison du Pendu" (The suicide's house), 1873
Under Pissarro's tutelage at Auvers, Cézanne briefly became a true Impressionist, conveying a vibrating light with much brighter colours.

VAN GOGH (right)
The bridge at La Grande Jatte, 1887
The thick strokes of the brush are undisguised and, with colour, give this work its underlying structure.

Vincent van Gogh

VAN GOGH (above)
Self-portrait, 1890
The intensity of expression,
reinforced by the icy back-
ground of swirling strokes,
is characteristic. This was
painted only a few months
before the artist's suicide.

In his short life Vincent van Gogh (1853-90) produced over 800 paintings and a comparable number of drawings; before his death he had sold in total two pictures. Yet he has become perhaps the most widely loved and reproduced painter in the history of Western art. In his posthumous fame the drama of his personal life plays an integral part – documented not only in his extraordinary autobiography in paint, his self-portraits, but in the running commentary contained in more than 700 vividly articulate letters, mostly to his devoted brother and supporter, Theo van Gogh.

He was born, in 1853, with dual affiliations, to religion and to art. His father was a parish priest at Groot Zundert in Holland; three of his uncles were art dealers. His first acquaintanceship with art was from the dealer's side, at The Hague and then for a spell in London. Dissatisfied, he started to train for the Church in 1876, only to realize that his radical view of Christianity was incompatible with orthodoxy. Living in great poverty, he began to draw seriously when he was 27, and so gradually realized his true, final and fatal vocation, to which he surrendered with the fervour of a convert; he had only ten years left to live.

The first five years (1880-85) of his new career were spent in Holland in painful self-training, in physical privation and constant emotional strain. From the beginning his subject matter was the earth and those who worked it; his social concern was crucial. In life, he acted on similar compassionate principles, even setting up house with a prostitute and her child. But while the message of his gospel in art and life was love, his temperament, ferociously independent and egocentric, made it impossible for him to sustain a close relationship with anyone, except Theo.

Vincent's work in Holland culminated in his masterpiece of 1885, *The potato eaters*, which is still traditional, though painted expressively dark in sombre greens, browns and blacks. In late 1885, he moved to Antwerp, and there discovered Rubens; his palette lightened, his touch became freer; and he also became fascinated by Japanese prints. Independently, he was beginning to discover that colour could have its own laws and meaning irrespective of the true colours of the subject matter. His letters reveal his longing to perfect his art, to establish new contacts and see the most modern painting. In February 1886 he arrived in

VAN GOGH (left)
The potato eaters, 1885
Van Gogh consciously used
the colour of dirty potatoes
and heavy, simplified forms
so as to convey poverty. As
a trainee missionary he had
shared the peasants' misery.
In seeking to express it as
lucidly as he was able, he
began to cross the bounds
of conventional naturalism.

VAN GOGH (right)
Sunflowers, 1888
On his arrival in Provence
in 1888 Vincent reacted to
southern warmth and the
sunny colours around him
in joy. His dashing strokes
of paint recall Impressionist
techniques, but the twisted
lines and the concentrated
colours of the series are
full of an original power.

VAN GOGH (right)
The night café, 1888
This is the little café in
Arles where van Gogh and
Gauguin drank together. It
is a nightmare – the harsh
lighting, giddy perspective
and hunched, lonely looking
patrons create the effect.
The colour symbolism is
attested in Vincent's own
description of the work.
"I have tried to express
the idea that the café is
a place where one can ruin
oneself, go mad or commit
a crime", he wrote. "I have
tried to express as it were
the powers of darkness in
a low public house, by the
use of soft Louis XV green
and malachite contrasting
with yellow-green and harsh
blue-greens – and all this in
an atmosphere like a devil's
furnace of pale sulphur".

VAN GOGH (above)
*Sailing boats coming
ashore*, 1888
The simple, bold lines of
the boats at Stes-Maries,
near Arles, rendered them
very suitable subjects for
paintings and sketches that
emulate Japanese prints.
His careful arrangements
of lines, shapes and patches
of colour reflect Vincent's
study of such prints – and
he and Gauguin learnt from
them not simply design, but
bold, non-naturalistic hues.

Paris, and there the impact of the work of the Impressionists revolutionized his painting.

In February 1888, he went south, to Arles. He was still passionately concerned with the social responsibilities of art and the necessity of the modern artist's involvement in life and the whole of life. He envisaged at Arles the establishment of a sort of artists' commune, interlocking with the local community. Yet his own painting was becoming ever more personal and subjective, and even mystical. His famous *Sunflower* series was conceived as a symphony in yellow and blue: the colours sing (the musical analogy recurs in his letters). But he also conceived these pictures as Gothic rose windows, to be decorations of his new home, the intended sanctuary and cradle of a new way of art and artistic life. His co-founder of the commune he hoped was to be Gauguin, but Gauguin's brief stay ended in a violent quarrel, in Vincent's frustrated assault on Gauguin, followed by his mutilation of his own ear and the macabre gift of the bleeding fragment to a prostitute in a brothel. On recovery, van Gogh realized that he was on the brink of insanity – more than that, he had been over it at least once. In May, 1889, he with-

drew voluntarily to an asylum at St-Rémy, but there continued frantic production (some 150 paintings) for the next year. In May 1890, he moved again, living as the patient and guest of a remarkable physician and connoisseur, Paul Gachet, until, overwhelmed by a final crisis of despair, he shot himself on 29 July 1890.

In the south, van Gogh had soon abandoned objective, "scientific" analysis of colour according to Impressionist doctrine. He continued to use, in the Impressionist manner, touches of different colours alongside each other, but generally his brushwork became stronger and more rhythmic, and colour took on its own symbolic function. Thus in his *Night café*, he wrote, he used "colours not locally true from the point of view of the stereoscopic realist, but colour to suggest any emotion of an ardent temperament". The quality of paint, laid on thick and rough and violent, is no less telling than the use of colour. Yet he remained rooted in his subject matter, and one reason for his differences with Gauguin was his distrust of the latter's "abstraction". In *"La Berceuse"*, his portrait of the postman's wife, Madame Roulin, the flat patterning is clearly influenced by Gauguin, and

later he had doubts about it for that very reason. As he painted it Vincent had come to think of it almost as a religious image, a *Madonna*, and as the focus of a polyptych surrounded by his sunflowers like candelabra. His idea was that "sailors, who are at once children and martyrs, seeing it in the cabin of their Icelandic fishing boat, would feel the old sense of being rocked come over them and remember their lullabies".

In the last year of his life, the whole Provençal landscape and its sun, moon and stars were caught up in the impassioned desperate swirl of his paint, and became molten. The image became a symbol of emotion ranging from despair to intoxicated exaltation.

Though he was virtually unknown when he died, the extent of van Gogh's achievement was revealed in a series of exhibitions in Europe and America during the next 25 years. The Fauves, the German Expressionists, all acknowledged him. Following the publication of his letters, he became a romantic hero of book and film, a stereotype – like Rimbaud – of the doomed artistic genius. Endless reproduction still seems unable to drain his drawings and paintings of their demonic vitality.

VAN GOGH (right)
"La Berceuse" (Mme Roulin rocking a cradle), 1889
After his breakdown van Gogh returned to his series of portraits of Mme Roulin, the postman's wife. She holds the ropes of a cradle in her hands, soothing the unseen baby and the viewer. The lack of modelling and the strong pattern reveal a concern for abstract as well as expressionist effects.

VAN GOGH (below)
Field with a stormy sky, 1890
Vincent's late paintings of landscapes around Auvers are essentially subjective: the vast open fields and the troubled skies express his melancholy and loneliness. The painting is structured solely by the brush-strokes and the choice of colour.

VAN GOGH (left)
Dr Paul Gachet, 1890
In letters to Gauguin and his brother Theo Vincent described his portrait in passionate terms. He was trying to create a new kind of portraiture, based not on the imitation of appearances but on the intensification of character. He gave his friend "the heartbroken expression of our time", projecting on to Gachet his own feelings.

VAN GOGH (below)
Country road by night, 1890
The paintings Vincent made in the asylum at St-Rémy unequivocally reveal madness – the rushing path, the hallucinatory sky, the greens lurid in the bursts of spiky corn. The retaining elements of the design – the figures, the horse and trap – are swept away by the violent flow of brush-strokes.

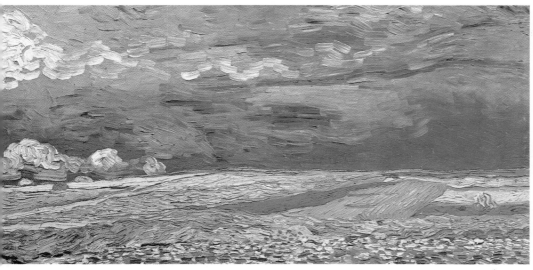

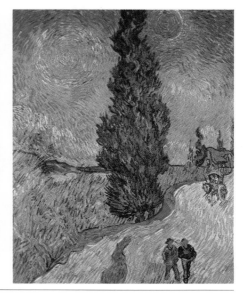

Paul Gauguin

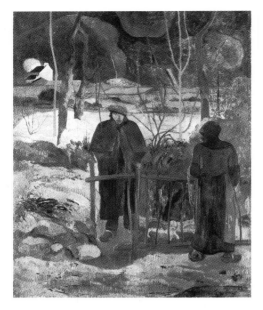

Gauguin's fierce independence, his rejection of centuries-old principles of Western art, surely owed something to his lack of any early training in art at all. Paul Gauguin (1848-1903) was born of mixed blood – French and Peruvian Creole – in a family in which bizarre traditions of violence, rape, sudden death and intellectual radicalism were strangely mixed. His youth in Peru and France was followed by six years in the merchant marine, and then (1871-82) by a successful career as stockbroker; he became a collector of Impressionist paintings, and experimented as an artist himself to such good effect that by 1879 a small statuette of his had been accepted for the fourth Impressionist exhibition, followed by seven paintings in the show the year after. By 1883, when he gave up his career to devote himself entirely to art, he was already questioning Impressionist principles. Between 1886 and 1891 he became the focus of a group of artists at Pont-Aven in Brittany, making a first brief visit to exotic lands (Martinique, in 1887) and spending two fraught months (which have become famous) with van Gogh in Arles in 1888.

These were years in which Gauguin ceaselessly questioned himself and his art, amid increasing difficulties: from affluence he sank to acute poverty, and to his great sadness he was separated from his wife and children. After he had rejected Impressionism, which he came to regard as "shackled by the needs of probability", the first fully realized statement of his aims came in *The vision after the sermon* of 1888, a vision of Breton peasant women rapt in silence and prayer, as if in church, as they behold in a blazing red field the winged angel, gold and brilliant blue, wrestling with Jacob – the women, too, seem winged with the weird shapes of their *coiffe* head-dresses. One critic categorized this art a little later as "idea-ist, symbolist, synthetic and subjective". While the construction acknowledges the basics of traditional perspective (and the looming foreground figures set against the action beyond recall Degas), the impact of Japanese prints is clear, and far-reaching – the schematic composition, the flat fields of unbroken, shadowless colour, the exploitation of silhouettes; even the stance of the wrestlers and of the bull are borrowed from the Japanese. The use, however, of heavy outline filled with pure colour, as in medieval enamelwork, and hence known as "*cloisonnisme*", owed much to Emile

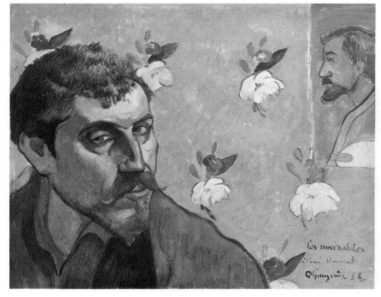

Bernard, one of the group in Pont-Aven. Above all, colour takes on a symbolic and emotional significance – a spiritual dimension.

Gauguin's art had become an art of imaginative concept rather than analytical observation. "Art is an abstraction", he wrote, and described his brilliant *Self-portrait* painted for van Gogh at Arles as "absolutely incomprehensible, of course, being so abstract. At first it looks like the head of a bandit … personifying also a discredited Impressionist painter. The drawing is quite special (complete abstraction), the eyes, the mouth, the nose are like flowers in Persian carpets, thus personifying the symbolic side. The colour is pretty far from nature … All the reds and violets streaked by flames (are) like a furnace radiating from the eyes, seat of the struggles of the painter's thought."

Gauguin knew the leading intellectuals of the day, notably the Symbolist poet Mallarmé, but eventually reacted decisively against the sophisticated theorizing, the material corruption and complication of Western civilization, and left for Tahiti in 1891, in search of primitive values and simplicity. Harassed by poverty and illness, he was forced to return to

Paris in 1893; leaving Europe again in 1895, he remained in Tahiti till 1901, in constant conflict with the authorities on behalf of the natives. Then he moved to the Marquesas Islands, where he lived until his death in 1903.

His genius was remarkably versatile. From about 1889, he revived his early interest in sculpture; the relief *Be in love and you will be happy* of 1889-90, which at the time he considered his "best and strangest work", is very much non-naturalistic, yet the roughly carved forms, enigmatic in meaning, have immense physical density and gravity. His mind and hands were for ever restless; he would carve a walking-stick, or experiment with pottery (inspired originally by oriental pots in the Musée Guimet in Paris). His woodcuts and zincographs have an uninhibited vigour; his distortion was combined with a feeling for the possibilities of the material, which had a decisive effect on the revival of the woodcut. In painting, his Tahitian works have become the most popular, due no doubt to their mysteriously dreamy subject matter, their offer of escape to a golden primitive land – even if their serenity is profoundly melancholy; but while the Pacific gave him new themes, it did not

enlarge the formal language with which he expounded them. The famous, and vast, picture that he painted "feverishly day and night" before an abortive suicide in late 1897, *Where do we come from? What are we? Where are we going?* was intended as his spiritual last testament. It was indeed his most ambitious synthesis, reassembling in its mysterious panorama mostly symbolic figures he had already used in earlier compositions – not least the enigmatic idol, in Gauguin's description "joining substance, in my dream in front of my house, with the whole of Nature reigning in our *primitive soul*". The symbolism is hardly ever explicit or explicable verbally, as opposed to the Symbolism of Puvis de Chavannes or Odilon Redon: Gauguin said of Puvis (see p. 370) that he "explained" his idea but he did not "paint" it.

Nevertheless, because of its purely decorative qualities and its "literary" echoes, his work tended to be depreciated in an age too conscious of purely formal values, though his primitivism was seen to be significant. Gauguin, however, is one of the major founding figures of modern art. "I have tried to vindicate the right to dare anything", he wrote.

GAUGUIN (left)
Noa Noa, c. 1893
Gauguin would scratch and score the surface of his woodcuts to create a varied effect. He adopted this one for the cover of his autobiography, *Noa Noa,* 1901.

GAUGUIN (right)
Nevermore, 1897
The naked girl exudes a rich tropical warmth and a mood of superstitious dread; Gauguin used eerie, dusky colours deliberately.

GAUGUIN (below)
Where do we come from? What are we? Where are we going? 1897
The monumental frieze emanates holy sanctity like an icon, but it is a dream without specific meaning.

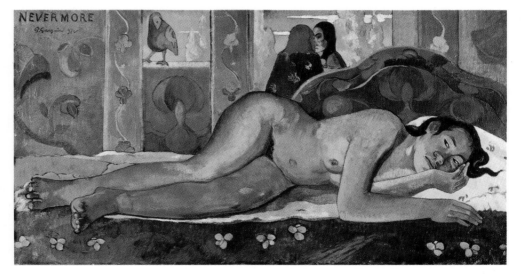

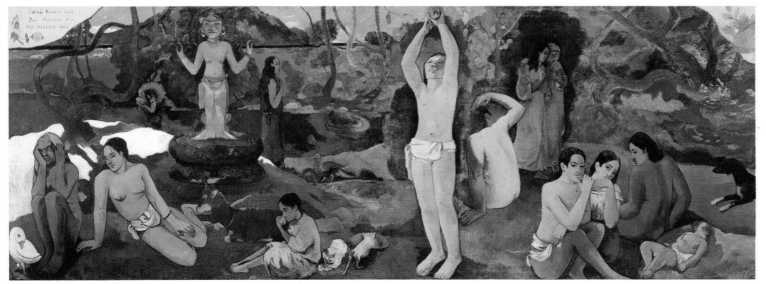

Cézanne: Mont Ste-Victoire

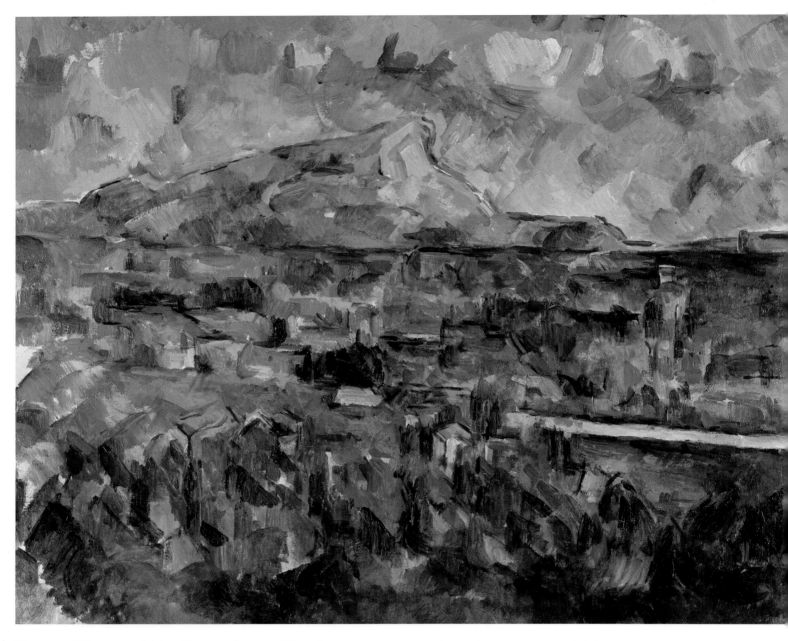

The year 1886 was crucial for Cézanne, then aged 47. His father died, leaving him a comfortable fortune, and he was at last able to seal with marriage his 17-year-old liaison with Hortense Fiquet. In the same year his friendship with Zola, dating from their school-days, came to an abrupt end, and in the 20 years remaining to him he left home in Provence increasingly rarely. He became more and more touchy and suspicious, almost a recluse, even after long-delayed recognition came rapidly, indeed spectacularly, after the dealer Vollard's exhibition of about 150 of his paintings in Paris in 1895. His life was concentrated on the stubborn battle with his art – the battle to achieve a reconciliation of the three-dimensional world confronting him with the two-dimensional limitations of his canvas. In 1903 he wrote: "I am beginning to see the Promised Land"; in 1906 he wrote: "I am old and ill and have sworn to myself to die painting". In October 1906 he collapsed after being caught in a storm while painting outdoors, and died a few days later.

These later years were occupied with still lifes, figure painting – ranging from portraits to more general, monumental themes – and landscapes. Still lifes enabled him to structure his compositions before painting; even so in the finished work traditional perspective and true shapes were distorted in answer to the needs of harmony and the stability of the whole. The portraits were painted, like the still lifes, in a long process of profound analysis: giving up his portrait of Vollard (see p. 374) after 115 sittings Cézanne was "not altogether displeased with the shirt". Yet in some portraits, built up laboriously touch upon touch like all the late work, the response to individual character can still be almost lyrical.

Cézanne was also preoccupied especially with the theme of nude, female figures in a landscape, or *Bathers*. The subject is still surely Impressionist, stemming from Manet's "*Déjeuner sur l'Herbe*" (see p. 342), but the picture goes much further, not just in its distortions, but in Cézanne's attempt to create something durable, "like the art of museums".

Most of all in his last years Cézanne painted landscapes, which allowed him the greatest breadth for the development of his style and necessitated working from and with nature. He had several chosen local views to which he returned, but the favourite – and one that has become almost as much a cult image as Mount Fuji in Japanese art – was Mont Ste-Victoire. His technique, building up a pictorial structure by the schematic overlay of colours applied mostly very thinly in short, square strokes of the brush, had been developing during the 1870s, at its peak in watercolours. In the London *Mont Ste-Victoire with a great pine*, 1885-87, the composition, though framed by the arabesque of a foreground tree, is determined by the logical recession of the planes or blocks of colour. Even the outline contours usually reveal themselves on close inspection to be built up of crisply defined patches of colour, of astonishingly subtle and varied shades. In the silence, the frontal monumentality of the scene, Cézanne surely achieves his avowed wish, to do Poussin again

CEZANNE (below)
Mont Ste-Victoire with a great pine, 1885-87
In the early days of the long struggle with Mont Ste-Victoire, details of the landscape survive the artist's attempt to translate his sensations into paint and so achieve a "harmony parallel to nature". In a related watercolour, these details are clearer still, and the diagonals sharper, the frontality less firm.

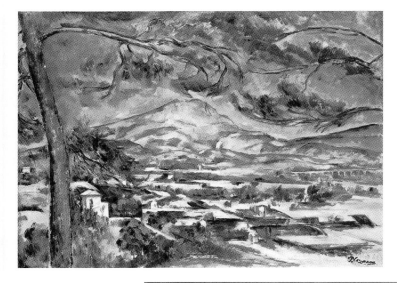

CEZANNE (above)
Mont Ste-Victoire, watercolour, 1906
In the late paintings, oil or watercolour, detail is unimportant; it is unclear precisely what – a house or a tree – is represented by any given patch of colour. The patches, overlapping and interlocking, build up their own coherent form. It was Cézanne's belief that "in the contrast and connection of colours – there you have the secret of drawing and modelling". There is a great variety in the brushwork and the tones of colour, sometimes gentle, sometimes savage.

CEZANNE (left)
The Philadelphia *Mont Ste-Victoire*, 1904-06
Rich colour applied in a mosaic-like pattern builds up and integrates the land and sky, held on the canvas with hallucinatory power. Cézanne's conversation in these years revealed that he felt that in his later views of Mont Ste-Victoire he was coming close to his goal.

CEZANNE (right)
Still life with onions, c. 1895-1900
Form and colour echo each other across the canvas; greens complement pink onions, the rim of a glass is tilted up, a plate bent, in the interests of overall harmony. Cézanne took so long painting that fruit and vegetables shrivelled; he used wax substitutes.

from nature: this is classical form. In his final contemplations of Mont Ste-Victoire, he used the same method still more austerely to extract – or abstract – his picture from the mass and profile of the landscape. The version in Philadelphia of 1904 may or may not be unfinished – Cézanne tended to advance work over the whole canvas simultaneously, so that, whenever he stopped, that stage cohered as a whole; this is faceted by those square brush-strokes, those sharp, even harsh, edges or planes of colour, into unconsoling yet majestic solidity – even in the sky. Yet there is, too, a sense of urgency: the silhouette of the mountain has become a beak or prow – aggressive or defiant. Cézanne's analytic-synthetic method was also a transposition of his own temperamental reaction to the sensation ("*ma petite sensation*") the landscape aroused in him.

Indefatigable as he was in his search for objectivity, Cézanne's example in paint nevertheless went far to establish the supremacy of the modern artist's subjectivity: the world is his, to translate into his own terms as he will.

CEZANNE (above)
Self-portrait with a goatee, c. 1906
In his last *Self-portrait* Cézanne treats himself as dispassionately as a still life – in contrast to van Gogh's or Gauguin's self-expressive images. In the reduction of his head to a compendium of hollows and planes of colour, the basic grammar both of Cubism and of Fauvism is implicit.

CEZANNE (left)
"The Great Bathers", 1898-1905
Whereas the early *Bathers* are often relatively static, rhythmic forces permeate the huge canvases of later years. These nudes seem to be primeval, fashioned of stone or wood, part of the cathedral-like structure of the forest. The picture is constructed with colour – pale shades of blue, ochre and green dappled by light.

Post-Impressionism 2, and Art Nouveau

The wild landscapes and the Atlantic coast of Brittany had attracted artists from the early nineteenth century; the little village of Pont-Aven, in particular, had been "discovered" by French painters in the 1860s, and was already an international artists' colony by the time Gauguin arrived there. Gauguin (see p. 364) stayed in Pont-Aven on various occasions between 1886 and his final migration to the Pacific in 1895. He worked out there the principles and practice of his mature style, and became the natural leader of a group of young artists, notably Emile Bernard (1868-1941; not shown), Maurice Denis (1870-1943; not shown) and Paul Sérusier (1863-1927).

Though able painters, Bernard (who had disputed with Gauguin the claim of having first used highly simplified forms and flat colour) and Denis are more important as theorists and propagandists: Denis, aged only 20, was responsible for a dictum in 1890 that has since been quoted in contexts he would not have dreamed of, and has served as a key tenet of several developments in modern art: "A picture – before being a war horse or a nude woman or some little genre scene – is essentially a flat surface covered with colours ar-

ranged in a certain order." It was Sérusier, however, whom Gauguin instructed one day in a celebrated painting lesson in a Breton wood: the result, a cigar-box lid roughly brushed with – at first glance – an abstract colour pattern, was later shown by Sérusier to his fellow-students at the Académie Julian in Paris. It became known as *"The Talisman"* and had a catalytic effect on these young painters, soon to coalesce as a group called the Nabis (a Hebrew word for "prophet").

Common to most artists of this group was a Christian religious fervour and a harking back, like the Pre-Raphaelites, to early Italian art. But its two most distinguished members ignored pious themes and treated contemporary, often everyday, subjects in the new style – an approach described as "Intimisme". Edouard Vuillard (1868-1940) transformed his banal, homely interiors into beautifully balanced compositions, most successfully on a small scale. In his portrait of his *Mother and sister*, the two figures are simplified into strongly patterned, almost flat, forms, and the surface of the picture, compartmented into a bold decorative design, is held in tension by the room's sharply exaggerated recessions. Yet the

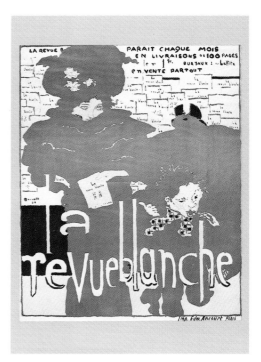

BONNARD (above)
La Revue Blanche, 1894
"The most Japanese Nabi", as Bonnard was hailed by an admiring critic, showed in his graphic art a unique assimilation of the spirit and principles of *ukiyo-e* colour prints. The formal qualities of his poster are openly oriental, even if the wit is peculiarly French.

BONNARD (left)
Nude in the bath, 1937
Vibrant with the light and colour of southern France, Bonnard's mature work is also suffused with a gentle nostalgia for time past. Until the death of his wife in her 60s he continued to portray her tenderly as a slim nubile girl, the model and mistress of his youth.

SERUSIER (above)
"The Talisman": landscape in the Bois d'Amour in Brittany, 1888
Gauguin virtually dictated the picture to his young disciple: "How do you see these trees?" he asked. "They are yellow? Well then, put down yellow. And that shade is rather blue. So render it with pure ultramarine. These red leaves . . .? Use vermilion."

VUILLARD (right)
Mother and sister of the artist, c. 1893
Vuillard may have gained his first fascination with contrasts of texture and pattern from his mother, a seamstress and designer of fabrics. She often appears, sewing or in repose, in his rather claustrophobic, but always affectionate, views of quiet, cosy domesticity. Vuillard later became a successful portrait painter.

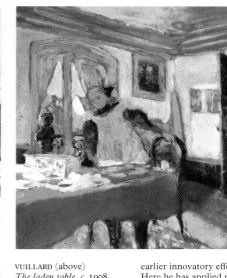

VUILLARD (above)
The laden table, c. 1908
Vuillard's experiments with mixed media might have been encouraged by Degas's earlier innovatory effects. Here he has applied pastel and gouache to a ground of distemper, achieving near-Impressionist spontaneity.

figures are still lively likenesses of specific individuals. Pierre Bonnard (1867-1947) was sharing a studio with Denis and Vuillard in 1890, and he, too, showed a masterly sensitivity and control of two-dimensional design in his everyday incidents. His most remarkable work, however, came very late in his career, in a great series of nudes painted in the 1920s and 1930s, in which he developed the luminous and sumptuous colour of late Monet.

In their early work both Vuillard and Bonnard reflect the asymmetrical balancing, the idiosyncratic perspective, the overall patterning so characteristic of the great masters of the Japanese print, and both were closely involved with the brilliant flowering of lithography in the 1890s – with the development not only of the *livre d'artiste* (see over) but also of the poster. Bonnard seems to have preceded Toulouse-Lautrec, who established the poster definitively as a major art-form.

Henri Marie Raymond de Toulouse-Lautrec (1860-1901), like Gauguin and van Gogh, was a misfit in society; in his case, the basic cause was physical abnormality. A grotesque dwarf, an alcoholic, he nevertheless created, in his brief life no less than in his work,

an heroic legend that has fascinated posterity. Degas's draughtmanship was always a prime inspiration for Lautrec, and he shared with Degas a fascination for metropolitan low life, the theatre and the circus; his eye was just as sardonic and unsentimental, but he also infused his characters with sharp individuality, and his vivid distortions can serve expressive as well as formal purposes. Brilliant as some of his paintings are, he found graphics his most congenial medium: he became perhaps the greatest poster designer ever. He, too, echoes the example of Japanese prints, in a witty economy of sinewy line, clear colour and strong silhouette, and in an exquisite balance between the rectangular format, the image and the lettering. Lautrec's looping forms, his exaggerations, link his graphic work with the international phenomenon of Art Nouveau.

Art Nouveau was primarily concerned with architecture and design, the applied arts. It fused its many sources of inspiration into an entirely original mode of expression, imparting to any object or design a sense of organic growth, often with erotic overtones and often fantastic in conception. It inspired, too, a handful of painters and draughtsmen of major

consequence. In England Aubrey Beardsley (1872-98) drew erotic and sinister images in blackest black on white in an extraordinary fusion of elements from Japanese prints, Greek vases, Celtic interlace, Pre-Raphaelite dream and Rococo, that seemed the epitome of 'nineties decadence. Beardsley became famous through his illustrations for the periodical *The Yellow Book* and for Oscar Wilde's *Salomé*, and achieved international celebrity before his death by tuberculosis aged 26. He was known all over Europe, for instance in Vienna, where Gustav Klimt (1863-1918), the most original painter associated with Art Nouveau, led the Austrian Sezession (formed by analogy with the German Sezessions, see p. 378). Klimt's work became progressively less naturalistic: though the heads of his figures are modelled in the round, bodies, draperies and background dissolve into a flat mosaic of colour, swirling line and spirals. His determined defence of the artist's freedom of expression in the face of a reactionary society was crucial for the growth of Austrian Expressionism (see p. 443); and, formally, many of the Expressionists throughout Europe took important elements from Art Nouveau, not least Munch (see p. 376).

TOULOUSE-LAUTREC (left)
Self-portrait, c. 1890
A hard strain of realism belies the decorativeness of Lautrec's café art; his caricature displays fine linear control and sad wit.

TOULOUSE-LAUTREC (right)
The English girl at "Le Star", Le Havre, 1899
The nicely judged pastel colours set her off; a swift line seems to capture the girl in full brazen giggle.

BEARDSLEY (below left)
Salomé: "J'ai baisé ta bouche, Iokanaan", 1894
The Baptist's head rises like a flower on a stem of blood – a gruesome subject chilled by the calligraphy.

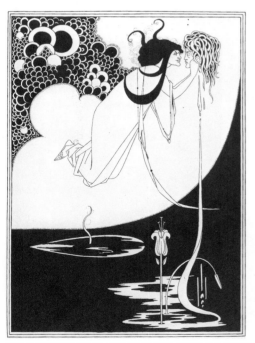

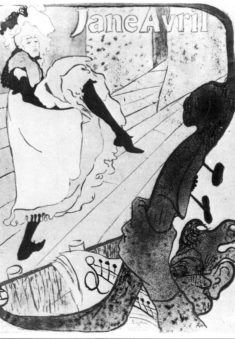

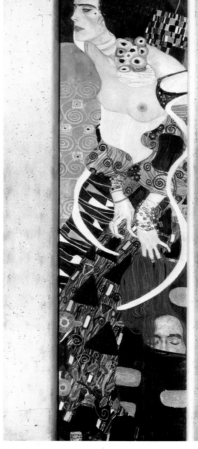

TOULOUSE-LAUTREC (left)
Jane Avril at the Jardin de Paris, 1893
Lautrec's inspiration was Montmartre's *demi-monde* – whores, and dancers, who appear in lithographs and posters in angled poses full of flounce and movement.

KLIMT (above)
Judith, 1909
Obsessive Symbolist *motifs* – female treachery and the severed head of Holofernes (probably a self-portrait) – set in a vivid, even jarring, patterned ground, charge the air with neurotic energy.

Symbolism

In late nineteenth-century France, in a mood both of political disillusion, after the Franco-Prussian War and the Commune of 1870, and of reaction against materialism and scientific rationalism, Courbet's insistence on a concrete art of "real and existing" things had lost much of its force. The Romantic emphasis on the imagination was sustained and revived. The artists who had briefly come together round Gauguin at Pont-Aven in Brittany had sought to express internal feeling, and those who then cohered in a group called the Nabis had spoken of themselves as Symbolists. But perhaps the most remarkable Symbolist, Odilon Redon, stood somewhat apart from that group, and work with an obviously symbolic content was already being produced by older artists, notably Moreau and Puvis de Chavannes.

For these painters literary sources were almost more significant than visual ones – the Symbolist movement crystallized around the doctrines and poetry of Baudelaire, Gautier, Mallarmé and Verlaine. Baudelaire was the arch-prophet of Symbolism. In his seminal *Fleurs du Mal*, published as long ago as 1857, he had written (in the sonnet *Correspondances*) of scents, colours and sounds communicating

not merely sensations, but states of mind. He implied that art, too, could give rise to states of mind and ideas independent of material reality – whether verbally, visually or musically. A typically Symbolist development was the *livre d'artiste*, a book in which text (usually poems) and images (usually lithographs) co-exist as aspects of one meaning, though the text does not "explain" the images nor the images "illustrate" the text. (An early and significant work of this kind had been Mallarmé's translation of Edgar Allan Poe's *The Raven*, with lithographs by Manet.) Baudelaire's aesthetics were developed by Verlaine and the major Symbolist poet Mallarmé, and Huysmans's novel *Against Nature* was virtually a Symbolist manifesto, with its archetypal "decadent" hero, des Esseintes, connoisseur of art, especially the art of Moreau and Redon.

Gustave Moreau (1826-98) was long disregarded, as being compromised by outmoded academic conventions in his figuration and by his "literary" content, which an admittedly modern sensibility could not redeem; he is now recognized as a crucial transitional figure (a role of which he himself was conscious). He painted on two scales – large, very heavily

worked oil-paintings and small, often weirdly incandescent watercolours. In both the subjects were the same – portentous and lurid landscapes or interiors with haunting mythological figures. The Surrealists naturally considered him an important precursor, but also his watercolours were reassessed in the light of Abstract Expressionism and Tachisme, while in his old age a remarkable group of future celebrities found in him a sympathetic teacher; they included Matisse and Rouault.

Puvis de Chavannes (1824-98) seems to present much more obviously a similar discrepancy between an apparently conventional, almost chilly, academic technique and a mysterious content. In fact Puvis's strange stillnesses, his wan, attenuated figures in lonely landscapes, are rendered evocative not only by the power of his imagination, but by his calculated and systematic use of distortion, and by their reduction to an almost two-dimensional pattern. His impact on Gauguin's schematic surface patterning is clear, while his cool, chalky colour and his enigmatic silences are echoed in Picasso's early work in Paris.

Odilon Redon (1840-1916) found a more satisfactory technique with which to realize

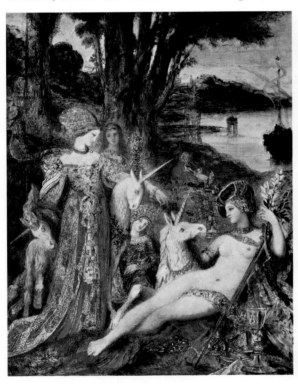

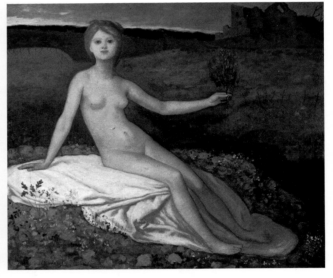

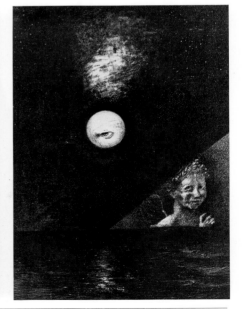

MOREAU (above)
*The unicorns, c.*1885
Certain details of costume suggest that Moreau made use of a set of six Gothic tapestries, *The Lady and the Unicorn*, in the Musée Cluny, Paris. Painted in oils and in watercolour, the surface is encrusted as if with gems, an effect achieved not only by rich impasto, but by rubbing and scratching the canvas; Moreau often incorporated into his composition the accidental images so made.

REDON (right)
Meadow flowers in a vase, after 1895
Redon's mastery of black and white was equalled by his achievements in the pastel medium. He was fascinated in youth by the botanical and zoological studies of Charles Darwin, and insisted on scientific reality, later, as the basis of his art. It is as if close scrutiny has heightened his perception of the object until it appears to glow with hallucinatory clarity.

PUVIS DE CHAVANNES (left)
Hope, 1872
Incongruous as it seems, Gauguin had a copy of this painting hung in his hut on Tahiti as a continuing inspiration. The images are traditional enough; yet the flattened forms and the decorative basis relate Puvis's art to the most progressive developments.

REDON (below)
On the horizon, the angel of certainties, 1882
The title can be fitted to the image without too much difficulty, but the flotsam of imagination that Redon convokes is irrational, and not susceptible to prosaic interpretation. He often, however, included as well organic forms that he had studied under a microscope.

imaginative concepts, by placing, as he put it, "the logic of the visible at the service of the invisible". His disconnected imagery, his repertoire of disparate and fragmentary symbols and of concocted elements of the imagination, anticipate the Surrealists' attempts to represent the inner worlds of dreams and of the Unconscious closely. Until the 1890s he worked almost entirely in black and white, but then moved to pastels, achieving a brilliant vibration of colour in which the simplest of themes, a vase of flowers, takes on a positively unearthly intensity.

Symbolism came closest in France to being a coherent movement in the fine arts with a clear-cut programme, but symbolic imagery flourished elsewhere in Europe, although formally it was usually much more traditional. Indeed a Symbolist kind of other-worldliness pervaded even orthodox academic painting. In England Sir Edward Burne-Jones was the first of the Pre-Raphaelites (see p. 330) to establish a European reputation, when his dreamy unexplained visions of pale women, so close in mood to those of Puvis de Chavannes, were exhibited and admired in Paris. The work of Dante Gabriel Rossetti, with its recurrent

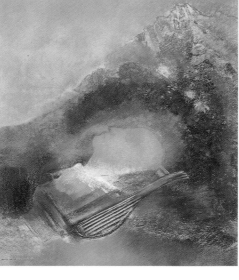

REDON
Orpheus, after 1913
Orpheus was torn apart by frenzied maenads who cast his head, still singing, into a river. Afloat in iridescent colour, he typifies *le poète maudit* (the accursed poet), destroyed by the beloved Symbolist *femme fatale*.

theme of the *femme fatale*, was even more mysterious and visionary. Even George Frederick Watts made an original contribution – his *Hope* of 1886 (see p. 331) is a fascinating contrast to Puvis de Chavannes's earlier painting of the same title.

In Belgium, the weird Neo-Rosicrucian group was a focus of Symbolism, though its members still painted in academic or conventional styles. The most striking of them was Fernand Khnopff (1858-1921). His most famous painting, *The caress* (1896; not shown), a male figure embraced by a leopard with a human head, is perhaps more bizarre than convincing, but the dreamlike, irrational intensity of *Memories* (1889) – superficially a banal representation of a tennis party – has all the inexplicable compulsion of Puvis de Chavannes or Burne-Jones at their best. In Germany, the Swiss-born Arnold Böcklin (1827-1901) exercised a transitional and seminal role rather akin to that of Moreau in France. His paintings, essentially traditional and academic in technique, are rooted in Romanticism, and have a remarkable power to evoke the supernatural – never more memorably than in his enduringly famous *Island of the dead*.

ROSSETTI (right)
Astarte Syriaca, 1877
By the mid-1860s Rossetti had developed beyond the strong medievalizing bent of his early painting, and was interested in Venetian art. Astarte's rich glazed greens surely owe much to Veronese. Her dark beauty – and that of many similar lavish and sinister exotic Venuses – was modelled on William Morris' wife, Jane. Their sexuality was often comparatively explicit – in one the bitten pomegranate held by a Proserpina is a cryptic image of a vagina.

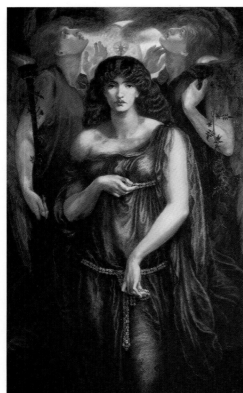

BURNE-JONES (below)
The mill, c. 1870-82
The presence of the Three Graces, which derive from Botticelli, might suggest a classical idyll; in fact the other age or world so wistfully evoked is neither antique nor medieval, even though it echoes both. The technique hardly offends academic canons, but the main figures are disposed across the foreground in a long, flattened frieze.

KHNOPFF (above)
Memories, 1889
The two foreground figures were both modelled, one from life and one from a photograph, on the artist's sister. As in a dream, one senses obscure significance in the calm expectancy and clear, unfocused gaze of these women, who seem to float rather than walk.

BOCKLIN (below)
The island of the dead, 1880
The gaping doors of what seem to be tombs hollowed out of rock and the black spires of cypress trees – traditionally associated with death – have probably suggested the painting's title; Böcklin was content to call it simply "a dream picture". Böcklin perhaps influenced Chirico, whose Surrealist "dummies" are anticipated in the blunt, faceless heads of the two tiny foreground figures. They are there to impart a sense of epic vastness (which recalls the settings for Wagner's operas – *The Ring* was produced for the first time at Bayreuth in 1876).

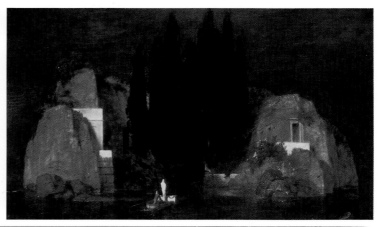

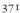

American Art in the Later 19th Century

A sense of national and cultural unity and identity began to consolidate in the United States only after the end of the Civil War in 1865: Emerson, in some ways the keeper of the new American conscience, proclaimed: "Our long apprenticeship to the learning of other lands draws to the close." The variations made by American artists within the European traditions took on an increasingly distinctive American character. Some talented artists had of course already explored the possibilities of American landscape and American genre (see p. 317), and in the early nineteenth century numbers of local, "primitive" artists had flourished, including some who in a European context might have been tamed into an average professionalism, but, in America, retained a forthright, uncompromised vision. This innocent directness is also to be found in the work of the early American photographers.

The outstanding professional painters of the late nineteenth century fall into two groups – those who remained based primarily in America and those who were more cosmopolitan or were indeed expatriates. The former developed, much along the lines of European Realist painting, an emphasis either on physi-cal detail or on a more psychological realism, and Eastman Johnson (1824-1906), the major forerunner, developed from the one towards the other. From Maine, he studied for six years at Düsseldorf, The Hague and Paris, acquiring from these diverse sources a fine technique in naturalistic detail and a taste for genre subjects, and from Couture in Paris he gained a respect for well-structured composition. Back in America his lively *plein-air* paintings of rural subjects (perhaps already nostalgic for a vanishing way of life) and also strong portraits became very popular.

Winslow Homer (1836-1910) is more often claimed as the archetypal American painter of the later nineteenth century. Conscientiously naturalistic ("When I have selected the thing carefully, I paint it exactly as it appears"), he was influenced by photographic reportage – recording rather than dramatizing. Visiting France in 1867 he received the message of Japanese prints, of Manet's flat tonal surfaces, but Impressionist colourism affected him little. His characteristic subjects of the 1870s, youths at play on the Massachusetts coast, are lightly drawn, fresh and vigorous. Later, preferring watercolour, he began to turn to more dramatic themes, the heroism of man's

HOMER (right)
"Breezing up", 1876
This picture was greeted as Homer's "greatest hit" with that conservative body, the National Academy of Design in New York, in 1876. The sea spray and scudding clouds are fresh and lively. The theme of children enjoying themselves was more popular than ever in the year that Mark Twain published his novel *Huckleberry Finn*.

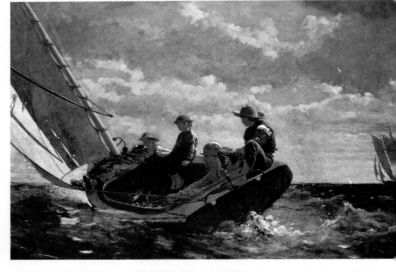

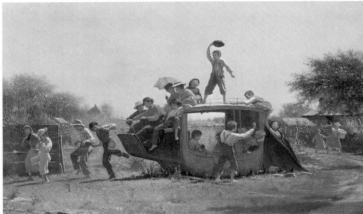

JOHNSON (above)
The old stagecoach, 1871
For the American nation and its artists, Johnson, Homer and Thomas Eakins especially, the 1870s were formative years. Here the outmoded coach symbolizes the end of an era, a game for these post-war children. Johnson was an enthusiast for outdoor painting, but his approach was academic.

HOMER (below)
Inside the bar, Tynemouth,
1883
Homer's watercolour shore scene, with its monumental fisherwoman who almost defeats the elements, was completed after he had left England for America in 1883. The strong two-dimensional design seems a response to the new French developments in painting.

EAKINS (right)
The Gross Clinic, 1875
Eakins wanted his large picture to be exhibited at the 1876 fair to celebrate American Independence. To his chagrin it was hung in the First Aid tent. An art critic found it "powerful, horrible ... fascinating". It is a remarkable statement of American positivism, enterprise, hope and will.

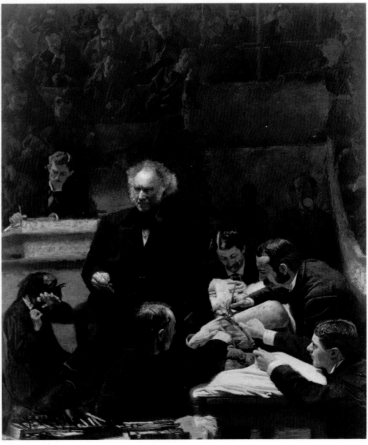

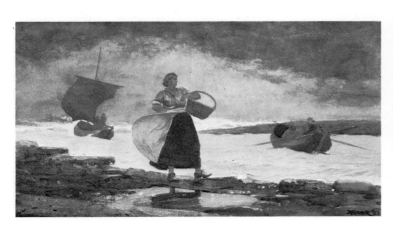

struggle against Nature, the pioneering spirit, and finally to Nature itself – the violence of the elements, particularly the sea.

The realism of Thomas Eakins (1844-1916) was applied more to figure painting and to portraiture. In Europe (1866-70) he learnt much from the Spanish masters and from Courbet's forceful Realism; the honesty of his own work often shocked contemporaries, and he was dismissed from the Pennsylvania Academy for posing a male model nude before female students. His masterpiece is the monumental *Gross Clinic* of 1875, showing a surgeon at work in his operating theatre amongst his students. If there are obvious echoes of Rembrandt's *Anatomy lesson of Dr Tulp* (see p. 216), Eakins proves himself a worthy successor, presenting the scene dramatically and yet with reverence and with compassion: science becomes intensely human. Eakins also produced wax models of horses in motion which owed much to the revolutionary photographs (see over) of Eadweard Muybridge (1830-1904), who showed for the first time how a horse really galloped.

There was a sturdy strain of realistic painters active at this time, often most successfully in still life. The finest of these was William Michael Harnett (1848-92), a craftsman of exquisite, vivid accuracy: the underlying formal quality of his compositions, their almost abstract intensity, have very recently revived interest in him. Albert Pinkham Ryder (1847-1917) was the most original among the more subjective and idealistic painters; his lyrical and poetic response to sensory experience is in the Romantic and Symbolist tradition, but his generalized forms and broad rhythms were something of an anomaly in his time.

Whistler, greatest of the expatriate painters, has to be seen in the European context (see p. 344). Mary Cassatt (1845-1926), from Pittsburgh but of French stock, moved to Paris in 1866, and after her work had attracted the attention of Degas at the Salon of 1872 she became associated with the Impressionists. Her stills of civilized everyday intercourse are like vignettes from a Henry James novel; her favourite motif, mother and child, repeated perhaps too often, made her very popular.

John Singer Sargent (1856-1925), born of rich American parents in Italy, lived all his life in Europe, though he made forays to the United States. His great technical gifts were developed in the studio of the highly skilful, fashionable painter Carolus-Duran in Paris, and probably Duran inculcated in Sargent his lifelong reverence for Velazquez and Hals, but much of his early work is Impressionist. His youthful success in Paris was blasted by a violent row over his portrait of *Madame Gautreau*, and Sargent then settled in London; there, though some still found his work eccentric, he became the outstanding portraitist of the Edwardian era. He is the last major exponent of the British portrait tradition, stemming from van Dyck through Gainsborough, Reynolds and Lawrence. He had all their glamour – the command of lavish and opulent movement, the ability to "orchestrate" his sitters' individuality in fluent line and brilliant colour, but he also had a sardonic eye, and at his best he refused to flatter his patron's features into fashionable beauty. Perhaps his masterpieces are his few large-scale shadowy groups, showing a rare skill in the disposition of figures in space – conversation pieces brimful of silence. He was, too, a brilliant watercolourist; the large murals he undertook in Boston in the United States at the end of his life are less successful.

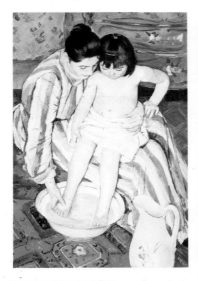

HARNETT (left)
My gems, 1888
Harnett collected *objets* for his still lifes while on tour in Europe. Later he painted them, artfully disposed, with minute care.

CASSATT (right)
The bath, 1892
Though domestic, intimate scenes were far from rare in this period, few were so tender as Cassatt's solemn pictures in pastel colours. The clarity of the design, the viewpoint and the juxtaposition of plain colours owe much to the example of Japanese prints. Cassatt had an important role in infiltrating into American art Impressionist ideas, and in forming Impressionist collections.

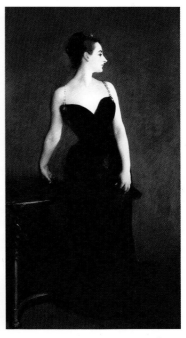

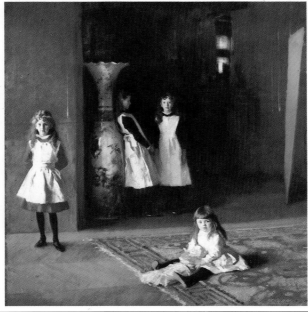

RYDER (above)
Moonlit cove, c.1890-1900
Ryder's small simplified seascapes have a mystical, symbolic dimension. He wrote: "The artist should fear to become the slave of detail. He should express his thought and not the surface of it." In a sense he is in the tradition of Allston, though not really pantheist.

SARGENT (above)
Mme Gautreau, 1884
The American society lady's *décolletage* and pronounced superiority outraged Salon visitors in Paris in 1884. Sargent – more gregarious than revolutionary – moved to London in the hope of a more sympathetic reception.

SARGENT (left)
The daughters of Edward D. Boit, 1882
An opulent, shadowy interior provides a perfect foil for the youthfulness and artlessness of the sisters, daughters of an American expatriate in Paris. The composition derives directly from Sargent's studies of Velazquez.

Art in the 20th Century: A New Constitution

The year 1900 marks with reasonable accuracy a great divide in the history of Western art, a revolution potentially more fundamental in its consequences than any change of direction since the collapse of Hellenic values in the fourth century AD. The first, ferocious challenge to the established order had been the French Revolution, the intellectual, moral and spiritual impetus for which had sprung in large part from the writings of the early Romantics. Romantic ideas as far as the arts were concerned gathered strength during the nineteenth century – if each individual and his conscience were to be free, so inevitably was the artist, and his function came increasingly to consist primarily in the truthful expression of his own self. Therein lay authenticity, originality and integrity. The artist began to look within himself just as much as he looked at the external world, and Picasso would insist: "I paint forms as I think them, not as I see them."

The rejection of the Renaissance tradition of naturalistic representation – what has been called "the retreat from likeness" – had already begun in the work of the Impressionists, for all their emphasis on scientific observation. Of all the Impressionists Monet was probably

the most dedicated to truth to Nature, but he himself compared his huge late paintings of the floating surface of his pond at Giverny to music, and worked and reworked this most ephemeral image in a protracted effort to express not just the subject but its effect, its meaning for him. In the laborious marriage of the world of appearances with the needs of purely pictorial structure that Cézanne battled to achieve, representation was losing out in the artist's fanatical urgency to remain true to his inner self – Cézanne's "*petite sensation*", his little sensation. His principle of conscientious

disintegration of the visible world and its reconstruction in the artist's own terms had an immediate heir in Cubism. On the other flank of the revolution Gauguin and van Gogh, prophets of Symbolism and of Expressionism, were struggling to reduce to order sensations of a more cataclysmic kind, and the subject matter of their art was even more obviously the artist himself, the private person of the artist rendered public.

It followed inevitably that the function of art became increasingly uncertain. Its religious purpose, consistently there probably since its

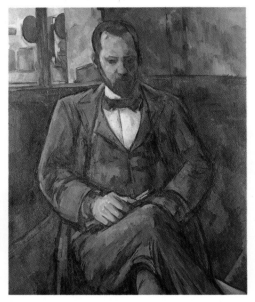

CEZANNE (left)
Ambroise Vollard, 1899
Cézanne's late portraits were treated almost like his still lifes – highly structured and patterned, the product of numerous sittings. Cézanne studied Vollard's shirt hardly less intensely than his face.

PICASSO (below)
Ambroise Vollard, 1910
The step from Cézanne's portrait seems logical: Picasso appears to have executed with confidence what Cézanne struggled to achieve in his unfinished portrait. Vollard the man becomes an abstraction.

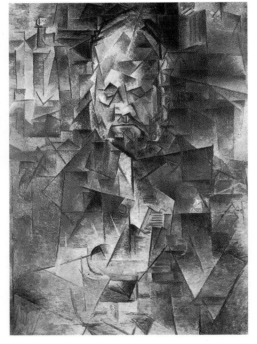

MONET
(below) *Waterlilies*, and (above) detail, 1900-09 Their scale, and Monet's wish to encircle a room with his wall-size shaped

canvases, anticipate the procedure, even some aims of Abstract Expressionists. They incite the viewer to a reflective mood, to the contemplation of colour.

UNKNOWN RUSSIAN
(left) *A yellow cat*, early 20th century *Lubki*, or folk woodcuts, were an inspiration on the one hand to Larionov and Goncharova in their progress to Rayonnism (see p. 404) and on the other to Chagall (see p. 433), who borrowed freely from folk imagery to set aglow his own fantasy.

UNKNOWN AFRICAN
(right) Ancestor figure, late 19th century The formal and expressive range of African tribal sculpture (see p. 16) was so wide that artists could choose from it what suited them, once they had begun to look. A wooden figure of the Congo Luba reveals that even for the massive, simplified forms of 1920s "Neoclassicism" tribal art was relevant.

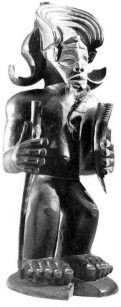

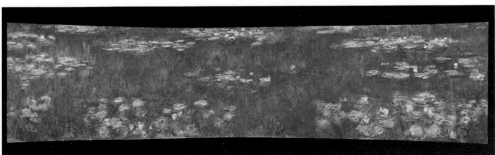

first known appearance in Palaeolithic cave-paintings, almost disappeared, and its traditional secular themes – such as the celebration of civic or national virtue – seemed no longer relevant. Even private patronage, and the role of the domestic user in supporting and promoting art, became suspect: the validity of the easel-painting itself came into question – what was it for? One major agent in the liberation of painting and sculpture from the slavery of imitating the natural world had been photography, invented in the 1830s and subsequently refined until it acquired the ability to record the world in motion. The recording of the visual appearance of the world had been the monopoly of art for centuries; with that removed, its practical justification was undermined; art became so much more a luxury.

Uncertainty about the nature and purpose of art is apparent not least in the noise of the debate, the dogma and anathema, the manifesto and counter-manifesto, the "isms" that constitute the development of art during the first half of the twentieth century. After 1900 the process accelerated by which an avant-garde emerged in an exhibition challenging the established art of the moment, and then itself solidified into an established art to be challenged by a new avantgarde group mounting its own exhibition, and so on: the necessity for originality, the hunger for novelty, became paramount. Artists deliberately seeking alternative means of expression began to seek inspiration in alien traditions – above all in "primitive" art, partly because it was at furthest possible remove from academic conventions. Picasso and Matisse and others, including the Fauve painter Vlaminck and the Cubist sculptor Lipchitz, eagerly collected tribal art, and the influence of African masks on Picasso's revolutionary proto-Cubist "Demoiselles d'Avignon" is unmistakable (see p. 396). The British sculptor Epstein had one of the most important collections of tribal art ever in private hands; Moore was obsessed in his early career by Pre-Columbian sculpture. Many of the Blaue Reiter group in Germany, notably Klee, studied also the "primitive" or folk art of their own country, and in Russia this interest was reinforced in some by socialism.

The development of twentieth-century art has also reflected the changed conditions and perceptions, the catastrophes and the continuing uncertainties that have affected the world.

A whole way of life perished in the 1914-18 War; centuries-old preconceptions of stability, of continuity, were being proved unsound. Einstein formulated the Theory of Relativity in 1905 – the year Picasso began studies for "Les Demoiselles d'Avignon". Kandinsky reported himself aghast at the news that Rutherford had split the atom. Solid matter was solid no more, and, following the investigations of Freud into the Unconscious, human consciousness and human identity were revealed as fronts and pretences. Some significant movements, however – Futurism, De Stijl – responded with missionary optimism to the new scope of the new world.

Almost all these avantgarde groups were at first greeted with indifference or hostility by the general public. Partly as a result of the Romantic notion that the bourgeoisie must be shocked, startled into life out of deadening habits and ossified imagination, a gulf opened between the artist and his audience. From the first fully abstract paintings of Kandinsky onwards the traditionally brought-up Western observer has had no familiar subject matter to engage and retain his attention; he has been left suspended in a void.

TOLTEC ARTIST (below)
Chacmool, 12th century
Chac, god of rain, holding a basin at Chichen Itza in Yucatan, inspired the heavy reclining figures of Moore. "Primitive" stone monuments set an example in the reaction to Rodin's light and texture.

MUYBRIDGE (below)
Two men wrestling, 1887
Muybridge's "stills" of men and animals not only instructed artists, they even opened up a new approach to depicting motion; both Duchamp's *Nude descending a staircase* (see p. 416) and Futurism presuppose him.

(above) *Paul Cézanne and Camille Pissarro*, 1872
The two men unmistakably are artists: Cézanne is wearing a smock, a work uniform. But their status is dependent on an ability to paint good pictures.

ARNATT (below)
I'm a real artist, 1972
Keith Arnatt (born 1930) is also clearly an artist, but he himself does not know why, or in what: it is his art to offer this question for discussion.

DEGAS (right)
Princess Metternich, 1861
The photograph adorning the Metternichs' visiting card by Eugène Disderi was patently "borrowed" by Degas for his (unfinished) portrait. He has copied not only the pose but the tonal values; photography is surely a factor behind the "cool", flattened tones recurrent in painting from Manet to Pop art. It has profoundly affected both the what and the how of figurative art – both used as an aid and emulated.

DISDERI (left)
Prince and Princess Metternich, c. 1860

I'M A REAL ARTIST

Edvard Munch

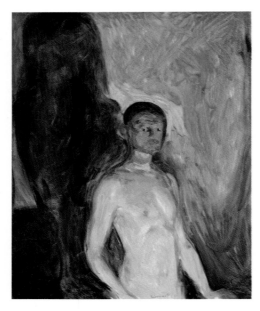

MUNCH
Self-portrait in Hell, 1895
The artist gazes out at the onlooker from inside the inferno of his tormented imagination – a simple and telling, if theatrical, image, and clearly Expressionist.

"No longer should you paint interiors with men reading and women knitting. These must be human beings who breathe and feel and love and suffer. I would paint such pictures in a cycle. People would understand the sacredness of them and take their hats off as if in church." This self-directive, an entry written in his notebook by Edvard Munch (1863-1944) when he was in France in 1890, formulates an aim that he was to pursue until the end of his life. He disclaims the cosy anecdotal genre of the Realist tradition popular in his native Norway (and most of Europe), and implicitly commits himself to a humanist vocation in which he would act as a prophet or priest.

Such an idea was the antithesis of the claimed objectivity of the Impressionists – though their influence was even then, in 1890, lightening Munch's palette – but more in key with Gauguin's objectives and virtually at one with van Gogh's belief in the power of art to communicate truths of existence to ordinary people. It was not, however, a message either of consolation or of joy. Munch's youth was profoundly disturbed by the deaths of his mother and sister from tuberculosis, and by the aggressiveness of his father, a doctor, who

seems to have come close to religious dementia. Later, as a student, he was involved with a radical group of writers in Oslo, the "Christiana Bohemians", influenced by Zola's harsh dissections of society and by Ibsen's questioning plays of the 1880s. In this climate Munch settled compulsively on his perennial themes – the intense expression of inner states of mind (usually suffering rather than pleasure); the union of man and woman in love, and the failure of union: no painter has surpassed him in the depiction of loneliness, and few have equalled him in conveying an awareness of the doom that haunts the passion of love, even though it is a theme implanted in the European imagination from Dante's Paolo and Francesca onwards. Woman has never been more vividly realized as both destroyer and creator than in Munch's *Vampire* or *Madonna*.

Abroad during much of 1889-92, Munch was influenced in France not only by the philosophy latent in Gauguin's and van Gogh's work, but also by their formal innovations. Gauguin's flowing contours, his simplification and occasional distortion of natural form, his juxtaposition of broad areas of bright, contrasting colour, these were of seminal import-

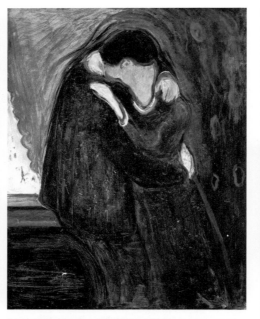

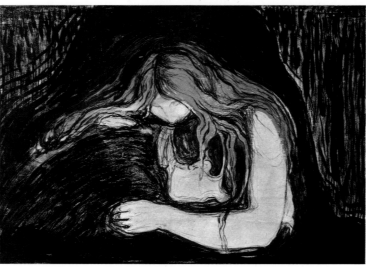

MUNCH (above)
Madonna, 1895
The Madonna, remote in her ecstasy, emanates the force of life, terrible in its impersonality; her red lips, nipples, navel and halo recall "Our Lady of Pain" of Swinburne's poetry. In a later lithograph Munch added an embryo, cowering as if in fear of the life into which he must be born.

MUNCH (right)
Vampire, 1895
Strindberg found expressed here his view of woman as the seductress and destroyer of man: "A rain of blood flows in torrents over the accursed head of him who seeks the misery, the divine misery, of being loved – or rather, of loving".

MUNCH (left)
The kiss, 1892
The two bodies, so merged in an embrace as to become one form, might be viewed as symbolic of union and fulfilment. But Strindberg, in his critical commentary on *The Frieze of Life*, conceived it as "the fusion of two beings, the smaller of which, shaped like a carp, seems on the point of devouring the larger, as is the habit of vermin, microbes, vampires and women". In a later, variant woodcut Munch simplified the forms even further, and incorporated in the design the grain of the wood itself – an innovative practice – in a violent statement of great power and economy.

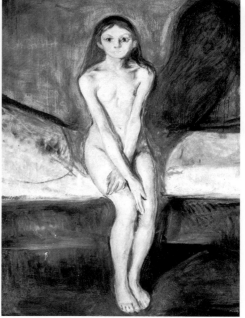

MUNCH (above)
Puberty, 1895
Women at varying stages in their maturity occupy a central role in Munch's art: for him, the progress of female development was a gripping symbol of the primary experiences of the journey through life – birth, sexual awareness and death.

These, for Munch, were all fraught with fear; and the anxiety which dominated his view of heterosexual love is explicit in this girl's pitiful nubility – she stares out, crossing large hands, overshadowed by her growing femininity, which seems to hover like ectoplasm in her shadow.

ance to Munch's art. For Munch, however, it was always the inner needs of the subject matter that shaped its outward form, and in a highly expressive and definite manner; with Gauguin it was more often the mood that compelled the subject matter into form, and the significance could be imprecise – Gauguin's "*inquiétude de mystère*" (mysterious disquiet). In contrast, it is Munch's desolations, his desires and his fears, that overwhelm.

Between 1892 and 1908 – the finest period of Munch's art – it was Berlin, not Paris, that provided him with audience, stimulation and patronage – and controversy. The forced closing of his first show in Berlin in 1892 led directly to the founding of the German breakaway group, the Berlin Sezession (see over). By 1908 he was famous, not only in Norway and in Germany, but internationally. In 1908, too, following a wretched love-affair apparently both passionate and absurd, and after various squalid brawls, he withdrew, an alcoholic and in what he called a "complete nervous collapse", to Dr Jacobsen's sanatorium at Copenhagen. The parallel with the crisis in van Gogh's career is striking, but with Munch sanity ultimately prevailed. For the rest of his

life he lived almost entirely in his native Norway, largely withdrawn from society. His fame, however, spread, and in 1933 he received the ultimate accolade as a leader of modern art, when 82 of his works were branded as "degenerate" by the Nazis. Having rejected all contact with the Quisling regime established in 1940, he bequeathed to Oslo on his death in 1944 all the works left in his possession; it is still to Oslo that those interested must go to experience the full range of his achievement, especially his later mural decorations.

The "cycle" that he had hoped for in 1890 was in part carried through, but only within his overall production. He linked a sequence of paintings under the general title *The Frieze of Life*, of which 22 were exhibited together at the Berlin Sezession in 1902. These, in their power, both formal and emotive, to convey *fin-de-siècle* disillusion and a sense of man as a victim, are perhaps his masterpieces. He was by this time, however, translating his themes into other media, and establishing himself as one of the greatest of printmakers (he learnt much technically from the printer Auguste Clot in Paris, who also worked for Vuillard and Bonnard). In his lithographs, and sometimes

in his paintings, he tried deliberately to relax conscious control of the hand, anticipating later experiments. His most remarkable and original graphic work was in woodcut, where his technical virtuosity was matched by an ability to distil his subject into its stark and startling essentials; his woodcuts were to have a profound impact on Expressionist idiom.

In his later years Munch moved towards a freer, lighter style, especially in his murals, designed to be "at one and the same time peculiarly Norwegian and universal". Like almost all twentieth-century large-scale institutional decorations, they verge on the banal, and his smaller work remained more satisfactory, although it became repetitive. However, his long series of self-portraits maintained their early quality, and the very late *Self-portrait between clock and bed* is an image of man in his loneliness as haunting as anything that Munch had realized before. His influence had permeated the ideas of the German Expressionists well before he died, but it is perhaps only since 1945, when Paris ceased to dazzle to the exclusion of other schools, that his towering stature in twentieth-century art has become universally recognized.

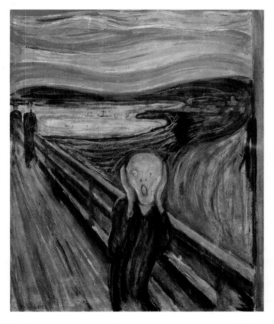

MUNCH
(near right) *The scream*, oils, 1893
"One evening I was walking along a path, the city on one side, the fiord below. I felt tired and ill ... The sun was setting and the clouds turning blood-red. I sensed a scream passing through Nature; it seemed to me that I heard the scream. I painted this picture, painted the clouds as actual blood. The colour shrieked."

(far right) *The scream*, lithograph, 1895
When translated from oil-paint into a graphic medium, Munch's images became still more sharply defined and more potently charged: instinctual panic is expressed in swirling rhythms in the sky, the lake and in the figure, drawn up in a tortured echo of the natural forms.

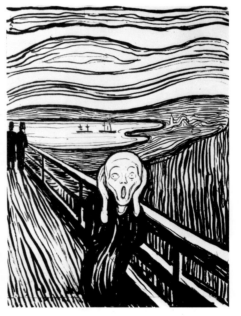

MUNCH (below)
Self-portrait between clock and bed, 1940-42
Standing in the narrow space between the time that remains to him and the bed on which he is shortly to die, the artist faces mortality against a backdrop of his paintings. But although the theme is sombre, the brilliant, sunny colours stress a positive, perhaps even a triumphant, pride: his art will survive his personal extinction.

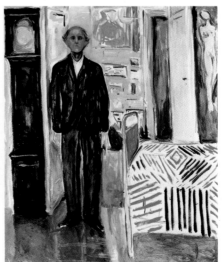

MUNCH
History, 1910-11
The decoration of the new assembly hall of Oslo University (1910-15) gave

Munch the opportunity to paint a set of murals on the themes of learning, beauty and the continuity of life. *History* is one of

three main panels and shows Age passing tradition on to Youth against a background of fiords – Norway – and below an oak tree – the

Tree of Life perhaps. The simple design, cool tones and monumental forms led the committee in charge to call it "Greek in spirit".

Impressionists and Expressionists outside France

A ferment of change was transforming the arts everywhere in Europe at the turn of the nineteenth century, although Paris was its most spectacular and most clearly defined focus. The restless movement of artists, and their eagerness to experiment, led to complex cross-fertilizations, and sometimes to disconcerting changes of direction within a single artist's style. In the 1890s in Holland, for example, where painting, though leavened by Impressionist colour, was still generally very traditional, the highly talented Jan Toorop (1858-1928) could blend the linear rhythms of Art Nouveau with both the emotional and literary subject matter of Symbolism and an exoticism owing something to memories of his native Java – and yet during the same period he was also painting pure divisionist pictures.

Toorop was a member of Les Vingt (The Twenty), a group founded in Brussels in 1883 which, before it was disbanded in 1893, had greatly assisted the dissemination of Post-Impressionist art by organizing enterprising exhibitions – showing Rodin, Monet, Redon, Seurat, Gauguin, van Gogh and Cézanne. Another member of Les Vingt was James Ensor (1860-1949). Some of Ensor's earlier

paintings were remarkably precocious – interiors foreshadowing Vuillard – and the work for which he is best known was produced in less than two decades before 1900; after 1900 his inspiration seems to have failed. His imagery – macabre, jagged, grotesque, reverting obsessively to the theme of the mask – was to be echoed immediately by the German Expressionists, and so was the style with which it was conveyed: a master of traditional composition if he so wished, Ensor chose to disrupt convention into chaos, and to distort and to make deliberately ugly in order to express a profoundly pessimistic view of mankind. His most famous picture, the huge *Entry of Christ into Brussels* of 1888, seems in places almost splattered with his vitriol, and was too much for Les Vingt. Etching was perhaps his most effective medium, but even broadcast in prints his vision was individual to the point of obscurity; in his isolation, his inability to come to terms with life, he followed the pattern set by van Gogh and Munch and to be followed again by several German Expressionists.

Germany proved to be the natural home of Expressionism. Without an acknowledged national capital until 1871, the culturally dis-

united states of the German-speaking peoples had nevertheless produced a number of flourishing artistic schools in their leading cities – in Munich and Berlin, but also in Düsseldorf, Dresden, Vienna and Weimar. The predominant style had been naturalistic, academic, high-gloss, often applied with great virtuosity to genre subjects or portraiture; in the 1890s the official or semi-official bodies were challenged by breakaway groups, generally called *Sezessionen*. The symbolic signal for revolt seems to have been the forcible closure of an exhibition of Munch in 1892, when the Munich Sezession was formed; the Berlin Sezession followed in 1898-99, led by Max Liebermann (1847-1935), an able and sensitive interpreter of Impressionism, to which he had turned not long before; but Liebermann could not go along with the Expressionist Neue (New) Sezession (see p. 382) which challenged his group in 1910. Liebermann remained, however, the grand old man of German art.

The other chief exponents of the Impressionist style in Germany, tending always, though in individual ways, to modulate it according to the German tradition of lyric

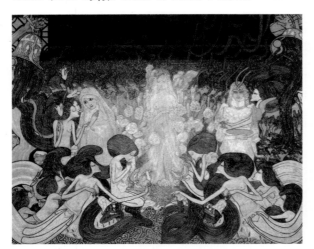

TOOROP (left)
The three brides, 1893
Three ghostly women stand enmeshed in an intricate web of Art Nouveau line – a nun, the bride of Christ, an earthly bride and the bride of Hell (another manifestation of the Symbolist *femme fatale*; her necklace of skulls recalls Kali, the Hindu goddess of death).

ENSOR (right)
The murder, 1888
Ensor's blend of sadism and fantasy makes him a modern Flemish successor to Bosch. The delicacy of his line, and whimsical distortions, make his theme yet more macabre – a fairy tale turned to nightmare.

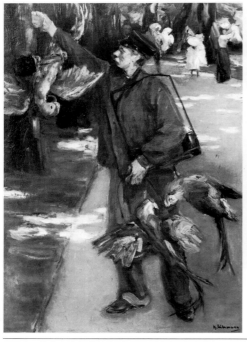

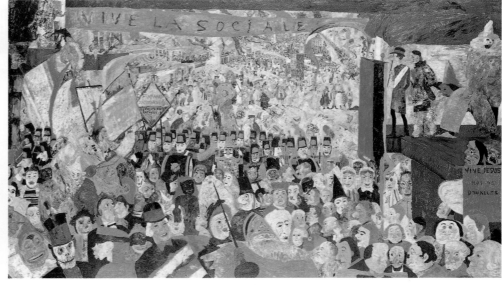

LIEBERMANN (left)
The parrot man, 1902
Influenced at first by Hals, *plein-air* painting and the

Barbizon school, Liebermann felt Manet's impact in the 1890s, then became increasingly Impressionist.

ENSOR (above)
The entry of Christ into Brussels, 1888
The fantastic mask-faces

of the people reveal a host of worldly concerns; Jesus' foredoomed entry is retold in terms of the modern city.

naturalism, were Fritz von Uhde (1848-1911), Lovis Corinth (1858-1925) and Max Slevogt (1868-1932; not shown). Their progress, however, was not easy; a vivid illustration of their difficulties is the fact that as late as 1908 Kaiser Wilhelm sacked the Director of the Berlin National Gallery, Hugo von Tschudi, because of his purchase of modern French paintings.

In sculpture, the influence of Rodin was paramount, but the major sculptors in Germany all developed styles in which profoundly personal emotions were expressed in severely simplified forms of great intensity. In his suffering figures Ernst Barlach (1870-1938) resolved the artistic problems of social realism more nobly than any artist encouraged by a totalitarian state (whatever its persuasion) has since succeeded in doing. Wilhelm Lehmbruck (1881-1919) evolved a fusion of classical reminiscence, German Gothic and the sensuous monumentality of Maillol. His strangely elegant, almost narcissistic figures – modelled rather than carved – in their simplified planes, their lean attenuation, are redolent of haunted melancholy. Käthe Kollwitz (1867-1945) was driven by sympathies with the poor and oppressed akin to Barlach's, but her art was more

personal: in her many self-portrait drawings she created an archetypal image of bereaved and suffering womanhood (her only son was killed in World War I, her grandson in World War II). Barlach, Lehmbruck and Kollwitz all found printmaking a satisfying medium, and, though she was a compelling sculptor, Kollwitz's best work was graphic; her lithographs, with those of Ensor and the woodcuts of Munch, prelude the Expressionists' resuscitation of the print.

Another woman pioneer of modern art was Paula Modersohn-Becker (1876-1907). She was encouraged by the dealer Vollard, and met Cézanne; her own work was more in key with the Nabis than with the forceful expressiveness to be developed by her younger compatriots. They responded to the message of the work of Gauguin, van Gogh or Munch but were increasingly aware of the contribution that their own Nordic genius must add to it; and much that they so startlingly developed had been foreshadowed in Germany, for instance by the critic Fiedler, who had declared that "the visual aspect of an object breaks free from the object and appears as a free, independent creation".

KOLLWITZ (above)
Woman welcoming death, 1934-35
Kollwitz's *Cycle of Death* uses taut line and menacing shadow to convey both a fear and desire for release. An intensely personal grief is stripped of egotism, pared down to barest essentials.

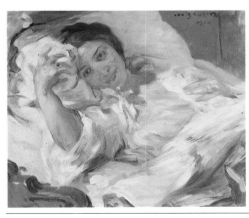

CORINTH (below)
Morning sunlight, 1910
Corinth's Impressionism was encouraged by study in Paris and then in Berlin under Liebermann. Beside

Uhde, his handling is much freer, but sentimentality is perhaps too evident; the sensuous, warm flesh tones of the model, his wife, show his admiration of Rubens.

UHDE (left)
At the summer resort, 1892
Uhde was a member of the Munich Sezession of 1892. His fresh and uncloying version of Impressionism, influenced by Liebermann, was still close to *plein-air*

Realism, being much less brightly and freely painted than the French original. There is even a faint echo of Runge's Romanticism in the aureoled child, who recalls the children in *The artist's parents* (see p. 323).

BARLACH (above)
The solitary one, 1911
Barlach was a friend of Kollwitz, who shared his sympathy with the miseries of the poor and lonely; he aspired, he said, to celebrate "the human condition in its nakedness between heaven

and earth", in poetry and prints as well as sculpture. He felt an affinity with the great Gothic woodcarvers, though in most figures the influence of Rodin seems paramount. This is almost bursting with some massive sorrow, too great to bear.

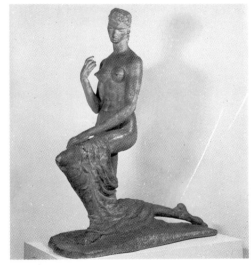

LEHMBRUCK (above)
Kneeling woman, 1911
The expressive elongation may derive from Rodin; the richly modelled surface is directly Rodinesque. Also Maillol could be cited. But the bowed head and docile pose, like that of some lost Virgin Annunciate, impart a distinctive spirituality – alien to France, but widely found in German sculpture.

MODERSOHN-BECKER (below)
Mother and child, 1906
The mother's heavy, almost animal body encloses the vulnerable form of the baby within a protective curve. Gauguin's impact is clear, but this is a powerful and tender image that has now an added poignancy, as it was painted the year before the artist died in giving birth to her first child.

Nolde: The Last Supper

"With light strokes I traced 13 figures on to the canvas, the Redeemer and the 12 Apostles seated at a table in the warm spring night, the night before the Passion. This was the occasion when Christ revealed His great idea of redemption to His beloved disciples. I obeyed an irresistible impulse to express deep spirituality and ardent religious feeling, but I did so without much deliberation, knowledge or reflection ... While working on *The Last Supper* and *Pentecost* I had to be artistically free ... These paintings marked the transition in my development from reliance on external optical stimulus to that of experienced inner value."

When Emil Nolde (1867-1956) painted his *Last Supper*, the genesis of which he was later to describe, as above, in his memoirs, he was already 43. He had been a slow developer. Brought up on a farm in Schleswig-Holstein, in the remoteness of north-east Germany, he always remained a somewhat solitary figure in the German Expressionist movement, with an almost hermetic, mystical dedication to his artistic vocation. He became a full-time painter only in 1894, but he had nevertheless by 1900 acquired considerable experience, in Munich, in Italy and in Paris, and had worked at Dachau in the school of Adolf Hölzel (1853-1934; not shown), whose use of symbolism and of expressive colour was probably very important for Nolde. Nolde's style evolved through Impressionism, but his real mentors were to be Munch and Ensor.

Nolde discovered or consolidated the themes that would preoccupy him for the rest of his life between 1900 and 1910 – religion, Nature (especially the wilderness of northern plains or the elemental forces of the sea), figure painting and, not least, flowers. These, however, he painted according to his inner vision: "All the free fantastic paintings of this period came into being without any prototype or model, without any well-defined idea ... a vague shape of glow and colour was enough. The paintings took shape as I worked." From such conceptions there evolved his idea of "passive artistic creation", defined in 1942 as "the moment when a spark glows in the

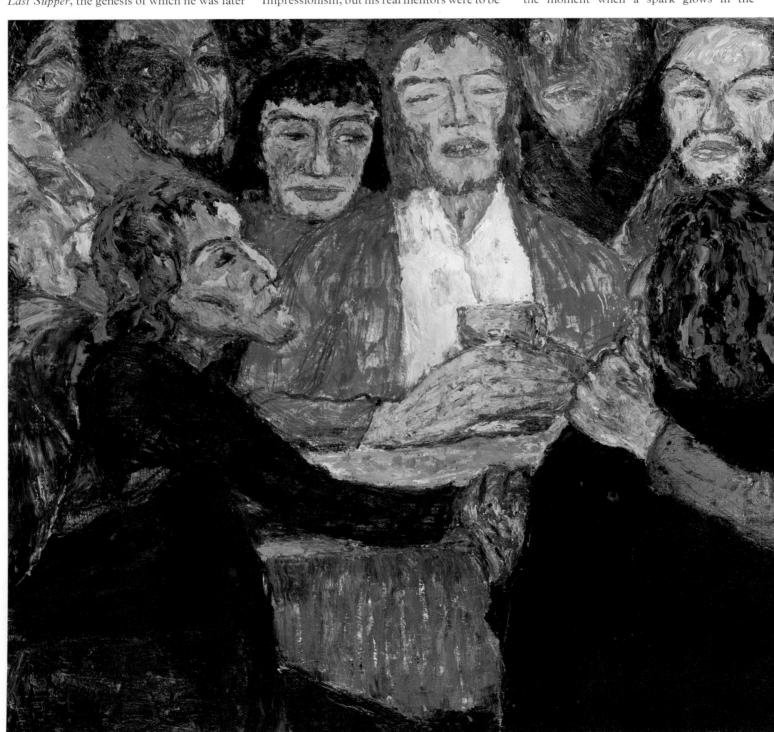

darkness and grows, if the circumstances are right, into a leaping flame."

The handling of Nolde's *Last Supper* is indeed a far cry from the traditional formulae evolving from the famous prototype by Leonardo da Vinci (see p. 128), though the force behind it owes something surely to the tortured anguish of Grünewald's religious painting. In its harsh, summary drawing, in its echoes of tribal African or Oceanic sculpture, in the strident reds and yellow greens and the compression of figures within the picture space, the painting is unequivocally in the mainstream of German Expressionism. But the religious impact is Nolde's own, and his only peer as a religious artist in the twentieth century is Rouault (see p. 391), also a great master of glowing colour. Nolde, however, lacked Rouault's sexual disgust, and also his formal restraint, for Nolde could unleash his brush in a wild gaiety of swirling paint in which the figures dissolve.

As a prolific printmaker, exploiting the technical potential of both woodcut and lithograph, Nolde had an importance in the development of Expressionist graphics. Yet perhaps his most remarkable achievements were in watercolour: in this medium, in the incandescent intensity with which he could kindle colour into blaze on paper, he has no peer in the twentieth century.

After he had briefly, in 1906-07, been a member of Die Brücke, Nolde withdrew to a farm in the northern German fastnesses at Seebüll (where a foundation now houses much of his work); and became more and more a recluse. The Nazis (of whom Nolde at first approved) declared him a "degenerate" artist, but, though he was officially forbidden to paint, he produced innumerable compositions in miniature (his secret "unpainted pictures") during World War II, and subsequently, in an astonishing burst of energy before his death, painted full-scale versions of a great many of them. Well aware of the example of van Gogh, Gauguin and Munch, he rivalled them in the intensity of his vision, in which he formulated an original, elemental imagery of great power.

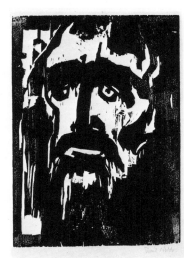

NOLDE (left)
The Last Supper, 1909
Early in 1909 Nolde had been dangerously ill; on his recovery he began painting a series of religious works – *The Last Supper*, *Pentecost*, *The mocking of Christ* and *The Crucifixion*. He said: "I stood almost terrified before my drawing, without any model in nature – I was about to paint the most profoundly significant episode in the Christian religion! ... Had I felt bound to keep to the letter of the Bible or dogma, I do not think I could have painted these deeply experienced pictures so powerfully."

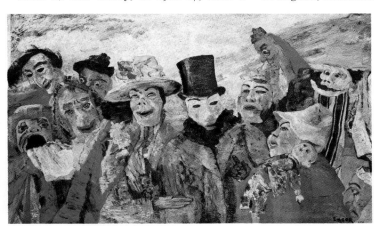

ENSOR (left)
Intrigue, 1890
Ensor was one of the first European artists to break traditional constraints on expression – turning to use the ugly and disturbing. In what seems to be a carnival there is here no festivity; the masks reveal an inner evil; the smiles are leers. Nolde, trying to give form to a personal vision, took up Ensor's example, conveying his emotion through garish colour and coarse features.

NOLDE (above)
A Friesland farm under red clouds, c. 1930
The wild and desolate landscape of Seebüll with its vast expanses of sky suited Nolde's fervent, solitary nature. A visit to China in 1913 perhaps stimulated the vivid hues and liking for pattern typical of his later watercolour style.

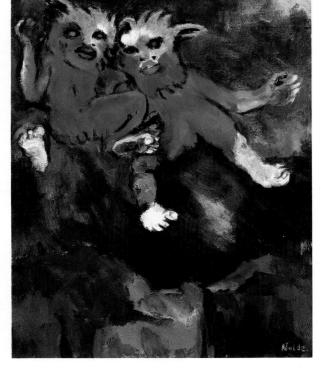

NOLDE (right)
The prophet, 1912
This is one of a series of woodcuts that Nolde made in 1912. He had earlier been associated with Die Brücke and he, too, was attracted by the German origin of the technique, and the powerful crudity of the kind of image it produces.

NOLDE (above)
Early morning flight, 1950
Nolde's late oil-paintings are all enlarged versions of watercolour improvisations, with glowing colours, free brushwork and a dreamy or mystical quality. Perhaps these are spirits heralding the coming of morning; the subject matter is usually fanciful or fey, expressing a joyous vivacity that had seldom appeared earlier.

Expressionism 1: Die Brücke

In 1905-06 a little band of young students at an architectural school in Dresden formed a group they styled "*Die Brücke*" (The Artists' Group of the Bridge). Their aim was to create a modern artistic community, like the Pre-Raphaelites, the Nazarenes, or Gauguin and van Gogh before them, but they were fired with a more aggressive missionary zeal. Very young themselves (the eldest, Kirchner, was only 25), they addressed themselves to the young: "One of the aims of Die Brücke is to attract all the revolutionary and surging elements – that is what the name signifies." Their ideals were to be achieved by their communal activity, and were to be propagated by travelling exhibitions of their work.

Die Brücke were concerned with the social role of art, and in this they differed from the Fauves (see p. 390) in France, although they shared with them a delight in the resonance of contrasting, non-representational colours. Both groups, formulating their revolutionary styles in about 1905 – simultaneously and, to begin with, quite independently – naturally took advantage of the formal explorations of the Post-Impressionists and of Art Nouveau, and also shared an excitement in the expressive

distortions and simplifications of so-called "primitive" art – for Die Brücke, the Oceanic and African collections in the Zwinger Museum at Dresden. In the Germans' work, however, which is angular, often harsh and crowded with detail, there is an emphasis on the Nordic tradition, stemming from Gothic art, from Grünewald and the great print-makers of the fifteenth and sixteenth centuries. The painters of Die Brücke created psycho-logical tensions in their work recalling those of Munch; they were reluctant, however, to ad-mit Munch as kindred spirit, and Munch himself, at his first sight of the work of one of the group (Schmidt-Rottluff), exclaimed: "May God protect us; evil times are coming."

The three outstanding founder members were Ernst Ludwig Kirchner, Karl Schmidt-Rottluff and Erich Heckel. They were followed by Max Pechstein and Otto Mueller, and Emil Nolde (see preceding page) was briefly a member in 1906-07. The manifesto of the group was cut on wood by Kirchner – in the broad-sheet tradition – and published in 1906, when its first exhibition was held, in Dresden. By about 1910, the leading members of the group were working in Berlin, where, rejected by the

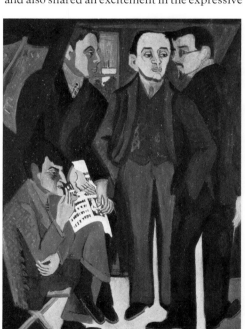

KIRCHNER (above)
The artists' group of the bridge, 1906
In choosing the emblem of a bridge the group wished to represent themselves as a link between the arts of past and future. They may have found the metaphor in Nietzsche's *Thus Spake Zarathustra*, a work they admired: "Man is great because he is a bridge and not a goal; he is only fit to be loved when he is a transition and a failure."

KIRCHNER (left)
Artists of Die Brücke, c. 1926
A compressed and flattened space is occupied by the angular, almost contorted figures of Mueller, seated, and Kirchner himself, with Heckel and a bespectacled Schmidt-Rottluff standing to his right. The group is portrayed as it was in the years before its dissolution.

KIRCHNER (right)
Street scene, 1913-14
Kirchner was fascinated by the people he observed in the streets of Berlin, by the movement of passers-by, dawdling or purposeful, by the anonymity of crowds, out of which a face might take form with startling immediacy. He registered the people he saw almost as caricatures – here they are shimmering repetitions of the fashionably dressed woman in the foreground, sporting the exaggeratedly tall and slender silhouette favoured just before 1914.

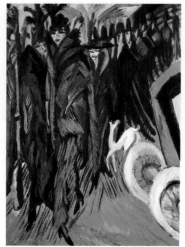

SCHMIDT-ROTTLUFF (above)
The sun in a pine wood, 1913
Against the warm ochres of the trees and the earth, the intensity of the sunlight is suggested in its whiteness. All form has been reduced to bold, violent simplicity, though both subject and mood have their roots in the landscape tradition of German Romanticism.

KIRCHNER (left)
The couple, 1923
The woman's features reflect Kirchner's interest in African tribal masks, while the theme, rendered in brilliant acid colours, is typically Expressionist – the tensions of sex – but not harshly or bluntly treated.

Berlin Sezession, they formed a rival association, the Neue Sezession, with Pechstein as president. In 1910 Herwarth Walden, a dynamic and eloquent champion of Expressionist art in all media, started his influential periodical *Der Sturm* (The storm), and in 1912 established a gallery of the same name in which the work of Die Brücke was shown along with that of the leading artists of the various revolutionary movements in Europe. By then, however, the coherence of Die Brücke was disintegrating: they had resigned from the Neue Sezession, losing Pechstein, who continued to exhibit with it, and Kirchner's *Chronicle of Die Brücke* of 1913 proved an obituary: the group dissolved that year.

Ernst Ludwig Kirchner (1880-1938), most articulate and most gifted of the group, was also the only one of its members to have had any formal training in painting, although he shared with the others a taste for awkwardness in composition. He delighted in subjects full of movement, cabaret or circus scenes; he was a prolific printmaker, and a sculptor, but is seen at his most striking in his painted nudes and haunting street scenes: these, while they reflect in some degree the successive impacts of Munch, of Fauvism and of Cubism, convey Kirchner's characteristic sense of urban and erotic desolation. His sensitivity was unable to stand the horrors of war, and in 1916 he suffered a breakdown; following his recovery his art became more decorative, lacking his earlier intensity. Condemned as "degenerate" by the Nazis, he committed suicide in 1938.

Karl Schmidt-Rottluff (1884-1976) developed a powerful command of simplified shapes and summarily modulated planes of strong colour, angular and interlocking. His landscapes painted in this idiom, from about 1911, have a magical and mystical intensity. After World War I, his work tended to be softer, more decorative, but in one famous print of 1918 he crystallized the horror of the trenches in an image of Christ, chopped and hacked on to the woodblock. His strength comes through most purely in his prints, and it was especially in the relatively coarse medium of the woodcut, whether black and white or coloured, that he and others of the group found their most striking and original expression. Erich Heckel (1883-1970), likewise a great printmaker, was a gentler talent; in his early work, angular like all Die Brücke images, his figures are possessed by anxieties, emaciated by them. He was profoundly moved by the great Russian novelists; his most famous painting, the claustrophobic *Two men at a table*, 1912, was dedicated to Dostoevsky.

Max Pechstein (1881-1955), who joined Die Brücke in 1906, offended less against conventional taste than the others, and so became more swiftly successful. The decorative quality of his work was closer to that of the French (he was strongly influenced by Matisse), while his reliance on the forms of tribal art was intensified by a South Seas tour in 1914. Older than the others, Otto Mueller (1874-1930), who joined the group in 1910, retained a softer, more delicate lyricism in contrast to their forceful expressiveness, and preferred pastoral to urban subject matter.

Mueller, dying in 1930, was spared the persecution that the Nazi artistic pogrom of the 1930s brought upon the others, all condemned as "degenerate" artists, their works confiscated, sold or even burnt. Indeed the achievement of early German Expressionism, its forceful relevance to the tragic condition of twentieth-century man, began to impress a larger audience only after 1945.

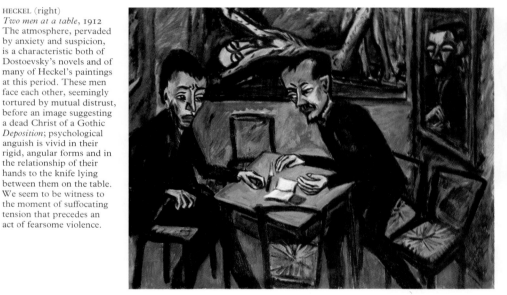

HECKEL (right)
Two men at a table, 1912
The atmosphere, pervaded by anxiety and suspicion, is a characteristic both of Dostoevsky's novels and of many of Heckel's paintings at this period. These men face each other, seemingly tortured by mutual distrust, before an image suggesting a dead Christ of a Gothic *Deposition*; psychological anguish is vivid in their rigid, angular forms and in the relationship of their hands to the knife lying between them on the table. We seem to be witness to the moment of suffocating tension that precedes an act of fearsome violence.

MUELLER (above)
Nudes on a beach, 1920
Gypsies, and nudes in landscape settings, these were Mueller's favourite themes. Their elongated bodies and graceful air of slightly fraught melancholy recall Lehmbrück's sculpture.

Mueller never adopted the strident colour favoured by his colleagues in Die Brücke: his pale, chalky palette enhances a wistful mood. But the figures have an angularity typical of Die Brücke. His prints are more Expressionistic.

SCHMIDT-ROTTLUFF (left)
The head of Christ, 1918
The woodcut reached its apogee in the art of Dürer and Holbein in the early 16th century, after the first printed images in Europe had appeared in Germany. Its national and medieval origins commended it to Die Brücke, and also its intrinsically "primitive" or stubborn handling, here exploited to forceful effect.

PECHSTEIN (right)
The harbour, 1922
Pechstein appears among the artists of Die Brücke as the chief practitioner of French ideas and methods. Fauve works such as this, though frankly derivative, have, however, a tension (here, perhaps, in the loud reds) lacking in French art.

Expressionism 2: Der Blaue Reiter

Der Blaue Reiter (The Blue Rider), the second of the two major early groups of Expressionist painters in Germany, was, unlike Die Brücke in Dresden and Berlin, quite a loose association that did not nurture a single specific style and did not envisage communal activity. It was formed in Munich in 1911-12 as a splinter group of the New Artists' Association which the Russian artist Wassily Kandinsky and others had founded in 1909; it, too, was headed by Kandinsky, with Gabriele Münter, Alfred Kubin and Franz Marc. Der Blaue Reiter (the name was taken from a picture by Kandinsky) was really a board or committee, which succeeded, before its dissolution at the outbreak of World War I, in realizing only one issue of an art publication, *The Blue Rider Almanac*, and in organizing two exhibitions. Other major artists associated with the group were August Macke, Alexei van Jawlensky and Paul Klee.

Der Blaue Reiter took its final form several years after Die Brücke, founded in 1905, but many of its members had been active in Munich since the late 1890s. Munich had by then become a fertile art centre, almost rivalling Paris, and attracting artists from both west and east. From 1896 two influential art maga-zines had been published from Munich, *Jugend* (Youth; sponsoring Art Nouveau) and *Simplizissimus*, notable especially for its graphic art. Der Blaue Reiter, compared to Die Brücke, was much more cosmopolitan in outlook, and the aim of its exhibitions was "simply to juxtapose the most varied manifestations of the new painting on an international basis ... and to show, by the variety of forms represented, the manifold ways in which the artist manifests his inner desire". Included, besides paintings by the Munich members, were works by Picasso, Braque and Delaunay (the last perhaps was the most influential on the group), by Malevich and Arp, by the recently deceased Douanier Rousseau and also paintings by the composer Schönberg. In its *Almanac*, Der Blaue Reiter published a remarkable variety of Naive, exotic and "primitive" material – African and Oceanic, Mexican and Brazilian objects; Russian and German folk art; Japanese prints; Bavarian glass-painting; children's art (especially important for Klee's development). The common factor in all these was their freedom from the constraints and conventions of European "fine" art; suggesting possibilities of expressing the artist's "inner necessity" more directly. The philosophy was that of Nietzsche: "Who wishes to be creative ... must first blast and destroy accepted values."

Wassily Kandinsky (1866-1940), born in Moscow, was the oldest of the group. Having studied law, he turned artist and migrated to Munich only at the age of 30, in 1896. His early work in Germany shows him modulating the styles of the time – Post-Impressionism, Art Nouveau, Fauvism – into a personal, distinctly Russian, fairy-tale vision expressed in rich and glowing colour. Having exhibited not only with the Munich and Berlin Sezessions but also in Paris, he was already moving in theory towards abstract art by about 1905; he later observed that even as a student he had found subject matter more of a hindrance than a help in painting. Only in 1912, however, when he was already working on his apologia, *Concerning the Spiritual in Art*, did he reach abstract art in practice (see over).

Together with Kandinsky, the Munich-born Franz Marc (1880-1916) gave Der Blaue Reiter an intellectual calibre Die Brücke never had. He had started as a student of philosophy and theology; fascinated by the physical grace

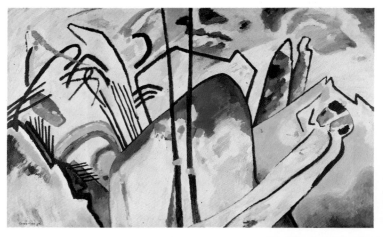

KANDINSKY (left)
Composition no. 4 (Battle), 1911
In what is at first sight an abstract work, figurative features may yet be found – in the rainbow spanning a gorge and the parachuting "matchstick" figure above. However, no other members of Der Blaue Reiter attained this degree of independence from the physical world in expressing "inner necessity".

MARC (right)
Deer in a forest II, 1913-14
Marc's search for a visual system in which to express his conviction of an "inner mystical structure of the world" was aided by a visit in 1912 to Delaunay. His debt to Orphism (see p. 399) is here strongly marked.

MARC (above)
The fate of the animals, 1913
Marc aspired to give form not to the visible world but to a subjective impression of it: "How wretched, how soulless", he wrote, "is our habit of placing animals in a landscape which mirrors our own vision, instead of sinking ourselves in the soul of the animal so as to imagine its perceptions."

MACKE (right)
Kairouan I, 1914
The crucial African journey made by Macke and Klee in 1914 (see p. 440) is evoked in exquisite tints applied in an almost abstract order.

and essential innocence of animals, he painted them at first naturalistically; then he evolved a counterpoint of form and colour, in which the sinuous rhythms of animal life invigorated broad planes of brilliant, joyous colour bearing no relation to the subject's "natural" hues – Marc's famous blue and red horses. In these an awareness both of Cubism and of Orphism is evident, and by 1913 Marc was moving to almost pure abstraction. His mature paintings are some of the most striking images of twentieth-century art, and his death in action at Verdun one of its greatest losses. Yet almost comparable was the death of August Macke (1887-1914). In sensitivity the most gifted of the group, in his last few years he produced enchantingly lyrical and elegiac visions of urban life – elegant women, children in the park – a poetry of the city very different from Kirchner's sinister evocations. He visited Paris often, but his art, far from being diluted by Fauve, Cubist, or Orphic example, was strong enough to absorb their influences into his own intensely personal view, expressed through shifting planes of colour.

Kandinsky's compatriot Alexei van Jawlensky (1864-1941) was never formally a mem-

ber of Der Blaue Reiter, but was closely sympathetic to its aims. Much influenced by the Fauves (he had met Matisse in Paris), he used strong colour in flat planes and often in heavy linear contours, and his work was increasingly invested with an almost mystical feeling. His most memorable imagery was provided by the theme of a very simplified mask-face on which he played endless variations. Also important were Gabriele Münter (1897-1962), one of the few women artists in the group, who lived with Kandinsky until his return to Russia; Heinrich Campendonk

(1880-1957; not shown), painting very stiff, primitive-looking images reminiscent of the glass-painting of Bavarian folk art; and Alfred Kubin (1877-1959), primarily a graphic illustrator with a fantastic demonic quality. Paul Klee was also working entirely in black and white when Kandinsky first came into contact with him in Munich, but then began to explore the delicate, infinitely subtle watercolour techniques that he was to deploy and develop for the rest of his life (see p. 440). But Wassily Kandinsky, self-proclaimed founder of abstract art, was undoubtedly the major force.

MUNTER (right)
A man at a table (Wassily Kandinsky), 1911
Münter concentrated on landscape, but her portrait of her lover also shows her Fauve-influenced style – areas of bold, unmodelled colour enclosed in heavy black contours. Objects are simplified in "primitive" fashion but the execution is vigorous and assured.

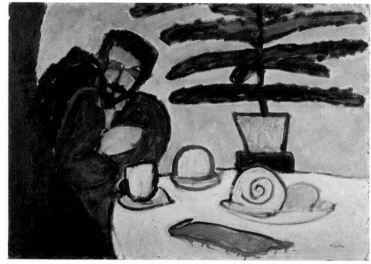

MACKE (left)
People at the blue lake, 1913
More than Marc, Macke dissolved modelled form in flat, floating colours almost alone constituting figures and setting. This tendency to generalize had its root in the aim, common to Der Blaue Reiter artists, to convey a universal truth behind surface appearances.

KLEE (below)
An animal suckling its offspring, 1906
The Bavarian folk craft of painting on glass aroused the interest of several Der Blaue Reiter artists, but Klee was the most active in the medium; he worked mainly in black and white and delighted in the sometimes unforeseen effects of the technique, retaining them in the final image.

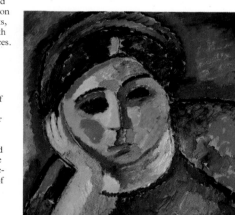

JAWLENSKY (left)
Woman meditating, 1912
Jawlensky's colour tends to be hotter than that of the French Fauves, and there is a rather more charged quality to his work. Though he often gave his subjects rather heavy features, his brush-strokes could almost be called painstaking; they are more minute than bold.

KUBIN (below)
The egg, c. 1900
A tragic childhood and an obsession with the macabre – it is said that he liked to watch the recovery of corpses from the river – dominated Kubin's graphic work, which was essentially Symbolist in direction.

Kandinsky: Study for Composition no. 7

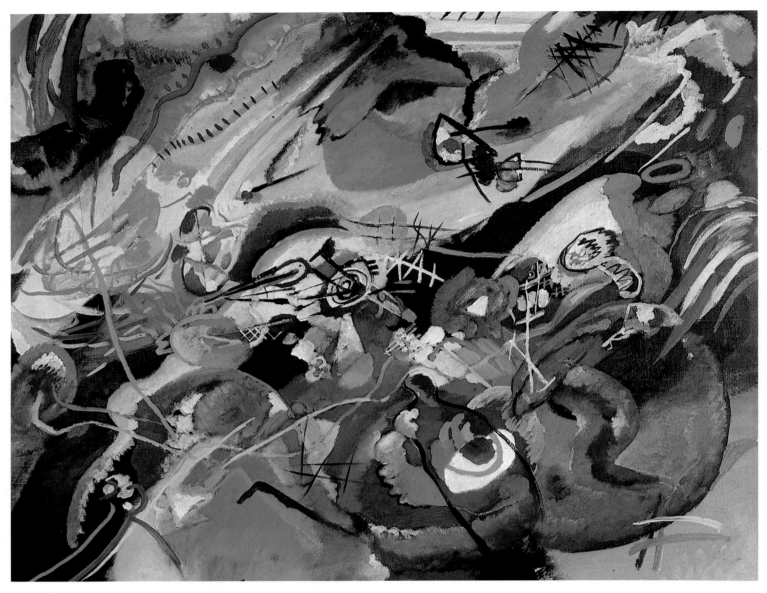

Composition no. 7 is one of the largest and most elaborate of the series of *Improvisations* and *Compositions* in which Kandinsky moved gradually, between 1910 and 1914, towards the elimination of all figurative or representational elements in his work. This study, of 1913, at first sight seethes, a hurly-burly of colour in conflict – colour that in places melts tenderly, even amorphously, and in others is hot, sharp and strident; here and there are sharp scratchy scorings or criss-crosses of lines. On longer inspection, the implications of the title, a *Composition*, may seem more valid. There is a main focus of attention in an emphatic clench of forms, of thunderous blue and of heavy black left of centre, while the rectangle of the painting is divided by a diagonal from lower left to upper right. Below this is relative calm, above it all is turbulence. The onlooker's first impression may be of uncontrolled explosion; longer acquaintance reveals that the explosion is profoundly excogitated.

Wassily Kandinsky had already completed his fundamental treatise *Uber das Geistige in der Kunst* (Concerning the Spiritual in Art) in 1910, though it was not published until 1912. In this, and his other theoretical writing, the argument is often obscure, but he was grappling with the huge difficulty of explaining the inexplicable, the unanalysable – the abstract values of colour and form completely detached from all representation of nature or objects. Very conscious of the danger of non-figurative art becoming mere vapid decoration, Kandinsky nevertheless believed that in pure colour and pure form the artist could find direct and valid expression of his mind or spirit. "The harmony of colour and form must be based solely upon the principle of proper contact with the human soul." Towards this end he worked out definitions of the qualities of colours and forms, but these, when not patently obvious, are generally highly subjective. One ready parallel with the art to which he aspired was, however, music: his own comments, and titles – *Improvisation, Composition* – indicate this clearly. For all his legal background, Kandinsky was always attracted by mysticism (particularly the theosophy of Madame Blavatsky), while his faith in materialism, in the value of the object, had been undermined by scientific revolution – the splitting of the atom.

Kandinsky's distrust of subject matter goes back to his student days in Moscow, when he saw one of Monet's *Haystacks* (see p. 349). in which the subject was dissolved into shimmering light and colour. Then in Munich, probably in 1910, he saw in one of his own paintings lying the wrong way up, in a subdued evening light, an apparition, a harmony of colour, line and form "of extraordinary beauty, glowing with an inner radiance"; and this precipitated the final conversion to non-figurative art: "Now I know for certain that subject matter was detrimental to my paintings." Kandinsky claimed to have been the first to paint purely abstract pictures – or rather non-figurative ones. The Cubists and others likewise "abstracted" their compositions from their subject matter, but never became completely detached from the object. Kandinsky's claim can be and has been contested, but it is clear that he was indeed the first to establish abstract art as a consolidated and valid mode of expression.

Following the revelation of his upside-down painting, Kandinsky did not proceed immediately to absolute non-figuration, nor did he altogether abandon landscape or other subjects even when he had. Figurative motifs, while becoming increasingly schematic or ves-

KANDINSKY (left)
Study for *Composition
no. 7*, 1913
Kandinsky found "vistas
of purely pictorial possi-
bility" in the "shock of
contrasting colours, the
checking of fluid spots
by contours of design, by
the mingling and the sharp
separation of surfaces".

KANDINSKY (right)
*Composition no. 7,
fragment no. 1*, 1913
Apocalyptic struggles have
been seen in these studies;
but also the first visual
equivalent of "conscious-
ness on a psychic level".

KANDINSKY (below)
*The first abstract
watercolour*, 1912
Is Kandinsky's title true?

There are rival claimants.
The difficulty is that all
the short-listed works were
long in the artists' hands

and might well have been
repainted later. This is the
favourite, as it seems fully
balanced, not an experiment.

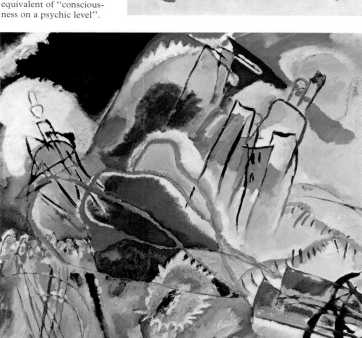

KANDINSKY
(left) *Improvisation
no. 30 – Cannons*, 1913;
(right) *Black lines*, 1913
Both works are abstract,
though Kandinsky agreed
that his own title *Cannons*
and their clear intrusion
might reflect the constant
war-talk of the time; and
Black lines seems eerily
prophetic of aircraft being
strafed in bursts of fire.

KANDINSKY (below)
Two poplars, 1913
Kandinsky did not become
an abstract painter over-
night; the landscapes he
continued to produce until
1914 reveal no impassable
gulf between painting the
soul and painting trees.

tigial, persist in some of his paintings as late as
1920. Before 1914, however, he had already
singled out the Unconscious as the mainspring
of his work. Thus of *Improvisation no. 30 –
Cannons* he wrote that it was "painted rather
subconsciously in a state of strong inner ten-
sion. So intensively did I feel the necessity of
some of the forms that I remember having
given loud directions to myself, for instance,
'But the corners must be heavy'." This may
suggest a closer parallel with the Abstract
Expressionism of American artists in the 1950s
than is really justifiable. Kandinsky's work-
ings, his intuition, were always controlled by
an inner discipline, and there are more than 12
preliminary studies for *Composition no. 7*; the
final painting took three days.

World War I disrupted Kandinsky's career.
Returning to Russia, he painted relatively
little, and after the Revolution was busily
employed as an artistic administrator, al-
though his work found no favour with the
young Constructivists. During this time, how-
ever, he was refining his practice towards the
geometric, "hard-edge" style that he was to
develop fully on his establishment, in 1921, in
the Bauhaus (see p. 438).

Le Douanier Rousseau: The Merry Jesters

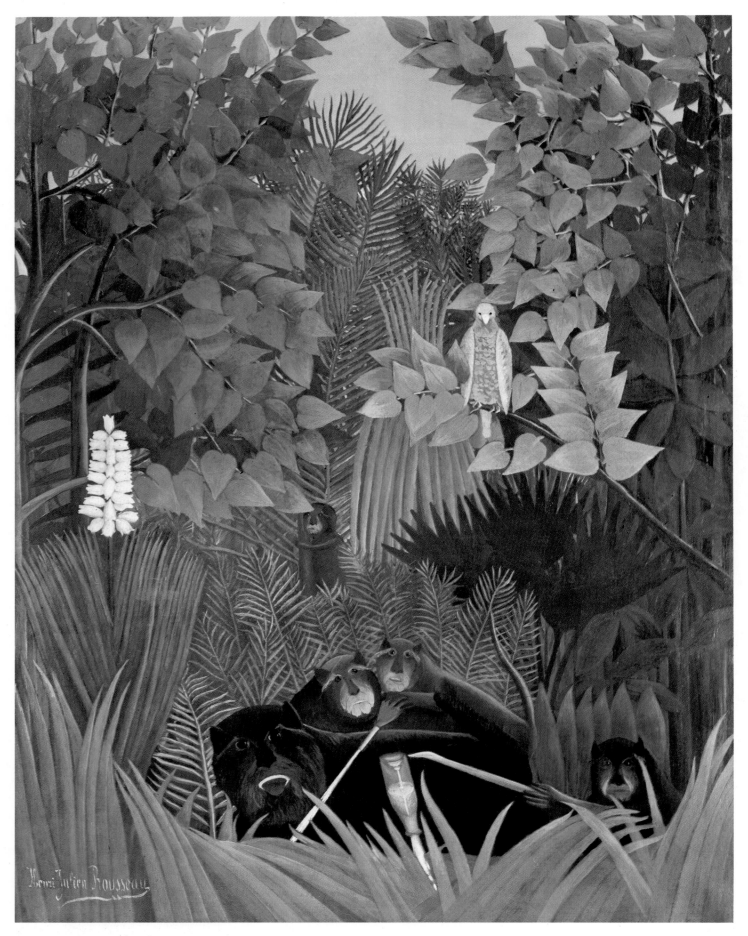

ROUSSEAU: *The merry jesters, c.* 1906

In the forest, a self-conscious, jokey little clutch of three brown furry animals of uncertain species gazes unblinkingly upon the spectator, as if posed for his camera. A fourth just protrudes at the bottom right corner; a fifth, somewhat melancholy, is erect in the middle distance, and on a branch a leaden bird sits leering. The jungle is a tapestry-like texture of subtly contrasting greens, in patterns of spear-like or heart-shaped sprays of leaves, grasses and magnified fronds; a large, exotic, white, pagoda-like flower rises primly vertical on the left; there is a glimpse of sky above. No shadows are cast. Suspended (by what?) in front of the central group is an inverted milk-bottle and a back-scratcher. *The merry jesters* is an impossible fiction: both the logistics and the significance of the action are inexplicable. But the gaze of the animals confronts the spectator with bland assurance. Mystery reigns, a dream is being dreamed, and yet the conviction of reality recorded is stunning. The prominent curvaceous signature of *Henri Julien Rousseau* at bottom left is an integral part of the design.

Henri Julien Rousseau (1844-1910) spent his adult career, until 1885, when he retired, as an official in a Parisian toll-house: hence he is always known as "Le Douanier". Though he is often categorized as "primitive", "Naive", "Sunday painter" or "amateur", he justly considered himself a professional. Personally Rousseau was indeed naive, innocent, distressingly gullible, pompous and absurd, and at times in trouble with the police (in a film he would have been played ideally by Charlie Chaplin), but he was unshakably convinced of his own destiny and of the grandeur of the contribution he had to make to the Glory of France. He claimed to have "no master but Nature and some advice from Gérôme and Clément" (two leading academic painters); he saw himself as "one of our first Realist painters", and observed to Picasso that they were the only two great modern painters, "I in the modern manner and you in the Egyptian". He had exhibited in Paris from 1885 on, but generally provoked only derision from the public. From about 1905, however, he was patronized by a few leading critics and dealers, especially Wilhelm Uhde (the first critical champion of the so-called "Naive" painters) and Vollard; and was celebrated as a sort of mascot by some of the leaders of the avant-garde, including Picasso, Apollinaire, Léger – but also as their peer, at a famous banquet in Picasso's studio in 1908. After his death, his work was hailed especially by Der Blaue Reiter; Kandinsky considered that Rousseau was arriving at the same goal as he and his colleagues, though by a completely different route. His work has continued to find a delighted response – from Dadaists, Surrealists and Pop artists, and from the public.

Rousseau's subject matter was of great variety, including not only the Parisian suburbs, of which he was the visual poet, but portraits of formidable four-square directness, allegorical compositions in the Grand Manner, flower-pieces, and above all the series of large-scale exotic fantasies inspired by his wanderings in the parks, botanical gardens and zoo of Paris. Naive though he was, untrained, working painstakingly across the canvas, diligently "filling in", he had a superb intuitive sense of design and composition, and this, and the range and intensity of his imagination, establish him well above the Naive painters who have since emerged. Uhde discovered one of them in his own household, in the shape of a housemaid, Séraphine Louis (1864-1934). The Naive painters were established as a serious – if awkward – component of twentieth-century art by Uhde's exhibition "The Painters of the Sacred Heart" in 1928, which also featured the postman Louis Vivin (1861-1936), the gardener André Bauchant (1873-1958) and the one-time circus wrestler Camille Bombois.

ROUSSEAU
The toll station, c. 1890-91
Here worked Le Douanier (not in fact as a customs officer, but as a collector of taxes levied on goods coming into Paris). Seurat's influence is apparent in the studied composition, in its contrived formality.

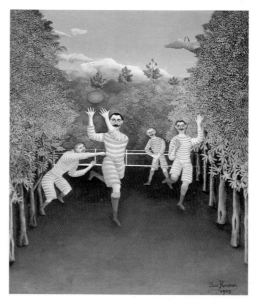

ROUSSEAU (above)
The ball players, 1908
The movement is conveyed almost solely by the interaction of the stripes on the player's shirts: Rousseau had the most sensitive and subtle command of colour. He was the first painter to make modern phenomena – football, flying machines – star in his compositions.

SERAPHINE (left)
The paradise tree, 1929
Séraphine painted vivid visionary trees and flowers peopled with lips and eyes. They are decorative, and yet there is an element of magic in them. Séraphine used to paint in a trance – informed, so she said, by a guardian angel – and would permit no one to see her at work. Sadly, once she was "discovered", she lost this happy source of inspiration.

VIVIN (above)
Notre Dame, Paris, 1933
Front and side views are combined – a reversion to Egyptian principles. Uhde boldly baptized Vivin "the Canaletto of modern Paris".

BAUCHANT (right)
Cleopatra's barge, 1939
Bauchant was still unknown when Diaghilev decided to employ him to decorate the sets for one of his ballets.

Fauvism

At the Salon d'Automne of 1905 in Paris, a critic found a classicizing torso in pale marble as if trapped amidst a pack of canvases of ferociously exuberant colours. His exclamation, "*Donatello au milieu des fauves!*" (Donatello amidst the wild beasts), baptized one of the most important movements of the early twentieth century – though it was barely cohesive enough to be called a movement, and very brief-lived.

The central figure amongst the Fauves was always Henri Matisse (see over), and that particular brilliance of colour and freshness characteristic of Fauvism in its prime recurs in his painting again and again until his very last work, in cut paper, in the 1950s. Matisse, Albert Marquet and Georges Rouault had all worked in Gustave Moreau's studio at various times between 1895 and 1899, and Moreau's expressive command of glowing colour surely affected all of them. Some 15 years, however, before Fauvism startled the public, Gauguin had defined a quality essential to it: "Instead of trying to render what I see before me, I use colour in a completely arbitrary way to express myself powerfully." In 1901, the work of another forerunner, van Gogh, had been dis-

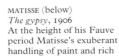
MATISSE (below)
The gypsy, 1906
At the height of his Fauve period Matisse's exuberant handling of paint and rich colour had a forcefulness moderated in his later art. Yet the form is defined in the abandon of colour: Matisse studied Cézanne.

played in Paris in a retrospective exhibition at which Matisse first met Maurice de Vlaminck. In 1903, dissatisfied with existing annual exhibitions, a group including Renoir, the Symbolist novelist and critic Huysmans and Rouault founded the Salon d'Automne (Autumn Salon) and gave that year a memorial exhibition of Gauguin; this was followed in 1904 by a large retrospective of Cézanne and in 1905 by the burst of colour that precipitated the Fauve painters' sobriquet.

Artists allied to those already mentioned in elements of style, though they never associated as an organized group, included André Derain, Raoul Dufy and Georges Braque. The adherence of some to Fauvist principles was brief indeed. André Derain (1880-1954), in the south of France in 1905 with Matisse, distilled brilliant, dazzling canvases from the light of the Midi sun, and soon afterwards in London, rather surprisingly, painted equally luminous, if cooler, versions of the river Thames. But within a year or two he had abandoned his brilliant palette, and an essential conservatism tamed his later ventures into Cubism. Georges Braque's Fauve period was even briefer, though to it are due a handful of the most

DERAIN (above)
The harbour at Collioure, 1905
Derain's sense of colour was transformed by strong sun: sunlight seems to burn in the unmodulated dashes applied on a white ground.

BRAQUE (below)
The little bay of La Ciotat, 1907
The seascape is only barely outlined, the arrangement of strokes almost abstract. There is a marked delicacy, and care for composition.

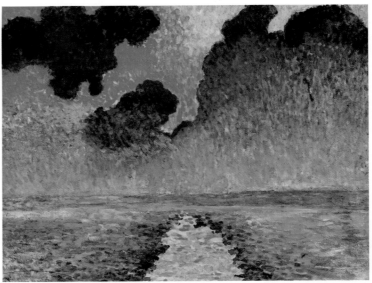

DERAIN (left)
Effects of sunlight on water, 1905
Derain once compared a tube of paint with a stick of dynamite, but he never, like Vlaminck, advocated arson. In the dazzling explosion of colour there still lurks structure – a firm horizon, for instance. His canvas is like a pointillist work energized and saturated.

DUFY (below)
Riders in the wood, 1931
Influenced by Marquet and Matisse's Fauve paintings, Dufy adopted the wild and free use of colour which distinguished the group, but, unlike most others, he was moved by a concern for an everyday realism and by a love of decorative effects, throughout a long career.

subtle and sensitive pictures in the style, and by late 1907 he was moving, with Picasso, into Cubist rigours (see p. 396).

For Raoul Dufy (1877-1953), who had started as an Impressionist, the Fauve vision proved too intense and exclamatory; soon he developed that characteristic lightness of touch, that elegant and witty calligraphy with which he was to describe the pleasures of leisure – beaches, yachts and racecourses – in later decades. Albert Marquet (1875-1947) was always more traditional, though he had a sure skill in extracting the essence of the scene before him, and after a brief explosion of colour as early as 1900 reverted to a more subdued tonal painting, exquisitely controlled.

Georges Rouault (1871-1958) perhaps never belonged emotionally to the Fauve movement: the closest of the Fauves to Moreau (and curator of the Musée Gustave Moreau in Paris), he was driven – by moral indignation, by a fascination with the scatological and, ultimately, by profound religious conviction – far away from the spontaneous hedonism and delight in decorativeness of the others. In this he was the direct heir to the Symbolists, while technically, in his *cloisonné* patterning of col-

our strongly reminiscent of the compartmentation of stained-glass windows, he followed the example of the painters of Pont-Aven. His prostitutes and clowns glow sombrely as if in the fires of Hell. Rouault is a direct link between Symbolism, including Gauguin, and the more ferocious output of German Expressionism, and he also ventured into graphic art, in his series of black and white prints "*Miserere et Guerre*" (War and pity; not shown) produced between 1914 and 1918. He stands apart, as perhaps the major religious artist of the twentieth century.

Maurice de Vlaminck (1876-1958) was the most committed of the Fauves, apart from Matisse, from whom in character he was very different: he was self-taught, anti-intellectual, fiercely scornful of the art of academies or museums. He was also for a short time a professional cyclist and peripatetic fiddler; he used to wear wooden ties varnished in bright colours, and indulged in hearty eating contests with Derain and the poet and critic Apollinaire. "I have never 'thought about art' . . . I wanted to burn the Ecole des Beaux-Arts with my cobalts and vermilions and I wanted to interpret my feelings with my brushes without

thinking what had gone before me." Profoundly stirred by the van Gogh exhibition in 1901, he unleashed his harsh primaries of red, white and blue against Vincent's favourite yellows, oranges and greens with forceful and sometimes discordant clangour. The vigour of his attack on the canvas can produce the feeling in the onlooker that he is passing though these streets and landscapes at speed, as if on Vlaminck's racing cycle, but in his later work impatience weakened his compositions.

Vlaminck's urge to convey the fleeting impression with the greatest possible immediacy was characteristic of the initial Fauve approach: the aim was to achieve the maximum force of expression in colour and in the movement of the brush – the more violent the contrast between the colours the better. The real world served only as a point of departure in the creation of an image that had conceptual or existential rather than representational value. Once the initial excitement – an essentially youthful excitement – had passed, the style could only degenerate into mannerism, as often in Vlaminck's later work. It was above all Matisse who had the stamina and discipline to control and adapt it to a developing art.

MARQUET (right)
Hoardings at Trouville,
1906
Under Matisse's influence Marquet used the Fauves' strong, unmodified colours for a time, but he was never as wild as the nickname. He would paint in bright tones one day, browns and greys the next, composing finely balanced pictures with a minimum of detail.

VLAMINCK (below)
Landscape with red trees,
1906-07
Vlaminck's best landscapes were composed in primary colours in which freshness becomes almost tangible. He would often squeeze the paint directly from the tube on to the canvas, with scarcely precedented freedom from constraint.

ROUAULT (above)
The prostitute, 1906
Although he exhibited at the Fauve Salon of 1905, Rouault stood apart from the Fauves in important aspects of style (he did not use pure colour) and choice of subject matter. His harsh brushwork and bold use of line evoke the prostitute with expressive power, creating a symbol of the degradation of man.

ROUAULT (left)
The face of Christ, 1933
Rouault remained true to his artistic convictions: the bold contours and deep colours which marked his work in his Fauve period, featuring clowns and social outcasts, later served his mainly religious themes. And yet his vigour was not dependent on colour, and is unsoftened in his graphics.

Matisse: Le Luxe II

"With '*Le Luxe II*'", George Heard Hamilton has observed, "Matisse completed and closed the Fauve revolution." By the time the painting was finished, in 1908, Henri Matisse (1869-1954) was no longer young, but in the previous years he had refined, consolidated and then unleashed his feeling for the expressive possibilities of luminous colour, first fostered in Moreau's studio ten years earlier.

Unlike his fellow-Fauve Vlaminck, Matisse was a conscientious student of the art both of the past and of his contemporaries: "I have never shunned outside influences. I should consider that an act of cowardice, and bad faith towards myself. I believe that the struggles that an artist undergoes help him assert his personality." In the late 1890s he was painting landscapes very much in Impressionist terms, with, however, at one stage (sometimes called "proto-Fauve") greater audacity of colour contrast than the Impressionists had ever shown; in 1900, though he was then quite the reverse of rich, he bought Cézanne's *Three bathers* (not shown), and certain compositions on the same lines show Matisse thereafter grappling with problems of form as well as colour. A crucial lightening and kindling of colour seems then to have been sparked by a summer spent at St-Tropez with Signac.

Matisse painted "*Luxe, Calme et Volupté*" in 1904-05, applying the divisionist technique in almost doctrinaire fashion, producing a mosaic of short stabs of colour. The result is somewhat stilted and inert, but it is nevertheless the point of departure for "*Le Luxe II*" (a shortened version of the first title, which was a phrase from Baudelaire) and for much of Matisse's future career. It states above all the theme of the female nude, but also the artist's mature quest for "an art of balance, of purity and of serenity devoid of troubling or disturbing subject matter ... like a comforting influence, a mental balm – something like a good armchair in which one rests from physical fatigue". Nothing, perhaps, could seem further from that ideal than the Fauve explosion of colour that came in 1905 (see preceding page), but in the great canvas "*La Joie de Vivre*", nearly two and a half metres (8ft) wide, which he finished in the following year, that aim is almost completely achieved. The divisionist technique has yielded to clear contour, curvaceous line – though there is little depth; the scenery seems composed of stage flats. Perspective is abandoned, and the figures and their scale are arbitrary, attenuated or distorted as the rhythms of the design may require. Technically, the picture owes much to Gauguin, and much also surely to the sinuous linearism of Art Nouveau. Its theme is Arcadian – such a vision as has haunted European fantasy since Titian's *Bacchanals* (see p. 145), a terrestrial paradise that not only Signac and Derain but also Renoir, Gauguin and Cézanne had glimpsed.

Then "*Le Luxe*" *I* and *II* come as the climax of this development – the process of reduction and elimination of inessentials in the design, the distillation of Matisse's art to its characteristic flat colour and line. The theme is still *Bathers*: indeed the two major figures are adapted from two on the left edge of "*La Joie de Vivre*". In the study, "*Le Luxe I*", the brushwork is relatively loose, the colours broken, the contours tentative, and auras, or penumbras, around the figures, though diminished, are present here and there. In the final version, "*Le Luxe II*", the clarity of contour is final, the penumbras eliminated; the ragged edge of the cloud is now smooth. The line is comprehensive, incisive, incomparably economic. The colour is lucent.

Matisse did not share Vlaminck's urge to translate impression into instant expression. "I want to achieve that state of condensation of sensations which makes a picture ... a representation of my mind." The sentiment may suggest a close relationship between Matisse and the early Cubists, but the *Luxe* series and *The dance* of 1910 could be read almost as anti-Cubist manifestos. Although Matisse's painting subsequently went through a phase sometimes described as "constructivist" – a sharp disciplining of the lyrical curve of his line – his pure singing colour and his characteristic fluent arabesque line were to be reasserted in the 1920s and 1930s (see p. 432) and not least in the remarkable colour cut-papers he made in his 70s and 80s (see p. 476).

MATISSE (below)
"*Luxe, Calme et Volupté*", 1904-05
The title is a phrase from Baudelaire's *Invitation to the Voyage*: "There, all is order, beauty, luxuriance, calm and voluptuousness." Cézanne's *Bathers* theme is treated in Signac's style.

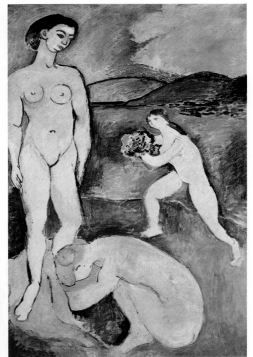

MATISSE (above)
"*La Joie de Vivre*", 1905-06
Here Matisse reached an expression unmistakably his own (greatly disappointing his mentor Signac). His soft, flat tints and strong curves exhale a serene bliss; some of the nudes retain from "*Luxe, Calme et Volupté*" their penumbras, on which they recline pneumatically.

MATISSE (right)
The dance, 1910
Matisse detached the group of dancers from "*La Joie de Vivre*", transforming the distant, relatively loose-knit circle into a tighter design, a fully independent picture. The fast tempo of a *farandole* performed at the famous Moulin de la Galette inspired him. The rhythmic lines of the figures are even bolder than those of "*Le Luxe II*", a lithe pattern in themselves – the rapid development of Matisse's flat colour and flowing line reaches culmination.

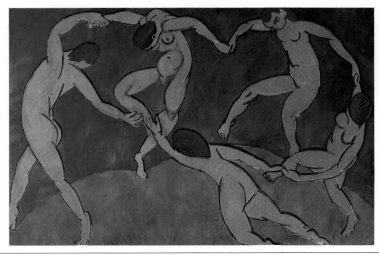

MATISSE (above)
"*Le Luxe I*", 1907
Viewing the full-scale oil-sketch for "*Luxe II*" the critic Barr felt that, after study, "the earlier picture ("*Luxe I*") grows on one despite its faults or perhaps because of them. The sense of experiment and struggle sets up a tension that holds the interest by comparison with the decorative grace of the second version."
The light is unnatural, but the colour more realistic than in Fauve paintings, the forms more modelled.

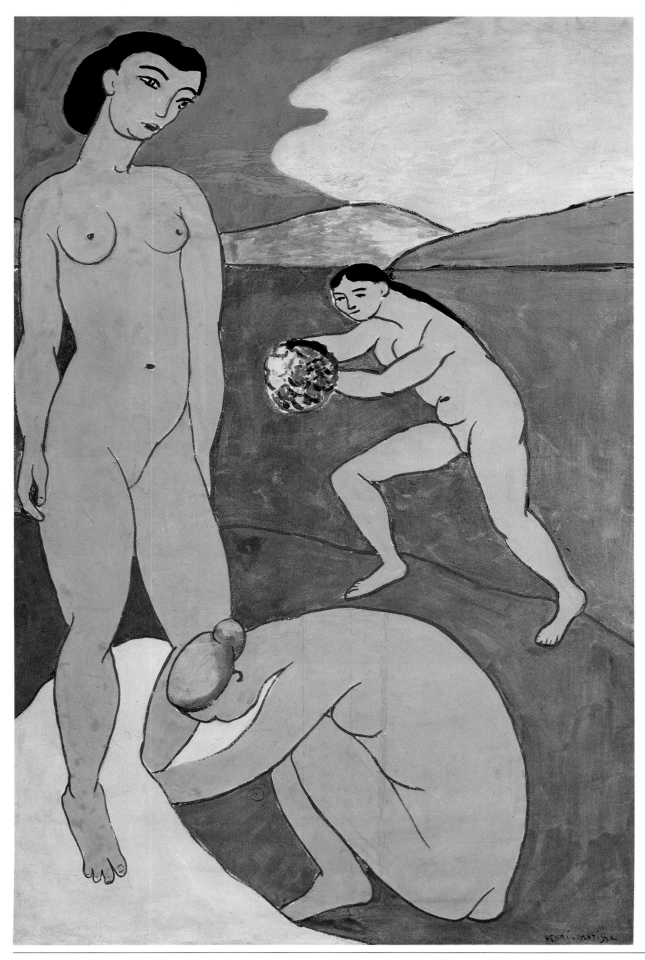

MATISSE (left)
"*Le Luxe II*", 1907-08
Matisse's teacher Moreau
is said to have remarked:
"Henri, you were born
to simplify painting."

Brancusi: The Kiss, 1910

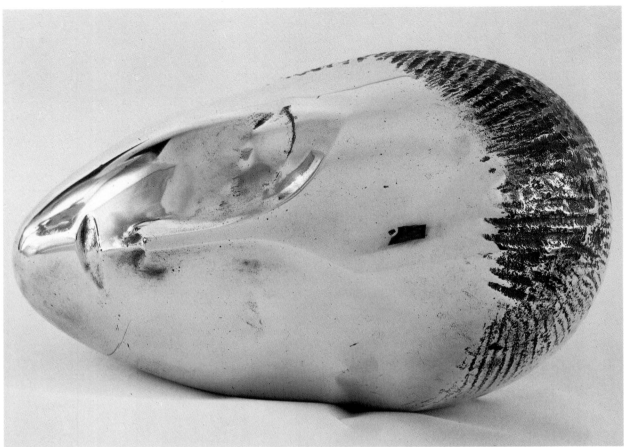

Born of prosperous peasant stock, Constantin Brancusi (1876-1957) trained in his native Romania first as a craftsman in wood and then in an academic school of fine art. In 1904 he made his way to Paris. Briefly (1906-07) he worked in Rodin's studio, but then, with the independence that was characteristic of his whole career, cut loose with a comment that has become proverbial: "No other trees can grow in the shadow of an oak-tree."

His early work was in fact strongly reminiscent of Rodin or of Medardo Rosso, but from 1907 to 1910 he evolved a revolutionary mode of sculpture. Its basis was "truth to materials", ideas advocated notably by the German sculptor Hildebrand, and stated by Brancusi in these terms: "We must try not to make materials speak our language. We must go with them to a point where others will understand their language." His guiding principle was the fusion of content with form and with the medium. He early abandoned modelling (except for preliminary studies) in favour of direct carving (most of Rodin's carving had been done by assistants), and his fastidiousness and feeling for his material never lessened throughout his career, though he experimented continually with the presentation of the same idea in different materials, usually polished marble or brass.

The years 1907-10 were the exact period of the Cubist breakthrough (see over). Brancusi, however, was only superficially affected by Cubist art; though *The kiss*, on which he was then working, is literally cubist in shape, it does not attempt the disintegration beloved of Cubist painters, but is a straightforward sim-

BRANCUSI (left)
Sleeping Muse, 1906
The head emerges from, or sinks back into, roughened marble, in Rodin's manner. It was one of Brancusi's first direct carvings, the portrait of a close friend.

BRANCUSI (below)
The table of silence, 1937
Like his *Endless column* (not shown) also at Tirgu Jiu, Brancus's stools and table repeat unvaryingly one simple unit or module. The forms unite the geometric and organic in a sublimation of them both.

BRANCUSI (above)
Bird in space, 1919
Brancusi was fascinated by the infinite: "All my life I have sought the essence of flight. Don't look for mysteries. I give you pure joy."

plification. In its chunkiness it is characteristic of one persistent aspect of Brancusi's work – a delight in the strong, rough-hewn forms that he knew from Romanian folk art, and also found again in African tribal sculpture, which clearly had a lasting influence on his vision. Such hard angular forms he often used for the bases of his sculptures, in rugged contrast to the sculptures themselves (bases and sculptures were in fact integral).

The contrary, and best-known, element of Brancusi's style is the smooth, exquisite finish, and the reduction of superficial detail until his model virtually vanishes in the primal form of the whole. "Simplicity is not an end in art", he once said, "but one arrives at simplicity in spite of oneself, in approaching the real sense of things. Simplicity is complexity itself, and one has to be nourished by its essence in order to understand its value." This creed is vividly illustrated by his progressive treatment of one form, evolving from naturalistic studies of a sleeping head: an early stage is represented by the *Sleeping Muse* in Bucharest of 1906; by 1909, it is purified into the polished and immaculate egg-form on which the human features are little more than adumbrated. Later, it could become pure egg. This primal ovoid form is at once very concrete and very ideal; encapsulating generation and birth, it is the blank on which human features will take shape. "What is real", wrote Brancusi, "is not the external form but the essence of things." He succeeded in fact in reconciling the tangible external with the ideal essential as no sculptor had done before him.

By 1910, the grammar and syntax of Brancusi's art was established, and so, too, the recurrent motifs on which he was to produce ever more refined variations during his long life. Generally withdrawn from the turmoil of artists' cliques and of public life, he worked aloof in Paris in a high white studio (which he bequeathed to the state, and which is preserved in Paris at the Centre Pompidou). Early accepted by fellow-artists, Brancusi took some time to be more generally accepted. In 1926, a famous turning-point in the popular history of modern art was provided by the legal victory won over the American customs, who claimed his bronze *Bird in space* was liable for duty as raw metal. But his fame was international before he died – it was already claimed that he was the greatest sculptor of the twentieth century, an assessment which Brancusi himself did not challenge.

In 1934 Brancusi was commissioned by his native country to work on a monumental scale: at the small town of Tirgu Jiu was set up the longest version (more than 29 metres (96ft) high) of his *Endless column*, a pole repeating the same motif over and over again, and theoretically extensible to infinity; also a great gateway incorporating once again the theme of *The kiss*, and a vast circular stone table, ringed with stone seats each composed of two hemispheres, awaiting some conference of giants who will never come – *The table of silence*.

It was Brancusi's achievement to abstract into three-dimensional stone or metal the essence of physical life, as if one could postulate from his birds or his fish all the fishes and birds that have ever been.

BRANCUSI
The kiss, 1910
Through the many versions of *The kiss* (perhaps most famous was the first, on the grave of a young suicide in Montparnasse cemetery, Paris, 1910), Brancusi stayed with his original image and material, rough stone. His form expresses both the block and what a kiss is in essence. His influence was crucial to 20th-century sculpture, from Modigliani to Moore.

Cubism 1: Picasso and Braque

The achievement of Pablo Picasso (1881-1973) reveals an astonishing stamina and inventiveness continuous through almost three quarters of the twentieth century. His fame has echoed beyond the confines of art and art history, placing him in a select category of genius – one of the names known throughout Western civilization, with Shakespeare, Michelangelo, Rembrandt, Napoleon.

Son of a Spanish art teacher, Picasso trained in Barcelona, and established a precocious reputation in Paris between 1900 and 1906. In his prolific "Blue" and "Rose" periods (1901-04; 1904-06) he drew on the example of Toulouse-Lautrec, Art Nouveau and Symbolism to create strange, haunting, melancholic images of lonely figures from the ranks of the deprived or outcast. In 1906-07, however, he performed the first, and most radically violent, of those changes of course that characterize his career, in "*Les Demoiselles d'Avignon*". Executed in 1907, it was not yet a fully resolved Cubist composition. Like Fauve painting (though Picasso never had a Fauve period), it rejects naturalistic colour, Renaissance perspective, consistent lighting – but it also rejects the sensuous pleasure of the

Fauves, and their flat, bright colours. There is certainly depth, the forms jut out from the picture; here and there it seems to incorporate views of the subject seen from different angles. The heads are treated in three different ways: the two central ones are closely related to two primitive Iberian sculptures that Picasso owned, while the head on the left (reworked) reflects the style of Ivory Coast tribal masks, and the two on the right, violently rehandled in the last phase of painting, relate to sculptures from the Congo. The realization of the power of African and Oceanic art had struck both Derain and Matisse in 1905-06; it was not, however, the expressive, emotional potential of "primitive" styles that was decisive for Picasso, so much as their freedom from illusionism, their lack of inhibition in amalgamating different views and aspects into one image.

Georges Braque (1882-1963) had been introduced to Picasso by the controversial champion of the avantgarde, the flamboyant poet and critic Guillaume Apollinaire. Like everyone else, Braque was initially bewildered by the *Demoiselles*, but he felt compelled to come to terms with it. In his "*Grand Nu*" (Great Nude) of the following year, 1908, the

BRAQUE (above)
Houses at L'Estaque, 1908
In 1908 Braque discovered both Cézanne and Picasso. The volumes and the space of a hilly countryside are evoked in firmly modelled, sombre, elemental blocks in a jigsaw of jutting forms composing an architecture.

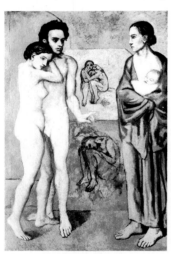

PICASSO (left)
Life, 1903
The group is suffused with a vague timeless sadness, typical of Picasso in his Blue period. In this he was essentially Symbolist, like Puvis de Chavannes (see p. 370). The forms are classical: *Demoiselles* was a kind of auto-iconoclasm.

BRAQUE (below)
"*Grand Nu*" (Great nude), 1907-08
Braque's monumental nude is a variant on one of the *Demoiselles* figures, no less bold in distortion, more severely sculptural. Later Braque said that African masks had opened horizons for him, helped him towards fresh, instinctive creation.

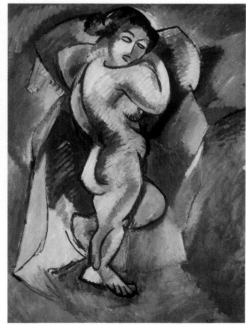

PICASSO (above)
"*Les Demoiselles d'Avignon*", 1907
Avignon is a reference not to the French town but to a famous street in the red-light district of Barcelona. The painting is more a record of work in progress, of an artist in the process of changing his mind, than a resolved composition: the forms are dislocated, inconsistent in style, in fact unfinished. It is still a disturbing picture, and in 1907 more so – overthrowing perspective, single viewpoint, integral form, local colour, decorative colour; it was also a travesty of the great theme of nude *Bathers*, running from Cézanne to Matisse.

"primitive" distortion is very strong; both object and space are arbitrarily modelled. But more evident in the Braque is the Cubists' debt to Cézanne: especially momentous was his technique of modelling in terms of interlocking and overlapping planes, his subjects being sometimes not only arbitrarily lit, but seen from slightly different angles: his patchwork of blocks of translucent colour, deployed across the whole surface, produced an effect of depth and volume without destroying the flatness, the integrity of the painting.

Between 1908 and 1910, often working closely together, Braque and Picasso perfected a joint style. Their harmony at this time was such that the question of primacy, who discovered what first, is controversial, and perhaps otiose. It was Braque's *Landscapes* of L'Estaque that in 1908 provoked a critic to speak of "cubes"; the movement was subsequently called "Cubism".

Their early Cubist work, up to 1912, fell into two phases, subsequently known as "analytical" and "synthetic". In the analytic phase, 1909-10, the more solid massing of forms of their first Cubist paintings gave way to a technique in which the contours of form were dissolved, so that one form opened and fused with another, and with the void of space surrounding it. The elements of form were taken apart and reorganized, not to sum up the essence of the subject comprehensively but rather to re-create it as a picture. The notion of a painting as a *peinture-objet*, an object in its own right independent of its subject matter, was abroad by 1910. Yet Cubism was claimed as a realist art, and its connection with its subject matter was never wholly lost, though it became tenuous. Picasso's "portrait" of Vollard of 1909-10 (see p. 374) is informed by a strong personal presence, and was greeted, it is said, with warm recognition by Vollard's dog; in that of Kahnweiler, however, late 1910, the sitter's individuality is scarcely hinted at. In Braque's and Picasso's still lifes of 1910-11 and early 1912 (known as their "hermetic" or esoteric period, when they reached their furthest point of abstraction) the subject matter appears to be incidental to the perfectly articulated structure of fragmented planes.

"Synthetic" Cubism was in part a reaction against the abstract tendency of the analytical phase. In 1911 both artists had included in their compositions stencilled capital letters, fragments of words (often puns, sometimes obscene – Picasso's humour could never remain repressed for long). When early in 1912 Picasso created his *Still life with chair-caning*, using extraneous objects stuck to the picture surface – the first collage-painting – he introduced reality literally and physically, reaffirming in the midst of abstraction ties with everyday ephemera. Picasso's collages were a development of Braque's experiments in the same year with *papiers collés*, pasted cut-papers which acted both as formal elements of the composition and representationally, yet at the same remained obdurately just objects. Once the synthetic principle – building up, putting together, rather than breaking down, rearranging – had been formulated, the conceptual nature of both artists' work became ever more marked.

In autumn 1912 Picasso moved to Montparnasse, where he was no longer a neighbour of Braque. Braque's subsequent career, interrupted by active service in World War I, was more one of refinement than of innovation (see pp. 426, 476), while Picasso, a neutral Spaniard, continued throughout the War and after to widen his scope (see pp. 426, 450, 476).

PICASSO (below)
Daniel Henry Kahnweiler, 1910
Kahnweiler was Braque's and Picasso's dealer, one of the Cubists' first patrons. He sat for his portrait more than 20 times, but it remains ghostly, veiled by the fragmented planes of the pictorial structure.

Expression of personality is not the artist's goal, it is rather that complex reconstruction of forms symptomatic of analytical Cubism in its last stage. Yet Picasso implanted in it recognizable details, the hands, button and watch-chain of the waistcoat, as if to help out the spectator.

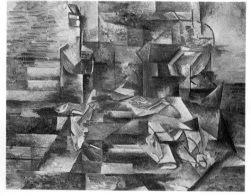

BRAQUE (above)
Still life with fish, c.1909-10
Even in the most austere phase of analytical Cubism Braque never quite lost his elegance and lustrous colour. In his *Kahnweiler* (left) Picasso tantalized the eye

with the play of plane and counter-plane in what must be a solid face; Braque's slightly earlier picture vibrates in scintillating blocks across the surface. It is more spacious, and the process of abstraction is less opaque, less riddling.

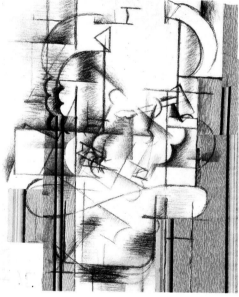

BRAQUE (above)
The man with a pipe, 1912
Braque and Picasso had developed Cubist painting together, almost neck and neck, using each other's inventions to extend the scope of their art with astounding rapidity. The Cubist use of *papier collé* is attributed to Braque, and *The man with a pipe* is a very early example. The extension of the idea to an art all of collage was an invention of Picasso. Braque was a craftsman's son, quick to fasten on to new devices which Picasso used more imaginatively: so, Braque taught Picasso to use a comb on wet brown paint to produce the effect of wood-graining; Picasso promptly exploited it to represent a woman's hair.

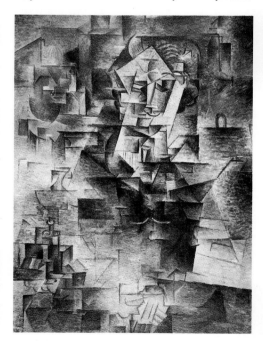

PICASSO (right)
Still life with chair-caning, 1911-12
A scrap of mechanically printed oilcloth with a pattern of caning is stuck to the picture, mocking the reign of illusionism over centuries of Western art. Collage almost embodies the principle of synthetic Cubism – the construction

of a picture with materials that are, once arranged, the subject of the painting. It was in 1911 that Braque had first used lettering in his pictures to this end, and Picasso soon joined in. The rope that replaces the conventional gold frame is a further touch, asserting literally self-containment – it is, it does not represent.

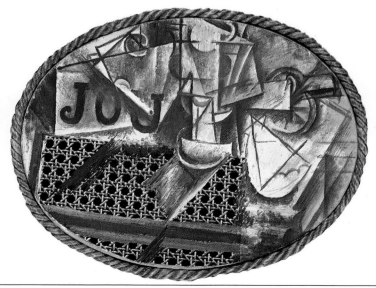

Cubism 2, and Orphism

Picasso and Braque (see preceding page) stood aloof from the usual means of making their work known – the various annual exhibitions in Paris – but their ideas and practice were on display at the gallery of their exclusive dealer, Kahnweiler, and soon attracted attention. Cubist works by enthusiastic followers began to appear just as Picasso and Braque were moving from analytical to synthetic Cubism – first at the Salon d'Automne in 1910, then in the Cubists' own room at the Salon des Indépendants in 1911, whence they were invited to Brussels in the same year. Events were known in Germany and Italy almost as soon as they unfolded in Paris. Picasso and Braque were included by Roger Fry in his second Post-Impressionist exhibition in London in 1912, inducing rage and fury; the epoch-making Armory Show exhibited Cubism to a startled New York in 1913. In 1912 the painters Gleizes and Metzinger published *Cubism*, which ran through 15 editions before the end of the year; Apollinaire in 1913 produced *The Cubist Painters*; A. J. Eddy's *Cubism and Post-Impressionism* appeared in America in 1914. Picasso had made Cubist sculpture as early as 1909, and others soon followed (see p. 426).

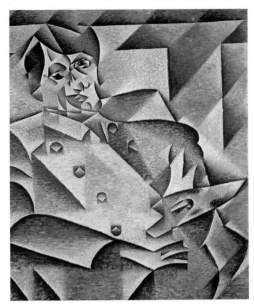

GRIS (below)
Homage to Picasso, 1911-12
When he applied analytical Cubism to its perpetrator, Gris achieved a sober, cool architecture distinct from Picasso's (whose neighbour he had been since 1907).

Juan Gris (1887-1927) had observed his fellow-Spaniard Picasso's early Cubist ventures very closely, and had also made his own independent study of Cézanne. Having begun to paint seriously only in 1911, he made a sensational début at the Salon des Indépendants of 1912 with *Homage to Picasso* – a methodical rearrangement of Picasso's person executed with great assurance. Developing with remarkable speed, by the end of the year he had established a distinctive style: while Braque and Picasso had seemed to move around their subject, to take views from different angles, and then as it were to reshuffle them into pictorial coherence, Gris set each facet of his model – each seen from a single, relatively consistent viewpoint – in a compartmented framework, rather like the leading of a stained-glass window. He eagerly adopted the new techniques of synthetic Cubism, collage and *papier collé*, but unlike Picasso and Braque did not tone down his colour. He soon increasingly abstracted form to fit his compositional needs, a method he described succinctly: "I begin by organizing my picture: then I define the object." "It is not picture X which manages to correspond with my subject

LEGER (right)
Nudes in the forest, 1909-10
This is an ambitious canvas on a monumental scale, and the choice of subject – three woodcutters at work like machines – introduced a Courbet-like Realism to the Cubist repertoire, reflecting Léger's belief in "the people". Further, in astonishing contrast to the static compositions of Picasso and Braque, the figures, the hills and the trees seem to thrum with a vigorous sense of action. Muted greys and greens reflect a dappled forest.

GRIS (above)
The wash-stand, 1912
Gris' synthetic Cubist still lifes were constructed with draughtsman-like skill and intellectual precision; he disposed his forms in mathematical relationships set up by a dissecting grid. Under the curtain, a mirror represents the mirror: it is a mirror, and reflects as one – rather a witty collage.

GRIS (right)
Landscape at Ceret, 1913
Gris often worked beside Picasso, Braque and Derain in southern France. The landscapes of Braque were solidly modelled, subdued in colour; Gris responded with rich, high-keyed colour harmonies, accentuating the flatness as if the picture were made of loose parts from a broken kaleidoscope.

LEGER (above)
Contrasting forms, 1913
Roughly painted highlights on Léger's characteristic cylinders flatten the plane, disrupted by split solids interpenetrating; angular shapes counterpoint round ones. The pyramidal organization assists the sense of monumentality; the movement may reflect the impact of the Futurists.

but subject X which manages to correspond to my picture." Deeply interested in the geometry of proportions and the mathematics of formal relationships, he was a leading contributor to the first exhibition of the Section d'Or (Golden Section) in 1912.

The Section d'Or artists were committed to Cubism but aware of its limitations: they wanted to reinstate colour and movement, and to expand its range of subject matter. They arrived at a resolved pictorial structure not by a reduction of the objects represented but by the application of the laws of musical harmony, of ratio and proportion. Amongst their members were the future exponents of Dada, Francis Picabia and Marcel Duchamp, and Fernand Léger. Fernand Léger (1881-1955) remained a Cubist throughout his career, but from the outset his aims went beyond those of Picasso and Braque: he wanted his work to reflect, to appeal to and to enhance the lives of ordinary people, so his subject matter was more important to him, and more emotive. His training as an architectural draughtsman gave his designs a clarity and precision of outline which emerged as an essential characteristic of his style, consolidated during and after World

War I (see p. 426). His earliest exhibition work in the Cubist idiom was *Nudes in the forest* of 1909-10: the forms are chunky, contained by their outlines and not opening into one another, and there is more than a hint of traditional perspective; in marked contrast to Braque and Picasso, there is a strong sense of movement, almost of clash and tumult. Already the form that obsessed Léger all his life, the cylinder (which earned him the title "tubist"), is dominant. He was then influenced, in the Section d'Or, to experiment with pure or nearly pure abstraction, notably in his series *Contrasting Forms*, 1913-14.

Robert Delaunay (1885-1941) moved quickly towards a completely abstract art, and one primarily concerned with colour. His *Eiffel Tower* series of 1910 demonstrates his grasp of Cubist fragmentation but also his feeling for the rhythms and contrasts of colour – his prime concern during the most important part of his career, the few years before World War I. His initiative was christened "Orphism" by Apollinaire, who found in it "pure" painting, a close analogy to music. By 1912 Delaunay was experimenting with colour wheels on circular canvases, as in his series of *Circular Forms* –

the first completely non-figurative paintings by a French artist. Colours were to act on each other reciprocally "in simultaneous contrasts", creating form and movement in space: "Colour is form and subject; it is the sole theme that develops, transforms itself apart from all analysis, psychological or otherwise. Colour is a function of itself." Delaunay's wife Sonia Terk and Frank Kupka (1871-1957) also turned very early to abstraction, Kupka applying colour theory and musical harmonies to his own "mystical" Orphism.

Although by 1914 Delaunay's painting had almost nothing in common with Cubism, Cubism proved a liberation for him, and for numbers of major artists who rapidly worked through their own understanding of it and advanced beyond it. Having observed Cubism in Paris, by 1914 Mondrian (see p. 436), back in Holland, was developing his own austere abstraction, and Orphism strongly attracted notably some artists of Der Blaue Reiter (see p. 384). The Futurists soon discovered (see over) that Cubism could serve their purposes. Though for some years to come Cubism remained controversial with the general public, it was already a fact of life.

DELAUNAY (right)
The Eiffel Tower, 1910
Delaunay sought a novel expression – of sensation, of the movement of light and the rhythm of structure, not as fixed at one moment or seen from one aspect, but as sensed "universally". The dynamism of the Tower is conveyed in crumbling, buckling, lurching forms.

DELAUNAY (below)
A window, 1912
The starting-point was an open window in sunlight through which reflections of the city (Delaunay was fascinated by the city) are seen. Thence he developed a series of virtually non-figurative paintings, with almost transparent planes of light in prismatic colours making crystalline patterns.

DELAUNAY (right)
Circular forms: sun and moon, 1912-13
Delaunay had created his first pure non-figurative painting by 1912, having arrived by a path utterly different from Kandinsky's (see p. 602). The Russian had insisted that abstract art must be founded on a "proper contact with the human soul"; Delaunay was more intellectual than intuitive, and demanded a self-sufficient abstraction: "So long as art does not free itself from the object, it remains descriptive ... degrading itself by using defective means." There was nothing mystical in Delaunay's art, which was an "absolute" investigation of the movement of colour in harmony and dissonance.

KUPKA (left)
The disks of Newton: study for a fugue in two colours, 1911-12
The interaction of colours was the theme of several series by Kupka. Here he sought to demonstrate that rotating wheels of colour, static disks energized by contrasting colours, create an effect of radiant white light. His experiments were intended to create "something between sight and hearing". Like Delaunay's, Kupka's interest in energy is a parallel to Futurism.

Futurism

The emergence of Futurism, the most aggressive, the most politically conscious and (Dada apart) the noisiest of the important early movements of twentieth-century art, was signalled by the publication in February 1909 of Marinetti's call to action, *The Founding and Manifesto of Futurism*. Filippo Tommaso Marinetti (1876-1944), poet and playwright, was aligned politically with Gabriele d'Annunzio and later (until 1919) with Mussolini in the attempt to consolidate the recently federated component states of Italy into a modern, glamorous, vigorously nationalistic unity. He was the instigator, the theoretician and the voice of the "art of the future", rejecting all art of the past ("*le Passéisme*") for a new art that would celebrate technology and scientific advance, psychoanalysis and all things modern. A more or less simultaneous supporting manifesto was signed by five artists, Umberto Boccioni (1882-1916), Carlo Carrà (1881-1966), Luigi Russolo (1885-1947), Giacomo Balla (1871-1958) and Gino Severini (1883-1966). Their underlying philosophy was greatly influenced by Henri Bergson's *Creative Evolution*, in which the importance of continual forward-looking development,

conditioned by universal dynamism and flux, was stressed. Successive manifestos claimed that dynamism and flux, in colour and in form, should power the new art.

Italian painting at the turn of the century had been generally conservative; there was no avantgarde, and little awareness of avantgarde developments in Paris. Two painters, Giovanni Boldini and Antonio Mancini, both had international reputations – Boldini as an almost fatuously skilful master of society portraiture, in what Sickert called his "wriggle-and-chiffon" style; Mancini for a blurred, atmospheric version of Impressionism – but the only truly major talent to emerge in Italy had been the sculptor Medardo Rosso (see p. 355). Rosso's mirroring of the fleeting moment of time and of form coming into being had some relevance for the Futurists. It was, however, an integral part of the Futurists' purpose to remedy what they felt to be a national shortcoming, and to create an art worthy of Italy – of the new Italy, not that of its artistic past; their movement was unusual in that its artistic practice was preceded by theoretical exposition – those manifestos, verbose, declamatory, arrogant and provocative,

which set the pattern for so many later variants in twentieth-century art. Marinetti's first famous broadside, however, had real panache: "We shall sing the love of danger, the habit of energy, boldness . . . a new beauty – the beauty of speed . . . a roaring automobile, which seems to run like a machine gun, is more beautiful than '*The Victory of Samothrace*'."

The problem of matching the programme with works of art worthy of it was not so easy. Futurist works were first exhibited in Milan in 1911, but it was recognized that Paris, the international focal point, must be attacked, if the movement were to be established. The first Futurist exhibition was staged in Paris in February 1912. Accompanied by a vigorous public relations campaign, it attracted great attention, but also considerable derision, although Apollinaire reviewed the exhibition with respect. The show then circulated in London, Berlin, Brussels, Amsterdam, Munich and elsewhere: everywhere it aroused interest spiced with alarm, but Futurism certainly became known, its works were sold, and its influence was felt wherever it was seen.

Futurist techniques owed much initially to Neo-Impressionist practice – breaking down

BALLA (right)
The street lamp, 1909
Balla's chief interests remained limited to the representation of light and movement, provoking rebuke from colleagues who felt that Futurism should champion radical, universal issues in a changing world.

BOCCIONI (below)
The city rises, 1910-11
The tempestuously surging waves, 3m (10ft) across, had sensational impact when launched in exhibition. The implicit radical politics were also likely to shock. Boccioni, like Balla, took up Divisionism at the turn of the century, informed by French example, pursuing the characteristic Divisionist effects of luminosity and scintillation. But these paintings were static, and Boccioni's Futurist ideals demanded movement. The Divisionist dots now became blurred with high speed.

BOCCIONI (below)
Farewells, 1911
The emotions of parting are Boccioni's theme: this is the centre of his triptych

States of mind, in which he hoped to force "colours and form to express themselves", that is, the energy latent within them. Cubist

devices appear amid "force lines", in an abstraction of a steam locomotive leaving. Delaunay (see preceding page) was a main influence.

BALLA (right)
Dynamism of a dog on a leash, 1912
The comic quality of the little dog survives the seriousness of the intent, the quasi-scientific study of motion, captured with Balla's usual delicacy. His superimposition of successive movements owed much to chrono-photography – studies by Muybridge (see p. 375) and others of the running horse or the moving human body, in "stills" taken in quick succession. Duchamp was later to apply the same principle in his *Nude descending a staircase* (see p. 416), though he claimed to have arrived at that image before he knew Futurism.

the colours into small fragmentary patches. Divisionism seemed the best means of reproducing the effect of light kindling and moving in colour, of form dissolving into flux, into speed. The treatment was applied to urban and political subject matter: one of the earliest fully Futurist paintings was Balla's dazzling *Street lamp*, 1909; here, however, movement and direction are indicated and defined by lines, "lines of force". The first Futurist attempts to convey the impression of velocity were sometimes somewhat naive – the indication, for example, of movement in a limb by showing it in different positions. The best-known example is Balla's delightful *Dynamism of a dog on a leash*, 1912; the same device was put to more serious, sharply dramatic use in Carrà's *Funeral of the anarchist Galli*, 1910-11.

Most satisfying, in terms of formal resolution, was the Futurist work produced by Boccioni. His huge *The city rises* of 1910-11 is impressive, but the violence of the divisionistic foreground, in tumult, does not marry happily with the naturalistic surge of the new city behind it; Boccioni in fact found his best form only when, in Paris in 1912, he carefully studied Cubist techniques. That these were

known to some of the group earlier is clear from such paintings as Carrà's *Funeral*, and Severini had been living in Paris since 1906, returning to Milan in 1911. It was Boccioni, however, who grasped how aptly the Cubist technique of interpenetrating planes, of one form opening into and fusing into another, could be applied to the very different aims of Futurist movement, so as to create an effect of simultaneity. Yet surely the most original of Boccioni's subsequent achievements came in the form of sculpture, in which he claimed to have realized "not pure form, but *pure plastic rhythm*: not the construction of the body, but the construction of the *action* of the body". He was indeed so successful in his aim that his striding *Unique forms in continuity* was compared favourably by later critics with the Hellenistic *"Victory of Samothrace"* (see 250) explicitly derided by Marinetti.

Boccioni died as a result of an accident in 1916. The vital spark of Futurism did not survive World War I, although adherents kept its name alive until about 1930, working in stylized, diluted and mannered versions of its original form. Its impact, however, had been considerable, not least on Dada.

BOCCIONI (above)
Unique forms of continuity in space, 1913
The complex forms of the bronze figure arose from Boccioni's investigation into the phenomenology of moving muscles. Hence his image of strength and speed, a "force form, the equivalent of the expansive power of the body".

BOCCIONI (left)
Development of a bottle in space, 1912-13
Boccioni was the first to translate successfully into three dimensions the Futurist faith in dynamic form, analysing the object in the Cubist manner. The bottle's roundness seems to expand around it while the neck screws upwards.

CARRA (above)
The funeral of the anarchist Galli, 1910-11
The desired effect, shock, was achieved by depicting the subject, the riot which broke out at the funeral, in violent, glaring colours and savage, stabbing forms.

SEVERINI (left)
Pam-Pam at the Monico, 1910-12
Severini's *Pam-Pam* was a hit at the 1912 Futurist exhibition in Paris – the gaiety of a dancing crowd caught by Futurist means.

RUSSOLO (above)
The revolt, 1911-12
Russolo himself saw this work as the "collision of two forces, the force of the revolutionary element made up of enthusiasm and Red lyricism against the force of inertia and reactionary resistance". Russolo was a keen political activist, the most literal exponent of Futurist thought, fond of grandiose, often absurd gestures expressed in bold colour and brave new form.

British Art: The Vortex

The standing of the British Royal Academy had been seriously undermined in the last two decades of the nineteenth century. The imagination of its members had ossified, their views were reactionary; worse, the standards of instruction in its school had sunk abysmally. More and more young students had found that Paris offered the only worthwhile training, but then found little recognition of their work in England. Although alternative schools and splinter groups of artists increased, generally English taste proved stubbornly slow to appreciate the discoveries even of the Impressionists, first shown in London in the 1880s.

The most important figures associated with the New English Art Club, founded in 1886 "with a view to protesting against the narrowness of the Royal Academy", were Walter Richard Sickert (1860-1942) and Philip Wilson Steer (1860-1942). Steer had studied in Paris in 1882-84; by 1889, his work was reflecting the high key of colour, raised horizon and broken handling of the Impressionists, and it even suggested at times knowledge of Seurat. For a brief spell, Steer snatched down on to a canvas vivid and original lyrics of sparkling light and vitality, though later he reverted to competence. Sickert was more consistent in quality, and seriously exploratory, throughout his long career. His friendships first with Whistler, then with Degas, established his standards; he kept to a low key of colour, a muted tonal subtlety, and in particular his reliance on drawing and delight in unorthodox "snapshot" compositions reflected his lifelong admiration for Degas. Sickert spent much time abroad, and even showed in Paris with modest success. His theatrical subjects recall again Degas, but also the Intimistes, especially Vuillard; though he never attempted flat Nabi patterning, and veered to the sensational or anecdotal, he was at his best Vuillard's peer. His "Intimiste" masterpiece is *Ennui*, of which he painted several versions from about 1913. He remained always the most professional and committed English painter of his generation, uneven in quality but inventive until the end. Even he, however, was initially unable to stomach the shock of the two Post-Impressionist exhibitions staged by the critic Roger Fry (1866-1934) in 1910 and 1912.

The Camden Town Group, formed round Sickert in 1911, included able painters of contrasting tendencies – those close in style to Sickert, such as Spencer Gore (1878-1914; not shown) and Harold Gilman (1876-1919); but also Robert Bevan (1865-1925, not shown), who had worked in Pont-Aven and applied flat colour and strong outline to scenes of horse fairs and urban streets; and many seeds of dissension, not least the irascible Wyndham Lewis. By 1911 Augustus John (1878-1961), destined to be a brilliant, erratic portrait painter, had already done his most original work – a kind of insular Fauve revolution, a series of broadly and boldly brushed little paintings, of an intensity he never recaptured. His sister Gwen John (1876-1939), refusing all group or doctrinal affiliations, isolated, finally a recluse, was the greater painter. Her work was muted, almost conventional in technique, but her variations on her chosen theme, the solitary girl, reveal an individual talent.

The Vorticists made their impact partly in paint and stone, partly in noise, argument and theorizing. The group centred round the turbulent figure of Wyndham Lewis (1884-1956), painter, novelist, myth-maker, aggressive controversialist. He set up the Rebel Art Centre in 1913, with its periodical *Blast* (a self-styled *Review of the Great British Vortex*, whence the

STEER (left)
Children paddling, Walberswick, 1894
Steer's Impressionism became especially lyrical when his introverted sensibility was touched by the fragile play of children.

GILMAN (right)
Mrs Mounter, 1917
Cézanne and van Gogh have influenced, respectively, the broad modelling of facial planes and Gilman's bright, expressive, molten colour.

AUGUSTUS JOHN (below)
David and Dorelia in Normandy, c. 1907
A springtime freshness, a handling perhaps recalling Goya, lend a gypsy air to an English family portrait.

SICKERT (left)
Ennui, c. 1913
Sickert has mastered his early problem in grasping solid form, arriving at a controlled composition in a tightly organized picture. Virginia Woolf admired the melancholy aura of this portrait of a marriage grown irremediably stale.

GWEN JOHN (right)
Girl with bare shoulders, c. 1910
Gwen John's understated style had its origin in her study of Whistler's tonal values. From 1903 she lived permanently in France; the female portraits she painted then reveal subtle and acute strength and sympathy.

poet Ezra Pound gave the movement its name). Lewis' own painting at this point was "Cubo-Futurist": he had been much influenced by the Italian Futurist Marinetti, who visited London in 1914. Although no one in England yet grasped the principles of Cubism, this misunderstanding does not disallow the individual and valid character of the Vorticist style, in its response to an urban and mechanistic environment. From the "vortex" of twentieth-century life Lewis aimed to precipitate what was in effect a classical structure, precise, cool and metallic, yet charged with emotional force. His most impressive colleagues were William Roberts (1895-1980), who has always challenged Lewis' primacy in Vorticism, and who in the late 1970s was still producing paintings of formidable logic in the same style though figurative; David Bomberg (1890-1957); and Christopher Richard Wynne Nevinson (1889-1946; not shown), applying a mechanistic, sometimes Légeresque vision to the experience of war. Lewis himself after World War I became increasingly figurative, and completed some remarkable portraits.

Two sculptors were amongst the most original talents of Vorticism, both foreign-born. Jacob Epstein (1880-1959), born in America, had met Picasso, Brancusi and Modigliani in Paris; he was a discerning collector of African and Polynesian sculpture, and also knew the Mexican and Buddhist traditions. His early work is a remarkably eclectic fusion of elements from such sources, electrified by a passionate Expressionist urge that must owe much to his central European and Jewish ancestry. His public commissions in London and in Paris (the tomb of Oscar Wilde) provoked violent controversy. His most comprehensively ambitious work, however, was *The rock-drill*, a haunting vision of mechanistic man. Realistic expressive modelling was nevertheless Epstein's essential talent, and he became an outstanding portraitist (see p. 446).

Henri Gaudier-Brzeska (1891-1915) made brilliant, reductive line-drawings as economical as those of Matisse, and his best sculpture shows a fierce vitality galvanizing simplicity of form and a feeling for his materials. He fell at the front, fighting in the French Army; the horrors of the first global war would mute the vitality of the avantgarde in British art for about a decade after the peace of 1919.

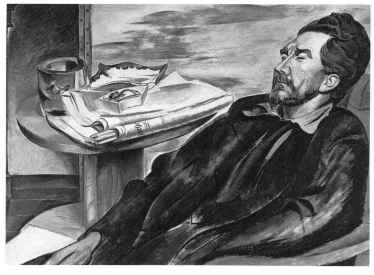

LEWIS (left)
Ezra Pound, 1939
Though Lewis was loudest in crying Vorticism, those few Vorticist paintings by him that have survived are less striking than those by Roberts. His portraits of the literary avantgarde, painted much later, are his best work as an artist: he has revealingly evoked the intellectual restlessness of Pound; his portrait of T. S. Eliot is equally good.

BOMBERG (below)
In the hold, 1913-14
The huge geometric canvas reveals a desire for order, though the order contains strong movement. Bomberg, the most programmatic of the Vorticists, rejected "everything in painting that is not pure form".

ROBERTS (below)
The diners, 1919
The Cubists' influence on Roberts' early work persisted in the continuing figurative bias of his art. It retains a sense of order and harmony, but seems barely capable of confining the energy of his subjects.

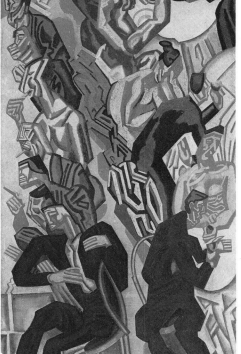

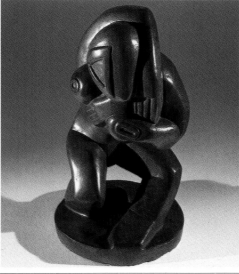

GAUDIER-BRZESKA (left)
Red stone dancer, 1913
This is an early example of a distinctively 20th-century sculpture: forms clearly inspired by tribal African art are combined in a classical harmony. But their contortions have also mesmeric dynamism.

EPSTEIN (above)
The rock-drill, 1913-14
Epstein later removed the support, a quarry drill, to leave only the cast bronze bust (the photograph dates from 1914). The impact is considerable: the machine has become a modern metaphor for sex, terror, power.

Russian Art 1: Symbolism to Suprematism

Though the frontiers of her vast territories border on both East and West, Russia had for some centuries turned to Europe for cultural inspiration. Her greatest national achievement in art had been the icon (rooted in Byzantine tradition, see p. 62), but even the finest examples remained begrimed with the smoke of candles and incense until the superb clarity of their line and colour was revealed when many were cleaned for the Romanov exhibition in Moscow in 1913. During the nineteenth century, however, distinctly Russian variations on Western styles had been evolving in the main cultural centres – the influence came mainly from France, from Realism, then from Symbolism and Art Nouveau.

One of the most important of the several groups of artists that formed in pre-Revolutionary Russia was The World of Art group in St Petersburg (Leningrad), which drew also on the strong indigenous tradition of peasant folk art: it included Alexandre Benois (1870-1960), Leon Bakst (1866-1924) and Mikhail Vrubel (1856-1910); Vrubel developed a personal, very Russian, anxiety-ridden Symbolism. The group also included Sergei Diaghilev (1872-1929), the great impresario

of ballet, and an innovator of genius in exhibition techniques: he first brought Russian art to western Europe, to Paris at the Salon d'Automne in 1906. This success encouraged further ventures, reaching a climax in the famous revelation of the Ballets Russes to Paris in 1909. Until 1914 successive seasons dazzled Paris with Russian culture – the music of Rimsky-Korsakov and Stravinsky, the dancing of Pavlova and Nijinsky, the choreography of Fokine, the décor of Benois and Bakst.

The explorations of the leading French Post-Impressionists were revealed in Moscow rather than in St Petersburg by the collections of three extraordinarily enterprising Moscow merchants, Riabuchinsky, Morozov and Shchukin. Shchukin owned 40 Picassos – including major Cubist works – and 37 Matisses; all bought direct in Paris, and even commissioned works. Riabuchinsky specialized in Rouault, but further founded a magazine and promoted exhibitions in Moscow; his exhibition of 1908 included works not only by the great Post-Impressionists but also by the Nabis and the Fauves. Two of the major pioneers in the revolutionary Russian abstract movements were particularly interested in the

BAKST (above)
"L'Après-midi d'un faune (Vaslav Nijinsky)", 1912
Sinuous rhythms of Art Nouveau evoke the grace and energy of the Ballets Russes' brightest star. The title, a phrase by Mallarmé, inspired Debussy's music, danced by Nijinsky.

GONCHAROVA (right)
Monk with a cat, 1910
The attempt of the Russian avantgarde to combine their native traditions with the current trends in Western painting is quite clear: the monk, recalling a saint in an icon, is rendered in broad and bold Fauve brushwork.

VRUBEL (left)
Six-winged seraph, 1904
The fragmented areas of rich but sombre colour and the hieratic pose owe much to glowing medieval mosaic (Vrubel had once worked in Kiev as a restorer).

BENOIS (left)
Backdrop for Stravinsky's Petrouchka: The fair, 1911
Benois's great contribution to stage design lay in his view of the production as a picture, the stage a canvas where the single elements all combined to create a visually dazzling scene.

LARIONOV (right)
Summer, 1912
Naive peasant art was the inspiration and model for four pictures by Larionov depicting the seasons of the year. The figures have a slightly comic appeal, but the uncompromising crudity reflects the profound dissatisfaction with academic modes of representation which led finally to total rejection of the object.

Nabi and Fauve use of broad and expressive flat patterning in vivid and emphatic line, but applied it to their own existing interest in the techniques and vision of Russian folk art: these were Mikhail Larionov (1881-1964) and his partner Natalia Goncharova (1881-1962).

Both Larionov and Goncharova drew deliberately on the crude, broad imagery of *lubki* (popular woodcuts, see p. 374), and later on the still cruder but vividly expressive graffiti of soldiers' barracks. The direct coarseness of the expression they achieved was unparalleled in Europe, even by the German Expressionist movements. Larionov initiated his own exhibitions, and at the first ("The Donkey's Tail" in Moscow in 1912) he included early, still figurative, works by Tatlin and Malevich. In 1913 he launched Rayonnism.

Rayonnism – not really a movement, the total production being a few paintings all by Larionov or Goncharova – was part of the headlong development in Russia in the years 1911-17 from the figurative to the non-objective, which made Moscow a prime centre of European avantgarde art. Malevich described his works of 1912-13 as "Cubo-Futurist", and this term indicates the basic

principles of the movement in its first stages, if it is not too strictly analysed. There was a seething ferment of often contradictory ideas; several very different styles might be represented in one exhibition. Rayonnism, however, was the expression of Larionov's belief that Cubism had not produced the final answer; it offered an alternative, entirely modern imagery, powered by principles close to those of Italian Futurism: it was an investigation of the interaction of rays of light sprung from the surfaces of (unseen) objects. This was virtually a purely abstract art. Both Larionov and Goncharova, however, soon withdrew from the Russian scene, following Diaghilev to Paris in 1914 and 1915 as ballet designers. The pursuit of abstraction was continued in Moscow by Kasimir Malevich (1878-1935) and Vladimir Tatlin (see over).

Malevich was born in Kiev of humble Polish-Russian stock. Coming to Moscow, he worked his own way through Impressionist and Cézannesque manners, but by about 1908 he was treating themes of peasant life (like Goncharova) in broad, "tubular" fashion. The tendency to the geometric very quickly increased, but differed from contemporary

French Cubism (though surely influenced by it) not least in Malevich's use of a bright peasant palette. Already by 1913 (he claimed) he had created his earliest "Suprematist" works in designs for an opera: one set was completely abstract, a white square and a black square. His first exhibited Suprematist work (1915) consisted of a simple combination of geometric elements. Though they were non-objective, Malevich gave them emotive and associative titles (*In a state of tranquillity; Painterly realism of the footballer*). His geometric forms increased in complexity, but for Malevich always had their roots in an extra-terrestrial mysticism – his "semaphore in space". From complexity he proceeded to the ultimate simplicity and purity, to the quintessential reduction of the famous *White on White* series of 1917-18. His progress to complete non-objectivity, unlike Mondrian's, was not by abstraction from natural forms, but from a more conceptual basis. Suprematism was the "supremacy of feeling in creative art". The more materialist and functionalist Tatlin and Rodchenko, having first joined Malevich in Suprematism, proceeded to reject it for the still more austere concepts of Constructivism.

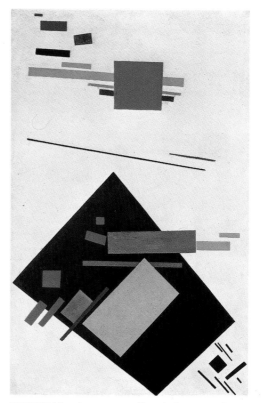

GONCHAROVA (above)
Cats, 1911
Rayonnism, according to Larionov, denotes "spatial forms which arise from the intersection of reflected rays of various objects, forms chosen by the will of the artist". "In this way painting parallels music while remaining itself. Here begins a way of painting which may be pursued only by following the specific laws of colour and its application to canvas." But while Larionov's own work approached complete abstraction, the motif was often still recognizable in the vivid, angular shapes of Goncharova's canvases.

MALEVICH (right)
Suprematist composition: white on white, c. 1918
Suprematism could go no further; a variation in the texture of the brush-strokes is the only means distinguishing the smaller square from its background.

MALEVICH (left)
Woman with buckets, 1912
Although it bears an extra-ordinary resemblance to Léger's tubular forms, Malevich's Cubo-Futurism seems to have developed independently and ahead of

the French approach to a truly non-objective art. Malevich admitted a social concern – the woman with water buckets is a peasant – which is another striking parallel with Léger (see his *Nudes in the forest*. p. 398).

MALEVICH (above)
Black trapezium and red square, after 1915
Experiments with collage led Malevich to concentrate on the formal relationships between geometrical shapes, which appear on the white ground like *papiers collés*.

Here the large trapezium exerts a subtle influence over the smaller shapes – distorting the squares and rectangles and the oblique lines into so many echoes of its fundamental form. These works quickly had an impact, not only in Russia.

Russian Art 2: Constructivism

The history of avantgarde art in Russia from about 1915 through the 1920s to its final obliteration in the 1930s by the promulgation of social realism under Stalin is complex and confused. Much of its documentation has vanished, including many of the works of art themselves, and the very existence of the movement has been expunged from the record. There are, however, four currents, now merging, now conflicting, that can be discerned – the pure abstract art with mystic overtones (Suprematism) of Malevich (see preceding page); the equally pure, materialist Constructivism of the brothers Pevsner and Gabo; the equally materialist counter-Constructivism of Tatlin and Rodchenko with its political and social commitment, developing into post-Revolutionary "Productivism"; finally, the high-art principles of Kandinsky.

The springboard for Constructivism, as for so many other developments in twentieth-century art, seems to have been Cubism in Paris, and specifically Picasso. In 1913, Vladimir Tatlin (1885-1953), associated in Russia with Larionov, and already aware not only of Cézanne but of both Fauve and Cubist explorations, visited Picasso in Paris, and saw there Picasso's experiments with collage, applied in three-dimensional constructions – in paper and string, and then in sheet metal, wood, wire. A basic concern of Russian Constructivist sculpture was to be the treatment of space rather than of mass. The void was as important as the solid. (Gabo was later to say: "I can use the same space in different positions in the same image.") Back in Russia, between 1913 and 1917, Tatlin produced painted reliefs, followed by relief constructions which included "corner reliefs", suspended on a wire across the corner of a room, in which he discarded the age-old convention of the frame or a base. Above all, these works abolished figuration, abolished even abstraction that referred back to identifiable objects.

Alexander Rodchenko (1891-1956) was associated with Tatlin from 1915, and moved early into purely abstract geometric designs – "compass-and-ruler drawings". Influenced by Malevich's command of dynamic non-figurative design, he expanded the application of these principles to different materials, from chunky constructions in wood that are as spare as Minimal art – or the paintings of Mondrian – to hanging constructions that introduced

RODCHENKO (below)
Composition, 1918
Rodchenko was dedicated to "the absoluteness of industrial art and to Constructivism, its sole form of expression". He had turned early more to design than to art, and his training in a rigorous draughtsmanship appears in abstract compositions with the linear precision of technical drawings. In 1922 he gave up fine art to apply his principles to photography, typography and the design of furniture.

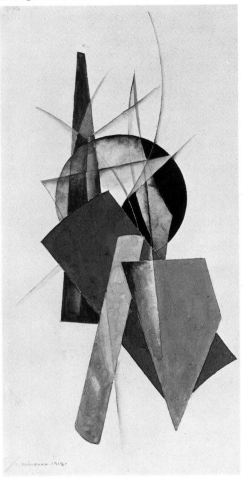

TATLIN (right)
Relief construction, c.1915
Tatlin's constructions of 1913-17 are known only from photographs. Tatlin's motto was "real materials in real space"; in these "counter-constructions", the absence of any frame, which would physically and symbolically distinguish the work from its context, is a sign of the integral relevance of art to life. Not only are these works non-figurative, they were also made out of flimsy and perishable materials rather than from bronze or stone.

MAYAKOVSKY (below)
Revolutionary poster, 1920
The crude, forceful images, recalling those of peasant woodcuts, spell out with uncompromising brutality the propaganda syllogisms of the Reds, written below: "(1) If we don't wipe out the White Guard utterly (2) White Guardism will rise again. (3) If we kill off the landowner and just stand back (4) then Vrangel (a general in the White Guard) will stretch out his hand for the worker. (5) Until the Red Flag flourishes (6) we cannot throw down the rifle."

1) ЕСЛИ БЕЛОГВАРДЕЙЩИНУ НЕ ДОБЬЕМ СОВСЕМ 2) БЕЛОГВАРДЕЙЩИНА СНОВА ВСТАНЕТ НА НОГИ

3) ЕСЛИ ПАНА ДОБЬЕМ И СЛОЖИМ РУКИ 4) РУКУ К РАБОЧЕМУ ПРОТЯНЕТ ВРАНГЕЛЬ

5) ПОКА НЕ УКРЕПИТСЯ КРАСНОЕ ЗНАМЯ, ВИНТОВКА НЕ МОЖЕТ БЫТЬ НАМИ БРОШЕНА.

MAYAKOVSKY (above)
Set design for *Misteria Bouffe*, 1919
Mayakovsky, a playwright and poet (ranked by some the equal of Bertolt Brecht) was a fervent advocate of Bolshevism, and predicted its triumph in his verse drama *Misteria Bouffe*. Its strident, declamatory quality is echoed in this angular design, influenced much by "Cubo-Futurism".

UNKNOWN ARTISTS
(above) "Agit" train, c.1919
The exuberantly painted railway carriage recalls, in all but the subject matter, a gipsy caravan. The decorative forms of Russian folk art found favour with the artists of the Revolution partly as authentic expressions of the working peasantry; these rather naive images, injected with a Futurist dynamism, are combined in exhortation to Communist victory – the red banner reads: "Long live the Third International!"

physical movement – purely abstract kinetic sculpture. Movement soon became a dominant feature in Constructivist art.

The success of the Revolution in 1917 united the most remarkable Russian artists in a common endeavour for a brief but hectic, heroic four years, 1917 to 1921. The brothers Naum Gabo (Naum Pevsner, 1890-1977), the sculptor, and Antoine Pevsner, at that point a painter, returned from Munich and Paris respectively. Kandinsky came back from his long sojourn in Munich (see p. 384) to become an administrative figure in the ambitious re-organization of the Russian galleries. In conditions of great difficulty and deprivation, art was harnessed nevertheless vigorously to Revolutionary ideals. Propaganda shows, produced by artists and actors, were toured in trains and boats; vast celebratory pageants were staged. The décor of these events was violently modern, closely related to early Constructivist sculpture. In 1917 Tatlin was a principal collaborator in the decoration of the Café Pittoresque in Moscow, an early attempt to combine Constructivist decoration with a Futurist life-style in a centre where the avant-garde met, involving art inextricably with life.

After 1919, Lenin encouraged the nascent film industry – hence the early masterpieces of pioneering geniuses such as Sergei Eisenstein. Vladimir Mayakovsky (1893-1930) was one ardent promoter of revolutionary values in poetry, plays, posters and stage designs.

As Gabo later remembered the ferment in Moscow in the early Revolutionary period, each artist brought "something to the clarification of another's work; our activities went on incessantly in both theoretical and concrete experiments at the workshops of the schools and in the artists' studios." Rifts and schism soon began to appear, however, not only from ideological differences but also from clashes of personality – Tatlin, a neurotically jealous character, had already come to blows with Malevich late in 1915. In 1920 Malevich, having mounted a triumphant last exhibition of Suprematism in 1919, announced that "fine" art was over, and turned to "laboratory" art. By 1923, in Petrograd, he was concentrating primarily on the application of abstract design to architecture. Kandinsky had reacted with a programme concerned with aesthetic investigation of the basic property of line and colour, and in his subsequent work

(see p. 438) was clearly much influenced by Malevich. Pevsner and Gabo were also concerned essentially with a modern version of Art for Art's sake (see p. 428). Tatlin's group, however, demanded the abolition of art – as an obsolete aestheticism spawned by a now-extinct capitalist society. Tatlin had envisaged the noblest project for the heroic celebration of the ideals of the Revolution, in his famous Tower of 1919-20 (see over), but after 1920 his Constructivism merged into Productivism, the construction of a socialist design for living, art applied to life for materialist, functional ends.

Pevsner and Gabo and Kandinsky (and also Chagall) withdrew to pursue their own ideals in freedom. The political and social bias grew until exploratory art was swamped in the 1930s in dogmatic social realism. Malevich fell foul of Stalin's reactionary repression, as did Mayakovsky, who committed suicide.

An important figure in the 1920s, coming and going between the West and Russia, a fertilizing agent in the development of crisp typography and of the poster, was the elegantly versatile El Lissitzky (1890-1941), who produced also playful, supremely decorative geometric paintings that he baptized *Prouns*.

RODCHENKO (right)
Hanging construction,
c. 1920
The artist, standing in the background, is seen through the spokes of his sculpture. Virtually all his work is lost, and known only from contemporary photographs, which cannot convey their crucial kinetic qualities.

AFTER RODCHENKO (below)
Hanging construction,
original *c.* 1920
Rodchenko made laths into fragile elliptical spirals, geometrically developed forms suspended from the ceiling with wire, slowly revolving as the air blew. They were an advance on Tatlin's "corner reliefs", free in space but fixed static between two walls.

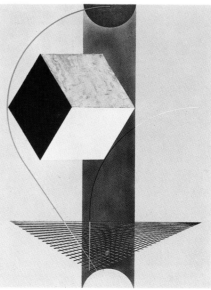

GABO (above)
Head of a woman, 1917-20
Gabo converted mass into empty space by making up his *Heads* from inclined planar surfaces, of either metal or cardboard. The abstract impulse already underlying Gabo's works incurred only disapproval in the Russia of the 1920s, when socialism demanded the sacrifice of creative freedom for the support of industry and state policy.

LISSITZKY (left)
Proun 99, 1924-25
Lissitzky's background was even more technical than Rodchenko's: he trained as an engineer before applying his skill in design to such cool, Suprematist-derived compositions. Cubism and the mechanistic images of Duchamp also made major contributions to his style.

Tatlin: Monument to the Third International

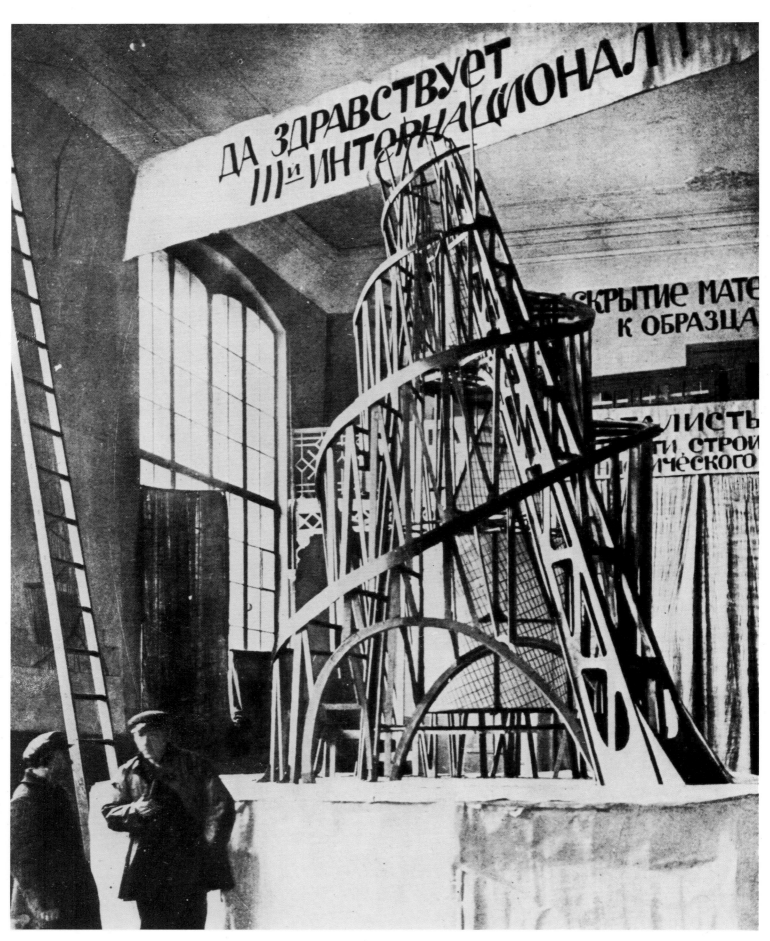

Vladimir Tatlin (with pipe) *beside the maquette for his Monument to the Third International*

Vladimir Tatlin's *Monument to the Third International* reads at first sight as an austere three-dimensional exercise in non-objective form, an open spiral with its axis slanted against firm verticals. But it has become also a romantic, nostalgic monument to the artistic side of the ideals of the Communist Revolution in its first euphoria – ideals which, like the monument itself, never materialized. Commissioned by the Revolutionary Department of Fine Arts from Tatlin in 1919, the full-scale monument was to be erected in the centre of Moscow; the height proposed was some 400 metres (1,300ft). It was intended, however, not as a symbol, but as a "union of purely artistic forms (painting, sculpture and architecture) for a utilitarian purpose". The functional "body" of the construction would have consisted of a glass cylinder, a glass cone and a glass cube, contained within the open steel framework (painted red). The three elements were to house different functions, from conference and executive accommodation to a topmost information centre including a projector to illuminate the sky above with slogans. These elements were to revolve slowly, and independently and at different speeds, while the whole was to teem with human movement.

Much later buildings were to realize some elements of this programme (the Postal Towers of Stuttgart or London, the transparent colossus laced with escalators of glass at the Centre Pompidou in Paris – but Frank Lloyd Wright's Mile-High Skyscraper has likewise yet to be built). Tatlin's scheme never went further than scale models, one of which was shown at the Exhibition of the VIIIth Congress of the Soviets in December 1920. It seems in fact not to have advanced beyond the form of an almost purely sculptural design, though this indicated clearly how the proposed mechanical and human movement of the completed project would be matched by the formal movement of the basic spiral. This quality of movement was by then a dominant stylistic motif of Constructivist principles (see preceding page). Tatlin's model foreshadows many developments in later sculpture, setting an aspiration of unequalled scale and grandeur.

The formal element of his design was, however, strictly subordinate to its function. In his *Programme of the Productivist Group*, 1920, clearly written as counter to Gabo's *Realist Manifesto* of slightly earlier (see p. 428), Tatlin had redefined Constructivism in terms of two compound words, "*tektonika*" and "*faktura*". The first relates to social and industrial processes, the second to the progression through these techniques towards a logically achieved goal. "*Tektonika* is derived from the structure of communism and the effective exploitation of industrial matter. Construction is organization. It accepts the contents of the matter itself, already formulated. Construction is formulating activity taken to the extreme, allowing, however, for further tektonical work. The matter deliberately chosen and effectively used, without, however, hindering the progress of construction or limiting the *tektonika*, is called *faktura* by the group." Tatlin's ideas committed art entirely to industrialization, to a degree that only communism could make possible.

In theory, all ties with the past were broken. In practice, the only cloud-caps into which Tatlin's Tower would ever soar were those of insubstantial dream. Even the theme of such a monument has obvious roots in stubborn continuing traditions from the past, such as the designs of the Neoclassical architects Boullée or Ledoux or Rodin's *Monument to Labour* – even the Eiffel Tower. The practicability of Tatlin's design is also more than doubtful, and it would in construction no doubt have run into problems as severe as those of an earlier forerunner – the Tower of Babel.

Tatlin, like Rodchenko, but unlike so many of the other most gifted artists of those four "heroic" years of the new artistic dawn after the Revolution of 1917, remained committed to his motherland and to the ideological aspect of art for the rest of his life. He was director of the department of the "culture of materials" in the Research Institute for Artistic Culture (INKHUK); he became primarily a theatrical designer, but still in line with the aspirations of the *Monument* were his designs for a glider or air-bicycle, based on the study of insect flight, and baptized as *Letatlin* – a compound of his own name and the Russian verb for "to fly".

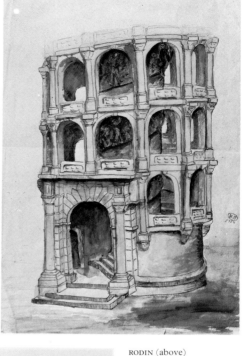

TATLIN (right)
Drawing for *Monument to the Third International*, c. 1920
An austere formal structure was to be transformed by the presence of people into living sculpture: "Least of all must you stand still or sit in this building, you must be mechanically transported up, down, carried along involuntarily ... creation, only creation."

TATLIN (below)
Letatlin, 1932
Tatlin's fascination with the dream of flying was also shared by Rodchenko and Malevich. The urge to transcend gravitational laws was perhaps one and the same with that of the Russian space programmes making a breakthrough only some 30 years later.

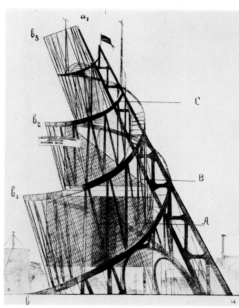

RODIN (above)
Monument to labour, 1893-99
Rodin's project was, like Tatlin's, never realized.

TATLIN (above)
Bent-tube chair, 1923
Traditional materials, wood and leather, are used in this innovatory design.

THE TWENTIETH CENTURY

The years since 1915 have witnessed more rapid changes than in any earlier period, in art no less than in science. The Cubist break with traditional methods of representation opened up an extraordinary range of artistic possibilities, and Cubism was to influence nearly all the most adventurous art of the years between the Wars. But the post-1914 avantgarde was distinguished above all by an urge to go beyond stylistic innovation, to work for a change in life and society as a whole. In so doing they called into question the very nature of art, and the interrogation has continued to this day, with little sign of ceasing.

The changing priorities of advanced artists were manifested most dramatically in the international Dada movement, for which the catastrophe of 1914-18 was evidence of cultural corruption. The survivors and successors of Dada who formed the Surrealist movement were as uncompromising in their rejection of established society, though their art was more positive, emphasizing the liberating role of the imagination and the Unconscious.

On the more formal side, the pioneering abstraction of Kandinsky and Malevich was carried forward by a group in Holland which also had social aims – De Stijl, whose austere geometric approach was intended to create a less individualistic form of culture. Such far-reaching ambitions did not survive the further shock of World War II, and the concerns of the most influential post-War artists have tended to be more personal. The persecution which accompanied Nazism drove many of Europe's best artists to America. Their interaction with a generation of talented and energetic American artists, and with a society not only wealthy but receptive to novelty, brought about, for the first time in history, artistic leadership in the New World rather than the Old.

The receptivity of the art market and of art critics to new ideas, and the establishment of great institutions dedicated to fostering contemporary art, are in striking contrast with the hostility against which advanced art struggled through the second half of the nineteenth century. Furthered by the mobility of ideas, images and people, abstraction became in the 1950s almost the dominant orthodoxy of art in the West.

Such ready acceptance has perhaps blunted the edge of satirical art, which might otherwise have proliferated in a contemporary culture addicted to satire; Pop, the post-War movement most akin to Dada, had none of its anarchic intent. In spite of noisy debate, perhaps the most conspicuous feature of contemporary painting and sculpture is the great variety of activity recognized as art, ranging as it does from theatrical flamboyance to Conceptual art, stressing idea rather than product and employing forms that are often as visually unremarkable as can be imagined. In the final section of this history these various movements are given equal consideration, though the likelihood is that the passage of time will, as always, reveal a different order of significance.

BRASILIA, BRAZIL (left)
The Foreign Office, begun 1957

BERLIN, GERMANY (right)
The AEG Turbine Factory, 1909

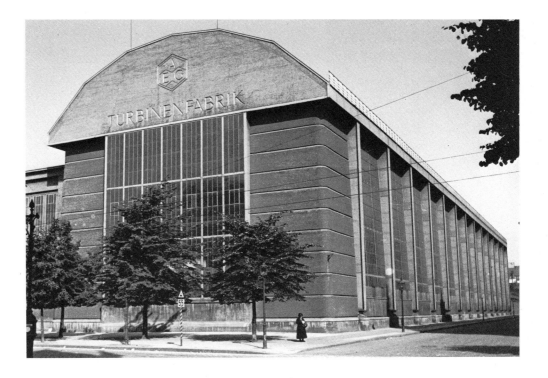

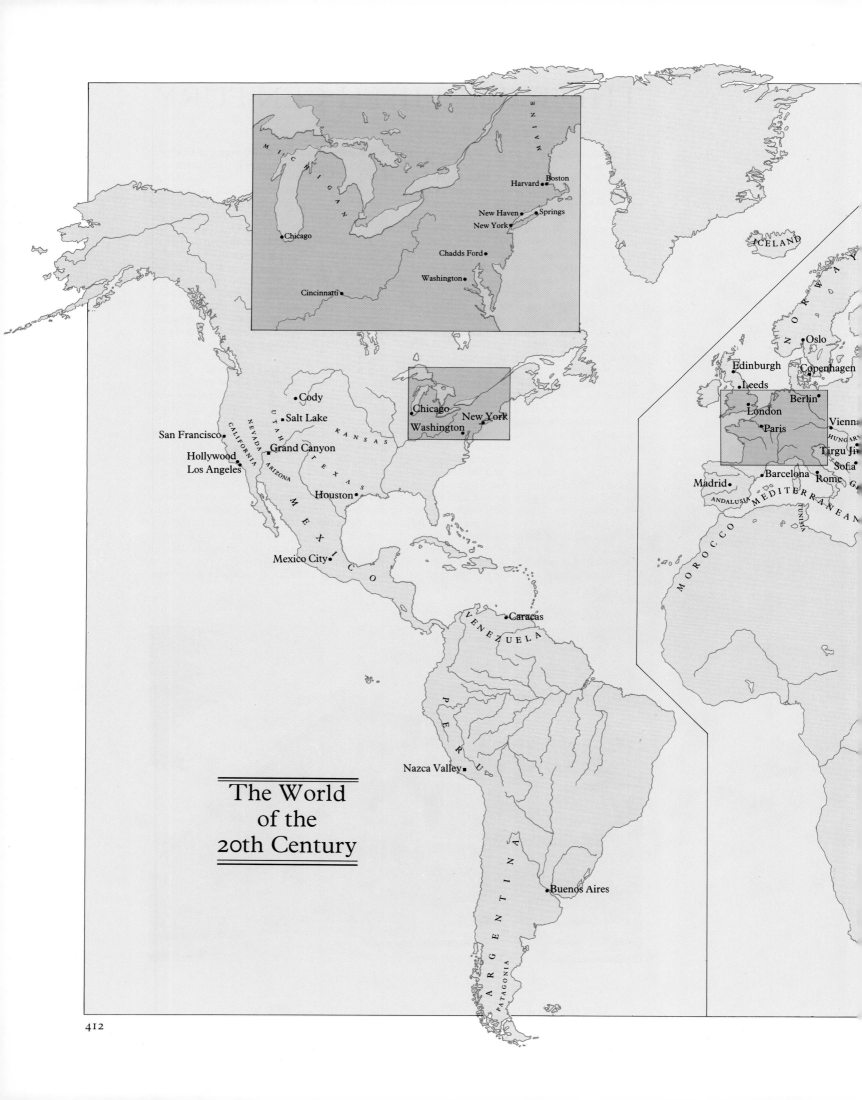

MICHIGAN

MAINE

Harvard •Boston

New Haven• •Springs
New York•

•Chicago

Chadds Ford•

Washington•

Cincinnatti•

ICELAND

Cody•

Salt Lake•

UTAH

NEVADA

KANSAS

CALIFORNIA

San Francisco•

Grand Canyon•

Hollywood•
Los Angeles•

ARIZONA

TEXAS

M E X I C O

Houston•

Chicago•
Washington•

New York•

Oslo•

N
O
R
W
A
Y

Edinburgh•

Copenhagen

Leeds•

Berlin•

London•

Vienna
•Paris

HUNGARY

Tirgu Ji

Madrid•

Barcelona•

Sofia•

Rome•

ANDALUSIA

TUNISIA

MEDITERRANEAN

MOROCCO

Mexico City•

V
E
N
E
Z
U
E
L
A

•Caracas

P
E
R
U

Nazca Valley•

The World
of the
20th Century

A
R
G
E
N
T
I
N
A

•Buenos Aires

PATAGONIA

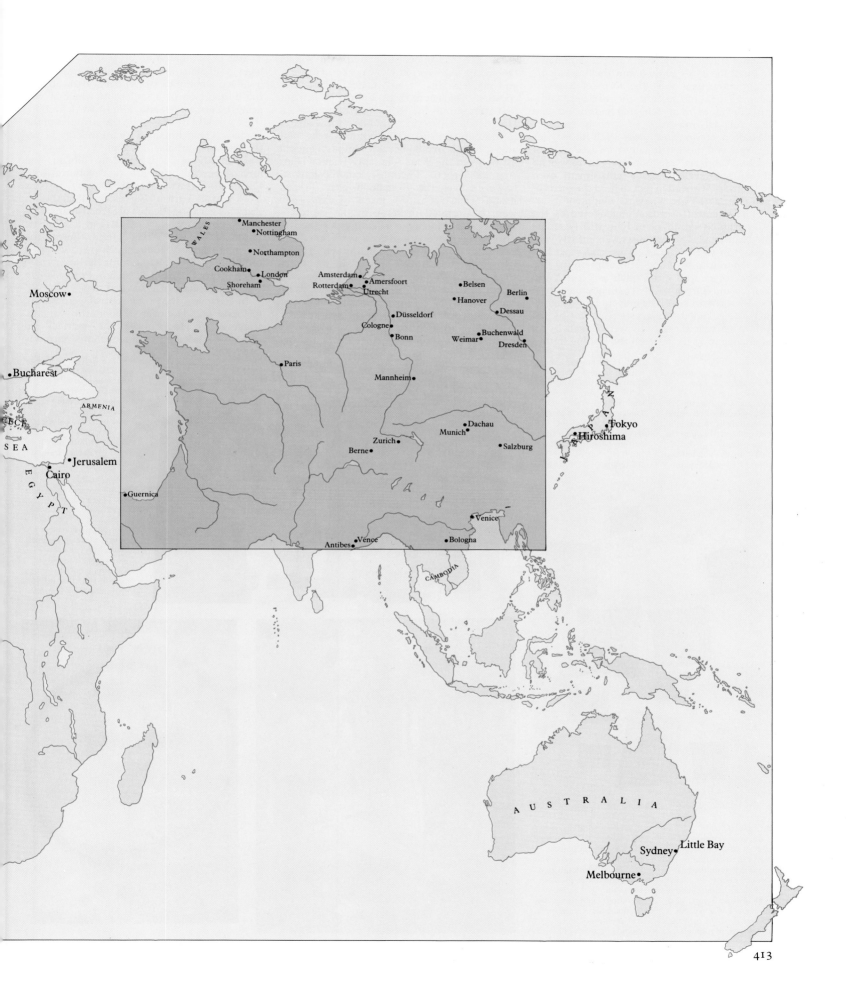

Moscow•

•Bucharest

ECE

SEA

ARMENIA

•Jerusalem

Cairo•

E
G
Y
P
T

WALES

Manchester•
•Nottingham

•Northampton

Cookham•
•London
Shoreham•

Amsterdam•
Rotterdam•
•Amersfoort
•Utrecht

•Belsen

Berlin•

•Hanover

•Düsseldorf
Cologne•
•Bonn

•Dessau

Weimar•
•Buchenwald
Dresden•

Paris•

Mannheim•

•Dachau
Munich•

Zurich•

Salzburg•

Berne•

J
A
P
A
N

•Tokyo
•Hiroshima

•Guernica

•Venice

Antibes•
•Vence

•Bologna

CAMBODIA

A U S T R A L I A

Sydney•
•Little Bay

Melbourne•

Dada

The orgy of destruction that convulsed the Western world between 1914 and 1918 checked the progressive spirit that had animated the arts in the years just before. Activity was not stifled (two global wars proved unable to quell Picasso's genius), but the most significant movement took the form of a revolt against the culture and the corrupt, complacent values (many felt) that had encouraged the suicidal massacre of trench warfare. "Modern civilization" was itself to be destroyed, and the instrument to be used was not art but "anti-art" or "non-art"; there was no thought of development or replacement, even if "non-art" proved in fact to hold the seeds of just that, a new art, a new development.

The intense frustration engendered by the War erupted simultaneously in widely separated centres. Its protagonists were mostly very young, in their early twenties, and most had "opted out", avoiding conscription in the shelter of neutral cities such as New York, Zurich and Barcelona. By 1918, however, even before the Armistice, the movement was igniting in blockaded, hungry Berlin, and by the following year the groups were linked by an exchange of visits between the leading figures

and a spectacular barrage of publications – periodicals, revues, manifestos – rather than by exhibitions. The title by which the movement came to be known was "Dada".

Some of the iconoclastic activities of Marcel Duchamp (see over) in New York in 1914-15, and not least his "ready-mades", were precociously Dadaist in spirit, but the movement first started into life as such in Zurich, when Hugo Ball (1886-1927) founded the Cabaret Voltaire there in 1916. With him were associated some who would become famous names in art between the Wars – notably Jean or Hans Arp (1887-1966). The most demonic activist, however, was the Romanian poet Tristan Tzara (1896-1963). All forms of expression were conscripted to serve in the protest – cabaret performances; meetings designed to provoke controversy and even (sometimes successfully) riot; events that had much in common with those to be dubbed in the 1960s "Happenings". The name itself is a nonsense word; accounts of its origin are contradictory, but it is a word common in many languages, and universal in baby-talk the world over. According to Breton, "Dada is a state of mind". According to Arp, "Dada is, like

Nature, without meaning. Dada is for Nature and against Art ... Dada stands for unlimited meaning and limited means. *For Dadaists life is the meaning of art.*" Dada's first manifesto, by Tzara, 1918, offered no programme, no apologia, no explanation. As a revolt the movement involved a complex irony, being dedicated to the destruction of a society of which it was nevertheless a part, and, almost by definition, there was also dissension in the attitudes of the Dadaists. Henchman to Tzara in Zurich was the volatile Francis Picabia (1879-1953) – Picabia, having participated in Cubism, had already been inciting artistic revolution with Duchamp and Man Ray (1890-1977) in New York and in 1916 in Barcelona. Together in Zurich Tzara and Picabia preached an increasingly subversive view of art and a nihilistic vision of life itself. Ball left for Berne; the German Richard Huelsenbeck (1892-1974), a founding member, had left for Berlin in 1917; when Tzara followed Picabia to Paris in 1920 the Zurich phase of Dada was over.

In Germany, the prime centres were Berlin, Cologne and Hanover. The Berlin version, triggered by Huelsenbeck, was satirical and actively political, its targets more narrowly

ARP (below)
Collages of squares arranged according to the laws of chance, 1916-17
Arp declared that the law of chance could be experienced only by means of a "complete devotion to the Unconscious"; further, that "anyone who followed this law was creating pure

life". His acknowledgment both of an innate creative drive and of a standard of aesthetic beauty sets Arp slightly apart from those Dadaists who were chiefly concerned with chance as an anarchic means of subverting established art; but it led directly into the realms of Surrealism.

MAN RAY (left)
The rope-dancer accompanies herself with her shadows, 1916
Though it is painted in oils, the picture owes a patent debt to collage. Solid blocks of shadow contrast with the delicate star of the dancer and the sinuous line of her rope.

PICABIA (below)
"*M'Amenez-y*" (Take me there), 1919-20
Nonsensical references in capital letters to pots of castor-oil and crocodile's dentures make up Picabia's provocative, iconoclastic composition; it presages his ultimate outrage, a blot of ink of 1920 that he chose to title *The Blessed Virgin*.

PICABIA (right)
I see again in memory my dear Udnie, 1914
By 1910, soon after he had met Duchamp, Picabia applied his gift for colour to delicate experiments with abstract forms, with a decidedly Cubist bias. In New York in 1913, he developed, in response to

its technological marvels, his "machinist" style; here, mechanical and suggestive biomorphic forms combine in a dynamic composition. Gabrielle Buffet-Picabia once said: "His activity was utterly gratuitous and spontaneous ... it never had any programme, method or articles of faith."

and precisely defined than elsewhere. Its armament was a number of magazines – *Club Dada, Der Dada* – produced between 1918 and 1920 by Huelsenbeck, in company with one Johannes Baader; Raoul Hausmann (1886-1971) became the editor of *Der Dada*. These periodicals deployed a raucous use of exploded and explosive typography and photomontage. The Cologne version, 1919-20, was by contrast biased towards aesthetics even if only in the sense of being anti-aesthetics. It included two major artists – Arp (see further p. 429) and Max Ernst (see p. 420). Ernst, with John Heartfield (see p. 442), exploited satirical collage techniques using popular printed material, in free play with the grotesque and the weirdly erotic, often foreshadowing Paris Surrealism; the Paris connection was confirmed when Ernst moved there in 1922.

In Hanover, Kurt Schwitters (1887-1948) invented *Merz*. Rejected by Berlin Dada as being too bourgeois, he was nevertheless, of all of them, perhaps the most enduringly committed to Dada principles, stubbornly individualistic, anarchistic and fantastic. *Merz* (a nonsense name from a torn scrap of print with the word *kommerziell*, meaning "commer-

HAUSMANN (above)
The art critic, 1920
Hausmann's photomontage
is typical of Dada weaponry – satiric invention, boast, scorn, ridicule, abuse.

cial") was the title of a magazine (1923-32), and was applied to his art, which he practised in Germany, in Norway, where he took refuge from the Nazi regime in 1937, and from 1940 in England. He never adopted the extreme "anti-art" stance, but he used the detritus of urban life – bus tickets, torn newspaper, cartons, broken bits of wood or metal – in collages or relief montages, transforming his base materials into exquisitely balanced and unified compositions. He was obsessed by the ideal of a *Gesamtkunstwerk*, an art that included all forms of art. His first *Merzbau* (including a chamber named "The Cathedral of Erotic Misery") was an endless construction of bits and pieces that wandered horizontally through the rooms of his house, vertically up through its floors and even out of the windows. This *Merzbau* in Hanover was destroyed by bombs in 1943; another in Norway was burnt in 1951; something of an English version was salvaged by the University of Newcastle.

Paris, though not until 1920, witnessed the climax of Dada, which began with a performance supporting an exhibition and ended in riot. But soon its impetus was sapped, and by 1924 it was ripe for take-over by Surrealism.

MAN RAY (right)
Crossroads, 1934
The leading lights of Dada and Surrealism are featured: from upper left to bottom right are Breton, Ernst, Dali, Arp, Tanguy (who looks oddly "punk"), Char, Creval, Eluard, Chirico, Giacometti, Tzara, Picasso, Magritte, Brauner, Peret,

Rosey, Miró, Mesens, Hugnet and Man Ray. Self-projection was a trait common to most of these artists; they made wide use of their own and each other's *personae* – often bizarrely clothed and posed. In this the forerunner had been Alfred Jarry (died 1907), author of *Ubu Roi*.

BAADER (below)
Collage A 92-22, c. 1920
Baader (Dada name, Ober-Dada) took eccentricity to
its limit; he caused uproar in Berlin Cathedral by shouting at worshippers "Christ is a sausage!"

SCHWITTERS (above)
"*Arbeiterbild*" (Worker-picture), 1919
The word *Arbeiter*, printed in red on a scrap of paper, gives the collage a name but not a message or purpose – rather, its socialist references are ignored. Stripped of associations, it becomes merely part of a harmony of colours and textures.

SCHWITTERS (right)
Ambleside, 1945-48
Dada tended to underline the original functions of *objets trouvés* in order to make their appearance in other contexts all the more absurd. Schwitters' deeper concern with abstraction led him to use materials in a way that freed them from their mundane identities.

Marcel Duchamp

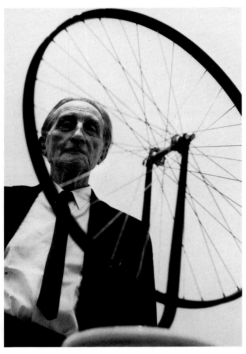

Marcel Duchamp (1887-1968) was the dandiacal cat who walked by himself through the highways and byways of modern art from his first important exhibition in 1912 till his death more than half a century later. Wherever he walked, controversy sprung up in his wake, and since his death his historical importance has become increasingly clear. Two of his brothers also made significant contributions: Raymond Duchamp-Villon was one of the most important sculptors associated with the Cubist movement (see p. 426), his career cut short by premature death, while Jacques Villon (1875-1963; not shown) had a long, very professional career, especially as a printmaker.

Marcel Duchamp became a member of the Cubist Section d'Or group in Paris (see p. 398) in 1912. His early experiments reached their climax in his *Nude descending a staircase*, 1911-12, one of the most famous of all twentieth-century works of art. In it he was clearly aware of Cubist techniques of dismantling an object into its constituent planes, then reshuffling them, and perhaps also of Futurist dynamism (though he denied that); he was certainly also aware of novel photographic techniques which showed the body in progressive stages of a movement, and his *Nude* does just that, but the stages are consolidated into an image of arresting originality. Sensing trouble, Duchamp withdrew it from the Salon des Indépendants exhibition; the following year, in the Armory Show in New York, it aroused clamorous controversy. By then, he was already preparing for his masterpiece, *The bride stripped bare by her bachelors, even*, known as "*The Large Glass*" (still incomplete in 1923, though he then signed it). Work on it began in 1915, in New York, where much of his subsequent activity took place – an activity not so much as an artist but as an iconoclast, an antiartist and a conceptualist. "I wanted to get away from the physical aspect of painting. I was much more interested in re-creating ideas in painting. For me the title was very important ... I wanted to put painting once again at the service of the mind." His early work had been influenced by Cézanne, by the Fauves; then into the Cubist world he reintroduced the human figure as prime subject, still disintegrating it, but in "*The Large Glass*" presenting it in terms of a pseudo-scientific diagram, in which nonsense mechanisms are activated by human desires.

Marcel Duchamp
Duchamp's art was always intellectual, not emotional, as if it were a chess game of ideas. It was continuous: he reworked, reinterpreted or developed his early, famous works later in life (in 1965, for instance, he exhibited a reproduction of the *Mona Lisa* with the title *Shaved*). It led nowhere, if only in the sense that every gambit implied a counter-gambit; one consistent trend in his later response was that the nature of the art is dependent on its spectator.

DUCHAMP (right)
Nude descending a staircase no. 2, 1912
Duchamp's approach to the abstraction of form was not so analytical or committed as that of the members of Section d'Or, which may explain their disapproval of the painting. But it was no more favourably greeted in the USA. Duchamp's prime inspiration was the mechanics of movement, as the three sets of dotted lines indicate, showing the rotation of the hips as the body moves through space.

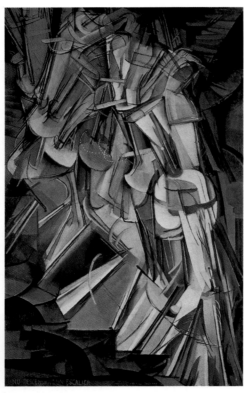

AFTER DUCHAMP (right)
Fountain, original 1917
In submitting a urinal for exhibition Duchamp was in effect undermining the assumption, held even by the avantgarde, that a work of art requires an artist. Although the Society of Independent Artists might pride itself on its freedom from bourgeois taste or convention, this *Fountain*, authorless and blatantly vulgar, forced it into just such bourgeois attitudes of outrage as it would condemn in others.

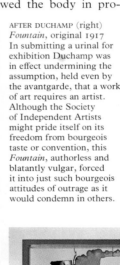

DUCHAMP (left)
A cemetery of uniforms and liveries – the bachelors, 1914
A study for part of the lower half of "*The Large Glass*" shows male sexuality in terms of implements like pistons or syringes. Duchamp called the group "the matrix of Eros".

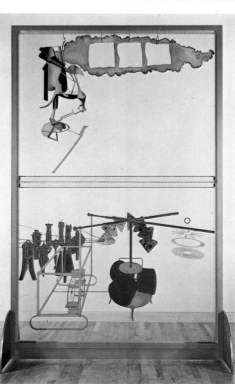

AFTER DUCHAMP (left)
The bride stripped bare by her bachelors, even ("The Large Glass"), original 1915-23
Duchamp's non-picture (it is not an easel-painting, anyway, being on glass) needs an elaborate verbal commentary; even then it defies critical assessment. It is perhaps the first example of Conceptual art, being as much a scheme or a plan as an art object. Essentially it represents the two forces that will also figure in the later "*Etant Donnés*" – male (in the lower panel), female (in the upper). Desire for sexual union is translated into an automatic process, divested of all sentiment but seemingly still prone to chance. This reconstruction was made in 1965-66 by the Pop artist Richard Hamilton.

His first published statement (1915) was entitled *A Complete Reversal of Art Opinions, by Marcel Duchamp, Iconoclast*, and he never ceased to question conventional responses and expectations regarding art. The invention of the "ready-made" principle was also of 1914-15: he claimed the right for anyone to choose virtually any object whatsoever, and by choosing it, and in some cases signing it, to establish it as a work of art. Early specimens were a bottle-rack, a snow shovel and a ventilator; the most notorious the urinal signed *R. Mutt*. The latter, offered for the exhibition of the Society of Independent Artists as *Fountain* in 1917, was rejected. Duchamp resigned. At this period, he was closely associated in New York with Picabia and Man Ray, and promoted two Dadaist revues, *The Blind Man* and *Rong Wrong*. He was indeed the *guru* of the New York Dada movement, and probably the only Dada artist to sustain its anarchic values and contradictions with uninhibited zest during a long career right to the end.

In 1918, he virtually gave up painting, and devoted himself to chess. He created another of the most mesmerizing images of twentieth-century art, simply by endowing a repro-duction of the *Mona Lisa* with a moustache and goatee and subscribing it with an obscene French pun, *L.H.O.O.Q.* (She's hot in the tail). This was another shot against received attitudes to art; it violated the most famous of all masterpieces, contradicted the idea of the sanctity of art and of the value of the unique art object; it swore against good taste – or any taste. "I have forced myself to contradict myself in order to avoid conforming to my own taste." But he also might deny that he was "anti-art": "Whether you are 'anti' or 'for' it's two sides of the same thing."

His work, or his not-work, his life-style, foreshadowed many aspects of mid- and late twentieth-century art. An arch-Dadaist, he became a prophet for the neo-Dadaist elements especially of Pop art. He was a star for the Surrealists. His experiments with "mo-biles" – first with a bicycle wheel revolving on a stool – anticipated kinetic art (see p. 428). His exploitation of chance was shared by others but he anticipated the Abstract Expressionists, when "*The Large Glass*" was broken accidentally in 1937, by rejoicing, and incorporating the breaks with loving care in the reassembled work. Perhaps above all he prefigured the Conceptual trend of the 1960s and 1970s. He expected audience participation, believing "it is the SPECTATORS who make the pictures". He lived on paradox; he was cultivated, intensely sensitive and gifted, devoting much time to chess and to calculating the risks of roulette. He refused to live from his art, though towards the end of his life he agreed to allow limited editions of facsimiles of his *Fountain*, doubtless thereby debunking the prestige as a unique art object that the original had acquired since he signed it 50 years before.

Not the least of his baffling and endlessly fascinating innovations was the injection of relentless irony into serious art, the questioning of all accepted values; he took advantage of any fortuitous offering that took his fancy, descending or soaring into coarse buffoonery. Yet in 1961 he stated: "I'm nothing else but an artist . . . I couldn't be very much more iconoclastic any more." After his death, it was revealed that his masterly inactivity of the previous quarter-century had in fact been diverted on and off with the creation of a final masterpiece, a large tableau, "*Etant Donnés*" (Given that . . .), featuring a life-size peep-show of a nude through a door.

AFTER DUCHAMP (right)
"Ready-made",
original 1913
The wooden stool with a bicycle wheel was the first of the "ready-mades", mass-produced, mundane objects taken out of context and presented to the viewer as art. The adjustment in the viewer's mind was of more significance than the form, to which Duchamp attached no importance, although these works usually reveal his interest in mechanical movement and were fairly new technological devices.

DUCHAMP (below)
"*Etant Donnés*" (Given that . . .), 1946-66
Reinstating in his name the unique art object, Duchamp's widow refuses permission to reproduce what the spectator can see through the cracks in the door – an allegorical peep-show of the human condition? Behind, there is a waterfall, in front of which reclines a nude (sprawling suggestively) with a gas burner – this "illuminating gas" and the cascade are the "given".

DUCHAMP (above)
"*The Large Glass*" (broken state), 1937
In Duchamp's meticulous reassembly of his broken original there was perhaps an urge to rule chance. Systematically paradoxical, paradoxically systematic, he had tried in the 1920s to find a way of always winning at roulette; here he played chance at art.

DUCHAMP (right)
L.H.O.O.Q., 1918
Duchamp's annotated postcard of Leonardo's *Mona Lisa* was first of all one more "ready-made", even if it has also been seen as the quintessential Dada work of art, being at the same time quite puerile and profoundly anarchic. The joke still runs – variations on it keep appearing.

Art in Italy: Metaphysical Painting

The most prominent avantgarde group in Italy in the early twentieth century, the Futurists (see p. 400), continued after World War I, but their impetus was spent. With three important exceptions, Italy produced no innovators in art of international renown until rather later – for example, the sculptors Marini and Manzù (see p. 478). The exceptions were Chirico, Morandi and Modigliani; Modigliani really belongs to the "school of Paris" (see p. 430).

Giorgio de Chirico (1888-1978) trained as an engineer before turning to painting, first in Athens and Munich, then settling in Paris in the years of ferment (1911-15). There he moved in avantgarde circles, and was celebrated by the poet and prophet Apollinaire (of whom he painted a famous portrait), and yet he remained essentially unmoved by the French discoveries, from Impressionism to Cubism, though the art of his early period could not have been conceived without the freedom these movements had established. Chirico's concern was primarily with content; form and technique were only the means by which the content could be expressed. He was far closer to the Douanier Rousseau than to such other pioneers as Cubist Picasso, Matisse or Kan-

dinsky. His imagery was essentially figurative and illusionistic, though the illusion was not of the everyday world but of an alternative reality that was later to be called "surreal". In its formulation he owed something to the dreamlike visions of Symbolist painters – his tall and still figures, enveloped in their own isolation, are prefigured in some of the works of Böcklin or Kubin. His strange poetry was certainly influenced by the writings of the philosopher Nietzsche, while his combinations of symbols often seem ready for Freudian analysis.

Chirico's stillness is that between dreaming and waking, and ominous. The setting is urban, the ground is paved, the vistas are of arcaded buildings or monuments under an implacable sultry sky, but civilization has been deserted. The images are described with intense conviction and according to traditional conventions, but the conventions are garbled: obsessed with the poetry of perspective, Chirico played tricks with it, exaggerating it, using different systems in one picture, exploiting it as an emotional device as well as a structural one; the hard light casts shadows, but the lighting is often inconsistent, and the shadows fall like a threat. Chronological in-

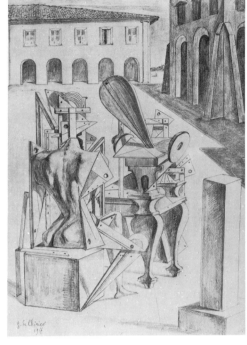

CHIRICO (above)
The enigma of the hour, 1912
The architecture is oddly dislocated so that everyday locations seem mysterious; we are invited to relate them to inner experience by Chirico's emotionally resonant titles. Thus deftly he evokes melancholy, loneliness, departure and the disquieting impassivity of the inanimate world.

CHIRICO (right)
The child's brain, 1914
Underlying Chirico's art was a childlike naivety, a yearning for that state of grace or innocence in which time seems hardly to pass, and in which the incomprehensible is accepted unquestioningly. This sinister looming figure has led some critics towards a Freudian interpretation.

CHIRICO (below)
The dream of the poet (Guillaume Apollinaire), 1914
Chirico's picture offers no suggestion of physical likeness. The unidentified, Napoleonic-looking bust in sunglasses, while echoing the blank eyes of classical statues, is also a metaphor for the introspection of the blind seer. Fish-mould and tailor's dummy are images from Apollinaire's poetry.

CHIRICO (below right)
The nostalgia of the infinite, 1913-14
Chirico said that we experience "the most unforgettable moments when certain aspects of the world ... suddenly confront us with the revelation of mysteries lying all the time within our reach, which we cannot see ... Their dead voices speak to us from nearby, but they sound like voices from another planet."

CHIRICO (above)
The mathematicians, 1917
"The phenomenal world", as Nietzsche had once observed, "is the adopted world which we believe to be real." Chirico's pencil-drawing introduces uneasy oddity and confusion into the "most certain" of the sciences – the geometers have become a jumble of their own instruments in a dazzling Cubist parody.

congruities abound – a locomotive may intrude on the timeless townscape, and time itself is sometimes shown stopped. *The enigma of the hour* was painted in 1912, its two tall main figures frozen to statues, the only movement the febrile flicker of the fountain, the clock stopped for ever at six minutes to three.

From about 1915, Chirico's desolate piazzas or stages became increasingly "peopled" with the abandoned equipment of life. Set squares, blackboards and easels, surgeons' gloves etc. congregate around mannequins like tailors' dummies, with egg-shaped heads sometimes bland, sometimes with an ancient symbol for infinity instead of eyes. Chirico returned to Italy in 1915, and in 1917 encountered the Futurist painter Carlo Carrà (see also p. 400); for about a year, Carrà produced imagery obviously inspired by Chirico's vision, but in a more delicate, lyrical mood. This was the brief flowering of the "Metaphysical" school (the adjective occurs earlier in some of Chirico's titles), and its rationale, or rather irrationale, was set out by Carrà in a book, *Metaphysical Painting*, in 1918. There he claimed a continuing validity for Renaissance techniques applied to twentieth-century imagery – of the

irrational, the Unconscious. Chirico's impetus, however, wavered, though he began to be recognized as an artist of major importance. Back in Paris from 1924, he inevitably became associated with the Surrealists, whose vision he had so vividly anticipated, but his own work lost intensity. In the 1920s he worked in the classical idiom widely used at the time, and finally turned back, almost disclaiming his earlier work, to an archaic, purely traditional academic style and subject matter. It is his early work that has lasted, still potent and inexplicably compulsive while the fantasies of many Surrealists already seem period pieces.

Giorgio Morandi (1890-1964) was briefly associated with the Metaphysical school about 1918-19. His still lifes then were confrontations of objects, sharply defined but not behaving according to everyday expectations – casting shadows that do not belong, or presenting an illogical structure. They were painted in much the same grey-green and ochreous palette as Chirico's, and each object, as in Chirico, had its own human presence, isolated in a concentrated stillness. These qualities were to persist, though Morandi's gaze shifted in about 1920, and settled on the three subjects

that were to monopolize the rest of his life – still lifes of everyday utensils (bottles, jugs); vases of flowers; and deliberately unpicturesque, sometimes positively banal landscapes. He worked quietly in Bologna, teaching and painting: his studio was one room in a modest flat. He travelled abroad only once, briefly. His paintings were usually small. It was only towards the end of his life that he was becoming recognized as perhaps the most important painter Italy had produced since 1900 – a twentieth-century Chardin. He was also a master of tonal etching, and his hazy etched landscapes are more compelling than most of his painted ones. He moved away from the harshly delineated techniques of Chirico, and behind his mature vision one can always sense the presence of his first love, Cézanne. His bottles and pots are posed as it were self-consciously: each has its own concentrated individuality, yet the interrelationship of each to each is indissoluble. Morandi's endless variations on his chosen theme are never monotonous, partly because a sense of strangeness persists all through his career – essentially that "Metaphysical" otherness which Chirico, Carrà and he had divined earlier.

CARRA (below)
The engineer's mistress, 1921

Carrà wished, in painting, to "express the mysterious life of ordinary things".

MORANDI (below)
Still life with a pipe, 1918

Even in this early Metaphysical work the objects have a unique intensity.

MORANDI (above)
Still life, 1937
Basic to Metaphysical art was a sense of alienation from everyday reality; but from this attitude Morandi soon departed. His simple arrangements of domestic

objects came to reveal the search for a principle of universal order, recalling again Cézanne in some ways; each is an apprehension of formal relationships hard won from an intense concentration of observation.

MORANDI (right)
Still life, 1938
Morandi's work, unlike that of his fellow Metaphysical painters, shows an interest in the sensuous properties of brushwork. Avoiding the distractions of perspective or a widely ranging palette, he used the delicate shapes of his chosen objects as a means of confining tonally modulated areas of paint. These shimmering objects induce a quiet meditation.

MORANDI (above)
Landscape with the River Savena, 1929
The Emilian landscape is

rendered in broad planes delicately cross-hatched, in varying textures quietly united in a flat pattern.

Max Ernst

In 1961, Max Ernst (1891-1976) revised for publication a selection from his own utterances, autobiographical notes in the third person. The text begins: "First contact with the sensible world: on April 2nd at 9.45 a.m. Max Ernst hatched from the egg which his mother had laid in an eagle's nest and over which the bird had brooded for seven years. It happened in Brühl, six miles south of Cologne. There Max grew up, and became a beautiful child. . . ." Clearly then, the habit of poetic fantasy, the superb egocentricity, the ability to dislocate the structure of the visible world and to reassemble it in the compulsive imagery of an alternative reality, these were all with him in the egg. They were to persist and flourish.

In the first decade of the twentieth century the theories of Freud, the concept of the Unconscious, were becoming widely known, and certainly were relevant to the development of Ernst's imagination. He enrolled in the University of Bonn for a degree in psychiatry, but found academic disciplines distasteful: "The young man, eager for knowledge, avoided any studies which might degenerate into breadwinning." His prime concern was painting. He seems to have been virtually self-taught, but in 1910-11 he saw the work of the most advanced artists: he was also, when visiting asylums, astounded by the art of the insane. August Macke introduced him to the Blaue Reiter group and in 1913 he exhibited with Macke, Kandinsky and others in Berlin. He met Robert Delaunay, and was dazzled by Apollinaire's verbal acrobatics; he made a first short visit to Paris. Early in 1914 he met Jean Arp, a lasting friend and influence.

"On August 1st 1914 Max Ernst died. He was resurrected on November 11th 1918 as a young man who aspired to find the myths of his time." He was in fact a gunner on active service; appalled by the experience of war ("Howl? Blaspheme? Vomit? . . ."), he was ripe for Dada. He found Arp again; he also came across scientific drawings of micro-organisms, and harnessed their strange shapes into a biomorphic imagery that the Surrealists later found irresistible, as did Arp. He discovered Chirico, which sparked off his first collages. "*Aquis Submersus*" (Plunged in the waters) of 1919, perhaps his first major painting, shows a clear debt to Chirico; it was shown at the first Cologne Dada exhibition. At the second exhibition, which was entered through the men's

Max Ernst
Ernst was an exponent of Dada in Cologne; in Paris from 1922, he was one who led it into Surrealism.

ERNST (right)
"*Aquis submersus*" (Plunged in the waters), 1919
The debt to Metaphysical painting is clear – blank, empty space, still statues – but the mood is both weird and almost merry. It rejoices in simple visual puns – the blank reflection in water of the clock-faced moon, an impossible diver inverting the shape of the dummy that grins in the foreground.

ERNST (below)
Katerina ondulata, 1920
The chevron design on the angular construction is in fact a piece of wallpaper, which Ernst has overlaid with gouache in a kind of *papier collé* in reverse.

ERNST (right)
Men shall known nothing of this, 1923
Dedicated to André Breton, the work incorporates many of the Surrealists' *leit-motifs*. A vast sky, an empty desert, are the setting for an erotic theme spelled out by a poem on the back of the canvas, which explains the image as an ideal of cosmic and sexual harmony.

ERNST (below)
The elephant Celebes, 1921
Grotesque mechanical forms that nevertheless suggest humans or animals recur in Ernst's work. This vivid, monstrous mix of vacuum-cleaner and elephant shows a developing Surrealist illusionism; by including some intelligible images within a still irrational composition, the artist can disturb more profoundly than with just the bizarre.

ERNST (above)
Hundred-headed Woman: Germinal, my sister, 1929

Engravings from popular Victorian fiction are set upon by sadism, corruption.

lavatory and which included works offered up for destruction, a collage of his was condemned as pornographic, but the pornographic element in it proved to be Dürer's print *Adam and Eve* (see p. 152). Some of Ernst's work of this time (probably influenced by Picabia) also presents nightmares of mechanical or scientific apparatus animated by human desires, somewhat like Duchamp's.

Ernst was interested neither in the political nor in the caricatural possibilities of Dada. Always attracted to Paris, he gravitated there in 1922. His reputation had preceded him. André Breton, soon to be the major prophet of Surrealism, had organized an exhibition of Ernst's collages in 1920; the greatest Surrealist poet, Paul Eluard, illustrated a volume with Ernst's images. By the time of Ernst's arrival in Paris, the brief Dada explosion there was almost spent, and the movement was ripe for consolidation into an orthodoxy by Breton.

The realistic element in Ernst's work was by now established. For him it was necessary to touch off "the strangest poetic sparks by bringing together two seemingly unrelated elements on a plane unrelated to both" – an effect vividly achieved, for example, by the juxtaposition or conjunction of two widely disparate but realistically rendered objects (such as a female torso and a bird's head) by the collage method. In Paris Ernst, in company with others such as Picabia, Arp, Man Ray, experimented with new techniques for precipitating images hidden in the unconscious mind. By 1923 he was working on paintings in a fully Surrealist vein, and in 1924 Breton announced the official birth of Surrealism as a coherent movement, soon to become a weird orthodoxy, and ultimately a dogma. In 1925, Ernst discovered a technique which was to prove most rewarding for him, *frottage* – a texturing achieved in simple form by rubbing pencil, chalk or even paint on paper laid over strongly grained wood or another textured material; subsequently elaborated by divers methods. This technique served him admirably in those characteristic paintings, at first glance naturalistic visions of moonlit forests, that turn on closer study into fearful dreams.

Ernst was never one to fit easily into an orthodoxy, and committed various heresies against Breton's gospel. His activities were vigorously diverse. His great collage novel, *La Femme Cent Têtes* (Hundred-headed woman), was published in 1929; he collaborated in films with Buñuel and Dali, designed sets and costumes for Diaghilev and the Ballets Russes. In 1938, he quit the Surrealists. In 1941, after being interned in France as an enemy alien, he moved to New York and there was briefly married to his second wife, the collector and art impresario Peggy Guggenheim. The fertility of his imagination, his technical inventiveness and improvisation, flourished unabated: in 1942, in *Man intrigued by the flight of a non-Euclidean fly*, he used a drip technique, preceding Pollock. In 1949, he returned to France, to become ultimately a French citizen. The mood of Ernst's paintings is often reminiscent of the haunted desolations of his great German Romantic predecessor, Friedrich, even if his pictures of the 1930s frequently seem omens of the nightmare about to take substance; his vision of *Europe after the rain*, painted 1940-42, could be a prophecy of the earth's surface in radioactive mutation after the atomic bomb. In his later years, Ernst's mood mellowed; at all times his wit and humour could break free, while his technical virtuosity, his range of glowing colour, are as brilliant as any painter's of modern times.

ERNST (left)
The great forest, 1927
Enchantment and terror, Ernst's feelings when he first entered a forest as a child, are recaptured in the almost fungal effects of his *frottage*, evoking "a new, incomparably vaster domain of experience".

ERNST (right)
Man intrigued by the flight of a non-Euclidian fly, 1942
A puzzled "geometric" man gazes in comic confusion at a fly, its dizzying motion conveyed in drips of paint (from a can circling above).

ERNST (below)
Europe after the rain, 1940-42
Even if inspired only by doodles or random images, such visions are convincing as descriptions of other, wholly credible realities.

Surrealism 1: Figurative

"Surrealism: noun, masculine. Pure psychic automation by which one intends to express verbally, in writing or by other method, the real functioning of the mind. Dictation by thought in the absence of any control exercised by reason, and beyond any aesthetic or moral preoccupation. (Encycl., Philos.) Surrealism is based on the belief ... in the omnipotence of dreams, in the undirected play of thought."

The definition comes from the *Manifesto of Surrealism* published by Breton in 1924. André Breton (1896-1966), the so-called "Pope" of Surrealism, deplored the nihilistic and destructive character of Dada; nevertheless he built on many Dada ideas to create a movement with a comparatively coherent philosophy, although, like Dada, it was as much a total way of life as an artistic credo. Fairly rapidly it developed into an orthodoxy, prone to disruption, heresy and schism, though it was armed (at least in the "Pope's" view) with powers of excommunication.

Surrealism was essentially a revolt against the intellectual concerns of Cubism, against formalist art, Art for Art's sake, against abstraction. Breton himself was a dedicated student of the work of Freud. Initially Surrealism was primarily literary, claiming as ancestors writers such as Rimbaud, Lautréamont, Jarry or Apollinaire (who had first used the term "surrealist"). "Pure psychic automatism" – the untrammelled expression of the Unconscious – is easier to achieve in writing than in the more complex, more constraining materials of the visual arts, which – especially sculpture – inhibit the desired spontaneity of free association. On the other hand, painting could trap a dream into physical substance, and in the works of Chirico (see p. 418) the Surrealists found a language of dream imagery that for some seemed almost definitive. Tribal art had again particular significance, and the congruence of incongruous objects, most vividly achieved in Ernst's collages, remained a staple of Surrealist imagery. The ideal text for a Surrealist painting had been provided by Lautréamont's famous phrase, "as beautiful as the chance meeting on a dissecting table of a sewing machine and an umbrella".

The movement early included artists enlisted from the ranks of Dada, some of them major, such as Ernst (see preceding page) and Arp (see pp. 414 and 429). It fostered its own

DALI (above)
The temptation of St Anthony, 1947
Dali has admitted a frank respect for the themes of the European tradition; St Anthony's persecution by the devil is reinterpreted as a confrontation with unconscious forces.

MAGRITTE (right)
Time transfixed, 1939
Some kind of logic in the relationship of seemingly unconnected objects may give Magritte's best work its power to disturb. The fireplace recalls a tunnel, the engine's smoke evokes the function of the hearth.

MAGRITTE (above)
The human condition, 1934
The perfect continuity of the landscape across the easel and window imparts an uneasy sense that the removal of the easel would reveal a frightening void. The idea might have come from the artist's early experiments with collage.

DALI (right)
The persistence of memory, 1931
Dali rejoices in fetishes and obsessions. His famous soft watches were allegedly inspired by the experience of eating Camembert cheese. He loves to set images of decay in a golden glare at once heavenly and sinister. He paints dream-pictures; Magritte made illusions.

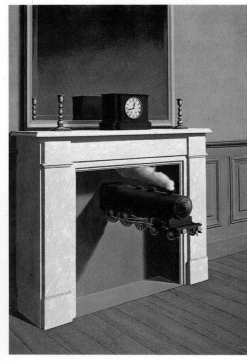

major artists, such as Miró, Dali and Magritte, but other major artists, not formally linked with the movement, also began to exploit imagery properly classifiable as Surrealist. Indeed, in the 1920s and 1930s, Surrealism was the dominant avantgarde art in Europe.

Two main trends co-existed. One was dependent on figuration, on the precise reproduction of natural forms – generally juxtaposed, transposed, displaced or mutated far from real situations. The other moved towards abstraction, to an imagery without specific reference to forms found in nature, to forms generated within the Unconscious (see over).

The most remarkable of the figurative painters was the Belgian René Magritte (1898-1967), who perfected an academic, naturalistic, illusionistic technique of accurate, flatly prosy description. Apart from a brief stay near Paris in 1927-30, when he met Breton and exhibited with the Surrealists, Magritte spent a discreet and industrious life in Brussels, painting the impossible with calm and confident conviction. Magritte was the most accomplished disappointer of conventional expectations, exploiting astonishing discrepancies of scale (an apple fills a room; a loco-

motive bursts through a giant fireplace); denying the laws of gravity; endowing the sky with a material substance that can be cut out and put on to an easel. His strangeness is heightened by his use of everyday objects: the hero of many of his later pictures is the man in urban uniform – coat, bowler hat, sometimes a brief-case – as expressionless in the even light as a tailor's dummy. The ambiguity of the relationship between the object and its painted image is stressed constantly – a faithful likeness of a pipe, inscribed *This is not a pipe*.

The quietness of Magritte's method had the result that his achievement was for some time undervalued; public attention to the Surrealists concentrated rather on the frenetic activities of the Spaniard Salvador Dali (1904-1989), *provocateur-en-chef* of the bourgeoisie from his first association with Parisian Surrealism in 1927 onwards. Like Magritte, however, his technique was that of nineteenth-century academic naturalism, applied to unreal (or a mixture of real and unreal) subjects as if they were real. He worked in many media, in writing, painting, jewellery, film – including, with Luis Buñuel, the famous Surrealist film *Un Chien Andalou* (An Andalusian dog) – but

perhaps above all in his own fantastically moustachioed person, in a spectacular public career often virtually like show business – a giant egocentricity powered by an energetic paranoia. His relations with official Surrealism, at first euphoric, later became strained.

A more constricted talent, but one that introduced an individual and enduringly mysterious note into the range of Surrealist imagery, was that of another Belgian, Paul Delvaux (born 1897). In paintings of the 1930s and since he has realized a world of lonely alienation, suburbs of desolation haunted by trains and trams, peopled by silent waiting women who prove on closer inspection to be all identical – perhaps the most intense realization of dream or nightmare achieved by any Surrealist. However, he was not formally associated with the Surrealists; nor was Maurits Escher (1898-1972), a Dutchman. Escher was not strictly a Surrealist at all, though he is most easily considered in that context. His best-known works are his brilliantly calculated games with perspective, presenting with great precision quite different images interpenetrating with such ambiguity that the eye cannot establish where one begins and the other ends.

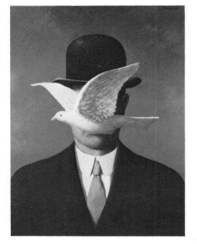

MAGRITTE (left)
Man in a bowler hat, 1964
The epitome of bourgeois respectability, a bowler-hatted man figures in many of Magritte's meticulous scenes of visual absurdity.

DALI (right)
The Venus de Milo of the drawers, 1936
The image suggests today Melanie Klein's theories that the infant desires to excavate the maternal breast, not only to suck.

DELVAUX (below)
The village of the sirens, 1942
Idealized forms set in a space recalling Chirico evoke an erotic dream.

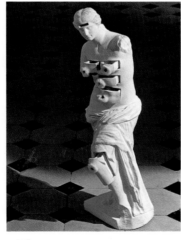

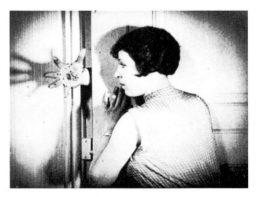

DALI AND BUNUEL (above)
Still from *Un Chien Andalou*, 1929
A hand swarming with ants

is one of the film's milder images; its gruesome early sequence provoked a riot. Breasts, buttocks abounded.

ESCHER (above)
Still life and street, 1937
Tricks of perspective and scale in Escher's work can

induce a sense of hallucination in the viewer. His prints became popular in the 1960s "drug culture".

Surrealism 2: Abstract

The representational side of Surrealist art appears at its most successful in the work of Magritte, Dali (at his best) and Delvaux (see preceding page), and in the work of certain other artists who in their variety and achievement escape categorization in any one mode. Picasso (see p. 450) was one, Ernst (see p. 420) was another, and Arp (see p. 429) yet another, and in the 1930s Giacometti, a late-comer. Nor can Henry Moore (see p. 448) be considered without reference to Surrealism, or Surrealism be considered without reference to the continued carryings-on of Marcel Duchamp (see p. 416), Picabia and Man Ray (see p. 414).

The non-representational wing of Surrealism was no less vigorous. The work especially of Arp was more often non-figurative than not, but the major artists most consistently independent of natural phenomena were the Spaniard Joan Miró (1893-1983) and the Frenchman André Masson (1896-1987), who had studios side by side in Paris and who both joined Breton's Surrealist group at its launch in 1924. For a time both experimented freely with "automatic" drawings, the visual counterpart of the crucial technique or non-technique of Surrealist irrationalism, "auto-matic" writing: its intention was to allow free association so as to find, if possible, an absolutely spontaneous expression. Both found the development of Cubism, whether into the rigid doctrinaire theories of Gleizes, or towards the austere geometric reductions of Mondrian, sterile and inadequate to their needs. Masson's outlook was conditioned permanently by appalling experiences in World War I; he was obsessed by the domination of the rule of tooth and claw in all life, animal or human, and his work is a release of the violence of base instincts. He was himself a violent man, who bellowed emotive phrases while he worked, and often physically attacked unsatisfactory canvases. By 1926 he was exploiting chance and accident as part of his technique: he would scatter sand over canvases previously spread in haphazard areas with glue, and then, at great speed, orchestrate their random configurations and textures into loose rhythms of brushwork and colour. The images that appeared were brutal; they gradually became more specific, and horrific creatures emerged. In 1929, Masson withdrew from the official Surrealist cadre, and some find his work of the 1930s less intense and less successful. How-

TANGUY (below)
The palace of windows at the rocks, 1942
In order to purge himself of all conscious intention, Tanguy is reputed to have painted his randomly titled compositions upside down.

MASSON (above)
Furious suns, 1925
The expressive potential of "automatic" writing and drawing was promoted by Breton, in whose theories Masson found the means to "seize at last the knife immobilized upon the Cubist table". This transformation of Cubism made him, later, a crucial link in the chain from Picasso to Pollock, from Cubism to Abstract Expressionism.

TANGUY (right)
The more we are, 1929
Tanguy taught himself to paint after seeing a work by Chirico in a Parisian shop-window. He had been a sailor, and the memories of his marine experiences are even more obvious in his early works than later, when he enlarged his forms: biomorphic, yet painted in metallic colours, they cast harsh shadows over a landscape of apparent infinity.

MASSON (above)
The battle of the fishes, 1927
Masson's spontaneous line learnt to make shapes, so to speak, in a Cubist school. But Cubist splintering has been energized to express movement, rage, instinct.

MIRO (below)
Dog barking at the moon, 1926
We recognize a few simple figurative images while at the same time allowing that they are visionary elements belonging to another, wholly fantastic, personal reality.

424

ever, in America during World War II, moved once again by the horror of man's inhumanity to man, he reverted to more "automatic" procedures, and his work of these years influenced the subsequent emergence of the Abstract Expressionist school after the War.

Yves Tanguy (1900-1955), largely self-taught, was taken into the Surrealist squad by Breton, and from 1926 discovered and developed his own vivid and original imagery, a realization of the hallucinatory state of mind in a convincing alternative to the dreams formulated by Chirico. Tanguy's imagery often seems submarine, suggesting an endless sea-bed littered with debris, some of it resembling ominous amoeba-like organisms previously unknown to science. Increasingly he developed the contrasts and variety of his textures, so that his pictures might be classed as a kind of Metaphysical Dutch still-life painting. Forms grew beneath Tanguy's brush under their own mysterious prompting, so he maintained, rather than by any intervention on his part.

The most prolifically various, most genial and also generally the most optimistic of the practitioners of abstract Surrealism was Joan Miró, though Miró himself has always dis-

missed suggestions that his work is abstract; for him, his armoury of fantastic forms always signifies real objects. He was, like Picasso and Dali, one of that brilliant breed of new Spanish artists who arrived in Paris in the early twentieth century but, unlike Picasso, he returned constantly from Parisian turmoil to his native country. Immediately after World War I Miró was working in a style of meticulous realism, from which the development of his mature style emerged almost abruptly, like a butterfly from its chrysalis, about 1924-25, certainly encouraged by his contacts with the new Surrealist group. Some commentators on Miró have been obsessed with the sinister overtones in his work, with omens and signals of catastrophe, and in his darker works (especially during and after the Spanish Civil War, 1936-39) such signs are certainly there, but again and again a positive gaiety sparkles from his canvases – ferocious, often, but with the ferocity that one finds in children's art.

Miró's imagery was fully established in a famous canvas of 1926, *Dog barking at the moon*, which one might well suspect to be the original fount from which the comic strip *Peanuts* developed. His strange images tend to

be biomorphic, similar to those of Arp, and his fantasy is often close to that of Klee: unknown but convincingly possible organisms take shape, defined in clear outline and sharp lucent colours – primary reds, blacks and whites predominate. Words and phrases sometimes float on the canvas: Miró admitted no differentiation between poetry and painting, and claimed that his work always grew from "a state of hallucination, provoked by some shock or other, objective or subjective, for which I am entirely irresponsible". Irresponsible or not, the initial conception is then marshalled by an unerring sense of design, of space and interval, into a strange formal harmony. During World War II, in Spain, he turned his attention to printmaking, and later to sculpture and especially ceramics. He began afterwards to work on a very large scale, in giant murals such as those for the Terrace Hilton Hotel in Cincinnati (1947; not shown) or the ceramic walls of the UNESCO building in Paris (1958). In his restless inventiveness he was prepared to investigate the possibilities of any medium, often in collaboration with specialist craftsmen, and the fertility of his vision has never slackened in his long career.

MIRO (right)
Painting, 1933
By the 1930s Miró had achieved his full artistic maturity, making dramatic use of colour; against the ground of limited primary colours bizarre, expressive organisms are suspended, absurd, idiotic, profound.

MIRO (above)
Aerial acrobatics, 1934
Miró's inherently graphic imagination tends to revert to linear creatures: these dance, float and wriggle in and about his pictures, apparently engaged in gentle, endearing games, in defiance of the laws of gravity.

MIRO (below)
The wall of the moon, 1958
His growing interest in the interaction of broadly handled abstract lines and colours attracted Miró to large-scale projects – these tiles adorn a wall of the UNESCO Building in Paris.

Cubist Developments

Cubism had been transposed into three-dimensional form, into sculpture, before World War I. Picasso once said that it would be enough simply to cut up an early Cubist painting, then assemble the pieces "according to the indications given by the colour", to be confronted by a sculpture. He had turned to sculpture even before 1910, and was to indicate many of the directions in which twentieth-century sculpture would develop in his *Glass of absinth* of 1914. But his later excursions into welded iron are best considered in relation to the mainstream of his work (see p. 450).

The work of other Cubist sculptors revealed rather different preoccupations, though most "opened up" form as the painters had done, introducing voids where one would expect solids, making out of voids distinct shapes. The two most original experimenters were Raymond Duchamp-Villon (1876-1918), the elder brother of Marcel Duchamp, and the Russian Alexander Archipenko (1887-1964). Archipenko created in his *Walking woman* of 1912 the first pierced-form figure sculpture of the modern era, conveying a dancing rhythm in its abstract arrangement of convex and concave curves. He also experimented with "primitive" forms, inspired by African and Egyptian art, and with figure constructions cut from glass, wood or sheet metal. His initial vigour, however, later subsided, during a long career, into an increasingly mannered elegance. Duchamp-Villon applied Cubist theory to sculptural form with perhaps the greatest success: his *Horse* of 1914 achieves a fusion of the mechanical and organic in a concentrated expression of elemental energy, of strength and thrust, that seems also to answer Futurist needs – even more than Boccioni's work. But Duchamp-Villon's career was interrupted by war, and he died from fever in 1918.

Other sculptors venturing into the Cubist idiom included Henri Laurens (1885-1954; not shown), Jacques Lipchitz (1891-1973) and Ossip Zadkine (1890-1967). Lipchitz – who heartily disliked the new ideas propagated by Brancusi (see p. 394) – remarked: 'Cubism was essentially a search for a new syntax. Once this was arrived at, there was no reason for not employing it in the expression of a full message." His early sculpture, in its marvellous and strong simplicity, remains the most impressive, for instance the justly famous *Bather* of 1915. Subsequently he elaborated style and

ARCHIPENKO (left)
Walking woman, 1912
Here space is expressed for the first time as a volume – holes represent forms, the woman's head and torso. The solid elements echo the painted forms of Picasso, his guitar curves.

DUCHAMP-VILLON (below)
The horse, 1914
There is little left of the naturalistic form, save a suggestion of the horse's head, a leg and a hoof. The subject is animal energy, resolved into spring-like spirals. There are links with Futurism: Duchamp-Villon had met Boccioni in 1913.

PICASSO (above)
The glass of absinth, 1914
Picasso's sculpture was the logical extension of his painting: the spoon is real, like elements in his "synthetic" collages; the bronze vessel is opened out, "analysed", and the whole structure brightly coloured.

ZADKINE (below)
The destroyed city, 1953
A tormented Atlas, both resisting and imploring, Zadkine's pierced bronze is violently contorted and torn. Emulating Rodin's ability to express a state of mind, he achieved a rare concentration of expression.

LIPCHITZ (above)
The bather, 1915
The geometrical precision of Lipchitz's figure evokes architectural rather than natural, human, structure. The sources of inspiration were tribal and archaic objects, which he collected.

content – approaching very close to Juan Gris' later style of synthetic Cubism – during a long and successful career, from 1941 in America. Laurens, a friend of Braque, produced at one point Cubist polychrome reliefs and constructions in wood, plaster and sheet metal, but later on developed a very different style – monumental organic forms, in which a feeling for swelling volume was predominant. Zadkine was never so purely Cubist; he exploited a jagged style, sometimes like a jazzed-up version of Cubism, but his finest achievement came in a few later works, such as *The destroyed city*, 1953, revealing an Expressionist intensity in his memorial to blitzed Rotterdam.

Painting could never be quite the same after the early Cubist developments (see pp. 396-399). Picasso and Braque went their separate ways; indeed, there was a rift between them. Braque, while retaining and exercising to the full that autocratic power over the anatomy of his subject matter which Cubist practice had revealed to him, relaxed from Cubist severity to become one of the most seductive decorative painters of all time, with a profoundly sensuous feeling for texture, for "*la matière*" and for colour. Juan Gris (not shown here) con-

tinued single-mindedly developing a rigorous, cool Cubism during the War and after, until illness sapped his strength before his early death in 1927. But Cubism continued also to provoke counter-movement, dependent but reactive development: "Purism" was the brainchild of Amédée Ozenfant (1886-1966) and Charles Edouard Jeanneret (1887-1965). Its tenets were set out in *After Cubism*, published in 1918: Cubism was held to have lapsed into mere decoration; Purism was a call to order, in which subjective fantasy would be eliminated and a crystalline architectonic structure established. A few paintings of serene clarity emerged, but Ozenfant became more important as a teacher and propagandist, while Jeanneret, under the name of Le Corbusier, went on to become perhaps the most famous of twentieth-century architects.

Fernand Léger (for his earlier work see p. 398) also associated with the Purists; their fascination with simplified machine forms was highly congenial to him. He, however, enriched the rather narrow and ultimately arid Purist doctrine with ingredients rejected by the Purists as impure, amongst them a profound sense of solidarity with working people,

brought home by his experience with "miners, navvies, workers in wood" in the Engineering Corps during World War I. He had also been dazzled by the beauty of machinery, such as "the breech of a 75 mm gun, which was standing uncovered in the sunlight; the magic of light on white metal ... Once I had got my teeth into that kind of reality, I never let go of objects again." He came to see painting as a reflection of – even a confrontation with – twentieth-century technology: "The work of art must bear comparison with the manufactured object." In fact a painting such as "*Le Grand Déjeuner*" (The feast) of 1921 amounts to a statement of serene classicism, almost a contemporary reformulation of Poussin, though despite its "Grand Manner" it retains an intimate charm. In the mid-1920s Léger was still painting in an essentially Purist manner – highly formalized still lifes. Later, this austerity was relaxed (see p. 477) in favour of freer contours and looser spatial arrangements. But his integrity and his certainty of touch held fast throughout his career, while he was able to respond imaginatively to all kinds of contemporary work: "Léger", as Ozenfant said, "can make good Léger out of anything."

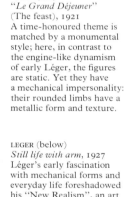

LEGER (left)
"*Le Grand Déjeuner*"
(The feast), 1921
A time-honoured theme is matched by a monumental style; here, in contrast to the engine-like dynamism of early Léger, the figures are static. Yet they have a mechanical impersonality: their rounded limbs have a metallic form and texture.

LEGER (below)
Still life with arm, 1927
Léger's early fascination with mechanical forms and everyday life foreshadowed his "New Realism", an art in which objects robbed of their normal values become symbols of a new world. An arm is isolated, no longer human, and bowl and fruit are fragmented in what still is a Purist kind of Cubism.

OZENFANT (left)
The jug, 1926
The Purists felt Cubism had become too whimsical, too like "embroidery and lace-making", when it had a mission to accomplish. Like the artists forming De Stijl at the same time, about 1917, the Purists shared a common style, governed by a geometric precision and by economy of means; but the Purist pictures were figurative. Theirs was an art for the contemporary world, but it had a timeless quality and a universal validity that recalled Neoclassicism. Ozenfant painted vases and vessels of everyday life in a sharp-edged style, in flat, rather deep colour.

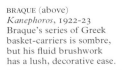

BRAQUE (above)
Kanephoros, 1922-23
Braque's series of Greek basket-carriers is sombre, but his fluid brushwork has a lush, decorative ease.

Sculpture between the Wars

The once relatively firm divisions between the branches of the arts began to dissolve in the twentieth century. Major and minor artists tended to experiment in all sorts of media; in particular, painters frequently turned to sculpture – not only Picasso (see p. 450) and Matisse but also Ernst, Dali (see p. 423), Magritte, Miró. Already by 1913 Marcel Duchamp was including non-sculpture in his non-art campaign: when he mounted a freely revolving bicycle wheel on a kitchen stool (see p. 417), he announced not only the "ready-made" – and the right of the artist to make anything a work of art or part of one simply by selecting it – but also the beginning of one of the major innovations of twentieth-century art, moving sculpture. By 1920 he had even begun to experiment with optical effects in his *Rotative plaques*, which foreshadow kinetic and Op art in the third quarter of the century.

Brancusi and the Cubist sculptors had opened up the main avenues to be explored in standing sculpture. In eliminating superficialities to reveal the essential core and shape of mass, Brancusi (see p. 394) brought the sculptor back into harmony with his material, sponsoring "direct carving". The Cubists (see preceding page) were primarily modellers or constructors, opening up the solid mass, giving value to voids, and exploiting new materials, such as welded iron. The scope or subject matter of sculpture ranged from the surreal to Constructivist abstraction.

The Russian Constructivist Naum Gabo, actively involved with Revolutionary art in Russia after 1917 (see p. 407) by 1922 realized that abstract art for the foreseeable future had no home in the communist state. He moved to Berlin in 1922, and his elder brother Antoine Pevsner (1886-1962) followed him in 1923. These two transplanted Constructivist principles and practices into the West. They defined their art in their *Realist Manifesto* of 1920 as "the realization of our perceptions of the world in the form of space and time . . . We construct our work as the universe constructs its own, as an engineer constructs his bridges, as a mathematician his formula of the orbits." The Constructivist sculpture existed simply as an object in its own right, governed by its own laws, but crucial importance was attached to the concept of movement: "A new element, kinetic rhythm, is the basic form of our perception of real time." Gabo's first kinetic

PEVSNER (below)
Marcel Duchamp, 1926
Pevsner had met Duchamp in Berlin in 1923. His little "homage" portrait consists of copper (originally zinc) and celluloid plates set on a wooden ground: he had in Gabo's celluloid heads of this period some precedent, but the faceted construction most recalls early Cubist portraits. A strong spirit inhabits its robotic form.

DUCHAMP (left)
Rotative plaques, 1920
Duchamp's experiments in kinetic art and in an art of optical illusions were spiced with a fine sense of the futility of it all – gadgets without purpose.

GABO (below)
Kinetic sculpture (Standing wave), 1920
Gabo made his first motorized construction in 1920. The vibrating rod creates in time a defined space, neither a mass nor a void.

PEVSNER (above)
Torso, 1924-26
Pevsner first produced sculpture in the 1920s. His thin copper sheets enclose spaces which form the volume of the torso, "utilizing emptiness and liberating us from solid mass" (*Manifesto*, 1920).

GABO (right)
Sculpture at Bijenkorf's, Rotterdam, 1954-57
Searching for a huge, free-standing image, Gabo came upon the idea of a tree of steel, its members twisting like branches. He said his sculpture was "the image of order – not of chaos".

construction (1920) was an erect moving rod, electrically oscillated. Later, he abandoned physical movement in favour of movement indicated or implied. He experimented continually with new materials, especially flexible and transparent plastics. The commission for the Bijenkorf Store in Rotterdam enabled him at last (1954-57) to realize his concepts on a monumental scale, in a steel and bronze wire construction nearly 26 metres (80ft) high. Gabo's brother Pevsner turned, under his influence, from painting to sculpture, and subsequently often achieved an exquisite marriage of high precision and poetry, echoing machine forms; Pevsner was always essentially concerned with movement.

Constructivist austerity did not evoke a wide popular response. The American Alexander Calder (1898-1976) moved towards a more sensuous poetry: initially an engineer, his fantastic experiments with animated toys excited Surrealist attention. Contact with Miró but also, more unexpectedly, with Mondrian influenced his first "stabiles", free-standing metal structures with moving elements; these in turn flowered into his famous "mobiles" (the term was coined by Duchamp). These

were inspired by the idea of "detached bodies floating in space, of different sizes and densities ... some at rest while others move in peculiar manners. Symmetry and order do not make a composition. It is the apparent accident to regularity that makes or mars a work." His career continued long after 1945 (see p. 479).

A still closer connection with living matter was developed by Jean (Hans) Arp, a poet as well as a sculptor. Early linked with Max Ernst and with Dada (see p. 414), he was associated with the Surrealists from the time he first exhibited with them in Paris in 1925. By 1914 he had experimented with coloured reliefs of cut-out plywood, abstract, but expressed in biomorphic shapes. With Sophie Taueber (1889-1933; not shown), whom he married, he worked in paper, tapestry, collage, creating "pictures that were their own reality, without meaning or cerebral intentions". Arp intended his material to take on its own shape; it was the role of the artist to create the conditions in which the work of art could create itself. His commitment to nature, however, was unshakable: "Art is a fruit on a plant, like a child in its mother's womb." This principle was developed more fully in the 1930s, when he turned

to modelling and then carving in the round: his organic forms are highly successful, best in marble, pure white and smoothly rounded, complete and superb alternatives to nature's own organic forms. In these he often came close to Brancusi, still active if aloof like a sage in his white studio (see p. 394).

The early work of Alberto Giacometti was perhaps more essentially Surrealist than was Arp's or Calder's – especially the series of enigmatic, magical constructions he made before his break with official Surrealism in 1935. Subsequently his work was to be much more Expressionist (see p. 480). Julio González (1876-1942), compatriot and friend of Picasso in Paris, was a prime innovator in the application of techniques of forging and welding iron to sculpture. Though very close to Picasso, in the 1930s he developed an independent, tough vein of imagery; starting always from the human figure, he achieved a formidable austerity and strength.

Many of the major sculptors of the 1930s (such as Henry Moore – see p. 448) consolidated their careers after World War II, but almost all the post-War developments are to be found in embryo in the work of the 1920s.

CALDER (above)
Romulus and Remus, 1928
Like Klee, Calder "took a line for a walk", but a walk in space, with a line of wire. The twins suckled by a wolf are figurative; later Calder became more abstract, but not completely so; simpler, but always light, fanciful.

ARP (below)
Human concentration, 1934
Arp regarded his sculpture as "concrete", not abstract – his forms are organic, not artificial, conditioned by his chosen material, and derived from nature. The artist's Unconscious and chance played their part.

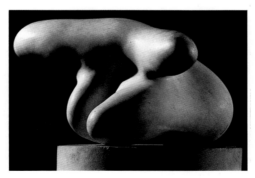

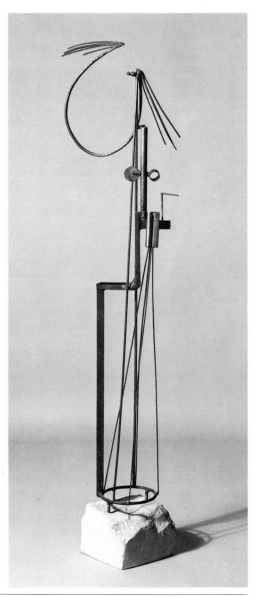

GIACOMETTI (left)
The cage, 1932
Associating with Arp and Miró in Paris, Giacometti created subtly suggestive sculptures, rediscovering strangely altered in them when completed "images, impressions, facts which have deeply moved me".

GONZALEZ (right)
Maternity, 1934
González evolved his daring reduction in welded iron in the 1930s, uniting "real with imaginary forms ... suggested by established points or perforations." New forms evolved through truth to these new materials.

Modigliani: Chaim Soutine

In 1917 in Paris Amedeo Modigliani (1884-1920) painted Chaim Soutine. Modigliani and Soutine were colleagues and drinking companions. Modigliani set his friend within the rather narrow compass of a tall canvas, which he had by then established as his chosen format for single portraits. Cézanne had used a similar scheme, and Modigliani had been impressed no doubt by Cézanne's example, his unflinching confrontation with his sitters; but the format also accentuates Modigliani's characteristically elongated, attenuated vision. His subject is reduced to an almost schematic formula of a long oval (the body, with the hands looped to clasp somewhat primly) linked to a second, smaller oval (the head) by an elongated neck (when his sitter was female, it grew sometimes swan-like). In Soutine's portrait there is a minor elaboration in the formula, provided by the compartmentation of the picture space by the corner of the room and by the rudimentary table with the glass, perhaps witness to their shared interest. However, the variations that Modigliani achieved within this simple, almost monotonous scheme were remarkable: Chaim Soutine is subtly but strongly characterized, an individual human being. Details are subordinate to the painter's need for a certain balance and rhythm in the composition, but the likeness is there, even though the neck is long and the eyes somewhat eccentrically aligned. There is surely a reflection of Soutine's character in the handling, and especially in the choice of colour. In his early paintings, Modigliani relied on a very limited, rather sombre palette of ochres, greys, browns and beautiful muted reds (with a pale fluid blue glint for the eyes); the strong colours used here may acknowledge the violence of colour of Soutine's own painting (see over).

Modigliani's colours may well have been influenced by the similar palette of Cubist painting, or even by that of Cézanne, but otherwise, apart from occasional angular distortions (which as much reflected the idioms of African art), Modigliani's style was not fundamentally affected by the Cubist revolution. His work vividly illustrates just how cogent traditional figurative painting can be in the hands of a great talent, taking what seemed profitable from avantgarde explorations and proceeding along its own course. Modigliani, from an Italian Jewish family, academically trained in Italy, came to Paris in 1905 or 1906. He rapidly established the Douanier Rousseau and Picasso as his idols, but his dependence on Italian tradition was ineradicable, and his linear fluency, his elegance, seem to echo Florentine Mannerist art, or Botticelli.

One might not perhaps guess from this portrait that both Modigliani and Soutine belonged to that group of artists sometimes known as *les peintres maudits* – doomed or accursed painters, the archetypal Bohemian artists of popular legend. Modigliani, however, was fatally infected by tuberculosis even before he came to Paris, and there his excesses of drink and drugs, combined with extreme poverty, hastened his death at the age of 36; the macabre coda to which was the suicidal fall of his mistress Jeanne Hébuterne with their baby daughter from a fifth-floor window the following day.

His legend, and the strict, even mannered limitations within which he worked, have in part obscured the remarkable strength and subtlety of Modigliani's work. Besides portraits, he also painted nudes, again in the same sinuous elongations, but with a freshness both pristine and evocatively sensuous. His modelling is achieved by the subtlest gradation of tone and hue; the dominant quality is always linear, and some of his prolific drawings are masterpieces of comprehensive economy. His ambitions as sculptor were furthered by Brancusi's example; he created in a series of tall enigmatic stone heads, in which an African mystery is combined with that of Archaic Greece or Egypt, some of the most haunting "archetypal" images of modern art.

MODIGLIANI (below)
Reclining nude, c. 1919
So harmonious and graceful is the line that one does not at first notice a dislocation of hip and torso as radical as any to be found in Matisse. Though the older man exercised a profound influence over Modigliani, studies such as this seem also to refer back to the great European tradition of reclining nudes, to Giorgione and Ingres – more sensuous than Manet.

MODIGLIANI (below)
Head of a young woman, 1907
The cool, subdued tones are typical of what the artist later liked to dismiss as his "Whistler period". His work became brighter and more sculptural after the major Cézanne exhibition of 1907.

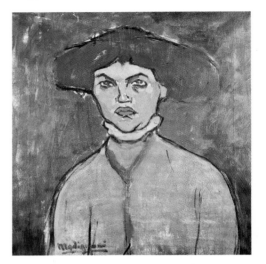

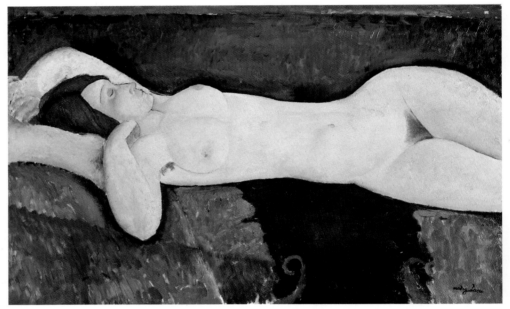

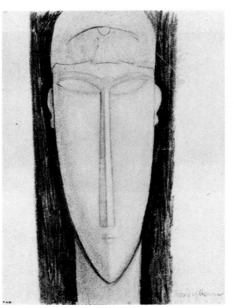

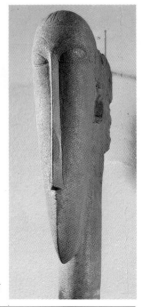

MODIGLIANI (left)
Study for a stone *Head*, 1909-15
The severely simplified shapes give the impression of being exercises in pure geometric drawing which, almost fortuitously, come together to suggest a human face. Within this reduction of form to essentials there is also a cool spirituality that is even more apparent in the carved stone *Heads*.

MODIGLIANI (right)
Head, 1911-12
Tuberculosis forced the artist to abandon sculpture in 1915; however, in a few years he had created from a knowledge of West African figures and Greek *Kouroi* some immensely powerful images. These heads have a refined monumental grandeur, confuting any notion of Modigliani's art as slight.

MODIGLIANI
Chaim Soutine, 1917

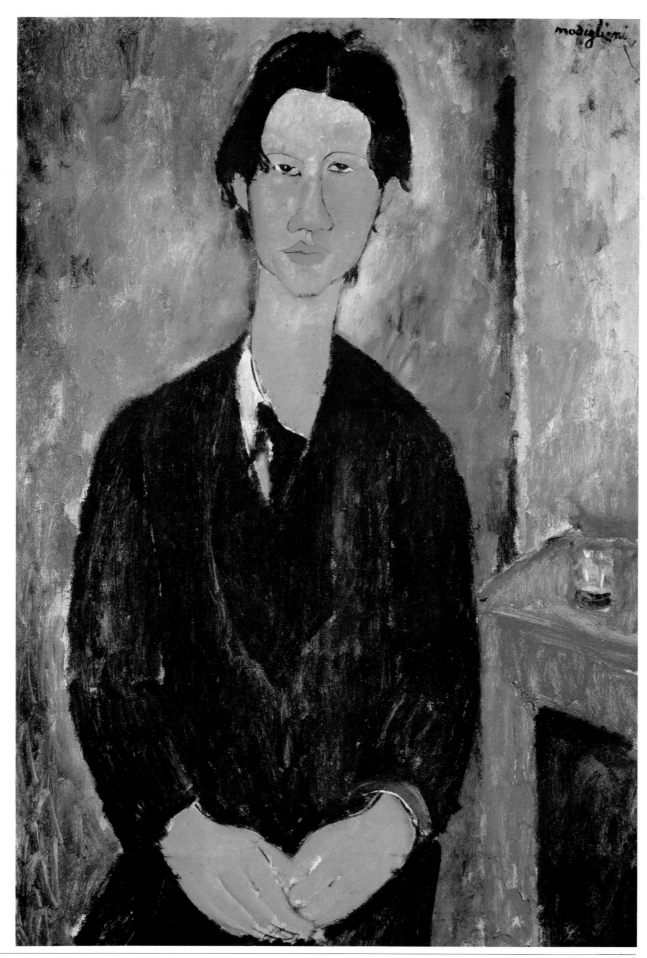

The School of Paris

The label "school of Paris" indicates a climate of opinion, an arena of artistic activity, rather than a coherent style prevailing in Paris in the 1920s and 1930s. The city's standing as the major centre of European art had been clearly established during the nineteenth century, and then in the brief years of the Cubist revolution before 1914. Once World War I was over Paris resumed its ascendancy as the leading art market of the world, sustained not only by artists but also by dealers, patrons and an interested public frequenting exhibitions that often provoked invigorating controversy and scandal. Paris was also the global centre for *haute couture* and *haute cuisine*, and much Parisian art answered comparable appetites for the sensuous and delectable. But the best of it was also informed by traditional French virtues – Chagall later said that on his arrival in Paris in 1910 he went directly "to the heart of French painting, where everything showed a definite feeling for order, clarity, an accurate sense of form".

An astonishing profusion of artists resident in Paris were foreign-born. Spain provided not only the major luminary, Picasso, but also Gris, González and Miró, and Dali arrived in the late 1920s. There came Modigliani from Italy, Mondrian from Holland, Brancusi from Romania. From Russia came Chagall, Soutine, Zadkine, Pevsner, Larionov and others, and finally Kandinsky. The ferment of ideas, the scope for spectacular individuality, the atmosphere of political, religious and social tolerance, these were no less potent magnets for artists than the prospects of a livelihood, which sometimes anyway did not materialize.

The impact of Cubism was registered by all artists of any stature working in Paris, but in varying and very different degree; those who developed more or less within its original principles are considered on page 426, and Picasso himself on page 450. The painters generally grouped as "school of Paris" turned to the figurative rather than the abstract – they included Picasso and Utrillo, for example, rather than Brancusi or Mondrian. The figuration often had a romantic tinge – Pascin's Bohemian prostitutes, Balthus' erotically wistful adolescents, the sinuous languor of Modigliani's men and women (see preceding page). Especially Matisse's continuing work, though he was living as much on the Riviera as in Paris, accorded with this dominant mood.

UTRILLO (above)
Sacré Coeur, Paris, 1937
Utrillo evoked a Sunday afternoon Paris, a sleepy monotony of Montmartre streets and squares that the bustle of tourists has now disturbed. His charm derives largely from the directness of the design, its easy understatement, its lightly touched colour.

MATISSE (right)
Odalisque in red trousers, 1922
That superb patterning of line and colour evolved in Matisse's early work (see p. 392) was developed and enriched still further in the lush harem settings of his *Odalisque* series. The flat decorative elements are offset by the rounded form and radiant flesh of the nude; Matisse reworks Delacroix and Renoir in his own unheady, unheated idiom.

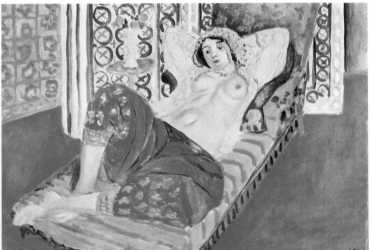

PASCIN (below)
Nude with a green hat, 1925
Pascin was a member of a circle including artists as diverse as Modigliani and Chagall and Soutine. His dreamy female nudes recall both Impressionism (Renoir) and Symbolism (Redon and others), but reveal a study, too, of Cubist structure.

SOUTINE (above)
Oscar Miestschaninoff, 1923
In 1923, the year in which his reputation was firmly founded in Paris due to the patronage of the American collector Dr A. C. Barnes, Soutine painted his friend and fellow-Russian, the sculptor Miestschaninoff (1886-1969). Through bold distortions of form and of colour, Soutine expressed nevertheless alienation and distrust: Miestschaninoff becomes a pained Pierrot.

SOUTINE (right)
The carcase of an ox, 1925
Soutine is reported to have said: "In the body of a woman Courbet was able to express the atmosphere of Paris – I want to show Paris in the carcase of an ox." In the 1920s Soutine's painting came increasingly close to the northern genre tradition – to Chardin and to Rembrandt, whose *Flayed ox* (see p. 246) was in the Louvre. Soutine visited abattoirs, and even brought a carcase home to paint.

Maurice Utrillo (1883-1955) was born into the purple of romantic artistic legend, the illegitimate son of Suzanne Valadon, dishwasher, acrobat, model, friend and mistress to great Impressionist painters and, not least, an artist of considerable talent. Utrillo himself became an alcoholic before he was 20. He established, largely self-taught, a highly personal vision of streetscape, often empty and shuttered, melancholic, expressed most typically in a subdued palette of greens, greys and pale blues over a predominant white: though repetitive, he was a master of the poetry of the Parisian banal. Chaim Soutine (1894-1943), Russian-born, arrived in Paris in 1913 and became a close ally of Modigliani. His violent and impassioned style surely owed much to van Gogh (even if he denied it); though he was a profound admirer of Cézanne, his vision had an explosive quality. His subject matter was often macabre – for example carcases, overtly inspired by Rembrandt. His landscapes could swirl as if molten, but perhaps his greatest strength was in figure studies and portraits, in which his distortions and savage brushwork and colour contrasts were tempered by a delicate perception of character. Jules Pascin

(1885-1930), born in Bulgaria of Spanish-Jewish and Italian stock, worked in Paris from 1905, and again from 1922 until his death by suicide. Between 1914 and 1920 he was in the United States, and took American citizenship; his reputation was higher in America and Germany than in Paris, but in the exotic gaiety, the sophistication of his drawing and his delicate colour, he has seemed to others very French – and he could reveal both the frivolity and the ugliness of the Parisian *demi-monde* with an incisiveness worthy of Lautrec.

The Russian Marc Chagall (1887-1985) is also generally described as "school of Paris", but escapes categorization with the same effortless levitation as the figures that hover in mid-air and swoop and swirl in his pictures. His "Naive" style and his imagery deriving from Jewish folklore absorbed what they needed, and no more, from successive Cubist revelations; Breton in due course was to salute him as a Surrealist – with Chagall, he said, "The metaphor made its triumphant entry into modern painting." In the threatened, anti-Semitic climate of the 1930s Chagall's imagery seems to have become clouded, but after the War the infectious joyfulness of his

visual poetry rekindled, and in a great variety of media. He had become a master of print-making before World War I (working especially for Vollard), and afterwards he branched out into ceramics and stained glass, and theatre design. But his style remained remarkably coherent, governed by his delightful, if often inexplicable, fantasy world.

Other exiles included the Russians Eugène Berman, an inventive stage-designer above all, and Pavel Tchelitchew, who was also a theatrical designer, and a Surrealist (both of these are associated more with New York than with Paris) and Balthus (Balthasar Klossowski de Rola, born 1908). Of Polish origin but born in Paris, Balthus worked alone and secluded for many years and became widely known only late in life; his peculiar ability was to produce strange atmospheric tensions in delineating the psychological unease of adolescence with minutely detailed realism.

Many artists of the school of Paris were scattered by World War II, and after it most lived elsewhere, while the art scene became decentralized and international, though it focused dramatically for a time after 1945 on the school of New York.

CHAGALL (left)
The cock, 1928
The Unconscious was for Chagall a bottomless well of imagery, but he could not accept the Surrealist attempt to exploit it at the expense of the artist's control. Here, the cock and its circus-like rider are fused in consummately balanced harmony of line and stippled colour, in an exquisitely luminous space.

BALTHUS (below)
The living room, 1941-43
The conventional realism of the bourgeois living room is strangely, paranormally, disturbed by the strained poses taken by the young girls; Balthus evokes the quiet dawn of their sexual desire. The space is still, laden with unearthly calm; an abstract rhythm unites shapes across the surface.

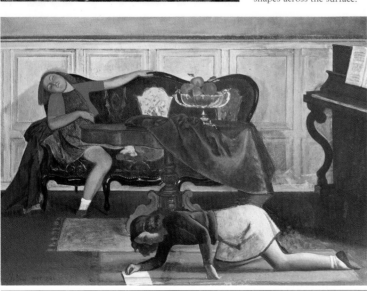

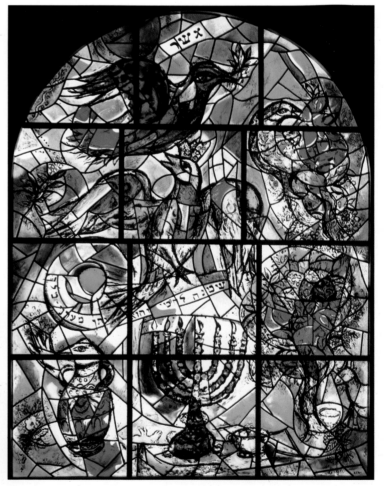

CHAGALL
The Asher window, Haddassah University Medical Centre, Jerusalem, 1960
The cycle of 12 stained-glass windows symbolizes the 12 tribes of Israel with zodiac signs, animals and a host of other images, but not the human form, in compliance to Mosaic law. Chagall's religious ideals and his sense of the past have increasingly animated the fantasy world of his painting, and in Jerusalem found fitting expression.

Art in Holland: De Stijl

During the 1914-18 War Holland successfully maintained her neutrality. In relative stability a small group of Dutch artists was able to consolidate a movement in art that would have perhaps a more pervasive influence in the Western world than any other in the twentieth century, though most lastingly in the fields of architecture and applied design. The leading spirits were Piet Mondrian (1872-1944) and Theo van Doesburg (Christian Emil Maries Küpper, 1883-1931); the movement took its name from its journal *De Stijl* (The Style), first published in 1917 and last in 1932, with a memorial number for van Doesburg. By then the movement had fragmented. Bart van der Leck (1876-1958) was initially an important representative in painting, and the major sculptor was the Belgian Georges Vantongerloo (1886-1965), moving towards geometrical constructions based on mathematical calculations, which were to influence architects perhaps more than fellow-sculptors. Among the architects and designers the most important was Gerrit Rietveld (1888-1964). Mondrian, the most important representative in all Europe of the Constructivist trend, is considered separately (see over), although he was,

with van Doesburg, the most articulate apologist for the underlying philosophy and theory of De Stijl (which he preferred to call Nieuwe Beelding, or Neo-Plasticism).

This Dutch group, with members representing various disciplines, had initially a greater coherence and wider ambitions than most avantgarde Parisian groups – it was almost like an academy. In the first issue of *De Stijl*, van Doesburg expressed its aim – "to state the logical principles of a style now ripening, based on a pure equivalence between the age and its means of expression . . . We wish to pave the way for a deeper artistic culture,

based on a collective realization of the new awareness." The rampant individualism and subjectivity that had become the norm from Romanticism onwards was to give way to an essentially classical, anonymous, collaborative art with a universally comprehensible frame of reference. The group hoped to create for all aspects of life total environments unified in a coherent style. In practice, like most avantgarde novelties, De Stijl was initially treated mostly as outrageous and meaningless.

The commitment was to an abstraction of a ruthlessly austere order – a reduction of form according to a strict grammar of flat surfaces,

VAN DOESBURG (right)
Contra-composition V, 1924
Van Doesburg issued the manifesto of Elementalism, his splinter movement, in 1926, but between him and Mondrian there had been trouble before that. Van Doesburg remained true to the right angle, but with his diagonals deliberately destabilized his pictures. He was influenced by the dynamic abstracts of the Suprematist Malevich.

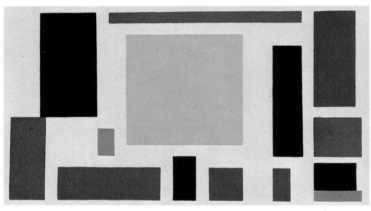

VAN DOESBURG (above)
The cow, 1916-17
Two intermediary stages explained how the final abstract arrangement was developed from the model.

VAN DOESBURG (below)
The card-players, 1916-17
The subject and the basic scheme is taken, in homage, from the series by Cézanne, but not the rigid flatness.

VAN DOESBURG (right)
The card-players, 1917
Even in this strictly De Stijl painting there is a volatility of movement foreign to Mondrian.

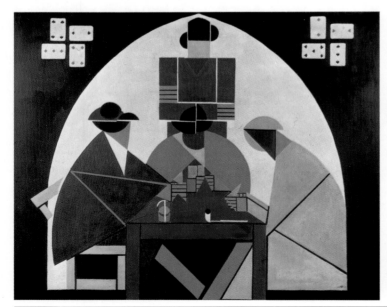

straight lines and right angles. Colour was cut back to three primaries, red, yellow, blue, and the neutrals, white, black and grey. But in the minds at least of the artists concerned these stark essentials were radiant with symbolic life, and reflected an underlying ideal unity and harmony of the universe – a concept derived in part from oriental mysticism and Western theosophy. Specifically, visual equivalents for the basic facts of nature were found in the vertical (the active principle) and the horizontal (the passive); the three primary colours could embrace all emotions, and black and white were clear as night and day. A longing for a universal style had emerged before; De Stijl stripped off all the frills.

Van Doesburg's works, though highly competent, often seem to illustrate a theory rather than to live as paintings in their own right; he was above all a restless, roving, tireless propagandist for abstract art. In his early work, as in Mondrian's, the initial process of abstraction can be traced as if through demonstration models. His *Card-players* of 1916-17 reflects the impact of Cubism and of Cézanne, but the figurative theme is reduced to a patterning of flat shapes and colours, with straight lines

predominant. Shortly afterwards, van Doesburg distilled the composition down to a schematic design expressed purely in terms of straight lines, and it would be impossible for the onlooker who was not aware of the first version to divine its origins. His famous *Cow* was exhibited beside a photograph of a standing cow in profile, with a demonstration of the principles and stages in the creation of a geometrical abstraction from a natural theme.

Having arrived about 1918 at variations on the theme of rectangular shapes distributed according to a proportional system – less spare, but perhaps more mathematically logical than Mondrian's – van Doesburg evidently found his pictures a little tame. In the early 1920s he introduced strong diagonals, which seem positively violent in contrast to Mondrian's purities of that decade. Van Doesburg's *Contra-compositions* were more dynamic and better attuned to the 1920s tempo; Mondrian found them heretical, and there was a rift between the two artists. Van Doesburg, the champion of abstraction, was always prepared to modify his art in the light of other developments – he associated with Dadaists, with the Bauhaus and (as also was Mondrian) with the

Parisian Abstraction-Création group, who were profoundly influenced by De Stijl.

Van der Leck, having entered into simplifications much like van Doesburg's perhaps as early as 1910, had reached by 1918 a most elegant and precise symmetry – in his *Composition* of that year, for instance, the elements are balanced with an unarguable finality; it proved perhaps a dead end, and in the 1920s he began to move back into a more figurative idiom. De Stijl principles were given three-dimensional form by Vantongerloo; his structures were built in straight-edged, cubical blocks until well into the 1930s, when he introduced curves; "I might have known", Mondrian somewhat resignedly commented on this latest deviation. But set in motion amongst the applied arts De Stijl principles proved astonishingly fertile and enduring: Rietveld's classic armchair of 1922 – looking as if it were built to a blueprint by Mondrian – would not seem out of place in a shop today. De Stijl ideals of clarity, certainty and order have been abroad in the world of art ever since, although perhaps only Piet Mondrian, the major prophet and practitioner of the movement, kept faith until death with its principles.

MONDRIAN (right)
Composition, 1917
Mondrian's progress in abstract painting until 1917 had been gradual and independent; with the birth of De Stijl he was affected by joint developments, and his work came very close to that of van Doesburg and van der Leck. This was desirable; it was consistent with a belief in universal values, with the pursuit not of a style but of the style.

VAN DER LECK (below)
Composition, 1918
Van der Leck was in part motivated by his social concerns to join De Stijl, with its Utopian ideals. He did not have Mondrian's single-minded commitment to abstract painting, and in his abstracts chose not to reject diagonals. Here nevertheless the urge to reduction is strong; only one detail obstructs total symmetry of the shapes.

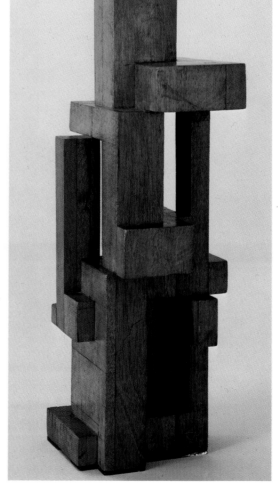

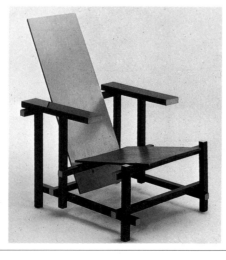

RIETVELD (left)
Armchair, 1917
The spare, uncompromising rigour of the chair demonstrates De Stijl tenets just as fully as the paintings.

VANTONGERLOO (above)
Construction of volume relations, 1921
The straight line, the right angle, the flat surface reign supreme, as in the paintings.

Mondrian: Composition in Yellow and Blue

Towards the end of his life Piet Mondrian wrote: "It is important to discern two sorts of equilibrium in art – (1) Static balance (2) Dynamic equilibrium ... The great struggle for artists is the annihilation of static equilibrium in their paintings through continuous oppositions (contrasts) ... Many appreciate in my former work just the quality which I did not want to express, but which was produced by an incapacity to express what I intended to express – dynamic movement in equilibrium."
At first glance *Composition in yellow and blue*, a classic specimen of Mondrian's most successful period, the 1920s and 1930s, may indeed impress the spectator as a precisely static balance; only on longer contemplation does the

tension between the component forms become more positive and vital. The forms – seven rectangles, one yellow, one blue, the rest pure white, compartmented by black lines of varying thickness – are a consequence of Mondrian's early discovery "that the right angle is the only constant relationship, and, through the proportions of dimension, its constant expression can be given movement, that is, made living". Mondrian's ability to avoid inertness in the most austere designs becomes clear when successive variations on a compositional theme are considered together: though the basic formula in each case is the same, the number of satisfactory resolutions appears infinite.

Piet Mondrian, born in Amersfoort, near Utrecht, was trained in Amsterdam in the prevalent Dutch naturalist tradition, but was soon affected by modern trends – Symbolism, Neo-Impressionism. Almost from the start a pronounced feeling for linear structure and a strong contrast between horizontal and vertical shaped his compositions; constant throughout his career was the ascetic austerity of his spiritual quest for essential truth. (It owed much no doubt to his strict Calvinist background; he was a committed theosophist, and deeply influenced by the philosophical writings of Schoemaekers.)
In 1911-14 Mondrian was in Paris, and was attracted by Cubist theory and practice, but

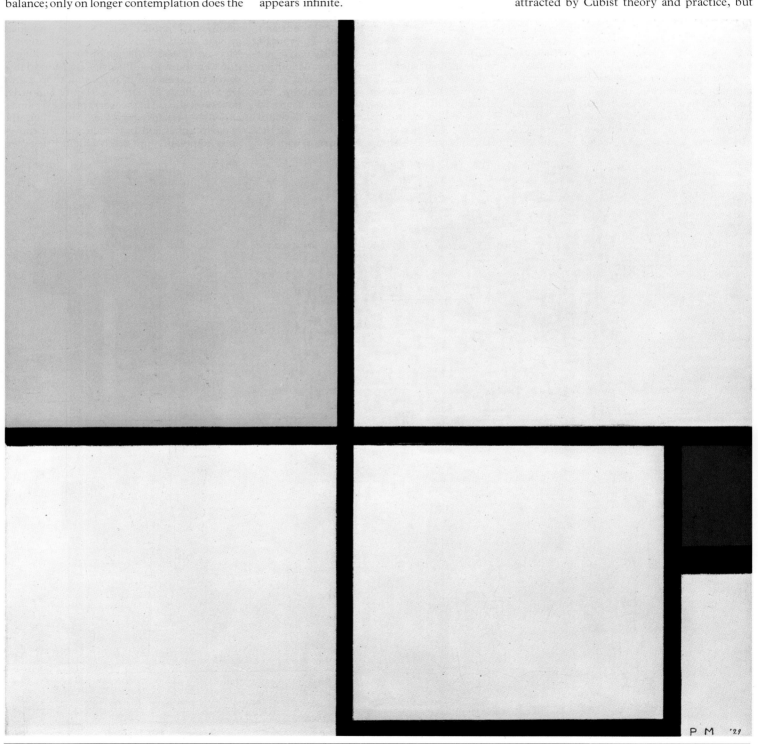

"gradually I became aware that Cubism did not accept the logical consequences of its own discoveries, it was not developing abstraction towards its ultimate goal, the expression of pure reality". Mondrian's urge to extract the essence is illustrated in variations on several themes early in his career, of which those on the tree are the most famous – moving from relatively naturalistic drawing, through vividly unnaturalistic and expressive colour, to linear and faceted simplification, resolved in nearly complete abstraction.

In Amsterdam, during World War I, Mondrian found sympathetic support for his views especially from Theo van Doesburg; De Stijl was established (see preceding page). In 1919

Mondrian moved back to Paris, where he remained until another war drove him first to London, then to New York. His living quarters in Paris were eloquent of his commitment to De Stijl theories – floor, walls and furniture were all integrated into a unity of design, a total environment. It was in Paris that Mondrian pared away his compositions to their utmost simplicity, reducing the number of elements, using a square rather than a rectangular canvas, banishing grey from his palette as too indecisive. He made diamond-shaped canvases from 1919 onwards, their diagonals acting as taut stays against the vertical and horizontal thrusts of the black lines: many paintings are in black and white

alone. *Fox-trot A*, 1930, is one of the most austere but also vital examples of his "dynamic movement in equilibrium". The title reflects another aspect of Mondrian's character; he was addicted to dancing and to jazz, and the theme recurs in the latest development of his style, in the four years in New York (which he loved) before his death in 1944.

Mondrian sought a completely objective quintessence in his art, and yet his paintings are not analysable or translatable in terms of scientific or mathematical formulae. They remain in the end a subjective statement, their success dependent on the exquisite sensibility with which the dynamic equilibrium is poised – his "equivalence of opposites".

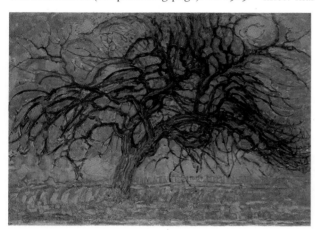

MONDRIAN (left)
The red tree, 1908
The desire for order is implicit (as in Cézanne, as in Seurat) not only in the stark, elementary subject but also in the controlled strokes, neatly juxtaposed, of the brush. Fauvism has liberated the colour.

MONDRIAN (right)
The flowering apple-tree, 1912
Cubism has intervened. It has hastened Mondrian to break down the forms into elements reconstituted on the canvas. But there is little depth; and soon he was to discard volume altogether.

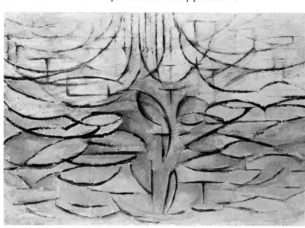

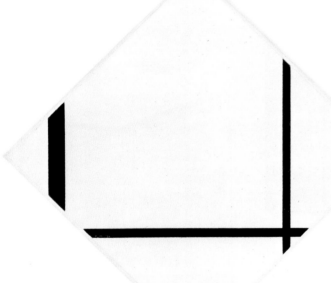

MONDRIAN (left)
Composition in yellow and blue, 1929
Mondrian's work was underpinned both by a rigorous sense of truth and by a profound belief in order. Human society was moving into a new age, in which, if there were order, there would be greater happiness. Of this art was an aspect.

MONDRIAN (above)
Fox-trot A, 1930
Mondrian observed that no loss of equilibrium was entailed in a square picture hung diagonally, although diagonals inside the picture destroyed its containment, introducing an alien commotion. He deplored other De Stijl artists' use of curves.

MONDRIAN (above)
Broadway Boogie-Woogie, 1942-43
Passionate about dancing, Mondrian was inspired by the jazzy pace of Boogie-Woogie in his last works. This painting, a delighted salute both to jazz and also to the dizzy street-grid of Manhattan, is a highly controlled explosion of colour

in a complex composition from which black has been entirely eliminated, though the other colours, red, blue and yellow, are Mondrian's usual primaries – the change does not betray principle. In 1944, only weeks before his death, he explained: "True Boogie-Woogie I conceive as homogeneous in intention with mine in

painting – destruction of melody, which is the equivalent of destruction of natural appearance; and construction through the continuous opposition of pure means ..." to achieve dynamic rhythm. *Victory Boogie-Woogie* (not shown), his unfinished last painting, hung diagonally, has the same clean clear rhythm.

Art in Germany: The Bauhaus

The Bauhaus was founded by the architect Walter Gropius (1883-1969) in Weimar in 1919; it moved to Dessau in 1925-26 and to Berlin in 1932, and was closed by the Nazi regime in 1933. The name and concept, however ("Bauhaus" is not precisely translatable into any other language; it means "building house" approximately), have certainly survived the repression of the institution itself.

The founding *Manifesto* of 1919 opened with the sentence: "*Das Endziel aller bildnerischen Tätigkeit ist der Bau!* (The final goal of all activity in the visual arts is the complete building)." It continued: "It was once the most distinguished task of the visual arts to adorn it; they were inseparable components of the great building. Today they exist in self-sufficient isolation, from which they can be rescued only by the conscious co-operation of all working people. Architects, painters and sculptors must recognize anew the complex, composite nature of a building, in all the parts of its entity. Only then will that work be imbued with the architectonic spirit that it has lost as 'Salon art' . . . Art is not a profession. There is no essential difference between the artist and the craftsman."

The inspiration for this gospel of creativity came from Henry van der Velde, active from before World War I in Weimar as a prophet of synthesis in art and of "pure form"; from the tenets of William Morris and the Arts and Crafts movement; not least from the example of the medieval guilds. Yet though Lyonel Feininger's woodcut frontispiece for the *Manifesto* showed the new unity of the arts in terms of a medieval cathedral, the Bauhaus, unlike its progenitors, welcomed the new technology of the Machine Age with enthusiasm, working to take full advantage of it structurally, theoretically and aesthetically.

Bauhaus teaching in each subject began with a six-month foundation course: each course was under the guidance of a *Formmeister* (concerned with fundamental principles of form and creativity) and a modern craftsman. Students were very much apprentices, and theory and practice were tightly allied; some of the Bauhaus textbooks became classic documents for the arts world-wide – Klee's *Pedagogical Sketchbook* (1925) and Kandinsky's *Point and Line to Plane* (1926). However, the curriculum was in continual evolution, as a matter of principle. In the early years of trial

FEININGER (below)
Frontispiece for the Bauhaus *Manifesto*, 1919
The socialist cathedral (still Expressionist, but also dynamic with light) was to "rise one day . . . from the hands of a million workers like the crystal symbol of a new faith".

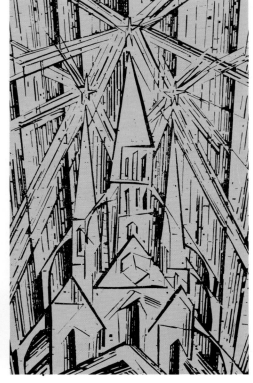

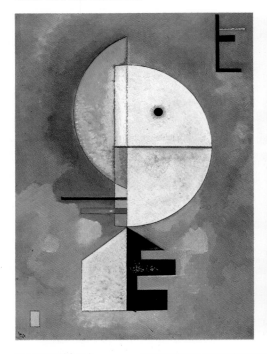

MOHOLY-NAGY (below)
Light-space modulator, 1922-30
Moholy-Nagy was a true mechanic-artist, applying art to industrial design and technology to art. He was fascinated especially by the media of light: the *Modulator* activates space by reflections and shadows of its revolving forms.

KANDINSKY (above)
On high, 1920
Kandinsky's encounter in Russia with Suprematism (see p. 407) led him into a disciplined style with a more geometrical basis: this cool austerity was further influenced by the Bauhaus spirit. The free personal expression of his Munich abstracts has been sacrificed in the creation of a more concrete order.

KANDINSKY (right)
Rows of signs, 1931
Kandinsky's hieroglyphs are like Miró's Surrealist forms subject to a regimen. They are a synthesis of pure, constructed forms and intuitive, suggestive ones.

KLEE (above)
Italian town, 1928
Klee made many references in his notebooks to the common structural ground of buildings and paintings: this was directly reflected in canvases that combine abstract arrangements of colour with lines defining planes, blocks and space of an architectural character. With the move to Dessau in 1925-26 the Bauhaus became more concerned with architecture and design, and Klee participated in this new spirit whole-heartedly. He left only in 1931 when functionalism – an interest in the "truth" primarily of technological materials – began to predominate.

and experiment, the emphasis on the theory of form and the nature of materials, on the sciences and on manual and technical skills, was balanced by the spiritual, even mystical intensity which notably Kandinsky and Klee brought to teaching – there was a positive awareness of the irrational side of creativity. But from 1923 the architectural side became more dominant, as the uniting factor of all the artistic disciplines, closely knit under the influence of László Moholy-Nagy (1895-1946), Josef Albers and Marcel Breuer (1902-1981). Then it was primarily in the fields of architecture and industrial and interior design – furniture, ceramics, textiles – that the Bauhaus made its greatest impact – the establishment of a basic grammar of spare, functional design, taking advantage of new techniques and materials, of mass-production no less than plastics. The aims of De Stijl were taken up and developed; the emphasis was increasingly Constructivist rather than Expressionist.

It was a crucial element in Gropius' genius that he could attract and recruit a cosmopolitan staff of the very highest calibre. His early appointments included the Swiss Johannes Itten (1888-1967) and Lyonel Feininger

(1871-1956), American-born but of German extraction. Feininger had earlier been decisively influenced by Art Nouveau and by Delaunay's Orphism, but from this he developed his personal lyrical dreams, abstracting architectural forms into delicate crystalline structures. The Russian Wassily Kandinsky was closely associated with the Bauhaus between 1922 and 1933, and there defined further the stricter, more geometrical development of his non-figurative work. Paul Klee, who had earlier associated with Kandinsky in Munich (see p. 385), was on the Bauhaus staff from 1920 to 1931, returning to his native Switzerland in 1933 (see over). A crucial and dynamic personality at the Bauhaus between 1923 and 1928 was the Hungarian Moholy-Nagy, on whom the revolutionary work of the Russians Malevich and especially El Lissitzky had had a decisive impact. Moholy-Nagy's interests, irrepressibly various and inventive, extended beyond painting and sculpture to experimental work in photography, film, even light itself as a medium for art; into theatre, ballet and typography. Despite the quality of its staff, however, the Bauhaus bred no outstanding painters and sculptors among its

students, and opportunities for free painting and sculpture diminished, until one of the most gifted painters there, Oskar Schlemmer (1888-1943), commented: "Painters are no more than a necessary evil there." Gropius (and Moholy-Nagy) left the Bauhaus in 1928, and under new direction the school entered a more functionalist phase; the political slant leant increasingly actively towards the Left and as an inevitable consequence it was closed by the Nazis in 1933.

The Bauhaus principles of design and of the relationship of art and industry, its theory of form and its teaching methods were not extinguished, but on the contrary broadcast through the Western world as former members of the Bauhaus became refugees from Nazi oppression. The strongest Bauhaus impact came in the United States, where Moholy-Nagy established in Chicago (1937-38) the Institute of Design, and Albers became a leading figure at Black Mountain College (see p. 468); Feininger, Gropius, the typographer Herbert Bayer, the master designer Marcel Breuer and the last Director of the Bauhaus, the architect Mies van der Rohe (1886-1969), all moved to America.

GROPIUS (above)
The Director's office at the Weimar Bauhaus, 1923
Shape and colour are ruled by clean lines, clear light.

MOHOLY-NAGY (below)
Yellow cross, c. 1923-28
Balance and space, static and kinetic movement were Moholy-Nagy's concerns.

ITTEN (left)
Benign light, 1920-21
Itten's dedication to the properties of colour, both physiological and psychological, gave his abstracts a firm, systematic basis. This multi-colour diagram of subtle tonal gradations was issued as a study aid; it was followed by a series of expressive and lucid grid paintings, which amount to more than merely didactic expositions of his theory, though Itten's reputation as a teacher has tended to overshadow that of his art.

BREUER (above)
Steel chair, 1925
Inspired by the handlebars of a bicycle, Breuer made the first tubular steel chair – strong, light and compact.

SCHLEMMER (right)
Concentric group, 1925
As master of the theatre workshop, Schlemmer had studied actors' positions and spatial relationships.

Paul Klee

Perhaps more than for any other great modern artist, the essential biography of Paul Klee (1879-1940) is his art, but his art remains triumphantly inexplicable. It does not respond very well even to commentary. For instance, historians tend to contradict each other flatly at a basic level – what is the prime motive of his work, the formal construction or the inspiration of the imagination? But in the most famous of his apothegms, Klee spoke of drawing (or at least of his drawing, or at any rate of some of his drawing) as "taking a line for a walk". In a variation of that, the image of a man taking a dog for a walk may come to mind, the reasonable man and the instinctive dog linked by the line of the leash, moving together in unpredictable rhythms, indissolubly.

Paul Klee was born in Switzerland into a family, part German, part French in origin, of professional musicians. Klee himself was a violinist of high calibre, and the movement of his compositions often seems closer to music than to the visual art of the other major artists of his time. And yet Klee was responsive to almost any visual stimulus, including that of the most advanced art being produced around him. By 1914 he had seen in Munich the work

of Der Blaue Reiter artists, and had been himself loosely associated with that group; he had travelled in Italy, spent almost a year in Paris in 1912, and travelled in 1914 with Macke in Tunisia. He was aware not only of Renaissance art but also of Byzantine and Coptic; he made reference to the colourism of the Fauves, to Cézanne's use of colour, to the Cubist colourism of Delaunay – but also to the colour patterning of Islamic carpets. He came to know the work of Douanier Rousseau, as also the "primitive" art of Africa and Oceania, and the drawing of children and of the insane. He was widely read in German and French poetry. Yet it is absurd to talk of influences in the case of Klee: he came, he saw, he digested. He was nourished.

He was based in Munich between 1906 and 1920 (with a break for army service, 1916-18), and the contact with Der Blaue Reiter, and especially with Kandinsky and Marc, decisively confirmed his belief in the spiritual well-springs of artistic creativity. Until 1914 his work was almost entirely in black and white (see p. 385) and generally in a Symbolist, Expressionist tradition deriving from artists such as Böcklin and Ensor, but with a very

Paul Klee
"He was a man who knew of day and night, of sky, sea and air. But ... our language does not suffice to express such things, and he had to find sign, colour or form", commented a devoted friend of Klee's.

KLEE (right)
Motif of Hammamet, 1914
The cube-like architecture set in shining sands under an intensely blue sky is fabricated into a patchwork of the local colours; the texture of the paper, visible through the paint, gives a shimmering effect.

KLEE (below)
The country child, 1923
Klee's first application for a teaching post was turned down because the board of governors found his work "frivolous"; now the value and significance of fairy tales are better understood and respected.

KLEE (above)
The vocal fabric of the singer Rosa Silber, 1922
The title, as so often with Klee's paintings, is a play on words: Rosa Silber is a name but also means "rose silver", the main colours. The canvas is just a piece of rough material on which patches of colour, letters (evoking a musical notation) and patterns are delicately disposed so as to suggest the structure of a sound.

KLEE (left)
Mask with small flag, 1925
Klee's fertile imagination and prolific output – 8,926 works in all – are the more astounding in that there is so little repetition within his work, though it is instantly recognizable. Instantly, too, he dazzles and entrances. It is, however, possible to see underlying preoccupations, such as the human face. But compare Kandinsky's *On high* (see preceding page).

original blend of fantasy and wit. He first made his name with etchings, influenced in style by Dürer. His progress towards colour is charted in his early journals and letters, and in 1914, in Tunisia with Macke, the bright desert sunlight transformed his vision as it had Delacroix's and Renoir's before him: "Colour has taken hold of me; I no longer have to chase after it . . . I and colour are one. I am a painter." He was then already 35 years old. The contribution he was to make in colour was a revelation of inexhaustible variations and permutations, of melody and harmony, probably unequalled in its variety. His subsequent production was remarkably prolific, amounting to rather more than 8,000 paintings and drawings.

Klee's appointment to the Bauhaus teaching staff in 1920 was of great importance to his art, even though the Bauhaus ethic, towards the end of his time there, had hardened into an active inhospitality towards painting. He taught there (see preceding page) not only painting but also textiles and stained-glass design, and an intimacy with his materials is an outstanding feature of his work. The Bauhaus gave Klee first a financial independence he had never had before and secondly encouragement

to proceed with an intellectual analysis of his own work. His *Pedagogical Sketchbook* of 1925 was the second of the 14 Bauhaus manuals edited by Gropius and Moholy-Nagy; a primer for his students, it illustrates vividly the tenets that underlie Klee's unique marriage of scientific and mathematical precision with the organic processes of the imagination. In 1923, in the course of a lecture *On Modern Art* (published only in 1945), he formulated a famous metaphor which still seems the most illuminating comment on the nature of his art – the metaphor or simile of the tree.

"The artist has studied this world of variety and has, we may suppose, unobtrusively found his way in it. His sense of direction has brought order into the passing stream of image and experience. This sense of direction in nature and life, this branching and spreading array, I shall compare with the root of the tree. From the root the sap flows to the artist, flows through him, flows to his eye. Thus he stands as the trunk of the tree. Battered and stirred by the strength of the flow, he moulds his vision into his work. As, in full view of the world, the crown of the tree unfolds and spreads in time and space, so with his work. Nobody would

affirm that the tree grows its crown in the image of its root ... Different functions expanding in different elements must produce vivid divergences ... (The artist), standing at his appointed place, the trunk of the tree, does nothing other than gather and pass on what comes to him from the depths. He neither serves nor rules – he transmits."

In 1931, Klee left the Bauhaus to take up a professorship at Düsseldorf, whence the Nazis expelled him in 1933. He settled in Berne, near his birthplace; his last years were clouded by illness, but his work continued. His later painting tended to be rather larger in scale (though all his work has a comparatively small format) and was sometimes sombre with an imagery and colour that seem to reflect his awareness not only of approaching death but also of the imminent tragedy of war. Yet the variety of Klee's imagery confounds categorization; it ranges from the menacing to the most delicately witty or nonsensical.

Historians have sometimes been reluctant to accept Klee's great stature, but that perhaps was before the propagation of the maxim "Small is beautiful"; there was some confusion about the importance of scale.

KLEE (right)
"*Ad Parnassum*", 1932
A mountainous landscape is portrayed in what Klee called his "divisionist" style, after Seurat. Tiny scales vibrate over a surface of modulated colour.

KLEE (below)
Fire in the evening, 1929
This belongs to the series of "magic squares" which occupied Klee from 1922 to the end of his life – these exquisite harmonies in major and minor keys disclose his musical talents.

KLEE (above)
Death and fire, 1940
Painted in the year of his death, *Death and fire* is a product of Klee's aim to "create much, spiritually, out of little". Klee could discover the world or more in the page of a notebook as surely as the poet Blake could in a grain of sand.

KLEE (left)
Under the angel's wing on a steep path, 1931
Not only was he a gorgeous colourist; Klee was also a magician with the pen or the pencil. Images of angels frequent his later work.

Expressionist Developments, and Neue Sachlichkeit

The term "Expressionism", used to categorize a certain kind of art and to distinguish it from other kinds, first became current about 1910. It is applied to an art in which the artist dominates his subject matter to the point of distorting its appearance, so as to express in the most forceful fashion possible his own view of the world, and to make a comment – generally but not necessarily critical – on its nature. "Expressionism" seems to describe aptly the work of several German artists active in the early years of the century – those of Die Brücke and Der Blaue Reiter, even those of Dada – but also to apply to many working in Germany after 1918 and to several outside Germany – Kokoschka in Austria, Permeke in Belgium, Rouault (see p. 391) in France.

Two of the most brilliant second-generation German Expressionists emerged directly from the politically orientated Dada group launched by Huelsenbeck in Berlin in 1917 – Grosz and Heartfield. George Grosz (1893-1959) began as a satirical caricaturist, and his best work was defined by an acid-sharp and relentlessly hard line throughout. His running commentary on German social and political life in the aftermath of war was one of the most savage and

GROSZ (below)
Dusk, 1922
Grosz's watercolour and pen drawings of urban scenes

are peopled with hard-faced burghers, war-victims and leering women, personifying inhumanity and suffering.

scathing made on any society ever, exposing the oppression and exploitation of the poor of Berlin by the military and capitalist classes in brutally explicit scenes of murder, prostitution and urban degradation. His characters – notably his bull-necked, squash-faced, cigar-smoking men with shaven heads – are profoundly disturbing and convincingly evil. Technically, he early on became aware of the dynamic Futurist style, then exploited brilliantly the fragmenting methods of Dada, including montage; his urban settings often echo those of Metaphysical painting. Grosz's overt, ferocious, utterly uninhibited satire was driven by an irrepressible and courageous anger against injustice (he was prosecuted on several occasions) but was countered by an ambivalent romanticism. Though he had been a member of the German Communist Party since its foundation, when with the coming to power of the Nazis he could no longer work in Germany he moved not to Russia but to America (becoming an American citizen in 1938). There, though his original satiric bent found expression occasionally, the impetus of his art was sapped, and his painting tended to become soft-edged (very close to Pascin's). His

GROSZ (right)
Eclipse of the sun, 1926
The images in *Eclipse*, one of Grosz's own favourite paintings, are savage – the men of money, without their heads, conspire with the fat decorated general, epitome of bloodthirsty cruelty.
The expression of political comment in such allegorical form was novel in painting.

DIX (below)
The match-seller, 1920
Dix's work is exclusively devoted to human beings, to their greed, brutality and to their suffering. He began his pictures of war-victims in 1919, with views of the crippled ex-soldiers seen on the streets of Dresden. His vision is beyond pity or sentiment: the dachshund pisses on the match-seller.

HEARTFIELD (above)
War and corpses, 1932
Heartfield's photomontage was used in Spain in 1934 as a communist poster, the decoration round the neck of the hyena being replaced by a swastika. Photography was for Heartfield a new international and populist language, which he exploited, and expressionistically manipulated, to reveal the inner truths of human society.

HOFER (left)
Three masqueraders, 1922
Hofer strove to probe the visible world as the Neue Sachlichkeit artists did, sharing their aesthetic of disillusionment. However, he refused to accept the "Expressionist" label – his roots lay in a classical idealism transformed by the influence of Cézanne and disturbed by the shock of service in the trenches.

friend John Heartfield (Helmut Herzfelde, 1891-1968), an active revolutionary, used photomontage as a weapon of social satire with an unsurpassed visual wit and efficacy.

Otto Dix (1891-1969) also made his mark in the early 1920s as a cutting and cynical satirist of contemporary society; horrific experience in war and disillusionment afterwards were bitterly expressed in his pitiless linear precision, his clear, often brilliant colour and modelling, and his formulation of repulsive human types. In the mid-1920s, he was the dominant personality of the trend known as "*Neue Sachlichkeit*" (New Objectivity), also called Magic Realism. The label "*Neue Sachlichkeit*" was coined for a projected exhibition in Mannheim in 1923 of "artists who have retained or regained their fidelity to positive, tangible reality". In that sense it was a reaction against abstraction and against the earlier Expressionist destruction of form, but in other senses it sustained some central characteristics of Expressionism – the directness of the artist's confrontation with reality, his use of distortion to emphasize his view of the world. The artist's emotion was, however, to be held in tight control, in a concentration that often invested his work with a neurotic, eerie tension.

There was no co-ordinated movement of Neue Sachlichkeit, and artists practising variations within it were working at several centres in Germany during the Weimar Republic; they included Carl Hofer (1878-1955), Franz Radziwill and Georg Schrimpf (1889-1938). Their work was not tolerated by the Nazis and, though few of them left Germany, most of them radically altered their styles after 1933.

Meanwhile there had been an extraordinary ferment of intellectual and artistic life in Vienna early in the century, nurturing Freud, Schönberg and the Vienna Sezession. Following on the work of Klimt, a fierce strain of Expressionism flared in the haunting psychological intensity of the portraits of Richard Gerstl (1883-1908; not shown), who committed suicide, in the works of Oskar Kokoschka (1886-1980) and in the starved, aching eroticism of Egon Schiele (1890-1918). Kokoschka was initially the *enfant terrible* of the Viennese art scene, a picturesque, flamboyant personality and a strenuous exhibitionist; he began there a long series of portraits (see p. 477), including a continuing sequence of *Self-portraits*, that constitute a great part of his achievement. In these, and in his figure paintings, the delicate exploratory line combines with broken and shifting depths of colour to produce an extraordinary strength of mood. After World War I he travelled extensively, and in Paris began a series of large landscape panoramas, Impressionistic in their brilliance of fragmented colour, Expressionistic in their tumultuous atmospheric vigour.

The Expressionist urge seems to have been a northern characteristic, and after the first inspirations of the Dutchman van Gogh and the Norwegian Munch it nowhere produced a richer harvest than in the Germanic countries, although it appeared in Italy, in the work of Scipione, and in the dour paintings of the earth and the peasantry by Constant Permeke (1886-1952) in Belgium. In Germany itself, Expressionist freedom was anathema to Nazi doctrine. Systematic suppression of free art culminated in the exhibition of "Degenerate Art" in 1937; Germany destroyed or dispersed the most remarkable achievements of her visual arts since the time of Dürer and Grünewald. And yet Max Beckmann (see over), living in obscurity in Amsterdam, continued his formidably apocalyptic painting undeflected.

SCHRIMPF (left)
Boy with a rabbit, 1924
The emergence of a rather stiff realism in Germany during the 1920s owed something to Rousseau's Naive reconstruction of reality. Schrimpf's gently romantic, unpretentious paintings are typical of the style – simple, monumental forms smoothly painted, carefully modelled.

KOKOSCHKA (right)
Lovers with a cat, 1917
Kokoschka's free brushwork distances his *Lovers* from their 16th-century source, a painting by Cranach, and creates a lyricism highly charged with emotion, as if the brush-strokes themselves were spiritual emanations. In this way he could, too, create violent, Promethean visions of human suffering.

SCHIELE (left)
The embrace, 1917
Schiele's own restlessness, in his personal life, seems to suffuse *The embrace*, this contorted clutching amidst crumpled sheets. The male figure is a self-portrait. His eroticism (which had occasioned his arrest in 1911) is anguished, but the complex, angular lines riot with a decorative rhythm.

PERMEKE (right)
The sower, 1933
Permeke's subject is clearly social realist, but a moral is not explicit; his massive figures have a chthonic, or elemental, timeless being. In their dignity and pathos they recall 19th-century heroic pastoral paintings, and late work by Millet.

Beckmann: Departure

BECKMANN (right)
Night, 1918-19
Symbols of human sadism
and anguish (Beckmann's
reaction to war and the
civil violence of post-War
Germany) are depicted in
livid colours, angular line
and with an exaggeration
of detail – the phonograph,
the torturer's bulging eyes
– anticipating aspects of
the Neue Sachlichkeit need
for intensity in the object.

BECKMANN (below)
*Self-portrait with a red
scarf*, 1917
Beckmann's *Self-portraits*
start before World War I
with images of an elegant,
unharrowed man: they then
chart a life of traumatic
experience through which
Beckmann always maintains
an appearance of toughness,
but sometimes his deep
anxiety breaks the surface.

The figures are almost clamped in heavy black
outlines, and the space they occupy bears in on
them and compresses them still further – the
claustrophobic effect is overwhelming. The
subject matter is unconscionably brutal, and
worked with an appropriately coarse violence.
Yet man in the lifetime of Max Beckmann
(1884-1950) proved to be only too capable of
the imprisonment, mutilation and mental tor-
ture that ravage his first triptych, *Departure*.
The colour is generally sombre, kindling with
the glow and flush of a stained-glass window,
and the three panels read as a sort of post-
Christian altarpiece recording the events of a
modern Revelations. Triptychs soon became a
favourite form of Beckmann's, and their vio-
lent, complex themes, evoking the circus, the
stage and classical myth in a very Germanic
interpretation, have, though always personal,
a resonant twentieth-century relevance.

Max Beckmann began his career as a painter
in a relatively orthodox style. His independent
spirit, however, amounted already to high
arrogance: his reaction on his first visit to

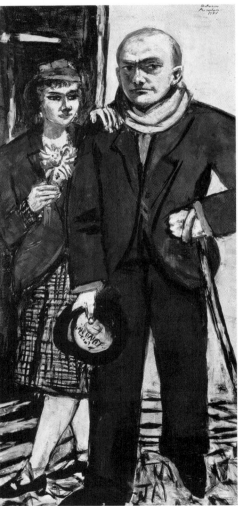

BECKMANN (left)
Quappi in pink, 1932-34
Whatever Beckmann made
of his own image in his
revealing *Self-portraits*,
he always painted his wife
Quappi as a lady, indeed
almost as a fashion-plate.
Both line and colour here
recall Die Brücke styles.

BECKMANN (above)
*Self-portrait with
Quappi Beckmann*, 1941
Fear and grim resignation
are expressed in these two
faces. With deep shadows
Beckmann dramatizes their
plight as refugees; he has
been spurned as an artist
but he remains formidable.

Paris, aged 19, was: "What's there, I know already." This confidence was matched by a striking ability. He had established a reputation by the time of his first one-man exhibition (in Frankfurt) in 1911, and by then he was demonstrating two qualities that would persist throughout his career – his ability to control large and complex compositions, and an obsession with horrific subject matter.

Before World War I, Beckmann had encountered in *Der Blaue Reiter* the belief of Franz Marc in an art "seeking and painting the inner spiritual side of nature", together with a demand for utter artistic objectivity towards the thing represented. In 1914, Beckmann worked as medical orderly on the front, but was released in 1915, apparently after a nervous breakdown. The experience of the horror of war proved the turning-point for his view of nature and of man. Stylistically and emotionally, his examples became Bruegel, Signorelli and the brutal assault on the emotions of Grünewald, while his stark and heavily outlined figures, massive within the frame,

directly recall the fierceness of Die Brücke artists, of Kirchner and also of Rouault. In his stubborn insistence on veristic representation he is close to some painters of the Neue Sachlichkeit, but Beckmann's intellectual stature, his ego, the thrust and concentration of his vocation, set him apart from all his German contemporaries; indeed the power of his achievement has caused some critics to compare him with Picasso (characteristically, Beckmann himself suggested that Picasso's *Guernica* (see p. 451) was a distorted Beckmann). Undoubtedly he was a myth-maker of the order of Picasso, capable of creating a world of events rationally and even symbolically inexplicable, yet which are compelling as illustrations of hidden but eternal truths.

Beckmann seems to have absorbed what he needed from the compositional methods of the Cubists, but the structural – as it were materialist – concerns obsessing modern movements did not involve him. "Self-realization is the urge of all objective spirits. It is this Ego for which I am searching in my life and in my art

... My way of expressing my Ego is by painting ... Nothing could be more ridiculous or irrelevant than a 'philosophical conception' painted purely intellectually without the fury of the senses grasping each visible form of beauty and ugliness."

Naturally one subject to which he reverted constantly in his search for his ego was his own person – a range of *Self-portraits* in which he appears in various disguises or with strange attributes – horns, saxophones – or as a character in one of his mythologies, or, most tellingly, foursquare as a modern urban man, often in suit and bowler hat, an implacable, unplaceable presence. Leaving Germany on the eve of the Nazi exhibition of "Degenerate Art" in 1937, he established himself in obscure isolation in Paris, and then in Amsterdam. "Nothing shall disturb my composure" is a note that recurs in his diary for the catastrophic year of 1940. In America from 1947 till his death three years later, he re-emerged into critical acceptance, and his stature has since continued to grow.

BECKMANN (left)
Departure, 1932-35
The triptych form evokes a long tradition in north European painting, from Gothic altarpieces to Hans von Marées' Symbolist art in the 19th century, and Nolde's religious triptychs in the 20th. Beckmann began to exploit the full symbolic and monumental potential of the form in 1932 with his *Departure*, the first of nine finished triptychs. The shadow of Christian imagery hangs over its mythical subject: in the left-hand panel the figure bound to a column echoes the flagellation of Christ. Beckmann's friend Perry Rathbone explained *Departure* in these words: "The side panels symbolize, on the left, man's brutality to man in the form of a callous executioner and his victims; on the right, the unbearable tragedy that Nature itself inflicts on human life as symbolized by the mad hallucinations of a woman encumbered by the lifeless form of a man. Out of this earthly night of torment and anguish, the figures of the central panel emerge into the clear light of redemption and release, embarked for eternity." Beckmann said that the centrepiece was the end of the tragedy, but could not be understood except as one part of the whole.

Art in Britain between the Wars

In Britain between the Wars there was almost a national resistance to Expressionist and non-figurative art. Portraiture flourished, mainly conventional, but sometimes given new twists by such artists as Augustus John and Wyndham Lewis (see p. 403); and Jacob Epstein, though continuing to be controversial (provoking the public to tar and feather his mildly Cubist carving *Rima* (not shown) in 1925), came to find his *forte* more and more in modelled portrait busts, which recall Rodin rather than his own Vorticist beginnings. With Augustus John, Walter Sickert was the grand old *enfant terrible* of British art, a leavening force on the fringe of English conservatism; in his last work Sickert developed a broad, almost Expressionist grasp of form that foreshadowed Francis Bacon.

The implications of Post-Impressionism, of Fauve colour, of Cubist structure, were not at first developed very far. A pioneering modernist group was the Seven and Five Society, formed in 1919. Its most important member was Paul Nash, who went on to organize in the early 1930s Unit One, which brought together some outstanding though diverse artists in the promotion of abstract art. Unit One included

Barbara Hepworth, Henry Moore and Ben Nicholson, all highly professional and austerely critical of the general sloppiness of the English response to post-Cubist developments. Succeeding Roger Fry, the leading propagandists of modern art were the poet, novelist and critic Herbert Read (1893-1968) and Clive Bell (1881-1964), who first in 1914 justified abstract art with his notion of "significant form"; the meaning of a work of art consisted not in its subject or message but in the experience of its formal qualities. Then during the 1930s the arrival in Britain of artists in flight from the Nazi threat on the Continent

had a profound effect. They included Gabo, Gropius and Mondrian – all closely associated with the architect Leslie Martin and with Ben Nicholson, who with Gabo edited *Circle*, a mainly Constructivist periodical. In 1936 the International Surrealist Exhibition in London was the most comprehensive showing yet; presiding at its opening were the high priests of the movement from France, including Breton.

The most original, and successful, of the British Surrealists (if one excludes Moore) was Paul Nash (1889-1946), but it is typical of the British temperament that when Nash exploited "found objects" they were nothing like

NASH (right)
Landscape from a dream, 1936-38
The British Surrealists responded rather uneasily to the dogmas of militant Continental Surrealism; it never became a way of life. Beginning with realistic landscape, Nash was then influenced by Chirico: here he places figures from his own complex mythology in the recognizable landscape of the Sussex coast.

EPSTEIN (left)
Jacob Kramer, 1921
Retaining the spontaneity of a free sketch, Epstein brought expressive vigour, craggy conviction, to the traditional portrait bust.

NICHOLSON (below)
White relief, 1935
Nicholson was concerned with what Read had called "the art of determined relations" – the relation of plane to plane, colour to colour, texture to texture.

NASH (left)
"Totes Meer" (Dead sea), 1940-41
What appears at first to be a stark lunar landscape was in reality a dump for enemy aircraft shot down in the Battle of Britain. These fragments piled into the pit of a disused quarry became for Nash "a great inundating sea ... It is hundreds and hundreds of flying creatures which invaded these shores ... By moonlight, this waning moon, one could swear they began to twist and turn as they did in the air. A sort of *rigor mortis*? No, they are quite dead and still." In World War I Nash had also painted remarkable evocations of desolation.

SUTHERLAND (right)
Entrance to a lane, 1939
Unlike Nash, Sutherland kept the creatures of his imagination and landscape separate, though in these highly charged evocations of the Welsh countryside he regenerated much of the intensity and lyricism of Samuel Palmer (see p. 311). "Organic abstractions" of poetry and mystery, they are underpinned by a close scrutiny of nature. Sutherland was a leading practitioner at this time of a "neo-Romantic" movement in British painting.

Duchamp's bicycle wheels or urinals. Nash relished the imagery provided by driftwood and flints and pebbles. War brought out his expressive powers: in 1940-41 he created one of his most vivid images, "*Totes Meer*" (Dead sea), a frozen sea of which the dead waves are the shattered wings of German aircraft. He found his most personal vision in a late series of intense, brooding landscapes with a strong Surrealist element; these almost rival the visionary dreams of Samuel Palmer (see p. 311).

Henry Moore, too, owed much to Surrealist example but is considered separately (see over). Leading the more austerely abstract front of British art was Ben Nicholson (1894-1982). His affiliations with Continental developments, early on notably with Picasso's linear style and with Cézanne's colour modulations, and later with Mondrian, are obvious, but at all stages of his long career his independence, the distinct and original nature of his contribution to modern art, have been striking. He always moved in and out of figurative art and abstraction with complete confidence (see p. 475); his concern with pure form had its finest expression in his best-known works, the *White reliefs* of 1934-39, shallowly cut and

carved with geometric precision, as definitive as any Mondrian.

Barbara Hepworth (1903-75), married to Nicholson until 1951, was the most distinguished sculptor of her generation in Britain after Moore, moving from biomorphic to geometric forms, exploiting the play of void against solid, and piercing mass even before Moore did. Though her allusions to nature and to landscape are far less overt than Moore's, she once described her carving as a "biological necessity". Her forms are refined to very simple shapes with an extremely subtle finish.

Graham Sutherland (1903-80) was a late starter, finding his form first in landscapes of Wales in the mid-1930s. After World War II he developed a convincingly eerie skeletal imagery which won him an international audience. His most enduring work, however, may prove to be the best of his portraits, on which he embarked in 1949 with a celebrated, vivid and almost grotesque likeness of the writer Somerset Maugham. (His *Sir Winston Churchill* (1954) was found too unflattering by its subject, whose wife had it destroyed.)

Sir Stanley Spencer (1891-1959) was an anomaly in the twentieth-century art world, with

his profoundly religious sensibility coupled to a raging and tormented sexuality. He saw eternity in the bricks and mortar and the village gardens of Cookham by the Thames; in his greatest work, his large-scale decorations for Burghclere Chapel, Berkshire, in the 1920s, his obsessive care for detail was married into a mystic, beatific vision of moving pathos and yet great serenity. Spencer scarcely changed his style at all, unimpressed by the formal revolutions in art going on around him. Victor Pasmore (born 1908) did, and his career, and the reactions to it, illustrate very well the English difficulty in coming to terms with modern art. His earlier painting was developed in the so-called Euston Road school – a somewhat austere reaction by avantgarde figurative painters to the growing vogue for abstraction. He then underwent conversion in the late 1940s to a vigorous non-figurative style, to Constructivist designs in wood, metal and plastic, and that led on, as it had with Tatlin and Malevich, to involvement with architectural projects. But many British connoisseurs, unmoved by the elegance of his constructions, mourn the loss of the most sensitive English painter of landscape in the twentieth century.

HEPWORTH (right)
Three forms, 1935
Hepworth progressed to a pure abstraction rapidly and with assurance: this, her first completely non-representational sculpture, appeals both to senses and to intellect. Between the exquisitely smooth marble forms, so dauntingly white, the spatial relationship is both rigorous and sensual. Hepworth was firmly in the school of "direct carving".

SUTHERLAND (left)
Somerset Maugham, 1949
Sutherland's principle was to define his sitters by their habitual gestures and expressions – which led to a caricaturist's cruelty. Maugham's shrewdness – or sourness – is conveyed in the narrowed eyes, hawkish pose and arrogant tilt of the head; he almost looks like one of Sutherland's insect-like biomorphisms.

PASMORE (below)
The quiet river: the Thames at Chiswick, 1943-44
Painted in oil, the scene has all the ethereal mist and limpid quality of the finest watercolours. These silvery tones conjure up a nebulous Whistler-like twilight, yet the firm spare elements within it have an abstract force; there are some Seurats with the same meditative stillness.

SPENCER (right)
The resurrection of the soldiers, 1928-29
Stanley Spencer, too, has to be compared with Blake, but Blake the eccentric visionary and myth-maker, not Blake the illustrator of Thornton's Virgil (see p. 311). Here the victims of World War I rise up from death; enemies join hands; a man in the foreground sees Christ on the altar.

PASMORE (above)
Snowstorm (Spiral motif in black and white), 1950-51
Pasmore moved through landscape to abstraction, until pure form supplanted every external reference. This title was suggested by the finished work; no storm suggested the abstraction. His abstract reliefs may also be utterly impersonal.

447

Henry Moore

Henry Moore (1898-1986) was the son of a miner in the northern English county of Yorkshire. The ancestry suggests a closeness to the earth, to soil and to rock, to the mute evidence of past geological upheaval in the fabric of the physical world It may not be coincidence that Brancusi, that other elemental sculptor of the twentieth century, came also from a stock close to the earth, in Romania, at the other, eastern, extremity of Europe. To both was given the power to retain even in their most abstract and revolutionary work a contact, at times almost electric, with the vital roots. Their imagery was very different – Brancusi reducing to formal essence, Moore much more prodigal; Moore more prone, like nature, to imperfection, but subject in his profusion to marvellous felicities.

After early experience as a soldier in World War I, Henry Moore studied at a provincial school of art, at Leeds, but came in contact there with an unusually enlightened collector of art, Sir Michael Sadler, who introduced him to the critical writings of Roger Fry and Clive Bell. Fry expounded the importance of "direct carving", and Moore's sensitivity to the inherent nature of his materials, his reliance on

their "feel" to guide him to their final shape, remained constant since that time. Through Bell in particular Moore was led to an appreciation of "primitive" carving, especially Pre-Columbian; later, from 1921, in London, he was to explore the cluttered ethnographic collections of the British Museum, although he also came to realize, as a student and then as a teacher at the Royal College of Art, the importance of drawing from the life: drawing was for him "a deep, strong, fundamental struggle to understand oneself as much as to understand what one's doing".

His carving in the 1920s, much of it on the theme of *Mother and child*, was strongly shaped by Pre-Columbian example; he began then his first experiments with the image he was to make peculiarly his own, the reclining figure, and on a visit to Paris in 1926 came across a cast of the reclining Toltec *Chacmool* from Chichen Itza (see p. 375) with a shock of recognition. The Leeds *Reclining figure* of 1929 shows the Pre-Columbian influence fully assimilated and transformed, the body's rhythm emphasized, as Moore began to develop the potential of a freer, rounder form, loosed from the rectangularity of Pre-Columbian sculp-

Henry Moore
Moore was widely known by the 1930s; his international reputation was secured when he won the sculpture prize in 1948 at the Venice Biennale.

MOORE (left)
Mother and child, 1924
The mood and rhythms of the figures are inspired by archaic Mexican sculpture: Moore said he admired its "tremendous power without loss of sensitivity".

MOORE (right)
Reclining figure, 1929
With one exception, the *Reclining figures* which constitute more than half Moore's work after 1924 are female – earth-mothers reduced to elemental mass, close to the earth in their posture and their essence.

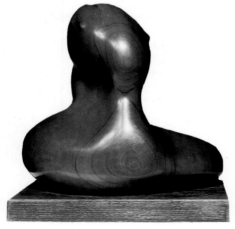

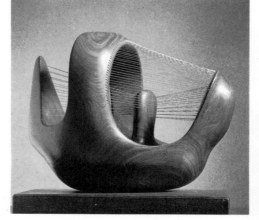

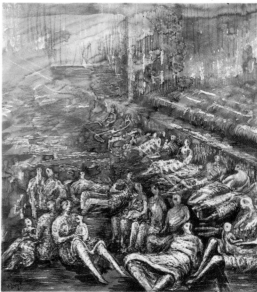

MOORE (above)
Composition, 1932
Moore produced during the 1930s a superb series of biomorphic abstractions by "direct carving", in which

form evolved in response to material – hence their purity and simplicity; those superfluities which before Brancusi concealed essence are rigorously eliminated.

MOORE (above)
Bird basket, 1939
The form is hollowed, both void and solid constitute the form; the wires enhance the tension between them.

MOORE (right)
The Tilbury shelter, 1941
The air-raid shelters of World War II seemed to Moore "catacombs filled with exhausted bodies".

ture. In 1929, too, he pierced his first hole through solid mass. In the early 1930s, with Hepworth, Nicholson, Nash and others he formed Unit One, a group united by its common interest in design "considered as a structural pursuit". His experiments continued with both *Mother and child* and *Reclining figure* themes, and in them reflections from contemporary masters are clear – Picasso's late-1920s giants on a seashore (see over); the nearly abstract biomorphic forms of Brancusi, and especially of Arp. Moore endorsed Surrealist principles – he had always acknowledged the tutelary guidance of the Unconscious – and was encouraged to make use of the accidental in his art, of found objects, pebbles and driftwood, more or less altered by the artist. He wrought his surfaces into organic, rhythmic patterns, and pierced and hollowed out his work, sometimes tying geometric striations of strings taut across the opened forms. In 1936 he exhibited at the International Surrealist Exhibition in London.

When war came in 1939, Moore began his famous drawings as an official war artist: in the prostrate swathed figures of Londoners sleeping in underground stations, sheltering from the Blitz, he found a subject to which the son of a miner could respond whole-heartedly. His series of shelter drawings, entirely unsentimental in their humanity, topical yet also timeless, touched a chord in a far wider public than he had reached before.

By the end of the War Moore was acknowledged internationally, as the greatest British sculptor since the Neoclassic Flaxman. A prodigious worker, and complete master of his art and craft, he could come to terms with the Renaissance tradition, carving (within his own *Mother and child* theme) a more naturalistic *Madonna* for St Matthew's, Northampton. Simultaneously he began exploring a *Helmet* theme – a metaphor of the womb, form enclosed within form, void and solid in complex interaction. He introduced totemic standing figures, draped seated females, bone-like and egg-like forms; besides massy biomorphs and monumental, immobile or sometimes struggling figures, he also made more geometric or mechanistic, straight-edged and slab-like constructions. He turned to bronze, with a series of family groups, and to marble (he spent long summers at the quarries in Carrara where Michelangelo had been before him); one of his *Helmets* was in lead. Bronze, golden or roughly scored and dull, and wood, swelling with a patterned grain, were the media of his major works of the 1960s; in bronze he produced notably huge abstracts, two or three pieces gaunt or interlocking in compelling interrelationship. His prolific output included both private work (numbers of finely attenuated miniature bronzes) and public commissions on a colossal scale for sites all over the world.

After he abandoned teaching in London in 1939 Henry Moore lived in the country, first in Kent, later in Hertfordshire. The undulating rhythms of the English landscape, its profiles, its swells and surges in vales and hollows, were answered in his mature work by the interplay of solid and void, and the finest of his *Reclining figures* are hauntingly evocative metaphors for the English landscape, spirit and substance. During the 1970s, working on an ever larger scale, he set much of his work in the landscape, standing close to the earth beneath the sky. His eightieth birthday in 1978 was celebrated with an exhibition of his cavernous voids and mysterious masses in Hyde Park, London, and over them swarmed thousands of children with an instinctive delight.

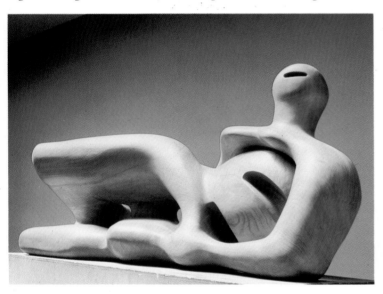

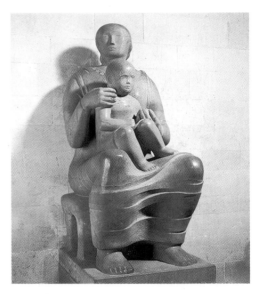

MOORE (left)
Reclining figure, 1945-46
In his large elmwood figure for the Cranbrook Academy of Art, Michigan, Moore worked sculptural rhythms through the body, locking inside it an infant's form.

MOORE (right)
Madonna, 1943-46
Concerned that the image should be appropriate to its Northampton church, Moore created a classical icon of placid dignity.

MOORE (below)
Two forms, 1966
Moore's later biomorphic abstractions, massive and complex, are often sculpted for landscape settings, and he himself supervises their placement. Like megaliths, the forms suggest the vital strength of natural forces.

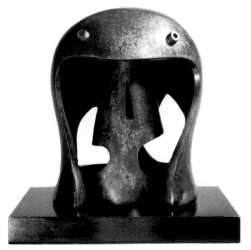

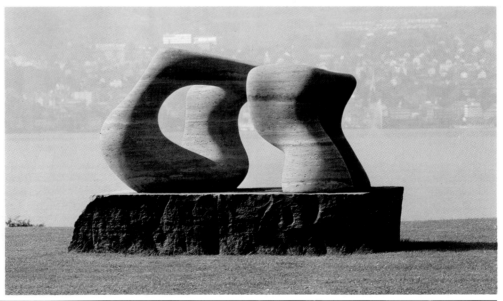

MOORE (above)
Helmet head no.1, 1950
The idea of an inner form both trapped and protected by its shell gave Moore another fruitful theme with which to continue exploring external and internal form.

Picasso between the Wars

Having invented between 1907 and 1914 with Braque (see p. 396) a mode of pictorial expression, Cubism, so fundamentally revolutionary that it seemed to overturn the entire Renaissance tradition of illusionism, Pablo Picasso proceeded to demonstrate in the years between the Wars that this was not necessarily so. The importance of Cubism was in no way diminished, but the most astonishing aspect of Picasso's subsequent work is its variety, the uninhibited freedom with which he was able to work in entirely different styles simultaneously, sometimes even in the same painting. These styles ranged from virtually naturalistic to near-abstract representation. The variety of media that he employed – not only painting, drawing, etching, sculpture, but also poetry and, in 1941, a play – and the sheer output of his work are scarcely less extraordinary. For Picasso, no style that could be retuned to answer his needs was obsolete.

In 1917, Picasso went with the poet and writer Jean Cocteau to Rome, and the impact of Roman monumental statuary and of the High Renaissance is obvious in a sequence of monumental "antique" figure compositions that he painted sporadically over the next decade; in these the overwhelming sense of massiveness is usually offset by the two-dimensional effect of the setting of the figures. At the same time (from as early as 1916) he was producing shaded pencil-drawings, realistic likenesses of his sitters incised with the most delicate strength, that are clear homage (and challenge) to the pencil-portraits that Ingres had perfected a century before in his years at Rome. In love, Picasso recorded faithfully and tenderly the literal appearance of his new wife (the ballerina Olga Koklova) and their child, and even extended this treatment to domestic still life. One such still life dates from 1919, the year in which he was painting brilliant variations on the same theme in a pure (if very free and painterly) late Cubist style.

In 1921 Picasso applied the austere techniques of synthetic Cubism to a major composition, *The three musicians* (not shown). The subjects consist of a Pierrot, a Harlequin and a monk – characters of his Blue period, here reconstituted in terms of a jigsaw mosaic of brilliant, flat colour. Their mood is ambiguous; some construe them to convey gaiety, others find them sinister. Three years later, in *The three dancers*, 1925, a similar composition

Pablo Picasso (1881–1973)
Picasso's work between the Wars no longer falls neatly into "periods"; rather, he demonstrated virtuosity at all he tried, without limit.

PICASSO (right)
Ambroise Vollard, 1915
From 1915, in a series of pencil-drawings, Picasso captured a generation of famous faces. A touch of caricature is offset by an almost sentimental quiet; even in this naturalistic image, as in the earlier Cubist portrait of Vollard (see p. 374), Picasso asserts independence from nature, through subtle distortions.

PICASSO (right)
Guitar, 1920
The diverse styles which Picasso used and reused in the 1920s included the continued development of synthetic Cubism; Gris and Mondrian influenced his more severe designs with flat, geometrical forms.

PICASSO (below)
The three dancers, 1925
The scene seems to embody a dictate of the Surrealist Breton, that "beauty must be convulsive or cease to be". The sharp colours, the jagged edges and the wild gesticulations of arms and legs electrify the canvas.

PICASSO (above)
Three women at the fountain, 1921
Picasso's "sculpturesque" matrons seem to intensify the dignified solemnity of their classical prototypes; also the serene, smoothly painted forms of Raphael and Ingres are echoed and transformed – for Picasso, great art was never dead.

PICASSO (above)
Seated bathers, 1930
Summers spent in southern France probably inspired the series of monstrously distorted *Bathers*, who lie nonchalantly beside clear Mediterranean sea. Their inside-out forms are like painted Cubist sculptures.

has been galvanized into a frenzy of movement, suggesting the staccato of early jazz or the Charleston, though again interpretations of the picture – as ominous or merry – vary considerably. About 1930, he opened up his earlier "antique" monumental figures into hollowed but massive constructions with pin heads and one Cyclopean blank eye whence all mind has withdrawn, disposed on the shore of what could be the sea of eternity. These creatures look suggestively Surrealistic, and Breton indeed claimed Picasso as a Surrealist; Picasso had sympathy for the movement (and exhibited in the great Surrealist exhibition of 1925), though he never condoned procedures such as "automatic" writing. About 1929-30 there was a fresh burst of sculptural activity, including open iron constructions.

The hedonistic facet of Picasso's Latin temperament is undeniable, and was sumptuously and abundantly illustrated in some colourful, curvaceous nudes of about 1930. And yet by about 1930 a violent and pessimistic strain was becoming more insistent. It reflected no doubt the increasing tensions of the looming Depression, of the threat of war, and also of the break-up of Picasso's marriage. The use of distortion becomes even more acute; the inventiveness does not flag (dating from about 1929 is the brilliant invention of the combined profile and full-face view in the drawing of a head), but in many works the mood and technique are far harsher. Certain themes are developed in obsessive variations – the 100 etchings of *The Vollard Suite* (not shown), partly inspired by Balzac's novel *The Unknown Masterpiece*, and exploring the relationship and interaction of model and sitter (a theme that haunted Picasso until his death, see p. 692); the meditations on bullfighting and on the enigmatic figure of the Minotaur, a half-sinister, half-pathetic symbol of irrationalism – culminating in one of his most complex etchings, *Minotauromachy* (1935; not shown).

The pessimistic strain took on full force in the enormous canvas *Guernica*, painted in 1937 in revulsion at the news of the bombing of an undefended town of that name in Spain. The power of this painting to convey the tragedy, horror and ruthlessness of modern warfare probably converted a far wider section of the public to accept the relevance of modern art to the ordinary person than any other single work. It is an allegory, expressed in terms of the bullfight (the Minotaur again), but there are also motifs reflecting the real effects of indiscriminate bombing of civilians, though Cubist techniques, presenting objects seen simultaneously from different viewpoints, disintegrate their naturalistic appearance. In *Guernica* Picasso synthesized the themes, moods and techniques of his whole career, his imagination convulsed and concentrated by the anguish of the event. In 1945, however, came the less well-known but hardly less moving *Charnel-house*, surely precipitated by the horrific revelation of the Nazi centres of genocide, Buchenwald, Belsen, Dachau, and their multitudinous wasted corpses. The symbolism of *Guernica* is abandoned, and silence drained of colour replaces the almost audible scream of the earlier vision. Picasso found himself unable to bring the picture to completion, but its impact is nonetheless awesome. "Painting", he said, "is not done to decorate apartments; it is an instrument of war against brutality and darkness." Though Picasso's art was to continue in self-regenerating variety for nearly 30 years more (see p. 476), *Guernica* and *The charnel-house* seem to close an era not only in his own career but in our civilization.

PICASSO (left)
Nude in an armchair, 1932
The direct sexuality of the woman, satisfied and warmly relaxed, is simply conveyed in a harmony of smooth, curving line and in clear, sunny colour.

PICASSO (below)
Guernica, 1937
Violent condemnation of indiscriminate massacre gave Picasso's art a new dimension; the allegory, with its timeless images of horror, roused an era.

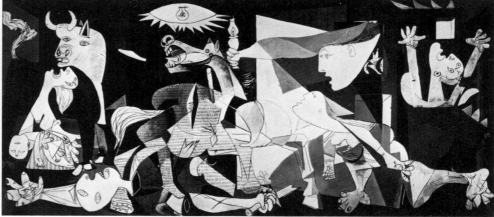

PICASSO (left)
Woman's head, 1931
As Breton noted, Picasso had "no prejudices about materials": in his metal assemblages, the pieces – a colander for example – retain their identity while becoming part of something new. The Spanish sculptor González taught him how to weld iron, but the forms Picasso created are pure Picasso, uniquely Picasso.

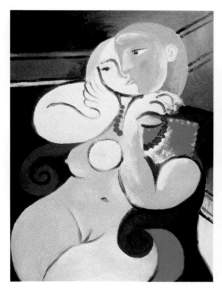

PICASSO (right)
The charnel-house, 1945-48
Picasso defined the artist (and himself) as a socially conscious "political being, constantly alive to heart-rending, fiery or joyful events" to which he reacts accordingly – here in a deeply meditated requiem.

Early Modernist Art in America

By the end of the nineteenth century, somewhat belatedly, America was beginning to generate its own artistic independence. The main teaching centres were the Pennsylvania Academy and Chase's Art School in New York, still propagating the nineteenth-century tradition of European realism, though it was applied to American subject matter; these bodies, like others elsewhere, tended with the years to become more academic, more conservative. In 1908, they were challenged by a vigorous group known as "The Eight". The Eight had formed in direct reaction to the restrictive exhibition policy of the National Academy, and their first show, in 1908, had something of the aura of a Salon des Refusés; it was, however, very successful.

The Eight included artists of fairly diverse styles, ranging from a realism relying ultimately on Courbet and early Manet to a mood and technique very much aware of French Impressionism. Several members, however, propounded a naturalistic interpretation of some of the harsher aspects of American life, urban or agricultural – often emphasized by a sombre palette – which led to the description "Ashcan school", the name by which they are now unfairly remembered. The leader of the group was Robert Henri (1865-1929); trained at the Pennsylvania Academy and then at the Académie Julian in Paris, he had a swift and expressive style (form should be "rendered according to its nature, but it is not to be copied"), but was perhaps above all an inspired teacher. George Luks (1867-1933) and John Sloan (1871-1951) held on to the vision of Eakins and seventeenth-century Dutch realism; both had started as newspaper illustrators, and a feeling for immediacy, with a quick instinct for telling detail, stayed with them. Sloan, strongly influenced by Henri, was fascinated by the life that teemed on and off urban streets, in the slums (it was his work that precipitated the epithet "Ashcan"); although his style changed key after 1914, lightening in colour and moving towards a more generalized, abstracted treatment of form, he had a great impact on the most remarkable of the American urban realists, Edward Hopper (see over). George Bellows (1882-1925), a pupil of Henri's, though not one of the Eight, was another gifted realist, with a psychological insight into the drama of street life and of popular sport.

The assertion of independence by The Eight in 1908 stimulated others in the following years, culminating in February 1913 in the now legendary Armory Show. Alfred Stieglitz (1864-1946), one of the most brilliant early twentieth-century photographers, had run since 1905 various avantgarde galleries in New York, in which advanced American and European work was shown, but the Armory Show was the first large-scale display of the revolutionary movements in European art that a wider American public had the chance to see – even though more traditional painting, both American and French, outweighed in numbers the more innovatory kind, and the balance of representation was very uneven. Public protest was loud and sharp, although all four paintings by Marcel Duchamp found buyers. The show was crowded, however, and in a reduced form travelled to Chicago and Boston.

The Armory Show is established in history as the starting point of modern American Art. From then on the works of modernists from Europe (mainly Paris) were shown frequently, and the American avantgarde (most of whom had worked for a time in Europe before 1914) began to find a public. Georgia O'Keeffe, wife

HENRI (left)
The masquerade dress, 1911
Henri's life-size portrait of his wife Marjorie, a newspaper cartoonist, has impact, but is a superficial picture. The auburn-haired beauty has a majestic, posed elongation that owes much to Sargent, but falls short of his panache and brilliance.

SLOAN (below)
McSorley's Bar, 1912
This was one of two works exhibited by Sloan in the Armory Show. More than 1,600 pieces of sculpture, paintings, drawings, prints were shown, provoking cries ranging from "Anarchists, bomb-throwers, lunatics and depravers!" (the magazine *Art and Progress*) on. Sloan's painting might well be described as European Realism (Manet, Degas) with an American subject, but its evocative instantaneity is in its own right superb.

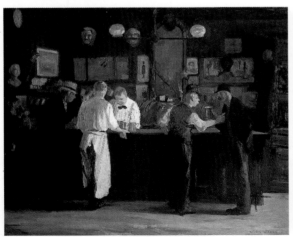

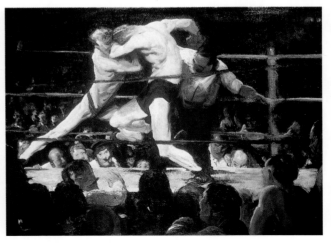

LUKS (above)
Hester Street, 1905
Luks was stimulated by the vivacity and colour of the New York slums and their way of life (he was himself a flamboyant character). He recalls French artists who freed their brushwork under Impressionist influence but did not adopt it entirely.

BELLOWS (left)
Stag at Sharkey's, 1909
The excitement and thrill of an illegal boxing match are typical of Bellows' subject matter: he carries the violence of the action over into swift paintwork. His interest in movement recalls Eakins and Homer; this is distinctly American in both subject and style.

of Stieglitz, pursued a long career far into the second half of the twentieth century, with a **highly personal, lyrical style** (see p. 458). One of the most original of the avantgarde was Marsden Hartley (1877-1943), affected more by German than by Parisian explorations (he knew the work of Der Blaue Reiter); though his usual theme was the rugged mountains and coast of New England, he also concocted bold and brightly coloured variations – almost with the effect of mosaic – on the unlikely theme of German militarism, and his fascination with flags announced a continuing inspiration for avantgarde Americans, from Stuart Davis to Jasper Johns. John Marin (1870-1953) also evolved a Cubist variation very much his own, nearest perhaps in spirit to the work of Robert Delaunay, but combining vigour with delicacy to remarkably decorative effect in watercolour, his subjects often Manhattan or the seas and islands of Maine in summer.

The achievement of the early pioneers of international styles in America is still under-valued elsewhere; at its best, its positiveness and individuality are no less striking than its variety. Arthur Dove (1880-1946; not shown) combined an advanced degree of abstraction

DEMUTH (below)
I saw the figure 5 in gold,
1928
The poem that provides the theme, *The Great Figure* by

William Carlos Williams, has a description of a fire-engine, emblazoned with the figure 5, flashing noisily through the wet, dark city.

with mystic but potent evocations of natural forms, which could be in effect Symbolist. The splendidly talented Joseph Stella (1877-1946), in a dynamic sequence of kaleidoscopic variations on *Brooklyn Bridge*, naturalized a virtuoso, romantic form of Italian Futurism in New York. Abstractions with a strong geo-metric structure were developed from Cubist inspiration in the 1920s by Charles Demuth (1883-1935) and other "Precisionists", though Demuth's most celebrated painting is stated with the startling forthrightness of a poster – *I saw the figure 5 in gold*. It is a direct ancestor of developments to come in Stuart Davis (see p. 458) and then Pop art.

In the Depression of the 1930s various federal programmes of sponsorship for art were established, which aided all sorts of artists, but especially assisted a revival of traditional figurative painting in genre and landscape – known as Regionalism. Something of the same spirit animated social realist pain-ters such as the idealistic Ben Shahn (1898-1969) and Edward Hopper; his evocative vision of urban atmospherics seemed at first uniquely American, but has since come to apply to almost any great city in the world.

MARIN (right)
Maine Islands, 1922
Marin, as Homer not long before him, felt a strong affinity with the rocky sea-scape and the shifting light of the Maine coast. The loose composition of washes is trapped on the paper by a brutal abstract frame.

HARTLEY (left)
A German officer, 1914
Hartley was an unsettled soul, who spent much of his life travelling in Europe and in America. His work ranges from such patterned, textured abstractions as this to raw landscapes and also figurative paintings.

SHAHN (below)
The prisoners Sacco and Vanzetti, 1931-32
Bartolommeo Vanzetti and Nicola Sacco were tried for robbery and murder, and on circumstantial evidence were found guilty and exe-cuted: there was uproar, an American Dreyfus case. Shahn presents the pawns in jerky worried sympathy, without giving the answers. This is one of a series of 23 paintings Shahn made recording their progress. With it he made his mark.

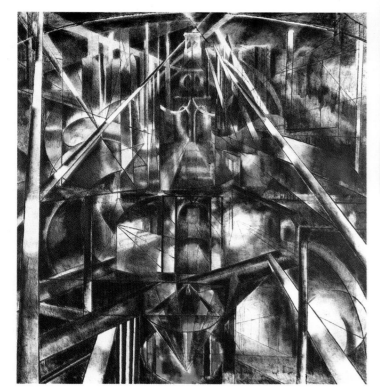

STELLA (left)
Brooklyn Bridge, 1917
Brooklyn Bridge was for Stella a vital symbol of America. He described it as "a weird metallic apparition ... supported by massive dark towers dominating the surround-ing tumult of the surging skyscrapers with their Gothic majesty sealed in the purity of their arches ... It impressed me as the shrine containing all the efforts of the new civilization of America".

Hopper: Nighthawks

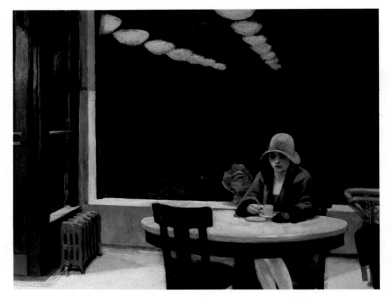

HOPPER (right)
Nighthawks, 1942
Hopper loved a long, low
light, defining structure
with firm clarity: in one
sense his compositions and
his handling are ruthless.
Inside a grid of vertical
and horizontal, human life
is held in a spotlight or
bubble; outside is desert.

HOPPER (above)
The automat, 1927
Hopper's admiration of
Degas is specially clear in
this work, so close in mood
to *The glass of absinth*
(see p. 352). In both, girls
sit in listless isolation –
Hopper's even more alone.

HOPPER (right)
Night shadows, 1921
The series of etchings he
made between 1915 and
1923 established Hopper's
career and subject matter.
The severity of the design
is enhanced by the stark
contrast of black and white.

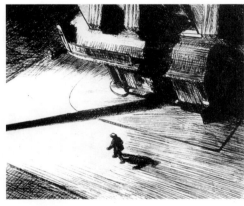

HOPPER (above)
Approaching a city, 1946
Hopper said he was trying
to express the emotions he
felt when he approached an
unknown city by train.
"You realize the quality of a
place most fully on coming
to it, or on leaving it."

BURCHFIELD (right)
The old farmhouse, 1932
Hopper's observations on
the younger Burchfield's
painting can very often be
applied equally to his own,
for example: "By sympathy
with the particular he has
made it epic and universal."

BENTON (left)
City activities, 1930-31
Benton is remembered as
Pollock's teacher, but was
a painter in his own right,
a fine observer of town and
country life and the leader
of the Regionalist school.
This is one of his murals in
the New School of Social
Research in New York.

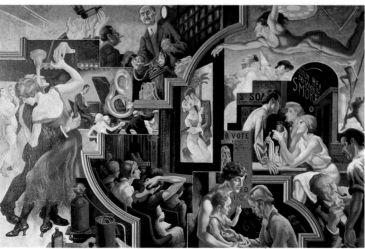

Edward Hopper (1882-1967) is the great visual
poet of big-city ennui, of the lonely desolation
of emptied streets and blankly windowed
houses, of skies and pavements scoured by
light and wind. *Nighthawks*, one of the most
haunting images in which he captured this sen-
sation, is unusual in the quantity of human
participants; for Hopper, master of depicting
two people contiguous but without communi-
cation, four was a crowd, and here the group of
three might be involved in a desultory ex-
change of talk – this amounts almost to pande-
monium. But in fact the figure on which the
picture pivots is the fourth one, the man with
his back towards you, solitary, closed in on his
own silence, plumb central. Further, the
human "action" of the picture is distanced
from you by the sheet glass that encloses the
snack bar, which underlines the onlooker's role
as an outsider, almost as a voyeur. The snack
bar is the main source of light, spilling on to the
pavement, revealing the streets to be empty; a
footfall would be startlingly loud, and a threat.
It seems the dead hour of the night, with these
four people washed up haphazard in the fragile
shelter of the light and the glass.

Hopper, a dour and austere man, was not
one to indulge in sensual felicities of colour and

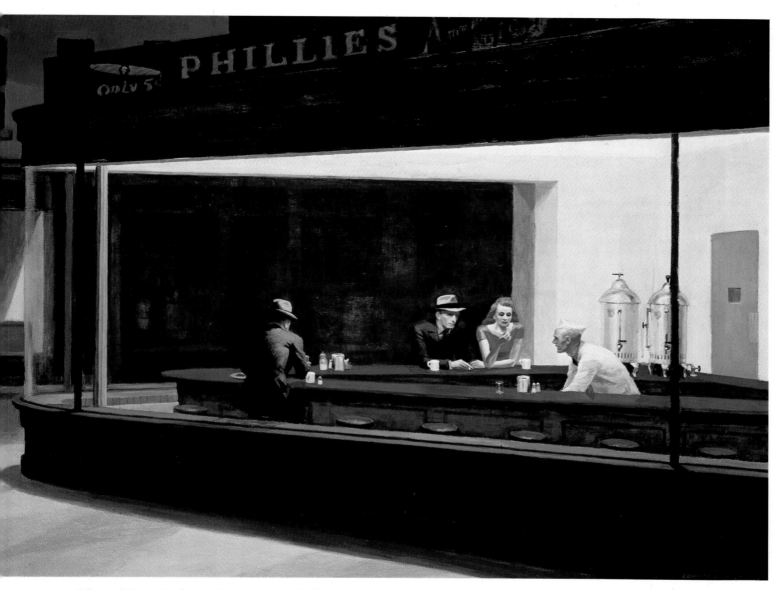

texture and line, of the feel of paint, but the raw harsh colour of the lit interior is offset very effectively by the sombre yet positive colour of the exterior setting. The mood is closely comparable to that expressed by Chirico in proto-Surrealist terms, but Hopper's realistic vision may be more convincing as a statement of the condition of twentieth-century urban man. Hopper's characters are real, unlike Chirico's puppets or statues, but they are far from home, in transit, and one of his most telling subjects is the hotel room, sometimes allied with a view of the railway tracks. Hopper's images of contemporary life touch on a nerve also exposed by the best of the realist novelists – Theodore Dreiser or Sinclair Lewis – a nerve touched again and again in certain films of mid-century – the streets and bars where Humphrey Bogart walked, the "blues" singers, the lyrics of jazz ("Every time we say goodbye, I die a little …").

The career of Edward Hopper, moving from poorly acknowledged beginnings to a position admired and accepted in all quarters, is a healthy reminder of the strength of the realist figurative tradition in the face of the once increasing fashion, especially in sophisticated New York, for abstraction and non-figurative

work. Hopper himself did not condone the move to abstraction: to him it seemed arbitrary and, in the end, frivolous and self-indulgent – not that he was in any way a slavish imitator of superficial phenomena. "My aim in painting is always, using nature as the medium, to try to project upon canvas my most intimate reaction to the subject as it appears when I like it most."

Hopper had been a pupil of Henri's, and retained a lasting admiration for him as an inspiring teacher, though it took some time to shed Henri's brisk, swift approach to painting. Trips to France before 1910 (after which he never went abroad again) seem not to have impressed him profoundly ("The only real influence I've ever had was myself"), though the mood of much of his work has something in common with that of Meryon's etchings, and he admired in Degas a quality which he also found in his compatriot Sloan – "the surprise and unbalance of nature". Vacancy and expectation co-exist. His people lack both characterization and movement, as if they are puppets of fate, and he did not share the social, humanistic concerns of some of the Ashcan school – he preferred "to paint sunlight on the side of the house". Some of his most potent images are of emptiness – a lonely room, or a

mansarded house looming against the sky.

The story of Hopper's career is that of his work – withdrawn from public life, ignoring artistic polemic. Nevertheless many of the painters collectively christened Regionalists shared his preoccupations – the painters of small-time America, the city and the country. The emptiness that Hopper found in the city Charles E. Burchfield (1893-1967) found in the farms of the Mid-West, though he tended towards a more nostalgic melancholy. The realism of Thomas Hart Benton (1889-1975) was more exuberant, sometimes taking a form recalling rather the allegories of British painters such as Ford Madox Brown than the instantaneity of Degas or the Ashcan school; and the contrast with Stuart Davis (see p. 458), juggling more formalistically with contemporary images, is even greater. Yet landscapes, urban scenes, interiors, the passive, the unspectacular, the commonplace could sometimes be structured by other realist painters than Hopper into pictorial drama, and this peculiarly American strain has continued all through the twentieth century, not quite forgotten amid the rage and fury of Abstract Expressionism and vindicated anew in the work of Andrew Wyeth (see p. 474).

The Mexican Muralists

The great indigenous traditions of art in Central and Southern America were smothered when European supremacy was established. The cultural effect of the Catholic colonialists was to re-create in America the setting and way of life of Spanish or Portuguese cities. In architecture, some variations of strikingly exuberant fantasy were built, but painting and sculpture were derivative and generally not of high quality. The emphatic and dramatic style of Zurbarán was a lasting influence. In some areas, however, local folk art extracted out of European religious iconography a colourful imagery of its own, and a few painters of more sophisticated talent emerged, such as Melchor Holguín in Bolivia.

In the twentieth century, important artists from Latin America have made significant contributions, but they have been active on the international scene, and generally based in Paris. In Mexico, however, from the Revolution of 1910 onwards, an indigenous national school became very active, and attracted an admiring or horrified attention both in the United States and in Europe. Working often in a medium and on a scale that had almost lapsed in Europe – monumental mural

decoration – its art was harnessed (under official patronage) to Revolutionary political and social programmes as nowhere else in the world, except in Russia, but the Mexican solution was artistically far more imaginative than the platitudes that by the mid-1920s were swamping the brilliant exploratory Russian art of the early Revolution.

In the late nineteenth century there had developed in Mexico a strong strain of popular imagery in the graphic media, published in the so-called "corridos", vehicles for both journalism and popular history. José Guadalupe Posada (1852-1913) had evolved a personal idiom in woodcut and lithograph, Expressionist, formally speaking, in that he used distortion to emphasize his message. In his fantasy world of weird skull-topped characters both the Mexican obsession with death and the Mexican talent for savage caricature were prominent. His popular art, commenting often controversially on current affairs, was a significant precedent for the subsequent development of Revolutionary mural-painting.

The tradition of mural-painting had never died out in Mexico, surviving from the decorations of Pre-Columbian cultures (see

p. 18) through the colonial versions of European Baroque styles in the churches. The revival of its techniques and its widespread application were sponsored consciously by the necessity, in a Revolutionary situation, to instil in a largely illiterate populace a sense of national and socialist identity; the programme was educational and inspirational, and in that its aims were similar to those of medieval church decoration. The major agents in the realization of this programme were the famous triumvirate of Rivera, Orozco and Siqueiros.

Diego Rivera (1886-1957) turned against the academic training offered in Mexico City, and between 1907 and 1921 was based almost entirely in Europe, settling in Paris, where he was associated with the Cubist painters, although by 1915 he was establishing a personal, poetic naturalism, expressed in a delicate linear style. On his return to Mexico in 1921, he became involved in a Revolutionary artists' commune, and worked towards the evolution of a straightforward, heroic, naturalist style that should both exploit the formal discoveries of modern art and be immediately comprehensible to the people; he studied the traditions of Mexican folk art, and experimented

RIVERA (right)
Mexico today, Mexico tomorrow, 1936
Part of a huge mural cycle in the National Palace of Mexico City, *The history of Mexico* (begun in 1929), this compartmented crowd of somewhat static figures constitutes a critique of Mexican society. Rivera, with Siqueiros, was one of the leading members of the Mexican Communist Party, but here he denounces the corruption of communist Revolutionaries as well as oppression by the fascists.

POSADA (above)
The alcoholic, c. 1912
Posada always remained close to the people whom he entertained or horrified. His workshop was a focus for the younger artists.

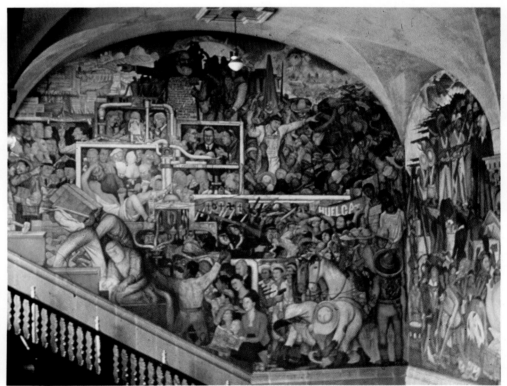

RIVERA (left)
A hymn to the earth, 1926-27
Rivera's fresco scheme exudes the crude power of the new mural movement. The message, justifying the collectivization of Mexican land after the Revolution and exalting the peasant worker, is made through symbols. On the altar wall a huge nude represents Mother Earth in harmony with nature and modern technology.

OROZCO (right)
The people and their false leaders, detail, 1937
Orozco's subjects reflect a wider view of humanity than that of Rivera or of Siqueiros: he was idealistic, but he was not politically active, though he was passionately concerned with the suffering of the common people. He conveys his bleak view of reality in an almost satirical style, with monochromatic tones and expressive brushwork.

with the techniques of early Italian fresco-painting. His themes were deployed in terms of labour, of mining, farming and industry; he celebrated the triumph of creative labour and the destruction of the evils of capitalism, poverty and the established Church. His imagery, and the spelling out of his message, can be distastefully crude, but his control of huge, complex compositions, his sheer energy, can be overwhelming.

José Clemente Orozco (1883-1949) was a second major force, contributing savage caricatures to the Revolutionary cause from 1910. But he developed a wider view of the Revolutionary struggle than did Rivera, and in his greatest series of murals in Mexico, at Guadalajara, which he executed after a stay in the United States, 1927-34, some have felt the titanic force of an artist of universal relevance. The third of the triumvirate, David Siqueiros (1896-1974), was the most politically active, abandoning painting altogether in 1925-30 for politics, imprisoned, exiled, fighting in the Spanish Civil War. The most spectacular Mexican artist of his time, he exploited both folklore and Surrealist and symbolic effects in his social realist synthesis; he used photo-

graphs and new techniques such as air-brushing. Like Orozco's and Rivera's, the rhetoric and bombast of his subject matter can carry enormous impact.

The pattern of official patronage in Mexico was far from consistent: the three main muralists all spent time abroad, and some of their major commissions were carried out in the United States, where their work had a profound effect on American realist painters of the 1930s and later, especially on those associated with the political left. Orozco undertook murals in California and on the East Coast; Rivera worked at the Rockefeller Center. Their most important work, however, was in the public buildings of Mexico itself, constituting a programme of social realist art unmatched in quality or scale anywhere else. The continuing Mexican tradition of mural-painting in bold colours on a colossal scale is unique in the world, though too often it tends to pastiche (usually of Pre-Columbian art).

Often ranked beside Rivera, Orozco and Siqueiros is Rufino Tamayo (born 1899), whose best works are his easel-paintings, in which he successfully synthesized modern European styles with Mexican folklore.

OROZCO
Man of fire, detail (above) of the cupola (below) at Guadalajara, 1938-39 Orozco's human torch is one of many dramatic and disturbing images in the great series of frescos,

begun 1936, at Guadalajara. The cupola, vaults (see far below) and the smaller areas of fresco in the Hospicio Cabanas amount to more than 12,000 square metres, painted by Orozco virtually without assistance.

OROZCO (above)
Machine horse of the conquest, 1938-39 The symbol of warfare and conquest, trailing chains

of slavery behind it, has an almost medieval-looking linear strength and roughness. The rider brandishes above the flag of Seville.

SIQUEIROS (left)
For the full safety and social security at work of all Mexicans, 1952-54 The miner, leading doctors and intellectuals towards a better life, represents the power of the working man: the style is typically dynamic. Siqueiros also designed the chamber, with parabolic curves.

SIQUEIROS (left)
The portrait of the bourgeoisie, detail, 1939 From 1939 Siqueiros had immense impact on mural-painting in Mexico. In the 1920s he had founded the Communist Syndicate of Artists in an effort to organize artists into an idealistic, unified force, but he had not found his place in the development of mural art. Here, in this detail from a huge scene, which was at first entitled *The image of fascism*, the high gloss of his mature style, enhanced by the use of spray-guns and of thick enamel, has a modernity which contrasts with both Rivera and Orozco.

TAMAYO (above)
Sleeping musicians, 1950 Tamayo has been labelled "decorative" in contrast to the monumental, apocalyptic mainstream of Mexican painting. Certainly he has none of the cosmic torment of Orozco, and he remains unaffected by the miseries of his subjects. Matisse was of rather greater interest.

The Sources of Abstract Expressionism

During the 1930s there had been an increasing influx of major European artists to the United States, refugees first from Hitler's repression in Germany and then from total war. Picasso and Matisse and Miró did not come, but Grosz, Léger, Albers and Mondrian did, and also – seminal for the triumphant emergence of American painting in the 1950s – practitioners of Surrealism, Tanguy, Masson, Ernst, and its "Pope", André Breton. There was also, in Marcel Duchamp, the enigmatic presence, disruptive yet fertilizing, of ongoing Dada.

The significance of these artists for the new American movement was generously acknowledged by Jackson Pollock, destined to be its most famous star, as early as 1944: "The fact that good European moderns are now here is very important, for they bring with them an understanding of the problems of modern painting. I am particularly impressed with their concept of art being the Unconscious." Yet the very presence of these exiles in the USA indicated the exhaustion of their native European climate; where indeed could art flourish and find a new relevance for a world in violent flux, except in America? The United States emerged in 1945 as the most powerful nation in

the world; during the War, unoccupied, unbombed, it seemed, in spite of its colossal military commitments to East and West, to have inexhaustible reserves of energy on which even the arts could draw.

The American public, though mainly in New York and only gradually and reluctantly, had become acclimatized to the shocks of modern art since 1913 and the Armory Show. A network, both cultural and commercial, was building up to sustain and increase its interest. The foundation of the Museum of Modern Art in New York in 1929 was a milestone: it was to develop not only as a museum in the old sense, but also as an active patron and trend-setter. Some of the most famous American private patrons and collectors (notably Gertrude Stein in Paris) were expatriate and orientated to Europe, but others – most famous among them Peggy Guggenheim (1898–1979) – were active and creative agents in America itself. Official acknowledgment of responsibility for the arts, including the avantgarde, had been demonstrated by the Federal Art Project of 1935.

Among indigenous painters, the key transitional figure linking pre-War with post-War American art was Stuart Davis (1894–1964),

who brought a concentrated integrity to his pursuit of pictorial structure. (In a curious parallel to George Stubbs' months-long investigation of equine anatomy in confrontation with horses' carcasses, Davis more or less shut himself up during '1927–28 in contemplation of an egg-beater.) Davis' contribution can be seen as an American extension of Cubism: he was at times close to Léger, but he used colour very differently, bright and clear, solid and flat: "People used to think of colour and form as two things. I think of them as the same thing." This, together with his conspicuous modernity, his celebration of the banal vocabulary of everyday urban life, was a decisive influence on artists of the 1940s and 1950s, and then on Pop art. Also significant were the Precisionists, a loosely unified group who portrayed contemporary America in a hard-edged, boldly coloured version of Cubism; with them for a time was Georgia O'Keeffe (1887-1986), who in a long career developed an increasingly abstract imagery, based on magnified organic forms and on the rolling, windswept plains of Texas.

American artists looked to the East as well as to the West; they also looked to native art,

DAVIS (left)
Lucky Strike, 1921
An illusionistic collage from cigarette packets was Davis' answer to Cubist *papiers collés*; he showed a dazzling virtuosity in the tight restructuring of his fragmented urban imagery.

DAVIS (right)
Ultra-Marine, 1943
The forms seem to stomp through Davis' pictures in jazz-like rhythms, in a magnetic dance: "Colour in a painting occupies different positions in space" was his comment.

NAVAJO ARTIST (below)
"Sand painting", 1966
The painting is performed by a medicine-man, as part of his healing ceremony.

O'KEEFFE (above)
Light coming on the plains II, 1917
The lyrical and evocative

shapes of O'Keeffe's work hover on a delicate border between representation and abstraction pure and free.

MATTA
Stop the age of Hemorr,
c.1942
Matta's imagery combines

study of ancient cultures with an extensive reading of science fiction and of South American novels.

American Indian and Pre-Columbian. Pollock was fascinated by Mayan glyphs, and was intrigued by Navajo "sand painting", not so much its form as its ritual and the manner of its painting, in large gestures and on the ground. It was the supposed motivation of such "primitive" art, its vital and direct contact with the Unconscious, that chiefly interested the Abstract Expressionists. The Chilean Surrealist Roberto Matta Echaurren (born 1912), who lived in the United States from 1939 to 1948, was instrumental in bringing to their notice the American Indian cultures that suggested his personal mythology.

The two main forerunners of Abstract Expressionism were Arshile Gorky (1905–48), Armenian-born, settled in the United States since 1920, and Hans Hofmann (1880–1966), German-born, who migrated to America in 1930. Gorky by 1942 had arrived at a very free calligraphic brushwork, very bright in colour, often entirely without figurative reference. "I never finish a painting – I just stop working on it for a while. I like painting because it's something I never come to an end of." Such statements, no less than his paintings, indicate his importance as a transitional figure for

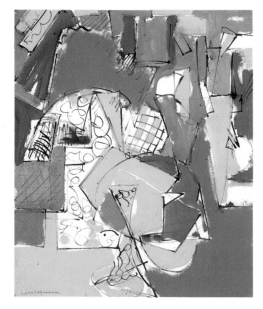

HOFMANN
Untitled, 1943
Much of Hofmann's work is founded on his theory of

"tensions" – he believed conflicting forces should be contained in a painting, in a tenuous equilibrium.

Abstract Expressionism, but his painterliness always reflected his European origins. Hofmann established a profoundly influential school in New York in 1934. He not only was able to provide a forcefully articulated theoretical support for non-figurative art, but remained very open to the stimulus of the new. In particular he reflected Symbolist ideas, of the independence of the world of art from the world of appearances; he used colour to express mood as Kandinsky had, yet retained a feeling for form that stems from Cézanne and Cubism. Anticipating Pollock, he had even experimented with "drip" techniques in 1940, but his own most magical colouristic inventions, coming at the end of his life, express a radiant serenity very far from Pollock's.

Mark Tobey (1890–1978) was never part of the Abstract Expressionist movement; rather, his work ran in parallel with it. He was crucially influenced by oriental example – by Japanese Zen philosophy and painting (see p. 294) with its own kind of "automatism".

After World War II New York was established with remarkable speed as the world centre of avantgarde art, displacing Paris, and so remained for the next 15 years.

GORKY (right)
Water of the flowery mill, 1944
Gorky, born in Armenia as Vosdanig Adoian, emigrated first to Russia and then to America, where he worked through the styles of the fathers of modern art, Picasso and Cézanne, of the Surrealists Miró, Matta, and of Kandinsky. He developed a personal Surrealism that verges on Abstract Expressionism; mercurial forms coagulate and merge, as fluid as the rich paint creating them. A devastating fire in his studio, an operation for cancer, a car accident that prevented him painting, his wife's adultery and his own impotence precipitated the artist's suicide at 44.

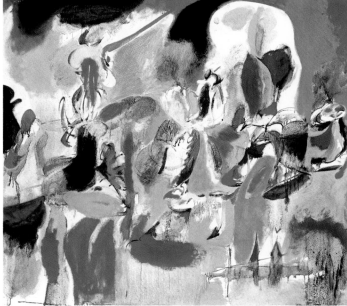

GORKY (above)
The limit, 1947
Greys and blacks pervade the works painted during the depression of Gorky's last years. Despite their appearance of spontaneity, even of automatism, they evolved from sketches, sometimes squared up and transferred to the canvas.

TOBEY (below)
Forms follow man, 1941
These frenzied meshes of agitated lines and forms Tobey once called "white writing"; they were directly inspired by his study of oriental scripts. Though his work seems sometimes to anticipate Pollock's, it is not so free, and on a small scale.

HOFMANN (left)
Radiant space, 1955
Hofmann brought with him to America long experience of teaching, in Paris and in Munich. This he imparted to the fledgling Abstract Expressionists attending his school in New York. In later work he managed to amalgamate his European and American careers in paintings of an expressive abstraction often somewhat like de Staël's (see p. 472).

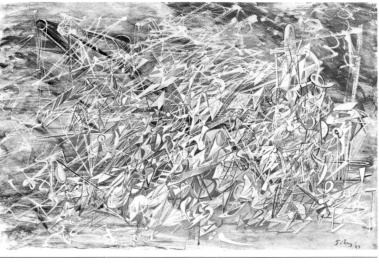

Jackson Pollock

Jackson Pollock (1912-56) was born in Cody, Wyoming. His father was an unsuccessful farmer, and later a government land surveyor: Pollock, in his teens, experienced the vast, elemental landscape of Arizona and the Grand Canyon and also, on surveying trips with his father, came into contact with Indian culture. Moving to New York in 1929, he was taught by Thomas Hart Benton (see p. 454), a leading figure in the American Realist tradition, portraying the rural and small-town Midwest. His subject matter only briefly influenced Pollock, but possibly Benton's rhythmic control of paint and his truculent, independent character made an impression that was to last. Pollock's restlessness was expressed in long, lonely hitch-hiking journeys about America; an addiction to alcohol began very early. In 1938 he started work for the Federal Arts Project and managed to stay with it, somewhat unsatisfactorily, until it ceased in 1943. By then he was in analysis. In the same year, 1943, he signed a one-year contract with Peggy Guggenheim, the most prestigious collector and dealer in wartime New York, and in a group exhibition at her gallery was singled out by the critic Clement Greenberg, who was in no small part responsible for establishing Pollock's controversial fame. In 1945, Pollock married the painter Lee Krasner and moved to Springs, Long Island. There he remained based, while his work became celebrated not only in New York but throughout the world. In 1956, he was killed in a car crash.

By the time of his death, Pollock was already a legendary figure, having fulfilled the public's expectations of a Bohemian artist by outrageous behaviour to match his outrageous pictures. Physically large and impressive, he was also gentle and somewhat inarticulate, almost shy, when sober; when drunk, he would become violently aggressive, hell-bent on shattering the conventions of ordinary society. The existence of his psychological difficulties is well attested, though the interpretation of them differs; it is clear, however, that he had a core of violence – seeking, and sometimes finding, release in his work – which could be irritated beyond control when he was threatened by success, by acceptance by the society whose conventions he scorned but on whom he depended for his livelihood. To his Jungian analyst, his condition when painting suggested "a parallel with similar states of mind ritually

NAMUTH (above)
Jackson Pollock, 1952
Namuth's photographs contributed to Pollock's fame, especially after his death. Magazine articles proliferated, discussing Pollock's private life in as much detail as his art. He was the first American artist to become a star.

POLLOCK (below)
Self-portrait, 1933
Pollock was often to be found in the Benton home in his early days in New York. Benton commented: "He was mostly a silent, inwardly turned boy, and even in gay company had something of an aura of unhappiness about him."

POLLOCK (left)
Going west, 1934-35
The influence of Benton is present not only in the subject matter but also in the undulating contours, in the thick, turbulent paint. Some of this, however, may reflect Pollock's youthful admiration for El Greco. He studied with Benton for two years; he thought his time with Benton was "important as something against which to react very strongly, later on".

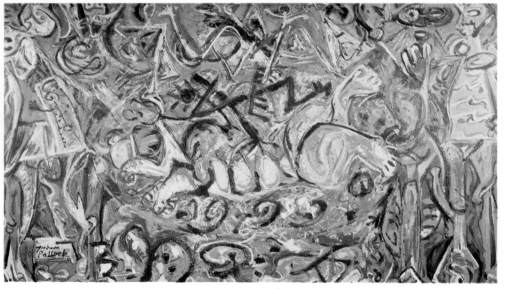

POLLOCK (right)
Pasiphaë, 1943
The wife of King Minos of Crete, Pasiphaë, was impregnated by a bull and so produced the Minotaur. The original title was *Moby Dick*; both legends featured huge, primordial animals. Between the Wars Jung had begun to inter-pret myths as metaphors of the working of psychic energies; Pollock, in the early 1940s, painted a set of works inspired by myths in which elemental forces seem to figure. *Pasiphaë* bears a strong resemblance to Picasso's *Guernica* (see p. 451); Pollock had copied some preliminary drawings.

induced among tribal societies or in shaman-istic trance states". He was anti-intelluctual, though highly intelligent, and drew deli-berately in his mature work on the irrational depths of the Unconscious.

Pollock's early work was influenced by the Mexican Revolutionary painters: they taught him, it has been said, by their expressive, often violent use of paint, "that art could be ugly". The large scale of Mexican work, especially the murals, impressed him, and Siqueiros introduced him to new materials and tech-niques, of crucial importance in Pollock's development, since his style was not only conditioned but even generated by his media and the way they could be handled. Picasso and Surrealist influences (especially from Miró) had their effect on Pollock's tumultuous figurative symbolism of the late 1930s. In the early 1940s, Pollock's "totemic" period, his work was full of mysterious forms associated with those primordial strata of the imagination from which "primitive" art was thought to emerge. The preoccupation with symbols van-ished about 1946, and the non-figurative, "all-over" work for which he is famous began. His method is well known from Hans Namuth's

photographs and films of him "in the act", and from his own description.

"My painting does not come from the easel. I hardly ever stretch my canvas before paint-ing. I prefer to tack the unstretched canvas to the hard wall or the floor. I need the resistance of a hard surface. On the floor, I am more at ease. I feel nearer, more a part of the painting, since this way I can walk around it, work from the four sides, and literally be *in* the painting. This is akin to the method of the Indian sand painters of the west. I continue to get further away from the usual painter's tools, such as easel, palette, brushes etc. I prefer sticks, trowels, knives and dripping fluid paint or a heavy impasto with sand, broken glass and other foreign matter added. When I am *in* my painting, I'm not aware of what I'm doing. It's only after a sort of 'get acquainted' period that I see what I have been about ... the painting has a life of its own. I try to let it come through ..."

With paint trailed, dribbled, dropped, splashed, smacked across expanses of canvas – often huge – the resulting object is an im-mensely complex network of linear colour. It denies traditional perspective, emphasizes the

flatness of the picture plane yet also creates a mysterious depth in its interstices. The method recalls Surrealist "automatism", though Pollock also claimed: "I *can* control the flow of the paint, there is no accident, just as there is no beginning and no end." To a bewildered public the result was at first insult-ingly incomprehensible, meaningless, devoid of form, yet as Pollock's work settles in history its original quality, then felt to be expressive of anger, revolt, even mindless violence, takes on enduring conviction; while losing none of its vitality, it seems now a classic statement.

There was a desperate, doomed aura about several artists associated with Abstract Expressionism, and Pollock's death, whether self-inflicted or drunken or purely accidental, seemed the necessary fulfilment of a death-wish. Intensely subjective, Abstract Expres-sionism demanded of its practitioners a total, almost religious, commitment but, with no established structure of tradition to support them, they were way out on their own, and for some the loneliness, the strain of freedom, proved too much. They were, in fact, true pioneers. The originality of the Abstract Ex-pressionists was their American own.

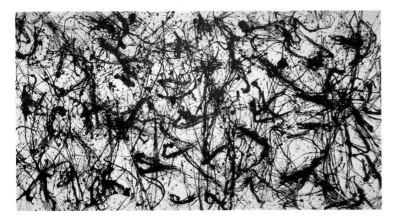

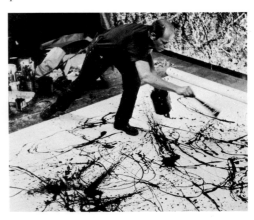

POLLOCK (left)
No. 32, 1950
Pollock produced a number of works between 1950 and 1952 using black paint only. Their rhythmic quality has since been likened to jazz improvisations with their off-beat tempi and sudden stresses. His habit of numbering his canvases has been explained by his wife, Lee: "Numbers are neutral, they make people look at the picture for what it is – pure painting."

NAMUTH (above)
Pollock painting, 1950
Namuth also photographed Pollock at work, and made two films of the progress of a painting from start to finish. "It was a great drama", Namuth said, "– the flame of explosion when the paint hit the canvas; the dance-like movement; the eyes tormented before know-ing where to strike ... my hands were trembling."

POLLOCK (left)
Convergence, 1952
This is one of Pollock's last paintings using the "drip" technique; in his few late works he reverted to a more formal method. It was originally one of the black paintings, and the scrawling network of black lines and splashes can be seen beneath the trails of floating white and primary colours – fixed in a state of flux, seething and dynamic.

Abstract Expressionism: The New York School

The term "Abstract Expressionism" seems to have first been used in Berlin in 1919; rediscovered in America about 1929, as relevant to aspects of Kandinsky's early abstract work, it came into general currency about 1946 to describe the work of a group of American painters centred in New York – though they only very loosely formed a group, and denied that they were abstract. An alternative label, "Action Painting", was coined in 1952 by Harold Rosenberg (born 1906); he and Clement Greenberg (born 1909) were the most influential critics, apologists and expounders of the new movement, which became known also as "The New York school". By 1955, it had become almost a new orthodoxy, matched by parallel or dependent movements in Western Europe under various titles – "Tachisme", "Art Informel", "Abstraction Lyrique"; in whatever guise, it was the expression of fervent individualism, and the communist cultures of Eastern Europe rejected it entirely.

Some of the European, native American and oriental antecedents of Abstract Expressionism have been suggested on page 458. The American upsurge differed from most European abstraction precisely in that it did not depend on an initial abstraction from perceived nature. The paintings had no context in the European tradition of representation or illusionism. The whole painting – the support, canvas or board, and the paint on it – became both subject and object, its primary reality; it was not an abstraction but a physical presence. This presence was emphasized by the very large scale on which most of the Abstract Expressionists worked.

Action painting was carried out at arm's length, with wide and rhythmic sweeps of a large and loaded brush, if brush were used; or, in Pollock's style, the artist almost climbed into the canvas, laid flat on the floor, and swung and dripped paint from the can. From such techniques the "all-over" character of the paintings emerged naturally. The limits of the canvas edges might impose a shape, although Pollock often cut his work for stretching and framing only after he had finished painting. As traditional concepts of composition, space, volume and depth were jettisoned, so the flatness of the picture plane came to be respected, and the varying insistences of colours, in ambiguous relationship with it, came to be

STILL (below)
1957-D no. 1, 1957
Still's enormous canvases dominate the spectator. Their effect is enhanced by the flames of paint which seem to move in and out of the canvas, suggesting that what is there is only a part of something even larger.

KLINE (above)
Orange and black wall, 1959
The major part of Kline's work is in black and white – so stressing the stroke – but throughout he also used colour; his pictures became increasingly larger – this is literally of mural size.

KLINE (left)
Mahoning, 1956
Mahoning is a county in Pennsylvania, Kline's native state. He habitually painted what seem to be memories of the local landscape, an industrial area dissected by numerous railway lines.

GUSTON (left)
Dial, 1956
Guston used to paint very close to his canvas for hours without stopping, so that he became completely immersed in his painting. Using different tones he built up throbbing areas of colour – hence the title "Abstract Impressionism".

GUSTON (right)
Untitled, 1958
Blacks and dark greys start to appear in Guston's work in the late 1950s, and these paintings are more sombre in mood. The brushwork is freer; he lets the viewer trace in the movements of the brush all the hesitations and doubts that are integral to the action of painting.

cherished. The physical action – or exertion – of painting became almost as much an end as a means, and the resulting imagery was the most direct expression, visceral rather than intellectual, of the artist's unconscious being.

Painting was a process of self-discovery by the artist. Artists' selves, however, obviously differ, and so the work of the leading figures in the movement differs likewise, not only in the expressive imagery that they used (or that used them) but in their techniques and attitudes. They can be categorized, if only for convenience, within two poles, the active, and the passive or contemplative. The passive element was common in some degree to all of them, in that they were the instruments of the Unconscious; and they all acted in "psychic improvisation". In some, however, the activity is violent and aggressive in gesture: as time passes, Pollock (see preceding page) and De Kooning (see over) emerge even more clearly as the outstanding figures at this end of the spectrum. The contemplative procedures of Mark Rothko and Barnett Newman mark the passive end, and they are considered beside the later, more colouristic painters (see p. 466). The work of Philip Guston, Clyfford Still,

Franz Kline, Robert Motherwell, Adolph Gottlieb and the ever experimental and articulate Hans Hofmann seems to lie between these two poles; except Hofmann (see p. 458), who was of an older generation, these are the painters illustrated here.

Clyfford Still (1904-80), always a detached figure, worked on a very large scale, his characteristic image being a heavily impasted, jagged form silhouetted in dramatic contrast against a broad, even plane of colour. Philip Guston (1913-80) had his own, highly personal variation, sometimes called "Abstract Impressionism"; from this he moved to a more expressive style in the late 1950s. The vigorous gestural work of Franz Kline (1910-62) has sometimes been compared to gigantically enlarged fragments of Chinese calligraphy; his best-known work was fiercely black and white, but he early began using colour, too. Robert Motherwell (born 1915), originally a scholar rather than a painter, was one of the theorists of the movement – articulate, involved with Existentialist philosophy, seeing painting as an essentially ethical activity. His work is bold and simple, often with symbolic, sometimes figurative and even political connotations.

Still's close contemporary Adolph Gottlieb (1903-74) exploited Surrealist imagery in the 1930s, but was also deeply interested in Indian art, and from this he developed in the 1940s his so-called "pictographs", characterized by very Freudian imagery. In the 1950s, his theme became abstract *Imaginary Landscapes*; these he distilled still further, and at the same time expanded to heroic scale, in his *Burst* series, variations on the theme of an overriding solar orb, luminous above an explosion of colours on Earth – paintings with an apocalyptic presence. The mystic vision developed by the younger painter Sam Francis (born 1923) was lighter, more optimistic – a series of large canvases of the 1950s in which colour runs, coalesces and spills over the canvas. Once described as a "portrait of the surface of the unconscious mind", the result, formless, evanescent as clouds moving in the upper air, invokes meditation. Francis is arguably not of the New York school, since he worked both in Japan and in Paris: his canvases sometimes have the effect almost of a late Monet *Water-lily* painting, while they look forward also to the so-called "colour-field" painting of the 1960s (see p. 466).

GOTTLIEB (below)
Black and black, 1959
Gottlieb's *Burst* series explores the relationship between two shapes, circle and rough rectangle, which have symbolic resonances – of harmony and violence, of freedom and control.

MOTHERWELL (above)
The voyage, 1949
The title is a tribute to a poem by Baudelaire, *Le Voyage*, which described modern art as travelling into unknown territory, much as Motherwell felt he and others were doing.

MOTHERWELL (right)
Elegy to the Spanish Republic no. 34, 1953-54
Motherwell denied that his *Elegies* – there are more than 100 – were political; he called them "general metaphors of the contrast between life and death".

FRANCIS (left)
Summer no. 2, 1958
Francis was Still's pupil in San Francisco and was influenced by Pollock's "drip" technique. He took as his basic theme tensions created between splashes and dribbles of vibrant colour against brilliantly white grounds. Unlike many Abstract Expressionists of the older generation his work lacks symbolic content; he was concerned solely with the emotive values latent in colour, especially white, to him "ringing silence . . . an endless, ultimate point at the end of your life".

De Kooning: Woman I

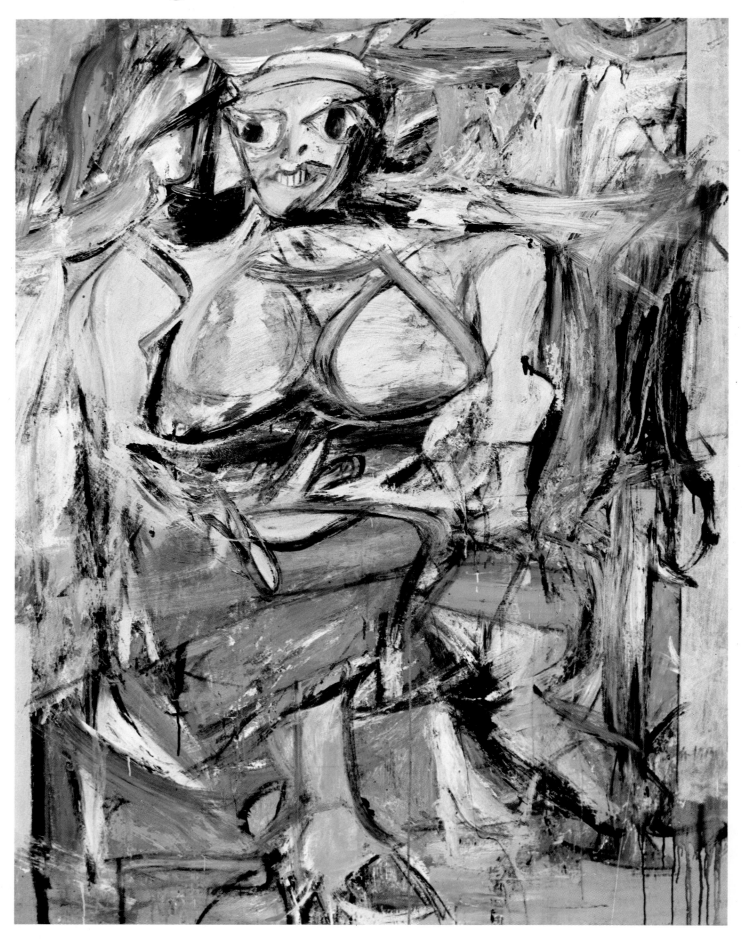

DE KOONING: *Woman I*, 1950–52

DE KOONING (right)
Excavation, 1950
Although De Kooning was
at his closest to complete
abstraction in *Excavation*,
its shapes tend to suggest
wild ghostly dancers. The
painting was very heavily
worked, reworked, scraped,
rubbed and slashed, until
its surface accumulated
a solid, densely charged,
intricately meshed relief.

DE KOONING (below right)
Study for *Woman*, 1949–52
Greenberg had described
De Kooning's aims, before
the *Women* alienated him,
with sympathy – to recover
"a distinct image of the
human figure, yet without
sacrificing anything of
abstract painting's deco-
rative and physical force".

DE KOONING (above)
Woman sitting, 1943–44
The thin washes of paint,
the muted, delicate tones
and graceful drawing recall
some works (see p. 458) by
Gorky, a fellow-European
sharing with De Kooning
a studio and an admiration
for Picasso and Cubism.
Gorky, however, painted
very few figurative works.

DE KOONING (right)
Woman, 1943
No more than a fraction of
De Kooning's 1940s work
is extant. His reluctance
to finish a painting was
ingrained; if possibilities
of further work on a canvas
seemed unpromising, then
often he would destroy it.

DE KOONING (below)
Woman on the dune, 1967
Splayed legs and a toothy
grin are the only parts of

the woman that are clearly
decipherable; the rest of
her is inextricably united
with the riotous landscape.

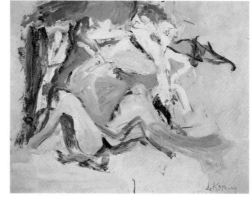

The stature of Willem De Kooning (born
1904) is today clear: he was, with Pollock, the
strongest and most original force amongst the
painters associated with Abstract Expres-
sionism. The intensity of dispute about the
relative success or failure of his various shifts
of style and subject is perhaps more telling
as a witness to his importance than as criticism.
While he was always committed to the physi-
cal, gestural side of Abstract Expressionism – a
true, relentless Action Painter – De Kooning's
work represents a figurative element in the
movement: figuration seems to lurk in the
tormented surface of his paint almost through-
out his career: it emerges irresistibly, thrash-
ing demonically through it.

De Kooning migrated from his native Hol-
land to New York when aged 23. By 1939 he
was a member of the group soon to be known as
the New York school, and especially close to
Arshile Gorky. In the 1930s he had painted, in
rather delicate greyish, pinkish, greenish
tones, alternately pure abstracts and what was
virtually traditional figuration. By 1948, when
he had his first one-man show, De Kooning's
work was generally similar in effect to
Pollock's – vigorous, gestural, and often in
black and white, for he could not always afford
to buy colour, although he was already cele-
brated in New York avantgarde circles. In
Excavation, an important work of 1950, he did
use colour; as soon as this abstract had left the
studio he was at work on *Woman I*. He
continued to work on it for two years (it has
been called "a noble battlefield rather than a
completed painting"). Finished, or at least
desisted from, in 1952, it was exhibited, with
five other *Women*, *nos II–VI*, at his third one-
man show in 1953; bought by the Museum of
Modern Art, it became one of the most widely
reproduced paintings of the 1950s and at the
same time a focus for pugnacious controversy
amongst not only public but critics: the two
most influential critics of the New York avant-
garde disagreed violently, Clement Greenberg
attacking with the rage of one betrayed,
Harold Rosenberg remaining De Kooning's
most loyal and articulate supporter. The be-
lievers in a rigorously abstract art were dis-
mayed; the general public was shocked by the
gross grinning ugliness of De Kooning's pre-
sentation of a classical subject, "the idol, the
Venus, the nude", as he said.

On first impact, the image is indeed sinister,
threatening. It has been construed as a satire
on women, an ejaculation of fascinated horror
at sexuality, an attempt at exorcism of the
threatening Black Goddess or Earth Mother.
De Kooning has insisted that it is also funny
(specifically, "hilarious"), and that its banality
is deliberate ("I seem always to be wrapped in
the melodrama of vulgarity") – this banality
was later to be exploited, in very different
techniques, by Pop artists. The ferocious leer
is a sharpening of the toothpaste smile of
magazine pin-ups: De Kooning liked to cut the
smiles from the magazines, and in a *Woman*
study of about 1950–51 the cut-out smile is
pasted directly on to the oil-paint. ("I felt
everything ought to have a mouth.") Portions
of the anatomy of the *Women* were inter-
changeable: De Kooning often did drawings of
details and tried them for size, pinning them
here or there on the canvas.

Violence, energy and ambiguity are staple
characteristics of De Kooning's work, but they
are not used destructively; instead they are
activated as part of the process of establishing
an aesthetic order. In his later work, there is an
element of landscape involved in the paint, and
the female figures in the landscapes all tend to
merge back into the vigorous brushwork:
many of his later paintings seem closer to pure
abstraction, and some find in them a falling off
in power, compared to his earlier work. De
Kooning is probably not worried. He once
said: "Painting the *Woman* was a mistake. It
could not be done . . . In the end I failed. But it
didn't bother me . . . I felt it was really an
accomplishment."

Abstract Developments 1: Colour-Field

Several important artists in America in the late 1940s and the 1950s were experimenting with the use of flat areas or fields of colour to induce contemplation in the beholder – even to a pitch of mystic intensity. Most of them are generally described as of the New York school and as Abstract Expressionists, but if they were Abstract Expressionists they were very much on the passive wing of that movement, in contrast to the agitation of Pollock or De Kooning, though it is hard to draw a dividing line – Clyfford Still's work, for example (see p. 462), can be thunderous in mood, but is positively severe in contrast with Pollock's action. The work of these artists was on a very large scale, in which it differed sharply from the related investigations of Albers and others, the scale being necessary to the creation of the effect.

The senior and most distinguished of these "colour-field" painters was Mark Rothko (1903-70), Russian-born, but brought up in the United States; he has been described, with Still, as the chief exponent of the "American Sublime". He had first exhibited in 1929, and by about 1940 was working in an expressively Surrealistic vein, busy with biomorphic imagery not unlike Gorky's (see p. 459). By 1947,

however, he was evolving the formula to which he was to remain faithful for the rest of his life. This formula, though generally interpreted on a monumental scale, is almost as simple as that of Albers' square (see over). Rothko's rectangular canvases proffer, on an even-coloured ground or field, two or three rectangles of different colours, varying in width or in height but seldom in both, disposed precisely horizontal or vertical. There, however, precision ends, for the colour is washed or stained with shifting tones, shifting luminous intensities, while the edges of the rectangles blur out of definition until the colour seems to float – and, so powerful and intense is the impression of mysterious radiance flooding from these great canvases, the spectator in contemplating them may seem almost to float, too.

"I am for the simple expression of complex thoughts", said Rothko, and indeed his best work invites and seduces to always unconcluded meditation. It is at its most potent when several canvases surround the onlooker, as in the series, on an heroic scale, at Harvard and in a chapel at Houston, Texas, which reproduces for a twentieth-century sensibility the effect of Bernini's Cornaro chapel (see p. 190) –

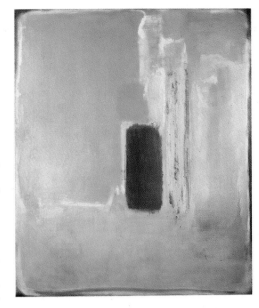

ROTHKO (above)
Central green, 1949
Rothko declared that he set out to use colour in such a way that it would stimulate in the spectator an emotional reaction, such as ecstasy or melancholy.

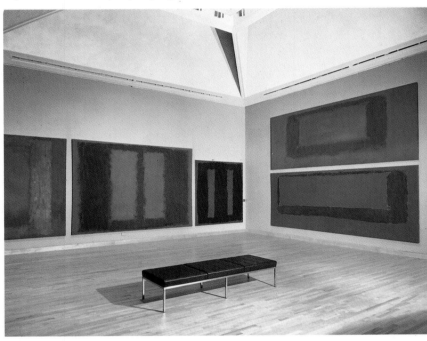

ROTHKO (above)
The Rothko room, Tate Gallery, London, 1958-59
Rothko required progress "towards clarity, towards the elimination of all obstacles between the painter and the idea, and between the idea and the observer. As examples of such obstacles I give ... memory, history, geometry."

NEWMAN (right)
The third, 1962
A writer and dialectician as well as a painter and also a sculptor, Newman has had battles of words with many; one of his best witticisms is "Aesthetics is for the artist as ornithology is for the birds."

NEWMAN (above)
Concord, 1949
By rejecting utterly all the traditional ingredients of painting, such as depth, figuration, shape or form, Newman believed that he was making an assertion of freedom. He once said in an interview that if the world could read his work correctly it would abolish all state or totalitarian control of the individual.

totally involving the onlooker, who becomes a participant. Rothko's first such commission was for a set of convases to decorate the Four Seasons restaurant in the Seagram building in New York: he produced in fact three sets, each more sombre in colour, and finally withdrew from the commission altogether. He later selected eight of the final set to be hung in the Tate Gallery, London, where he knew his paintings would be hanging under the same roof as Turner's.

Barnett Newman (1905-70) was associated with Rothko and Motherwell in the founding of an art school on Eighth Avenue, New York, in 1947 and with the Abstract Expressionist group in general: he worked for a time on the magazine *The Tiger's Eye*, which voiced the opinions of many of the group. In his mature work he arrived at even more simplified solutions than Rothko, and was never influenced by the gestural painting of Pollock. His formula already by 1950 was closer to the investigations of Mondrian or of Constructivism than to those of either Rothko or Pollock, although, like Pollock, he sought inspiration in the elemental art of the North American Indians, finding there a "terror before the unknowable". In his formula, however, the mystical aim is distilled down to the sparsest symbolic geometry: the composition is that of the rectangular canvas, essentially a field of colour divided by one or more vertical stripes. Newman seems to have seen this reduction also as an assertion of the sublime; though his paint is still laid on, applied not stained, and the brush-marks remain, Newman's work is unimpassioned in character, and essentially "cool" in the sense that the young abstract painters of the 1960s would be cool. Close in mood both to Newman and to Rothko was William Baziotes (1912-63), though he developed a style that verged on the figurative as theirs never did; his paintings contain often relatively complex shapes suggestive of animate or inanimate forms.

One figure crucial to the development of colour-field painting was Helen Frankenthaler (born 1928). After working in a Cubist tradition, she moved into an Abstract Expressionist key in the early 1950s, making a significant development of Pollock's "drip" technique. In a painting of 1952, *Mountains and sea*, the paint, rather than being dripped and trailed on the prostrate but primed canvas, is instead stained or soaked, diluted very thin into raw, unprimed cloth, and becomes integral with it rather than applied. The method allows the spontaneity and immediacy of Pollock's work, but mutes his "bravura rhetoric". Through Frankenthaler's work generally there emerges a sensation of landscape, of lyricism, of lightness and airiness.

When in 1952 Morris Louis (1912-62) visited New York from Washington, he was as much impressed by *Mountains and sea* as by Pollock's work, and in 1954 he developed a refinement of its technique, using thinned acrylic paint, very liquid, on unprimed cotton duck. In his series called *Veils*, the translucent colours, the weave and texture of the cloth, drift down in inextricable unity: the illusion of depth, reduced in Pollock's work but still present there, is eliminated. In his last works, influenced partly by his younger friend, Noland (see p. 470), he produced his *Unfurled* and *Pillar* series, in which he set off rivulets or stripes of opaque and brilliant colour against a vast white blankness of the canvas. His work became increasingly impersonal, closer to the hard-edge colour investigations of Albers (see over) and others.

BAZIOTES (left)
White bird, 1957
Baziotes differs from most Abstract Expressionists in his attention to subject matter, though he was no more willing to be tied down by it than the rest. His images are free forms.

FRANKENTHALER (right)
Mountains and sea, 1952
The seminal importance of this painting's technique has tended to overshadow its fine formal qualities. Frankenthaler abandoned in later work its whipping, wiry lines of charcoal.

LOUIS (below)
Floral, 1959
The achievement of Louis' mature work was built on a foundation provided by Frankenthaler. Louis said of her: "She was a bridge between Pollock and what was possible".

LOUIS (above)
Gamma zeta, 1960
The expanse of "unfurling", nearly 4m (12ft) across, bound only by the banks of rivulets, suggests an abyss into which the spectator is drawn. The scale of the canvas makes it possible to take it in as a whole only from a great distance, and as the viewer approaches there is a growing feeling of magnetic attraction and of unavoidable engulfment.

Albers: Homage to the Square

The post-War movement in painting that shocked and dazzled the eyes of the Western world in the 1950s was the Abstract Expressionism of the New York school. The scale of their paintings, the unorthodox behaviour of the painters – the noise of it all – diverted the attention of the media and the general public from other, parallel trends in art. These did not, however, wither away. Problems of harmony and proportion in abstract painting were being explored by Josef Albers (1888-1976), who had been teaching at Black Mountain College in North Carolina since 1933, when he migrated there from the Bauhaus (see p. 439), closed in that year by the Nazis.

Albers was a quintessential product of the Bauhaus. He was there first as a student and then as a teacher, and was concerned as much with the applied as with the fine arts, working on the Constructivist side of Bauhaus theory, in the glass and furniture workshops. The clarity and irreducible economy of his future painting was already present in his stained or sand-blasted glass, and in his furniture designs – he was responsible for one of the first laminated wood chairs. In North Carolina, where he had a reputation primarily as a teacher, he explored the relations between geometry and colour in a series of paintings, *Variations on a Theme*, but only after he had moved to Yale, in 1950, did he begin in earnest the sequence called *Homage to the Square*.

Homage to the Square consists of hundreds of paintings and prints all within a square format; though they vary in size, they all feature three or four squares, superimposed – a nest of squares positioned with vertical but not horizontal symmetry. Some are distinguished, within the series, by lyrical subtitles (*Distended, Softly spoken, Curious* etc.); some are only numbered. Albers used the formula to demonstrate his abiding belief in an essential dichotomy of art, "the discrepancy between physical fact and psychic effect". Thus the linear structure of his square pictures is of the most simple, unarguable clarity. The colour structure is created likewise in evenly applied paint, straight from the tube; the colour of each of the three or four squares usually has no variation of intensity, and so should be completely inexpressive of any quality other than its particular blueness, redness – its local colour. In fact, in the eyes of the onlooker, the flat picture plane becomes three-dimensional as one colour seems to advance, another to recede, according to its nature; furthermore, the pure evenness of colour within each square is affected optically by reaction to its neighbours – and all the colours shift character as the light in which they are seen changes. The colour is a mystery floating on the canvas, independent of the lines which contain it.

ALBERS (right)
Fugue, 1925
This is a good example of Albers' Bauhaus work, on opaque glass. The colour is removed through stencils to reveal the glass beneath.

ALBERS (below)
Variation in red, 1948
Each of the *Variations on a Theme* has the same basic geometry in varied colours.

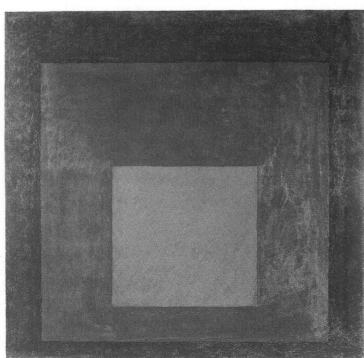

ALBERS (below)
Transformation of a scheme no. 24, 1952
The disturbing optical effect prefigures Op Art. This, too, is from a series.

ALBERS
Studies for *Homage to the Square*:
(left) *Rain forest*, 1965;
(right) *R-NW IV*, 1966
In all the variations the largest square measures 10 units; the other squares set within it measure a varying number of units or half units. These two show a progression from base to top of $\frac{1}{2}$:1:4:3:1$\frac{1}{2}$; across the ratios are 1:2:4:2:1. *Confirming* (far right) has four squares, not three; the ratios are from base to top $\frac{1}{2}$:$\frac{1}{2}$:$\frac{1}{2}$:4:1$\frac{1}{2}$:1$\frac{1}{2}$:1$\frac{1}{2}$; across the ratios are 1:1:1:4:1:1:1.

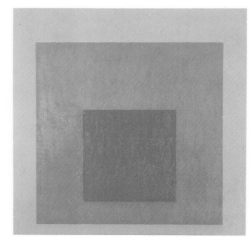

ALBERS: Study for *Homage to the Square - Confirming*, 1971

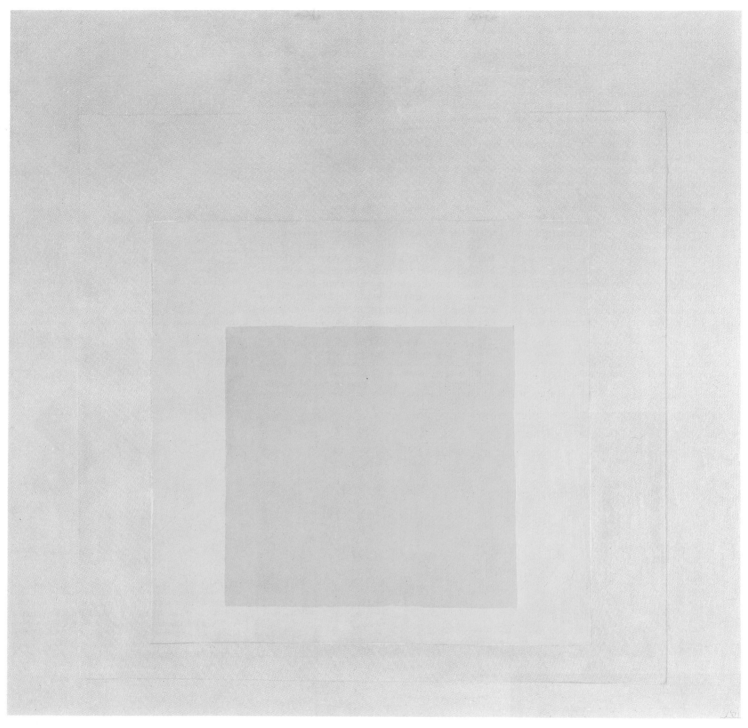

Albers thought long and deeply on colour phenomena; his treatise *Interaction of Color* was published in 1963. He also played with another form of optical illusion in a series of linear drawings, black on white or vice versa, called *Structural Constellation* – the abstract equivalent of Escher's famous figurative non-sense drawings (see p. 423). He was not, however, the slave to a need to produce a closed logical system, and in *Homage to the Square* he presents the problem in an endless series of solutions, or variations, of the unreconciled yet reconciled co-existence of colour and geometrical linear structure on his canvases. He was

also a poet, and some of his poems state the paradox with equal wit and clarity.

Initial confrontation with a single Albers painting may be disappointing: they need really to be seen in a sequence, when the variation in scale, in the internal relationships of the nesting squares, but above all the play of colour over and through the invariable physical fact of the square, make their full impact.

Homage to the Square was the climax of Albers' remarkable career as a transitional figure between the European traditions and the new American. His work evolved from the European, non-objective art of the Construc-

tivists – of the early Russians, of Mondrian and De Stijl – through the aesthetic, and the moral and social commitment, of the Bauhaus. It is European in scale, best when small and intense (his large-scale murals were done by assistants from his blueprints); some have likened his *Homage* to Monet's famous series. His heirs, however, were the Americans of the late 1950s and the 1960s, who, while respecting the Abstract Expressionist achievement, found in his work a pattern and an intense colour sensation on which they could build (see over). Later again, his interest in perception became relevant for Op and even Conceptual art.

Abstract Developments 2: Hard-Edge and Minimal

Ad Reinhardt (1913-67) emerged as a major figure in the 1950s, pursuing with rigour an impersonal abstraction dominated by purely formal problems. Reinhardt had been working in a fairly geometric, rectangular style since the late 1930s, unaffected by the expressive, gestural work of Pollock and De Kooning; by the 1950s he had reduced his elements even further than Newman and Rothko (see p. 466): he painted series, each in terms of a field of one colour – red, blue and, finally, black. At first glance these may seem just rectangular canvases painted in one colour; the component rectangles or squares lurking in the colour only gradually emerge. His aim was "art-as-art", to be achieved only by reduction to the ultimate abstraction – "no other art or painting is detached or empty or immaterial enough" – and his severity was highly influential.

The impersonal effect of Reinhardt's and also of Newman's and Albers' canvases provoked a strong response from the younger artists who would form the "hard-edge" wing of colour-field painting. Kenneth Noland (born 1924) looked at Pollock but "could gain no lead from him". As it had been for his friend Morris Louis (see p. 466), Frankenthaler's technique of colour-staining was seminal for Noland, and he, too, integrated his acrylic colour into the substance of the cloth, not applying it to the surface as Newman did, in oil; colour materializes in the shape of his picture. Like Louis, too, he would become obsessed by one image, working through variations on it until its possibilites were exhausted. Unlike Louis', however, Noland's colours, in a lucid high key, are usually defined with geometrical precision by a knife-sharp contour, the "hard edge". His first series, concentric rings of colour within the white field of the unprimed canvas, dates from the late 1950s and early 1960s. About the same time, Jasper Johns (see p. 484) was investigating the same image, as a *Target*, but with very different aims, moving towards Pop art; Noland's interests, however, have more to do with the workings of colour vision, after-images, induced colours and the like – Op art. Later on, in variations on a chevron theme, Noland shifted the image to an asymmetrical position on the canvas, and then allowed the image to form its own white field and to dictate the shape of the picture: in works such as the elongated-diamond-shaped canvases of about

NOLAND (above)
Ember, 1960
Though moving towards a hard-edged style, Noland sometimes in this series would leave the outer ring unfinished, suggesting that the whole is pulsating and expelling unwanted energy.

NOLAND (below)
Apart, 1965
For two years Noland was at Black Mountain College with Albers; the fruits of their contact are evident in Noland's hard edges, his concentration on one image, the kind of image he chose.

REINHARDT (below)
Untitled, 1948
Reinhardt's earliest work shows the assimilation of various abstract styles: prime and prior was the influence of Mondrian (not least the late work, see p. 437) and of Stuart Davis. His paintings of the 1930s are hard-edged and bright in colour, but during a period of close contact with the Abstract Expressionists in the 1940s he softened both the angularity and the colour of his painting. Reinhardt's intention, to produce an art devoid of any external associations, was shared by Rothko and Newman, but his work is purer, if only because its emotional effect is less.

OLITSKI (below)
Green goes around, 1967
Olitski's works have been described as "the first fully abstract version of Impressionism". They are built up from layers of sprayed paint which shift in hazes across the canvas with a result reminiscent of the atmospheric effects of Monet's *Waterlilies* (see p. 374); Olitski spent a year studying in Paris.

REINHARDT (left)
Black painting, 1960-66
Reinhardt has described his progression towards the black squares as a search for an image like that of the Buddha, which he once called "breathless, time-less, styleless, lifeless, deathless, endless". His ultimate aim was, he said, "to paint and repaint the same things over and over again, to repeat and refine the one uniform form again and again" – which is a Minimal art.

1966, the unity of image, colour, surface and object is absolute. Some of his vast horizontal-stripe paintings are only centimetres tall, but several metres long (Barnett Newman had preceded him in this kind of narrow painting, but vertical, in the early 1950s).

The Russian-born Jules Olitski (born 1922) had moved by the early 1960s into pure fields of colour, saturating (using a fine spray) un-primed canvas with paint, obliterating linear design, depth of space and all composition other than the shape provided by the (usually vast) rectangle of the cloth. Ideally, he once said, he would like "nothing but some colours sprayed into the air and staying there". The colour is indeed lusciously rich, sometimes too sweetly rich for some palates. In one phase – whether in a nod in the direction of Abstract Expressionism or in an ironic snook against it – there is gesture sprawled at just one edge.

The development of hard-edge painting in the 1950s and early 1960s can be read as stages in the progress towards the "ultimate abstraction" that Reinhardt sought, into the utterly impersonal realm of Minimal art (see further p. 494); and yet that progress was undertaken by distinctively different personalities. Ells-

worth Kelly (born 1923) and Al Held (born 1928) both reflected in their work European sensibilities, each having spent some time in Paris in his twenties, setting on a flat-coloured ground large, clear-cut, flat-coloured shapes that seem to echo Matisse's cut-paper pictures (see p. 476) or the flat reliefs of Arp rather than any American example. Kelly in particular was influenced by the European Constructivists and produced paintings and prints composed of bold, striking colours set one next to the other; though he was not so obviously concerned with optical effects as Albers, Kelly's work has a similar impact. Forms abstracted from natural ones seemed to linger behind Kelly's images in the early and mid-1950s, but then, perhaps finding it difficult to resolve satisfactorily the relationship of image to colour field, he moved into true Minimal art with featureless sculpture – at its simplest, two sheets of metal, coloured. Al Held first attempted to reconcile Pollock and Mondrian, then moved into the Abstract Expressionist orbit with very heavily pigmented work. By the late 1950s, however, his constructions, while still heavily painted, were greatly simplified, but on a very large scale: one remarkable series was

structured on capital letters of the alphabet. In 1964-66 came the colossal, 17-metre (56ft) long *Greek garden*, and then his work, no longer classifiable as Minimal, moved towards the three-dimensional.

The archetypal hard-edge Minimal painter in those years was perhaps Frank Stella (born 1936). By 1958-59 he was implicitly criticizing the energetic gesturing of Abstract Expressionism in an austere group of black canvases, patterned with concentric, geometric, very thin lines: his aim was "to force illusionistic space out of the painting at a constant rate by using a regulated pattern. The remaining problem was simply to find a method of paint application which followed and complemented the design solution. This was done by using the house-painter's techniques and tools." He advanced to aluminium and copper stripes, and to very strongly shaped irregular canvases, which, hung on a wall, do not so much decorate it as take charge of it. He has experimented with shapes of many kinds, using vivid, often harshly discordant colour, sometimes fluorescent, applied utterly impersonally: with Stella the individualism crucial to Abstract Expressionism was finally eliminated.

KELLY (below)
Four panels, 1964
The term "hard-edge" was coined by the Los Angeles art critic Jules Langser in 1958; it was then taken up by the British-born critic Lawrence Alloway and applied to a tendency in American painting of the early 1960s. The clean, clear colour and forms of hard-edge work constitute a homogeneous surface – without figure or ground.

HELD (above)
Greek garden, detail, 1964-66
A decisive factor in the development of hard-edged painting was the European sojourn of its practitioners – Held, Olitsky, Kelly and Noland, who were all studying in Paris in the late 1940s and the 1950s, and so were not closely involved in the onset of Abstract Expressionism. Reacting to the style of Pollock and others, Held wanted, he said, to "give the gesture structure".

STELLA (below)
Port aux Basques, 1969
Stella insists that his work is totally objective. In an interview in 1966 he declared: "My painting is based on the fact that only what can be seen there is there. It really is an object. All I want anyone to get out of my paintings, and all I ever get out of them, is the fact that you can see the whole idea without any confusion. What you see is what you see". This non-associative colour and weaver's pattern corroborate his words, but his recent art is exuberant.

STELLA (above)
Black adder, 1965
Although shaped supports have often been used in the past in altarpieces or in canvases for specific locations, in this century few artists before Stella had experimented with the painting's shape. Arp had, Chirico had, but for them shape was not the prime subject. Mondrian's *Fox-trot* series offered some precedent. But for Stella shape is inseparable from what shape contains, the one determining the other.

Informal Abstraction in Europe

When World War II ended, some European refugees remained in America, to be integrated into the American scene; others returned to Europe. Those who returned tended to go back to Paris: there was Picasso like a living monument. But for many Picasso was now an Old Master; the interests of the so-called "middle generation" lay in other directions, some of them strikingly parallel to those of the rising New York school of Abstract Expressionism, but initially quite independent of it. In France, these tendencies had various labels, corresponding to the niceties of underlying theory, if not so obviously to definable differences in practice – "Art Informel", "Tachisme", "Abstraction Lyrique", "Art Autre" – now generally called "Informal" art. They were essentially a reaction of the irrational and spontaneous against Constructivist abstraction, for instance in Mondrian.

Jean Fautrier (1898-1964) had painted during World War II a series called *Hostages*, inspired by victims of Nazi brutality – images built up in thick, clotted layers of paint. Their modelling was rudimentary in any naturalistic sense, but they revealed great feeling for refined colour and for the sensuous quality of the raw material of paint. Wols (Wolfgang Schülze, 1913-51), German-born, was early associated with the Surrealists (Miró, Tristan Tzara, Ernst) in Paris, but took to drawing and painting as his primary activity only during the War – his work was intensely subjective, an expression of his psychic reactions to experiences endured in these years. Like Fautrier, he used densely worked paint textures. Wols' later paintings, however, are a record of the activity of manipulating paint rather than an attempt to evoke associations; the parallel with Pollock is striking – the doomed charisma, the alcoholism, the social and artistic nonconformity – and both died young. But Wols was an Existentialist, a friend of Sartre, and his paintings do not express exuberance as Pollock's so often do, but often seem the very image of alienation. Hans Hartung (born 1904), another German-French artist, was painting abstracts by 1922, and even before the War had formulated his own characteristic, linear style – clusters, bundles or sheaves, usually sharp and brittle, often on a field of translucent colours. This is a sort of calligraphy responding directly to unconscious energies – "drawing flowing from the fingers", as Wols once described his own work. Pierre Soulages (born 1919; not shown) achieved similar contrasts with broad, elemental bands of black, resonant against white.

By 1947 Georges Mathieu (born 1921), self-styled founder of Abstraction Lyrique, propagandist and publicist of verve and panache – "the fastest painter in the world" – was painting in spontaneous splashes, with paint squeezed from the tube, worked with the fingers, in a rapid but elegant calligraphy of colour whipped across a plain background. The affinities with Pollock's Action Painting (though Mathieu worked quite independently) are clear; Mathieu, too, worked on a very large scale. His avowed purposes were different, however: Mathieu aimed to create in his abstract painting the equivalent of traditional epic "history" painting, and above all – this applies to all the painters of the Paris school, except Dubuffet, when compared to the leading American Abstract Expressionists – Mathieu's work is somehow stamped with European qualities of tastefulness and succulence, and lacks the elemental force of the Americans.

European delicacy and suggestion are most exquisite in the work of the Russian-born

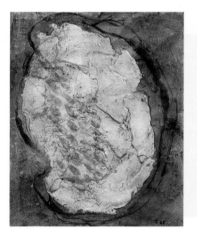

WOLS (left)
The blue phantom, 1951
The mysterious forms that inhabit Wols' paintings resemble huge monocellular organisms. He disliked, he said, "too much ambitious purpose and gymnastics".

DE STAEL (right)
Figure by the sea, 1952
De Staël's brilliant and sensitive colour harmonies were stimulated by trips to Morocco and the South of France: this was painted at Antibes shortly before his suicide. A friend of Braque's, he painted not "psychic improvisations" but constructed evocations.

FAUTRIER (above)
Head of a hostage, 1945
Fautrier's source, though he has abstracted from it, was decayed human heads. The agony of his theme is conveyed not by realistic rendering of the wounded features, but by a hacked impasto, pink-tinged, which merely suggests some brutal mutilation. Fautrier's later works are like reliefs, the paint is laid on so thickly.

HARTUNG (right)
T 1955-23, 1955
Hartung's work is typical of Art Informel: his lines are a record of a release of the artist's energy. If his painting is compared to Kline's (see p. 462), then the problem in assessing the European equivalent to American Action Painting is clear: Hartung's work has been judged "eloquent" or "monotonous"; Kline's work has a brash vigour that is neither of these.

MATHIEU (below)
Painting, 1952
Speed, for Mathieu, was essential, to prevent ideas and memories hampering the brush's dancing rhythm.

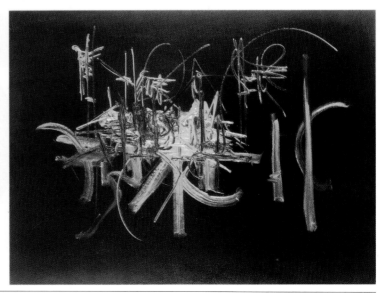

Nicolas de Staël (1914-55). His chords of colour and his infectious delight in the sheer sensuous qualities of his paint ("*la matière*") were unrivalled in his generation. His art was a development of Cubism, and he found himself unable to resolve, at least to his own satisfaction, the equation he sought – the union of an abstract picture surface with the natural image of reality. Expressed in rather different terms, a comparable concern with surface textures and the integrity of materials appeared elsewhere in Europe, in Spain in the work of Antonio Tàpies (born 1923) with its rough, decaying, scrawled and scratched surfaces, and in Italy in the rags, sacking and bandages of Alberto Burri (born 1915).

Nearest to the American Action Painters in uninhibited, even brash vigour were the artists of the brief-lived CoBrA group (the original members came from Copenhagen, Brussels and Amsterdam), which held together from about 1948 to 1951. The Dutchman Karel Appel (born 1921) was the major talent here, assaulting the canvas with stridently savage slashes of colour, sometimes abstract, sometimes swirling into crude imagery. The most original spirit of this European generation was, however, the Frenchman Jean Dubuffet (1901-85), who settled into full-time painting only in the 1940s; his first exhibition was in 1944. Initially taking Klee's ideas perhaps still further, he found models of a fiercely direct expression of the Unconscious in the paintings of the insane and of children – "Art Brut".

The variety and quantity of Dubuffet's output has been formidable. In the late 1940s and the 1950s his characteristic media were sand, earth, glue, clinkers etc., with pigment mixed in, bashed and scratched into vitality to reveal weird primordial creatures, foetuses, fertility figures and the like. But Dubuffet's variations on different combinations of materials to produce new relationships are almost unclassifiable. In the early 1960s, he experimented extensively with a brilliantly coloured all-over imagery he called *L'Hourloupe*, or *The Twenty-Third Period of My Works*. In these sometimes enormous canvases – one is 8.2 metres (27ft) long – a coagulating writhe of interlocking squiggles resolves itself on closer inspection into an endless jig of small totemic frenzied creatures. Through much of his work there runs a sort of manic gaiety; it vividly expresses many of the main preoccupations of the post-War period, including the paradox of highly cultured, self-conscious and sophisticated urban man deliberately seeking out the primitive, the Unconscious, the ugly.

APPEL (right)
A bird with a fish, 1956
The members of CoBrA shared a common interest in "primitive" and Naive art and in automatism. In most of his work Appel's dynamic, violent textures are used to express natural forces, animal vitality.

TAPIES (below)
Pale blue composition, 1956
Tàpies combines sand, glue and matt, cracked paint in severe compositions, "when dull, inert matter begins to speak with incomparable expressive force". His attitude to materials was almost moral; formulated in the mid-1950s, it was highly significant for the 1960s.

BURRI (right)
Sacking with red, 1954
Burri began to paint when he was a prisoner of war in Texas: there he had to paint on pieces of sacking instead of canvas, and his post-War work contains similar wasted materials – sacks and rags roughly sewn and torn, often singed, splashed with paint. His *Sacchi* (Sacks), resembling stained bandages, express Burri's war experiences, but are also a metaphor for decay and destruction, for the mortality of mankind.

DUBUFFET (left)
The very rich earth, 1956
All the myriad variety of the cells making up a speck of earth is suggested in the variegated mosaic of the painting. It contains, however, a figure – goblins like this inhabit most of Dubuffet's clotted abstracts.

DUBUFFET (right)
Uncertain situations, 1977
This recent work seems to be directly inspired by Dubuffet's collection of Art Brut: crude cartoon figures like those found in children's drawings are in abundance. All save one are enclosed in capsules, from which some strain to be free – a comment perhaps on contemporary existence.

Wyeth: Christina's World

More sorts and kinds of people have responded directly to the paintings of Andrew Wyeth (born 1917) than to any other post-War American painter, yet his work remains controversial. In many accounts of post-War painting, for which the great American breakthrough of Abstract Expressionism is the springboard, he is simply omitted as an anachronistic irrelevance, yet not only is *Christina's world* (in the Museum of Modern Art, New York, since 1949) one of the best known and loved images of American art, but in 1976 Wyeth was given a major one-man retrospective exhibition in the Metropolitan Museum.

Andrew Wyeth is the son of N.C. (Newell Convers) Wyeth, a distinguished illustrator and painter. Brought up as it were breathing art, he proved a precocious virtuoso, and had his first one-man show in New York when he was only 20. In 1939 he came to know a brother and sister called Olson, on a remote farm in Maine; he spent the summers there, painting the farm, the region and a series of remarkable portraits of Christina Olson until her death in 1967. The first impact of *Christina's world* (finished in 1948) is eerie and troubling: the figure of the girl, seen from behind, twisted

WYETH (left)
Christina Olson, 1947
Christina is sitting on the doorstep of her house. Late afternoon sun falls on the lined and wrinkled face and frail body, and it casts a strange shadow on the door behind her, which is as weathered as she is. She is looking out across the fields towards the sea: Wyeth said she reminded him of "a wounded seagull".

WYETH (above)
Christina's world, 1948
Wyeth was devoted to his sitter; he said: "*Christina's world* is more than just her portrait. It really was her whole life and that is what she liked in it. She loved the feeling of being out in the field, where she couldn't go, finally, at the end of her life ... a lot of it came out of what she told me." The composition was prompted by a sight of her from a window in the house, when she had been out getting vegetables, "pulling herself slowly back towards the house".

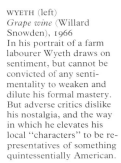

WYETH (left)
Grape wine (Willard Snowden), 1966
In his portrait of a farm labourer Wyeth draws on sentiment, but cannot be convicted of any sentimentality to weaken and dilute his formal mastery. But adverse critics dislike his nostalgia, and the way in which he elevates his local "characters" to be representatives of something quintessentially American.

WYETH (left)
Nick and Jamie, 1963
Many of Wyeth's works seem to be charged with an electric poignancy; this is particularly true of some interiors and landscapes that are portraits and yet unpeopled. Wyeth has discovered a way to invest objects and places with the presence of those no longer there; thus two sacks on a late autumn day evoke the artist's sons.

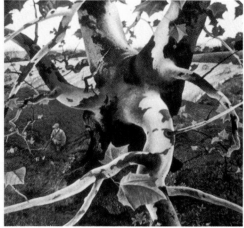

WYETH (left)
River cove, 1958
Tempera, for Wyeth, is almost a building material, and crucial to his aims: "I love the quality and the feel of it ... to me, it's like the dry mud of the Brandywine valley in certain times of the year, or like these tawny fields ... I really like tempera because it has a cocoon-like feeling of dry lostness – almost a lonely feeling."

WYETH (above)
The hunter, 1943
Apart from his holidays in Maine, on the Olsons' farm, Wyeth has spent his entire life in the small village of Chadds Ford, Pennsylvania. That is in part why his art is remote: these two regions form his world, he lives their landscapes, people and animals, while most artists, he has said, "just look at an object and there it sits".

awkwardly in the expanse of grass, is focused on the house on the crest of the slope. This house and the second house, seen directly behind Christina's head, and Christina's body are linked inexorably, pinioned on the three corners of a triangle, yet the sense of huge distance, seemingly unbridgable, physically or psychologically, between the woman and the main house on which the grey sky sits so claustrophobically is overwhelming. Many, perhaps most people assume at once that the subject is an attractive young girl, an interpretation prompted by what could be a youthful abandon in the grass, and by the slightness of the body, the adolescent fragility of the arms. In fact Christina Olson was at this time a mature woman, somewhat gaunt, and so severely crippled that she proceeded by dragging herself on her arms. Several of Wyeth's initial rough drawings (not shown) record his determination to discover the exact articulation of the maimed body, which in the finished painting seems to express both the tragedy and the joy of life with such vivid poignancy that the painting becomes a universal symbol of the human condition – and is recognized as such: the picture has had a continuing fan mail from people who have identified with it.

Wyeth has described his sequence of portraits of Christina: "I go from *Christina Olson* (1947), which is a formal one, a classic pose in the doorway, all the way through *Christina's world*, which is a magical environment, that is, it's a portrait but with a much broader symbolism, to the complete closeness of focusing in *Miss Olson* (1952; not shown). *Miss Olson* was a shock to some people who had the illusion that the person in *Christina's world* was a young, beautiful girl. And that is one reason why I did it, in order to break the image. But I didn't want to ruin the illusion really, because it's not a question of that. One has to have both sides – one, the highly poetic; the other, the close scrutiny"

Wyeth has denied any fundamental influence on his development from other painters, though he has acknowledged generously inspiration from artists as diverse as Winslow Homer and Albrecht Dürer. His affinities with the impassioned detail of Dürer (particularly the watercolours) are obvious, and his technique of dry brush over watercolour is close to Dürer's, and not far short of him in brilliance and virtuosity. In his large paintings, too, his techniques are resolutely traditional; he uses tempera rather than oil, with extreme sensitivity and with a range of earth colours. His practice is minute, laborious and slow, and the paintings are prefaced in great detail by preparatory drawings.

Wyeth's work at its best demonstrates that the traditional subjects, media and techniques of Renaissance painting can still result in images that have a profound significance. His work is also quintessentially American, and in a sense, though so different in technique, he offers the rural counterpart to Edward Hopper's earlier characterization of American urban townscape. A comparable sense of vastness, and of isolation and loneliness, invests the work of both, but is expressed by Wyeth in the intensity of his realization of detail.

After 1945: Old Masters of the New

Picasso established a new type of career as a desirable norm for many artists – a career consisting of a sequence of discoveries, of new periods or styles, each style being worked until its possibilities were exhausted, at which point a new discovery, a fresh point of departure into a new seam, was necessary. In fact Picasso himself could work in entirely different styles at the same time (see p. 450). None could match his prodigal inventiveness, the speed with which he would see and grasp possibilities before anyone else, the ruthlessness with which he executed his *volte-faces*, his independence, his charisma, his legend. There were, however, other outstanding artists of the pre-War generation who were content to develop after World War II along their own lines. Their progress tends to be unjustly overlooked in the historians' compulsive charting of the new, but artists whom one tends to regard as pre-World War II figures (or even as pre-World War I figures) were producing superb work from the late 1940s even into the 1970s. This is true not least of Braque, who in his later works, before his death in 1963, achieved a series of masterpieces, notably one famous sequence, *Ateliers*. He worked always within

the Cubist idiom: still life provided his most constant theme as it had half a century before, but it yielded now compositions of superbly resolved balance and serenity, yet sensually rich in colour and texture.

Picasso occupied a place apart, even if, in the last 20 years before his death at the age of 91 in 1973, he was more a monument to be skirted respectfully by younger artists than an active influence. For the general public, for the media world-wide, he remained a focus of unflagging fascination. In a secular age, he was almost venerated. Through a series of acts, as copious as the rain of heaven – his pictures, sculptures, graphics – he created not least money by a process as mysterious and incomprehensible to most people as were once the miracles of the saints. Waiters snatched the table-cloths on which he had doodled during a meal; his signature was a blank cheque.

The work itself was a different matter. After *Guernica* and *The charnel-house* (see p. 451), his recharged energies exploded in some splendid affirmations of hope (at the same time he joined the Communist Party, though it cannot be said either that it had much influence on his work, or that his work had a discernible

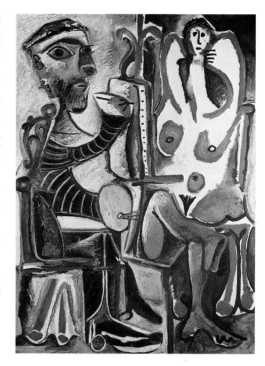

PICASSO (above)
The painter and his model, 1963
This had been a favourite theme of Picasso's since the early days, one which he revived with new vigour in the early 1960s after his second marrage. His young wife, Jacqueline, was often the model. Her bland sexuality contrasts with his uneasy self-consciousness.

PICASSO (left)
Mounted rider, c. 1951
In the late 1940s Picasso began working within the small community of ceramic artists in Vallauris near Antibes. Other painters, notably Gauguin and Miró, had turned to ceramic art, but Picasso's reputation and his magical charisma stimulated new interest in this "minor" art form.

BRAQUE (above)
Atelier II, 1949
The spectator enters the artist's private world as if through veils of space wrought with signs of his presence – the palette and brushes, the head, the bird on a canvas. No suggestion of location detracts from the decorative surface patterns of the great *Atelier* series.

PICASSO (right)
Women of Algiers, 1955
Between December 1954 and February 1955, Picasso carried through 15 variant reworkings of Delacroix's painting of the same title (see p. 329). He retained the perfumed vermilions and smoky golds, also the voluptuous curves of the famous original in each.

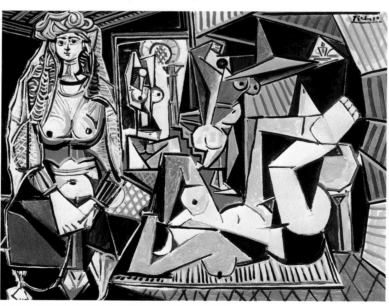

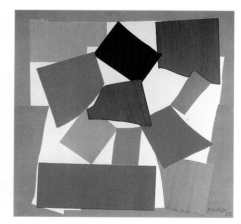

MATISSE (above)
The snail, 1953
Crippled with arthritis, Matisse directed from his chair the execution of this huge work, a slow winding surge of glorious colour.

influence on the Communist Party). The best known of his later paintings are the series of variations in his own manner on masterpieces of the past – by Velazquez and Poussin, by Delacroix and Manet – reflecting once again the inescapable obsession of twentieth-century art with art; and his often moving variations on the theme of the aging artist and his young nude sitter. Much of this shows supreme virtuosity, but often not much more (the famous film made by Henri-Georges Clouzot in 1955 of Picasso painting with a light-bulb was revealing – in effect the recording of a performing juggler or conjuror). The quality in his work that so often confounded the critics, that irreverent wit, also expressed itself in sculpture – in sheet-metal cut-outs sometimes colossal in scale, in ceramics, in bronzes of figures and animals, sometimes painted. Of these last, some famous examples – the bull's head which is a bicycle saddle and handlebars, the ape whose head is a toy motor-car – delighted multitudes but encouraged a suspicion that Picasso was not perhaps wholly serious. It is too often forgotten that one of his great achievements was to add to the gaiety of nations, over and above enlarging the scope of

art with Braque way back about 1910.

The grand old man who in his late work proved a more exploratory and inspirational figure was Henri Matisse: during the 1920s and 1930s (see p. 432) he had pursued his own way, stubbornly independent of Picasso, almost deliberately unprovocative and aloof from the social or political mission of many other artists, intent on producing paintings serenely resolved and luminous with colour, to give pleasure. From 1948, in addition to a continuing output of exquisitely reductive yet vital linear work (ranging from book illustrations to the monumental simplicity of his wall and stained-glass decorations (1949-51) for his chapel at Vence near Antibes) he embarked on a series of famous compositions in cut-out paper (*gouaches découpées*). In some of them, he came far closer to extreme abstraction than he had before. He did not revert to sculpture; he spoke, however, of his cut-outs in three-dimensional terms. "Cutting into living colour reminds me of the sculptor's direct carving" – in this sense he had distilled a new mode for painting. It was in one way comparable to the Minimal art of the rising generation, yet was also an exhilaration of radiant colour

acting and interacting, a triumphant affirmation of the fullness of life. Matisse died in 1954, nearly 20 years before Picasso, but it was his last work rather than Picasso's that younger artists found stimulating.

Other masters of the school of Paris continued to develop within their own terms of reference – notably Léger, returning from America after the War, who died in 1955. The later work of European and American artists who made their impact before World War II has mostly been discussed when their names have first come up (Calder and Giacometti had perhaps greater impact after the War (see over), though we have glanced at their earlier work in context). They were generally impervious, though seldom oblivious, to the cut and thrust and the new arguments of the younger generation; to this Ben Nicholson and Oscar Kokoschka were no exception, but they have perhaps been too little considered. Kokoschka, who died in 1980, made little change to his masculine Expressionist style (see earlier p. 443); Nicholson (see previously p. 446) after World War II went on to a superb synthesis of severe abstraction with an evocation of English mist and light.

NICHOLSON (right)
Poisonous yellow, 1949
The still life on a table was a recurrent theme in Nicholson's work: in this he was trying to achieve, as he said, such an effect "as if the paint had been wished on to the canvas".

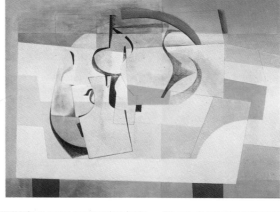

LEGER (below)
The builders, 1950
Léger has used the frame of a modern building under construction as if it were a prefabricated Cubist form. His distinct late style has the sturdy, free directness of Naive art.

KOKOSCHKA (below)
Louis Krohnberg, 1950
Kokoschka continued in a long series of portraits to explore personality in corrosively Expressionist brushwork. His colours became noticeably brighter and happier after the War.

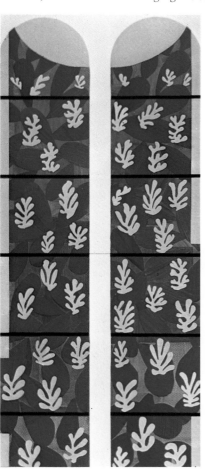

MATISSE (above)
The Tree of Life in the Chapel of the Rosary, Vence, 1949-53
Matisse himself thought the Chapel was his masterpiece. It exemplifies his mature style: here simple organic shapes flow across azure and turquoise; the walls are black and white.

Post-War Sculpture 1

World War II caught several major sculptors in mid-career. In England Moore (see p. 448) and Barbara Hepworth (see p. 447) steadily continued to develop along lines established earlier, while the international reputations of both rose higher. Moore opened the way for other sculptors in Britain, and the important talents that emerged mainly in the 1960s owed much to him, although formally their work was mostly in sharp reaction to his (see p. 494). In France, Picasso's energies were unleashed in sculpture of great variety and invention (see preceding page), culminating, in size at least, in his colossal, sheet-metal monument of 1966 for the Civic Center in Chicago, 20 metres (65ft) high. In Switzerland Alberto Giacometti had shifted from "orthodox" Surrealism about 1935, but the remarkable originality of his new style was only revealed after the War (see over); and after 1945 the work of some other European sculptors of the same generation, whose reputations had hitherto been confined to their native countries, almost abruptly took on international significance. All had achieved in different ways an original synthesis of traditional values with a contemporary sensibility.

Marino Marini (1901-80) in Italy had discovered his enduring theme of *Horse and rider* even before the War. His inspiration came rather from the medieval equestrian statue at Bamberg (see p. 76) than the classical *Marcus Aurelius* (see p. 51) in Rome or the heroic Renaissance variations of Donatello and Verrocchio; close parallels are perhaps also to be found in the equestrian figurines of Tang pottery (see p. 285). The theme in his hands became the reverse of triumphant, seemingly the expression of anguished despair at a hostile fate. His elemental imagery, handled with almost primitive roughness, so that the figures seemed to have been recently excavated from centuries of oblivion, certainly touched responsive chords in a wide public, with the force of a new but valid and recognizable mythology. In the 1950s Marini drove his theme to the extremes of stylization, in the 1960s into an abstraction sometimes recalling Moore's recumbent figures (the two sculptors shared a mutual admiration). He was also a painter and printmaker, and not least a consistently powerful portraitist, succeeding in capturing remarkable likenesses of his sitters without diluting his personal style at all.

MARINI (left)
Horse and rider, 1946
There is no suggestion of the movement of riding; Marini's interest is the tension between horizontal and vertical. In the lively skew of faces and limbs, in the spontaneity of the childlike image and its modelling, there is an instant appeal.

MARINI (below)
The miracle, 1943
Marini was trained both as painter and as sculptor, and his textures reveal a painterly sensibility. He patinates his bronzes with acids, and adds dashes of colour to his plaster. His bust carries both Gothic and Expressionist echoes.

RICHIER (above)
Storm, 1949
Female companion to this

menacing personification was *Hurricane* – scabrous, stark, elemental spirits.

MANZU (left)
Detail of the Portals of Death in St Peter's, Rome: *The stoning of St Stephen; the death of St Gregory the Great; death in space; death on earth*, 1950-64 Manzù succeeds where other religious sculptors of today have failed: he invigorates Neoclassicism.

MANZU (right)
Great cardinal, 1955 Manzù made more than 50 *Cardinals*, varying in size from bust to larger than life: this is 2m (7ft) high. He insists that they are really still lifes, that he intends to capture "not the majesty of the Church, but the majesty of form".

Likewise, in France, Germaine Richier (1904-59) created a personal mythology with something of the same elemental, universal quality, though the general public found her work shocking. She used traditional forms – animals, birds, insects or the human figure – but their traditional anatomies are savaged or decomposing in places – in a sort of visceral symbolism grafted on to realistic detail. When she applied what seemed a morbid Expressionism to sacred themes such as Christ's crucifixion she provoked outrage. The new aspects of death and mutation revealed by the destruction of Hiroshima seemed never far from her thoughts. She was a pupil of Antoine Bourdelle, who was himself a pupil of Rodin, and her violence extended some of the idioms of Rodin's later work, but her imagery also recalls Giacometti and Dubuffet.

The aims of the Italian Giacomo Manzù (born 1908) have been very different, although he has aligned himself firmly with the great, unbroken European tradition from Donatello to Rodin, Degas and Maillol. His life-size bronze nudes (not shown), at first glance "cast from the life", and his chairs with bronze still lifes of vegetables on the seats evoke un-expected echoes of the work of Johns or some Pop artists. The naturalistic detail is in fact fused with artistry into the volume of the whole. In his long series of tented *Cardinals* in their copes, begun as early as 1936, he pushed towards simplification and monumentality. He also returned to the tradition stemming from Ghiberti's Baptistery doors (see p. 100): not without controversy, he was commissioned to make bronze doors for St Peter's in Rome and for Salzburg Cathedral.

In America, there was no immediate revelation in sculpture to parallel the explosion of Abstract Expressionism in paint – it is difficult indeed to imagine the equivalent of a Pollock "drip" painting in stone or metal. Alexander Calder, however, the most delightful and joyous sculptor of the twentieth century, had far from exhausted his invention. His mobiles had created dreamy arpeggios in the middle air already in the 1930s (see p. 429), after the War he continued to play variations with these, but developed them, and his standing mobiles, and his stabiles, to a monumental scale. His later colossal stabiles – *Man* (1967, not shown) soars 29 metres (95ft) high – are like a new breed of fossilized anthropomorphic dinosaurs, and have a strong architectural presence, relating to the ground more like an Eiffel Tower than a sculpture. His mobiles continued, and they also now demonstrated conclusively that the traditional base was not an inevitable component of sculpture – a vital fact in the work of David Smith.

David Smith (1906-65) had turned from painting to sculpture about 1930-33, much influenced by the metal sculpture of González and Picasso. Vigorously exploratory, before arriving at his most original and successful forms he experimented in many modes, from Surrealist fantasy to "drawing in space" with steel, from the use of found objects (usually elements of farm machinery) to Cubism. His last, most celebrated sequence, *Cubi*, was based on a grammar of cubiform elements in stainless steel, polished and then abraded, arranged at odd angles, and raised on a monumental scale against the sky with an extraordinary authority, a totemic expressiveness. Smith was the reverse of the Bohemian type: allied with the working man, the factory technician, he had a strong social conscience, and was aware both of the splendour and of the miseries of mechanized civilization.

CALDER (left)
The spiral, 1958
Calder's undertakings since 1945 have included a series of large-scale commissions for public places. Beside his giant indoor mobile at John F. Kennedy Airport or his acoustical ceiling in Caracas his standing mobile outside the UNESCO building in Paris is quite modest, but it, too, is a feat of construction engineering.

CALDER (below)
Slender ribs, 1943
Calder wished to enable "nature and chance to replace the mechanical and calculable as the motive forces". For his friend Sartre his sculptures were at once "almost mathematical technical combinations, and symbols responsive to Nature".

SMITH (above)
11 books, 3 apples, 1959; *Zig II*, 1961; *Cubi II*, 1963
The photograph was taken by the sculptor in 1965 in the field behind his studio. *Zig II* is painted; *Cubi II* is just behind a forerunner of the series, the polished steel *11 books, 3 apples*.

SMITH (right)
Head, 1959
Smith once said feelingly: "Steel is so beautiful because of all the movement associated with it, its strength, its functions. Yet it is also brutal, the rapist, the murderer, and death-dealing giants are often its offspring."

Giacometti: Man Pointing

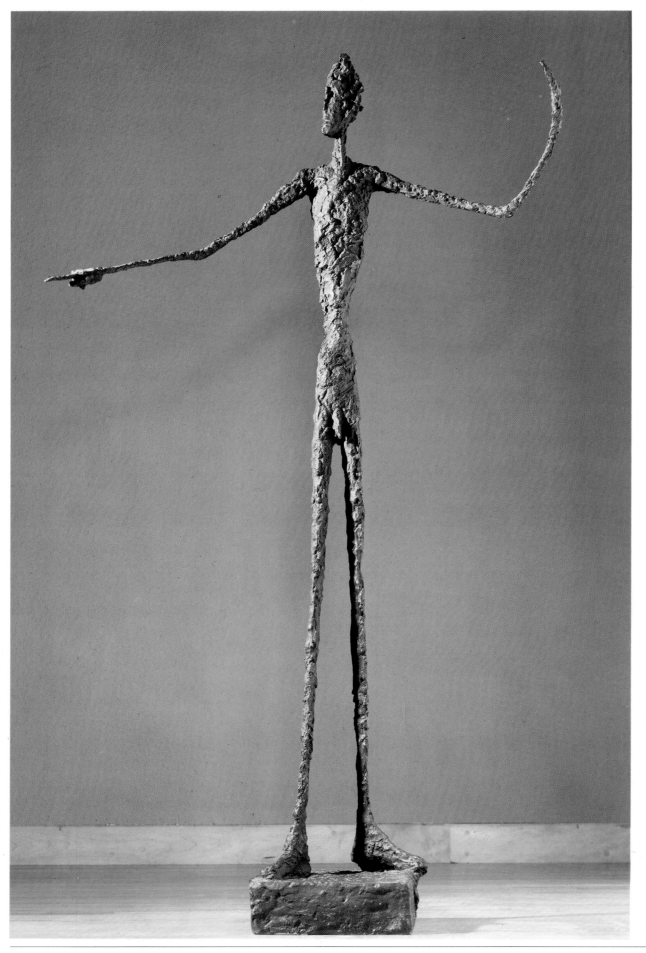

MICHEL DESJARDINS (above)
Alberto Giacometti, c. 1965
The artist is moulding clay

or plaster round a stick: the
model was cast in bronze,
often issued in a set of six.

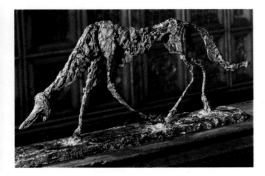

GIACOMETTI (above)
Dog, 1951
"It's me. One day I saw
myself in the street just
like that. I was the dog."
Dog has accordingly been
read as a *Self-portrait
in a moment of depression.*
Subjects other than men
and women are very rare in
Giacometti's post-War art.

GIACOMETTI (right)
*Composition with seven
figures and one head (The
forest),* 1950
"The composition with
seven figures reminded me
of a forest corner seen for
many years (it was during
my childhood) where trees
... with their naked and
slender trunks, limbless
almost to their tops, had
always appeared to me like
personages immobilized in
the course of their wander-
ings and talking among
themselves." The figures
of the forest are all women.

About 1935 Alberto Giacometti (1901-66) had
become increasingly dissatisfied with his work,
and returned to direct study of the life model:
"I saw afresh the bodies that attracted me in
life and the abstract forms which I felt were
true to sculpture, but I wanted the one without
losing the other." He then worked almost
exclusively, throughout the War, on the
human figure, from life and then from mem-
ory, but he emerged into public attention only
in 1948, with an exhibition in New York,
introduced by the Existentialist philosopher
Jean-Paul Sartre. Painting, which he had
abandoned altogether in 1937, he resumed in
1946. In both painting and sculpture, he
pursued his quest, primarily in terms of the
human figure, until his death in 1966.

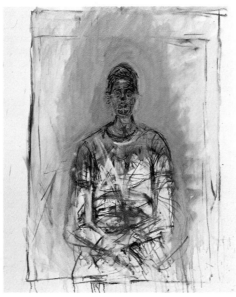

GIACOMETTI (above)
Caroline, 1962
Giacometti's paintings are

most commonly portraits
– of Caroline, his model, or
of his wife or his brother.

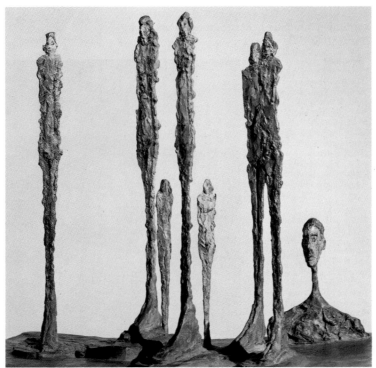

The process of his search for truth was
essentially reductive – at first almost catas-
trophically so: "... to my terror the sculptures
became smaller and smaller. Only when small
were they like (reality), and yet these dimen-
sions revolted me, and tirelessly I began again,
only to end up, a few months later, at the same
point. A big figure seemed to me to be false and
a little one just as intolerable, and then they
became so minuscule that with a final stroke of
the knife they disappeared into dust. But the
heads and figures only seemed to me to have
any bit of truth when small." Finally about
1945 he was able to make figures to a larger
scale, finding "to my surprise that only when
tall and slender were they like", but the
reductive principle was never abandoned. His
vision was always conditioned by his know-
ledge that reality escapes clear definition: he
once said that he tended to see people as if
against the setting sun, their edges "whittled
away by the light refracted about them".
"Whatever I look at, everything gets beyond
me and astonishes me, and I do not know
exactly what I see. It is too complex ... It is as
if reality is continually behind curtains that
one tears away – and then there is another,
always another ... And so one goes on, know-
ing that the nearer one comes to the 'thing', the
more it recedes. The distance between me and
the model tends always to increase ... It is a
quest without end." So, too, his figures seem to
exist not at the apex but within the cone of the
spectator's vision: the focus of one's eyes is
always on some elusive point beyond them.
Giacometti's world was that of the modern
physicist: it was composed not of solid, inert
matter but of entities apprehensible only as
centres of energy. Especially in his paintings
his sitters become a sort of vortex of energy,
re-creating their own spatial environment.

Possibly the relevance of Giacometti's art
will diminish, but in the 1950s and 1960s it was
quite startlingly real; the works of Giacometti
and of Francis Bacon (see over) were compel-
ling evidence that the figurative tradition still
had profound importance. Sartre found the
essence of Giacometti's art to exist in absolute
freedom – the Existentialist *Angst.* He noted
more specifically: "What must be understood
is that these figures, who are wholly and all at
once what they are, do not permit one to study
them." It is perhaps the physical presence of
Giacometti's people, combined with the diffi-
culty of grasping that presence, that is the most
compelling quality of his art. They are there,
but they are also "other"; they keep their
distance. The men may walk, may point: the
women, whether the size of a pin or giants
anchored on huge feet, are immobile with such
intensity that their rigidity can affect the way
people stand as they look at them. They reject
ownership: they are metaphors of human iso-
lation, even more tellingly when grouped in
clusters or groves, often in entirely disparate
sizes. Though their ancestors in art are clearly
discernible (and Giacometti himself was fully
aware of them – Etruscan bronzes, Egyptian
sculpture, Oceanic art), they remain disturb-
ing. They are Existentialism personified, hav-
ing heroic loneliness (which some have com-
pared to the dour and doomed integrity of
characters in Samuel Beckett's plays).

Bacon: Figures in a Landscape

The emergence – eruption almost – of Francis Bacon's work in the 1950s was a shock to international art. Critics at first found his paintings hard to accept; his expressionist images forced attention in a context of all-conquering abstract or near-abstract art, developed in the early post-War years by Pollock and the Abstract Expressionists in America, by Ben Nicholson in England, and by Nicolas de Staël or Hans Hartung in Europe. Picasso, working in the figurative tradition, was already regarded as an Old Master.

However, the pictures of Francis Bacon (born 1909) were disturbingly relevant; and their formidable immediacy made it necessary to reconsider the assumptions made about figurative painting. Its once basic function, to achieve "a good likeness", had been undermined by photography a century earlier – portraiture especially seemed to be surviving as a social rather than as an artistic phenomenon – but this was not a return to naturalism. Bacon, abandoning the abstract decorations of his pre-War years, exploited photography for his own artistic ends. It became a springboard for a figurative art that was fundamentally unphotographic. Bacon also works from the life, but the results are not what an old-fashioned sitter would accept as portraiture. Though Bacon himself might not agree that this was his intention, he transmutes these given images into fluid, mutating visions that convey horror, violence and suffering. In his early figurative work, such as *Figure in a landscape* of 1945, he used some more or less traditional devices of Surrealism, but by 1950 he was concentrating on the theme, seemingly inexhaustible, that he has explored ever since – studies of a single figure in spotlit isolation, or two figures locked in struggle (or perhaps sometimes in love).

The origins of his images are usually clearly discernible, but always they have suffered melting, dissolving, change. Often his imagination seizes on one particular image from which a sequence of variations develops. The first and most famous of these was the *Screaming Popes* series, based on one of the most vividly sane and seemingly definitive portraits in all European painting, Velazquez's *Pope Innocent X*. This Bacon has avoided seeing in the original, but knows only from reproductions. Subsequent series included one based on van Gogh on his way to work, and one developed round the life-mask of the poet-painter William Blake. Other pictures, including *Figures in a landscape*, 1956, are inspired by the rapid-sequence photographs of the human body in action made by Eadweard Muybridge (see p. 375). In Bacon's portraits a constant theme is the confined, clinical space in which the isolated sitter is trapped.

Superficially, Bacon's compositions have a traditional structure, a perspective recession into depth; but once having entered the picture's space, the viewer's eye is puzzled and baffled. In *Figures in a landscape*, 1956, the subject seems unfocused, ambiguous – here the vertical stripes of green at the back might be a fence, or a curtain; the central landscape sprouts grass of some kind, but reads more like a pit or an arena; the two naked figures are certainly human – or used to be, or are about to be, human. Are they wrestling? If so, in hate or love? Even their sex is unclear. The subject rejects exact definition, and yet mesmerizes.

Bacon's appeal to post-War sensibility lies in the fact that while his creatures are indisputably flesh and blood and compel our unwilling identification with them, they are also convincing embodiments of mental anguish. Bacon has invented a new grammar and imagery of human expression. Its frame of reference is contemporary awareness of the horrors of the twentieth century – concentration camps, gas chambers, the continuing techniques of torture throughout the world – as well as the private mental disturbances revealed by psychoanalysis or described in Kafkaesque literature of claustrophobia and alienation. Bacon's use of a glass box (not only holding his figures in focus but trapping them) even prophesied a haunting image of post-War reality – Press photographs of the Nazi war criminal Eichmann in an armoured-glass dock at his trial in Israel.

BACON (right)
Figures in a landscape, 1956
The naked human body is a main theme of Bacon's; a powerful sense of flesh as heir to pain and decay may stem from his view of man as "an accident, a completely futile being".

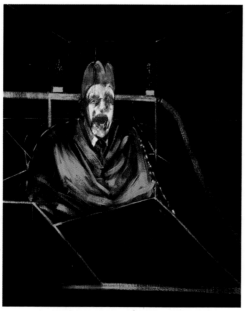

VELAZQUEZ (right)
Pope Innocent X, 1650
The very opposites of the qualities Velazquez set himself to convey – spiritual authority and temporal might – inspire Bacon: his studies of agonized beings are seemingly gripped by a horrific, negative vision of life. Feeling for colour and texture, however, is something in common.

BACON (left)
Study after Velazquez, 1953
Among the sources for this early study in the series of *Screaming Popes* are not only Velazquez's painting but a photograph of Pope Pius XII borne in a litter above the crowds and the sketch of a howling face by Poussin for his *Massacre of the Innocents* (not shown).

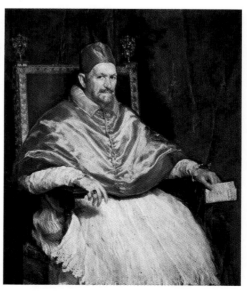

BACON (right)
Figure in a landscape,
1945
A photograph of a friend
dozing in the park becomes
an image of menace; hands
rest casually on the arm
of the chair, but the head
has melted away and at the
elbow is a machine-gun.

BACON (above)
Isabel Rawsthorne, 1966
Features grossly distorted
by dynamic brushwork, as if
rent by an obsessive scream,
are typical of Bacon's
expressive portraiture.

EISENSTEIN (below)
Still from the film *The
Battleship Potemkin*, 1925
The helpless individual, a
children's nurse caught in
a Revolutionary chaos, was
a potent image for Bacon.

Johns and Rauschenberg

Two young American painters emerged into the ferment of the New York artistic scene almost simultaneously in 1955 – Jasper Johns (born 1930) and Robert Rauschenberg (born 1925). When Abstract Expressionism seemed in the intensity of its subjectivity to have reached a point of no return – or at least to offer no future in its own terms – these two offered a way forward, and were to have a profound effect on the development of several currents in painting during the next two decades.

Rauschenberg had the more varied apprenticeship, in Kansas, briefly (1947) in Paris and then at Black Mountain College in North

Jasper Johns
In contrast to his friend Rauschenberg, Johns has a rather reserved, precise temperament; in the words of one interviewer, "He has a remoteness that, while very amiable, makes all questions sound vaguely coarse and irrelevant."

Carolina; there, too, came Johns. The presiding gurus of the college were Josef Albers and the philosopher-musician John Cage (born 1912). The austere detachment and geometric clarity of Albers' work (see p. 468) has affinities more with Johns' early practice than with Rauschenberg's, but Albers' approach to art, his persistent questioning of its philosophy and its aims, his intellectual seriousness, certainly influenced both of them. Cage's music reached out of the conventional framework of the art into (in one form) silence: the listener was to identify, even create, his own music in the silence beneath the surface of random sounds. "The thing to do is to keep the head alert but empty. Things come to pass, arising and disappearing. There can be no consideration of error. Things are always going wrong." Cage's principle of "unfocusing" the mind – which owes much to Japanese Zen Buddhism – was equally applicable to art.

The most obvious novelty of Johns' and Rauschenberg's work was their return to representation. Johns' early work was often literal, illusionistic. He tended to paint series as Albers was doing, and to represent objects that were both everyday, even banal, yet also

charged with universally recognizable symbolism. His most famous series was *American Flag*. The flag is often copied faithfully in detail, and its proportions determine exactly those of the canvas on which it is painted – if it were painted on both sides you might fly it as a flag. Yet it is worked in a positively tactile, sensitively textured, painterly medium of pigmented encaustic, so it is also very firmly a work of art. In a way this is an alternative position to Marcel Duchamp's. Duchamp's ready-mades were posited as works of art by the act of the artist simply designating them as such; Johns, as it were, took ready-mades and with uncompromising objectivity painted them back into art – or sculpted them, as in his notorious painted bronze facsimiles of beer-cans. He could also, however, introduce weird and disturbing extraneous elements: the most famous of his *Target* series has four half-seen plaster casts of impassive faces built into it – like the masked faces of a firing squad, or the blindfolded faces of victims. Here the heritage of Dada and Surrealism is obvious.

The impact of Johns' one-man show of 1958 was very great, partly because it offered avenues of development out of Abstract Expres-

JOHNS (left)
Painted bronze II, 1964
The object was back, if not quite figuration in the old sense. It is quite clear that these exact reproductions of beer-cans are not beer-cans: they are art, and they look like it. The step that Warhol then took, with his *Brillo* sculpture (see over), was to remove this quality.

JOHNS (below)
Untitled, 1972
The four sections of the work portray a progressive abstraction from right to left. The pattern of the "real" elements of wood and plaster is repeated in the representation of flagstones in the centre and in the cross-hatched abstraction on the left.

JOHNS
(left) *Three flags*, 1958;
(below) *Target with four faces*, 1955
"Using the designs of the American flag took care of a great deal for me because I didn't have to design it, so I went on to similar things like the target – things the mind already knows. That gave me room to work on other levels." Ambiguity and paradox are central to John's vision: things are not necessarily what they seem. Abstract qualities – texture, colour, drawing – are emphasized in a representational painting; a *Flag* is not only a flag or a reproduction of a flag but also neither – a third object in its own right.

sionism without overturning the dogma that a painting was primarily a worked surface, subject and object in itself. Johns then, however, shifted his own attitudes: "The early things", he observed in 1965, "to me were very strongly objects. Then it occurs that, well, any painting is an object, but there was . . . I don't know how to describe the sense alterations I went through doing this, in thinking and in seeing. But I thought then, how to make an object which is not so easily defined as an object?" By 1974, he was stating his wish "to focus the attention in one way, but leave the situation as a kind of actual thing, so that the experience of it is variable". Thus he offers his work to the spectator not only to arouse a traditional aesthetic response but also as a platform for open-ended dialectical discussion.

In this he is sometimes very close to Rauschenberg. Rauschenberg moved through experiments with all white, all black and all red paintings in the early 1950s to what he called "combine-paintings", a development of collage and montage techniques, first seen in exhibition in 1955. Some were quite modest, but the notorious *Bed* (not shown) of that year incorporated a real quilt and pillow amidst Abstract Expressionist splashes and runs of paint on the canvas. Four years later, *Monogram*, since widely exhibited, presented a complete stuffed angora goat or ram girt with an automobile tyre standing on a horizontal canvas treated more conventionally with collage and paint. Other works have incorporated items such as radios and clocks. At this stage, Rauschenberg was not transforming objects for his imagery, but simply transferring them. "I am, I think, constantly involved in evoking other people's sensibilities. My work is about wanting to change your mind. Not for the art's sake, not for the sake of that individual piece, but for the sake of the mutual co-existence of the entire environment." In the 1960s, he reverted to a flat surface, and implanted much of his imagery in the form of silk-screen transfers – at one remove from the real objects – but the method of heterogeneous juxtaposition remains much the same. Latterly he has emphasized its casualness, its dissociation from the traditional conception of making and using pictures, by suspending his canvases slack and loose, even behind a slightly opaque covering. Like Johns, he presents art as an idea to be cogitated by the viewer; in both their work there is implicit criticism of the long-standing Western acceptance of art as a commodity to be owned or merely enjoyed.

The work of Johns and Rauschenberg proved a rich mine for subsequent movements. Pop was to take heart from Johns' use of the most contemporary, banal and ephemeral imagery, though adapting it for different ends. Both Johns and Rauschenberg continually stretched the constraints of painting; Rauschenberg has danced on stage (on roller-skates). Indeed Happenings may seem only an intensification, animation and expansion into real life of his "combine-paintings".

Robert Rauschenberg
"Everything goes crazy whenever he is here", said his printer. "You work his hours, his way, non-stop . . . It's incredibly exciting and incredibly exhausting."

RAUSCHENBERG (above)
Monogram, 1959
"Painting relates to both art and life. Neither can be made. (I try to act in that gap between the two.)" Out of his materials he tries to conjure latent meanings, new references.

RAUSCHENBERG (left)
Story-line 1, 1968
This includes stills from the film *Bonnie and Clyde*, which established a cult following in the late 1960s. The images are set in an abstract mosaic – content is played against form.

RAUSCHENBERG (right)
Sleep for Yvonne Rainer, 1965
The artist believes that "there is nothing that everything is subservient to": therefore in his work no element is given more importance than any other.

American Pop Art

The "pop" in Pop art is for "popular", but also for a bright explosive quality, a visual counterpart to "snap-crackle-pop". Its application to a strong, controversial and highly publicized trend in the art of the 1960s originated in a painting of 1956 by a British artist, Richard Hamilton (see over), but though the British Pop movement preceded the American one in time, the American version originated independently; and it was in New York and also in California, sunlit home of Hollywood fantasy, that the style found its fullest and most spectacular destiny.

Pop art is often seen as part of a reaction against Abstract Expressionism, but from Abstract Expressionism Pop art inherited various elements, not least an immensely enlarged sense of the possibilities for art in general, and, specifically, for the effects of large-scale work and "all-over" painting. In contrast to Abstract Expressionism, however, it is, most obviously, a return to figuration; and the paintwork is often clean and crisp. The subject matter represented is the material of contemporary urban life, the new, the instantly banal, the consumable, the ephemeral, the highly sophisticated "folk art" of the second half of the twentieth century – comic strips, giant billboards, slickly styled automobiles, cigarette packets or film-star pin-ups. Pop art did not so much draw from these as reproduce them in different terms.

Pop artists exploited ground already opened up earlier in the twentieth century by Dada, by the Surrealists. Pop, however, even though it was sometimes called "neo-Dada", did not have the satirical or anarchic edge of the original Dada. Pop was affirmative rather than destructive, though the artists celebrated at a distance, with detachment, objects not previously found worthy of celebration, and objects that had already been processed – even reproductions of reproductions.

The immediate, most direct forebears of Pop were Johns and Rauschenberg (see preceding page), though they always held somewhat apart, and their painterly interests were not followed. Another in-between figure was Larry Rivers (born 1923), whose very sensitive and sensuous pleasure in paint traditional connoisseurs gratefully recognize. By the late 1950s he was applying it to a mixed and fragmented imagery, a free play of words and images. Rivers is an empiricist, often irre-

WARHOL (above)
Liz no. 2, 1962
The glamour of fame and the media obsesses Warhol; in a sense it is the mainspring of his work, though his view of it is typically ironic. It is all surface, but surface is the interest.

WARHOL (below)
Brillo, 1964
"I adore America", Warhol said, explaining his work. "My image is a statement of the harsh impersonal products and ... materialistic objects on which America is built today."

RIVERS (right)
French money, 1962
Johns and Rauschenberg and Larry Rivers bridge the gap between Pop and Abstract Expressionism, relating everyday objects and sensuous paint – even if Rivers is less dialectical. His canvases are not large, but cool, relaxed, elegant. He has perhaps influenced British Pop rather more than American; he denies, however, any "super visual strength and mystery in the products of Mass Culture ... I have a bad arm and am not interested in the art of holding up mirrors."

WHY, BRAD DARLING, THIS PAINTING IS A MASTERPIECE! MY, SOON YOU'LL HAVE ALL OF NEW YORK CLAMORING FOR YOUR WORK!

LICHTENSTEIN (left)
Masterpiece, 1962
Lichtenstein has described in detail how he set about making one of his "cartoon" paintings. Having selected a self-contained "frame" from a comic, he made a pencil drawing, introducing perhaps a few changes. He projected the drawing on to canvas, painted in the main lines, and made dots with a toothbrush through a perforated screen. The result works on several levels, but is also entirely "straight".

INDIANA (right)
Yield brother, 1963
Indiana (the name is that of his native state) is an aggressive, bold nationalist committed to an American style of hard-edged, sign-like painting, which often looks like a giant badge – hammering its message. "I propose to be an American painter, not an internationalist speaking some glib visual Esperanto – possibly I intend to be a Yankee."

YIELD BROTHER

verent and witty, rejecting dogma; he was nevertheless probably the first to treat the "vulgar" subject matter of Pop seriously.

Roy Lichtenstein (born 1923) has been one of the most consistent and pure practitioners of Pop ideas – a painter of types and media ideals. He is best known for his recycled extracts from comics, blown up, hugely enlarged: in these the stencil-like dots of cheap reproduction printing processes are faithfully reproduced, but the whole image is simplified into a unified design, a controlled composition. Later, he abstracted similar giant simplifications from reproductions of "fine art" – the brush-marks (see p. 502) of Abstract Expressionists, even the diagrammatic analysis by an "art-appreciator" of a Cézanne painting. One objective may be to force the spectator to question his own scale of values. Andy Warhol (1930-1987) in some works questions specifically the traditional values of the hand-made and unique art-object and, even more forcefully, the concept of originality. He uses mechanical processes – especially silk-screens – facilitating repetition, and employs assistants like factory hands: all traces of personal involvement by the artist with the work are avoided. His subject matter varies from the banal – a battalion of identical Coca-Cola bottles; sleep recorded in a film six hours long of a man asleep; a stack of Brillo boxes – to the ideal – a popular beauty or sex symbol, Marilyn Monroe, Liz Taylor, Jackie Kennedy, dehydrated in turn to banality – to the horrific – a deadpan juxtaposition of almost endless prints of the electric chair. So, too, in the glare of publicity the artist's own personality is simplified, enlarged and drained of reality until it becomes as impersonal as an image on the film screen. When, in 1968, Warhol was shot and severely wounded by an acolyte, it seemed almost another dimension of his work, though it proved him human after all.

Warhol makes no overt comment. Often he seems to register boredom by boring the spectator, but on an heroic scale with mesmeric intensity. Robert Indiana (Robert Clark, born 1928) in contrast was positively Romantic and Symbolist, though generally non-figurative, combining letters and slogans in very clear-cut designs (his colour and clarity owe something to Ellsworth Kelly). He has functioned as a social and political commentator, and imbued his work with a strong sense of American history and literature. James Rosenquist (born 1933) worked for a time as a billboard painter, and in his enormous Pop paintings used the impersonal, generalized billboard techniques of representation – fragmented, the fragments juxtaposed in disarray. This can be read as a modern variation on the theme of Vanity of Vanities, and Rosenquist's formal inventiveness does seem to have a moral import. Tom Wesselmann (born 1931) produced a celebrated set of variations on the theme *The Giant American Nude*, simplified almost to silhouettes of sharp clear colour, their erotic content tantalizingly set at a great distance. Wesselmann has also been closely involved with an expansion of collage, "assemblage" art – incorporating real objects such as ringing telephones or televisions switched on.

Claes Oldenburg (born 1929) and Jim Dine (born 1935) can also be considered Pop artists, although their work crosses many boundaries. Oldenburg's giant soft sculptures of everyday objects and Dine's incorporation of similar real objects in his paintings are consistent with the idea of Pop. Both, however, are equally well known for their participation in the development of Happenings (see p. 490).

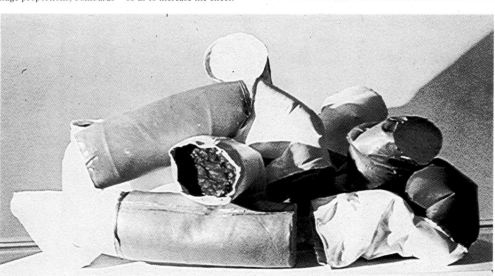

WESSELMANN (below)
Great American nude no. 14, 1961
After an initial training in Abstract Expressionism, Wesselmann went figurative. But he considered that "to paint a flower would be boring": he used collage – or three-dimensional bits. His nudes belong not to the life-class but to magazines.

ROSENQUIST (above)
Flamingo capsule, 1970
Rosenquist's imagery, taken from advertising and colour magazines, then expanded to huge proportions, bombards the spectator with scale and glaring, aluminized colours as in a free fall or a car crash. The two ends reach out to enclose the viewer, so as to increase the effect.

DINE (above)
Things in their natural setting, 1973
Dine's work is openly autobiographical, concerning his life (his grandfather owned a hardware shop) and experiences as a painter.

OLDENBURG (right)
Giant fag-ends, 1967
The foam-filled cigarettes are truly gigantic; they are intended to get in the way, almost ludicrous in their very obvious irony. Like Warhol, Oldenburg annoys.

British Pop Art

British Pop art took shape in a group of young artists and critics (The Independent Group) at the Institute of Contemporary Art in London in the early 1950s. It was in part a revulsion against the grey austerity of post-War Britain (where rationing still persisted) and the anti-climax of an impoverished peace following an alleged victory. It celebrated the delights of Western, especially American, materialism, and came as a shock to the still-new orthodoxy of belief in abstraction, in underlying values, and equally to a more traditional pastoral romanticism that had revived in the 1940s. Pop artists proposed in contrast initially a blatant, even vulgar, emphasis on figuration, but the subject matter they figured, and the way they figured it, bore little relation to previous movements, whether Romantic or Realist, idealist or naturalistic. The imagery that excited them was extruded by mass-produced urban culture – the movies, advertising, science fiction, pop music, consumer goods and their packaging.

The first Pop art work exhibited was *Just what is it that makes today's homes so different, so appealing?* by Richard Hamilton (born 1922), a small, almost miniature, collage blown up to life scale at the entrance to the exhibition "This is Tomorrow" held in London in 1956. The exhibition was concerned with wider problems of the way art could and should affect urban man's total environment, and brought together artists, architects and critics of very different persuasions, including the severest of abstract Constructivists and the two leading figures of early English Pop art, Hamilton himself and Eduardo Paolozzi (born 1924). For "This is Tomorrow" Hamilton wrote: "Tomorrow can only extend the range of the present body of visual experience. What is needed is not a definition of meaningful imag-ery but the development of our perceptive potentialities to accept and utilize the continual enrichment of visual material." The qualities he then identified as most desirable were "transient, popular, low-cost, mass-produced, young, witty, sexy, gimmicky, glamorous and big-business". Hamilton is a spiritual heir of Dada, and specifically of Marcel Duchamp: he executed a meticulous copy of Duchamp's *Large Glass* (see p. 416).

Paolozzi has been equally original and even more inventive and exploratory. He is best known as a sculptor, but, like Hamilton, is also

HAMILTON (right)
Just what is it that makes today's homes so different, so appealing? 1956
Pop says the racket-like lollipop Charles Atlas is holding. Irony and parody were constituents of the movement from the start, but Hamilton makes myths even as he debunks them. The wit is celebratory; the joy in advertisement images and consumer goods is real; and Pop flourished until disillusion and credit squeeze bruised its roots.

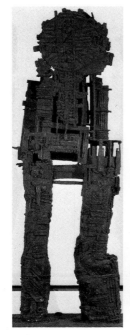

PAOLOZZI (left)
Conjectures to identity, 1963
The assorted images are unified by the medium into a coherent pattern; each print of the edition came in variant colours.

KITAJ (below)
Where the railroad leaves the sea, 1964
Bright, clear, slick, Pop in style, Kitaj's work has a wider range of image and allusion than typical Pop art, seeming to occupy

an arcane dimension of the imagination. The literary element is subservient: "The picture always takes over, but you can't help being moved by the great cultural issues peripheral to the picture", he says.

PAOLOZZI (above)
Japanese war god, 1958
Paolozzi has always been fascinated by the world of science fiction. His robot is like a junk King Kong.

SMITH (below)
Giftwrap, 1963
"Everything", says Smith, "comes in boxes; you buy boxes when you're shopping, you do not buy visible goods; you don't buy cigarettes, only cartons. The box is your image of the product." The boxes here dominate the canvas, forced by them into high relief.

important as a printmaker. In the early 1950s he was experimenting with a variety of assemblage, building up fragments of mechanical junk into enigmatic but brooding sculptures suggesting slot machines or rudimentary computers. He is sometimes excluded from the Pop category, as he always transmuted his found objects, consolidating his multi-source imagery in bronze. But, like Hamilton, he insists on the right to use whatever lies to hand for the purposes of art. "It is conceivable that in 1958 a higher order of imagination exists in S.F. pulp produced on the outskirts of L.A. than (in) the little art magazines of today."

This first, precocious wave of British Pop was in a sense highly romantic, celebrating consumer goods with the fervour of those seeking the Promised Land – which was virtually America. The work of younger artists following fast on the heels of Hamilton and Paolozzi took on a more abstract form. The characteristic early paintings of Richard Smith (born 1931) were giant interpretations of cigarette packets. Significantly, he has worked much in America, moving more recently into large, purely abstract compositions on elaborately shaped canvases. R.B. (Ronald) Kitaj

(born 1932), however, moved from his native America to Britain in 1957, to become a determining influence in British Pop, when Pop was becoming an international movement.

Kitaj combines a virtuoso, intellectual eclecticism with a most sensitive mastery of colour, texture and composition. According to a younger painter, Allen Jones, his widely admitted influence "wasn't one of imagery but of a dedicated professionalism and real toughness about painting". His imagery is, however, striking and often complex: fragments of incidents – from comic strips, famous murder stories, classical mythology, learned journals – are jumbled, shuffled and reshuffled in amongst the paint. Allen Jones (born 1937) and David Hockney (born 1937) have both reflected his inspiration, though both have moved on to their own individual styles, and Hockney has become a popular and international celebrity. The delicacy, certainty and wit of Hockney's early talent found its most congenial medium in graphics – almost parodies of child art; his most satisfactory works are perhaps his prints and drawings. His developed painting style, apparently as bland and inert as travel posters, celebrates a con-

tinuing love-affair with consumer society, especially with golden California. Perhaps because so blatantly decorative, his *Splash* series of swimming pools has disappointed some critics, but he has the power to invest familiar topics with electric strangeness, and in his portraits – especially the double ones – to indicate troubling psychological tensions. Jones, however, has become notorious for his unabashed use of kinky, erotic subject matter, inspired by the imagery of sex magazines, of fetish rubber and leather garments, painted in simplified flat planes of colour (often garishly acid); this tends to obscure his talent for formal invention. Patrick Caulfield (born 1936), who shows no such eroticism, is the nearest in England to Lichtenstein's adaptation of the visual clichés of cheap magazine reproduction; he makes no comment, but presents what are almost huge diagrams (heavily outlined as if for painting-in by numbers) of banal scenes, or of exotic scenes that he presents as banal.

Pop Art caught on with the general public throughout the Western world and the media as has no other modern movement in art, but it was in Britain and America that it found its true and most concentrated expression.

HOCKNEY (left)
The sprinkler, 1967
Glass and water, whether transparent or reflecting, are often prominent in the cool, spare vision of which Hockney is a main exponent: they assist in reducing the world to flat, sharp, air-brushed-looking colour.

HOCKNEY (below)
Christopher Isherwood and Don Bachardy, 1968
There is a tense balance between the cool, severe, toned-out interior with its stilled still life and the more emphatic modelling of the faces; the movement is frozen, almost repressed.

JONES (left)
Red latex suit, 1973
Jones always insists that "the shapes themselves suggest the subject, not the subject the shapes". Sometimes he seems ready to explore how far erotic shapes can be abstracted and still be erotic; more often his aim seems to be to titillate or scandalize.

CAULFIELD (below)
Town and country, 1979
The cool, impersonal, uncommitted style in which Caulfield works has more in common with American Pop than British; here he is perhaps suggesting the heterogeneous décor of a brashly ghastly snack-bar.

Environmental Art, Happenings and Performance

In a sense Environmental art is nothing new: it is the distant heir of tribal ritual, of medieval pageant, of Baroque church interiors, even of Wagner's opera; a more direct ancestor was Dada, especially Schwitters' *Merzbau* (see p. 415). But in the 1960s it was the expression particularly of an urge to free art from the frame and the wall, where it was set apart from life, and to involve art with life, until art should become indistinguishable from life. In order to achieve its purposes art could call on the resources of any and all techniques and media – three-dimensional sculpture and sound; time and motion; living people. "Happenings" or "Performance" art can be seen in one way simply as activated Environmental art, and in another way virtually as theatre – exhibitions could become very like showbiz. Central to it all was the desire to dissolve the barriers that separated the various disciplines of art.

A starting point was a now legendary lecture given at Black Mountain College in 1952 by John Cage, musician and intellectual progenitor of late twentieth-century avantgarde experiment in all media. The lecture, given from the top of a ladder, featured long silences, music both live and mechanical, poetry, dance.

From Black Mountain College came also Johns and Rauschenberg (see p. 484), whose work had anticipated aspects of Environmental art, and was soon extended into it: Cage and Rauschenberg were both involved in an elaborate showpiece of the movement in 1966, *Nine evenings of theatre and engineering*.

Two artists, classifiable basically as sculptors, early extended their practice to the scale of the Environmental or to the actuality of the Happening, injecting a disturbing, surreal element – Edward Kienholz (born 1927) and George Segal (born 1924). Both can in fact be seen as practitioners in modern dress of traditional genre themes. Kienholz, not an academically trained artist, has drawn on his experience of mental hospitals, drinking clubs, dance bands for constructions that have grown in size and detail since 1954, sometimes to become replicas of entire rooms. The tableau offered is generally sleazy in feeling, a comment, moral and satirical, on the condition of modern urban humanity. Segal has also created settings featuring real furniture, but peopled by plaster casts from living bodies. These date from 1961, and what was at first a

SEGAL (right)
The photo booth, 1966
Segal casts his friends in plaster; the casts give the impression that there is still someone inside. The works have an eerie quality, and are pervaded by an intense feeling of loneliness – the painter Rothko once aptly called them "walk-in Hoppers".

KAPROW (below)
Basic thermal units, 1973
A Happening, according to Kaprow, is "a convergence of events which are being performed in more than one unity of time and place ... In contrast with a piece of theatre, a Happening can take place in a jam factory ... or in a friend's kitchen ... the Happening unfolds according to plan, but without repetition, without audience, without rehearsal. It is art but it seems nearer to life." The only materials needed in his *Basic thermal units* were thermometers and ice.

KIENHOLZ (right)
The birthday, 1964
Kienholz's brutal, seedy but also bizarre, surreal art reflects the dire side of life in California – Kienholz is a product of Los Angeles and the West Coast, not of New York. Grey, in dirty grey garb, a woman becomes a victim not so much of the pain of childbearing as of the squalor of her situation.

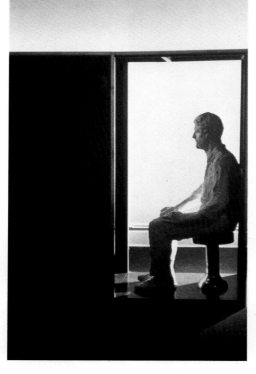

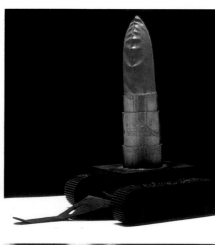

OLDENBURG (left)
Model for *Monument for Grand Army Plaza, New York*, 1969
This is one of the few Environmental projects by Oldenburg executed as yet. More than 7m (24ft) high, it was built by the Colossal Keepsake Company at Yale University, though in time opposition to it there has caused it to lead a rather nomadic existence. The lipstick is telescopic, and the monument moves around on its tank base. Oldenburg's work shocks: "I have tried to make it in every way so that anyone who comes into contact with it is ... inconvenienced."

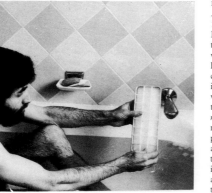

KLEIN (right)
Anthropometry: ANT 63, 1961
Klein was fascinated by the culture of Japan: he visited the country and learnt judo – it was the ceremonial that specially interested him. Ritual is vital to the creation of the works in the *Anthropometry* series; here female nudes lay on the canvas as paint was sprayed round and about them; in others they covered themselves in blue paint and rolled and shifted on the canvas to the artist's directions.

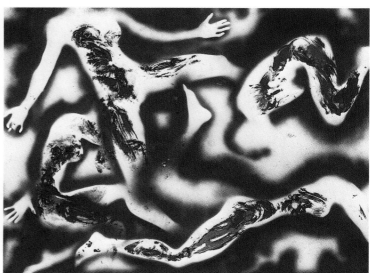

neo-Dadaist joke has grown into a new, continuing mythology. He has experimented with Happenings, but prefers a static presence for his figures, caught, it seems, in an instant deep-freeze and drained to unearthly pallor – an essence of reality contrasted with the contrived art of their settings.

Allan Kaprow (born 1927) has been a central organizing figure in the development of Happenings. Starting in New York as an Abstract Expressionist, he studied with Cage, and in the mid-1950s developed increasingly complex assemblages. Set at first in the context of a gallery or museum, these grew into total environments; he moved his events to parking lots, gymnasia or stores, including spectators as his cast, using any techniques and materials that might be available, from sophisticated mechanisms to found junk. These events, however, while welcoming accidents of chance, always had a basic programme or "plot", unlike some developments, notably in Europe. Later, he experimented with simpler, more austerely Conceptual ideas (*Fluids*, of 1967, consisted of 20 monumental blocks of ice left to melt in city streets). Kaprow also established a sort of information centre, encouraging the pooling and recording of Happenings.

Pop artists involved with Environmental or Happening experiments include Dine and Oldenburg (see p. 487). Dine staged an ambitious and well-publicized "psychodrama", *Car crash*, in 1960. Oldenburg in 1961 opened a store on East Twenty-first Street, New York, in which he sold, in manic parody of a commercial operation, various bits and pieces he had made, including painted plaster replicas of food. Oldenburg exploits the banal, with an inspired sense of the absurd on a Rabelaisian scale; he has suggested gigantic designs for urban monuments – a ballcock floating in the Thames by the Houses of Parliament, but bigger; lipsticks, ironing-boards, electric plugs as tall as the Empire State Building.

Environmental art and Happenings seem to have flourished particularly in America, but the trend has its practitioners both in Japan and in Europe. In France the short-lived Yves Klein (1928-62) was a brilliant forerunner. His reductive approach produced canvases of pure blue ("the most cosmic colour"), and an exhibition consisting of the white walls of an empty gallery, and he also painted by exposing canvases to the weather, or by using a blowlamp as a brush. Very germane to the ideas behind Happenings were his ceremonial *Anthropometries* of 1958-61: one featured naked girls being dragged across canvas to the accompaniment of an orchestra sustaining a single note. A later variant on Happenings is "Body" art, in which the artist's body, in action, is used as both subject and object. Body art has been practised by the American Vito Acconci (born 1940) and in Europe by the Italian Gina Pane (born 1939). And yet the approach of Body artists has been as much Conceptual (see p. 494) as experiential.

The work of the German Joseph Beuys (1921-1986), who achieved an international reputation in the 1970s, has a firm conceptual basis. His activities have often been Happenings, having weird, transcendental overtones, in which Beuys has the character of both high priest and research scientist. He sees himself primarily as a teacher, crossing disciplines, and acts out art as if it were life – it is for him. He has taken the interaction of art and life further than anyone – if not always to the immediate enlightenment of those who behold him, as other artists of revolutionary originality have previously found.

ACCONCI (left)
Rubbing piece, 1970
The work consisted of the artist, Acconci, sitting in a restaurant rubbing one arm (being photographed every five minutes) until a distinct weal appeared.

PANE (right)
Action psyche, 1974
"My corporeal experiments ... have the aim", states Pane, "of demystifying the common image of the body experienced as a bastion of individuality." Body art is, more generally, an experiment with roles – relationships of audience, performance and performer.

BEUYS (below)
Room installation, 1968
Beuys, having started his career as an artist in the early 1950s with sculpture, has worked with materials that are for him symbolic, mystic – especially felt and fat, by which his life was saved after an air crash in World War II. In spite of permanent injury he has involved himself in acts of extreme endurance. But most recently his art has become above all teaching: he teaches those who come about art (the marks made by him on the blackboards are sprayed with fixative).

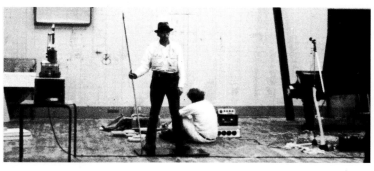

WELFARE STATE (below)
Action, 1972
Welfare State was one of a number of British art-orientated theatre groups touring in the early 1970s.

"We will react ... spontaneously and dramatically, and ... fake unbelievable art as a necessary way of offsetting cultural and organic death", they cried.

BEUYS (above)
Scottish symphony, 1970
Enacted at the Edinburgh festival, this work included tapes, films and periods of silence. (Beuys is centre.)

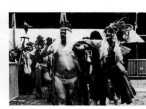

Kinetic and Op Art

Kinetic means relating to motion – causing it or resulting from it. The aspect of kinetic art that startled popular and journalistic attention in the early 1960s was optical or retinal art, which was inevitably dubbed "Op" art, following so closely as it did on Pop. Kinetic art embraces works that themselves move, or (the kind known as Op art) that induce on the retina the illusion of movement, though physically static. Op art exploits or manipulates, even to the point of inducing physical dizziness, tendencies in the physiology and psychology of human sight that in everyday life are normally corrected or ignored. Kinetic and Op art is generally conceived, however, as essentially non-figurative: the natural or biomorphic references that persist in the work of Calder (see p. 479), an obvious precursor, distance him from the recent kinetic movement, and the experiments of Maurits Escher (see p. 423) with disturbed perspective, though they also exploit the fallibility of the human perceptual system, are concerned to extract surreal effects from what seems at first sight real.

The senior exponent, and pioneer of Op art effects even as early as the 1930s, is Victor Vasarély (born 1908), Hungarian in origin, but working in France since 1930. He has taken a radically sceptical view of traditional ideas about art and artists: in the light of modern scientific advances and modern techniques, he claims that the value of art should lie not in the rarity of an individual work, but in the rarity and originality of its meaning – which should be reproducible. He began as a graphic artist; much of his work is in (easily reproducible) black and white, though he is capable of brilliant colour. His best work is expressed in geometric, even mechanistic terms, but integrated into a balance and counterpoint that is organic and intuitive. He claims that his work contains "an architectural, abstract art form, a sort of universal folklore". His vision is of "a new city – geometrical, sunny and full of colours", resplendent with an art "kinetic, multi-dimensional and communal. Abstract, of course, and closer to the sciences".

Vasarély's work can sometimes dazzle the eye, but he does not aim to disturb the spectator's equilibrium. The effect of the work of the British Bridget Riley (born 1931) can be to produce such vertigo that the eye has to look away. Though carefully programmed, her patterns are intuitive and not strictly derived from

VASARELY (right)
Zebras, 1938
Vasarély's early works, though figurative, showed already his delight in an optical trickery. He was later a main inspiration to many in early 1960s Paris.

RILEY (below)
Cataract 3, 1967
Riley's canvases, despite their austere abstraction, carry allusions in both title and overall effect to natural phenomena, to sources of energy such as water, fire and wind.

scientific or mathematical calculations, and their geometrical structure is often disguised by the illusory effects (as Vasarély's structure never is). Riley refuses to distinguish between the physiological and psychological responses of the eye. Peter Sedgley (born 1930), a Briton living mainly in Germany, became known about 1965 for his experiments with one of the recurrent images of late twentieth-century painting, the "target" of concentric rings of colour. The effect was intensified by changing lights of red, yellow and blue, electrically programmed. Later he developed "video-rotors", stippled with brilliant fluorescent colour, rotating and still further animated by the play of ultraviolet and stroboscopic light upon them. His latest work has explored relationships between light and sound, with screens on which the noise and movement of spectators or passers-by are reflected in coloured light.

Ideas similar to those behind Sedgley's screens have dictated the work of the Venezuelan Jesus-Raphael Soto (born 1923), working in Paris, who started with transparent images layered in depth so that they seemed to move, but only as the spectator moved; later Soto produced very elegant linear designs

across which suspended rods introduced changeable variations, and then he created total environments necessitating spectator participation, not only optical, but tactile and aural – neither paintings nor sculptures but experiments or games for each spectator. As early as 1960 the extension of kinetic art into the Environmental, virtually into Happenings, was a central aim of GRAV (Research Group for the Visual Arts) founded in Paris by artists including Vasarély's son Yvaral and the Argentinian Julio Le Parc (born 1928; not shown) under Vasarély's auspices.

Kinetic or mobile sculpture more closely linked with the inter-War experiments of Gabo or Moholy-Nagy (see pp. 428, 438) has been produced by the American George Rickey (born 1907; not shown), who has built austere, deeply cogitated abstracts in stainless steel, all wind-driven, and by the Greek Takis (Panayotis Vassilakis, born 1925), working in Paris, who used slender rods that vibrated gently in moving air, almost like bulrushes. Light is a dominant medium in recent kinetic art – Takis' Signals, appearing in 1954, were flashing lights at the end of long, wavering rods – but Takis, like other artists, also used noise,

and then began extensive experiments with electromagnetic sculpture: he aims to induce spiritual contemplation, to suggest the presence of invisible energy ("If only I could capture the music of the beyond with an instrument similar to radar").

Some of the most spectacular and delightful creations of kinetic art have been those of the Swiss Jean Tinguely (born 1925), who constructs elaborate nonsense machines, manic sometimes to the point of self-destruction. In 1959 he invented a "Métaméchanique" (Metamachine) that gallivanted about the floor recording its hiccoughing progress on a roll of paper built into itself. Study no. 2 for the end of the world, a complex construction in the Nevada desert near Las Vegas, worked itself into a frenzy in March 1962 and blew itself up. Tinguely's works verge on Happenings but also on the surreal, and often are definitely figurative in an eccentric way. Though much more abstract, the extremely spooky moving constructions of the Belgian Pol Bury (born 1922) again have surreal overtones; their elements shift very gently, articulating long periods of silence with a sigh or a click (their motors are always concealed, and noiseless).

SOTO (left)
Cardinal, 1965
Soto here exploits "the *moiré* effect": a diagonal line drawn across narrow parallel lines will appear to break where it intersects. Thus Soto's coloured rods, suspended before a thinly lined background, flicker.

TINGUELY (right)
Puss in boots, 1959
Tinguely's work has been likened to the fantasies of his fellow-Swiss Klee, but translated into three dimensions. Tinguely also has roots in Dada: this is obvious in the absurdity of his often self-destructive rubbish-dump machinery.

BURY (below)
3,069 white dots on an oval ground, 1967
Bury sets out to create a movement "anonymous, silent and supernatural". Here the shiver of these "feelers" is suddenly shot with a scarcely perceptible twitch at long intervals, to marvellous eerie effect.

TAKIS (above)
Signal: Insect animal of space, 1956
Railway signals inspired the series: to Takis they were "a necessary part of our century . . . I used thin wires as bodies to hold the signals, accidentally they started moving."

Post-War Sculpture 2: Minimal and Conceptual

In the attempt to emancipate art from what appeared to some as the stultifying bonds of tradition, radical spirits have concentrated more and more on the idea of art or the idea behind art. In order to widen the scope of art, or at least to alter its references, or to purify it of conventional dross, artists have stripped art down to its essentials – Minimal art – or to its definition or basic idea – Conceptual art. Both approaches lead ultimately to a contradiction in terms – Minimal art tending perhaps towards a reduction to nothing, to the absurd, Conceptual moving from the visual to the purely mental, from the physical to the metaphysical. Some of the artists who identify themselves as Conceptual acknowledge the problem – thus Joseph Kosuth: "There is always something hopelessly real about materials, be they ordered or unordered."

Conceptual art reveals itself in as many ways as there are Conceptual artists. The first true conceptualist was no doubt Marcel Duchamp (see p. 416), who seemed finally to abandon both art and anti-art in favour of silence and chess, yet Duchamp's influence, from his emergence in 1912 until his death in 1968, has proved endlessly and most variously fruitful.

Modern self-acknowledged Conceptual artists include the Frenchman Daniel Buren (born 1938; not shown), the Briton Victor Burgin, the Japanese On Kawara (born 1933) and the Americans Don Burgy, Joseph Kosuth (born 1945) and Bruce Nauman (born 1941). To the layman their productions may seem generally incomprehensible or meaningless (and usually are unintelligible unless accompanied by explanatory texts); and even their positive contribution to visual or anti-visual metaphysics may seem an inadequate replacement for the sensory enrichment of life which they strive to eliminate. And yet, as with Duchamp, the feedback from their explorations will certainly nourish the mainstream of art, even if they prove not to be a decisive current within it.

The conceptual approach has in fact affected virtually all the non-figurative trends in art since Abstract Expressionism. The various types of art that emerged in the 1960s and 1970s – Minimal, Conceptual, Environmental, Performance, Process, Land, Earth, even "Real" – have often been used by the same artist, and they are best seen as different modes of working, rather than as different styles – as different indications of the artist's theoretical

CARO (above)
The month of May, 1963
From 1951 to 1953 Caro was assistant to Moore, enlarging his maquettes to actual size. This contact with the older sculptor's work was surely formative, although Caro's straight-edged and rambling style is partly in strong reaction. He painted his work so as to deny the physical nature of his metals, but recently has returned to "truth to materials". Caro's work has aspects in common with that of David Smith (see p. 479).

KAWARA (right)
Today series: *April 5th, 1966*, 1966
Since 1966 Kawara has been producing the paintings in this series with obsessive, unveering regularity – each is accompanied by a newspaper clipping of that day. By his constant reckoning of himself against the outside world he seems to be seeking reassurance of his need to exist. A further development has been series of postcards, sent on consecutive days, stating his precise time of getting up.

KOSUTH (above)
Chair I and III, 1965
Kosuth is concerned with "art language": he probes the nature of visual and verbal presentations of objects. Here the concept "chair" is arrived at by the bringing together of a wooden chair, a photograph of it and a photocopy of the dictionary definition of "chair". Kosuth finds philosophy and religion bankrupt, sterile, useless, no longer valid: only art can investigate "the state of things beyond physics".

NAUMAN (above)
Perfect door: perfect odor: perfect rodo, 1972
Nauman is an artist typical of that international trend or school of experimental "art workers" who function usually in "workshops" and work not in one medium or kind of art but freely, interacting, communicating and creating ideas almost in a kind of group therapy. Nauman, for instance, has practised Body art (see p. 491); he has also explored neon and fluorescent light in a controlled environment: his intention here is the "examination of physical or psychological response to simple or even oversimplified situations". The audience also participates.

NEVELSON (above)
Royal tide IV, 1960
Nevelson's sculptures are composed of found objects more or less altered, most of wood, arranged in boxes or shelves occupying a wall, taller than the spectator. The assembled sculpture is sprayed on completion in white, black or gold, which unifies the objects and reduces the shadows: the effect produced is of a multifaceted low relief in some homogeneous, even nondescript material. The works are often installed in the gallery in groups, sometimes forming rooms which seem like mysterious caves or tombs, stuffed full of trophies or tributes from a forgotten, mystic past.

approach. The Minimal was already emerging in the late 1950s in the work of colour-field and hard-edge painters (see p. 470) such as Reinhardt, Newman, Noland, Stella or even Olitski (although Olitski's output was dismissed by some as "visual Musak"). These artists, rather than painting pictures in the traditional sense, often seem to be illustrating or demonstrating ideas about making a painting. But the label "Minimal" was first applied to sculpture, and found even more (or, literally, less) expression in three dimensions, though it was only one trend in 1960s sculpture.

One very powerful and influential sculptor was the Englishman Anthony Caro (born 1924) who, while reducing his materials to a minimum – pieces of industrial cast metal – assembles them in positive shapes that may be completely abstract but which also strongly suggest analogies in nature. With Caro, sculpture demonstrates its new ability to get down from the plinth and extend across the floor. Caro's work, however, which is very open and involved with space, interpenetrated and interpenetrating, is atypical of the general trend in Minimal sculpture, which has been towards the smooth, closed and impersonal.

An older sculptor who came to prominence at about the same time was Louise Nevelson (1899-1988), an American of Russian origins. She found her most characteristic mode of expression only in the 1950s and 1960s, in a constructive, assemblage method in which she produced huge walls built of wood filled with objects – geometric blocks, or bits and pieces of furniture. These, painted monochrome, can produce the effect of a mysterious Environmental shrine, almost a Byzantine iconostasis.

The Americans Tony Smith, Robert Morris and Carl Andre are more strictly Minimal innovators. Tony Smith (1912-1980) has speculated with pure form often on a monumental scale – ranging from a two-metre (6½ft) plain cube of painted metal to vast geometric complexes the size of a large gallery. Robert Morris (born 1931) proceeds very strictly from theoretical considerations, and the visible results range from geometric metal shapes as basic as those of Tony Smith to exercises in felt, rope, wood or fibreglass, or even earth and grease. Working mostly in Europe, Carl Andre (born 1935), theorist, poet, likes to use as his material standard constructional elements such as 2 × 4 in timbers, or (most provocat-

ively) common building bricks. He began with pyramidal forms, and then spread his forms horizontal on the floor. Bricks or tiles can be arranged in symmetrical, repetitive sequences according to the extent and shape of floor space available. His avowed prime inspiration is Brancusi's *Endless column* (see p. 394).

Sol LeWitt (born 1928) and Donald Judd (born 1928) are two of the most rigorous American conceptualists still making art objects. LeWitt deploys grids, progressions, modules in strictly neutral materials, often in basic geometric forms arranged to a strict serial formula (he is fascinated by architectural modular systems and by serial music). "Conceptual artists", he has said, "are mystics rather than rationalists. They lead to conclusions that logic cannot reach." For Judd, the "extreme structivist", progressions with constant ratios between the successive quantities, expressed severely in enamelled metal, have provided a typical basic theme, fruitful in variation. The spectator is expected to react intellectually to his work. A more instinctual response is aroused by the no less controversial development, with some Conceptual element, of Earth and Land art.

SMITH (left)
Gracehoper, 1972
Smith was assistant to the American architect Frank Lloyd Wright for several years before he turned to sculpture – he had found that architects have to compromise their ideas to meet the needs of people; sculptors can more easily stay true to their original ideas. It was the extreme geometric simplicity of the forms used by Smith and other sculptors that earned the label "Minimal" art.

ANDRE (above)
Proposal for The Hague Museum – *Lock* series, 1967
Andre exemplifies a main trend in recent sculpture – the installation. Formerly sculptors have often made works for specific outdoor locations, but not for one particular gallery. Running parallel is the trend to make the sculpture transformable, with components that are interchangeable, so that new combinations are always inherent in it. Andre has minimal interest in the form or aesthetic of his work; he wishes to materialize a concept.

LEWITT (right)
Cube structure, 1972
The idea which LeWitt is exploring in his grids and modular structures is the conflict that is inevitable between "conceptual order and visual disorder". A number of identical cubes, when joined together, can no longer remain identical, because of the effect of perspective, of the play of light, of the spectator's always varying viewpoint.

MORRIS (above)
Untitled, 1966-67
Strips of black felt fall like pasta from a fork to a writhing mass. Morris, like Oldenburg before him, rejected the traditional hardness of sculpture; and he wanted the material he used to speak for itself. He has also worked in Earth, Happenings, Performance.

JUDD (above)
Untitled, 1974
Judd, like Caro, has used colour in order to disguise the intrinsic properties of his materials. He covers his aluminium in brilliant paint, creating unexpected sensuous qualities. Like LeWitt and other Minimal artists, Judd usually has his work made from blue-prints by professionals: this detaches him from the final outcome and confirms the premise of Conceptual art, that "the execution is a perfunctory affair".

He is a learned and acute historian and critic, and calls on Alberti's Renaissance theories of harmonic proportions in statuary as precedents for his own art.

Land and Earth Art

One of the most intriguing elements in the almost infinitely variegated texture of art in the late twentieth century has been one that stresses landscape, the land, the earth itself. In some of its forms, this new development becomes as mystical or transcendental in its moods as the paintings of Washington Allston or the poems of Wordsworth: some purist critics have diagnosed in it an archaizing, "back-to-nature" ideology, a nostalgic leaning to woolly Romanticism. Land and Earth artists work in matter – rock, soil, turf, snow – without making an object or work of art in the traditional sense. Their product is essentially anonymous and often impermanent. Though in stark contrast to the geometric, structural concerns of artists such as Judd or LeWitt (see preceding page), their art is at one with Conceptual and Minimal theory in its rejection of traditional methods and forms, and it rejects even more emphatically the traditional outlook in which the work of art is a rare and precious commercial object, a mere decoration of life as jewellery is a decoration of the body. Most of its practitioners have nevertheless come to terms to some extent with the gallery system, as it is still their major source of livelihood.

The best-known and indeed most spectacular artist in Land (rather than Earth) art is Christo (Christo Javacheff, born 1935), who has moved through Sofia, Prague, Vienna, Paris, New York. In Paris he was associated with Yves Klein (see p. 490), and by the early 1960s was already executing fairly spectacular Environmental projects, such as blocking the Rue Visconti in Paris with a wall of oil-drums (*Iron curtains*). The works for which he became internationally notorious, his packaging projects, have been proceeding since 1968, when he wrapped up a monumental public building, the Kunsthalle in Berne, in plastic sheeting like some vast parcel. The effect close to is rather like that of a building shrouded for washing, but the realized concept, though lasting only a matter of a day or days, establishes the artist's control: he sets up a mystery, upsets the passer-by's expectations. Christo can lift what is in part uselessness and absurdity to epic scale, as when in 1976 he built across two counties in northern California his *Running fence*, a nylon fence 5.5 metres (18ft) high and nearly 40 kilometres (24 miles) long. Its lifespan was two weeks; the mechanics of setting it up, its impact on the landscape and

not least on its human neighbours, its environmental, social and scandalous effects, its sheer effrontery and economic nonsense – these were all important elements in the concept of the whole. Christo has wrapped skyscrapers, and in *Wrapped coast, Little Bay, Australia* (1969, not shown) packaged a million square feet of Australian seaboard.

For Christo, landscape or architecture is something that can be parcelled up or parcelled out. Land is used by two British artists in rather different ways. Hamish Fulton (born 1946) records landscapes by camera in what is almost "straight" photography, but his photographs, juxtaposed in a discernible composition, suggest spatial structures and circumstances in an almost abstract way, with landscape as the vehicle. Richard Long (born 1945) also depends on photographic documentation but he marks and alters the ground outdoors or moves indoors, into the gallery, earth or rocks, vegetation or driftwood. His work can be seen as a metaphor of human permanence and impermanence on earth.

The American Michael Heizer (born 1944), the son of a geologist, has been called "the boldest, most intransigent of the Earth work-

CHRISTO (right)
Project for Milan: *The Arco della Pace wrapped*, 1970
Christo has extended his work to encompass both the land untouched by man and the shapes of civilization. In the tradition of Dada, his aim is to provoke in the spectator questions about the object or area he has wrapped or shrouded.

CHRISTO (below)
Running fence, 1972-76
This work, which like the rest of Christo's projects was extensively documented, was designed to be viewed along a stretch of road in Sonoma and Marin counties. "I want to present", he said, "something that we never saw before ... not an image but a real thing like the pyramids in Egypt or the Great Wall of China."

FULTON (left)
Untitled, 1969
Fulton and Long are both extremely reticent about themselves, their ideas and their work; thus the photographs which Fulton shows, rarely having any explanation, take on an aura of romantic mystery. His presentations are the product of a journey to a predetermined site and serve as a souvenir or witness to the artist's feeling about the event. Fulton is at the Minimal extreme of Land art.

LONG (right)
A line in Australia, 1977
Long's work in particular surely corresponds to an interest that has grown in the 1970s in prehistoric sites, from the mysterious ancient patterned tracks in the Nazca Valley, Peru, (man-made, but their forms can be seen only from an aircraft) to the "avenues" or lines of direction that seem to link in a colossal nexus mounds and henges near Salisbury, England. His arduous and lengthy journeys across the globe seem to have a ritualistic intensity: in lonely sites he makes some mark of his presence – for instance he creates a line by walking continually to and fro along it, or with stones, as here. In the gallery he exhibits variously marked maps, or arrangements of unworked found pieces of stone, in lines, circles, squares or spirals – very obvious forms invested with a mysterious significance, "a paradox of the perfectly explicable and the finally secret."

ers in his insistence on large-scale works, remote from the galleries and museums". His work, too, approaches the Minimal extreme – thus *Double negative* (1969, reworked 1970) is two cuts in a remote mesa, each nine metres (30ft) wide and 15 metres (50ft) deep. This should or can evoke Conceptual questionings, for example, which is the negative and which the positive shape? "I want to create without mass and volume", Heizer has said; nevertheless he produces exhibition works for galleries in the form of very austere geometrical paintings. There is a similar dichotomy in the work of Walter De Maria (born 1935); he has made earthworks, but also produced relatively traditional, though ultra-Minimal, objects in sculptural form. His most celebrated exhibit, in Munich in 1968, was a gallery containing 45 cubic metres (1,600cu.ft) of level dirt (not shown). The archetypal Earth artist, however, was Robert Smithson (1938-73), who plummeted to premature death from an aeroplane over Texas while surveying a potential site. Though Smithson, too, developed a form of art commensurable with gallery exhibition, in his most remarkable work he used the landscape as his raw material, choosing sites where he could set the theme of the inexhaustible fertility of nature against that of decay, fossilization and entropy.

Some Earth artists of the 1970s have turned more to man-made landscapes than to the desolate wilderness. In France Anne and Patrick Poirier (born 1942) have constructed immensely detailed models of archaeological sites, as if they were laying bare the skeleton of some embedded racial memory. The German Hans Haacke (born 1936), who has lived in New York since 1967, has advanced from installing miniature ecosystems in the gallery to surveys of the patterns of ownership in Manhattan. Haacke has consistently challenged both the enshrining of art in museums and the validity of boundaries between branches of art or between art and life, raising ecological and sociological issues without comment but insistently. The late twentieth-century art scene has not remained unchanged by the fact that man since 1945 has possessed instruments which can destroy all life whatsoever; and it continues to alter its scope as the effects of the computer, the silicon chip, the laser beam and microbiology alter us.

SMITHSON (right)
Spiral jetty, 1970
Projected by bulldozers into Salt Lake, Utah, in 1970, the work consists of black basalt, limestone, earth and the red algae that thrive in the otherwise desolate water. The spiral, 450m (1,500ft) long, 2,700 cubic metres (nearly 100,000cu.ft) in volume, 6,650 tons in weight, was a gigantic, unanswerable question mark. The simple shape and obvious symbol took on a new meaning as materialized on such a vast scale, though Smithson was concerned particularly with the theme of change; the jetty soon began to decay.

DE MARIA (right)
Vertical earth kilometre, 1977
De Maria was responsible for the first (unexecuted) Earth work, *Art yard* of 1961, in which spectators were to watch a large hole being dug. He also proposed in 1968 parallel lines 3.7m (12ft) apart and 800 metres (half a mile) long across the Nevada desert, where his fellow-earthworker Heizer (left) later moved a quarter of a million tons to create his *Double negative*. This project De Maria managed to execute: sinking in the ground (rather than erecting) his sculpture, a metal rod one kilometre long: only the base of it is visible.

HEIZER (above)
Double negative, 1969-70
"In the desert I can find that kind of unraped, peaceful, religious space that artists have always tried to put in their work", Heizer has commented.

THE POIRIERS (right)
Ancient Ostia, 1971-73
This scale model of ruins of the port of antic Rome was stimulated by a visit which the Poiriers made to Cambodia in 1970: there they saw venerated, ruined temples being lived in. It prompted interest in the past experienced through the present environment, on "the role of emotional radar in our relations with our ancestral wombs". The model is not a reconstruction but a facsimile.

HAACKE (above)
Rhine water installation, 1972
Haacke has extended the scope of Earth art into water and ice, or even into complete ecologies.

In this work a comment on the current pollution of the Rhine is implicit. As Haacke sees it, "An artist is not an isolated system . . . there are no limits to his involvement."

Traditional Easel-Painting

The rapidly expanding scope of art since Pop has been a development less from one style to another, more from one kind of art to another – Environmental, Conceptual, Junk, Land, Earth – as art has climbed first off the wall or plinth and then out of the gallery. It has seemed at times that to paint on canvas at all, whether abstract or figurative, was reactionary or obsolete. Nevertheless ordinary picture-making – generally, if loosely, called the academic tradition – has continued in flood, both figurative and non-figurative, though figurative art seems to retain a more direct, empathetic appeal to the wider public. This is partly due to recognition of, or identification with, the subject matter, and many people look to art for comfort – as Matisse suggested they were by no means wrong to do. Visions of the rustic past, for example, offer a dream of security, of a Golden Age (even if it never was): in Britain, reproductions of Constable's *Haywain* (see p. 319) head the bestseller list. In figuration, not least, the erotic element is also an enduring attraction.

Quite apart from the sensory pleasures it offers, figuration also fulfils some specific social functions, and, both in totalitarian and in other states, some pronouncedly political ones. Photography is still far from killing the demand for portraiture in oil-paint or in stone or bronze, especially for formal and commemorative purposes. At its worst this kind of art degenerates into kitsch; but Kokoschka (see p. 477), still painting some portraits in the 1970s, or Sutherland, who turned to portraiture only in the late 1940s (see p. 447), remained uncompromisingly artists. As a result their work was not always acceptable to subject or patron: Sutherland's portrait of Sir Winston Churchill (not shown) was subsequently destroyed at Lady Churchill's order (Churchill had held that a portrait should be 75% sitter and only 25% artist).

The appeal of "primitive" or Naive painters, or those seeming to be so, has increased since the Douanier Rousseau's day (see p. 389). Like the glimpses of a pastoral, pre-industrial Eden offered by Constable, they, too, offer a vision of innocence. The most celebrated of genuinely Naive painters was Mary Anne Robertson (1860-1961), known as Grandma Moses, who, aged about 60, began first embroidery and then painting: her first one-woman show was in New York in 1940, when she was 80. She did without traditional perspective, consistency of scale or of subject matter, but spelled out in minute detail across the picture surface a section of New York State, a countryside she peopled with animals, characters in all sorts of historical costume, and farm equipment, all drawn as if from stiff toys rather than nature, but conveying nevertheless a quick response to nature through a sure sense for brilliant colour and pattern.

Many other artists, though academically qualified, strive with more or less success to preserve a primitive vision – especially in France, where the Douanier Rousseau is a continuing inspiration. In Britain, the traditional visionary strain of Blake and Samuel Palmer was still strong in Stanley Spencer (see p. 447), but the painter to achieve widest recognition, his work welcomed on the walls of the middle-class parlours of England as Spencer's never quite was, was L.S. (Laurence Stephen) Lowry (1887-1976), who painted in greys, blacks and white the industrial townscapes of northern England, haunted with a mute poetry of desolation and an unexpectedly idyllic nostalgia. In France, Bernard Buffet (born 1928) propagated a spiky,

GRANDMA MOSES (left)
In harvest time, 1945
In her embroideries and her paintings the old lady evoked with great feeling a nostalgia for the customs and way of life which she had seen disappearing over the course of her many long years as a farmer's wife.

BUFFET (right)
Two Breton women, 1950
Buffet worked in France at the same time as Wols, Fautrier, Hartung (see p. 472), but unlike them used an anguished figuration to express the anger, sorrow and also bewilderment of the post-War generation.

GUTTUSO (below)
Occupation of the land, 1947
Guttuso is committed to an eloquent exposition of all social injustices. Picasso's *Guernica* (see p. 451) has much influenced his work.

LOWRY (above)
Industrial landscape, 1955
Lowry's snow-bright landscapes of a grim northern England harked back to the Depression years, 1922-35, when he collected rents in Manchester, in daily, close contact with the poverty and deprivation rife there. He shows little sympathy, however; indeed he sought the absurd: "I like the look of ill-fitting clothes, big bowlers and clumsy bodies", and his small, matchstick-thin people are impassive inhabitants of his vistas.

near-monochrome style, portraying a bleak world fit for Existentialist heroes, a style that was nevertheless also very seductive, then later more patently decorative, and from the beginning commercially hugely successful.

Established modern traditions have by no means been exhausted in Europe or in America. The austere painterly preoccupations of the "Euston Road" school in Britain, headed by Sir William Coldstream (1908-1987) not shown) stem from the ideas of Cézanne. Some of the preoccupations of the School of Paris between the Wars live on in the emotionally

charged realism of Balthus (see p. 433). The very different politically committed social realism of Renato Guttuso (1912-1987) in Italy adapts and expands Cubist techniques. In Britain again Frank Auerbach (born 1931) has evolved his own powerful, highly personal development of Expressionism, figuration battling its way through turbulent paint. Sidney Nolan (born 1917), a remarkable colourist, has established Australian painting on the international map; his most famous sequence, variations on the Australian folk legend of the bushranger Ned Kelly, merged Expressionist

techniques with Surrealist fantasy.

Landscape still answers many different styles and techniques. Nicolas de Staël (see p. 472) achieved a remarkable synthesis (now generally underrated) of abstract colour with the evocation of landscape. The Icelander Gudmunder Gudmundsson (born 1932), known as Erro, has replaced the traditional concept of landscape with other "scapes", in which with the clarity of Pop art he piles food upon food or 'plane upon 'plane. In America Milton Avery (1893-1965) and Richard Diebenkorn (born 1922) both adapted, in different ways, the discoveries of post-War abstraction to landscape themes with brilliant success.

All the revolutions in twentieth-century art seem not yet to have abolished or dislodged the traditional urge to realistic depiction. Since the pioneering Constructivism of the early Revolution the dominant style in the USSR has been a literal, sometimes melodramatic, realism: artists such as Arkady Plastov (1893-1972) have infused images of the everyday with heroic virtue. Then in the late 1960s and 1970s there was an international surge of interest in an extremely meticulous, photographic brand of realism – Superrealism.

NOLAN (left)
Kelly in landscape, 1969
The bandit Ned Kelly was famous for his iron mask; out of scale, it assists the sense of lunar mystery in this vision of the outback.

ERRO (below)
Plainscape, 1972
Erro's "scapes" bombard the senses of the viewer with a seemingly endless proliferation of objects, mute comment on the waste and consumerism of society.

AUERBACH (left)
E. O. W. nude, 1953-54
Auerbach has said the aim of his crusted paintwork is "to render a sensation ... fully tangible". E. O. W. are his model's initials.

AVERY (below)
Morning sea, 1955
Avery's landscapes have an aura of joyous well-being and subtle thin colouring reminiscent of the artist he most admired, Matisse.

DIEBENKORN (left)
Ocean Park no. 108, 1978
Diebenkorn continues to move between abstract and figurative with assurance. His *Ocean Park* series, in progress since 1967, makes evocations of the dry, sundrenched and shaded streets of California, the artist's adopted home. His feeling for space is superlative.

PLASTOV (right)
The tractor drivers' dinner, 1951
One of Plastov's favourite themes is the harmonious integration of old and new ways of life. The peasant farmer is mellowly depicted as being content and at one with both nature and the machine that has replaced the old ways of working.

Superrealism

The fascination of creating a facsimile that gives the illusion, as completely as possible, of being what it represents has been recurrent since the Renaissance. The object represented may range from a human being to a flower to a beer-can. At an instinctive level the pleasures of conjuring are involved, of *trompe-l'oeil*; on an intellectual level the artist questions ideas of illusion and reality, the reality of reality.

The immediate progenitor of the vigorous resurgence of this kind of realism in the 1970s – Superrealism – was clearly Pop art, although elements were inherited also from earlier post-War American movements – largeness of scale, all-over painting, and a coolness, a distancing, in the approach to subject matter. The overt comment (and also humour) often present in Pop is very rare in Superrealism; also completely absent is the kind of comment central to the form of realistic art that had been continuous and dominant in the communist states of the Western world since the 1920s – social-realist art which is essentially propaganda. The Superrealists often use similar everyday subject matter but never vitiate their art with heroics or sentimental rhetoric. (They seem also almost as suspicious of the interpretative

approach of the traditional figurative realism practised, for instance, by Andrew Wyeth (see p. 474) in a closely similar technique.)

Already in the 1950s several artists both in Europe and the USA were working towards an uncompromising attempt to transcribe reality in precise detail. Thus in Britain Lucian Freud (born 1922), though not using photographs, achieved and achieves a photographic veri-similitude: his studies of the nude seem naked rather than nude, and his portraits trace every furrow and wrinkle. The intensity of Freud's scrutiny produces Surrealistic overtones, although these are said not to be intended. The American Philip Pearlstein (born 1924) likewise painted realistic "nakeds" rather than nudes in the 1960s, and then concentrated on portraiture – portraiture not of celebrities but of ordinary people, and as dispassionate as a photograph. As he put it, "I'm not painting people ... I'm concerned with the human figure as a found object."

The Superrealists concentrated, however, not directly on real life, but on real life held at arm's length, pre-frozen by the camera. Probably for the first time the photograph became the prime, often the sole source of the art and

aesthetic of painting. For the Superrealist, a photograph can be virtually the equivalent of what Nature was for Constable. Working from photographs, sometimes from colour slides projected on to the canvas on which he paints, a Superrealist can achieve a remarkable, detached intensity: often a strange tension is created by the banality of what is represented, realized with such skill and often on a large scale on a gallery wall.

Superrealism seems quintessentially American, but became rapidly international, and even before its emergence several artists in Europe were working in closely allied idioms. One highly original example was the Italian Michelangelo Pistoletto (born 1933): his point of departure was life-size photographs, tracings of which were cut out, painted, and pasted to reflecting sheets of steel, so that the spectator, seeing both himself and the painted photographic image, had to adjust to two levels of perception. The Frenchman Jacques Monory (born 1934; not shown) often conjoins in one frame two or more images resembling film-stills, evoking in virtual monochrome the disillusioned memory of some unresolved action; he avoids the gloss, the surface lustre, of

FREUD (above)
John Minton, 1952
Lucian Freud, grandson of the famous psychologist, has been interested in the portrayal of human faces since childhood. Friends of his such as John Minton and Francis Bacon appear in inquisitorial close-up.

PISTOLETTO (right)
Marzi with the little girl, 1964
Although Pistoletto has since moved on to work in other media it was his mirror art of the 1960s that made his reputation. The cut-off silhouette of a woman and child, affixed to the reflecting steel, is the only object: everything else seen is a reflection.

PEARLSTEIN (left)
Female nude reclining on an Empire sofa, 1973
Pearlstein, unlike other Superrealists, never uses the camera, but through his dispassionate recording of the human body adopts the role of a camera himself. This effect is increased by his use of peculiarly photographic techniques such as cropping and odd angles. "Stilled-action choreography" is his own description of the nudes.

ESTES (left)
Grossinger's bakery, 1972
In reproduction, Estes' work often looks exactly like a photograph because his paintwork is invisible. He exploits photographs in much the same way as Roy Lichtenstein uses cartoon strips – changing, cutting, editing their composition. He has gone on to make the most elaborate silk-screen prints, superimposing bland reflection on reflection to make a curtain-glass maze.

MORLEY (above)
United States Marine at Valley Forge, 1968
In order to be objective about his subject matter, Morley often cuts up the photograph he is copying and then paints one piece at a time, the rest of the canvas remaining covered until the whole is complete. The "wedding photograph" white border, which he uses as a substitute for the traditional picture frame, emphasizes the flat image.

the American practitioners. In fact the first painter to work in a pure Superrealist style, Malcolm Morley (born 1931), was English, though he had been established in New York since 1964. He works from photographs, but the subject matter of the photographs is unimportant: "I accept the subject matter as a by-product of surface"; seen close to, his work becomes visibly "painterly".

Of the Americans, Richard Estes (born 1936), while concentrating on street scenes, store fronts, reflections in curtain-glass buildings, nevertheless regards photographs "as a sketch to be used" rather than as "a goal to be reached". There is something perhaps of the sense of American urban reality that Hopper had, but drained of Hopper's latent mystery. Ralph Goings (born 1928) has said: "The subject matter is what the painting is all about. I don't select it because it has dramatic compositional elements." On the other hand, "It's not the object I'm concerned with, it's the painting of the object." Several artists have developed the gigantic close-up of a face, most famously Chuck Close (born 1940): his heads, maybe two metres or more high, are painted from blown-up photographs of people chosen

at random: the human face is simply another phenomenon in a world full of phenomena. His medium is usually acrylic through an air-brush, avoiding any hint of the artist's personality in the handling of the paint.

Superrealist sculptors have obvious precursors in Pop and Environmental artists such as Segal or Kienholz (see p. 490). Their concern is to produce simulacra in the round, as literally and as impersonally as the painters: using painted fibreglass or other plastics, real hair or clothes, they produce presences from everyday life – tourists, shoppers in supermarkets – that are horrific precisely in their illusionistic common ordinariness. John De Andrea (born 1941) produces nudes that all but breathe. The best-known of the Superrealist sculptors, Duane Hanson (born 1925), is, however, not neutral in his attitudes, but in his commonplace people congealed in banal action suggests the spiritual void of a materialistic society: "I just want to express my feelings of dissatisfaction." These sculptures often achieve the macabre "otherness" of an older tradition of modelling, not generally categorized as fine art – waxworks, most famously Madame Tussaud's

GOINGS (left)
Twin Springs diner, 1976
There is often an empty, brittle quality present in Superrealist art which is due in part to the subject, in part to the labour of its technique. Goings has often spent a day painting only three square inches.

DE ANDREA (above)
Seated woman, 1978
Unlike Hanson, with whom he is often bracketed, De Andrea deals not with the type but the particular; he is neutral in attitude, even though, despite their nudity, his subjects betray their background and personality,

by their stance, their hair, their make-up, etc. They are extremely lifelike, but aptly enough the effect is even more pronounced in a photographic reproduction. The woman is made of oil-painted polyvinyl, life-size; she is unerotic (if perhaps shocking), unselfconscious.

CLOSE (left)
Keith, 1970
Close's concern here is the discrepancies between a photograph and what it reproduces; he faithfully copies the areas which are out of focus and reveals, on a magnified scale, the limitations of the camera.

HANSON (right)
Couple with shopping-bags, 1976
Hanson has commented on his recent sculpture: "My most successful pieces are naturalistic or illusionistic, which results in an element of shock, surprise or psychological impact for the viewer. The subject matter that I like best deals with the familiar lower- and middle-class American types of today." His work reveals "the emptiness and loneliness of their existence".

The Popularization of Art

During the last century the proliferation of images across the face of the world has intensified at an astonishing rate. Art history, the history of images, once the speciality of the German philosophic genius, is now a standard part of the academic curriculum in the universities of the world. The critic can become more famous than the artist whose work he comments on: in the nineteenth century John Ruskin had the stature of a prophet, and in the twentieth century Kenneth Clark, expounding culture and civilization on colour television, has achieved an enormous audience.

By art history and art criticism modern art is provided with an ancestry, with status and by implication with a future. The complaint has indeed been made that today art historians dictate their future to artists, and that modern artists have made art-history or painted theories rather than made or painted art. In 1975, in a brisk attack on modern art entitled *The Painted Word*, Tom Wolfe suggested that a great retrospective art show of AD 2000 would consist of enlarged reproductions of crucial texts from the critics, with small photographs of works of art alongside. Verbal commentary and explanation have become increasingly

necessary not only because modern art has become ever more private, more esoteric, but also because the conventions dictating the art of the past have become increasingly remote.

On the other hand the opportunities for people to see works of art in the original or in reproduction have increased enormously. The growth of museums and galleries, and of educational courses in art, together with the sponsorship, organization and cataloguing of major and minor retrospective exhibitions, have brought works of art before a huge new public. As a result of technical improvements in the processes of reproduction, works can also be more faithfully and cheaply copied and broadcast than ever before, in books, colour slides and films.

For drawings and prints, the standard of reproduction can now be so high that even the expert can mistake facsimile for original, but the very best reproductions of an oil-painting can still only offer at obvious second-hand, diluted, its original complexity, the texture and specific gravity of the paint. Both subtly and in obvious ways – by change of scale – reproductions distort the original. Outside the Bargello in Florence platoons of coarsened

WARHOL (below)
Thirty are better than one, 1963
What is probably the best-known portrait in the world becomes an image to rank beside contemporary icons such as pin-ups of movie-stars. The context, the true meaning of the original, is swamped by its fame – its only real life today is its life as a reproduction; no-one can see it as it is.

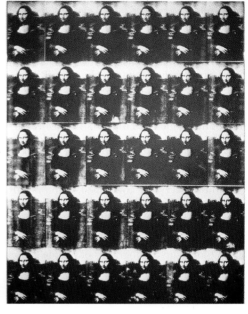

(left) *Kenneth Clark* with Nôtre Dame, Paris, in the background, in part of *Civilization*, 1969 Lord Clark's television series *Civilization* was shown all over the world. Specifically intended "for the layman of no specialized knowledge", the series helped millions who had perhaps never visited an art gallery to appreciate their heritage.

LICHTENSTEIN (below)
Brush-strokes, 1967
The creation of prints is a natural extension of this artist's preoccupation in his painted work with the comic-strip image. He has made two prints and a few paintings showing enlarged details of brush-strokes – caricatures, he says, of the gestural marks made by Abstract Expressionists, in particular De Kooning.

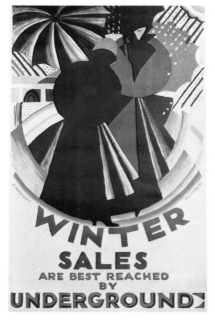

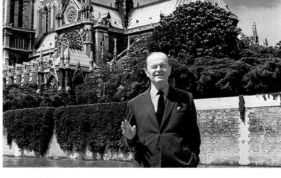

MCKNIGHT-KAUFFER (left)
Winter sales, 1924
The artist developed his "Cubo-Vorticist" style in a series of posters made in the 1920s and 1930s for London Transport, then following a policy of using the services of modernist artists to brighten up its stations and fill trains.

MATISSE (right)
The swan, 1930-33
Matisse's earliest prints date from 1903, but he created what are perhaps the consummate examples of his reductive line in the illustrations he made in the early 1930s for an edition of Mallarmé. The prints are the product of many drawings, honed to absolute essentials, to one unwavering line that contains in its arabesque body, neck, head and beak. Picasso, too, turned his talents to illustration.

diminutive replicas of Michelangelo's *David* await sale, and what was the over-life-size embodiment of a proud city's independence becomes a decorative accent in a suburban sitting-room. This, the translation of masterpieces into other forms – a Morandi still life into a cheap mosaic, "*The Venus de Milo*" into a lamp-stand – is a version of the taste known as "kitsch", but is also evidence of the endlessly changing function of art. As its boundaries and definitions shift, what once was kitsch becomes museum art, as recently the decorative arts of the 1930s became Art Deco.

It is long since Duchamp thumbed his nose at art by adding a moustache and a pun to a postcard of the *Mona Lisa* (see p. 417). Andy Warhol in 1963 produced a barrage of *Mona Lisas* in his *Thirty are better than one*, reduplicating her in exactly the same deadpan presentation as his *Marilyns* or his *Soup-cans*. Lichenstein turns strip-cartoon imagery into monumental gallery paintings (and vice versa). The feedback into late twentieth-century art of the dazzling speed and ease with which art can be broadcast is incalculable: while some artists have delighted in it, especially since Pop, others have defied it, producing works that require the physical presence of the spectator – whether because of their scale, or because they are kinetic, or because the spectator's participation completes the work.

It follows, too, that it is impossible for the public to ignore modern art, whether they like it or not. If in no other way, and usually in very diluted and distorted form, the public of the capitalist world becomes conscious of the innovations and discoveries of modern artists through commercial advertising. Advertisers have adapted for their own purposes styles developed from all sources, from Picasso and Mondrian to Op art and even Land art. The particular form in which they began to exploit advanced visual imagery, in the late nineteenth century, was the poster. When artists of the stature of Bonnard or Toulouse-Lautrec (see p. 369), or Jules Cheret or Alphonse Mucha, began to demonstrate that the poster was a form in which highly original artistic work could be developed, it became almost immediately also a collectors' field – museum art. Though much poster art is ephemeral, of no artistic value, it has, in the hands of artists as various as the Russian Constructivists, Beardsley, the American Ernie McKnight-Kauffer (1891-1954), Munch, Picasso and Matisse, produced its own masterpieces.

Advances in graphic processes also assisted in the same period the revival of the illustrated book – the Symbolist *livre d'artiste* (see p. 370). Especially since 1945, the production of prints has increased enormously and has become for many artists a major source of livelihood. The traditional methods of printmaking are still extensively practised – engraving, etching – but lithography and silk-screen printing are particularly favoured media. Published in limited editions, original works by important artists do thus become available for people of moderate income to own. Meanwhile the borderlines between the traditional categories of art are further eroded, when cartoonists and illustrators start to put on sale their original artwork, and when commercial manufacturers issue limited editions of prints of their most successful advertisements. Whether or not a new artistic orthodoxy emerges from the constant flux of late twentieth-century art, it seems certain that technical innovation will continue to go hand in hand with creative innovation, even though the future of art lies still in the imagination of the individual artist.

ADAMI (right)
Arabian landscapes, 1969
Valerio Adami (born 1935) spent two years in London in the early 1960s, when he came into contact with British Pop. His style, close to Caulfield's in its bold, flat colours in black contour, is one that transfers particularly well to prints; Pop found its art form in silk-screen, as Expressionism in woodcut.

STEADMAN (below)
Illustration to Hunter S. Thompson's *Fear and Loathing in Las Vegas*, 1970
Ralph Steadman (born 1937) is one of many artists who have moved "up" from newspaper cartoons to book illustrations and prints. Images such as this are an accompaniment to the new journalism of writers such as Norman Mailer, Hunter S. Thompson, Tom Wolfe.

MIRO (left)
Marvellous puzzles, 1970s
Art has always been an investment, originally in materials and craft, then in the artist's prestige, too. An artist's own "handwriting", as opposed to the reproducible design, still has a value. An "authored" modern print has not much inherent rarity value, but it makes "real" works of art available to more people.

COLLETT, DICKINSON, PEARCE & PARTNERS (below)
(*Government warning: Smoking can seriously damage your health*), 1979
When a set of 12 of these slick, beguiling cigarette advertisements was printed in a limited edition of 250 in 1979 they were snapped up. They seem to exploit the Superrealist idiom, with visual puns perhaps after Salvador Dali.

List of Illustrations and Acknowledgments

Works of art illustrated are listed in the order in which they appear in the book. In general, the order runs from top to bottom and left to right on each page, though works by the same artist or of the same origin are grouped together.

The name of the artist (or, if the artist is not known, the place or origin) and the title or description of each work are followed by its medium, its dimensions (metric) and its present location and ownership. Photographic credits are given in brackets, unless the photograph has been supplied by the owner.

Though every effort has been made to check the accuracy of these specifications, it has not always been possible to verify all of the information at source.

2–3 Frontispiece
TITIAN: *Charles V at Mühlberg*, 1548, oil on canvas, 332 × 279 cm, Madrid, Prado (S). AFTER APELLES: *Aphrodite wringing her hair*, original c. 350 BC, marble, height 30.5 cm, Philadelphia, University of Pennsylvania, University Museum.

8–9 Ancient Worlds
PAESTUM, ITALY: The Temple of Neptune, c. 470-460 BC (Michael Holford). PALENQUE, MEXICO: The Pyramid of the Inscriptions, c. AD 700 (Michael Holford).

10–11
(Map by Colin Salmon and Dinah Lone)

12–13 Palaeolithic Art
LAKE TRASIMENE: "*Venus*" figure, Aurignacian period?, stone, height about 13 cm, Florence, Private Collection (S). BRASSEMPOUY: Female head, c. 22000-20000 BC, ivory, height 3.5 cm, St-Germain-en-Laye, Musée des Antiquités Nationales (S). LESPUGUE: "*The Venus of Lespugue*", c. 20000-18000 BC, ivory, height 14 cm, Paris, Musée de l'Homme (S). LA MADELEINE: Bison, c. 12000 BC, reindeer antler, length 10 cm, St-Germain-en-Laye, Musée des Antiquités Nationales (Photoresources). LAUSSEL: "*The Venus of Laussel*", c. 20000-18000 BC, stone slab, height 45 cm, Musée d'Aquitaine (S). WILLENDORF: "*The Venus of Willendorf*", c. 30000-25000 BC, limestone, height 11 cm, Vienna, Kunsthistorisches Museum (Photoresources). THE DORDOGNE: *Reclining woman*, c. 12000 BC, stone, length 71 cm, *in situ* (S). LASCAUX: "The Hall of Bulls" (Colorphoto Hans Hinz); detail, *Man and bison*, rock-painting, length of bison 109 cm, *in situ* (Colorphoto Hans Hinz). ALTAMIRA: *Two bison*, c. 13000 BC, rock-painting, length of each bison about 1.85 m, *in situ* (S). ADDAURA: *Human figures*, c. 10000 BC, rock engraving, height of engraved area about 1 m, *in situ* (S). SKARPSALLING: Decorated bowl, 3rd millennium BC, terracotta, height 17 cm, Copenhagen, National Museum.

14–15 African Art 1
TANZANIA: Rock-painting from a neolithic site (Werner Forman Archive). TASSILI: Rock-painting: *Masked figure*, at Sefan, height about 2.5 m, *in situ* (Robert Harding Picture Library); Rock-painting of the "Pastoralist" type, at Jabaren, height of painted area about 20 m, *in situ* (Robert Harding Picture Library); Rock-painting of the "Wheeled chariot" type, length of image about 50 cm, Algiers, Musée de Préhistoire et d'Ethnographie (Werner Forman Archive). BRANDBERG: "*The White Lady*", San, rock-painting, figure about 40 cm high, *in situ* (Gerald Cubitt). IVORY COAST: Embroidered cotton representing a fertility dance, Senufo, The Hague, van Bussel Collection (Werner Forman Archive). NIGERIA: *Human head*, Ife, bronze, height 36 cm, London, British Museum; *Human head*, Nok, terracotta, height 23 cm, Lagos, National Museum (Werner Forman Archive); *Queen Mother head*, Benin, bronze, height 91 cm, London, British Museum (Werner Forman Archive); *Human head*, Ife, terracotta, height about 10 cm, Berlin, Museum für Volkerkunde (Werner Forman Archive); *A Benin king and his retinue*, Benin, bronze relief, height 46 cm, Kansas, Nelson Gallery of Art (S); Salt-cellar, Afro-Portuguese, ivory, height 30 cm, London, British Museum (Werner Forman Archive). GHANA: A weight, Ashanti, brass, height about 5 cm, British Museum (Werner Forman Archive).

16–17 African Art 2
MALI: Dogon dancers (Robert Harding Picture Library); *Walu* mask: *An antelope*, Dogon, wood, fibres, height 54 cm, Paris, Vérité Collection (Werner Forman Archive); *Chi wara* head-dress: *An antelope*, Bambara, wood, height about 90 cm, Private Collection (Werner Forman Archive). IVORY COAST: Weaving pulley, Baule, wood, height about 20 cm, New York, Mr and Mrs Harold Rome Collection (Werner Forman Archive). ZAIRE: *Kifwebe* mask, Basongye, painted wood, height 60 cm, Zurich, Rietberg Museum (Werner Forman Archive); A mask: *Woot*, for a young man's society, Bakuba, wood, beads, shells and fibre, height 60 cm, Tervueren, Musée Royal de l'Afrique Centrale (Werner Forman Archive). NIGERIA: Shango cult figure, Yoruba, wood, height 71 cm, New York, Museum of Primitive Art (S); Egungun cult mask, Yoruba, painted wood, height about 1 m, London, British Museum (Michael Holford); Bead embroidered crown, Yoruba, glass beads, height (not including fringe) 30 cm, London, British Museum (Michael Holford). CONGO: A chief's stool, Buli (Baluba), wood, height 53 cm, Tervueren, Musée Royal de l'Afrique Centrale (S). MALI: Granary door, Dogon, wood, height about 1.5 m, New York, Museum of Primitive Art (Robert Harding Picture Library).

18–19 Pre-Columbian Art
TLATILCO: *Female figure*, Pre-Classic period, Olmec, terracotta, height 11 cm, Mexico City, Museum of Anthropology (Vautier-Decool), TIKAL: Door lintel, c. AD 747, Mayan, wood, about 1.5 × 2 m, Basel, Museum für Volkerkunde. MEXICO: *Head*, c. 1200-600 BC, Olmec, basalt, height about 3 m, Vera Cruz, University (Werner Forman Archive). BONAMPAK: *Two warriors*, c. AD 750, Mayan, mural, height of figures 114 cm, *in situ* (Norman Hammond). JAINA: *Priest* or *Official?*, c. AD 600-900, Mayan, clay, height 18 cm, Mexico City, Museum of Anthropology (Werner Forman Archive). PERU: Ceremonial knife, c. AD 1100-1470, Chimu, gold and turquoise, height 43 cm, Lima, Museum (Joseph P. Ziolo); *Ex voto: An alpaca*, c. AD 1500, Inca, silver, height 10 cm, Cuzco, University of San Antonio (South American Pictures); *Head*, portrait vase with stirrup spout, c. AD 500, Moche, clay, London, British Museum (Robert Harding Picture Library). MEXICO: *Tlazolteotl*, c. AD 1300-1500, Aztec, stone, height 20.5 cm, Washington, Woods Bliss Collection (S). TULA: "Atlas figures", c. 900-1200, Toltec, stone, height about 4.5 m, *in situ* (Werner Forman Archive).

20–21 A Tlingit House-post
NORTH PACIFIC COAST: Carved house-post, Tlingit, painted wood, height 230 cm, Philadelphia, University of Pennsylvania, University Museum. THE SOUTH-EAST: pipe bowl, from Ohio, stone, length 10 cm, London, British Museum. EASTERN WOODLANDS: "False-face" mask, Iroquois, wood and hair, height 28 cm, New York, Museum of the American Indian, Heye Foundation (Carmelo Guadagno). THE PLAINS: *Blackfoot dignitaries* (Bird Rattler, Curly Bear and Wolf Plume), photograph (Peter Newark's Western Americana); Shield, Crow, painted buffalo hide, diameter 61 cm, New York, Museum of the American Indian, Heye Foundation (Carmelo Guadagno). THE SOUTH-WEST: *Kachina* doll, Pueblo, wood and fibre, height 33 cm, New York, Brooklyn Museum; *Weaving a blanket*, Navajo, photograph (Peter Newark's Western Americana). ARCTIC REGIONS: Arrowshaft straighteners, Eskimo, ivory, length varying from 13 to 18 cm, London, British Museum.

22–23 Oceanic Art
NEW IRELAND: *Uli* figure, wood, mother of pearl, snail-shells and roots, height 124 cm, Basel, Museum für Volkerkunde (S); *Malanggan*, painted wood, bark and cloth, height 85 cm, Basel, Museum für Volkerkunde (S); "Soul-boat", painted wood, length about 6 m, Stuttgart, Linden Museum. SEPIK: Ancestor figure (ceremonial seat), wood, hair and shells, height 76 cm, Zurich, Rietberg Museum (S); *Crocodile head*, wood, length about 1 m, Paris, Musée de l'Homme (S). NEW ZEALAND: House-post, wood, height 120 cm, New York, Museum of Primitive Art (S). HAWAII: *Kukailimoku*, feathers, shells, teeth and wicker, height 82 cm, Honolulu, Bishop Museum (S). EASTER ISLAND: Ancestor figure, stone, height about 8 m, *in situ* (Ardea). *Tattooed warrior*, Engraving, plate 100 in G. H. von Langsdorff, *Voyages and Travels in Various Parts of the World*, 1803-07, London, British Library. NUKURO: *Tino*, wood, height 30 cm, Leyden, Rijksmuseum voor Volkerkunde. AUSTRALIA: *A kangaroo*, bark-painting (Werner Forman Archive).

24–25 Egyptian Art 1
MEMPHIS: The Palette of Pharaoh Narmer, c. 3100 BC, stone, height 63.5 cm, Cairo, Egyptian Museum (Werner Forman Archive). SAQQARA?: *Servant straining beer*, c. 2400, painted wood, height 25 cm, Florence, Museo Archeologico (S). GIZA: Giant Sphinx, c. 2530 BC, sandstone, height 73 m, *in situ* (Ronald Sheridan). SAQQARA: *Hesy-ra before an offering table*, c. 2650 BC, from the tomb of Hesy-ra, wood, relief, height 115 cm, Cairo, Egyptian Museum (S); *Cutting a hyena's throat*, c. 2400-2150 BC, painted limestone relief, *in situ* (William Macquitty); The tomb of Mereruka, c. 2400-2150 BC, relief and free-standing figure painted limestone, height of figure about 1.6 m, *in situ* (S); The tomb of Ptah-hotep, *Funerary procession*, c. 2400 BC, painted limestone relief, *in situ* (William Macquitty). GIZA: *Pharaoh Chephren*, c. 2585-2560 BC, diorite, height 160 cm, Cairo, Egyptian Museum (Werner Forman Archive). MEIDUM: *Prince Rahotep and his wife Nofret*, c. 2550 BC, painted limestone with inlaid eyes, height 120 cm, Cairo, Egyptian Museum (Werner Forman Archive); "*The Geese of Meidum*", c. 2550 BC, from the tomb of Nefermaat, painted gesso, height of field 27 cm, Cairo, Egyptian Museum (Werner Forman Archive). SAQQARA: *Seated scribe*, c. 2450 BC, painted limestone, height 54 cm, Paris, Louvre (S).

26–27 Egyptian Art 2
AMARNA: *Akhenaten with his baby daughter*, c. 1379-1361 BC, limestone relief, height about 1 m, West Berlin, Staatliche Museen (Photoresources); *Nefertiti*, c. 1379-1366 BC, painted limestone, height 50 cm, Florence, Museo Archeologico (S). THEBES: *A banquet*, c. 1413-1367 BC, from the tomb of Nebamun, painted relief, height 61 cm, London, British Museum; One of four cases for Tutenkhamun's viscera, c. 1361-1352 BC, from the tomb of Tutenkhamun, gold, cornelian and glass, height 21 cm, Cairo, Egyptian Museum (S); *Tutenkhamun hunting ostriches*, c. 1361-1352 BC, flabellum, incised gold, width 94 cm, Cairo, Egyptian Museum (S); A panel of Tutenkhamun's throne, before c. 1361 BC, wood plated with gold and silver, inlays of glass and paste, height 104 cm, Cairo, Egyptian Museum (Werner Forman Archive). KARNAK: *Akhenaten*, c. 1379-1361 BC, fragment of a column, sandstone, height of statue when complete about 4 m, Cairo, Egyptian Museum (S). DEIR EL MEDINA: *Cha' and Mere pay homage to Osiris*, c. 1405-1367 BC, from a *Book of the Dead* in the tomb of Cha' and Mere, painted papyrus, total length 14 m, Turin, Museo Archeologico (S). ABU SIMBEL: The Temple of Ramesses II, c. 1304-1237 BC, height of figures about 20 m, *in situ* but raised above original location (Ronald Sheridan). SAQQARA?: *Cat*, after 30 BC, bronze, nose and earrings gold, breast inlaid with silver, height 33 cm, London, British Museum (Ronald Sheridan). EDFU: *The Falcon of Horus*, 3rd century BC, from the Temple of Horus, stone, height about 3 m, *in situ* (Ronald Sheridan).

28–29 Western Asian Art
ERIDU: Male figure, c. 4500 BC, terracotta, height 14 cm, Baghdad, Iraqi Museum (Holle Bildarchiv, Baden-Baden). MESOPOTAMIA: Cylinder seal, stone, height 5 cm, Baghdad, Iraqi Museum (S). UR: Panel from the sound-box of a harp, c. 2600 BC, gold and shell inlaid on wood, height 39 cm, Philadelphia, University of Pennsylvania, University Museum (Holle Bildarchiv). NINEVEH: *Sargon?*, c. 2340 BC, bronze, height 30 cm, Baghdad, Iraqi Museum (S). WARKA: "*The Lady of Warka*", c. 3500 BC, marble, height 20 cm, Baghdad, Iraqi Museum (Holle Bildarchiv). LAGASH: *The ruler Gudea*, c. 2100 BC, diorite, height 106 cm, Paris, Louvre (Holle Bildarchiv). MESOPOTAMIA: *The goddess Lilith*, c. 2000-1800 BC, terracotta, height 50 cm, Colonel Norman Colville Collection (Holle Bildarchiv).

LURISTAN: Horse bit, 9th century, bronze, length 10 cm, Baltimore, Walters Art Gallery (Holle Bildarchiv). PERSEPOLIS: The processional stair in the Palace of Darius, c. 500 BC, stone (Holle Bildarchiv). MESOPOTAMIA: Enamelled vase, c. 700 BC, clay, height 43 cm, New York, Metropolitan Museum of Art, J. Pulitzer Bequest (Holle Bildarchiv); Ewer, 6th/7th century AD, silver on gold, height 34 cm, Paris, Bibliothèque Nationale (Holle Bildarchiv).

30–31 The Lion Hunt Reliefs from Nineveh

KHORSABAD: *Lamassu*, c. 710 BC, limestone, height about 4 m, Paris, Louvre (S). NIMRUD: *Bird-headed god*, c. 865-860 BC, alabaster relief, height 110 cm, Louvre (S). NINEVEH: *A herd of gazelles*, c. 645-640 BC, stone relief, height 53 cm, London, British Museum (Photoresources); *A lion springing at King Assurbanipal*, c. 645-640 BC, stone relief, height 157 cm, British Museum. NIMRUD: *Cooks in a fortified camp*, c. 858-824 BC, stone relief, height about 1 m, London, British Museum (Ronald Sheridan).

32–33 Cycladic, Minoan and Mycenaean Art

THE CYCLADES: *Female figure*, c. 2300 BC, from Naxos, marble, height 58 cm, Athens, National Museum (S); "Fiddle" figurine, c. 2800-2500 BC, marble, Eleusis, Museum (S). MINOAN CRETE: *Two goats*, c. 1700 BC, impression of chalcedony seal, diameter 2 cm, London, British Museum (Ronald Sheridan); Beaked jug, "Kamares" style, from Phaistos, terracotta, height 26 cm, Heraklion, Archaeological Museum (Photoresources). KNOSSOS: *An acrobat leaping over a bull*, c. 1600 BC, bronze, length 15.5 cm, London, British Museum (Michael Holford); "Snake Goddess", c. 1600 BC, faience, height 34 cm, Heraklion, Archaeological Museum (Photoresources); Bull's head *rhyton*, c. 1500 BC, stone, wood, crystal and shell, height 21 cm, Heraklion, Archaeological Museum (Sonia Halliday); "La Parisienne", c. 1600 BC, fresco, height 25 cm, Heraklion, Archaeological Museum (S). THERA: An interior: *Rocks and lilies*, c. 1500 BC, fresco, Archaeological Museum (Ronald Sheridan). MYCENAE: Gold face mask, c. 1500 BC, gold, height 29 cm, Mycenae, National Museum (S); Decorated bronze dagger; *Ramping lions*, c. 1500 BC, gold and bronze, length 23 cm, Mycenae, National Museum (S).

34–35 Archaic Greek Art

ATHENS: Protogeometric amphora, 10th century BC, clay, height 52 cm, Athens, Kerameikos Museum (The Mansell Collection); Geometric amphora, c. 750 BC, clay, height 155 cm, Athens, Archaeological Museum (Giraudon). CORINTH: Stoppered *oinochoe* (wine cruet), 7th century BC, clay, height 16 cm, Syracuse, Museo Archeologico Nazionale (S). EXEKIAS: *Aias and Achilles play draughts*, c. 550-540 BC, black-figure amphora, clay, height 61 cm, Rome, Vatican (S). EUPHRONIOS: *Herakles strangling Antaios*, c. 510-500 BC, red-figure *krater*, clay, height 48 cm, Paris, Louvre (Giraudon). UNKNOWN GREEK SCULPTOR: "The Lady of Auxerre", c. 630 BC, limestone, height 62 cm, Paris, Louvre (Giraudon). ATHENS, ACROPOLIS: "The Peplos Kore", c. 540-530 BC, marble, height 122 cm, Athens, Acropolis Museum (Photoresources); "The Kritios Boy", c. 490-480 BC, marble, height 82 cm, Athens, Acropolis Museum (S). SOUNIUM, ATTICA: *Kouros*, c. 600-580 BC, from the Temple of Poseidon, marble, approximate

height 3 m, Athens, National Museum (Ronald Sheridan). ANAVYSOS, ATTICA: *Kouros*, c. 540-515 BC, marble, height 193 cm, Athens, National Museum (S). CORCYRA, TEMPLE OF ARTEMIS: West pediment, *A gorgon and two lions*, c. 600-580 BC, limestone, height 275 cm, Corfu, Archaeological Museum (Photoresources). CERVETERI, ETRURIA: *Reclining couple*, 550-520 BC, painted terracotta, length 201 cm, Rome, Villa Giulia (Giraudon). VEII, ETRURIA: "The Apollo of Veii", c. 500 BC, marble, height 178 cm, Rome, Villa Giulia (S).

36–37 The Artemisium Zeus Poseidon

AFTER KRITIOS AND NESIOTES: *Harmodios and Aristogeitòn*, original 477-476 BC, marble, height of figures 203 and 195 cm, Naples, Museo Nazionale (S). DELPHI: *A charioteer*, fragment of a group, c. 475-470 BC, bronze, height 180 cm, Delphi, Archaeological Museum (Sonia Halliday and (detail) S). CAPE ARTEMISIUM: *Zeus? or Poseidon?*, c. 460 BC, bronze, 210 cm, Athens, Archaeological Museum (S and (detail) Ronald Sheridan). AFTER KRESILAS: *Perikles*, original c. 429 BC, marble copy of bronze original, height 48 cm, West Berlin, Staatliche Museen (Archiv für Kunst und Geschichte). AFTER AN ATHENIAN SCULPTOR: *Anakreon*, original c. 450 BC, marble, height 198 cm, Copenhagen, Ny Carlsberg Glyptotek.

38–39 Classical Greek Art

OLYMPIA, THE TEMPLE OF ZEUS: Metope: *Herakles' twelfth Labour*, 465-457 BC, marble, height 156 cm, Olympia, Archaeological Museum (S); The west pediment, 465-457 BC, marble, height of Apollo 305 cm, Olympia, Archaeological Museum (S). AFTER MYRON: "Diskobolos" (The discus thrower), original c. 450 BC, marble, height 147 cm, Rome, Museo delle Terme (S). ATHENS, THE ACROPOLIS: "Mourning Athene", c. 470-450 BC, marble relief, height 54 cm, Athens, Acropolis Museum (S). OLYMPIA: *Zeus carries off Ganymede*, c. 470 BC, painted terracotta, height 110 cm, Olympia, Archaeological Museum (S). UNKNOWN ARTIST: "The Ludovisi Throne": *The birth of Aphrodite*, c. 470-460 BC, this face 140 × 102 cm, Rome, Museo delle Terme (S). ATHENS, THE PARTHENON: Fragment of the east pediment: *Aphrodite and two other goddesses*, 438-432 BC, marble, overall length 315 cm, London, British Museum (S); the frieze, c. 440 BC, marble, height 106 cm, London, British Museum (S). THE PENTHESILEA PAINTER: *Greeks and Amazons, Achilles killing Penthesilea?* c. 455 BC, kylix, glazed clay, diameter 43 cm, Munich, Staatliche Antikensammlungen und Glyptothek. ATHENS, THE ERECHTHEION: Caryatid, before 409 BC, marble, height of caryatid 216 cm, *in situ* (S). PAIONIOS: *Nike*, c. 420 BC, marble, height 216 cm, Olympia, Archaeological Museum (S).

40–41 Fourth-century Greek Art

HALICARNASSUS, THE MAUSOLEON: Frieze: *Greeks and Amazons*, c. 353 BC, marble, height 90 cm, London, British Museum (Michael Holford); "Mausolos", c. 353 BC, marble, height 301 cm, London, British Museum (S). (AFTER?) PRAXITELES: *Hermes and the infant Dionysos*, c. 350-330 BC, marble, height 216 cm, Olympia, Archaeological Museum (S). UNKNOWN ARTIST: "The Anticythera Youth", c. 350-330 BC, bronze with glass, limestone and copper, height 196 cm, Athens, National Museum (S). AFTER PRAXITELES: "The Cnidian Aphrodite", original c. 350-330 BC, marble, height 204 cm, Vatican, Museum (S). AFTER LYSIPPOS?: *Alexander the Great* ("The Azara Herm"), original c. 325 BC,

the head 25 cm high, Paris, Louvre (Giraudon); "Apoxyomenos" (Youth scraping down), original c. 325-300 BC, marble, height 206 cm, Vatican (Archiv für Kunst und Geschichte); "The Farnese Hercules", original c. 350-300 BC, marble copy of bronze, height 306 cm, Naples, Museo Nazionale (S). SYRACUSE: Tendrachma piece, c. 479 BC, silver, diameter 3.2 cm, London, British Museum. AFTER LEOCHARES?: "The Apollo Belvedere", original 4th century BC, marble, height 215 cm, Vatican (S). UNKNOWN ARTIST: *Comic actor*, c. 350 BC, terracotta, height about 15 cm (Ronald Sheridan).

42–43 Hellenistic Art

AFTER POLYEUKTOS: *Demosthenes*, original c. 280 BC, marble, height 202 cm, Copenhagen, Ny Carlsberg Glyptotek. PERGAMUM: The Altar of Zeus, outer frieze, east side: *The battle of the gods and giants*, c. 180 BC, marble, height 230 cm, East Berlin, Pergamon Museum (Archiv für Kunst und Geschichte); inner frieze, *Telephos and companions*, c. 165-150 BC, East Berlin, Pergamon Museum (Bildarchiv Preussischer Kulturbesitz). AFTER A PERGAMENE SCULPTOR: *A dying Gaul*, original c. 200 BC, marble, height 73 cm, Rome, Capitoline Museum (S). SAMOTHRACE: *Nike*, c. 190 BC, marble, height 240 cm, Paris, Louvre (S). AFTER AN UNKNOWN SCULPTOR: "The Aphrodite of Cyrene", original c. 100 BC?, marble, height 149 cm, Rome, Museo delle Terme (S). MYRINA: *Two women gossiping*, c. 100 BC, painted terracotta, height 20 cm, London, British Museum (Michael Holford). AFTER AN UNKNOWN SCULPTOR: "The Medici Venus", original c. 150-100 BC?, marble, height 153 cm, Florence, Uffizi (S). POMPEII: Candelabrum support: *Silenos*, c. 100 BC-AD 69, bronze, height 61 cm, Naples, Museo Nazionale (S). AGASANDROS OR ALEXANDROS: "The Venus de Milo", late 2nd or 1st century BC, marble, height 180 cm, Paris, Louvre (Michael Holford). AFTER AN UNKNOWN SCULPTOR: "Antiochos III of Syria", original c. 200-150 BC, marble, height 35 cm, Paris, Louvre (Documentation Photographique de la Réunion des Musées Nationaux).

44–45 The Lost Riches of Classical Painting

PAESTUM: *A banquet*, c. 480 BC, wall-painting, Paestum, Museum (S); *A diver*, c. 480 BC, wall-painting, height of field 98 cm, Paestum, Museum (S). THE ACHILLES PAINTER: *A Muse*, c. 440 BC, white-ground *lekythos*, clay, height 37 cm, Munich, Staatliche Antikensammlungen und Glyptothek. AFTER PHILOXENES?: The Alexander mosaic, *Alexander meets Darius in battle*, original c. 300 BC, mosaic, height 3.7 m, Naples, Museo Nazionale (S). AFTER APELLES: *Aphrodite wringing her hair*, original c. 350 BC, marble, height 30.5 cm, Philadelphia, University of Pennsylvania, University Museum (S); *Zeus enthroned*, c. 350 BC, from Pompeii, House of the Vettii, wall-painting, height 51 cm, *in situ* (Mauro Pucciarelli). AFTER NIKIAS?: *Perseus and Andromeda*, original c. 350 BC, from Pompeii, House of the Dioskurides, wall-painting, height of field 106 cm, Naples, Museo Nazionale (The Mansell Collection). ROME, ESQUILINE: *Odysseus enters Hades*, original c. 150 BC, wall-painting, height about 1.5 m, Vatican, Museum (S). DIOSKOURIDES: *Street musicians*, c. 100 BC, from Pompeii, Villa of Cicero, mosaic, height 62 cm, Naples, Museo Nazionale (S). ROME: The garden painting in the house of Livia at Prima Porta, c. AD 25, wall-painting, height of wall about 3 m, Rome, Museo delle Terme (S). POMPEII: *A cat with a bird, ducks and fish*, original c. 250 BC, mosaic, height

53 cm, Naples, Museo Nazionale (S).

46–47 Roman Art 1

HAGESANDROS, POLYDOROS AND ATHENODOROS: *Laocoön*, 1st century AD?, marble, height 244 cm, Vatican, Museum (S). APOLLONIOS: "The Belvedere Torso", c. 100 BC, marble, height about 1.4 m, Vatican, Museum (S). ROME: "The Capitoline Brutus", 3rd century BC, bronze, height 69 cm, Rome, Capitoline Museum (S); *Ampudius, his wife and daughter*, 1st century BC, relief from a tomb near Porta Capena, Rome, marble, length 164 cm, London, British Museum; *Pompey* (Pompeius Magnus), c. 50 BC, marble, height 25 cm, Copenhagen, Ny Carlsberg Glyptotek; *Augustus*, after 27 BC, marble with traces of purple paint, height about 2 m, Rome, Museo delle Terme (S); Gold coin, with head of Nero on obverse, c. AD 60-68, diameter 20 mm, New Haven, Harvard University, Fogg Art Museum, Van Nest Bequest; The Gemma Augustea, 1st century AD, onyx cameo, 18 × 23 cm, Vienna, Kunsthistorisches Museum (Archiv für Kunst und Geschichte); The Altar of August Peace (*Ara Pacis Augustae*), 13-09 BC, marble, width of front 10.5 m, Rome, Lungotevere in Augusta (S); The Arch of Titus, interior relief panel: *Triumph with the spoils of Jerusalem*, c. AD 81, marble, height of relief 239 cm, Rome, Forum (S). POMPEII: *Paquius Proculus and his wife*, before AD 79, wall-painting, height of field 58 cm, Naples, Museo Nazionale (S); A room in the House of the Vettii, before AD 79, length 6.5 m, width 3.5 m, *in situ* (S).

48–49 Trajan's Column

BENEVENTUM: Trajan's Arch, AD 114-17, marble, height 14.5 m, width 13.1 m, depth 5.1 m, *in situ* (S). ROME: *Trajan*, c. 98-117, porphyry, life-size (Ronald Sheridan); Trajan's Column, 106-13, marble, height 38 m, length of relief 198 m, height of relief band about 120 cm, *in situ* (Photoresources; (*Decebelus' suicide*) Ronald Sheridan; (base and other details) S).

50–51 Roman Art 2

DELPHI: *Antinoüs*, c. 130, marble, height about 1.7 m, Delphi, Archaeological Museum (S). ROME: *Hadrian*, c. 117-38, marble, Rome, Museo delle Terme (S); *Commodus as Hercules*, c. 180-92, marble, height 106 cm, Rome, Capitoline Museum (Archiv für Kunst und Geschichte); The Column of Marcus Aurelius, c. 181, marble, height 42 m, diameter 3.8 m, *in situ* (Alinari); The Ludovisi sarcophagus; *Romans fight Germans*, mid-3rd century, marble 1.5 × 2.7 × 1.3 m, Rome, Museo delle Terme (S); The Velletri sarcophagus, early 2nd century, marble, 1.4 × 2.7 × 1.4 m, Velletri, Museo Archeologico (Mauro Pucciarelli); *Marcus Aurelius*, c. 161-80, bronze with traces of gilt, height 3.5 m, Rome, Campidoglio (Michael Holford); *Septimius Severus as Sérapis*, c. 200, bronze, about life-size, Brussels, Musées Royaux des Beaux-Arts; *Alexander Severus*, c. 222-35, marble, about life-size, Vatican, Museum (S); *Philip the Arab*, c. 244-49, marble, about life-size, Vatican, Museum (S). EGYPT: *Septimius Severus and his family*, c. 199-201, tempera on wood, diameter 30.5 cm, West Berlin, Staatsbibliothek (Bildarchiv Preussischer Kulturbesitz). LEPTIS MAGNA: The Arch of Septimius Severus: *Triumphal procession*, c. 202, marble, overall dimensions of frieze 1.7 × 7.4 m, Tripoli, Museum (R. Wood).

52–53 Early Christian Art

ROME: *The Emperor Constantine*, c. 313, marble, height about 2.5 m, Rome,

Capitoline Museum (S); The Arch of Constantine, *c.* 312-15, marble, height about 21 m, height of frieze with *largitio* 104 cm, *in situ* (S; (frieze) The Mansell Collection). ROME, CATACOMB OF PRISCILLA: *The breaking of bread*, late 2nd century, wall-painting, height 36 cm, *in situ* (S); *The Good Shepherd*, *c.* 250-300, wall-painting, *in situ* (S). CONSTANTINOPLE: *The Tetrarchs*, *c.* 303, porphyry, height 130 cm, *in situ* (S), Venice, Piazza (S). ROME, CATACOMB IN THE VIA LATINA: *Hercules and the Hydra*, 4th century, wall-painting, height 84 cm, *in situ* (S). ROME, S. COSTANZA: An apse: *Christ gives the law to SS. Peter and Paul*, 5th century, mosaic (S); Detail of the vault of the ambulatory: *Putti harvesting grapes*, *c.* 350, mosaic (S). ROME, S. SABINA: Panel of a door: *Moses and the burning bush*, *c.* 432, wood, panel 85 × 40 cm, *in situ* (S). UNKNOWN ARTIST: *The three Marys at the tomb*; *the Ascension*, late 4th or early 5th century, ivory, 18 × 11 cm, Munich, Bayerisches National Museum.

54–55 Medieval and Early Renaissance Art
AMIENS, FRANCE: Interior view, facing east, of the Cathedral, begun 1220 (A. F. Kersting). URBINO, ITALY: The courtyard of the Ducal Palace, by Luciano Laurana, 1465-69 (S).

56–57
(Map by Colin Salmon and Dinah Lone)

58–59 Byzantine Art 1
ROME, SS. COSMA E DAMIANO: *Christ with saints*, *c.* 530, mosaic (S). RAVENNA, S. VITALE: *The Emperor Justinian*, before 547, mosaic (S); *The Empress Theodora*, before 547, mosaic (S); View of the apse (S); Detail of a capital (S). RAVENNA: *Theodora?* *c.* 530, marble, height 27 cm, Milan, Castello Sforzesco (S). MT SINAI, ST CATHERINE: *The Transfiguration*, *c.* 548-65, mosaic (Ronald Sheridan). SYRIA: The Rabula Gospel: *The Ascension*, 586, folio 13v, ink on vellum, Florence, Biblioteca Laurenziana (S). CONSTANTINOPLE: The Barberini diptych: *The Emperor as defender of the faith*, 6th century, 18 × 13 cm, Paris, Louvre (Documentation Photographique de la Réunion des Musées Nationaux). SALONIKA, ST DEMETRIOS: *St Demetrios and the Virgin*, late 6th or early 7th century, mosaic (A. Held/Joseph P. Ziolo). RAVENNA: Archbishop Maximian's Throne, *c.* 550, wood with ivory panels, height 1.5 m, width 60 cm, Ravenna, Museo Arcivescovile (S).

60–61 Byzantine Art 2
CONSTANTINOPLE, HAGIA SOPHIA: *The Virgin and Child enthroned*, 867, mosaic (Photoresources). DAPHNI, CHURCH OF THE DORMITION OF THE VIRGIN: *The Crucifixion*, *c.* 1100, mosaic (Ken Takase/Joseph P. Ziolo); *Christ Pantocrator*, *c.* 1100, mosaic (Sonia Halliday). TORCELLO CATHEDRAL: *The Virgin and Child*, 12th century, mosaic (S). CEFALU CATHEDRAL: View of the apse, *c.* 1148 (S). CONSTANTINOPLE: The Paris Psalter: *David harping*, *c.* 950, folio 378v, colour on vellum, 38 × 28 cm, Paris, Bibliothèque Nationale (Immédiate 2); The Joshua Roll: *The stoning of Achan*, *c.* 950, ink on papyrus, 30 × 1050 cm, Vatican, Library; The Veroli casket: *The rape of Europa*, 10th or 11th century, ivory, 11.5 × 40.5 × 15.5 cm, London, Victoria and Albert Museum. CONSTANTINOPLE, HAGIA SOPHIA: *The Deesis*, *c.* 1261?, mosaic (Sonia Halliday). SOPOCANI: *The dormition of the Virgin*, *c.* 1265, fresco, Church of the Trinity (S). KIEV, HAGIA SOPHIA: View of the apse, 1042-46 (Cercle d'Art/Joseph P. Ziolo). THEOPHANES THE GREEK: *The Holy Trinity*, 1378, fresco, Novgorod, Church of Our

Saviour and of the Transfiguration (Cercle d'Art/Joseph P. Ziolo).

62–63 The Virgin of Vladimir
FAYOUM: *Artemidorus*, portrait on a mummy-case, 2nd century AD, encaustic on panel, height of image 31 cm, London, British Museum. MT SINAI: *The Madonna among saints*, 6th century, encaustic on panel, 68.5 × 50 cm, Monastery of St Catherine (Ronald Sheridan); *St Peter*, early 7th century, encaustic on panel, 93 × 53 cm, Monastery of St Catherine (Percheron/Joseph P. Ziolo). NOVGOROD SCHOOL: *The Presentation in the Temple*, 16th century, panel, 89 × 58 cm, Moscow, Tretyakov Gallery (S). ANDREI RUBLEV: *The Holy Trinity*, *c.* 1411, panel, 140 × 112 cm, Moscow, Tretyakov Gallery (G. Mandel/Joseph P. Ziolo). CONSTANTINOPLE: *St Michael*, *c.* 950-1000, silver inlaid with ivory, gold, jewels and enamel, 44 × 36 cm, Venice, Tesoro di S. Marco (S); *"The Virgin of Vladimir"*, *c.* 1131, panel, 78 × 55 cm, Moscow, Tretyakov Gallery (Cercle d'Art/Joseph P. Ziolo).

64–65 Christ in Chora
The Anastasis, fresco, height of Christ 163 cm (Sonia Halliday); *The miracle at Cana*, mosaic, width of vault 3.9 m (Sonia Halliday); View of the apse (Sonia Halliday); *Theodore Metochites presenting the church to Christ*, mosaic, height of Christ 140 cm (S); *The Last Judgment*, fresco, width of Christ's mandorla 98 cm (Sonia Halliday); *Scenes from the life of the Virgin*, mosaic, width of vault about 2.5 m (Sonia Halliday); all *in situ* in Istanbul, Museum of Kariye Camii.

66–67 Celtic Art
PFALZFELD: Carved stone, 4th century BC, height 148 cm, Bonn, Rheinisches Landesmuseum (S). HOCHDORF: *Lion*, ornament from a bronze vessel, *c.* 500 BC (Deutsche Presse Agentur). SUTTON HOO: Purse lid, *c.* AD 650, gold and enamel with garnets, width 19.5 cm, London, British Museum. MOONE: High Cross, 9th century AD, granite, height 5.3 m (Photoresources). BEWCASTLE: High Cross, late 7th century AD, sandstone, height 5.1 m (Photoresources). IRELAND: The Book of Durrow: *St Matthew*, *c.* AD 680, folio 21v, colour on vellum, height 16.5 cm, Dublin, Trinity College. JARROW: The Codex Amiatinus: *Ezra restoring a damaged bible*, *c.* AD 690, folio 5r, colour on vellum, 50 × 34 cm, Florence, Biblioteca Laurenziana (S). LINDISFARNE: The Lindisfarne Gospels: *St Mark*, *c.* 690, folio 93v; Carpet page, *c.* 690, folio 94v, both colour on vellum, 34 × 24 cm, London, British Library. IONA: The Book of Kells: *St John*, *c.* 800, folio 291v; The Incarnation Initial, *c.* 800, folio 34r, both colour on vellum, 32 × 25 cm, Dublin, Trinity College. IRELAND: The Lichfield Gospels: Carpet page, early 8th century, folio 3, colour on vellum, 29 × 22 cm, Lichfield, Cathedral.

68–69 Carolingian and Ottonian Art
AUXERRE, ST GERMAIN: *St Stephen preaching*, begun 851, fresco (Faillet/Joseph P. Ziolo). RHEIMS: The Utrecht Psalter: Psalm 108, *c.* 816-823, folio 54r, ink on vellum, height 33 cm, Utrecht, University Library; The Ebbo Gospels: *St Mark*, *c.* 816-35, folio 60v, ink and colouring on vellum, 26 × 20 cm, Epernay, Bibliothèque Municipale. AACHEN: The Godescalc Evangelistary: *Christ in benediction*, 781-83, folio 3r, colour, gold and silver on vellum, 30.5 × 21 cm, Paris, Bibliothèque Nationale; The Coronation Gospels: *St John*, *c.* 795-810, folio 178v, colour on vellum, 32 × 25 cm,

Vienna, Kunsthistorisches Museum (Photo Meyer); The Lorsch Gospels: *Christ between angels*, early 9th century, back cover, ivory, 37 × 27 cm, Vatican, Library (Ronald Sheridan). MILAN, S. AMBROGIO: The Golden Altar of St Ambrose, central panel: *Christ in majesty with the Evangelists and the apostles*, *c.* 824-59, gold with silver, jewels and enamel, height of this panel 84 cm, *in situ* (S). HILDESHEIM CATHEDRAL: Bernward's Column, *c.* 1010, bronze, height 3.7 m, *in situ* (S); The bronze doors, detail: *The Nativity* and *The Adoration of the Magi*, 1015, width of panel 59 cm (S). ECHTERNACH: The Speyer Gospels: *St Mark*, 1045-46, folio 61v, colour on vellum, 31.5 × 25.5 cm, Madrid, Escorial (Ampliaciones y Reproducciones Mas). COLOGNE CATHEDRAL: Gero's Crucifix, 969-76, height 213 cm, *in situ* (Bildarchiv Foto Marburg).

70–71 Romanesque Sculpture
MOISSAC ABBEY: *St Peter*, *c.* 1100, stone relief in the cloister (S); *The Apocalypse*, *c.* 1115-20, stone relief in the portal tympanum (Photo Bulloz); *Jeremiah?*, stone jumeau of the portal (Ronald Sheridan). TOULOUSE, ST SERNIN: *Christ in majesty*, 1094-96, marble relief in the ambulatory (S). CONQUES, STE FOY: *The Last Judgment*, stone relief in the portal tympanum (S). CLUNY, ST PIERRE: *The third tone of plainsong*, 1088-95, stone capital, Cluny, Musée du Farinier (Photo Bulloz). RENIER DE HUY: The brass font of Nôtre Dame des Fonts: *The baptism of Christ*, *c.* 1110, brass, height of font 63.5 cm, Liège, St Barthélemy (Bildarchiv Foto Marburg). GLOUCESTER ABBEY: The Gloucester candlestick, *c.* 1110, gilt bronze, height 58.5 cm, London, Victoria and Albert Museum. MERSEBURG CATHEDRAL: *Rudolf of Swabia*, after 1080, bronze, height 197 cm, *in situ* (Bildarchiv Foto Marburg). VERONA, S. ZENO: The bronze doors, detail: *The Crucifixion*, *c.* 1140, bronze plaque nailed on wood (S). BARI, S. NICOLA: The Archbishop's Throne, *c.* 1098, marble inlaid with colour pastes, *in situ* (S).

72–73 Gislebertus: The Sculpture at Autun
ST PIERRE: *The fourth tone of music*, 1088-95, stone capital, Cluny, Musée du Farinier (Photo Bulloz). AUTUN, ST LAZARE: *The flight into Egypt*, *c.* 1125-35, stone capital, Autun, Cathedral Museum (Sonia Halliday); *The dream of the Magi*, *c.* 1125-35, stone capital, Autun, Cathedral Museum (S); *The fourth tone of music*, *c.* 1125, stone capital, *in situ* (S); *Eve*, fragment of the north transept lintel, before 1132, stone, height 72 cm, Autun, Musée Rolin (S); The west tympanum and lintel: *The Last Judgment*, *c.* 1135, stone, width 6.4 m, *in situ* (M. Babey/Joseph P. Ziolo); The west portal, *c.* 1135 (M. Babey/Joseph P. Ziolo). VEZELAY, STE MADELEINE: The tympanum of the central west narthex portal: *The mission to the apostles*, *c.* 1130, stone (S).

74–75 Romanesque Painting
MASTER HUGO: The Bury Bible: *Moses expounding the law*, *c.* 1130-40, folio 94r, colour on vellum, height 51 cm, Cambridge, Corpus Christi College. BERZE-LA-VILLE: The apse: *Christ in majesty with apostles*, before 1109, mural, Berzé-la-Ville Priory (A. Held/Joseph P. Ziolo). WINCHESTER: The Winchester Psalter: *The mouth of Hell*, *c.* 1150, folio 39v, colour on vellum, 29 × 21 cm, London, British Library. CITEAUX: *St George*, initial from a *St Gregory's Moralia in Job*, before 1111, folio 156, colour on vellum, 52 × 37 cm, Dijon, Bibliothèque

Municipale. ST-SAVIN-SUR-GARTEMPE: *Scene from the life of St Savin*, *c.* 1100, fresco, St Savin (Pelissier/Joseph P. Ziolo). FLANDERS: The Stavelot Bible: *Christ in majesty*, folio 136r, ink on vellum, 44 × 27 cm, London, British Library. MEUSE DISTRICT: The Floreffe Bible: *The Crucifixion; the sacrifice of Isaac*, *c.* 1155, folio 187, colour on vellum, height 28 cm, London, British Library. STEPHANUS GARCIA: The St-Saver Apocalypse: *The torture of souls*, mid-11th century, folio 84v, colour on vellum, 36.5 × 28 cm, Paris, Bibliothèque Nationale. CITEAUX: *The Tree of Jesse*, from a *St Jerome's Explanatio in Isaiam*, folio 4v, ink and colour on vellum, 38 × 12 cm, Dijon, Bibliothèque Municipale. URGEL: Altar frontal: *Christ in majesty with apostles*, early 12th century, painted wood, 130 × 150 cm, Barcelona, Museo de Arte Cataluña (S). CANTERBURY?: The Bayeux Tapestry: *King Edward of England*, *c.* 1080, embroidered cotton, height 50 cm, length 69 m, Bayeux, Town Hall (S).

76–77 Gothic Art in Northern Europe
CHARTRES CATHEDRAL: Detail of west portal figures: *A queen and king*, *c.* 1150 (Sonia Halliday); Detail of south portal figures: *St Gregory*, *c.* 1215-20, stone (Sonia Halliday). NICHOLAS OF VERDUN: The Klosterneuberg Altar: two of the 45 enamel plaques with biblical scenes, completed 1181, each panel 20 × 16 cm, Vienna, Kunsthistorisches Museum (Toni Schneiders/Joseph P. Ziolo). PARIS, SAINTE CHAPELLE: Interior looking east, 1243-48 (Sonia Halliday). BAMBERG CATHEDRAL: *"The Bamberg Rider"*, *c.* 1236?, stone, *in situ* (S). RHEIMS CATHEDRAL: *The Annunciation* and *The Visitation*, *c.* 1230-40, stone (K. Takase/Joseph P. Ziolo); The west façade, begun *c.* 1225 (Candelier-Brumaire/Joseph P. Ziolo). NAUMBERG CATHEDRAL: *Eckhart* and *Uta*, *c.* 1250, stone, *in situ* (S). MASTER HONORÉ: *The death of the Virgin*, from the Nuremberg Book of Hours, *c.* 1290?, folio 22r, colour of vellum, Nuremberg, Stadtbibliothek. MATTHEW PARIS: *The Virgin and Child*, frontispiece to *A History of the English*, *c.* 1250, folio 6, ink and colour on vellum, 36 × 24 cm, London, British Library. ST-DENIS: Tomb of Philippe IV, begun 1327, marble, St Denis (Archives Photographiques/Joseph P. Ziolo).

78–79 The Genesis of Italian Painting
ROME, S. MARIA ANTIQUA: *The Crucifixion*, 8th century, mural (S). COPPO DI MARCOVALDO: *The Madonna and Child*, 1261, tempera on panel, 220 × 125 cm, Siena, S. Maria dei Servi (S). GIOTTO?: *St Francis makes the first crib*, *c.* 1290-1300, fresco, 2.3 × 2.7 m, Assisi, S. Francesco, Upper Church (S). CAVALLINI: *Four apostles*, detail of *The Last Judgment*, *c.* 1293, mural, height of figures about 1 m, Rome, S. Cecilia in Trastevere (S; detail of head S). CIMABUE: Crucifix, *c.* 1285, tempera on wood, 450 × 390 cm, Florence, S. Croce (S); *"The S. Trinita Madonna"*, *c.* 1280, tempera on panel, 380 × 220 cm, Florence, Uffizi (S). DUCCIO: The *Maestà*, rear face: *Scenes from the life of Christ*: front face: *The Virgin in majesty*, 1308-11, tempera and gilt on panel, 210 × 430 cm (panel of *Christ's Arrest* and *The Agony in the Garden* 102 × 76 cm), Siena, Museo dell' Opera del Duomo (both sides and detail S); *"The Rucellai Madonna"*, 1285, tempera and gilt on panel, 470 × 290 cm, Florence, Uffizi (S). GIOTTO: *"The Ognissanti Madonna"*, *c.* 1305-10?, tempera on panel, 320 × 200 cm, Florence, Uffizi (S).

80–81 Italian Gothic Sculpture

PISA, CAMPO SANTO: *Phaedra*, detail of a sarcophagus, 3rd century, marble, *in situ* (S). NICOLA PISANO: *The Adoration of the Magi*, detail of the Pisa Baptistery pulpit, 1260, marble, field 85 × 113 cm, *in situ* (S); *The Visitation*, detail of the Siena Cathedral pulpit, 1265-68, marble, field 85 × 97 cm, *in situ* (S); *December*, detail from the Great Fountain, Perugia, 1278, marble, field 49 × 30 cm (S). GIOVANNI PISANO: *The Massacre of the Innocents*, detail of the Pistoia pulpit, 1301, marble, field 84 × 102 cm, Pistoia, S. Andrea Fuorcivitas (S); *Temperance* and *Chastity*, detail from the base of the Pisa Cathedral pulpit, 1302-10, marble, height of figures 1.2 m, *in situ* (S); Fragments of the tomb of Margaret of Luxembourg, 1313, marble, height of Empress 65.5 cm, Genoa, Palazzo Bianco (S). ARNOLFO DI CAMBIO: Detail of a crib: *The Three Magi*, c. 1290, marble, height of figures about 1 m, Rome, S. Maria Maggiore (S); Tomb of Cardinal de Braye, after 1282, marble, Orvieto, S. Domenico (S). TINO DI CAMAINO: *The Madonna and Child*, 1321, marble, height 78 cm, Florence, Bargello (S). ANDREA PISANO: *The death of St John the Baptist*, panel of the Florence Baptistery doors, 1330-37, bronze, panel 50 × 43 cm (S). MAITANI: The centrepiece of the façade of Orvieto Cathedral: *The Madonna enthroned*, 1330, the figure marble, height about 1 m, the baldachino and the angels bronze (S).

82–83 Giotto di Bondone
GIOVANNI PISANO: *The Madonna and Child and two angels*, c. 1302-10, marble, height of the Madonna 129 cm, Padua, Arena Chapel (S). GIOTTO: *The Last Judgment* in the Arena Chapel, Padua, detail: *Scrovegni presents the chapel*, before 1306, fresco, size of wall 10 × 8.4 m (S); Crucifix, c. 1290-1300, tempera on wood, 590 × 410 cm, Florence, S. Maria Novella (S); *St Francis, praying in S. Damiano, receives divine instruction*, c. 1290-1300, fresco, 2.7 × 2.3 m, Assisi, S. Francesco, Upper Church (S); The Arena Chapel, Padua: interior, looking east, dedicated 1306 (S); *Moses*, fresco, height of field 70 cm (S); *The expulsion of Joachim, The feast at Cana, The mocking of Christ*, fresco, each 200 × 185 cm (all S); The death of *St Francis*, detail from the Bardi Chapel, S. Croce, Florence, c. 1320, fresco, 2.8 × 4.5 m (S); *The dance of Salome*, detail from the Peruzzi Chapel, S. Croce, Florence, c. 1325, fresco, 2.8 × 4.5 m (S).

84–85 Italian Gothic Painting
SIMONE MARTINI: *Maestà* (The Madonna in majesty), 1315-21, fresco, 7.6 × 9.7 m, Siena, Palazzo Pubblico (S); *St Louis*, 1317, tempera and gilt on panel, 200 × 140 m, Naples, Museo di Capodimonte (S); *The Annunciation*, 1333, tempera and gilt on panel, 260 × 300 cm, Florence, Uffizi (S); *Guidoriccio da Fogliano*, 1328, fresco, 3.4 × 9.7 m, Siena, Palazzo Pubblico (S). AMBROGIO LORENZETTI: *The Presentation in the Temple*, 1342, 260 × 170 cm, tempera on panel, Florence, Uffizi (S). PIETRO LORENZETTI: *The Virgin and saints*, 1320, tempera and gilt on panel, 300 × 330 cm, Arezzo, Pieve di S. Maria (S); *The birth of the Virgin*, 1342, tempera on panel, 190 × 180 cm, Siena, Museo dell' Opera del Duomo (S). TADDEO GADDI: *The Presentation of the Virgin*, c. 1332-38, fresco, Florence, S. Croce, Baroncelli Chapel (S). MASO DI BANCO: *St Sylvester and the dragon*, late 1330s, fresco, width 5.35 m, Florence, S. Croce, Bardi Chapel (S). ORCAGNA: *The Redeemer*, detail of the Strozzi altarpiece, 1354-57, tempera and gilt on panel, 160 × 290 cm, Florence, S. Maria Novella (S).

86–87 Lorenzetti: The Good Commune
AMBROGIO LORENZETTI: *The effects of Good Government on town and countryside; Allegory of Good Government; Allegory of Bad Government; Grammar*, 1338, all fresco, Siena, Palazzo Pubblico (all S); *Landscape*, c. 1335, tempera on panel, 23 × 33 cm, Siena, Pinacoteca (S). SIENA: *Winged Victory*, 2nd century?, stone relief, Siena, Pinacoteca (S). NICOLA PISANO: *The Liberal Arts*, detail of the Siena Cathedral pulpit, 1265-68, marble, height of figures 61 cm, *in situ* (S).

88–89 The International Gothic Style
GENTILE DA FABRIANO: *The Adoration of the Magi*, 1423, tempera and gilt on panel, 300 × 280 cm, Florence, Uffizi (S). PISANELLO: *St George and the Princess*, c. 1435, fresco, Verona, S. Anastasia (S); *Horses*, undated, pen on paper, 20 × 16.5 cm, Paris, Louvre (The Mansell Collection); *Filippo Maria Visconti*, 1440, bronze medal, diameter 10 cm, Florence, Bargello (S). UNKNOWN ARTIST: The Wilton diptych, c. 1377-1413, London, National Gallery (Michael Holford). SASSETTA: *The Adoration of the Magi*, c. 1430?, tempera on panel, 32 × 35 cm, Siena, Chigi-Saraceni Collection (S). STEFANO DA VERONA: *The Virgin in a rose garden*, c. 1405-10, tempera on panel, 127 × 93 cm, Verona, Museo di Castelvecchio (S). THE MASTER OF THE UPPER RHINE: *The Garden of Paradise*, c. 1420, tempera on panel, 26 × 33 cm, Frankfurt, Städelsches Kunstinstitut. MASTER THEODORIC: *Charles IV receiving fealty*, detail of frescos in Karlstein Castle, Czechoslovakia, c. 1348-70 (Faillet/Joseph P. Ziolo). THE LIMBOURG BROTHERS: Les *Très Riches Heures du Duc de Berri: February*, 1413-16, folio 2v, colour on vellum, 21.6 × 13.9 cm, Chantilly, Musée Condé (Giraudon). PUCELLE: The Belleville Breviary: *Strength and Weakness*, c. 1325, folio 37, colour on vellum, 24 × 17 cm, Paris, Bibliothèque Nationale (Photo Bulloz).

90–91 Netherlandish Art 1
BROEDERLAM: *Scenes from the life of Mary*, altarpiece for the Chartreuse de Champmol, 1396-99, oil and tempera on panel, each wing 167 × 124 cm, Dijon, Musée des Beaux-Arts (S). SLUTER: The tomb of Duke Philip the Bold, 1385-1405, painted stone, Dijon, Musée des Beaux-Arts (Pelissier/Joseph P. Ziolo); The Well of Moses, 1395-1403, stone, height of figures 182 cm, Dijon, Chartreuse de Champmol (R. Roland/Joseph P. Ziolo). CAMPIN?: The Mérode altarpiece: *The Annunciation*, c. 1425, oil on panel, centre panel 63.5 × 63.5 cm, New York, Metropolitan Museum of Art, Cloisters collection. THE BOUCICAUT MASTER: *The Visitation*, from the Hours of the Marechal de Boucicaut, c. 1405, folio 65v, tempera on vellum, 28 × 18 cm, Paris, Musée Jacquemart-André (Photo Bulloz). JAN and HUBERT VAN EYCK: The Ghent altarpiece, oil and tempera on panel, overall height 340 cm, Ghent, St Bavo (*The Virgin* (height of panel 170 cm) S; *The adoration of the Lamb* (height of panel 140 cm) S; *The Virgin Annunciate* (height of panel 160 cm) S). JAN VAN EYCK: *The Madonna with Canon van der Paele*, 1436, oil on panel, 122 × 157 cm, Bruges, Groeningemuseum (S); *The Madonna with Chancellor Rolin*, c. 1435, oil on panel, 66 × 62 cm, Paris, Louvre (S).

92–93 Jan van Eyck: The Arnolfini Marriage
JAN VAN EYCK: *"The Arnolfini Marriage"*, 1434, oil on panel, 82 × 60 cm, London, National Gallery; *Giovanni Arnolfini*, c. 1437, oil on panel, 29 × 20 cm, West Berlin, Staatliche Museen (Archiv für

Kunst und Geschichte); *A man in a turban*, 1433, oil on panel, 25.5 × 19 cm, London, National Gallery; *Cardinal Albergati*, c. 1431, silverpoint, 21 × 18 cm, Dresden, Staatliche Kunstsammlungen (Gerhard Reinhold, Leipzig-Molkau/Joseph P. Ziolo); *Cardinal Albergati*, c. 1432, oil on panel, 34 × 26 cm, Vienna, Kunsthistorisches Museum (Photo Meyer).

94–95 Netherlandish Art 2
AFTER CAMPIN: *The Deposition*, c. 1430-35?, oil on panel, 59 × 60 cm, Liverpool, Walker Art Gallery. VAN DER WEYDEN: *St Luke painting the Virgin*, c. 1434-35? oil on panel, 135 × 122 cm, Boston, Museum of Fine Arts, Gift of Mr and Mrs Henry Lee Higginson; *The Last Judgment*, c. 1450?, oil on panel, width 560 cm, Beaune, Musée de l'Hôtel-Dieu (Photo Bulloz); *The Deposition*, c. 1430-35?, oil on panel, 220 × 260 cm, Madrid, Prado (S); *The Madonna and saints*, c. 1450, oil on panel, width 32 cm, Frankfurt, Stadelsches Kunstinstitut; *A young woman*, c. 1440?, oil on panel, 35.5 × 26.5 cm, Washington, National Gallery of Art, Andrew W. Mellon collection. CHRISTUS: *St Eligius and two lovers*, 1449, oil on panel, 98 × 85 cm, New York, R. Lehman Collection; *Edward Grimston*, 1446, oil on panel, 33 × 24 cm, London, the Gorhambury Collection, St Albans, on loan to the National Gallery (by permission of the Earl of Verulam). BOUTS: *The Last Supper*, 1464-68, oil on panel, central panel, 180 × 151 cm, Louvain, St Pierre (S); *A young man*, 1462, oil on panel, 31 × 20 cm, London, National Gallery.

96–97 Netherlandish Art 3
VAN DER GOES: The Portinari altarpiece: *The Adoration of the shepherds*, c. 1474-76, oil on panel, height 310 cm, Florence, Uffizi (S); The Monforte altarpiece: *The Adoration of the Magi*, early 1470s, oil on panel, 147 × 241 cm, West Berlin, Staatliche Museen (Bildarchiv Preussischer Kulturbesitz); *The death of the Virgin*, c. 1480, oil on panel, 145 × 120 cm, Bruges, Groeningemuseum (S). MEMLINC: The Donne triptych: *The Virgin and Child with saints and donors*, c. 1480, oil on panel, height 71 cm, London, National Gallery. JUSTUS OF GHENT: *The Institution of the Eucharist*, 1473-75, oil on panel, 330 × 330 cm, Urbino, Galleria Nazionale delle Marche (S). LOCHNER: *The Adoration of the shepherds*, 1445, oil on panel, 120 × 80 cm, Munich, Alte Pinakothek (S). THE MASTER OF THE CUER D'AMOUR ESPRIS: *How Hope rescued Heart from the water*, 1457, *Le Livre du Cuer d'Amour Espris*, folio 21v, tempera and oil on vellum, 29 × 20 cm, Vienna, Österreichische Nationalbibliothek. WITZ: *The miraculous draught of fish*, c. 1444, oil on panel, 132 × 157 cm, Geneva, Musée d'Art et d'Histoire (S). AVIGNON SCHOOL: *"The Avignon Pietà"*, c. 1460, oil on panel, 160 × 220 cm, Paris, Louvre (S). FOUQUET: *"The Virgin of Melun"*, c. 1450, oil on panel, 93 × 104 cm, Antwerp, Musée Royal des Beaux-Arts (S).

98–99 Bosch: The Garden of Earthly Delights
BOSCH: *The Garden of Earthly Delights*, c. 1505-10, oil on panel, wing panels 220 × 97 cm, centre panel 220 × 195 cm, Madrid, Prado (all details S); *The Crowning with thorns*, undated, oil on panel, 73 × 59 cm, London, National Gallery. GEERTGEN TOT SINT JANS: *Christ as the Man of Sorrows*, c. 1490, oil on panel, 24.5 × 24 cm, Utrecht, Rijksmuseum het Catharijne Convent. MASTER OF THE VIRGO INTER VIRGINES: *The Annunciation*, c. 1495, oil on panel, 57 × 47 cm, Rotterdam,

Museum Boymans-van Beuningen.

100–101 Italian Renaissance Sculpture I
GIOVANNI PISANO: *"The Ballerina"*, from the parapet of Pisa Baptistery, 1297-98, stone, height 132 cm, Pisa, Museo Nazionale (S). ANDREA PISANO: Bronze doors of Florence Baptistery, 1330-37, height about 4 m (S). GHIBERTI: *The sacrifice of Isaac*, 1401, bronze plaque, 45 × 38 cm, Florence, Bargello (S); *The Annunciation*, c. 1405-10; *The Flagellation*, c. 1415-20, both panels of the north Baptistery doors, bronze, 52 × 45 cm (both S); *Self-portrait*, detail of the "Paradise" doors, c. 1450 (S); *Joseph in Egypt*, panel of the "Paradise" doors, c. 1425-47, bronze, 79 × 79 cm (S). BRUNELLESCHI: *The sacrifice of Isaac*, 1401, bronze, 45 × 38 cm, Florence, Bargello (S). *Leon Battista Alberti*, bronze medal by Matteo de'Pasti, width 7 cm, Paris, Louvre (S). *Filippo Brunelleschi*, detail of a panel attributed to Uccello, tempera, height 42 cm, Paris, Louvre (Documentation Photographique de la Réunion des Musées Nationaux). NANNI DI BANCO: *Four martyr saints*, c. 1414-18, marble, height of figures 182 cm, Florence, Orsanmichele (S). JACOPO DELLA QUERCIA: The Great Door of S. Petronio, Bologna, c. 1425-35 (S); a relief from it, *The sacrifice of Isaac*, marble, 87 × 70 cm (S). LUCA DELLA ROBBIA: *Musicians*, panel from the Cantoria (Singers' Gallery), c. 1430-38, marble, 103 × 93 cm, Florence, Museo dell'Opera del Duomo (S); *The Madonna and Child*, c. 1455-65, enamelled terracotta, diameter 180 cm, Florence, Orsanmichele (S).

102–103 Donatello
DONATELLO: *St George*, c. 1415-17, marble, height of figure 209 cm, Florence, Bargello (S); *The feast of Herod*, detail of the Siena Cathedral font, 1423-27, gilt bronze relief, 60 × 61 cm, *in situ* (S); *The Annunciation*, c. 1430?, sandstone with residual gilt and polychrome, 4.2 × 2.5 m, Florence, S. Croce (S); *Jeremiah?*, 1423, marble, height 191 cm, Florence, Museo dell'Opera del Duomo (S); The High Altar, S. Antonio, Padua, 1443-54, artwork after J. White by MB Studio; its central statue, *The Madonna and Child*, bronze, height 159 cm, *in situ* (S); *Mary Magdalen*, c. 1456?, wood, height 188 cm, Florence, Baptistery (S); *David*, undated, bronze, height 159 cm, Florence, Bargello (S); *Gattamelata*, 1443-48, bronze on marble and limestone base, height of statue 340 cm, Padua, Piazza del Santo (S); *Lamentation on the dead Christ*, detail of one of the pulpits in S. Lorenzo, Florence, c. 1465, bronze, height of panel 137 cm, *in situ* (S).

104–105 Masaccio: The Holy Trinity
MASACCIO: *The Holy Trinity*, 1428, fresco, 6.7 × 3.2 m, Florence, S. Maria Novella (S); detail of the Virgin (S); artwork after P. Sanpaolesi by MB Studio; *The Crucifixion*, fragment of the Pisa altarpiece, 1426, tempera on panel, 76 × 63.5 cm, Naples, Museo di Capodimonte (S). DONATELLO: *St Louis*, c. 1422-25, gilt bronze, height 266 cm, reinstated in its niche outside Orsanmichele, Florence, now in S. Croce, Florence (S). BRUNELLESCHI?: *Crucifix*, c. 1412, wood, height about 1 m, Florence, S. Maria Novella. LORENZO DI NICCOLO GERINI: *The Holy Trinity*, late 14th century, tempera on panel, Greenville, South Carolina, Bob Jones University. MASOLINO: *The Crucifixion*, c. 1428, tempera on panel, 53 × 32 cm, Vatican Gallery (S).

106–107 Italian Renaissance

ILLUSTRATIONS AND ACKNOWLEDGMENTS

Painting 1
MASACCIO: *The tribute money*, 1425-28, fresco, 2.5 × 6 m, Florence, S. Maria del Carmine, Brancacci Chapel (S); detail of heads (S); *The expulsion of Adam and Eve*, 1425-28, fresco, 2 × 0.9 m, S. Maria del Carmine, Brancacci Chapel (S). MASOLINO: *Adam and Eve under the Tree of Knowledge*, 1425-28, fresco, 2 × 0.9 m, S. Maria del Carmine, Brancacci Chapel (S). UCCELLO: *The Battle of San Romano*, c. 1455, tempera on panel, 180 × 320 cm, London, National Gallery; *The Flood*, c. 1445, fresco, 2.2 × 5.1 m, Florence, S. Maria Novella (S); *The night hunt*, c. 1460, tempera on panel, 65 × 165 cm, Oxford, Ashmolean Museum. FILIPPO LIPPI: *The Madonna and Child with two angels*, c. 1460, tempera on panel, 92 × 64 cm, Florence, Uffizi (S); *The Annunciation*, c. 1440, tempera on panel, 175 × 183 cm, Florence, S. Lorenzo (S); One of the Prato frescos: *The feast of Herod*, 1452-64, Prato, Cathedral (S). DOMENICO VENEZIANO: *St John the Baptist in the desert*, predella panel from the St Lucy altarpiece, c. 1445-48, tempera, 28 × 32 cm, Washington, National Gallery of Art, Samuel H. Kress collection; The St Lucy altarpiece, c. 1445-48, tempera on panel, 209 × 216 cm, Florence, Uffizi (S). DONATELLO: *St Louis*, c. 1422-25, gilt bronze, height 266 cm, Florence, S. Croce (S).

108–109 Fra Angelico: The Annunciation
FRA ANGELICO: *The Annunciation*, at the top of the dormitory stairs in S. Marco, Florence, c. 1450?, fresco, 2.2 × 3.2 m (S); *The Deposition*, c. 1440?, tempera on panel, 105 × 164 cm, Florence, S. Marco; *The Annunciation*, for S. Domenico, Cortona, c. 1428-32, tempera on panel, 175 × 180 cm, Cortona, Museo Diocesano (S); *The Annunciation*, in Cell 3 of the dormitory of S. Marco, c. 1441, fresco, 1.9 × 1.6 m (S); *St Stephen preaching and addressing the Jewish council*, c. 1447-49, fresco, 3.2 × 4.1 m, Vatican, Chapel of Nicholas V (S).

110–111 Italian Painting 2
GOZZOLI: *The journey of the Magi*, 1459-61, fresco, Florence, Palazzo Medici-Riccardi (S); *Man treading grapes*, detail of the Campo Santo frescos, 1468-97, Pisa, Campo Santo (S). CASTAGNO: *God the Father*, detail of S. Zaccaria apse, 1442, fresco, Venice, S. Terasio presso S. Zaccaria (S); *The Last Supper*, c. 1445-50, fresco, Florence, Museo di S. Apollonia (S). PIERO DELLA FRANCESCA: *The Compassionate Madonna*, begun 1445, tempera on panel, 134 × 91 cm, Borgo San Sepolcro, Palazzo Communale (S); *The baptism of Christ*, c. 1440-50, tempera on wood, 167 × 116 cm, London, National Gallery (Angelo Hornak); Details from the Arezzo frescos, 1452-64, *The old age and death of Adam; The victory over Khosroes; The dream of Constantine; The Annunciation*, S. Francesco (all S); *The Resurrection*, c. 1463, fresco, 2.25 × 2 m, Borgo San Sepolcro, Palazzo Communale (S).

112–113 Piero della Francesca: The Flagellation
BERRUGETE?: *Federigo da Montefeltro*, 1477, tempera on panel, 135 × 79 cm, Urbino, Galleria Nazionale delle Marche (S). PIERO DELLA FRANCESCA: *Federigo da Montefeltro*, c. 1465, tempera on panel, height 47 cm, Florence, Uffizi (S); *The flagellation of Christ*, undated, tempera on panel, 59 × 81.5 cm, Urbino, Galleria Nazionale delle Marche (S); artwork by Peter Courtley. UNKNOWN ARTIST: *Ludovico Gonzaga*, c. 1450, bronze, life-size, West Berlin, Staatliche Museen (S).

URBINO, DUCAL PALACE: The *Cappella del Perdono*, 1468-72 (S). ALBERTI: The Holy Sepulchre in the Rucellai Chapel, Florence, 1467, marble (S).

114–115 Italian Sculpture 2
BERNARDINO ROSSELLINO: *Leonardo Bruni*, c. 1445-50, marble, height of tomb about 6 m, Florence, S. Croce (S). ANTONIO ROSSELLINO: *Giovanni Chellini*, 1456, marble, height 51 cm, London, Victoria and Albert Museum; *The Cardinal of Portugal*, 1460-66, marble with some paint, height of tomb 5 m, Florence, S. Miniato al Monte (S). MINO DA FIESOLE: *Piero de' Medici*, 1453, marble, height 55 cm, Florence, Bargello (S). DESIDERIO DA SETTIGNANO: Tabernacle in S. Lorenzo, c. 1460, marble, Florence, S. Lorenzo (S). POLLAIUOLO: *St Sebastian*, 1475, tempera on panel, 290 × 200 cm, London, National Gallery; *Ten nudes fighting*, c. 1460, engraving, Florence, Uffizi, Gabinetto Nazionale dei Disegni e Stampe (S); *Hercules and Antaeus*, c. 1475-80, bronze, height 45 cm, Florence, Bargello (S). VERROCCHIO: *Bartolommeo Colleoni*, 1481-90, bronze, height about 4 m, Venice, Campo SS. Giovanni e Paolo (The Mansell Collection); *The doubting of Thomas*, 1465, bronze, height of Christ 230 cm, Florence, Orsanmichele (S); *Putto with a fish*, c. 1470, bronze, height 69 cm, Florence, Palazzo Vecchio (S). MATTEO DE' PASTI?: *Botany*, c. 1460-68, marble, Rimini, Tempio Malatestiano, Chapel of the Liberal Arts (S).

116–117 Italian Painting 3
PERUGINO: *The giving of the Keys to St Peter*, 1481-82, fresco, 3.5 × 5.5 m, Vatican, Sistine Chapel (S). GHIRLANDAIO: *The birth of St John*, 1485-90, fresco, Florence, S. Maria Novella (S); *The calling of the first apostles*, 1481-82, fresco, 3.5 × 5.5 m, Vatican, Sistine Chapel (S). BOTTICELLI: "*The Madonna of the Magnificat*", c. 1480-90, tempera on panel, diameter 116 cm, Florence, Uffizi (S); *The punishment of Corah*, 1481-82, fresco, 3.5 × 5.5 m, Vatican, Sistine Chapel (S); *Lamentation over Christ*, c. 1490-1500, tempera on panel, 140 × 207 cm, Munich, Alte Pinakothek (S); *A young man*, c. 1482?, tempera on panel, 37 × 28 cm, Washington, National Gallery of Art, Andrew W. Mellon collection. FILIPPINO LIPPI: *The vision of St Bernard*, c. 1480, tempera on panel, 206 × 192 cm, Florence, Badia (S). GHIRLANDAIO: *Old man and his grandson*, c. 1475?, tempera on panel, 60 × 45 cm, Paris, Louvre (S).

118–119 Botticelli: Primavera
BOTTICELLI: *Primavera*, 1478, tempera on panel, 203 × 314 cm, Florence, Uffizi (S; detail S); *The birth of Venus*, c. 1482-84, tempera on canvas, 172 × 287 cm, Florence, Uffizi (S); *Abundance*, undated, pen, chalk and body-colour on paper, 31 × 24 cm, London, British Museum; *Mars and Venus*, late 1480s, tempera on panel, 69 × 173 cm, London, National Gallery. PIERO DI COSIMO: *The discovery of honey*, c. 1500, on panel, 79 × 128 cm, Worcester, Massachusetts, Worcester Art Museum (S).

120–121 Renaissance Painting in North and Central Italy
DONATELLO: Relief from the Santo altar: *The miracle of the mule*, c. 1447, bronze, 52 × 123 cm, Padua, *in situ* (S). MANTEGNA: Fresco from the Eremitani: *The martyrdom of St Christopher*, 1448-51, fresco, width 332 cm, Padua, Church of the Eremitani, Ovetari Chapel (S). MANTEGNA?: *Self-portrait*, c. 1490, bronze, life-size, Mantua, S. Andrea (S); The *Camera degli Sposi*, c. 1474, fresco,

Mantua, Palazzo Ducale (ceiling and general view S); *The Triumph of Caesar*, c. 1486-94, tempera on canvas, 274 × 274 cm, Hampton Court (by gracious permission of Her Majesty the Queen); *St Sebastian*, undated, tempera on panel, 275 × 142 cm, Paris, Louvre (Documentation Photographique de la Réunion des Musées Nationaux). COSIMO TURA: *The Virgin Annunciate*, 1469, tempera on canvas, 400 × 150 cm, Ferrara, Museo dell' Opera del Duomo (S). CRIVELLI: *Pietà*, 1493, tempera on panel, 128 × 241 cm, Milan, Brera (S).

122–123 Renaissance Painting in Venice
JACOPO BELLINI: *Christ before Pilate*, undated, silverpoint and pen on vellum, 42 × 29 cm, Paris, Louvre (Documentation Photographique de la Réunion des Musées Nationaux). CARPACCIO: *St Ursula taking leave of her parents*, 1495, tempera and oil on canvas, 280 × 611 cm, Venice, Accademia (S). GENTILE BELLINI: *Sultan Mehmet II*, c. 1480, canvas, 70 × 52 cm, London, National Gallery; *The miracle at Ponte di Lorenzo*, 1500, canvas, 316 × 611 cm, Venice, Accademia (S). ANTONELLO DA MESSINA: *St Jerome in his study*, c. 1460, oil on panel, 46 × 36 cm, London, National Gallery; *A young man*, 1478, oil on panel, 20 × 14 cm, West Berlin, Staatliche Museen (Archiv für Kunst und Geschichte). GIOVANNI BELLINI: *Doge Loredan*, c. 1502, oil on panel, 61 × 45 cm, London, National Gallery; The Brera *Pietà*, c. 1470, tempera on panel, 86 × 107 cm, Milan, Brera (S); *St Francis in ecstasy*, c. 1470-80, oil and tempera on panel, 124 × 142 cm, New York, The Frick Collection (copyright); "*The Sacred Allegory*", c. 1490-1500, oil and tempera on panel, 72 × 117 cm, Florence, Uffizi (S).

124–125 The Sixteenth Century
VENICE, ITALY: Interior view of S. Giorgio Maggiore, by Palladio, begun 1565 (A. F. Kersting). PRAGUE, BOHEMIA: Vladislav Hall, Prague Castle, by Benedict Ried, begun 1487 (Architectural Association).

126–127
(Map by Colin Salmon and Dinah Lone)

128–129 The High Renaissance 1
MELOZZO DA FORLI: *Sixtus IV ordering his nephew Palatina to reorganize the Vatican library*, 1475-77, fresco, 3.6 × 3.1 m, Vatican, Pinacoteca (S). ANDREA SANSOVINO: *The baptism of Christ*, 1502-05, marble, height of Christ 340 cm, Florence, Baptistery (S). PINTORICCHIO: *Susannah and the Elders*, lunette from the Borgia apartments in the Vatican, c. 1492-94, fresco and gilt gesso, *in situ* (S). LEONARDO: "*Vitruvian Man*", c. 1490, ink on paper, 34 × 24.5 cm, Venice, Accademia (S); *The Last Supper*, c. 1495, oil, tempera and fresco, 4.2 × 9.1 m, Milan, S. Maria delle Grazie (S); *The Virgin and Child with a cat*, c. 1478-81, ink and wash over stylus drawing on paper, 13 × 9.5 cm, Florence, Uffizi, Gabinetto Nazionale dei Disegni e Stampe (S). AFTER LEONARDO: *The Battle of Anghiari*, 1503-06, copy by Rubens, chalk and ink on paper, 43.5 × 36.5 cm, Paris, Louvre (Documentation Photographique de la Réunion des Museés Nationaux). RAPHAEL: "*The Madonna della Sedia*" (The Virgin enthroned), c. 1515-17, oil on panel, diameter 71 cm, Florence, Palazzo Pitti (S); *Baldassare Castiglione*, c. 1516, oil on canvas, 82 × 67 cm, Paris, Louvre (S). MICHELANGELO: "*The Pitti Madonna*", 1504-05, marble, 86 × 82 cm, Florence, Bargello (S). FRA BARTOLOMMEO: *The Entombment*, 1515, oil on panel, 157

× 203 cm, Florence, Palazzo Pitti (S).

130–131 Leonardo da Vinci
VERROCCHIO AND LEONARDO: *The baptism of Christ*, c. 1472, oil on panel, 177 × 151 cm, Florence, Uffizi (S). LEONARDO: *Self-portrait*, c. 1512, chalk on paper, 33 × 21 cm, Turin, Biblioteca Reale (S); *The Adoration of the Magi*, 1481, underpaint on panel, 243 × 246 cm, Florence, Uffizi (S); *Landscape*, 1473, ink on paper, 19 × 28.5 cm, Florence, Uffizi, Gabinetto Nazionale dei Disegni e Stampe (S); *Ginevra de' Benci*, c. 1474?, oil on panel, 42 × 37 cm, Washington, National Gallery of Art; *The Virgin of the rocks*, c. 1483-85, oil on panel transferred to canvas, 197 × 119.5 cm, Paris, Louvre (S); *The Virgin and Child with St Anne*, c. 1495, chalk on paper, 139 × 101 cm, London, National Gallery; *Flying machine*, c. 1486-90, from Manuscript B, folio 80r, ink on paper, 23 × 16 cm, Paris, Institut de France (S); *Mona Lisa*, c. 1503-06, oil on panel, 77 × 53 cm, Paris, Louvre (S); Anatomical drawing: *Sexual intercourse*, c. 1492-94, from Anatomical Manuscript C, folio 3v, pen and ink, 27 × 20 cm, Windsor, Royal Collection (by gracious permission of Her Majesty the Queen).

132–133 Michelangelo Buonarroti
Michelangelo Buonarroti, portrait attributed to Jacopino del Conte, oil on panel, 98.5 × 68 cm, Florence, Casa Buonarroti (S). MICHELANGELO: The Vatican *Pietà*, 1499, marble, height 174 cm, Vatican, St Peter's (S); Study for *Leda*, c. 1530?, chalk on paper, 35 × 27 cm, Florence, Uffizi, Gabinetto Nazionale dei Disegni e Stampe (S); *Tityus*, 1532, chalk on paper, 19 × 31.5 cm, Windsor, Royal Collection (by gracious permission of Her Majesty the Queen); *David*, 1501-04, marble, height 434 cm, Florence, Accademia (S); *Moses*, 1513-16, marble, height 235 cm, Rome, S. Pietro in Vincoli (S); "*Dying slave*", 1513-16, marble, height 215 cm, Paris, Louvre (S); The tomb of Giuliano de' Medici in the Medici Chapel, S. Lorenzo, 1534, marble, Florence (S); *The crucifixion of St Peter*, 1546-50, fresco, 6.2 × 6.6 m, Vatican, Cappella Paolina (S); *The Last Judgment*, 1534-41, fresco, 13.7 × 12.2 m, Vatican, Sistine Chapel (S); "*The Rondanini Pietà*", c. 1555-64, marble, height 195 cm, Milan, Castello Sforzesco (S).

134–135 Michelangelo: The Sistine Chapel Ceiling
MICHELANGELO: The Sistine Chapel ceiling, 1508-12, fresco, 13 × 36 m, Vatican, Sistine Chapel (S); Interior of the Sistine Chapel (S); Details of the ceiling (S).

136–137 Raphael
RAPHAEL: *The marriage of the Virgin*, 1504, oil on panel, 118 × 170 cm, Milan, Brera (S); "*La Belle Jardinière*" (The Madonna and Child with St John), c. 1506, oil on panel, 122 × 80 cm, Paris, Louvre (S); *Agnolo Doni*, 1505, oil on panel, 63 × 45 cm, Florence, Palazzo Pitti (S); "*The Sistine Madonna*", 1512, oil on canvas, 265 × 196 cm, Dresden, Gemäldegalerie (S); "*The School of Athens*" in the *Stanza della Segnatura*, 1509-11, fresco, width at base about 7.7 m, Vatican (S); *Self-portrait*, detail (S); *The triumph of Galatea*, c. 1513, fresco, 2.95 × 2.25 m, Rome, Villa Farnesina (S); *The expulsion of Heliodorus*, 1511-13, fresco, width at base about 7.5 m, Vatican, *Stanza d'Eliodoro* (S); *Two apostles*, study for *The Transfiguration*, chalk on paper, 50 × 36 cm, Oxford,

Ashmolean Museum.

138–139 Bellini: The S. Zaccaria Altarpiece

GIOVANNI BELLINI: The S. Zaccaria altarpiece: *The Virgin and Child with saints*, 1505, oil on panel transferred to canvas, 500 × 235 cm, Venice, S. Zaccaria (S); *The Madonna and Child*, c. 1465-70, tempera on panel, 72 × 46 cm, New York, Metropolitan Museum of Art, Bequest of Theodore H. Davis; "*The Madonna of the Meadow*", c. 1501, oil on panel, 67 × 86 cm, London, National Gallery; The S. Giobbe altarpiece, c. 1490, oil on panel, 471 × 258 cm, Venice, Accademia (S). GIORGIONE: "*The Castelfranco Madonna*", c. 1504, oil on panel, 200 × 152 cm, Castelfranco Veneto, S. Liberale (S).

140–141 Giorgione: The Tempest

GIORGIONE: "*The Three Philosophers*", after 1505?, oil on canvas, 123 × 144.5 cm, Vienna, Kunsthistorisches Museum (Photo Meyer); "*Laura*", 1506, oil on canvas, 41 × 33.5 cm, Vienna, Kunsthistorisches Museum (Photo Meyer); *Venus*, c. 1509-10?, oil on canvas, 108 × 175 cm, Dresden, Gemäldegalerie (S); *The tempest*, 1st decade of the 16th century, oil on canvas, 83 × 73 cm, Venice, Accademia (S).

142–143 Titian

TITIAN: *An allegory of Prudence*, c. 1570, oil on canvas, 76 × 69 cm, London, National Gallery; "*Noli Me Tangere*" (Christ with Mary Magdalen), c. 1512, oil on canvas, 109 × 91 cm, London, National Gallery; "*Le Concert Champêtre*" (Pastoral music-making), c. 1510, oil on canvas, 110 × 138 cm, Paris, Louvre (S); *The Assumption of the Virgin*, 1516-18, oil on panel, 690 × 360 cm, Venice, S. Maria dei Frari (S); Apse of S. Maria dei Frari (S); "*The Pesaro Madonna*", 1519-26, oil on canvas, 485 × 270 cm, S. Maria dei Frari (S); *The girl in a fur wrap*, c. 1535, oil on canvas, 95 × 63 cm, Vienna, Kunsthistorisches Museum (S); "*The Young Englishman*", c. 1540, oil on canvas, 111 × 93 cm, Florence, Palazzo Pitti (S); *Charles V at Mühlberg*, 1548, oil on canvas, 332 × 279 cm, Madrid, Prado (S); *Pope Paul III and his grandsons*, 1546, oil on canvas, 200 × 173 cm, Naples, Museo di Capodimonte (S); *Pietà*, 1576, oil on canvas, 353 × 248 cm, Venice, Accademia (S).

144–145 Titian: The Rape of Europa

TITIAN: *The rape of Europa*, 1562, oil on canvas, 178 × 204 cm, Boston, Isabella Stewart Gardner Museum; *Sacred and Profane Love*, c. 1514, oil on canvas, 118 × 279 cm, Rome, Galleria Borghese (S); *The Andrian Bacchanal*, 1518-23, oil on canvas, 175 × 193 cm, Madrid, Prado (S); "*The Venus of Urbino*", c. 1538, oil on canvas, 119.5 × 165 cm, Florence, Uffizi (S); *Diana and Actaeon*, 1558, oil on canvas, 188 × 206 cm, Edinburgh, National Gallery of Scotland (S); *The death of Actaeon*, after 1562, oil on canvas, 179 × 198 cm, London, National Gallery.

146–147 The High Renaissance 2

SEBASTIANO DEL PIOMBO: The Viterbo *Pietà*, c. 1515, oil on panel, 270 × 190 cm, Viterbo, Museo Civico (S); *Pope Clement VII*, 1526, oil on canvas, 140 × 98 cm, Naples, Museo di Capodimonte (S). PALMA VECCHIO: *The three sisters*, c. 1520-25, oil on panel, 88 × 123 cm, Dresden, Gemäldegalerie (S); *Venus and Cupid*, c. 1520, oil on panel, 118 × 209 cm, Cambridge, Fitzwilliam Museum. LOTTO: *The Madonna and Child with St John and St Peter Martyr*, 1503, oil on panel, 55 × 85 cm, Naples, Museo di Capodimonte

(S); *Andrea Odoni*, 1527, oil on canvas, 101 × 104 cm, Hampton Court, Royal Collection (by gracious permission of Her Majesty the Queen). TULLIO LOMBARDO: *Bacchus and Ariadne*, c. 1520-30, marble, 56 × 72 cm, Vienna, Kunsthistorisches Museum (Photo Meyer). RICCIO: *Pan*, 1st quarter of the 16th century, bronze, height 150 cm, Oxford, Ashmolean Museum; The Easter Candlestick, 1507-15, bronze, height 3.9 m, Padua, S. Antonio (S). JACOPO SANSOVINO: *Mercury*, c. 1540-45, bronze, height 149 cm, Venice, Loggetta (S).

148–149 The High Renaissance 3

CORREGGIO: "*La Notte*" (The Adoration of the shepherds), c. 1527-30, oil on panel, 256 × 188 cm, Dresden, Gemäldegalerie (Gerhard Reinhold, Leipzig-Molkau/Joseph P. Ziolo); *The vision of St John on Patmos* in the dome of S. Giovanni Evangelista, 1521, fresco, Parma (S); *The Assumption* in the dome of Parma Cathedral, 1526-30, fresco (S); *Danaë*, c. 1531, oil on canvas, 193 × 161 cm, Rome, Galleria Borghese (S). MORETTO: *St Justina*, c. 1530, oil on panel, 98 × 137 cm, Vienna, Kunsthistorisches Museum (Photo Meyer); *A gentleman*, 1526, oil on canvas, 198 × 88 cm, London, National Gallery. MORONI: "*Titian's Schoolmaster*", undated, oil on canvas, Washington, National Gallery of Art, Widener collection. SAVOLDO: *Mary Magdalen*, c. 1530?, oil on canvas, 86 × 79 cm, London, National Gallery. DOSSO DOSSI: *Melissa*, c. 1523, oil on canvas, 176 × 174 cm, Rome, Galleria Borghese (S). PORDENONE: *The Crucifixion*, in Cremona Cathedral, 1520-21, fresco (S).

150–151 Dürer and Grünewald

DÜRER: *The piece of turf*, 1503, watercolour and gouache on paper, 41 × 31.5 cm, Vienna, Albertina (S); *The Adoration of the Magi*, 1504, oil on panel, 99 × 113.5 cm, Florence, Uffizi (S); *A young Venetian woman*, 1505, oil on panel, 33 × 26 cm, Vienna, Kunsthistorisches Museum (Photo Meyer); *The Adoration of the Trinity*, 1511, oil on panel, 144 × 131 cm, Vienna, Kunsthistorisches Museum (S); *Erasmus of Rotterdam*, 1526, drypoint etching, 25 × 19 cm, Vienna, Albertina (S); *Self-portrait*, 1498, oil on panel, 52 × 41 cm, Madrid, Prado (S); "*The Four Apostles*", 1526, oil on panel, 214.5 × 76 cm, Munich, Alte Pinakothek (S). GRÜNEWALD: The Isenheim altarpiece, 1515, oil on panel (*The Crucifixion*, 269 × 307 cm; *The Resurrection* and *The Annunciation*, both 269 × 143 cm; *The temptation of St Anthony*, 265 × 139 cm), Colmar, Musée d'Unterlinden (all details

152–153 Dürer: The Four Horsemen of the Apocalypse

DÜRER: The Apocalypse: *The angels staying the four winds; The Whore of Babylon; The four horsemen*, all 1498, woodcuts, all 39 × 28 cm (*The angels* and *The Whore*, London, British Museum; *The Horsemen*, Florence, Uffizi, Gabinetto Nazionale dei Disegni e Stampe (S); *Melancolia 1*, 1514, drypoint etching, 24 × 19 cm, Vienna, Albertina (S); *Adam and Eve*, 1504, drypoint etching, 25 × 19 cm, London, British Museum.

154–155 Painting in Germany

SCHONGAUER: "*Noli Me Tangere*", after 1471, oil on panel, 115 × 84 cm, Colmar, Musée d'Unterlinden (Colorphoto Hans Hinz); *The temptation of St Anthony*, c. 1470, drypoint engraving, 31 × 23 cm (The Fotomas Index). PACHER: *The Four Doctors of the Church*, central panel, c. 1483, oil, 212 × 200 cm, Munich, Alte Pinakothek (S). CRANACH: *Martin Luther*,

1521, oil on panel, 37.5 × 23.5 cm, Florence, Uffizi (S); *Adam and Eve*, 1526, oil on panel, 117 × 80.5 cm, London, Courtauld Institute Galleries. THE MASTER OF THE ST BARTHOLOMEW ALTARPIECE: *St Bartholomew with SS. Agnes and Cecily*, central panel, c. 1505-10, oil, 129 × 161 cm, Munich, Alte Pinakothek (S). ALTDORFER: *St George and the dragon*, 1510, oil on panel, 28 × 22.5 cm, Munich, Alte Pinakothek (S); *The battle of Alexander and Darius on the Issus*, 1529, oil on panel, 158 × 120 cm, Munich, Alte Pinakothek (S). BURGKMAIR: *Hans Baumgartner*, 1512, chiaroscuro woodcut, 29 × 23 cm, London, British Museum (The Fotomas Index). BALDUNG GRIEN: *Death and the Maiden*, 1517, oil on panel, 28 × 16 cm, Basel, Öffentliche Kunstsammlungen (Colorphoto Hans Hinz).

156–157 Holbein: The Ambassadors

HOLBEIN: "*The Ambassadors*", 1533, tempera on panel, 206 × 209 cm, London, National Gallery; *The dead Christ*, 1521, tempera on panel, 30.5 × 200 cm, Basel, Öffentliche Kunstsammlungen (Colorphoto Hans Hinz); *The Virgin and Child with the Meyer family*, c. 1528, tempera on panel, 146.5 × 102 cm, Darmstadt, Schloss Darmstadt (S); *Sir Thomas More*, 1527, tempera on panel, 74 × 59 cm, New York, The Frick Collection (copyright); *Jane Seymour*, c. 1535, chalk and primer on paper, 50 × 29 cm, Windsor, The Royal Library (by gracious permission of Her Majesty the Queen); *King Henry VIII*, 1542, tempera on panel, 92 × 67 cm, Castle Howard, Howard Collection.

158–159 Sculpture in Germany

GERHAERTS: "*Self-portrait*", c. 1467, sandstone, height 43 cm, Strasbourg, Musée de l'Oeuvre de Notre Dame (S). RIEMENSCHNEIDER: The altar at St Jakob, Rothenburg, 1501-05, varnished wood, height of figures about 1 m (Tony Schneiders/Joseph P. Ziolo). PACHER: The high altar of St Wolfgang, c. 1471-81, gilded and painted wood, central field 3.9 × 3.3 m (Snark International/Joseph P. Ziolo). STOSS: The high altar at St Mary's, Cracow, 1477-89, painted wood, height of tallest figure 2.8 m (Almasy Archives/Joseph P. Ziolo); *The Virgin and Child*, c. 1520, painted stone, height about 2 m, Nuremberg, Germanisches Nationalmuseum (S). KRAFT: The Tabernacle at St Lorenz, 1493-96, sandstone, Nuremberg, *in situ* (S). THE VISCHER FAMILY: The Shrine of St Sebaldus, 1507-19, bronze, height of free-standing figures 90 cm, Nuremberg, St Sebaldus (Bildarchiv Preussischer Kulturbesitz). MEIT: *Judith with the head of Holofernes*, 1510-15, alabaster, height 30 cm, Munich, Bayerisches Nationalmuseum (S). LOSCHER: Fragments from the Fugger chapel in Augsburg: *Putti*, 1515 height about 30 cm, Vienna, Kunsthistorisches Museum (S). FLOTNER: The Apollo Fountain, 1532, bronze, height of Apollo 76 cm, Nuremberg, Hof Pellerhaus (S).

160–161 Netherlandish and French Painting

MABUSE: The Malvagna triptych: *The Virgin and Child, and saints*, 1510-15, oil on panel, height 45 cm, Palermo, Galleria Nazionale (S). MASSYS: *The banker and his wife*, 1514, oil on panel, 74 × 68 cm, Paris, Louvre; *Egidius* (Peter Giles), 1517, oil on canvas, 224.5 × 219 cm, Private Collection. ORLEY: *Georges de Zelle*, 1519, oil on panel, 39 × 32 cm, Brussels, Musées Royaux des Beaux-Arts (S). PATENIER: *The Flight into Egypt*, undated,

oil on panel, Antwerp, Musée Royal des Beaux-Arts (S). MASSYS AND PATENIER: *The Crucifixion; saints and donors*, c. 1520-30, oil on panel, central panel 156 × 92 cm, Antwerp, Musée Mayer van den Bergh (S). VAN SCOREL: *Mary Magdalen*, c. 1540, oil on panel, 67 × 76.5 cm, Amsterdam, Rijksmuseum. HEEMSKERK: *Self-portrait beside the Colosseum*, 1533, oil on panel, 44 × 54 cm, Cambridge, Fitzwilliam Museum. CLOUET: *A lady in her bath*, c. 1550?, oil on panel, 92 × 81 cm, Washington, National Gallery of Art, Samuel H. Kress collection. VAN LEYDEN: *The engagement*, c. 1520-30, 30 × 32 cm, Antwerp, Musée Royal des Beaux-Arts (S). FONTAINEBLEAU SCHOOL: *Three minions*, c. 1580-89, oil on slate, 57 × 57 cm, Milwaukee, Art Center, Gift of the Women's Exchange.

162–163 Bruegel: August

AERTSEN: *Christ in the house of Martha and Mary*, 1559, oil on panel, 126 × 200 cm, Rotterdam, Museum Boymans-van Beuningen. BRUEGEL: *January* (The hunters in the snow), 1565, oil on panel, 117 × 162 cm, Vienna, Kunsthistorisches Museum (S); *August* (The corn harvest), 1565, oil on panel, 118 × 161 cm, New York, Metropolitan Museum of Art, Rogers Fund; *The peasant wedding*, c. 1567, oil on panel, 114 × 163 cm, Vienna, Kunsthistorisches Museum (S); *The procession to Calvary*, 1564, oil on panel, 124 × 177 cm, Vienna, Kunsthistorisches Museum (S); *The Adoration of the Magi*, 1564, oil on panel, 111 × 83 cm, London, National Gallery.

164–165 Mannerist Painting in Italy 1

RAPHAEL: *The Transfiguration*, 1520, oil on panel, 400 × 279 cm, Vatican, Pinacoteca (S). MICHELANGELO: *Victory*, c. 1530, marble, height 145.5 cm, Florence, Palazzo Vecchio (S). ANDREA DEL SARTO: "*The Madonna of the Harpies*", 1517, oil on panel, 208 × 178 cm, Florence, Uffizi (S). GIULIO ROMANO: The *Sala dei Giganti*, 1534, fresco, Mantua, Palazzo del Té (S). PONTORMO: *Joseph in Egypt*, c. 1515, oil on panel, 96.5 × 109.5 cm, London, National Gallery; *The Deposition*, c. 1526-28, oil on panel, 313 × 109 cm, Florence, S. Felicità (S); *The halberdier*, c. 1529-30, oil on panel, 92 × 72 cm, New York, Private Collection, on loan to the Frick Collection. ROSSO: *The Deposition*, 1521, oil on panel, 375 × 196 cm, Volterra, Galleria Communale (S). BECCAFUMI: *The birth of the Virgin*, c. 1543, oil on panel, 233 × 145 cm, Siena, Pinacoteca (S). PARMIGIANINO: "*The Madonna of the Long Neck*", c. 1535, oil on panel, 216 × 132 cm, Florence, Uffizi (S); "*The Priest*", c. 1523, oil on panel, 89 × 64 cm, London, National Gallery (Angelo Hornak).

166–167 Mannerism 2

BRONZINO: Chapel of Eleanora of Toledo, Palazzo Vecchio: *The crossing of the Red Sea*, 1542-44, fresco, Florence (S); *Venus, Cupid, Folly and Time*, c. 1545, oil on panel, 146 × 116 cm, London, National Gallery; *Eleanora of Toledo*, c. 1546?, oil on panel, 83 × 60 cm, Florence, Uffizi (S). SALVIATI: Frescos in the Palazzo Sacchetti: *Bathsheba going to David*, c. 1552-54, Rome (S). VASARI: *Alessandro de' Medici*, c. 1533, oil on panel, Florence, Museo Mediceo (S); Cosimo I's *studiolo*, Palazzo Vecchio, 1570-73, Florence (S). ROSSO AND PRIMATICCIO: The Gallery of Francis I, Château de Fontainebleau (Giraudon). PRIMATICCIO: The Room of the Duchesse d'Etampes, Château de Fontainebleau (René Roland). GOUJON: Panel from the Fountain of the Innocents: *Nymphs and tritons*, 1547-79, marble, height about 1 m,

509

Paris, Louvre (Documentation Photographique de la Réunion des Musées Nationaux). CELLINI: "*The Nymph of Fontainebleau*", 1540-43, bronze, 203 × 408 cm, Paris, Louvre (Documentation Photographique de la Réunion des Musées Nationaux). PILON: The tomb of Henri II and Catherine de Médicis, 1563-70, marble with bronze effigies, St-Denis, St Denis (René Roland).

168–169 Mannerist Sculpture in Italy
FLORENCE: The Piazza della Signoria (S). AMMANATI: The Fountain of Neptune, 1571-75, marble with bronze figures, Florence, Piazza della Signoria (S). CELLINI: *Perseus*, finished 1554, bronze, height of statue with base 3.2 m, Florence, Loggia dei Lanzi (S); The salt-cellar of Francis I, c. 1540, gold and enamel, height 33.5 cm, Vienna, Kunsthistorisches Museum (Photo Meyer). GIAMBOLOGNA: *Mercury*, c. 1564, bronze, height 180 cm, Florence, Bargello (S); *Apollo*, 1570-73, bronze, height 88 cm, Florence, Palazzo Vecchio (S); *Hercules and the centaur*, 1594-1600, marble, height 270 cm, Florence, Loggia dei Lanzi (S); *Duke Cosimo I*, 1587-95, bronze, height 450 cm, Florence, Piazza della Signoria (S); *The rape of the Sabine*, 1579-83, marble, height of statue with base 410 cm, Florence, Loggia dei Lanzi (both views S).

170–171 Painting in Venice
TINTORETTO: *St Mark frees a Christian slave*, 1548, oil on canvas, 410 × 545 cm, Venice, Accademia (S); *Bacchus and Ariadne*, 1578, oil on canvas, 146 × 167 cm, Venice, Doge's Palace (S); *The finding of the body of St Mark*, 1562-66, oil on canvas, 399 × 399 cm, Milan, Brera (S); *The Last Supper*, 1592-94, oil on canvas, 366 × 568 cm, Venice, S. Giorgio Maggiore (S); *Susannah and the Elders*, c. 1557, oil on canvas, 147 × 193 cm, Vienna, Kunsthistorisches Museum (S). BASSANO: *The Adoration of the shepherds*, 1568, oil on canvas, 238 × 149 cm, Bassano, Museo Civico (S). VERONESE: *The feast in the house of Levi*, 1573, oil on canvas, 554 × 1280 cm, Venice, Accademia (S); *Mars and Venus united by Love*, c. 1580, oil on canvas, 205 × 160 cm, New York, Metropolitan Museum of Art, Kennedy Fund; A fresco from the Villa Maser: *Giustiniana Barbaro and her nurse*, c. 1561, width 1.6 m, Maser, Villa Barbaro (S).

172–173 Tintoretto: The San Rocco Crucifixion
TINTORETTO: *The Crucifixion*, 1565, oil on canvas, 536 × 1224 cm, Venice, Scuola di San Rocco (The Mansell Collection; detail S); *Self-portrait*, 1573, oil on canvas, 72 × 57 cm, Scuola di San Rocco (S); *The Flight into Egypt*, 1583-87, oil on canvas, 422 × 580 cm, Scuola di San Rocco (S); *The road to Calvary*, 1566, oil on canvas, 515 × 390 cm, Scuola di San Rocco (S); *The temptation of Christ*, 1579-81, oil on canvas, 539 × 330 cm, Scuola di San Rocco (S).

174–175 Art in Spain
MORO: *Mary I of England*, 1554, oil on panel, 109 × 84 cm, Madrid, Prado (Bildarchiv Preussischer Kulturbesitz). LEONI: The tomb of Charles V, 1593-98, bronze, Madrid, Escorial. EL GRECO: *Christ driving the money-changers from the temple*, c. 1572, oil on canvas, 117.5 × 150 cm, Minneapolis, The Minneapolis Institute of Arts; *Giulio Clovio*, c. 1570, oil on canvas, 65 × 95 cm, Naples, Museo di Capodimonte (S); "*El Espolio*" (The disrobing of Christ), 1577-79, oil on canvas, 285 × 173 cm, Toledo, Cathedral (S); *The burial of Count Orgaz*, 1586, oil

on canvas, 487.5 × 360 cm, Madrid, Prado (Bildarchiv Preussischer Kulturbesitz); *Cardinal Fernando Nino de Guevara*, c. 1600, oil on canvas, 171.5 × 108cm, New York, Metropolitan Museum of Art, H.O. Havemeyer collection; *View of Toledo*, c. 1595-1600, oil on canvas, 121.5 × 108.5 cm, New York, Metropolitan Museum of Art, H.O. Havemeyer collection; *The Immaculate Conception*, c. 1607-13, oil on canvas, 236 × 118 cm, Toledo, Museo de Santa Cruz (Salmar).

176–177 The Baroque Era
VERSAILLES: *The Galerie des Glaces*, begun 1678, by Lebrun (A. F. Kersting). TWICKENHAM: Strawberry Hill, begun 1747, by Horace Walpole (A. F. Kersting).

178–179
(Map by Colin Salmon and Dinah Lone)

180–181 Michelangelo de Caravaggio
CARAVAGGIO: *Boy bitten by a lizard*, c. 1596-1600, oil on ___ vas, 66 × 50 cm, Florence, Longhi Collection (S); *The fortune teller*, c. 1594-95, oil on canvas, 99 × 131 cm, Paris, Louvre (S); *St John the Baptist*, 1597-98, oil on canvas, 132 × 97cm, Rome, Capitoline Museum (S); *The Supper at Emmaus*, c. 1596-1600, oil on canvas, 141 × 196 cm, London, National Gallery; *The Supper at Emmaus*, c. 1605-06, oil on canvas, 141 × 175 cm, Milan, Brera (S); *St Matthew and the angel* (1st version), c. 1599, oil on canvas, 223 × 183 cm, formerly Berlin, Staatliche Museen, destroyed (S); *The Calling of St Matthew*, c. 1597-99, oil on canvas, 338 × 348 cm, Rome, S. Luigi dei Francesi (S); *The death of the Virgin*, 1605-06, oil on canvas, 369 × 245 cm, Paris, Louvre (S); *The Resurrection of Lazarus*, 1609, oil on canvas, 380 × 275 cm, Messina, Museo Nazionale (S).

182–183 Caravaggio: The Conversion of St Paul
CARAVAGGIO: *The crucifixion of St Peter*, 1600-01, oil on canvas, 230 × 175 cm, Rome, S. Maria del Popolo (S); *The conversion of St Paul*, 1600-01, oil on canvas, 230 × 175 cm, S. Maria del Popolo (S). DURER: "*The Large Horse*", 1505, etching, 17 × 21 cm, London, British Museum. MICHELANGELO: *The conversion of St Paul*, 1546-50, fresco, 6.1 × 6.5 m, Vatican, Cappella Paolina (S). MANTEGNA: *The dead Christ*, c. 1505, tempera on canvas, 66 × 81 cm, Milan, Brera (S). ANNIBALE CARRACCI: *The Assumption of the Virgin*, 1600-01, oil on panel, 245 × 155 cm, Rome, S. Maria del Popolo (S).

184–185 The Carracci and their Pupils
ANNIBALE CARRACCI: *The butcher's shop*, c. 1582, oil on canvas, 185 × 266 cm, Oxford, Christchurch Picture Gallery (Angelo Hornak); *Landscape with the Flight into Egypt*, c. 1604, oil on canvas, 122 × 230 cm, Rome, Palazzo Doria Pamphili (S); *Pietà*, c. 1599-1600, oil on canvas, 156 × 149 cm, Naples, Museo di Capodimonte (S); *A prisoner*, early 1590s, red chalk, 42 × 35 cm, Florence, Uffizi (S). AGOSTINO CARRACCI?: *Annibale Carracci*, late 1580s, oil on panel, 16 × 13 cm, Florence, Uffizi (S). AGOSTINO CARRACCI: *The last communion of St Jerome*, 1593-94, oil on canvas, 375 × 224 cm, Bologna, Pinacoteca (S). LUDOVICO CARRACCI: *The Madonna and Child with saints*, c. 1590, oil on canvas, 219 × 144 cm, Bologna, Pinacoteca (S). LANFRANCO: *The Virgin in glory*, detail of dome of S. Andrea della Valle, 1625-27, fresco, Rome (S). GUIDO RENI: *Atalanta and Hippomenes*, c. 1620, oil on canvas, 194

× 264 cm, Naples, Museo di Capodimonte (S). GUERCINO: *Profile head of a man*, undated, red chalk on paper, 18 × 16 cm, London, British Museum (John Freeman); *Aurora*, 1621-23, fresco, Rome, Villa Ludovisi (S). DOMENICHINO: *The martyrdom of St Cecilia*, 1611-14, fresco, Rome, S. Luigi dei Francesi (S).

186–187 Annibale Carraci: The Farnese Gallery
AGOSTINO CARRACCI: Cartoon for *Glaucus and Scylla* on the inner wall of the Farnese Gallery, c. 1597-99, on paper, 203 × 410cm, London, National Gallery. ANNIBALE CARRACCI: The Farnese Gallery: *The loves of the gods*, 1597-1600, fresco, length of ceiling 20 m, width 6.4 m (details, *Venus and Anchises*, S; *The triumph of Bacchus and Ariadne*, S), Rome, Palazzo Farnese (S). *View of the inner wall of the Farnese Gallery*, engraving by Giovanni Volpato, London, Victoria and Albert Museum (A. C. Coopers). RAPHAEL: The ceiling of the Villa Farnesina *loggia*, detail: *The marriage of Cupid and Psyche*, 1518, fresco, Rome (S).

188–189 The High Baroque in Rome
BERNINI: *Neptune and Triton*, 1620, marble, height 182 cm, London, Victoria and Albert Museum; *Apollo and Daphne*, 1622-24, marble, height 243 cm, Rome, Borghese Gallery (S); *David*, 1623, marble, height 170 cm, Rome, Borghese Gallery (S); *Cathedra Petri* (St Peter's Chair), 1656-66, stucco and bronze, Vatican, St Peter's (S); *Louis XIV*, 1665, marble, height 80 cm, Versailles, Salon de Diane (Documentation Photographique de la Réunion des Musées Nationaux); *Costanza Buonarelli*, c. 1635, marble, height 72 cm, Florence, Bargello (S); *The four rivers*, 1646-51, marble, Rome, Piazza Navona (S). *The Piazza and Basilica of St Peter's, Rome*, engraving by Francesco Piranesi, 38 × 54 cm, London, British Museum. PIETRO DA CORTONA: *Allegory of divine Providence and Barberini power*, 1633-39, fresco, Rome, Palazzo Barberini (S).

190–191 Bernini: The Cornaro Chapel
BERNINI: The Cornaro Chapel, S. Maria della Vittoria, 1647-52, marble, bronze, stucco, gilt wood and fresco, Rome (whole and details S).

192–193 French Art 1
LOUIS LE NAIN: *The peasants' meal*, 1642, oil on canvas, 211 × 122 cm, Paris, Louvre (S). ANTOINE LE NAIN: *A woman and five children*, 1642, oil on copper, 22 × 29.5 cm, London, National Gallery. MATHIEU LE NAIN: *The guardroom*, 1643, oil on canvas, 115 × 134 cm, Paris, Louvre (Photo Bulloz). THE LE NAIN BROTHERS: *The Adoration of the shepherds*, c. 1640, 120 × 90 cm, sold Christie's, London, 1979 (Photo Bulloz). GEORGES DE LA TOUR: *St Jerome*, 1621-23, oil on canvas, 157 × 100cm, Grenoble, Musée des Beaux-Arts (Cooper-Bridgeman Library); *A woman crushing a flea*, c. 1645, oil on canvas, 120 × 90 cm, Nancy, Musée Historique Lorrain (Cooper-Bridgeman Library); *The new-born child*, c. 1650, oil on canvas, 76 × 91 cm, Rennes, Musée des Beaux-Arts. VOUET: *St Charles Borromeo*, late 1630s, oil on canvas, 360 × 260 cm, Paris, Louvre (S). CHAMPAIGNE: *Ex voto*, 1662, oil on canvas, 165 × 229 cm, Paris, Louvre (Documentation Photographique de la Réunion des Musées Nationaux); *Cardinal Richelieu*, c. 1635-40, oil on canvas, 221 × 154 cm, Paris, Louvre (S).

194–195 Poussin: The Holy Family on the Steps
POUSSIN: *The Holy Family on the steps*,

1648, oil on canvas, 69 × 97.5 cm, Washington, National Gallery of Art, Samuel H. Kress collection (S); *Self-portrait*, 1649-50, oil on canvas, 98 × 74 cm, Paris, Louvre (S); *The poet's inspiration*, c. 1628-29, oil on canvas, 184 × 214 cm, Paris, Louvre (S); Preparatory drawing for *The Holy Family*, 1648, pen and bistre and chalk on paper, 18 × 24 cm, Paris, Louvre (Documentation Photographique de la Réunion des Musées Nationaux). RAPHAEL: "*The Madonna of the Fish*", c. 1513, 215 × 158 cm, Madrid, Prado (S). ROME, ESQUILINE: "*The Aldobrandini Marriage*", 1st century BC, fresco, 91 × 242 cm, Vatican, Museum (S).

196–197 Landscape Painting in Italy
ELSHEIMER: *Rest on the Flight to Egypt*, 1609, oil on copper, 31 × 41 cm, Munich, Alte Pinakothek (S). PAUL BRIL: *Landscape with hunting scene and the Baths of Titus*, c. 1620, London, Private Collection (S). POUSSIN: *The burial of Phocion*, 1648, oil on canvas, 114 × 175 cm, Ludlow, Earl of Plymouth Collection (S); *Summer, or Ruth and Boaz*, 1660-64, oil on canvas, 118 × 160 cm, Paris, Louvre (S). CLAUDE: *Tree*, c. 1650, chalk and wash on paper, 25 × 18 cm, London, British Museum; *Ulysses returning Chryseis to her father*, 1644, oil on canvas, 119 × 150 cm, Paris, Louvre (S); *Egeria mourning over Numa*, 1669, oil on canvas, 155 × 199 cm, Naples, Museo di Capodimonte (S); *Self-portrait*, after 1644, frontispiece to the Liber Veritatis, drawing, 15 × 12 cm, London, British Museum. SALVATOR ROSA: *Landscape with a bridge*, c. 1640, oil on canvas, 106 × 127 cm, Florence, Palazzo Pitti (S). GASPARD DUGHET: *View near Albano*, c. 1630-40, oil on canvas, 48 × 66 cm, London, National Gallery.

198–199 French Art 2
LE SUEUR: *The Muses*, c. 1647-49, from the Cabinet d'Amour in the Hotel Lambert, oil on canvas, 128 × 128 cm, Paris, Louvre (Documentation Photographique de la Réunion des Musées Nationaux). LEBRUN: *Louis XIV visiting the Gobelins factory*, 1663-75, oil on canvas, height 256 cm, Paris, Louvre (Documentation Photographique de la Réunion des Musées Nationaux); *Louis XIV adoring the risen Christ*, 1674, oil on canvas, 473 × 261 cm, Lyons, Musée des Beaux-Arts (Giraudon). COYSEVOX: *Louis XIV*, 1687-89, marble, height about 2.5 m, Paris, Musée Carnavalet (Photo Bulloz). SARRAZIN: Caryatids on the Pavillon d'Horloge of the Louvre, 1641, marble (Giraudon). MICHEL ANGUIER: *Amphitrite*, 1680, marble, height about 2 m, Paris, Louvre (Photo Bulloz). GIRAUDON: *Apollo tended by nymphs*, 1660, marble, height of figures about 1.7 m, Versailles (Ken Takase/Joseph P. Ziolo). BOURDON: Mythological drawing, undated (Photo Bulloz). LEBRUN AND COYSEVOX: The *Salon de la Guerre* (Hall of War) at Versailles, 1681-83, marble and mixed media, Versailles (S). PUGET: *Milo of Crotona*, 1683, marble, height 269 cm, Paris, Louvre (S). RIGAUD: *Louis XIV*, 1701, oil on canvas, 274 × 177 cm, Paris, Louvre (S).

200–201 Art in Flanders
RUBENS AND "VELVET" BRUEGHEL: *The Virgin and Child in a garland*, c. 1620, oil on panel, 79 × 65 cm, Madrid, Prado (S). PAUL DE VOS: *The stag hunt*, c. 1630-40, oil on canvas, 212 × 347 cm, Madrid, Prado (S). VAN DYCK: *Marquesa Caterina*, c. 1625, oil on canvas, 230 × 170 cm, Paris, Louvre (S). SNYDERS: *The fruit-seller*, before 1636, oil on canvas, 153 × 214 cm, Madrid, Prado (S). CORNELIS DE VOS: *The artist and his family*, 1621, oil on canvas,

188 × 162 cm, Brussels, Musées Royaux des Beaux-Arts (S). JORDAENS: *The riding academy*, c.1635, oil on canvas, 90 × 153 cm, Ottawa, National Gallery of Canada; *The King drinks*, c.1645, oil on canvas, 156 × 210 cm, Brussels, Musées Royaux des Beaux-Arts (S). TENIERS: *The country fair*, c.1650, oil on canvas, 77 × 99 cm, Madrid, Prado (S); *The picture gallery of the Archduke Leopold*, c.1650, oil on canvas, 106 × 129 cm, Madrid, Prado (S).

202–203 Peter Paul Rubens

RUBENS: *Self-portrait*, c.1639, oil on canvas, 109 × 85 cm, Vienna, Kunsthistorisches Museum (S); *The Duke of Lerma*, 1603, oil on canvas, 289 × 205 cm, Madrid, Prado (S); *The horrors of war*, 1638, oil on canvas, 206 × 342 cm, Florence, Palazzo Pitti (S); *Self-portrait with Isabella Brandt*, 1609, oil on canvas, 178 × 136 cm, Munich, Alte Pinakothek (S); *Hélène Fourment in a fur wrap*, c.1638, oil on panel, 175 × 96 cm, Vienna, Kunsthistorisches Museum (S); *The rape of the daughters of Leucippus*, c.1618, oil on canvas, 222 × 209 cm, Vienna, Kunsthistorisches Museum (S); The ceiling of the Banqueting House: *The apotheosis of James I*, 1629-34, London, Whitehall (Cooper-Bridgeman Library); *The Château de Steen*, c.1636, oil on panel, 131 × 229 cm, London, National Gallery; The Luxembourg Palace cycle: *Marie de Médicis lands at Marseilles*, 1622-25, oil on canvas, 394 × 295 cm, Paris, Louvre (S).

204–205 Rubens: The Descent from the Cross

RUBENS: *The Descent from the Cross*, 1611-14, oil on panel, 240 × 310 cm, Antwerp, Cathedral (S); *The raising of the Cross*, 1610-11, oil on canvas, 240 × 310 cm, Antwerp, Cathedral (A. De Belder/Joseph P. Ziolo); Drawing of the *Laocoön*, c.1606, black chalk on paper, 43 × 25 cm, Milan, Biblioteca Ambrosiana; Copy after Caravaggio's *The Entombment*, c.1600, reworked c.1613, oil on panel, 88 × 65 cm, Ottawa, National Gallery of Canada. DANIELE DA VOLTERRA: *The Descent from the Cross*, 1541, fresco, Rome, S. Trinita ai Monti (S).

206–207 Art in England

EWORTH: *Queen Mary I*, 1554, oil on panel, 21 × 17 cm, London, National Portrait Gallery. HILLIARD: *Young man in a garden*, c.1588, watercolour on vellum, 13.5 × 7 cm, London, Victoria and Albert Museum. VAN DYCK: *William Fielding, Earl of Denbigh*, c.1633, oil on canvas, 248 × 149 cm, London, National Gallery; *Lady Elizabeth Thimbleby and Dorothy, Viscountess Andover*, c.1637, oil on canvas, 130 × 140 cm, London, National Gallery; *Charles I hunting*, c.1638, oil on canvas, 272 × 213 cm, Paris, Louvre (Documentation Photographique de la Réunion des Musées Nationaux); *Charles I on horseback*, c.1638, oil on canvas, 367 ×.292 cm, London, National Gallery; *Charles I from three angles*, c.1636, oil on canvas, 84.5 × 100 cm, Windsor, Royal Collection (by gracious permission of Her Majesty the Queen). COOPER: *Oliver Cromwell*, 1656, colour on card, height 7 cm, London, National Portrait Gallery. LELY: *Anna, Countess of Shrewsbury*, c.1670, oil on canvas, 100 × 61 cm, London, National Portrait Gallery. DOBSON: *A cavalier*, c.1643, oil on canvas, 95 × 76 cm, London, National Maritime Museum. KNELLER: *Jacob Tonson*, c.1717, oil on canvas, 91 × 71 cm, London, National Portrait Gallery. BARLOW: *Buzzards about to attack some owlets*, undated, oil on canvas, 106 × 137 cm,

London, Tate Gallery.

208–209 Art in Spain

RIBALTA: *St Bernard embracing Christ*, c.1620-28, oil on canvas, 158 × 113 cm, Madrid, Prado (S). RIBERA: *The bearded woman*, 1631, oil on canvas, 196 × 127 cm, Toledo, Hospital Tavera, Fondacion Lerma (S); *The martyrdom of St Bartholomew*, c.1630, oil on canvas, 234 × 234 cm, Madrid, Prado (S); *The mystic marriage of St Catherine*, 1648, oil on canvas, 201 × 152 cm, New York, Metropolitan Museum of Art, Samuel D. Lee Fund. MENA: *Mary Magdalen*, 1644, painted wood, height about 1.5 m, Valladolid, Museo Nacional de Escultura (S). ZURBARÁN: *St Anthony of Padua with the infant Christ*, 1650s, oil on canvas, 148 × 108 cm, Madrid, Prado (S); *Hercules seared by the poisoned robe*, 1634, oil on canvas, 136 × 167 cm, Madrid, Prado (S); *Still life*, c.1664?, oil on canvas, 46 × 84 cm, Madrid, Prado (S). MURILLO: *Boys playing dice*, undated, oil on canvas, 146 × 108 cm, Munich, Alte Pinakothek (S); *The Immaculate Conception*, c.1655-60, oil on canvas, 206 × 144 cm, Madrid, Prado (S). VALDES LEAL: *The triumph of Death*, 1672, oil on canvas, 220 × 216 cm, Seville, Hospital de la Caridad (S).

210–211 Velazquez: Las Meninas

VELAZQUEZ: *Christ in the house of Mary and Martha*, 1618, oil on canvas, 60 × 103 cm, London, National Gallery; *The tapestry weavers*, c.1654, oil on canvas, 220 × 289 cm, Madrid, Prado (S); *The Infanta Margarita*, c.1656, oil on canvas, 70 × 59 cm, Paris, Louvre (S); *Philip IV*, 1634-35, oil on canvas, 191 × 126 cm, Madrid, Prado (S); *"Las Meninas"* (The maids of honour), 1656, oil on canvas, 318 × 276 cm, Madrid, Prado (S).

212–213 Art in the Dutch Republic

HOOGSTRATEN: *The slippers*, c.1660-75, oil on canvas, 103 × 71 cm, Paris, Louvre (Documentation Photographique de la Réunion des Musées Nationaux). SAENREDAM: *St John's Church, Haarlem*, 1645, oil on canvas, 49 × 42 cm, Utrecht, Centraal Museum. VAN DE CAPPELLE: *The large ferry*, 1660s, oil on canvas, 122 × 154.5 cm, London, National Gallery. REMBRANDT: *The syndics of the Cloth Guild*, 1662, oil on canvas, 191 × 279 cm, Amsterdam, Rijksmuseum; *Two women teaching a child to walk*, c.1637, chalk on paper, 10 × 13 cm, London, British Museum (The Fotomas Index); *Four orientals beneath a tree*, c.1654, pen and bistre, wash on paper, 19 × 12 cm, London, British Museum (The Fotomas Index); HONTHORST: *The banquet*, 1620, oil on canvas, 138 × 204 cm, Florence, Palazzo Pitti (S); *William of Orange*, after 1637, oil on canvas, 130 × 108 cm, The Hague, Mauritshuis (S). LASTMAN: *Juno discovering Jupiter with Io*, 1618, oil on panel, 54 × 78 cm, London, National Gallery. REMBRANDT: *A girl sleeping*, c.1656, pen and bistre on paper, 22 × 20 cm, London, British Museum (The Fotomas Index).

214–215 Hals: A Banquet of the St George Civic Guard

VERONESE: *The feast at Cana*, 1559-60, oil on canvas, 660 × 990 cm, Paris, Louvre (S). CORNELIS VAN HAARLEM: *The banquet of Haarlem guardsmen*, 1583, 156.5 × 222 cm, Haarlem, Frans Hals Museum. FRANS HALS: *The banquet of the St George Civic Guard*, 1616, oil on canvas, 175 × 324 cm, Haarlem, Frans Hals Museum; *The regents of the St Elizabeth Hospital*, c.1641, oil on canvas, 153 × 252 cm, Haarlem, Frans Hals Museum; *"The Laughing Cavalier"*, 1624, oil on canvas,

86 × 89 cm, London, Wallace Collection; *The banquet of the St George Civic Guard*, c.1627, oil on canvas, 179 × 257.5 cm, Haarlem, Frans Hals Museum; *Willem Croes*, c.1660, oil on canvas, 47 × 34 cm, Munich, Alte Pinakothek (S).

216–217 Rembrandt van Rijn

REMBRANDT: *Self-portrait in studio attire*, c.1650-60, oil on canvas, 25 × 31.5 cm, Amsterdam, Rembrandt Huis; *Balaam*, 1626, oil on panel, 65 × 47 cm, Paris, Musée Cognacq-Jay (Photo Bulloz); *The blinding of Samson*, 1636, oil on canvas, 236 × 302 cm, Frankfurt, Städelsches Kunstinstitut (S); *The anatomy lesson of Dr Tulp*, 1632, oil on canvas, 169.5 × 216.5 cm, The Hague, Mauritshuis (S); *The Descent from the Cross*, 1633, oil on panel, 89 × 65 cm, Munich, Alte Pinakothek (S); *The return of the Prodigal Son*, 1636, etching, 15.5 × 13.5 cm, Amsterdam, Rijksmuseum; *Nude on a mound*, 1631, etching, 18 × 16 cm, Paris, Bibliothèque Nationale (Immédiate 2); The Hundred-Guilder Print: *Christ healing the sick*, c.1648-50, drypoint and burin etching, 28 × 40 cm, London, British Museum (The Fotomas Index); *"The Night Watch"* (The Company of Frans Banning Cocq and Willem van Ruytenburch), 1642, oil on canvas, 359 × 438 cm, Amsterdam, Rijksmuseum; *"The Jewish Bride"*, c.1665, oil on canvas, 121.5 × 166.5 cm, Amsterdam, Rijksmuseum.

218–219 Rembrandt: The Self-Portrait at Kenwood

REMBRANDT: *Self-portrait* in Munich, detail, c.1629, oil on panel, 18 × 14 cm, Alte Pinakothek (S); *Self-portrait with Saskia*, c.1635, oil on canvas, 161 × 131 cm, Dresden, Gemäldegalerie; *Self-portrait* in Berlin, 1634, 55 × 46 cm, West Berlin, Staatliche Museen; *Self-portrait after Titian's "Ariosto"*, 1640, oil on canvas, 102 × 80 cm, London, National Gallery; *Self-portrait drawing by a window*, 1648, drypoint and burin etching, 16 × 13 cm, Paris, Bibliothèque Nationale (Immédiate 2); *Self-portrait* in Kenwood, London, c.1665, oil on canvas, 114 × 95 cm (The Greater London Council as Trustees of the Iveagh Bequest, Kenwood); *Self-portrait* in Vienna, 1652, oil on canvas, 113 × 81 cm, Kunsthistorisches Museum (Photo Meyer); *Self-portrait* in Cologne, c.1669, oil on canvas, 82 × 63 cm, Wallraf-Richartz Museum; *Self-portrait* in London, 1669, oil on canvas, 86 × 70.5 cm, National Gallery.

220–221 Dutch Landscape 1

CONINXLOO: *The forest*, c.1660, oil on panel, 56 × 85 cm, Copenhagen, Statens Museum fur Kunst. SAVERY: *Orpheus charming the animals*, c.1625, oil on panel, 62 × 131 cm, Verona, Museo di Castelvecchio (S). SEGHERS: *Landscape*, c.1630, oil on panel, 55 × 100 cm, Florence, Uffizi (S). AVERCAMP: *Winter landscape*, c.1610, oil on panel, 36 × 71 cm, The Hague, Mauritshuis (S). ESAIAS VAN DE VELDE: *The ferry-boat*, 1622, oil on panel, 75.5 × 113 cm, Amsterdam, Rijksmuseum. BOTH AND POELENBURGH: *Landscape with the Judgment of Paris*, undated, oil on canvas, 97 × 129 cm, London, National Gallery. BERCHEM: *The crab-fishers*, undated, oil on panel, 31.5 × 40 cm, York, City Art Gallery. REMBRANDT: *Landscape with a village*, c.1650, ink and wash on paper, 16 × 23 cm, London, British Museum (The Fotomas Index); *"Six's Bridge"*, 1645, etching, 13 × 22 cm, London, British Museum (The Fotomas Index).

222–223 Dutch Landscape 2

VAN GOYEN: *View of the village of Overschie*, c.1645, oil on panel, 66 × 96.5 cm, London, National Gallery. SALOMON VAN RUYSDAEL: *View of a river*, 1630s or early 1640s, 33 × 51 cm, The Hague, Mauritshuis (S). JACOB VAN RUISDAEL: *View of Haarlem*, 1660s, oil on canvas, 55 × 61 cm, The Hague, Mauritshuis (S). SAENREDAM: *St Bavo's, Haarlem*, 1660, oil on canvas, 70 × 55 cm, Worcester, Massachusetts, Art Museum. CUYP: *View of a road near a river*, mid-1650s, oil on canvas, 112 × 165 cm, London, Dulwich College Gallery (by permission of the Governors). POTTER: *Cows resting*, 1649, oil on canvas, 53 × 66 cm, Turin, Galleria Sabauda (S). HOBBEMA: *The avenue at Middelharnis*, 1689, oil on canvas, 103.5 × 141 cm, London, National Gallery. VAN DE CAPPELLE: *View of the mouth of the river Scheldt*, c.1650?, 69 × 91 cm, New York, Metropolitan Museum of Art, Michael Friedsam collection. WILLEM VAN DE VELDE THE YOUNGER: *The cannon shot*, c.1660, oil on canvas, 78.5 × 67 cm, Amsterdam, Rijksmuseum.

224–225 Ruisdael: The Jewish Cemetery

JACOB VAN RUISDAEL: The Dresden *Jewish cemetery*, 1660s, oil on canvas, 84 × 95 cm, Dresden, Gemäldegalerie (G. Reinhold, Leipzig-Molkau/Joseph P. Ziolo); The Detroit *Jewish cemetery*, 1660s, oil on canvas, 142 × 189 cm, Detroit, Institute of Arts, Gift of Julius H. Haass in memory of his brother; *Tombs in the Jewish cemetery at Ouderkerk*, c.1660, chalk and wash on paper, 19 × 27.5 cm, Haarlem, Teylers Museum; *Winter landscape*, c.1670, oil on canvas, 41 × 49 cm, Amsterdam, Rijksmuseum. REMBRANDT: *The stone bridge*, c.1637, oil on panel, 29 × 42.5 cm, Amsterdam, Rijksmuseum. EVERDINGEN: *A waterfall*, 1650, oil on canvas, 112 × 58 cm, Munich, Alte Pinakothek (S). KONINCK: *View over flat country*, 1650s or 1660s, 118 × 166 cm, Oxford, Ashmolean Museum.

226–227 Dutch Genre and Portraiture 1

BUYTEWECH: *Merry company*, c.1617-20, oil on panel, 49 × 68 cm, Rotterdam, Museum Boymans-van Beuningen. LEYSTER: *The offer*, c.1635?, oil on panel, 31 × 24 cm, The Hague, Mauritshuis (S). DIRCK HALS: *A garden party*, c.1624, oil on panel, 78 × 137cm, Amsterdam, Rijksmuseum. BROUWER: *Peasants in an inn*, c.1627-31, oil on panel, 19.5 × 26.5 cm, The Hague, Mauritshuis (S). ADRIAEN VAN OSTADE: *Inside an inn*, 1653, oil on panel, 40 × 56 cm, London, National Gallery. DOU AND REMBRANDT: *The blind Tobit and his wife Anna*, c.1630, oil on panel, 64 × 48 cm, London, National Gallery. MAES: *Admiral Binkes*, c.1670-77, oil on canvas, 44 × 33 cm, New York, Metropolitan Museum of Art, Gift of J. Pierpont Morgan. VAN DER HELST: *A young girl*, 1645, oil on canvas, 75 × 65 cm, London, National Gallery. MIERIS THE ELDER: *Soap bubbles*, 1663, oil on oak, 25.5 × 19 cm, The Hague, Mauritshuis (S). STEEN: *The doctor's visit*, c.1665, oil on panel, 48 × 41 cm, The Hague, Mauritshuis (S). METSU: *The hunter's gift*, c.1661-67, oil on panel, 56 × 50 cm, Florence, Uffizi (S).

228–229 Dutch Genre and Portraiture 2

FABRITIUS: *View of Delft*, 1652, oil on panel, 15.5 × 32 cm, London, National Gallery; *A goldfinch*, 1654, oil on canvas, 33.5 × 23 cm, The Hague, Mauritshuis (S). VERMEER: *The procuress*, 1656, oil on canvas, 143 × 130 cm, Dresden,

Gemäldegalerie; *A woman weighing pearls*, c. 1665, oil on canvas, 41.5 × 35 cm, Washington, National Gallery of Art, Widener collection; *A girl asleep at a table*, c. 1656, oil on canvas, 42.5 × 38 cm, New York, Metropolitan Museum of Art, Benjamin Altman Bequest; *View of Delft*, c. 1660, oil on canvas, 98.5 × 117.5 cm, The Hague, Mauritshuis (S). DE HOOGH: *The backgammon players*, 1653, oil on canvas, 46 × 33 cm, Dublin, National Gallery of Ireland; *A man smoking, a woman drinking and a child in a courtyard*, c. 1656, oil on canvas, 78 × 65 cm, The Hague, Mauritshuis (S); *A musical party*, c. 1677, oil on canvas, 83.5 × 68.5 cm, London, National Gallery. TERBORCH: *Self-portrait*, c. 1668, oil on canvas, 61 × 42.5 cm, The Hague, Mauritshuis (S); *A boy picking fleas from a dog*, c. 1655, oil on panel, 34 × 27 cm, Munich, Alte Pinakothek (S).

230–231 Vermeer: The Artist's Studio

VERMEER: "*The Artist's Studio*" (The art of painting), c. 1665-70, oil on canvas, 120 × 100 cm, Vienna, Kunsthistorisches Museum (Photo Meyer); *The head of a girl*, c. 1666, oil on canvas, 47 × 40 cm, The Hague, Mauritshuis (S); *A soldier and a laughing girl*, c. 1657, oil on canvas, 50.5 × 46 cm, New York, The Frick Collection (copyright); *An allegory of the New Testament*, c. 1669, oil on canvas, 113 × 88 cm, New York, Metropolitan Museum of Art, Michael Friedsam collection; *Diana and her nymphs*, c. 1654, oil on canvas, 98.5 × 105 cm, The Hague, Mauritshuis (S). REMBRANDT: *The artist in his studio*, c. 1628-29, oil on panel, 25 × 32 cm, Boston, Museum of Fine Arts, Zoe Oliver Sherman collection.

232–233 Dutch Still-life Painting

AMBROSIUS BOSSCHAERT THE ELDER: *A vase of flowers*, c. 1620, oil on canvas, 64 × 46 cm, The Hague, Mauritshuis (S). HEDA: *Breakfast piece*, c. 1634, oil on panel, 46 × 69 cm, The Hague, Mauritshuis (S). CLAESZ.: *Still life*, 1623, oil on canvas, Paris, Louvre (S); "*Breakfast*", 1637, oil on panel, 83 × 66 cm, Madrid, Prado (S). DE HEEM: *Still life of books*, c. 1625-29, oil on panel, 36 × 48.5 cm, The Hague, Mauritshuis (S). KALF: *Still life*, c. 1643, oil on canvas, 115 × 86 cm, Cologne, Wallraf-Richartz Museum (S). JAN VAN HUYSUM: *A vase of flowers*, c. 1710-20, oil on canvas, 62.1 × 52.3 cm, London, National Gallery. VAN BEYEREN: *Still life*, undated, oil on panel, 98 × 76 cm, The Hague, Mauritshuis (S). HONDECOETER: *Cocks, hens and chicks, with other birds*, c. 1668, oil on canvas, 85.5 × 110 cm, London, National Gallery. REMBRANDT: *Self-portrait as a hunter*, 1639, oil on panel, 121 × 89 cm, Dresden, Gemäldegalerie (Archiv für Kunst und Geschichte).

234–235 Late Italian Baroque

POZZO: *Allegory of the missionary work of the Jesuits*, 1691-94, fresco, Rome, S. Ignazio (S). RAGGI: St Ignatius' Chapel, Il Gesù, 1683, stucco and other materials, Rome (S). MARATTA: *The Virgin and Child with St Philip Neri*, c. 1690, oil on canvas, 197 × 343 cm, Florence, Palazzo Pitti (S). GIORDANO: *Venus, Cupid and Mars*, undated, oil on canvas, 152 × 129 cm, Naples, Museo di Capodimonte (S). SOLIMENA: *The Virgin and Child with St Philip Neri*, fresco, Naples, Museo di Capodimonte (S). PIAZZETTA: *The Adoration of the shepherds*, c. 1725, oil on canvas, 73 × 53 cm, Padua, Museo Civico (S). SEBASTIANO RICCI: *Pope Paul III reconciles Francis I with Charles V*, 1686-88, oil on canvas, 108 × 94 cm, Piacenza, Museo Civico (S). SEBASTIANO AND MARCO

RICCI: *Allegorical tomb for the Duke of Devonshire*, c. 1720, oil on canvas, 217 × 138 cm, Birmingham, University of Birmingham, The Barber Institute of Fine Arts. AMIGONI: *Venus and Adonis*, c. 1740-47, oil on canvas, 52 × 73 cm, Venice, Accademia (S).

236–237 Tiepolo: The Residenz at Würzburg

TIEPOLO: *Abraham visited by the angels*, c. 1732, oil on canvas, 140 × 120 cm, Venice, Scuola di San Rocco (S); *St Thecla delivering the city of Este from the plague*, 1759, oil on canvas, 80 × 44 cm, New York, Metropolitan Museum of Art, Rogers Fund; *The banquet of Cleopatra and Anthony*, detail of the Palazzo Labia ballroom, 1745-50, fresco, Venice (S); *Olympus with the four quarters of the Earth*, detail of the ceiling of the Treppenhaus, Würzburg, 1752-53, fresco; *America*, in the *Treppenhaus* (S); *Apollo leads Beatrice to Barbarossa* in the *Kaisersaal*, Würzburg, fresco (S); *The marriage of Beatrice and Barbarossa*, in the *Kaisersaal* (S). NEUMANN AND TIEPOLO: The *Kaisersaal* in the Residenz, Würzburg (S).

238–239 Watteau: The Embarkation for Cythera

RUBENS: *The Garden of Love*, c. 1632, oil on canvas, 198 × 283 cm, Madrid, Prado (S). WATTEAU: "*L'Enseigne de Gersaint*" (Gersaint's signboard), 1721, oil on canvas, 182 × 307 cm, West Berlin, Staatliche Museen (S); The Louvre "*Embarkation for Cythera*", properly *The pilgrimage to Cythera*, 1717, oil on canvas, 129 × 194 cm, Paris, Louvre (Documentation Photographique de la Réunion des Musées Nationaux); "*La Toilette*", c. 1720, oil on canvas, height 44 cm, London, Wallace Collection; The Berlin "*Embarkation for Cythera*", 1718, oil on canvas, 130 × 192 cm, West Berlin, Staatliche Museen (S).

240–241 French and German Rococo

BOUCHER: *Vulcan presenting the arms of Aeneas to Venus*, 1732, oil on canvas, 320 × 320 cm, Paris, Louvre (S); *Diana bathing*, 1742, oil on canvas, 55 × 72 cm, Paris, Louvre (S). FRAGONARD: *Music, or M. de la Bretèche*, 1769, oil on canvas, 80 × 65 cm, Paris, Louvre (S); *Women bathing*, 1777, oil on canvas, 63 × 79 cm, Paris, Louvre (S). ROBERT: *Felling Trees at Versailles*, 1778?, Lisbon, Fundação Calouste Gulbenkian. THE ASAM BROTHERS: The altar of the church of Maria Victoria, Ingolstadt, 1734, stucco and other materials (Claus and Liselotte Hansmann); St John Nepomuk, 1733-46, interior, stucco and other materials, Munich (Claus and Liselotte Hansmann). ST NICHOLAS MALA STRARIA, PRAGUE: Detail of the upper nave, frescoed 1760-61 (S). THE ZIMMERMANN BROTHERS: Detail of the ceiling of Die Wies, Bavaria, 1745-54, stucco and other materials (S).

242–243 French Rococo 2

NATTIER: *Mlle Manon Balletti*, 1757, oil on canvas, 54 × 46 cm, London, National Gallery. LARGILLIERE: *The painter with his wife and daughter*, c. 1700, oil on canvas, 147 × 208 cm, Paris, Louvre (S). CARRIERA: *Self-portrait with an image of the artist's sister*, 1709, pastel on card, 71 × 57 cm, Florence, Uffizi (S). THE MEISSEN FACTORY: *The concerto*, c. 1760, painted porcelain, height about 17 cm (S). DROUAIS: *Comte and Chevalier de Choiseul*, 1746, oil on canvas, 139 × 107 cm, New York, The Frick Collection (copyright). BOUCHER: *Mme de Pompadour*, 1759, oil on canvas, 91 × 65 cm, London, Wallace Collection. FALCONET: *Peter the Great*, 1766-68, bronze, height of statue about

3.5 m, Leningrad, Square of the Decembrists; *Erigone*, 1747, terracotta, height about 27 cm, Sèvres, Musée National de Céramiques (Documentation Photographique de la Réunion des Musées Nationaux). QUENTIN DE LA TOUR: *M. Claude Dupouch*, 1739, pastel, 60 × 50 cm, St-Quentin, Musée A. Lecuyer (Photo Bulloz). CLODION: *Bacchante*, c. 1760, terracotta, height about 20 cm, Orléans, Musée des Beaux-Arts (Giraudon). ROUBILIAC: Monument to Lady Elizabeth Nightingale, 1761, marble, Westminster Abbey, London (Angelo Hornak).

244–245 Genre and Still-life Painting

TROOST: *The city garden*, c. 1742, oil on canvas, 66 × 56 cm, Amsterdam, Rijksmuseum. PIAZZETTA: *The fortune-teller*, 1740, oil on canvas, 160 × 114 cm, Venice, Accademia (S). LARGILLIERE: *Still life*, c. 1690, oil on canvas, Chatsworth, Trustees of the Chatsworth Settlement. LONGHI: *The rhinoceros*, 1751, oil on canvas, 60 × 47 cm, Venice, Ca' Rezzonico (S). DOMENICO TIEPOLO: *The winter promenade*, 1757, fresco, Villa Valmarana (S). OUDRY: *The white duck*, 1753, oil on canvas, 93 × 62 cm, Houghton Hall, Collection of the Dowager Lady Cholmondeley (Eileen Tweedy). GREUZE: *The son punished*, c. 1777, oil on canvas, 127.5 × 157.5 cm, Paris, Louvre (S); *The broken pitcher*, c. 1773, oil on canvas, 108 × 84 cm, Paris, Louvre. HAYMAN: *The wrestling scene from Shakespeare's As You Like It*, c. 1774, oil on canvas, 32 × 89 cm, London, Tate Gallery (Angelo Hornak). DEVIS: *The James Family*, 1752, oil on canvas, 97 × 122.5 cm, London, Tate Gallery (John Webb).

246–247 Chardin: The House of Cards

CHARDIN: *Skate, cat and kitchen utensils*, 1728, oil on canvas, 114 × 145 cm, Paris, Louvre (S); *Saying grace*, c. 1740, oil on canvas, 49.5 × 38.5 cm, Paris, Louvre (Documentation Photographique de la Réunion des Musées Nationaux); *Still life with a wild duck*, 1764, oil on canvas, 133 × 97 cm, Springfield, Massachusetts, Museum of Fine Arts, James Philip Gray collection; *Self-portrait with an eyeshade*, 1775, pastel, 46 × 38 cm, Paris, Louvre (Documentation Photographique de la Réunion des Musées Nationaux); *The house of cards*, c. 1741, oil on canvas, 81 × 65 cm, Washington, National Gallery of Art, Andrew W. Mellon collection. BOUCHER: *Breakfast*, 1739, oil on canvas, 80 × 61 cm, Paris, Louvre (Documentation Photographique de la Réunion des Musées Nationaux). REMBRANDT: *The flayed ox*, 1655, oil on canvas, 94 × 69 cm, Paris, Louvre (S).

248–249 William Hogarth

ROUBILIAC: *William Hogarth*, c. 1741, terracotta bust, height 70 cm, London, National Portrait Gallery. HOGARTH: *Self-portrait*, 1745, oil on canvas, 86.5 × 69 cm, London, Tate Gallery; *Marriage à la Mode: Soon after the marriage*, 1743-45, oil on canvas, 70 × 90.5 cm, London, National Gallery; *Sigismunda*, 1759, oil on canvas, 100 × 124 cm, London, Tate Gallery (John Webb); Engraving from *The Analysis of Beauty*, 1753, 36 × 47 cm, London, British Museum (John Freeman); *The Four Times of Day: Night*, 1738, oil on canvas, 76.5 × 61 cm, London, British Museum (John Freeman); *The Rake's Progress: The orgy; The madhouse*, 1733-35, both oil on canvas, 61 × 74 cm, London, Sir John Soane's Museum (courtesy of the Trustees); *The shrimp girl*, 1745, oil on canvas, 63.5 × 51 cm, London, National Gallery; *An Election: Chairing the member*, 1754, oil on canvas,

101 × 131 cm, London, Sir John Soane's Museum (courtesy of the Trustees); *Captain Coram*, 1740, oil on canvas, 37.5 × 23 cm, London, The Coram Foundation (Cooper-Bridgeman Library).

250–251 British Portraiture and Genre

REYNOLDS: *The Hon. Augustus Keppel*, 1753-54, oil on canvas, 231 × 297 cm, London, National Maritime Museum; *Sarah Siddons as the Tragic Muse*, 1784, oil on canvas, 236 × 144 cm, San Marino, California, Henry E. Huntington Library and Art Gallery; *Nelly O'Brien*, 1760-62, oil on canvas, 315 × 250 cm, London, Wallace Collection; *Lady Sarah Bunbury sacrificing to the Graces*, 1765, oil on canvas, 235 × 150 cm, Chicago, Art Institute; *Self-portrait*, 1773?, oil on canvas, 125 × 100 cm, London, Royal Academy of Arts. RAMSAY: *Margaret Lindsay*, c. 1775, oil on canvas, 74 × 61 cm, Edinburgh, National Gallery of Scotland. STUBBS: *Flayed horse*, 1766, engraving, 48 × 61 cm, London, Royal Academy of Arts; *The reapers*, 1786, 88 × 113 cm, London, Tate Gallery (Angelo Hornak). ROMNEY: *Emma, Lady Hamilton*, 1785, oil on canvas, 54 × 61 cm, London, National Portrait Gallery. WRIGHT: *The experiment on a bird in an air pump*, c. 1767-68, oil on canvas, 182 × 243 cm, London, Tate Gallery (Angelo Hornak). ZOFFANY: *Mr and Mrs Garrick by the Shakespearean temple at Hampton*, 1762, oil on canvas, 100 × 125 cm, London, National Portrait Gallery.

252–253 Gainsborough: Mary, Countess Howe

GAINSBOROUGH: *Mr and Mrs Andrews*, c. 1748, oil on canvas, 70 × 119 cm, London, National Gallery; "*The Blue Boy*", c. 1770, oil on canvas, 175 × 120 cm, San Marino, California, Henry E. Huntington Library and Art Gallery; *Mrs Sarah Siddons*, 1785, oil on canvas, 126 × 100 cm, London, National Gallery; *Mrs Philip Thicknesse*, 1760, oil on canvas, 44 × 132.5 cm, Cincinnati, Art Museum, Mary M. Emery Bequest; "*The Morning Walk*", 1785, oil on canvas, 236 × 179 cm, London, National Gallery; *Mary, Countess Howe*, 1763-64, oil on canvas, 240 × 150 cm, London, Kenwood House (Greater London Council as Trustees of the Iveagh Bequest).

254–255 Landscape Painting

CANALETTO: *The stonemason's yard*, c. 1730, oil on canvas, 123.5 × 163 cm, London, National Gallery; *The Arch of Constantine, Rome*, 1742, oil on canvas, 184 × 105 cm, London, Royal Collection (by gracious permission of Her Majesty the Queen). PANINI: *The interior of St Peter's, Rome*, 1731, oil on canvas, 150 × 223 cm, London, National Gallery. PIRANESI: *View of the Villa of Maecenas at Tivoli*, c. 1760-65, etching, 44 × 66 cm, London, British Museum (The Fotomas Index); Etching from the *Carceri d'Invenzione* (Imaginary Prisons), 1744-48, 55 × 41 cm, London, British Museum (The Fotomas Index). TISCHBEIN: *Goethe in the Campagna*, 1787, oil on canvas, 162 × 205 cm, Frankfurt, Städelisches Kunstinstitut. VERNET: *View of the Bay of Naples*, 1742, oil on canvas, Alnwick, Collection of the Duke of Northumberland (Cooper-Bridgeman Library). STOURHEAD, WILTSHIRE: View of the park (Simon Pugh). WILSON: *Snowdon*, c. 1766?, oil on canvas, 101 × 124 cm, Nottingham, Castle Museum (Cooper-Bridgeman Library). GAINSBOROUGH: "*Cornard Wood*", 1748, oil on canvas, 122 × 155 cm, London, National Gallery. GUARDI: *View of a canal*, c. 1750, oil on canvas, Florence, Uffizi (S).

256–257 Eastern Art
ISFAHAN: View of the court of the Madraseh Chaharbagh, 1706-14 (Spectrum Colour Library). ANGKOR WAT: View of the temple in the centre, early 12th century (ZEFA).

258–259
(Map by Colin Salmon and Dinah Lone)

260–261 Indian Art 1
HARAPPA: *A buffalo*, c. 2500-2300 BC, steatite, 4 × 4 cm, Lahor, Museum (William Macquitty); *Ceremonial dancer*, 3rd millennium BC, limestone, height 9 cm, New Delhi, National Museum of India (Ravi Bedi). SARNATH: *Lion capital*, 240 BC, sandstone, height 213 cm, Sarnath, Museum (René Roland). BHARHUT: *Yakshi*, 2nd century BC, sandstone, height 2.1 m, *in situ* (India Office). DIDARGANJ: *Yakshi? or Royal devotee?* mid-1st century BC?, sandstone, height 163 cm, Patna, Museum (René Roland). SANCHI: The eastern gate of the Great Stupa, inner side, 1st century BC, sandstone, height about 10 m, *in situ* (Giraudon). KARLE: The *Buddha preaching, flanked by worshippers*, 1st/2nd century AD, sandstone, height of larger figures about 2.5 m, *in situ* (Ann and Bury Peerless). AMARAVATI: *The presents of King Bandhuma*, from the *Vessantra Jataka*, late 2nd century AD, marble, diameter about 90 cm, Madras, Government Museum and National Art Gallery (Giraudon). KATRA: *Seated Buddha*, mid-2nd century AD, sandstone, height 68 cm, Mathura, Archaeological Museum (René Roland). MATHURA: *Yakshi*, 2nd century AD, sandstone, height 140 cm, Calcutta, Indian Museum (S).

262–263 Indian Art 2
GANDHARA: *Standing Bodhisattva*, 2nd century AD, sandstone, height 109 cm, Paris, Musée Guimet (Giraudon). AJANTA: *Flying nymph*, late 5th century AD, fragment of a mural in Cave 17, tempera on plaster (Ann and Bury Peerless). PAHARPUR: *Shiva and dancing girls*, 8th century AD, terracotta, Durham, Gulbenkian Museum. SARNATH: *The first sermon*, 5th century AD, sandstone, height 160 cm, Sarnath, Museum (René Roland). NALANDA: *Seated Bodhisattva*, 8th or 9th century AD, stucco, Durham, Gulbenkian Museum. BENGAL: *The Ashtasahasrika Prajnaparamita: The Bodhisattva Samantabhadra with Tara, the incarnation of Buddhist wisdom, and the dwarf Acharya Vajrapani*, c. 1120, colour on palm-leaf, 54 × 6 cm, London, Victoria and Albert Museum. SULTANGANJ: *Standing Buddha*, early 9th century?, bronze, height 226 cm, Birmingham, Museum and Art Gallery. TIBET: *The Heruka in union with his shakti Nairatmya*, 17th century?, gilt bronze, Germany, Private Collection (Claus and Liselotte Hansmann); *Thangka* (temple banner): *The goddess Tara, the incarnation of Buddhist wisdom*, late 17th century, paint on cotton, 62 × 41 cm, Durham, Gulbenkian Museum.

264–265 Indian Art 3
AJANTA: *Panchika and Hariti*, 6th century, from Cave 2, sandstone (Robert Harding Associates). BADAMI: *Vishnu sitting on Ananta*, 578, sandstone (Robert Harding Associates). MAMALLAPURAM: *The descent of the goddess Ganga*, mid-7th century, granite (A.F. Kersting). ELEPHANTA: *Shiva*, 8th century, sandstone, Cave of Maharastra (Giraudon). SIGIRIYA: *Apsaras*, c. 480, wall-painting from the rock fortress (Douglas Dickens). TANJORE: *Dancing girl*, c. 1000, wall-painting (Ravi Bedi). ELURA: *Shiva's dance in the elephant skin*, c. 580-642, stone relief (Robert Harding Associates). MADRAS: *Parvati*, 10th

century, bronze, height 92 cm, Washington DC, Smithsonian Institution, Freer Gallery of Art. COCHIN: *Vishnu*, late 17th century, wall-painting, the Maharajah's Palace (Douglas Dickens). BELUR: *Heavenly nymph*, 12th/13th century, sandstone (William Macquitty).

266–267 The Kandarya Mahadeva Temple
ORISSA: *Shiva and Parvati*, 12th century, stone (Claus and Liselotte Hansmann). KONARAK: The Surya temple, detail: *A wheel, emblem of the chariot of the sun-god Surya*, 13th century, sandstone, *in situ* (A.F. Kersting). BHUVANESHVARA: The Rajarani temple, detail, c. 1000, sandstone (Michael Ridley). DEOGARH: *Vishnu lying on Ananta*, 6th century, sandstone (Robert Skelton). KHAJURAHO: The Kandarya Mahadeva temple, details of the Heavenly Bands, c. 1000, sandstone (An Apsara Ann and Bury Peerless; general view René Roland).

268–269 Indian Art 4
Detail of the sculptured calligraphy on the Q'utb Minar, c. 1200, sandstone (Lawrence Clarke). WESTERN INDIA: *The Uttaradhyayana Sutra: Mahavira surrounded by dancers and musicians*, c. 1460, gouache on paper, height 11 cm, London, Victoria and Albert Museum. RAJASTHAN: *The marriage of Vasudeva and Devaki*, 1525, gouache on paper, 17 × 23 cm, London, Victoria and Albert Museum. AKBAR'S ATELIER: *The Hamsanama* (Deeds of Mohammed's uncle, Hamsa): *Gardeners beating a giant trapped in a pit*, c. 1570, gouache on paper, 67 × 51 cm, London, Victoria and Albert Museum (Michael Holford); *The Akbarnama* (Deeds of Akbar): *Akbar's officers reconcile a rebel*, c. 1590, gouache on paper, 32 × 19 cm, London, Victoria and Albert Museum (Michael Holford). SCHOOL OF NIHAL CHAND: *Radha*, c. 1750, gouache on paper, 22 × 35 cm, Kishangarh, Collection of the Maharaj of Kishangarh (Studio Vista). SHAH JAHAN'S ATELIER: *Jade cup*, 1657, jade, 5 × 17 cm, London, Victoria and Albert Museum (Michael Holford). JEHANGIR'S ATELIER: *The zebra*, 1621, gouache on paper, 20 × 25 cm, London, Victoria and Albert Museum (Michael Holford). KANGRA: *Krishna and Radha in a grove*, c. 1780, gouache on paper, London, Victoria and Albert Museum (Michael Holford).

270–271 Islamic Art 1
IRAQ OR SYRIA: Chapter heading from a Koran, 9th/10th century, MS no. 1407, colours on paper, 33 × 23 cm, Dublin, Chester Beatty Library. BAGHDAD: Frontispiece from a Koran, early 16th century, MS no. 1544, colours on paper, 18 × 13 cm, Dublin, Chester Beatty Library. IRAN: Text from a Koran, 11th/12th century, MS no. 1436, colours on paper, 33.5 × 49 cm, Dublin, Chester Beatty Library. TURKEY: *Hilyah* (Description of the Prophet), 1691-92, from a Koran, colours on paper, 46 × 33.5 cm, Dublin, Chester Beatty Library; *Basmallah* (In the name of God the compassionate, the merciful), 1834, from a Koran, colours on paper, Dublin, Chester Beatty Library. NORTH AFRICA OR SPAIN: Text from a Koran, 11th century, MS no. 1424, gilt on vellum, 28 × 23 cm, Dublin, Chester Beatty Library. IRAN: Frontispiece from a Koran, early 16th century, MS no. 1544, colours on paper, 35.5 × 23 cm, Dublin, Chester Beatty Library; *Tailor at work*, early 17th century, ink on paper, 71 × 11 cm, Washington DC, Smithsonian Institution, Freer Gallery of Art. NISHAPUR, IRAN: Earthenware bowl, late 10th century,

London, Bluett and Sons (Cooper-Bridgeman Library).

272–273 Islamic Art 2
IRAQ: A fragment of silk, 9th/10th century, London, Victoria and Albert Museum (Michael Holford). IRAN: Carpet, 16th century, silk, Washington DC, National Gallery of Art, Widener collection; Bronze cauldron, 12th/13th century, Baltimore, Walters Art Gallery; Standard, 16th century, gilt steel, Stockholm, Livrustkammaren; Tiles, late 14th century, glazed terracotta, Copenhagen, C.L. David Collection. SYRIA: Brass inlaid basin, 1240, inlaid with silver, Paris, Louvre (Documentation Photographique de la Réunion des Musées Nationaux); Bowl, 12th/13th century, earthenware, Copenhagen, C.L. David Collection. EGYPT: Inscribed marble slab, 9th/10th century, London, British Museum; Pair of doors inlaid with ivory, 13th/14th century, wood and ivory, New York, Metropolitan Museum of Art, Edward C. Moore Bequest. TURKEY: Mosque lamp, c. 1557, ceramic, London, Victoria and Albert Museum (Michael Holford).

274–275 Islamic Art 3: Representational Art
IRAN: Firdausi's *Shahnameh: Bahram Gur slays a dragon*, c. 1340, colours on paper, 40 × 30 cm, Cleveland, Museum of Art, Grace Rainey Rogers Fund. MIR SAYYID ALI?: Firdausi's *Shahnameh: Bahram Gur slays onagers*, detail, c. 1525-30, colours on paper, New York, Metropolitan Museum of Art, Gift of Arthur A. Houghton Jnr. EGYPT: Panel, 11th-12th century, ivory, West Berlin, Museum für Islamische Kunst (Bildarchiv Preussischer Kulturbesitz). HERAT, IRAN: Hafiz's *Divan: Dancing Sufi dervishes*, c. 1490, colour on paper, New York, Metropolitan Museum of Art, Gift of Arthur A. Houghton Jnr. SULTAN MUHAMMAD?: Nizami's *Khamseh: The ascension of Mohammed*, early 16th century, folio 195r, colours on paper, London, British Library. AQA MIRAK?: Firdausi's *Shahnameh: King Khosroes I's war prizes are pledged for*, c. 1530, colours on paper, New York, Metropolitan Museum of Art, Gift of Arthur A. Houghton Jnr. TURKEY: Murad III's *Surnama: Sweepers performing before the sultan*, c. 1582, folio 341, colours on paper, 30 × 21 cm, Istanbul, Topkapi Palace Museum. MIRZA ALI?: Jami's *Haft Aurang: A father's discourse on love*, mid-16th century, colours on paper, 34 × 23 cm, Washington DC, Smithsonian Institution, Freer Gallery of Art.

276–277 South-East Asian Art 1
SUMATRA: Ancestor figure?, stone, on the island of Samosir in Lake Toba (Vautier-De Nanxe). NORTH VIETNAM: *The god of wine*, 1st century BC, bronze candelabrum, height 33 cm, from a tomb at Lach Truong, Hanoi, National Museum (Werner Forman Archive). KALIMANTAN: *Ikat* textile (Werner Forman Archive); *A hornbill*, wood, Liverpool, Merseyside County Museums. SULAWESI: Ancestor figures, Toraja (Claire Leimbach); The façade of a house, Toraja (Vautier-De Cool). IRIAN JAYA: Ancestor figure, stone and bone, height about 1 m, Leyden, Rijksmuseum voor Volkerkunde. BALI: *Kris* and scabbard, wood, gold and bronze, length about 50 cm, Bali, Collection R. Draptowi-Hardjo-Jogjakarta (Vautier-De Nanxe). JAVA: *Batik* textile (Werner Forman Archive).

278–279 South-East Asian Art 2
BOROBUDUR: *Pippalayana and Bhadra*, 8th/9th century, stone, *in situ* (Werner Forman Archive); One of the 72 *Buddhas*,

8th/9th century, stone, *in situ* (Vautier-De Nanxe); *The story of King Sibi*, detail: *Visitors arrive in their ship*, 8th/9th century, stone, *in situ* (Werner Forman Archive). CHANDI MENDUT: *The Bodhisattva Vajrapani*, 8th century, stone, *in situ* (Werner Forman Archive). PRAMBANAN: *Rama and Sita with Lakshmana*, early 10th century, stone, *in situ* (Werner Forman Archive). BELAHAN, EASTERN JAVA: *Vishnu seated on Garuda*, c. 1042, tufa, height 190 cm, Djakarta, National Museum. UPPER BURMA: *The Buddha in the bhumisparsamudra*, 17th century, bronze, Oxford, Ashmolean Museum. PAGAN, BURMA: Frescos decorating an arch in the temple of Muy-tha-kut, 11th or 12th century (Werner Forman Archive); Terracotta ornament, 12th century (Werner Forman Archive). BURMA: *Sutra* chest, 18th century, Oxford, Ashmolean Museum.

280–281 South-East Asian Art 3
CAMBODIA: *Vishnu*, late 7th century, sandstone, height 86 cm, Cleveland, Museum of Art, Gift of Hanna Fund. SULAWESI: *The Buddha*, detail, 3rd/5th century, bronze, height 75 cm, Leyden, Rijksmuseum voor Volkerkunde. ANGKOR WAT: *Apsara*, 12th century, stone, *in situ* (Mireille Vautier); Detail of the great frieze showing *The battle of the Pandavas and the Kauravas* on an outer gallery, early twelfth century, stone, *in situ* (Mireille Vautier). BANTEAY SREI: Pediment, 10th century, stone, Paris, Musée Guimet. ANGKOR THOM: *Devata*, early 13th century, from the Bayon temple, stone, *in situ* (T.J. Mair); Details of reliefs from the outer terrace of the Bayon temple: *A military parade*, early 13th century, stone, *in situ* (William Macquitty). CHAIYA, THAILAND: *Bodhisattva*, mid-8th century, bronze, height about 50 cm, Durham, Gulbenkian Museum. CENTRAL THAILAND: *The Buddha calling the earth to witness*, 14th century, bronze, West Germany, Private Collection (Claus and Liselotte Hansmann). THAILAND: *The Buddha with two Bodhisattvas attended by spirits*, 18th century, paint on cloth, Munich, Museum für Volkerkunde.

282–283 Chinese Art 1
NORTHERN CHINA: Incense burner, c. 200 BC, inlaid bronze, height 18 cm, Washington DC, Smithsonian Institution, Freer Gallery of Art; Pictogram, and inscription, from bronze vessels, c. 1200 BC, rubbings, Durham, Gulbenkian Museum; Animal-shaped plaques, c. 1200 BC, jade and bronze, Durham, Gulbenkian Museum. ANYANG: Bronze vessel, c. 1200 BC, height 24 cm, Washington DC, Smithsonian Institution, Freer Gallery of Art. MANCHENG: Burial suit, c. 113 BC, jade plaques sewn with gold, length 188 cm (Michael Ridley). WUWEI, WESTERN CHINA: "Flying Horse", 2nd century AD, bronze, length 45 cm, from tomb at Lei T'ai, Gansu (Robert Harding Associates). LONGQUAN: One of the Emperor Taizong's chargers, c. AD 649, sandstone, 165 × 191 cm, Xiangdu, Nan Yiian Museum (Richard and Sally Greenhill). XIANYANG: *Recumbent horse*, c. 177 BC, stone, height about 1 m, Xiangdu, Nan Yiian Museum (Richard and Sally Greenhill). MT LI: *A warrior*, c. 246-210 BC, terracotta, height 195 cm, *in situ* (Xinhua News Agency).

284–285 Chinese Art 2
YUNKANG: *The Buddha*, c. 460-70, stone (Michael Ridley). LONGMEN: *An empress visits Longmen*, c. 522, stone, height 198 cm, Kansas City, William Rockhill Nelson Gallery of Art. NORTHERN CHINA:

Maitreya, 522, gilt bronze, New York, Metropolitan Museum of Art, Rogers Fund; *Bodhisattva*, 8th century, stone, Washington DC, Smithsonian Institution, Freer Gallery of Art. XIANGTANGSHAN: *Bodhisattva*, c. 550-77, stone, height 188 cm, Philadelphia, University of Pennsylvania, University Museum. WESTERN CHINA: Devotional stela, 554, stone, height 214 cm, Boston, Museum of Fine Arts. YICHOU: *Luohan*, late 10th century, glazed terracotta, London, British Museum. NORTHERN CHINA: Hanging scroll, 14th century, colour on silk, whole scroll 132 × 71 cm (Michael Ridley); *Guanyin*, Song dynasty, wood and plaster painted and gilded, height 225 cm, Kansas City, William Rockhill Nelson Gallery of Art.

286–287 Song Porcelain
HEBEI: Spitoon, c. 850, height 10.5 cm, China, Collection the People's Republic of China (Robert Harding Associates). HAIDIAN, PEKING: Vase and cover, late 14th century, height 66 cm, China, Collection the People's Republic of China (Giraudon). JINGDEZHEN: Stem cup, c. 1426-35, height 10 cm, and Plate, c. 1723-35, diameter 21 cm; Jar, c. 1506-21, diameter 15 cm; *Meiping* vase, c. 1662-1722, with enamels, height 14 cm, all porcelain, all Durham, Gulbenkian Museum. CHINA: Items of Song porcelain: A: Northern celadon bowl, 11th century, porcelain, diameter 21 cm; B: Jun bowl, probably 12th century, porcelain, diameter 13 cm; C: Ding bowl, 12th century, porcelain, diameter 23 cm; D: Cizhou vase, 12th century, stoneware, height 32.5 cm, all Durham, Gulbenkian Museum. SOUTHERN CHINA: *Bodhidharma*, 18th century, porcelain, London, British Museum (William MacQuitty).

288–289 Chinese Art 3
FAN KUAN: *Travelling among the mountains and streams*, early 11th century, ink and colour on silk, 155 × 74 cm, Taiwan, National Palace Museum. AFTER GU KAIZHI: *Admonitions of the instructress*, original c. 375, ink and colour on silk, height 25 cm, London, British Museum (Cooper-Bridgeman Library). MI FEI: *Spring mountains, clouds and pine-trees*, c. 1050-1100, ink and slight colour on paper, height 35 cm, Taiwan, National Palace Museum. MUQI: *A mother gibbon and her baby*, c. 1250?, part of a triptych, ink on silk, height 178 cm, Kyoto, Daitoku-ji (Tokyo, Kodansha Ltd). GUO XI: *Early spring*, 1072, ink and light colour on silk, 158 × 108 cm, Taiwan, National Palace Museum. WANG MENG: *Forest dwellings at Juqu*, c. 1370, ink and colour on paper, 69 × 43 cm, Taiwan, National Palace Museum. TANG YIN: *A poet and two courtesans*, c. 1500, ink and colour on paper, Taiwan, National Palace Museum. SHITAO: *The gleaming peak*, c. 1700, light colour on paper, 24.5 × 17 cm (Cologne, Rheinisches Bildarchiv).

290–291 Korean Art
KYONGJU: Royal crown, 4th/6th century, gold and jade, Seoul, National Museum (Mikihiro Taeda on loan from Hans Hinz). KOGURYO: *A nobleman and his wife*, mid-5th/6th century, mural, Anak, Tomb 3 (Werner Forman Archive). SILLA OR PAEKCHE?: *Maitreya*, early 7th century, gilt bronze, height 93.5 cm, Seoul, Toksu Palace Museum (Colorphoto Hans Hinz). KANG HUI-AN: *A sage resting on a rock*, 15th century, ink on paper, 23.5 × 16 cm, Seoul, National Museum (Charles E. Tuttle Co. Inc., Tokyo). KOREA: Wine pot, late 12th century, porcelain, Seoul, Toksu Palace Museum (Colorphoto Hans Hinz). AN KYON: *The dream of the peach-blossom garden*, 1447, colour on silk, 39 × 106 cm,

Nara, Tenri Central Library. CHONG SON: *The mountain by the river*, 18th century, ink on paper, Kyongju, Museum (Werner Forman Archive). YI IN-MUN: *Young Immortal under a fir tree*, 18th/19th century, ink on paper, Pyongyang, Museum (Werner Forman Archive).

292–293 Japanese Art 1
JAPAN: Jomon figurine, 1st millennium BC, terracotta, height about 30 cm, Tokyo, National Museum (Vautier-De Cool); A *haniwa*: *A warrior*, 3rd/6th century AD, terracotta, height about 70 cm (Vautier-De Cool); "*The Kudara Kannon*", 7th century, wood, height 205 cm, Nara, Horyu Daitoku-ji (Benrido Company Ltd, Kyoto). TOHAKU: *Pine-trees*, detail of screen, late 16th century, ink on paper, height 155 cm, Tokyo, National Museum (The Zauho Press). KENZAN: Ceremonial tea-bowl: *Evening glory*, late 17th or early 18th century, pottery, height 9.5 cm, Nara, Yamato Bunkakan Museum. NITEN: *Bird and branch*, late 16th or early 17th century, ink on paper, Philadelphia, Museum of Art, Fiske Kimball Fund. KOETSU AND SOTATSU: *Deer*, detail of a scroll, 17th century, gold, silver and ink on paper, height 33 cm, Shizuoka, Atami Museum. BUNCHO: *Heron wading among lotus flowers*, 18th/19th century, ink on paper, 83 × 26 cm, Durham, Gulbenkian Museum.

294–295 Japanese Art 2
SESSHU: *Autumn landscape*, late 15th century, ink and colour on paper, height 46 cm, Tokyo, National Museum (The Zauho Press). BUNSEI: *The layman Vimalakirti*, 1457, ink on paper, 92 × 34 cm, Nara, Yamato Bunkakan Museum. MOTONOBU: *The small waterfall*, early 16th century, ink and colour washes on paper, 45 × 87 cm, Nara, Yamato Bunkakan Museum. EITOKU: *Plum trees by water*, 16th century, ink and colour washes on paper, height 172 cm, Kyoto, Juko-in (Kodansha Ltd, Tokyo); A Matsuura screen, early 17th century, colour on gold paper, 152 × 366 cm, Nara, Yamato Bunkakan Museum; Lacquer box, late 18th century, painted lacquer, Vienna, Kunsthistorisches Museum (Claus and Liselotte Hansmann). MORONOBU: *A river-boat party*, c. 1682, coloured woodcut, London, British Museum (Cooper-Bridgeman Library). JIHEI: *An insistent lover*, c. 1685, coloured woodcut, Chicago, Art Institute (Cooper-Bridgeman Library).

296–297 Japanese Art 3
TAKANOBU: *The courtier Taira-no-Shigemori*, late 12th century, colour on silk, 137 × 112 cm, Kyoto, Collection Jingo-Ji (The Zauho Press). MITSUNAGA: *Ban Danaigon: The flight of the court*, late 12th century, ink on paper, height 31 cm, Tokyo, National Museum (The Zauho Press). KORIN: *White plum-trees in spring*, c. 1705-10, colour on gold paper, 166 × 172 cm, Shizuoka, Atami Museum. UNKNOWN ARTIST: *The Tale of Genji: An interior with figures*, 12th century, colour on paper, height 22 cm, Nagoya, Tokugawa Museum (The Zauho Press). YAKUSHI-JI, NARA: *The Buddha and two Bodhisattvas*, c. 726, bronze, height of central figure 3.3 m, *in situ* (Zentrale Farbbild Agentur). HORYU-JI, JAPAN: *The death of the Buddha*, 711, clay, figures life-size, Nara, Horyuji Temple (Benrido Company Ltd). TOSHODAI-JI, JAPAN: "*The Kannon with 1,000 arms*", after 759, gilt and dry-lacquer, height nearly 5.5 m; *The priest Ganjin*, before 763, dry-lacquer, height 80.7 cm, both Nara, *in situ*. JAPAN: *Fudo*, 13th century, wood, height about 2 m, London, British Museum; *The Bodhisattva Fugen*, 12th century, colour

on silk, 160 × 73 cm, Tokyo, National Museum (The Zauho Press).

298–299 Japanese Art 4
KAIGETSUDO: *A courtesan*, c. 1714, coloured woodblock print, Chicago, Art Institute. UTAMARO: Folio from *The poem of the pillow*, 1788, woodblock colour print, London, art market (Angelo Hornak). HARUNOBU: *A lady dressing her hair*, 1768, woodblock colour print, West Germany, Private Collection (Claus and Liselotte Hansmann). KIYONAGA: *Cherry blossom*, c. 1787-88, woodblock colour print, London, British Museum (Cooper-Bridgeman Library). KORYUSAI: *At the gate*, c. 1771, woodblock colour print, Chicago, Art Institute (Cooper-Bridgeman Library). SHARAKU: *The Actor Otani Oniji as Edohei*, 1794, woodblock colour print, 38 × 23 cm, Chicago, Art Institute. HOKUSAI: Folio from *Little Flowers: Peonies and a sparrow*, 1828, woodblock colour print, West Germany, Private Collection (Claus and Liselotte Hansmann); Folio from *Thirty-six Views of Mount Fuji: Southerly wind and fine weather*, c. 1823-29, woodblock colour print, 25.5 × 38 cm, London, Victoria and Albert Museum (Cooper-Bridgeman Library). HIROSHIGE: Folio from *Fifty-three Stages of the Tokaido Highway: A shower at Shono*, c. 1833, woodblock colour print, 22 × 35 cm (Claus and Liselotte Hansmann). KUNIYOSHI: Folio from *The Heroes of Suikoden: Tameijiro dan Shogo grapples with his enemy under water*, 1828-29, woodblock colour print, London, B.W. Robinson Collection (Cooper-Bridgeman Library).

300–301 The Age of Revolutions
PARIS: View of the grand staircase of the Opéra, 1861-74, by Charles Garnier (Giraudon). BARCELONA: The façade of Casa Batlló, began 1905, by Antoni Gaudi (ZEFA). CHICAGO: The Carson Pirie Scott store, 1899-1904, by Louis Sullivan (Angelo Hornak).

302–303
(Map by Colin Salmon and Dinah Lone)

304–305 David: The Oath of the Horatii
POUSSIN: *Extreme Unction*, 1644, oil on canvas, 117 × 178 cm, Edinburgh, Duke of Sutherland Collection, on loan to the National Gallery of Scotland. GREUZE: *Septimius Severus reproaches Caracalla for seeking his death*, 1769, oil on canvas, 124 × 160 cm, Paris, Louvre (Documentation Photographique de la Réunion des Musées Nationaux). MENGS: *Parnassus*, 1760-61, ceiling fresco, about 3 × 6 m, Rome, Villa Albani (The Mansell Collection). VIEN: *The cupid seller*, 1763, oil on canvas, 95 × 119 cm, Château de Fontainebleau (Giraudon). HAMILTON: *The oath of Brutus*, c. 1763, oil on canvas, 208 × 270 cm, London, Drury Lane, Theatre Royal (The Iveagh Bequest). DAVID: *The oath of the Horatii*, 1784, oil on canvas, Paris, Louvre (Documentation Photographique de la Réunion des Musées Nationaux); *The lictors bringing Brutus the bodies of his sons*, 1789, oil on canvas, 325 × 425 cm, Paris, Louvre (S).

306–307 Neoclassical Painting
DAVID: *The intervention of the Sabine women*, 1799, oil on canvas, 386 × 520 cm, Paris, Louvre (S); *The death of Marat*, 1795, oil on canvas, 165 × 126 cm, Brussels, Musées Royaux des Beaux-Arts (S); *Mme Récamier*, 1800, oil on canvas, 173 × 243 cm, Paris, Louvre (Documentation Photographique de la Réunion des Musées Nationaux); *Napoleon in his study*, 1812, oil on canvas, 202 × 124 cm, Washington, National Gallery of Art, Andrew W. Mellon

collection. WEST: *The death of Wolfe*, 1771, oil on canvas, 151 × 213 cm, Ottawa, National Gallery of Canada. STUART: *George Washington*, 1795, oil on canvas, 122 × 94 cm, Washington, National Gallery of Art, Andrew W. Mellon collection. TRUMBULL: *The death of General Warren at the Battle of Bunker Hill*, 1786, oil on canvas, 61 × 86 cm, New Haven, Connecticut, Yale University Art Gallery. COPLEY: *A boy with a squirrel* (The artist's half-brother), c. 1765, oil on canvas, 77 × 63 cm, Boston, Museum of Fine Arts. GIRODET: *Atala's entombment*, 1808, oil on canvas, 205 × 284 cm, Paris, Louvre (S). GERARD: *Mme Récamier*, 1802, oil on canvas, 225 × 148 cm, Paris, Musée Carnavalet (Giraudon). PRUD'HON: *Justice and Divine Vengeance pursuing Crime*, 1808, oil on canvas, 243 × 292 cm, Paris, Louvre (Documentation Photographique de la Réunion des Musées Nationaux).

308–309 Neoclassical Sculpture
HOUDON: *Voltaire*, 1778, terracotta, height about 40 cm, Versailles, Musée Lambinet (Giraudon); *Denis Diderot*, 1791, terracotta, height 41 cm, Paris, Louvre (Documentation Photographique de la Réunion des Musées Nationaux); *George Washington*, 1788-92, marble, height of figure 188 cm, Richmond, Virginia, State Capitol (Photri). CANOVA: *Theseus and the Minotaur*, 1781-82, marble, height 147 cm, London, Victoria and Albert Museum; *Cupid and Psyche*, 1789-93, marble, height 155 cm, Paris, Louvre (Documentation Photographique de la Réunion des Musées Nationaux); Sketch for *Cupid and Psyche*, 1787, terracotta, height 16 cm, Possagno, Museo Canova (Courtauld Institute of Art); *Paulina Borghese as Venus Victrix*, 1805-07, marble, height 160 cm, Rome, Villa Borghese (S); Monument to Archduchess Maria Christina, 1799-1805, marble, height of pyramid nearly 6 m, Vienna, Augustinerkirche (Vienna, Österreichische Nationalbibliothek). THORVALDSEN: *Hebe*, 1806, marble, height 150 cm, Copenhagen, Thorvaldsen Museum (S). SCHADOW: *Field-Marshal Blücher*, 1819, bronze, height of figure about 2.5 m, Rostock, Universitätsplatz (Courtauld Institute of Art). PIGALLE: *Voltaire*, 1770-76, marble, height 147 cm, Paris, Louvre (Documentation Photographique de la Réunion des Musées Nationaux).

310–311 Neoclassics and Romantics in England
FLAXMAN: Illustration to the *Iliad: Princes all Hail!*, 1795, engraving, 30 × 45 cm (The Fotomas Index); Illustration to Aeschylus' *The Furies*, 1795, engraving, 29 × 46 cm (The Fotomas Index); Monument to Sophia Hoare, 1821, marble, 78 × 132 cm, Streatham, Parish Church (Courtauld Institute of Art). BLAKE: *The good and evil angels struggling for the possession of a child*, 1795, monotype finished in pen and watercolour, 43 × 58 cm, London, Tate Gallery; *Newton*, 1795, monotype finished in pen and watercolour, 46 × 58 cm, London, Tate Gallery; *The circle of the lustful*, from Dante's *Inferno*, Canto V, c. 1824, pen, pencil and watercolour on paper, 37 × 52 cm, Birmingham, Museum and Art Gallery; *Thenot under a fruit tree*, 1821, monotype, 3 × 7 cm, London, Tate Gallery. FUSELI: *The artist moved by the grandeur of ancient ruins*, 1778-79, red chalk and sepia wash on paper, 41 × 35 cm, Vienna, Kunsthistorisches Museum (S); *The nightmare*, 1781, oil on canvas, 101 × 127 cm, Detroit, Institute of Arts, Gift of Mr and Mrs Bert L. Smokler and Mr and Mrs Lawrence Fleischmann. PALMER: *Early morning*, 1825, sepia and gum on paper, 19 × 22 cm, Oxford,

Ashmolean Museum.

312–313 Francisco de Goya

GOYA: *Los Caprichos*, frontispiece: *Self-portrait*, 1798, etching, 21 × 13 cm (The Fotomas Index); The dome of Nuestra Senora del Pilar, Saragossa: *The Virgin, Queen of martyrs*, detail, 1781, fresco (Ampliaciones y Reproduciones Mas); *The sunshade*, 1777, oil on canvas, 104 × 152 cm, Madrid, Prado (S); *The Duchess of Alba*, 1797, oil on canvas, 210 × 149 cm, New York, Hispanic Society (S); *Nude maja*, 1802-05, oil on canvas, 97 × 190 cm, Madrid, Prado (S); *Don Manuel de Godoy*, 1801, oil on canvas, 181 × 268 cm, Madrid, Academy of San Fernando (S); *Two majas on a balcony*, c. 1800-14, oil on canvas, 195 × 125 cm, New York, Metropolitan Museum of Art, H.O. Havemeyer collection; *Charles IV and his family*, 1800, oil on canvas, 280 × 336 cm, Madrid, Prado (S); *May 3rd, 1808*, 1814, oil on canvas, 266 × 345 cm, Madrid, Prado (S).

314–315 Goya: The Colossus

GOYA: *The Disasters of War: This is how it is; This is worse*, c. 1810-15, both etchings, 16 × 22 cm (The Fotomas Index); *The straw manikin*, 1791-92, oil on canvas, 267 × 160 cm, Madrid, Prado (S); *Los Caprichos*, plate 43: *The sleep of Reason*, 1799, etching, 21 × 13 cm (The Fotomas Index); *Self-portrait with Dr Arrieta*, 1820, oil on canvas, 117 × 79 cm, Minneapolis, Institute of Arts; *Saturn*, 1820, fresco transferred to canvas, 146 × 238 cm, Madrid, Prado (S); *The colossus*, 1808-12, oil on canvas, 116 × 105 cm, Madrid, Prado (S).

316–317 Romantic Landscape in Britain and America

LOUTHERBOURG: *Coalbrookdale by night*, 1801, oil on canvas, 68 × 106 cm, London, Science Museum. MARTIN: *Joshua commanding the sun to stand still*, 1816, oil on canvas, 149 × 231 cm, London, Freemasons' Hall, United Grand Lodge of England (Cooper-Bridgeman Library). CROME: *The Poringland oak*, c. 1818, oil on canvas, 71 × 110 cm, London, Tate Gallery. COTMAN: *Greta Bridge*, 1805, watercolour on paper, 23 × 33 cm, London, British Museum. JOHN ROBERT COZENS: *Lake Nemi*, c. 1778-79, watercolour on paper, 36 × 50 cm, London, Victoria and Albert Museum. GIRTIN: *Kirkstall Abbey*, c. 1800, watercolour, pen and pencil on paper, 39 × 52 cm, London, Victoria and Albert Museum. ALLSTON: *Moonlit landscape*, 1819, oil on canvas, 61 × 89 cm, Boston, Museum of Fine Arts, Gift of William Sturgis Bigelow. COLE: *Sunny morning on the Hudson River*, c. 1827, oil on panel, 47 × 64 cm, Boston, Museum of Fine Arts, Mr and Mrs Karolik collection. DURAND: *Kindred spirits*, 1849, oil on canvas, 111 × 91 cm, New York, Public Library. BINGHAM: *Fur traders descending the Missouri*, c. 1844, oil on canvas, 73 × 93 cm, New York, Metropolitan Museum of Art, Morris K. Jessup Fund.

318–319 Constable: The White Horse

CONSTABLE: "*The White Horse*", 1819, oil on canvas, 131 × 188 cm, New York, Frick Collection (copyright); Oil-sketch for "*The White Horse*", c. 1819, oil on canvas, 127 × 183 cm, Washington, National Gallery of Art, Widener collection; *Clouds, Sept. 5th*, 1822, oil on paper, 29 × 48 cm, London, Victoria and Albert Museum; *The haywain*, 1821, oil on canvas, 130 × 185 cm, London, National Gallery; *Stonehenge*, watercolour, 38 × 59 cm, London, Victoria and Albert Museum; Pencil sketch, 1814, from sketch-book no. 132, on paper, 8 × 11 cm,

London, Victoria and Albert Museum.

320–321 Turner: Dawn after the Wreck

TURNER: *Dawn after the wreck*, c. 1840, watercolour on paper, 34.5 × 36 cm, London, Courtauld Institute Galleries; *Tintern Abbey*, c. 1795, watercolour over pencil with pen and ink, 33.5 × 26 cm, Oxford, Ashmolean Museum; *The slave ship*, 1840, oil on canvas, 91 × 122 cm, Boston, Museum of Fine Arts, Henry Lillie Pierce Fund; *Venice: S. Giorgio Maggiore*, 1819, watercolour on paper, 22 × 28 cm, London, British Museum (Cooper-Bridgeman Library); *Sun rising through vapour: fishermen cleaning and selling fish*, 1807, oil on canvas, 134 × 179 cm, London, National Gallery; *The Thames near Walton Bridge*, c. 1807, oil on panel, 36 × 73 cm, London, Tate Gallery; *Snowstorm: Hannibal crossing the Alps*, 1812, oil on canvas, 144 × 236 cm, London, Tate Gallery.

322–323 German and Scandinavian Romanticism

JUEL: *Northern lights*, c. 1790, oil on canvas, 31 × 39 cm, Copenhagen, Ny Carlsberg Glyptotek. KOCH: *Schmadribach waterfall*, 1808-11, oil on canvas, 123 × 93 cm, Leipzig, Museum of Fine Arts (S). DAHL: *Clouds*, 1825, oil on paper, 21 × 22 cm, West Berlin, Staatliche Museen (Bildarchiv Preussischer Kulturbesitz). FRIEDRICH: *Monk by the sea*, 1809, oil on canvas, 110 × 171 cm, West Berlin, Schloss Charlottenburg (Staatliche Schlösser und Gärten). RUNGE: *Morning*, 1808-09, oil on canvas, 152 × 113 cm, Hamburg, Kunsthalle (S); *Morning*, from *The Phases of the Day*, 1803, engraving, 72 × 48 cm, Hamburg, Kunsthalle (S); *The artist's parents and children*, 1806, oil on canvas, 194 × 131 cm, Hamburg, Kunsthalle (S). CORNELIUS: *Faust and Mephisto on the Brocken*, c. 1811, engraving, 40 × 34 cm, Frankfurt, Stadelisches Kunstinstitut (Bildarchiv Preussischer Kulturbesitz). PFORR: *The entry of Emperor Rudolf of Hapsburg into Basel in 1273*, 1808-10, oil on canvas, 90 × 119 cm, Frankfurt, Stadelisches Kunstinstitut (S). OVERBECK: *Italia und Germania*, 1811-28, oil on canvas, 95 × 105 cm, Dresden, Gemäldegalerie (S).

324–325 Friedrich: Man and Woman Gazing at the Moon

FRIEDRICH: *Abbey graveyard under snow*, 1810, oil on canvas, 121 × 170 cm, West Berlin, Schloss Charlottenburg (Bildarchiv Preussischer Kulturbesitz); *Moonrise over the sea*, 1822, oil on canvas, 55 × 71 cm, West Berlin, Staatliche Museen (S); The Tetschen altar: *The Cross on the mountains*, 1809, oil on canvas, 115 × 110 cm, Dresden, Gemäldegalerie (S); *A dolmen near Gützkow*, c. 1837, pencil and sepia, 22 × 30 cm, Copenhagen, The Library of Her Majesty Margrethe II, Queen of Denmark (Hans Petersen); *Man and woman gazing at the moon*, c. 1830-35, oil on canvas, 34 × 44 cm, West Berlin, Staatliche Museen (S); *The stages of life*, c. 1835, oil on canvas, 72 × 94 cm, Leipzig, Museum der Bildende Künste (S). KERSTING: *Friedrich in his studio*, oil on canvas, 51 × 40 cm, West Berlin, Staatliche Museen (S).

326–327 French Romanticism

GROS: *The plague at Jaffa*, 1804, oil on canvas, 532 × 720 cm, Paris, Louvre (Documentation Photographique de la Réunion des Musées Nationaux). GERICAULT: *An officer of the Chasseurs*, 1812, oil on canvas, 349 × 266 cm, Paris, Louvre (Documentation Photographique de la Réunion des Musées Nationaux); *A

wounded cuirassier leaving the field*, 1814, oil on canvas, 358 × 294 cm, Paris, Louvre (Documentation Photographique de la Réunion des Musées Nationaux); *The raft of the Medusa*, 1819, oil on canvas, 491 × 716 cm, Paris, Louvre (S); *A kleptomaniac*, 1822-23, oil on canvas, 60 × 50 cm, Ghent, Musée des Beaux-Arts (S). DELACROIX: *The barque of Dante*, 1822, oil on canvas, 189 × 246 cm, Paris, Louvre (Documentation Photographique de la Réunion des Musées Nationaux). RUDE: *The departure of the volunteers*, 1833-36, stone relief, 12.7 × 6 m, Paris, Arc de Triomphe (Giraudon); *The awakening of Napoleon*, 1847, bronze, 215 × 195 cm, Fixin (Côte d'Or), Parc Noisot (René Roland). BARYE: *Jaguar devouring a crocodile*, 1850, bronze, length 32 cm, Copenhagen, Ny Carlsberg Glyptotek.

328–329 Delacroix: The Death of Sardanapalus

DELACROIX: *The death of Sardanapalus*, 1827, oil on canvas, 395 × 495 cm, Paris Louvre (S); *The massacre at Chios*, 1824, oil on canvas, 422 × 352 cm, Paris, Louvre (S); *Still life with a lobster*, 1827, oil on canvas, 80 × 106 cm, Paris, Louvre (Documentation Photographique de la Réunion des Musées Nationaux); *Women of Algiers*, 1834, oil on canvas, 180 × 220 cm, Paris, Louvre (S); *Baron Schwitter*, 1826-30, oil on canvas, 218 × 143 cm, London, National Gallery; *Liberty leading the people*, 1830, oil on canvas, 260 × 325 cm, Paris, Louvre (S).

330–331 Painting in Victorian Britain

FRITH: *Derby Day*, 1856-58, oil on canvas, 101 × 223 cm, London, Tate Gallery. WILKIE: *Chelsea pensioners reading the Gazette of the Battle of Waterloo*, 1822, oil on canvas, 91 × 152 cm, London, Victoria and Albert Museum. MILLAIS: *Christ in the house of his parents*, 1850, oil on canvas, 86 × 137 cm, London, Tate Gallery. HOLMAN HUNT: *The awakened conscience*, 1852-54, oil on canvas, 76 × 56 cm, London, Tate Gallery. LANDSEER: *The monarch of the glen*, 1850, oil on canvas, 162 × 167 cm, London, Dewar House (John Dewar and Sons Ltd). ROSSETTI: *The Annunciation*, 1850, oil on canvas, 71 × 41 cm, London, Tate Gallery. MADOX BROWN: *Work*, 1852-63, 134.5 × 196 cm, Manchester, City Art Gallery; *Pretty baa lambs*, 1851, oil on wood, 20 × 26 cm, Oxford, Ashmolean Museum. BURNE-JONES: *King Cophetua and the beggar maid*, 1884, oil on canvas, 292 × 135 cm, London, Tate Gallery. WATTS: *Hope*, oil on canvas, 141 × 110 cm, London, Tate Gallery.

332–333 Ingres: La Grande Odalisque

INGRES: "*La Grande Odalisque*" (*The concubine*), 1814, oil on canvas, 91 × 162 cm, Paris, Louvre (S); "*The Valpinçon Bather*", 1808, oil on canvas, 146 × 97 cm, Paris, Louvre (Documentation Photographique de la Réunion des Musées Nationaux); *The Turkish bath*, 1859-62, oil on canvas, diameter 108 cm, Paris, Louvre (S); *The apotheosis of Homer*, 1827, oil on canvas, 386 × 515 cm, Paris, Louvre (Documentation Photographique de la Réunion des Musées Nationaux); *Oedipus and the Sphinx*, 1808, reworked 1825, oil on canvas, 189 × 144 cm, Paris, Louvre (S); *Louis-François Bertin*, 1832, oil on canvas, 116 × 95 cm, Paris, Louvre (Documentation Photographique de la Réunion des Musées Nationaux); *Joseph Woodhead, his wife Harriet and her brother Henry Comber*, 1816, pencil on paper, 30 × 22 cm, Cambridge, Fitzwilliam Museum; *La Comtesse d'Haussonville*, 1845, oil on canvas, New York, Frick Collection (copyright).

334–335 Academic Art in Europe

COUTURE: *The Romans of the Decadence*, 1847, oil on canvas, 466 × 775 cm, Paris, Louvre (Documentation Photographique de la Réunion des Musées Nationaux). GEROME: *The gladiators*, c. 1859, oil on canvas, 97 × 149 cm, Phoenix, Art Museum. MEISSONIER: *Napoleon III at the Battle of Solferino, June 24th, 1859*, 1863, oil on canvas, 44 × 76 cm, Paris, Louvre (Documentation Photographique de la Réunion des Musées Nationaux). INGRES: "*La Source*" (The spring), 1856, oil on canvas, 164 × 82 cm, Paris, Louvre (S). FLANDRIN: *Theseus recognized by his father*, 1838, oil on canvas, Paris, Ecole des Beaux-Arts (Giraudon). CHASSERIAU: *The toilet of Esther*, 1841, oil on canvas, 44 × 36 cm, Paris, Louvre (Documentation Photographique de la Réunion des Musées Nationaux). LEIGHTON: *The Garden of the Hesperides*, 1892, oil on canvas, diameter 169 cm, Liverpool, Walker Art Museum. CABANEL: *The birth of Venus*, 1863, oil on canvas, 130 × 225 cm, Paris, Louvre (Documentation Photographique de la Réunion des Musées Nationaux). REGNAULT: *Automedon with the horses of Achilles*, 1868, oil on canvas, 54 × 45 cm, Paris, Louvre (Documentation Photographique de la Réunion des Musées Nationaux). ALMA-TADEMA: *The Baths of Caracalla*, 1899, oil on canvas, 152 × 94 cm, Wynyard Park, Co. Durham, Lord Londonderry collection (Dennis Wompra).

336–337 French Realism

NADAR: *Charles Baudelaire*, c. 1863, photograph, Paris, Caisse Nationale des Monuments Historiques et des Sites. DAUMIER: *Ratapoil*, c. 1850, bronze, height 44 cm, Buffalo, Albright-Knox Art Gallery, Elizabeth H. Gates Fund; *Rue Transnonain, April 15th, 1834*, 1834, lithograph, 29 × 44cm, Paris, Bibliothèque Nationale (Immédiate 2); *Nadar in a balloon*, 1862, lithograph, 27 × 22 cm, London, British Library; *The dream of the inventor of the needle gun*, 1866, lithograph, 23 × 20 cm, London, British Library; *The third-class carriage*, c. 1862, oil on canvas, 65 × 90 cm, New York, Metropolitan Museum of Art, H.O. Havemeyer collection. GUYS: *Two ladies with muffs*, c. 1875-80, wash drawing, 18 × 14 cm, London, Courtauld Institute Galleries. MILLET: *The sower*, 1850, oil on canvas, 101 × 82 cm, Boston, Museum of Fine Arts, Shaw collection; *The angelus*, 1855-57, oil on canvas, 55 × 66 cm, Paris, Louvre (Documentation Photographique de la Réunion des Musées Nationaux). MERYON: *The morgue*, 1854, etching, 190 × 213 cm, London, Victoria and Albert Museum.

338–339 Courbet: The Artist's Studio

COURBET: *The artist's studio*, 1854-55, oil on canvas, 361 × 598 cm, Paris, Louvre (Documentation Photographique de la Réunion des Musées Nationaux); *Self-portrait with black dog*, 1844, oil on canvas, 46 × 55 cm, Paris, Louvre, Petit Palais (S); *The stone-breakers*, 1849, oil on canvas, 165 × 238 cm, formerly Dresden, Gemäldegalerie, destroyed (Courtauld Institute of Art); *The bathers*, 1853, oil on canvas, 227 × 193 cm, Montpellier, Musée Fabre (Claude O'Sughrue); *A burial at Ornans*, 1849-50, oil on canvas, 314 × 663 cm, Paris, Louvre (S); *Pierre-Joseph Proudhon and his family*, 1865, oil on canvas, 147 × 198 cm, Besançon, Musée des Beaux-Arts (S).

340–341 French Landscape

ROUSSEAU: *A group of oaks near Barbizon*, 1852, oil on canvas, 63 × 99 cm, Paris, Louvre (S). BONINGTON: *View of*

Normandy?, c. 1824, oil on canvas, 38 × 53 cm, London, Tate Gallery. HUET: *Elms at St-Cloud*, 1823, oil on canvas, 36 × 27 cm, Paris, Louvre, Petit Palais (Photo Bulloz). MICHEL: *The storm*, c. 1820-30, oil on panel, 58 × 73 cm, Chicago, Art Institute. DAUBIGNY: *Snow scene: Valmondois*, 1875, oil on canvas, 89 × 153 cm, Perth, Art Gallery of Western Australia. MILLET: *Spring*, 1868-73, oil on canvas, 86 × 111 cm, Paris, Louvre (Documentation Photographique de la Réunion des Musées Nationaux). COURBET: *The Loue valley in stormy weather*, c. 1849, oil on canvas, 56 × 66 cm, Strasbourg, Musée des Beaux-Arts. DIAZ DE LA PENA: *Gypsies going to a fair*, 1844, oil on canvas, 99 × 80 cm, Boston, Museum of Fine Arts, Bequest of Mrs Samuel Dennis Warren. COROT: *The island of San Bartolommeo in Rome*, 1825, oil on canvas, 25 × 43 cm, Boston, Museum of Fine Arts, Harriet Otis Cruft Fund; *View of Avray*, c. 1835-40, oil on canvas, 53 × 78 cm, Metropolitan Museum of Art, Bequest of Catherine Lorillard Wolfe.

342–343 Edouard Manet

FANTIN-LATOUR: *Edouard Manet*, 1867, oil on canvas, 117 × 90 cm, Chicago, Art Institute. MANET: *The absinthe drinker*, 1858, oil on canvas, 180 × 106 cm, Copenhagen, Ny Carlsberg Glyptotek; *Olympia*, 1863, oil on canvas, 150 × 190 cm, Paris, Louvre, Jeu de Paume (S); *"Le Déjeuner sur l'Herbe"* (The picnic), 1863, oil on canvas, 208 × 264 cm, Paris, Louvre, Jeu de Paume (S); Oil-sketch for *The execution of Maximilian*, 1867, oil on canvas, 252 × 305 cm, Copenhagen, Ny Carlsberg Glyptotek; *Emile Zola*, 1868, oil on canvas, 190 × 110 cm, Paris, Louvre, Jeu de Paume (S); *Chez Père Lathuille*, 1879, oil on canvas, 92 × 112 cm, Tournai, Musée des Beaux-Arts (René Roland); *Argenteuil*, 1874, oil on canvas, 92 × 112 cm, Tournai, Musée des Beaux-Arts (S); *Civil war*, 1871, lithograph, 39 × 50 cm, London, British Museum.

344–345 Whistler: Falling Rocket

WHISTLER: *Falling rocket: Nocturne in black and gold*, c. 1874, oil on panel, 60 × 47 cm, Detroit, Institute of Arts, Dexter M. Ferry Jnr Fund; *At the piano*, 1858-59, oil on canvas, 66 × 90 cm, Cincinnati, Art Museum, Louise Taft Semple Bequest; *Cremorne lights: Nocturne in blue and silver*, 1872, oil on canvas, 49 × 74 cm, London, Tate Gallery (Angelo Hornak); *Wapping-on-Thames*, 1861-64, oil on canvas, 71 × 101 cm, New York, Collection of Mr and Mrs John Hay Whitney; *The white girl: Symphony in white no. I*, 1862, oil on canvas, 214 × 108 cm, Washington, National Gallery of Art, Harris Whittemore collection; *The artist's mother: Arrangement in grey and black no. I*, 1862, oil on canvas, 145 × 164 cm, Paris, Louvre (Documentation Photographique de la Réunion des Musées Nationaux); *Venetian palaces: Nocturne*, 1879-80, etching, 29 × 20 cm (Courtauld Institute of Art).

346–347 Impressionism 1

RENOIR: *At the inn of Mother Anthony*, 1866, oil on canvas, 195 × 130 cm, Stockholm, National Museum; *Monet working in his garden*, 1873, oil on canvas, 50 × 62 cm, Hartford, Connecticut, Wadsworth Atheneum. BOUDIN: *The jetty at Deauville*, 1865, oil on canvas, 235 × 325 cm, Paris, Louvre, Jeu de Paume (S). PISSARRO: *Red roofs*, 1877, oil on canvas, 53 × 64 cm, Paris, Louvre, Jeu de Paume (S). MONET: *Impression: Sunrise*, 1872, oil on canvas, 50 × 62 cm, Paris, Musée Marmottan (S). BAZILLE: *The*

artist's family, 1867, oil on canvas, 152 × 230 cm, Paris, Louvre, Jeu de Paume (S). SISLEY: *Floods at Port-Marly*, 1876, oil on canvas, 60 × 81 cm, Paris, Louvre, Jeu de Paume (S). RENOIR: *Mme Charpentier and her children*, 1878, oil on canvas, 154 × 190 cm, New York, Metropolitan Museum of Art, Wolfe Fund. MORISOT: *The butterfly chase*, 1874, oil on canvas, 47 × 56 cm, Paris, Louvre, Jeu de Paume (S).

348–349 Claude Monet

NADAR: *Claude Monet*, 1899, photograph, Paris, Caisse Nationale des Monuments Historiques et des Sites. MONET: *The cart – snow-covered road at Honfleur*, 1865, oil on canvas, 65 × 92 cm, Paris, Louvre, Jeu de Paume (S); *Ladies in the garden*, 1867, oil on canvas, 254 × 206 cm, Paris, Louvre, Jeu de Paume (S); *La Grenouillère*, 1869, oil on canvas, 75 × 99 cm, New York, Metropolitan Museum of Art, H.O. Havemeyer collection; *Gare St Lazare*, 1877, oil on canvas, 75 × 100 cm, Paris, Louvre, Jeu de Paume (S); *Two haystacks*, 1891, oil on canvas, 64 × 99 cm, Chicago, Art Institute; *The cliff at Etretat*, 1883, oil on canvas, 64 × 81 cm, New York, Metropolitan Museum of Art, Bequest of William Church Osborne; *The lilypond*, after 1900, oil on canvas, 89 × 100 cm, Paris, Louvre, Jeu de Paume (S); *Two haystacks*, 1891, oil on canvas, 60 × 100 cm, Paris, Louvre, Jeu de Paume (Documentation Photographique de la Réunion des Musées Nationaux).

350–351 Impressionism 2

PISSARRO: *A view from the artist's window, Eragny*, 1888, oil on canvas, 55 × 81 cm, Oxford, Ashmolean Museum; *The Boulevard Montmartre at night*, 1897, oil on canvas, 55 × 65 cm, London, National Gallery; *The potato harvest*, 1886, etching, 28 × 22 cm, New York, Public Library. RENOIR: *Umbrellas*, c. 1881-84, oil on canvas, 180 × 116 cm, London, National Gallery; *The bathers*, c. 1884-87, oil on canvas, 115 × 170 cm, Philadelphia, Museum of Art, Mr and Mrs Carroll S. Tyson collection; *Ambroise Vollard*, 1908, oil on canvas, 81 × 64 cm, London, Courtauld Institute Galleries; *The washerwoman*, 1917, bronze, height 120 cm, New York, Museum of Modern Art, A. Conger Goodyear Fund. GAUGUIN: *Harvest in Brittany*, 1888, oil on canvas, 29 × 36 cm, Paris, Louvre, Jeu de Paume (S). MONET: *Rouen Cathedral: full sunlight*, 1894, oil on canvas, 107 × 73 cm, Paris, Louvre, Jeu de Paume (S).

352–353 Degas: The Little 14-Year-Old Dancer

DEGAS: *The Bellelli family*, 1858-59, oil on canvas, 199 × 252 cm, Paris, Louvre, Jeu de Paume (S); *The glass of absinth*, 1876, oil on canvas, 94 × 69 cm, Paris, Louvre, Jeu de Paume (S); *The little 14-year-old dancer*, 1880, bronze, muslin, satin and paint, height 98 cm, Paris, Louvre, Jeu de Paume (both views Documentation Photographique de la Réunion des Musées Nationaux); *A dancer on stage with a bouquet*, 1878, pastel on paper, 72 × 76 cm, Paris, Louvre, Jeu de Paume (S); *Woman drying her feet*, c. 1885, pastel on paper, 53 × 51 cm, Paris, Louvre, Jeu de Paume (S).

354–355 Sculpture in the Later 19th Century

GIBSON: *The tinted Venus*, 1851-52, marble and paint, height 198 cm, Liverpool, Walker Art Gallery. POWERS: *The Greek slave*, 1843, marble, height 157 cm, Washington DC, Corcoran Gallery of Art, Gift of William Corcoran. STEVENS: Monument to the Duke of Wellington,

detail: *Valour and Cowardice*, 1858-1912, marble and bronze, London, St Paul's Cathedral (Angelo Hornak). HILDEBRAND: The Hubertus fountain, detail: *The archer* marble, Munich, Waisenhausstrasse (Courtauld Institute of Art). CARPEAUX: *The dance*, 1866-69, plaster, height 232 cm, Paris, Louvre (Documentation Photographique de la Réunion des Musées Nationaux). RODIN: *The Age of Bronze*, 1875-76, height 175 cm, Paris, Musée Rodin; *Honoré de Balzac*, 1892-98, bronze, height 275 cm, Paris, Musée Rodin; *The burghers of Calais*, 1884-86, bronze, height of figures about 2 m, Paris, Musée Rodin. ROSSO: *Conversation in a garden*, 1893, plaster, 33 × 67 cm, Milan, Collection Gianni Mattioli (Fabbri/Joseph P. Ziolo); *"Ecce Puer"*, 1910, wax over plaster, height 43 cm, Piacenza, Galleria d'Arte Moderna (S). MAILLOL: *Young girl with drapery*, 1910, bronze, height 175 cm, Paris, Musée National d'Art Moderne (Caisse Historique des Monuments et des Sites).

356–357 Rodin: The Gates of Hell

RODIN: *Crouching woman*, 1882, height 83 cm, Paris, Musée Rodin; *The Danaïd*, 1885, marble, height 33 cm, Paris, Musée Rodin; *The thinker*, 1880, bronze, height 200 cm, Paris, Musée Rodin; *Nero*, c. 1900-05, pencil and gouache drawing, 31 × 25 cm, New York, Metropolitan Museum of Art; The Gates of Hell, 1880-1917, bronze, 550 × 370 cm, Paris, Musée Rodin (detail, *Ugolino*, also Musée Rodin).

358–359 Seurat: La Grande Jatte

SEURAT: *La Grande Jatte*, 1884-86, oil on canvas, 205 × 305 cm, Chicago, Art Institute; *"Une Baignade, Asnières"* (A bathing scene at Asnières), 1883-84, oil on canvas, 200 × 301 cm, London, National Gallery; *The yoked cart*, 1883, oil on canvas, 33 × 40 cm, New York, Solomon R. Guggenheim Museum (Robert E. Mates); *The "Bec du Hoc" at Grandchamp*, 1885, oil on canvas, 64 × 81 cm, London, Tate Gallery; *Seated boy with a straw hat*, 1883-84, Conté crayon on paper, 22 × 28 cm, New Haven, Connecticut, Yale University Art Gallery, Everett V. Meeks Fund; Study for *The circus*, 1890, oil on canvas, 55 × 46 cm, Paris, Louvre, Jeu de Paume (Documentation Photographique de la Réunion des Musées Nationaux). SIGNAC: *View of the marina at Marseilles*, 1905, oil on canvas, 86 × 114 cm, New York, Metropolitan Museum of Arts, Gift of Robert Lehman.

360–361 Post-Impressionism 1

GAUGUIN: *Vincent van Gogh*, 1888, oil on canvas, 73 × 91 cm, Amsterdam, Museum Vincent van Gogh. PISSARRO: *Paul Cézanne*, 1874, oil on canvas, 74 × 61 cm, Private Collection (Sotheby Parke Bernet). VAN GOGH: *Self-portrait*, 1888, 62 × 52 cm, Cambridge, Massachusetts, Harvard University, Courtesy of the Fogg Art Museum, Bequest of Maurice Wertheim; *Montmartre with windmills*, 1887, oil on canvas, 94 × 119 cm, Amsterdam, Stedelijk Museum; *The bridge at La Grande Jatte*, 1887, oil on canvas, 32 × 40.5 cm, Amsterdam, Museum Vincent van Gogh. CEZANNE: *The rape*, 1867, oil on canvas, 90 × 117 cm, Cambridge, Fitzwilliam Museum; *Achille Empéraire*, 1868-70, oil on canvas, 199 × 122 cm, Paris, Louvre, Jeu de Paume (Documentation Photographique de la Réunion des Musées Nationaux); *"La Maison du Pendu"* (The suicide's house), 1873, oil on canvas, 56 × 66 cm, Paris, Louvre, Jeu de Paume (S); *The little bridge at Maincy*, 1882-85, oil on canvas, 53 × 78 cm, Paris, Louvre, Jeu de Paume (S).

362–363 Vincent van Gogh

VAN GOGH: *Self-portrait*, 1890, oil on canvas, 63 × 53 cm, Paris, Louvre, Jeu de Paume (S); *The potato eaters*, 1885, oil on canvas, 82 × 114 cm, Amsterdam, Museum Vincent van Gogh; *The night café*, 1888, oil on canvas, 70 × 89 cm, New Haven, Connecticut, Yale University Art Gallery; *Sunflowers*, 1888, oil on canvas, 93 × 73 cm, London, National Gallery; *Sailing boats coming ashore*, 1888, ink on paper, 24 × 31 cm, Brussels, Musées Royaux des Beaux-Arts; *Field with a stormy sky*, 1890, oil on canvas, 50 × 101 cm, Amsterdam, Museum Vincent van Gogh; *"La Berceuse"* (Mme Roulin rocking a cradle), 1889, 92 × 73 cm, Otterlo, Museum Kröller-Müller; *Dr Paul Gachet*, 1890, oil on canvas, 68 × 57 cm, Paris, Louvre, Jeu de Paume (S); *Country road by night*, 1890, oil on canvas, 93 × 73 cm, Otterlo, Museum Kröller-Müller.

364–365 Paul Gauguin

GAUGUIN: *Bonjour, M. Gauguin*, 1889, oil on canvas, 92 × 54 cm, Prague, National Gallery; *Self-portrait*, 1888, oil on canvas, 71 × 89 cm, Amsterdam, Museum Vincent van Gogh; *Be in love and you will be happy*, 1889-90, painted wood, 96 × 72 cm, Boston, Museum of Fine Arts; *The vision after the sermon*, 1888, oil on canvas, 73 × 92 cm, Edinburgh, National Gallery of Scotland (Tom Scott); *The spirit of the dead watching*, 1892, oil on canvas, 73 × 92 cm, Buffalo, New York, Albright-Knox Art Gallery, A. Conger Goodyear collection; *Noa Noa*, c. 1893, woodcut, 14 × 8 cm, Paris, Bibliothèque Nationale (Immédiate 2); *Where do we come from? What are we? Where are we going?*, 1897, oil on canvas, 139 × 374 cm, Boston, Museum of Fine Arts; *Nevermore*, 1897, oil on canvas, 54 × 115 cm, London, Courtauld Institute Galleries.

366–367 Cézanne: Monte Ste-Victoire

CEZANNE: The Philadelphia *Mont Ste-Victoire*, 1904-06, oil on canvas, 53 × 91 cm, Philadelphia, Museum of Art, George W. Atkins collection; *Mont Ste-Victoire with a great pine*, 1885-87, oil on canvas, 66 × 90 cm, London, Courtauld Institute Galleries; *Still life with onions*, c. 1895-1900, oil on canvas, 63 × 78 cm, Paris, Louvre, Jeu de Paume (S); *"The Great Bathers"*, 1898-1905, oil on canvas, 208 × 249 cm, Philadelphia, Museum of Art, William P. Wilstach collection (S); *Mont Ste-Victoire*, watercolour, 1906, on paper, 36 × 54 cm, London, Tate Gallery; *Self-portrait with a goatee*, c. 1906, 63 × 50 cm, Boston, Museum of Fine Arts.

368–369 Post-Impressionism 2, and Art Nouveau

SERUSIER: *"The Talisman": landscape in the Bois d'Amour in Brittany*, 1888, oil on panel, 27 × 22 cm, Alençon, Collection F. Denis (Giraudon). VUILLARD: *Mother and sister of the artist*, c. 1893, oil on canvas, 46.5 × 56.5 cm, New York, Museum of Modern Art; *The laden table*, c. 1908, pastel and gouache and distemper, 47 × 54 cm, London, Tate Gallery. BONNARD: *Nude in the bath*, 1937, oil on canvas, 93 × 147 cm, Paris, Louvre, Petit Palais (René Roland); *La Revue Blanche*, 1894, lithograph poster, 77 × 60.5 cm, New Haven, Connecticut, Yale University Art Gallery. TOULOUSE-LAUTREC: *Self-portrait*, c. 1890, black chalk, 25.5 × 16 cm, Rotterdam, Museum Boymans-van Beuningen; *The English girl at "Le Star", Le Havre*, 1899, sanguine and gesso on paper, 62 × 47 cm, Albi, Musée Toulouse-Lautrec (Cooper-Bridgeman Library); *Jane Avril at the*

Jardin de Paris, 1893, lithograph poster, 130 × 95 cm, Albi, Musée Toulouse-Lautrec. BEARDSLEY: *Salomé: "J'ai baisé ta bouche, Iokanaan*, 1894, printed illustration to Oscar Wilde's *Salomé*, 26 × 13 cm. KLIMT: *Judith*, 1909, oil on canvas, 84 × 42 cm, Vienna, Österreichische Galerie (S).

370–371 Symbolism

MOREAU: *The unicorns*, c. 1885, oil on canvas, 115 × 90 cm, Paris, Musée Gustave Moreau. PUVIS DE CHAVANNES: *Hope*, 1872, oil on canvas, 70 × 82 cm, Paris, Louvre. REDON: *Meadow flowers in a vase*, after 1895, pastel, 57 × 35 cm, Paris, Louvre, Jeu de Paume (Documentation Photographique de la Réunion des Musées Nationaux); *On the horizon, the angel of certainties*, 1882, lithograph, 27 × 20.5 cm, Chicago, Art Institute; *Orpheus*, after 1913, pastel, 70 × 31 cm, Cleveland, Museum of Art, Gift of J.H. Wade. ROSSETTI: *Astarte Syriaca*, 1877, oil on canvas, 185 × 109 cm, Manchester, City Art Gallery. BURNE-JONES: *The mill*, c. 1870-82, oil on canvas, 90.5 × 195.5 cm, London, Victoria and Albert Museum. KHNOPFF: *Memories*, 1889, pastel on canvas, 127 × 200 cm, Brussels, Musées Royaux des Beaux-Arts. BOCKLIN: *The island of the dead*, 1880, oil on panel, 74 × 122 cm, New York, Metropolitan Museum of Art.

372–373 American Art

JOHNSON: *The old stagecoach*, 1871, oil on canvas, 93 × 155 cm, Milwaukee, Art Center, Layton Art Collection. HOMER: *Inside the bar, Tynemouth*, 1883, watercolour on paper, 39 × 72 cm, New York, Metropolitan Museum of Art; *"Breezing up"*, 1876, oil on canvas, 61 × 97 cm, Washington, National Gallery of Art. EAKINS: *The Gross Clinic*, 1875, oil on canvas, 244 × 198 cm, Philadelphia, University, College (Cooper-Bridgeman Library). HARNETT: *My gems*, 1888, oil on panel, 46 × 35.5 cm, Washington, National Gallery of Art, Gift of the Avalon Foundation. RYDER: *Moonlit cove*, c. 1890-1900, oil on canvas, 35.5 × 43 cm, Washington DC, Phillips Collection. SARGENT: *The daughters of Edward D. Boit*, 1882, oil on canvas, 221 × 221 cm, Boston, Museum of Fine Arts; *Mme Gautreau*, 1884, oil on canvas, 209 × 110 cm, New York, Metropolitan Museum of Art, Arthur Hoppock Hearn Fund. CASSATT: *The bath*, 1892, oil on canvas, 100 × 66 cm, Chicago, Art Institute (S).

374–375 Art in the 20th Century

MONET: *Waterlilies*, 1900-09 (*Morning III*), oil on canvas, 197 × 425 cm, Paris, Louvre, Orangerie (whole and detail Joseph P. Ziolo/René Roland). CEZANNE: *Ambroise Vollard*, 1899, oil on canvas, 100 × 81 cm, Paris, Louvre, Jeu de Paume (Joseph P. Ziolo/René Roland). UNKNOWN RUSSIAN: *A yellow cat*, early 20th century, woodcut (S.C.R. London). PICASSO: *Ambroise Vollard*, 1910, oil on canvas, 92 × 65 cm, Moscow, Museum of Modern Art (Joseph P. Ziolo/A.P.N. Paris). UNKNOWN AFRICAN: Ancestor figure, late 19th century, wood, height about 1 m (Werner Forman Archive). TOLTEC ARTIST: *Chacmool*, 12th century, stone, Chichen Itza, Temple of the Warriors (ZEFA/K. Rohrich). DEGAS: *Princess Metternich*, 1861, oil on canvas, 41 × 29 cm, London, National Gallery. MUYBRIDGE: *Two men wrestling*, 1887, photograph, Kingston-on-Thames, Museum and Art Gallery. DISDERI: *Prince and Princess Metternich*, c. 1860, photograph, Melton Constable, Aaron Scharf Collection. *Paul Cézanne and Camille Pissarro*, 1872, photograph, Paris, Collection Roger Viollet. ARNATT:

I'm a real artist, 1972, from "The New Art", London, Hayward Gallery, 1972 (courtesy of the artist).

376–377 Edvard Munch

MUNCH: *Self-portrait in Hell*, 1895, oil on canvas, 82 × 59.5 cm, Oslo, Munch Museet (S); *Madonna*, 1895, oil on canvas, 91 × 70.5 cm, Oslo, National Gallery (S); *Vampire*, 1895-1902, lithograph, 38.5 × 54.5 cm, Oslo, Munch Museet (S); *The kiss*, 1892, colour woodcut, 47 × 47.5 cm, Oslo, Munch Museet (S); *Puberty*, 1895, oil on canvas, 151 × 110 cm, Oslo, National Gallery (S); *The scream*, 1893, oil and pastel on cardboard, 91 × 73.5 cm, Oslo, National Gallery (S); *History*, 1910-11, oil on canvas, 455 × 1160 cm, Oslo, University Hall (S); *The scream*, 1895, lithograph, 35 × 25 cm, Oslo, Munch Museet (S); *Self-portrait between clock and bed*, 1940-42, oil on canvas, 149.5 × 120.5 cm, Oslo, Munch Museet (S).

378–379 Impressionists and Expressionists in Germany

TOOROP: *The three brides*, 1893, crayon on paper, 78 × 98 cm, Otterlo, Museum Kröller-Müller. LIEBERMANN: *The parrot man*, 1902, oil on canvas, 110 × 71 cm, Essen, Folkwang Museum. ENSOR: *The murder*, 1888, etching, 18 × 24 cm, Stuttgart, Staatsgalerie, Graphische Sammlung; *The entry of Christ into Brussels*, 1888, oil on canvas, 258 × 431 cm, Antwerp, Musée Royal des Beaux-Arts. UHDE: *At the summer resort*, 1892, oil on canvas, Munich, Neue Pinakothek (Blauel). CORINTH: *Morning sunlight*, 1910, oil on canvas, 68.5 × 81 cm, Darmstadt, Hessisches Landesmuseum. BARLACH: *The solitary one*, 1911, oak, height 59 cm, Hamburg, Kunsthalle. KOLLWITZ: *Woman welcoming death*, 1934-35, lithograph, 31.5 × 31 cm, Washington, National Gallery of Art. LEHMBRUCK: *Kneeling woman*, 1911, cast stone, height 179.5 cm, Buffalo, New York, Albright-Knox Gallery, Charles Clifton Fund. MODERSOHN-BECKER: *Mother and child*, 1906, oil on canvas, 84 × 125 cm, Bremen, Ludwig-Roselius Sammlung (Angelo Hornak).

380–381 Nolde: The Last Supper

NOLDE: *The Last Supper*, 1909, oil on canvas, 83 × 106 cm, Seebüll, Nolde Foundation; *A Friesland farm under red clouds*, c. 1930, watercolour on paper, 32.5 × 46.5 cm, London, Victoria and Albert Museum; *The prophet*, 1912, woodcut, 32 × 22 cm, Washington, National Gallery of Art, Rosenwald collection; *Early morning flight*, 1940, 70 × 86 cm, Seebüll, Nolde Foundation. ENSOR: *Intrigue*, 1890, oil on canvas, 90 × 150 cm, Antwerp, Musée des Beaux-Arts.

382–383 Expressionism 1: Die Brücke

KIRCHNER: *Artists of Die Brücke*, c. 1926, oil on canvas, 167 × 125 cm, Cologne, Wallraf-Richartz Museum (S); *Street scene*, 1913-14, oil on canvas, 125 × 91 cm, Stuttgart, Staatsgalerie; *The artists' group of the bridge*, 1906, woodcut, Dresden, Staatliche Kunstsammlungen; *The couple*, 1923, oil on canvas, Paris, Musée National d'Art Moderne (S). SCHMIDT-ROTTLUFF: *The sun in a pine tree*, 1913, oil on canvas, 76.5 × 90 cm, Amsterdam, Collection Thyssen; *The head of Christ*, 1918, woodcut, 50 × 39.5 cm, New Haven, Connecticut, Yale University Art Gallery. HECKEL: *Two men at a table*, 1912, oil on canvas, 97 × 120 cm, Hamburg, Kunsthalle. PECHSTEIN: *The harbour*, 1922, oil on canvas, 80 × 100 cm, Amsterdam, Stedelijk Museum. MUELLER: *Nudes on a beach*, 1920, oil on canvas, Hamburg,

Kunsthalle.

384–385 Expressionism 2: Der Blaue Reiter

KANDINSKY: *Composition no. 4 (Battle)*, 1911, oil on canvas, 159.5 × 250.5 cm, Düsseldorf, Kunstsammlung Nordrhein-Westfalen (Joseph P. Ziolo/M. Babey). MARC: *The fate of the animals*, 1913, oil on canvas, 195 × 263 cm, Basel, Kunstmuseum; *Deer in a forest II*, 1913-14, oil on canvas, 100.5 × 100.5 cm, Karlsruhe, Kunsthalle. MACKE: *Kairouan I*, 1914, watercolour, 20.5 × 24.5 cm, Munich, Neue Pinakothek; *People at the blue lake*, 1913, oil on canvas, 60 × 48.5 cm, Karlsruhe, Kunsthalle. KLEE: *An animal suckling its offspring*, 1906, drawing, Munich, Neue Pinakothek. MUNTER: *A man at a table* (Wassily Kandinsky), 1911, oil on cardboard, 51.5 × 68.5 cm, Munich, Lenbachhaus. JAWLENSKY: *Woman meditating*, 1912, oil on canvas, Lugano, Collection Thyssen (S). KUBIN: *The egg*, c. 1900, etching, Vienna, Albertina.

386–387 Kandinsky: Study for Composition no. 7

KANDINSKY: Study for *Composition no. 7*, 1913, watercolour, 78 × 100 cm, Berne, Collection Felix Klee; *Improvisation no. 30 – Cannons*, 1913, oil on canvas, 110 × 110 cm, Chicago, Art Institute; *Composition no. 7, fragment no. 1*, 1913, oil on canvas, 87.5 × 100.5 cm, Milwaukee, Art Center, Gift of Mrs Harry Lynde Bradley; *The first abstract watercolour*, 1912, watercolour, 50 × 65 cm, Paris, Musée National d'Art Moderne; *Black lines*, 1913, oil on canvas, 130 × 130.5 cm, New York, Solomon R. Guggenheim Museum; *Two poplars*, 1913, Chicago, Art Institute.

388–389 Le Douanier Rousseau: The Merry Jesters

ROUSSEAU: *The merry jesters*, c. 1906, oil on canvas, 145.5 × 113 cm, Philadelphia, Museum of Art, Louise and Walter Arsenburg collection; *The toll station*, c. 1890-91, oil on canvas, 41 × 33 cm, London, Courtauld Institute Galleries; *The ball players*, oil on canvas, 100 × 80 cm, New York, Solomon R. Guggenheim Museum. SERAPHINE: *The paradise tree*, 1929, oil on canvas, 195 × 129 cm, Paris, Musée National d'Art Moderne. VIVIN: *Notre Dame*, Paris, oil on canvas, 65 × 81 cm, Paris, Musée National d'Art Moderne. BAUCHANT: *Cleopatra's barge*, 1939, oil on canvas, 84 × 100 cm, New York, Museum of Modern Art, Abby Aldrich Rockefeller Fund.

390–391 Fauvism

DERAIN: *The harbour at Collioure*, 1905, oil on canvas, 72 × 91 cm, Paris, Musée National d'Art Moderne (Documentation Photographique de la Réunion des Musées Nationaux); *Effects of sunlight on water*, 1905, oil on canvas, 81 × 100 cm, St-Tropez, Musée de l'Annonciade (Documentation Photographique de la Réunion des Musées Nationaux). BRAQUE: *The little bay at La Ciotat*, 1907, oil on canvas, 38 × 46 cm, Paris, Musée National d'Art Moderne (S). MATISSE: *The gypsy*, 1906, oil on canvas, 55 × 46 cm, St-Tropez, Musée de l'Annonciade (S). DUFY: *Riders in the wood*, 1931, oil on canvas, 213 × 260 cm, Paris, Musée National d'Art Moderne (S). VLAMINCK: *Landscape with red hues*, 1906-07, oil on canvas, 65 × 81 cm, Paris, Musée National d'Art Moderne (Documentation Photographique de la Réunion des Musées Nationaux). MARQUET: *Hoardings at Trouville*, 1906, oil on canvas, 81 × 65 cm, Paris, Musée National d'Art Moderne (Giraudon).

ROUAULT: *The face of Christ*, 1933, oil on canvas, 91 × 65 cm, Ghent, Musée des Beaux-Arts (S); *The prostitute*, 1906, gouache, watercolour and pastel, 71 × 54 cm, Paris, Musée National d'Art Moderne (Photo Bulloz).

392–393 Matisse: Le Luxe 11

MATISSE: *"Luxe, Calme et Volupté"*, 1904-05, oil on canvas, 86 × 116 cm, Paris, Mme Signac Collection (Cooper-Bridgeman Library); *The dance*, 1910, oil on canvas, 260 × 391 cm, Leningrad, Hermitage (Joseph P. Ziolo/Studio Adrion); *"La Joie de Vivre"*, 1905-06, oil on canvas, 175 × 238 cm, Merion, Pennsylvania, Barnes Foundation; *"Le Luxe I"*, 1907, oil on canvas, 210 × 138 cm, Paris, Musée National d'Art Moderne; *"Le Luxe II"*, 1907-08, oil on canvas, 210 × 139 cm, Copenhagen, Statens Museum fur Kunst.

394–395 Brancusi: The Kiss

BRANCUSI: *Sleeping Muse*, 1910, bronze, length 27 cm, Paris, Musée National d'Art Moderne; *Sleeping Muse*, 1906, marble, height 27.5 cm, Bucharest, National Museum; *The table of silence*, 1937, stone, height of table 80 cm, diameter of stools 55 cm, Tirgu Jiu, Public Park (Susan Grigg Agency/AdamWoolfitt); *Bird in space*, 1919, bronze, height 137 cm, New York, Museum of Modern Art; *The kiss*, 1910, stone, height 50 cm, Paris, Musée National d'Art Moderne (Joseph P. Ziolo/René Roland).

396–397 Cubism

PICASSO: *Life*, 1903, oil on canvas, 197 × 127 cm, Cleveland, Museum of Art, Gift of Hanna Fund; *"Les Demoiselles d'Avignon"*, 1907, oil on canvas, 244 × 233 cm, New York, Museum of Modern Art, acquired through the Lillie P. Bliss Bequest; *Daniel Henry Kahnweiler*, 1910, oil on canvas, 100 × 73 cm, Chicago, Art Institute, Mrs Charles B. Goodspeed collection; *Still life with chair-caning*, 1911-12, oil and pasted oil-cloth, length 33 cm, Paris, Estate of the Artist (Documentation Photographique de la Réunion des Musées Nationaux). BRAQUE: *"Grand Nu"* (Large nude), 1908, oil on canvas, 136 × 102 cm, Paris, Private Collection (Joseph P. Ziolo/André Held); *Houses at L'Estaque*, 1908, oil on canvas, 73 × 60 cm, Berne, Kunstmuseum; *Still life with fish*, c. 1909-10, oil on canvas, 61 × 75 cm, London, Tate Gallery; *The man with a pipe*, 1912, *papier collé* on paper, 62 × 48 cm, Basel, Öffentliche Kunstsammlung.

398–399 Cubism 2, and Orphism

GRIS: *The wash-stand*, 1912, oil with mirror and *papier collé*, 132 × 90 cm, Paris, Private Collection (Colorphoto Hans Hinz); *Homage to Picasso*, 1911-12, oil on canvas, 74 × 94 cm, Chicago, Art Institute, Gift of Leigh B. Block; *Landscape at Ceret*, 1913, oil on canvas, 180 × 65 cm, Stockholm, National Museum. LEGER: *Nudes in the forest*, 1909-10, oil on canvas, 122 × 173 cm, Otterlo, Museum Kröller-Müller; *Contrasting forms*, 1913, oil on canvas, 80.5 × 60 cm, Düsseldorf, Kunstsammlung Nordrhein-Westfalen. DELAUNAY: *A window*, 1912, oil on canvas, 111 × 89 cm, Paris, Musée National d'Art Moderne (S); *The Eiffel Tower*, 1910, oil on canvas, 202 × 138.5 cm, New York, Solomon R. Guggenheim Museum; *Circular forms: sun and moon*, 1912-13, oil on canvas, 100 × 68 cm, Zurich, Kunsthaus. KUPKA: *The disks of Newton: Study for a fugue in two colours*, 1911-12, oil on canvas, 49.5 × 67 cm, Paris, Musée National d'Art Moderne.

400–401 Futurism
BALLA: *The street lamp*, 1909, oil on canvas, 175 × 115 cm, New York, Museum of Modern Art, Hillman Periodicals Fund; *Dynamism of a dog on a leash*, 1912, oil on canvas, 90 × 110 cm, Buffalo, New York, Albright-Knox Art Gallery, Bequest of A. Conger Goodyear to George E. Goodyear. BOCCIONI: *The city rises*, 1910-11, oil on canvas, 200 × 300 cm, New York, Museum of Modern Art, Mrs Simon Guggenheim Fund; *Farewells*, 1911, oil on canvas, 70.5 × 96 cm, New York, Nelson A. Rockefeller Collection (S); *Unique forms of continuity in space*, 1913, bronze, height 109.5 cm, New York, Museum of Modern Art, Lillie P. Bliss Bequest; *Development of a bottle in space*, 1912-13, silvered bronze, height 38 cm, New York, Museum of Modern Art, Aristide Maillol Fund. CARRA: *The funeral of the anarchist Galli*, 1910-11, oil on canvas, 200 × 259 cm, New York, Museum of Modern Art, Lillie P. Bliss Bequest. SEVERINI: *Pam-Pam at the Monico*, 1910-12, oil on canvas, 113 × 162 cm, Paris, Musée National d'Art Moderne (S). RUSSOLO: *The revolt*, 1911-12, oil on canvas, 150 × 194.5 cm, The Hague, Gemeentemuseum.

402–403 British Art: The Vortex
STEER: *Children paddling, Walberswick*, 1894, oil on canvas, 64 × 92 cm, Cambridge, Fitzwilliam Museum. SICKERT: *Ennui*, c. 1913, oil on canvas, 76 × 56 cm, Oxford, Ashmolean Museum. AUGUSTUS JOHN: *David and Dorelia in Normandy*, c. 1907, oil on canvas, 37 × 45 cm, Cambridge, Fitzwilliam Museum. GILMAN: *Mrs Mounter*, 1917, oil on canvas, 36 × 23 cm, Leeds, City Art Gallery. GWEN JOHN: *Girl with bare shoulders*, c. 1910, oil on canvas, 43.5 × 26 cm, New York, Museum of Modern Art, A. Conger Goodyear Fund. LEWIS: *Ezra Pound*, 1939, oil on canvas, 76 × 102 cm, London, Tate Gallery (Angelo Hornak). ROBERTS: *The diners*, 1919, oil on canvas, 152 × 83 cm, London, Tate Gallery (Angelo Hornak). BOMBERG: *In the hold*, 1913-14, oil on canvas, 196 × 231 cm, London, Tate Gallery (Angelo Hornak). GAUDIER-BRZESKA: *Red stone dancer*, 1913, sandstone, height 43 cm, London, Tate Gallery (Angelo Hornak). EPSTEIN: *The rock-drill*, 1913-14, bronze, height of torso 71 cm, London, Tate Gallery (Anthony d'Offay).

404–405 Russian Art 1: From Symbolism to Suprematism
VRUBEL: *Six-winged seraph*, 1904, oil on canvas (S.C.R. London). BENOIS: Backdrop for Stravinsky's *Petrouchka; The fair*, 1911, Hartford, Connecticut, Wadsworth Atheneum. BAKST: *"L'Après-midi d'un faune (Vaslav Nijinsky)"*, 1912, 40 × 27 cm, Hartford, Connecticut, Wadsworth Atheneum. GONCHAROVA: *Monk with a cat*, 1910, oil on canvas, 100 × 92 cm, Edinburgh, National Gallery of Modern Art; *Cats*, 1911, oil on canvas, 85 × 85.5 cm, New York, Solomon R. Guggenheim Museum. LARIONOV: *Summer*, 1912, oil on panel, Paris, Collection Mme Larionov. MALEVICH: *Suprematist composition: white on white*, c. 1918, oil on canvas, 79 × 79 cm, New York, Museum of Modern Art; *Woman with buckets*, 1912, oil on canvas, 80 × 80 cm, New York, Museum of Modern Art; *Black trapezium and red square*, after 1915, oil on canvas, Amsterdam, Stedelijk Museum.

406–407 Russian Art 2: Constructivism
MAYAKOVSKY: Set design for *Misteria Bouffe*, 1919 (S.C.R. London); *Revolutionary poster*, 1920 (S.C.R. London). TATLIN: *Relief construction*,

c. 1915, destroyed (S.C.R. London). UNKNOWN ARTISTS: "Agit" train, c. 1919 (S.C.R. London). RODCHENKO: *Composition*, 1918, gouache on paper, 33 × 16 cm, New York, Museum of Modern Art, Gift of the artist; *Hanging construction*, c. 1920, destroyed (Oxford, Museum of Modern Art). AFTER RODCHENKO: *Hanging construction*, original c. 1920, reconstruction by John Milner, painted plywood, width 110 cm, England, Collection John Milner (Oxford, Museum of Modern Art). LISSITZKY: *Proun 99*, 1924-25, oil on panel, 128.5 × 99 cm, New Haven, Connecticut, Yale University Art Gallery. GABO: *Head of a woman*, 1917-20, celluloid and metal, height 62 cm, New York, Museum of Modern Art.

408–409 Tatlin: Monument to the Third International
Vladimir Tatlin beside the maquette for his Monument to the Third International, photograph (Stockholm, Statens Konstmuseer); *Monument to the Third International*, c. 1920, drawing, Stockholm, Statens Konstmuseer; *Letatlin*, 1932, wood, cork, silk, ball-bearings, Stockholm, Statens Konstmuseer; Bent-tube chair, 1923, wood, leather (Arts Council of Great Britain). RODIN: *Monument to Labour*, 1893-99, drawing, Paris, Musée Rodin (Joseph P. Ziolo/René Roland).

410–411 Art Since 1915
BRASILIA: The Foreign Office, begun 1957, by Oscar Niemeyer (Spectrum Colour Library). BERLIN: The AEG Turbine Factory, 1909, by Peter Behrens (Bildarchiv Foto Marburg).

412–413
(Map by Colin Salmon and Dinah Lone)

414–415 Dada
ARP: *Collage of squares arranged according to the laws of chance*, 1916-17, collage of coloured papers, 45.5 × 33.5 cm, New York, Museum of Modern Art, Gift of Philip Johnson; PICABIA: *I see again in memory my dear Udnie*, 1914, oil on canvas, 250 × 199 cm, New York, Museum of Modern Art, Hillman Periodicals Fund. MAN RAY: *The rope-dancer accompanies herself with her shadows*, 1916, oil on canvas, 132 × 186.5 cm, New York, Museum of Modern Art, Gift of G. David Thompson; *Crossroads*, 1934, photomontage, Paris, Man Ray Archive. PICABIA: *"M'Amenez-y"*, 1919-20, oil on cardboard, 129 × 89 cm, New York, Museum of Modern Art, Helena Rubinstein Fund. SCHWITTERS: *"Arbeiterbild"* (Worker-picture), 1919, collage, 125.5 × 91 cm, Stockholm, Moderna Museet; *Ambleside*, 1945-48, mixed media, height about 3 m, Little Langdale, University of Newcastle upon Tyne. HAUSMANN: *The art critic*, 1920, drawing in ink, chalk and pencil, with collage, 32 × 25.5 cm, London, Tate Gallery. BAADER: *Collage A92-22*, c. 1920, collage, Paris, Musée National d'Art Moderne.

416–417 Marcel Duchamp
Marcel Duchamp, photograph by J.S. Lewinski (Camera Press). DUCHAMP: *A cemetery of uniforms and liveries – the bachelors*, 1914, pencil, ink and watercolour on paper, 66 × 100 cm, New Haven, Connecticut, Yale University Art Gallery, Gift of Katherine S. Dreier; *Nude descending a staircase no. 2*, 1912, oil on canvas, 148 × 90 cm, Philadelphia, Museum of Art, The Louise and Walter Arsenberg collection; AFTER DUCHAMP: *The bride stripped bare by her bachelors, even ("The Large Glass")*, original 1915-23, oil and other media on glass, reconstruction

by Richard Hamilton, 277 × 176 cm, London, Tate Gallery; *Fountain*, original 1917, replica 1964, vitreous enamel, height 63 cm, Milan, Galleria Schwartz. DUCHAMP: *"The Large Glass"* (broken state), 1937, oil and other media on glass, 277 × 176 cm, Philadelphia, Museum of Art, Katherine S. Dreier Bequest; *L.H.O.O.Q.*, 1918, postcard retouched in pencil, 19 × 12 cm, Stuttgart, Staatsgalerie; *"Etant Donnés ..."* (Given that ...) 1946-66, assemblage, height of door 242 cm, Philadelphia, Museum of Art, Gift of the Cassandra Foundation. AFTER DUCHAMP: *"Ready-made"*, original 1913, replica 1951, wooden stool and bicycle wheel, height 126 cm, New York, Sidney Janis Gallery.

418–419 Art in Italy: Metaphysical Painting
CHIRICO: *The enigma of the hour*, 1912, oil on canvas, 71 × 55 cm, Milan, Collection Gianni Mattioli (S); *The child's brain*, 1914, oil on canvas, 80 × 63 cm, Stockholm, Statens Konstmuseer; *The dream of the poet* (Guillaume Apollinaire), 1914, oil on canvas, 89 × 39.5 cm, New York, Solomon R. Guggenheim Museum, Peggy Guggenheim collection; *The nostalgia of the infinite*, 1913-14, oil on canvas, 135 × 65 cm, New York, Museum of Modern Art; *The mathematicians*, 1917, pencil on paper, 32 × 21.5 cm, New York, Museum of Modern Art, Gift of Mrs Stanley B. Resor. CARRA: *The engineer's mistress*, 1921, oil on canvas, 55 × 40 cm, Milan, Collection Gianni Mattioli (S). MORANDI: *Still life*, 1938, oil on canvas, 24 × 39 cm, New York, Museum of Modern Art; *Still life with a pipe*, 1918, oil on canvas, Milan, Collection E. Jesi (S); *Still life*, 1937, oil on canvas, 27 × 40 cm, Hamburg, Kunsthalle; *Landscape with the River Saverna*, 1929, etching, 26 × 25 cm (Arts Council of Great Britain).

420–421 Max Ernst
Max Ernst, photograph (Agence Rapho). ERNST: *Katerina ondulata*, 1920, wallpaper overlaid with gouache and pencil, 30 × 25 cm, London, Sir Roland Penrose Collection (Eileen Tweedy Archive); *"Aquis Submersus"* (Plunged in the waters), 1919, oil on canvas, 54 × 43 cm, Frankfurt, Stadelsches Kunstinstitut; *The elephant Celebes*, 1921, oil on canvas, 130 × 110 cm, London, Tate Gallery; *Men shall know nothing of this*, 1923, oil on canvas, 81 × 65 cm, London, Tate Gallery (Angelo Hornak); *Hundred-headed Woman: Germinal, my sister*, 1929, printed illustration (Courtauld Institute of Art); *The great forest*, 1927, oil on canvas, 115 × 147 cm, Basel, Kunstmuseum (Colorphoto Hans Hinz); *Europe after the rain*, 1940-42, oil on canvas, 54 × 147.5 cm, Hartford, Connecticut, Wadsworth Atheneum, Ella Gallup Sumner and Mary Catlin Sumner collection; *Man intrigued by the flight of a non-Euclidian fly*, 1942, oil and varnish on canvas, 82 × 66 cm, Zurich, Private Collection.

422–423 Surrealism 1: Figurative
MAGRITTE: *The human condition*, 1933, oil on canvas, 100 × 81 cm, Choisel, Private Collection (P. Willi/Agence Top); *Time transfixed*, 1939, oil on canvas, 146 × 97 cm, Chicago, Art Institute; *Man in a bowler hat*, 1964, oil on canvas, 64 × 50 cm, New York, Private Collection. DALI: *The persistence of memory*, 1931, oil on canvas, 24 × 33 cm, New York, Museum of Modern Art; *The temptation of St Anthony*, 1947, oil on canvas, 89.5 119.5 cm, Brussels, Musées Royaux des Beaux-Arts; *The Venus de Milo of the drawers*, 1936, plaster, height 100 cm, Paris, Private Collection (Joseph P. Ziolo/Robert Descharnes). DELVAUX: *The*

village of the sirens, 1942, oil on canvas, 105 × 127 cm, Chicago, Art Institute. DALI AND BUNUEL: Still from *Un Chien Andalou*, 1929, photograph, London, National Film Archive (Stills Library). ESCHER: *Still life and street*, 1937, woodcut, 49 × 49 cm, The Hague, Gemeentemuseum.

424–425 Surrealism 2: Abstract
MASSON: *Furious suns*, 1925, ink on paper, 42 × 32 cm, Paris, Galerie Louise Leiris; *The battle of the fishes*, 1927, sand, gesso, oil, ink and charcoal on canvas, 36.5 × 73 cm, New York, Museum of Modern Art. TANGUY: *The more we are*, 1929, oil on canvas, Paris, Collection Collinet (Giraudon); *The palace of windows*, 1942, oil on canvas, 163 × 132 cm, Paris, Musée National d'Art Moderne. MIRO: *Dog barking at the moon*, 1926, oil on canvas, 73 × 92 cm, Philadelphia, Museum of Art, E.A. Gallatin collection; *Painting*, 1933, oil on canvas, 130 × 161 cm, Hartford, Connecticut, Wadsworth Atheneum; *Aerial acrobatics*, 1934, Courtauld Institute; *The wall of the moon*, 1957, ceramic tiled wall, Paris, UNESCO Building (Michel Claude).

426–427 Cubist Developments
ARCHIPENKO: *Walking woman*, 1912, painted bronze, height 67 cm, Denver, Art Museum. DUCHAMP-VILLON: *The horse*, 1914, bronze, height 100 cm, New York, Museum of Modern Art, Van Gogh Purchase Fund. LIPCHITZ: *The bather*, 1915, bronze, height 80.5 cm, New York, Private Collection. PICASSO: *The glass of absinth*, 1914, painted bronze with silver sugar strainer, height 22 cm, New York, Museum of Modern Art, Gift of Mrs Bertram Smith. ZADKINE: *The destroyed city*, 1953, bronze, height 6.4 m, Rotterdam, Schiedamse Dijk. BRAQUE: *Kanephoros*, 1922-23, oil on canvas, 180 × 72 cm, Paris, Musée National d'Art Moderne. OZENFANT: *The jug*, 1926, oil on canvas, 301 × 148 cm, Providence, Rhode Island, Rhode Island School of Design. LEGER: *"Le Grand Déjeuner"* (The feast), 1921, oil on canvas, 151 × 183.5 cm, New York, Museum of Modern Art, Mrs Simon Guggenheim Fund; *Still life with arm*, 1927, oil on canvas, 55 × 46 cm, Essen, Folkwang Museum.

428–429 Sculpture between the Wars
PEVSNER: *Torso*, 1924-26, plastic and copper, height 75.5 cm, New York, Museum of Modern Art; *Marcel Duchamp*, 1926, celluloid on copper (originally zinc), 94 × 65 cm, New Haven, Connecticut, Yale University Art Gallery. DUCHAMP: *Rotative plaques*, 1920, wood, metal and glass, 120 × 184 cm, New Haven, Connecticut, Yale University Art Gallery. GABO: *Sculpture*, 1954-57, bronze and stainless steel, height 25.5 m, Rotterdam, at Bijenkorf's store (Rotterdam, Museum Boymans-van Beuningen); *Kinetic sculpture (Standing wave)*, stone and metal, motorized, height 62 cm, London, Tate Gallery. CALDER: *Romulus and Remus*, 1928, metal wire, length 284.5 cm, New York, Solomon R. Guggenheim Museum. GIACOMETTI: *The cage*, 1932, wood, height 48.5 cm, Stockholm, National Museum. ARP: *Human concentration*, 1934, marble, height 78.5 cm, Paris, Musée National d'Art Moderne (S). GONZALEZ: *Maternity*, 1934, welded iron, height 128 cm, London, Tate Gallery.

430–431 Modigliani: Chaim Soutine
MODIGLIANI: *Reclining nude*, c. 1919, oil on canvas, 72 × 116.5 cm, New York, Museum of Modern Art, Mrs Simon Guggenheim Fund; *Study for a stone Head*, 1909-15, coloured chalks on paper,

34 × 22 cm, London, Victoria and Albert Museum; *Head of a young woman*, 1908, 56 × 55 cm, Marvaux, Private Collection (René Roland); *Head*, 1911-12, stone, height 63 cm, London, Tate Gallery (Angelo Hornak); *Chaim Soutine*, 1917, oil on canvas, 92 × 60 cm, Washington, National Gallery of Art, Chester Dale collection.

432–433 The School of Paris
MATISSE: *Odalisque in red trousers*, 1922, oil on canvas, 57 × 84 cm, Paris, Musée National d'Art Moderne (S). SOUTINE: *Oscar Miestschaninoff*, 1923, oil on canvas, 82 × 64 cm, Paris, Musée National d'Art Moderne; *The carcase of an ox*, 1925, oil on canvas, 140 × 82 cm, Buffalo, New York, Albright-Knox Art Gallery. UTRILLO: *Sacré Coeur, Paris*, 1937, gouache on canvas, Indianapolis, Museum of Art. PASCIN: *Nude with a green hat*, 1925, oil on canvas, 92 × 77 cm, Cincinnati, Ohio, Art Museum. CHAGALL: *The cock*, 1928, oil on canvas, Lugano, Collection Thyssen (S); *The Asher window*, Haddassah University Medical Centre, Jerusalem, 1960, stained glass, 3.5 × 2.5 m (Haddassah Medical Relief Association). BALTHUS: *The living-room*, 1941-43, oil on canvas, 114 × 147 cm, Minneapolis, Institute of Arts.

434–435 Art in Holland: De Stijl
VAN DOESBURG: *The cow*, 1916-17, oil on canvas, 37.5 × 63.5 cm, New York, Museum of Modern Art; *The card-players*, 1916-17, tempera on canvas, 147 × 169 cm, Meudon, Mme van Doesburg Collection (Joseph P. Ziolo/A. Held); *Contra-composition V*, 1924, oil on canvas, 100 × 100 cm, Amsterdam, Stedelijk Museum; *The card-players*, 1917 (*Composition IX*), oil on canvas, 116 × 106 cm, The Hague, Gemeentemuseum. VAN DER LECK: *Composition*, 1918, oil on canvas, 101 × 100 cm, Amsterdam, Stedelijk Museum. MONDRIAN: *Composition*, 1917, oil on canvas, 108 × 108 cm, Otterlo, Museum Kröller-Müller. RIETVELD: Armchair, 1917, painted wood, height 87 cm, New York, Museum of Modern Art, Gift of Philip Johnson. VANTONGERLOO: *Construction of volume relations*, 1921, wood, height 41 cm, New York, Museum of Modern Art, Gift of Silvia Pizitz.

436–437 Mondrian: Composition in Yellow and Blue
MONDRIAN: *Composition in yellow and blue*, 1929, oil on canvas, 52 × 52 cm, Rotterdam, Museum Boymans-van Beuningen; *The red tree*, 1908, oil on canvas, 70 × 99 cm, The Hague, Gemeentemuseum; *Fox-trot A*, 1930, oil on canvas, height 110 cm, New Haven, Connecticut, Yale University Art Gallery; *Broadway Boogie-Woogie*, 1942-43, oil on canvas, 127 × 127 cm, New York, Museum of Modern Art; *The flowering apple-tree*, 1912, oil on canvas, 78 × 106 cm, The Hague, Gemeentemuseum.

438–439 Art in Germany: The Bauhaus
KANDINSKY: *On high*, 1920, oil on canvas, New York, Solomon R. Guggenheim Museum (S); *Rows of signs*, 1931, ink on paper, Basel, Kunstsammlung (S). KLEE: *Italian town*, 1928, watercolour on paper over cardboard, 35 × 27 cm, Berne, Felix Klee Foundation. FEININGER: Frontispiece for the Bauhaus *Manifesto*, 1919, woodcut on brown paper, 30.5 × 19.5 cm, Cambridge, Massachusetts, Harvard University, Busch-Reisinger Museum, Gift of Mr and Mrs Lyonel Feininger. MOHOLY-NAGY: *Light-space modulator*,

1922-30, steel, plastic and wood, height with base 151 cm, Cambridge, Massachusetts, Harvard University, Busch-Reisinger Museum, Gift of Mrs Sibyl Moholy-Nagy (Diana Wyllie Ltd); *Yellow cross*, c. 1923-28, oil on canvas, Rome, Galleria d'Arte Moderna (S). GROPIUS: The director's office at the Weimar Bauhaus, 1923 (Diana Wyllie Ltd). ITTEN: *Benign light*, 1920-21, oil on canvas, Lugano, Collection Thyssen (S). BREUER: Steel chair, 1925, tubular steel, height 71 cm, New York, Museum of Modern Art, Gift of H. Bayer (Architectural Association). SCHLEMMER: *Concentric group*, 1925, oil on canvas, 97 × 62 cm, Stuttgart, Staatsgalerie.

440–441 Paul Klee
Paul Klee, photograph, Berne, Felix Klee Collection. KLEE: *The country child*, 1923, oil on canvas, Grenoble, Musée des Beaux-Arts (S); *Motif of Hammamet*, 1914, watercolour on paper, 20 × 15 cm, Basel, Öffentliche Kunstsammlung; *The vocal fabric of the singer Rosa Silber*, 1922, gouache and gesso on canvas, 52 × 42 cm, New York, Museum of Modern Art; *Mask with small flag*, 1925, watercolour on paper, 65 × 49.5 cm, Munich, Neue Pinakothek (S); *Fire in the evening*, 1929, oil on cardboard, 34 × 33.5 cm, New York, Museum of Modern Art, Mr and Mrs Joachim Jean Abelbach Fund; "*Ad Parnassum*", 1932, oil on canvas, 100 × 126 cm, Berne, Kunstmuseum; *Death and fire*, 1940, oil and distemper, 46 × 44 cm, Berne, Kunstmuseum; *Under the angel's wing on a steep path*, 1931, pen and ink on paper, 56 × 43 cm, Berne, Felix Klee Collection.

442–443 Expressionist Developments
GROSZ: *Eclipse of the sun*, 1926, oil on canvas, 210 × 184 cm, Huntington, New York, Heckschet Museum; *Dusk*, 1922, watercolour on paper, 52 × 40 cm, Lugano, Collection Thyssen (S). DIX: *The matchseller*, 1920, oil on canvas, 141 × 166 cm, Stuttgart, Staatsgalerie. HEARTFIELD: *War and corpses*, 1932, photomontage, printed in Arbeiter-Illustrierte-Zeitung, April 27, 1932 (Arts Council of Great Britain/John Webb). HOFER: *Three masqueraders*, 1922, oil on canvas, 129 × 103 cm, Cologne, Wallraf-Richartz Museum. SCHRIMPF: *Boy with a rabbit*, 1924, oil on canvas, 56 × 42 cm, Marburg, Marburger Universitätsmuseum für Kunst und Kulturgeschichte. SCHIELE: *The embrace*, 1917, oil on canvas, 110 × 170.5 cm, Vienna, Österreichisches Galerie. KOKOSCHKA: *Lovers with a cat*, 1917, oil on canvas, 93 × 130 cm, Zurich, Kunsthaus (S). PERMEKE: *The sower*, 1933, oil on canvas, 200 × 100 cm, Jabbeke, Provincial Museum Constant Permeke.

444–445 Beckmann: Departure
BECKMANN: *Self-portrait with a red scarf*, 1917, oil on canvas, 80 × 60 cm, Stuttgart, Staatsgalerie; *Quappi in pink*, 1932-34, oil on canvas, Lugano, Collection Thyssen (S); *Night*, 1918-19, oil on canvas, 134 × 154 cm, Düsseldorf, Kunstsammlung Nordrhein-Westfalen; *Self-portrait with Quappi Beckmann*, 1941, oil on canvas, 194 × 89 cm, Amsterdam, Stedelijk Museum; *Departure*, 1932-35, oil on canvas, centre panel 215 × 115 cm, side panels 215 × 98 cm, New York, Museum of Modern Art.

446–447 Art in Britain between the Wars
EPSTEIN: *Jacob Kramer*, 1921, bronze, height 63.5 cm, London, Tate Gallery (John Webb). NICHOLSON: *White relief*, 1935, painted wood, 101.5 × 165.5 cm, London, Tate Gallery. NASH: *Landscape from a dream*, oil on canvas,

67.5 × 101.5 cm, London, Tate Gallery; "*Totes Meer*" (Dead sea), 1940-41, oil on canvas, 101.5 × 152.5 cm, London, Tate Gallery (Angelo Hornak). SUTHERLAND: *Entrance to a lane*, 1939, oil on canvas, 61 × 51 cm, London, Tate Gallery; *Somerset Maugham*, 1949, oil on canvas, 137 × 63.5 cm, London, Tate Gallery. HEPWORTH: *Three forms*, 1935, marble, 20 × 53.5 × 60 cm, London, Tate Gallery. PASMORE: *The quiet river: the Thames at Chiswick*, 1943-44, oil on canvas, 76 × 101.5 cm, London, Tate Gallery (Angelo Hornak); *Snowstorm (Spiral motif in black and white)*, 1950-51, oil on canvas, 119.5 × 152.5 cm, Arts Council of Great Britain. SPENCER: *The resurrection of the soldiers*, 1928-29, mural, Burghclere, Sandham Memorial Chapel (Jeremy Whitaker/National Trust).

448–449 Henry Moore
Henry Moore, photograph (Henry Moore Foundation). MOORE: *Mother and child*, 1924, Hornton stone, height 57 cm, Manchester, City Art Gallery; *Composition*, 1932, marble, height 44 cm, London, Tate Gallery (Angelo Hornak); *Bird basket*, 1939, lignum vitae and string, height 42 cm, Much Hadham, Collection Mrs Irene Moore (Henry Moore Foundation); *Reclining figure*, 1929, Hornton stone, length 84 cm, Leeds, City Art Gallery; *The Tilbury shelter*, 1941, watercolour and gouache on paper, 42 × 38 cm, London, Tate Gallery (Angelo Hornak); *Reclining figure*, 1945-46, elmwood, length 190.5 cm, formerly Bloomfield Hills, Michigan, Cranbrook Academy of Art (Henry Moore Foundation); *Helmet head no. 1*, 1950, lead, height 33 cm, London, Tate Gallery; *Two forms*, 1966, Soraya marble, length 152 cm, Zurich, Collection Dr and Mrs Stachein (Henry Moore Foundation); *Madonna*, 1943-46, Hornton stone, height 150 cm, Northampton, St Matthew's (Henry Moore Foundation).

450–451 Picasso between the Wars
Pablo Picasso, photograph (Popperfoto). PICASSO: *Three women at the fountain*, 1921, oil on canvas, 204 × 131 cm, New York, Museum of Modern Art; *Ambroise Vollard*, 1915, pencil drawing, 47.5 × 32.5 cm, New York, Metropolitan Museum, Elisha Whittelsey Fund; *The three dancers*, 1925, oil on canvas, 215 × 145 cm, London, Tate Gallery; *Guitar*, 1920, oil on canvas, Basel, Emmanuel Hoffman Foundation (Colorphoto Hans Hinz); *Seated bathers*, 1930, oil on canvas, 163 × 129.5 cm, New York, Museum of Modern Art, Mrs Simon Guggenheim Fund; *Nude in an armchair*, 1932, oil on canvas, 130 × 97 cm, London, Tate Gallery; *Woman's head*, 1931, metal assemblage, height 81 cm, Paris, Estate of the artist (John Hedgecoe); *Guernica*, 1937, oil on canvas, 351 × 782 cm, New York, on loan from the artist's estate to the Museum of Modern Art; *The charnel-house*, 1945-48, oil and charcoal on canvas, 200 × 250 cm, New York, Museum of Modern Art.

452–453 Early Modernist Art in America
HENRI: *The masquerade dress*, 1911 (Mrs Robert Henri), oil on canvas, 194 × 92 cm, New York, Metropolitan Museum of Art, Arthur Hoppock Hearn Fund. SLOAN: *McSorley's Bar*, 1912, oil on canvas, 66 × 81 cm, Detroit, Institute of Arts. LUKS: *Hester Street*, 1905, oil on canvas, 66 × 91 cm, New York, Brooklyn Museum, Dick S. Ramsay Fund. BELLOWS: *Stag at Sharkey's*, 1909, oil on canvas, 92 × 122.5 cm, Cleveland, Museum of Art, Hinman B. Hurlbut collection. STELLA: *Brooklyn Bridge*, 1917,

oil on canvas, 216 × 190 cm, New Haven, Connecticut, Yale University Art Gallery. MARIN: *Maine islands*, 1922, watercolour on paper, 43 × 51 cm, Washington DC, Phillips Collection. DEMUTH: *I saw the figure 5 in gold*, 1928, oil on board, 91 × 76 cm, New York, Metropolitan Museum of Art, Alfred Stieglitz collection. HARTLEY: *A German officer*, 1914, oil on canvas, 173 × 105 cm, New York, Metropolitan Museum of Art, Alfred Stieglitz collection. SHAHN: *The prisoners Sacco and Vanzetti*, 1931-32, tempera on paper over board, 27 × 31 cm, New York, Museum of Modern Art, Gift of Abby Aldrich Rockefeller (S).

454–455 Hopper: Nighthawks
HOPPER: *The automat*, 1927, oil on canvas, 71 × 91 cm, Des Moines, Art Center, James D. Edmundsen Fund; *Approaching a city*, 1946, oil on canvas, 69 × 91 cm, Washington DC, Phillips Collection; *Night shadows*, 1921, etching, 18 × 21 cm (Courtauld Institute of Art); *Nighthawks*, 1942, oil on canvas, 84 × 152 cm, Chicago, Art Institute, Friends of American Art collection. BURCHFIELD: *The old farmhouse*, 1932, watercolour on paper, 38 × 53 cm, Cambridge, Massachusetts, Fogg Art Museum. BENTON: *City activities*, 1930-31, tempera on linen, 231 × 818 cm, New York, New School of Social Research (Snark International).

456–457 Mexican Muralism
POSADA: *The alcoholic*, c. 1912, etching (Courtauld Institute of Art). RIVERA: *A hymn to the earth*, 1926-27, fresco, total painted area 700 square metres, Chapingo, Mexico, Chapel of the Agricultural College (Desmond Rochfort); *Mexico today, Mexico tomorrow*, 1936, fresco, area of south wall 65 square metres, Mexico City, National Palace, main staircase (Desmond Rochfort). OROZCO: *The people and their false leaders*, detail, 1937, fresco, Guadalajara, University of Guadalajara Assembly Hall (Desmond Rochfort); *Man of fire*, 1938-39, fresco, Guadalajara, Hospicio Cabanas (general view of cupola and detail Desmond Rochfort); *Machine horse of the conquest*, 1938-39, fresco, on the vault neighbouring the cupola, Guadalajara, Hospicio Cabanas (Desmond Rochfort). SIQUEIROS: *For the full safety and social security at work of all Mexicans*, 1952-54, pyroxiline and vinylite paint on celotex, total painted area 310 square metres, Mexico City, La Raza Hospital, vestibule to the auditorium (Desmond Rochfort); *The portrait of the bourgeoisie*, 1939, pyroxiline paint on a cement base, total painted area 100 square metres, Mexico City, Electrical Trades Union Building, stairwell (Desmond Rochfort). TAMAYO: *Sleeping musicians*, 1950, oil on canvas, 135 × 192 cm, Mexico City, Museu Nacional d'Arte Moderno (René Roland).

458–459 The Sources of Abstract Expressionism
DAVIS: *Lucky strike*, 1921, oil on canvas, 84 × 46 cm, New York, Museum of Modern Art, Gift of The American Tobacco Co. Inc.; *Ultra-Marine*, 1943, oil on canvas, 51 × 102 cm, Philadelphia, Pennsylvania Academy of the Fine Arts, Temple Purchase Fund. NAVAJO ARTIST: "Sand-painting", 1966, coloured sand, 175 × 175 cm, London, Horniman Museum. O'KEEFFE: *Light coming on the plains II*, 1917, watercolour on paper, 28.5 × 22 cm, Fort Worth, Texas, Amon Carter Museum. MATTA: *Stop the age of Hennrri*, 1948, Paris, Galerie du Dragon (P. Willi/Agence Top). HOFMANN: *Radiant space*, 1955, oil on canvas, 152.5 × 122 cm, New York, André Emmerich Gallery; *Untitled*, 1943, mixed media on paper,

61 × 84 cm, New York, André Emmerich Gallery. GORKY: *Water of the flowery mill*, 1944, oil on canvas, 107.5 × 123.5 cm, New York, Metropolitan Museum, George A. Hearn Fund; *The limit*, 1947, oil on paper, 128.5 × 159 cm, London, Mrs A.M. Phillips Collection (Michael Holford). TOBEY: *Forms follow man*, 1941, gouache on cardboard, 34.5 × 49 cm, Seattle, Washington, Art Museum, Eugene Fuller memorial collection.

460–461 Jackson Pollock
NAMUTH: *Jackson Pollock*, 1952, photograph (Hans Namuth); *Pollock painting*, 1950, photograph (Hans Namuth). POLLOCK: *Self-portrait*, c. 1933, oil on canvas, New York, Marlborough Gallery; *Going west*, 1934-35, oil on gesso over composition board, 39 × 52.5 cm, Washington DC, Smithsonian Institution (Cooper-Bridgeman Library); *Pasiphaë*, 1943, oil on canvas, 143 × 244 cm, New York, Marlborough Gallery; *No. 32*, 1950, 269 × 457.5 cm, Düsseldorf, Kunstsammlung Nordrhein-Westfalen; *Convergence*, 1952, oil and enamel on canvas, 237 × 396 cm, Buffalo, New York, Albright-Knox Art Gallery, Sherwin Greenberg collection.

462–463 Abstract Expressionism
STILL: *1957-D no. 1*, 1957, oil on canvas, 287 × 404 cm, Buffalo, New York, Albright-Knox Art Gallery. GUSTON: *Dial*, 1956, oil on canvas, 183 × 193 cm, New York, Whitney Museum of American Art, Gift of friends of the Whitney Museum; *Untitled*, 1958, oil on canvas, 165.5 × 188 cm, New York, David McKee Gallery (Steven Sloman). KLINE: *Orange and black wall*, 1959, oil on canvas, 169 × 366 cm, Amsterdam, Collection Thyssen (S); *Mahoning*, 1956, oil on canvas, 203 × 254 cm, New York, Whitney Museum of American Art. MOTHERWELL: *The voyage*, 1949, oil and tempera on paper over composition board, 122 × 239 cm, New York, Museum of Modern Art, Gift of Mrs John D. Rockefeller III; *Elegy to the Spanish Republic no. 34*, 1953-54, oil on canvas, 203 × 254 cm, Buffalo, New York, Albright-Knox Art Gallery. GOTTLIEB: *Black and black*, 1959, acrylic on canvas, 202 × 183 cm, London, art market (Sotheby's). FRANCIS: *Summer no. 2*, 1958, oil on canvas, 183 × 244 cm, New York, André Emmerich Gallery.

464–465 De Kooning: Woman 1
DE KOONING: *Woman I*, 1950-52, oil on canvas, 192 × 148 cm, New York, Museum of Modern Art; *Woman sitting*, 1943-44, oil and charcoal, 122 × 106.5 cm, New York, Xavier Fourcade Inc.; *Woman*, 1943, oil on canvas, 114 × 71 cm, USA, Collection of the artist (Visual Arts Library); *Excavation*, 1950, oil on canvas, 204 × 254.5 cm, Chicago, Art Institute; Study for *Woman*, 1949-52, oil and charcoal on canvas, 117 × 81 cm, Private Collection (Visual Arts Library); *Woman on the dune*, 1967, oil on paper, 137 × 122 cm, New York, Xavier Fourcade Inc.

466–467 Abstract Developments 1
ROTHKO: The Rothko room, Tate Gallery, London, 1958-59, all paintings oil on canvas, London, Tate Gallery (John Webb); *Central green*, 1949, oil on canvas, 171 × 137 cm, London, art market (Sotheby's). NEWMAN: *The third*, 1962, oil on canvas, 256.5 × 307.5 cm, New York, Estate of the artist (Visual Arts Library); *Concord*, 1949, oil on canvas, 227.5 × 136 cm, New York, Metropolitan Museum of Art, George A. Hearn Fund. BAZIOTES: *White bird*, 1957, oil on canvas, 152.5 × 122 cm, Buffalo, New York,

Albright-Knox Art Gallery, Gift of Seymour A. Knox. LOUIS: *Floral*, 1959, acrylic on canvas, 256 × 362 cm, New York, Private Collection; *Gamma zeta*, 1960, acrylic on canvas, 258 × 377 cm, New York, André Emmerich Gallery. FRANKENTHALER: *Mountains and sea*, 1952, oil on canvas, 221 × 297 cm, Washington, Collection of the artist, on loan to the National Gallery of Art.

468–469 Albers: Homage to the Square
ALBERS: *Variation in red*, 1948, oil on canvas, 51 × 77 cm, London, art market (Sotheby's); Studies for *Homage to the Square: Rain forest*, 1965, oil on board, 74 × 74 cm, London, art market (Sotheby's); *R-NW IV*, 1966, oil on masonite, 122 × 122 cm, Basel, Galerie Beyeler; *Fugue*, 1925, oil on glass, 24.5 × 66 cm, Basel, Kunstmuseum (Colorphoto Hans Hinz); *Transformation of a scheme no. 24*, 1952, engraved vinylite, 43 × 57 cm, New Haven, Connecticut, Yale University Art Gallery; Study for *Homage to the Square – Confirming*, 1971, oil on masonite, 79.5 × 79.5 cm, London, art market (Sotheby's).

470–471 Abstract Developments 2
REINHARDT: *Untitled*, 1938, oil on canvas, 193 × 366 cm, New York, Private Collection (Visual Arts Library); *Black painting*, 1960-66, oil on canvas, 60 × 60 cm, New York, Pace Gallery. OLITSKI: *Green goes around*, 1967, acrylic on canvas, 153 × 227 cm, New York, Mr and Mrs Arnold Ginsberg Collection (André Emmerich Gallery). NOLAND: *Ember*, 1960, acrylic on canvas, 179 × 178 cm, New York, André Emmerich Gallery; *Apart*, 1965, acrylic on canvas, 178 × 178 cm, New York, André Emmerich Gallery. KELLY: *Four panels*, 1964, silk-screen, 92.5 × 157.5 cm, Los Angeles, Gemini Gallery. STELLA: *Port aux Basques*, 1969, silk-screen, 96.5 × 178 cm, Los Angeles, Gemini Gallery; *Black adder*, 1965, metallic powder in polymer emulsion on canvas, 195.5 × 352 cm, New York, Leo Castelli Gallery. HELD: *Greek garden*, detail, 1964-66, oil on canvas, 366 × 1607 cm, New York, André Emmerich Gallery.

472–473 Informal Abstraction in Europe
FAUTRIER: *Head of a hostage*, 1945, oil on canvas, 35 × 26 cm, London, art market (Christie's). HARTUNG: *T 1955-23*, 1955, oil on canvas, 162 × 122 cm, Collection of the artist. WOLS: *The blue phantom*, 1951, oil on canvas, 60 × 73 cm, Milan, Collection Riccardo Jucker (S). MATHIEU: *Painting*, 1952, oil on canvas, 51 × 64 cm, London, Gimpel Fils Gallery. DE STAEL: *Figure by the sea*, 1952, oil on canvas, 161.5 × 129.5 cm, Düsseldorf, Kunstsammlung Nordrhein-Westfalen. TAPIES: *Pale blue composition*, 1956, oil and sand, 97 × 161 cm, London, art market (Sotheby's). DUBUFFET: *The very rich earth*, 1956, oil on paper, 156 × 117 cm, France, Private Collection (Visual Arts Library); *Uncertain situations*, 1977, acrylic on canvas, 213 × 353 cm, New York, Pace Gallery. APPEL: *A bird with a fish*, 1956, oil on canvas, 130 × 145 cm, London, Gimpel Fils Gallery. BURRI: *Sacking with red*, 1954, acrylic and mixed media, 86.5 × 100 cm, London, Tate Gallery.

474–475 Wyeth: Christina's World
WYETH: *Christina's world*, 1948, tempera on panel, 82 × 121 cm, New York, Museum of Modern Art; *Christina Olson*, 1947, New York, Private Collection (Visual Arts Library); *Grape wine (Willard Snowden)*, 1966, tempera on panel, 66 × 74 cm, New York, Metropolitan Museum of Art, Gift of Amanda K. Berls;

Nick and Jamie, 1963, Richmond, Virginia, Museum of Fine Arts (Visual Arts Library); *River cove*, 1958, USA, Private Collection (Visual Arts Library); *The hunter*, 1943, Toledo, Ohio, Museum of Art (Visual Arts Library).

476–477 After 1945: Old Masters of the New
BRAQUE: *Atelier II*, 1949, oil on canvas, 131 × 162.5 cm, Düsseldorf, Kunstsammlung Nordrhein-Westfalen. PICASSO: *Women of Algiers*, 1955, oil on canvas, 114 × 146 cm, New York, Victor Ganz Collection (S); *Mounted rider*, c. 1951, ceramic, London, Victoria and Albert Museum (Michael Holford); *The painter and his model*, 1963, oil on canvas, 195 × 160 cm, Paris, Private Collection (S). MATISSE: *The snail*, 1953, gouache and coloured paper on paper, 286.5 × 287 cm, London, Tate Gallery; *The Tree of Life*, 1949-51, stained glass, height of windows 515 cm, Vence, Chapel of the Rosary (Visual Arts Library). LEGER: *The builders*, 1950, oil on canvas, 302 × 216 cm, Biot, Musée Fernand Léger. NICHOLSON: *Poisonous yellow*, 1949, oil on canvas, 124 × 162 cm, Venice, Galleria d'Arte Moderna (S). KOKOSCHKA: *Louis Krohnberg*, 1950, oil on canvas, England, Private Collection (Cooper-Bridgeman Library).

478–479 Post-War Sculpture 1
MARINI: *Horse and rider*, 1946, bronze, height 52 cm, Rome, Galleria d'Arte Moderna (S); *The miracle*, 1943, painted plaster and collage, height 70 cm, Milan, Collection E. Jesi (S); MANZÙ: *The stoning of St Stephen; the death of St Gregory the Great; death in space; death on earth*, detail from the Portals of Death, 1950-64, bronze, Rome, St Peter's (S); *Great cardinal*, 1955, bronze, height 2 m, Venice, Galleria d'Arte Moderna (S); RICHIER: *Storm*, 1949, bronze, height 200 cm, Paris, Musée National d'Art Moderne (S). CALDER: *The spiral*, 1958, painted steel, height 500 cm, Paris, UNESCO Building (S); *Slender ribs*, 1943, painted steel, height 358 cm, Humlebaek, Louisiana Museum (Visual Arts Library). SMITH: *11 books, 3 apples*, 1959; *Zig II*, 1961; *Cubi II*, 1963, Bolton Landing, New York, Estate of the artist (Visual Arts Library); *Head*, 1959, steel, height 56 cm, Bolton Landing, New York, Estate of the artist (Visual Arts Library).

480–481 Giacometti: Man Pointing
MICHEL DESJARDINS: *Alberto Giacometti*, c. 1965, photograph (Agence Top). GIACOMETTI: *Man pointing*, 1947, bronze, height 176 cm, London, Tate Gallery (Angelo Hornak); *Dog*, 1951, bronze, Lugano, Collection Thyssen (S); *Composition with seven figures and one head (The forest)*, 1950, painted bronze, height 58 cm, London, Thomas Gibson Fine Art; *Caroline*, 1962, oil on canvas, 100 × 81 cm, Basel, Kunstmuseum (Colorphoto Hans Hinz).

482–483 Bacon: Figures in a Landscape
VELAZQUEZ: *Pope Innocent X*, 1650, oil on canvas, 140 × 120 cm, Rome, Galleria Doria-Pamphili (S). BACON: *Study after Velazquez*, 1953, oil on canvas, 152 × 117.5 cm, New York, Museum of Modern Art, Gift of Mr and Mrs William A.M. Burden; *Figures in a Landscape*, 1956, oil on canvas, 152.5 × 119.5 cm, Birmingham, City Art Gallery; *Figures in a landscape*, 1945, oil on canvas, 145 × 128 cm, London, Tate Gallery; *Isabel Rawsthorne*, 1966, oil on canvas, 81 × 68.5 cm, London, Tate Gallery. EISENSTEIN: Still from the film *The Battleship Potemkin*, 1928, photograph,

London, National Film Archive (Stills Library).

484–485 Johns and Rauschenberg
Jasper Johns, photograph by Judy Tomkins (Leo Castelli Gallery). JOHNS: *Painted bronze*, 1960, bronze, height including base 137 cm, New York, Collection of the artist; *Three flags*, 1958, oil on 3 canvases, 78 × 115 cm, New York, Leo Castelli Gallery; *Target with four faces*, 1955, oil and mixed media on canvas, 28.5 × 21 cm, New York, Museum of Modern Art; *Untitled*, 1972, oil, encaustic and collage, with objects, on canvas, 183 × 488 cm, Cologne, Collection Ludwig (Leo Castelli Gallery). RAUSCHENBERG: *Monogram*, 1959, oil and mixed media on canvas, height 122 cm, canvas 183 × 183 cm, Stockholm, National Museum; *Story-line 1*, 1968, silk-screen, 43 × 57 cm, New York, Museum of Modern Art; *Sleep for Yvonne Rainer*, 1965, mixed media on canvas, 213.5 × 152.5 cm, London, art market (Sotheby's); *Robert Rauschenberg*, photograph (Sunday Times).

486–487 American Pop Art
LICHTENSTEIN: *Masterpiece*, 1962, oil on canvas, 137 × 137 cm, New York, Private Collection (Leo Castelli Gallery). RIVERS: *French money*, 1962, oil on canvas, 46 × 81 cm, London, art market (Gimpel Fils Gallery). WARHOL: *Brillo*, 1964, painted wood, 43 × 43 × 35.5 cm, New York, Collection of the artist (Leo Castelli Gallery); *Liz no. 2*, 1962, silk-screen, 101.5 × 101.5 cm (Visual Arts Library). INDIANA: *Yield brother*, 1963, oil on canvas, 152.5 × 127 cm, London, art market (Sotheby's). ROSENQUIST: *Flamingo capsule*, 1970, oil on canvas with aluminized myler, each panel 290 × 175 cm, New York, Collection of the artist (Leo Castelli Gallery). DINE: *Things in their natural setting*, 1973, oil on canvas and mixed media, 183 × 152.5 cm, London, art market (Christie's). OLDENBURG: *Giant fag-ends*, 1967, canvas, foam formica and wood, height 244 cm, New York, Whitney Museum of American Art (Visual Arts Library). WESSELMANN: *Great American nude no. 14*, 1961, oil on canvas and collage, 122.5 × 122.5 cm, London, art market (Sotheby's).

488–489 British Pop Art
PAOLOZZI: *Japanese war god*, 1958, bronze, height 153 cm, Buffalo, New York, Albright-Knox Art Gallery; *Conjectures to identity*, 1963, screenprint lithograph, 76 × 51.5 cm, London, Tate Gallery (Visual Arts Library). SMITH: *Giftwrap*, 1963, oil on canvas and plywood, 203 × 528 × 79 cm, London, Tate Gallery (Visual Arts Library). HAMILTON: *What is it that makes today's homes so different, so appealing?*, 1956, collage, 26 × 24.5 cm, Tübingen, Kunsthalle, Professor Dr Georg Zundel collection. KITAJ: *Where the railroad leaves the sea*, 1964, oil on canvas, 122 × 152.5 cm, London, Marlborough Fine Art. HOCKNEY: *The sprinkler*, 1967, acrylic on canvas, 122 × 122 cm, London, art market (Sotheby's); *Christopher Isherwood and Don Bachardy*, 1968, acrylic on canvas, 212 × 304 cm, USA, Private Collection (Visual Arts Library). JONES: *Red latex suit*, 1973, oil and latex on canvas, 122 × 122 cm, London, art market (Christie's). CAULFIELD: *Town and country*, 1979, acrylic on canvas, 231 × 165 cm, England, Private Collection (Visual Arts Library).

490–491 Environmental Art, Happenings and Performance
KAPROW: *Basic thermal units*, 1973, activity with thermometers and ice at Essen, Duisburg, Bochum and Remscheid,

March 14-18 (Galerie Inge-Baecker). SEGAL: *The photo booth*, 1966, plaster, plastic, glass, metal, wood and electric lights, height 183 cm, Toronto, Collection Dr and Mrs Sidney Wax (Visual Arts Library). KIENHOLZ: *The birthday*, 1964, plastics and other media, figure life-size, Collection of the artist (Visual Arts Library). KLEIN: *Anthropometry: ANT 63*, 1961, acrylic on paper over canvas, 153 × 209 cm, Paris, Flinker Gallery (Visual Arts Library). OLDENBURG: Model for *Monument for Grand Army Plaza New York*, 1969 (Sunday Times). ACCONCI: *Rubbing piece*, 1970, activity at Max's Kansas City Restaurant, New York (John Gibson Commissions Inc./Betty Jackson). WELFARE STATE: *Action*, 1972, activity (Visual Arts Library). BEUYS: *Scottish symphony*, 1970, activity at the Edinburgh Festival, Edinburgh, 1970 (Visual Arts Library); *Room installation*, 1968, mixed media, 10 × 12 m, Darmstadt, Hessisches Landesmuseum, Karl Stöher collection (Visual Arts Library). PANE: *Action psyche*, 1974, activity at Paris, January 21, 1974 (Visual Arts Library).

492–493 Kinetic and Op Art

RILEY: *Cataract 3*, 1967, emulsion PVA on linen, 222 × 223 cm, British Council. VASARELY: *Zebras*, 1938, print, Paris, Collection of the artist; *Arny-C*, 1969, Paris, Collection of the artist. SEDGLEY: Wind Tone Tower, 1979, steel, sailcloth and electronics, height about 10 m, West Germany, Collection of the artist. SOTO: *Cardinal*, 1965, mixed media, 156 × 105.5 × 25.5 cm, London, Tate Gallery. TAKIS: *Signal: Insect animal of space*, 1956, metal, kinetic, height 205.5 × 35.5 × 37.5 cm, London, Tate Gallery. BURY: *3,069 white dots on an oval ground*, 1967, metal and cork, kinetic, 67 × 120 × 25.5 cm, London, Tate Gallery. TINGUELY: *Puss in boots*, 1959,

painted wire and steel, motorized, 77 × 17 × 20 cm, New York, Museum of Modern Art, Philip Johnson Fund.

494–495 Post-War Sculpture 2: Minimal and Conceptual

KOSUTH: *Chair I and III*, 1965, photographs and chair, Aachen, Ludwig Collection (Visual Arts Library). NAUMAN: *Perfect door: Perfect odor: Perfect rodo*, 1972, neon tubing, New York, Leo Castelli Gallery. KAWARA: *Today*, series: *April 5, 1966*, 1966, liquitex on canvas, 20.5 × 25.5 cm, London, Lisson Gallery. NEVELSON: *Royal tide IV*, 1960, painted wood (Visual Arts Library). CARO: *The month of May*, 1963, painted steel, height 280 cm, length 358 cm, London, Kasmin Ltd. TONY SMITH: *Cigarette*, 1966, plywood, height 4.6 m, length 8 m, New York, Fischbach Gallery (Visual Arts Library). MORRIS: *Untitled*, 1966-67, thickness of felt 10 mm, New York, Leo Castelli Gallery. JUDD: *Untitled*, 1974, anodized aluminium, length 172 cm, New York, Leo Castelli Gallery. LEWITT: *Cube structure*, 1972, painted wood, 62 × 61 × 122 cm, London, Lisson Gallery. ANDRE: Proposal for the Hague Museum – *Lock series 1967*, felt pen on paper, 21 × 30 cm, Aachen, Ludwig Collection (Visual Arts Library).

496–497 Land and Earth Art

CHRISTO: *Running fence*, 1972-76, erected in California, Sonoma and Mann Counties, 1976 (Wolfgang Volz); Project for Milan: *The Arco della Pace wrapped*, 1970, drawing and collage, 50 × 70 cm, Milan, Collection Françoise Lambert. FULTON: *Untitled*, 1969, photomontage, New York, John Gibson Commissions Inc. LONG: *A line in Australia*, 1977, earth and stones (Lisson Gallery). HEIZER: *Double negative*, 1969-70, rhyolite and sandstone, 24,000 tons displaced on the

Virginia river mesa, Nevada (Xavier Fourcade Inc./Gianfranco Gorgoni). SMITHSON: *Spiral jetty*, 1970, black basalt, limestone, salt crystal, red algae and earth, at Rozelle Point, Great Salt Lake, Utah (Visual Arts Library). THE POIRIERS: *Ancient Ostia*, 1971-73, soil and fixative, France, Collection of the artists (Visual Arts Library). DE MARIA: *Vertical earth kilometre*, 1977, at Kassel, West Germany (New York, Dia Art Foundation/Nic Tenwiggenhorn). HAACKE: *Rhine water installation*, 1972, fish, Rhine water, chemicals, plastic container and pump, West Germany, Collection of the artist (Visual Arts Library).

498–499 Traditional Easel-Painting

GRANDMA MOSES: *In harvest time*, 1945, oil and tempera on cardboard, 45.5 × 71 cm, New York, Grandma Moses Properties Inc. LOWRY: *Industrial landscape*, 1955, oil on canvas, 114.5 × 152.5 cm, London, Tate Gallery (Visual Arts Library). GUTTUSO: *Occupation of the land*, 1947, Italy, Private Collection (Fabbri). BUFFET: *Two Breton women*, 1950, oil on canvas, France, Private Collection (Maurice Garnier). NOLAN: *Kelly in landscape*, 1969, oil on canvas, 122 × 152.5 cm, London, Marlborough Fine Art. AUERBACH: *E.O.W. nude*, 1953-54, oil on canvas, 51 × 77 cm, London, Tate Gallery (John Webb). DIEBENKORN: *Ocean Park no. 108*, 1978, oil on canvas, New York, Knoedler Gallery. ERRO: *Plainscape*, 1972, Paris, Private Collection (Visual Arts Library). AVERY: *Morning sea*, 1955, California, Private Collection (Visual Arts Library). PLASTOV: *The tractor drivers' dinner*, 1951, oil on canvas, Moscow, Tretyakov Gallery (Visual Arts Library).

500–501 Superrealism

FREUD: *John Minton*, 1952, oil on canvas, 40 × 25.5 cm, London, Royal College of

Art (Visual Arts Library). PISTOLETTO: *Marzi with the little girl*, 1964, photographic transfer on steel, 200.5 × 119.5 cm (Visual Arts Library). PEARLSTEIN: *Female nude reclining on Empire Sofa*, 1973, oil on canvas, 122 × 152.5 cm, Private Collection (Visual Arts Library). ESTES: *Grossinger's bakery*, 1972, oil on canvas (Visual Arts Library). MORLEY: *United States Marine at Valley Forge*, 1968, oil on canvas, 150 × 125 cm, Paris, Collection Daniel Hechter (Visual Arts Library). GOINGS: *Twin Springs diner*, 1976, oil on canvas, 96.5 × 132 cm, New York, OK Harris Gallery (Eric Pollitzer). CLOSE: *Keith*, 1970, acrylic on canvas, 130 × 105 cm, Paris, Private Collection (Visual Arts Library). DE ANDREA: *Seated woman*, 1978, painted polyvinyl, life-size, New York, OK Harris Gallery. HANSON: *Couple with shopping bags*, 1976, painted vinyl, life-size, New York, OK Harris Gallery.

502–503 The Popularization of Art

MCKNIGHT-KAUFFER: *Winter sales*, 1924, poster, 76 × 51 cm, London, London Transport Ltd. (Sunday Times). MATISSE: *The swan*, 1930-33, pen and ink on paper, Baltimore, Museum of Art. *Kenneth Clark*, photograph, still from *Civilization* (BBC Picture Library). *They are better than one*, 1963, silk-screen, New York, Leo Castelli Gallery. LICHENSTEIN: *Brush-strokes*, 1967, London, British Museum. STEADMAN: Illustration to Hunter S. Thompson's *Fear and Loathing in Las Vegas*, 1970, pen and paper (Visual Arts Library). ADAMI: *Arabian landscapes*, 1969, silk-screen (Visual Arts Library). MIRO: *Marvellous puzzles*, 1970s, lithograph, London, art market (Christie's). COLLETT, DICKINSON, PEARCE & PARTNERS: (*Government warning: Smoking can seriously damage your health*), 1979, photomontage, London, Gallagher Ltd.

Index

Credits